SULTAN IBRAHIM MIRZA'S

Haft Awrang

A Princely Manuscript from Sixteenth-Century Iran

MARIANNA SHREVE SIMPSON *with contributions by Massumeh Farhad*

Freer Gallery of Art
Smithsonian Institution, Washington, D.C.
Yale University Press
New Haven & London

In Honor of My Parents

Published in 1997 by Yale University Press, New Haven and London, in association with
the Freer Gallery of Art, Smithsonian Institution, Washington, D.C.

This book was published with the assistance of the Getty Grant Program
and with funds provided by the Smithsonian Institution Scholarly Studies Program.
Additional funding was provided by the Freer and Sackler Galleries' Publications Endowment Fund,
initially established with a grant from the Andrew W. Mellon Foundation
and generous contributions from private donors.

Typeset in Monotype Poliphilus with Blado Italic
Printed on 135 gsm Garda Matt
by Amilcare Pizzi, S.p.A., Milan, Italy
Edited by Ann Hofstra Grogg
Designed by Derek Birdsall RDI

Library of Congress Cataloging-in-Publication Data
Simpson, Marianna Shreve, 1949–
Sultan's Ibrahim Mirza's Haft awrang : a princely manuscript from sixteenth-century Iran /
Marianna Shreve Simpson with contributions by Massumeh Farhad.
 p. cm.
"Freer Gallery of Art, Smithsonian Institution, Washington, D.C."
ISBN 0-300-06802-6 (cl : alk . paper)
1. Sultan Ibrahim Mirza's Haft awrang-Illustrations.
2. Illumination of books and manuscripts, Iranian. 1. Farhad,
Massumeh. 11. Title.
ND3399.S84S56 1997
745.6'7'0955-dc21
96-49395
CIP

CONTENTS

All historians of Persian painting are ultimately fascinated by—and struggle to answer—the same fundamental questions: Why do these paintings look the way they do, and what do they mean? Despite a century of scholarship, the answers remain elusive.

Any contemporary study of painting in Islamic cultures must actually deal with two traditions, one historical, the other historiographic. The first is found in the brilliant remains of one of the most distinctive and least understood of all pictorial traditions—an art practiced from Spain to India with astonishing range and imagination over the last millennium. The second, more immediate but subject to its own intellectual complexities, is the cumulative legacy of previous scholarship. At any moment, this body of achievement—with its inevitable imperfections and misunderstandings—forms the foundation for all subsequent knowledge. Historical understanding is now moving beyond the impressionistic interpretations, sequences of dates, and taxonomic concerns so important to our current thinking toward bold new attempts at broad cultural and aesthetic interpretations. The interaction of these two traditions shapes all attempts to analyze the forms and dynamics of Persian painting. And progress can be made only by both acknowledging the achievements and defining the limitations of past scholarship.

Sultan Ibrahim Mirza's Haft awrang: A Princely Manuscript from Sixteenth-Century Iran is testimony as much to these recent intellectual shifts as to the continuing importance of research and scholarship at the Freer Gallery of Art and the Arthur M. Sackler Gallery. It represents more than a decade of work by Marianna Shreve Simpson, formerly the galleries' curator of Islamic Near Eastern art, and her efforts are important to the study of both visual creativity in sixteenth-century Iran and the arts of the book more generally. In reexamining a critical moment in the history of painting under the Safavid dynasty (1501–1736), her goal has been to restore awareness of these paintings as parts of books, not as independent works of art. The result is a comprehensive, meticulous analysis of the physical and conceptual totality of a single manuscript. To this day, few illustrated Islamic manuscripts have been published in their entirety, a situation barely comprehensible considering the attention that has been paid to individual European volumes. *Sultan Ibrahim Mirza's Haft awrang* is an attempt to fill this lacuna. It admirably documents the creation and physical production of one of the most celebrated illustrated Persian manuscripts; moreover, few volumes of comparable importance remain intact today. Acquired for the Freer Gallery of Art in 1946 by its then director Archibald Wenley, the "Freer Jami" has long been recognized and discussed not simply as a prized and beautiful object but as a crucial aesthetic document of Safavid art.

By means of a rigorous and exhaustive codicological inquiry, an archaeology of the manuscript has now emerged, and it defines how the book was conceived, written, painted, decorated, and bound. Dr. Simpson's study is deeply informed by an understanding of the circumstances surrounding the production and dissemination of illustrated books and paintings in the Persianate cultural sphere, in particular the workings of artistic ateliers in Safavid Iran, and important new information about a host of artists and their work has been assembled here for the first time. Equally significant among the author's many contributions is a careful and much-needed assessment of the respective values of text, painting, and illumination in the conception and production of an illustrated manuscript, an equilibrium that casts new light on the structure, function, and meaning of the book in Islamic culture. The result is a work that both complements and extends the last major study of Safavid painting, the monumental *Houghton Shahnameh*, written by Martin Dickson and Stuart Cary Welch and published in 1981. *Sultan Ibrahim Mirza's Haft awrang* is a worthy successor and clearly stands as a major addition to our knowledge of how a culture defines its place and meaning in the world.

This book is part of a series of scholarly publications devoted to the permanent collections of the Freer and Sackler Galleries made possible by funding through an endowment for publications. This endowment was initially established by a major grant from the Andrew W. Mellon Foundation. A grant from the Smithsonian Institution Scholarly Studies Program enabled Dr. Simpson to complete her research for the book. And finally we are grateful to have received a generous grant from the Getty Grant Program toward the publication of this volume.

Milo Cleveland Beach
Director
Freer Gallery of Art and Arthur M. Sackler Gallery
Smithsonian Institution

In the fall of 1979 I had the privilege of assisting Esin Atil, then curator of Islamic art at the Freer Gallery of Art, in the preparation of an exhibit drawn from the museum's impressive holdings of Persian manuscripts and paintings of the Safavid period. One of the highlights of the exhibition was to be the deluxe manuscript commonly known as the Freer Jami—a copy of the *Haft awrang* of Abdul-Rahman Jami made for the Safavid prince Sultan Ibrahim Mirza. The necessity of having to write an exhibition label led me to examine the Freer Jami and the literature surrounding it at that time. This first, rather straightforward encounter initiated a research project lasting well over a decade. It is typical of the complexity and subtlety of a masterpiece that its full dimensions, including in this case the literary and artistic contents and historical and art-historical contexts, should extend widely and reveal themselves slowly. The "revelation" of the Freer Jami has been marked by fascinating discoveries, protracted preoccupations, and lingering mysteries, and I have no doubt that even now this superb manuscript contains many facets yet to be explored.*

My investigation of Ibrahim Mirza's *Haft awrang* and the preparation for its publication have been aided and abetted over the years by many colleagues at the Freer Gallery and, since 1987, at its sister institution the Arthur M. Sackler Gallery. I would like to thank in particular the former and current directors, Thomas Lawton and Milo Cleveland Beach, and the following members of the Freer and Sackler staff: Patricia Adams, Martin Amt, Carol Beehler, Susan Bliss, Mary Cleary, David Cole, Jeff Crespi, Elizabeth Duley, Laveta Emory, Scott Husby, Lily Kesckes, Rebecca Kingery, Craig Korr, Toni Lake, Jane McAllister, Kathryn Phillips, Eleanor Radcliffe, Jim Smith, Martha Smith, Loi Thai, John Tsantes, Sarah Wilke, and Mary Kay Zuravleff. I also would like to express my gratitude to Glenn D. Lowry, curator of Islamic art at the Freer and Sackler from 1984 to 1990, for his support of my proposal to publish a monograph on the Freer Jami, and to Thomas W. Lentz, deputy director, for his counsel and assistance in bringing the project to completion. Special appreciation goes to Esin Atil, whose initial endorsement and stead-fast encouragement of my research have meant a great deal over the years.

I am also pleased to acknowledge the generous award from the Smithsonian Institution through its Scholarly Studies Program during the time I served as curator of Islamic Near Eastern art at the Freer and Sackler Galleries and continuing to 1997. I am particularly grateful to Tom Freudenheim and Roberta Rubinoff for their interest. This book was published with the assistance of the Getty Grant Program. Additional funding was provided by the Freer and Sackler Galleries' Publications Endowment Fund, initially established with a grant from the Andrew W. Mellon Foundation and generous contributions from private donors.

As with so many studies of Persian manuscripts, the Freer Jami project necessitated research at the Topkapi Sarayi Müzesi in Istanbul. Words cannot express my deep appeciation to Filiz Çağman, head of the Topkapi library, as well as to Zeren Tanindi and Banu Mahir, former library assistants, for countless courtesies and gracious assistance before, during, and after various visits to Istanbul.

Many other colleagues and friends within the ranks of Islamic and Persian art history have been extremely helpful, critical, and supportive. My sincere thanks, as well as apologies for this imper-sonal listing, go to Karin Adahl, Ada Adamova, Chahryar Adle, Terry Allen, the late Elise Anglade, Nurhan Atasoy, Kathryn Babayan, Julia Bailey, Joachim Bautze, Marthe Bernus-Taylor, Carol Bier, Irene Bierman, Sheila S. Blair, Na'ama Brosh, Layla S. Diba, Dorothea Duda, Marcus Fraser, Francesca Galloway, Sadashiv Gorakshar, Oleg Grabar, Jo-Ann Gross, Ann Gunter, Jessica Hallett, Prudence O. Harper, Regina Hickmann, Eva Irblich, David James, Mary A. McWilliams, Helga Rebhan, Maria Queiroz Ribeiro, Francis Richard, Winifred Riesterer, B. W. Robinson, Michael Rogers, A. P. Romanov, David Roxburgh, Michael Ryan, John Seyller, Robert Skelton, Priscilla Soucek, Lucienne Thys-Senocak, Norah Titley, Olga Vasilieva, Pierre Chiesa Gautier Vignal, Muhammad Isa Waley, and Stuart Cary Welch. I also am extremely grateful to Prince Sadruddin Aga Khan and his assistant Madame Liliane Tivolet, Edmund de Unger, the late Arthur B. Houghton, Farzad Rastegar, Abolala Soudavar, Friedrich Spuhler, and Nourollah Elghanayan for allowing me to study and publish works of art in their collections.

*This supposition was borne out during the very final production stage of this publication when I discovered—to my equal delight and consternation—a minute signature on folio 120a. The specifics are recorded in Chapters Two and Three. The full implications for my hypotheses and conclusions about the Freer Jami will be taken up in a subsequent study.

Much of the research on the Freer Jami involved linguistic, literary, and cultural concerns beyond my ken. I am especially grateful to Jerome W. Clinton for his assistance with the *Haft awrang* text at an early phase in the project and to Wheeler M. Thackston for his critical review of the *Divan*s by Sultan Ibrahim Mirza and for his good-natured advice and thoughtful commentary on a myriad of issues, from the translation of mystical poems to the customs of yogurt-making and sheep-herding.

This project also has depended on the participation of a series of dedicated research assistants whom it is a great pleasure to thank publicly here. Rita Offer prepared synopses of the *Haft awrang masnavi*s and drew together a great deal of important material on the life and poetry of Abdul-Rahman Jami and on the Safavid period. Marjan Adib checked the Persian inscriptions and transliterations as well as numerous details in the chapters, footnotes, appendices, and references. Sharon Littlefield helped assemble the photographs, prepare the captions, and review the copy-edited text.

My greatest debt is to Massumeh Farhad, who carried out a wide variety of research tasks from 1988 to 1991, from combing primary sources for Sultan Ibrahim Mirza and his artists (a particularly fruitful process with regards to the little-studied *Khulasat al-tawarikh* by Qazi Ahmad) to verifying the iconography of *Haft awrang* illustrations. Dr. Farhad, now associate curator of Islamic Near Eastern art at the Freer and Sackler, also examined many works of art on my behalf in England, France, Portugal, and Turkey and undertook the final compilation of the artists' oeuvres and the transcription and translation of all their colophons and signatures. Her many suggestions, unfailing tact, and good cheer have been indispensable, and I am proud to acknowledge her invaluable contributions on the title page of this book.

I am also indebted for technical support to Curtis Millay, who has the amazing ability to make the development of indices and other automated aids seem like fun. My thanks, too, to Michelle Smith, who prepared the index.

Much of the research on and writing about the Freer Jami took place during my very happy tenure at the Center for Advanced Study in the Visual Arts at the National Gallery of Art. There I benefited enormously from stimulating discussions about art history, historiography, and methodology with Henry A. Millon, dean, and Therese O'Malley, associate dean, as well as twelve "seasons" of senior and predoctoral fellows. Professor Millon has been the best possible colleague, constantly guiding and goading me toward the completion of this research project. I hope that, if nothing else, my study will answer his incredulity about the manufacture of inlaid paper. I am also grateful to the Center for Advanced Study for support for my travel and other research needs, and to the Board of Advisors of the Center and the Board of Trustees of the National Gallery for the award of a Board of Advisors Sabbatical Fellowship in 1987–88. I would like to thank Gary Vikan and my other new colleagues at the Walters Art Gallery for their interest in this project as it wound its way to completion.

The final preparation of the book for publication involved considerable editorial intervention, first by Kathleen Preciado, who labored mightily to control the text, and then by Ann Hofstra Grogg, whose meticulous care instilled order and consistency. General editorial direction has been provided by Karen Sagstetter, editor in chief for the Freer and Sackler Galleries, whom I would like to thank for her willingness to undertake this project and for her forbearance during the protracted editorial and publication process. I am equally grateful to John Nicoll of Yale University Press and to designer-extraordinaire Derek Birdsall for their imaginative and sensitive response to both manuscript and monograph.

Finally, I would like to express my eternal gratitude to Richard L. Kagan for his patience and sagacity during the many years in which the Freer Jami occupied our shared study, and to Loren Simpson Kagan for the countless questions that have made me more aware of those features—such as polychrome mountains and high-spirited horses—that give the *Haft awrang* made for Sultan Ibrahim Mirza much of its enduring appeal.

Marianna Shreve Simpson
Baltimore, Maryland
February 1997

The transliteration system for Arabic, Persian, and Turkish has been developed in consultation with Wheeler M. Thackston, Harvard University, and, in general, follows the style used by the Freer and Sackler Galleries, Smithsonian Institution. Diacritical and other orthographic marks are omitted, except for the *hamza* (') and internal and final *ayn* ('). Place names are given in their generally accepted English spellings. Foreign words are italicized at their first usage only. A glossary of frequently used foreign terms follows the appendices at the end of the book.

Historical events and dated works of art are cited according to the hegira (*hijra*) calendrical system (A.H.) followed by the corresponding date in the common era (A.D.).

The works of art discussed here include calligraphies, manuscript illustrations, and album paintings. The calligraphies are executed in ink on paper, and the manuscript illustrations, illuminations, and album paintings in opaque watercolor, ink, and gold on paper unless otherwise noted. Dimensions are cited in centimeters; height precedes width. Most of the Freer Jami details reproduced in this book are shown actual size. Unless otherwise credited, works are reproduced courtesy of the Freer Gallery of Art, Smithsonian Institution. The concordance to reproductions guides the reader to the various appearances of the same work of art. A map of Safavid Iran appears on page 229. Endnotes appear within chapters, at the end of each section. Citations to manuscript folio numbers should be understood as Persian is read—right to left.

The page grid of this book is based on that of the Freer Jami, and the typeface, Monotype Poliphilus, is based on a type first used in an edition of *Hypnoerotamachia Poliphili*, printed and published by Aldus Manutius in Venice, 1499. The gold-flecked pages that appear as chapter dividers are reproductions of folio 182a of the Freer Jami.

INSTITUTIONS AND COLLECTIONS

AHT	Art and History Trust, Courtesy of Arthur M. Sackler Gallery, Smithsonian Institution, Washington, D.C.
AMSG	Arthur M. Sackler Gallery, Smithsonian Institution, Washington, D.C.
BAY	Bayani Collection, Tehran
BL	British Library, London
BM	British Museum, London
BMFA	Museum of Fine Arts, Boston
BN	Bibliothèque Nationale de France, Paris
BOD	Bodleian Library, Oxford
BSB	Bayerische Staatsbibliothek, Munich
BSM	Staatliche Museum, Berlin
CB	Chester Beatty Library, Dublin
CHR	Christie's, London
CMA	Cleveland Museum of Art
CUL	Cambridge University Library
DAM	Archaeological Museum, Delhi
DC	David Collection, Copenhagen
ELG	Elghanayan Collection, New York
FGA	Freer Gallery of Art, Smithsonian Institution, Washington, D.C.
FRE	Free Library, Philadelphia
FSB	Forschungsbibliothek, Gotha
FWM	Fitzwilliam Museum, Cambridge
GEBO	General Egyptian Book Organization, Cairo
GL	Gulistan Library, Tehran
GULB	Calouste Gulbenkian Foundation, Lisbon
HRM	Hermitage Museum, Saint Petersburg
HUAM	Harvard University Art Museums, Cambridge
IM	Israel Museum, Jerusalem
IO	India Office Library, London
IOS	Institute of Oriental Studies, Academy of Sciences, Tashkent
IUL	Istanbul University Library
JHU	The Johns Hopkins University, Baltimore
JS	Jean Soustiel Collection, Paris
KAR	Karimzadeh Collection, Tehran
KEIR	Keir Collection, Richmond, Surrey
KEV	formerly Hagop Kevorkian Collection, New York
KNM	Dar al-Athar al-Islamiyyah (Alsabah Collection), Kuwait (formerly Kuwait National Museum)
LACMA	Los Angeles County Museum of Art
LKM	Kunstgewerbemuseum, Leipzig
LMV	Museum für Völkerkunde, Leipzig
LVR	Musée du Louvre, Paris
MAH	Musée d'art et histoire, Geneva
MAR	formerly Marteau Collection, Paris
MDV	Mahdavi Collection, Tehran
MET	Metropolitan Museum of Art, New York
MIA	Minneapolis Institute of Art
ML	Majlis-i Shoray-i Melli Library, Tehran
MOA	Museum of Oriental Art, Moscow
MSL	Mashhad Shrine Library
NL	Nurosmaniye Library, Istanbul
NM	Negarestan Museum, Tehran
NYPL	New York Public Library
ÖNB	Österreichische Nationalbibliothek, Vienna
PLK	Public Library of Kabul
PWM	Prince of Wales Museum, Bombay
RYL	John Rylands Library, Manchester
SAK	Collection of Prince Sadruddin Aga Khan, Geneva
SAY	Sayeedia Library, Hyderabad
SJML	Salar Jung Museum and Library, Hyderabad
SNL	Stockholm National Library
SOTH	Sotheby's, London
SPB	Sotheby Parke Bernet, New York
SPL	National Library of Russia (formerly State Public Library), Saint Petersburg
STJ	Saint John's College Library, Cambridge
TEH	Private Collection, Tehran
TIEM	Türk ve Islam Eserleri Müzesi, Istanbul
TKS	Topkapi Sarayi Müzesi, Istanbul
TQV	Taqavi Collection, Tehran
TRN	Trinity College Library, Cambridge
VA	Victoria and Albert Museum, London
WAG	Walters Art Gallery, Baltimore

INTRODUCTION

Sometime in the late spring or summer of 963/1556, the young Safavid prince Sultan Ibrahim Mirza commissioned a copy of the great Persian classic, the *Haft awrang* of Jami. Ibrahim Mirza consigned the transcription of the poetic text to at least five court calligraphers, who spent the next nine years on this task. By mid-972/1565 the text pages were turned over to another group of gifted artists for illumination and illustration. When finally gathered and bound, the manuscript contained some three hundred folios of elegant nasta'liq script, richly decorated margins, thousands of gold column dividers and multicolored rubrics, nine illuminated headings, nine colophons, and twenty-nine full-scale paintings (fig. 1).

In its present form the volume is only slightly different from what Sultan Ibrahim Mirza must have originally possessed. Its binding, first text folio, and initial illuminated heading have been replaced. A page of poems unrelated to Jami's text has been substituted for the last *Haft awrang* folio, which undoubtedly contained a final colophon. Two folios, one illustrated, have been removed, perhaps along with one or more double pages of illuminated front matter. Modern flyleaves have been added at the beginning and end, and interleaves have been inserted between many folios.

Despite these lacunae, substitutions, and additions, the *Haft awrang* of Sultan Ibrahim Mirza remains today a masterpiece of the Islamic arts of the book and, since 1946, one of the treasures of the Freer Gallery of Art in Washington, D.C. The renown of the Freer Jami (as it is commonly called) has ensured its appearance in all surveys of Iranian painting and a central place in studies of Safavid art. Most scholarly attention has focused on the manuscript's beautiful, unsigned illustrations and specifically on their style and attribution.

The connoisseurship of these paintings remains a compelling concern. Yet a discriminating patron such as Sultan Ibrahim Mirza must have valued his *Haft awrang* for its complete contents and not simply the superb pictorial compositions. To capture this original value, the manuscript should be considered in its poetic and artistic entirety. The volume's colophons and inscriptions contain a wealth of historical documentation, complementing the literary and visual evidence. Thus it becomes possible to reconstruct the manuscript's internal chronology and deduce something about its meaning, the motivation of the person who ordered it, and the methods of those who copied and embellished it.

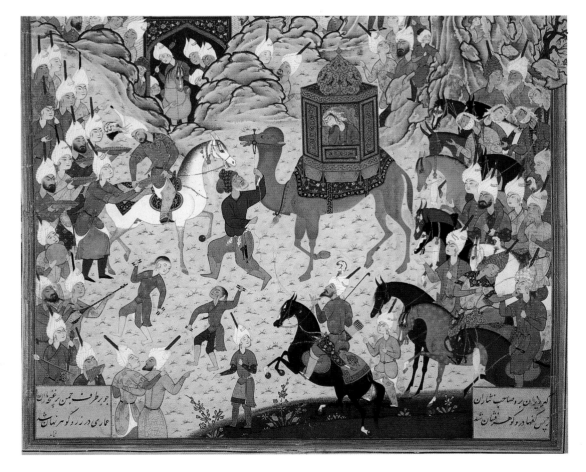

1
The Aziz and Zulaykha Enter the Capital of Egypt and the Egyptians Come Out to Greet Them (detail) in the *Haft awrang* of Jami
963–72/1556–65, Iran
29.1×19.5 cm (painting)
FGA 46.12, folio 100b

Some of these deductions have been previously proposed, along with certain technical data.[1] The present publication provides additional information about the Freer Jami's textual and material contents, patron and artists, process of production, and purpose and meaning, and also seeks to address the broader historical and art-historical issues raised by this remarkable work of art. These include the *kitabkhana* system and the practices of deluxe-manuscript production in sixteenth-century Iran; the respective roles and relationships of those involved in what seems to have been quite a complicated enterprise, especially patrons, calligraphers, illuminators, and painters; the intersection of art and literature in a culture that privileged both form and content; and the significance of an illustrated book, especially one on which much care was lavished, as a document of its time.

Initially it was tempting to present the Freer Jami as a work of art belonging to one person and to place it primarily within the context of the artistic patronage of Sultan Ibrahim Mirza. Certainly it is important to understand why Ibrahim Mirza wanted a deluxe volume of the *Haft awrang* and why he went to considerable effort to possess one. While the Safavid prince is without doubt the

2
Masnavi heading folio of *Salaman u Absal*
Copied by Ayshi ibn Ishrati
in the *Haft awrang* of Jami
968/1560–61, Iran
34.5×23.4 cm (folio)
FGA 46.12, folio 182b

most memorable personality in the story, he remains in many ways the most elusive, partly because of the unevenness of the biographical record. Although an account of his patronage can be sketched, it is not possible to make Ibrahim Mirza as princely patron the central focus of the Freer Jami's history. Similarly no single artist known to have worked on the manuscript warrants being placed at the head of this tale.

Ultimately it is the sheer physical presence and beauty of the manuscript that first impress anyone fortunate enough to peruse its pages (fig. 2). Thus this study begins with a description of the work's contents. From the "what" of the Freer Jami (Chapters One and Two), the study proceeds to the "who" (Chapter Three), and finally to the "how" and "why" (Chapter Four). A series of appendices treating the manuscript's collation and historiography (Appendices A and B) and listing the illustrated manuscripts and illustrations of the *Haft awrang* and the oeuvres of the Freer Jami artists (Appendices C, D, and E) supplement these discussions.

The Freer Jami was created at a time when the arts of the book in Iran had attained full maturation, when scores of artists of all kinds, including calligraphers, illuminators, painters, bookbinders, and other specialists, were busily engaged in a veritable industry of manuscript-making. This was a particularly vital period for painters, who developed many original modes of manuscript illustration involving, early in the sixteenth century, a melding of the painting styles practiced in eastern and western Iran during the late Timurid and Turcoman periods. This synthesis of the elegant Timurid painting and the more exuberant Turcoman painting emerged under the auspices of the first Safavid monarch, Shah Isma'il (r. 907–30/1501–24). Isma'il's encouragement of painters (including the great master Bihzad) and pictorial innovation were continued by his sons Tahmasp (who reigned as the second Safavid ruler, 930–84/1524–76), Sam Mirza, and Bahram Mirza. Safavid patronage was carried on into the third generation by Isma'il's grandson Sultan Ibrahim Mirza, who inherited the family passion for the literary and visual arts and an appreciation for imaginative approaches toward painting. Indeed the prince continued to support artists and artistic innovation even after Shah Tahmasp's celebrated renunciation of painting and other arts at midcentury. It remains to be seen whether Tahmasp's changed attitude and the dispersal of his court artists affected the initiation of Ibrahim Mirza's *Haft awrang* project. What is not in doubt, however, is the manuscript's importance as a model of creative patronage and painting and of the artistic standards of Safavid Iran through the reign of Shah Tahmasp.[2]

This monograph began as an attempt to situate the Freer Jami in context. What that turns out to be, of course, is a variety of contexts, including this manuscript in relation to other deluxe manuscripts of the Safavid period, in relation to other codices owned by or associated with Sultan Ibrahim Mirza, in relation to other works made by the artists to whom the prince entrusted the Jami commission, and in relation to other illustrated copies of the *Haft awrang*. As with the examination of the Freer Jami itself, the study of these and other relationships depends on a combination of codicological, literary, historical, and art-historical methods. Inevitably, certain aspects of the subject have received less consideration. The most obvious omission is extensive discussion of the authorship of individual paintings. Given the absence of signatures in the compositions and the diverse attributions in the scholarly literature, it seemed more worthwhile to concentrate on other points, for instance the manuscript's overall illustrative program, for which the identity of specific painters may not be crucial.

The study of the Islamic illustrated book is still in an elementary state, and the monograph as a scholarly genre has been less frequently employed than the catalogue or the survey. Yet while a focus on a single manuscript may be viewed as restrictive, lacking the possibility for the development of broad historical chronologies and artistic trends, the monograph offers the opportunity for a detailed case study by which a single work of art may serve as an exemplar and a series of particular circumstances may point to a general pattern. If any manuscript can fulfill this potential, it is the *Haft awrang* of Sultan Ibrahim Mirza.

1. Simpson, "Codicology"; Simpson, "Jami."
2. The significance of the Freer Jami is widely recognized today, as evidenced by its characterization as "an excitingly inventive undertaking" (S. C. Welch, *PP*, 27), "one of the crucial artistic documents for the understanding of Safavid book-painting in the mid-sixteenth century" (Gray, "Safavid," 889), "a watershed manuscript" (A. Welch, *Artists*, 157), and the "swan song of the *époque*" (Kevorkian & Sicré, 48).

CHAPTER ONE: CONTENTS

Sultan Ibrahim Mirza's *Haft awrang* is a manuscript of many splendid parts. This chapter presents the contents of the volume, beginning with Abdul-Rahman Jami's *Haft awrang*, a work long cele-brated in classical Persian literature. Ibrahim Mirza's choice of Jami's *masnavi*s among the various poetic texts commonly selected for illustration during the sixteenth century was unlikely to have been capricious. Thus an understanding of the *Haft awrang*'s author and text may help reveal Ibrahim Mirza's literary taste and the rationale for this commission (fig. 3).

The discussion of the literary content of the Freer Jami is followed by an analysis of its internal history, as documented by colophons, inscriptions, and seals. The colophons at the end of eight sec-tions of the *Haft awrang* are particularly valuable as a collected roster of names, dates, and places and as a collective index to the process of the manuscript's formation. Although many Persian manuscripts contain colophons, the amount of information recorded in the Freer Jami, including the names of five scribes and three cities and the dates 963–72/1556–65, seems unique—a telling feature for Ibrahim Mirza's perception of the value of his beautiful work of art. Certainly he, or at least the artists in his employ, seemed intent on ensuring that his role as patron would not be over-looked or forgotten, judging from the extended invocations of his names in five colophons and inscriptions incorporated into three illustrations. The seal impressions found throughout the man-uscript and dated to 1017/1608–9 tell of a subsequent moment in the volume's fortunes, when it formed part of an endowment given by the Safavid ruler Shah Abbas to the dynastic shrine at Ardabil.

3
Text folios of *Layli u Majnun*
Copied by Muhibb-Ali
in the *Haft awrang* of Jami
972/1565, Iran, Herat
34.5×46.8 cm (two folios)
FGA 46.12, folios 228b–29a

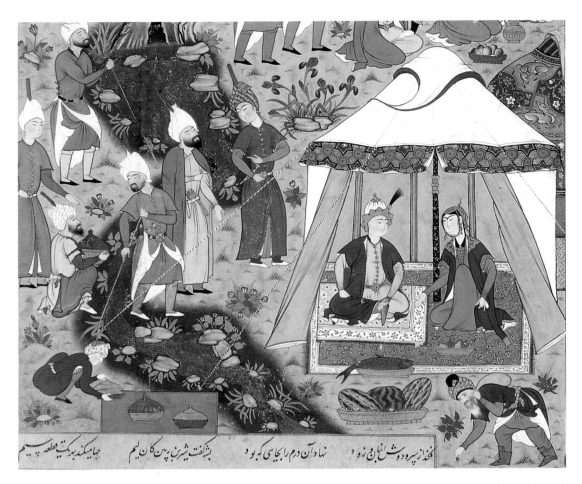

4
Khusraw Parviz and Shirin Deal with the Fishmonger
(detail)
in the *Haft awrang* of Jami
963–72/1556–65, Iran
25×17.2 cm (painting)
FGA 46.12, folio 291a

Much about the history of the Freer Jami also can be learned by an examination of its physical condition and contents. The third section of this chapter summarizes the manuscript's codicology, with an emphasis on several noteworthy material and structural features, specifically the folios, calligraphy, and gatherings. A complete codicological record, including dimensions, types of illumination, unfinished areas, and modern alterations, is outlined in Appendix A.ı and given in the full collation in Appendix A.ıı.

The last two sections of this chapter concern the decorative and pictorial contents of the Freer Jami, which both on their own and in combination elevate this manuscript into the rarefied ranks of masterpiece. Relatively little attention has been paid to the decoration that enriches every folio of the Freer Jami. The extent and diversity of illumination throughout the manuscript are breath-taking, and an examination of its various forms—from headings to rulings to margins—offers distinct aesthetic rewards.

More than anything else, the paintings in Ibrahim Mirza's *Haft awrang* have secured its reputa-tion as a great work of art and its patron's renown as a great connoisseur of the Safavid period (fig. 4). They also occupy a principal position in this study, and each receives extended attention in Chapter Two. Chapter One considers the technical and formal features shared by the composi-tions and their idiosyncrasies. Again the purpose is to explain how the paintings fit into the manu-script and to identify what they contribute to the overall character of this deluxe codex.

LITERARY

The *Haft awrang*, known in English as *Seven Thrones* or *Constellation of the Great Bear*, comprises seven poems in masnavi form by the celebrated Sufi scholar and writer Mawlana Nuruddin Abdul-Rahman Jami (817–898/1414–1492). Three *Haft awrang* poems—*Yusuf u Zulaykha*, *Layli u Majnun*, and *Salaman u Absal*—are allegorical romances. Another three—*Silsilat al-dhahab*, *Tuhfat al-ahrar*, and *Subhat al-abrar*—consist of a series of didactic discourses, while the seventh—*Khiradnama-i Iskandari*—combines the two genres. All seven masnavis are based on religious, philosophical, gnostic, and ethical themes of Sufi origin and inspiration and are specifically grounded in the mys-tical attitudes and beliefs of the Naqshbandi order to which Jami was attached. With three collec-tions of divans (lyric poems), the masnavis of the *Haft awrang* long have been regarded as among the masterpieces of Jami's considerable oeuvre and have earned their author the dual reputation as the last of the classical Persian poets and the last of the mystical poets of Iran (fig. 5).[1]

Abdul-Rahman Jami was already held in high esteem when he wrote the *Haft awrang*, some-time between 1468 and 1485.[2] Jami spent most of that period and most of his life in Herat, capital of the Timurid dynasty and seat of its last and most cultivated ruler, Sultan-Husayn Mirza.[3] During his long reign (872–911/1470–1506) Herat flourished economically and culturally, sup-porting the most talented members of the intellectual and artistic elite in Iran.[4] Foremost among the literary figures at Sultan-Husayn Mirza's court was Mir Ali-Sher Nava'i (844–906/1441–1501), champion of the development of eastern Turkic (so-called Chaghatay) as a literary language and author of many important works, including the invaluable *Majalis an-nafaʾis* (Gathering of the exquisite).[5] Although often described as a vizier, Mir Ali-Sher did not actually hold ministerial rank or long-term administrative office.[6] His relationship to the sultan was that of friend, confidant, and *kükältash* (foster brother)—a far more influential and unique role than any official appointment.

5
Text folio of *Subhat al-abrar*
Copied by Shah-Mahmud al-Nishapuri
in the *Haft awrang* of Jami
963/1556, Iran, Mashhad
21.8×13 cm (written surface)
FGA 46.12, folio 179a

In that capacity and by virtue of his literary accomplishments, Mir Ali-Sher exercised tremendous authority as a patron of the arts and letters, functioning essentially as doyen of the literary life of Herat.[7]

The other giant in the late Timurid literary scene was Abdul-Rahman Jami, who, while not a court poet per se, was greatly admired as a supreme poetic master and model.[8] His friend Mir Ali-Sher composed an entire work, the *Khamsat al-mutahayyirin* (Quintet of the astonished), on Jami's biography and writings as well as on their close relationship.[9] Jami, in turn, dedicated his *Baharistan* (Abode of spring) to Mir Ali-Sher and profusely acknowledged him in his *Nafahat al-uns* (Life of the Sufis). Similar laudatory references are found in Jami's other writings, such as the punning allusion to the lion (*shir*) at the end of *Yusuf u Zulaykha*.[10]

These compliments in *Yusuf u Zulaykha* are part of a twofold blessing that Jami invokes from God on his monarch and his friend. Although Jami enjoyed considerable autonomy and independence from the court at Herat, he was aware of the importance of maintaining the favor of Sultan-Husayn Mirza, the person who was ultimately his most powerful patron. Four of the seven masnavis of the *Haft awrang* (*Silsilat al-dhahab*, *Subhat al-abrar*, *Yusuf u Zulaykha*, and *Khiradnama-i Iskandari*) honor the Timurid ruler.[11] The extended panegyric to Sultan-Husayn Mirza in the prelude to *Yusuf u Zulaykha*, with its flattering evocation of the sultan's beauty, character, generosity, and justice, typify these dedications.[12] Jami's patron graciously returned the artist's esteem with praises of his own.[13]

Sultan-Husayn Mirza also rewarded Jami with political and economic favors in his lifetime and with high honors after his death. Jami received large land grants, exemption from taxes, and monetary gifts.[14] The poet was, in effect, financially independent and even wealthy by contemporary standards. Jami's fiscal affluence was paralleled by political influence, and he seems to have enjoyed easy access to Sultan-Husayn Mirza and to have advised the monarch on various matters. Jami's writings include twenty or so letters addressed to Sultan-Husayn Mirza, who during his military campaigns corresponded with the poet. Other documentation further reveals that Jami often acted as an intermediary at court in political and taxation disputes.[15] On at least one occasion he also served as an emissary from Sultan-Husayn Mirza on a delicate matter involving a political appointee.[16] When Jami died in 898/1492, Sultan-Husayn Mirza is said to have mourned him as he would a son and to have been saddened that a leg pain prevented him from helping his own sons carry the poet's body. The monarch's grief was shared by Mir Ali-Sher, who apparently helped wash the body, selected the burial site, arranged a meal in commemoration of Jami for the entire population of Herat, and composed an elegy. Mir Ali-Sher also built a mausoleum in honor of Jami at the grave site, which he and Sultan-Husayn Mirza often visited and for which a waqf (endowment) was established.[17]

Jami's prestige and honor at the last Timurid court derived only in part from his political abilities, literary accomplishments, and panegyric skills (fig. 6). Equally important was his role as a pir (master) of the Naqshbandi order of Sufi Islam. Named after the Bukharan shaykh Muhammad Baha'uddin al-Bukhari Naqshband (717–791/1317–1389), the Naqshbandiyya originated in the twelfth century as one of the various mystical brotherhoods of the medieval period. Through its *silsila* (spiritual chain), the order traces its origins to Abu Bakr, first of the so-called rightly guided caliphs of Islam and successor to the Prophet Muhammad. Like that of other Sufi orders, the focus of Naqshbandi doctrine involves the worship of God through spiritual purification and repentance. A series of eight principles, including *khalvat dar anjuman* (solitude within society) and *safar dar vatan* (journeying within the homeland), governs its central beliefs. The hidden or silent *dhikr* (invocation of God) is its most distinctive practice.[18] Owing to the strength of Baha'uddin's spiritual personality and the conviction that involvement within society may be more effective than seclusion as an expression of spiritual devotion, the Naqshbandiyya quickly gained prominence in the religious, social, economic, and political life of Central Asia. The order's political dominance grew even greater under the leadership of Khwaja Nasiruddin Ubaydullah Ahrar (806–896/1404–1490). He established close ties with both Timurid and Uzbek dynasties and, in the process, expanded the influence of the Naqshbandiyya from its Transoxiana homeland to Khurasan, where the order assumed an increasingly active role in the internal affairs of the Timurid court at Herat.[19]

Jami joined the Naqshbandiyya at a young age, apparently as an initially reluctant disciple. His

spiritual mentor was Saʿduddin Muhammad al-Kashghari, a prominent and politically active member of the order in Herat who traced his line of spiritual descent back to Muhammad Bahaʾuddin Naqshband.[20] Jami variously praises, quotes, and mourns both masters in several masnavis of the *Haft awrang*.[21] He also greatly admired the superior of the order, Khwaja Ahrar. Jami is said to have referred to Ahrar variously as *ustad* (teacher) and *makhdum* (master) and to have traveled to meet with him several times.[22] The poet later named his *Tuhfat al-ahrar* after the *khwaja* (doctor), whom he also praised at great length in *Yusuf u Zulaykha*, *Layli u Majnun*, and *Khiradnama-i Iskandari*.[23] After the death of Saʿduddin al-Kashghari in 860/1456, Jami took his master's place as pir and *murshid* (leader) of the Naqshbandiyya ulama (theologians) in Herat. The poet's eminent position in the order has been credited with its widespread diffusion among Timurid court circles.[24] Among those whom Jami initiated into the order was Mir Ali-Sher, one obvious reason for the close friendship between the two literary colleagues.

Jami's position within the Naqshbandi order may also explain the favor he enjoyed at courts other than the Timurid, particularly that of the rival Aqqoyunlu (White Sheep) Turcomans, whose rulers maintained close relations with various popular religious brotherhoods.[25] Although Jami never resided at the Aqqoyunlu capital of Tabriz, he accepted the hospitality of the dynasty's first leader, Uzun Hasan, while returning home from the hajj to Mecca in 878/1472. A few years later he characterized his host with the honorific "sultan of the ghazis."[26] Jami continued to correspond with Uzun Hasan's son and successor, Yaʿqub, after his accession to the Aqqoyunlu throne in 883/1478, and praised the new ruler for his exercise of justice in the *Silsilat al-dhahab* and in several shorter panegyrics among his divans.[27] Jami wrote the second masnavi of the *Haft awrang*, about the ill-fated love of Salaman and Absal, in honor of Yaʿqub, with homage paid to the sultan's brother Yusuf.[28] Jami also seems to have had contact with the Ottoman court and mentions Sultan Bayazid II (r. 886–918/1481–1512) in the third *daftar* (book) of the *Silsilat al-dhahab* (fig. 7).[29]

That Jami presented his masnavis to widely diverse and even rival patrons raises the issue of whether he conceived the composition of the *Haft awrang* as an integral, long-term project. A related question is whether he originally envisioned writing a total of seven poems.[30] The poems are consistent in their structure and coherent in their underlying theme, suggesting a preconceived and integrated plan. The same, however, could be said of nearly all examples of the masnavi genre, a form of rhyming versification favored by Persian poets for narrative and romantic epics and for heroic, historical, didactic, ethical, religious, and mystical themes long before Jami's time.[31]

Jami followed traditional poetic conventions not only in his use of the masnavi verse form but also in his choice of a general literary scheme and specific subject matter.[32] The compilation of individual masnavis by the same author under a single title is associated most closely with the poet Nizami (535–605/1141–1209), whose five well-known epic poems were assembled after his death into the *Khamsa* (Quintet).[33] Jami was clearly inspired by the *Khamsa* in his concept of a series of poems and took Nizami as his model for three specific masnavis: *Tuhfat al-ahrar*, *Layli u Majnun*, and *Khiradnama-i Iskandari*. Other earlier authors whose works directly influenced Jami's seven poems include Amir Khusraw Dihlavi, Awhadi, Nasiruddin Tusi, Rumi, and Sanaʾi.[34]

Four *Haft awrang* masnavis are titled with the names of their central characters: Yusuf and Zulaykha, Layli and Majnun, Salaman and Absal, and Iskandar. These poems are fundamentally narrative in content and structure. The three other masnavis are more abstruse in title and more abstract in subject matter: *Silsilat al-dhahab* (Chain of gold), *Tuhfat al-ahrar* (Gift of the free), and *Subhat al-abrar* (Rosary of the pious). Jami emphasizes the didactic point of these particular poems through a sequence of apologues or anecdotal stories. He employs a series of allegorical and illustrative narratives to frame his discussion of philosophical and ethical issues. Usually succinct, these anecdotes bracket one or more longer discourses to which they relate thematically. The principal texts of the *Tuhfat al-ahrar* and *Subhat al-abrar* are structured through a pattern of alternation, with each discourse (called a *maqalat* in the *Tuhfat al-ahrar* and an *aqd* in the *Subhat al-abrar*) followed by an apposite story. The anecdotes appear as separate and distinct elements within the masnavi text. Occasionally, however, they link together in an extended sequence, with one long tale bracketing briefer, related tales to create a kind of frame story. Although their presence and purpose are most apparent in the three abstract masnavis, anecdotal stories are also prominent within the more narrative poems of *Salaman u Absal* and *Khiradnama-i Iskandari*.[35]

6 *(overleaf)*
Text folios of *Silsilat al-dhahab*, second daftar
Copied by Malik al-Daylami
in the *Haft awrang* of Jami
964/1557, Iran, Mashhad
34.3×46.8 cm (two folios)
FGA 46.12, folios 53b–54a

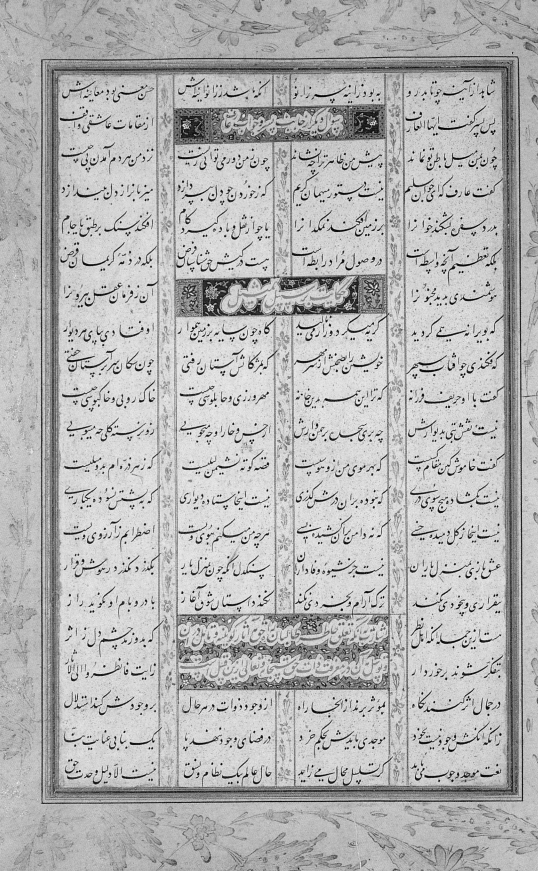

شاها از آینه چون تابد برو

انکه بود در زر این پرده

پس پیر گفت ایها العارف

چون بین سیل بطن قو نماند

کفت عارف که ای جان سلیم

بر زمین افکند نمک دار ا

در وصول آنچه در پی است

چون گیرد خواب پرویز الیها الی فتح

پیش من از نظاره اینها نماند

چون من دوری توانی نیست

نیست پس تو ر سبحان کریم

که خورد و چه دل به پرداخت

یا چو ار شل و با دکیر کرد

پست در کیش چشم نشان فرض

به بود زر از این پرده برو

حسن حسنی به دیده معاینه اش

از مقامات عاشقی وقف

زد من مردم آمدن پی پست

میزبانی ز دل میازد

الخند پسند برطبق پا جام

بلکه در د ته کریک قبض

کلید بیت شیرین

سوختی شدی بدید بجو ز ر ا

که بویی را سیه کرد و ر ا

که خنده چو آفتاب سپهر

کفت با او حریف ز را نه

نیست نقش تی به دو باریش

کفت خاموش کن مقام ش

نیست کشا د بی چو سوی در

نیست انجا ز کل دیده جنی

عشق از بی بن ل ل یا ن

یقراری و چخود یک کف

مست این جب لا که گه ظل

تفکر شوند بر خور دار

گربه یک د و ز ابر جیوا ر

خویش چو آفتاب فتی

که ز این همه بدین خانه

چه بر بی احسن بر بهن و ارش

که به سوی من از و سوست

که نبود بر ان در شک کذری

سر چه من میکنم مو سی ت

نیست جر جیوه و فا دار ل

زک آرام و بحده دی نکند

کاه چو پایه بر زمین جیوا ر

مهرورزی و جا بلوسی ست

ارجس و خار او چه جوبی

قصه کوته نشیمن للمیت

نیست اینجا پا د یواری

پسکدل اگکه چون غزل یار

لخد است پستان شی آغا ز

اوفتا دی پای مرد یار

چون سکان بر آبریستان حق

خاک ز روبی و خاک بوی پست

زور پستکی جه میبوبی

که ز مهر ذر ام بر ملیت

که بشی سود ه بکجار بی

اضطرابم ز کل آرزوی ویست

بیکذر د کمگذر د رویش وقار

با در و بام و کو بید راز

که بدوز مرد چشم دل ز اثر

زایت فانظر والا الاثر

بر وجو د ش کند اند تبلال

یک بنایی به عنایت یتا

نیست الا دلیل و حدیث حق

[panel: Arabic]

موثر بر مذار الخبا راه

از وجود و ذوات در حال

موجدی با بدیش حکم خرد

در فضای وجو د نهد پا

حال عالم بک نظام و بنش

در حال اثر کند این کاه

زانکه انکش و وجو د نیت بخود

کرت سل بل بک نظام می بل

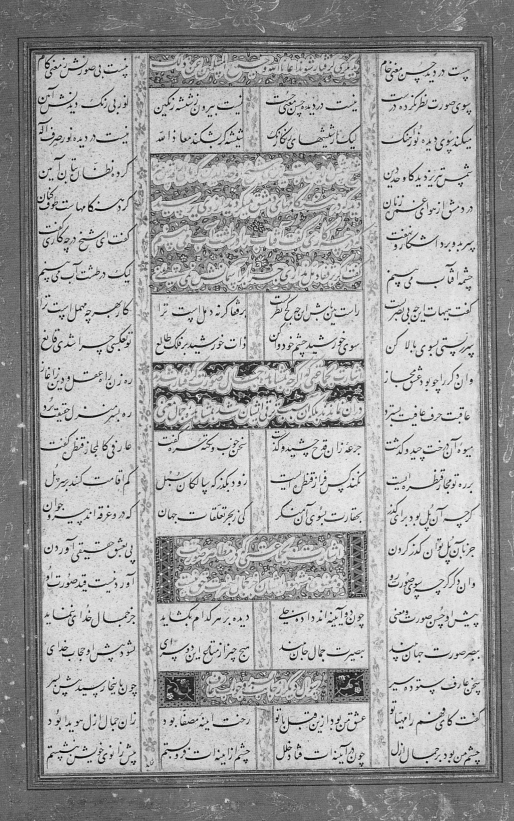

پست در دیده چشن معنی خام

پوی صورت نظر کنر د دست

میکند پوی دیده نورنگ

شمس تبریز دیده کا و حدین

در دمش ز مواعی عنم زنان

پره بد و برد اشکار رفت

چشمه افتاب می چشم

کفت بهات ایخ بی بصرت

پرستی پوی بالا کن

وان که راچو دعش حجاب

عاقبت حرف عافیت ستیز

میوه آن درخت چید و کشت

پره توجا قاطر لایت

کرچه آن پل بود برای کنز

جزنان پل پیان کذر کردن

وان د کرکر پی صوری صورت

پیش او چشن صورت معنی

بصورت جهان بین

سخن عارف پسنده سر

کفت کا فهم راهیا

چشم من بود بر جمال ازل

نیست صورت نظر کنز د دست

یک از رشتها بی نارنک

راست من ش برج کح کطر

ذات خورشید بر فلک طالع

جرعه زان قرح چشید و کشت

کنند کس فرا قطر لایت

بحقارت پوی آن میشکن

دیده بر هر کرام بکشاید

بصیرت جمال جان بین

رخت اینه می بانو

چون و آینه انداد بجایی

سیج چیزی مناع این دری

عش تن بود ازین مصفا بود

چون آینه ذات خلل

شیشه که بشکند معاذا لله

برگا که نه دل است ترا

سخن خوب و کته کفت

رو د و بکر که پیا کان لایت

کی ز بجر تعلقات جهان

جز جمال خدا ی نماید

نشود پیش او و حجا ی جدای

چون بنجار پسید پیش سر

زان جمال ازل سویدا بود

چشم از آینه ذات و بستم

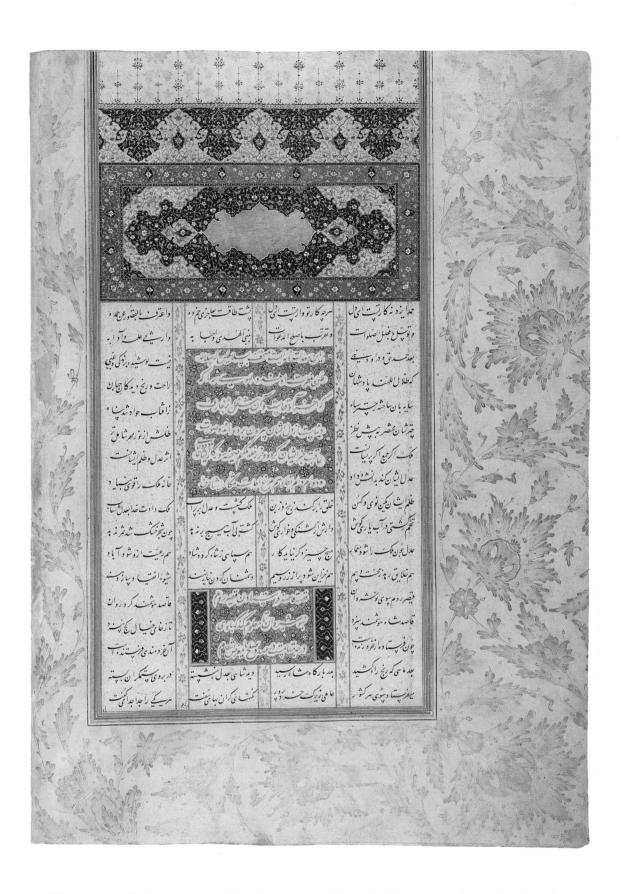

7
Masnavi heading folio of *Silsilat al-dhahab*,
third daftar
Copied by Malik al-Daylami
in the *Haft awrang* of Jami
966/1559, Iran, Qazvin
34.5×23.5 cm (folio)
FGA 46.12, folio 70b

The subjects of the instructive allegories are as varied as the discourses and episodes they gloss. They usually feature animals and humans, including well-known historical and mythical person-ages such as religious leaders, kings, poets, and heroes. The characters are generally involved in spe-cific incidents, which may be challenging, tragic, and even quite funny. Occasionally the principal figures in the narrative of one masnavi, such as Yusuf and Zulaykha or Layli and Majnun, appear in the apologue of another.[36] Many apologues are repeated almost verbatim or with only slight variations.[37]

A single example may suffice to elucidate the nature of the anecdotes. One passage within the *Silsilat al-dhahab* discusses gnostics who live in seclusion to avoid those "far from God." The point is reinforced with a short tale about the fox cub who asks a fox to teach him a game so that he might overcome his fear of dogs. The fox reacts to the request by saying, "The best thing for you is to stay in the plain and for the dogs to stay in the village."[38]

Although Jami may have conceived such parables as instructive devices for those who would read the *Haft awrang*, they proved to be equally important for those who would illustrate the text. The pictorial cycles of the *Silsilat al-dhahab*, *Tuhfat al-ahrar*, and *Subhat al-abrar* consist exclusively of representations of the apologues that help structure the poems and reinforce the moralizing message of the discourses. Even the illustrative programs to *Salaman u Absal* and *Khiradnama-i Iskandari* include many paintings of the secondary illustrative tales instead of scenes of the primary narrative episodes.

The narrative portions of the *Haft awrang* serve, with all the philosophical discourses, as vehicles for the development of profound spiritual ideas derived from Sufism.[39] Jami's principal concern in his seven masnavis was to explore and express the phenomenon of love and its primacy in the soul and mind of the lover whose goal was to be spiritually reborn in the unity of God.[40] Within Sufi doctrine God is manifest everywhere and is the sole and absolute source not only of love but also of beauty, truth, purity, goodness, and wisdom. The material and phenomenal world is a mere reflection of that perfection. The Sufi struggles constantly to transcend daily human sensations and physical experiences to achieve a state of true being through selfless, all-embracing love of the divine essence.

Jami's commitment to the ideal of divine perfection and spiritual perfectibility—as embodied in the dual concept of *fana'* (annihilation) and *baqa'* (eternal life)—resonates throughout the *Haft awrang* and imparts a deliberate ambiguity to even his most amusing narratives. Like that of other Sufi poets, his language is rich in metaphorical images and mystical symbols, which are open to wide-ranging interpretations, from the esoteric to the mundane (fig. 8).[41] When Jami describes, for instance, Majnun's retreat to the wilderness after failing to win permission to marry Layli, he is talking less about a heartbroken lover who has momentarily lost his reason than about a mystic who deliberately shuns society and becomes intimate with nature as one stage of self-purification and ultimately self-annihilation in God.[42]

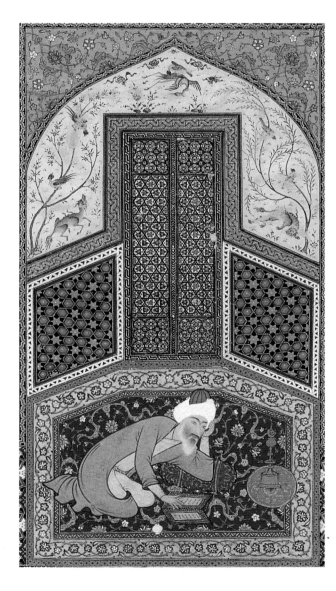

8
The Gnostic Has a Vision of Angels Carrying Trays of Light to the Poet Sa'di (detail)
in the *Haft awrang* of Jami
963–72/1556–65, Iran
23.1×16.7 cm (painting)
FGA 46.12, folio 147a

Jami intertwines the *Haft awrang*'s leitmotif of the mystical quest with various subthemes, some clearly rooted in personal concerns. The masnavis contain, for instance, many references to the poet's advancing years and deteriorating health and admonitions to his young son.[43] Equally self-referential and at times self-promotional are the many discussions of poetry—including its use and misuse, pure and divine nature, and value as a language for praising God—and of the relationship between poet and patron.[44]

It has been said that Jami's popularity and fame began to wane after his death in 898/1492, and especially after the Safavids, a Shi'ite dynasty with no tolerance for the Naqshbandiyya, took control of Iran in 907/1501. Several sources suggest that Shah Isma'il, the first Safavid ruler, hated Jami so much that he planned to destroy the poet's tomb in Herat and ordered that whenever Jami's name was found in a book it should be rewritten as *khami* (raw, uncouth, barbaric).[45] Shah Isma'il's grandson, Sultan Ibrahim Mirza, however, had no compunction in commissioning a deluxe copy of the *Haft awrang*. The prince's manuscript contains all seven masnavis, arranged in the following order: *Silsilat al-dhahab, Yusuf u Zulaykha, Subhat al-abrar, Salaman u Absal, Tuhfat al-ahrar, Layli u Majnun,* and *Khiradnama-i Iskandari*.[46] This sequence does not follow the chronology by which Jami is supposed to have composed the seven masnavis and evidently resulted from the way the manuscript was physically assembled.

1. The edition of the *Haft awrang* used for this study is by Mudarris-Gilani. Manuscript copies are occasionally catalogued under the title *Sab'a* (Septet). Secondary sources for Jami are *EIs* 2, Cl. Huart (rev. H. Massé), "Djami"; Browne, *LHP*, 1:439–42, 3:507–48; Rypka, 286–88; Hikmat, with reference to pertinent primary sources; and Saljuqi, 86–95. An important biography of Jami is "Maqamat-i Mawlavi Jami" by Adul-Vasi al-Nizami (Institut Vostokovedeniia, Tashkent, MS 2480–81); I owe this reference to Professor Jo-Ann Gross. In general, studies of Jami and his works are not strong on literary analysis and criticism. What follows here is intended as only a general introduction to Jami and the *Haft awrang*, including the historical circumstances of its composition.

2. Jami's sequence for writing his masnavis is said to have been: *Silsilat al-dhahab, Salaman u Absal, Tuhfat al-ahrar, Subhat al-abrar, Yusuf u Zulaykha, Layli u Majnun,* and *Khiradnama-i Iskandari*. Jami himself mentions five of his poems in the following order: *Tuhfat al-ahrar, Subhat al-abrar, Yusuf u Zulaykha, Layli u Majnun,* and *Khiradnama-i Iskandari* (Mudarris-Gilani, 927–28). Scholars differ regarding the dating and sequence of the *Silsilat al-dhahab, Salaman u Absal, Yusuf u Zulaykha,* and *Khiradnama-i Iskandari*.

3. The ruler's full name was Sultan-Husayn ibn Mansur ibn Bayqara (Roemer, 121). He is variously referred to as Sultan-Husayn, Sultan-Husayn Bayqara, Husayn-Bayqara, and Sultan-Husayn Mirza.

4. The following remarks on the cultural life of Herat during the reign of Sultan-Husayn Mirza and Jami's position at the Timurid court are based largely on the seminal study by Subtelny, "Poetic Circle," and a series of related articles by the same author. For further information about artists supported by Sultan-Husayn Mirza, see Lentz & Lowry, especially chapter 4; and Stchoukine, *PMT*, 18–28.

5. Subtelny, "'Ali Shir." See also Subtelny, "Poetic Circle," 81–97, 98–110; and Lentz & Lowry, 254–55.

6. Mir Ali-Sher held appointments as amir in the *divan-i a'la* (supreme military council) in 876/1472 and governor of Astarabad in 892/1487. He relinquished government positions in 893/1488 but retained the title of amir. See Lentz & Lowry, 254.

7. Mir Ali-Sher was also an important patron of architecture and endowed at least one major waqf foundation. See Golombek & Wilber, 1:63–64; Lentz & Lowry, 255; O'Kane, *Timurid*, 85–87; and Subtelny, "Ikhlasiyya."

8. Subtelny, "Poetic Circle," 110–13. For a definition of court poet, see ibid., 114–15; and Subtelny, "Herat," 146.

9. Browne, *LHP*, 3:508; Saljuqi, 1. Mir Ali-Sher also lauded Jami in the preface to his first divan, *Gharayib al-sighar* (Novelties of youth): "His Revered Excellency Mawlana Abdul-Rahman Jami, the luminous candle of the retreat of sacrosanctity, the poetic nightingale of the garden of familiarity, the sweet-speeched parrot of the sugarcane break of rhetoric" (see Thackston, *Century*, 366). For a telling anecdote about the value Mir Ali-Sher placed on Jami's work, see Soucek, "*Makhzan*," 2.

10. Massé, 193–95; Sacy, 39–40. For Jami's compliment to Mir Ali-Sher in his *Yusuf u Zulaykha*, see Mudarris-Gilani, 748; Bricteux, *YZ*, 226. These kinds of praises belong to the genre of *tadhkira* (biographical dictionary).

11. Jami did not technically dedicate these masnavis to Sultan-Husayn Mirza. In fact, the *Tuhfat al-ahrar* is the only *Haft awrang* poem that Jami seems to have presented to a specific individual.

12. Mudarris-Gilani, 590–91; Bricteux, *YZ*, 18–20. See also Mudarris-Gilani, 12–14 (*Silsilat al-dhahab*), 456–57 (*Subhat al-abrar*), and 920–21 (*Khiradnama-i Iskandari*). Jami did not, however, refrain from criticizing the monarch, as in a verse found in his *Kulliyat* (Collected poems) in which he chastises Sultan-Husayn Mirza for his love of painting (Gandjei, 162–63).

13. In his so-called Apologia, Sultan-Husayn Mirza characterized Jami as the "most learned and most excellent, a pure pearl from the ocean of erudition, a shining sun of the spheres of saintliness, a master stringer of poetical gems." See Thackston, *Century*, 375–76; and Gandjei, 163–64, 170–71.

14. Gross, "Status," 93; Gross, "Roles," 112 n. 6; Subtelny, "Socioeconomic," 484. As these articles make clear, Jami's economic position, especially his landownership, was shared by other prominent figures of the Timurid period including patrons such as Mir Ali-Sher, amirs, intellectuals, and religious leaders.

15. Hikmat, 25; Gandjei, 163–64; O'Kane, *Timurid*, 93; Subtelny, "Socioeconomic," 488. Jami's involvement in financial matters and specifically taxes parallels earlier efforts of the Naqshbandi leader Khwaja Ahrar to relieve taxes in Bukhara and Samarqand (Hikmat, 72, 77; Gross, "Status," 93).

16. O'Kane, *Timurid*, 94; Subtelny, "Reform," 144–45.

17. These details about Jami's death are reported by Saljuqi, 87–93; see also Hikmat, 59–60.

18. The Prophet Muhammad is said to have transmitted the silent dhikr to Abu Bakr while they were together in a cave en route between Mecca and the oasis community of Yathrib (Schimmel, *MM*, 13). The Naqshbandi order eschews certain other Sufi practices such as music and dance, specifically the *sama'* ritual.

19. While the literature on the Naqshbandiyya is vast, an overview of its history and doctrine remains to be written. See Algar, 123–52; *EIs* 2, H. Algar, "Nakshband," and "Nakshbandiyya 1: In Persia"; Habib; *Naqshbandis* (especially Gross, "Roles," 109 n. 2); and Schimmel, *MD*, 174–75. Jami's *Nafahat al-uns* is an important contemporary source for the Naqshbandi in the fifteenth century as well as a summary of classical Sufi thought. For Khwaja Ahrar, see *EIr*, H. Algar, "Ahrar"; Gross, "Roles"; and Gross, "Status."

20. A succinct account of Jami's career as a Sufi, including all the pertinent primary and secondary sources, is given in Heer, 1–29. For Jami's early education, see Hikmat, 62–64; and Saljuqi, 86.

For his relation to Sa'duddin al-Kashghari, see Algar, 141; and Subtelny, "Poetic Circle," 110.

21. Mudarris-Gilani, 33–34, 164 (*Silsilat al-dhahab*), 382–84 (*Tuhfat al-ahrar*), 761–63 (*Layli u Majnun*).

22. Hikmat, 71–72.

23. See Mudarris-Gilani, 158–61 (*Silsilat al-dhahab*), 753–55 (*Layli u Majnun*), and 918–19 (*Khiradnama-i Iskandari*); Heer, 2.

24. Algar, 141.

25. Woods, 96.

26. Woods (p. 101) dates this tribute to after Uzun Hasan's last *ghaza* (holy war) in 881/1476–77.

27. Mudarris-Gilani, 294; Razi, 11–12, 57–58, 79–80; Hikmat, 37–38.

28. Woods, 150; Soucek, "*Makhzan*," 2–4.

29. Mudarris-Gilani, 263; see also Hikmat, 38, 43–50. It is unclear why Hikmat believes that Jami dedicated *Silsilat al-dhahab* to Bayazid. Jami compares the Ottoman Sultan Bayazid and the Aqqoyunlu ruler Ya'qub to the Persian ruler Khosrow 1 (Anushirvan), known for his justice.

30. Many sixteenth-century copies of Jami's masnavis contain only four, five, or six of the seven poems, with considerable variation in their selection. Examples include CB MS 213 (*Silsilat al-dhahab, Subhat al-abrar, Layli u Majnun, Khiradnama-i Iskandari*); BOD Elliot 186 (*Tuhfat al-ahrar, Subhat al-abrar, Khiradnama-i Iskandari, Layli u Majnun, Yusuf u Zulaykha*); BN suppl. pers. 547 (*Tuhfat al-ahrar, Subhat al-abrar, Yusuf u Zulaykha, Layli u Majnun, Khiradnama-i Iskandari*); TKS B. 143 (*Silsilat al-dhahab, Salaman u Absal, Tuhfat al-ahrar, Yusuf u Zulaykha, Layli u Majnun, Khiradnama-i Iskandari*); TKS R. 890 (*Silsilat al-dhahab, Salaman u Absal, Tuhfat al-ahrar, Subhat al-abrar, Yusuf u Zulaykha, Khiradnama-i Iskandari*); and TKS R. 911 (*Tuhfat al-ahrar, Yusuf u Zulaykha, Layli u Majnun, Khiradnama-i Iskandari, Subhat al-abrar*). These abridged versions suggest that nothing was sacrosanct about the compilation of the seven poems. According to Hikmat (p. 184), some later manuscripts of the *Haft awrang* include an introduction referring to the work as made up of seven parts. The earliest copies of the poem lack such an introduction. On the strength of certain statements in the *Khiradnama-i Iskandari* (Mudarris-Gilani, 927–28), Hikmat proposes that Jami originally intended to write a *khamsa* (quintet) on the model of Nizami and Amir Khusraw Dihlavi and only later decided to add two more masnavis. The additional poems were the *Silsilat al-dhahab* and *Subhat al-abrar*, generally considered among the earliest poems. Based on the *Haft awrang* manuscripts of the 1520s through the 1580s examined for this study, a canonical order of the masnavis did not seem to exist during the sixteenth century.

31. The masnavi consists of a string of verses in which each *bayt* (distich) is composed of two *misra's* (hemistiches), with a series of independently rhyming bayts forming a pattern of *aa, bb, cc*, and so forth. Sometimes the last word in a pair of consecutive misra's is the same, in which case the preceding word carries the rhyme. Jami's proficiency in this traditional form of rhyming versification is undoubtedly one reason he has been deemed one of the last, if perhaps not the ultimate, great classical Persian poet. See *EIs* 2, J. T. P. de Bruijn, "Mathnawi"; Levy, 42–43; and Rypka, 93, 98. For remarks on its use by Sufi poets before Jami, see Awn, 14–15. For Jami, see Bricteux, *SA*, 33–34.

32. By his own account Jami came to the masnavi genre after already having developed proficiency in the ghazal, *qasida*, and ruba'i forms (Mudarris-Gilani, 927; Hikmat, 119).

33. Rypka, 210–13.

34. In general on this point see *EIs* 2, Cl. Huart (rev. H. Massé), "Djami"; and Hikmat, 19. Among those authors cited as models for Jami is Firdawsi, whose authorship of a poem about *Yusuf and Zulaykha* is, however, no longer accepted (Rypka, 155). For Jami's relationship to Nizami, see Browne, *LHP*, 3:540–42. In the third daftar of

the *Silsilat al-dhahab* Jami lists the poets of the past he admires. They include Anvari, Rudaki, Sa'di, and Unsuri, in addition to Nizami and Sana'i (Mudarris-Gilani, 301–2; Hikmat, 121–24).

35. The use of apologues, singly or as a linked sequence in a frame story, appears in various popular and official literary genres, ranging from collections of fables to "mirrors for princes" to biographical dictionaries. See, for instance, Rypka, 660–69; Subtelny, "Poetic Circle," 19–38; Woods, 33; and Ghazoul. The only consideration of Jami's use of apologues appears in Jewett, 181. Southgate (p. 179) has dismissed as irrelevant the apologues in the *Khiradnama-i Iskandari*.

36. The *Silsilat al-dhahab*, for instance, contains several anecdotes about Majnun (Mudarris-Gilani, 155, 207, 220–21), and *Salaman u Absal* describes Zulaykha's visit to Yusuf in prison (ibid., 349; Arberry, 184).

37. For example, the anecdote about the caliph's slave girl and slave boy who throw themselves into a river appears in the *Silsilat al-dhahab* and *Subhat al-abrar* (Mudarris-Gilani, 227–28, 518). The anecdote about the young beloved who throws an old lover off the roof appears in these same masnavis, with a variant in the *Tuhfat al-ahrar* (ibid., 251, 436, 514–15; see FGA 46.12, folio 162a). The anecdote about an ugly East African who looks at himself in the mirror occurs in the *Silsilat al-dhahab* and *Tuhfat al-ahrar* (Mudarris-Gilani, 255, 432; see FGA 46.12, folio 221b).

38. Mudarris-Gilani, 97–99.

39. For Sufi ideas and imagery in general, see Schimmel, *MD*.

40. Ibid., 289.

41. Many of Jami's specific ideas and much of his imagery were first developed by Muhyiuddin Muhammad Ibn Arabi (d. 638/1240) and Fakhruddin Iraqi (d. 688/1289). This point is made by Schimmel, *MD*, 288 (regarding the intentional ambiguity of Sufi poetry), 354, 357. Schimmel also remarks (p. 365) that, in general, Jami's lyrical poetry reveals little of his adherence to the Naqshbandiyya. For Jami's ideas and imagery, see Browne, *LHP*, 1:438–43; Browne, "Sufiism," 323, 329–30; Chittick; and Farhadi.

42. Mudarris-Gilani, 815–16; Khayrallah, 107–25.

43. These references are made more pointed through the use of apologues as, for example, at the end of the prologue to the *Khiradnama-i Iskandari* where Jami's reflections on the swift passage of his life are followed by the story of a falcon and a frog. Grown too old and weak to hunt, a falcon waits by a pond and just manages to grab a frog. The frog pleads that he is only skin and bone and not worth eating and proposes to show the falcon a delicious fish if he is let go. The falcon is tricked into opening his mouth, and the frog leaps away. The falcon dives into the pond to catch his quarry and becomes stuck in the mud with neither frog nor fish. The point is that Jami is stuck in old age with neither heart nor words (Mudarris-Gilani, 929–30). For Jami's advice to his son, see ibid., 326–29.

44. Ibid., 49, 64, 141–45, 300–305 (*Silsilat al-dhahab*), 386–87, 437–39 (*Tuhfat al-ahrar*), 465–67, 539, 570–72 (*Subhat al-abrar*), 923, 926–29 (*Khiradnama-i Iskandari*); Arberry, 143, 145–48, 152–53, 170 (*Salaman u Absal*).

45. Algar, 142; Hikmat, 51–52; Saljuqi, 94. The opinion that Jami fell out of favor during the sixteenth century is belied by the many extant copies of the *Haft awrang* and other of the poet's compositions dating from the period. His works appear to have been particularly popular in Central Asia, especially among the Uzbek Shaybandids, and many copies of his masnavis illustrated in (or attributed to) Bukhara survive today.

46. Although Ibrahim Mirza's *Haft awrang* is complete, its text differs slightly from modern critical editions. These variations are discussed in the précis of the individual masnavis given in Chapter Two.

DOCUMENTARY

Unlike so many deluxe Persian manuscripts whose provenance must be inferred from circumstantial evidence or deduced through comparative analysis, the origin of Sultan Ibrahim Mirza's *Haft awrang* is well documented. Its documentation comes in a series of colophons and inscriptions providing information about the manuscript's production and a set of seals recording its subsequent history. Although certain information, such as the names of the artists responsible for the illustrations, is not given, the data in the colophons and inscriptions make it possible to reconstruct a fairly detailed account of the volume's original chronology. The seal impressions, in turn, document what happened to the manuscript several decades after the death of its patron in 984/1577.

Colophons

The Freer Jami today contains eight colophons written by five calligraphers. (Full transcriptions and translations are provided in Appendix A.1.14.) One colophon appears at the end of each daftar of the *Silsilat al-dhahab* (folios 46a, 69b, and 83b). Five individual colophons serve as codas to the *Yusuf u Zulaykha* (folio 139a), *Subhat al-abrar* (folio 181a), *Salaman u Absal* (folio 199a), *Tuhfat al-ahrar* (folio 224b), and *Layli u Majnun* (folio 272a).[1] It is likely that a ninth colophon, written either by one of the five known scribes or by a sixth individual, came at the end of the *Khiradnama-i Iskandari* on its now-missing final folio.[2]

9
Colophon folio of *Silsilat al-dhahab*, first daftar
Signed by Malik al-Daylami
in the *Haft awrang* of Jami
963/1556, Iran, Mashhad
21.8×13 cm (written surface)
FGA 46.12, folio 46a

10
Colophon folio of *Silsilat al-dhahab*,
second daftar
Copied by Malik al-Daylami
in the *Haft awrang* of Jami
964/1557, Iran, Mashhad
21.8×13 cm (written surface)
FGA 46.12, folio 69b

CHAPTER ONE: CONTENTS

Three of the eight colophons (folios 69b, 199a, and 224b) form basic scribal annotations. Two of these (folios 199a and 224b) identify the calligrapher responsible for copying the text. All three supply a completion date (the month and year in folios 69b and 224b; only the year in folio 199a).[3] The five other colophons (folios 46a, 83b, 139a, 181a, and 272a) are more expansive and include additional particulars, such as the city where their masnavis were transcribed and elaborate evocations of the manuscript's patron.

The first and third colophons, at the end of the first and third daftars of the *Silsilat al-dhahab*, are signed by Malik al-Daylami, who probably also transcribed the second daftar of the same masnavi. He completed the initial daftar "by the high order of his highness . . . Abu'l-Fath Sultan Ibrahim Mirza al-Husayni al-Safavi" in Dhu'l-hijja 963/October 1556 in "the holy, the sublime Mashhad" (fig. 9). He completed the next daftar in Ramadan 964/June–July 1557, without giving a signature or place (fig. 10). The last daftar was written "by order of the library [*bayt al-kutub*]" of Sultan Ibrahim Mirza in the city of Qazvin in Ramadan 966/June–July 1559 (fig. 11). Malik al-Daylami also reiterates that, although he completed the *Silsilat al-dhahab* in Qazvin, most of his work was done in Mashhad, suggesting that the second daftar, like the first, was also written there. The fourth colophon, at the end of *Yusuf u Zulaykha*, is dated 12 Rajab 964/11 May 1557 and signed by Muhibb-Ali the librarian, in Mashhad (fig. 12). It, too, records that the poem was written by order of the library (in this case, kitabkhana) of Sultan Ibrahim Mirza. The fifth colophon, ending the

11
Colophon folio of *Silsilat al-dhahab*, third daftar
Signed by Malik al-Daylami
in the *Haft awrang* of Jami
966/1559, Iran, Qazvin
21.8×13 cm (written surface)
FGA 46.12, folio 83b

12
Colophon folio of *Yusuf u Zulaykha*
Signed by Muhibb-Ali
in the *Haft awrang* of Jami
964/1557, Iran, Mashhad
21.8×13 cm (written surface)
FGA 46.12, folio 139a

Subhat al-abrar, was finished under the same patronage by Shah-Mahmud al-Nishapuri in Mashhad at the beginning of Dhu'l-hijja 963/early October 1556 (fig. 13). A very short colophon (the sixth), written by Ayshi ibn Ishrati and dated 968/1560–61, concludes *Salaman u Absal* (fig. 14). The equally terse seventh colophon, for the *Tuhfat al-ahrar*, was finished by Rustam-Ali at the beginning of Shawwal 963/early August 1556 (fig. 15). The eighth and final surviving colophon, at the end of *Layli u Majnun*, is signed, again by Muhibb-Ali, in Herat at the beginning of Shawwal 972/early May 1565, another indication that the transcription of this masnavi was carried out by order of Sultan Ibrahim Mirza (fig. 16).

In sum, these eight colophons record that the transcription of the first six masnavis of the Freer Jami involved five calligraphers (Malik al-Daylami, Muhibb-Ali, Shah-Mahmud al-Nishapuri, Ayshi ibn Ishrati, and Rustam-Ali) working in three different cities (Mashhad, Qazvin, and Herat) over a nine-year period (963–72/1556–65) by order of Sultan Ibrahim Mirza or his kitabkhana.[4] Of all this information, apparently the most significant at the time was that the manuscript was made for a scion of the Safavid dynasty. Invoked at the outset of five colophon texts, his name is surrounded by strings of honorifics and benedictions, including such formulaic and fulsome phrases as "the illustrious, who is as majestic as the heavens, as renowned as the sun" (folio 139a) and "may the shadows of his reign not diminish under the shadow of the shadow of God and the effects of his noble works remain magnificent among the people" (folio 83b). His name is

13
Colophon folio of *Subhat al-abrar*
Signed by Shah-Mahmud al-Nishapuri
in the *Haft awrang* of Jami
963/1556, Iran, Mashhad
21.8×13 cm (written surface)
FGA 46.12, folio 181a

14
Colophon folio of *Salaman u Absal*
Signed by Ayshi ibn Ishrati
in the *Haft awrang* of Jami
968/1560–61, Iran
21.8×13 cm (written surface)
FGA 46.12, folio 199a

highlighted in gold and gold and pink in two colophons (folios 139a and 46a respectively). His patronage, as credited here, included the commissioning of a deluxe copy of a celebrated literary text, the sponsorship of a kitabkhana, where this book was presumably created and housed, and the employment of five elite artists.

In contrast to their proclamations of Sultan Ibrahim Mirza, the scribes of the Freer Jami present themselves in abased terms, of which the most extreme may be Malik al-Daylami's characterization of himself as "exiled from the regions of power and joy" (folio 83b). Such formulaic self-deprecations notwithstanding, all five scribes are known from varied historical sources as among the ranking artists at the Safavid court and the most gifted calligraphers of the period. Judging from the colophon record, at least two of the five appear to have been quite peripatetic. Malik al-Daylami began working on the *Silsilat al-dhahab* in 963/1556 in Mashhad (folio 46a) and completed the masnavi three years later in Qazvin, noting explicitly that this was "after its beginning and the greatest part of it [was done] in . . . Mashhad" (folio 83b). Muhibb-Ali also copied two sections in two different places at two different times: *Yusuf u Zulaykha* in 964/1557 in Mashhad (folio 139a) and *Layli u Majnun* in 972/1565 in Herat (folio 272a).

The colophons are of documentary value not only for their contents but also for their chronological disorder. This lack of sequential chronology is not uncommon in manuscripts containing separate texts (such as a collection of poems by the same author or an anthology of works by

15
Colophon folio of *Tuhfat al-ahrar*
Signed by Rustam-Ali
in the *Haft awrang* of Jami
963/1556, Iran
21.8×13 cm (written surface)
FGA 46.12, folio 224b

16
Colophon folio of *Layli u Majnun*
Signed by Muhibb-Ali
in the *Haft awrang* of Jami
972/1565, Iran, Herat
21.8×13 cm (written surface)
FGA 46.12, folio 272a

17
*Yusuf Gives a Royal Banquet
in Honor of His Marriage* (detail)
in the *Haft awrang* of Jami
963–72/1556–65, Iran
27×19.4 cm (painting)
FGA 46.12, folio 132a

18
*The Simple Peasant Entreats the Salesman
Not to Sell His Wonderful Donkey* (detail)
in the *Haft awrang* of Jami
963–72/1556–65, Iran
26.3×14.5 cm (painting)
FGA 46.12, folio 38b

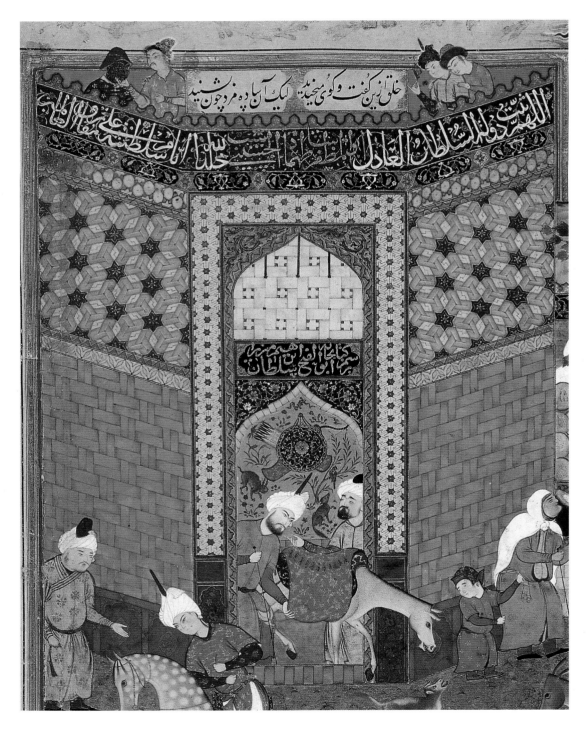

different authors) and multiple colophons. Sometimes this disorder results from a manuscript's having been taken apart and put back together again incorrectly. In other cases, a manuscript's material and physical structure may explain the chronological disjunction. The Freer Jami may be said to serve as a "leading indicator" of this latter phenomenon. The arrangement of its colophons signals that the manuscript was assembled as a set of self-contained units (the individual masnavis) rather than as continuous text.[5] Clearly, it was not considered necessary for the gathering of the masnavis to follow the precise order of their transcription.

The colophons of the Freer Jami also point to flexibility in another aspect of the making of this manuscript, one that may pertain to other codices of the period as well. The masnavis were transcribed in three different cities: Malik al-Daylami began working on the *Silsilat al-dhahab* in Mashhad and completed it almost one thousand kilometers away in Qazvin, while Muhibb-Ali copied the *Yusuf u Zulaykha* in Mashhad and the *Layli u Majnun* in Herat. These circumstances suggest not only that scribes moved and took their work with them but also that the process of manuscript production, at least the phase of text transcription, was portable. In short, the colophons reveal that the Freer Jami was physically as well as literally a manuscript of many parts with a complicated history involving the participation of artists working independently.

Inscriptions

Besides the colophon invocations, Sultan Ibrahim Mirza's patronage of the *Haft awrang* is documented by inscriptions in three illustrations (folios 38b, 132a, and 162a). These documentary epigraphs are incorporated into the paintings' architectural decor, a practice not uncommon in fifteenth- and sixteenth-century Persianate painting.[6] Folio 132a, representing a party in celebration of the marriage of Yusuf and Zulaykha, contains the name "Abu'l-Fath Sultan Ibrahim Mirza" in a rectangular panel over the iwan (archway)(fig. 17). The prince's name occupies only the left side of the panel. A medallion canopy obscures the right side. It is tempting to suppose that the inscription is longer and provides additional information, perhaps some mention of Ibrahim Mirza's kitabkhana as on folios 38b and 162a.[7]

These two illustrations each contain a pair of inscriptions similarly juxtaposed (fig. 18). The shorter inscription, written in two superimposed lines of gold *riqaʿ* (a cursive script) over an entryway, reads: "By order of the kitabkhana of Abu'l-Fath Sultan Ibrahim Mirza." It is thus identical in terms of documentation to the colophons at the end of several *Haft awrang* poems. The longer inscriptions are written in Arabic in thuluth script. Both language and script appear frequently on Persian monuments after the early fourteenth century and in architectural inscriptions on paintings.[8] Although their wording differs, both epigraphs exalt Shah Tahmasp, second ruler of the Safavid dynasty (r. 930–84/1524–76), to whom Ibrahim Mirza was directly and doubly related.[9] The shah's name and titles are written in gold and centered above the citation of Ibrahim Mirza, visually emphasizing the hierarchy of the Safavid dynasty.

The epigraph on folio 38b, inscribed on the facade cornice, invokes divine blessings on Shah Tahmasp and corresponds to the royal panegyrics typically found on Safavid buildings, as depicted in contemporary paintings.[10] The epigraph on folio 162a, written in a band framing the entrance to the building, relates more directly to its architectural context and credits Shah Tahmasp with the structure's construction and decoration (fig. 19). In style and content this inscription closely follows Safavid foundation epigraphs, particularly those on royal mosques.[11]

While it is not difficult to find precedent and parallel for these two inscriptions praising and blessing the Safavid shah, it is more difficult to explain their function in Ibrahim Mirza's *Haft awrang*. Clearly they document the relationship between the prince and his monarch. It also may be assumed that a certain amount of flattery was deliberately intended, particularly in folio 162a where the inscription implies that the shah's deeds will be recorded until the end of time and that the buildings he built as acts of pious virtue will stand forever.[12] Perhaps they also were meant to suggest something about the circumstances of Ibrahim Mirza's commission of the manuscript. Besides what they say, where they appear (in these two particular paintings rather than in any others with architectural settings) gives greater portent to the scenes and thus to their place within the manuscript's pictorial program. Whatever the reason and motivation for these inscriptions, their presence heightens the already complex history of Sultan Ibrahim Mirza's *Haft awrang*. In a manuscript of this kind such an addition can hardly be by whim or accident.

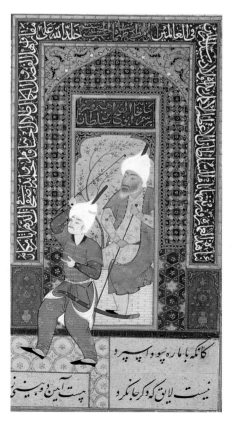

19
The Fickle Old Lover Is Knocked off the Rooftop
(detail)
in the *Haft awrang* of Jami
963–72/1556–65, Iran
24.8×19.4 cm (painting)
FGA 46.12, folio 162a

20
Masnavi heading of *Yusuf u Zulaykha* (detail)
Signed by Abdullah al-Shirazi
in the *Haft awrang* of Jami
964/1557, Iran, Mashhad
7.3×13 cm (heading)
FGA 46.12, folio 84b

Another documentary inscription in the Freer Jami does seem serendipitous. Like all the masnavis in the manuscript, *Yusuf u Zulaykha* begins with an illuminated heading incorporating a central gold cartouche (folio 84b; fig. 20). The seven other cartouches are blank. The cartouche on folio 84b contains a short poem in praise of the masnavi, flanked by a pair of intersecting floral scrolls with pink and green blossoms. Directly below the cartouche, in a green band with black crosses, is a tiny inscription, measuring about one millimeter high and bracketed by two Xs: "Illuminated by Abdullah al-Shirazi."[13] Like the scribes of the Freer Jami, Abdullah al-Shirazi was a recognized artist of the Safavid period and seems to have had a penchant for minute, virtually hidden, signatures. This is the only inscription in the Freer Jami to record the name of an artist other than a calligrapher and as such is extremely important documentation.*

Seals

According to contemporary sources, after the death of Sultan Ibrahim Mirza, his widow, Gawhar-Sultan Khanim, destroyed a treasured album by washing it out with water.[14] Fortunately the prince's *Haft awrang* escaped this fate, perhaps because it had already passed into other hands. Although the manuscript's whereabouts immediately following its patron's demise may never be traced, by the early seventeenth century the book had been endowed by waqf to a Safavid foundation. This donation is documented by a seal stamped on fifty-four of the manuscript's folios, of which the impression is clearly visible on five (4a, 12a, 15a, 16a, and 17a; fig. 21). The seal reads: "Waqf of the blessed and pure Safavid threshold 1017/1608–9." This waqf can reasonably be identified as one endowed to Ardabil by Abbas I, Ibrahim Mirza's first cousin (once removed) and fifth Safavid ruler (r. 995–1038/1587–1629).[15]

Around the year 1300, Safiuddin (650–734/1252–1334) designated the town of Ardabil in the Caspian region of western Iran as the center of the Safaviyya, a new and extremely popular Sufi order that he founded and that provided the name for the Safavid dynasty.[16] Ardabil assumed even greater political importance two centuries later when Isma'il I, then the grand master of the Safaviyya, led his supporters out from Ardabil on a holy war that successfully imposed Safavid dynastic rule over the territory stretching from Azerbaijan to Transoxiana. Although Ardabil was never the dynastic capital, throughout the sixteenth century it remained the seat of the Safavid order and the locus of considerable building activity, primarily around the tomb of Shaykh Safi and other early members of his order.[17]

Abbas I was particularly devoted to Ardabil and carried out an extensive expansion and restoration of the shrine complex and its monuments.[18] Shah Abbas further manifested his support of Ardabil and other holy sites when, in his twenty-first regnal year (1015–16/1606–8), he transformed all his personal estates and household property into waqf endowments.[19] To the shrine of the Imam Reza at Mashhad, for instance, the shah gave "his library copies of the Koran and scientific books in Arabic."[20] The shrine of Safiuddin at Ardabil received his Persian books.[21]

The seals in the Freer Jami may not be sufficient to place the manuscript as part of the Abbas waqf to Ardabil. The case is strengthened, however, by circumstantial evidence. Other known manuscripts with the same waqf seal dated 1017/1608–9 include, in addition, the following hand-

*But see the discovery of a signature by Shaykh-Muhammad made in the final stages of production of this book and reported on pages 8, 141, and 315.

21
Waqf seal on text folio of *Silsilat al-dhahab*,
first daftar
in the *Haft awrang* of Jami
963/1556, Iran, Mashhad
34.5×23.5 cm (folio)
FGA 46.12, folio 15a

written inscription: "Manuscript endowed to the tomb of Shaykh Safi, peace be unto him, by Abbas al-Safavi, the dog of the guardian of the threshold of Ali, son of Abi Talib, may God's blessing and mercy be upon him. Whosoever wishes to read [this work] may do so, provided that he does not take it outside the shrine; anyone who takes it will be [considered] responsible for the blood [martyrdom] of Imam Husayn, may God's blessing be upon him, 1017."[22] It may be surmised therefore that any work with the 1017 waqf seal belonged to the Abbas endowment to Ardabil.[23] Furthermore, an inventory of the manuscript collection in Ardabil made in 1167/1752 by order of Sayyid Muhammad Qasim Beg, custodian of the shrine, includes at least two manuscripts bearing the same dated waqf seal as the Freer Jami.[24]

The *Haft awrang* may not have spent very long in Ardabil, and it is possible that Shah Abbas withdrew it from the shrine library within twenty years of his endowment. This development is suggested by the series of seals and inspection notes on folio 304b, most of which seem to date from the time of the Mughal emperor Shah Jahan (1037–68/1628–57). Although these documents are recorded on an inserted folio that was not original to Sultan Ibrahim Mirza's manuscript, one of the inspection notes, dating from Shah Jahan's first regnal year, describes a volume that sounds remarkably similar to the Freer Jami, including the margins and page layout. Another note, from the last year of the emperor's reign, refers to a manuscript with 316 folios, which is eight to ten more than can be accounted for in the *Haft awrang* as reconstructed now but might include additional flyleaves at the beginning and end. A number of the Mughal annotations cite the value of the manuscript as 4,000 and 5,000 rupees—an extremely high valuation.[25] Evidently the *Haft awrang* was as precious to the Mughals as it had been to Sultan Ibrahim Mirza and Shah Abbas.

Notes
1. Ettinghausen listed the eight colophons in the folder sheet he prepared on the manuscript following its acquisition by the Freer Gallery of Art in 1946 (Ettinghausen, fs, 3–5). The relatively few published references to the colophons are extracts, often omitting documentary details (Atil, *Persian*, cat. no. 39; Dickson & Welch, 1:246A n. 4, 250B n. 8; Nizamuddin, 141; Stchoukine, *MS*, 127; S. C. Welch, *PP*, 31). The first consideration of the colophons in their entirety appears in Simpson, "Jami," 93–94, 106.
2. The recto of replacement folio 304, consisting of ghazals by Qasim Anvar, Hafiz, and Amir Khusraw Dihlavi, contains a colophon signed by Sultan-Muhammad Khandan. As early as 1926, it was recognized that this text and scribal notation did not have anything to do with the *Haft awrang*

(*Chiesa* 3, lot 447; Ettinghausen, fs, 2, 4, 27). Certain later references mistakenly accept the inserted sheet and its contents as original to the Freer Jami (Dickson & Welch, 1:246A n. 4; Stchoukine, *MS*, 127). A scribe named Sultan-Muhammad Khandan did work for Sultan Ibrahim Mirza and even transcribed a manuscript for the prince. The calligraphy and signature on folio 304a seem, however, to belong to another older and far more famous Sultan-Muhammad Khandan, with whom Ibrahim Mirza's artist has been confused.

3. Folio 69b at the end of the second daftar of the *Silsilat al-dhahab* lacks the name of its scribe, but it can be assumed that this section was completed by Malik al-Daylami, who transcribed the first and third daftars.

4. As convenient as it may be to regard the eight extant colophons as a collective record of the manuscript's complete history, their data pertain only to the transcription of the individual masnavis. The dates 963–72/1556–65 derived from the colophons refer to the period when the *Haft awrang* text was copied and are not necessarily relevant to the illumination and illustration of the codex, which could have taken place sometime later.

5. For more on this issue, including discussion of other manuscripts with disjunctive colophons, see Simpson, "Codicology," 133–39.

6. For documentary inscriptions on representations of architecture, see *Tahmina Enters Rustam's Chamber*, illustration from an unknown manuscript attributed to Herat, circa 1434–40, inscribed with the name of the Timurid prince Ala'uddawla (HUAM 1939.225; repro. color: Lentz & Lowry, 130); *Bustan* (Orchard) of Sa'di, dated Rajab 893/June 1488, folio 2a, inscribed with the name of the Timurid ruler Sultan-Husayn Mirza (GEBO Adab Farsi 908; repro. color: Lentz & Lowry, 260); *Haft manzar* (Seven visages) of Hatifi, dated Sha'ban 944/January 1538, folio 78a, inscribed with the name of the Shaybanid ruler Abdul-Aziz Bahadur Khan (FGA 56.14); *Subhat al-abrar* of Jami, dated 902/1496–97, folio 76a, inscribed with the name of the Shaybanid ruler Abdullah Bahadur Khan (KNM LNS 16 MS; repro. color: Atil, *Kuwait*, 239).

7. The inscription probably could not be absolutely identical to those on Freer Jami folios 38b and 162a as these contain only the equivalent of two additional words, too few to fill the right half of the panel in folio 132a.

8. For architectural epigraphs in Timurid period, see Golombek & Wilber, 209–11; and O'Kane, *Timurid*, 72–74, and the catalogues of monuments in both publications. For examples from the Safavid period, see Hunarfar.

9. Tahmasp was simultaneously Ibrahim Mirza's uncle and father-in-law. Ibrahim Mirza's father, Bahram Mirza, was Tahmasp's younger—and only uterine—brother. Ibrahim Mirza's wife, Gawhar-Sultan Khanim, was the shah's daughter.

10. For instance, specific references to Tahmasp and general royal panegyrics are found in the shah's copies of Nizami's *Khamsa* (folio 60b, citing Tahmasp) and Firdawsi's *Shahnama* (Book of kings) (folios 30b, 65b, 71b, 80b, 84b, 221a, 239b, 442b, 538a, 547a, 638a, and 731a; only 442b directly invokes Tahmasp). See Dickson & Welch, 1: fig. 134, and 2: pls. 17, 52, 58, 66, 70, 135, 144, 206, 221, 223, 273, 258, and discussion 2:539A–42B.

11. See, for example, Hunarfar, 402, 429.

12. The inscription on the facade cornice in folio 38b may also have been intended to invoke the economic power of the Safavid dynasty, while the inscription on folio 162a may replicate an epigraph on a building constructed by Tahmasp and have been familiar to Ibrahim Mirza and the artist(s) of his *Haft awrang*. It may also be telling that both illustrations accompany text passages referring to flatterers, and specifically to foolish old men.

13. The signature was first noticed by Priscilla Soucek and published by her in *EIr*, Priscilla P. Soucek, "ʿAbdallāh Šīrāzī." It obviously was added after the illumination of the *Yusuf u Zulaykha* heading. See also Simpson, "Jami," 98, and nn. 42–43.

14. Iskandar Beg Munshi [Afshar], 1:209; Iskandar Beg Munshi [Savory] 1:311; Qazi Ahmad [Minorsky], 184; Qazi Ahmad [Suhayli-Khunsari], 144.

15. The identification was first made by Ettinghausen (fs, 26–27), although he limited the association to Shah Abbas without specifically mentioning Ardabil. Ibrahim Mirza himself had the possibility of an association with Ardabil. Toward the end of 970/beginning of 1563 Shah Tahmasp gave the prince the governorship of Ardabil but withdrew the appointment when he heard that Ibrahim Mirza and a colleague had joked about it. Ironically, Ibrahim Mirza's *Haft awrang* ended up in Ardabil.

16. *EIr*, C. E. Bosworth, "Ardabil"; *EIs* 2, Richard N. Frye, "Ardabil"; *CHI*, 6: chapter 5.

17. For a discussion of the shrine complex during the reign of Shah Tahmasp, with extensive commentary on subsequent Safavid additions and renovations, see Morton, "Ardabil" 1 and 2.

18. Iskandar Beg Munshi [Afshar], 1:447, 460, 682, 708, 753, 790–91, 795, 826, 848, 869, 921; Iskandar Beg Munshi [Savory], 2:621, 633, 873, 900, 946, 987–89, 993, 1033, 1057, 1082, 1138; *CHI*, 6:273; A. Welch, *Isfahan*, 17.

19. Iskandar Beg Munshi [Afshar], 2:761; Iskandar Beg Munshi [Savory], 2:953–55. The waqf of 1015–16/1606–8 was among a series of endowments Shah Abbas deeded to diverse institutions and beneficiaries in various parts of Iran. For a fascinating discussion of the political context of these waqfs, see McChesney, especially 172–74 for the waqfs to Ardabil. Abbas's donations to Ardabil were implemented over several years (Morton, "Ardabil" 1, 35 n. 32).

20. Iskandar Beg Munshi [Afshar], 2:761; Iskandar Beg Munshi [Savory], 2:954–55.

21. Iskandar Beg Munshi [Afshar], 2:761; Iskandar Beg Munshi [Savory], 2:955. The manuscript bequest (comprising "historical works, collected works of poets, and the composition of Persian authors in general") was part of a larger donation including the shah's collection of Chinese porcelain as well as jewelry, weapons, horses, sheep, and goats "in number beyond computation." The Chinese ceramics have been the subject of much discussion. See especially Pope, *Ardabil*, in particular pp. 7–11 for Abbas's waqf to Ardabil and the dedication of the porcelains; also *EIr*, Margaret Medley, "Ardabil"; and Misugi, vol. 3.

22. The text of the waqf inscription is as follows:

وقف نموده این کتاب را کلبه آستانه علی ابن
ابیطالب علیه السلام عباس الصفوی بر آستانه
منوّر شاه صفی علیه الرَحمه که هر که خواهد
بخواند مشروط بر انکه از آن آستانه بیرون
برد شریك خون امام حسین علیه السلام بوده
باشد ۱۰۱۷

See Dorn, xxxvii–xxxviii; Hafiz-i Abru [Bayani], *lam* ل; Morton, "Ardabil" 1, 35. This is similar to individual waqf notices written in the manuscripts given to Mashhad. For these *waqfiyya*s (endowment deeds) and for remarks on the seals made for another waqf endowment, see McChesney, 174–75.

23. As, for instance, a tinted album drawing of masked dancers and musicians (Ettinghausen, fs, 26; repro.: Atil, *Brush*, cat. no. 18).

24. Mashkur, 324–83. This inventory documents 972 manuscripts (744 copies of the Koran, including 30 separate *ajza'* [chapters; sing. *juz'*], and 228 other manuscripts), 224 detached folios, and 32 bindings. Mashkur's listing includes entries for seven Jami manuscripts: four copies of the *Sa'ba* (another name for *Haft awrang*), two *Tuhfat al-ahrar*, and one *Silsilat al-dhahab*, plus another combined entry mentioning three *Sa'ba* (ibid., 341–45, 358). The seven individual entries contain summary descriptions of the manuscripts, including rulings, headings (here called *sarlawh*s), and margins. Four entries name the calligrapher. The information given about one *Tuhfat al-ahrar* volume is sufficient to identify it as SPL Dorn 425 (ibid., 344). At least one illustration in this manuscript is stamped with the same seal as in the Freer Jami (repro.: USSR Colls., 87). The inventory also mentions a copy of Jami's *Lawa'ih* (Shafts of light)(Mashkur, 341), which can be identified as SPL Dorn 256 and also bears the 1017 seal (repro.: USSR Colls., 19).

None of the summary descriptions of *Haft awrang* manuscripts in the 1752 inventory fit the Freer Jami, probably because the volume had long since been removed from Ardabil and sent to India. Also according to Mashkur (pp. 380–82), precious objects and books, including copies of the Koran and a lavishly illustrated copy of the *Khamsa* of Nizami, were removed from the shrine by the Afsharid ruler Nadir Shah (r. 1148–60/1736–47), his brother, Ibrahim Khan, and other members of his entourage.

In 1828 the Russian army occupied the Ardabil shrine, and many of its manuscripts, including the two with the 1017 waqf seal, were removed to Saint Petersburg. Other volumes once in Ardabil eventually passed into collections outside Iran and Russia, including: (1) *Mantiq al-tayr* (Language of the birds) of Attar, dated 888/1483, with waqf seal of 1017/1608–9 on all its text folios and eight of its paintings, and the word "waqf" on the paintings and frontispiece (MET 63.210.28) (for a discussion of the manuscript's Ardabil provenance, see Grube, "Language," 339, fig. 7; Lentz & Lowry, 313); (2) *Six Masnavis* of Jami, dated 978/1570–71, with the Abbas waqf seal on folios 28a, 60a, 105a, 151a, 185a, and 229a (TKS H. 1483) (for references, see Appendix C); (3) *Poems* of Hilali, dated 976/1568, with traces of the Abbas waqf seal on folio 5a (GULB LA 192) (see Gray, *OIA*, cat. no. 127, with no mention of the waqf seal).

For the Russian occupation of Ardabil and the plunder of the shrine, see Barthold, *Découverte*, 317; Barthold, *Geography*, 217; Barthold, *Sochineniia*, 468 and editor's note 5; Dorn, xi–xii; and *EIr*, C. E. Bosworth, "Ardabil." These sources give slightly varying accounts of the transfer of the Ardabil manuscripts to Saint Petersburg. For a revealing nineteenth-century account of the Russian seizure of Ardabil manuscripts, see Lady Sheil, 328–29. Robinson ("Muhammadi," 21) has noted that the Freer Jami escaped the Russian plunder of the shrine.

25. These Mughal seals and inspection notes are translated in Appendix A.1.15.c,d. See especially IN2 and IN3. The Indian connection is further evidenced by late-sixteenth-century Mughal copies of two illustrations in the *Yusuf u Zulaykha* masnavi (folios 105a and 132a). There is also the possibility, suggested by Milo Cleveland Beach (private communication), that the *Haft awrang* went from Iran to India as a loan at the time of the accession of the Mughal emperor Jahangir in 1014/1605. It then would have been sent back in time to be deposited at the Ardabil shrine in 1017/1608–9.

Given the princely origins and complicated chronology of the Freer Jami, it should come as no surprise that its material form and structure are also complex and the product of diverse bookmaking techniques.[1] Certain aspects of the manuscript's codicology, specifically the format and construction of the folios and collation of the gatherings or quires, provide important clues for the lack of sequence in its colophons.[2] The calligraphy is also noteworthy for its quality and remarkable stylistic consistency despite its execution by five (or perhaps six) scribes over an extended period.

Although the immediate concern here is with the codex's tangible format and forms, the making and assembling of the materials themselves and the artists' working methods emerge as equally important. Again, it becomes apparent that the codicology of the Freer Jami helps explain its chronology. This summary will demonstrate how the manuscript's physical form and material structure elucidate the order of its collation.[3]

While no longer in mint condition, the manuscript looks much the way it did in Ibrahim Mirza's time, and later alterations are easily identifiable. These are reviewed first to clarify what may be accepted as the manuscript made by order of the kitabkhana of Sultan Ibrahim Mirza and what should be considered part of its more recent history.

Condition

The Freer Jami has been refurbished and rebound and its illustrations retouched at least once and probably several times. One such refurbishment may have been necessitated by water damage, resulting in the replacement of the first text folio, the restoration of a series of folios at the end of the manuscript (folios 299b–303a), the repainting of the upper section of *Iskandar Suffers a Nosebleed and Is Laid Down to Rest* (folio 298a), and the removal of the last text folio (fig. 22). What is now the

22
Text folios of *Khiradnama-i Iskandari* in the *Haft awrang* of Jami
963–72/1556–65, Iran
34.2×46.8 cm (two folios)
FGA 46.12, folios 299b–300a

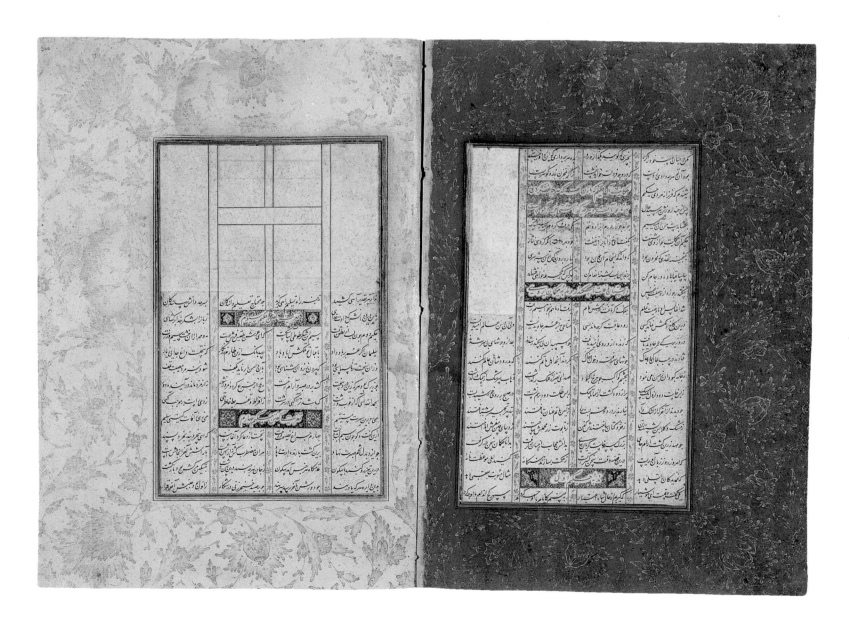

penultimate leaf (folio 303) in the *Khiradnama-i Iskandari* became displaced, evidently during rebinding, and two other leaves (one with an illustration) were removed from the *Layli u Majnun* poem, perhaps at the same time.[4] Guard sheets in two different sizes were inserted in front of the illustrated and some illuminated folios. At some point the volume lost its original binding and acquired new covers and flyleaves.[5] It also gained a substitute final leaf (folio 304) with Persian ghazals copied by Sultan-Muhammad Khandan on one side and a set of Mughal seals and inspection notes on the other (fig. 23). Whereas all these modifications probably occurred at specific instances, the repainting visible on most illustrations is likely to have occurred variously over a long period of time.

23
Ghazals by Qasim Anvar, Hafiz, and Amir
Khusraw Dihlavi, signed by Sultan-
Muhammad Khandan
in the *Haft awrang* of Jami
Early 16th century, Iran
34.3×22.7 cm (folio)
FGA 46.12, folio 304a

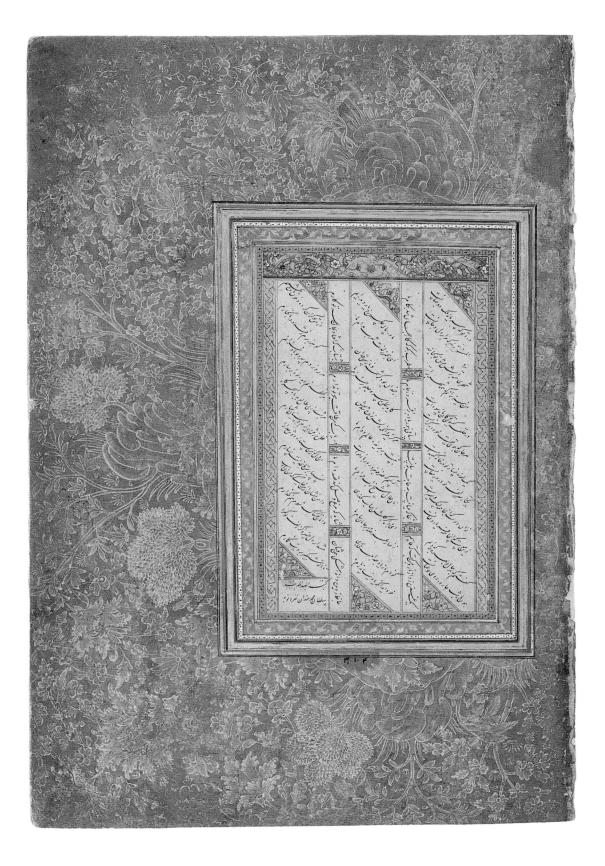

CHAPTER ONE: CONTENTS

An idea of when at least some of these replacements, restorations, and additions may have taken place can be inferred on stylistic grounds. Replacement folio 1, for instance, with the opening verses of the *Silsilat al-dhahab* on its verso, has a heading illuminated in a style associated with Qajar art of the late eighteenth and nineteenth centuries (fig. 24).[6] This is also the period of the volume's lacquered covers with their floral compositions on a red ground.[7] These are attached to a red leather spine in the style of European bindings of the late nineteenth or twentieth century, suggesting that the binding may have been put together after the manuscript came to Europe or North America.

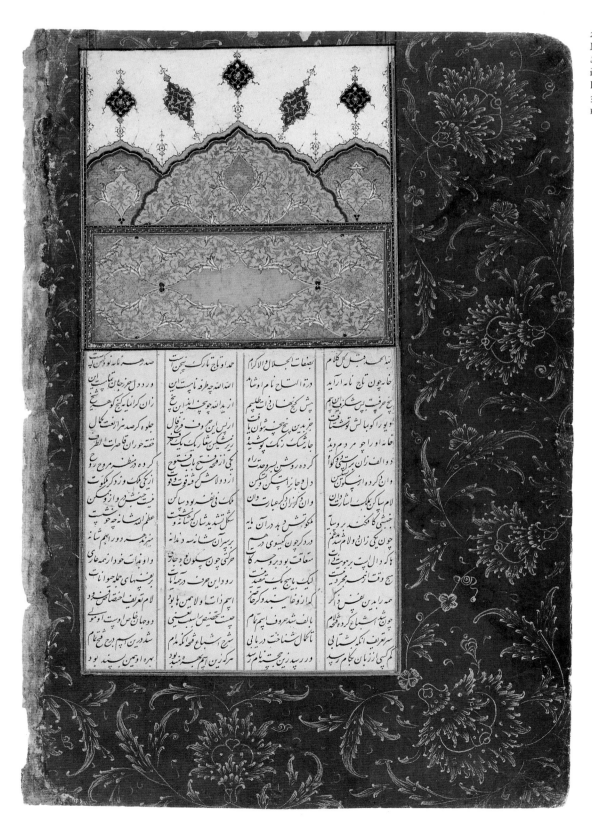

24
Masnavi heading folio (replacement) of *Silsilat al-dhahab*, first daftar in the *Haft awrang* of Jami
Late 18th–19th century, Iran
34.5×23.5 cm (folio)
FGA 46.12, folio 1b

Folios

In its original form the Freer Jami contained 306 text folios, including twenty-nine with illustrations, and perhaps two other folios of illuminated front matter.[8] Each unillustrated text folio consists of two pieces of paper: a thin, single-ply, ivory paper in the center for the text and a thicker, double-ply colored paper for the margins.[9]

Preparatory to its use as a writing surface, the single-ply, ivory paper was dusted or sprayed with gold and polished with a burnishing tool or smooth stone such as agate.[10] To mark the layout of the writing surface, it was then impressed with a stencil consisting of a grid of twenty-one horizontal lines and four columns defined by three pairs of vertical lines.[11] Virtually every sheet is laid out

25
Text folio of *Tuhfat al-ahrar*
Copied by Rustam-Ali
in the *Haft awrang* of Jami
963/1556, Iran
21.8×13 cm (written surface)
FGA 46.12, folio 224a

according to this same system.[12] Besides its primary function as a guide for the calligraphers in writing out the *Haft awrang* verses, the columnar and linear grid was an essential aid to the illuminators in their work, particularly for the placement, alignment, and proportions of the masnavi headings, rubrics, and other decorative areas. Thus the grid determined the geometry of the written surface, including the relationship of calligraphy and decoration and, by extension, the aesthetic of every element on the folio (fig. 25).[13]

The preparation of the border or margin paper involved tinting the double-ply sheets in various colors: pink, yellow, brown, green, and three shades of blue.[14] A window for the text paper then was cut at about the same off-center position on all these colored sheets. The uniformity throughout the manuscript of both these and the text sheets suggests that they were prepared all at once, presumably in advance and specifically for this codex.

The formation of full folios occurred after the scribes had finished transcribing Jami's masnavis on both sides of the writing surface. The thin text paper was inlaid into the thicker, colored margin paper, creating folios with a double-sided written surface and the same colored borders on both recto and verso.[15] Later, a series of colored rulings were drawn to mask the joints between the text and margin papers (fig. 26). In a few cases, notably between individual sections of the *Haft awrang* text where the rulings were never added, the meeting point of text and border papers is readily apparent.[16]

26
Text folios of *Subhat al-abrar*
Copied by Shah-Mahmud al-Nishapuri
in the *Haft awrang* of Jami
963/1556, Iran, Mashhad
34.4×46.8 cm (two folios)
FGA 46.12, folios 157b–58a

The material structure of the illustrated folios is more complex and less uniform than that of the unillustrated text folios. With two exceptions (folios 10a and 207b), the *Haft awrang* illustrations were painted on full sheets of cream-colored paper. In other words, the painted surface and the margins are the same on the illustrated sides of twenty-six folios.[17] The unillustrated sides of these folios are constructed, however, like the unillustrated text folios, with thin ivory paper for the text inlaid into thicker paper for the margins (fig. 27). All but six of these folios have cream-colored margins on the unillustrated sides, following the practice of the unillustrated text folios. Folios 59, 194, 221, 253, 264, and 275 differ in having margins of various colors on their unillustrated sides. These six folios are laminates, with separate or independent recto and verso sides joined together.

The Freer Jami contains a half-dozen other laminate folios, all with blank rectos and all falling between masnavis (folios 47, 70, 84, 182, 225, and 273). Their rectos consist of single sheets of cream-colored or light blue paper. Their versos are the same as the unillustrated text folios except that the margins vary in color.

27
Text folio of *Layli u Majnun* and *Majnun Approaches the Camp of Layli's Caravan* in the *Haft awrang* of Jami
963–72/1556–65, Iran
34.5×46.8 cm (two folios)
FGA 46.12, folios 252b–53a

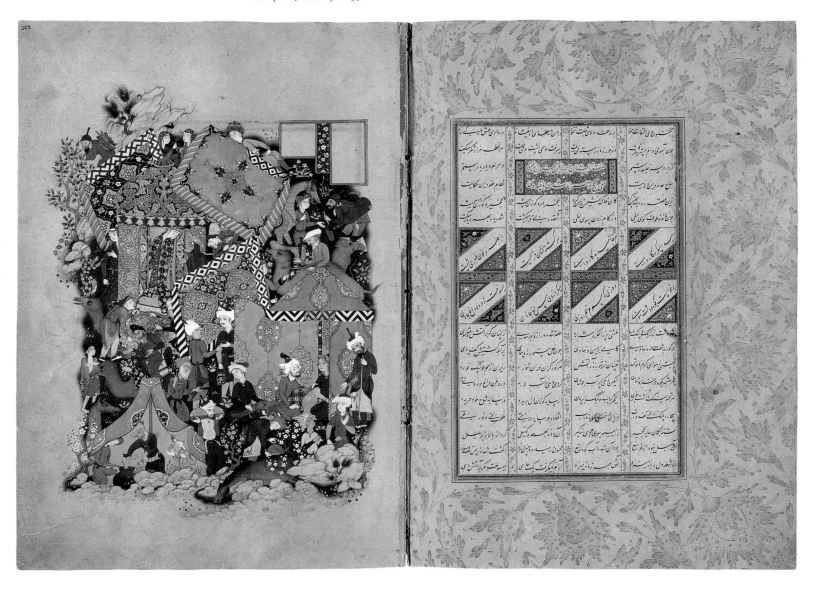

Calligraphy

The text of the *Haft awrang* is written in the elegant nasta'liq script favored for Persian manuscripts, particularly poetic volumes, from the early fifteenth century on (fig. 28). Although at least five scribes were involved in the transcription, it is almost impossible to distinguish their hands—a tribute to their ability to achieve the high standards set for nasta'liq by Mir-Ali Tabrizi, the "first calligrapher" of that script.[18]

The layout of the written surface, predetermined by the grid impressed onto the writing surface, consists of a maximum twenty-one lines per page, spaced about one centimeter apart, and two verses per line, divided into four columns each approximately 2.8 centimeters wide.[19] The horizontal grid lines bisect the horizontal written lines; the calligraphers used the grid not as a base line but as a centering line. On forty-six folios the text is written on the diagonal (both right to left and left to right), generally preceding or following an illustration or preceding a colophon. Each diagonal line is equal in length to three horizontal lines.[20] Throughout the manuscript the text verses are written in black ink.

28
Text folios of *Silsilat al-dhahab*, first daftar
Copied by Malik al-Daylami
in the *Haft awrang* of Jami
963/1556, Iran, Mashhad
34.4×46.7 cm (two folios)
FGA 46.12, folios 35b–36a

The verso of nearly every folio contains catchwords, comprising the first word or two of the distich beginning on the recto of the following folio. These were written on the diagonal, apparently at the bottom left of the writing surface. The catchwords were often trimmed or covered up when the text paper was joined to the margins. They were then rewritten in the left-hand column divider. Illustrations on verso sheets occasionally had catchwords in the lower margin. Some original catchwords remain visible on text and illustrated folios, including a few enframed in small roundels or cartouches (fig. 29; see also figs. 53 and 134).[21]

The many hundred rubrics in the Freer Jami are written in nasta'liq in colored ink: pink, green, red, and various shades of blue. The functional equivalent of chapter headings, these rubrics consist of one to four lines of prose text, enframed in panels spanning the two central text columns. It is interesting that the grid of the writing surface was not followed as regularly for the rubric text as for the *Haft awrang* verses. Some rubrics are centered above the grid line, and others fall between two grid lines.[22] All the rubric panels are illuminated.

Gatherings and Collation
The folios of the Freer Jami were originally collated in at least thirty-nine gatherings or quires, of which all but two seem to have been quaternions (sets of eight leaves).[23] Each gathering is made up of conjoint bifolios, created by the overlap of two separate folios.[24] This union occurred after the borders were illuminated and seems to follow a thin gold line along the gutter of each folio. The gatherings were then stitched together as a full codex in preparation for binding.[25] At this point the dated masnavis were assembled in their current, nonsequential order.

Process and Chronology of Compilation
Many different operations took place between the formation of the folios and collation and stitching of the gatherings.[26] During the initial stage—the transcription of the text—the calligraphers worked not with gatherings of leaves or even full folios but with stacks of single sheets of text paper. This practice, together with the small size, individuality, and portability of materials, including pens, inks, and paper, allowed for flexibility in the transcription process. It also explains how five scribes could work in three different cities more or less simultaneously and independently. Simply put, no one was waiting to write on the same sheet of paper as his colleague, and a calligrapher could pick up and put down his assignment at will, as Malik al-Daylami evidently did with the *Silsilat al-dhahab*. The scribes' use of separate sheets of text paper also meant that work on different parts of the *Haft awrang* could be carried out at an individual pace and according to individual schedules. This arrangement obviously has a bearing on and may be the primary explanation for the nine years it took to transcribe the seven masnavis. It may not have been possible, for instance, for Ayshi ibn Ishrati to finish copying the *Salaman u Absal* poem until five years after Rustam-Ali had completed the succeeding masnavi. This delay did not, however, affect Rustam-Ali's task since he, like all the other calligraphers, evidently had his own supply of text paper.

Only after the transcription of all the masnavi verses was completed were the text sheets joined to their colored borders. These full-size folios then could be passed along to the illuminators for decoration. The painters probably received their full-size folios following the completion of the illu-

mination on the text sides. So at this stage, one phase of work may have had to wait for another. Within their own areas of responsibility, however, illuminators and painters retained the same autonomy and flexibility as the calligraphers, since they, too, were working on individual but larger sheets. In theory at least, these artists could work wherever and whenever they chose.

Thus the Freer Jami probably remained in a proto-codex state (consisting first of small, single sheets of text paper and later of larger, fully formed but still separate folios with borders) until every bit of work—transcription, illumination, and illustration—was accomplished. Only then were the beautifully calligraphed and decorated folios paired to form bifolios, and the bifolios assembled into gatherings.

Considering that the Freer Jami consists of seven masnavis copied by five scribes in three cities over nine years, it might be assumed that each poem would start and stop with a new gathering. A definite visual break occurs between each poem, in the form of a sheet of undecorated or gold-flecked paper (fig. 30).[27] Nonetheless, the poems do not begin or end on separate gatherings or even separate bifolios. As the collation (Appendix A.II) reveals, all but one successive text section shares bifolios and quires.[28] Again, this arrangement is accounted for by the manuscript's structure, specifically by the composition of the gatherings as a set of four artificial bifolios.

Because no one part of the manuscript ever physically depended on any other and because the folios were joined into bifolios and the bifolios compiled into gatherings only in the final stage of production, the seven masnavis could be arranged in any order, no matter what their individual completion dates. Why it is that the *Yusuf u Zulaykha* of 12 Rajab 964/11 May 1557 precedes the *Subhat al-abrar* of Dhu'l-hijja 963/October 1556 cannot be determined by a structural analysis of the manuscript; this sequence must have resulted from a decision by the patron or the members of his kitabkhana. The codicology of the manuscript explains, however, how such an arrangement was physically possible.

Notes

1. The history of the many arts involved in Islamic book manufacture has yet to be studied as a whole, although a number of techniques, particularly the preparation of inks, paper, and leather and the craft of bookbinding, are well known through such important treatises as the *Umdat al-kuttab wa uddat dhawi al-albab* (Staff of the scribes and implements of the discerning) of Ibn Badis (422–501/1031–1108) and the *Sina'at tasfir al-kutub wa hall al-dhahab* (Craft of bookmaking and the dissolving of gold) completed by al-Sufyani in 1029/1619. (For these texts, see Bosch; and Levey.) The exhibition catalogue by Bosch et al. contributes significantly to our knowledge of the materials and techniques employed in the general tradition of Islamic bookmaking, while Porter takes up Indo-Persian practices as elucidated in primary sources. Titley (*PMP*, 238–43) is also informative regarding paper.

2. In 1987–88 the manuscript was taken apart in the conservation laboratory of the Freer Gallery of Art. This procedure permitted a more thorough examination of the manuscript's material form and structure and has resulted in confirming and correcting previously published observations. The codicological methods followed here have been adopted from those employed for the study of western medieval manuscripts (Delaissé, "History"; Delaissé, *Siècle*; Delaissé et al.; Gruijs). The "archaeology of the book," as codicology is sometimes called, has emerged in relatively recent times as a concern for Islamicists, often within the

categorizing paleographic features. See, for instance, Déroche, *BN*; Déroche, *Manuscrits* (especially Waley); Witkam; and *Manuscripts of the Middle East*, a journal established by Witkam in 1986 specifically to consider codicological issues.

3. Two studies by Calkins ("Distribution" and "Stages") have been particularly helpful in considering the material composition of the Freer Jami.

4. Folio 303 belongs after folio 299. The evidence for the two missing folios in the *Layli u Majnun* poem is literary and physical. Ninety-five verses of the masnavi are missing between folios 261b and 262a. The layout of the Freer Jami allowed for a maximum of eighty-four verses per folio, and most folios have considerably fewer verses due to the presence of illuminated rubrics. The ninety-five missing verses can only be accounted for by three text pages (that is, one and one-half folios), including various rubrics and verse illuminations and a full-page illustration. The collation of the manuscript (see Appendix A.11) further attests to the missing bifolio since gathering 34 consists of a ternion (three bifolios or six leaves) instead of the quaternions found throughout the rest of the manuscript. The absence of any pigment offset on either folio 261b or 262a suggests that the illustration was on one of the inner faces of the missing bifolio. The presence of five lines of verses written on the diagonal and illuminated with triangular cornerpieces and of two additional lines of horizontal bands of illumination on folio 261b suggests that the next folio may have been illustrated.

5. A technical report prepared in April 1987 describes the Freer Jami as having been "rebound in the European fashion with a rounded back and endbands on cords" (Technical Laboratory files, Freer Gallery of Art).

6. The blank recto of folio 1 contains traces of an inscription and a seal, now effaced.

7. Diba, "Lacquerwork" 1, 249–52; Diba, "Lacquerwork" 2, 168.

8. The term "folio" is used here to refer to a single manuscript leaf. Occasional references to "page" (note 4) mean one side of a folio. As in many Islamic manuscripts, the Freer Jami folios do not seem to have been numbered. The current folio numbers are modern additions. Previously I had speculated (Simpson, "Codicology," 133) that the manuscript may have contained 308 or 310 folios. The higher figure now seems less likely for the actual text and illuminated front matter.

9. This folio structure seems to have been quite common in later Islamic manuscripts. See, for example, IM O.S. 5033.1.79, Milstein, cat. no. 27; also Taherzade Behzad, 3:1926; and Akimushkin & Ivanov, "Illumination," 46–48. Its use in the Freer Jami is first noted in the 1926 Chiesa sale catalogue (*Chiesa* 3, lot 447).

10. The dusting or spraying of paper with gold (*ghubar*, *afshan*, or *zarafshan*), either before or after the text was written, is generally regarded as a fifteenth-century innovation. It appears to have been widely practiced in the sixteenth century. See Akimushkin & Ivanov, "Illumination," 46–48; and Porter, 56–58; also for the technique in general, Taherzade Behzad, 3:1923; and Soucek, "*Makhzan*," 13–17 (discussion combined with that of colored paper). The polishing of paper was standard practice in Islamic bookmaking and was occasionally represented (AMSG S1986.221, repro. color: Lowry, no. 59; FGA 54.116, repro. color: Atil, *Brush*, cat. no. 63).

11. The Mughal emperor Babur mentions his preparation of such a *mistar* (matrix) in his memoirs, the *Baburnama* (Beveridge, 643). For discussion in secondary sources, see Huart, 13; Akimushkin & Ivanov, "Illumination," 48; Porter, 62–63; Raby, 17 n. 19, fig. 20; Schimmel, *Calligraphy*, 42–43 (with repro.); and James, *Mamluks*, 15–16.

12. Folios with verses written on the diagonals and those with triangular colophons are gridded according to the same system as those completely

filled with *Haft awrang* verses written in horizontal lines. Each sheet has a ridged side and an indented side. The use of ridged versus indented sides for the recto side of the text folio is not consistent, however. The grid system can be best seen on several blank folios: 46b, 139b–40a, 181b, 199b–200a, and 272b. Folios 140a and 181b are not gold-dusted, suggesting that perhaps this step was carried out after the grid was impressed.

13. For a fascinating investigation of the theory and role of page layout in Islamic manuscripts, see Adle, "Module" 1, especially 94–100, fig. 4; Adle, "Module" 2, especially 212–17. For more on the idea and application of the mathematical module in Persian painting and architecture, see also Porter, 61–62, 71–72; and Sims, "Timurid," 67–68, 71–77.

14. The identification of the colors of the border paper has been corrected from my previous account (Simpson, "Jami," 94 and appendix B.3). See here Appendix A.1.3.a. Most of the pink margins have taken on a yellowish tinge, while many green borders appear to have discolored to blue-green. The latter may have originated as deep blue. The tinting of paper is discussed by Ibn Badis (Levey, 10) and depicted in at least one sixteenth-century painting (AMSG S1986.221; repro. color: Lowry, no. 59). For more on technical aspects, see Porter, 41–51. For the use of colored paper as a writing surface and as a frame around the written surface, see Soucek, "*Makhzan*," 13–17.

15. Cockerell (pp. 64–65) describes the preparation of sheets for inlaying. See also Taherzade Behzad, 3:1926, where the calligraphers are credited with joining the central panel of paper and the borders. It is likely that a similar process was followed for the Freer Jami. The location of the overlap on the manuscript's inlaid folios is quite unpredictable, occurring as often on the recto as on the verso. Perhaps more curiously, no pattern in the distribution of margin colors throughout the manuscript can be discerned (see Appendix A.11). With some rare exceptions (folios 32–33, 184–85), no two consecutive folios have the same color margins.

16. Folios 46b, 139b–40a, 181b, 199b–200a, and 272b.

17. Folios 10 and 207 are composed in the same way as unillustrated text folios, with a separate piece of paper in the center (on which the illustrations were painted after the full folio was formed) and a separate border.

18. Schimmel, *Calligraphy*, 29.

19. This system yields a maximum of forty-two verses per page, or eighty-four per folio. Most folios have fewer verses because of the space taken up by hundreds of illuminated rubrics. Illustrated folios and those with the text written on the diagonal contain even fewer verses.

20. The text of the diagonally written verses is frequently reversed. For instance, folio 20a (repro.: Fu et al., 143) contains six lines written on the diagonal, each with two distichs (Mudarris-Gilani, 73). Lines 2, 4, and 5 have reversed distichs and hemistichs: instead of the distichs reading *a/b*, *c/d*, they read *d/c*, *b/a*. A similar pattern occurs on folios 37b, 38a, 39a–b, 45b, 46a, 58b, 63b, 64a, 90a–b, 98b, 99a–b, 104b, 110a, 114a, 194a, 221a, 230b, 252b, and 261b. Usually such reversed lines alternate with "regular" lines. When the two are read in sequence, they create a looped effect (*a/b*, *c/d*; *d/c*, *b/a*). Reversed distichs and hemistichs appear on folios with single and multiple lines of diagonally written text, running right to left and left to right. Verse reversal is therefore not correlated with the number or direction of the diagonally written lines of text.

Folios with reversed verses are concentrated in the manuscript's first two masnavis. All but one folio with diagonal lines in the *Silsilat al-dhahab* contain reversed verses (folio 58a has only one line of text written on the diagonal, lower right to upper left). All but three folios in the *Yusuf u Zulaykha* (folios 99b–100a with a total of seven lines, lower

right to upper left, and 131b with three lines plus a pair of diagonal verses, all written lower right to upper left, flanking the rubric) contain reversed verses. The next masnavi, *Subhat al-abrar*, has no reversed verses. The fourth masnavi, *Salaman u Absal*, has one folio with reversed verses, as does the fifth, *Tuhfat al-ahrar*. The three folios with lines of diagonal text in *Layli u Majnun*, the sixth masnavi, all contain reversed verses. None of the folios with diagonal text in the *Khiradnama-i Iskandari* has reversed verses. Reversed verses may be a kind of literary or artistic conceit favored by individual calligraphers. The concentration of such folios in certain masnavis and their absence in others also may reflect the hierarchy of the manuscript.

21. Original catchwords are visible on folios 43b, 45b, 70b, 104b (enframed in a roundel), 110b, 131b (enframed in a roundel), 153b (enframed in a cartouche), 169b (enframed in a cartouche), and 220b (enframed in a roundel). Many rewritten catchwords, especially those in *Yusuf u Zulaykha*, *Salaman u Absal*, and *Khiradnama-i Iskandari*, are as fine as the originals and are sometimes incorporated into the rubric illumination (folios 192a, 295b, and 303b). Other catchwords are in a cruder and presumably later hand.

22. This consistent irregularity explains why the rubric panels are neither of constant size nor in proportion to the one-centimeter space between the horizontal grid lines.

23. Due to the various refurbishments to the manuscript, the original collation of gatherings at its beginning and end cannot be reconstructed with certainty. It is possible, however, that the now-missing two folios of front matter were collated with folios 1 and 2 to form a binion (a gathering with two bifolios or four leaves) and that folios 3 through 10 formed the first quaternion. It is probable that folios 297 through 304 (including the original folio 304 with the last verses of the *Khiradnama-i Iskandari* text) formed a ternion. Folios 259–64, now forming a ternion, originally were gathered as a quaternion from which the middle, illustrated bifolio was removed.

24. Elsewhere (Simpson, "Codicology," 134) I have referred to these as artificial bifolios as opposed to natural bifolios resulting from the successive folding and trimming of a large sheet of paper into pairs of naturally conjoined leaves. For general remarks on the making of artificial bifolios, see Bosch et al., 41. In the Freer Jami the overlap between folios occurs on the outer side and is visible throughout the manuscript in its current, unbound state, most clearly on the central bifolio of a gathering. The overlap is difficult to detect on bifolios with the same color margin, and it is even possible that some of these, especially the outer bifolios (the first and last leaves of a gathering), may be "natural."

25. Five principal stitching stations are still visible. Quite small, these pierce the fold of the bifolios (folios 245 and 248). Other holes are also found in various parts of the manuscript. Some may have been the result of mistakes during the original binding, while larger holes probably were made when the European-style binding was added and cord was used to form end bands. The present sewing thread of orange silk seems to date to the nineteenth to twentieth centuries.

26. For a summary of the process, see Simpson, "Jami," 94–97.

27. The breaks occur on folios 46b–47a, 70a, 84a, 139b–40a, 181b–82a, 199b–200a, 225a, and 272b–73a. The first daftar of the *Silsilat al-dhahab*, *Yusuf u Zulaykha*, *Subhat al-abrar*, *Salaman u Absal*, *Tuhfat al-ahrar*, and *Layli u Majnun*, each of which ends on the recto, is followed by a double spread consisting of an unadorned sheet facing another unadorned sheet or a gold-flecked sheet. None of the Freer Jami masnavis begins or ends on the verso or facing recto of its predecessor.

28. The exception is the final masnavi, the *Khiradnama-i Iskandari*, which starts with a separate gathering (G36).

DECORATIVE

The decorative program of the Freer Jami contributes significantly to its character as a deluxe codex.[1] Each folio contains column dividers and margins illuminated in gold and multicolored rulings around the written surface. All but a handful of folios have illuminated rubrics, and triangular designs in gold and polychrome embellish many individual verses. Eight *Haft awrang* text sections begin with elaborate headings or title pieces, and five end with illuminated colophon surrounds (fig. 31).

The diversity and profusion of the illuminations are dazzling. Of particular note are the incredible range and combination of colors, set against the gold-dusted ivory text paper, and the liberal application of gold, enhanced by the varied colors of the margin paper. The multitude of design elements—geometric devices framing the primary decorative planes and floral motifs filling each illuminated field—is remarkable. At the same time the variety of decorative patterns is circumscribed, and a certain sameness of form pervades the ornamentation.

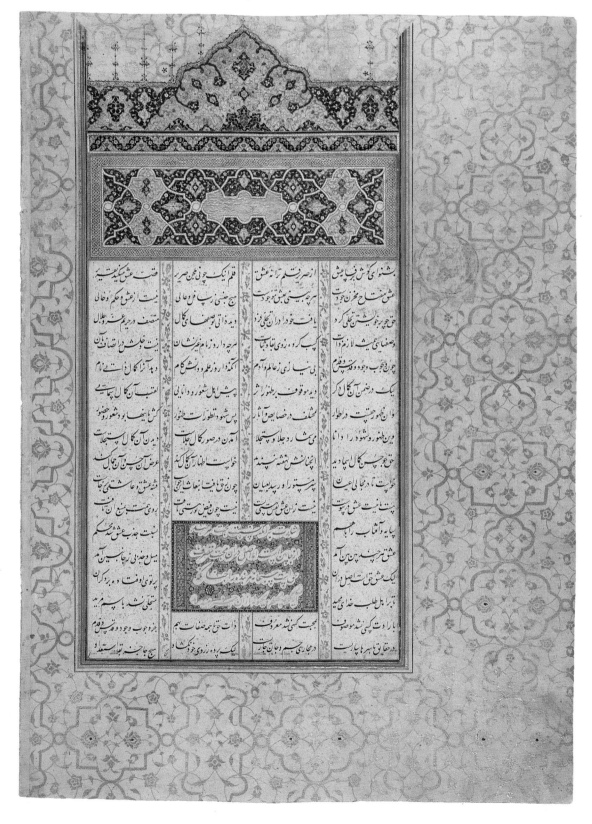

31
Masnavi heading folio of *Silsilat al-dhahab*, second daftar
Copied by Malik al-Daylami
in the *Haft awrang* of Jami
964/1557, Iran, Mashhad
34.5×23.4 cm (folio)
FGA 46.12, folio 47b

Both variability and predictability were presumably intentional and the consequence of both a single master plan for the manuscript's decoration and a diverse labor force. Although one masnavi heading is signed by Abdullah al-Shirazi, it is unlikely that this illuminator was solely responsible for the entire decorative program (fig. 32). Indeed it can be assumed, and in some cases demonstrated on stylistic grounds, that various teams of artists contributed to the manuscript's illumination. That these teams consisted of highly skilled illuminators is evident from the virtuosity of drawing and painting manifest throughout the manuscript, even in such elements as the column dividers. The quality is so consistent and the artistry so uniform that, as with the calligraphy, it is difficult to differentiate individual hands or identify specific groups of illuminators who may have worked on particular parts of the manuscript.

While some elements—column dividers, triangular verse illuminations, and colophons—could have been decorated before the text pages were joined to their margins, other elements, such as masnavi headings, rubrics, rulings, and margins, could have been illuminated only after the full folios were formed.[2] From this sequence it can be posited that the decoration of the manuscript was a lengthy process requiring advance planning. One of the most notable characteristics of the Freer Jami's illumination is that, while ubiquitous, it is irregular. Some sections are more heavily orna-mented than others, suggesting that there may have been a hierarchy in the decorative program.

Front Matter

Although the Freer Jami no longer possesses its original opening folios, it may be assumed that these would have been illuminated. Continuing artistic practices of the Timurid and earlier periods, deluxe Safavid manuscripts typically begin with a series of illuminated folios preceding and often incorporating the first page, or pages, of text. These initial illuminations might include a medal-lion or rosette, often recalling a sunburst (therefore its traditional designation, *shamsa*), and enclose the name of the patron or book.[3] There could also be a double frontispiece with the book title, name of the author, or table of contents and an elaborate frame, usually with an illuminated heading, around the first page or pages of text. Illustrated frontispieces are also common, either in place of or in addition to the illuminated frontispiece. The sequence of front matter generally varies from manuscript to manuscript.

The collation of the Freer Jami suggests that the original manuscript may have included two folios preceding the first text folio.[4] These would have provided four surfaces for decoration. Folio 1 recto also would have been suitable for decoration. The many references to Sultan Ibrahim Mirza throughout the manuscript suggest that the prince might have wished his patronage to be pro-claimed at the very outset. A shamsa inscribed with the prince's name and titles was probably incor-porated on one of these opening folios, possibly the recto of the first sheet.[5] The next two sets of facing folios easily could have accommodated a double-page illuminated frontispiece and a double-page illustrated frontispiece.[6]

32
Masnavi heading folio of *Yusuf u Zulaykha*
Copied by Muhibb-Ali and illuminated by
Abdullah al-Shirazi
in the *Haft awrang* of Jami
964/1557, Iran, Mashhad
34.5×23.4 cm (folio)
FGA 46.12, folio 84b

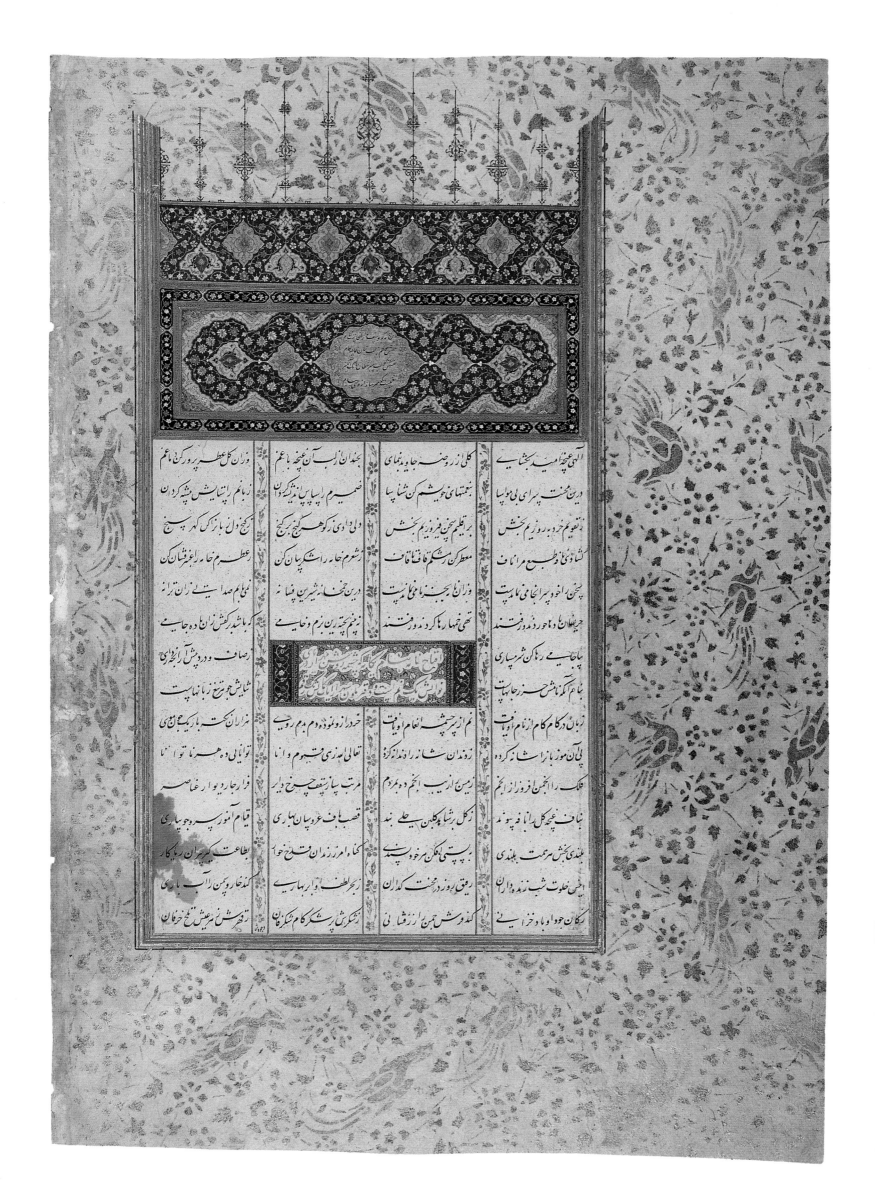

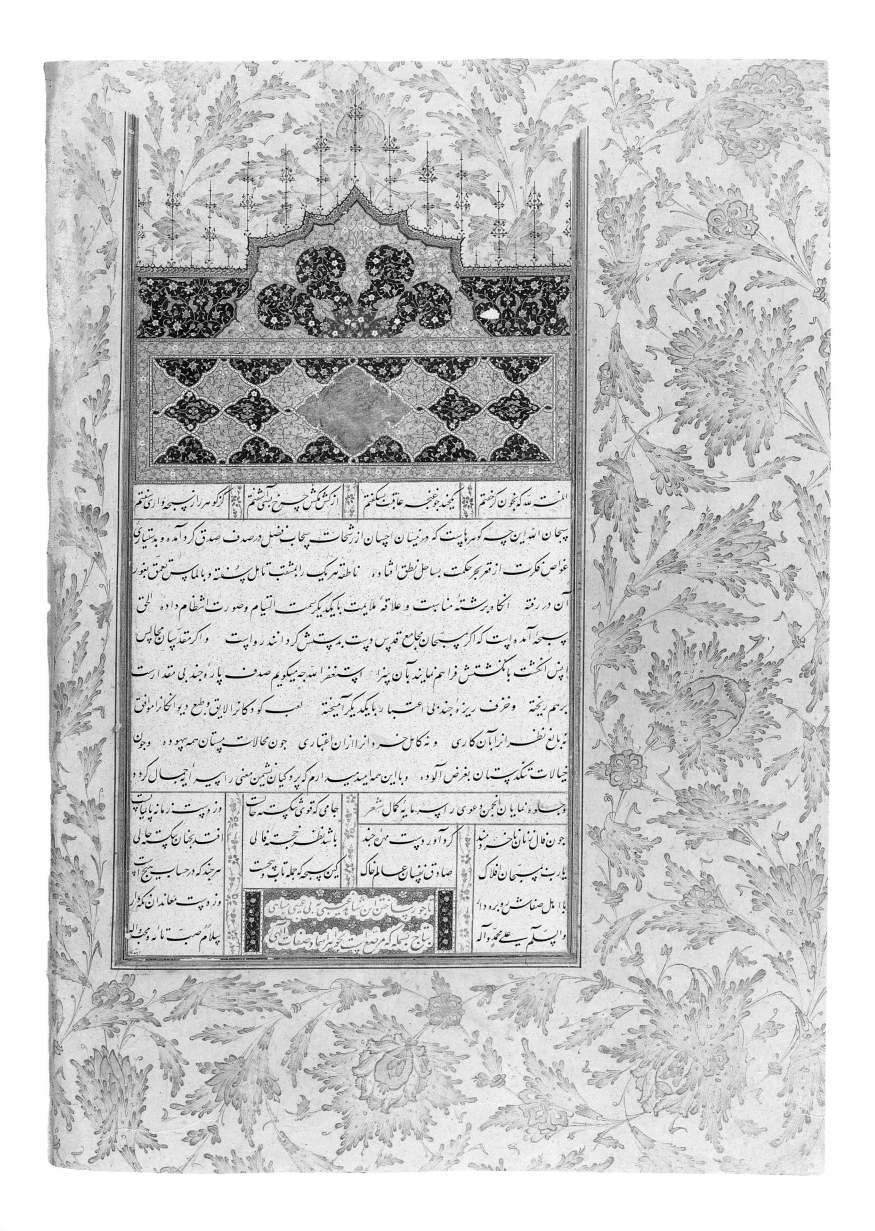

Masnavi Headings

Persian manuscripts with more than one text, such as anthologies or collected works, generally have an illuminated superscription preceding each individual work.[7] Such illuminated headings or title pieces provide a visual and literary prelude to the text that follows.

Sultan Ibrahim Mirza's copy of the *Haft awrang* contains eight original masnavi headings: folios 47b, 70b, 84b, 140b, 182b, 200b, 225b, and 273b.[8] Although no two are identical, all conform to the same compositional typology (fig. 33). The structure of the title pieces is clearly bound to that of the manuscript's standardized written surface, specifically its division into four text columns separated by three dividers. The principal design and decorative elements in the headings are invariably aligned with the columns and column dividers below. Their proportions are synchronized with those same coordinates.[9] With a single exception (folio 200b; fig. 34), each heading consists of two superimposed rectangles filled with symmetrical designs.[10] The larger, lower rectangle includes a gold cartouche in the center, flanked by other geometric units. Variously shaped, the individual cartouches were presumably intended for the masnavi title.[11] Only one cartouche, however, contains an inscription (folio 84b).[12] A floral or geometric band, sometimes one of each of varying width, enframes the lower rectangle of each heading.[13] The narrower, upper rectangle has a straight edge at the top (folios 70b and 84b) or, more frequently, a large triangular projection rising from the center (folios 47b, 140b, 182b, 225b, and 273b; fig. 35). In both cases a series of blue finials of varying heights tops the upper edge.[14]

33 (*opposite*)
Masnavi heading folio of *Subhat al-abrar*
Copied by Shah-Mahmud al-Nishapuri
in the *Haft awrang* of Jami
963/1556, Iran, Mashhad
34.5×23.5 cm (folio)
FGA 46.12, folio 140b

34
Masnavi heading folio of *Tuhfat al-ahrar*
Copied by Rustam-Ali
in the *Haft awrang* of Jami
963/1556, Iran
34.5×23.4 cm (folio)
FGA 46.12, folio 200b

35
Masnavi heading folio of *Layli u Majnun*
Copied by Muhibb-Ali
in the *Haft awrang* of Jami
972/1565, Iran, Herat
34.5×23.4 cm (folio)
FGA 46.12, folio 225b

All the masnavi headings straddle the thin text paper and the thicker margin paper of the folios, evidence that these illuminations were executed after the full folios had been formed.[15] As in the text folios of the Freer Jami, a set of colored rulings hides the bottom and lateral juncture of text and margin papers on the folios with masnavi headings. These rulings continue alongside and above the headings, forming two parallel frames and terminating at an oblique angle in the upper margin. The relationship of the rulings and blue finials at the top of the headings to the marginal designs of the folio also indicates that the headings were illuminated after the margins had been decorated.[16]

The most distinctive and individualized aspect of the Freer Jami's eight title pieces is the decoration that fills the upper and lower rectangles, consisting of varied and intricate geometric devices and detailed floral motifs (fig. 36). Although the specific forms are difficult to describe, their arrangement may be characterized as a series of juxtapositions or superimpositions. Thus the cartouche in the lower rectangle may be read as the topmost unit of several layers of geometric fields, each with a different color background and floral design. Just as the upper and lower rectangles are two distinct elements of the heading composition, always separated by bands of color, so the individual decorative patterns and motifs are also discrete. Thus a masnavi heading consists of separate areas of illumination, which may be repeated but are never repetitious (fig. 37). Only the floral scroll, appearing in many guises within the illuminated headings and background, spreads from one area to another. Yet even this device does not spill over, for instance, from the lower to the upper rectangle.

جمال جهان پوشش بنقش برون | کال از حد آویش برون
مقید با نهایم نجا اهم ترا | زنهایی بلندی و پستی نویی
جو پرتوی از عقل و وهم و قیاس | تو جوی جمله نشناسم ین نشناس
جهان بیت خرپاد و پوش نامه | بدو صنع تو حرف کش خانه
بود آخرین جمال ازآن می | بر وخستم شد منصب خانی
کز آر دیکی نام محود در بار | مفصل ش و پنجه نام پت
کوبیم کرامت مدار و بکیت | شد درا حد صبح کم کی
وزان بهن کردان قنی پشین | کرد روز دو پیچه بیان نوم
ازانت این مهره کرد وبش | طبالی کر با کک کر چکی ی
زتو خال مرباو آوبخت | شدار ضلع ایشان ربین بیم
زمین پرحتان بار ازرست | وزانت در جا نور زندیکی
یزد انش کار بندد کشاد | تویی کنوی پس با باشد کز بر
زدرپت توابی آبادیکی با پس | دراقاک می کهانوبی و پستیکم
تعانون نکت آبان کنی | ز جون فیض خورشید نفی نویت
نداوی براین بختیار احتیار | ولی سر سر ازمری سر آگایت
جوپر رشته کار کار دربست | کشنده بهر کار با پار پت

Rubrics

Among the most ubiquitous forms of illumination in Islamic manuscripts are the rubrics marking individual text passages (fig. 38).[17] The Freer Jami contains more than 750 such illuminations. Their number in each *Haft awrang* poem and location on the written surface depends entirely on the text of the individual masnavi.[18] The four masnavis with more or less continuous narratives developed in lengthy episodes (*Yusuf u Zulaykha*, *Layli u Majnun*, *Salaman u Absal*, and *Khiradnama-i Iskandari*) have proportionately fewer rubrics than the three other, primarily didactic, masnavis with shorter text passages.

Each rubric consists of one to four (sometimes more) lines of prose enclosed in a rectangular panel and extending across the two central text columns.[19] Although the enframed rubrics vary widely in height, their width is standardized.[20] The rubric text is written in colored inks. Bright blue and orange predominate; dull shades of pink and green also appear frequently. Even had the rubrics been designed without further embellishment, the colored inks alone would have added considerable adornment to the manuscript, as can be appreciated, by contrast, on a few folios with undecorated, and presumably unfinished, rubrics (folios 162b and 253b).

These incomplete rubrics also prove that the illumination of the rubrics followed their inscription. Other rubrics further indicate that the decoration occurred after the lines of the column dividers had been drawn.[21] It is also possible to deduce that the rubrics were illuminated after the text paper had been joined to the margins and before the rulings were added around the written surface.[22]

Besides their rectilinear format, standard width, and multicolored inks, the rubrics share the same basic decorative scheme. A contour line follows the rises, dips, and swoops of each line of rubric text to create a reserved panel in the shape of a cloud.[23] Either dark blue or gold paint fills the area outside this cloud panel.[24] The gold ground is often pricked with single dots or a cluster of three dots, adding texture to the surface and enhancing the gold's reflective property.[25] Whether the

38
Text folios of *Khiradnama-i Iskandari*
in the *Haft awrang* of Jami
963–72/1556–65, Iran
34.4×46.8 cm (two folios)
FGA 46.12, folios 280b–81a

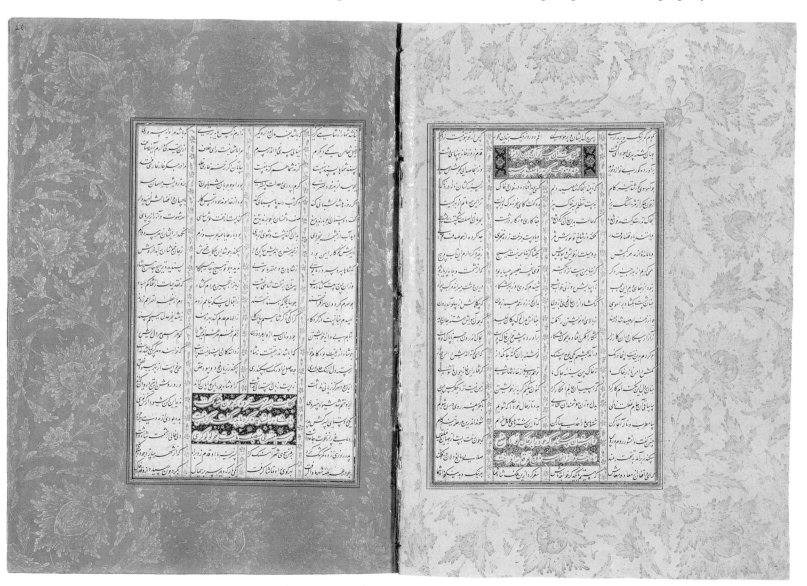

background is gold or blue, it is always decorated with flowers: single blossoms and buds of various shapes, sizes, and colors, each with a stem and one or more leaves. Most stems grow out of the contour lines. The variation and disposition of the blossoms, buds, and leaves depend largely on the amount of space available for decoration between the contour outlines and outer edges of the rubric panel. As elsewhere in the decorative program of the Freer Jami, most flowers are poly-chrome, with primary colors predominating. Often they are highlighted in white or edged in red. Occasionally a rubric contains flowers of a single color only, usually red or blue highlighted in white (folios 224a and 277b). Stems and leaves are usually green and blue in the gold-ground rubrics and thin gold in the blue-ground rubrics.

39
Text folio of *Silsilat al-dhahab*, first daftar
Copied by Malik al-Daylami
in the *Haft awrang* of Jami
963/1556, Iran, Mashhad
21.8×13 cm (written surface)
FGA 46.12, folio 15a

The basic decorative system of colored calligraphy set on a white ground against (or perhaps more accurately, surrounded by) a polychromatic field involves two types of illuminated rubrics (*a* and *b*). These appear randomly throughout the Freer Jami. Their basic distinction derives from the varying width of the rubric text.[26]

In type *a*, text lines occupy the entire width of the rubric panel, with the final letters or word often written above the base line (fig. 39). Blossoms and buds on gold stems dominate the back-ground illumination.[27] About half the rubrics in the manuscript are composed in this fashion.

The internal arrangement of type *b* rubrics is tripartite, with the text concentrated in the middle and flanked by two narrower panels of decoration (fig. 40).[28] The three sections are generally

40
Text folio of *Silsilat al-dhahab*, first daftar
Copied by Malik al-Daylami
in the *Haft awrang* of Jami
963/1556, Iran, Mashhad
21.8×13 cm (written surface)
FGA 46.12, folio 22a

straightedged, with their shapes related to the number of text lines in the rubric. The central section is illuminated in the same fashion as the first type of rubric, with flowers against a dark blue or gold ground. The side sections also have either a gold or dark blue background, contrasting with that of the central section. The decoration of this ground is, however, far more distinctive than that of the center and involves a vast array of geometric, floral, and figural motifs. The diverse star patterns, braids, zigzags, and human heads encircled with petals are particularly striking. These designs are formed of pairs and are rarely, if ever, repeated. The Freer Jami thus includes approximately 350 unique rubrics.

Very thin gold lines between a pair of thin black lines enframe most rubrics in the Freer Jami. Sometimes a thicker colored band, usually dark blue with small black crosses, appears between the thin gold lines.[29] A thick colored band with small black crosses consistently frames the side sections of type *b*.[30]

The *Silsilat al-dhahab* contains several variations on the two main types of rubrics, which may point to the participation in this section of the manuscript of illuminators other than those who decorated, for instance, the *Yusuf u Zulaykha* folios. In type *a* rubrics with three or more lines of text, the last line is sometimes centered in the middle of the panel and flanked by two small boxes of illumination, similar to the side sections of the type *b* rubric.[31] Sometimes such multiline rubrics contain a vertical band of illumination on one side only, in an adaptation of the type *b* layout.[32] A more creative variation, found only in the first daftar of the masnavi and then only in rubrics with a single line of text, treats the central section like a cartouche with scalloped ends. The two flanks provide indented fields for additional illumination.[33]

A unique variation on the type *b* rubric appears below the illustration on folio 10a. A dark blue band with a floral scroll separates the two lines of rubric text, surrounded by contour lines and set against a gold ground decorated with flowers. The scroll band links similarly decorated vertical sections on either side to form a strong H design.

Internal distinctions among the several hundred rubrics in the *Silsilat al-dhahab* point further to the involvement of illuminators working in various formal modes. The colors of the seventy-seven rubrics in the second daftar, for example, are richer and more saturated than those in the first daftar, with a greater use of salmon, green, and mauve, especially for the frames of type *b* rubrics. Furthermore, the blossoms in type *a* rubrics in the second daftar are much larger and highlighted with white and bright colors. The flowers of these rubrics have a greater mass and volume than those in the other two *Silsilat* daftars. A similar use of highlighting is apparent in type *a* and *b* rubrics in the *Salaman u Absal* and *Tuhfat al-ahrar*, suggesting that the same team of illuminators did these two masnavi rubrics and the second daftar of the *Silsilat*. Additional idiosyncrasies appear in the *Subhat al-abrar* where a dark blue line between two sets of gold and black lines enframes a series of folios (163b–78a). It is interesting that these folios belong to two successive gatherings, suggesting that the illumination of the rubrics may have been assigned according to gatherings. This masnavi also contains many type *b* rubrics with the vertical side sections filled with half-medallions, forming unusual scalloped designs. The *Subhat* also contains a singular example of a type *b* rubric totally enframed with an illuminated band (folio 180a).

Verse Illuminations

Forty-six folios in the Freer Jami have one or more lines of text (comprising two distichs or four hemistichs per line) written on the diagonal. Most precede or follow an illustration and, in folio 261b, signal the existence of a now-missing illustration. Several such folios precede colophon folios (fig. 41). Diagonal text also appears on the written surface above the colophon. Sometimes the diagonal verses run from the lower right to the upper left and sometimes in the opposite direction, from upper right to lower left. Often successive lines contain verses written on alternate diagonals, creating a series of vertical Vs or zigzags across the written surface.[34] Whatever its orientation, each diagonal hemistich is contained within a square panel, bound at the sides by column dividers and at the top and bottom by a thin gold line between two thin black lines.[35] The two opposite corners of each square, above and below the diagonal hemistich, are ruled off into right-angle triangles and richly illuminated. Thus each line of four diagonal hemistichs contains four pairs of triangular cornerpieces.

41 *(overleaf)*
Text and colophon folios with two waqf seals of *Silsilat al-dhahab*, first daftar
Signed by Malik al-Daylami
in the *Haft awrang* of Jami
963/1556, Iran, Mashhad
34.3×46.8 cm (two folios)
FGA 46.12, folios 45b–46a

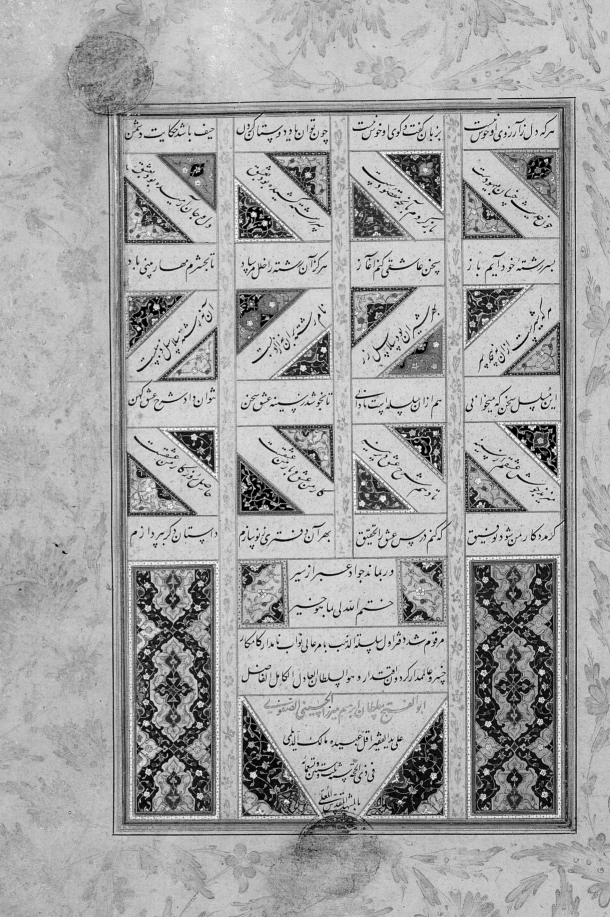

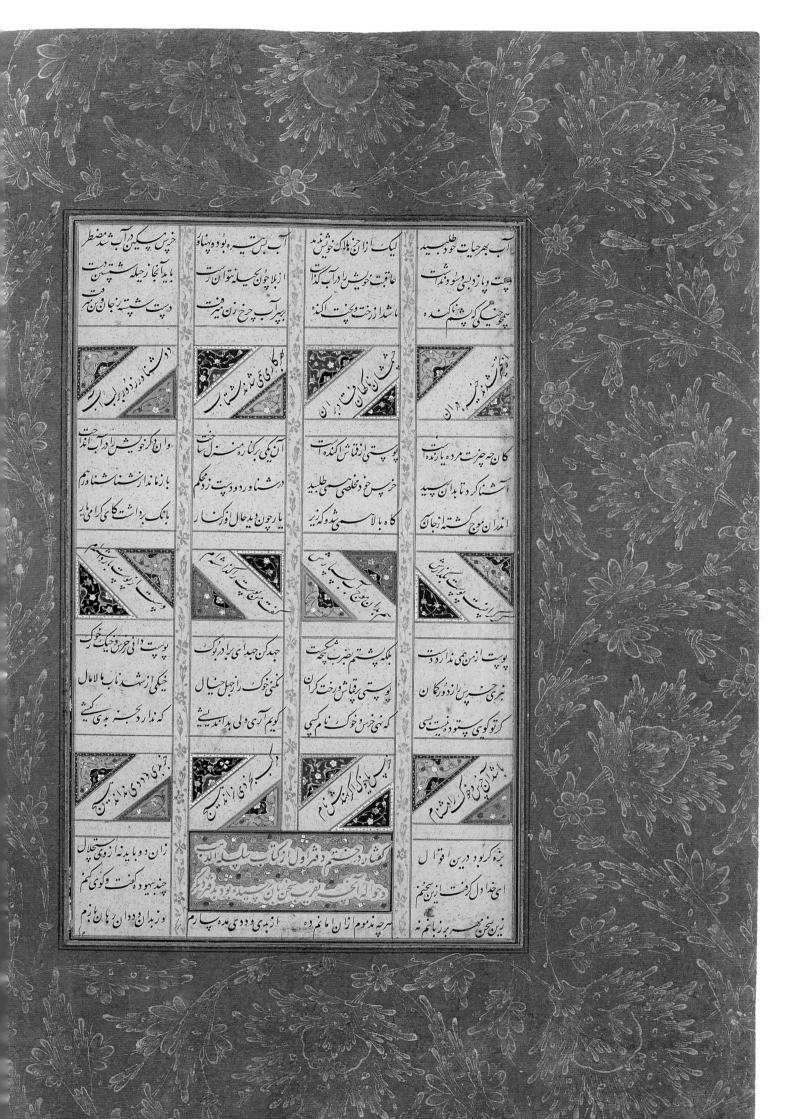

آب بهر حیات خود بخشید / لیک از آن بلک خویش نشمید

پشت و پا زو بسی بسود دست / عاقبت خویش را بآب گذاشت

هیچ جای کی پشت آکنده / نشد از درخت و خشت آکنده

خویش پیکین در آب شد مضطر / آب پس تیره بود و بی پناو

باید آنجا زحیله پشت پست / از بلا جون حیله نتوان رست

دست شسته پشت با جان رفت / ببر آب چرخ زن میرفت

کان چو چربت مرده یا زنده است / پوستی از نفاش کنده است

آشنا کرد تا بدان بشید / خرپشت و خفاشی سمی طلبید

اندران موج کشته اجهاس / که با لاشی شده و کبر زبر

وان که خویش را بآب انداخت / آن کمی برکار رهم دل شناخت

از ندارد شناسا وارم / در شناسا ورد و پشت زو حکم

بانک بر داشت کای کرامی بار / یار چون دیده حال و کن را

پوست از زمین هی ندارد دست / پوست دانی خزن دیک خرک

نربی خنده س راز درکان / جهدکن جهبای برا در کوک

تو کوی بستوده نیست بسی / لگنی خوک راجهل حیال

پوست از زمین هی ندارد دست / بلکه پشتم نضرب شکست

که نهی خرس و خوک نام کسی / کویم آری ولی بداندیشی

بره که بود درین افوال / کشاید در جستم دفزاول از کتاب سلب بالات

ای خدا دل کرفت ازین بحم / دلها آنخ غیب بیخ جان سیده بود و ذفرکم

زین سخن مهر بر زبانم نه / از بدی و دی مده پارم

زان دو با بیده زه از سوی جلال / چندی بهود و کنت و کوی کنم

وز بدان ددوان هان پازم

White or colored bands with black, and occasionally white, crosses enframe all the corner-pieces.[36] Grounds of primary and pastel colors (mauve and light blue predominating) fill their interiors, which are decorated with multicolored geometric, floral, and figural motifs (fig. 42). The diversity of motifs is comparable to that found in the corresponding side sections of type *b* rubrics, although the designs are never identical. Just as the illumination of type *b* rubrics seems to consist of many unique compositions, cornerpiece illumination is repeated only rarely in different parts of the manuscript. Each line of a diagonal verse includes four pairs of illuminated triangles. These pairs are composed not of two units that face each other across the same square panel but of two identical triangles in different panels, which may be contiguous or at the opposite ends of the diagonal line. Sometimes the match occurs across several lines, including those extending in opposite directions, or even across two facing pages, as, for instance, on folios 98b–99a (fig. 43).[37]

Various divider bands usually separate multiple lines of diagonal verses and illuminated cornerpieces. These may be one or more lines of text written on the horizontal, or a line of illuminated horizontal panels, or a line of four empty horizontal rectangles.[38] Some folios combine these schemes.[39] Folios with these arrangements often include rubrics cutting across the middle two columns of text, and sometimes two diagonal verses with matching cornerpieces flank these illuminations.[40]

The layout of these particular folios, with their diagonal verses, triangular cornerpieces, divider bands, and additional illuminated panels, was likely conceived in terms of overall patterns rather

42
Text folios of *Silsilat al-dhahab*, first daftar
Copied by Malik al-Daylami
in the *Haft awrang* of Jami
963/1556, Iran, Mashhad
34.4×46.8 cm (two folios)
FGA 46.12, folios 37b–38a

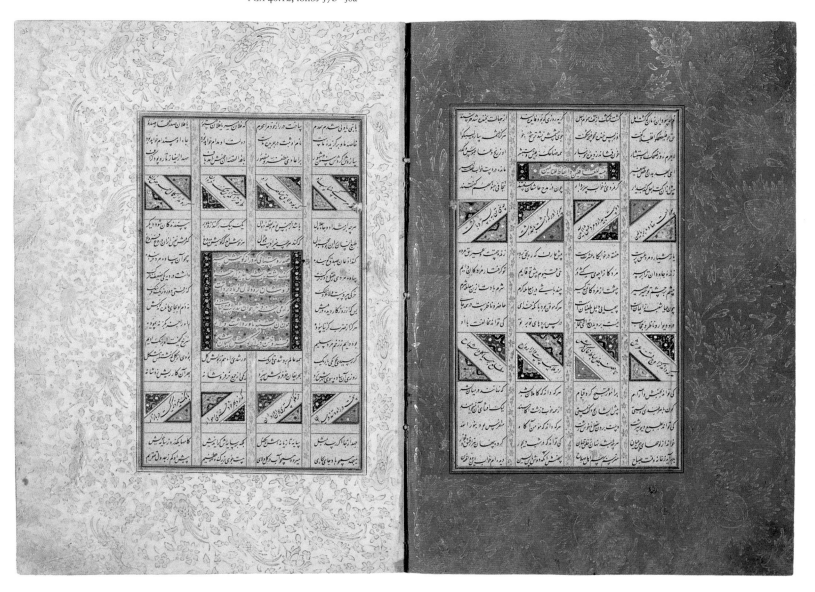

than specific decorative designs. In essence, they constitute exercises in patterning. Whether single, as on folios with one line of diagonal verses, or sequential, as on folios with multiple lines, the patterns are deliberate, precise, and controlled, almost mathematical in their varied arrangements.[41] Their function is also quite clear. Just as title pieces introduce each of the seven masnavi poems and rubrics announce sections and passages of text, so the folios with verses written on the diagonal and illuminated in patterned formats herald other, special features in the manuscript: the illustrations and colophons. It may even be that these pages indicate not only the presence but also the importance of those they precede, follow, or bracket.[42]

Diagonally written lines of text are not uncommon in Safavid and earlier manuscripts, although cornerpieces are not always illuminated or at least not in such elaborate patterns.[43] It has been remarked that the Freer Jami verses were written on the diagonal "to make the text come out right" since each diagonal line occupies the space of three horizontal lines.[44] It seems unlikely, however, that a manuscript on which so much care and preparation was lavished would require adjustments so that the text would fill a requisite number of folios. Little would have been left to chance or to the last minute in the layout, transcription, and decoration of such a deluxe manuscript. It makes far better sense that these folios are the deliberate result of what Dickson and Welch have aptly termed, apropos the Tahmasp *Shahnama*, "textual manipulation . . . that is, textual engineering . . . for maximum visual effect."[45] They are, in other words, part of the overall aesthetic of the book.

43
Text folios of *Yusuf u Zulaykha*
Copied by Muhibb-Ali
in the *Haft awrang* of Jami
964/1557, Iran, Mashhad
34.3×46.8 cm (two folios)
FGA 46.12, folios 98b–99a

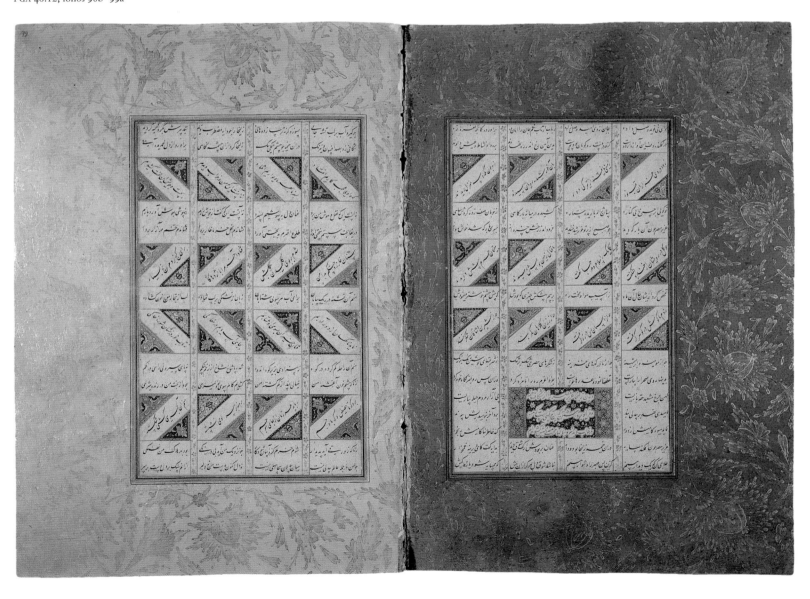

Colophons

Apart from a diversity in designs and motifs, a basic consistency of compositional and decorative concept governs the Freer Jami's headings, rubrics, and triangular cornerpieces. The manuscript's colophons, however, vary considerably in format and illumination. The only feature shared by the colophons is that each scribal coda is contained in a panel defined by thin gold and black lines between a pair of thin black lines and aligned, in whole or in part, with the two middle columns of the written surface. Otherwise, they are totally individualized and, as such, appear to be ad hoc additions to the program of decoration.[46]

Three colophons are in simple, unadorned panels (folios 139a, 199a, and 224b).[47] The absence of decoration is all the more striking since an ample area of blank paper surrounds each colophon. Some form of decoration, like that in Shah Tahmasp's *Khamsa*, may have been planned for these three pages and simply never executed.[48]

The five other colophons occupy the last lines of their respective pages and are illuminated with geometric and floral designs (fig. 44).[49] The areas of illumination include the calligraphy of the colophon text itself. On folios 69b and 83b the text is enclosed within a gold contour line and the outer panel decorated with multicolored flowers, in the same decorative scheme familiar from the Freer Jami rubrics. All five colophons have illuminated panels of various sizes and shapes around the central panel of colophon text. Many flank the text and, like the side sections of type *b* rubrics, form symmetrical compositions with matching designs. The geometric and floral forms used here are comparable to those employed in the rubric illuminations, although no two specific forms are identical. Some illuminated panels (for instance, on folios 46a and 83b) are considerably larger than those found in the rubrics, and their designs are more expansive, with greater repetition of individual forms. One matching set of panels, flanking the colophon on folio 272a, features a pair of white vases, each sprouting a gold lotus with three stems of pink and white buds and four sprays of pink blossoms (fig. 45). Within the context of the Freer Jami illumination this motif is unique.

The individuality of the colophon decoration is perhaps best seen at the end of the three daftars of the *Silsilat al-dhahab* (folios 46a, 69b, and 83b). Since they belong to the same masnavi and two are signed by the same scribe (with the other presumed to be his work as well), it might be expected that their illumination would share certain details. These colophons are, however, totally distinctive and bear virtually no resemblance to each other except in the most fundamental features common to all eight colophons.

44
Colophon of *Silsilat al-dhahab*, first daftar
Signed by Malik al-Daylami
in the *Haft awrang* of Jami
963/1556, Iran, Mashhad
34.5×23.5 cm (folio)
FGA 46.12, folio 46a

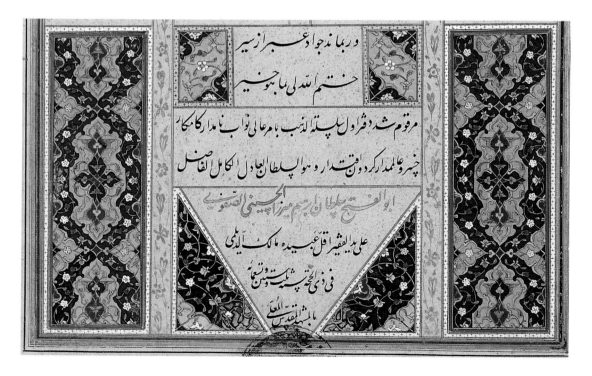

45
Colophon of *Layli u Majnun*
Signed by Muhibb-Ali
in the *Haft awrang* of Jami
972/1565, Iran, Herat
34.5×23.4 cm (folio)
FGA 46.12, folio 272a

Column Dividers

In standard Persian poetic manuscripts the written surface is divided into columns, usually two or four to a page, with each corresponding to the width of a hemistich and separated by one or three vertical shafts. In most manuscripts of the Safavid and earlier periods, the column dividers consist of a thin black, gold, or red line and often a series of such lines. Occasionally elaborate geometric or floral designs in bright colors illuminate the shafts.[50]

The approximately seventeen hundred column dividers in the Freer Jami feature a decorative scheme incorporating simple outlining and rich decoration. A pair of thin gold lines between thin black lines defines the three shafts on each text page.[51] Each pair of lines flanks a band of gold flowers on long gold leafy stems, which wind up the column in a series of complementary S curves. The curving scrolls generally consist of two different blossoms (resembling daisies and jonquils) alternating and facing in opposite directions. The style of the flowers and leaves varies throughout the manuscript: sometimes the petals of the daisies are fat, rounded, and completely filled in with gold paint, and sometimes they are long and open; sometimes the leaves are sketchy and elongated and at other times quite broad. The consistency in the composition of the column dividers and subtle variations in the individual motifs suggest that this element of the decorative program was planned as a whole and executed over an extended period by illuminators working either singly or in groups.

Rulings

As in most Persian manuscripts, a series of parallel and variably spaced lines in black, gold, and diverse colors enframes the written and painted surfaces of the Freer Jami.[52] These rulings demarcate the elegant calligraphy, illuminations, and illustrations in the central section of each folio and the richly decorated borders on the perimeter. They also mask the physical juncture between the thin white text paper and the thicker colored margin paper. After the two sets of paper were joined, the ruling lines were drawn, primarily on the inner edge of the margin paper.[53]

The system of rulings is uniform on all the Freer Jami text folios, including those with colophons. The basic sequence starts at the inner edge (closest to the written surface) with five thin colored lines (two in gold; one each in blue, brownish red, and green) alternating with thin black lines. At the outer edge are two more thin black lines, followed by a generous space through which the color of the margin paper shows, and finally a dark blue line.

The rulings are more elaborate on six title pieces and include another gold line and an orange line, along with two additional black lines. The arrangement becomes even more diverse and complex on the illustrated pages, with many additional lines and color substitutions.[54] Even on the title piece and illustrated pages, however, the rulings conclude with the same sequence of lines and spaces typical of the text folios.[55]

After the opening folios, the most extensive field for illumination in an Islamic manuscript is the border surrounding the written and painted surfaces. Beginning in the early fifteenth century, margins were frequently decorated with gold designs of various kinds, ranging from gold spraying to intricate figural compositions.[56] Except for one unfinished folio and a few blank pages between individual masnavis, all the folios in the Freer Jami are embellished with marginal decoration, executed as the final step in the program of illumination.

Most border illuminations comprise floral and leaf designs painted in gold (fig. 46). These appear on all the text folios (with their colored paper margins) and about twenty-three of the twenty-eight illustrations (with their cream-colored margins). The border illuminations consist of six large, heart-shaped blossoms connected by thin, curving stems and leaves of various sizes and evenly spaced around the top, fore edge or side, and bottom margins. The top and bottom margins each have one blossom aligned approximately with the middle of the written surface, while the side margin has two, one facing inward and the other out. The third pair of blossoms grows out on the diagonal from the upper and lower outer corners of the written surface. Stems bending outward and around on either side appear to encircle each blossom. Large and small leaves grow along these stems, which terminate in long, thin leafy branches. The stems and their leafy growths cross over each other at regular intervals around the margins, and small rosettes mark their points of intersection. The stems curving closest to the rulings often include, among their foliage, at least two pairs of "flopped-over" leaves. A series of long, leafy "branches," similar to those in the wider margins, growing upward in a wavy line, decorate the narrow, inner margin. This gutter illumination includes a thin gold line at the innermost edge.[57]

In short, these marginal illuminations were composed as a series of identical primary motifs (the blossoms), spaced at regular intervals and placed at complementary angles and simultaneously

46
Text folio of *Salaman u Absal* and *Solomon and Bilqis Sit Together and Converse Frankly*
Copied by Ayshi ibn Ishrati
in the *Haft awrang* of Jami
963–72/1556–65, Iran
34.4×46.8 cm (two folios)
FGA 46.12, folios 187b–88a

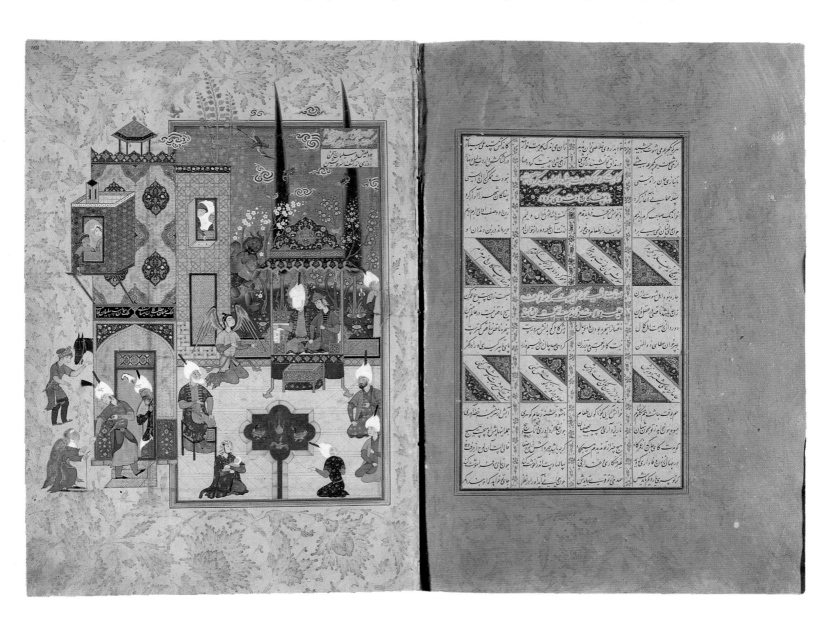

united and enframed by curving, intersected lines (the stems) and secondary motifs (leaves and rosettes) (fig. 47).

Among the most striking characteristics of these elegant designs is their fullness. This sense of volume is achieved in part by the profusion of feathery forms at the contours and on the interiors of the blossoms and leaves and by the gradation of gold paint, from delicate shading and striations defining the internal markings of the floral motifs to thicker gold at their tips. Such a painting style is unusual for the illuminations of the Freer Jami, in which flat, two-dimensional forms predominate.[58]

Another noteworthy aspect of the border decorations is that the primary and secondary motifs do not form a floral scroll, since the stems are not continuous. Instead they establish a rhythmic and fluid pattern throughout the manuscript. The execution is not, however, mechanical or repetitive. The highest quality is maintained throughout, and the striations on the interiors of the blossoms and leaves, for instance, are as delicate on the first folio as the last. Furthermore, as in other areas of the decorative program, certain motifs, such as the small rosettes and sometimes even the large blossoms, vary in size, shape, and placement.[59] Such variations do not detract, however, from the coherence of the marginal designs and are likely to signal something about the distribution of artistic labor.

Another distinctive feature is that the gold marginal designs form mirror-image compositions on two facing pages due to the reversed and thus complementary placement of the blossoms and leaves. Finally, the stems and long branches in the top, bottom, and side margins and the stems in the gutter parallel the rulings around the written surface. On the illustrated pages, however, these motifs bend around painting details that protrude into the margin and even vary their otherwise uniform size and arrangement to accommodate the projections. Often these adjustments are quite clever. On folio 38b leaves and rosettes weave in, out, and around the landscape encroaching into

47
Text folios of *Salaman u Absal*
Copied by Ayshi ibn Ishrati
in the *Haft awrang* of Jami
968/1560–61, Iran
34.5×46.8 cm (two folios)
FGA 46.12, folios 192b–93a

the margin at right. On folio 59a one leafy branch comes down between the two black slaves at the top left, while others bend around the building facade and horse and groom below.[60] Such instances suggest that the marginal designs were painted as the last step in the execution of the illustrated pages.

Two other pages in the manuscript also have painted margins, although the designs are of a type totally different from the ubiquitous floral compositions. The borders around the illustrations on folios 110b and 291a are painted in various shades of gold with real and fantastic animals and birds in landscape settings. Such animal compositions are common in sixteenth-century Persian manuscripts and have been characterized as a special Safavid contribution to the art of marginal illumination.[61]

The margins of twenty-one Freer Jami folios, including three with masnavi headings and the rest with paintings, are illuminated with stenciled, rather than painted, decorations on their recto or verso side and sometimes on both (fig. 48). With a single exception, these designs consist of long-tailed peafowls in various poses amid peonies, rosettes, stems, and leaves. In general, the birds, flowers, and leaves are stenciled in pink and outlined in gold. In four instances the designs are stenciled in gold with little or no outlines (folios 10a, 84b, 207b, and 225b). Folio 47b, with its heading at the beginning of the second daftar of the *Silsilat al-dhahab*, is stenciled with an arabesque design—unique for this manuscript—composed of two superimposed patterns that repeat continuously around all four margins. One pattern consists of a series of geometric units: polylobed cartouches and quatrefoils linked by small circles, all with thick gold lines and forming a lattice pattern not dissimilar to the lattice pattern in the lower rectangle of the title piece. The other is a delicate scroll of large lotus blossoms, smaller rosettes, and narrow, pointed leaves, all widely spaced on thin stems that loop in regular, symmetrical curves.[62]

As with the rubrics, verse illuminations, and column dividers, the painted and stenciled designs were likely the work of various illuminators.

48
Text folios of *Subhat al-abrar*
Copied by Shah-Mahmud al-Nishapuri
in the *Haft awrang* of Jami
963/1556, Iran, Mashhad
34.4×46.8 cm (two folios)
FGA 46.12, folios 168b–69a

The Decorative Process

It may be helpful at this point to summarize the sequence of the Freer Jami's illumination. The seventeen hundred column dividers were probably executed first. Next and perhaps simultaneously came the verse illuminations and colophons. Technically, these three areas may have been completed before the full folios were formed. Thus individual text sheets made up the "canvas" for the column dividers, verse illuminations, and colophons. The decoration of the rubrics, which clearly followed that of the column dividers, may have been similarly executed. Evidence suggests, however, that this step followed the union of the text and margin papers.[63]

Three phases of illumination took place after the formation of the full folios, although some ambiguity remains in reconstructing the precise sequence. Furthermore, some variability occurred in the illumination of the vast majority of Freer Jami folios and those with title pieces. All the text folios had colored and gold rulings added at this point to mask the inlaid paper. This step was followed by the decoration of the margins with floral and leaf designs painted in gold. The masnavi headings were the final form of illumination to be executed. The drawing of the blue finials on top of the margins of the eight title-piece folios indicates clearly that the marginal decoration of these folios already had been accomplished, perhaps before the addition of the outer blue ruling.

The extent and complexity of the Freer Jami illumination obviously required careful and detailed planning and considerable coordination. The decorative program undoubtedly was devised in advance and considered not only the kinds and forms of illumination but also their placement. Since much of this program consisted of embellishments to the *Haft awrang* text, the master plan would have included precise specifications for the placement and layout of the rubrics, verse illuminations, and title pieces. Even the width of the rubric text, for instance, is likely to have been specified, which means that even the type of rubric illumination, whether type *a* or *b* or a variant, would have been predetermined. This planning also would have considered the position and design of the illumination on facing folios. Thus folios 98b and 99a each contain three lines of triangular cornerpieces that match across the double-page spread; there is also a fourth line on folio 99a that aligns precisely with a rubric on folio 98b.

Obviously both the calligraphers and illuminators would have received advance instructions of their respective tasks. The master plan prepared each set of artists for the eventual metamorphosis of the leaves from text sheets to illuminated folios. The calligraphers were aware of the breaks in the text for the rubrics and verses to be written on the diagonal. They also knew which rubrics were to fill the entire width of the panel and which were to be concentrated in the center. In theory, the transcribed text folios could be passed along for illumination without any intervention, since every successive step in the process had been orchestrated and coordinated before pen or brush was ever set to paper.[64]

1. The manuscript's decorative scheme is not, however, unusual for the sixteenth century, although the literature on Safavid illumination is sparse. The only attempt at a systematic discussion appears in Ettinghausen, "Illumination," 3:1968–74. The following sources are also relevant: Akimushkin & Ivanov, "Illumination"; Bosch et al., 41; *DA*, "Decoration"; Dickson & Welch, 1:5B–6B, 2: pls. 266–69; Marteau & Vever, 1:29–34; Porter, 110–16; Taherzade Behzad, 3:1926; Titley, *PMP*, 229–38; and Waley, 9–10. See also the very helpful glossaries in Lentz & Lowry, 380–81; Porter, 209–15; Thackston, *Century*, 379–87; and related remarks on Turcoman illumination in Soucek, "Makhzan," 3–5, and on Ottoman illumination in Rogers & Ward, 59–61. The theoretical underpinnings of Islamic decoration in general is the subject of Grabar's *Mediation of Ornament*.

2. See also Calkins, "Distribution"; and Calkins, "Stages."

3. Such sunburst medallion designs are sometimes called *dibacha* (Lentz & Lowry, 380), meaning "brocade," although this term is also used for double-page illuminated frontispieces. In addition, secondary sources frequently use the term "ex libris" (Adle, "Autopsia," 235, pl. XIa). See also Porter, 65, 115, and *dibace* and *samse* in his *lexique*.

4. These are labeled Aa and Ab, Ba and Bb in gathering [1] of the collation (Appendix A.II). It is assumed, on the basis of the sequence of *Haft awrang* verses, that replacement folio 1 faithfully replicates the original. One of the Mughal inspection notes on folio 304b indicates that the manuscript had an illumination at the beginning of the text as well as a shamsa and sarlawh. See Appendix A.I.15.d, 1N2, and the following notes.

5. Hypothetical folio A recto. Certainly this placement would have been in keeping with the practices of other Safavid patrons, including immediate members of Ibrahim Mirza's family. The celebrated album commissioned by his father, Bahram Mirza, dated 951/1544–45, begins with a beautiful shamsa (TKS H. 2154, folio 1a; repro.: *IA*, fig. 1) and the two equally famous manuscripts made for his uncle, Shah Tahmasp: the now-dispersed *Shahnama* of Firdawsi (folio 16a, repro.: Dickson & Welch, 2: frontispiece [color] and pl. 4); and the *Khamsa* of Nizami of 946–49/1539–43 (BL Or. 2265, folio 1b; repro.: S. C. Welch, *WA*, cat. no. 48).

6. Folios Ab–Ba, Bb–1a. The two opening text pages of the Freer Jami probably did not include an illuminated text surround, since folio 2a, which is original, has no such decoration. Thus the Freer Jami did not contain the elaborate illuminations around the opening lines of text that appear in the great *Shahnama* made for Shah Tahmasp (folios 2b–3a; repro.: Dickson & Welch, 2: pl. 1).

7. Such illuminated headings are variously referred to as *unvan* and *sarlawh*. For a succinct discussion of the interchangeability of these terms, see Ettinghausen, "Illumination," 3:1939 n. 1; for an amusing gloss, see Waley, 14. See also Akimushkin & Ivanov, "Illumination," 36–46; Porter, 66, 115–16, and his *lexique*; and Thackston, *Century*, 385.

8. A ninth heading on replacement folio 1b also exists. It is not discussed since it is not original to the manuscript.

9. The dimensions and proportions were also likely regulated by the layout of the writing surface and the one-centimeter spacing between the text lines.

10. The superimposed rectangles are actually oblongs since their width is greater than their height.

11. Folios 47b, 182b, 200b: polylobed oblongs, of slightly different sizes; folios 70b, 225b, 273b: scalloped oblongs; folio 84b: scalloped oval; folio 140b: diamond.

12. The other headings may have been intended to be inscribed, but the task was never completed.

13. Of the two enframing bands, the outer band is floral (folios 84b, 182b, 225b, and 273b). Sometimes very narrow intermediate bands of colors with black crosses separate the primary field of the lower rectangle from its principal frame (folios 47b and 70b). Similar bands also separate geometric and floral bands (folio 182b). In addition to enframing the lower rectangle, these bands separate it from the one above. Folio 47b also includes a horizontal band with a zigzag design that further separates its lower and upper rectangles.

14. The original dimensions of the finials cannot always be determined since their upper edges have often been cropped.

15. On the folios with masnavi headings, the heading illumination masks the top, horizontal joint between the text and margin paper. This joint usually falls at the top of the central field of the lower rectangle or at one of the borders surrounding that rectangle and separating the lower rectangle from the one above or at the upper edge of the top rectangle. In some cases the break can be verified by sight or feel on the blank recto side of the first masnavi folios. The layout and alignment of the headings at the top of the text block apparently were achieved with the use of a stylus. Vertical and horizontal marks are visible in the headings, most noticeably in the central gold cartouche (folios 47b, 70b, 182b, 220b, 225b, and 273b) and between the blue finials (folios 84b, 140b, and 273b).

16. This relationship is especially apparent on folios 47b, 84b, 200b, and 225b, where the finials are painted over the marginal decoration. The presence of gold stenciling on top of the gold and colored ruling on folios 84b and 225b indicates that the margins were decorated before the rulings. The outer blue ruling on these folios was done, however, after the stenciled margins. See Ettinghausen, "Illumination," 3:1972.

17. These forms of illumination are known in Persian as *lawh*. See Thackston, *Century*, 382.

18. I have not been able to find information about the original internal divisions of the individual masnavis of the *Haft awrang* or to determine whether Jami himself provided rubrics for his text. Certainly rubrics abound in sixteenth-century copies of the *Haft awrang* as well as in modern editions and translations.

19. Multiple lines of text are generally centered on top of each other, but in a few instances are staggered (folio 226a). The text of a few single-line rubrics is slightly off-center (folios 282b, 283b, 285a, 287a, and 286b).

20. The width of the standard rubric averages 6.2–6.3 centimeters. The rectangular panel invariably ends at the inner lines of the first and third column dividers, although occasionally a rubric extends through the column dividers (folio 276a) and even across the entire written surface (folio 188b). It is interesting that the dimensions of the rubrics do not correspond to the one-centimeter grid into which the written surface is divided but are larger by one to three millimeters in both height and width, because of the framing lines.

21. For example, in folio 242b a splash of orange paint from the illumination extends over the gold line of a column divider.

22. For examples, in folio 72b the lower rubric illumination incorporates an original catchword; in folio 73a, the rulings cut off the top of the rubric text; and in folio 202a, the rulings cut off the lower edge of the bottom rubric.

23. The use of the contour lines (*tahrir*) and cloud panels (*tarsi*ʾ) is quite common in Safavid and earlier manuscripts and often envelops entire lines of the written surface (as seen, for instance, on the opening folios of deluxe manuscripts) and rubrics. See Ettinghausen, "Illumination," 3:1951–52, 1959; Akimushkin & Ivanov, "Illumination," 48, pls. VI, VIII, figs. 21, 47.

24. The background color complements the contour line: when the ground is gold, a thin black

line outlines the panel and the outer ground is gold; when a gold line augments the black contour, the outer ground is blue.

25. Pricked gold also occurs in the masnavi headings.

26. It is quite common for rubrics of different types to appear on the same folio.

27. Three type *a* rubrics (two on folio 193b and one on folio 295b) contain human and animal heads. The top rubric in folio 193b is particularly unusual and includes the heads or faces of a man, a monkey, a deer, a duck, a hare, and what looks like a crustacean.

28. The relative proportions of these three sections are roughly two-thirds center and one-third sides or 2–5–2 centimeters in width. Sometimes the side panels are narrower, as in folios 189a and 189b.

29. Rubrics with different kinds of outlines often appear on the same folio, just as type *a* and *b* rubrics often coincide.

30. Whenever the center section of such a rubric has a similar band at top and bottom, that band is always in a color different from the one around the flanking sections.

31. In folios 5a and 82a two illuminated panels flank the middle line. This variant is labeled *a–b* in Appendix A.II.

32. Folios 23a (this rubric has only one line of text), 26b, 27b, 30b, and 39b. This variant is labeled *a+b* in Appendix A.II.

33. This variant is labeled *b¹* in Appendix A.II. The floriated ground surrounding the contour panel is always gold. The flanks generally enclose a geometrical unit or units, such as a palmette or bisected lozenge or two such motifs linked together on a horizontal axis (similar to what is found in the masnavi headings), punctuated in the center by a blossom or bud. This is the originating point for thin gold stems and large blossoms that grow out in paired scrolls to form a symmetrical pattern against the colored ground. Occasionally the decoration consists only of symmetrical floral sprays or scrolls emerging from the pointed ends of the central text cartouche. The ground in these side sections is normally dark blue, effectively contrasting with the gold ground of the central section. A couple of rubrics have side grounds of bright red or black (folio 35b). The color scheme of a rubric on folio 22a switches from a light blue ground immediately outside the central cartouche to a black ground beyond.

34. Folios 20a, 37b, 38a, 39a, 45b, 46a, 58b, 64a, 99a, 104a, and 110a. In folio 39b the direction of the diagonal shifts within the same line, so that the zigzag effect is horizontal.

35. One exception to this general format appears on folio 114a, where the column dividers separating the horizontal verses do not continue through the one line of diagonal verses. Instead of square panels, illuminated parallelograms separate the diagonal verses. The middle column divider is also missing on folio 58a, and here, too, an illuminated parallelogram separates two hemistichs.

36. The colored bands are light green, orange, mauve, and deep blue. White crosses are used only on the deep blue bands (folio 63b).

37. A number of illuminated triangles lack mates, especially in the *Silsilat al-dhahab*.

38. The following folios are separated by one or more lines of standard horizontal text: 37b, 46a, 63b, 64a, 90a, 98b, 99a, 168b, 169a, 187b, 193b, 207a, 214a, 230b, 302a, and 302b. Those separated by one or more lines of illuminated horizontal panels include folios 58b, 90b, 99b, 104b, 161b (this folio has six horizontal bands, each containing a gold floral scroll identical to the scroll in the column dividers with which the horizontal lines intersect), 220b, 221a, and 252b. Folio 20a (repro.: Fu et al., 143) is separated by a line of four empty horizontal rectangles, enframing the diagonal lines at top and bottom.

39. Folios separated by combined devices include

38a, 39a–b, 45b, 110a, 131b, 179a, 180a–b, 194a, 215a, and 261b.

40. These folios include 64a, 131b, 169a, and 214b. A few other panels on either side of a rubric consist exclusively of illumination, either in the form of square compositions or parallelograms between two triangular cornerpieces: folios 20a (square panels of illumination) and 58b (with a cornerpiece in the lower corner, a large parallelogram in the middle, and a large triangle, formed of two identical and contiguous cornerpieces above).

41. Folio 99b, for instance, has six lines of diagonal verses with triangular cornerpieces composed of four repeat motifs arranged in three different patterns.

42. Admittedly this interpretation does not explain why these pages appear only in conjunction with a selection of paintings and colophons in the Freer Jami. Nor does it explain anomalous folios 20a and 90a–b, for which the triangular cornerpieces seem to exist purely as decoration for the text. Here the question really may be why the verses they decorate were written on the diagonal.

43. For general remarks, see Ettinghausen, "Illumination," 3:1965, 1974. For triangular cornerpieces in the Tahmasp Shahnama (where they are called "small flag-like decorations"), see Dickson & Welch, 1:6A, and 2: pls. 266–67.

44. Ettinghausen, fs, 25.

45. Dickson & Welch, 2: opposite pls. 266–67. "Textual engineering" refers to the "delayed" placement of an illuminated rubric so that it would fall on a page preselected for additional illumination.

46. For general remarks about the decoration of colophons, see Akimushkin & Ivanov, "Illumination," 50, figs. 24, 26.

47. Folio 139a is square, folio 199a more or less pyramidal, and folio 224b a vertical rectangle. The colophons on folios 199a (at the end of Salaman u Absal) and 224b (at the end of Tuhfat al-ahrar) are separated from the final verses of their respective masnavis by a horizontal set of lines identical to the panel frames and seem suspended beneath the middle two columns of Jami's text. The final verse of the Yusuf u Zulaykha poem on folio 139a is written in the two middle columns. Below this verse is a thin gold line, after which the colophon text begins. Thus this colophon appears to be an extension of the masnavi text.

48. BL Or. 2265, fol. 128a; repro.: S. C. Welch, WA, cat. no. 60.

49. Like the three unadorned colophons, each illuminated colophon consists of a distinctive shape: folio 46a is a truncated triangle, folio 69b a long horizontal band, folio 83b a small rectangle flanked by two trapezoids, folio 181a a pyramidal form similar to folio 199a, and folio 272a a large rectangle.

50. See, for instance, Dickson & Welch, 2: pl. 266; Stchoukine, MS, pls. LI–LVIII. Although the example in Dickson & Welch displays column dividers on an illustrated page, the unillustrated side of the same folio also has the same kind of illumination, in a formula recurring throughout the Tahmasp Shahnama.

51. Actually only the right-hand set of lines follows the grid; the left-hand set is drawn about one millimeter to the inside of its grid line. The average width of each column is five millimeters. The black lines defining the column dividers were probably drawn before the verses were transcribed, whereas the gold line was added after. See, for instance, folios 46a, 83b, and 193b, where the gold line breaks for ascending letters.

52. A succinct discussion of the development of jadval (rulings) is given in Akimushkin & Ivanov, "Illumination," 48. For further technical detail and primary sources, see Porter, 63–64. For a description of the rulings in the Tahmasp Shahnama, see also Dickson & Welch, 1:5B. Instructions for creating rulings, possibly from the

Safavid period, appear in Qazi Ahmad [Minorsky], 195–96; also Porter, 64.

53. The sequence of steps is confirmed wherever the rulings break to allow for ascending letters, as on folio 87a. The physical relationship of the rulings to the margin paper may be observed in a few places where the text paper has "popped out" (folio 299a). The function of the rulings in hiding the overlap between two different sets of paper does not apply to the twenty-six laminated folios with illustrations since these consist of single sheets of paper. In manuscripts in which the folios consist of a single sheet of paper, the rulings may have preceded the calligraphy. See Porter, 65.

54. The same arrangement is employed for the rulings of two folios with masnavi headings (folios 140b and 200b) and two with paintings (folios 10a and 207b).

55. The drawing of the outer blue line seems to have been a separate step on some of the title-piece and illustrated folios. For instance, on folio 215a gold from the stenciled margin designs covers the inner colored and gold rulings, while the outer blue line extends over the stenciled margins, as if added in a final step. Similarly folio 253b has inner rulings but lacks the outer blue ruling, as if the process had never been completed.

56. Akimushkin & Ivanov, "Illumination," 48–50; Ettinghausen, "Illumination," 3:1965, 1971–74; Titley, PMP, 236–37. See also the fascinating article by Swietochowski, "Borders."

57. This gold line served as a guide when the folios were conjoined into bifolios and the gatherings stitched together.

58. The style of the marginal blossoms and leaves recalls that of the saz style in Ottoman Turkey, which also features long, broken leaves. Since the saz design derived from fifteenth-century Iranian art, the similarities here are understandable. Although the foliage forms in the Freer Jami margins share a sense of organic growth with their Turkish counterparts, their contours are less bold and jagged and lack, for instance, the heavy calligraphic outlining of the main design elements typical of the saz style. Part of this greater softness may be due to the exclusive use of gold paint, presumably applied with a brush, instead of pen and ink. See Atil, Süleyman, 97–100; Atil, Süleymanname, 267; Denny, "Saz"; and Rogers & Ward, 61.

59. Compare, for instance, the rosettes on folios 83b (thin, regular petals), 140a (squared-off petals), and 199a (scalloped petals). Slight variations can also be observed on the two sides of illustrated folios and on two different illustrated folios in the same masnavi.

60. See also folios 52a, 105a, 110b, 114a, 120a (where the marginal illumination has definite internal breaks), 147a, 179a, 188a, 194b, 215a, and 221b.

61. Ettinghausen, "Illumination," 3:1971, citing as examples the Khamsa made for Shah Tahmasp (BL Or. 2265) and a Yusuf u Zulaykha (BL Or. 4122). See also the reproductions of BL Or. 2265 in S. C. Welch, WA, cat. nos. 49, 51–53, 60–65, along with other examples (cat. nos. 45–46, 85; Dickson & Welch, 1: fig. 119); and Soudavar, cat. nos. 90, 93, 136, pp. 178–79. The lion with the twisted hindquarters on folio 291a reappears in a Mughal album painting of circa 1585 (S. C. Welch, India, cat. no. 104).

62. The physical evidence suggests that the stenciling of the margins was executed after the rulings were drawn around the written surface. See folios 84b and 225b, where the stenciled gold flecks are clearly visible on top of the colored ruled lines.

63. For instance, the rewritten catchword in the left-hand column divider on folio 72b is incorporated into the bottom rubric illumination. Since it was necessary to rewrite the catchwords only when the text paper was inlaid into margin paper, this illuminated catchword signifies that the union of

text and margin paper had already taken place.

64. Advance planning and coordination notwithstanding, mistakes occasionally occurred. For instance, folio 211a has at the top a band of vine scrolls with grapes in a panel evidently intended for rubric text. Either the calligrapher neglected to write the rubric or the rubric was not required at this point in the Tuhfat al-ahrar text. In either case, the illuminator had a large field to decorate and improvised with a splendid design unique in the Freer Jami. The rubric text at the top of folio 217a is quite cramped, as if the size of the panel had been miscalculated.

PICTORIAL

Ever since the first scholarly notice in *A Survey of Persian Art* in 1939, interest in the Freer Jami has focused largely on its paintings. Of particular concern has been the formal analysis of these twenty-eight unsigned compositions, including the classification of their style and school and the identification of individual painters. The primary goal of such connoisseurship has been the placement of the paintings within a specific artistic and art-historical milieu. The emphasis here is, rather, on the paintings' material and formal character, and the discussion is cast primarily in terms of artistic process. The purpose is to reveal the paintings as integral to Sultan Ibrahim Mirza's *Haft awrang* and introduce their artistic particulars.

In their technique and style, the paintings are by far the most original and least predictable element in the Freer Jami. They exhibit much more artistic "personality" than the calligraphy and less repetition and standardization than the illumination. In short, while uniformity and consistency were sought in the transcription and decoration of the manuscript, individuality and variability were privileged in the painting.

Technique

It occasionally has been commented, apropos Safavid manuscripts such as Shah Tahmasp's *Shahnama*, that certain paintings were created to replace original images, apparently after a volume had been completed and at the behest of its patron.[1] The pictorial program of the Freer Jami shows no signs of any additions, however, and all the manuscript's paintings are original to its compilation. Furthermore, it can be reiterated that the volume once contained another composition in the *Layli u Majnun* masnavi, which probably illustrated the passage about the illness and death of Layli's husband.

Although the extant paintings clearly originated with the codex itself, not all have survived in their original condition. The illustration on folio 298a, *Iskandar Suffers a Nosebleed and Is Laid Down to Rest*, offers the most obvious example of subsequent refurbishment, evidently necessitated by water damage to the manuscript's final gathering. The blue sky at the top of the composition has been carefully repainted, and the flaming tree in the center has also likely been redone (fig. 49). This painting, like virtually all others in the manuscript, has suffered various paint losses that have been retouched. In general the inpainting blends with the original painted surface. In some cases, however, such as the gray horse in the foreground of folio 298a, the restoration is rather crude. In a few instances, notably in the center of folio 30a, where the paint has flaked off a musician's face, pigment losses have never been restored.

49
Iskandar Suffers a Nosebleed and Is Laid Down to Rest (detail) in the *Haft awrang* of Jami
963–72/1556–65, Iran
23.8×16.7 cm (painting)
FGA 46.12, folio 298a

Even more pertinent to the history of the Freer Jami at its origins is that some illustrations are incomplete. Although all the painted surfaces seem to have been finished, including the text panels incorporated into the picture plane, many illustrations lack the actual verses (folios 194b, 253a, 264a, 275a, and 298a) or column dividers separating the masnavi verses (52a, 110b, 153b, 231a, and 291a).[2] In addition, folio 194b lacks the colored lines in its rulings, and folio 253a has neither rulings nor marginal decoration.[3] These lacunae point to the general order in which the paintings were executed and, more specifically, the variable sequence of the "detail work" done on individual paintings in their final stages. More significantly perhaps, the incomplete paintings reveal that they were being worked on until the last minute and that it was possible to collate the manuscript gatherings with certain compositions still in progress.

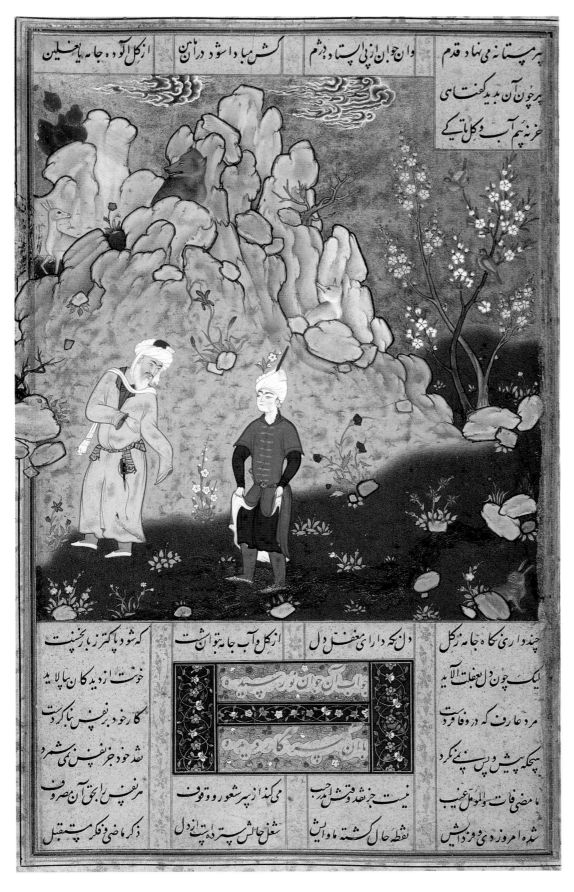

50
The Wise Old Man Chides a Foolish Youth
in the *Haft awrang* of Jami
963–72/1556–65, Iran
14.6×13 cm (painting)
FGA 46.12, folio 10a

Two illustrations were painted on text paper set into separate margins (folios 10a and 207b; fig. 50). These illustrated folios share the same material structure as the text folios, with a piece of central text paper set into the margin paper. The painted surface of 207b coincides with the written surface on its recto; that of folio 10a is considerably smaller, with lines of text occupying the remaining area above and below the painting. In both cases, the compositions were painted after the text on the unillustrated reverse (and on the obverse of folio 10) had been transcribed and the text paper, with a blank space left for the illustration, inset into its margins. Thus the artists of these two illustrations painted on fully formed folios with text on one side and a blank (or partial blank in the case of folio 10a) on the other. This sequence is confirmed on the first painting by the rock and bush that grow out of the picture plane and overlap into the surrounding margin.[4]

The structure of the other illustrated folios is more complex and the process of fabrication less evident. All the illustrated sides consist of a single piece of cream-colored paper. The unillustrated sides maintain the same form as the text folios in the manuscript: thin paper in the center inlaid into thicker margin paper.[5] Thus they are laminates with two independent sides.[6] Unlike folios 10a and 207b, however, where the paintings clearly were executed after the text was transcribed, the sequence of the text transcription and illustration on the twenty-six other folios is not readily apparent. Indeed the painting surface is difficult to determine: single sheets of paper, blank on both front and back, or full folios with text on the obverse. The great variety in the dimensions of the compositions, within their common rectangular format, suggests that the artists conceived and created their compositions on blank sheets without concern for the module of the written surface to be added on the other side. Certainly it is difficult to determine any pattern in the size of the painted surfaces or in the variations within their proportions. All the illustrated folios but one, however, have completely finished obverses. This arrangement points to the possibility that the artists were painting on fully formed, laminated folios. Only folio 253, the sole folio to lack rubric illumination (on its verso text side), rulings (on its recto illustrated side), and marginal decoration (on both recto and verso sides), hints at a different order. Perhaps various types of painting surface were available. Certainly there seems to be no sure way of determining or even deducing if a single "system" for fashioning these illustrated folios existed.

Whether the "canvas" was a single sheet or a laminated folio, all the surfaces to be painted were laid out in the vertical rectangle customarily used for Persian painting since the late fourteenth century and possibly defined by a black drafting line.[7] The outlines and perhaps also the details of the compositions were presumably then drawn with graphite, as evidenced by folio 264a, where the flesh-colored paint around the herdsman's ear has flaked off to reveal black underdrawing (fig. 51). Half the paintings have gold sky. It is possible that these background areas were painted first, as suggested by folio 120a, where the gold stops exactly at the edge of the building that itself seems to have been delineated with a stylus. Other than these few details, the compositions offer little physical evidence as to how they were painted.

Close examination of the paintings, as well as the evidence of the incomplete illustrated folios, reveals that the rulings were added after the scenes were painted. In general, the scheme of black, gold, and colored lines is similar to that found around the written surfaces of the manuscript but with many more variations in color. An even more obvious distinction is that the rulings around the painted surfaces are rarely continuous. They instead break for parts of the composition—such as landscape and architectural features, animals, and people—that project into the margins. In some cases (notably folios 38b, 52a, 105a, 120a, 132a, 188a, 194b, and 215b) the rulings vanish altogether whenever the contour of the composition is particularly irregular (fig. 52). It is interesting that this kind of significant interruption or suppression of the rulings occurs only on one of the four sides of the painted surface, as if the composition was allowed to diverge from the basic rectilinear format and attain its own pictorial limit in a single dimension only. The great variety of the rulings' colors and their persistent irregularity suggests that they were done individually—perhaps as each illustration or illustrated folio was passed from painter to illuminator—and not as part of the same, apparently uniform, process or operation in which the text folios were ruled.

51
Majnun Comes before Layli Disguised as a Sheep (detail)
in the *Haft awrang* of Jami
963–72/1556–65, Iran
23.3×14.5 cm (painting)
FGA 46.12, folio 264a

The ruling of the paintings evidently preceded the addition of the incorporated verses (see, for example, folios 264a and 275a, where empty text panels abut a finished set of rulings). More positive evidence is found where ascending letters, such as *kaf*s, cross the rulings.[8]

Several illustrated folios also have catchwords, written in a lower text panel, column divider, or margin.[9] In two cases (folios 153b and 169b) the catchwords have been written in the margin and enframed in a cartouche, evidently to ensure their visibility and legibility within the marginal decoration (fig. 53). This placement suggests that these catchwords were written before the marginal illumination.

52
The Simple Peasant Entreats the Salesman Not to Sell His Wonderful Donkey (detail)
in the *Haft awrang* of Jami
963–72/1556–65, Iran
26.3×14.5 cm (painting)
FGA 46.12, folio 38b

53
The Arab Berates His Guests for Attempting to Pay Him for His Hospitality (detail of catchword)
in the *Haft awrang* of Jami
963–72/1556–65, Iran
34.5×23.4 cm (folio)
FGA 46.12, folio 169b

With the exception of incomplete folio 253a–b, all the folios with paintings have marginal dec‑ oration on both illustrated and unillustrated sides. Most share the same painted gold designs (large bushy blossoms, stems, leaves, branches, and rosettes) found on the text folios.[10] Of particular note is the way this standard marginal illumination varies to accommodate compositional elements that project into the margin. In folio 59a the elements of the floral and leaf design dip and swoop around buildings and figures; a leafy branch even slips between the heads of the horse and the groom waiting outside the bathhouse. Similar, clever advantage of composition and iconography has been taken on folio 188a, where a branch with a broken stem hangs between the groom and the old woman at left, mirroring both the groom's hand gesture and the woman's posture. Again, each mar‑ ginal design is treated as a singular decorative project.

This distinctiveness seems to be borne out by the handful of folios in which the margins are dec‑ orated with painted animal scenes or stenciled bird designs. The painting on folio 110b is sur‑ rounded by an elaborate landscape featuring a menagerie of real and fantastic creatures (fig. 54). The general scale of the composition and mode of painting, particularly the delicate shading to create volume and mass, are similar to that of the standard floral margins. The other animal border, on folio 291a, is quite different in style, with a greater number of smaller animals, more trees and vegetation, a denser application of gold paint, and a greater sense of texture in the animal hides and skins.

Besides these painted animal margins, many illustrated folios have stenciled margins in their text obverses. The decor depicts long‑tailed birds in various poses amid peonies, rosettes, stems, and leaves. Both birds and foliage are stenciled in pink and outlined in gold. The illustrated sides of folios 10 and 207 are decorated with the same design, except that the stenciling is in gold and not outlined.

54
Marginal design around *Yusuf Tends His Flocks* (detail)
in the *Haft awrang* of Jami
963–72/1556–65, Iran
34.5×23.4 cm (folio)
FGA 46.12, folio 110b

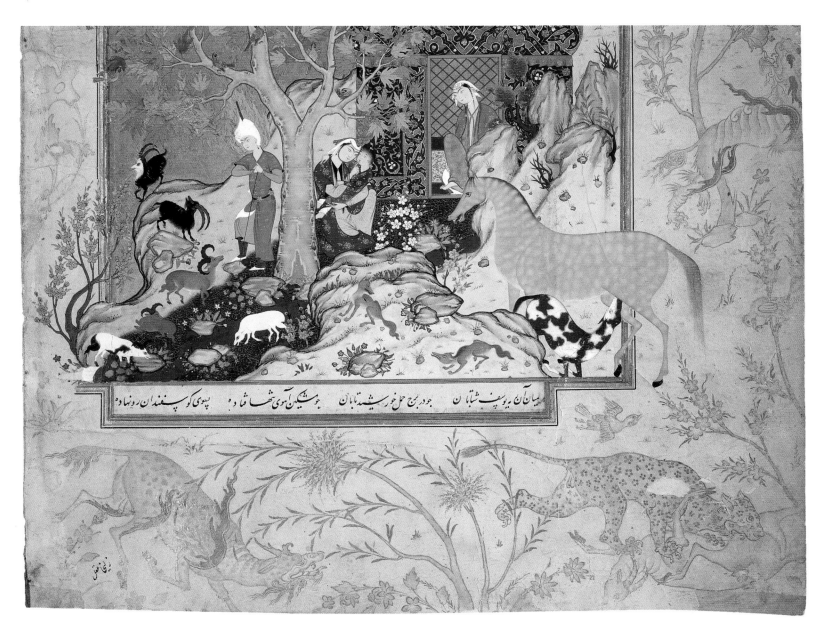

Such painted and stenciled margins are commonly found in sixteenth-century Persian manuscripts. What may be perhaps more unusual in the Freer Jami is that the margins on the rectos and versos of its illustrated folios are always so different. Eighteen folios have painted floral designs around their illustrations and pink stenciled birds on the other sides. Two have gold stenciled birds without outlines around their paintings and pink birds with outlines on the obverse. Two have animal designs around their paintings and stenciled birds on the other side; and six have floral designs painted on both sides. These examples further testify to the variability and individuality in the conception and execution of the volume's illustrated folios.

In addition to the illuminated rulings and margins, a few Freer Jami compositions include what might be called internal illumination, found within their text panels. Curiously the most prominent such decoration appears on folio 253a, which otherwise is totally lacking in illumination, where a multicolored floral scroll on a bright blue ground fills the column divider between the empty text panels at the upper right of the illustration. The other examples of internal illumination are more modest: the column dividers on folios 147a and 221b are filled with curving bands of gold flowers, stems, and leaves similar to those on the text folios throughout the manuscript, while the incorporated verses on folio 38b are set within gold panels above and flanked by narrow panels of polychrome flowers and gold stems on a bright blue ground below. Folio 188a also has an illuminated rubric, with the text written in pale blue and enframed by gold contour panels, in the upper-right corner of the picture plane.

Style

The twenty-eight compositions in the Freer Jami belong to the so-called classical tradition of Persian painting that emerged in the second half of the fourteenth century, matured throughout the fifteenth, and produced some of its most memorable achievements during the late Timurid and early Safavid periods.[11] The final phases of this well-known development long have been associated with extremely gifted painters, many with secure identities and oeuvres and others more problematic, who trained or worked at the late Timurid court in Herat and at the subsequent Safavid courts of Tabriz and Qazvin. During the early decades of the Safavid era the style of refined naturalism associated with the legendary artist Kamaluddin Bihzad and manifest in codices made for the last Timurid ruler Sultan-Husayn Mirza, such as the *Zafarnama* (Book of victory) dated 872/1467–68 (JHU) and the *Bustan* of Saʿdi dated Rajab 893/June 1488 (GEBO Adab Farsi 908), was enriched by the more exuberant and visionary mode of Turcoman painting, as represented by a *Khamsa* of Nizami dated 886/1481 (TKS H. 762).[12] The effects of this synthesis are seen in celebrated Safavid manuscripts such as the dispersed *Divan* of Hafiz generally thought to have been made for Prince Sam Mirza circa 1526–27 (on loan HUAM) and the undated *Shahnama* of Firdawsi (dispersed) and *Khamsa* of Nizami of 946–49/1539–43 (BL Or. 2265), both made for Shah Tahmasp. While each masterpiece boasts its own special character—the cumulative result of various individual artistic peculiarities and specialties—in general they share the same deluxe Safavid style: bright, broad palette of jewel-like (and often precious) pigments with a high sheen; fluid, rhythmic lines; large-scale compositions frequently overflowing into the margins; deliberate modeling of forms; expansive architectural and landscape settings; elegant figures in gorgeous attire; diverse flora and fauna; and intricate ornamental patterns derived from the arabesque and used on textiles (including costumes, carpets, tents, and canopies) and buildings (especially brick, tile, and woodwork). Full of contrasts, this common formal mode fuses the heritage of its two principal sources. It deftly juxtaposes the ideal and fantastic (sometimes even mystical) with the everyday, mixes rigorous control and decorum with the earthy and ribald, and matches a calculated sense of space with illogical proportions. Perhaps the style's most pervasive and palpable feature is its sense of energy. Many of the most remarkable Safavid paintings positively throb with life.

The illustrations in the Freer Jami partake directly of this vital stylistic mode. Certain compositions have been regularly signaled out for commentary as simultaneously lifting the tradition to its apex and dragging it toward ultimate decline (folio 253a, for example; fig. 55). Whether the fate of an entire tradition of manuscript painting can rest with a single work of art is debatable. What is clear, however, is that the *Haft awrang* paintings regularly combine familiar pictorial elements with those that appear to be new and innovative.[13]

55
Majnun Approaches the Camp of Layli's Caravan
in the *Haft awrang* of Jami
963–72/1556–65, Iran
23.5×19.5 cm (painting)
FGA 46.12, folio 253a

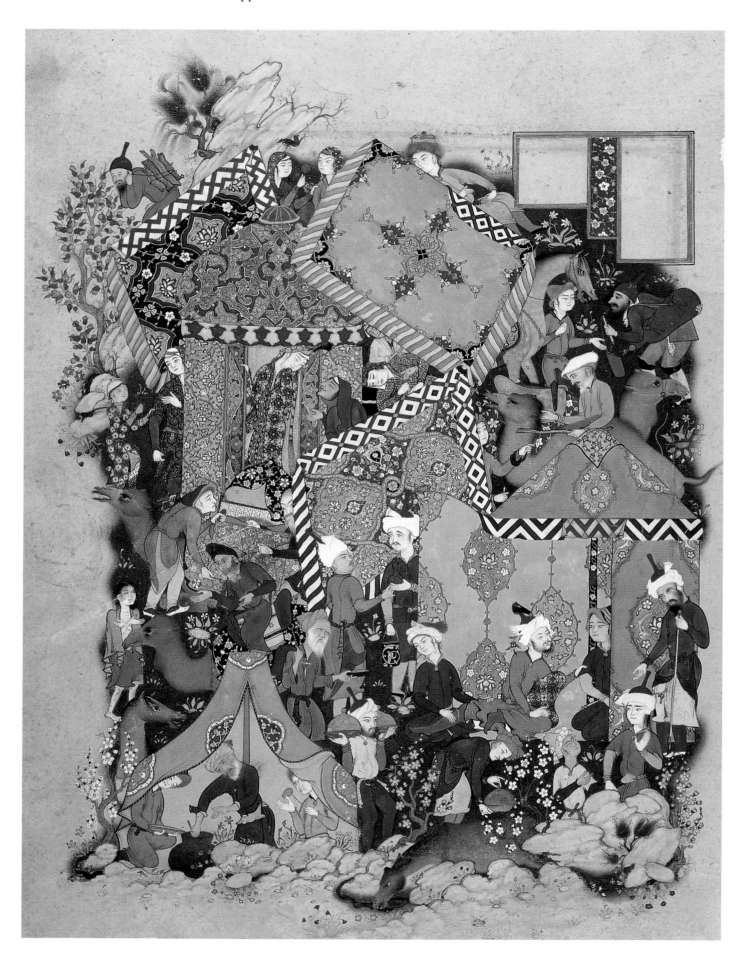

CHAPTER ONE: CONTENTS

With the exception of the initial painting (folio 10a), the Freer Jami compositions all occupy the full space of the manuscript's writing surface, and most are considerably larger. With few exceptions, the compositions take advantage of their generous picture planes, often with extremely complex and expansive arrangements of settings and figures. Not every composition, however, is an original invention. As in most classical Persian painting, the Freer Jami illustrations reflect certain typologies and formulas. A few scenes replicate, or at least closely follow, well-established compositional prototypes. The most obvious instance is *The Mi'raj of the Prophet* (folio 275a), in which Muhammad rides on his human-headed steed Buraq through a celestial firmament populated by a host of angels with Gabriel in the lead. *The Flight of the Tortoise* (folio 215b) also belongs to a specific compositional scheme that can be traced back several centuries. Other compositional elements are more generic, such as the battle dominating *Bandits Attack the Caravan of Aynie and Ria* (folio 64b); the core grouping in *The Pir Rejects the Ducks Brought as Presents by the Murid* (folio 153b), derived from the topos for a prince visiting a hermit; the lower register of *The Dervish Picks Up His Beloved's Hair from the Hammam Floor* (folio 59a; fig. 56), a variation of standard bath scenes; and the upper part of *The Townsman Robs the Villager's Orchard* (folio 179b), the tradition of outdoor idylls.

56
The Dervish Picks Up His Beloved's Hair from the Hammam Floor (detail)
in the *Haft awrang* of Jami
963–72/1556–65, Iran
34.5×23.4 cm (folio)
FGA 46.12, folio 59a

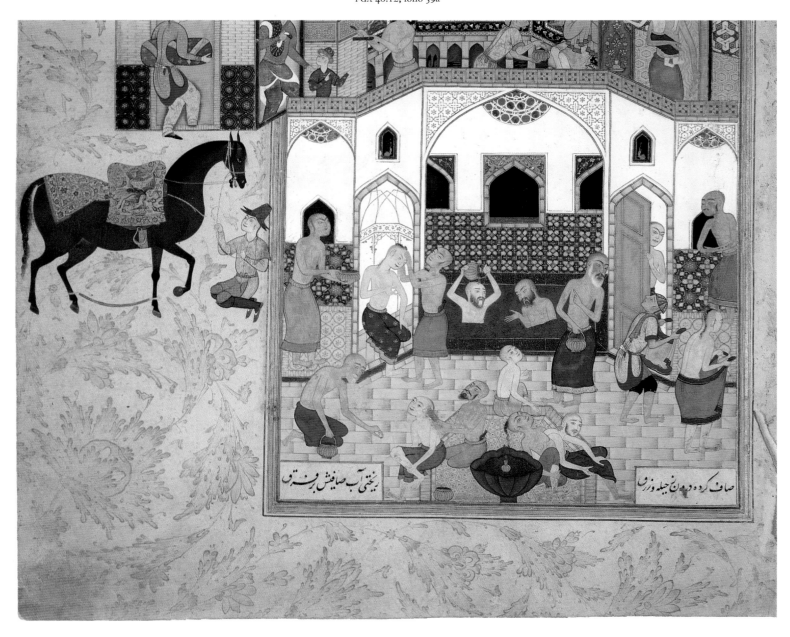

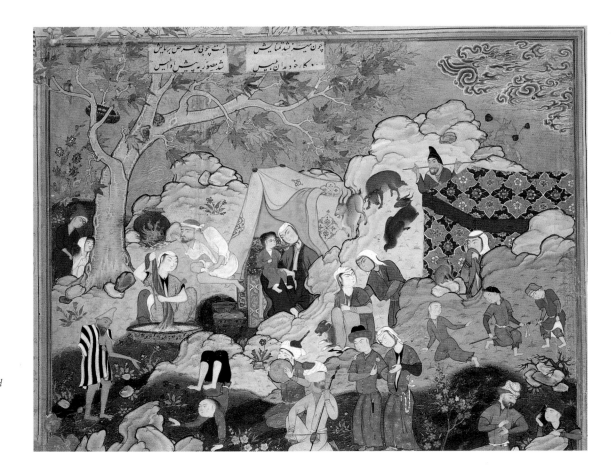

57
*A Depraved Man Commits Bestiality and Is Berated
by Satan* (detail)
in the *Haft awrang* of Jami
963–72/1556–65, Iran
25×19 cm (painting)
FGA 46.12, folio 30a

In addition, many specific personages in the Freer Jami emerge from the figural repertoire of classical Persian painting (fig. 57). A quick pass through the paintings yields a catalogue of familiar individuals, including the washerwoman (folio 30a), the milkmaid (folio 231a), the languid youth (folios 52a, 105a, and 147a), the horse and groom (folios 59a, 153b, and 188a), the decapitated warrior (folio 64b), the woodsman (folios 110b and 253a), the second-story observers or hilltop onlookers (folios 120a, 162a, 188a, 207b, and 291a), the eager attendants (folios 132a and 291a), the elderly doorkeeper (folio 162a and 188a), the aged petitioner (folio 188a), the gardener with a spade (folios 52a and 207b), and the grief-stricken mourner (folio 298a).

Yet for every set compositional unit and fixed figure type, the Freer Jami offers something unexpected, typically a fresh way of conveying a familiar visual theme. For instance, the *hammam* (bathhouse) of folio 59a is conceived as a multichambered structure and presented in sectional elevation. Bathers and bath attendants enter the building's doorways and move through its passageways, thus emphasizing the unified architectural space. The sense of interior versus exterior is further enhanced by the projecting facade and waiting horse and groom at the left, a device employed to similar advantage in folio 188a.[14] The many outdoor scenes, where palaces, pavilions, and other habitats (notably tents) are often situated in lush settings, also provide extended spatial and perspectival schemes. By juxtaposing open plain, craggy hills, and intricate facades and rooftops, the first illustration in the *Yusuf u Zulaykha* masnavi (folio 100b), for example, conveys the expanse and richness of the domains belonging to the *aziz* (vizier) of Misr (Egypt) and the imminent progression of Zulaykha and her bridal party into the Egyptian capital. The vista into and through the garden scene in folio 52a is perhaps even more imaginatively arranged (fig. 58). It starts at an open gateway at the lower left, passes up a long staircase (which ends rather improbably at a wall), continues across the central terrace into a back iwan sheltering diverse activities, and exits through a window or door opening onto a rocky scape beyond. Often the entrée into a painting is achieved by a figure (or animal) placed at the very bottom edge or in the corner of the picture plane, such as the servant making his way up the staircase in folio 52a, the beggar at the doorway in folio 179b, and the camel in 231a.

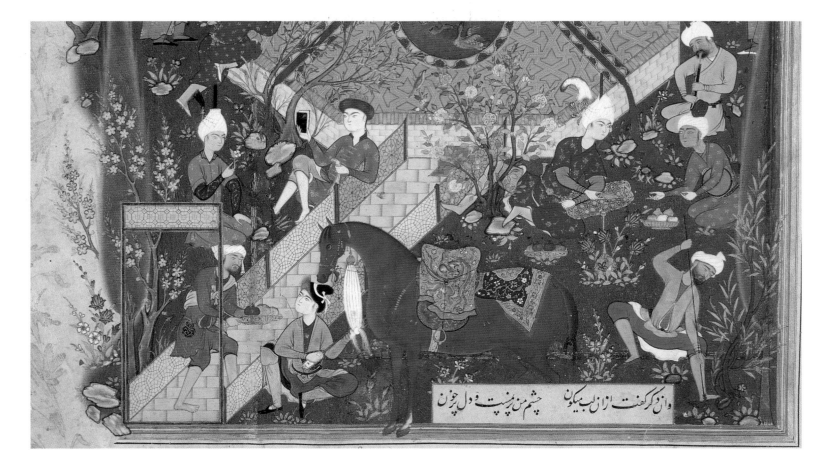

58
A Father Advises His Son about Love (detail)
in the *Haft awrang* of Jami
963–72/1556–65, Iran
34.5×23.4 cm (folio)
FGA 46.12, folio 52a

Another pervasive feature of the Freer Jami compositions is their multiple focuses. These not only provide the field for diverse action but also encourage much visual "wandering" through the pictures and consequent diversion from the principal scene.[15] It is easy at first to overlook, for instance, the negotiations between the peasant and the donkey seller in folio 38b while listening in on the baker and his elderly customer at the side of the bazaar or cantering along in front with the dappled horse and its elegant rider, or the telltale fish and the fishmonger picking up his coin in front of Khusraw Parviz and Shirin in folio 291a while admiring the many courtiers outside the royal tent, or the stricken Iskandar in the crush of so many soldiers and mourners in folio 298a (fig. 59), or even the bestial deed being committed in folio 30a while enjoying the acrobats, musicians, and children encamped above. Folio 253a presents the most extreme—and notorious—example of the artistic tendency, found throughout the Freer Jami, to overload the compositions. Here the eye is so inexorably led along switchbacks and into cul-de-sacs, past curious, even bizarre, exchanges and spatially ambiguous and improbable situations that the lonely figure of Majnun at the side can be missed altogether.

59
Iskandar Suffers a Nosebleed and Is Laid Down to Rest (detail)
in the *Haft awrang* of Jami
963–72/1556–65, Iran
23.8×16.7 cm (painting)
FGA 46.12, folio 298a

Beyond such imaginative and distracting schemes, perhaps the most compelling characteristic of the Freer Jami paintings is their high level of human interest, sustained through the activities and emotions, number and diversity of the principal and secondary figures. As an aggregate, the Freer Jami paintings present a wide range of human experience, from fornication (folio 30a) to imminent death (folio 298a), passing by way of spiritual apotheosis, revelation, and prayer; commercial transactions; domestic chores (preparing food, washing clothes, spinning and sewing, gathering firewood); intellectual interests (chess and reading); entertainment and leisure (music and games); animal husbandry (milking cows); and personal hygiene. Also regularly encountered are expressions of love and devotion, anger, amazement, self-doubt, fear, incredulity, and censure.

The population of the Freer Jami is equally diverse. Folio 100b, for instance, contains more than one hundred figures, plus several "hidden" rock-face creatures, who take part in many different ways in the encounter of Zulaykha and the aziz of Egypt.[16] Most figures are extraneous to the central scene. The illustration of the flying tortoise on folio 215b, for example, portrays an embroidering woman who seems totally oblivious to the amazing scene taking place over her head (fig. 60). Sometimes the figures are not so easy to identify or explain, such as the beggar and his young companion in the middle of a battle scene (folio 64b). There is, in fact, a certain, apparently deliberate, level of human ambiguity and mystery in these compositions.

60
The Flight of the Tortoise (detail)
in the *Haft awrang* of Jami
963–72/1556–65, Iran
21.7×19.5 cm (painting)
FGA 46.12, folio 215b

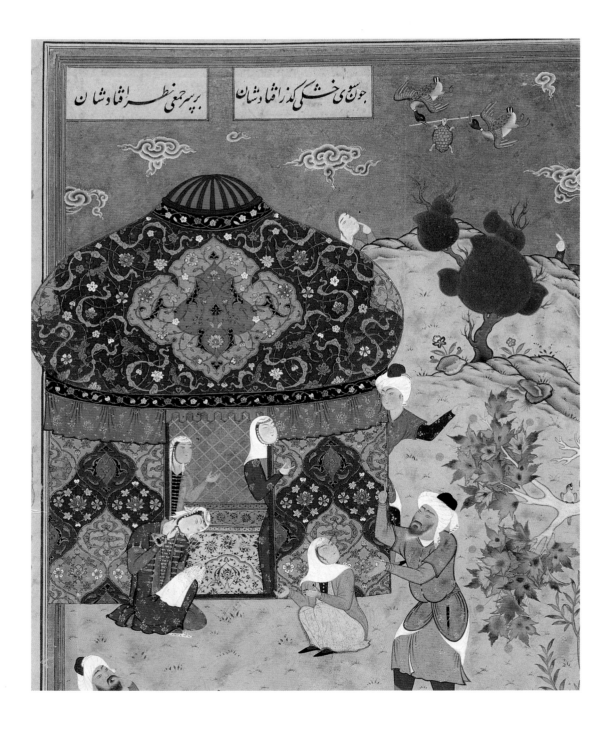

The cast of supplemental characters in the Freer Jami includes many twosomes, often embracing or conversing, as well as single figures in awkward positions (crouching or sprawling). There is, in addition, a plethora of children, including several babes in arms. Only folio 120a requires the presence of a child, the infant who miraculously testifies to the innocence of the prophet Yusuf. Here, however, the infant-witness resembles a small adult, whereas the other Freer Jami children are convincingly portrayed and engaged in playing, shopping, riding, and general merriment (folios 30a, 38b, and 52a). Sometimes their activities are more serious, such as the boy leading the beggar in folio 64b, or less certain, such as the young girl who may be trying to restrain an older female holding a ewer at the left side of folio 253a. Many family groupings include mothers suckling and cuddling babies and tending young children (folios 30a, 110b, 169b, 188a, and 231a) as well as two or three clearly identifiable or probable fathers (folios 52a, 59a, 179b, and 231a) and possibly even a grandmother (folio 38b). Nurturing and caretaking are also implicit in the illustration *The Wise Old Man Chides a Foolish Youth* (folio 10a) and explicit in the scene *Yusuf Tends His Flocks* (folio 110b), where a dappled mare nurses a piebald foal virtually alongside a human mother hugging her child.

The animal world, well represented in the Freer Jami, contributes significantly to the manuscript's pictorial vitality. Numerous species of wild and domesticated animals abound. Many creatures are specifically required by the iconography of the compositions (the donkey in folio 38b; flocks in folios 110b and 264a; Zulaykha's camel in folio 100b; horses in folios 64b and 169b). Others make the natural setting more realistic—animals being tended, ridden, and slaughtered (folio 105a), twittering birds (folio 147a), a sea teeming with aquatic life (folio 194b)—or mirror the principal action of the scene (folio 10a).

In addition, particular landscape features regularly appear in the Freer Jami and form part of its special style. As in all Safavid painting, the outdoor scenes, here constituting three-quarters of the illustrations, include many tall, leafy trees. Throughout the Freer Jami the *chinar* (plane tree) predominates and provides a home to flocks of birds and their nests. Although sometimes simply an attractive landscape element, most plane trees serve a significant compositional and iconographic function. The most active and dramatic roles are played by the tree with the twisted trunk and whirligig leaves that shelters Layli and her flock in folio 264a and the massive stumps that burst into flame as Iskandar is laid down in folio 298a. Other trees provide essential vantage points (folio 100b), encourage mischief-making (folio 52a), shelter domestic activities (folios 30a, 105a, 110b, and 231a), and anchor the scene (folios 38b, 64b, 153b, 169b, 179b, 194b, 215b, 221b, and 291a).

Also noteworthy are the inscriptions incorporated into the architecture of nine paintings. Although hardly unprecedented, they seem to be more specific here than in other Safavid manuscripts.[17] Several are documentary epigraphs in prose referring to Sultan Ibrahim Mirza and Shah Tahmasp (folios 38b; 132a, with a fragmentary inscription mentioning the prince only; and 162a).[18] One inscription comes from the Koran (folio 147a, over outside door) and another from the *Makhzan al-asrar* (Treasure chamber of mysteries) of Nizami (folio 188a). The rest are also poetic, but the verses are not derived from the *Haft awrang* or any other identifiable work of Persian literature. That they may have been composed especially for the Freer Jami is suggested by the close relation between the content of the verses and the subject of the paintings. The verses written on the back wall of *A Father Advises His Son about Love* (folio 52a), for instance, concern a lover's heartache, while the ruba'i on the cornice of the building in *The Gnostic Has a Vision of Angels Carrying Trays of Light to the Poet Sa'di* (folio 147a) addresses a paradisiacal theme. Perhaps even more direct and self-referential are the verses in three illustrations to the *Yusuf u Zulaykha* masnavi (folios 100b, 114b, and 120a).

Creativity and Chronology

The Freer Jami painters enjoyed considerable freedom in their work, including great flexibility in the layout of the illustrations and possibly also a voice in their subsequent decoration. The diversity of layout, format, and decoration (especially the ruling and margins) and the expansive and energetic compositions of all the paintings executed on full sheets contrast sharply with the two whose painted surfaces coincide with the written surface (folios 10a and 207b). Folio 10a is the first illustration in the manuscript as well as the first in the *Silsilat al-dhahab* masnavi. Likewise folio 207b is the initial painting in the *Tuhfat al-ahrar*. These two poems are among the earliest transcribed for the manuscript, and they could have been ready for illustration before other sections of the text. It is intriguing to consider the possibility that these two paintings—modest in size and unassuming in character—were executed early in the process of the manuscript's illustration and judged as lacking the verve and creativity envisioned for the manuscript as a whole.[19] In other words, these small and beautiful, but not terribly exciting, paintings may have been seen as the antithesis of the desired pictorial standard. Thus they inspired, by negative example, the creation of the twenty-six other remarkable scenes.

This possibility leads to a final consideration of the internal chronology of the Freer Jami's painting style. The overall distribution of compositions, with the simplest scene at the beginning of the manuscript and some of the more ambitious appearing near the end, seems to have encouraged scholars to chart a straightforward stylistic progression in pictorial program from start to finish. The impression of a sequential development from the conceptually simple to the complex is deceptive, however, as many elaborate scenes illustrate the manuscript's first two masnavis. Furthermore, the codicological evidence argues against any consecutive or fixed chronology. Indeed there is no evidence that the paintings were conceived or executed at the same time because the masnavis they illustrate happen to bear the same date. Similarly the nine-year span separating the transcription of the first daftar of the *Silsilat al-dhahab* from the *Layli u Majnun* masnavi does not necessarily have a bearing on the date of the paintings since the calligraphers and artists were likely to have been working independently.[20]

1. Dickson & Welch, 1:45A. Here it is imagined that Shah Tahmasp ordered his artists to paint new pictures for his *Shahnama*, "perhaps to replace a page that had begun to cloy or bore." It is not clear, in codicological terms, how substitutions of this kind would be made. (For more specific comments regarding the same manuscript, see also S. C. Welch, *KBK*, 20; and S. C. Welch, *WA*, cat. nos. 27, 31.) Such a scenario differs from a manuscript that gains new illustrations during the course of later refurbishment, as happened with the *Khamsa* of Nizami, also made for Shah Tahmasp and dated 946–49/1539–43 (BL Or. 2265), now containing three illustrations added in the late seventeenth century.

2. In addition, certain other paintings (folios 114b and 169b) lack illumination between the column dividers and in the flanking panels such as found, for instance, in folios 38b and 221b. The absence of verses in folio 298a may be the result of the later repainting of this illustration.

3. The other, unilluminated side of the folio (253b) also lacks marginal decoration and rubric illumination.

4. Folio 207b has no such projecting features. A continuous horizontal line of green paint at the bottom of the terrace tiles finishes off the lower edge of the composition and delineates the end of the central text paper, here used for the painted surface.

5. See also Simpson, "Jami," 95–96. At least two folios have a third piece of paper, visible where the corners have split, between their illustrated and text sides (folios 52 and 188). This sheet presumably provided additional support for the painting and may be present in all the illustrated folios. Most illustrated folios have cream-colored margins on the obverse. Six have margins of different colors (folios 59b, light blue; 194a, deep blue; 221a, pink; 253b, yellow, 264b, light blue; and 275b, pink).

6. In a previous discussion of these illustrated folios (Simpson, "Jami," 95–96), the term "laminate" is applied only to the six illustrated folios with colored margin paper on their unillustrated sides. The extension of the term to all the folios with independent sides does not, unfortunately, solve the question as to how and when the two sides were joined.

7. What may be a drafting line is visible under the rocks in the lower right of folio 264a.

8. See, for example, the first incorporated verse on folio 221b. The rulings appear to break for the ascending letters in the bottom text panels of folio 114b, suggesting that they were drawn after the verses were written. The addition of the verses may have been a variable step in the creation of the illustrations, as indicated by those paintings without verses (or with incomplete verse illuminations, folios 52a, 100b, 153b, 231a, and 291a).

9. Catchwords appear on the verso of virtually every Freer Jami folio and constitute the first word or two of the distich beginning on the next recto. Twelve Freer Jami illustrations are painted on the versos of their folios. Of these, only five have catchwords: folios 100b, 110b, 114b (possibly a later addition), 153b, and 169b.

10. Gold marginal designs extend over parts of the painting on folio 264a, demonstrating that at least these margins were illuminated after the illustration was painted.

11. The specific stages of this art-historical development have frequently been discussed, most recently by Canby, *PP*; Robinson, "Survey"; and Titley, *PMP*.

12. For a trenchant assessment of Bihzadian "realism," see Lentz, "Bihzad." The notion of a Timurid-Turcoman synthesis has been developed by Welch and discussed in Dickson & Welch, 1: chapter 4; S. C. Welch, *KBK*, 33–42, 68; S. C. Welch, *PP*, 14–18; and S. C. Welch, *WA*, 18–19. See also Lentz & Lowry, 310–13; Robinson, "Survey," 47–50; and Titley, *PMP*, 80.

13. Certain formal features of the Freer Jami can arguably be associated with individual painters and painting styles. Some more noteworthy characteristics, however, pervade the entire manuscript and are found in paintings unlikely to be by the same artistic hand.

14. The figure in the doorway is a standard topos of Persian painting. What is interesting in the Freer Jami is the depiction of actual or imminent movement through the doorway.

15. Various other Safavid manuscripts also have their share of extremely active compositions. See the general comments in Dickson & Welch, 1:12B–13A; S. C. Welch, *KBK*, 30; and the many examples reproduced in S. C. Welch, *WA*, such as cat. nos. 8–9, 11, 13. The proportion of such scenes seems to be higher here, however, and the artistic tendency pushed even further.

16. See O'Kane, "Rock Faces," for a discussion of the history of these creatures in Persian painting.

17. See Melikian-Chirvani, "Mirak."

18. Documentary epigraphs of the same type, giving the name and title of the patron, are also found on illustrations in Shaybanid manuscripts. See, for example, the *Haft manzar* made for Abdul-Aziz Sultan Bahadur Khan and dated Sha'ban 94[4]/January 1538 (FGA 56.14), where the patron's name appears above the frontispiece on folios 1b–2a and above the text illustration on folio 22a.

19. For a chronology of the paintings in the Tahmasp *Shahnama*, see S. C. Welch, *KBK*, 19–20.

20. See comparable comments by Arnold, *PI*, 48, concerning the time that may elapse between a manuscript's transcription and its illustration.

CHAPTER TWO: POETRY AND PAINTING

From virtually the time of their creation, Jami's seven masnavis gave rise to a rich and varied pictorial tradition, as evidenced by the numerous surviving copies with illustrations. Of these, the *Haft awrang* made for Sultan Ibrahim Mirza is today the best known. Certain of its twenty-eight pictures stand out because of original stylistic features; others impress because of imaginative iconographic details; all are memorable for their symbiosis of illustration and painting.

This chapter examines the compositions in Ibrahim Mirza's manuscript within the context of Jami's seven masnavis. Although several *Haft awrang* poems, notably *Yusuf u Zulaykha* and *Layli u Majnun*, are relatively familiar to modern readers, others require more extensive introduction. Thus each of the seven sections that follows, arranged according to the order of the masnavis in the Freer Jami, begins with a summary of the masnavi's history, content, and meaning. The paintings in each poem are then discussed. The entry for each illustration begins with a précis of the specific portion of the *Haft awrang* text to which the painting relates. It proceeds to a descriptive analysis of the composition and its formal and iconographic contents, including comparisons with other illustrations to the same passage in the *Haft awrang* text.[1]

1. The Persian edition of the *Haft awrang* by Mudarris-Gilani is used as the source for the masnavi texts throughout this study. The rubric at the beginning of each entry is translated directly from the text in the Freer Jami. Quotations and paraphrases in the masnavi summaries and text précis are translated from the Mudarris-Gilani edition. These translations were prepared by Rita Offer. Certain technical information, including dimensions, translations of *Haft awrang* verses incorporated into the compositions (as well as any omitted verses), attributions, and bibliographic references accompany the discussions of each Freer Jami painting. Comments on condition are given in cases of significant losses or repainting. A complete list of other known illustrations to the *Haft awrang*, with citations to published reproductions, appears in Appendix D.

Silsilat al-dhahab

Jami took the title for his first masnavi, the *Silsilat al-dhahab* (Chain of gold), from the terminology of the Naqshbandi order of Sufism to which he was attached.[1] The long poem is divided into three daftars, dedicated respectively to the themes of faith, love, and royalty.[2] Each daftar begins with a poem on the unity of God, the basic message of the entire *Haft awrang*. Jami was not, however, the first author to treat the subject at such length. Previous works include Sana'i's *Hadiqat al-hiqiqat wa shari'at al-tariqat* (Garden of truth and the law of the way) of 525/1130–31 and the *Masnavi Jam-i jam* (Jam's goblet; or, The mirror of the universe) written by Awhadi of Maragha in 733/1332–33.[3]

The first daftar of the *Silsilat al-dhahab* is the longest of the three and introduces many subjects elaborated on in the succeeding books.[4] One of Jami's initial concerns here is with the nature of the Sufi as a creature apart, as someone not attached to created phenomena. The poet also expresses his contempt for false Sufis and gives examples of spiritual hypocrisy. He then takes up the importance of the silent dhikr, a critical element within Naqshbandi training and practice in achieving unity with God.[5] These discussions are often amplified with citations attributed to Muhammad Baha'uddin Naqshband (FGA 46.12, folio 10a). This first daftar of the *Silsilat al-dhahab* also includes an extensive discourse, with numerous illustrative stories, on the four pillars of gnostic devotion: seclusion, silence (FGA 46.12, folio 30a), hunger, and the all-night vigil (FGA 46.12, folio 38b).[6]

The much shorter second daftar "consists chiefly of dissertations on the different kinds and phases of love, both 'metaphorical' and 'real,' and anecdotes on saints and lovers."[7] It begins by introducing the Naqshbandi categorization of love (FGA 46.12, folio 52a), which leads to a consideration of the various ways in which believers witness the absolute beauty of divine truth and the essences of God. From here Jami discusses the four types of closeness to the divine, ranked according to their sanctity, and then the different stages through which the lover's heart passes to reach true love of God (FGA 46.12, folios 59a and 64b). He concludes the daftar with a disquisition on death and a description of Muslims.

The third and final daftar of the *Silsilat al-dhahab* is devoted primarily to kings, especially the just ruler and royal justice.[8] Jami also discusses the king's need for a scholar to oversee religious affairs and a vizier to run the kingdom. He explains that good speech and actions are equally obligatory for kings, scholars, and viziers. Kings also require the services of astrologers and physicians. Some illustrative stories involve familiar historical figures, such as Caesar, Khusraw Nushirvan, Nizam al-Mulk, Mahmud of Ghazna, Ghazan Khan, and Sultan Sanjar. Literary personages, including Unsuri, Sana'i, and Nizami, figure in the daftar's concluding "discourse describing and extolling poetry" and an accompanying "exchange of words between a panegyric poet and his lauded lord."[9]

Jami reinforces his final point about the relationship between poet and royal patron with a story about a merchant who supported a gnostic by providing him with food and other services. Although ostensibly admirable, the merchant's patronage was motivated by the selfish wish to be associated with the gnostic's good name, popularity, and divine blessing.

Although the *Silsilat al-dhahab* was undoubtedly the first of Jami's seven masnavis, written in honor of Sultan-Husayn Mirza, whom the poet praises at the outset, the precise time of its composition remains uncertain.[10] The first daftar was completed in Dhu'l-qa'da 876/April 1472, as recorded in Jami's colophon, and the second finished in 890/1485–86, according to its penultimate verse.[11] Nothing is known about the date of the third daftar, and the fourteen-year interval between the first and second books is not explained. Despite the paucity of available documentation, the *Silsilat al-dhahab* is generally cited as having been written between 875/1470, when Sultan-Husayn Mirza ascended the Timurid throne, and 877/1472–73, when Jami embarked on a pilgrimage to the Hijaz.[12]

1. The source for the masnavi text is Mudarris-Gilani, 2–309. For an introduction to the silsila and its meaning in Naqshbandi thought, see Algar, 129–30. See also Triningham, 149–50; and Habib. For a more cosmic interpretation, see Bürgel, 142.

2. Browne, *LHP*, 3:516–23.

3. *EIs* 2, Cl. Huart (rev. H. Massé), "Djami"; Rypka, 236, 254.

4. Mudarris-Gilani, 2–183 (first daftar).

5. Schimmel, *MD*, 167–78, 366.

6. Several passages of the first daftar of the *Silsilat al-dhahab* are omitted from the Freer Jami, as follows: omitted from folio 14a: Mudarris-Gilani, 49–52, four passages about the heretical Rafedites (a name given to the Shiʿa; see *EIs* 3, "Rafedites"); omitted from folio 41a: Mudarris-Gilani, 146–48, three and one-half passages about the Rafedites; omitted from folio 43a: Mudarris-Gilani, 158–63, two long passages, the first about the ability of gnostics to see unity in plurality and the second about the Prophet and his companions; omitted from folio 46a (end of this part of manuscript): Mudarris-Gilani, 170–82, thirty-two passages, comprising praises to God and his books, the Prophet Muhammad and his family, the community of the faithful, and the judgment and resurrection. Jami's final discourse (on concluding the first book of the *Silsilat al-dhahab* and commending the transferral from the point reached in it to another—the second book) is included on folios 45b–46a. Jami's colophon at the end of the first daftar (Mudarris-Gilani, 183) is, however, missing.

7. Mudarris-Gilani, 185–258 (second daftar); Browne, *LHP*, 3:522.

8. Mudarris-Gilani, 260–307 (third daftar).

9. According to Browne (*LHP*, 3:522), Jami drew on Nizami Arudi's *Chahar maqala* (Four treatises) for the anecdotes incorporated into this section of the *Silsilat al-dhahab*.

10. Mudarris-Gilani, 12–14. Jami also praises the Ottoman Sultan Bayazid and the Aqqoyunlu ruler Yaʿqub in the third daftar (ibid., 263, 294).

11. Ibid., 183, 258; the words *sat* and *zat* give the years 890/1485. See also Robertson, 165–68.

12. Hikmat, 82; Browne *LHP*, 3:510–11; *EIs* 2, Cl. Huart (rev. H. Massé), "Djami"; Heer, 4 n. 4. A frequently described incident occurred when Jami was returning from the hajj, presumably sometime in 878/1473–74. During a stopover in Baghdad he was falsely accused of having ridiculed Shiʿite beliefs in several *Silsilat al-dhahab* verses.

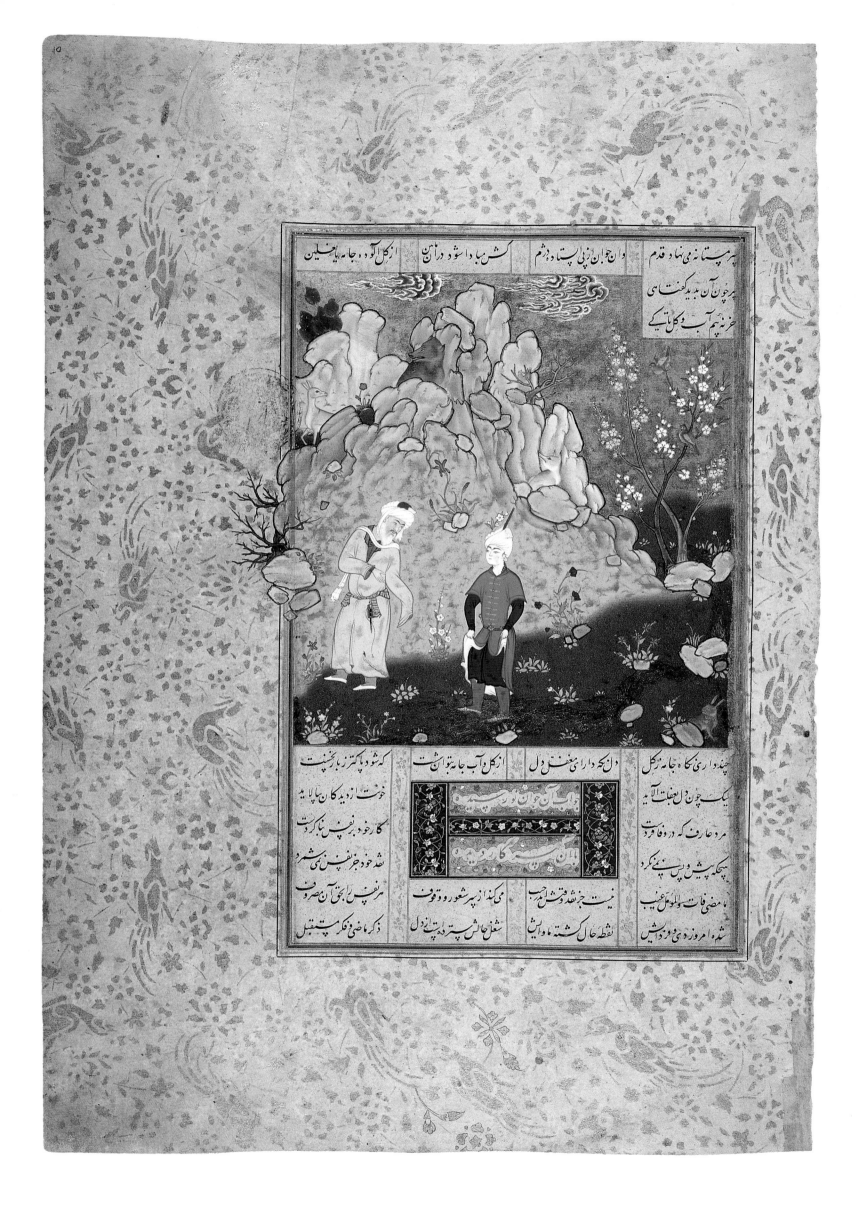

Folio 10a

THE WISE OLD MAN CHIDES A FOOLISH YOUTH

Text Source
Mudarris-Gilani, page 33.

Rubric before Illustration (folio 9b)

> The story of an experienced old man and an adolescent youth.

Précis

A Sufi pir and his young disciple are traveling together along a road when it suddenly turns to mud. The master continues walking, but the youth stops, afraid of soiling his clothes and shoes. The old man then chastises the disciple, reminding him that it is far more important to keep his heart pure than his clothes clean.

The painting appears between two quotations from Muhammad Baha'uddin Naqshband concerning spiritual enlightenment. The first quotation states that constant contemplation is rare and precious. Those who manage to gain it are free of cares and able to oppose carnal desire. This statement is preceded by another adage regarding contemplation as an aid to fixing the seeker's gaze on unity (God). The second quotation from Baha'uddin declares that the past is dead and the future invisible. The only time to spend is the present, and each breath should express the truth.

61 *(opposite)*
The Wise Old Man Chides a Foolish Youth
in the *Haft awrang* of Jami
963–72/1556–65, Iran
34.5×23.4 cm (folio)
FGA 46.12, folio 10a

62
The Wise Old Man Chides a Foolish Youth (detail)
in the *Haft awrang* of Jami
963–72/1556–65, Iran
14.6×13 cm (painting)
FGA 46.12, folio 10a

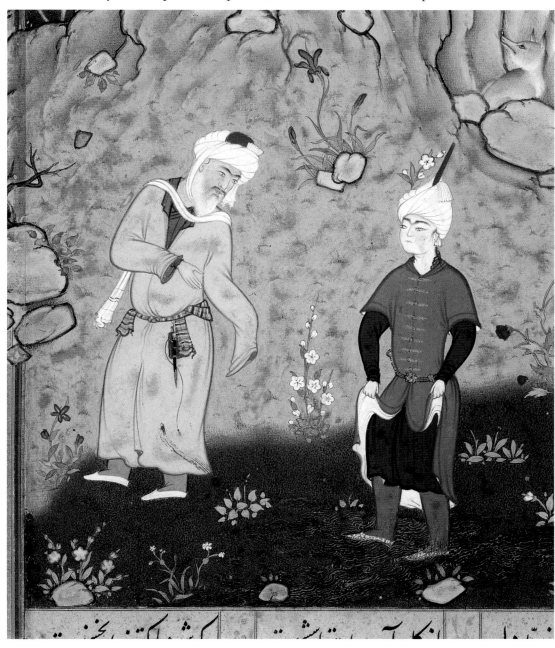

Illustration

The first composition in the Freer Jami is also the smallest, most compact, and most basic (fig. 61).[1] The pir and novice pass through a stream rather than the muddy road specified in Jami's text, although the water spreads out to create a field of mud. The old man stands on higher ground at the left and turns back to chide the youth. Brown stains, presumably mud, cover the old man's tan robe. The young man lifts his bright orange outer robe to avoid the water lapping over his left shoe (fig. 62). From behind a rock at lower right a brown hare observes the scene. The craggy background contains its own little drama, with a fox gazing up at a bear who looks down at a deer who in turn peers back across the hill at the fox.[2] A formulaic series of paired features, including racing clouds and entwined trees and birds, seems to mirror the protagonists below.

Dimensions

14.6×13 cm

Surrounding Verses

Three verses above illustration:

> *The old man paced right along, drunk [oblivious],*
> *The young man stopped despondent in his tracks,*
>
> *Fearing that in that stretch of road,*
> *His clothes or sandals would become soiled with mud.*
>
> *When the old man saw this, he said, "Hey,*
> *You are not a donkey. Why do you fear the mud?*

Three verses below illustration:

> *For how long will you take care to protect your clothes from mud?*
> *Preserve instead your heart, which you have been neglecting.*
>
> *Clothes can be washed [so] clean of mud,*
> *That they become cleaner than new.*
>
> *Yet when the heart is soiled through neglect,*
> *You will strain your blood through your eyes as tears."*

Attributions

Stchoukine: Group 1; S. C. Welch: Mirza-Ali.

References

Dickson & Welch, 1:141A, 150A, fig. 199; Simpson, "Jami," fig. 15; Stchoukine, *MS*, 127; S. C. Welch, *PP*, 24, fig. 1.

1. It is also only one of two illustrated folios (the other is folio 207b) composed in the same fashion as the text folios in the manuscript. The illustrations were painted in the center on thin, ivory paper; the margins consist of double-ply cream-colored paper. These are also the only two folios with stenciled designs of peafowls on both recto and verso. Furthermore, these are the only two paintings almost entirely confined within the rulings of the written surface of the page.
2. S. C. Welch also finds hidden animals and spirits in these rocks (Dickson & Welch, 1:150A).

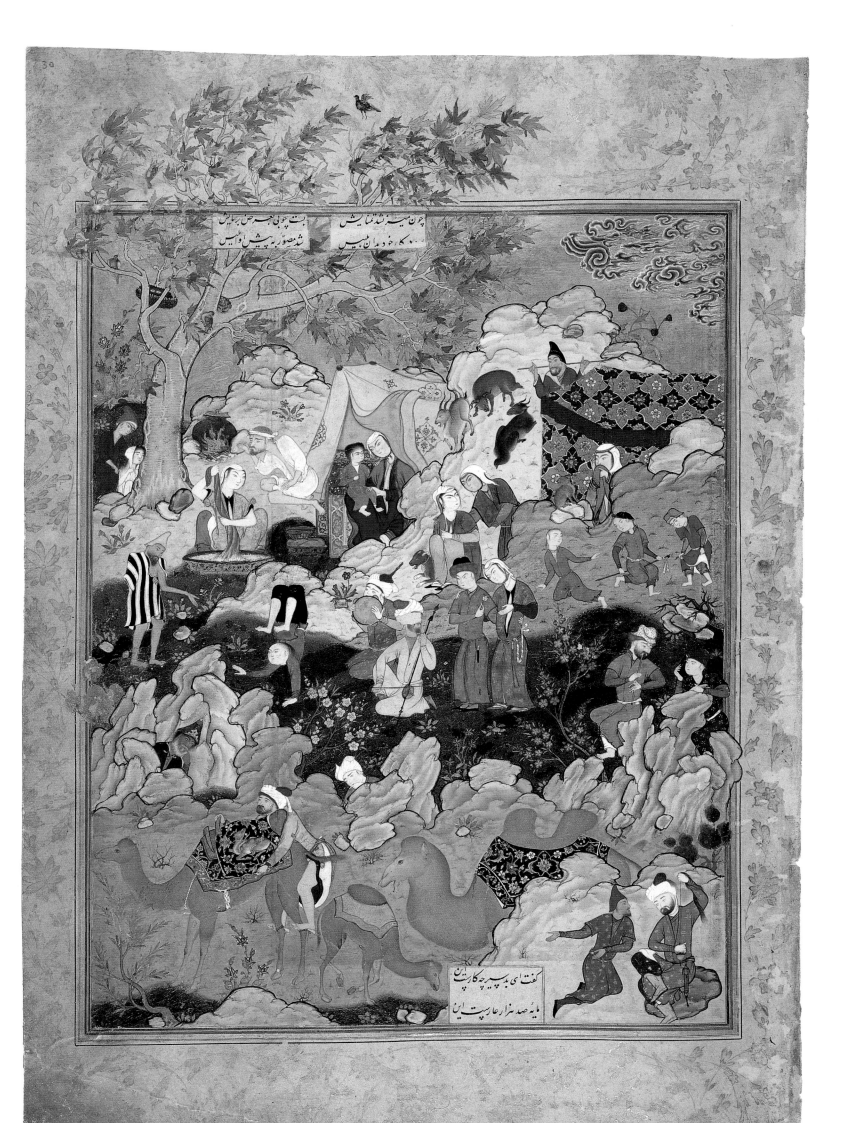

Folio 30a

A DEPRAVED MAN COMMITS BESTIALITY
AND IS BERATED BY SATAN

Text Source
Mudarris-Gilani, page 109.

Rubric before Illustration (folio 29b)

> *The story of a depraved man who in the attainment of his carnal desires played a trick [so vile]*
> *that Satan swore, "That trick [has] never crossed my mind."*

Précis

A man in the desert is overcome by lust. After a long search he finds a female camel and mounts her by binding a stick across her legs. While he is thus occupied, Iblis (Satan) appears and begins to curse him for this act. "Before people reproach you," rails the devil, "they will blame me, and that would be giving me a bad name. By God, such a trick has never entered my heart, and such vileness has never come to my mind."

The section of text immediately preceding the illustration concerns two of the four pillars of gnostic devotion: seclusion and prolonged silence. Jami ends his description of the latter by praising those who in their wisdom keep silent and speak and listen only to God. Whoever does not uphold these pillars, the poet warns, is corrupt and acts and talks as Satan's deputy, even outdoing and astonishing the devil himself. This, of course, is the theme of the story of the man mounting the camel. This daftar of the *Silsilat al-dhahab* contains many references to the sin of sodomy.[1]

Illustration

The subject of the anecdote appears in the foreground of this splendid painting, with the "vile trick" taking place in the lower-left corner (fig. 63). The depraved man (looking more pained than lustful) has hitched up his clothes and mounted the camel from two pieces of wood tied to the animal's back legs.[2] For further support he grasps the camel's saddle and saddle covering. This covering is decorated with a recumbent *qilin* (a fabulous creature) who stares up reproachfully at the sodomite. Another animal observer is the large, seemingly indignant Bactrian camel who may be the she-camel's mate. Grazing peacefully between the two is a young and oblivious camel, presumably an offspring.

Dark-faced, white-bearded, and wearing an embroidered pointed cap, Iblis peers from a rocky outcropping at left just above the camel (fig. 64). He holds a finger to his mouth in the standard gesture of astonishment. Given the impassioned speech he makes in Jami's poem, his position and action in the illustration seem almost inconsequential. His identification is based exclusively on his swarthy, white-bearded visage and proximity to the bestial deed.[3] Various other figures also take an interest in what is going on, including a young man wearing a white turban who stares down from behind the rocks. Meanwhile on a promontory at the right, one man plays a *nay* (flute) and another holds a book beside his ear. In the immediate foreground at lower right a man spins wool, an activity common among Iranian herdsmen. His dark-faced companion wearing a pointed cap (another candidate for the devil) kneels and gestures toward the action taking place at left.

A lively encampment scene dominates the middle and upper planes of the composition. Two tents, one large and made of a brightly colored fabric with linked medallions, the other smaller with a few delicate lozenges in light blue, are pitched on the upper ground. The flap of the smaller tent is raised to reveal several carpets and a young boy sitting on his mother's knee. Between the tents, and on the highest ground, a herdsman watches three goats while holding a staff behind his neck.[4] In front of the large tent a woman covers her mouth with a long green sleeve and a lynxlike cat turns its head in the direction of two conversing women, one holding a panting dog. On the patch of gold ground to the right three young boys play hobbyhorse with a long beribboned stick. One child is astride, another seems to have fallen off, and the third lifts his robes in anticipation of his ride.[5]

63
A Depraved Man Commits Bestiality
and Is Berated by Satan
in the *Haft awrang* of Jami
963–72/1556–65, Iran
34.5×23.4 cm (folio)
FGA 46.12, folio 30a

64
*A Depraved Man Commits Bestiality
and Is Berated by Satan* (detail)
in the *Haft awrang* of Jami
963–72/1556–65, Iran
25×19 cm (painting)
FGA 46.12, folio 30a

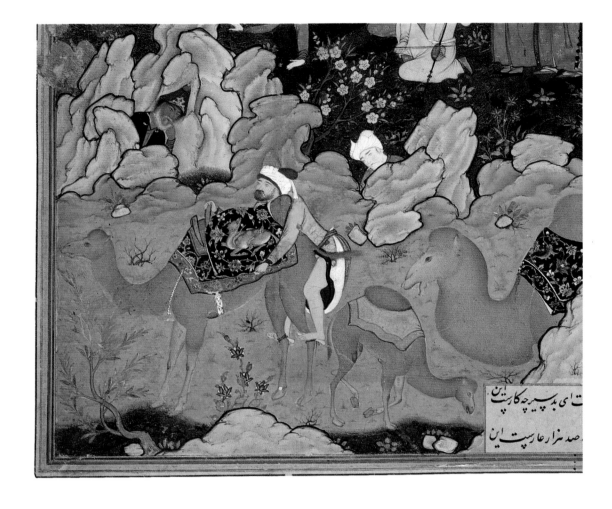

65
*A Depraved Man Commits Bestiality
and Is Berated by Satan*
in the *Six Masnavis* of Jami
Second half 16th century, Iran,
attributed to Shiraz
30×19 cm (folio)
TKS Y. 47, folio 29a
Topkapi Sarayi Müzesi, Istanbul

CHAPTER TWO: POETRY AND PAINTING

A large plane tree sheltering a nest and many birds, some hanging upside/down in the upper branches, arches over the encampment. Under the tree is a campfire and large, once/silver pot with a gold lid. Smoke (barely visible in reproductions) swirls up into the golden sky. To the right kneels an emaciated man, dressed in underwear and with a white headband around his forehead, who cups his right hand to blow at the fire. Two small figures observe him from the other side of the tree. The one nearest the tree, who may be a child, is totally naked save for a white kerchief pulled over long dark hair. A washerwoman, her sleeves rolled up above the elbows, squats in front of the tree and lifts a beautiful piece of blue cloth out of the sudsy water in a shallow golden basin. Two other silver basins, now oxidized, one containing a light brown cloth, are to her right. It may be that the entire group of figures around the tree is involved in the laundry operation and that the man wearing the white underwear is heating the washing water while the naked, crouching child is waiting for his or her clothes to be washed.[6]

On the sward of green in the middle ground of the scene two kneeling musicians, playing a *kamancha* (spike fiddle) and tambourine, provide the musical accompaniment for a young man who walks on his hands. Balancing on one hand, this fellow waves toward a skinny, dark/skinned bearded man at left, who gestures back. This figure, who may be another performer, wears only a light brown pointed cap and a black and white striped robe draped over his shoulder. A couple stand next to the musicians watching the acrobat; the young man hugs the woman's waist with his left arm and offers her a white posy with his right hand.

In Iranian manuscript painting the textual narrative may often require an accompanying illus/tration to be set in or combined with an encampment scene.[7] The compositional juxtaposition found in folio 30a—an encampment that is not only absent from the text but that overwhelms the principal narrative action—appears far more uncommonly, although not without precedent.[8] Equally unusual are some of the activities, especially the performance in the middle ground. The jaunty acrobat and his strangely clad companion seem particularly original. These two personages, and perhaps all those in the upper part of the composition, may be gypsies, and the scene thus rep/resents a gypsy encampment. Gypsies have long occupied a place in Iran as wandering musicians and acrobats, as attested by oral tradition and written sources.[9] The first such entertainers suppos/edly came from India during the reign of the Sasanian king Bahram Gur (r. 420–38). Called *luri* or *luli* by medieval Iranian authors, their descendants were described as amusing, having dark com/plexions, playing the flute, wandering, and living in a disorderly fashion.[10] Other, possibly related, groups of gypsies among the Lurs were acrobats, bear leaders, and rope climbers.[11] All such peri/patetic performers were traditionally regarded as having loose morals and were synonymous with shamelessness.[12] Compared to the salacious activity going on in the left foreground, their behavior here seems exemplary. The combination of two such seemingly unrelated scenes—bestiality and gypsy encampment—and juxtaposition of domestic activities and entertainment may constitute a twofold pictorial reproach against an individual miscreant and a group of social outcasts.[13] Another interpretation suggests that the gypsies here were intended to serve as metaphors for love, as they appear, for instance, in the poems of the mystic Mawlana Rumi. Such a reading still con/trasts moral corruption and spiritual purification.[14]

Whatever its significance within the pictorial program of the Freer Jami, this superb painting certainly is an infinitely more imaginative treatment of the *Silsilat al/dhahab* anecdote than the two other known representations (IOL P&A 49, folio 61b; and TKS Y. 47, folio 29a; fig. 65).[15] Notwithstanding the differences of iconography and style, all three paintings may reflect an appre/ciation of Jami's metaphorical and mystical use of the she/camel as symbolizing the temptations of the animal soul.[16] This is not, however, the interpretation given the Freer Jami painting within the scholarly literature, which has tended to see the subject as offensive and obscene, on the one hand, and humorous and farcical, on the other, and the composition as a complex disguise to render its principal content innocuous.[17]

Dimensions
25×19 cm

Condition
The green middle ground has been repainted in many areas, and several leaves have been retouched. The face of the kamancha player has flaked off.

Incorporated Verses

Two verses at top of illustration and one omitted verse, shown in brackets:

> *When what he sought proved difficult,*
> *He bound a stick across its legs.*
>
> *[He placed his feet on this, and mounted up.*
> *The man's lust reached what he desired.]*
>
> *He was busy with this deceitful business,*
> *When Iblis took form beside him.*

One verse at bottom of illustration:

> *He said, "Oh, vile man, what is this you are doing?*
> *This is the stuff of a hundred thousand shames."*

Attributions
Stchoukine: Group 1, artist close to Mir Sayyid-Ali; S. C. Welch: Muzaffar-Ali.

References
Atil, "Humor," 22, 25, with repro. and color detail; Dickson & Welch, 1:115B, 159A, fig. 219; Inal, 64–65, fig. 3; Stchoukine, *MS*, 127; S. C. Welch, "Pictures," 72; S. C. Welch, *PP*, 24, fig. J.

1. Mudarris-Gilani, 95–96, 103–4, 216–17.
2. The verse describing how the man placed his feet on the stick is missing from the text on folio 29b. Obviously the artist did not need to be told for what purpose the stick was intended. Furthermore, in imagining the scene the artist realized that two sticks would be necessary although the text mentions only one.
3. Iblis has been associated in Islam with twilight and night since the time of the Prophet Muhammad. This association is undoubtedly the origin of his dark visage here and in other Persian paintings, such as those in the celebrated large-scale *Falnama* (Book of divination) of circa 1550 (AMSG S1986.251, 254, see Lowry et al., cat. nos. 169, 172; Lowry, color pls. 32–33). A sixteenth-century copy of the *Majalis al-ushshaq* (Lovers' meetings) by Sultan-Husayn Mirza includes the composition of *Satan Refusing to Worship Adam* in which the devil is also shown as a dark-faced man standing in the lower-left corner (TKS B. 146, folio 14a [repro.: Stchoukine, *Nizami*, pl. LXIIa]). For a study of the importance of Iblis within Sufi beliefs, see Awn. Chapter 3 of Awn's work discusses Iblis's redemption and his role as a model of the mystic. It is within this context that Jami's Iblis probably belongs.
4. The herdsman wears a pointed cap not unlike the one worn by Iblis, as do two other figures here. In this context the pointed cap appears to be a type of rustic or peasant headgear.
5. The game of hobbyhorse, or ride-a-cock-horse as it is also called, usually involves a stick mounted with something to resemble a horse's head. Here ribbons are substituted for a head. The sexual connotations of this game are strengthened by the activity taking place in the foreground.
6. Outdoor washing scenes seem to constitute a kind of minor topos in Safavid painting. Another volume of the *Haft awrang*, copied by Muhammad ibn Ala'uddin of Raza in the district of Bakharz and completed on 1 Dhu'l-qa'da 971/11 June 1564, includes a double-page encampment and picnic scene with a large tree in the background and a washerwoman underneath, who is virtually identical in attire and pose to the woman in the Freer Jami (PWM MS 55.102, folio 76a). Another washing scene, even closer in certain details to the Freer vignette, appears in the celebrated composition inscribed with the name Mir Sayyid-Ali and believed to have been detached from a copy of the *Khamsa* of Nizami made for Shah Tahmasp and dated 946–49/1539–43 (HUAM 1958.75 [repro.: S. C. Welch, *WA*, cat. no. 67]). S. C. Welch has noted the similarities of the Fogg and Freer washerwomen and the men blowing the fire within the waterpot and concludes that the latter is a spoof of Mir Sayyid-Ali by the artist Muzaffar-Ali (Dickson & Welch, 1:159A; see also the discussion of the attribution of FGA 46.12, folio 30a). At the very least all three examples of the washing scene reflect a similar iconographic source. See also Inal, figs. 2, 5.
7. See, for instance, the illustration of Majnun brought in chains to Layli's tent in the Tahmasp *Khamsa* (BL Or. 2265, folio 157b [repro.: S. C. Welch, *WA*, cat. no. 61]). This encampment has much of the flavor and figural features of FGA 46.12, folio 30a, and HUAM 1958.75 and may have been its compositional prototype.

8. A contemporary manuscript of Jami's *Yusuf u Zulaykha* contains an illustration of Yusuf with his flocks in which the saintly hero is barely noticeable amid a large and active camp scene (BL Or. 4122, folio 87b). While Jami's masnavi does not prescribe an encampment setting for Yusuf's activities, it seems as logical an artistic interpretation of the text as does the composition on folio 30a. The same may be said about the double-margin camp scene in the celebrated *Divan* (Poems) of Sultan Ahmad Jalayir (FGA 32.34–35 [repro.: Atil, *Brush*, cat. nos. 5–6]). The original textual referent, however, remains problematic for many encampment scenes and for those created as discrete paintings, including frontispieces and drawings. See, for example, HUAM 1960.199 and 1958.75 (repro.: Simpson, *Fogg*, cat. nos. 14, 17); MINN 43.31.2 (repro.: Grube, *MMP*, cat. no. 95), and *Encampment in the Mountains* from a copy of the *Sifat al-ashiqin* (Disposition of lovers) of Hilali dated 990/1582 (AHT no. 90b, repro. color: Soudavar, 233). Inal (pp. 63–65) has considered the realistic aspects of such encampment scenes, including FGA 46.12, folio 30a, and their use of certain set motifs, introducing into her discussion two album paintings in Istanbul (TKS H. 2155, folio 8b, and TKS H. 2165, folio 57a [repro.: Inal, figs. 1–2]).
9. The origin of gypsies in Iran and especially their identification with the terms *luri* and *luli* and the uncertain relationship to Lur tribes are discussed at length in Minorsky, "Tsiganes," 281–305. See also *EIs* 2, V. Minorsky (rev. L. P. Elwell-Sutton), "Luli," with extensive bibliography; and Soulis.
10. Minorsky, "Tsiganes," 283, 284, 289; *EIs* 2, V. Minorsky (rev. L. P. Elwell-Sutton), "Luli"; *EIr*, W. L. Hanaway Jr., "Bahram Gur." By the early Islamic era colonies of Indians existed in Iran and were known rather vaguely as *zutt*. The etymology of this term suggests that these Indians may have been acrobats.
11. A telling album painting signed by Shaykh-Abbasi, an artist of the second half of the seventeenth century, depicts a tambourine player and an acrobat. The latter figure bends over backward and touches the ground with his hands in a reversed version of the pose assumed by the acrobat in the Freer Jami painting (*EIr*, Priscilla P. Soucek, "'Abbāsī, Šayk," pl. 1). Compare the descriptions of gypsy acrobats and jugglers in Byzantium, Egypt, and Syria during the late thirteenth to early fourteenth century (Soulis, 148–51, 163) and in Luristan during the late nineteenth and early twentieth century (Minorsky, "Tsiganes," 301).
12. Dihkhuda, *Lughatnama*, لولی, 326, 344; *EIs* 2, V. Minorsky (rev. L. P. Elwell-Sutton), "Luli"; Soulis, 163. According to an early-seventeenth-century observer, gypsies also practiced prostitution (*Don Juan*, 57).
13. The celebrated early-fifteenth-century *Mi'rajnama* (Ascent of the Prophet) contains an illustration in which bad Muslims are represented in white tunics striped in black similar to the robe worn by the acrobat's companion in folio 30a (BN suppl. turc 190 [repro.: Séguy, pl. 27]). Wheeler Thackston (conversation with author) has suggested that a number of elements in folio 30a—the entertainers, musicians, cavorting children, amorous couple, and naked figure behind the tree—may be intended to reinforce the idea of shame, evil, and Satanism. The paradox in the Jami anecdote, of course, is that the sodomite expresses no shame while Satan feels ashamed.

14. For the basis of this interpretation, see Schimmel, *Veil*, 87, 241 n. 77, 247 n. 184. As Schimmel indicates (p. 241 n. 77), one of Rumi's poems refers to a gypsy who plays a kind of lute. Perhaps the kamancha player in folio 30a is related to this poetic image.
15. In one of the two comparative illustrations, from a manuscript attributable to Shiraz circa 1550–60, four men look down on the scene of bestiality from behind a high horizon (TKS Y. 47). The other painting is a simpler composition and includes only a second camel in addition to the principal characters (IOL P&A 49). It may be of more immediate relevance to the Freer Jami, however, since the manuscript to which it belongs was transcribed by Shah-Mahmud al-Nishapuri, who copied the *Subhat al-abrar* in Ibrahim Mirza's codex.
16. As, for instance, the poet expounds again in his *Layli u Majnun* (Mudarris-Gilani, 775–78).
17. For example, S. C. Welch, "Pictures," 72; and Dickson & Welch, 1:12A, 115B (where the camel driver is characterized as "blatantly abusing his beast"), 159A.

Folio 38b

THE SIMPLE PEASANT ENTREATS THE SALESMAN
NOT TO SELL HIS WONDERFUL DONKEY

Text Source
Mudarris-Gilani, pages 137–38.

Rubric before Illustration (folio 38a)

> The story of a villager who took his lame, scabby old donkey to the donkey bazaar. The seller cried out, "Who will buy a sprightly young healthy donkey?" The villager heard him, believed him, and regretted selling his donkey.

Précis

A simpleminded villager takes his overworked donkey to be sold in the town bazaar. The animal is so old, weak, thin, and lame that it cannot travel a single league in two days. Its rump is red from the peasant's blows. In town the villager turns the pathetic creature over to professionals in the donkey trade. One makes a special effort to sell the animal, loudly extolling its youthful strength and energy. Everyone laughs at the salesman's pitch except the simple peasant, who naively believes that his wretched donkey is a noble ass and asks for its return. The seller calls the owner a fool: "From the rubbish that I spouted once or twice, solely to heat up the marketplace, on the qualities of this wretched piece of merchandise, how have you, through ignorance, fallen into error?"

This anecdote is one of several explicating the fourth pillar of gnostic devotion: keeping the all-night vigil. The basic theme is that man spends his time pursuing his carnal desire, which is the sleep of negligence. The passage immediately preceding the story of the peasant and his donkey is an "admonition to the heedless and the arousal of those asleep." The moral of these tales, including one about a young widow from a village who is raped by a city man, and another about a greedy khwaja who praises a parsimonious khan, is that one should always question the motive of flatterers.[1] The only worthy eulogy, says Jami, is praise of God.

Illustration

The donkey market of the *Silsilat al-dhahab* tale is depicted as an open space in front of the facade of a tiled building—evidently the bazaar—with two pairs of youths standing on the roof above and a large arched portal, adorned with what may be a heraldic device in the form of a shield, bow, and quiver in the center below (fig. 66). The cornice bears an inscription praising the Safavid monarch Shah Tahmasp. Another inscription, containing the name of Sultan Ibrahim Mirza, appears above the arched entranceway. The function of this exterior space as a marketplace and the building as a bazaar, perhaps under royal patronage, is suggested by the bakery set back at the right side of the facade.[2] A bearded shopkeeper sits on a raised platform in front of shelves laden with loaves of bread. He uses gold and silver weights to measure out flour from a black sack for a stout, matronly customer. Hanging onto the old woman's sash is a child who looks down in trepidation at a yapping dog. Several groups of men in pairs, some evaluating the merits of the villager's old donkey, occupy the central space. The two bearded figures standing together and conversing behind the beast must be the donkey seller, wearing a white turban and tucked-up salmon robe and gesturing toward the donkey, and the peasant, with a short blue tunic, coarse leggings, and sack slung diagonally across his chest and back. Two other donkeys appear in the scene: one is ridden out (perhaps just having been purchased) of the picture plane and into the right margin; the other emerges (perhaps to be put up for sale) from a rocky outcropping at right. Looking downtrodden if not crippled, a gray horse is prodded out of the bazaar entranceway. It is closely flanked by two men who may be discussing a transaction. Another horse, dappled and fit, canters across the marketplace, ridden by an elegant youth. A herdsman tending a flock of goats in the lower right completes the market scene.

66
*The Simple Peasant Entreats the Salesman
Not to Sell His Wonderful Donkey*
in the *Haft awrang* of Jami
963–72/1556–65, Iran
34.5×23.4 cm (folio)
FGA 46.12, folio 38b

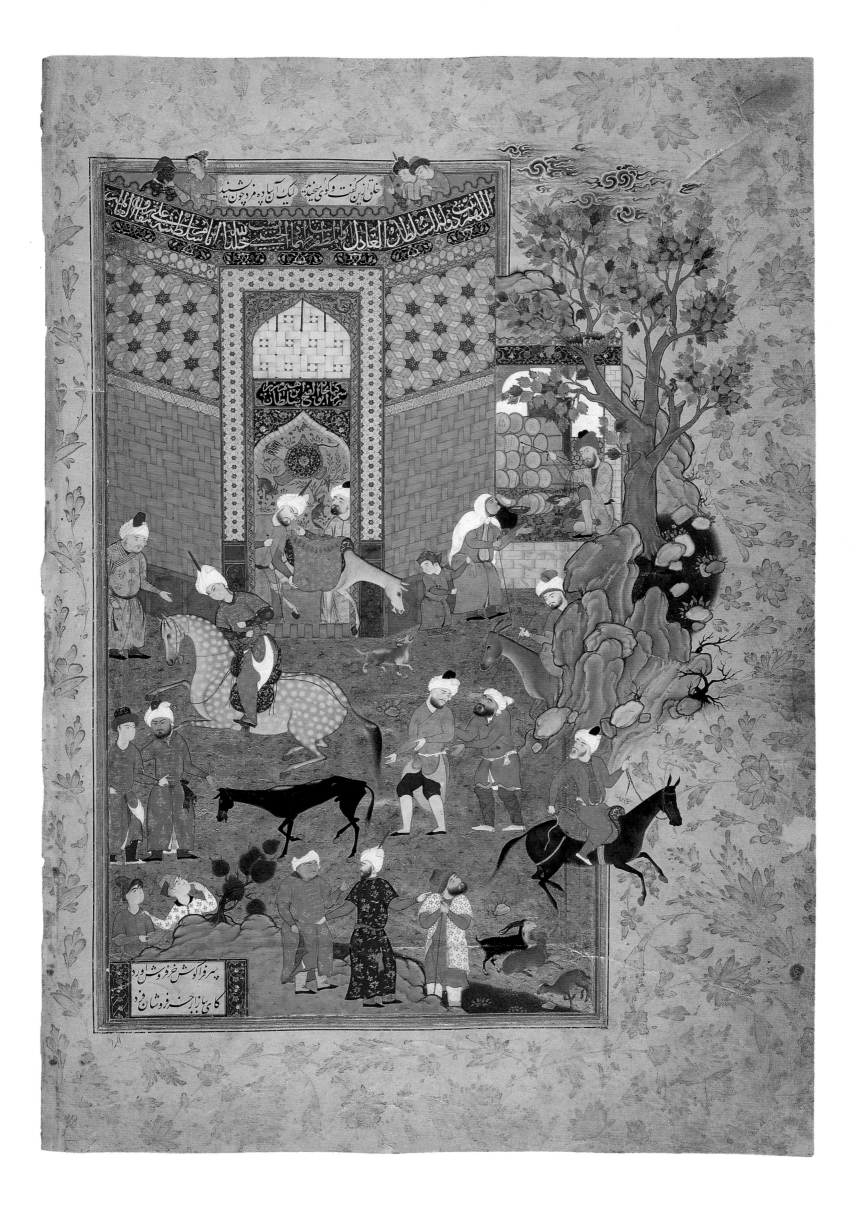

Capturing the bustle of a city market, the diverse focuses of this extremely active composition are achieved through the movement of animals and figures and direction of hands and glances. The pictorial contents not only portray Jami's narrative but also hint at his underlying point about God's greatness. Most striking is the difference between the emaciated donkey stumbling in the middle of the scene and the elegant dappled horse prancing through the marketplace. The opposition of town versus country, and by extension venality and naiveté, is also portrayed by juxtaposing the suave donkey seller and the simple peasant and the townsman wearing a beautiful blue robe decorated with gold flowers and the shepherd in a fur coat. Other contrasts include the old woman and young child, the white-faced and black-faced youths on the roof, and the two donkeys entering and departing the marketplace.

S. C. Welch connects the exuberance of this scene with the elation Sultan Ibrahim Mirza must have felt on his appointment as governor of Mashhad by Shah Tahmasp and on being given the use of the greatest artists and calligraphers of the Safavid court.[3] The painting does refer to the king and governor and proclaims the relationship between them in its two architectural inscriptions, the upper one praising Tahmasp, with the king's name prominently displayed in gold, and the lower one in smaller scale referring to Ibrahim Mirza's kitabkhana. While epigraphs of this type were not uncommon in the Safavid period and regularly appear in sixteenth-century paintings, their presence in a bazaar scene defies precise explanation, unless a general evocation of the dynasty's commercial strength was intended.

This scene appears to have been little illustrated. The only other known representation, from a manuscript dated 1006/1597–98 (SPL IIHC-86, folio 35b; fig. 67), places the emaciated donkey in the center of a simple landscape composition, flanked by the peasant and donkey seller.

67
The Simple Peasant Entreats the Salesman
Not to Sell His Wonderful Donkey
in the *Haft awrang* of Jami
1006/1597–98, Iran, attributed to Shiraz
13.7×10.2 cm (folio)
SPL IIHC-86, folio 35b
National Library of Russia, Saint Petersburg

CHAPTER TWO: POETRY AND PAINTING

Dimensions
26.3×14.5 cm

Incorporated Verses

One verse at top of illustration:

> The people laughed at his words,
> But when the simpleton heard,

One verse at bottom of illustration:

> He brought his head close to the auctioneer's ear saying,
> "Oh, unique among sellers of donkeys."

Architectural Inscriptions

On cornice of building, in Arabic:

العالمين اللهمَ ثَبتُ دولتَہ السُّلطانُ العادل ابوالمظفر شاه طهماسب الحسینی خلدالله ایام سلطنته علی مفارق

*Oh God, strengthen the rule of the just Sultan Abu'l-Muzaffar Shah Tahmasp al-Husayni
[in gold]. May God perpetuate his reign beyond the separation of the two worlds [death].*[4]

Over doorway, in Persian:

برسم کتابخانه ابوالفتح سلطان ابرهیم میرزا

By order of the kitabkhana of Abu'l-Fath Sultan Ibrahim Mirza

Attributions
Stchoukine: Group 1, artist close to Mir Sayyid-Ali; S. C. Welch: Mirza-Ali.

References
Dickson & Welch, 1:141A, 150B, fig. 200; Inal, 65–66; Qazi Ahmad [Suhayli-Khunsari], repro. facing p. 158; Simpson, "Jami," fig. 18; Stchoukine, *MS*, 127; S. C. Welch, *PP*, 98–101, with repro. and color detail.

1. Mudarris-Gilani, 133–34, 138–39.
2. A similar building, with an outdoor shop seemingly stuck onto its side, appears in the Tahmasp *Shahnama* (folio 521b [repro.: S. C. Welch, *KBK*, 173]).
3. In addition, S. C. Welch (*PP*, 98, 100) identifies the princely figure riding the dappled horse as Sultan Ibrahim Mirza at about age sixteen and characterizes the depiction as one of the liveliest and most accurate equestrian portraits in Safavid art.
4. First published, with some differences in reading, in Dickson & Welch, 1:249A–B n. 10.

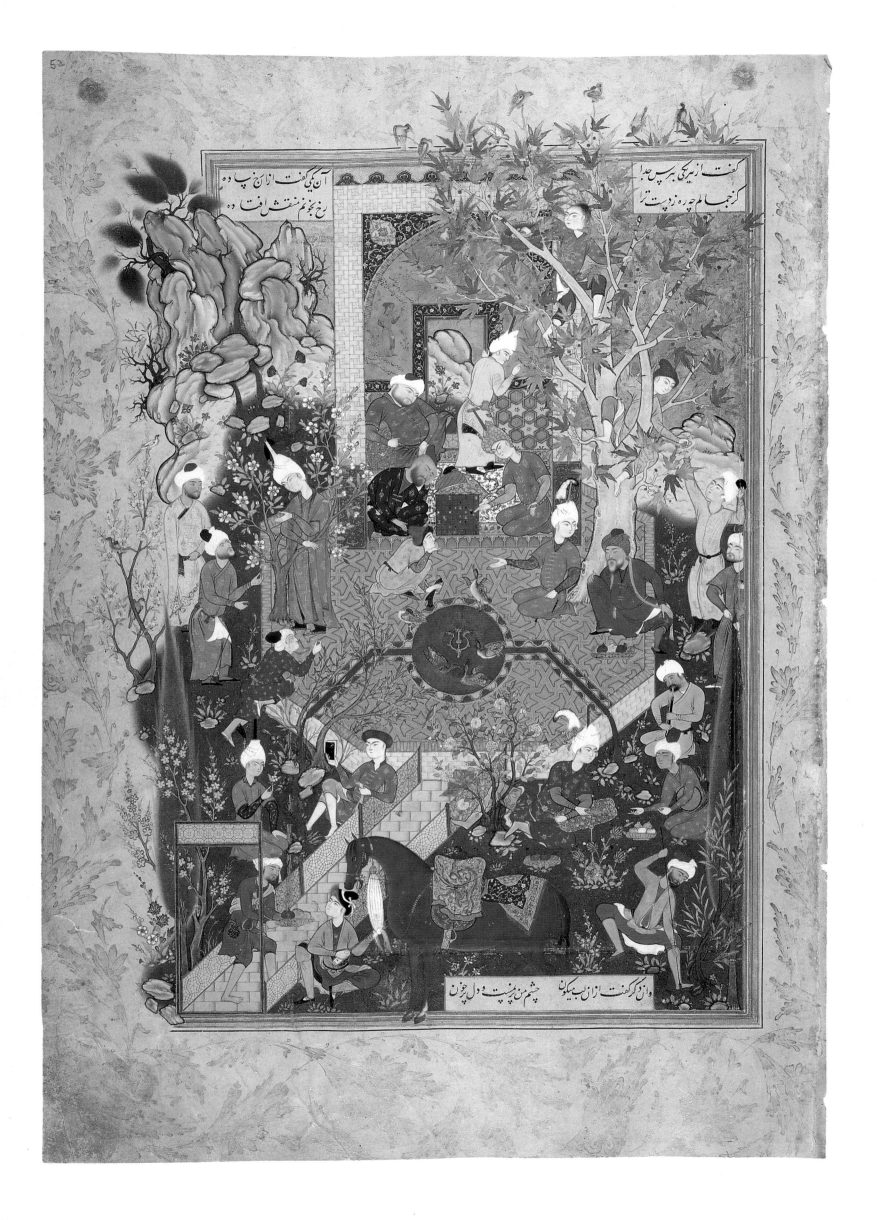

Folio 52a

A FATHER ADVISES HIS SON ABOUT LOVE

Text Source
Mudarris-Gilani, pages 200–201.

Rubric before Illustration (folio 51b)

The beautiful son's question to his perfect father and [the latter's] answer to that question.

Précis

A lovely youth asks his wise father how to choose from among those courting his favors. How can I judge, asks the boy, who is the true suitor when "each speaks of the pain of love and the burning in his heart in some different language." The wise father counsels his son to question the would-be lovers about the features each has found so attractive. He then proposes the various answers his son is likely to receive. One suitor is sure to praise the boy's "drunken narcissi-eyes," another his wine-red lips, yet another his stature and movement. After reciting the standard litany of poetic images for youthful male beauty, the father gives the reply of a hypothetical suitor: "I am free of lovelocks and heedless of [beautiful] faces. I do not know what thing I seek." This is the response the father hopes his son will recognize as an expression of true devotion. His advice, then, is to ignore protestations of affection for physical beauty and to look for an admirer who has passed beyond infatuation with external attributes to the deep love of inner qualities. Do not be proud, the pir is saying, of youthful beauty or surrender to temporary attachments. The true lover speaks last and has gone beyond form.

The same message underlies a preceding anecdote about a lovely princess and a man from Aleppo. This is actually an extended parable in the form of a frame story incorporating two briefer tales about the lover's search for beauty and union with God. All these anecdotes, including the father's advice to his son, concern the divisions of love and illustrate the category of *zati* (essential). The thesis here is that God is the qibla of love, the realm of veiled mystery, the indescribable essence known fully by no one. The frame story of the princess and the Aleppine ends with the notion that love involves the opposition of qualities and essence, an idea developed further in conversation between father and son. Their talk continues at some length on the subject of the gnostic lover's finding meaning through the defective beauty of the beloved's face. It concludes with the father explaining that, although divine beauty is eternal and divine love faultless, each man sees beauty according to his own capacity.

Illustration

The discussion about the essence of love takes place in a beautiful garden bower, a characteristic setting for lovers in Iranian literature and art (fig. 68).[1] The identification of father and son is not immediately apparent. The most likely candidates are the two figures sitting beneath a tree on the right side of the raised, octagonal terrace: the gray-bearded father in a brown robe with one knee drawn up and the son in an orange robe gesturing toward the center.

The uncertainty in identifying the principal characters is due primarily to the complexity of the outdoor scene and diversity of activities represented. The central focus of the circular composition is a round fountain in which several ducks cavort. Two channels flow from the fountain at either side.[2] A brick walkway with a framed entrance leads up to the terrace from the lower left. Curiously, this walkway ends at the wall of the terrace enclosure, and one would have to step over the wall to get onto the terrace. Various pairs and small groups of figures, all male and many presumably lovers with attendants or onlookers, are disposed around the terrace and surrounding lawn. At lower-center right an elegant youth in a red and gold robe leans against a patterned bolster. He holds out a small gold wine cup to be offered to or accepted from a kneeling youth with a tambourine tucked under his arm who also leans forward, less assertively, across a bowl of fruit. A bearded flutist provides background music from the other side of a stream spilling out of the right water channel. The awkward position of the youth with the wine cup is paralleled by that of the gardener digging at the base of a slender tree alongside a now-oxidized stream in the lower-right corner.

68
A Father Advises His Son about Love
in the *Haft awrang* of Jami
963–72/1556–65, Iran
34.5×23.4 cm (folio)
FGA 46.12, folio 52a

A large and richly caparisoned horse attended by a seated groom dominates the bottom edge of the painting. The groom plays a sitar and looks up at a servant, quite humbly attired, who has started up the terrace staircase bearing a gold bowl laden with fruit. On the other side of the terrace steps are two young men. One is bare-legged and reclines backward against the staircase railing while holding up a book. The other youth kneels directly in front of his companion and holds a flower.[3] At the left side of the terrace above, another elegant young man stands between the spreading branches of a flowering tree. He gestures toward two bearded figures standing on the grass below. The foremost of this pair inclines toward the youth as if in respect or supplication. The erect man to the rear has a book tucked into his yellow robe. Immediately beneath this group a young boy climbs up onto the terrace.

Flowers and plants dot the grassy landscape stretching up the left side of the composition and into a rocky hillside encompassing a waterfall, small trees, and flowering plants. Another prominent landscape feature is the large plane tree under which the father and son converse. As in the two previous illustrations, the tree harbors many birds. Far more unusual is the presence among the branches of two boys stealing birds from a nest and passing their booty to another boy down below.[4] To reach the stolen prize, the accomplice stands on tiptoe on a rock, causing his turban to slip. A bearded man with a staff observes this little vignette.

The figures on the terrace and lawn do not constitute a literal rendering of the Jami verses; at least no one approaches the person identified as the son to plead for his love. The various groups could be engaged in the kinds of exchanges between beloved and lover that the wise father cautions his son to avoid, or alternatively they may represent the various stages of love.[5] The catalogue of beautiful physical traits described by the pir is not, however, depicted.

If the literal content of this *Silsilat al-dhahab* anecdote seems elusive in the illustration, its message and moral are forcefully conveyed by the activities taking place in the iwan at the back of the garden terrace. There two figures are intently engaged in a game of chess, a traditional metaphor in Iranian literature both for life and for the relations between lover and beloved.[6] The elegant young man to the right of the board may be scoring a point. His obviously older, bearded partner rests his bare head in his hand, either in reflection or despair. A corpulent bearded man straddling his left leg over the doorframe at the upper left and a skinny boy in an awkward, hunched posture at the lower left observe the players. The prominent position of the chess game, taking place just above the central focus of the composition, and the difference in age and demeanor between the two players and between the two onlookers are clear visual allusions: first, to the subject of the interchange between father and son and then to the distinction between physical qualities and spiritual essence, the theme of the *Silsilat al-dhahab*.

An even more pointed and poignant commentary on the meaning of the poetic verses appears on the back wall of the iwan, decorated with a figural painting, where a young man pens a poem begun to the left of the doorway (fig. 69):

نوشتم بر دیوار هر منزل غم عشقت

که شاید بگذری روز و خانی [sic] شرح حال من

با دل خود صورت او در مقابل داشتم

در مقابل صورت دیدم که در دل داشتم

نکند غمت ...

I have written on the door and wall of every house about the grief of my love for you.
That perhaps you might pass by one day and read the explanation of my condition.

In my heart I had his face before me
With this face before me I saw that which I had in my heart.

May your grief . . .

69
A Father Advises His Son about Love (detail)
in the *Haft awrang* of Jami
963–72/1556–65, Iran
26.3×16.8 cm (painting)
FGA 46.12, folio 52a

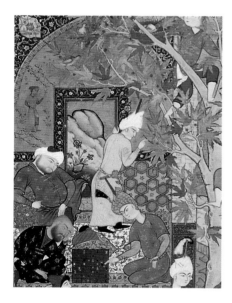

These lines, with their evocation of the heart-as-mirror theme, form a perfect gloss on Jami's text, in which the son's suitors speak of the pain of their love and the passion in their hearts. The inscribed verses may have been inspired by Jami's distich in which the son bemoans:

> I do not know what face to put on in response.
> Whom shall I join with, from whom shall I flee?

They also enframe a standing painted figure who represents the beloved whom the poet at the back wall addresses and who now reads about the poet's lovelorn condition.[7] Thus poetry and painting are doubled on a functional level—a picture within a picture and a poem within a poem—and joined on a metaphorical level to reinforce the idea that the true lover looks through the beloved's physical beauty to find the essence of love in his heart.

The only other known painting of this subject belongs to a manuscript that, although undated, appears virtually contemporary with the Freer Jami. This second illustration (MOA MS 1961/II, folio 52a) represents six male couples and several observers in a mountainous landscape. As with the Freer Jami, it is difficult to determine which pair represents the father and son. Here, however, at least the distinction between the lover and beloved seems clearer since each couple consists of a bearded man (traditionally the lover) and a beardless youth (the beloved). At the same time, there are some curious features, such as a youth who tears open his robe in a gesture of supplication generally associated with the lover and a bearded man who raises a rock as if to strike the youth standing in front, suggesting that this illustration may have its own interpretation of Jami's text. It does not, however, approach the sophisticated reading involving multiple relationships of text and images manifested in the Freer Jami painting.

Dimensions
26.3×16.8 cm

Incorporated Verses

Two verses at top of illustration:

> The father said, "Ask each separately,
> 'In what way has my beauty struck you?'"
>
> That one said, "By that unadorned face [of yours]
> Has my face become embroidered with blood."[8]

One verse at bottom of illustration:

> And another said, "From your wine red lips
> My eyes have grown moist, my heart filled with blood."

Attributions
Stchoukine: Group 1, artist close to Mir Sayyid-Ali; S. C. Welch: Mirza-Ali.

References
Dickson & Welch, 1:150A, fig. 201; Kevorkian & Sicré, 170–71, with repro. color; Stchoukine, MS, 127; S. C. Welch, PP, 102–5, with repro. color and detail; Wilber, fig. 19.

Notes
1. S. C. Welch (*PP*, 103) sees this scene more specifically as representing the private world of Sultan Ibrahim Mirza.
2. S. C. Welch (*PP*, 104) has commented also on the "bold, even excessive, design elements" in this picture, particularly the polygons, rectangles, and curves.
3. A similar pair of figures appears in an illustration detached from an unknown Jami manuscript attributed to Mashhad or Qazvin circa 1575 (MIA 43.31.2 [repro.: Grube, *MMP*, cat. no. 95]). The reading youth here is virtually a twin of the Freer Jami figure.
4. The thief in the highest limbs wears his hair in a fashion similar to that of the naked child in FGA 46.12, folio 30a.
5. A possible clue to the differentiation of lover and beloved among the many pairs of figures in this illustration may be found in the clothing styles and more particularly in the turbans. Each pair includes one figure who wears a white turban wrapped around a tall, thin *taj-i Haydari* (Haydar cap) and another who wears a cap or a turban wrapped around a conical cap. The bareheaded chess player may be the quintessential lover, who has shed worldly adornments.
6. Schimmel, *MD*, 285; Murray, 182–85; *EIs*, B. Carra de Vaux, "Shatrandj." For another, early Safavid representation of a chess game incorporated into the frontispiece of a masnavi of Rumi, see AMSG S1986.35, folio 2a (repro. color: Lowry, 158).
7. This entire vignette also evokes the well-known equivalence of poet and lover in Iranian literature and particularly in Sufi poetry. In general, see Schimmel, *MD*, chapter 7. Jami also developed the theme in the *Haft awrang*; see Mudarris-Gilani, 386–87 (*Tuhfat al-ahrar*). The youth painted on the back wall resembles single-figure studies commonly found in Safavid painting (S. C. Welch, *WA*, cat. no. 71).
8. The past tense of the Persian, translated literally here, is not precisely accurate. The father is proposing hypothetical answers his son is likely to hear from various lovers: "Let's say one says this . . . then another may say that . . . then you are bound to hear this," etc.

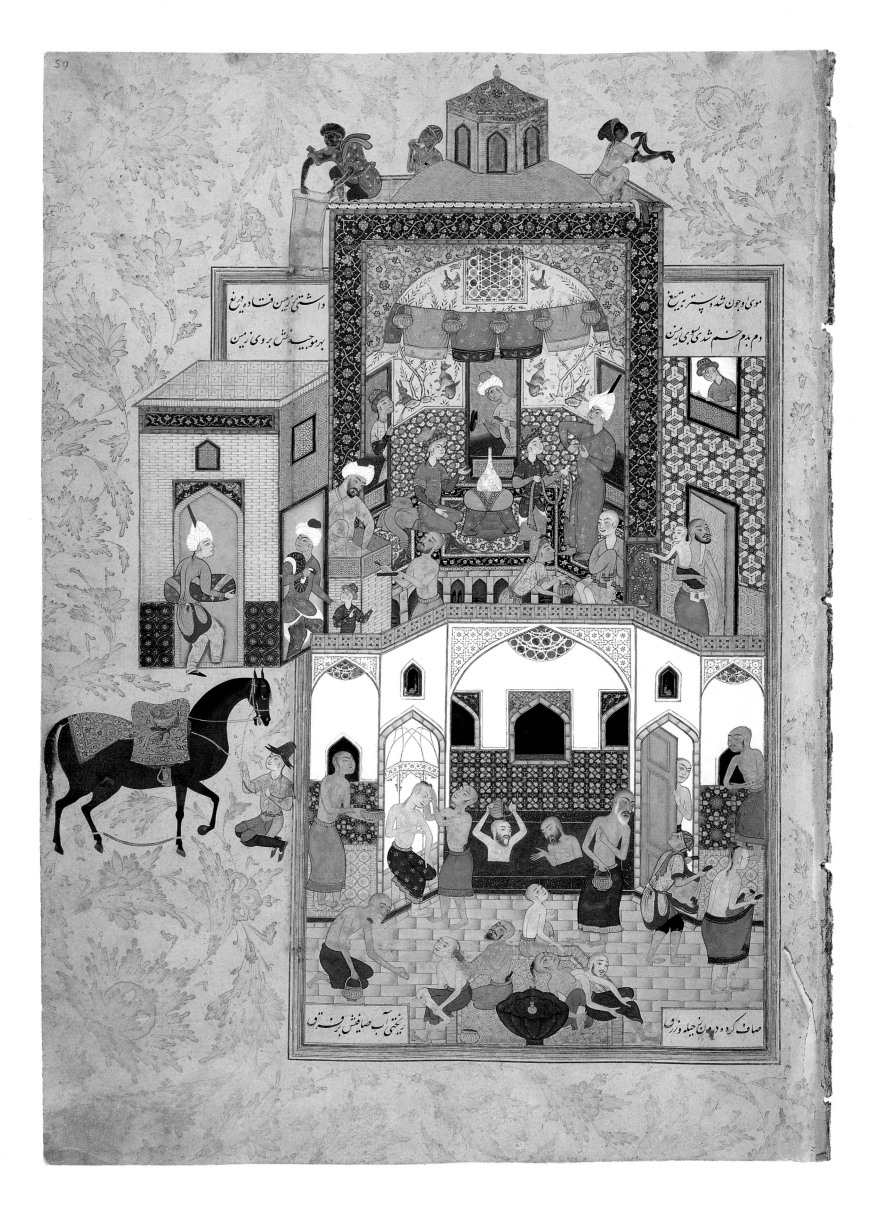

Folio 59a

THE DERVISH PICKS UP HIS BELOVED'S HAIR
FROM THE HAMMAM FLOOR

Text Source
Mudarris-Gilani, pages 223–24.

Rubric before Illustration (folio 58b)

> *The story of the witnessing by Shaykh Abu Ali Rudabari, may God sanctify his grave, of the death of that*
> *agitated dervish from love of that youth [who was] proud of his beauty and good looks.*

Précis
One day Shaykh Abu Ali Rudabari goes to the hammam and sees in the changing room the shabby
rags of a Sufi. Further inside the bath he comes upon the old dervish to whom the shabby clothes
belong and watches as the poor man tries unsuccessfully to court a beautiful, self-centered youth.
The young man is having his head shaved, and the dervish collects every strand of hair as it falls to
the ground. Next the dervish brings perfumed towels to dry the young man's body and then trails
his beloved out of the hammam. Shaykh Rudabari follows the pair outside and witnesses the
dervish take off his own clothes and throw them down in front of the youth in a display of devo-
tion. The sad wretch begins to sprinkle rose water, light aloe wood, fan the air around the beauti-
ful youth, and hold up a mirror to his face, all to no avail. In anguish the dervish cries out, "Alas,
I am burned by your coquettishness. What shall I do so that you will notice me?" To this the youth
replies: "My attention . . . is not toward the living. Die before me, so that I may notice you." Then
the dervish dies on the spot, and the youth goes on his way without so much as a glance at the fallen
lover.

Sometime later, Shaykh Rudabari is on the pilgrimage to Mecca and comes upon the same
youth, now clad in a coarse cloak. The young man explains that the night after the dervish died, he
dreamed that the deceased rebuked him for ignoring him even in death. The youth was so shaken
by this apparition that he cast off his fine clothes and donned those of poverty. To expiate his sin he
now goes on the hajj every year and rubs his face on the grave of the dead dervish.

This tale of sin and repentance forms part of many similar anecdotes explicating the develop-
ment of love.[1] Through his acts of atonement for the dervish's death the youth seeks to achieve
perfect love: love of God.

Illustration
The painting relates to the beginning of the story when the shaykh watches the dervish try to win
the affections of the beautiful youth in the hammam (fig. 70). As an illustration it seems to have
much less to do with the subject of the accompanying text (the actions and reactions of lover and
beloved) than with the mise-en-scène (the hammam where Jami sets the first part of his moralizing
tale).

The bathhouse is an elaborate, multichambered structure, depicted in sectional elevation with
one room stacked above the other. Its upper or rear room has a side entrance projecting into the left-
hand margin and a central iwan and lanterned dome rising above (fig. 71). On top of the roof are
three dark-skinned figures: the one at left shakes out a pale salmon towel, the one at right appears to
wring out a wet cloth, and the third standing just behind the dome raises his hands to his chin and
looks up. Below, a turbaned youth enters the hammam through the outer doorway, apparently
having just dismounted from the richly caparisoned horse now hobbled with a rope and attended
by a young groom in the left margin. The bath patron holds two wrapped bundles under his arms,
perhaps containing a suit of elegant clothes to wear after the bath.

Another young man and a little boy, both looking back toward the latest arrival at the portal,
emerge from a secondary door at the end of the entrance passageway into an octagonal changing
room. Immediately inside this door a bearded man sits in an elevated podium. He may be a door-
keeper or bath supervisor to whom a client or attendant, attired only in pants, offers a spoon and a

70
The Dervish Picks Up His Beloved's Hair
from the Hammam Floor
in the *Haft awrang* of Jami
963–72/1556–65, Iran
34.5×23.4 cm (folio)
FGA 46.12, folio 59a

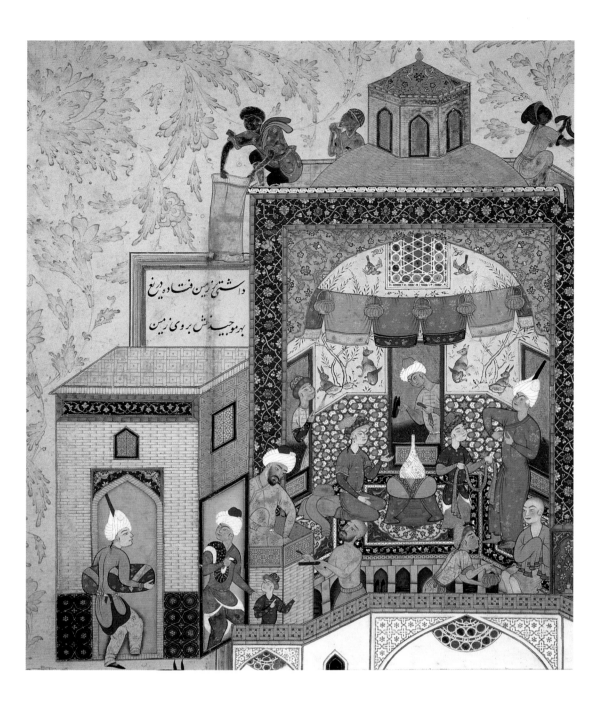

71
*The Dervish Picks Up His Beloved's Hair
from the Hammam Floor* (detail)
in the *Haft awrang* of Jami
963–72/1556–65, Iran
30.1×19 cm (painting)
FGA 46.12, folio 59a

flat plate, possibly containing food. Colorful towels and metal buckets hanging between the iwan spandrels decorate the changing room.[2] Covered with three bright-yellow medallion carpets, the floor appears to rise above a row of small, pointed storage niches for shoes. A large pile of clothes, wrapped in bundles similar to those being carried by the elegant young man at the hammam's outer doorway and topped with a large white turban, marks the center of the room. The clothes may belong to the beautiful youth, the subject of Jami's story. The smaller pile of clothes to the left includes a long-sleeved robe and plain cap similar to those worn by Sufis and may have been removed by the love-stricken dervish. Occupants of the changing room include a youth kneeling next to the central bundles; a young man untying his orange outer robe, helped by a boy holding a gold sash; a youth at the middle window holding a pair of shoes and a blue handkerchief; and a youth peering into the changing room from the window at left. At the right side of the room a bather sits wrapped in green and beige towels, his legs dangling over the lower storage niches. A bath attendant approaches, his sleeves rolled up, and offers him a bucket. A bearded man carrying a small boy, both wrapped below the waist in long bath towels, leaves the locker room through a door to the right, presumably heading for the bathing areas depicted below. A youth at an upper-story window follows their progress.

The bath chamber dominates the lower half of the painting and includes about a dozen bathers, clad only in large towels. In the center is a large iwan containing a colored-glass dome above and a rectangular tank below, where two bearded, middle-aged men soak immersed up to their chests. The one at left pours water on his head from a bronze bucket. To the left of the central iwan is a niched wall with a painted vault and a seating platform where a bather is having his head

shaved. Another attendant offers a bronze bowl from a recessed tiled niche with a colored-glass dome. On the other side of the tank a youth pushes open a door leading from the passage connecting the disrobing and bathing chambers. In these side walls are a pair of small arched blind windows, each containing an oil lamp. In the arched space to the right, also with a colored-glass dome, stands a mustached man who seems to have burn marks on his left arm.[3] A naked young man turns discreetly toward the right and wraps a towel around his waist, apparently having just completed his bath. Another towel is held open by an attendant standing to the left. The servant, the only fully dressed figure in the room, turns his head back to look at a tall, gray-bearded man. This impressive gentleman, who holds a bucket in his left hand and points upward with his right, may be Shaykh Rudabari.

Directly in front of the rectangular tank is an octagonal pool with a silver scalloped fountain. Off to the right is a pair of intertwined figures. The one with a mustache appears to be rubbing or drying the other's legs. A young boy sits alongside them at the edge of the pool and stares up at the graybeard towering above. To the left a bath attendant with a dark beard, mustache, and perhaps a razor stuck in his waistband scrubs the head of a young client with a green *kissa* (bath mitten). The attention of both figures seems focused on an elderly white-bearded man stooping down at left to pick up something quite small from the green-tiled floor. This aging figure may be the dervish of Jami's anecdote, collecting the hairs of his beloved, who may be the young man being shaved.

This painting contains little, if anything, to connect it with the *Silsilat al-dhahab*'s theme of love, death, and repentance. As a text illustration it is an enigma. As a composition it is an immensely detailed re-creation of hammam activities, through what amounts to a continuous pictorial narrative.

A contemporary representation of the same scene—sharing the iconographic complexity and illustrative ambiguity of the Freer Jami painting—appears in an undated manuscript copied by Muhammad Qivam katib Shirazi, a scribe active in Shiraz circa 1575 (BOD Elliot 149, folio 64b; fig. 72). Here the activities of the bathhouse take place in a side-by-side architectural setting rather than the upstairs-downstairs arrangement of the Freer Jami.

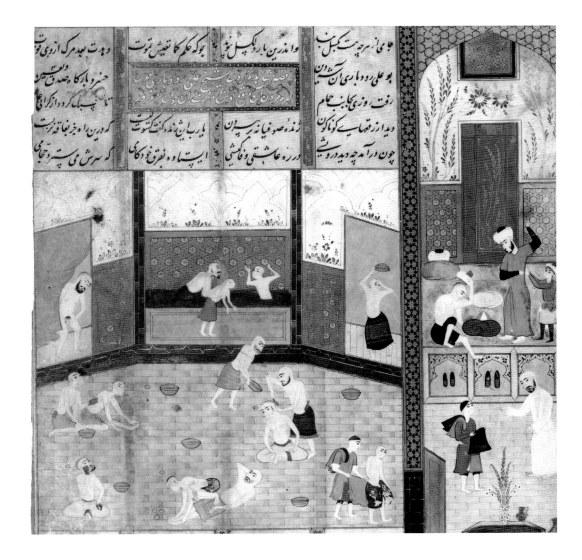

72
The Dervish Picks Up His Beloved's Hair
from the Hammam Floor
in the *Haft awrang* of Jami
ca. 1575, Iran, attributed to Shiraz
8.8×7.4 cm (painting); 14.4×9.5 cm (folio)
BOD Elliot 149, folio 64b
The Bodleian Library, University of Oxford

Although limited in regards to a specific poetic referent, these paintings are recognizable in terms of the bath-scenes genre. A familiar precursor in this iconographic tradition is the illustration by Bihzad in a *Khamsa* of Nizami, dated 900/1494–95, depicting a disrobing room hung with towels and a bath chamber where a barber is shaving a client's head.[4] Scenes of bathing continued to be popular subjects for illustration in the sixteenth century, with the compositions generally constructed in two lateral sections.[5] The Freer Jami may be one of the few such scenes with a vertical structure. Although adjacent chambers in other bath scenes are usually connected by doors, the sense of continuous architectural space, conveyed so effectively by the movement of bathers and attendants through multiple doorways, is unique to the Freer Jami.

Dimensions
30.1×19 cm (including architectural extensions)

Incorporated Verses

Two verses at top of illustration:

> *When his hair was shaved off by the blade,*
> *He thought it a shame for it to fall to the ground.*

> *Each moment he would bend down to the ground*
> *To pick up his hair from the floor.*

One verse at bottom of illustration:

> *Having cleared his interior of guile and deceit,*
> *He poured pure water on his forehead.*[6]

Attributions
Soudavar: Abdullah; Stchoukine: Group 1; S. C. Welch: Painter A (Qadimi).

References
Dickson & Welch, 1:206B, fig. 263; Qazi Ahmad [Suhayli-Khunsari], repro. within the text (n.p.); Soudavar, 258 n. 64; Stchoukine, *MS*, 127; S. C. Welch, *PP*, 106–7, with repro. color.

1. Beginning on Mudarris-Gilani, 215.

2. The origin of these particular bulbous-shaped buckets can be traced to the twelfth century. Similar buckets are still in use in modern-day Syria, where they are known as *burniya* or *barniya*. See Ettinghausen, "Bobrinksi," 195.

3. These may be self-inflicted burn marks, an ordeal prescribed by some Sufi orders (Gramlich, 108). Apparently inspired by this Sufi practice, lovers in the later sixteenth and seventeenth century burned various parts of their bodies to show the extent of their devotion to their beloveds (*Don Juan*, 54–55). For a further discussion, see Welch & Welch, cat. no. 36. The burn marks on the arms of the mustached bather in folio 59a may be intended to emphasize the presence of the dervish in the hammam.

4. BL Or. 6810, folio 27b (repro.: Gray, *PP* 2, 117).

5. For other representations of bathhouses in two parts, see an illustration from an unknown manuscript, apparently misidentified as a *Haft awrang* of Jami and attributed to the Timurid period (Kabul Library, manuscript number unknown [color detail: Nasr, pl. 97]); a detached illustration from unknown copy of the *Shahnama* of Firdawsi of the mid-sixteenth century (LACMA M.73.5.591 [Pal, cat. no. 207 and repro.: 122]); *Shahnama* of Firdawsi, dated 992/1585 (SPL Dorn 334, folio 11a [repro.: Ashrafi, 76, fig. 61]). The latter two compositions are quite similar and include many details comparable to FGA 46.12, folio 59a. For several much simpler and virtually identical bathhouse compositions depicting only the bath hall itself, see *Khamsa* of Nizami, dated 952/1545 (SPL PNS 105, folio 32b [repro.: Ashrafi, 71, fig. 56]); *Khamsa* of Nizami, dated 19 Dhu'l-hijja 915/21 April 1509 and 934/1527–28 (AMSG S1986.037, folio 32b [repro.: Lowry et al., 219]); *Khamsa* of Nizami, dated 936/1529–30 (CB MS 196, folio 32b); *Makhzan al-asrar* of Nizami, dated Safar 947/June 1540 (STJ MS 1434 [repro.: Hillenbrand, 73, cat. no. 166]); *Khamsa* of Nizami, dated 5 Shawwal 955/7 November 1548 (FGA 08.261 [repro.: Guest, pl. 3]).

6. This verse presumably refers to the dervish who seeks to be a pure lover.

Folio 64b

BANDITS ATTACK THE CARAVAN OF AYNIE AND RIA

Text Source
Mudarris-Gilani, pages 239–40.

Rubric before Illustration (folio 64a)

> The story of [how] her father sent Ria, with Aynie, to Medina after forty days; the attack of the bandits on the road and [the couple's] death at their hands.

Précis
This is the penultimate episode of a long and tragic love story that begins when Muʿtamar, a noble Arab, hears someone lamenting at the tomb of the Prophet.[1] The mourner is a youth named Aynie who had been attracted to a beautiful woman while praying in a mosque. Although Aynie does not know the woman's name, he has been in despair ever since seeing her. Together Muʿtamar and Aynie go off to the mosque and there learn that the beautiful young woman is Ria. Muʿtamar then agrees to help his young friend win the woman's hand and takes him to Ria's camp, where he proposes to her father on Aynie's behalf. The proposal is accepted and agreement reached on the terms of the dowry. Aynie and Ria then take an oath of betrothal.

After forty days of marriage, the young couple sets out for Medina in a caravan organized by the bride's father. The newlyweds are also accompanied by their friend, Muʿtamar. While only a *farsang* (10 kilometers) from the holy city, they are set upon by armed bandits. Aynie bravely attacks the marauders, routing the pack. One bandit remains, however, and strikes a mortal blow to Aynie's chest. When Ria sees her husband's lifeless body drenched in blood, she places her face on his and laments at great length, until she, too, dies. The couple's friends shroud them in silk and bury them in a single grave, to be forever united. The story concludes years later when Muʿtamar goes to Aynie and Ria's grave and discovers a tree streaked in yellow and red representing the paleness of the couple's faces and their tears of blood.

The story of Aynie and Ria belongs to a series illustrating the stages of love, which also includes the anecdote about the dervish wooing the beautiful youth in the hammam (FGA 46.12, folio 59a). Aynie and Ria die for love of each other: the husband dies protecting his bride, who in turn expires because she cannot live without her husband. These pure souls—their love cut off in full flower—are then joined in eternal union and spiritual resurrection.[2]

Illustration
The illustration depicts the moment when Aynie, mounted on a camel and holding a long spear, seems to have succeeded in routing the attackers, while Ria, also on camelback, looks on from the far right (fig. 73). Most of the bandits, to center left, wear green bands wrapped around their turbans. Some have been slain (two by decapitation), and others flee on horseback or on foot. One turns back to take aim at the hero with bow and arrow. Another, brandishing a sword and wearing an orange robe, charges from a higher position; his may be the fatal blow. Two donkeys with packs, a camel, and three attendants at lower right represent Aynie and Ria's caravan. Another groom, armed with a staff, holds the halter of Ria's braying camel. The couple's honor guard includes a horseman lifting a sword and a man kneeling and aiming a gun at two young bandits just above Aynie.[3]

73
Bandits Attack the Caravan of Aynie and Ria
in the *Haft awrang* of Jami
963–72/1556–65, Iran
34.5×23.4 cm (folio)
FGA 46.12, folio 64b

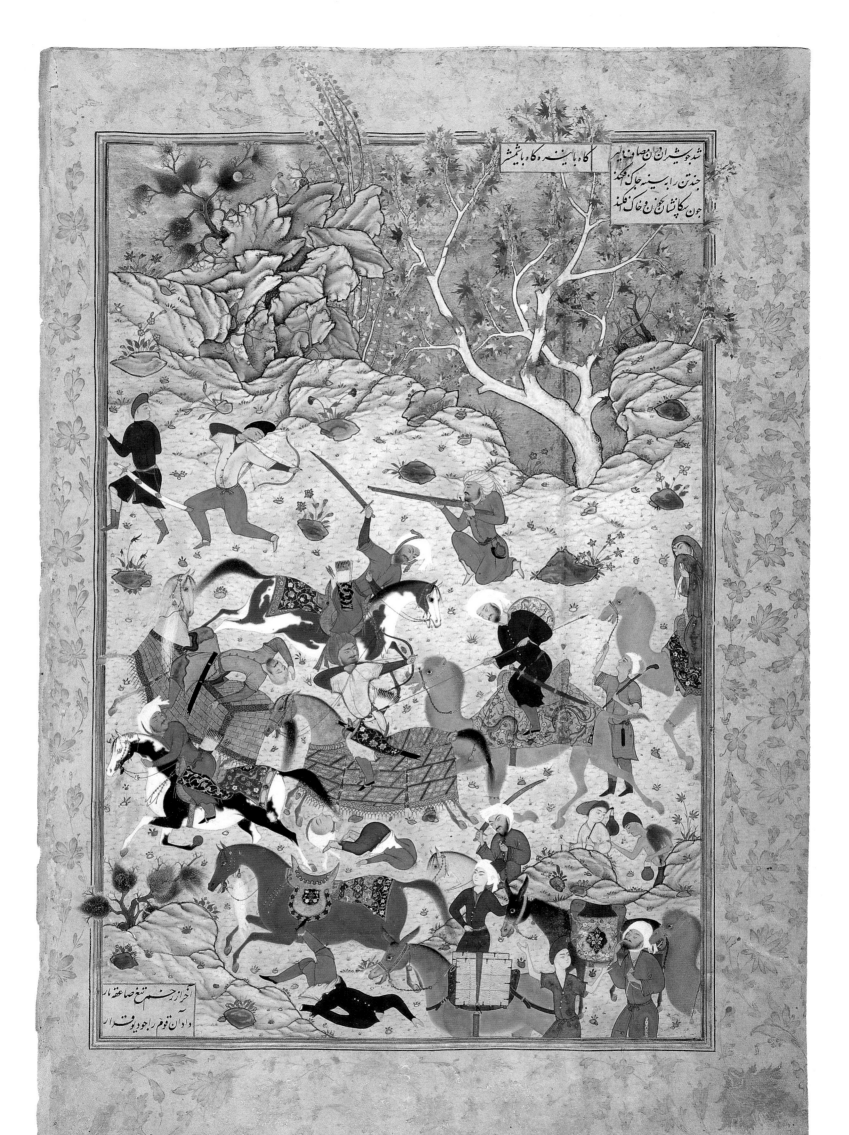

This is a standardized battle scene with a few specific elements, such as Ria and Aynie on camel-back, complementing the visual iconography with the poetic, and others, such as the two foxes in the rocky outcropping, possibly intended as silent commentary. The two other known illustrations of this episode also render the action as a generic battle. The first version, from a manuscript attributed to Shiraz, circa 1560, modifies the scene with a few particularized features, such as Ria in a camelback palanquin at the right and, in the foreground, a young man, who may be Aynie, fighting off the attacking robbers (IOL MS 366, folio 75b). The other scene, in a manuscript copied in Khurasan in Dhu'l-qa'da 971/June 1564, contains nothing, not even a sign of Ria, to tie it visually to this Jami narrative (PWM MS 55.102, folio 70a; fig. 74).

By contrast, the Freer Jami illustration includes several significant details. The simurgh and dragon confronting each other on Aynie's saddle blanket may be intended to parallel the duel between good and evil taking place in the composition.[4] Far more anomalous and intriguing is the pair of figures entering the battlefield behind the mounted swordsman (fig. 75). The more distinctive of the two is a stooped blind man wearing a fur piece and carrying a bronze begging bowl in

74
Bandits Attack the Caravan of Aynie and Ria
in the *Haft awrang* of Jami
971/1564, Iran, Raza (Bakharz district,
Khurasan)
18×13.5 cm (painting); 29.2×18.2 cm (folio)
P.WM MS 55.102, folio 70a
Courtesy, Trustees, Prince of Wales Museum
of Western India

75
Bandits Attack the Caravan of Aynie and Ria
(detail)
in the *Haft awrang* of Jami
963–72/1556–65, Iran
27.9×18.2 cm (painting)
FGA 46.12, folio 64b

CHAPTER TWO: POETRY AND PAINTING

one hand while resting his other hand on the arm of a young man leading the way in front. The youth, equipped with a walking stick, staff, and flask, turns back to look at his blind companion. Although this duo may represent an artistic topos, they could have some greater meaning within the context of the *Silsilat al-dhahab*. The blind beggar may refer specifically to Ria's lament that the sun went into decline upon Aynie's death, or he may allude more generally to Jami's discussion of how, after the lover has come to know darkness, he turns his face from himself and toward the beloved. After love reaches perfection, it turns the lover's face away from the beloved toward itself (the divine).[5]

Dimensions
27.9×18.2 cm

Incorporated Verses

Two verses at top of illustration:

> He attacked their ranks as bravely as a lion
> Sometimes with a spear, sometimes with a sword.

> He overthrew several, splitting their breasts.
> He threw them down in the dirt like dogs.

One verse at bottom of illustration:

> At last, by the wounds of his blade loaded with lightning bolts,
> He sent that pack in flight swift as a demon's.

Attributions
Stchoukine: Shaykh-Muhammad (*MS*, 47, 126), and Group 1, possibly Shaykh-Muhammad (*MS*, 128); S. C. Welch: Shaykh-Muhammad.

References
Dickson & Welch, 1:168B, 175A, fig. 227; Stchoukine, *MS*, 47, 126–28; S. C. Welch, *PP*, 108–9, with repro. color.

1. Mudarris-Gilani, 230–41.
2. For a discussion of the Sufi concept of death and resurrection, see Schimmel, *MD*, 25, 134–35, 322–23.
3. Firearms seem to have been introduced into Iran from Europe by the latter part of the fifteenth century. According to the *Ta'rikh-i Amini* (History of Amini), in 1471 the signory of Venice agreed to supply Uzun Hasan with six bombards, six hundred culverins, and matchlocks in preparation for his battle against the Ottomans (Khunji [Minorksy], 115–16; Woods, 127–28). A seventeenth-century English traveler reported that firearms came to Iran via the Portuguese during the reign of Shah Tahmasp (Herbert, 235; Bier, cat. no. 30), although a claim for the Safavids' using handguns as early as 1507, during the reign of Shah Isma'il, has been based on other European sources (Savory, 78). Beginning in the 1520s, contemporary Persian histories refer to the use of guns, including infantry units equipped with handguns forming part of the Safavid garrison in Herat in 1528 and detachments of musketeers in the Safavid army when Tahmasp led it against the Uzbeks in 1528 (Iskandar Beg Munshi [Afshar], 1:53; Iskandar

Beg Munshi [Savory], 1:88). It now seems possible to replace the long-standing belief that the Sherley brothers (Thomas, Anthony, and Robert) introduced firearms into Iran in the late sixteenth–early seventeenth century with a chronology that begins much earlier with the Venetians and continues with the Portuguese (Savory, 81; see also Matthee). Curiously the Tahmasp *Shahnama* contains no depictions of firearms. The firearms in the Freer Jami (folios 64b and 153b) are among the earliest representations in Persian painting.
4. For these two creatures, see Gierlichs, 10–20. The general significance of their combat in Persian art does not seem to have been extensively discussed.
5. Another explanation may relate to the rubric for this part of the *Haft awrang* text. The word *pishrah*, rendered in the rubric translation here as "on the road," literally means "coming before [them]." The youth guiding the blind beggar thus comes before the beggar just as the bandits came before Aynie and Ria. Another illustration (BOD Elliot 337, folio 83a) contains the same rubric as folio 64b, but its iconography, consisting of a view of the Ka'ba, relates to the destination that Aynie and Ria were doomed never to reach.

Yusuf u Zulaykha

Universally regarded as the masterpiece of the *Haft awrang*, *Yusuf u Zulaykha* is also the most popular of the many Persian adaptations of this classic story, whose protagonists are better known outside the Near East as Joseph and Potiphar's wife.[1] It is also the most frequently illustrated of Jami's seven masnavis.[2] The Islamic tradition to which *Yusuf u Zulaykha* belongs starts with the Koran in which an entire sura is devoted to the Judeo-Christian prophet and the trials he endured, first at the hands of his brothers and then because of the propositions of his master's wife.[3] Later commentators greatly amplified the Koranic account, giving Yusuf's temptress a name and idealizing the prophet as a symbol of monotheism.[4] Subsequent literature transformed Yusuf into a "triple paragon of purity, of prophetic inspiration and, above all, of physical beauty."[5] Jami further embellished this characterization in his epic-length poem, making Yusuf a revelation of divine beauty and the relations between Yusuf and Zulaykha an allegory of the mystic's search for truth and union with God.[6]

Jami introduces the theme of his story in the prologue, with an evocative discourse on absolute beauty and the power of love and a description of Yusuf as the most beautiful beloved and Zulaykha as the most devoted and ardent lover.[7] From there his romantic allegory progresses through a dense plot and series of subplots narrating Yusuf's childhood; Zulaykha's beauty, her dreams of Yusuf, betrothal to the aziz of Misr (Egypt), and arrival in Egypt (FGA 46.12, folio 100b); the perfidy of Yusuf's brothers (FGA 46.12, folio 105a) and how they sold him into slavery; Yusuf's arrival in Egypt, his sale at market, and his purchase by the aziz, who is persuaded by Zulaykha to keep Yusuf as his son; the story of Bazigha, a beautiful and rich Egyptian maiden, and her love for Yusuf; Zulaykha's devotion to Yusuf (FGA 46.12, folio 110b), her declaration of love, and repeated attempts at seduction (FGA 46.12, folio 114b); the denunciation of Yusuf, his reprieve (FGA 46.12, folio 120a), and eventual imprisonment; Yusuf's release from prison, interpretation of the pharaoh's dreams, and elevation to the position of aziz; Zulaykha's old age and piteous condition, her eventual renunciation of idolatry and glorification of God; the restoration of Zulaykha's youth, beauty, and sight; the union of Yusuf and Zulaykha (FGA 46.12, folio 132a); and Yusuf's death, followed by that of Zulaykha, who cannot bear to live without her beloved.[8]

Jami uses every twist and turn in this complicated narrative as metaphors for the stages in the mystic's arduous quest. When Zulaykha dreams of a radiant male youth of superhuman beauty and grace, she is captivated by the outward form, oblivious to the underlying truth. She remains in this state for years, despite Yusuf's constant refusal to yield to her advances and his efforts to expose her sinful ways. Only after she becomes a blind widow living in poverty does she reject the idols she had previously revered, thereby gaining God's grace and Yusuf's love.[9] By contrast, Bazigha, a minor character in the story, understands when Yusuf explains that his beauty is but the reflection of the power of the creator and that she should not worship ephemeral appearances. Bazigha immediately abandons her passion for Yusuf, gives her considerable wealth to the poor, and spends her life in pious seclusion and contemplation of God.[10] Yusuf also progresses on the path to the divine. In the end he loves Zulaykha with passionate ardor and is transformed from beloved to lover. Thus both heroes achieve the goal of perfect love as self-annihilation in the beloved.

Jami composed *Yusuf u Zulaykha* in a single year, 889/1484–85, which he gives as a chronogram at the end of the text.[11] The beginning mentions that Jami entered the mystical state of sama' (the ritual Sufi dance) during the poem's composition.[12] The masnavi is generally considered to have been written in honor of Sultan-Husayn Mirza, whom Jami praises in the prologue along with his pir, Khwaja Ubaydullah Ahrar.[13]

The beautifully illuminated title piece on the opening folio of *Yusuf u Zulaykha* in the Freer Jami (folio 84b) contains a ruba'i (quatrain) signed by the illuminator Abdullah al-Shirazi, proclaiming the divine origin of the masnavi's poetic contents. This verse, which is not by Jami or found in other *Yusuf u Zulaykha* manuscripts, also lauds the beauty of the calligraphy and paintings in this copy of the poem. Its imagery is that commonly used in Persian poetry to describe the beloved.

1. Yohannan contains selected excerpts, with commentary and bibliography, from various versions of the Joseph legend, ranging from ancient Near Eastern folklore through Thomas Mann. This invaluable anthology also contains an introductory diagram of the partial distribution of the story of Joseph and Potiphar's wife in world literature, outlining the transmission of the seven main variants of this universal tale and their historical and literary connections. Also helpful for understanding the common elements of this story is Sarna, 214–15.

The source for the masnavi text is Mudarris-Gilani, 578–748. Translations are in Bricteux, *YZ*, and Pendlebury. Because the *Yusuf u Zulaykha* is a continuous narrative, the précis of the text related to each Freer Jami illustration includes preceding episodes, as relevant.

2. See Brosh, 52. It is debatable, however, whether "the number of its [the poem's] illustrated manuscripts almost exceeded that of the *Shahnama*" (ibid., 23).

3. Sura 12 is an adaptation of the Old Testament account (Genesis 39:1–23) rather than a direct imitation. For its sources in and amplification on Judeo-Christian material, ancient and classical texts, and pre-Islamic Arabic legends, see *EIs*, Bernard Heller, "Yusuf"; *EJ*, Nahum M. Sarna, "Joseph and Asenath"; Pendlebury, 173; Philonenko, 117–21; Rypka, 632; Sidersky, 52–68; and Yohannan, 158–59, 164–65 (excerpted translation of sura 12).

4. *EIs*, Bernard Heller, "Yusuf."

5. The characterization is by Bricteux, *YZ*, ix. The preface of this prose translation of Jami's text gives additional information about the story of Yusuf and Zulaykha in Persian literature. See also Brosh, 32–35, 52; *EIs*, Bernard Heller, "Yusuf" (with a series of important earlier references); Knappert, 85–104; Rypka, 157–58 (discussing the so-called Firdawsi version of *Yusuf u Zulaykha*); and Yohannan, 160–63.

6. Bricteux, *YZ*, ix, xii–xvi; Brosh, 35, 52, 54–58; Browne, *LHP*, 3:531–33; Bürgel, 132–33; Davis, 27; Dols, 340–45; Pendlebury, 155, 171–84; Philonenko, 122; Yohannan, 160–62, 166–220.

7. For a brief discussion of these ideas and translation of excerpts from the prologue, see Browne, "Sufiism," 328–30; and Browne, *LHP*, 1:439, 442. Jami's discourse on love has been described as "practically a commentary on the well-known Sufi aphorism, 'the Phenomenal is the Bridge to the Real'" (ibid., 3:531 n. 2).

8. For an excellent summary of the narrative, based on the Pendlebury translation, see Brosh, 54–58.

9. Schimmel (*MD*, 429) discusses the theme of idolatry and characterizes Zulaykha as "a fine symbol for the enrapturing power of love expressed by the mystic in contemplation of divine beauty revealed in human form" and "the symbol of the soul, purified by ceaseless longing in the path of poverty and love." For remarks on the relationship among seduction, idolatry, and the art of painting as manifest in *Yusuf u Zulaykha*, see Pendlebury, 171–72; and Bürgel, 132–33.

10. For the relationship of the Bazigha episode to the theme of idolatry, see Pendlebury, 172.

11. Mudarris-Gilani, 746; Bricteux, *YZ*, 226, 250 n. 19; Pendlebury, 146. The date is sometimes given as 888/1483 (Browne, *LHP*, 3:516; Hikmat, 199; *EIs* 2, Cl. Huart [rev. H. Massé,] "Djami").

12. Mudarris-Gilani, 594; Hikmat, 104.

13. Mudarris-Gilani, 588–91; Bricteux, *YZ*, 16–20.

Folio 100b

THE AZIZ AND ZULAYKHA ENTER THE CAPITAL OF EGYPT AND THE EGYPTIANS COME OUT TO GREET THEM

Text Source
Mudarris-Gilani, pages 627–29.

Translations
Bricteux, *YZ*, pages 66–69; Pendlebury, pages 34–36.

Rubric before Illustration (folio 100a)

> *Zulaykha enters Egypt with the aziz of Egypt and the Egyptians come out [to greet them], strewing trays of festive coins on Zulaykha's litter.*

Précis

Believing the aziz of Egypt (Misr) to be the beautiful youth of her dreams, Zulaykha becomes over-joyed when her father arranges her marriage to the Egyptian, and she sets off to meet her beloved escorted by a magnificent caravan. Delighted at the prospect of such a lovely bride, the aziz prepares a large cortege to go to Zulaykha's camp and welcome her. Desperate for a glimpse of her beloved, Zulaykha has her nurse cut a slit in the aziz's tent. It is then that she realizes that he is not the man of her dreams, and she falls into despair. Eventually she receives a divine message telling her that her misfortunes will pass and that although the aziz is not her desire, she cannot attain it without him. She is advised not to avoid his company: "He will leave your silver lock untouched, for his key is of the softest wax." At this news she ceases to lament and silently endures her suffering.

The aziz arrives at Zulaykha's camp at dawn to escort her to his capital on the banks of the Nile. His entourage includes horsemen sheltered by golden parasols, performing musicians, and singing camel drivers. At the aziz's invitation, Zulaykha climbs into her litter, surrounded on all sides by festive accompaniment. Her handmaidens are thrilled that their mistress has been rescued from the demons that tormented her for so long, but all Zulaykha can do is bemoan her cruel fate: "Oh heaven, why do you treat me so? . . . First you stole my heart in sleep, then in my waking life you piled on griefs by the thousand." Shouts announcing her arrival at the capital of Egypt soon inter-rupt Zulaykha's lamentations. Thousands of cheering people, mounted and on foot, greet their aziz and his bride. The aziz then performs a traditional custom, signaling servants to shower the bridal party with gold, silver, pearls, and jewelry until the litter almost disappears beneath the avalanche of wealth. The crowds lining the banks of the river also lavish gold and gems on the bride. The bedecked cortege then advances in regal pomp toward the palace, where Zulaykha is enthroned and crowned "like a jewel set in gold." But what is the use, asks Jami, of a crown to someone full of grief and despair?[1]

Illustration

The painting depicts the moment when the bridal procession has reached the city gates and the aziz initiates the traditional shower of gold (fig. 76). Zulaykha sits in an elaborately decorated and domed litter, her mount led by a bearded cameleer. Behind her are ranks of elegant horsemen and women. Zulaykha's ladies all have bandanas wrapped over their mouths.[2] Just below in the fore-ground a black steed rears up over a stream. Its rider is probably a guide, flanked by two attendants on foot. Men and boys observe the procession from a rocky hillside above Zulaykha's escorts. Some climb into a plane tree for a better view.

The aziz approaches from the left on a white horse and turns backward to take a gold platter, presumably full of jewels, from an attendant. Other men stand in rows behind him, with four holding heaping platters of jewels and what look like gold coins.[3] Musicians playing the tam-bourine, sitar, flute, kamancha, and panpipes perform in the lower left, while two young boys with castanets dance for Zulaykha.[4] These dancers are also watched by an embracing male couple in the foreground.

76
The Aziz and Zulaykha Enter the Capital of Egypt and the Egyptians Come Out to Greet Them
in the *Haft awrang* of Jami
963–72/1556–65, Iran
34.5×23.4 cm (folio)
FGA 46.12, folio 100b

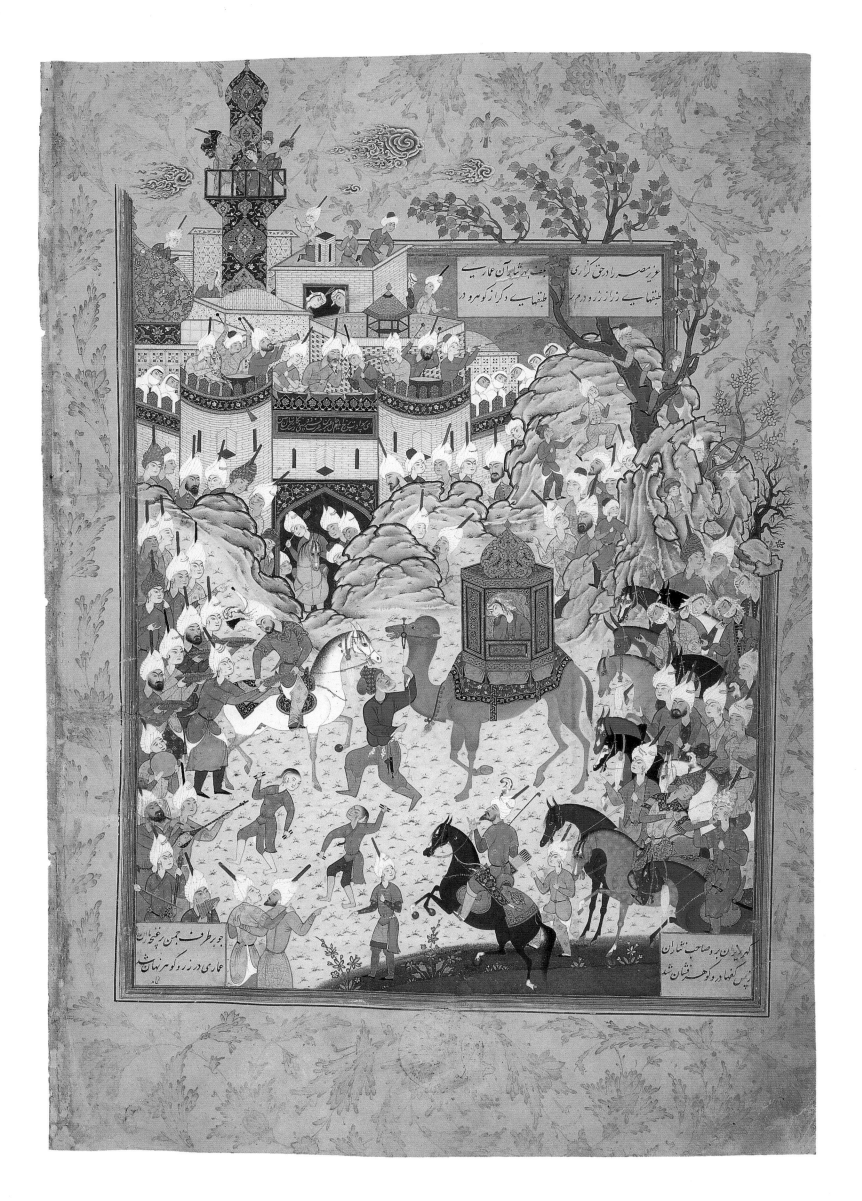

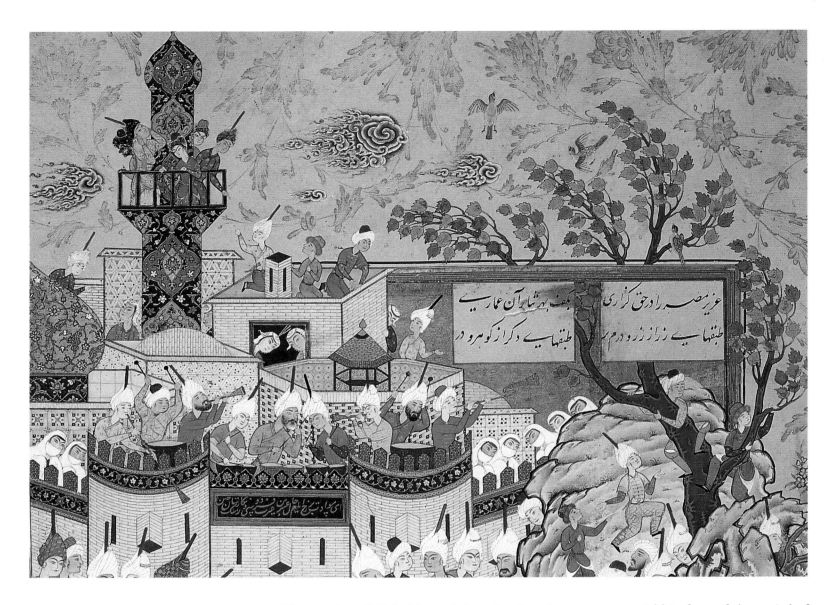

77
The Aziz and Zulaykha Enter the Capital of Egypt
and the Egyptians Come Out to Greet Them (detail)
in the *Haft awrang* of Jami
963–72/1556–65, Iran
29.1×19.5 cm (painting)
FGA 46.12, folio 100b

The meeting of Zulaykha and the aziz takes place on a grassy field in front of the capital of Egypt. The city rises into folded hills where many townspeople peer down onto the procession below (fig. 77). The main entrance to the city is visible through a cleft in the hills. The arched portal is jammed with people, including a youth on horseback. Two rounded towers with crenellated walls flank the archway. Three groups of musicians pound kettledrums and sound clarions behind the central ramparts, while women dressed in white (with their mouths and hands concealed) look out from over the walls. The city roofs are visible beyond, including part of a beautifully decorated dome, a less prominent brick dome, an octagonal terrace with lantern, a square brick belvedere with a window on the side and a *badgir* (wind catcher) above, and a tiled minaret encircled with a balcony.[5] Women and children occupy every possible vantage point; a young boy even pops out from behind the large dome at left.

Teeming with people, this expansive composition represents the principal actors and action of Jami's text. It captures the excitement of those accompanying the party and those waiting inside and outside the city and conveys the wealth and ceremony of the aziz's court.[6] Zulaykha's grief, however, is barely apparent, and the contrast between the bride's external circumstances and inner suffering seems not to be visually rendered. Yet the textual focus on Zulaykha is acknowledged and even enhanced by an inscription over the city entrance:

ای سوادت بررخ ایام خال عنبرین

عزت فردوسی و رشگ نگارستان چین

The black pupil of your eye is an ambergris-scented beauty mark on the face of time,
[You are] the glory of paradise and the envy of the picture gallery of China.

CHAPTER TWO: POETRY AND PAINTING

This conventional bayt is not part of Jami's *Yusuf u Zulaykha* and could easily have been composed by the artist responsible for the painting.[7] Indeed the equation of heaven and a picture gallery may have been intended to suggest the value placed on the illustration and the compliment meant to be directed at the celebrated beauty, Zulaykha. The description of beautiful eyes, considered a woman's most expressive feature in Iran, is particularly apt considering the emphasis on this part of female physiognomy in the painting.

None of the other known illustrations to this scene contains the same enriched epigraphic detail. The Freer Jami painting is also the only one depicting the capital city of Egypt, the throngs of people in and around the capital, and the bridal procession. Its setting, arrangement of the principal figures, and certain details are shared, however, with an earlier painting in a manuscript dated Shawwal 931/August 1525 and copied by Shah-Mahmud al-Nishapuri (TKS R. 910). The work may have been executed in Tabriz for Shah Tahmasp, in which case its illustration of the entry into the city (attributed to Sultan-Muhammad) may be a prototype for the Freer Jami painting.[8] Neither analogous composition, however, contains a literal feature found in a *Yusuf u Zulaykha* manuscript of 946/1539–40 (SPL Dorn 430): a young attendant standing on the horizon and overturning a platter of gems onto Zulaykha's litter.

The Freer Jami has often been considered the stylistic forerunner of Mughal painting in India, and direct comparisons have been drawn between specific compositions. Robert Skelton has observed, for instance, that the Freer Jami's entry of the aziz and Zulaykha into the capital of Egypt has a mirror-image counterpart in an *Akbarnama* (Book of Akbar) illustration of circa 1586–87. Ascribed to the artist Farrokh Beg, the illustration depicts the Mughal emperor's entry into Surat in 1573.[9] The many points of comparison—representation of turreted cities in the background, placement of principal figures, ranks of courtiers accompanied by musicians, *repoussoir* rider, diagonal arrangements, and great crowds of people—suggest that Farrokh Beg may have known the Freer Jami picture at firsthand.[10]

Although the Freer Jami composition clearly belongs to an established iconographic type deriving from the Jami text, its myriad figures, city walls, and other details may have yet another source. In the spring of 967/1560, Sultan Ibrahim Mirza married Gawhar-Sultan Khanim, the daughter of Shah Tahmasp (and thus his first cousin). Qazi Ahmad, the celebrated author whose father, Mir-Munshi, served as senior adviser to Ibrahim Mirza and negotiated the marriage arrangements on the prince's behalf, gives a detailed account of the wedding. According to Qazi Ahmad, the shah sent his daughter to Mashhad in the company of a large party, including members of the royal family and court. When news of his bride's approach reached Sultan Ibrahim Mirza, he sent "white beards and their wives with gifts and presents to Sabzivar to welcome [them]." The prince himself, "accompanied by illustrious amirs, princes, valis and wealthy men, went to the area of Alaqa-band and the plain of Arifi to receive the party. On an auspicious hour, he brought it to the Bagh-i Shahi outside the gate of Sarab to rest." Meanwhile preparations were being made to decorate the city of Mashhad. "The stretch between the Sarab gates and the gates of the Chahar-bagh along the princess's route was decorated in such a way that it became the envy of eternity and the picture gallery of China. . . . The heavens with their thousand eyes had never seen such wedding feast preparations, and the hosts of the moon and the sun had never witnessed a celebration as beautiful or preparations as refined."[11]

Not only do many details found in folio 100b correspond to Qazi Ahmad's description, but the verse over the city entrance employs the same literary conceit about the picture gallery of China.[12] Thus the eyes being praised may be those of Gawhar-Sultan Khanim. It is possible that the description of Gawhar-Sultan Khanim's wedding party and the depiction of Zulaykha's are rooted in a common topos for such celebrations. In any event, the art and life of Ibrahim Mirza appear to come together in folio 100b—precisely what the prince may have intended.

Dimensions

29.1×19.5 cm (including extensions)

Incorporated Verses

Two verses at top of illustration:

> *Then the aziz, in fulfillment of his duty,*
> *Had jewels scattered on that litter.*

> *[With] golden trays filled with gold and silver coins,*
> *And other trays with jewels and pearls.*

Two verses at bottom of illustration:

> *Those appointed [to the task] scattered gems and coins,*
> *Like rain on the rosebuds of a garden,*

> *The scattering of gold and pearls was so great,*
> *That the litter disappeared in the avalanche of riches.*

Attributions

Stchoukine: Shaykh-Muhammad (*MS*, 47, 126), and Group 1, possibly Shaykh-Muhammad (*MS*, 128); S. C. Welch: Painter A (Qadimi).

References

Atil, *Persian*, cat. no. 39, with repro.; Dickson & Welch, 1:206B, fig. 264; Ferrier, 212, pl. 24; Inal, 66; Qazi Ahmad [Suhayli-Khunsari], repro. back cover and text (n.p.); Skelton, "Farrokh Beg," 396, pl. 3, fig. 6; Stchoukine, *MS*, 47, 126–28, pl. XLII; S. C. Welch, *PP*, 25, fig. K.

1. Pendlebury (p. 162) sees all the wealth showered on Zulaykha on her arrival in Misr as "in cruel, almost sinister contrast to her inner state of anguish."

2. Similar bandanas are worn by six women in an illustrated copy of the *Majalis al-ushshaq* dated 959/1552 (BOD Ouseley Add. 24, folio 54a [repro.: Stchoukine, *MS*, pl. XXXVIII right]). According to the French traveler Jean Chardin, Persian women of the early seventeenth century wore four different veils, two in the house and two more outside. He describes the fourth as a kind of handkerchief that covers the face and fastens at the temples (Chardin, 4:12). Scarce (p. 7, fig. 6) refers specifically to the short face veils worn by the women in folio 100b and suggests that this rather informal style of face covering, while current in the second half of the sixteenth century, was short-lived and disappeared in the seventeenth century. A much earlier form of female face covering appears in the *Kitab al-diryaq* (Book of antidotes) dating to the mid-thirteenth century (ÖNB A.F. 10, folio 1a [repro. color: Ettinghausen, *AP*, 91]).

3. In Iran the scattering of coins and jewels over a bride and wedding guests is called *nithar* and, more idiomatically for the time, *sachigh*, in Turki. See Mu'in, 2:1784; 4:4673. See also FGA 46.12, folio 147a.

4. The hairstyle of these castanet players resembles that of some of the youthful gypsy entertainers in FGA 46.12, folio 30a.

5. The cityscape is similar to an illustration in a *Khamsa* of Nizami dated 900/1494–95 (BL Or. 6810, folio 273a [repro. color: Lentz & Lowry, 250]) and even closer (because of the minaret) to a well-known scene in the Tahmasp *Shahnama* (folio 521b [repro.: Dickson & Welch, 2: pl. 218]). Inal (pp. 66–67) also compares the setting and scene of folio 100b to a *Shahnama* illustration depicting Bahram Gur taking the princess of China to Persia (TKS R. 1548, folio 460b [repro.: Inal, fig. 7]).

6. Skelton ("Farrokh Beg," 396) counts 103 people in the illustration. (I count 101.) Atıl (*Persian*, cat. no. 3) characterizes the scene as "a series of vignettes placed around the central theme, producing a rich and varied composition."

7. Similar verses, including the notion of something beautiful inciting envy in China and surpassing the skills of the legendary Mani, are incorporated into the architectural decor of various paintings in the *Shahnama* made for Shah Tahmasp (folios 35a, 77b). See Dickson & Welch, 2: pls. 22, 63, and discussion 540A–B. Mir Ali-Sher Nava'i, the famous Timurid author, literary patron, and royal confidant, employed the same imagery in the preface to the first divan of his *Gharayib al-sighar* (Novelties of youth) (Thackston, *Century*, 368). The long artistic association of this well-established literary topos is attested to by a verse similar to that on FGA 46.12, folio 100b, inscribed in an illuminated title piece in a late-thirteenth-century copy of the *Shahnama* (Simpson, *Epic*, 326–27). For general remarks on the poetic image of China as a country of pictures and its connection with Mani as the prototype of the skillful painter, see Schimmel, "Review," 175.

8. For the paintings in TKS R. 910, see Stchoukine, "Poème." The features shared by TKS R. 910, folio 45b, and FGA 46.12, folio 100b, include the high-horizoned ground cleft in two; Zulaykha in her litter and her attendants meeting the aziz on horseback and his attendants in the middle ground (although the position of the two groups is reversed); golden platters carried by the aziz and several foot servants; and bandanas over the mouths of several female onlookers.

9. VA IS2-1896 117/117; Skelton, "Farrokh Beg," 396, pl. 3, figs. 5–6. For the manuscript's production and date, see also Seyller.

10. Skelton does not actually make this suggestion, but the two works are too similar to have been caused by general stylistic influence and inclination alone. Farrokh Beg came to the Mughal court at the end of 1587 (Seyller, 384), possibly having begun his career in the orbit of Sultan Ibrahim Mirza. For a more concrete instance of a Mughal artist's firsthand familiarity with Sultan Ibrahim Mirza's *Haft awrang*, see FGA 46.12, folio 132a.

11. The quotations here come from Qazi Ahmad [Ishraqi], 1:416, and are translated by Massumeh Farhad. See also FGA 46.12, folio 132a.

12. Dust-Muhammad, quoting Sa'di, used the same conceit in his preface to the Bahram Mirza album (Dust-Muhammad [Thackston], 344).

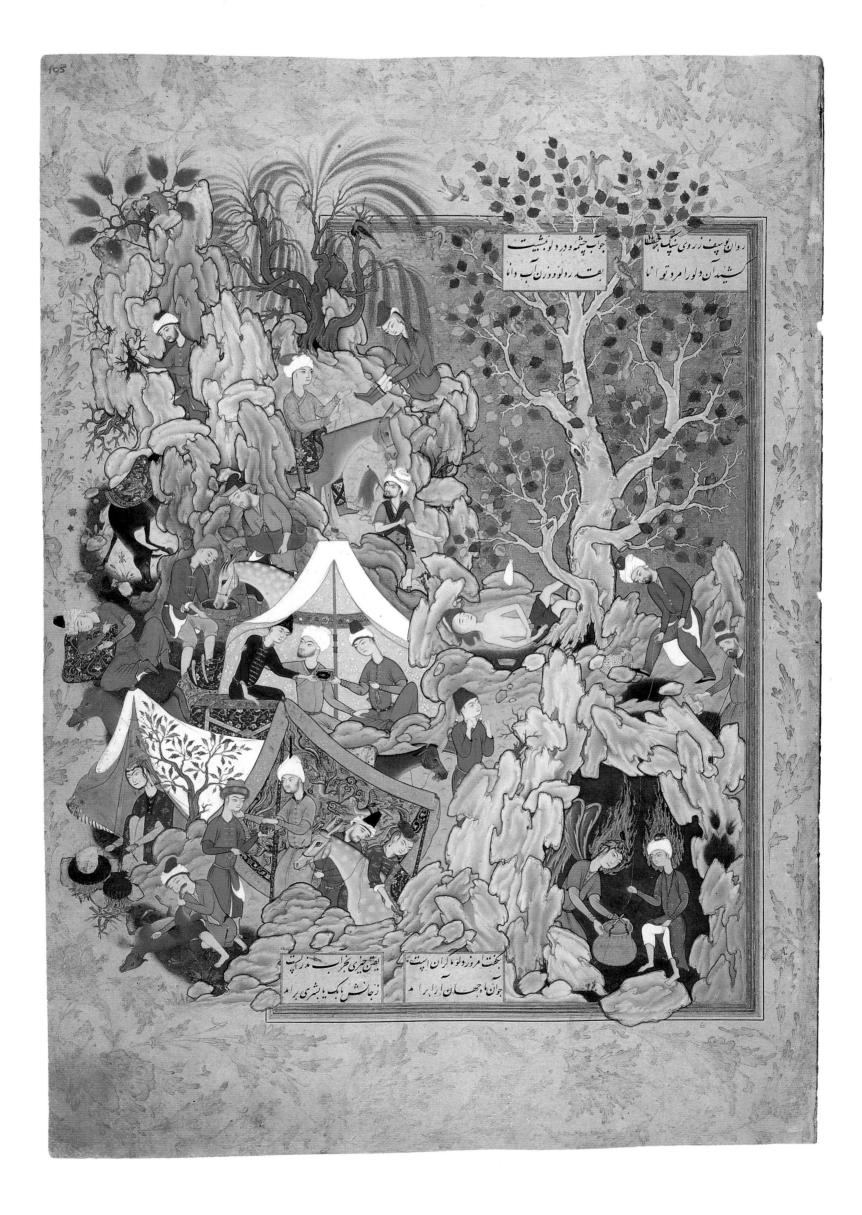

Folio 105a

YUSUF IS RESCUED FROM THE WELL

Text Source
Mudarris-Gilani, pages 642–43.

Translations
Bricteux, *YZ*, pages 84–86; Pendlebury, pages 46–47.

Rubric before Illustration (folio 104b)

> The caravan arrives at the edge of the well, Yusuf is brought out, and the world is once more lit up by the sunshine of his beauty.

Précis
Yusuf's eleven brothers grow increasingly jealous of the favor paid to him by their father, Jacob, and plot to get rid of him. Their plan is to throw Yusuf down a well, with the idea that whoever pulls him out will adopt or enslave him, thus breaking his links with the house of Jacob. The brothers then persuade Jacob to let them take Yusuf along on an outing into the country. When they are out of their father's sight, they begin to abuse him. After a long walk they find a well and lower Yusuf into it until the water comes up to his waist. Luckily, Yusuf is able to sit on a boulder at the bottom of the well. Soon the angel Gabriel appears and clothes Yusuf in a miraculous tunic removed from an amulet on the youth's arm. The angel also brings a message from God that one day the eleven brothers will come before Yusuf in shame and ignorant of his identity. He will then recount their evil deeds.

Yusuf remains in the well for three days. On the fourth day a caravan of Midianites on their way to Egypt passes by. Having strayed off their route, they decide to unload their baggage and camp beside the well. The first person to draw water from the well is a man named Malik. When the bucket appears, Gabriel tells Yusuf to stand in it, "and when you rise above the rim of the well, you will once more fill the sky with light." Yusuf leaps from the rock where he had been perched and climbs into the bucket. Up above, Malik pulls with all his strength and realizes that there is something more than water in the bucket. When Yusuf appears at the top of the well, Malik exclaims, "What a lucky fate is this, which sends such a shining moon from the depths of a dark well."

Meanwhile Yusuf's jealous brothers have been roaming the area, waiting to see the outcome of their plot. They finally see Yusuf in the camp and denounce him as a worthless slave who had escaped their service. They then sell him to Malik for a paltry sum, after which the caravan is loaded again and continues toward Egypt. Thus, says Jami, was a treasure of happiness bought for a few copper coins.

Illustration
Much of the composition is devoted to the caravan encampment, pitched in a rocky landscape that spills out into the left margin (fig. 78). Some caravanners are cooking and looking after animals, while others attend to their own comforts. In the upper left, a bearded man hacks at the branches of a small bush. On the other side of the hill a young man perched on a rock seems to be removing his boots or massaging his legs. In front of him another youth holding a stick drives a donkey out from behind a hill. Immediately below is an older, bearded man in a short yellow tunic with a blanket or shawl crossed over his chest and a staff with an animal skin over his right shoulder. Although rough in appearance, he has a small red flower stuck into his white-fur headgear. He may not be part of the caravan but a local herdsman observing what is going on in the camp.

Three tents are pitched close together in the middle and left foreground of the scene (fig. 79). Behind the uppermost shelter two men feed and water a dapple-gray horse, while another horse, wearing a saddle embroidered with a colorful duck, grazes on a patch of grass. At left, a youth in an orange robe sleeps against a patterned pillow or saddlebag. A brown camel is also lying beside this first tent. Inside are three male figures engaged in what initially appears to be some kind of literary discussion. The central bearded figure has his right hand around the shoulder of the youth

78
Yusuf Is Rescued from the Well
in the *Haft awrang* of Jami
963–72/1556–65, Iran
34.5×23.4 cm (folio)
FGA 46.12, folio 105a

perched on elaborately decorated boxes at the left and rests his left hand on the knee of the other youth. The two young men exchange a small open book, bound in a gilded leather cover. In front of the second tent below, the sole female member of the caravan tends two cooking fires. Over one she holds a piece of flatbread while poised to stir a pot on top of the other fire. Perhaps this pot is at the ready for the small deer whose neck is being slit by a boy at lower left. (The boy appears to grasp a knife, but nothing, in fact, is in his hand.) The third tent is a canopy held up by two poles, its underside decorated with a trio of magnificent simurghs flying amid clouds. The tent shelters two pairs of male figures. On the left a tall youth accepts a jug from a young boy while chucking him under the chin. On the right two other figures saddle a dapple-tan horse.

The right side of the composition is dominated above by a large plane tree full of birds and below by the well in which Yusuf was cast by his jealous brothers. At the base of the tree is a young man, bare chested and wearing a pair of short brown pants with a knife stuck in the waistband, sleeping on his back with his legs propped up against the gnarled trunk and his head on a rock pillow cushioned with an animal skin. Judging from the earring, a traditional sign of servitude, this may be a servant who has taken a break or slacked off on the job. Beside him is a small basin. A white pouch hangs from a lower tree branch. Although no whey drips from the pouch, it is possible that yogurt is being made and that the servant has fallen asleep during the long, soporific process.

On the other side of the tree Malik has let his bucket, tied to a twisted white rope, down into the well below. The unwitting rescuer leans over the wellhead, represented as a black hole in the ground, and braces one foot against a rock for greater leverage while drawing up the bucket. A two-handled jug with a short tube and spigot is wedged between this rock and a smaller one behind. Close to Malik at the right is another bearded man holding a staff and a jug; he may be waiting his turn at the well. A boy also approaches from the other side carrying what appears to be two leather water jugs over his back and followed by a donkey munching hay. The well is rendered in cross section as an irregular cave surrounded by piles of jagged, rather slick pastel rocks, similar to those around the campsite. Within its depths are Gabriel and Yusuf, both nimbed in flames. The winged angel holds the bucket with both hands as Yusuf prepares to step into it from the boulder on which he has been perched throughout his ordeal. The youth steadies himself by holding onto the bucket rope with his right hand, while with his left he lifts his bright orange and gold robe and reveals the white pantaloons underneath.

Two intriguing versions of the same composition are known. These have an apparent, although not easily explainable, relationship to one another. The finer work is a lightly tinted drawing, probably intended for an album, in mid-seventeenth-century style (fig. 80).[1] Although it shares the same general dimensions and layout, the drawing also modifies many compositional features found in the *Haft awrang* illustration, including animal and human participants. For instance, a youth has been inserted behind the middle tent, and the bearded mountain man carrying a pelt over a stick has been transformed into a youth holding a small bag. Differences also are seen in facial features, hat styles, accessories, and textiles (which lack any designs, probably because this is an outline drawing).

The other version of Yusuf rescued from the well forms the right half of a double-page frontispiece from an unknown *Shahnama* manuscript attributable to Shiraz in the sixteenth or seventeenth century (SOTH 26.IV.90, lot 105).[2] While this work shares as many details as the drawing, its format evidently required the artist to adjust the composition's left side. Furthermore, part of folio 105a has been considerably softened and reduced and the figures made to appear much stockier.

The general similarities and many differences between the tinted drawing and painted frontispiece suggest that neither work is copied from the other but from a common source. It is doubtful, however, that Freer Jami folio 105a was that source. If it was the direct inspiration, neither the artist responsible for the drawing nor the one who executed the painting chose to replicate folio 105a exactly.

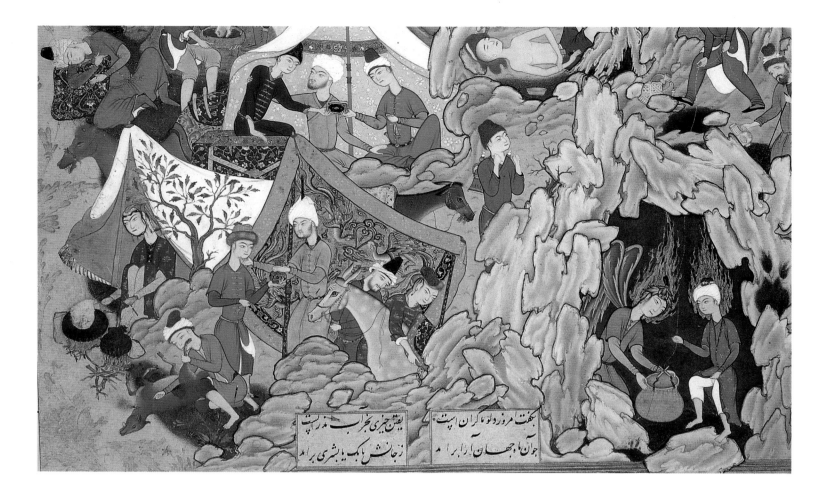

79
Yusuf Is Rescued from the Well (detail)
in the *Haft awrang* of Jami
963–72/1556–65, Iran
24×20.8 cm (painting)
FGA 46.12, folio 105a

80
Yusuf Is Rescued from the Well
Tinted drawing
Attributed to mid-17th century, Iran
27×21.8 cm (folio)
Dr. Spuhler, Berlin

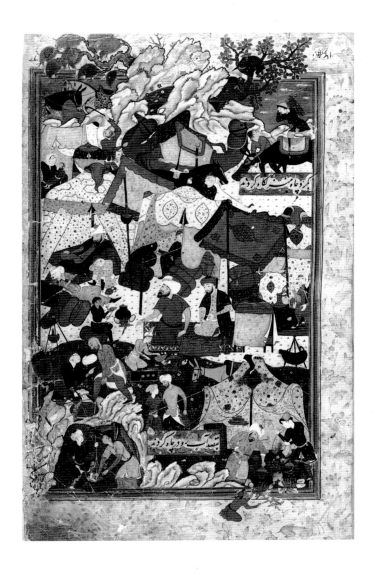

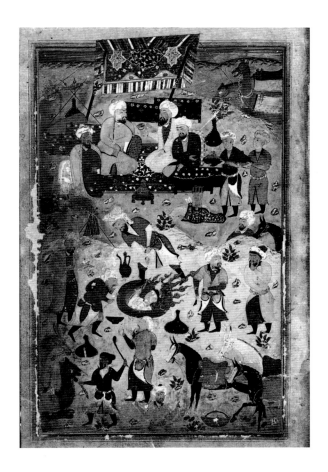

81
Yusuf Is Rescued from the Well
in the *Yusuf u Zulaykha* of Jami
975/1568, Iran, Bukhara
27.5×16.5 cm (folio)
BL Or. 4389, folio 58a
By permission of the British Library

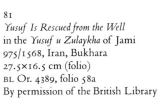

82
Yusuf Is Rescued from the Well
in the *Yusuf u Zulaykha* of Jami
ca. 1565–70, Iran, attributed to Shiraz
40.2×25.1 cm (folio)
BL Or. 4122, folio 69a
By permission of the British Library

Besides inspiring independent compositions, the rescue of Yusuf from the well ranks among the most frequently illustrated episodes in Jami's *Yusuf u Zulaykha*.[3] Most of its two dozen or so known illustrations belong to manuscripts dating from the 1550s through 1570s, and all but one depict the same moment in the story as the Freer Jami (fig. 81).[4] Usually the well, rendered in cross section, occupies the middle of a high-horizoned landscape, with Malik leaning over and pulling on his rope above. Yusuf, invariably nimbed, clambers into or is already seated in the bucket down below. In several instances Yusuf has begun to emerge from the top of the well while hanging onto the rope. In these cases only the opening of the well is rendered as a black, and sometimes gold, circle or oblong.[5] Generally several people stand around the well, often with jugs in their hands, and watch what is going on.[6] As in the Freer manuscript, many illustrations flesh out the caravan scene beyond Jami's perfunctory description, which specifies only that the Midianite merchants unloaded their baggage and camped around the well.[7]

These pictures also share with folio 105a the placement of the rescue on one side of the composition with Gabriel helping Yusuf into the bucket. In addition to this apparently unusual iconographic treatment, one illustration, from a manuscript of circa 1565–70 (BL Or. 4122, folio 69a; fig. 82), is similar to the Freer painting in its compositional structure, descriptive details (including accessories and costumes), and relationship of the figures to each other and to the landscape. The two illustrations are, in many respects, mirror images. In the London version the rescue takes place on the left and the preparation of food on the right. The artist responsible for the London manuscript was just as concerned as his counterpart who worked on the Freer Jami with creating a lively setting for Yusuf's rescue, to the point that, here too, it is easy to overlook the illustration's actual subject.[8]

Sharing many distinctive features and original forms, the Freer and British Library illustrations are straightforward narratives. Although the scene is poised on the brink of the emergence of divine beauty, nowhere is there any recognition of the eventual, momentous outcome. The only feature of any potential significance appears in the Freer Jami, where the sleeping servant may presage Yusuf's imminent fate.[9]

CHAPTER TWO: POETRY AND PAINTING

Dimensions

24×20.8 cm (including projections on left side)

Incorporated Verses

Two verses at top of illustration:

> *Yusuf leapt nimbly as if [he were] spring water from the rock,*
> *And sat in the bucket.*
>
> *The strong man [Malik] pulled on the rope*
> *And, knowing from experience the weight of water in a bucket,*

Two verses at bottom of illustration:

> *Said, "How heavy my bucket is today!*
> *Certainly there is something in it other than water!"*
>
> *Then when the moon, light of the world [Yusuf], appeared,*
> *Malik uttered a cry of joy from his soul, saying "Glad tidings."*[10]

Attributions

Stchoukine: Group 2, Artist 1; S. C. Welch: Muzaffar-Ali.

References

Chiesa 3, lot 447, with repro.; Dickson & Welch, 1:159B, fig. 220; Kevorkian & Sicré, 174–75, with repro. color; Simpson, *AI*, 55, with repro.; Stchoukine, *MS*, 128; S. C. Welch, "Pictures," 72; S. C. Welch, *PP*, 110–11, with repro. color.

1. The drawing is mounted on cardboard with narrow pink borders. Overall dimensions measure 29.3×34.2 cm; image size: 27×21.8 cm. Obviously it was once folded into four parts and may have been partly reworked when it was mounted. Certain figures in the bottom half, including the youth being chucked under the chin and bearded man with fur cap, have more pronounced contours, executed in somewhat crude pen stokes. The light pink and blue tinting, likewise confined to the lower half, also may be later embellishments. Ignoring for a moment the probable reworking of the drawing, its overall style and quality recall that of a tinted drawing, *Haftvad and the Worm*, inscribed "Ay Dust / Oh Friend" attributed to the Safavid painter Dust-Muhammad, circa 1555 (SOTH 29–30.IV.92, lot 291). This work is a mirror image of the *Haftvad* illustration signed by Dust-Muhammad in the Tahmasp *Shahnama* (folio 511b [repro. color: S. C. Welch, *KBK*, 173]).

2. The left side represents the preparations of a feast. The half-naked youth washing his hands in the foreground may refer to Yusuf bathing in the Nile. The full frontispiece is reproduced in SOTH 26.IV.90, 58–59.

3. It is one of the most popular stories for illustration in the entire *Haft awrang*, surpassed in the number of known representations only by those to the subsequent episodes of Yusuf's sale at the market in Misr and Zulaykha's tea party at which Yusuf overwhelms the Egyptian women with his beauty. See Appendix D, Mudarris-Gilani, 648–50, 689–90.

4. The sole exception known to me appears in a manuscript dated 957/1550–51 (CB MS 216) in which Yusuf is out of the well and seated among the caravanners as related in Jami's text. This illustration also includes a youth holding the bucket and chain that Malik used to draw Yusuf out of the well.

5. See BL Or. 4535, folio 60b; BL Or. 4389, folio 58a; BOD Whinfield 12, folio 57b; ELG 62, folio 55b; IM 5032.1.79, folio 55a; IOS MS 9597, folio 64a; and TKS H. 725, folio 52a. Two compositions, in manuscripts dated five years apart and attributable to Bukhara—BL Or. 4389, folio 58a, dated 975/1568, and IM 5032.1.79, folio 55a, dated 980/1572–73—are virtual mirror images with very similar color schemes and figure placement. The two works vary in certain details, as for instance the greater number of camels in the background of IM 5032.1.79 and addition of the cameleer about to strike a camel in the foreground of BL Or. 4389. The overwhelming mass of similar features suggest common authorship or direct borrowing of the 980/1572–73 manuscript from its predecessor. Another painting from an undated Bukharan manuscript combines iconographic details and compositional features of both manuscripts (BOD Whinfield 12, folio 57b).

6. Only one illustration depicts Malik pulling Yusuf up without any observers or other incidental details (IOS MS 9597, folio 64a).

7. Extra textual details are found in BL Or. 4122, folio 69a; ÖNB A.F. 66, folio 102b; TKS H. 810, folio 197a; TKS H. 1084, folio 73a; and TKS R. 907, folio 70b.

8. There exists yet another painting that resembles FGA 46.12, folio 105a, so closely that it may actually be a copy (SOTH 24.IV.90, lot 105). This composition is the right side of a double-page frontispiece and thus not actually a text illustration. It apparently comes from a copy of the *Shahnama* of Firdawsi attributed to late sixteenth-century Shiraz. The left side extends the encampment theme with the representation of men skinning animals, preparing food, stirring cooking pots, and related activities. The right half is a virtual duplicate of FGA 46.12, folio 105a, with only a few minor compositional variations. Some landscape details serve notice that the frontispiece scene may not be a contemporary analogue of folio 105a but a much more recent imitation. This also may be the case with an illustration of Yusuf rescued from the well published as from a manuscript of Attar's *Mantiq al-tayr* that has the same general iconography as the Freer scene and individual features similar to other Freer Jami illustrations. See *Persian Art*, cat. no. 249, with repro.

9. Wheeler Thackston made this intriguing suggestion.

10. This exclamation is from the Koran, sura 12:19.

Folio 110b

YUSUF TENDS HIS FLOCKS

Text Source
Mudarris-Gilani, pages 657–59.

Translations
Bricteux, *YZ*, pages 105–7; Pendlebury, pages 61–62.

Rubric before Illustration (folio 110a)

> *Yusuf pleads to be a herdsman since there has never been a prophet who has not been a herdsman, and Zulaykha prepares everything so that he can be a herdsman.*

Précis
Yusuf is set on becoming a herdsman, since only those who tend flocks are fit to be prophets and leaders of nations.[1] When Zulaykha realizes her beloved's desire, she does everything possible to ensure that he attains it. First she has a sling, adorned with pearls, made for him by skilled masters. Then she calls on her herdsmen to put aside some special lambs with silken fleece and heavy tails. Yusuf then goes off to the plains to tend these flocks, accompanied by Zulaykha, who devotes herself to watching over him.

This episode immediately precedes Zulaykha's declaration of love for Yusuf and the start of conflict in their relationship. Its point, as articulated by Jami at the outset, is that when a lover divests himself of all personal desires, as Zulaykha can do for the moment, the lover becomes totally immersed in the will of the beloved.

Illustration
The plain where Yusuf grazes Zulaykha's flocks rises from a twisted flowering bush at the lower left in a gentle diagonal slope toward the upper right (fig. 83). Its pastel fore- and backgrounds are marked with tufts of grass. The middle ground is a grassy sward with flowering plants and bushes and a large plane tree filled with many birds. Two knotted "sinicized" clouds race through the golden sky. A graybeard in a blue robe trudges along the horizon, bending forward under a load of fagots. At the upper edge of the meadow is a large and impressive trellis tent, its bulbous roof adorned with a bold design of split palmettes and its smoke hole half covered with a back flap decorated in gold floral sprays.[2] A barefooted young woman sits in the yurt's doorway; this must be Zulaykha watching over her beloved. In front of the tent is another woman cradling a little boy in her arms and gently touching his lips. A tall plane tree shelters the pair. Yusuf stands on the other side of the tree, grasping the top of a staff with both hands and resting one foot on a rock. In front of him a flock of goats and sheep graze and gambol across the flowering meadow and tufted plain.[3] One goat pauses to stare up intently at the nimbed herdsman.

Two sections divide the right portion of the plain. In the central foreground, delineated as a low folded hill with several large rocks and blossoming plants, a pair of foxes confront one another. To the right the ground rises to a series of rocky outcroppings alongside Zulaykha's tent. Just at the break between lower and higher planes an imposing dapple-blue mare nurses a piebald foal. The mare's hindquarters are placed in the margin of the folio. Here the theme of animals in a landscape, with vignettes of real and fantastic animals attacking each other, is continued in the illumination of the three principal borders.[4] This is one of two illustrations in the Freer Jami with margins painted with such designs.

This charming painting is among the smallest in the manuscript. Faithful to the text in its representation of Yusuf as herdsman and would-be prophet and Zulaykha as guardian and would-be lover, the illustration also contains certain features that reinforce the themes of caretaking, nurturing, and selfless love. Most obvious are mother-and-child pairings, one human and the other equine. The attentive goat at Yusuf's feet seems to parallel Zulaykha in the tent above. The seemingly antagonistic foxes in the foreground may refer to the imminent tension in the Yusuf and Zulaykha story. The aggressive scenes in the margins may also foreshadow the increasing conflict about to develop in Jami's narrative.

CHAPTER TWO: POETRY AND PAINTING

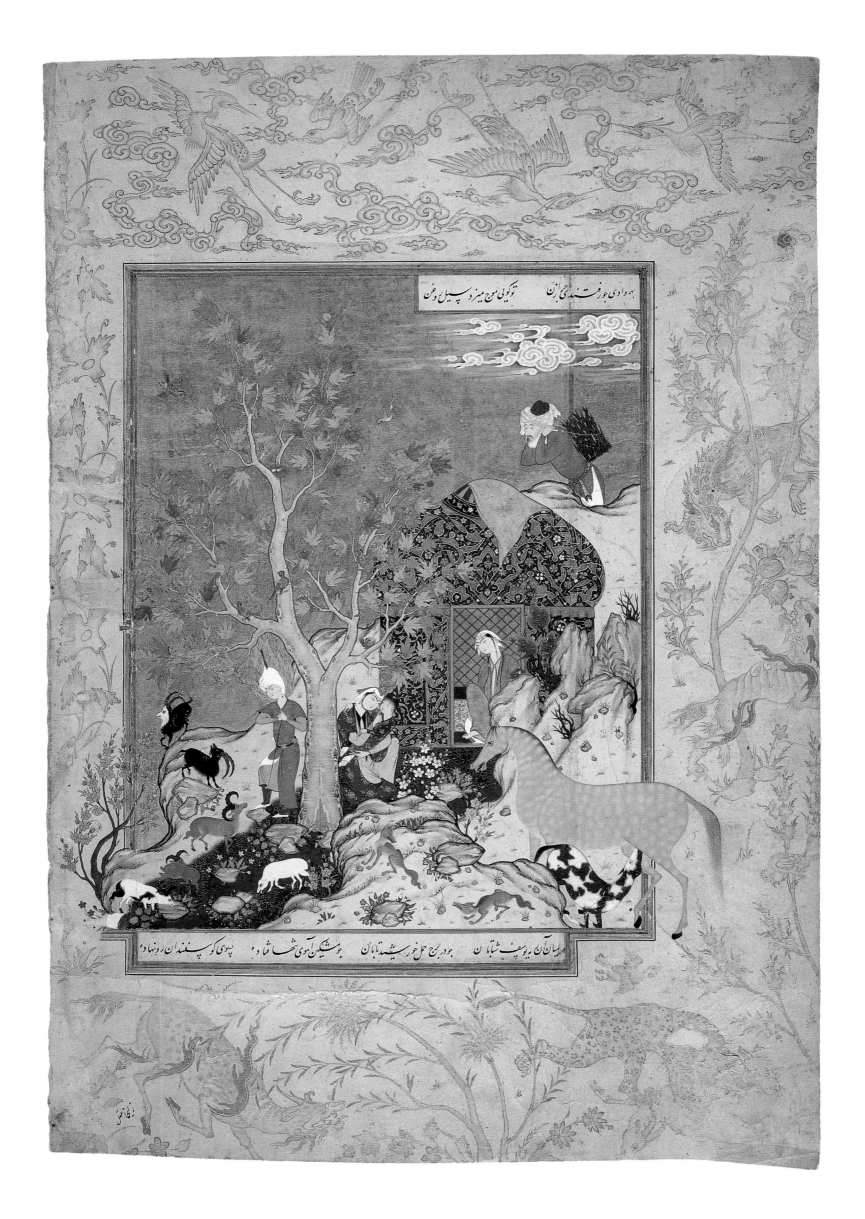

Ten other representations of Yusuf with his flocks are known. Most concentrate on Yusuf, who stands or sits by himself amid a large flock without Zulaykha.[5] One painting evokes the theme of protection by having Yusuf cradle a baby goat under his arm, among other telling details (MET 13.228.5, folio 69a; fig. 84). Another painting depicts the nimbed herdsman apparently shaking the leaves of a tree with his crook, under the gaze of a man pouring liquid from an animal skin, and a woman, who could be Zulaykha, kneeling near a stream. This illustration also includes part of a tent at its left side (IOS MS 9597, folio 81a).

Two other compositions are extremely similar and far more elaborate and expansive than the Freer Jami (BL Or. 4122, folio 87b; and TKS H. 1084, folio 93a; fig. 85). In these highly original versions the scene is in a large encampment, implied but not specified by text, comprising tents and several dozen inhabitants of all ages occupied with many activities: chatting, washing clothes, nursing, shaving, spinning, milking bullocks, making music, breaking firewood. The nimbed Yusuf is barely noticeable amid all the lively action. In the British Library illustration Yusuf's gamboling flocks, including a pair of fighting rams, are much more attentive to the rest of the scene than to their keeper.[6]

Dimensions
20.5×16.4 cm (including extensions)

Incorporated Verses

One verse at top of illustration and one omitted verse:

When the grazing [flocks] passed through a ravine,
You would have said they surged like a torrent of foaming oil.

[The wind raised its head (so violently) in the face of the wave,
That it took up the craft of chain-making.][7]

Two verses at bottom of illustration:

Yusuf hurried into the midst of that flock,
Like the resplendent sun in the sign of Aries [springtime],

Like a musky deer who, alone and stray,
Has sought out the company of sheep.

Attributions
Stchoukine: Group 1; S. C. Welch: Muzaffar-Ali.

References
Dickson & Welch, 1:159B, fig. 221; Kevorkian & Sicré, 184–85, with repro. color; Robinson, *PD*, 135, pl. 45; Stchoukine, *MS*, 127; S. C. Welch, *PP*, 25, fig. L.

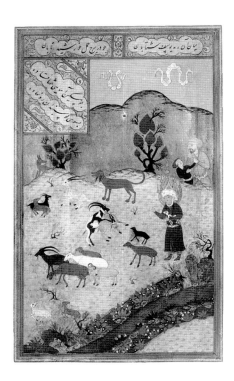

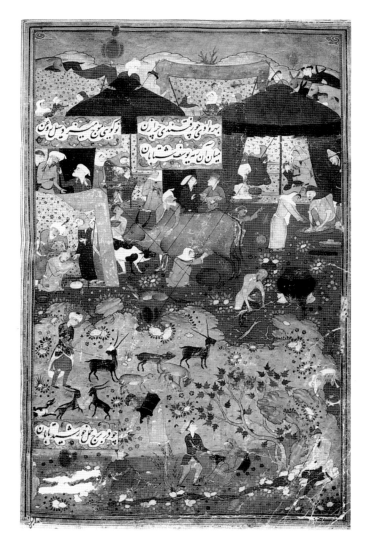

84
Yusuf Tends His Flocks
in the *Yusuf u Zulaykha* of Jami
930/1523–24, Iran, attributed to Bukhara
26.8×17.6 cm (folio)
MET 13.228.5, folio 69a

85
Yusuf Tends His Flocks
in the *Yusuf u Zulaykha* of Jami
ca. 1565–70, Iran, attributed to Shiraz
40.2×25.1 cm (folio)
BL Or. 4122, folio 87b

1. Most translations and adapted versions of this episode have Yusuf yearning to become a "shepherd," and standard Persian-English dictionaries translate *sha'ban* as "shepherd." In spoken Persian, however, *sha'ban* means someone who tends or herds flocks of animals, with no distinction made among sheep, goats, or horses. Iranian herds usually include animals of various types, particularly sheep and goats (see FGA 46.12, folio 264a).
2. Wilber (p. 129) describes this tent as a *kibitka* (yurt). The doorway of a similar domical tent in the frontispiece to the celebrated *Bustan* of Saʿdi, dated Rajab 893/June 1488, is annotated (admittedly in a later hand) with the phrase *dar khargah* (GEBO, Adab Farsi 908, folio 2a [repro. color: Lentz & Lowry, 260]). The same term for tents of this kind is used by Adle, "Module" 2, 203–4; Andrews, 149; and Thackston, *Century*, 327. Jami refers to tents as *khayma* (Mudarris-Gilani, 773, 842).
3. Among the flock is a goat picking its way down a rocky slope. A similar animal appears in a detached *Silsilat al-dhahab* illustration attributed to Muhammadi (AHT no. 93 [repro. color: Soudavar, 238]).

4. The surrounding landscape is elaborate, featuring a trio of cranes and an eagle flying amid knotted clouds in the top margin. A pair of qilin circle each other warily around the tall trunk of a fanciful pomegranate tree in the outer margin. A spotted snow leopard bites into a stag underneath a flowering tree with birds in the lower-right corner, and another cloven quadruped, complete with horns and flaming haunches, peers from underneath a willowlike tree and looks across at the attack scene from the lower-left corner.
5. See BN suppl. pers. 561, folio 84b; BN suppl. pers. 1768, folio 100b; ELG 62, folio 73b; MET 13.228.5, folio 69a; and TKS H. 810, folio 203b. The flock in the ELG 62 illustration includes a black ram mounting a white ewe while Yusuf raises his staff to break up the mating pair.
6. Although the figures and their activities are virtually identical in both compositions, their placement is not always the same. Their differences notwithstanding, the two illustrations are obviously directly related and may be by the same hand.
7. The waves at the crest of the wind-whipped water look like chain links.

Folio 114b

YUSUF PREACHES TO ZULAYKHA'S MAIDENS IN HER GARDEN

Text Source
Mudarris-Gilani, pages 669–71.

Translations
Bricteux, *YZ*, pages 120–23; Pendlebury, pages 72–74.

Rubric before Illustration (folio 113b)

> *Evening falls and the slave girls display their [beauty] to Yusuf, may peace be unto him, to see which one of them he will desire.*

Précis
Zulaykha has an enclosed garden, as beautiful as paradise, bordered by fragrant rosebushes and ornamented with date palms. Songbirds trill amid the green leaves, and fish wriggle in the stream. Between two crystalline fountains, one spouting milk and the other honey, Zulaykha builds a throne intended for her beloved Yusuf. It is to this paradisiacal spot that the frustrated woman sends Yusuf after he resists her initial advances. She also sends along one hundred pretty maidens, telling Yusuf that, since he had rejected her, he could enjoy the voluptuous delights of youth with them. She advises the maidens, in turn, to do anything Yusuf commands, and to let her know immediately which maiden he fancies. When one girl succeeds in seducing Yusuf, Zulaykha plans to slip secretly into her place, thus adding deceit to desire. At this point in the narrative Jami counsels that if the beloved demands to be left alone, the lover should bear the trials of separation patiently. In this situation separation is sweeter than union.

At nightfall, Zulaykha's one hundred maidens stand around Yusuf, each seeking to arouse him with flirtatious words and gestures. The youth immediately recognizes their ruse. Yusuf's sole desire is to guide them onto the path of worship and lead them to the truth of God. Throughout the night he preaches to them of the mercy and wisdom of God and of their duty to adore Him. He then teaches them to recite the *shahada* (profession of the faith of Islam). In the morning Zulaykha rushes into the garden and finds all her maidens surrounding Yusuf and listening avidly to his teachings while plying rosary beads and proclaiming the one true God. Seeing a new luster in Yusuf's face, she begins to taunt the youth, asking him which maiden has enhanced his beauty. Flushed with shame, Yusuf remains silent. Realizing that her stratagem has failed, Zulaykha leaves the garden in despair.

86
Yusuf Preaches to Zulaykha's Maidens in Her Garden in the *Haft awrang* of Jami
963–72/1556–65, Iran
34.5×23.4 cm (folio)
FGA 46.12, folio 114b

Illustration
A large pavilion, not specified in the text, dominates the garden setting (fig. 86). The building is irregularly shaped and illogically constructed, with two separate, unaligned high walls flanking a richly decorated iwan. Near the top of the pavilion's right-hand tower is an open window with a single, intricately inlaid wood shutter. The woman leaning out this window must be Zulaykha, who has come at daybreak to see what happened during the night. The crescent moon and tall, lighted taper in the blue and white candlestick toward the back of the iwan indicate that it is still dark in the garden.

Yusuf sits on a raised octagonal platform in front of the iwan, his left hand raised in a gesture of speech. Ten of Zulaykha's maidens, dressed in long- and short-sleeved robes, surround him. They also wear white head coverings adorned with flowers or brushes and long, thin "tails" terminating in tassels looped around their shoulders, chests, or arms and tucked into their waistbands.[1] One maiden kneels at Yusuf's feet and gestures toward him with both hands. Behind her two other girls approach the pavilion's octagonal terrace. One holds a lit candle and turns backward to beckon to another maiden on the grass, who also holds a taper and has one hand to her mouth to indicate silence. Behind Yusuf on the terrace another maid pulls a companion closer to their teacher, while another pair advances from the left. Immediately in front of Yusuf, also on the grass, are two more

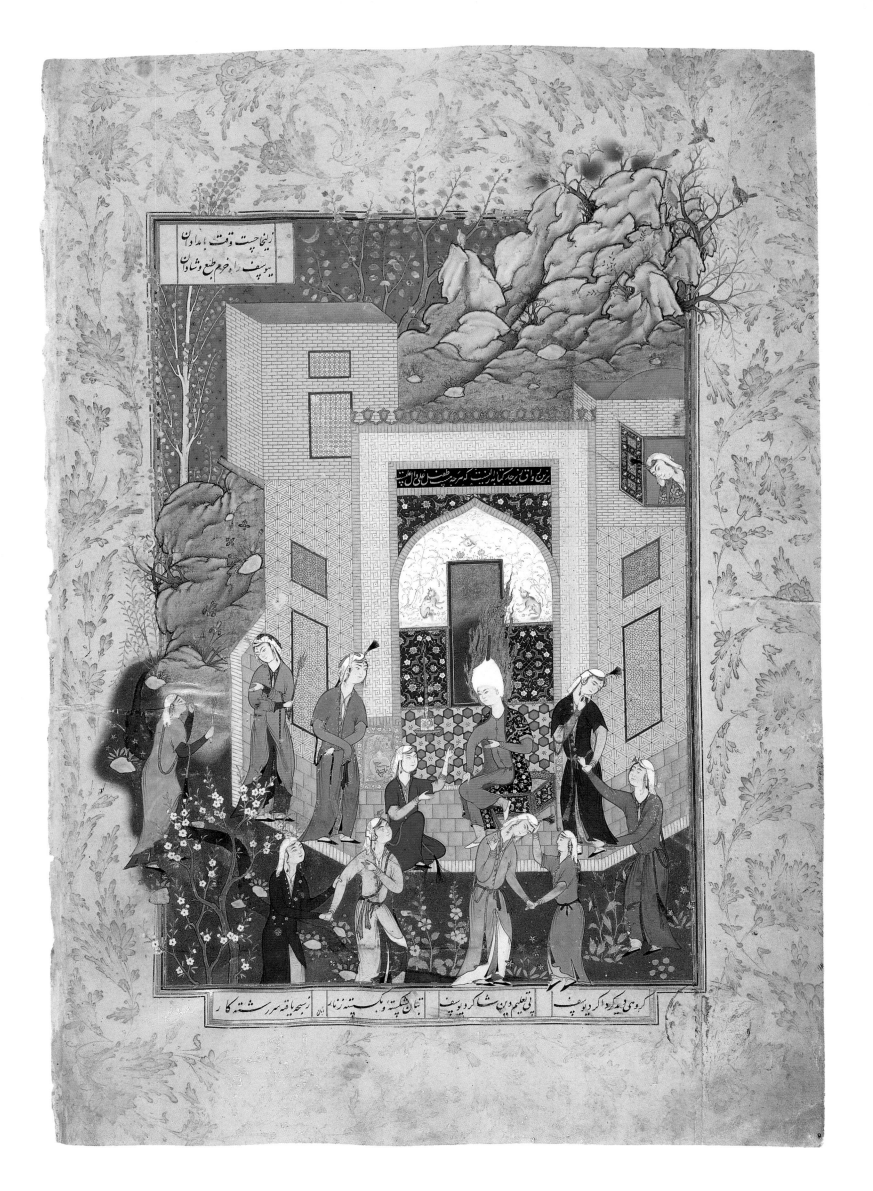

girls, who seem less attentive. These two face each other holding hands. The one at left bends her head down to have her headdress ornament straightened by her shorter and possibly younger companion.

In overall representation this painting closely follows the text. Yet it includes certain additional features, notably the pavilion, which may serve an important function in terms of the underlying meaning of the episode. The position of Zulaykha, assuming she is the woman at the window, is perhaps not what one might have imagined from Jami's words, although the relevant verse is ambiguous. More curious is the absence of any representation of the girls' conversion, such as broken idols or rosary beads. The lack of any visual sign is compensated for by the inscription over the iwan archway:

برین رواق ز برجدکتابه ازلیست

که هرچه هست صفل علی و آل علیست

Upon this emerald arch there is a pre-eternal inscription:
"Everything that [exists] is dependent upon Ali and his family."

Written in green ink, this inscription is punning and self-referential, with the "arch" referring literally to the iwan and metaphorically to the vault of heaven (fig. 87).[2] The brick and tile archway thus may be a terrestrial mirror image of heaven's arch and its epigraph a reflection of the implicit celestial message about God's mysterious purpose. This is, of course, what Yusuf has been instructing the young women: "Without Him, whoever we may be, we are worthless." The inscription may have been intended to emphasize the spiritual nature of Yusuf's discourse with Zulaykha's maidens and Jami's theme of the power of divine love. It is, however, not unusual to find inscriptions with Shi'ite overtones in Safavid art.[3] Thus the application of this pious invocation may have little significance, although the presence of Ali's name above might be expected to deter any untoward behavior below.

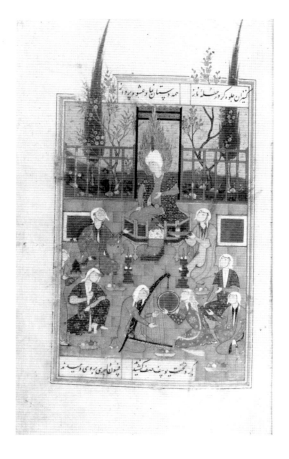

Folio 114b belongs to a group of confirmed illustrations to the story of Yusuf's seduction transformed into the maidens' conversion and is the only one to represent its nighttime setting.[4] Most other paintings set the scene in a garden, often with a fountain, pond, or stream and very lush vegetation. Two add a terrace and railing with the garden beyond (CB MS 251, folio 94a; and ELG 62, folio 86b; fig. 88). Another joins the Freer Jami in placing Yusuf on a terrace outside a pavilion, although it is a much more peculiar structure (BL Or. 4535, folio 83b) than that depicted in folio 114b. Yusuf generally sits on some kind of seat, which in several cases is an elaborate throne.[5] The number and arrangement of the maidens around Yusuf vary greatly. One composition includes as many as nineteen.[6] Occasionally these women hold rosary beads, a textual detail not found in the Freer Jami, and sometimes platters of food or musical instruments. As in the Freer Jami, it is often difficult to identify Zulaykha in these illustrations, although in one case she may be sitting next to Yusuf (BL Or. 4122, folio 101a) and in another she stands directly in front of him (BL Or. 4535, folio 83b).

One comparative illustration treats the episode in a completely different scene (TKS R. 888, folio 81b). Instead of a garden setting, the gathering takes place indoors, with Yusuf seated on the tile floor under an arch. Instead of maidens, Yusuf addresses four men, seated in pairs. In the immediate foreground lies a golden male idol, broken into four pieces. Zulaykha stands on a terrace outside, finger to mouth. This composition precisely depicts the Jami verse, written immediately above the picture plane (and at the bottom of the Freer Jami scene), in which Zulaykha watches Yusuf instructing the assembly in religion, with idols and *zonnar* (idolaters) broken. Even the substitution of men for women can be explained since there is no mention of maidens in the relevant verse, although it is curious that the artist did not know or read the preceding narrative. In any event, this painting comes from a manuscript dated 912/1506–7 and subsequently refurbished. Its apparently unique iconography evidently was not continued later in the sixteenth century.

Dimensions
23.7×15.9 cm

Incorporated Verses

One verse at top of illustration:

> *Zulaykha leapt up at the break of dawn,*
> *Happy and cheerful, [and hurried] toward Yusuf.*

Two verses at bottom of illustration:

> *She saw Yusuf in the middle of the assembly,*
> *Instructing [her maidens] in religion,*
>
> *The idols [were] broken and the zonnar broken,*
> *With a firm clasp on their rosaries.*

Attributions
Stchoukine: Group 1; S. C. Welch: Shaykh-Muhammad.

References
Dickson & Welch, 1:168B, fig. 228; Stchoukine, *MS*, 127; S. C. Welch, *PP*, 25, fig. M.

Notes
1. The brushes are typical of female headgear in the second half of the sixteenth century. See, for example, BOD Ouseley Add. 24, folio 127b (repro.: Arnold, *PI*, pl. XXXIII); and BL Or. 4535, folio 104a (repro.: Stchoukine, *MS*, pl. LXXII).
2. This anonymous verse is similar to an ode from the *Divan* of Hafiz inscribed on four illustrations in the Tahmasp *Shahnama* (folios 83b, 183b, 442b, and 633b):
 On this chrysolite portico they write so righteously in gold:
 "What alone endures is the good of the pure in heart."
(repro.: Dickson & Welch, 2: pls. 69, 118, 206, 242, and discussion 540B–42B).
3. The paintings in the Tahmasp *Shahnama*, for instance, contain numerous invocations of Ali and other religious figures important in Shi'ite Islam. These usually occur on banners carried in battle scenes: folios 58b, 326b, 341b, 342b, 413a, 496a, and 745b (repro.: Dickson & Welch, 2: pls. 45, 173, 177, 179, 196, 213, 261, respectively, and discussion 539B). In addition, the name Ali is incorporated in the building inscription on folio 71b of the *Shahnama* (repro.: Dickson & Welch, 2: pl. 58).
4. There also exist illustrations to the preceding episode in the *Yusuf u Zulaykha* poem, when Zulaykha sends both Yusuf and the maidens into the garden (Mudarris-Gilani, 666–69; Bricteux, *YZ*, 117–20; Pendlebury, 71–72). Because the iconography of these two successive scenes is basically the same, they are easily confused.
5. In one illustration Yusuf sits directly on the ground (BN suppl. pers. 1015, folio 84b), and in two others he is on a rug (BL Or. 4122, folio 101a; BOD Elliot 186, folio 200b).
6. BL Or. 4122, folio 101a. Among the nineteen women is one in the foreground who appears to swoon into the arms of her companion. This detail, along with the bowls of pomegranates included in this illustration, may have been adapted from the standard iconography for a later episode, not illustrated in BL Or. 4122, in which the Egyptian woman are overwhelmed by Yusuf's beauty.

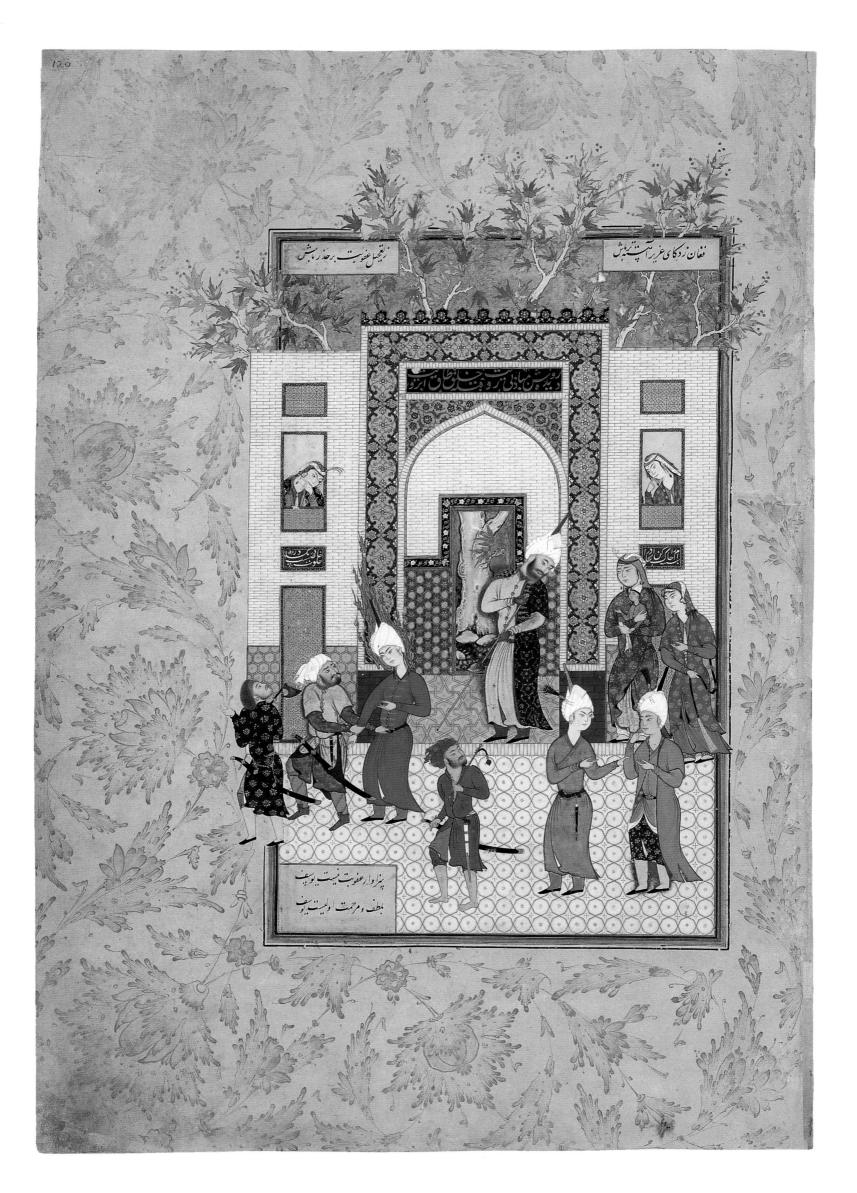

Folio 120a

THE INFANT WITNESS TESTIFIES TO YUSUF'S INNOCENCE

Text Source
Mudarris/Gilani, pages 687–88.

Translations
Bricteux, *YZ*, pages 144–46; Pendlebury, pages 89–90.

Rubric before Illustration (folio 119b)

> *The guards drag Yusuf, peace be unto him, to prison, and a suckling child gives testimony to his purity, and frees [Yusuf].*

Précis
In her continuing efforts to seduce Yusuf, Zulaykha lures the youth into her magnificent palace. Yusuf is on the verge of yielding to her passionate advances, when he suddenly becomes aware of Zulaykha's idolatry, breaks out of her embrace, and flees the palace. Immediately outside, Yusuf encounters Zulaykha's husband, the aziz, who asks what has caused the youth to become so flus/ tered. Yusuf makes an innocuous reply, but when Zulaykha emerges and sees the two men, she assumes that Yusuf has told her husband what happened inside. Taking the offensive, she accuses Yusuf of having raped her and insists that the aziz jail the youth. Yusuf protests his innocence and recounts how Zulaykha has continually pursued him and just attempted to seduce him in the palace. Zulaykha swears that she is telling the truth. Her tearful oaths totally deceive the aziz, who then orders Yusuf imprisoned until the truth can be learned.

As Yusuf is led to prison, he prays to heaven for his honesty to be revealed. The answer to his prayer comes from a totally unexpected quarter: a three/month/old baby belonging to a woman in Zulaykha's retinue. This infant, who has never so much as uttered a word, suddenly proclaims Yusuf's innocence in a loud voice and cautions the aziz against punishing the slave. The aziz listens dumbfounded while the baby urges him to check the tear in Yusuf's shirt. If it is torn in front, then Zulaykha is blameless and Yusuf is lying to save himself; if it is torn from behind, then Yusuf is innocent and Zulaykha is a perjurer. The aziz immediately takes this advice and examines the shirt. On discovering that it is torn from behind, he turns on his wife and curses her for straying from the path of honor and good repute. The aziz then releases Yusuf, asking him to keep his lips closed about the affair: "Do not tread the path of slander; it is better to draw a veil over this than to tear the veil in two."

Illustration
This dramatic revelation of innocence and guilt occurs in front of Zulaykha's palace, comprising a central iwan enframed in elaborate tilework, two flanking walls, and tiled terrace (fig. 89). The bearded aziz, wearing a bright yellow robe and gold embroidered cloak, stands under the archway. Holding a long spear, he turns backward to listen to the child held in the arms of a woman to the right. The infant witness, gesturing in speech and wearing a high, conical hat, looks more like a miniature adult than a suckling baby. As the aziz listens to the babe's testimony, Yusuf is escorted off the terrace by two guards, with swords hanging in scabbards from their waists (fig. 90). The lead guard is further armed with an ax resting over his shoulder. Both guards look back at their prisoner and perhaps beyond him to the infant. The leader twists his head back and upward in a very awkward position. A third armed man, barefoot and much rougher looking than Yusuf's two escorts, walks across the front edge of the terrace toward the left. A sword and long dagger hang from his waist. His curved insignia of office over his left shoulder identifies him as a stan/ dard/bearer. He, too, looks backward, possibly at the pair of male courtiers talking at right. Both figures are elegantly attired. The one closest to the right edge of the composition holds a finger to his mouth in astonishment. The activity on the terrace is observed from above by two women, one at each of two palace windows. Another woman stands next to the baby's mother at the right edge of the terrace.

89
The Infant Witness Testifies to Yusuf's Innocence
in the *Haft awrang* of Jami
963–72/1556–65, Iran
34.5×23.4 cm (folio)
FGA 46.12, folio 120a

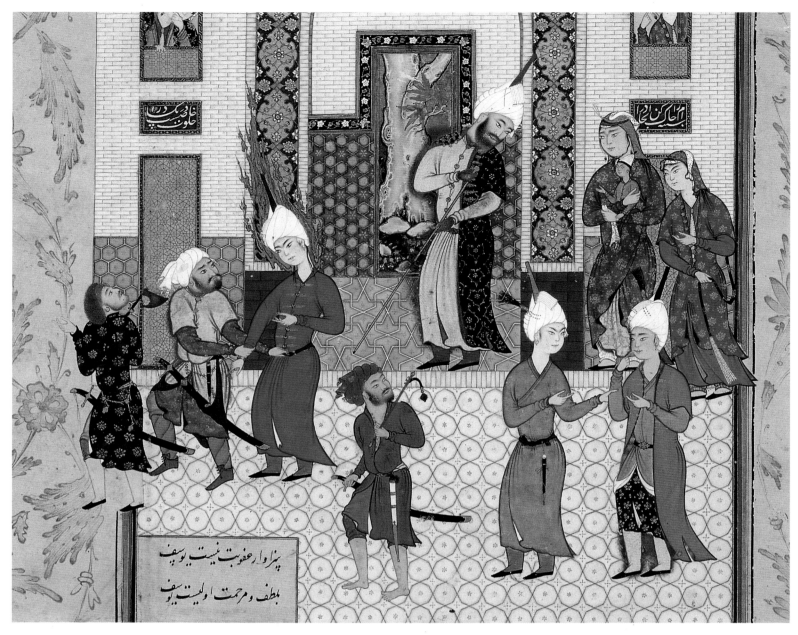

پنرا و ار عفونت نیست یوسف

بلطف و مرحمت اولیت یوسف

90
The Infant Witness Testifies to Yusuf's Innocence
(detail)
in the *Haft awrang* of Jami
963–72/1556–65, Iran
21.6×14 cm (painting)
FGA 46.12, folio 120a

As the iconography and incorporated verses suggest, this painting may depict the moment when the baby begins to testify to Yusuf's innocence. All the principals are present except Zulaykha; at least she cannot easily be identified as any of the four women in the scene, although she may be the figure leaning out the left-hand window and wearing a headdress similar to the one worn by the woman holding the infant witness. As in the preceding illustration (folio 114b), the representation is raised from the literal to the literary by verses inscribed on the palace facade. Written in orange nasta'liq on a blue band over the central arch is the following bayt, which is not from the *Haft awrang*:

دیده روشن مباد بی رویت

قبله خلق طاق ابرویت

May [no] eye be graced with light without [the sight of] your face;
The arch of your eyebrow is the qibla of the people.

Here is another inscription with a punning reference to the architecture on which it is written (the arch of an iwan) and its metaphorical counterpart (the qibla niche in a mosque). The couplet also amounts to a paean to Yusuf and his future position as a prophet.[1] The first misra' is particularly apt since Jami employs light images, including the sun and stars, throughout *Yusuf u Zulaykha* to describe his hero and stresses that joy and beauty are eclipsed whenever Yusuf is confined.[2]

Another inscription written over the left and right doors of the palace, with one hemistich over each door, is more enigmatic:

بسته ام راخاك كن درانجا

درخلوت خاصیست درابگشا

Tear [open] my breast [and] enter here.
It is a most private place of seclusion, open the door and come in.

This could be the palace talking, in the Islamic artistic tradition (particularly prevalent in medieval Iran) of objects proclaiming their function or worth.[3] It is more likely, however, that the verse refers to a mystical union with God or perhaps more specifically to Yusuf's resolve to maintain his purity.[4] It could also recall the imagery Jami employs to describe Zulaykha's palace, particularly the isolated inner chamber in which Zulaykha almost succeeded in seducing Yusuf, and anticipates the imagery the poet uses later to describe the nuptial chamber of Yusuf and Zulaykha, where their union is finally consummated.[5]

None of the few other known illustrations to this scene includes architectural epigraphs. All the compositions are generally similar, however, and the action always takes place on a terrace next to a palace or garden railing, with the aziz standing in the center listening to the infant witness held in the mother's arms. In one illustration Yusuf looks on from the side (BOD Marsh 431, folio 111b); in another he is led away by an armed guard (BL Or. 4535, folio 99a). Zulaykha's position also varies. In the London illustration she stands in front of the aziz and in the Oxford illustration next to the mother and child. The most elaborate representation, from the same manuscript that includes illustrations related to Freer Jami folios 105a and 110b (TKS H. 1084, folio 129b; fig. 91), expands the scene with a larger landscape and many more people.

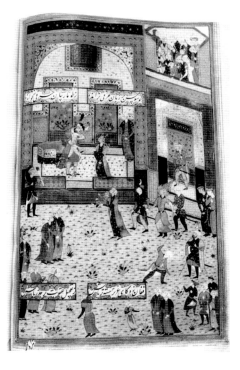

91
The Infant Witness Testifies to Yusuf's Innocence
in the *Yusuf u Zulaykha* of Jami
Late 16th century, Iran, attributed to Shiraz
40.3×26.6 cm (folio)
TKS H. 1084, folio 129b
Topkapi Sarayi Müzesi, Istanbul

Dimensions
21.6×14 cm (including extensions)

Incorporated Verses

One verse at top of illustration:

He cried aloud, "Oh aziz, move slowly,
Beware of the result of being hasty in judgment.

One verse at bottom left of illustration:

Yusuf does not deserve punishment,
Yusuf is worthy of your favor and mercy."

Signature
Signed in minute script to left of inscription over central arch:

كتبه شيخ محمد مصور

Written by Shaykh-Muhammad [the] painter

Attributions
Stchoukine: Group 2, Artist 2; S. C. Welch: Shaykh-Muhammad.

References
Dickson & Welch, 1:168B, 252B n. 12, fig. 229; Stchoukine, *MS*, 128;
S. C. Welch, *PP*, 25, fig. N.

Notes
1. Another such anonymous verse, in which the arch of an eyebrow shapes a niche like a mosque's mihrab, with similar panegyric overtones, appears above the royal iwan in folio 385b of the Tahmasp *Shahnama* (repro.: Dickson & Welch, 2: pl. 190, and discussion 542A).
2. Mudarris-Gilani, 640–41, 699–700. Conversely, wherever Yusuf is present, even in prison, he brings light and beauty (ibid., 704).
3. Tahmasp's *Shahnama* (folios 89b, 221a, and 442b) includes a similar inscription on three "talking buildings" (repro.: Dickson & Welch, 2: pls. 74, 135, 206, respectively). For the related phenomenon of talking objects, see Simpson, *Epic*, 327 and n. 69.
4. The idea of entering a secluded space, with its obvious Sufi connotations, is also expressed in a verse by Hafiz inscribed over a doorway in folio 89b of the Tahmasp *Shahnama* (repro.: Dickson & Welch, 2: pl. 74, and discussion 540B–41A).
5. Bricteux, *YZ*, 133, 196–97; Mudarris-Gilani, 725–28.

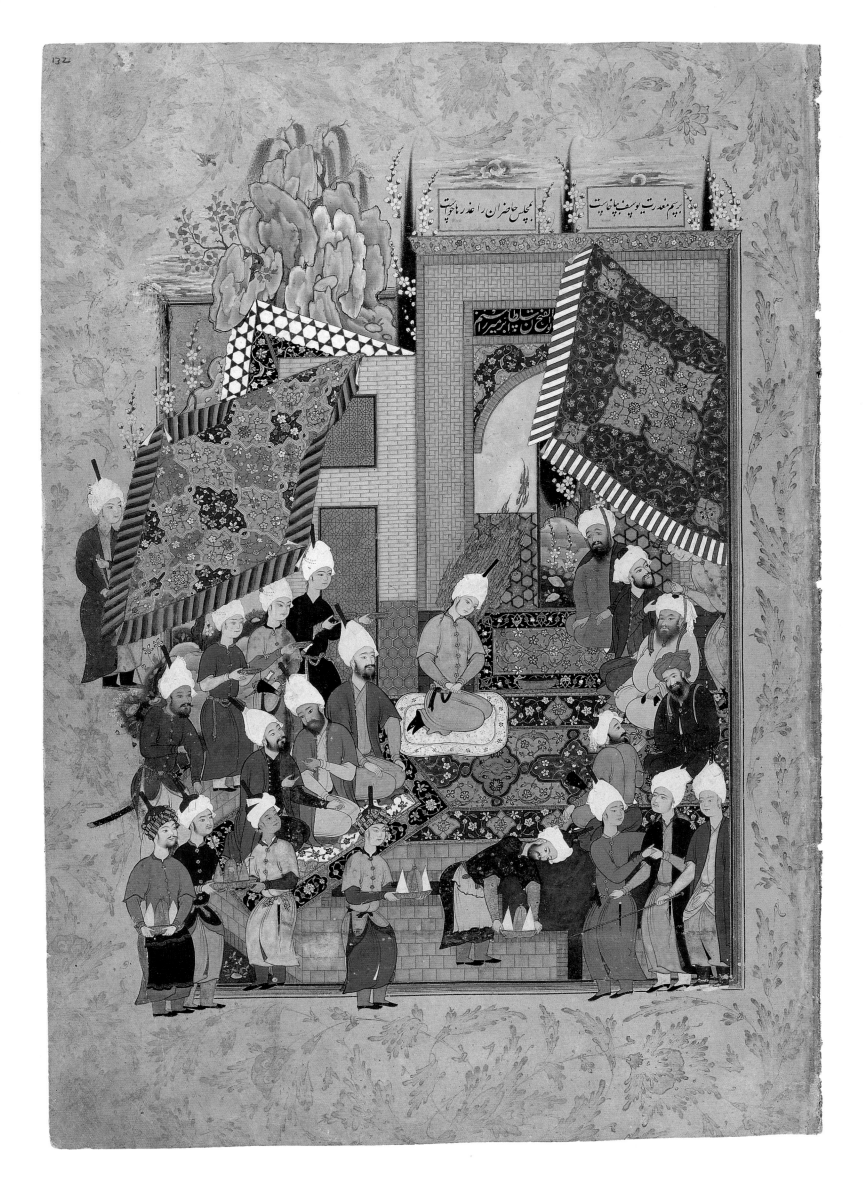

Folio 132a

YUSUF GIVES A ROYAL BANQUET IN HONOR OF HIS MARRIAGE

Text Source
Mudarris-Gilani, page 725.

Translations
Bricteux, *YZ*, page 195; Pendlebury, page 126.

Rubric before Illustration (folio 131b)

> The marriage of Yusuf, may peace be unto him, and Zulaykha by the order of God, and their marriage night.

Précis
After many years of suffering for Zulaykha and of honor and glory for Yusuf, the two meet again. Through his prayers, Yusuf can restore Zulaykha's sight, youth, and beauty. But when Zulaykha expresses her desire to live with him forever, Yusuf feels torn by his commitment to purity and his vow to help her. All hesitations are removed, however, when the angel Gabriel arrives with a message of divine approval.

Having received the command from God to unite himself to Zulaykha in marriage, Yusuf prepares a regal banquet to which he invites the king and all the dignitaries of Egypt. Then, according to the law of Abraham and Jacob, Yusuf and Zulaykha are married. Everyone showers the newlyweds with presents, and the king and his army offer their congratulations. Eventually Yusuf excuses himself to the assembly and sends Zulaykha to their nuptial chamber, where she waits in nervous anticipation. Finally bride and groom are alone together and consummate their marriage in long, passionate lovemaking. Yusuf is amazed that Zulaykha is still a virgin, and his ardor deepens when she tells him that she has kept herself for him. Zulaykha then asks her husband's pardon of her wickedness since it had been caused by her absolute love for him.

Illustration
Yusuf's wedding party consists of an all-male gathering in a richly appointed terrace setting (fig. 92). Yusuf occupies the most prominent spot in the assembly, kneeling on a small white rug at the left side of an iwan, his hands clasped together and his nimbed head bowed modestly. Guests and attendants surround the groom, with three bearded courtiers, two of whom clasp hands, seated on the left, and five bearded shaykhs or clerics, including a quite portly one, on the right. A young servant ducks out from under a large medallioned canopy to confer with one of the shaykhs. A rank of three youthful attendants carrying small golden bowls stands behind the courtiers. Next to them is an older, bearded retainer with a sword at his waist and a cane or crutch under his arm. These figures stand under a canopy decorated in interlaced medallions. It seems to be fastened at an upper corner to the top of the palace wall and supported by a pole at the upper corner. Standing outside the picture plane in the left margin, a young man with a staff peers from behind the canopy.

At the right edge of the terrace is a group of three young men. Two embrace and the third holds out a long stick at the level of their knees. A bearded servant bends down before this trio to place a golden platter on the terrace. This vessel contains traditional Iranian wedding sweets: two white sugar cones separated by a glass jar with two sticks of what may be dates. Waiting in the lower margin, a second, younger attendant holds another platter of the same sugar treats. Three other attendants, two holding yet another sugar platter and the third with a fourth platter, stand in the lower-left corner and look across at the young courtiers.

This wonderful painting illustrates the moment when Yusuf has sent Zulaykha to the nuptial chamber and remains behind for a time with his guests (fig. 93). It could easily be understood as a scene of the party in honor of the marriage of Jami's bride and groom were it not for the inscription over the iwan:

Abu'l-Fath Sultan Ibrahim Mirza

ابوالفتح سلطان ابرهیم میرزا

92
*Yusuf Gives a Royal Banquet
in Honor of His Marriage*
in the *Haft awrang* of Jami
963–72/1556–65, Iran
34.5×23.4 cm (folio)
FGA 46.12, folio 132a

The incorporation of the name of the patron of this manuscript into the architecture just above the head of the divine Yusuf is not simply an artistic conceit. Although this figure may not represent an actual portrait of Sultan Ibrahim Mirza,[1] it seems very likely that the iconography of the painting, like folio 100b, relates directly to the prince and specifically to his marriage to Gawhar-Sultan Khanim. Qazi Ahmad chronicles the events leading to and surrounding the marriage, including several gatherings of the Safavid court. There was, for instance, an occasion in Tabriz when Mir-Munshi, the emissary sent by Sultan Ibrahim Mirza to bring Gawhar-Sultan Khanim back to Mashhad, was received in a royal audience attended by scholars and learned men.[2] When the bride and her entourage of female relatives, advisers, and eunuchs arrived in Mashhad, several months of celebration followed until the marriage was consummated. While Qazi Ahmad's account does not mention any specific parties, it seems probable that the festivities would have included feasts of

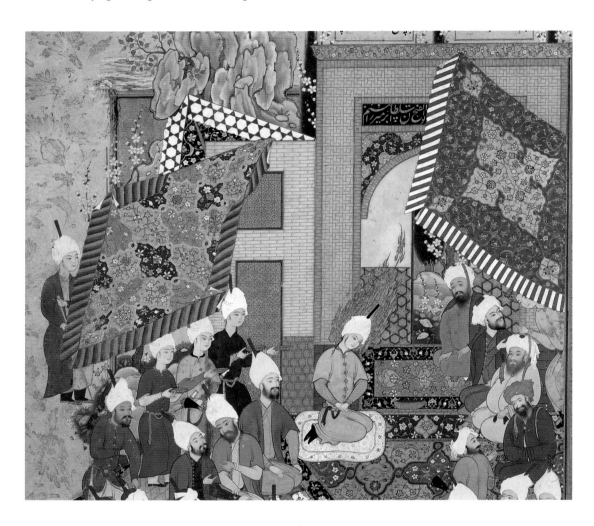

various kinds, including all-male affairs. One can imagine, for instance, that Sultan Ibrahim Mirza himself might have given a reception in honor of his bride's male escorts and invited clerics from the Imam Reza shrine in Mashhad. That folio 132a evokes such a fête would explain the absence of the king featured in Jami's narrative of Yusuf's banquet, since Shah Tahmasp did not make the trip to Mashhad with his daughter.[3]

Numerous copies of *Yusuf u Zulaykha* illustrate the subsequent moment in the narrative when the newlyweds are alone in their nuptial chamber. The actual wedding attracted little attention, however, perhaps because it constitutes but a brief prelude to the much longer and quite explicit account of how Yusuf and Zulaykha consummated their marriage. One of the few known illustrations of the wedding party, from a manuscript attributable to Shiraz in the second half of the sixteenth century, is a mediocre composition depicting Yusuf seated on a carpet with a man, possibly the king, who reaches out toward another man kneeling in front (WAG W.644, folio 150b; fig. 94). The scene includes a pen case and envelope in front of the person with whom Yusuf shares his carpet and two additional envelopes in front of some attendants. The purpose of these accessories is not explicated by Jami's text but may represent the marriage contract.

There is, in addition, a mirror-image copy of folio 132a. This is an album painting dating from around 1600 and attributable to Aqa Reza, a Persian artist who left Iran in the 1580s for India, where he worked for Prince Salim, later Emperor Jahangir (BSM I 4596, folio 19; fig. 95).[4] This version of Yusuf's wedding party replicates the composition of the *Haft awrang* illustration and suggests that Aqa Reza made a tracing directly from the original, which he subsequently reversed, probably for use as a pounce.[5] Having fixed the outlines of the scene, including the placement of the figures, based on the tracing from Ibrahim Mirza's manuscript, Aqa Reza then created an entirely distinctive painting with his own palette, textile patterns, architectural designs, and landscape features. He also gave many faces, including that of Yusuf, a pronounced Indian cast. Also noticeable is the absence of the young attendant standing just beyond the canopy that projects into the left margin of folio 132a. (It is always possible that this figure was trimmed off when the painting was mounted as an album page.) An equally telling change appears in the iwan inscription in which the name Ibrahim Mirza has been replaced with a formulaic invocation:

The Prophet said: "Peace be upon him."　　　　قال النبی صلاله علیه و سلمه

Aqa Reza obviously understood the reference to the *Haft awrang*'s patron in the original inscription and probably saw no need to duplicate it in his copy. He may even have been trying to conceal the source of his composition. Aqa Reza may also have been inspired to replicate the *Haft awrang* scene for a completely opposite purpose: to give his Mughal patron some idea of the glorious manuscript commissioned by Sultan Ibrahim Mirza and of the high quality of Safavid painting. Whatever the motivation, his painting provides further evidence of artistic appreciation for the *Haft awrang* within a Mughal milieu.[6]

Dimensions
27×19.4 cm (including top and side extensions)

Incorporated Verse

One verse at top of illustration:

*Making apologies, Yusuf rose
And excused himself to the assembled guests.*

Attributions
Stchoukine: Group 2, Artist 2; Titley: Shaykh-Muhammad; A. Welch: perhaps Shaykh-Muhammad; S. C. Welch: Shaykh-Muhammad.

References
Chiesa 3, lot no. 447, with repro.; Dickson & Welch, 1:47B, figs. 48, 230; Kevorkian & Sicré, 180–81, with repro. color; Najam, 64, with repro.; Stchoukine, *MS*, 128; Titley, *PMP*, 106; A. Welch, *Artists*, 112–13, fig. 34; S. C. Welch, *PP*, 112–13, with repro. color.

Notes
1. Dickson & Welch, 1:47B, fig. 48; Titley, *PMP*, 106; S. C. Welch, *PP*, 113; S. C. Welch, *WA*, 28.
2. Qazi Ahmad [Ishraqi], 1:415.
3. Tahmasp and Ibrahim Mirza apparently were not together at any point during the prenuptial negotiations or marriage celebration.

S. C. Welch (*WA*, 28) also sees a connection between folio 132a and Ibrahim Mirza's court at Mashhad, although without specific reference to the prince's marriage. He suggests that this illustration, which he attributes to the artist Shaykh-Muhammad, whose father was a Sufi, should be interpreted in a mystical light with the beautiful youth (whom he sees as both Yusuf and Ibrahim Mirza) representing the *shahid* (witness of divine beauty). "To contemplate his face in this form of Sufi meditation, known as *nazar*, is a kind of worship, and adoring him from a distance might induce true ecstasy." Although the pictorial program of the Freer Jami reflects the mystical themes central to Jami's masnavis (and contained in Ibrahim Mirza's own poetry), it is difficult to apply such an interpretation broadly.
4. The painting forms part of a group of albums assembled or acquired in India during the mid-eighteenth century by a Swiss engineer named Antoine Louis Henri de Polier and bought by the Museum für Islamische Kunst, Berlin, in 1882 (for an account of these albums, see Enderlein, 5–9]). It has been published by Ettinghausen, "Indische," 169–70 (but without reference to FGA 46.12, folio 132a). See also Chapter One, Documentation, and Appendix B under Ettinghausen. The painting measures 27.7×18 cm, a slight variation from the dimensions of the Freer Jami painting (27×19.4 cm). For Aqa Reza, see Beach, *Grand Mogul*, 92–94, cat. nos. 24–25; *EIr*, Priscilla P. Soucek, "Aqa Reza Heravi"; Losty, cat. no. 75; Okada, 105–11; Soucek, "Artists," 175–79.
5. A similar scenario has been proposed in relation to a mirror-image drawing (SOTH 29–30.IV.92, lot 291 [repro.: ibid., 129]) and a fully painted album painting (in an album made for Jahangir; Berlin, Staatsbibliothek Preussischer Kulturbesitz, Orientalabteilung, Libr. Pict. A117, fol. 14r; see S. C. Welch, *KBK*, 172–83 [repro.: Adle, "Dust-Mohammad," pl. XVI, fig. 20]) copied from the illustration *Haftvad and the Worm* in the Tahmasp *Shahnama*. The link between these two works and the *Shahnama* original is not direct, however, and they may have depended on a yet another version of the scene, as proposed here for the two versions of FGA 46.12, folio 105a.
6. Aqa Reza also may have drawn on the Freer Jami for stylistic inspiration when painting two compositions bound into the Gulshan Album in Tehran. See Beach, *Grand Mogul*, 92–93. Soucek ("Artists," 177) has commented on Aqa Reza's "use of paintings to convey personal messages to his patrons."

Subhat al-abrar

The *Subhat al-abrar* (Rosary of the pious) was written around 887/1482–83 in honor of the Timurid ruler Sultan-Husayn Mirza.[1] This didactic masnavi consists of forty sections, each composed according to the same tripartite pattern. A discourse or aqd on a specific theme precedes an illustrative anecdote introduced to clarify the aqd. A *munajat* (prayer to God) concludes the theme of the aqd and often provides a transition to the next discourse.

The principal subject of the *Subhat al-abrar* is the progression of the soul toward union with God. Specific themes include, in aqds one through seven, the purification of the heart to admit God; speech, particularly versed speech, as the "noblest pearl of humanity" (FGA 46.12, folio 147a); the uniqueness of God and the proof and essence of His existence; and the nature of Sufism. The following eleven aqds describe stages in reaching Truth and attaining God's pleasure: intention, renunciation, abstinence (FGA 46.12, folio 153b), piety, spiritual poverty, patience, gratitude, fear, hope, and trust. The nineteenth through thirtieth aqds treat the subsequent stations of loving (FGA 46.12, folio 162a): delight, zeal, intimacy, modesty, freedom, liberality, truthfulness, sincerity, generosity (FGA 46.12, folio 169b), contentment, and humility. The next three aqds describe "some virtues of humankind," including wisdom, openness, and loving others. The thirty-fourth describes sama', the ritual Sufi dance, and the thirty-fifth through thirty-seventh concern kings, viziers, and subjects. In the final three aqds Jami offers advice to his son and to himself and then begs his readers to react favorably to the *Subhat al-abrar* (FGA 46.12, folio 179b).[2]

Some apologues to Jami's aqds feature historical personages, including prophets (Abraham, Moses, Joseph, and Jesus), authors (Ghazali, Sa'di, and Sana'i), and rulers (Nushirvan). Others involve generic characters: philosophers and kings, pirs and devotees, lovers and beloveds, slaves and masters, Persians and Arabs, townspeople and gardeners, wise old men and foolish boys. Several anecdotes take the form of animal fables. The sixth aqd, for instance, which explains that "the essence of divine Truth is existence itself," is accompanied by the tale of fish who set out in search of the ocean, only to lose their way and become stranded on dry land. A few struggle half-dead into the ocean and come to life in the "ocean of witnessing."[3]

Much of the philosophical and ethical content and many of the literary devices of the *Subhat al-abrar* appear in Nizami's *Makhzan al-asrar*, circa 572/1176–77, the first epic poem in his *Khamsa*, and in Amir Khusraw Dihlavi's *Matla' al-anwar* (Rising of the lights), 698/1298–99. Jami's version of 1482–83 was likely informed by these earlier works.

CHAPTER TWO: POETRY AND PAINTING

1. The source for the masnavi text is Mudarris-Gilani, 445–575.

2. The final passage of the *Subhat al-abrar* as given in the Mudarris-Gilani edition (pp. 575–76: "the ending of the book") is omitted from the Freer Jami (folio 181a). It appears instead at the end of *Salaman u Absal* (folio 199a). This passage is a panegyric to the Aqqoyunlu ruler Ya'qub, in whose honor Jami wrote *Salaman u Absal*. The switch of these final verses from one masnavi to another is more likely a modern editorial transposition than an original scribal error.

3. Mudarris-Gilani, 475–77.

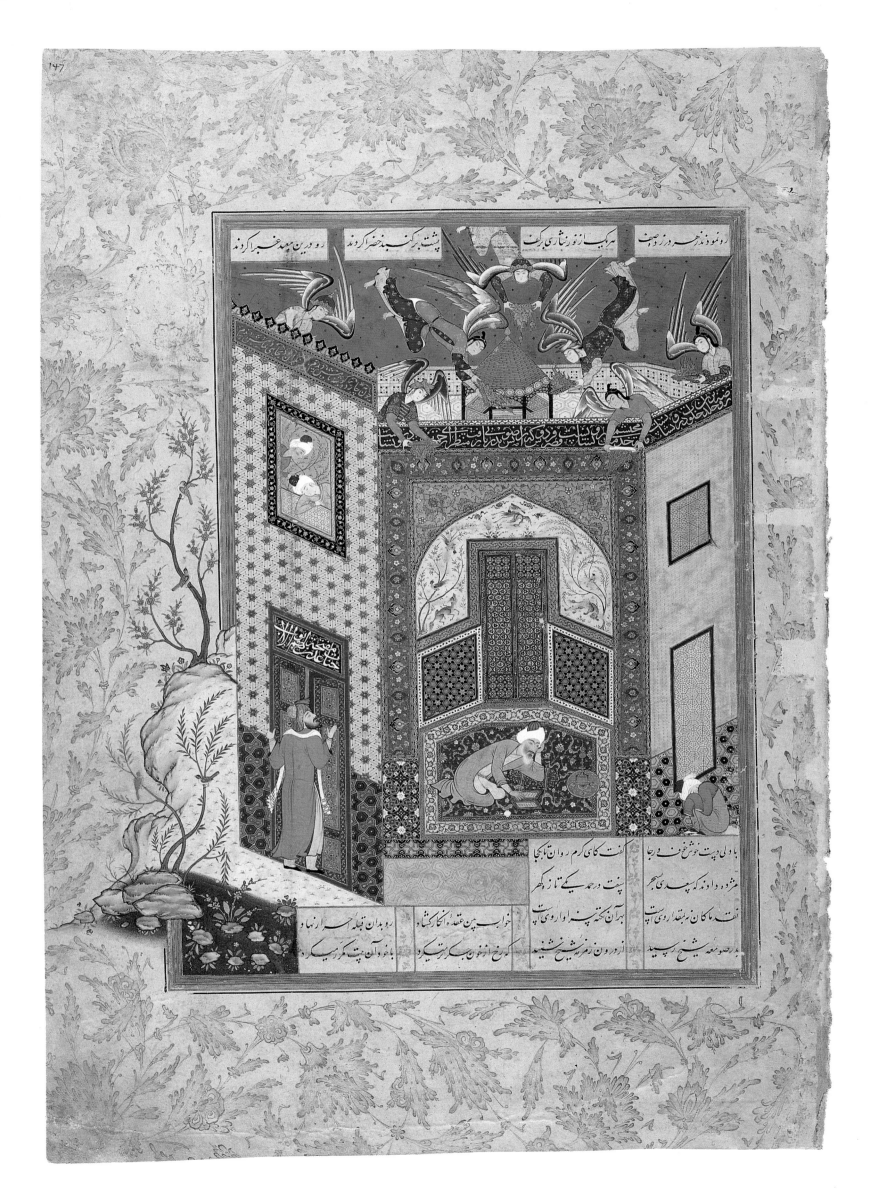

Folio 147a

THE GNOSTIC HAS A VISION OF ANGELS
CARRYING TRAYS OF LIGHT TO THE POET SA'DI

Text Source
Mudarris-Gilani, pages 467–68.

Rubric before Illustration (folio 146b)

The story of Shaykh Muslihuddin Sa'di, may God rest his soul, who when he said this verse:

> *A leaf of green trees, in the sight of the intelligent [person],*
> *Is a volume for knowing the creator*

one of the great [Sufis] saw in a vision a group of angels carrying trays of light as a gift for him [Sa'di] and another person who scoffed at him saw that very same thing in a dream.

Précis

One night the poet Sa'di of Shiraz writes a bayt in praise of God. This verse is so moving that "the soul found in it glad tidings of the beloved, the intelligence found in it a ray of spiritual learning." A gnostic, troubled in his belief in the divine, dreams of a group of angels coming down through the gates of heaven to earth and carrying coins of light. The gnostic asks the heavenly spirits where they are going, and they reply that Sa'di has written a new verse of praise and that they are taking a gift from heaven to him. He then goes to the door of Sa'di's cell and hears the poet reciting the very bayt for which he was rewarded by the angels in the dream.

The lesson of this tale may be that pious or mystical poets have the capacity to produce works of great spirituality and assuage the doubts of those seeking enlightenment. The story of the gnostic's dream follows the third aqd of the *Subhat al-abrar* concerning "versed speech which is more excellent than poetry." This aqd concludes with a description of the pure and divine nature of poetry and is bracketed by two munajat prayers on the same theme. The first munajat is on "the deficiency of speech in describing divine action." The second gives "thanks for metered speech and for [Jami's] success in demonstrating the existence of God."

Illustration

The illustration depicts Sa'di reading in his cell at night with the gnostic at the door and a group of angels on the roof under a starry sky (fig. 96). The poet's abode is a splendid structure, with a central iwan, rooftop lantern, and two flanking walls of different heights, all richly embellished with geometric tiles, floral designs, and landscape paintings. The architectural decor also includes three inscriptions. One wrapping around the cornice level of the right wall and iwan and another at the cornice of the left-hand wall are poetic verses. The third above the door at left is from the Koran.

The bearded gnostic, wearing a *futa* (prayer shawl) around his shoulders, presses against Sa'di's door with outstretched hands. He looks up, as if reading the Koranic inscription above or listening intently for sounds from within. Sa'di reclines inside the iwan on a beautiful carpet woven with blossoms and ribbons, his left side and elbow resting on a gold embroidered bolster. He appears deep in thought, perhaps contemplating the words written on the book over which he leans and holds open with his right hand. A lighted candlestick burns in front of the poet, while outside a boy hunches over in sleep, his face buried in his crossed arms and long dangling sleeves. Another youth sleeps at the window supported by a wooden *mashrabiyya* (screen). His companion, who leans over him from the left, seems about to lift or pull off his turban. The most active figures in the composition are the angels swooping down and alighting on the rooftop. All have brilliant, multicolored wings and wear their hair knotted on top or covered with crowns or petal headgear. Six carry flaming trays. A seventh, peering down over the parapet at left, seems to have arrived empty-handed.

96
The Gnostic Has a Vision of Angels Carrying Trays of Light to the Poet Sa'di
in the *Haft awrang* of Jami
963–72/1556–65, Iran
34.5×23.4 cm (folio)
FGA 46.12, folio 147a

In its iconographic ensemble this painting reveals considerable artistic sensitivity to the theme of the pure and divine nature of poetry (fig. 97). The idea of a verse, such as the one Saʿdi has composed, as a source of spiritual enlightenment is implicit in the angels' flaming trays. While these obviously illustrate radiant rewards from heaven, they also signify the guiding light so admired in Saʿdi's bayt. The verses inscribed on the building also reinforce the general theme of the third aqd and accompanying prayers and bear directly on the content of the anecdote. The Koranic verse over the door, for instance, is from sura 38:50 concerning the divine punishment of disbelievers:

Gardens of Eden, whereof the gates are opened for them جنات عدن مفتحة لهم الابوب

The complete passage describes the rewards of paradise, reserved for all true believers on the "day of reckoning," and the torments awaiting the insolent. Clearly Saʿdi is considered as blessed and the gnostic as one who has heeded the word of God and escaped the tortures of the damned.

The theme of paradise and specifically the garden of paradise as the abode of dervishes is also developed in the two partially obscured rubaʿi verses on the cornice over the right side of the building and over the iwan beneath the angels bearing celestial gifts.

روضهٔ خلد برین خلوت درویشان

مایه محتشمی خدمت درویشانست

قصر فردوس که رضوانش بدربانی رفت

منظری از رحمت درویشانست

The solitary retreat of the dervishes is the garden of paradise above;
To serve dervishes is the leaven of pomp [meritorious].

The castle of paradise to which Rezvan is the gatekeeper[1]
Is a belvedere for the mercy of the dervishes.[2]

Again, the association is with Saʿdi, who has arrived in paradise and received divine mercy. The small belvedere on the rooftop where the angels alight may be a pictorial analogue to the word *fazr* (belvedere), used in the rubaʿi below to describe the castle of heaven. Finally, the verse, which may be the beginning of a ghazal, at the left-hand cornice refers to seeing the beloved.

چون چهارده گوشه نامش دیدم

نگران بود بجابی و تماشم دیدم

When I saw him like the full moon at the edge of the roof,
He was looking for something, and I saw him complete [like the full moon].[3]

97
The Gnostic Has a Vision of Angels Carrying Trays of Light to the Poet Saʿdi (detail)
in the *Haft awrang* of Jami
963–72/1556–65, Iran
23.1×16.7 cm (painting)
FGA 46.12, folio 147a

Here, too, the verbal and visual combine. In the first distich the lover sees the beloved, just as the gnostic at the door looks up to see the youth, a standard symbol for the beloved, and the angel above the cornice. Thus the specific message of the *Subhat al-abrar* anecdote and the details of the illustration join with the general Sufi theme, developed throughout the *Haft awrang*, of union with the divine.

Other illustrations of this text include a simplified version of the Freer composition with Sa'di kneeling on a rug inside a chamber and raising his hands in prayer (TKS R. 898, folio 26b). Two other verifiable illustrations, both from manuscripts attributable to Bukhara in the first half of the sixteenth century, differ significantly from the Freer Jami, although they dispose their figures around a tall, central iwan (IM 5028.1.79, folio 16b; and KNM LNS 16 MS, folio 76a). In both pictures a pair of angels showers gems from above, while one graybeard, presumably Sa'di, dances and another, presumably the gnostic, looks on from the side. The sama' dance does not figure in the passages describing versed speech, and its representation in these two Bukharan pictures suggests a lack of familiarity with the third aqd or a deliberate expansion of the interpretation of this aqd by equating dance with poetry.[4]

Dimensions

23.1×16.7 cm

Incorporated Verses

Two verses at top of illustration:

> *They came forth from each door in ranks.*
> *Each carried a nithar of light in his palm.*[5]
>
> *They turned their backs to the green dome [heaven].*
> *They advanced to this dusty place of worship [earth].*

Six verses at bottom of illustration and one omitted verse:

> *With a heart filled with fear and hope*
> *He said, "Oh, where are you going so speedily?"*
>
> *They said, "Sa'di at dawn*
> *Pierced a new pearl of praise [wrote a new verse].*
>
> *[So that the evil eye not afflict him,*
> *An ear-satisfying gift from heaven is appropriate.]*
>
> *[All] the cash in [worldly] existence is not of enough value*
> *For that utterance of his [filled with] divine mysteries."*
>
> *The dreamer loosened the knot of denial*
> *And turned to that qibla of the free.*
>
> *He came to the door of Shaykh [Sa'di's] cell*
> *And within he heard the Shaykh murmuring*
>
> *Which [was so moving it] would stain the face with the liver's blood:*
> *He [Sa'di] was repeating that bayt to himself.*

Attributions

Stchoukine: Group 1; S. C. Welch: Painter D (Abdul-Aziz?).

References

Dickson & Welch, 1:224A, fig. 272; Papadopoulo, pl. 56; Stchoukine, *MS*, 127; S. C. Welch, *PP*, 25, fig. O.

Notes

1. Rezvan is also the gatekeeper and gardener of paradise. Dihkhuda, *Lughatnama*, رذوان, 496.
2. Translation by Wheeler Thackston.
3. Translation by Wheeler Thackston.
4. Schimmel, *MD*, 178–86, discusses the sama' dance.
5. Nithar are coins and jewels strewn at a wedding, as discussed with reference to FGA 46.12, folio 100b.

Folio 153b

THE PIR REJECTS THE DUCKS BROUGHT AS PRESENTS BY THE MURID

Text Source
Mudarris-Gilani, page 489.

Rubric before Illustration (folio 153a)

> *The story of how the abstainer from water [pious ascetic] refused to accept a waterbird hunted by a falcon as food not to be eaten.*

Précis

To save his soul, a powerful monarch becomes the murid (pupil) of a pious dervish. The king takes a hundred gifts to his master, who accepts none. One day the king goes hunting and catches several ducks with his falcon. These he also offers to the pir, only to be spurned again. In the eyes of the ascetic, the king lives by tyranny, so nothing he does is right and nothing he touches is pure.[1]

The tenth aqd, which this anecdote illustrates, concerns the discovery of "the secret of scrupulous abstinence from anything wrong or doubtful, which breaks the back of greed and ambition." The subsequent munajat prayer says that "true renunciation [means] turning away from the world and seeking God's truth in the station of piety." This prayer also serves as a transition to the next aqd on ascetic piety.

Illustration

The encounter between pir and pupil takes place at a cave in the middle of a rocky hillside (fig. 98). The white-bearded ascetic, gaunt and bareheaded, kneels inside the entrance to the cave and gestures to a dead duck lying on its side. In front to the left is a small buff-colored, double-handled vessel with a spigot, which may have been one of the king's previous offerings.[2] From the top of the cave hangs a leather water bottle, its expanded sides indicating the pir's abstinence. To the left of the cave stands a dark-skinned man, whose slender frame and humble demeanor mark him as a disciple to the pir. The king, in elegant attire, kneels immediately outside the cave, with his falcon perched on one gloved hand. Behind him stands a youthful attendant, who holds a second falcon beating the air with its wings. Three other pairs of royal retainers approach the cave up a sloping path. One pair, a youth wearing a tall turban and an older bearded assistant, carry a large fowl between them. Behind them and to the side of the rocks marking the path's edge, two other men follow each other. The older, bearded one to the rear may be having difficulty getting up the hill since he clutches a staff with one hand and the arm of his young companion with the other. Two grooms wait at the bottom of the path, holding the king's dappled horse.

The landscape around the cave teems with animals and people, many of whom are engaged in hunting. Toward the top left a bearded hunter, mostly concealed in the rocks, aims a musket at a bear. The unknowing prey, its back turned, stares down at a fox who returns the gaze. On the other side of a large plane tree and precipice another royal attendant with a falcon straddles a large boulder and looks back down at another falconer, whose attention is fastened on a mountain goat at right. Immediately below, two boys scale the rocks, one leaning over to haul up his companion. To the right another boy attempts to restrain an eager Saluki hunting dog. Among the rocks at the lower left a bearded hunter leans over to bash a snow leopard with a mace, under the gaze of a white fox. Three other figures occupy this rocky outcropping: an older bearded man cautions a younger boy to be silent (perhaps so as not to disturb the hunter), while a second youth holding a cloth scabbard over his shoulder turns back to observe two men carrying the live duck up to the cave.

The many falconers and hunters may be the normal retinue of a royal hunting party. They may also serve to reiterate the point about the king's intrinsic unworthiness (since he engages in and supports hunting) as contrasted with the pir's abstinence and purity.

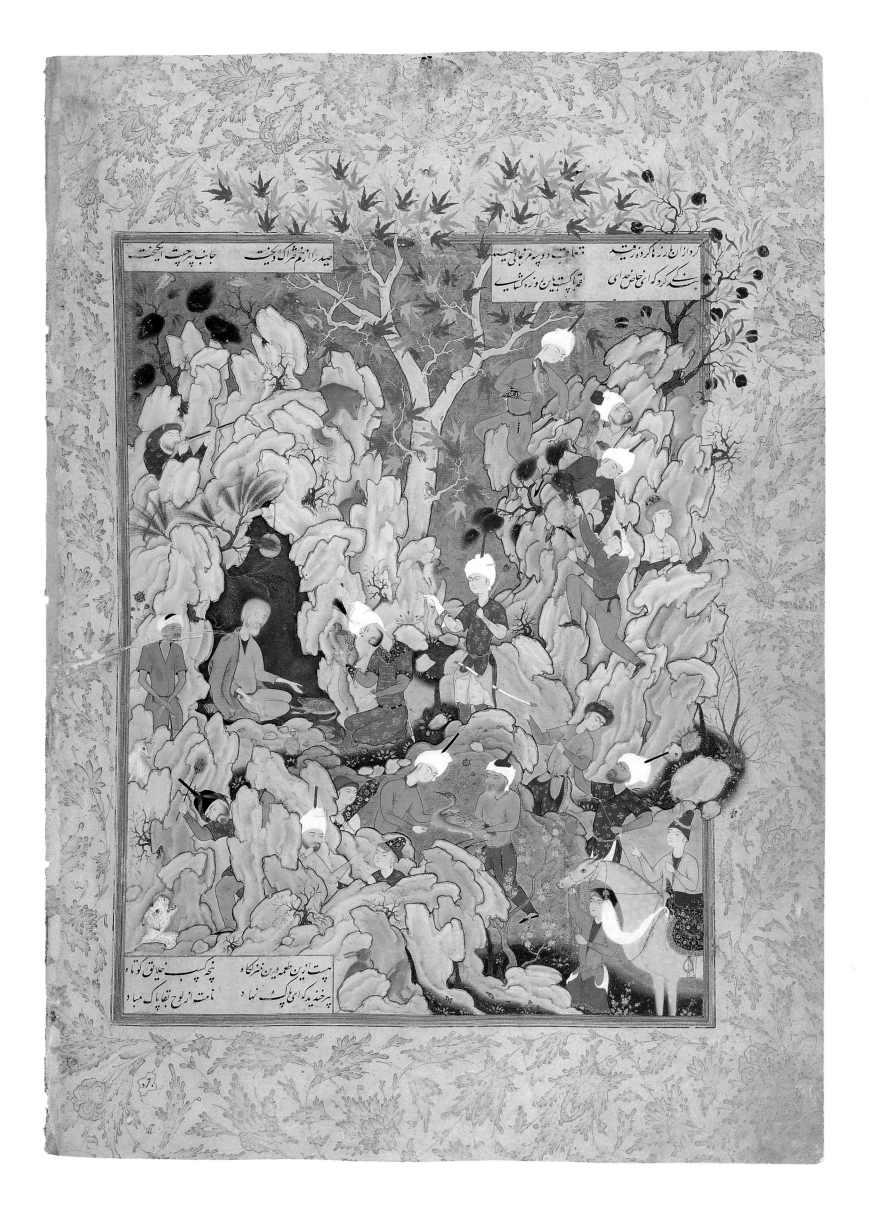

Considerable variety marks the few other known illustrations to this episode. One illustration, from a *Haft awrang* executed in Khurasan in Dhu'l-qa'da 971/June 1564, depicts the prince mounted on horseback with a live bird (clearly neither a duck nor a falcon) perched on his right hand (PWM MS 55.102, folio 146a). The prince also remains mounted in another composition in a Shiraz manuscript from the second half of the sixteenth century (TKS R. 898, folio 48a). Yet another painting offers a much closer comparison with the Freer Jami (SOTH 13.IV.76, lot 167). The work is so similar in composition, iconography, and style that it could be a copy of folio 153b. Unfortunately it has been skillfully repainted in later Mughal style, compounding the difficulty of evaluating its relationship to the Freer Jami.[3]

The iconography and style of folio 153b are also quite comparable to the left side of a double-page frontispiece pasted into a *Subhat al-abrar* manuscript copied by Sultan-Muhammad Khandan (GULB LA 159, folio 2a; fig. 99).[4] In composition, landscape setting, and individual features—falconer climbing a rocky crag at lower left, musketeer, pair of figures in conversation at right, pose and appearance of the pir, bearded prince, horse, and groom at lower right—this painting is very close to the Freer Jami. The theme of a princely visit to a hermit continues in another double-page frontispiece to a poetic anthology copied by Muhammad Husayn al-Husayni at Qazvin in Dhu'l-hijja 982/March–April 1575 (SOTH 6.XII.67, lot 206).[5] Here the setting and relationship of the principals also relate generally to folio 153b.

Another, perhaps even more relevant, painting appears in a posthumous copy of the *Divan* of Ibrahim Mirza (SAK MS 33, folio 23a).[6] It is signed by the artist Abdullah al-Shirazi and dated 990/1582–83. Although considerably more compact and concentrated, this composition contains the same principal figures—pir, prince, humble disciple, royal horse, and groom—as the Freer Jami, disposed in virtually the same setting and relationship. It also depicts a royal retainer with a bow similar to the one in the *Subhat al-abrar* frontispiece. It is likely that Abdullah was familiar with the Freer Jami painting and drew from it to create his *Divan* composition.

99
A Prince Visits a Hermit
(left half of a double-page frontipiece)
in the *Subhat al-abrar* of Jami
ca. 1575–80, Iran, attributed to Mashhad
21.7×14.5 cm (folio)
GULB LA 159, folio 2a
Calouste Gulbenkian Foundation, Lisbon

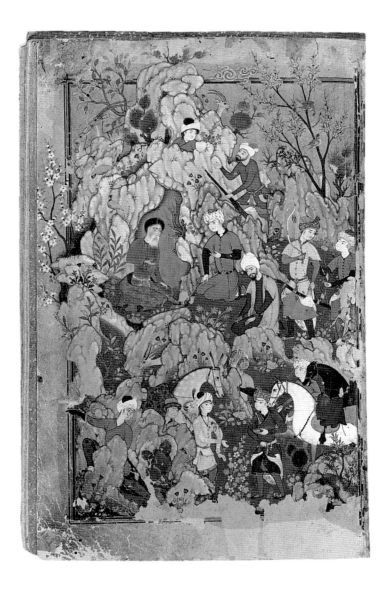

Dimensions
23.9×17.4 cm

Incorporated Verses

Three verses at top of illustration:

> *Released from its constraints,*
> *The falcon pursued two or three ducks as prey.*
>
> *He hung the catch from his saddle loop*
> *[And] spurred his mount off toward the pir.*
>
> *He made obeisance saying, "Oh special friend of God*
> *This is a clean morsel, break your fast with it.*

Two verses at bottom of illustration:

> *This morsel, in this halting place*
> *Has not been touched by the grasping fist of human gain."*
>
> *The pir laughed, "Oh, pure of nature,*
> *May your name never be erased from the tablet of eternity."*

Attributions
Stchoukine: Abdullah al-Shirazi (*MS*, 126), and Group 2, Artist 1 (*MS*, 128);
S. C. Welch: Mirza-Ali.

References
Dickson & Welch, 1:141B, fig. 202; Ettinghausen, "Choice," fig. 13;
Kevorkian & Sicré, 172–73, with repro. color; Stchoukine, *MS*, 126–27, 128;
S. C. Welch, *PP*, 27, 114–15, with repro. color.

1. The same anecdote appears in Shaykh
Ala'uddawla Simnani's *Risala-i Iqbaliah* (Treatise
by Iqbalshah), which Jami may have known or
borrowed. See Thackston, *Simnani*, 190.
2. This vessel may be Chinese and is reminiscent of
a type sometimes referred to as *yue ping* (moon
flask). See, for example, Carswell, cat. no. 15;
Pope, *Ardabil*, pl. 69. Vessels of this type (but
without the spigot) were also made in Safavid Iran,
as evidenced by seventeenth-century examples (WAG
W.48.1191; VA 991.1876 [repro.: Rogers, *IAD*, cat.
no. 153]).
3. Repro.: SOTH 13.IV.76, facing p. 34. It is not
possible to verify if this painting illustrates the same
text as folio 153b.
4. Gray, *OIA*, cat. no. 126. Stchoukine (*MS*, 126)
first made the comparison with FGA 46.12, folio
153b.
5. Repro.: SOTH 6.XII.67, facing p. 71. See also
Canby, *PP*, 84, fig. 51, for another example of the
same theme.
6. Repro. color: *Treasures*, cat. no. 77.

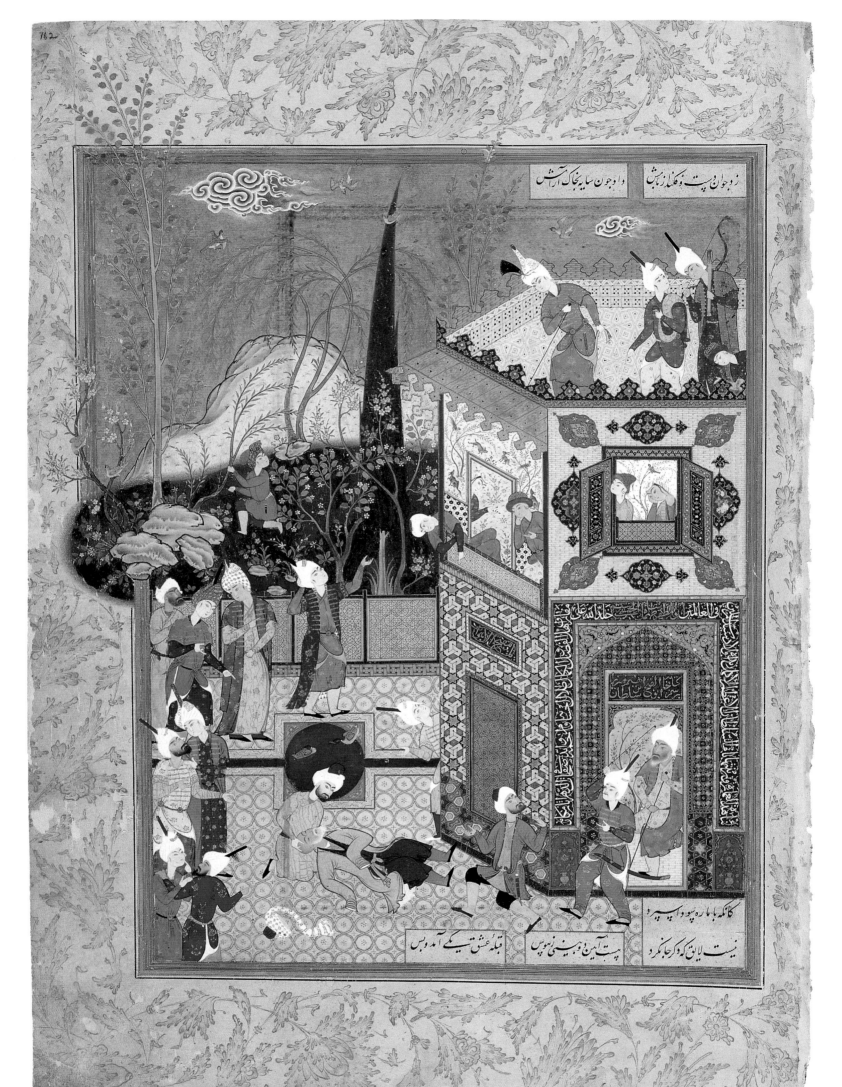

Folio 162a

THE FICKLE OLD LOVER IS KNOCKED OFF THE ROOFTOP

Text Source
Mudarris-Gilani, pages 515–16.

Rubric before Illustration (folio 161b)

> *The story of that crooked-back old man who on the path of love did not stand upright [behave properly] and who, because of his own crooked behavior regarding his beloved, came to see straight.*

Précis

A beautiful fourteen-year-old boy stands on the edge of a roof, flirting with the suitors assailing his dwelling. Suddenly a crooked-back old man approaches, loudly declaring his passion for the youth. In reply, the boy tells him to turn around and look at someone even more beautiful. As the old man moves to follow this directive, the youth knocks him off the roof and he falls flat on the ground. The violent rebuff is intended to straighten the old man out and teach him that it is impossible to have more than one love.

The nineteenth aqd of the *Subhat al-abrar* concerns "loving which is the heart's inclination toward studying the perfection of qualities and the attraction of the spirit toward witnessing the beauty of essence." The moral of the accompanying anecdote about the foolish old man, who is obviously crooked in spirit and body, is that love exists only in unity and there is no room for double vision.

Versions of this apologue appear in other masnavis of the *Haft awrang*. The *Silsilat al-dhahab*, for instance, contains an anecdote about a youth who tests an aged suitor by telling him to look at his even more beautiful brother. When the old man does so, the youth throws him off the roof.[1]

Illustration

The painting records the moment when the fickle old man has landed on the ground beneath the youth's roof (fig. 100). The building from which he has been pushed is a two-story hexagonal structure, surrounded on the front and left side by a tiled terrace with a square pond, water channels, and a wooden-screen fence, behind which is a grassy area of trees, flowers, and rocks and a tufted plain that rises to a gold sky. A young boy kneels in the middle of the lawn next to a sapling, apparently about to cut it down with a knife but diverted from his task by the commotion on the terrace.[2] The rooftop is occupied by a pair of youths, one equipped with a bow and quiver and the other pointing downward, who obviously are discussing the action below, and a crouching companion who bends down and peers over the crenellated parapet. Standing apart from this trio and at the corner of the roof, another young man leans on a staff and looks down at the old man on the terrace. His stance and elegant attire mark him as the main protagonist of Jami's anecdote. Several others also look down from vantage points on the building's second story. The best view must be from a balcony on the left. There one young man hangs over the railing from a reclining position while a woman with hennaed hands emerges from the balcony entrance and a boy leans forward with his finger to his mouth. Just beneath the balcony at the corner of the building a young man cranes his head upward, as if to tell those above what is going on. Another boy and woman peer over the wooden barrier of the window above the entrance. Rushing past the door is a man raising a staff as if to strike the bearded figure in front, who prances out of the way with his hands held up to ward off the impending blow. An impassive graybeard at his post just inside the entry observes the scene. In a symmetrical composition, two large hares flanked by a pair of foxes eyeing peafowls in the branches above decorate the wall around the balcony entrance. The startled demeanor of the hares and watchful pose of the foxes may have been deliberately intended to parallel the behavior of the participants in the *Subhat al-abrar* incident.

The rejected white-bearded lover lies flat on the ground at the side of the building, his bare head cradled in the lap of a man who has come to his aid. Groups of male figures, who gesticulate and converse in great animation, surround these two figures. Bystanders include an elegant youth who raises his left arm toward the roof while holding his turban steady with his other hand. This posture

100
The Fickle Old Lover Is Knocked off the Rooftop
in the *Haft awrang* of Jami
963–72/1556–65, Iran
34.5×23.4 cm (folio)
FGA 46.12, folio 162a

may intentionally contrast with the position of the old man, whose striped turban has unraveled in his fall and come to rest upside-down at the lower edge of the terrace.

Although the building that serves as the stage for this lively scene is compact, every surface is decorated in distinctive materials, designs, and colors to animate the composition.[3] Particularly striking are the eight large and colorful medallions—more familiar perhaps from carpets, illuminations, and bookbindings than architectural decor—surrounding the second-story window to the right. Three inscription bands are also noteworthy. The panel high on the first-story wall at left is an Arabic exclamation and household blessing of Koranic origin regularly inserted into the decoration of doorways and other openings in Safavid painting.[4] The other two inscriptions are similar to those on folio 38b. The short epigraph in a rectangular panel over the doorway refers to Sultan Ibrahim Mirza and the longer one enframing the entranceway to his uncle Shah Tahmasp. Besides evoking God's blessing on the king, the latter mentions the construction of a building by order of Tahmasp. The palatial edifice in this composition may replicate a structure of the period.[5] It is more likely, however, that the building represented here provided a convenient place to flatter the monarch.[6] This does not exactly explain, however, why this illustration includes inscriptions documenting its patron and his monarch. As with the other pair of historical epigraphs on folio 38b, the main purpose may be to proclaim the relationship between Ibrahim Mirza and Tahmasp. It may be telling, however, that both inscribed paintings illustrate anecdotes concerning a foolish old man.

The incorporation of documentary evidence into an elaborate architectural structure is the principal difference between the representation of the crooked old lover being pushed off the roof in the Freer Jami and the treatment of the same scene elsewhere. This *Subhat al-abrar* anecdote was illustrated with some frequency in sixteenth-century manuscripts attributed to various artistic centers. The iconography is of two types. Most known paintings depict the fickle man falling head-first alongside the building (e.g. TKS H. 810, folio 155a; fig. 101). Several other examples have the old man resting on the ground (BOD Elliot 186, folio 54b; ÖNB Mixt. 1614, folio 62b; and TKS H. 804, folio 49b, which depicts the old man lying in the margin of the folio beyond the primary picture plane). As in the Freer Jami, all the paintings include a tall building, with the youth standing on the roof looking down at the falling or fallen man. In several scenes the beloved is depicted as a young woman instead of a young man (BOD Ouseley Add. 23, folio 72a; TKS H. 810, folio 155a; and TKS R. 900, folio 57a). Most known representations of the scene include onlookers. Yet for all the similarities, no two compositions are alike, and the Freer Jami does not imitate or anticipate other illustrations.[7] Although the painting in the Freer Jami does not display any particular originality in iconography or great subtlety in its interpretation of Jami's verses, it can be judged as the most artful painting to this *Subhat al-ahrar* anecdote.

101
The Fickle Old Lover Is Knocked off the Rooftop
in the *Haft awrang* of Jami
Mid-16th century, Iran, attributed to Shiraz
36×22.6 cm (folio)
TKS H. 810, folio 155a
Topkapi Sarayi Müzesi, Istanbul

Dimensions
24.8×19.4 cm

Condition
The green lawn in the background has been retouched.

Incorporated Verses

One verse at top of illustration:

> *The youth struck him and knocked him off the roof*
> *And laid out him to rest like a shadow on the ground.*

Two verses at bottom of illustration:

> *He who travels the road of commerce with me,*
> *Ought not to look anywhere else.*

> *Seeing double comes from lust,*
> *The qibla of love is single, that is all.*

Architectural Inscriptions

On left-hand wall, in Arabic:

Oh, opener of doors [of paradise]　　　　　　　يا فتح الاواب

Around door frame, in Arabic:

بناة هذا العمارة و زينتهابامر السُلطان الاعضم الاكمل زنده اولاد سَيدالمرسلين \ فى العالمين

ابوالمظفر شاه طهماسب الحسينى خلدالله على\ مفارق اهل افضل والكمال ظلال احسانه و امر و

حمة و ايَد فى صفحات الدَهر اثار مكان

The building of this structure and its decoration [was done] by order of the mightiest and most perfect sultan, Abu'l-Muzaffar Shah Tahmasp al-Husayni [in gold], may the offsprings of the lord of apostles [Muhammad] support him in this world and the next. May God perpetuate the shadow of his beneficence and mercy over the crowns of heads of people of knowledge and excellence and [may God] support the traces of his generous works through the pages of time.

Over doorway, in Persian:

برسم كتابخانه ابوالفتح سلطان ابرهيم ميرزا

By order of the kitabkhana of Abu'l-Fath Sultan Ibrahim Mirza

Attributions
Kühnel: Muzaffar-Ali; Stchoukine: Shaykh-Muhammad (*MS*, 47, 126), and Group 1, possibly Shaykh-Muhammad (*MS*, 128); S. C. Welch: Painter D (Abdul-Aziz?).

References
Dickson & Welch, 1: 224A, fig. 273; Kühnel, "History," 1878–79; Stchoukine, *MS*, 47, 126–28; *Survey*, 5: pl. 904; S. C. Welch, *PP*, 25, fig. P.

Notes
1. Mudarris-Gilani, 251.
2. The cutting down of the sapling may be a metaphor for death as, for example, in Iskandar Beg Munshi's description of the murder of the Safavid prince Haydar Mirza (Iskandar Beg Munshi [Afshar], 1:195). See also Dihkhuda, *Amsal*, 2:785.
3. Some architectural details are found in other Freer Jami paintings. The grisaille panels flanking the door are comparable to those in FGA 46.12, folios 38b, 59a, and 207b.
4. Other illustrated manuscripts of the Safavid period with this identical invocation include a *Khamsa* of Nizami dated 931/1524–25 (MET 13.228.7, folios 104b, 220a [repro. color: Chelkowski et al., facing p. 40 and p. 91]) and the Tahmasp *Shahnama* (folios 36b, 77b, 166a, 239b, 286b [repro.: Dickson & Welch, 2: pls. 23, 63, 107, 144, 166, respectively, and discussion 539B–41B]).
5. The inscription closely follows the panegyric style and format of Safavid foundation inscriptions, particularly those of royal mosques. See, for example, Hunarfar, 402, 429.
6. Several laudatory inscriptions in the Tahmasp *Shahnama* also credit an anonymous "sultan" (who may be the shah) with the commission or construction of buildings (folios 71b and 84b [repro.: Dickson & Welch, 2: pls. 58, 70, and discussion 540A–B). The encomium on FGA 46.12, folio 162a, is clearly in the tradition of royal panegyric.
7. The illustration in TKS H. 810, executed in Shiraz circa 1550–60, is compositionally and iconographically closest to the Freer Jami, with the exception of its substitution of a female for a male lover.

Folio 169b

THE ARAB BERATES HIS GUESTS FOR ATTEMPTING TO PAY HIM FOR HIS HOSPITALITY

Text Source
Mudarris-Gilani, pages 539–40.

Rubric before Illustration (folio 169a)

> The story of that desert Arab who in the exchange of generosity and honor returned his guests' sack of dinars and dirhams with the threat of a blow from his spear.

Précis

A desert Arab provides generously for an unexpected group of travelers, sacrificing a camel on each day of their stay. One day he mounts his camel and goes away to do something. On his return he discovers that the guests have departed, leaving a sack of gold with his family as payment. The Arab snatches up the sack and a spear and rides off after the travelers, cursing them for trying to repay his hospitality. He also threatens to kill them if they do not take the money back. The travelers have no choice but to reclaim their gift before continuing on their way.

This anecdote accompanies the twenty-eighth aqd "on liberal giving and munificence, the first of which is giving dirhams and dinars and the last is liberal giving and munificence." It is part of a long sequence on the stages of loving, beginning with delight, "which is a lasso for reining in union," and concluding with "showing love and joining [others], which means mingling with God's creations in love and affection and not fleeing from what is necessary to mix with them."

Illustration

The desert landscape in which the scene is set is rendered as a tufted plain, divided into two gently folded "hills" and punctuated by a large plane tree (fig. 102).[1] A finely striped, black felt tent (its texture barely visible in reproduction), presumably the Arab's home, is pitched in the right background, with a woman and little boy, presumably members of the Arab's family, standing at the entrance (fig. 103). With one hand the woman restrains the boy from going outside, while with the other she pushes up the front of the tent.[2] Down in front the bearded Arab, mounted on camelback, rides up to a group of six horsemen who are moving off at a leisurely pace, obviously not expecting confrontation. The extent of the host's displeasure is not immediately apparent, but a spear rests over his left shoulder and a white sack hangs in his right hand. One rider turns back to meet the Arab, gesturing outward in speech. This youthful figure is probably the ranking member of the group of errant guests, judging from his distinctive turban plume and the long white brush hanging under his horse's chin. Several of his companions look back to watch the exchange with the Arab. Most are young and clean-shaven, but one has a dark beard and another, a portly gentleman mounted on a small donkey, has the gray beard of advancing age.

Among the most literal illustrations of the entire manuscript, this folio contains no extraneous features that might extend the subject or reinforce the moral of the twenty-eighth aqd. Its iconographic simplicity is matched by crystalline clarity and precise draftsmanship. The rendering of textile patterns, especially the saddle blankets, is particularly noteworthy.

The episode has been rarely illustrated. One illustration treats the scene similarly to the Freer Jami, with the Arab galloping on camelback, his spear in one hand and a white sack in the other, after his former guests (TKS R. 900, folio 78a; fig. 104). Another composition presents the same cast of characters but replaces the Arab's tent with a tall building with female figures at the window and on the roof (TKS R. 898, folio 100a).

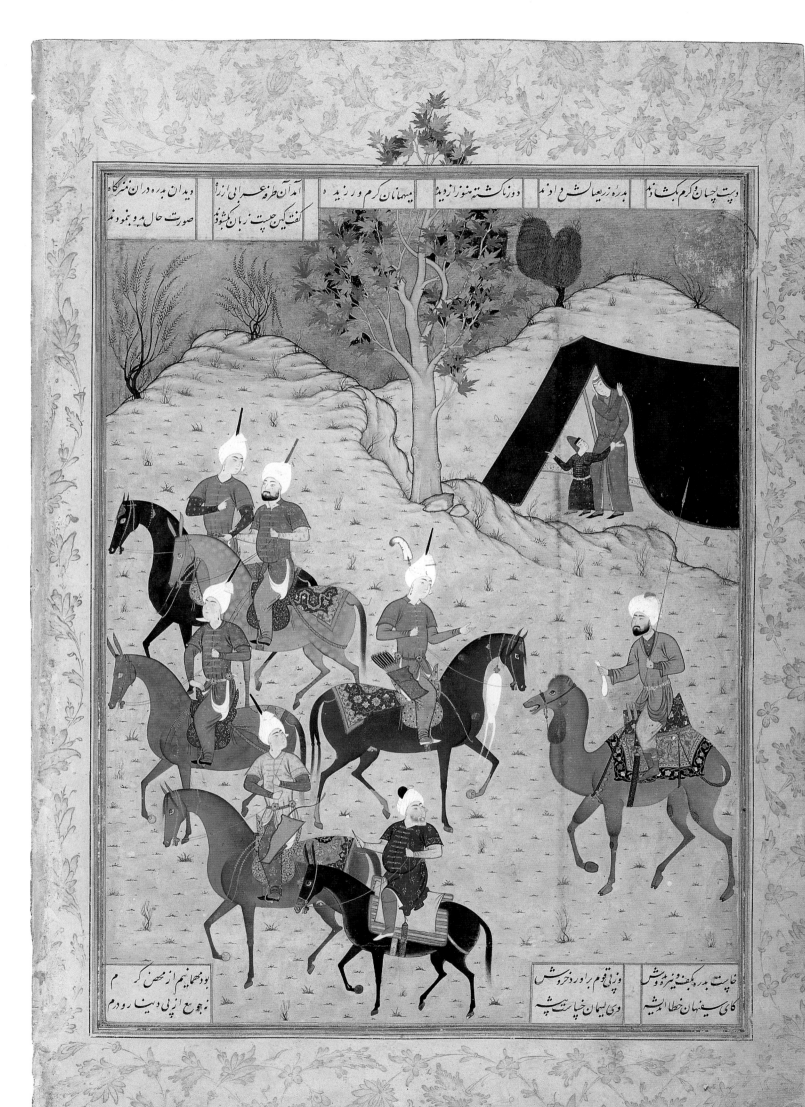

The Arab Berates His Guests for Attempting to Pay
Him for His Hospitality (detail)
in the *Haft awrang* of Jami
963–72/1556–65, Iran
26.2×19 cm (painting)
FGA 46.12, folio 169b

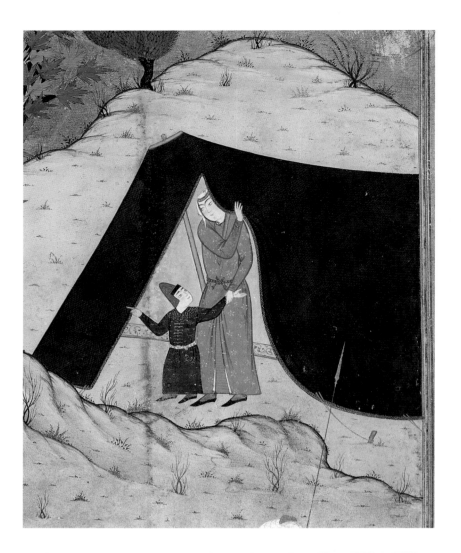

104

The Arab Berates His Guests for Attempting to Pay
Him for His Hospitality
in the *Subhat al-abrar* of Jami
First half 16th century, Iran, attributed to Shiraz
26×16 cm (folio)
TKS R. 900, folio 78a
Topkapi Sarayi Müzesi, Istanbul

Dimensions
26.2×19 cm

Incorporated Verses

Four verses at top of illustration:

> *They opened the hand of honorable beneficence,*
> *They gave a sack of gold to his family.*
>
> *The guests who had displayed honor*
> *Had not yet traveled far out of sight.*
>
> *When the desert Arab returned,*
> *He saw the sack at that stopping place.*
>
> *He said, "What's this?" They loosened their tongues*
> *And told him what the situation was.*

Three verses at bottom of illustration:

> *He rose, the sack in his hand and a spear on his shoulder,*
> *And cried out as he tracked the group.*
>
> *"Oh, fools of erroneous mind!*
> *And oh base men of ignoble character!*
>
> *My generosity to guests was out of honor,*
> *Not a bargain for dirhams and dinars."*

Attributions
Stchoukine: Group 1; S. C. Welch: Aqa-Mirak.

References
Dickson & Welch, 1:114B, fig. 163; Stchoukine, *MS*, 127; S. C. Welch, *PP*, 26, fig. Q.

1. The lilac tone of the front hill is the same as the hillside of FGA 46.12, folios 10a and 215b, only more thinly applied, allowing the tan base to show through.
2. The same mother and son duo appear in reverse at the tent entrance in a *Haft awrang* manuscript that has many connections to the Freer Jami (PWM MS 55.102, folio 231b). They reappear in an illustration taken from another Jami manuscript of circa 1575 (AHT no. 93 [color repro.: Soudavar, 238]).

Folio 179b

THE TOWNSMAN ROBS THE VILLAGER'S ORCHARD

Text Source
Mudarris-Gilani, pages 572–73.

Rubric before Illustration (folio 179a)

> The story of the townsman [with a] villager who had taken him to his orchard.

Précis

A city dweller goes to the country, where a *dihqan* (landlord) has invited him to his garden. The orchard is "adorned like the garden of paradise," with rich grapevines and trees laden with apples, pears, filberts, and pomegranates. At the sight of such bounty the visiting townsman goes berserk, breaking off branches, yanking off fruits, and ravaging vines. The villager watches this gratuitous despoliation in agony and does not know how to respond when the townsman offers to stop if his "bustling" displeases his host. How could the visitor comprehend the dihqan's feelings when he has never planted one seed, pruned a tree, gotten blisters from the spade, or spent long nights irrigating plants? "Who shares [my] pain," replies the villager, "knows [my] pain, [but] the description of it is dull to those who do not feel the pain."

Toward the end of the *Subhat al-abrar* Jami becomes very personal, as he does from time to time throughout the *Haft awrang*. The thirty-eighth aqd contains a "mandate to [my] own beloved son Ziauddin Yusuf." In the munajat prayer that follows, this mandate is transferred from the son to the poet himself, who continues the same theme in the subsequent aqd: "Advice to [my] own self, which is more in need of advice than any other." Jami then turns to his reader in the subsequent prayer. In the fortieth and final aqd he begs them to "look on [this book] with affection and goodwill and avoid ill opinion and bad remarks." The accompanying anecdote about the townsman robbing the villager's orchard is clearly meant to reinforce the point that, although readers can easily engage in destructive criticism, they are unaware of the author's training and efforts.

Illustration

The dihqan stands, stoic and resigned, within his enclosed orchard, gesturing outward with both hands to the city dweller, who pulls down the slender branch of a pomegranate tree and plucks off a fruit (fig. 105). Two other limbs of this tree hang at an unnatural angle, evidence of the visitor's ruthlessness. Looking like he has come prepared to do dirty business, the townsman wears work clothes and has a stick and pouch at his waist and a sack draped over his shoulder and back. The dihqan has a pick or garden implement stuck in his sash. In general, however, he appears more like a refined city gentleman, and the townsman like a rough-hewn country fellow—as if the artist had deliberately switched the traditional attire of the two protagonists.

A hexagonal baldachin with a raised plinth and splendid canopy, under which four young men relax, dominates the upper verdant garden, where a small stream flows and numerous birds flock. Two youths hang their arms around two columns. The boy at the far left holds a small wine cup, which he probably has filled from the bottle next to the railing, while his counterpart gestures upward in speech. The pair kneeling in the center of the kiosk engages in intimate conversation. The youth at right plays the sitar, while his companion rests what looks like a closed book or an envelope against his cheek.

105
The Townsman Robs the Villager's Orchard
in the *Haft awrang* of Jami
963–72/1556–65, Iran
34.5×23.4 cm (folio)
FGA 46.12, folio 179b

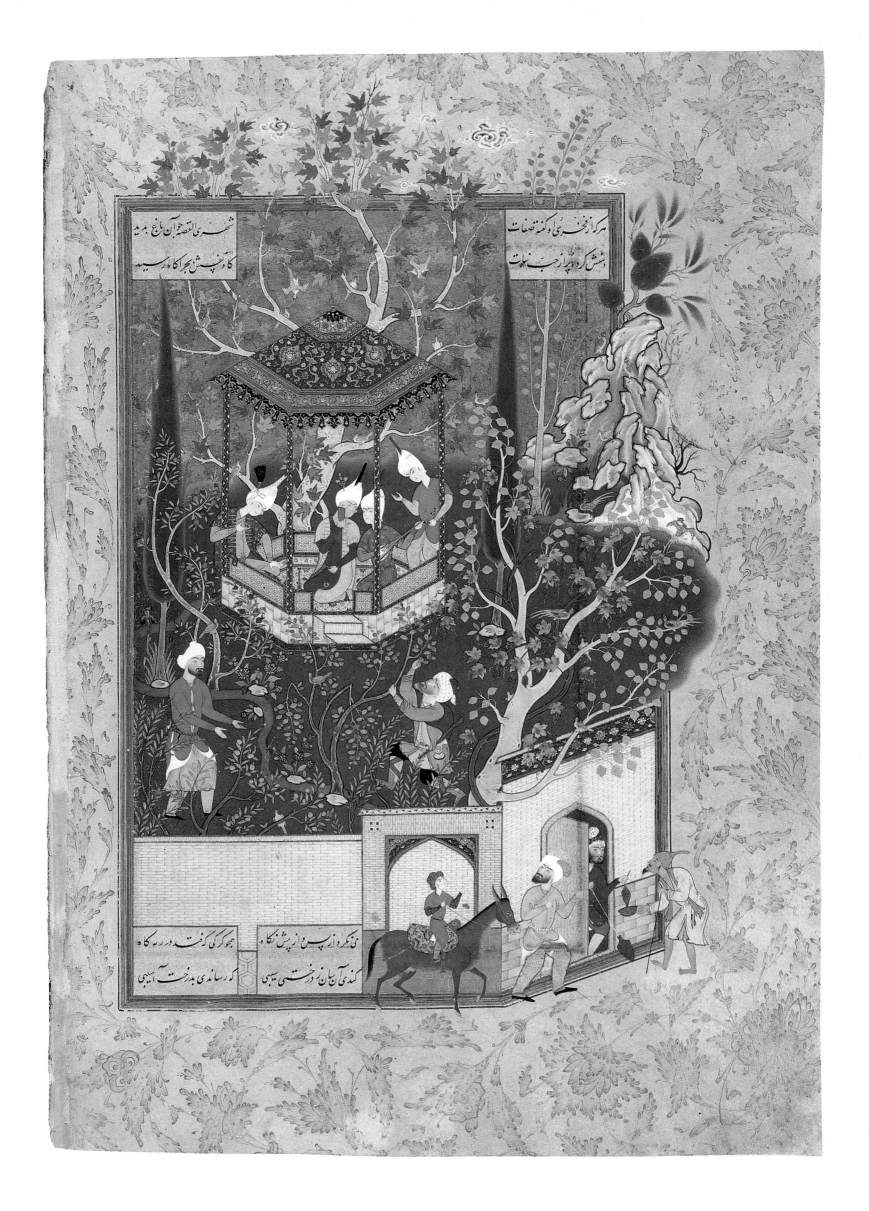

Four other figures gather next to the garden's outer brick wall, which is divided into three sections (fig. 106). A young boy wearing a fur-edged cap rides a donkey past the wall's midsection. Holding his mount's reins, he gestures toward a bearded man walking in front. This older fellow has just turned the corner of the tall facade and heads toward the garden's main entrance. Coming out from behind the half-opened door is a gardener grasping a spade in his left hand. With his right he offers a large bunch of grapes to a mendicant with a staff. Bearded, skinny, hunched over, and shabbily attired, the beggar gives the impression of age without necessarily being aged. A knife and spoon hang from his sash, and he holds out a metal bowl to accept the gardener's present.

The two vignettes in this splendid composition provide striking contrasts to the primary action. The peaceful scene of four youths at leisure in the garden pavilion, a variation on a most familiar subject in Persianate painting, reinforces the image of the garden as paradise, another standard literary and artistic theme.[1] The gardener giving a bunch of grapes to the beggar at the door performs an act of charity, which surely would be lost on the city dweller, who has no compassion for the villager and no understanding of the effects of his greed. The significance of the boy on the donkey and his older companion is less clear. Perhaps these figures refer to the poet Jami and his young son, who are the focuses of the preceding aqds.

The garden pavilion and relaxing youths in *The Townsman Robs the Villager's Orchard* also appear in the right half of a frontispiece signed by Abdullah al-Shirazi and dated 989/1581–82.[2] It is possible that Abdullah saw the Freer Jami scene when he inscribed the verse on folio 84b and later used elements of its composition for his own work.

As in a few other Freer Jami pictures, the margin around this composition acts as the ground for various figures, as if the artist wanted to expand the picture plane and meaning of the illustration in both time and space.

106
The Townsman Robs the Villager's Orchard (detail)
in the *Haft awrang* of Jami
963–72/1556–65, Iran
24.5×15.6 cm (painting)
FGA 46.12, folio 179b

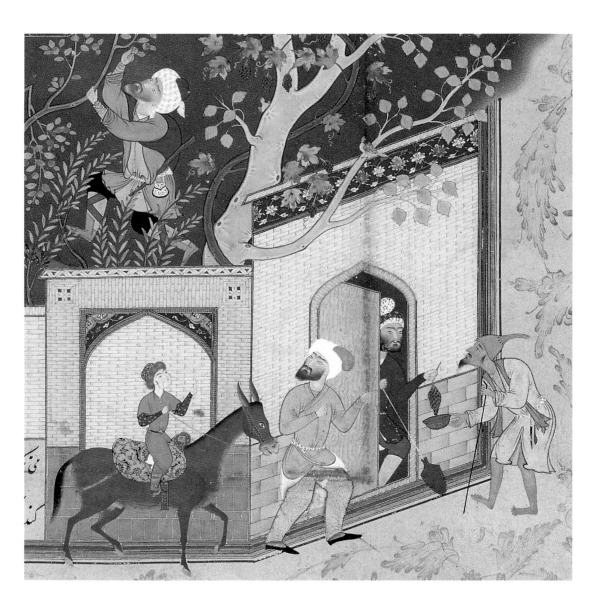

CHAPTER TWO: POETRY AND PAINTING

Dimensions

24.5×15.6 cm

Incorporated Verses

Two verses at top of illustration:

> *Whoever would describe it [out of a desire] to vaunt it,*
> *Would find his mouth with grains of sugar.*

> *In short, when that townsman saw that orchard,*
> *The ox of his soul reached its pasture.*

Two verses at bottom of illustration:

> *He did not look before or behind,*
> *Like a wolf, he fell upon the fold.*

> *Like a wind when it blows fiercely from the plain,*
> *He snatched an apple from the tree [with such force] that it caused damage to the tree.*

Attributions

Soucek: Abdullah al-Shirazi; Stchoukine: Shaykh-Muhammad (*MS*, 47, 126), and Group 1, possibly Shaykh-Muhammad (*MS*, 128); S. C. Welch: Painter D (Abdul-Aziz?).

References

Dickson & Welch, 1:224A, fig. 274; *EIr*, Priscilla P. Soucek, "ʿAbdallah Šīrāzī"; Kevorkian & Sicré, 178–79, with repro. color; Schmitz, "Harat," pl. 256; Stchoukine, *MS*, 47, 126–28; S. C. Welch, *PP*, 116–17, with repro. color.

1. For example, see IOL J.28.11 (repro.: Robinson, *IOL*, 210).
2. AHT no. 90a (color repro.: Soudavar, 231). The structure and decoration of the pavilion and the youth on the right, with his arm wrapped around a column, are also identical to a lacquer binding (BM 1948 12-11027-8, repro.: *Arts*, cat. no. 606).

Salaman u Absal

Jami wrote what is generally considered to be his second masnavi in honor of the Aqqoyunlu ruler Ya'qub, who assumed leadership of the confederation of White Sheep Turcomans in Rabi' II 883/July 1478.[1] An allegorical romance, *Salaman u Absal* begins with a long prelude alternating eulogies (praises to God, panegyrics to Ya'qub and the sultan's brother Yusuf, and so forth), moralizing anecdotes (the story of the haughty slave and the story of the wine bibber), and authorial comments (Jami's description of himself as an old poet, his ailments, and his reasons for composing this book).

The masnavi narrative relates how the king of Greece turns for advice to a renowned philosopher and confides his yearning for a son. This confession launches the sage onto a protracted discourse on the nature of passion and the evils it can bring (FGA 46.12, folio 188a). Eventually the philosopher contrives to have a son born without the collaboration of a woman, by taking the king's sperm and depositing it in a place "which is not a womb." Nine months later a child is born. His faultless appearance suggests *salamat* (wholeness or health), hence the name Salaman. The baby is suckled by a captivating nurse named Absal. Salaman grows into a radiant youth, with a keen intellect and generous spirit. The nurse Absal has been charmed by her charge since birth. When his beauty reaches full maturity she falls in love and plots to ensnare him. Her strategies have their effect, and, although Salaman initially resists for fear that even one union with Absal would deprive him of rank and majesty for life, he soon succumbs to his own newly awakened desires. The two lovers spend the next year enjoying each other's company.

Before too long both sage and king hear of Salaman and Absal's conduct. Each chides the boy and counsels him to realize his inner worth. Salaman reacts by abandoning his father and adviser and fleeing with Absal to the "happy isle," where they are blissfully alone (FGA 46.12, folio 194b). When he learns of his son's flight, the king uses his magical "world-displaying" mirror to discover the lovers' hiding place. At first he feels compassion for the pair but eventually grows anxious at Salaman's continued infatuation for Absal and mourns the waste of his throne. Through the force of paternal willpower, he makes it impossible for Salaman to touch Absal. After long torment the young man realizes what his father has been doing and returns to beg his forgiveness. The king melds compassion with a long exposition on the conditions of kingship, which do not allow a ruler to be the plaything of wily courtesans. Salaman is grieved by his father's continued reproaches and proceeds to the desert, where he lights a fire and enters the pyre with Absal. The lovers had intended to kill themselves, but only Absal dies, while Salaman survives through the force of his father's will. Salaman laments the loss of Absal for so long that the king seeks the assistance of his sage, who gives the youth magical wine and periodically shows him a picture of Absal to ease his pain. Gradually the sage intersperses descriptions of Venus in this "treatment," finally managing to replace Absal with Venus in Salaman's perception. Free of the bonds of grief, Salaman is worthy to be ruler and is crowned by his father, who uses the coronation as an opportunity for another long speech about the qualities and duties of kings.

Jami reiterates almost every phase in his unfolding narrative by anecdotes relating similar circumstances or emotions (FGA 46.12, folio 188a), repeating the technique employed in the poem's prelude and in other masnavis, such as the *Subhat al-abrar*. Salaman's initial refusal of Absal, for example, is followed by the tale of a blind raven on the shore of a brackish sea who is offered sweet water by a pelican. The raven refuses the gift because he is used to brackish water and it would be agony to go back to it after tasting the sweet. The description of Salaman's grief after his beloved's death is glossed by a story of a Bedouin who falls asleep while riding his camel and then tumbles off. The next morning the camel is gone and the rider laments: "I wish I were lost with him and had escaped this separation."

CHAPTER TWO: POETRY AND PAINTING

Jami concludes his poem with an explanation of its purpose.[2] The point of the Salaman and Absal story lies in its inward meaning. Jami would have his masnavi understood as an allegory of the search for truth rather than an account of doomed lovers. The poet states clearly that God is the creator and king of the world, its "active intellect," and dispenser of good and evil. The sage, a "learned and wonderful initiate of the [gnostic] path," emanates the grace of God that constantly flows into the world. Salaman is the pure spirit, "named the rational soul," born of divine intelligence without bodily connection. Absal, by contrast, is the passion-worshiping body. The body lives by the soul, and the soul perceives through the body. Therefore Salaman and Absal love each other and part company only for a good reason. They sail the "sea of animal passions, the billow of carnal delights." Salaman's later inability to touch Absal denotes the decline of passion. His subsequent return to the throne represents his yearning for intellectual joys. The fire in which Absal perishes frees the soul of animal passions. Finally the image of Venus signifies the lofty perfections by which the soul "becomes truly noble," clearly at peace with the divine.

Jami does not reveal the sources for his allegory and imagery. Although the story of Salaman and Absal had never been treated before in Persian poetry, a pair of protagonists with the same names appears in the *Kitab al-isharat wa'l tanbihat* (Book of directives and remarks) of Ibn Sina (d. 428/1036–37).[3] Salaman is described as "a symbol typifying thyself" and Absal as "typifying the degrees of attainment in mystical gnosis."[4] Two successive commentators of the thirteenth century, Fakhruddin Razi (d. 606/1209–10) and Nasiruddin Tusi (d. 672/1273–74), sought to identify Ibn Sina's story of Salaman and Absal. Tusi succeeded in discovering not only Ibn Sina's text but also an earlier version said to have been translated from Greek into Arabic in the ninth century by Husayn ibn Ishaq, also known as al-Ibadi (d. 260/873–74). Tusi included summaries of both renditions of the tale in his commentary on *al-Isharat*. The supposed Hellenistic version, as translated by Husayn and summarized by Tusi, may have been Jami's source for his masnavi, into which the poet interjected new details and reiterative anecdotes. Rumi's masnavis may have inspired Jami in the form and meter used in his allegory.[5]

Salaman u Absal is perhaps the least regarded of all Jami's masnavis. Modern critical assessment of its contents and style range from "curious" and "silly" to "crude" and "grotesque."[6] It has been proposed that Jami was drawn to the tale of Salaman and Absal, as preserved in Nasiruddin Tusi's commentary, through his own misogynistic inclinations and that he developed the character of the sage as a way of currying favor with Sultan Ya'qub and his vizier and establishing his qualifications as a worthy poet at the Aqqoyunlu court.[7]

1. The source for the masnavi text is Mudarris-Gilani, 311–64. Translations include Arberry; Bricteux, *SA*; and Jewett.

Jami's panegyrics to Ya'qub appear in the prelude and coda to the *Salaman u Absal* (Mudarris-Gilani, 314–15 [this edition does not include the final panegyric here but places it instead at the end of the *Subhat al-abrar* poem, 575–76]; Arberry, 141–42, 144–45, 204–5).

The date for the masnavi is generally given as 885/1480–81 (see Hikmat, 190; *EIs* 2, Cl. Huart [rev. H. Massé], "Djami"). Woods, however, points out (p. 154 n. 65) that the *Salaman u Absal* prologue includes a passage praising Sultan Ya'qub for no longer indulging in the vice of wine (Mudarris-Gilani, 321; Arberry, 149–50) and suggests that the masnavi was written to commemorate Ya'qub's repentance. This interpretation would put the date of composition after 893/1488 and make this the final, instead of the second, masnavi. Arberry (p. 41) states that Jami offered *Salaman u Absal* to Ya'qub as a coronation present.

2. Arberry, 202–4; Bürgel, 133; Mudarris-Gilani, 362–64.

3. Arberry, 40.

4. Dehqan, 118. For a discussion of Jami's sources, see Arberry, 41; Bricteux, *SA*, 47–56; Rypka, 287; and especially Dehqan, 118–22. See also Corbin, 330.

5. Dehqan, 122.

6. Arberry, 39; Browne, *LHP*, 3:523; Dehqan, 125–26 ("uncouth in language . . . language of the poem defective . . . commonplace ideas expressed in clumsy and immature language . . . conventional patterns of similes and metaphors . . . worn-out clichés"); Rypka, 287.

7. For the misogynistic interpretation, see Rypka, 287. For Jami ingratiating himself at the Turcoman court but without specifying the vizier he might have been trying to flatter, see Arberry, 41–42. Woods (p. 144) identifies three people who occupied positions of greatest power during Ya'qub's reign (the sultan's mother, Saljuqshah Begum; his guardian, Süleyman Beg Bijan; and his preceptor, Qazi Isa Savaji), without designating any one individual as vizier.

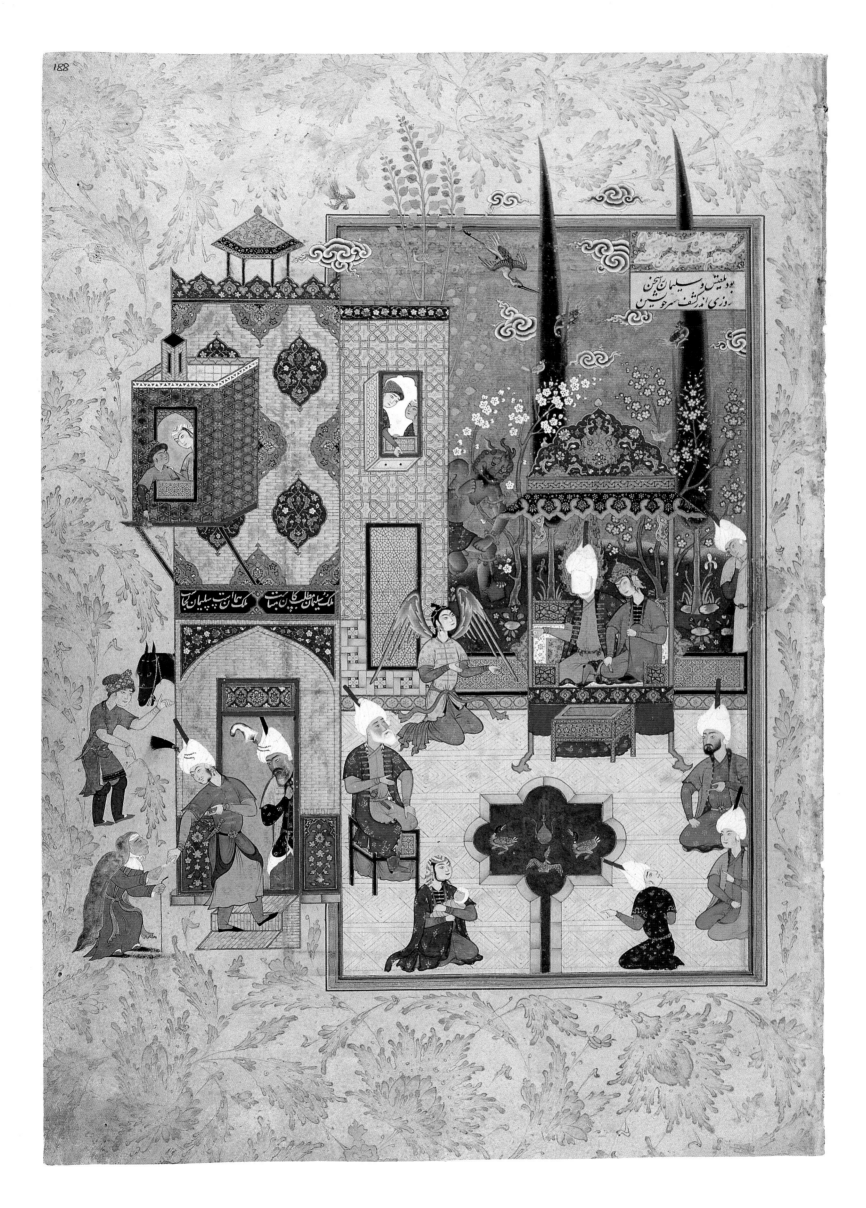

Folio 188a

SOLOMON AND BILQIS SIT TOGETHER AND CONVERSE FRANKLY

Text Source
Mudarris-Gilani, pages 330–31.

Translation
Arberry, page 161.

Rubric Incorporated into Illustration

The story of Solomon and Bilqis, may peace be upon him, and how they spoke frankly together.

Précis
One day King Solomon and Bilqis (the queen of Sheba) speak openly to each other, exchanging their innermost secrets.[1] Solomon confesses that, despite his absolute power, he always looks first at the presents brought by visitors seeking to increase their honor and glory in his eyes. Bilqis, in her turn, confides that she longs for every young man passing by. Thus the royal duo reveal a mutual need for gratification.

This confessional tête-à-tête is one of the moralizing tales told to the king by the sage toward the beginning of the *Salaman u Absal* narrative and follows a passage condemning women, "who are the focus of that passion upon which the child's existence depends." It is the sage's opinion that men caught up in passion become the playthings of women, who are greedy and faithless. Furthermore, when a man is old, his wife will crave a younger and more vigorous companion. In the Solomon and Bilqis story all women, even those of good character, are full of vice. Jami reinforces this message at the end of his anecdote by evoking the wise Firdawsi, "who uttered scathing maledictions against the good woman." How, Jami asks rhetorically, "should vicious women ever become virtuous? Good men will hold her worthy of malediction." This apologue anticipates the subsequent development of the Salaman and Absal narrative and the unnatural love affair of the young man and his former nurse.

Illustration
Solomon and Bilqis sit cozily side-by-side, the king's left arm over the queen's shoulder, on a baldachin placed at the upper edge of a garden terrace, adjacent to a palatial, multistoried facade (fig. 107). A white cloth, denoting his status as a prophet, covers his face, and a flaming nimbus frames his white turban. Bilqis's colorful attire is topped by a gray cap with a gold arabesque design and gold finial with a red stone. It is fastened by a strand of pearls under the chin. The couple's seat is a very elaborate structure with a wide footstool and a pedimentlike canopy decorated with medallions and ribbons.[2] Three painted ducks swim around the footstool skirt, while three live ducks splash in the lobed pool in front of Solomon and Bilqis.

By his hand gesture Solomon is evidently addressing an angel who kneels to the left of the baldachin and holds his palms upturned (fig. 108). This heavenly creature's wings are of marvelous green, red, crimson, and orange hues. Strands of pearls adorn its black locks and topknot. The fluttering ends of its blue sash suggest that the angel may have alighted only momentarily in front of the king. Another apparent participant in the discussion is the white-bearded man wearing a magnificent fur-lined robe. Seated on a low stool to the left of the pool, this venerable personage has a pen box tucked into his sash, perhaps to signify that he is a man of letters. In front of him kneels a young woman holding a swaddled babe. A young man points to her from the other side of the water channel while turning his head sharply up and backward, apparently to talk to two other males, one young and the other bearded, seated to the rear.

The garden behind the terrace and pavilion abounds with cypress, blossoming trees, and iris and other flowers, while the gold sky is the playground for a half-dozen knotted clouds and birds of various kinds, including a swooping crane. A crimson monster, clad only in a loincloth and

107
Solomon and Bilqis Sit Together and Converse Frankly
in the *Haft awrang* of Jami
963–72/1556–65, Iran
34.5×23.4 cm (folio)
FGA 46.12, folio 188a

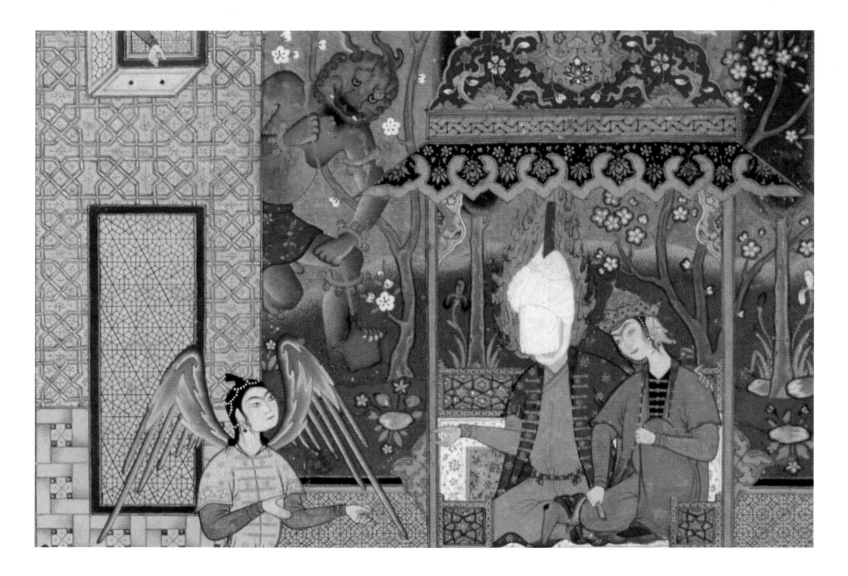

bangles, rests one clawed foot on a spade and leans through the slender branches of a flowering tree at the left. On the other side of the garden, near the intricate railing, stands a young man, finger to mouth, who watches the activities. Other observers include a young man and woman whose vantage point is a window overlooking the terrace.

The principal facade of the palace, the one that faces the margin, provides the setting for other secondary figures and activities. These include a male and female couple in the boxlike belvedere topped by a badgir. The young man appears to direct his companion's attention down toward a young attendant holding the reins of a brown horse whose head emerges from behind the lower story. The groom also points downward to an old woman wearing a white wimple under a long cloak. The elderly woman leans heavily on a staff and hands what looks like a piece of paper to a mustached man, who pauses to accept the paper while going up the stairs of the arched doorway. This man is obviously a person of stature, judging from his gold belt buckle, jewel-studded dagger, dangling gold earring with red stone, and turban ornaments. Looking out from the portal is another older man, leaning on a tall staff. Perhaps the door attendant, he has a full graying beard and fancy turban.

The painting depicts the *Salaman u Absal* anecdote as announced in the illuminated rubric at the upper right of the picture plane. Many details, however, including the verse inscribed on the building, suggest that the iconography is more concerned with the well-established lore about Solomon than with the *Haft awrang* theme of the vice of women.[3] The composition contains several obvious signs of Solomon's legendary civil and divine authority, such as his white facecloth and flaming nimbus, the winged angel, and hoary *div* (demon). His reputation for wisdom and justice is signified by the elderly man seated on the terrace, identifiable as Asraf ibn Barakiya, who served King Solomon as vizier, and by the aged woman presenting a petition at the door.[4] In all likelihood, the woman with babe in arms refers to Solomon's celebrated proposal to split a child between two contesting mothers. The verse inscribed in gold over the palace doorway invests these various Solomonic symbols with more coherent meaning:

ملك سليمان مطلب كان هباست

ملك همان است سليمان كجاست

Seek not the kingdom of Solomon, for it is dust.
The kingdom is [still] there, but where is Solomon?

This verse comes from the *Makhzan al-asrar* written by Nizami around 572/1176–77 as the first poem of his celebrated *Khamsa* and was well known in later eras. It is incorporated, for instance, within a long poem about Solomon inscribed near an entry portal at the Achaemenid palace of Persepolis and signed by Ali ibn Sultan Khalil, the nine-year-old son of the Aqqoyunlu prince Mirza Sultan Ali (d. 856/1452–53). This young prince's poetic composition is quoted in full by Qazi Ahmad in the *Gulistan-i hunar* (Garden of the arts).[5] Whatever the precise source of the verse as it appears on folio 188a, it seems to have attained almost proverbial status, with possibly a self-referential twist since it adorns the representation of a facade, that is, an impermanent structure made of "dust." Solomon's control, or kingdom, may extend over all the personages depicted in the composition, and he may always seek to expand his dominions. Nevertheless, as the verse proclaims, his power and glory are only temporary. The conviction that it is futile to strive for worldly possessions is a touchstone of Jami's philosophy and one of the central themes of the *Haft awrang*.

Specific features in this illustration may have additional significance vis-à-vis Jami's text. Solomon's vizier, Asraf ibn Barakiya, is the counterpart to the philosopher who helps the king in the Salaman and Absal story fulfill his desire for a son. The two couples at the upper windows might represent what happens when a man grows old and his wife looks for younger men, especially since the women here are not attending to the activities below but instead direct their attention at their male companions, some of whom look considerably younger than the women.

Simultaneously certain lighthearted details may have been intended to offset the serious themes of both picture and text. The playful clouds are one such distraction. There is also the clever insertion of a broken leaf into the marginal illumination just beneath the hand of the young groom. This leaf mirrors exactly the groom's downward gesture (which in turn parallels the gesture of the youth in the window above) and draws further attention to the old woman at the door. Finally although the div in the garden may have a more meaningful role in the painting, he is an amusing character.

The representation of Solomon and Bilqis is hardly a novelty in classical Persian painting, although the royal pair more frequently graces frontispieces than narrative text illustrations.[6] While manuscripts with Solomon and Bilqis frontispieces vary considerably in literary content, the paintings themselves are quite consistent, at least during the sixteenth century. The composition invariably appears over two facing pages, with Solomon on the right, seated outside on a high throne and surrounded by courtiers and attendants, angels and divs, real and fantastic creatures, and Bilqis on the left, also enthroned but in an interior setting and attended by servants, angels, musicians, and dancers. The two face toward each other but do not interact.[7] The Freer Jami illustration thus continues and enriches, through specific details, a familiar artistic tradition.

Dimensions
23×18.7 cm (including architectural extensions)

Incorporated Verses

One verse at top of illustration:

One day Solomon and Bilqis were speaking
Openly about themselves.

Attributions
Soudavar: Abdullah; Stchoukine: Group 1; S. C. Welch: Painter A (Qadimi).

References
Dickson & Welch, 1:47B, 206B, 210A, fig. 265; Soudavar, 229, fig. 36 (color detail); Stchoukine, *MS*, 127.

Notes
1. The first Muslim account of the Old Testament story of Solomon and the queen of Sheba appears in the Koran, sura 27. Here the wise king, a believer in Islam, urges the idolatrous queen to adopt the true faith. The queen received the name Bilqis from subsequent commentators, who also elaborated on many aspects of the original Koranic tale. See *EIs* 2, J. Walker, "Sulaiman," and E. Ullendorf, "Bilkis"; also Knappert, 1:138–45. The anecdote of the exchange of secrets between these legendary figures seems to be peculiar to Jami. The poet also mentions King Solomon in the *Tuhfat al-ahrar* in an anecdote about pilgrims in which he alludes to the value of abiding in the kingdom of Solomon (Mudarris-Gilani, 401).
2. S. C. Welch has characterized the ornamentation of the throne canopy as vulgar and compared it to one in the Tahmasp *Shahnama* (Dickson & Welch, 1:206B, 210A).
3. In general, see Knappert, 1:124–45.
4. *EIs* 2, A. J. Wensinck, "Asaf b. Barkhya"; Knappert, 1:144. The elderly figures in this picture (secretary/adviser, female petitioner, and doorkeeper) also represent visual topoi commonly found in Persian painting. See, for instance, Stchoukine, *MS*, pls. XVII left, XLVIII, LXI, LXIV right (doorkeeper); and XXVII (seated adviser); S. C. Welch, *WA*, pls. 11 (doorkeeper), 29, 35, 39 (seated adviser), 51 (female petitioner).
5. Melikian-Chirvani, "Saloman," 35–36; Qazi Ahmad [Minorsky], 71–72; Qazi Ahmad [Suhayli-Khunsari], 31–32.
6. Text illustrations with Solomon and Bilqis date from the fourteenth century onward and include *Tarjuma-yi tarikh-i Tabari* (Translation of Tabari's history), first half fourteenth century, FGA 57.16, folio 79b; *Khamsa* of Nizami, dated 848/1444–45, TKS H. 870, folio 172a (Stchoukine, Nizami, cat. no. IV [20], with repro., pl. XIII); *Six Masnavis* of Attar, dated 877/1472–73, BL Or. 4151, folio 92b (Titley, *MPM*, cat. no. 92 [6]); *Majalis al-ushshaq* of Sultan-Husayn Mirza, circa 1560, BL Or. 11837, folio 162b (Titley, *MPM*, cat. no. 229 [58]); *Qisas al-anbiya* (Tale of the prophets) of Ishaq Nishapuri, dated 989/1581–82, BN pers. 54, folio 138a (Stchoukine, *MS*, cat. no. 198); *Majalis al-ushshaq* of Sultan-Husayn Mirza, second half sixteenth century, BOD Ouseley Add. 24, folio 127b (Robinson, *BL*, cat. no. 808 [repro.: Arnold, *PI*, pl. XXXIII]); *Makhzan al-asrar* of Mawlana Haydar, dated 985 (?)/1577–78 (?), AMSG S1986.54, folio 24a (Lowry et al., cat. no. 167).
7. Typical examples include *Khamsa* of Nizami, dated 890/1485–86, TKS H. 768, folios 1b–2a (Stchoukine, *Nizami*, cat. no. XV [1–2]); *Divan* of Shahi, circa 1500–1505, BOD Selden superius 98, folios 1b–2a (Robinson, *BL*, cat. no. 563); *Khamsa* of Nizami, dated 935/1528–29, CB MS 195, folios 1b–2a (Arberry et al., 2: cat. no. 195; Stchoukine, *MS*, cat. no. 100); *Khamsa* of Nizami, circa 1560, TKS A. 3559, folios 1b–2a (Stchoukine, *Nizami*, cat. no. LI [1–2]); double page from an unidentified manuscript, Shiraz, circa 1560–70, SAK MS IR.M. 21 (A. Welch, *CIA*, 1:152–55 [with reference to other examples listed here]); *Kulliyat* of Sa'di, dated 974/1566–67 and 976/1568–69, BL Add. 24944, folios 2b–3a (Stchoukine, *MS*, cat. no. 133, with repro.: pl. LXV; Titley, *MPM*, no. 354 [1–2]); *Kulliyat* of Sa'di, circa 1560–70, BL Add. 5601, folios 1b–2a (Titley, *MPM*, cat. no. 352 [1–2]); *Khamsa* of Nizami, probably dated 989/1581–82, TKS H. 750, folios 1b–2a (Stchoukine, *Nizami*, cat. no. LII [1–2]).

Folio 194b

SALAMAN AND ABSAL REPOSE ON THE HAPPY ISLE

Text Source
Mudarris-Gilani, pages 350–51.

Translation
Arberry, page 186.

Rubric before Illustration (folio 193b)

Salaman and Absal embark upon the sea and reach the happy isle where they repose and lodge.[1]

Précis
Vexed by the reproaches of the king and sage, the two lovers decide to flee the court. Salaman and Absal spend the first week of their flight traveling over land and then embark by skiff on a seemingly boundless and savage sea. After a month's voyage they reach an island full of springs, trees, fruit, and birds. This is such a tranquil and beautiful spot that they remain there in carefree, blissful companionship. "In short," says Jami, "their hearts [were] full of joy and gladness. . . . Indeed, what better than to have your beloved at your side and your faultfinders afar?"

Illustration
This representation of the happy isle is every bit as lush as described by Jami (fig. 109). Its topography consists of grassy verges studded with plants and boulders. The flora includes a fruit tree, cypress, several blossoming trees, small plants, and flowers, while the fauna comprise a monkey, peafowl, and other colorful birds. Small rivulets and springs gush forth from under trees and rocks, and colorful and convoluted clouds race past the golden sun and trail off through the rocky outcropping and large plane tree that mark the island's upper boundary. The silver (now oxidized) waves lapping at the shore teem with aquatic creatures: a white swan flaps its wings toward the sky, a long snake swallows a fish, two large fish skim the waves, and a tortoise paddles along. In the foreground two rabbits occupy a patch of rocky and reeded shoreline. The skiff, which transported Salaman and Absal to the wooded island, bobs at shore's edge. This sleek wooden vessel has curved sides and a massive fan-shaped rudder off the sternpost. Its arched prow terminates in the head of a white swan or goose, under which hangs a long white brush.

Having disembarked, the lovers seem to be taking stock of their surroundings (fig. 110). Both are elegantly attired, considering that they have just endured a difficult sea crossing. Absal rests on a large boulder, leaning back on one hand for support and pointing upward with the other hand. Salaman holds a bow and arrow and looks up as if about to take aim at the large peafowl perched in a flowering tree.

There is no doubt that Salaman and Absal have arrived at an idyllic spot, removed from the rest of the world. Yet various details in this illustration allude to the censure the lovers have fled and give portent of future grief. The flapping swan, snake devouring a fish, and snarling rabbit may be normal signs of nature in the raw, yet they also signify struggle and conflict. Indeed, in an anecdote related at the beginning of the *Salaman u Absal* narrative, sea creatures are described as impure and seawater as unfit for ablution. That Salaman and Absal embarked on a sea of animal passions is made clear in Jami's remarks at the end of the poem. This idea is reinforced pictorially by the roiling waters and further reflected in the racing clouds above. The hero himself strikes a particularly discordant note with his bow and arrow as if he prepares to disturb the tranquility of his refuge. Absal seems unconcerned, but the large chattering monkey under the apple tree surely must be reprimanding Salaman for thoughtlessly shattering the peace of the happy isle.

The rendering of animals in this composition has been praised as "delightfully sympathetic" and the clouds have been compared with the "curdled convolutions with comet-like tails" on the background of robes worn by Chinese officials during the Ming dynasty.[2] The rubbery rendering of the human figures has also provoked comment.[3]

109
Salaman and Absal Repose on the Happy Isle
in the *Haft awrang* of Jami
963–72/1556–65, Iran
34.5×23.4 cm (folio)
FGA 46.12, folio 194b

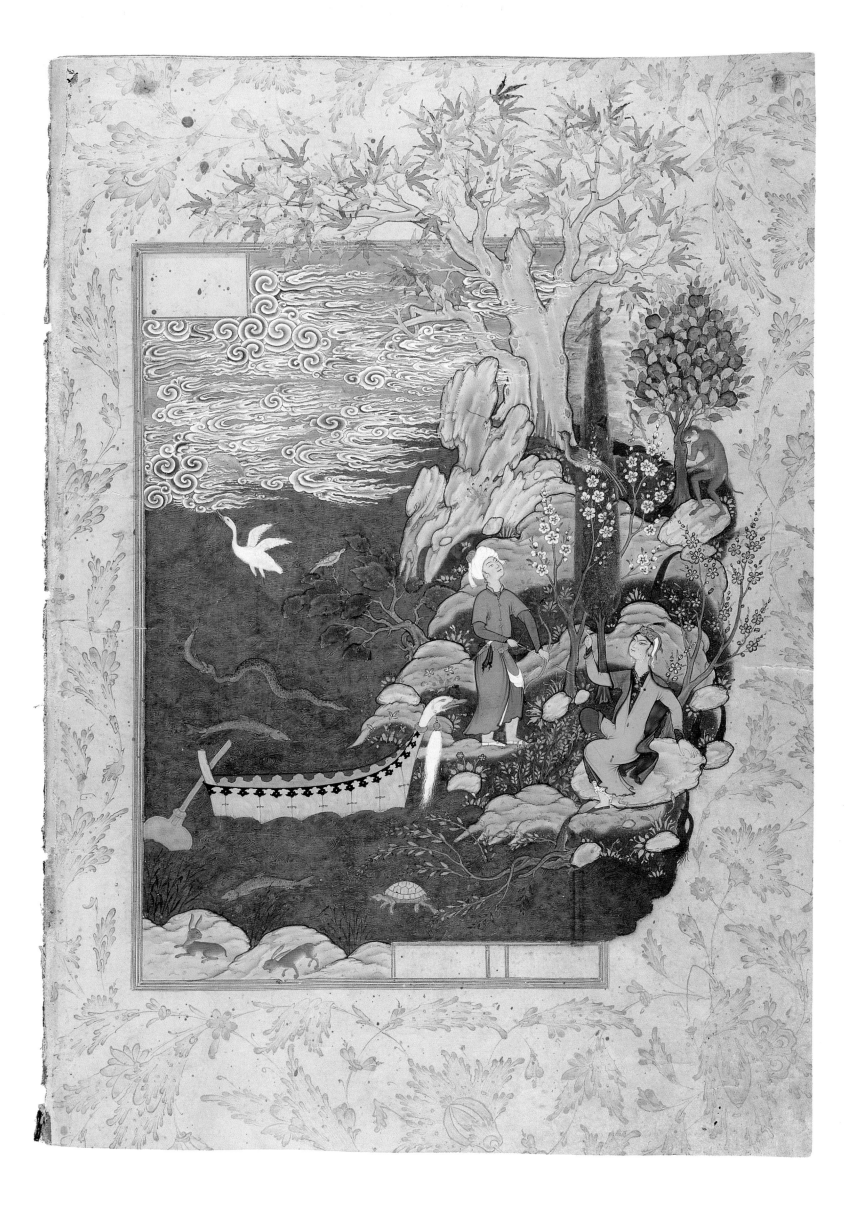

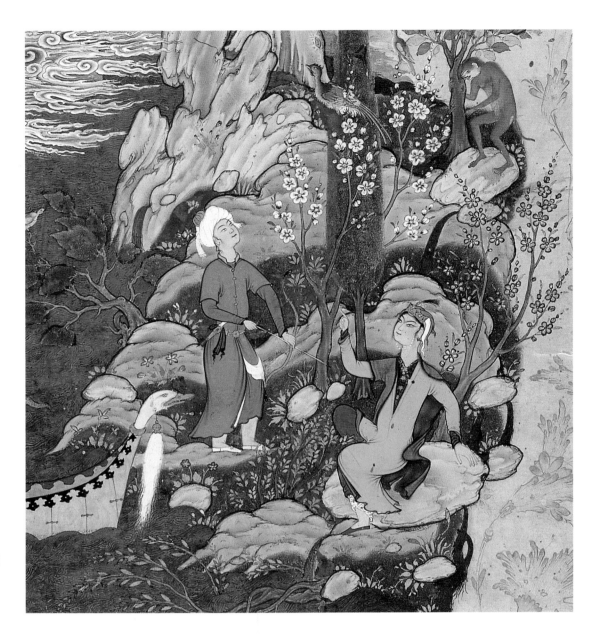

110
Salaman and Absal Repose on the Happy Isle (detail)
in the *Haft awrang* of Jami
963–72/1556–65, Iran
22.7×19 cm (painting)
FGA 46.12, folio 194b

 Salaman u Absal does not seem to have exercised particular appeal for artists or connoisseurs during the sixteenth century, and its pictorial cycle is especially sparse. Only one other representation of Salaman and Absal on the happy isle has been recorded, in a *Haft awrang* dated 911/1505–6 (SOTH 11.IV.88, lot 131, folio 71b). Here the sea life includes a mermaid, dragon, and fish.[4] The lovers' earlier embarkation on the stormy sea is the subject of an illustration in another copy of the *Haft awrang* (TKS R. 912, folio 288a). The date of the transcription and illustration of this manuscript is problematic, however, and the paintings may be much later than the sixteenth century.

Dimensions
22.7×19 cm (including landscape extensions on right)

Incorporated Verses

One omitted verse at top of illustration:

> [Both happy as body and soul together,
> Both happy as rose and lily together.]

One omitted verse at bottom of illustration:

> [A friendship far from the trouble of strangers,
> A tranquility far from the mixture of care.]

Attributions
Stchoukine: Group 2, Artist 1; S. C. Welch: Mirza-Ali.

References
Arberry, frontispiece; Dickson & Welch, 1:141B, 150B, fig. 203; Gray, *PP* 2, 145, with repro. color, 143 (with incorrect folio number); Robinson, "Survey," fig. 25; Stchoukine, *MS*, 128; S. C. Welch, *PP*, 118–19, with repro. color; S. C. Welch, *WA*, 29–30, fig. 11.

1. The word *khurram*, translated here as "happy," also means "lush." In the context of Jami's verses, the happiness of the couple and the lushness of the island setting could be considered synonymous.
2. Gray, *PP* 2, 142–45.
3. S. C. Welch, *PP*, 118. Welch likens Absal to flat-chested flappers of the 1920s and sees the figural forms in general as typical of the distorted way in which Safavid artists painted the human figure in the 1560s: conelike necks, and unreasonably outstretched bodies, with especially lean and supple chests, stomachs, and hips.
4. This information is given in the sales catalogue in which the painting was published and has not been independently verified.

Salaman u Absal

Tuhfat al-ahrar

The title of this masnavi is generally translated as "Gift of the Free."[1] Its name is derived from that of Khwaja Ahrar, the superior of the Naqshbandi order to whom Jami presented the poem as a *tuhfa* (rare gift).[2] Composed in 886/1481–82, the *Tuhfat al-ahrar* is the shortest of the seven poems in the *Haft awrang*.

The work begins with a series of munajat, followed by praises of the Prophet Muhammad, Muhammad Baha'uddin al-Bukhari Naqshband (founder of the Naqshbandiyya), and Khwaja Ahrar. The main text opens with an encomium to poetry and then turns to three conversations between Jami and a pir about knowledge and truth (FGA 46.12, folio 207b). Throughout the poem Jami employs nature metaphors, especially flower images, to describe his state of mind. The text continues with a series of twenty maqalat on a variety of philosophical and spiritual themes: the creation of the world and of mankind; the value of Islam and mystical meaning of its rituals; the virtues of self-seclusion, silence (FGA 46.12, folio 215b), and keeping vigil; Sufis and other religious people; royal justice; the allure of beauty (FGA 46.12, folio 221b); love and its characteristics; and poetry and the poet. In the final discourse Jami advises his four-year-old son, Ziauddin Yusuf, about wisdom and truth.[3]

Each of the twenty maqalat in the *Tuhfat al-ahrar* is followed by an illustrative anecdote reinforcing a moral message, in a structure of alternations similar to that of the *Subhat al-abrar* and *Salaman u Absal*. As in these two masnavis, each apologue in the *Tuhfat al-ahrar* is designed to teach a spiritual lesson and usually involves one or more persons, who may be named (and often quite well known, such as Yusuf and Ali) or anonymous. Sometimes the protagonist is a talking animal with a variety of human foibles.

In a brief prose prologue to the *Tuhfat al-ahrar* Jami implies that it was inspired by two earlier works: *Makhzan al-asrar* of Nizami and *Matla' al-anwar* of Amir Khusraw Dihlavi.[4] Then at the very end he asserts that his masnavi contains divine secrets and comes from divine sources, thereby evoking the authority of God in an effort to validate his verses.

CHAPTER TWO: POETRY AND PAINTING

1. The source for the masnavi text is Mudarris-
Gilani, 366–443. Browne, *LHP*, 3:526, translates
this title as "Gift of the Noble."
2. Jami mentions Khwaja Ahrar at the beginning
and end of the masnavi (Mudarris-Gilani, 384,
442). The last reference contains the dedication: "I
have called it *Tuhfat al-ahrar*, and I have sent [it] to
[Shaykh] Ahrar as a rare gift." *EIs* 2, Cl. Huart
(rev. H. Massé), "Djami," states that Jami also
wrote the poem in honor of Baha'uddin.
3. Mudarris-Gilani, 439–41. This ending is similar
to the concluding passages of the *Subhat al-abrar*
(ibid., 565–66).
4. Ibid., 367; *EIs* 2, Cl. Huart (rev. H. Massé),
"Djami."

Folio 207b
THE MURID KISSES THE PIR'S FEET

Text Source
Mudarris-Gilani, pages 389–90.

Rubric before Illustration (folio 207a)

> *First conversation with a pir of luminous soul, on the dark night of doubt and uncertainty,
> and the arrival of the murid, through him, at the knowledge of certitude.*[1]

Précis
Speaking in the first person, Jami describes his "dark night of the soul," when he was overcome
with remorse at his lack of faith. As he was praying to God for guidance, suddenly "a lamp
appeared in the distance and in [his] heart the light of relief appeared." This illumination came as
a pir, whom Jami praises in terms of Khadir ("the green," a legendary servant of God first men-
tioned in the Koran) and Jesus. Filled with the "light of certainty," the poet fell to his feet and
rubbed his face on the pir's sandals. The pir urged Jami not to be troubled by doubts and fears. He,
the pir, would be his friend and physician and would remain opposite him like an unclouded
mirror, so that the murid might receive enlightenment though reflection and freedom and joy in
unity with God.

This first conversation of the *Tuhfat al-ahrar* is preceded by an explanation of how the heart
becomes open and truthful when one is beside men of heart (gnostics). God's true nature is clothed
in layers of phenomenal appearance. Those who wish to penetrate to the essence of the divine need
the true knowledge to be gained through close association with a pir. In the last line of this discus-
sion, Jami urges himself to strive for knowledge and to turn to such a pir.

Illustration
The grateful murid kneels on the terrace of a tall building and kisses the shoe of the pir standing
above him (fig. 111). The pir is depicted as an old man, with a graying mustache and long white
beard. He wears an olive green turban wrapped under his chin, a brown cloak with long sleeves,
and a green robe split in the skirt and at the neck to reveal a deep blue underrobe. He leans forward,
supported by a long crook, to look down and gesture at the disciple at his feet. The murid has a
dark beard, white turban, gray-blue robe tied with a green sash, and a yellow and red shawl around
his shoulders. He is almost totally prone on the terrace, with his lips on the tip of the pir's right foot,
which he cradles in his hand (fig. 112).

Several people watch this expression of gratitude at the pir's arrival. The tall building at the side
of the terrace consists of two facades, with bricks laid in two distinctive geometric patterns and geo-
metric tile panels up to the dado level. Its flat roof has a boldly decorated cornice and an octagonal
lantern with a conical canopy. The building's side wall is pierced at the upper level by a small
mashrabiyya and by an open window, where two women converse. One holds a finger to her mouth
in a gesture of emotion. The upper part of the principal facade contains a large wooden balcony,
supported by two braces. A youth seated at the edge of the balcony leans over its screened railing
and points down at the scene below while simultaneously turning back toward a young attendant
peering out from around an interior door. Directly underneath the balcony a young man holding a
flaming candle steps through the building's portal. The arched door is only half-open. Delicate
floral panels of pink on orange creating a grisaille effect decorate its closed half. Above the door is
a rectangular tile panel reminiscent of a medallion carpet or a bookbinding.

CHAPTER TWO: POETRY AND PAINTING

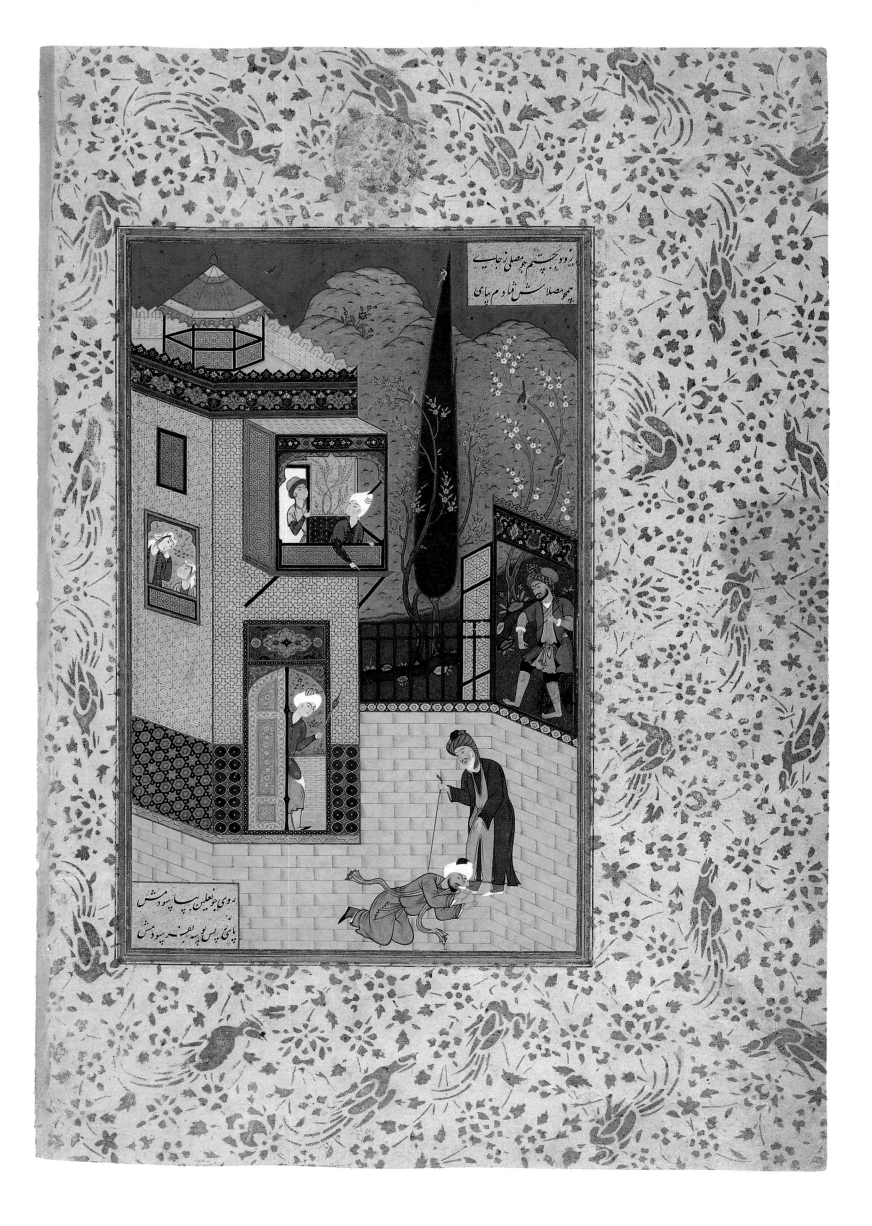

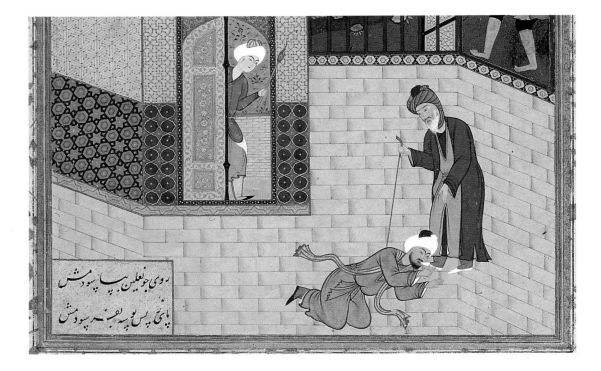

A band of octagonal tiles, a wooden railing, and at the right a high gateway with an inlaid wooden door, now open, mark the terrace edge. A bare-legged gardener wearing a short tunic and a striped cloth wrapped around his cap stands at the gate, holding either a staff or spade. In the garden beyond is a lawn with flowers, a cypress, blossoming trees, and birds. This grassy verge then turns into a solid tufted hillside that rises to meet the bright blue sky with a thin crescent moon.

Among the most straightforward illustrations in the manuscript, folio 207b is comparable in iconographic precision and compositional clarity to folios 10a and 169b.[2] Since Jami does not describe the location of the meeting of pir and murid, the artist was obliged to create an appropriate setting, complete with witnesses. The youth carrying the taper indicates that this is a night scene, as stated in the text. This figure may also personify the light imagery in the first conversation ("light of certainty," "light of relief," "light of knowledge") and, more specifically, the illumination cast by the pir and the enlightenment attained by the murid.[3]

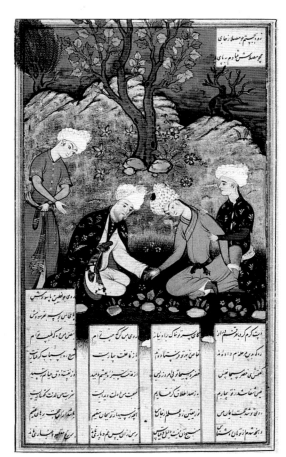

Three other illustrations to this scene are known, of which two belong to manuscripts copied in the mid-1560s by Muhammad ibn Ala'uddin of Raza in the Bakharz district of Khurasan (BN suppl. pers. 547, folio 9b; and PWM MS 55.102, folio 117a). In these compositions the murid and pir sit in the center of a hilly landscape with several attendants standing nearby. In the Prince of Wales manuscript the two principals sit side-by-side, their heads inclined toward each other and grasping hands (fig. 113). A young attendant on the right holds the murid's arm as if to restrain him from further emotion. In the Bibliothèque Nationale manuscript the murid is placed slightly below the pir and leans over to kiss his hand. In the third related illustration, from a contemporary manuscript dated 970–72/August 1563–July 1565, the murid is prostrate in front of the pir, as specified in the text and as depicted in the Freer Jami (BOD Elliot 186, folio 11a).

Dimensions

21.6×13.2 cm

Incorporated Verses

One verse at top of illustration:

> *I swiftly leapt from my place like one praying.*
> *I fell at his feet, flat as a prayer carpet.*

One verse at bottom of illustration:

> *I rubbed my face, like sandals, on his feet,*
> *I wore out his feet with [my] kissing.*

Attributions

Stchoukine: Group 1; S. C. Welch: Painter D (Abdul-Aziz?).

References

Dickson & Welch, 1:224A, fig. 275; Stchoukine, *MS*, 127; S. C. Welch, *PP*, 26, fig. S.

1. According to Schimmel (*MD*, 141–42), the *ilm al-yaqin* (knowledge of certitude) is one of the stations on the path to union with God, leading to *ayn al-yaqin* (vision of certitude) and culminating in *haqq al-yaqin* (reality of certitude). The last two stations also figure in the discussion between the murid and his various masters in the *Haft awrang* (Mudarris-Gilani, 391–94).
2. As with FGA 46.12, folio 10a, this illustration is painted on a piece of paper set into separate borders and is confined entirely within the colored rulings delineating margin and picture.
3. Schimmel (*MD*, 142) points out that in his *Kitab al-tawasin* (Book of adornment), Hallaj illustrates the stage of ilm al-yaqin with the imagery of the moth and the candle: the moth experiences "knowledge of certitude" when it sees the light of the candle, a connection that also helps explain the significance of the youth carrying a taper.

Folio 215b

THE FLIGHT OF THE TORTOISE

Text Source
Mudarris-Gilani, page 415.

Rubric before Illustration (folio 215a)

> *The story of a tortoise who began to fly with the wings of ducks and [who] through one out-of-place comment fell from the zenith of the sky to the nadir of the earth.*

Précis

A tortoise befriends two ducks on a riverbank. After a while the ducks yearn to fly away, and the tortoise begins to grieve at the thought of his friends' departure. Fortunately the ducks find a way for the tortoise to accompany them. Each seizes one end of a stick from a nearby thicket and has the tortoise clamp onto the middle with his teeth. The trio then take off into the air over dry land and fly over a crowd of people, who marvel at the sight. The tortoise opens his mouth to tell the onlookers not to be envious and consequently loses his grip and falls to the ground. The moral, says Jami, is that thoughtless speech can cause a downfall.

This amusing parable comes from the ancient genre of the mirror for princes, in which animal fables are used to instruct kings about proper conduct. The story is best known in the Islamic world from the *Kalila wa Dimna*, a tale about two jackals named Kalila and Dimna, which originated in India probably around A.D. 300. The Sanskrit original was translated into Pahlavi during the reign of the Sasanian monarch Nushirvan and from Pahlavi into Arabic by Abdullah ibn al-Muqaffaʿ around 750. Al-Muqaffaʿ's text was the basis for several Persian translations, in both prose and poetry, of which the most celebrated is the *Anwar-i suhayli* (Lights of Canopus) of Husayn Waʿiz Kashifi (d. 910/1504), a contemporary of Jami at the court of Sultan-Husayn Mirza in Herat.[1] The Arabic version of al-Muqaffaʿ and the Persian version of Husayn Waʿiz both include the story of a tortoise who lived in a marsh with two geese.[2]

Jami's version of this popular tale accompanies the ninth discourse of the *Tuhfat al-ahrar*: "On silence, which is the capital for salvation and the ornament of elevated degree." The discourse ends with an exhortation not to speak in vain, a point reiterated by what happened to the tortoise.

Illustration

Two mallards fly through a golden sky with one supporting the all-important stick from below, while the other swoops down from above (fig. 114). Their friend the tortoise hangs onto the stick with his mouth, his legs splayed. The landscape over which this improbable trio flies occupies most of the composition: a tufted lilac plain rises gently to a high horizon, a stream cuts through a grassy sward in the left foreground, and a multicolored rocky outcropping and tall plane tree spill out into the right-hand margin.[3]

A large tent, its bulbous roof and outer walls brilliantly decorated with medallions, dominates the upper part of the plain.[4] Two women, their heads covered in white wimples, peek out from around the open door of the tent and gesture to a bearded man standing in front and pointing upward to the ducks and tortoise. A younger man leans around the side of the tent as if to report on the same curiosity. Seated in front of the tent are two other women. One bends her head over a piece of embroidery, oblivious to what is going on overhead; the other squats and looks back toward the sky.

The marvelous sight above is also the focus of attention of all the other onlookers, who react in various ways. They include three men beyond the horizon and three others at left in front of the tent. The grassy sward in the lower foreground is occupied by a pair of embracing men; an older male wearing a dagger at his waist and a sack on his back who strides forward with a staff and points upward with enthusiasm; another youth with a long curving sword and a finger to the mouth; and a bearded man behind the rocks at right. Two foxes play hide-and-seek among the rocks below, and several birds, including a pair of peafowl, perch in the plane tree with its fall foliage.

114
The Flight of the Tortoise
in the *Haft awrang* of Jami
963–72/1556–65, Iran
34.5×23.4 cm (folio)
FGA 46.12, folio 215b

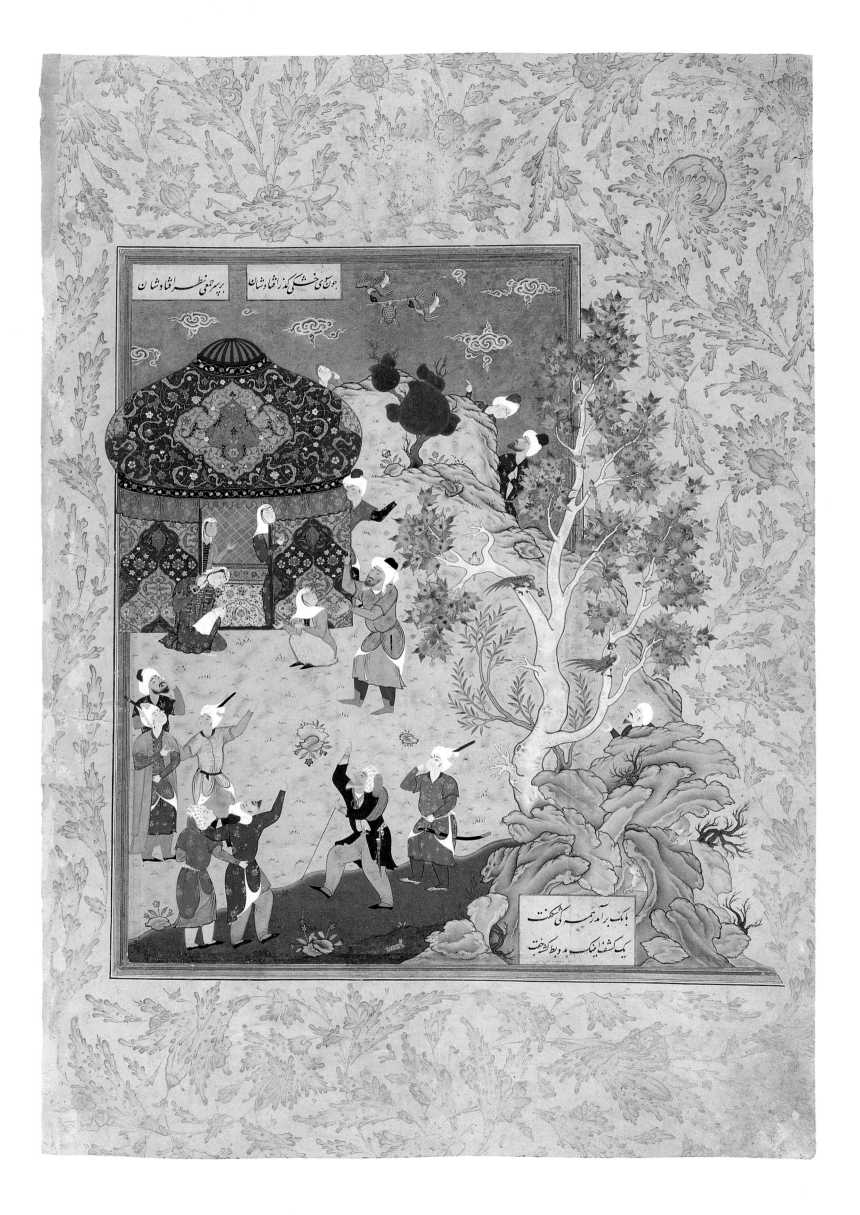

The composition illustrates the moment just before the tortoise's fall and, as with the *Tuhfat al-ahrar* text itself, follows a well-established iconographic tradition. The earliest representations, in both Arabic and Persian manuscripts of the *Kalila wa Dimna* of the thirteenth and fourteenth centuries, depict the two waterfowl supporting the stick while the tortoise hangs onto the middle. The landscape below is generally very simple, with perhaps a single tree and a small group of observers. During the late fourteenth through fifteenth centuries the landscape over which the ducks and tortoise fly continues to expand and the number of figures to multiply, until by the sixteenth century the principal characters are left with only a small corner of the picture plane.[5]

This scene seems to have been quite popular for illustration in copies of the *Haft awrang* in which the composition is generally treated as in the Freer Jami (e.g., CB MS 215, folio 18a; fig. 115). Only folio 215b, however, provides a habitat for its onlookers, some of whom engage in domestic activities, such as the woman sewing.[6] Furthermore, the Freer Jami is by far the liveliest rendition of the anecdote, with the figures disposed in more varied groups and expressing greater excitement. It is also the only one in which the landscape reflects the spirit of the occasion with its dancing clouds (as in FGA 46.12, folio 188a), foxes playing hide-and-seek, and waving tree limbs. Most distinctive, perhaps, of all these animated features are the anthropomorphic heads tucked into the contours of the rocky outcropping, which seems to have a life of its own.

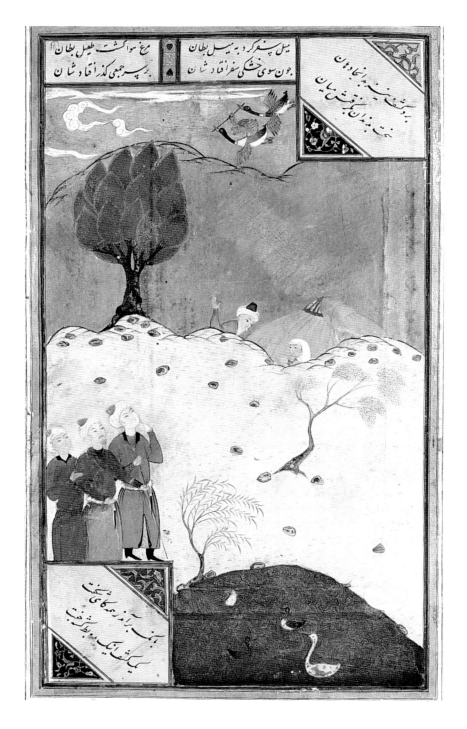

Dimensions
21.7×19.5 cm (including extensions on the right)

Incorporated Verses

One verse at top of illustration:

> *As their journey took them over dry land,*
> *They happened to pass in view of a group of people.*

One verse at bottom of illustration:

> *A cry arose from them all, "Oh, marvel!*
> *A tortoise has joined thus with two ducks."*

Attributions
Stchoukine: Group 1; S. C. Welch: Painter D (Abdul-Aziz?).

References
Manijeh Bayani, 126, fig. 128; Dickson & Welch, 1:224A, fig. 276; Inal, 71; Stchoukine, *MS*, 127; S. C. Welch, *PP*, 26, fig. T.

1. For a complete survey of this long literary tradition, see *EIs* 2, C. Brockelmann, "Kalila wa Dimna"; also Grube, *MP*, 2–15. For further details on the Persian versions, see Rypka, 222–23, 313, 660–61. It is interesting to note that in 1503–4, Husayn Waʿiz Kashifi wrote a biography of Khwaja Ubaydullah Ahrar, called the *Rashhat ayn al-hayat* (Drops from the source of life), based on notes he had taken during two visits with Ahrar (Browne, *LHP*, 3:441).
2. Ibn al-Muqaffaʿ [Miquel], 91–92, para. 214; Kashifi [Ouseley], book 1, chapter 23, 134–43 (in Persian); Kashifi [Wollaston], book 1, chapter 23, 121–29.
3. The lilac-colored plain is identical to that of FGA 46.12, folio 10a.
4. For a discussion of this type of tent, see Chapter Two, folio 110b. The tent coverings closely resemble the designs on rugs.
5. An extensive listing of illustrations of the flying tortoise in *Kalila wa Dimna* manuscripts appears in Grube, "Prolegomena," 320 n. 4, 441 (D.2.2). See also the discussion in Grube, "*Kalilah wa Dimnah*," 36; and text synopsis in Grube, *MP*, 155 (D.2), figs. 22–29, 39, 104, 127. For other reproductions, see Atil, *KD*, 27; Bothmer, 80–81, 119; Robinson, "Bidpai," 151, fig. 11; Walzer, fig. 23. To Grube's list may be added a fourteenth-century preparatory drawing, highlighted with gold (TKS H. 2152, folio 83b), and a fifteenth-century version of the scene attributed to northwest India (Fehérvári & Safadi, cat. no. 13, folio 52b).
6. One other illustration (SAK MS 17, folio 48b, dated 971/1563–64 [repro.: A. Welch, *CIA*, 4:66]) includes a tent, but it is half-hidden behind the horizon with only its smoke hole and uppermost walls visible and thus does not occupy a position of prominence within the composition. Another early illustration of this scene contains a boy angling for a marvelous fish in a foreground pool (AMSG S1986.52, folio 41a [repro.: Lowry et al., 150).

Folio 221b

THE EAST AFRICAN LOOKS AT HIMSELF IN THE MIRROR

Text Source
Mudarris-Gilani, pages 433–34.

Rubric before Illustration (folio 221a)

> The story of a Negro who saw his face in an unrusted mirror and did not see his reflection in the mirror and blamed the clear mirror for the defect of his dark face.[1]

Précis

A Negro with dark blue lips and gaping mouth ("hanging open like the mouth of a corpse") finds a dirty mirror beside the road. He picks it up and cleans it off. When he looks into its shining surface, he begins to curse, thinking that the ugly reflection is the fault of the mirror. The moral, according to Jami, is that what you see is the image of your own actions.

This brief tale illustrates the seventeenth discourse of the *Tuhfat al-ahrar* concerning the beauty and allure of the beloved. When people behold beauty, they are looking at their own desire. Since that desire is selfish and holds no light, their eyes soon become satiated and their mirror (the beautiful beloved who is the object of their gaze) turns into torment. A similar apologue appears in the *Silsilat al-dhahab*.[2]

Illustration

A tall, gangling dark-skinned youth stands in the foreground of a hilly landscape and holds a silver (now-oxidized) mirror in his left hand (fig. 116). His lips are extremely thick, as mentioned in the text (although pink instead of blue), and his eyes are conspicuously protuberant. He seems disgruntled as he gazes into the mirror. He wears only a pair of loose orange shorts lined in green, rolled down at the waist. A white sash loops across his torso and shoulders and hangs down his back. He holds one end in his right hand. A large gold hoop earring, signifying servitude, adorns his left ear, and an orange bow is tied under each knee.

Considerably more attention has been devoted to the landscape setting than to its sole occupant. A mass of smooth, almost sinuous, rocks rises at left, topped by a twisting tree.[3] From the rocky outcropping emerges a small stream, which meanders between verdant banks studded with boulders and flowering plants of various kinds and splits near the foreground to end in two paired branches and three small pools. The grassy stream bed separates the mauve, tufted plane with its own rocky contour from the bit of tufted gold ground on which the African stands. As in the upper left of the composition, the right and lower perimeters are edged with trees, including a tall plane tree, a flowering tree growing into the right-hand margin, and a willowlike specimen bending sideways in the immediate foreground. Other than the "natural" rhythms and movements of cliffs, stream, flowers, and trees, which seem exaggerated for effect, the only action occurs in the golden sky, where a large crane chases a knotted cloud. The central figure, by contrast, seems frozen in time and place, as if unable to believe what he sees in the mirror (fig. 117).

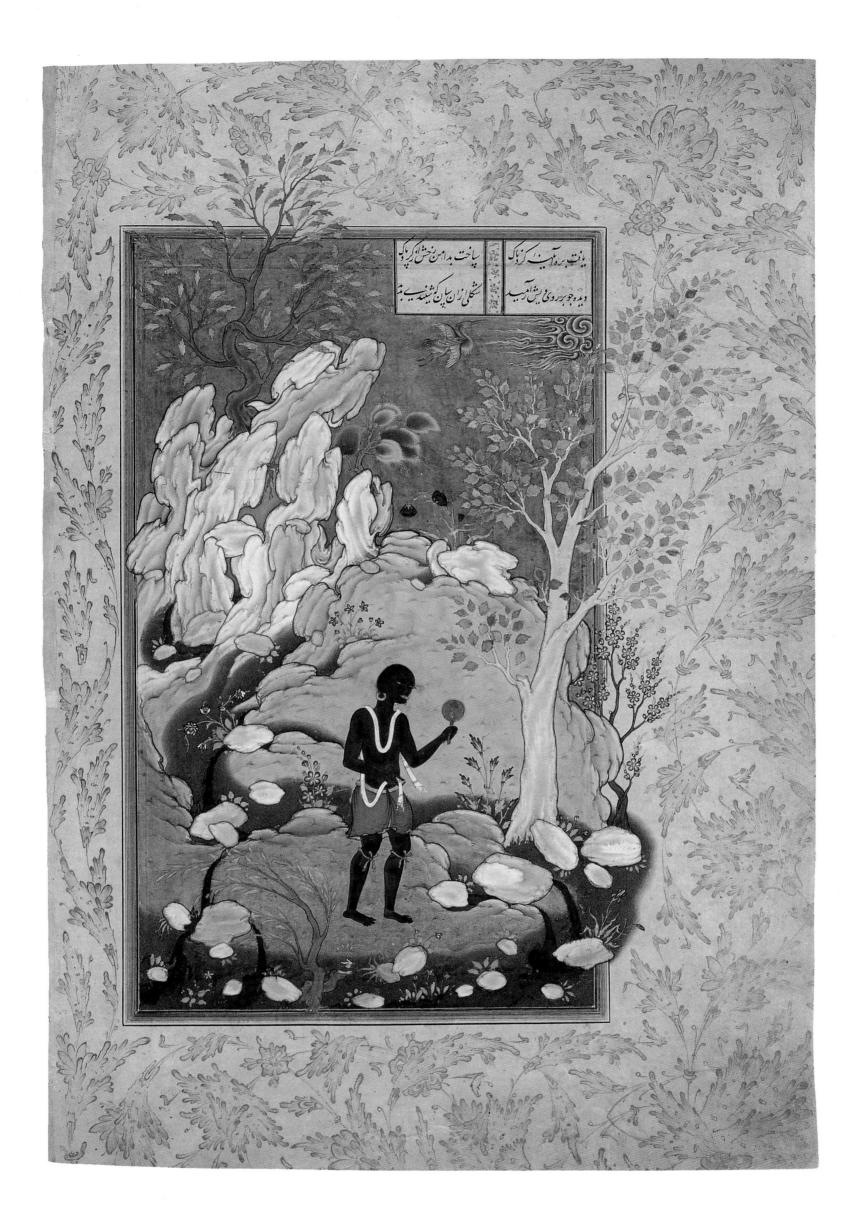

Sixteenth-century Persian painting is full of dark-skinned personages, usually in subsidiary roles such as the bathhouse attendants on the roof in FGA 46.12, folio 59a. The representation of folio 221b is a rare, possibly unique, instance of a Negro as a principal character. Within Safavid manuscript illustration it is also unusual for a narrative composition to consist of a single figure.[4] The dialogue between the solitary African and the dirty mirror thus assumes added significance for the pictorial program of the Freer Jami.

117
The East African Looks at Himself in the Mirror (detail)
in the *Haft awrang* of Jami
963–72/1556–65, Iran
24×13.7 cm (painting)
FGA 46.12, folio 221b

CHAPTER TWO: POETRY AND PAINTING

Dimensions
24×13.7 cm

Incorporated Verses

Two verses at top of illustration:

> *Found beside the road a dirty mirror.*
> *He cleaned it with the skirt of his cheek.*
>
> *When his eye came to rest on his face,*
> *He saw an image of the sort you have heard.*

Attributions
Stchoukine: Group 2; S. C. Welch: Mirza-Ali.

References
CHI, 6: fig. 62; Dickson & Welch, 1: 141B, 150A, fig. 204; Stchoukine, *MS*, 128;
S. C. Welch, *PP*, 26, fig. U.

1. The text of the Freer Jami rubric differs from
that in the Mudarris-Gilani edition. There is a
play of words here with *zangi* (Negro) and *bizang*
(unrusted). *Zang* (Arabic, *zanj*) is the name used in
early Islamic history and literature for the blacks of
East Africa (Lewis, 116).
2. Mudarris-Gilani, 255. For the mirror in Persian
literature, art, and mystical thought, see Bürgel,
chapter 6.
3. S. C. Welch (Dickson & Welch, 1:150A) has
written a uniquely evocative description of these
cliffs: "which seem to slither upwards with a
strangely celestial, gravity-defying life of their own.
They seem to reach for heaven and most of their
rock-quality has disappeared."
4. Even Majnun in the wilderness has animals for
companionship (see S. C. Welch, *PP*, pl. 30). The
Negro in FGA 46.12, folio 221b, resembles single-
figure studies of the type mounted in Persian
albums, although his action is directly related to the
Tuhfat al-ahrar text. See Lewis (pp. 6–37) for an
introduction to attitudes toward blacks in the early
Islamic period (seventh–eleventh centuries).

Layli u Majnun

Like Jami's other allegorical romances, his *Layli u Majnun* of 889/1484 belongs to an old poetic tradition of Arabic, and probably oral, origin.[1] Its most direct sources are the well-known poems of Nizami (584/1188) and Amir Khusraw Dihlavi (698/1298–99). While praising both predecessors near the beginning of the masnavi, Jami asserts that he will follow his own inspiration.[2] Jami actually added little to the plot and episodic structure of previous versions. The point of his poem is not the narrative but the development of the protagonists as archetypes of Sufi love and of their story as an allegory for a spiritual quest.[3] This emphasis is made clear in the prologue in which Jami explains that he chose to write about Layli and Majnun because love is the most inspired of all themes. This explanation is bracketed by a description of the doctrine of Sufi love, including the importance of loving attachment to a pir for guidance, and by a discussion of the meaning of love. The Sufi connection is underscored by Jami's homage to Khwaja Ubaydullah Ahrar, superior of the Naqshbandi order.[4]

Although faithful to the tale as told by Nizami and Amir Khusraw, Jami deviates from previous versions at the outset in introducing Qays (later to become Majnun) not as a childhood friend of Layli's but as a carefree young poet always on the lookout for beautiful girls. The youth's search leads him to Layli's tribe, where he meets the lovely young woman (FGA 46.12, folio 231a). The two immediately fall in love and spend the day together. At nightfall they must separate. The effect of this first separation is evoked by Jami with an extended metaphor of the soul in its worldly prison. The next day the two manage to meet again, despite the efforts of Qays's friends to keep them apart, and Layli confesses her love and suffering. This confession leads Qays into his first state of ecstasy, but the trance is interrupted by friends, who gather around and deprive him of his vision. The next day the two lovers succeed in meeting in private, and Qays experiences his first struggle with the temptations of the "animal soul."

To test his devotion, Layli momentarily shuns Qays. Having passed this hurdle, he then concludes a pact of love with Layli, comparable to the Sufi notion of humanity's pact with God. At this point Qays loses his reason and proudly bears the name Majnun (mad). A series of trying incidents involving parental and social pressures then follows. Although he becomes more enamored of Layli, Majnun is deprived of his beloved, who is forced to marry another man.

Majnun then goes to live in the desert, where he becomes increasingly intimate with nature, another sign of his greater communion with the divine. Soon everyone hears about the mad youth roaming the desert obsessed with love for Layli. His fame attracts the attention of the caliph, who orders the youth to be brought to court, where he recites poems of love and suffering. The caliph is so impressed by these poignant verses that he proposes to have Layli's father bring her to him. Majnun pays no heed and returns to the desert, where he continues to wander restlessly in search of Layli. One day he sees a tent camp at a distance and learns from a departing cameleer that this is the caravan of Layli's tribe, en route to Mecca (FGA 46.12, folio 253a). Majnun follows the caravan at a distance, trying to glimpse his beloved's tent. Eventually, during ceremonies at the Ka'ba, he manages to stand near Layli for a brief moment, after which they part with painful looks.[5]

Majnun's purity during the hajj symbolizes the final stages of his spiritual development. His religious practices are now identical with those of the Sufis, as when he dons a sheepskin and joins Layli's flock (FGA 46.12, folio 264a). On another occasion Majnun goes to Layli's tent disguised as a beggar. In this garb he symbolizes *faqr* (spiritual poverty), the epitome of all gnostic virtues. When Layli breaks his cup instead of filling it, Majnun begins the Sufi song and dance, or sama'. He then experiences his most intense suffering and ecstasy with a final vision of Layli, and from that moment he is completely mad. When Layli returns to him, Majnun does not recognize her and sends her away. In this "station" (*maqam*) of love-crazed madness, he has lost the ability to distinguish between lover and beloved. Just before dying, Majnun again recites poetry, by which, as through love and madness, a mystic can achieve unity with the divine. In death Majnun finally transcends the world of appearances and becomes one with God. His demise causes Layli great sorrow. Eventually she falls into a lingering illness and joins him in death.

The leitmotif of *Layli u Majnun*—the struggle for purification through love and suffering—pervades other masnavis of the *Haft awrang*. Thus Majnun may be regarded as the model of mystical passion and Layli as the manifestation of divine beauty in which the enraptured devotee wishes to be annihilated.[6]

1. The source for masnavi text is Mudarris-Gilani, 750–810. For the tale's history, see Dols, 320–39; *EIs* 2, Ch. Pellat & J. T. P. de Bruijn, "Madjnun Layla."

2. Mudarris-Gilani, 760.

3. The discussion that follows draws heavily on Khayrallah, especially 107–25.

4. Mudarris-Gilani, 753–55. Notwithstanding these praises and the markedly Sufi tenor of the poem, literary historians do not consider that Jami wrote *Layli u Majnun* in honor of Khwaja Ubaydullah Ahrar. In fact, this masnavi is the only one of the *Haft awrang* without a recognized patron or "dedicatee."

5. The masnavi text continues with a passage on the illness and death of Layli's husband. The scene may have been illustrated in the Freer Jami on a folio now missing after folio 261b.

6. Schimmel, *MD*, 292, 431–32; Schimmel, *Veil*, 129.

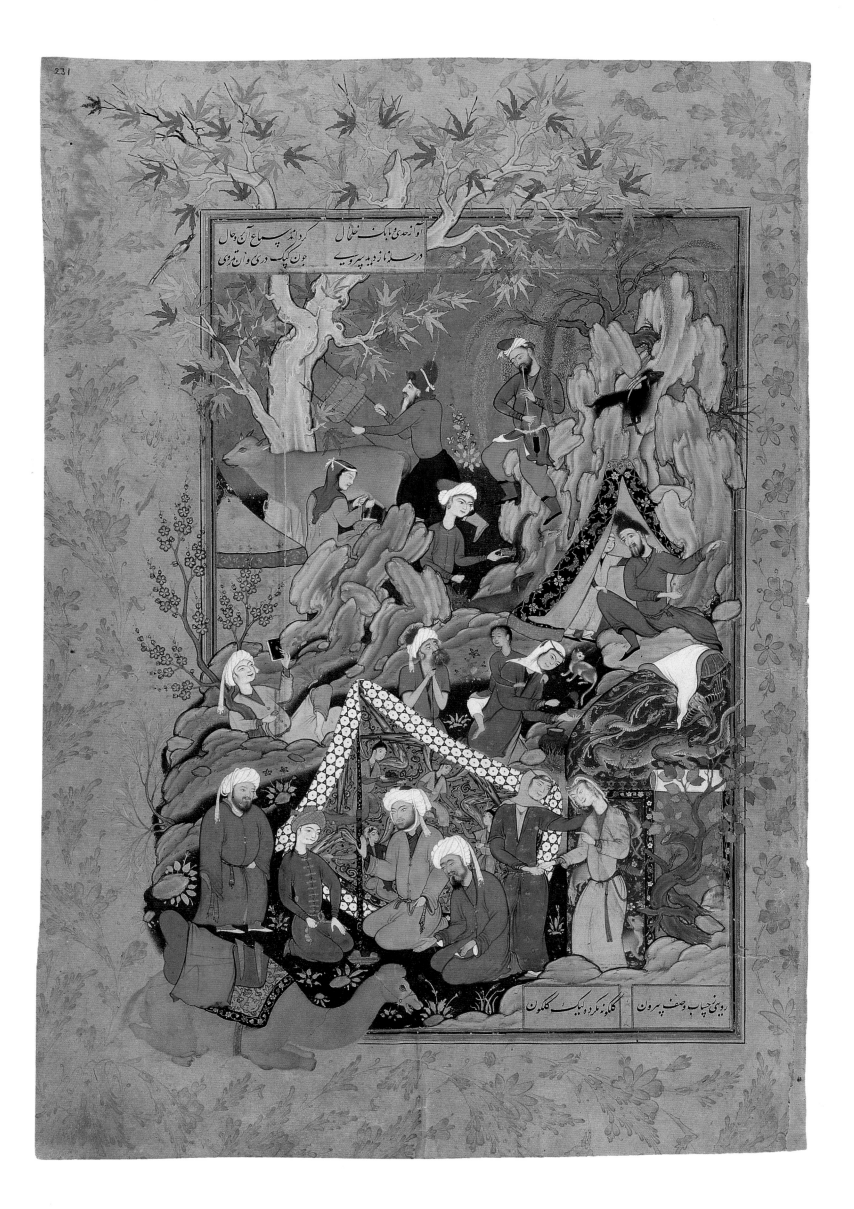

Folio 231a

QAYS FIRST GLIMPSES LAYLI

Text Source

Mudarris-Gilani, pages 768–70.

Rubric before Illustration (folio 230b)

Majnun hears a description of Layli's beauty and goes to her tribe and beholds her beauty.[1]

Précis

In a lovelorn state, Qays asks everyone he encounters for news of a young beauty. One group tells him of a certain Layli. An exultant Qays changes clothes and dashes off on camelback to the camp of Layli's tribe. There he receives a warm welcome but sees no sign of the reported beauty. The youth is about to despair when suddenly he spies a beautiful woman. Qays then comes face to face with Layli, and the two are soon totally enamored of one another. They spend the day together in intimate conversation, carefree and joyous. When night comes, they experience the agony of separation.

The imagery Jami uses to describe Qays's first glimpse of Layli includes stock phrases about a lover losing his reason, which foreshadow the youth's later transformation into Majnun.[2] At this point in the narrative only the rubrics identify the young lover as Majnun, the madman.

Illustration

The encounter of Qays and Layli occurs in the foreground of an encampment scene where the hopeful lover kneels on a plot of grass and his beautiful beloved emerges from a tent (fig. 118). Qays seems to be accompanied by the short, rotund, bearded man, who stands with one hand tucked into his waistband as if to support his impressive paunch. The large caparisoned camel, which brought Qays to the camp, kneels, as specified in Jami's text, at the very bottom edge of the scene in the illuminated margin. The two kneeling men who face Qays and make various gestures of speech must be tribal members. The man with a longer beard streaked with gray is clearly older but perhaps of lesser rank or authority, judging from his downcast eyes and humble demeanor. A beautiful canopy, supported by a black and gold ridgepole and decorated with four winged angels carrying bowls of fruit, shelters the group.

While the men converse, two young women approach from the right (fig. 119). The first girl, her head and neck swathed in a wimple, turns backward and urges her companion forward by pulling her hand and pushing her gently around the shoulders. The hesitant maiden must be Layli, judging from her dangling earrings and fancy headcloth with its long tassel looped up and tucked into her waistband. Layli inclines her head demurely, perhaps in acquiescence to the other woman or in acknowledgment of Qays's presence, and points toward the group of men. The two women evidently have just emerged from the rolled-up door of the tent behind. This structure has a rounded roof decorated with a vivid scene of a simurgh attacking a large dragon. The white flap of the smoke hole covers part of the bird's body. The outer wall of the tent, largely hidden behind Layli, also has a figurative scene on a bright red ground in which a fox with a long bushy tail, a snarling feline, and a fantastic quadruped are visible. These creatures look extremely vicious, in contrast to the pacific angels on the interior of the adjacent tent.[3] A sense of realism extends to the mythical dragon, whose tail flips off the tent top and onto the ruling at the right side of the picture.

Having pitched camp on a rocky hillside, members of Layli's tribe are occupied with various domestic activities. Behind the foreground canopy and tent a woman kneels over a cooking fire and ladles soup from a black pot into a gold bowl, while a large male child clings to her back and shoulders. The boy's attention is focused not on the food but on an old mountain man with a grizzled beard who leans on a staff to the left and seems to return the boy's gaze. Above the cooking fire is a small blue pup tent that evidently belongs to the bearded man with the tall fur cap who sits in front, his legs sprawled across a large boulder. He is busy spinning wool and holds the spindle and skein in his outstretched hands. A small girl, just coming out of the tent, places her hands on the man's shoulder and knee. The two incline their heads together with apparent affection. It is likely that

118
Qays First Glimpses Layli
in the *Haft awrang* of Jami
963–72/1556–65, Iran
34.5×23.4 cm (folio)
FGA 46.12, folio 231a

father and daughter are related to the mother and son at the cooking pot below. Between these family groupings is a small calico cat apparently riveted by the twisting wool.

Just behind the pup tent a goatherder perches on a stony ledge and plays a long pipe, while one of his flock eyes a fat partridge above and two other goats gaze up from the base of the rocks. The waters of a gushing spring are caught by a young man holding a small gold bowl in one hand and a tall-necked ewer in the other. Directly opposite the rock formation is a tall plane tree, its leafy branches sheltering a woman who milks a cow into a brown ceramic bowl and a white-bearded man who makes cheese or butter. The latter chore is performed with the use of a laced skin pouch, suspended on a kind of hammock, which in turn is supported by two long sticks. The stick ends are tied together by a rope looped around a tree branch. It is through the agitation of the sticks that the pouch's contents are transformed into butter or cheese. At the milkmaid's back is a small, round, blue tent, pitched behind another pile of large boulders and stretch of rocky ground. In the middle of this outcropping is a barefooted young man reading a small leather-bound book. He sprawls against a flowering tree, the one person in the tribe who seems engaged in a frivolous activity.

119
Qays First Glimpses Layli (detail)
in the *Haft awrang* of Jami
963–72/1556–65, Iran
25.2×15.6 cm (painting)
FGA 46.12, folio 231a

120
Qays First Glimpses Layli
in the *Six Masnavis* of Jami
978–79/1570–72, Iran,
attributed to Qazvin and Mashhad
23.3×13.2 cm (painting); 34.9×23.3 cm (folio)
TKS H. 1483, folio 65b
Topkapi Sarayi Müzesi, Istanbul

121
Qays First Glimpses Layli
Painting mounted as an album page
Second half 16th century or later, Iran or Turkey
25.5×16.3 (painting)
TKS H. 2156, folio 4a
Topkapi Sarayi Müzesi, Istanbul

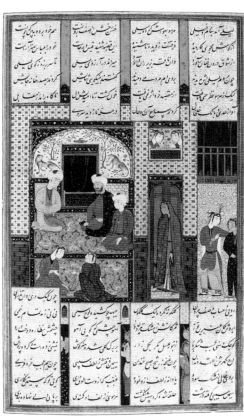

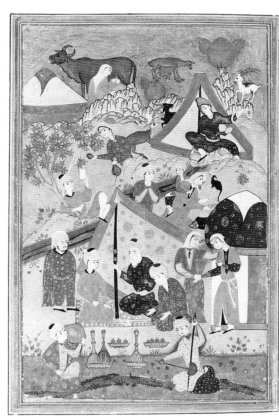

The encampment scene includes several details also found in FGA 46.12, folio 30a, such as the pipe player and wool spinner. The styles of the two paintings, however, differ considerably. In folio 231a the figures loom large in relation to the landscape, and their bodies exhibit odd proportions, as, for instance, the young boy riding piggyback, whose head and neck do not seem to belong to his torso, which in turn seems too short for his very long legs. In addition, the rocky terrain seems slimy, with sharply defined, rounded, contours. Here folio 231a appears much closer to FGA 46.12, folio 105a, with which it also shares comparable tents and canopies and certain details of human form and physiognomy as, for instance, Qays and the young man being chucked under the chin in the foreground of the other encampment scene. Both compositions also have a hard-edged quality, the effect perhaps even more pronounced in folio 231a.[4]

Folio 231a is the most elaborate of a set of roughly contemporary representations of the first meeting of Layli and Qays. One of the other two compositions, in a manuscript dating from 978–79/1570–72 (TKS H. 1483, folio 65b; fig. 120), sets the scene in an interior with Qays and two other men, one old and one young, sitting beneath an archway. Layli, covered head to foot in a green cloak, enters through a doorway. The other illustration, belonging to an undated manuscript tran-scribed by Muhammad Qivam katib Shirazi around 1575 (BOD Elliot 149, folio 226a), resembles the Freer Jami in setting and compositional scheme, although the encampment is more expansive and includes four tents with numerous individuals.[5]

Elements of the Freer Jami painting also appear in two drawings associated with the sixteenth-century artist Muhammadi (BN suppl. pers. 1572, p. 8; and CMA 41.491). Among the common features are the six foreground figures (minus the sheltering canopy and tent), the youth (minus the book) reclining against a tree, and the flutist perched on the rocky promontory.[6] An illustration of the betrothal of Aynie and Ria in a *Silsilat al-dhahab* of circa 1550–60 also contains a variation of the foreground group, here with a canopy and a flutist (MOA MS 1961/II, folio 63b). Clearly all these figures and figural groups belong to a repertoire shared by Safavid artists.

The teeming camp life of the Freer Jami illustrations influenced a later artist who replicated the scene in a composition now mounted in an Istanbul album (TKS H. 2156, folio 4a; fig. 121). Although not a precise duplicate of folio 231a, the album painting follows the same placement and relationship of figures and tents and includes many of the same specific individuals and activities.[7]

Dimensions

25.2×15.6 cm

Incorporated Verses

Two verses at top of illustration:

> *A caravan-leading song and the jangle of camel bells.*
> *Hearing it turned him spinning round in ecstasy.*
>
> *In the charming abode of evergreens he saw a cypress,*
> *Like a beautiful partridge with a pheasant's [graceful] gait.*

One verse at bottom of illustration:

> *[She had] a face beyond the measure of descriptions of praise.*
> *No rouge had she used, yet she had cheeks like a rose.*

Attributions

Stchoukine: Group 2, Artist 1; Titley: Shaykh-Muhammad; S. C. Welch: Muzaffar-Ali.

References

Beach, *Imperial Image*, figs. 1 (detail of Layli) and 2 (full painting); Dickson & Welch, 1:159B, fig. 222; Inal, 64, fig. 4; Kevorkian & Sicré, 176–77, with repro. color; Stchoukine, *MS*, 128, pl. XLIII; Titley, *PMP*, 106; S. C. Welch, "Pictures," 72; S. C. Welch, *PP*, 120–21, with repro. color.

Notes

1. This rubric is completely different from that in Mudarris-Gilani, 768.

2. See, for instance, Mudarris-Gilani, 769:
 She would unwind the curl of her hair,
 He would extend the hand of yearning.
 She would lift the veil off her face,
 He would abandon patience and wisdom.
 Translation by Massumeh Farhad.

3. S. C. Welch (*PP*, 121) has given a marvelous description of this animal scene. It may be that the tension and excitement manifest among the animals foreshadow what will occur as the narrative develops.

4. A poor imitation of folio 231a appears as the frontispiece (possibly inserted) to an undated manuscript of Sa'di's *Gulistan* now in Jerusalem (IM 5004.1.79 [repro.: Milstein, cat. nos. 25, 53]). Various compositional features found in folio 231a are integrated much more successfully into folio 14b of a *Sifat al-ashiqin* of Hilali copied in 990/1582–83 (AHT no. 90b [repro. color: Soudavar, 23]).

5. The moment when Qays enters the camp on camelback just before meeting Layli (Mudarris-Gilani, 766–68) is illustrated in a manuscript completed in Dhu'l-qa'da 971/June 1564 (PWM MS 55.102, folio 231b). Interestingly, this composition contains a pastiche of genre details found in folio 231a and other Freer Jami illustrations. The woman inside the lower tent at the right appears to be spinning, as is the bearded man seated outside the pup tent in the upper right of FGA 46.12, folio 231a. The woman and child standing at the opening of the tent at the upper left of PWM MS 55.102, folio 231b, more closely parallel the Freer Jami. They are identical, in reverse, to the mother and child in FGA 46.12, folio 169b. The figure in profile with the pointed cap in the upper background of the PWM scene recalls the gesticulating man at the lower right of FGA 46.12, folio 30a. A similar pointed cap is also worn by the herdsman at the top of folio 30a. Close cousins of Layli and her companion in FGA 46.12, folio 231a, appear in PWM MS 55.102, folio 76a, a painting that also shares features with FGA 46.12, folio 30a.

6. Robinson, "Muhammadi," 20–21 (nos. M10–M11); Martin, 2: pls. 103–4. The flutist also appears in a painting attributed to Muhammadi (AHT no. 93 [repro. color: Soudavar, 238]).

7. This same album also contains a drawing on folio 57a that Inal (p. 64, fig. 2) mentions with reference to FGA 46.12, folio 231a, pointing to the apparent similarities between the two represen-tations of Layli.

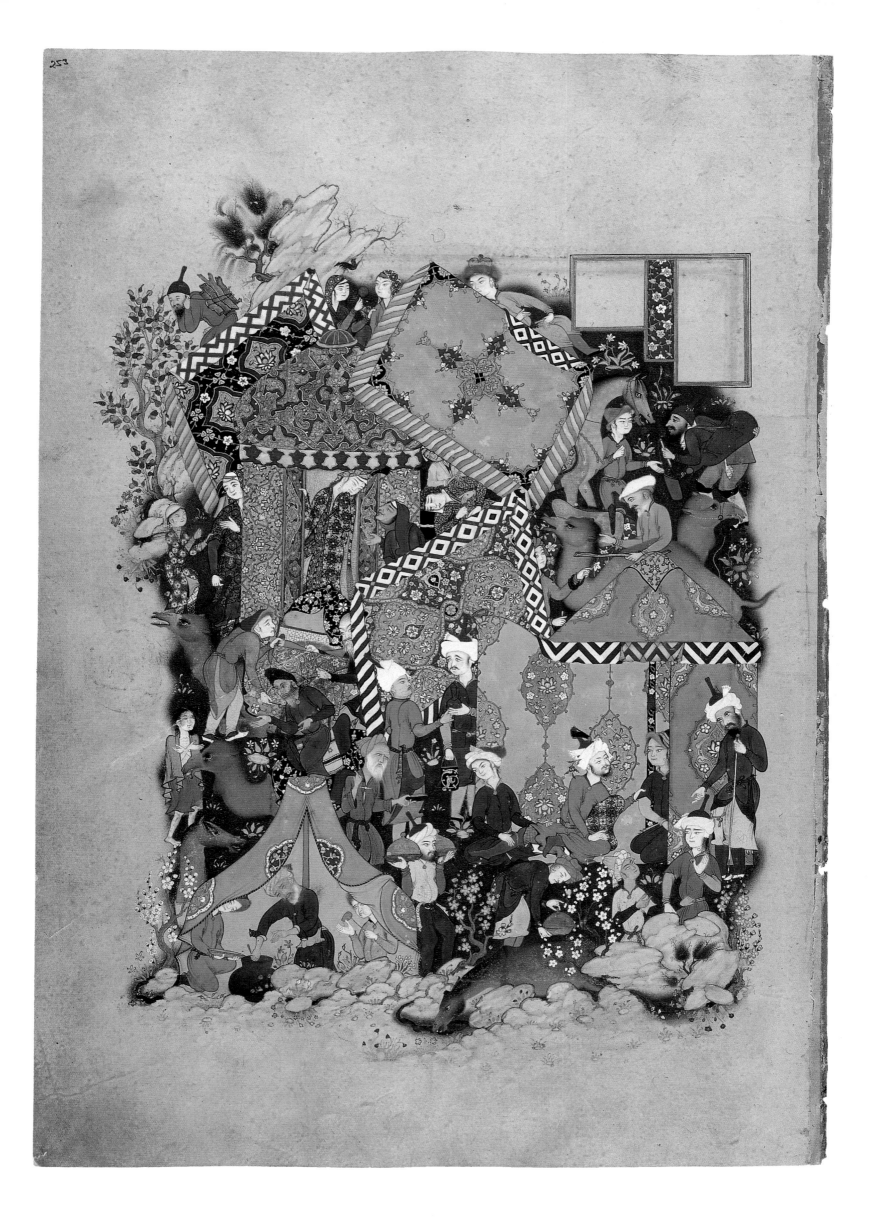

Folio 253a

MAJNUN APPROACHES THE CAMP OF LAYLI'S CARAVAN

Text Source
Mudarris–Gilani, pages 841–44.

Rubric before Illustration (folio 252b)

> *A description of summer; Majnun hears the news that Layli has gone on the hajj, and joins her caravan.*

Précis

Majnun resumes his restless wanderings in search of Layli. Like the burning in his heart, the summer heat of the desert is unbearable. Mountain streams have turned into boiling water; the antelope seeks shade under the shadow of its own antlers; the soles of the oryx blister. "The searing heat had turned Majnun into a finger, his heart a flame licking out from his body, [and] constantly sending out fire." Then from the top of a hill Majnun sees a caravan encampment, and he heads toward it. A camel rider leaving the camp tells him that the caravan belongs to Layli and her family and that they are on the hajj. Hearing his beloved's name, Majnun faints. He then revives and follows the caravan at a distance, trying to catch a glimpse of Layli's tent. But Layli is unattainable, and Majnun becomes totally absorbed in her imagined presence, kissing the traces of Layli's footsteps, for instance, instead of her feet.

Jami concludes this episode with a discourse, addressed to himself, about the world as the ardent lover of the divine beloved.

Illustration

This is without a doubt the Freer Jami's most enigmatic illustration and most complicated, even confusing, composition (fig. 122). It is also the most frequently discussed and reproduced painting in the entire manuscript and has been cited as representing the spirit of Safavid art and royal patronage between 1556 and 1565 and the last, so-called decadent, phase of stylistic development within Ibrahim Mirza's *Haft awrang*.[1]

The pictorial structure of this complex encampment scene is anchored by a half-dozen brilliantly decorated tents and canopies set next to each other, often at overlapping angles. These enframe and provide the backdrop for numerous slices of camp life, including some puzzling vignettes. The composition grows up along a series of switchbacks, with occasional dead ends, starting at lower left. There the walls of a small pup tent are pulled back to reveal an old, white-bearded man grinning maliciously and stirring a large, once-silver pot. He is flanked on the left by a youth crouching over and holding out a large gold platter and on the right by another young man blowing on a skewered morsel, which must have just come out of the cooking pot. Outside to the left a gray horse looks up, as if startled, and peers over the tent top. Just behind the tent at the right a bearded man carries two dome-lidded gold platters. He holds these up to his shoulders as if to balance himself, while another attendant bends over in front to set yet one more lidded platter on the ground. Just below and at the bottom edge of the picture plane, a brown horse stretches its neck over a rocky bank to drink from a small stream. Behind this animal and a small pile of rocks to the right are two youths. The figure dressed in yellow seems younger. He looks backward and beckons while grasping his companion's sash as if to pull him forward. The taller youth, whose brown hair hangs down in long wisps from beneath his loosely wrapped turban, holds up his left hand in a gesture of protest.

Behind this duo is a large tent decorated inside and out with large floral medallions. A bright zigzag band marks the juncture of its walls and conical roof. The left side of the tent wall is open, stretched out, and rolled back to form a kind of screen. A bearded man holding a white staff stands just outside to the far right. He inclines his head and gestures forward as if to direct attention to where a young man in a purple robe kneels. The youth's upper arm is in the grip of a foppish man sporting a wispy beard and a loosely wrapped turban who reclines against a cushion in front of the bright blue screen wall. He wears high green boots and stretches one leg onto the lap of another

122
Majnun Approaches the Camp of Layli's Caravan
in the *Haft awrang* of Jami
963–72/1556–65, Iran
34.5×23.4 cm (folio)
FGA 46.12, folio 253a

beardless youth sitting cross-legged at left. This fellow rests his hands on his companion's leg and thigh, but his gaze is fastened on a white-haired beggar at the left holding an empty sack over his back and a small begging bowl in his outstretched hand.

The screen wall of the round tent overlaps a large rectangular canopy decorated with inter-locking floral medallions in blue and gold.[2] Two mustached youths stands between the tent wall and canopy. Wearing a short purple tunic, the one on the right seems to head off behind the tent but stops to turn back toward his companion. He has what looks like a book or envelope tucked under his right arm and holds a black bucket decorated with a large gold split-palmette scroll in his right hand. He may be exchanging a silver (now oxidized) bottle with the other man. This second figure, depicted in profile, wags two fingers as if admonishing the first man while simultaneously touching the jug with his other hand.

The canopy where this pair exchanges the jug forms the approximate midpoint of the picture. Both the slant of the canopy and gaze of the finger-wagger move the composition upward toward the right, where the canopy intersects at the corner with another canopy decorated with a central quadripartite medallion on a mauve ground. The intersection of the two canopies forms a grassy, flowered area at the upper right, bound below by the crown of the medallion tent and above by two empty panels (separated by a band of floral illumination), obviously intended for several verses of the *Layli u Majnun* poem. Two camels, one facing left and the other right, stand side-by-side just behind the tent top. The one at the rear has a halter and a saddle with floral saddle blanket. The one nearest the tent top is unbridled. A man with a pointed white beard and flat white hat appears sand-wiched between the two beasts. He rests a thick stick over the neck of the lower camel and scratches the back of its head. He may also be talking to the young boy who emerges from the side of the car-touched canopy and points at the camel. This figure is spinning and has a skein of wool wrapped around his left wrist and a spindle in his right hand. Another encounter takes place just above. There a dark-bearded man wearing a red turban cap bends over to pour water into a leather bucket from a large skin slung over his back. The water is evidently for a dapple-gray horse being led from behind the top canopy by a young man, perhaps a groom, wearing a fur cap and gesturing toward the water carrier.

The mauve canopy is slanted up to the left. Immediately behind its upper edge is a youth wearing a yellow robe and fur-edged cap. This fellow reclines on his back on the grass and props himself up with his right arm to peer intently over the canopy. It is likely that he is watching the two young women who are looking at each other in the small space to the left of the canopy. Both females wear brightly patterned scarves and V-necked garments. The one on the left holds up a round mirror in one hand and rests her other hand on the shoulder of her companion, who looks back in response. A rocky outcropping with two twisted trees soars at a sharp angle above the girls' heads. Moving down this slope toward a leafy tree at its base is a bearded man bent under a heavy load of fagots, which he carries roped onto his back.[3]

The two girls and the woodsman are separated from each other and from the rest of the camp by a third rectangular canopy, decorated with scalloped floral medallions on a black ground and tilted at an angle parallel to that of the upper rock formation and to that of the other canopy below. Much of the upper canopy is hidden behind a trellis tent. Its domical roof is covered with a network of two split-palmette scrolls in two shades of gold on a dark blue ground and edged at the bottom with a band of red fleur-de-lis. Its side walls are decorated with interlocking medallions and a floral scroll. A pair of panels with split-palmette scrolls flanks the tent's entrance and may even serve as its door. This striking structure is the locus of various, apparently unrelated, activities. A young woman, dressed in an elaborately patterned robe reminiscent of tile revetments and holding a tall-necked, once-silver ewer in her right hand, seems about to disappear around the back of the tent. She is momentarily restrained by a young girl in braids, who wears a patterned tunic and stockings and a bowl-shaped yellow cap. She grasps the woman's upper arm, forcing her to turn backward to look at the red twig the younger female holds up. (Or what looks like a twig may be a rope around the woman's neck.) Another young female, wearing an even more colorful and densely designed costume, ducks her head beneath the tent's open doorway. She rests one hand on the left doorjamb and brings her other hand, hidden under the dangling sleeve of her cloak, up to her chin. This gesture may be in reaction to something said by the wrinkled older woman bent over with age. Another curious pair of females occupies the small triangular space to the right, formed by the inter-section of the tent and the two canopies. Here a young woman sleeps or perhaps has fainted in the

arms of another female. The former, wearing a patterned robe and head covering, closes her eyes, places her hands on her chest and stomach, and rests her head on a black and gold cushion. She has a peculiar, slightly demented expression. The hand with which she supports the girl has a large spot, probably of henna. Her other hand, skinny and clawlike, rests on the girl's shoulder.

In front of the trellis tent two men unload a kneeling camel. They seem to have already removed a domed container or perhaps the upper section of a litter, covered with a floral cloth and resting at the feet of a young woman standing in the doorway. They are now dealing with a large rectangular packet shaped like an envelope and decorated with a floral arabesque.[4] The younger of the two men, with a hooked nose and doltish face, lifts the packet at its left corners, while his co-worker pulls at the ropes binding the load onto the camel. Bald and with a scraggly white beard, the older figure is half-hidden by the central canopy. His mind is clearly less on the task at hand than on what is going on below to the left. Here another older, bearded man mounted on camelback leans forward in animated conversation with a bedraggled youth who approaches the camp from the left edge. The youth raises his crossed arms to his skinny chest. He wears only a short brown skirt and a blue blanket around his shoulders. His emaciated frame, minimal attire, and humble demeanor identify him as Majnun, who is learning from the camel rider that the encamped caravan is that of Layli's family.[5]

It is these two figures, stuck off to one side amid the jumble of people, animals, and tents, that connect this composition with the *Layli u Majnun* text (fig. 123).[6] The verses that should have been written into the panels at the upper right of the composition describe Majnun standing on a hill and seeing a tent camp at a distance. His encounter with the cameleer occurs a couple of verses later. This illustration thus anticipates a moment possibly considered as more critical to the development of the narrative or to Majnun's progress on the path of spiritual enlightenment.[7]

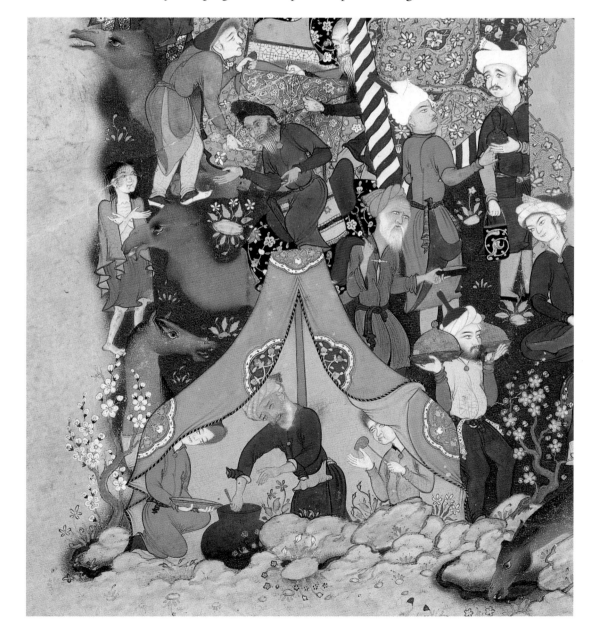

123
Majnun Approaches the Camp of Layli's Caravan
(detail)
in the *Haft awrang* of Jami
963–72/1556–65, Iran
23.5×19.5 cm (painting)
FGA 46.12, folio 253a

The real subject of this riveting picture is clearly the encampment, its denizens and activities. Much of the painting's fascination lies in its visual ambiguities and artistic contradictions. Many vignettes—the cooking scene, attendants carrying platters, camel being unloaded, horse being watered, man lugging fagots, and beggar holding out his bowl—make sense within the context of a camp scene. Certain details—the rolled-up sleeves of the cook and boy blowing on the skewered victual—add even greater verisimilitude. Still other personages—the male trio in front of the bright blue tent wall at the lower right—come from a familiar sixteenth-century topos also seen, for instance, in FGA 46.12, folio 105a. The significance of various other groupings—the little girl in braids restraining the taller girl with a ewer, the girl sleeping in the arms of another woman, the girls exchanging a mirror, the mustached men exchanging a jug, and two other men behind the rocks at bottom right—is not at all evident.[8] The meaning or purpose of specific individuals—notably the bearded man with the staff at the far right of the composition and the young woman in the trellis tent doorway (whom S. C. Welch identifies as Layli)[9]—and the relationship between individuals are also unclear. In addition, the tendency toward caricature or distortion of features makes even the most innocuous figures, such as the younger of the two baggage handlers, seem bizarre.[10] The camels and horses also wear peculiar expressions, and all look as if ready to bite someone's head off.

Furthermore, the rendering of body parts often defies anatomical logic. Where, for instance, are the legs of the horse drinking from the stream at the bottom of the composition or those of the camel ridden by the caravanner talking to Majnun? It is often difficult to construct the spatial relationship of people and animals to each other, to the tents, and to the landscape. The lack of logic in rendering physical forms extends to the tents and canopies as well. None of the canopies seems to be supported by the poles or architectural elements seen in other Freer Jami paintings (folios 105a and 231a), and the blue screen wall of the large tent in the lower right seems to be stretched out without being fastened.[11] Thus, although the tents may provide the painting's compositional structure and contribute to the striking impact of the ensemble, they are really no more stable or believable than the people standing in and around them. Their instability is masked, through distraction, and enhanced, through diversity, by the dazzling patterns of decoration, including the striped, zigzag, and diamond borders and equally varied medallions and arabesques on interior and exterior surfaces.[12]

The impact of this painting has been variously characterized as "audacious," "picturesque," and "unorthodox." It has also been likened to a nightmare, a blue movie, or a huge windmill breaking up in a hurricane, and its impact has been related to the allover tapestry effect of Flemish and French illuminated manuscripts.[13] Although a few other illustrations in the Freer Jami share some of these features, notably folios 105a and 231a (perhaps because they were painted by the same artist), none creates the same impression of having been conceived despite the *Layli u Majnun* text and, indeed, despite the norms of traditional Persian painting, much less those of the "real world."[14]

Folio 253a is incomplete. In addition to the empty panels in the text block at the upper right, the folio lacks marginal illuminations around the illustration and text on the verso. In addition, there are no rulings around any part of the picture plane. While other illustrations in the Freer Jami have empty blocks for verses or illuminations, this is the only illustrated folio without rulings and decorated margins. These omissions could have resulted from a last-minute completion and submission of the painting. They could also have been quite deliberate, in recognition of the illustration's unusual pictorial qualities.

CHAPTER TWO: POETRY AND PAINTING

Dimensions

23.5×19.5 cm

Incorporated Verses

Three omitted verses at top of illustration:

> *[Then, like a tulip branded on its heart,*
> *He halted on a hill.*
>
> *He looked in every direction,*
> *And saw in the distance a tent camp.*
>
> *People had put up tents in groups,*
> *The earth glittered like a celestial sphere with stars.]*

Attributions

Gray: an artist who may have seen or been influenced by Flemish or French illuminated manuscripts; Stchoukine: Group 2, Artist 2; Titley: Shaykh-Muhammad; S. C. Welch: Shaykh-Muhammad.

References

Blair & Bloom, 172–73, color pl. 216; Dickson & Welch, 1:45B, fig. 47; Ferrier, 17, with repro. color; Golombek, "Draped," fig. 8; Gray, *PP* 2, 145; Grube, *WI*, 144, color pl. 83; Kevorkian & Sicré, 182–83, with repro. color; Robinson, "Survey," fig. 24; Simpson, "Shaykh-Muhammad," fig. 9; Stchoukine, *MS*, 128, pl. XL; Titley, *PMP*, 106; A. Welch, "Abbas," 460; S. C. Welch, *KBK*, 70–71, with repro.; S. C. Welch, *PP*, 27, 122–23, with repro. color; S. C. Welch, *WA*, 29, fig. 10.

1. The painting has exercised particular fascination for S. C. Welch, whose various discussions rank among the most imaginative pieces of art-historical prose ever written. For instance (Dickson & Welch, 1:45B), he likens the painting to "a malignant tissue, for it is, although superb, a stunning piece of putrefaction; a rich morsel for jaded connoisseurs." In a similar vein he writes (*PP*, 27): "Gaudy with stripes, arabesques and tooled gold, this miniature is as rich as a fruitcake. Tasting such a confection could prove nauseous—but we should bear in mind that when the need is great catharsis becomes ecstasy. You can only know the heights if you have seen the depths."
2. The gold medallions are pricked, a common technique for illumination used elsewhere in this illustration and throughout the Freer Jami.
3. A similar man carrying fagots appears on the horizon of FGA 46.12, folio 110b.
4. The domical container is reminiscent of Ottoman Koran cases (see Atil, *Süleyman*, cat. nos. 109–10 [repros. color: 169–70]). What looks like a large envelope may be a manuscript, perhaps the Koran for the domed box just off-loaded.
5. The identification of this figure as Majnun differs from that of S. C. Welch (*PP*, 123) and Blair & Bloom (p. 172), who see Majnun as the youth peering down into the camp from behind the mauve canopy at the very top of the composition.
6. A. Welch ("Abbas," 460) has commented on the lack of narrative content here, observing that the painting "all but loses its subject beneath the wild display of unreal tents and the weird posturings of its unsettling characters."

7. It is more typical in the Freer Jami for illustrations to relate directly to the preceding or incorporated verses, rather than those that follow. The divergence from this pattern here raises various issues, including the choice of scenes for illustration, the physical and iconographical relationship of text and image, and the purpose and meaning of the illustrations.
8. S. C. Welch has interpreted various of these figures in sexual terms (Dickson & Welch, 1:45B; S. C. Welch, *KBK*, 71) and the entire composition as an example of occasional "lapses into viciousness and disturbing sexuality" (S. C. Welch, "Pictures," 71).
9. S. C. Welch, *PP*, 123.
10. Gray (*PP* 2, 145) has characterized the features as "quite unpleasantly realistic."
11. S. C. Welch (*KBK*, 71; Dickson & Welch, 1:45B) has also described the implausible spatial relationships here. It may be, however, that the poles were deliberately omitted so as not to break the zigzag composition with verticals.
12. The tent borders are often flipped over to reveal a contrasting design. Golombek ("Draped," 30, fig. 8) has commented on the extensive use of textiles in encampment scenes and has referred specifically to FGA 46.12, folio 253a, noting the "ambiguity of [the artist's] intention" in employing textiles for domicile, furniture, and decoration. "Is he depicting a seasonal dwelling or a summer holiday?"
13. Stchoukine, *MS*, 128; Grube, *WI*, 144; S. C. Welch, *PP*, 27; Dickson & Welch, 1:45B; Gray, *PP* 2, 145.
14. Grube (*WI*, 144) has commented that the painter of this scene "had broken entirely with conventions of Persian painting of [the] time."

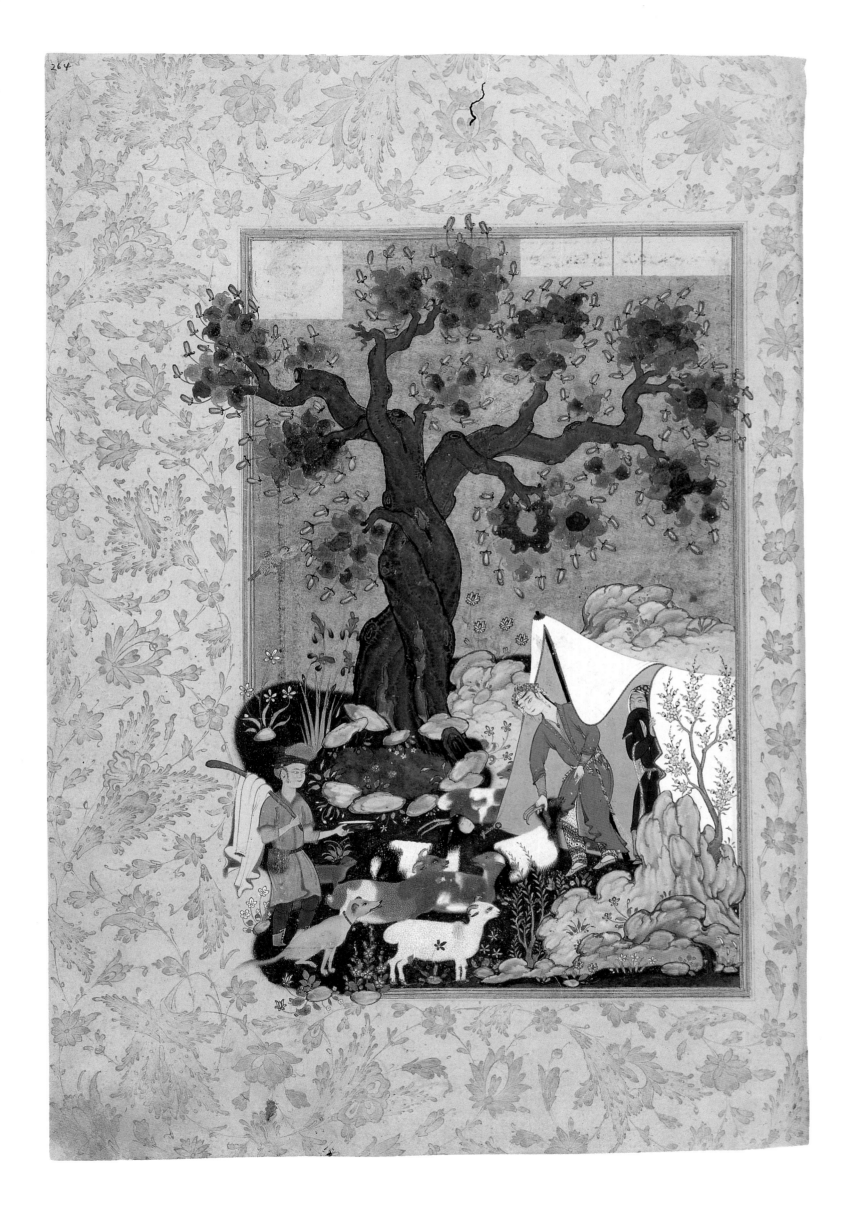

Folio 264a

MAJNUN COMES BEFORE LAYLI DISGUISED AS A SHEEP

Text Source
Mudarris-Gilani, pages 879–82.

Rubric before Illustration (folio 263a)

> *Majnun puts on a skin, goes out among Layli's sheep, and gets close to her tent.*[1]

Précis
Majnun continues to wander in the desert, talking intently to himself about his suffering and need for kindness and mercy. He describes his body as

> *. . . a broken soul*
> *A bone without skin or flesh*

and begs for a hide he can put on and join Layli's flock, perhaps stealing a glimpse of her. Following this impassioned speech, Majnun falls down unconscious. A passing herdsman pities the suffering lover and brings him a skin to wear as a veil. Infused with fresh hope, Majnun mingles with the flock, calling his skin a robe of honor. At nightfall, the herdsman takes the flock home, and Layli watches each animal as it passes in front of her.

When it is Majnun's turn to be inspected, he cries out and faints. Layli takes Majnun in her arms and washes the dust from his cheek with her tears. After Majnun regains consciousness, he begins to speak, addressing Layli not by name but as the qibla and the light of the exalted lamp. He is unable to believe his good fortune that Layli is next to him. In reply, Layli invites Majnun to take off his skin and to be her guest. They sit together talking all night, sharing their sorrows of the past years. At morning they part. In contrast to their first meeting (FGA 46.12, folio 231a), their union is at night and separation by day. This reversal represents the reconciliation of good and evil that has occurred as Majnun moves to a higher plane of spiritual development.

By this section of the narrative Majnun is readily identifiable as an ascetic by his animal skin, the traditional symbol of those who have "left this world."[2] The herdsman is the mediating pir, leading Majnun down the *tariqa* (mystical path) to union with the beloved. The poem's metaphorical language also discloses that at this stage Layli has become a symbol of God ("the light of the illustrious lamp").[3] Jami begins the episode with a discourse on the metaphysical images of *pust* (outer shell or hide) growing close to *maqhz* (inner core) after a long period of tribulation. He concludes with general comments about a devotee finding union with the beloved after encountering a thousand obstacles and still having to break away.

Illustration
This small painting is one of several in the Freer Jami lacking verses in its text blocks (fig. 124). The omission may be deliberate since the iconography of folio 264a does not correspond to the verses that would have been written there and that tell, in part, of how Layli revived Majnun after he had fainted. Here instead Majnun and the other animals seem to have just arrived in front of Layli, who now inspects her flock as recounted in the last verse on folio 263b.[4]

A flat gold sky and exuberant flowering tree dominate the landscape (fig. 125). The two fat trunks of the tree twist around each other and fork into separate groups of gnarled branches with large leafy clusters and red buds resembling elongated radishes and radiating outward like whirligigs.[5] Several plants, including purple irises and blue peonies, are silhouetted against the sky. A rocky plain stretches away from the tree toward the right. Other rocks are arranged in an irregular circle around a little pool at the base of the tree and at the top of the grassy sward with flowers, which forms the composition's left side and foreground.

Layli's white and blue tent is pitched at the juncture of the rocky and verdant areas and sheltered behind a steep outcropping and delicate flowering tree. A rivulet pours forth from these rocks into a stream in the foreground. A flock of goats approaches the tent from the left, and Layli ducks

outside to inspect them. Her female companion covers the lower part of her face with an empty sleeve while looking out from beneath the tent's raised side. Layli bends over to pet a long-haired black and white goat at the head of the flock. Other animals follow, each differentiated by the shape of its horns (or lack of them) and color and pattern of its coat. One brown and white specimen kicks up its hindquarters as if to escape behind the tent. The white goat in the foreground is marked with an orange splotch, which looks a little like spurting water and may be a brand. Majnun gazes up at Layli from the middle of the flock, his small face peering out from a horned skin of black and white fur. A young herdsman with a yellowish dog and small brown kid follows the flock. A fur bag is tucked into his striped belt. Over his right shoulder he carries a long, stout stick, draped with a large fur-lined cloak. In his left hand he holds a flat wooden bowl with a handle.[6]

The texture of goat hair in this picture is so rich that one can almost feel the deep pile underneath Layli's hand. Perhaps this deft representation of fleece, in so many different colors, patterns, and layers, was intended to emphasize the explicit Sufi imagery and meaning in *Layli u Majnun*.[7]

Although no other illustrations to this scene are known, two representations of the next moment in the narrative—one recounted in the verses belonging in the empty text blocks in the Freer Jami folio, when Majnun faints at the sight of Layli who takes him in her lap and revives him—are known. The first composition, from an undistinguished Bukharan manuscript dated 954–75/1547–68, has Layli kneeling in the immediate foreground with Majnun's head on her lap and his feet flailing in the air. A herdsman stands at the right edge of the composition, gesturing outward and surrounded by a flock of multicolored goats (CB MS 213, folio 130a).[8] The second, possibly a later addition to a manuscript completed in Khurasan in Dhu'l-qa'da 971/June 1564, is quite similar except that Majnun's feet are firmly placed on the ground and the herdsman stands on the left with his flock dispersed in the lower and upper ground (PWM MS 55.102, folio 266b). Another illustration, in a manuscript dated Muharram 951/March 1544 and attributable to Bukhara, relates to the subsequent moment when Majnun regains consciousness and prays in front of Layli as if she were the qibla (ÖNB A.F. 66, folio 191a). This composition represents Majnun wearing an animal-skin skirt and prostrating himself at Layli's feet.

Dimensions

23.3×14.5 cm

Condition

The illustration may have been partly repainted, as suggested by the peculiar shape of the tree. The green ground has been repainted throughout. The flesh-colored paint around the herdsman's ear has flaked off to reveal the underdrawing.

Incorporated Verses

Two or three omitted verses at top of illustration (nine in Mudarris-Gilani):

> [Each living creature from goats to sheep
> From that herd passed in front of her.
>
> When it was the turn of that afflicted shepherd,
> From under the skin he caught sight of his friend (beloved).
>
> Neither patience nor tranquility stayed with him,
> And he lost his composure.
>
> He cried out and fell to the ground (fainted),
> Like a shadow cast by man.
>
> When Layli heard the cry she recognized
> Him and looked in his direction.
>
> She saw fallen to the ground, his withered skin,
> Filled with the deep red blood like a bladder of musk.
>
> He had lost both sense and consciousness,
> Neither his eyes saw nor his ears heard.
>
> She sat next to him and cradled his head
> And bathed his face with her tears.
>
> Nourishing sweat into the scent of rosewater
> He regained consciousness from his unconscious state.]

Attributions

Stchoukine: Group 2; S. C. Welch: Shaykh-Muhammad.

References

Dickson & Welch, 1: fig. 231; Stchoukine, *MS*, 128; S. C. Welch, *PP*, 26, fig. V.

1. As in FGA 46.12, folio 110b, a slight problem arises in conveying the rich meaning of certain Persian terms for herds of animals and their keepers. *Gusfandan*, translated here as "sheep," may also mean "goat," which apparently is how the artist of the composition understood it. The précis of the Jami text encompasses generic terms ("herdsman" for sha'ban rather than the more commonly used "shepherd"), whereas in the discussion of the illustration the animals are described as they are represented (as goats).
2. Schimmel, *MD*, 14–15. See also Khayrallah, 118–19.
3. Schimmel, *MD*, 431–32.
4. *She came and stood beside the flock*
 And looked at them, inspecting them.

5. It is possible that this tree has been repainted, as evidenced by the retouching of the leaves. Its trunk is similar in thickness and outline to the tree in FGA 46.12, folio 298a.
6. In reproductions this bowl blends with the landscape and looks like a rock. It is very similar, however, to the bowl held by the beggar in FGA 46.12, folio 253a. Its presence may foreshadow Majnun's subsequent visit to Layli when he is disguised as a beggar (Mudarris-Gilani, 884–86).
7. For further discussion of Sufis dressed in animal skins, see Ettinghausen, "Zoomorphic."
8. The verses incorporated into this painting recount an earlier moment when Majnun revels at wearing the sheepskin, whereas its iconography derives from the verses that could have been incorporated into folio 264a. Once again text and image do not precisely correspond.

Khiradnama-i Iskandari

Jami's seventh masnavi belongs to the venerable tradition of Alexander romances that began soon after the Macedonian's death in 323 B.C.[1] Alexander the Great occupied a significant position in Near Eastern history and literature well before the Muslim era, and his fabulous exploits remained legendary throughout the Islamic koiné even until modern times.[2] Perhaps nowhere did Alexander exercise greater fascination than in medieval Persian literature. As Iskandar, he appears variously as a daring adventurer, romantic hero, benevolent monarch, philosopher, and prophet. Several poetic renditions of the Iskandar theme had already been written long before Jami composed his own. Of these the versions by Nizami and Amir Khusraw Dihlavi were Jami's most immediate sources. Indeed the Iskandar masnavi in the *Haft awrang* has been characterized as an imitation of the second half of Nizami's famous poem, the *Iqbalnama* (Book of happiness, 587/1191).[3] Jami wrote *Khiradnama-i Iskandari* (Iskandar's book of wisdom) around 890/1485 in honor of Sultan-Husayn Mirza.[4]

Like the *Salaman u Absal*, this masnavi is a more or less continuous narrative punctuated with moralizing anecdotes. Minoo S. Southgate's observation that these tales are not related to Iskandar is literally correct in that their content deals with completely different subjects and does not advance the development of the principal story.[5] Yet their message is always apropos, and every anecdote reinforces the theme of the narrative that it follows (FGA 46.12, folio 291a).

The prologue to the *Khiradnama-i Iskandari* praises the Prophet Muhammad (FGA 46.12, folio 275a), Khwaja Ubaydullah Ahrar, and Sultan-Husayn Mirza. It also records Jami's counsel to his son, Ziauddin Yusuf, and advice to himself. The main text begins with Philip of Macedon (Filqus), on the verge of death, asking the sage Aristotle to test his son Iskandar and prepare a book of wisdom to teach Iskandar the secrets of ruling. After Filqus's death, Iskandar is elevated to the rank of king over his protestations of inferiority. The young king then orders the wise sayings of the philosophers Plato (Aflatun), Socrates, Hippocrates (Buqrat), Pythagoras, and Hermes Trismegistus to be compiled into books. Armed with these sources of wisdom, Iskandar sets off "to conquer the world, to build cities, and to make the most perfect inventions." These expeditions take him to Iran where he fights Dara, to India where he visits the Brahmans, to China where he receives a demeaning gift from the emperor, and to fabulous Qaf Mountain where he seeks counsel from an angel. Other accomplishments include the building of the fabled wall against Gog and Magog, denizens beyond the civilized world.

The last part of the *Khiradnama-i Iskandari* narrates events leading to and following Iskandar's death (FGA 46.12, folio 298a). A wise man had prophesied that the young ruler would die in a land made of iron under a sky of gold. When Iskandar realizes that the end is near, he writes his mother, making out a will and giving instructions for his burial. After his death, wise men recite funeral orations, and Iskandar's coffin is carried to Alexandria.

Jami draws his account of Iskandar's demise and burial and a subsequent exchange of letters between Iskandar's mother and Aristotle to a close with a discourse on the fickle nature of the world. This account is followed by a story about the lunatic of Balkh, who spent his life in bitterness, crying over the city's dead. Each death reminded him of his own. Thus, like Iskandar, he was wise and not a fool.

1. The source for masnavi text is Mudarris-Gilani, 912–1013. For a succinct discussion of the Alexander romance tradition and its extensive historiography, see *DMA*, W. T. H. Jackson, "Alexander Romances."

2. Alexander's appearance in the Koran and his manifestations in Arabic, Persian, and Turkish history and literature are summarized in *EIs 2*, G. Stronmaier, "Al-Iskandar," and A. Abel, "Iskandar Nama," both with useful bibliographies. See also Abel; and Becka.

3. Southgate, 179–81. This volume includes appendices discussing medieval Persian Alexander romances, Alexander in Pahlavi literature, and Alexander in Persian and Arabic historical texts. For thoughtful criticism of Southgate's study and additional bibliography, see the review by Russell.

4. Southgate (p. 179) gives the date as 1485–91. Like *Silsilat al-dhahab*, *Yusuf u Zulaykha*, and *Subhat al-abrar*, the masnavi is generally described as honoring Sultan-Husayn Mirza, whom Jami praises in the prologue. This eulogy is preceded by tributes to Khwaja Ubaydullah Ahrar, to whom the *Tuhfat al-ahrar* is dedicated (Mudarris-Gilani, 918–19).

5. Southgate, 179.

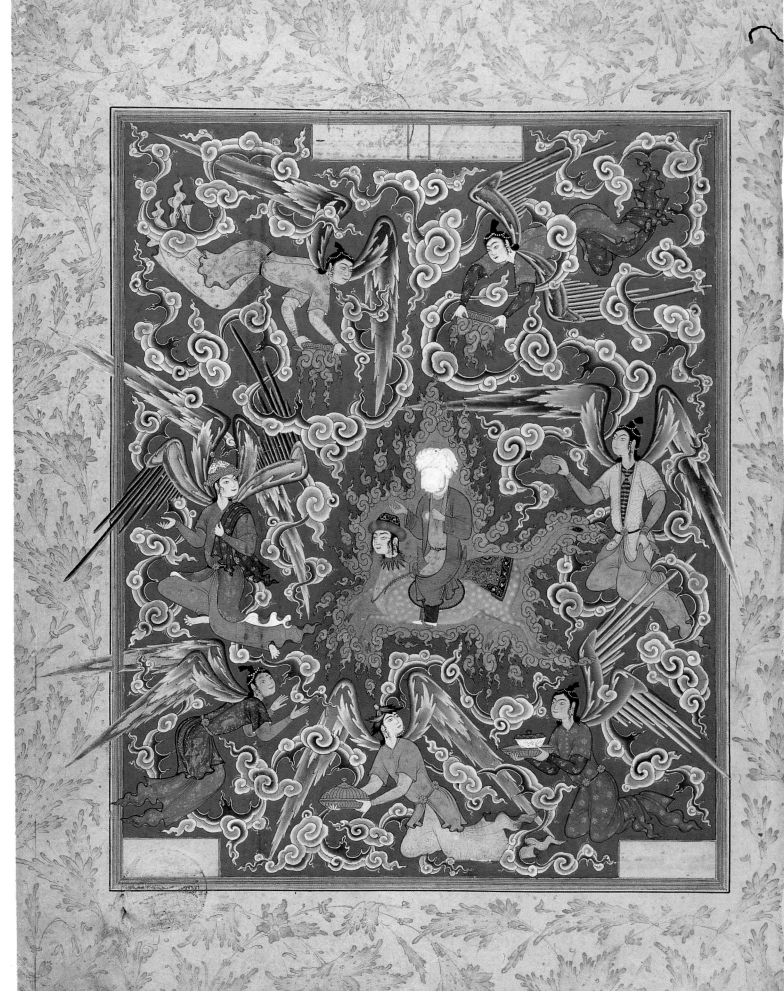

Folio 275a
THE MI'RAJ OF THE PROPHET

Text Source
Mudarris-Gilani, pages 916–17.

Rubric before Illustration (folio 274b)

Elevating the level of the mi'raj [and] bringing it to the highest level of magnitude and eminence of his [the Prophet's] mi'raj.[1]

Précis

The description of the mi'raj (Muhammad's miraculous ascension to heaven first mentioned in the Koran, sura 17:1) appears at the beginning of the *Khiradnama-i Iskandari*, immediately after a passage extolling the Prophet Muhammad. Jami's praises form a general panegyric on Muhammad's supremacy in various roles and realms. The last few lines contrast darkness and light and the distance between heaven and earth. This panegyric leads directly to the tale of the mi'raj.[2] Jami begins his rendition with an extended description of the luminosity of night and of Muhammad's steed Buraq as miraculously bright, beautiful, and swift. This description is followed by a short account of Muhammad's flight on Buraq from Mecca to Jerusalem while "the planets gathered around him and scattered coins in his path." The poet then compares the Prophet to the sun, planets, and other celestial bodies and casts his glorious qualities and achievements in images related to the scattering of gems. The passage, into which Jami inserts his own name, ends with a benediction on the companions of the cave, referring to Muhammad and Abu Bakr, who spent the night in a cave en route to Medina.[3]

Illustration

Like the poetic text it accompanies, this illustration follows a well-established iconography for the representation of the Prophet's ascension to heaven (fig. 126).[4] Muhammad rides Buraq across a bright blue sky, surrounded by angels and clouds.[5] In keeping with traditional Islamic color symbolism, the Prophet wears a green cloak and his wondrous steed a spiky green collar or ruff.[6] Muhammad's head is swathed in a white turban with one end looped around the chin, and his face is completely hidden under a short white veil.[7] Buraq's human head with its long locks of hair is protected by a fur-edged hat, and his dappled hindquarters are covered with a beautifully decorated blanket. A ring of knotted flames, rendered in various shades of gold, which rise to a peak above the Prophet's head, encircle Muhammad and Buraq.

Muhammad's celestial escorts include the archangel Gabriel and six other angels who fly and float on brilliant, multicolored wings. Leading the way, Gabriel simultaneously turns back and gestures outward as if to urge Buraq forward (fig. 127). His dark hair is covered with a close-fitting domical cap with an upturned gold brim held in place under his chin by a strand of pearls. The effect of this headgear is that of a crown.[8] Besides his position and details of attire such as the crownlike hat and over-the-shoulder cloak, Gabriel is distinguished from the other angels by having two pairs of wings. He also is the only one whose feet are visible; these are noteworthy for their splayed toes.

Bearing golden platters and pouring golden flames, a pair of angels swoops down, while a third angel hovers and sprinkles the Prophet and Buraq with rosewater. Beneath the horse's feet one angel at right holds a large gold platter and a blue and white bowl covered with a red lid, another in the center carries a gold platter with a domical gold lid, and a third at the left immediately beneath Gabriel bends over with outstretched hands as if paying homage to the Prophet.

126
The Mi'raj of the Prophet
in the *Haft awrang* of Jami
963–72/1556–65, Iran
34.5×23.4 cm (folio)
FGA 46.12, folio 275a

Like Gabriel, all these creatures wear short-sleeved robes and long, trailing pantaloons of various colors and patterns. Five angels have pageboy hairdos with one section pulled up into a topknot. Strands of pearls decorate the entire coiffeur and loop under the chin. The angel with the covered platter just below Muhammad wears a leafy headdress and a strand of pearls. In general, the depiction of the angels, including their positions, hairstyles, and clothing, fits within an artistic tradition familiar from sixteenth-century Iranian and Turkish manuscript illustrations and album drawings.[9] Garlands of knotted "sinicized" clouds weave and swirl through the exalted company and further animate the scene.

In addition to being the least original composition in the Freer Jami, following as it does conventional schemes for the representation of the miʿraj and its participants, this painting is also perhaps the least successful. Although admired for its "wildly electric flame and sky patterns,"[10] it is flat with no sense of the heavenly expanse that is present, for example, in the comparable scene in the 946–49/1539–43 *Khamsa*. Rather mechanical and stolid, the angels seem frozen in place, and some lack the grace of the angels in folio 147a. Not only do their psychedelic wings twist and stretch at bizarre angles; they pierce through the clouds and into the margins like weapons.

No other illustrations of the miʿraj in copies of the *Khiradnama-i Iskandari* are known. Jami refers to this climactic episode in the life of the Prophet Muhammad in several of his other *Haft awrang* poems, however, and some of these are illustrated.[11] These compositions subscribe to the same pictorial conventions as folio 275a. Several are quite beautiful and in the general mode of the 946–49/1539–43 *Khamsa*, notably one in a manuscript of 940/1533–34 (GEBO litt. pers. M45, folio 8b), another in a manuscript of 971/1564 (PWM MS 55.102, folio 113a), and a third in an undated codex attributable to about the same period (TKS R. 892, folio 7a).[12]

127
The Miʿraj of the Prophet (detail)
in the *Haft awrang* of Jami
963–72/1556–65, Iran
23.3×17.6 cm (painting)
FGA 46.12, folio 275a

CHAPTER TWO: POETRY AND PAINTING

Dimensions

23.3×17.6 cm

Incorporated Verses

One omitted verse at top of illustration:

> [He turned the reins of guidance from Batha (near Mecca),
> In one instant he hastened from Batha to Aqsa (in Jerusalem).]

One omitted verse at bottom of illustration:

> [From Aqsa he raised the standard upward,
> He carried his tent (traveled) to the high sphere.]

Attributions

Soudavar: Abdullah; Stchoukine: Group 2, Artist 3; S. C. Welch: Painter A (Qadimi).

References

Dickson & Welch, 1:210A, fig. 266; *DMA*, Priscilla P. Soucek, "Ascension," with repro.; Robinson, *PD*, 136, pl. 48; Soudavar, 258 n. 64; Stchoukine, *MS*, 128; S. C. Welch, *PP*, 27, fig. W.

1. This rubric differs from the rubric in the Mudarris-Gilani edition.
2. Schimmel, *MM*, chapter 9. In addition to introducing the history of this fascinating episode in the life of the Prophet, Schimmel discusses its treatment by various Persian poets, including Jami (p. 170), and painters (pp. 171–72). The tale of the mi'raj appears in many works of Persian prose and poetry predating the *Haft awrang*: *Divan* of Hafiz, *Ilahinama* (Book of the divinity) of Attar, *Khamsa* of Amir Khusraw Dihlavi, *Khamsa* of Nizami, *Masnavi* of Rumi, and *Mihr u Mushtari* of Assar. The *Khavarannama* (Tale of the Imam Ali) of Ibn Husam, *Layli u Majnun* and *Timurnama* (Tale of Timur) of Hatifi, and *Layli u Majnun*, *Shah u gada* (King and beggar), and *Sifat al-ashiqin* of Hilali are roughly contemporary with Jami's work. See also Schimmel, *MD*, 218–20, for a general discussion of the Sufi interpretation of the mi'raj; Morris, "Miraj" 1 and 2; and *DMA*, Priscilla P. Soucek, "Ascension," where the mystical view of the mi'raj is characterized as the "model of the soul's purification and ultimate unification with God."
3. Jami also recounts the mi'raj in the *Silsilat al-dhahab* (Mudarris-Gilani, 176–77), *Tuhfat al-ahrar* (ibid., 377–78), *Subhat al-abrar* (ibid., 454), and *Yusuf u Zulaykha* (ibid., 584–86).
4. It is likely that the mi'raj was illustrated from the earliest period of Persian painting, judging from the well-known mention (by the Safavid artist Dust-Muhammad, in his preface to the Bahram Mirza album, TKS H. 2154; see Dust-Muhammad [Thackston], 345) of Ahmad Musa who illustrated a *Mi'rajnama* during the reign of the Il-Khanid ruler Abu-Sa'id (r. 717–36/1317–35). The most famous fifteenth-century manuscript with illustrations of Muhammad's celestial journey is the *Mi'rajnama* of Mir Haydar copied in Uighur script by Malik Bakhshi of Herat and bound with another text written by the same scribe in 840/1436–37 (BN suppl. turc 190 [repro.: Séguy, especially pl. 3 (folio 5a)]). The most celebrated scene of the mi'raj from the Safavid period is undoubtedly the painting in the *Khamsa* of Nizami made for Shah Tahmasp in 946–49/1539–43 (BL Or. 2265, folio 195a [repro.: S. C. Welch, *PP*, pls. 33a–b]. For a detailed listing of representations of the mi'raj in Nizami's *Khamsa*, see Dodkhudoeva, 106–7 (no. 19), 123 (no. 42), 170 (no. 117), 203 (no. 165), 235 (no. 212). For examples of mi'raj illustrations in fifteenth- and sixteenth-century manuscripts other

than Nizami's *Khamsa* and Jami's *Haft awrang*, see Titley, *MPM*, cat. nos. 51.1; 54.1; 56.1; 88.2; 98.1; 179.3; 182.1; 186.1, 7, 13; 233.1. Many fifteenth-century representations have Muhammad flying over the Ka'ba in Mecca. See, for example, Stchoukine, *PMT*, pl. LXIX.
5. An apparently unique painting, attributable to Shiraz in the second half of the century, diverges from this norm and shows Muhammad mounting Buraq (repro.: Grube, *MMP*, cat. no. 67).
6. The color green has been associated with those of the highest spiritual level, such as the Prophet and the legendary servant of God, Khadir (see Schimmel, *MD*, 102).
7. The practice of covering Muhammad's face seems to have begun in the fourteenth century, as evidenced by several album paintings of the mi'raj, inscribed with the name Ahmad Musa and attributable to the late fourteenth century (see Ettinghausen, "Ascension," figs. 3–7). This practice was not consistently followed, however, and Muhammad's face is visible in the well-known copy of Ibn Husam's *Khavarannama* of ca. 1470–80 (Gray, *PP 2*, 105–7) and various late-fifteenth-century paintings of the mi'raj (Titley, *MPM*, cat. nos. 56.1 and 319.2; Stchoukine, *PMT*, pl. LXIX), including the well-known *Miscellany* made for Iskandar Sultan in 813–14/1410–11 (BL Add. 27261, folio 6a; Titley *MPM*, cat. no. 98.1).
8. The headgear resembles that worn by Bilqis in FGA 46.12, folio 188a.
9. For similar angels, see the mi'raj illustration in the *Khamsa* of 946–49/1539–43 (BL Or. 2265, folio 195a [repro.: S. C. Welch, *PP*, pl. 33]). Many sixteenth-century drawings of such creatures are known. For reproductions and discussions, see Atil, *Brush*, cat. nos. 12–13 (where angels, described as peris, flock around secular figures); Denny, "Saz," 113–16, pls. 20–24. These particular creatures, also referred to by Denny as peris, appear in album drawings attributed to Istanbul, circa 1570–90. They have rather more elaborate accessories than their Safavid counterparts.
10. Dickson & Welch, 1:210A. See also S. C. Welch, *PP*, pl. 33.
11. See Appendix D, listings under Mudarris-Gilani, 377–78 (*Tuhfat al-ahrar*) and 584–86 (*Yusuf u Zulaykha*).
12. The first two listed here have been published in Binyon et al., pl. XCIIa; and Skelton, "Bakharz," 202.

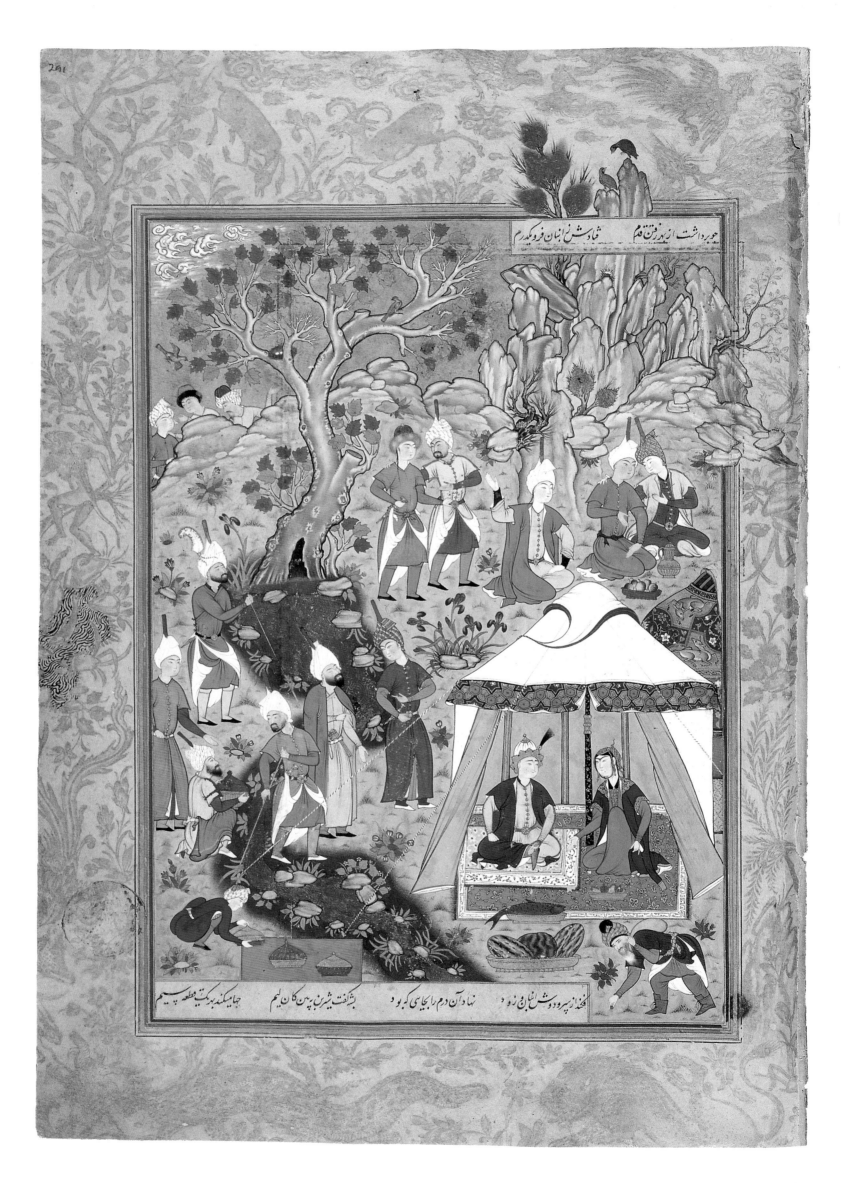

Folio 291a

KHUSRAW PARVIZ AND SHIRIN DEAL WITH THE FISHMONGER

Text Source
Mudarris-Gilani, pages 971–72.

Rubric before Illustration (folio 290b)

> *The story of [Khusraw] Parviz and the fishmonger to whom he poured out dirhams like fish and of how, by sweet Shirin's bitter advice, that pouring out of dirhams was doubled.*[1]

Précis

One day King Khusraw Parviz and his wife Shirin are presented with a beautiful fish by a fish-monger who wishes the royal pair well. This is not just an ordinary fish "but a beautiful silver tal-isman." Khusraw Parviz is so pleased that he orders his treasurer to reward the fishmonger with thousands of dirhams. Shirin rebukes the king for this excessive generosity and advises him to get his money back by asking if the fish is male or female. Whatever way the fishmonger replies, Shirin continues, Khusraw Parviz should say that it is unlawful to eat such a fish and then require the return of his reward. Khusraw Parviz duly puts the question to the fishmonger, who immediately understands what prompted it. He answers that the fish is neither male nor female but neuter. This clever reply so amuses Khusraw Parviz that he orders the amount of the reward to be doubled, and the fishmonger receives a big bag of dirhams. As he starts to walk off with the sack on his back, one dirham falls out, and he sets the sack down to retrieve the errant coin. Shirin becomes enraged at this demonstration of miserliness and tells Khusraw Parviz that it is reason enough to demand the return of the money. Khusraw Parviz calls the man back to chastise him, and the man explains that he picked the coin up because it has the king's name stamped on it and he does not want it to be ground into the dirt. Khusraw Parviz again rewards this fine reply and concludes that "when something is done at a woman's command, it is loss upon loss and disaster upon disaster. . . . That to the wise this point is well known: Whoever is commanded by a woman is less than a woman."

This anecdote is part of a series of apologues interjected between the stories of how Iskandar conquered the world, building cities and making inventions, and how he was sent a demeaning gift from the emperor of China. It is preceded by another short narrative on the same theme and under the same rubric of "advice to single men not to disgrace themselves by associating with women." Jami's point is that all women are wicked and attachment to them means enslavement. Even if a man finds a good woman, which is virtually impossible, he should not take orders from her.

Illustration

The principal action of this illustration takes place in the foreground where Khusraw Parviz and Shirin converse and the fishmonger picks up the fallen dirham (fig. 128).[2]

The royal couple sits in a white and blue tent supported by a black and gold ridgepole and secured by long white ropes. Part of another tent, its top decorated with a pair of gazelles between medallions and its smoke hole half-open, is visible above and to the right. The front walls of the royal tent are pulled back to reveal a mustached Khusraw Parviz, seated cross-legged on a folded arabesque carpet and looking directly at Shirin. A gold fruit bowl rests beside the queen atop the floral carpet with a pseudo-kufic border covering the entire tent floor. The large fish that has been presented to the royal pair rests on a gold platter at the edge of the tent's floor covering. A much larger platter containing three melons sits on the ground outside. Below in the right corner of the composition, the bearded fishmonger bends over to pick up the dirham that has fallen from the sack slung over his shoulder.

128
Khusraw Parviz and Shirin Deal with the Fishmonger
in the *Haft awrang* of Jami
963–72/1556–65, Iran
34.5×23.4 cm (folio)
FGA 46.12, folio 291a

Flowing through the left side of the composition is a once-silver stream, edged with rocks, flowers, and grassy banks. This winds through the plain where the royal tent is pitched and stops at the base of a large plane tree about three-quarters of the way up the hill. Courtiers and attendants stand along the banks of the stream. One young attendant crouches down to place a silver platter with a domed lid on a green cloth spread along the left bank.[3] Simultaneously he lifts the vessel's cover to reveal its contents: a large pile of coins. It is likely that the two other lidded bowls resting on the same cloth also contain money. Just above, an older attendant with a dark beard kneels and offers a deep gold bowl, covered with a silver lid and possibly also filled with coins, to a bearded man standing on the opposite bank.[4] This fellow turns backward, leaning on a long staff. The skirts of his green robe are tucked up around his waist as if to keep his hem dry while he crosses the stream. A tall young man who stands behind the kneeling attendant observes the presentation of the pot of money. Next to the man with the staff is a fourth bearded man, obviously a senior courtier and possibly the secretary or treasurer who counted out the coins to be given to the fishmonger. He has a gold pen box in his waistband and a blue cloak draped over his shoulders. He points toward the royal tent with his right hand and gestures downward with his left, apparently commenting on the scene for the benefit of the youth with a striped turban standing to his right.

A bit further upstream, on the left bank, another bearded man, distinguished by the white feather plume in his turban, leans on a staff with both hands. He may be about to cross to the other side, judging from the way his orange robe is looped up around the dagger at his waist. Uninterested in the action taking place around the tent, he focuses his attention on the hillside and beyond the tree where five other men are located. These include a pair of standing figures, one bearded and the other clean shaven, with their arms around each other. They, too, have their robes tucked into their sashes as if they had just forded the stream. In front of them to the right three youths sit on the ground. One sits apart and raises his right arm in the air as if exclaiming. The other two are enjoying a cozy tête-à-tête, one hugging the other around the shoulders. A gold jug and silver fruit bowl rest on the ground in front.

129
Khusraw Parviz and Shirin Deal with the Fishmonger
in the *Six Masnavis* of Jami
Second half 16th century, Iran, attributed to
Shiraz
30×19 cm (folio)
TKS Y. 47, folio 227b
Topkapi Sarayi Müzesi, Istanbul

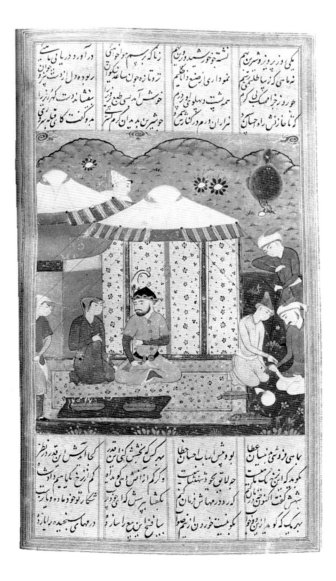

The landscape behind these youths rises into a steep promontory of pastel rocks, with several small bushes and trees and a pair of quail perched on the upper peaks. The rest of the horizon is less mountainous and harbors a group of three males, one with a wispy mustache and a beard and the other two much younger, who are engaged in animated conversation. Like the figures on the upper hillside, these characters do not seem at all concerned with Parviz, Shirin, and the fishmonger below.

This painting, with its multiple focuses and crisp drawing, is far more original as a narrative and more successful as a painting than other illustrations of the same scene. One such composition, in a manuscript dated 954–75/1547–68 (CB MS 213, folio 156b), has Khusraw Parviz and Shirin seated on a carpet spread in the open air with the fishmonger standing below and holding a fish. The scene is treated similarly in a manuscript attributed to mid-sixteenth-century Shiraz, except that the fishmonger kneels to the side with a pile of coins wrapped in a white cloth in his lap (TKS Y. 47, folio 227b; fig. 129). A third painting, in a manuscript of 973–74/1565–67 (BN suppl. pers. 547, folio 181b), places the scene indoors with the royal couple seated on a carpet and surrounded by various attendants. The fishmonger stands in front of them, holding up a huge fish.

Dimensions
25×17.2 cm

Incorporated Verses

One verse at top of illustration:

When he took the first pace in setting out,
One dirham fell from the sack.

Two verses at bottom of illustration:

He threw down the sack from his shoulder,
And placed that dirham back where it had been.

Shirin said to the king, "See what
This villain endures for the sake of a morsel of silver."

Attributions
Stchoukine: Group 2, Artist 3; S. C. Welch: Aqa-Mirak.

References
Dickson & Welch, 1:114B–15B, fig. 164; Stchoukine, *MS*, 128; Welch, *PP*, 27, fig. X.

1. Shirin's name is repeated twice in the rubric, obviously a scribal error. The Freer Jami uses the term "fishmonger," whereas Mudarris-Gilani (p. 971) has "fisherman."
2. This painting has been described as a "picnic scene . . . in which a prince entertains his beloved" (Dickson & Welch, 1:114B).
3. This crouching attendant is identical to a figure in the lower right of folio 110b of the Tahmasp *Shahnama* (repro.: Dickson & Welch, 2: pl. 83).
4. Welch (Dickson & Welch, 1:114B) refers to the presence of "cooks," presumably the figures with the domed platters.

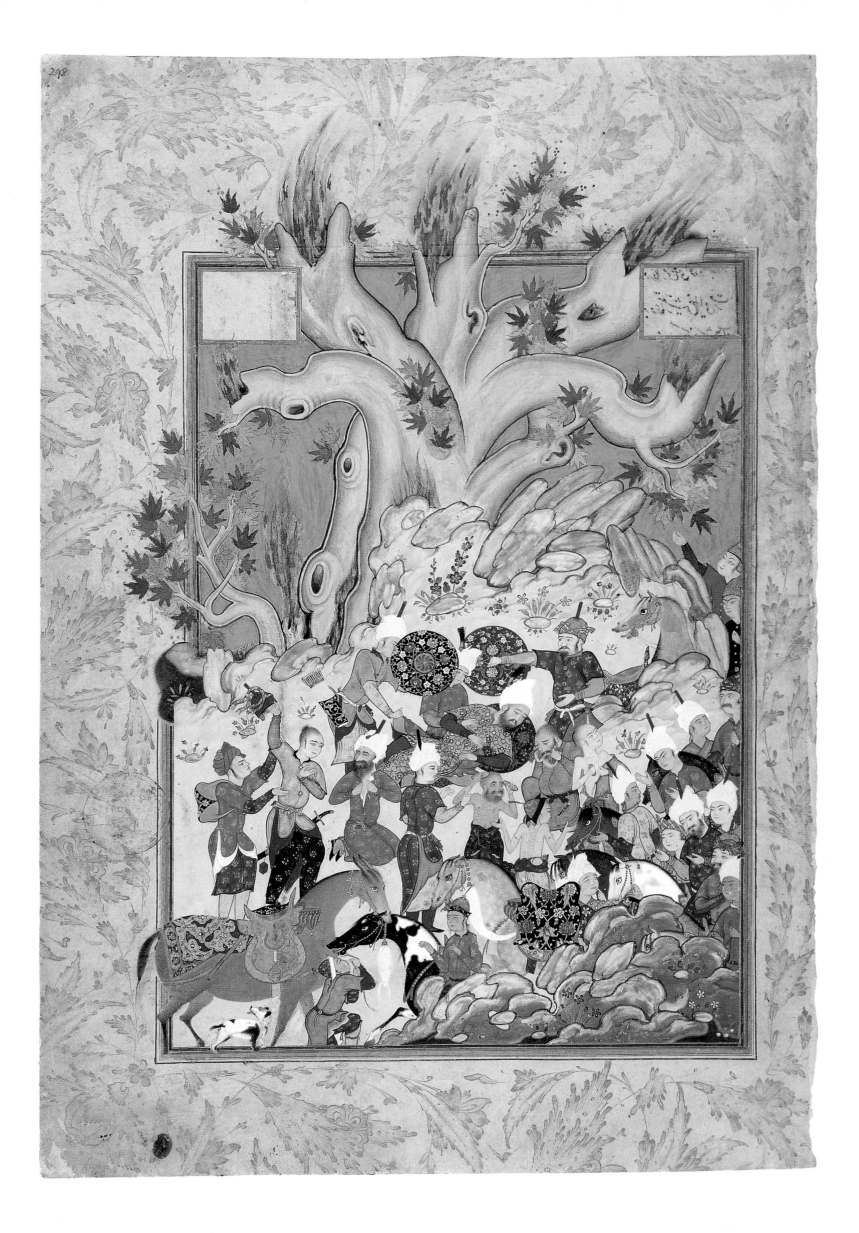

Folio 298a

ISKANDAR SUFFERS A NOSEBLEED AND IS LAID DOWN TO REST

Text Source
Mudarris-Gilani, pages 993–97.

Rubric before Illustration (folio 297b)

The manifestation of the portents of his death to Iskandar and his writing a letter to his mother.

Précis
A sage has predicted that Iskandar will die while traveling in an infernal region where the ground is iron and the sky gold. Knowing of this prediction, Iskandar disembarks from the sea (he has been returning from India) and leads his army back toward Rum, galloping furiously without resting. One day he reaches a desert, where he is overcome by the blazing heat and suffers a nosebleed that will not stop. Unable to remain in the saddle, he is helped to the ground by his attendants who spread out his armor for a carpet (the iron ground) and his shield for shade (the golden sky). Iskandar lies on the ground unconscious for a long time. When he regains consciousness, he hears the voice of the angel Surush whispering in his ear that this is the place where he will die. He then calls a scribe and writes a letter to his mother, announcing his imminent death and praising her for all she has enabled him to achieve. This letter of condolence includes an extended metaphor about a tree (Iskandar), which is planted and watered by a dihqan (his mother). After many years the tree begins to bear fruit, when suddenly a fierce wind comes up and blows it away. Iskandar then instructs his mother not to torment herself with mourning rituals and not to let the mourners become overwhelmed with emotion at the funeral banquet. He concludes with a discourse on wisdom and the transcendence of earthly bonds: "What is there to gain from that which is not eternal, as there is no hope for escape from death." Iskandar then seals this final missive with his blood, kisses it, and hands it over to a messenger. Finally he summons a cupbearer and musician to help him "open the gate to the court of union."

Illustration
Like the text it illustrates, this painting anticipates Iskandar's death by incorporating elements of the funeral soon to come (fig. 130). It does not, however, represent the actual moment of death, as often identified in scholarly sources.

The bearded king, attired in a flowered robe and white turban, has been laid down to rest in the middle of a rocky plain, at the foot of a large tree (fig. 131).[1] His eyes are shut, signaling his state of prostration and imminent death. A young attendant cradles the king's right shoulder and lowers his head and torso onto a round shield.[2] Another piece of armor peeks out from underneath the young man's left leg. This same fellow's head is partly obscured by two round floral shields held up by two soldiers as if to protect Iskandar. The soldier at the left, wearing a quiver and bow at the waist, hides his face behind the shield he bears and bends over to rest his right hand on the raised knee of the seated attendant. The mustached and bearded shield bearer on the other side wears a quiver full of arrows, a bow in its case at his waist, and a gold turban cap wrapped with a thin striped cloth. He stands fully upright and stretches his right arm straight out to shade the stricken king, while gesturing toward him with his other hand. Immediately behind this man is a neighing horse with a floral saddle. This may be the steed Iskandar was riding before his nosebleed began. To the horse's right and at the very edge of the composition are two young men, identifiable by their helmets as soldiers.[3] One youth reaches a hand toward the lower leaves of the enormous tree that fills the background.

Just below Iskandar and his attendants is a large, confused mass of animals and men, among them several mourners. Concentrated in the center of the composition, they display their grief in diverse ways. The bearded man kneeling on the ground to the immediate left of Iskandar's feet expresses his sorrow by tugging open the front of his brown and gold robe. He is also noteworthy

130
Iskandar Suffers a Nosebleed and Is Laid Down to Rest
in the *Haft awrang* of Jami
963–72/1556–65, Iran
34.5×23.4 cm (folio)
FGA 46.12, folio 298a

for his prominent nose and contorted features. Momentarily distracted from his ritual act of grief, he turns to stare at two young soldiers. One, wearing a sword and red box attached to his sash, holds his left arm up to his chest and turns his hand out at an awkward angle. With his other arm he raises his helmet, wrapped with a striped cloth, high into the air and seems about to hurl it onto the ground. He is restrained by another youth, depicted in profile and with a large blue bundle on his back. Directly across from him on the right is another young man, perhaps a courtier, judging from his attire, who also stands in profile and tries to console a mourner. This third youth rests his right hand on the upper arm of an old bearded man who stands in the center of the composition just below Iskandar.

This grimacing figure is one of four who display the most overt signs of grief at their leader's impending demise. Bare to the waist, he exposes his emaciated torso. A dark green cloak or robe, its sleeves knotted in front, covers his lower body. The old man raises his bony arms, elbows akimbo, and clutches an oblong rock in each hand with which he seems about to strike his shaven head. In his sorrow he scrunches up his eyes and grits his teeth. Next to this mourner is a much younger man who stands facing backward, with the upper part of his clothing wrapped around his waist and a close-fitting cap with a feather on his head. He is also extremely skinny, and all his vertebrae are clearly visible. He shrugs his shoulders and gesticulates with both arms. Each upper arm is tied with a small amulet. In front of this half-naked youth and closer to Iskandar is another mourner, older and with a grizzled gray beard and shaved head, sitting with one leg drawn up. Unlike his grieving companions, this man is portly and, although bareheaded, is fully clothed in a green and gold robe tied under his sagging belly. Moreover, he expresses sorrow in a more personal and private fashion. His head hangs forward on his chest, his forehead is furrowed, and in his raised hands he holds handkerchiefs, presumably to catch the tears rolling down his cheeks. The fourth and final member of this active group of mourners stands to the right. This thin young man shrugs his salmon robe from his left shoulder while clutching a rock to his naked breast. He turns his head sharply upward and to the right, giving a clear view of the small lock of hair hanging like a pigtail from the top of his shaven head.[4] Perhaps he is a soldier, as his hairdo is identical to that of the young man raising his helmet on the left.

131
*Iskandar Suffers a Nosebleed
and Is Laid Down to Rest* (detail)
in the *Haft awrang* of Jami
963–72/1556–65, Iran
23.8×16.7 cm (painting)
FGA 46.12, folio 298a

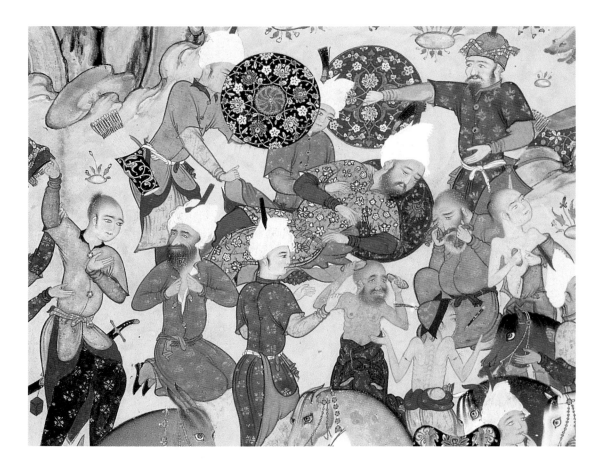

CHAPTER TWO: POETRY AND PAINTING

The young mourner's gaze is apparently directed toward the pair of soldiers just underneath the tree the upper right. These are but two of a dozen soldiers who advance down the sloping ground and occupy the foreground of the composition, behind a convoluted rock formation. This troop comprises males of various ages and includes two men who bear a strong resemblance to the shield bearer at Iskandar's head.

Far more distinctive than the men, however, are the animals, particularly those in the center and left foreground. At the head of the troop is a dappled gray and white horse, caparisoned with a black-ground floral-scroll saddle cover. The steed's absent rider has left his helmet hanging upside-down on the saddle. Just in front is a smaller black and white horse with a white brush under its chin. A much larger horse advancing from the left bites the head of the smaller horse. This animal also is fully caparisoned, with a blue and gold saddle and split-palmette blanket. Here, too, a helmet hangs from the front of the saddle. The way these three horses have their ears laid back suggests that their interaction is more combative than playful. The two young grooms in the midst of the conflict seem unable to stop it. One stands in front of the black and white steed and raises his hands helplessly. The other, turned sideways and stepping up as if emerging from the lower margin, tugs down with both hands on the horse's reins, apparently without success. There is yet another participant in this equine drama. A small brown and white dog stands under the large brown horse, its head turned backward and tongue stuck out, as if scrutinizing the horse's belly or genitals.

The large tree above Iskandar poses certain problems. It may refer to the sapling that Iskandar uses metaphorically in the letter to his mother as an emblem of life and death. Its five thick, truncated branches terminating in flames add yet another powerful element to a scene already fraught with pathos. Yet the upper part of this composition has been repainted, most apparently in the blue sky. The leaping flames may also be the contribution of a later restorer.[5]

This painting is comparable to folio 253a in many respects: crowded composition; often illogical spatial relationships; awkward poses; exaggerated, almost caricatural facial features; and individual details such as the gray horse. The similarities are so many that the two works may very well have been executed by the same artist. The major difference is that the principal character is readily identifiable, even though he seems overshadowed by his grief-stricken attendants.

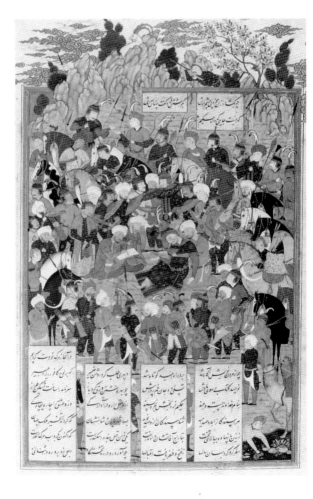

132
*Iskandar Suffers a Nosebleed
and Is Laid Down to Rest*
in the *Six Masnavis* of Jami
978–79/1570–72, Iran,
attributed to Qazvin and Mashhad
28.7×21.5 cm (painting); 34.9×23.3 cm (folio)
TKS H. 1483, folio 223b
Topkapi Sarayi Müzesi, Istanbul

The same episode is illustrated with an even more crowded and detailed composition in a manuscript of 978–79/1570–72 (TKS H. 1483, folio 223b; fig. 132). It is tempting to suggest that the Freer Jami painting was the pictorial model for this second rendition, especially since Muhibb-Ali, the scribe who transcribed the later manuscript, also worked on Sultan Ibrahim Mirza's *Haft awrang* and served as the prince's *kitabdar* (librarian). Furthermore, the verses incorporated into the picture plane are the same as those that should have occupied the two empty boxes at the top of the Freer Jami painting. The iconography of the later painting is quite distinctive and represents Iskandar in the center propped up in the arms of an attendant, bleeding from the nose into a gold bowl and dictating a letter to his mother. This illustration is much more literal than the painting in the Freer Jami in its relationship to the masnavi verses and much less dramatic and emotional in its evocation of death.

The iconography of folio 298a is comparable to representations of Iskandar attending the dying Achaemenid king Dara, often found in copies of the *Shahnama* of Firdawsi and the *Khamsa* of Nizami.[6] Of even greater note is the placement of the composition as the final illustration in Sultan Ibrahim Mirza's manuscript. The imminent death of a great Iranian hero (who overcame many obstacles to reach "the court of union") makes an undeniably dramatic finale to the prince's *Haft awrang*. It is equally difficult to imagine that the choice of this scene for the volume's last illustration was serendipitous.

Toward the end of the transcription of his Jami manuscript, Sultan Ibrahim Mirza participated in two military campaigns, including an expedition against the rebellious governor of Herat.[7] During this period the prince may have had reason to ponder his own mortality and that of other royal brothers and cousins. Perhaps he witnessed a death among the Safavid forces that made a profound impression. As elsewhere in the prince's masterpiece (folios 100b and 132a), we are left with the distinct sense that a particular personal purpose lies behind its final painting.

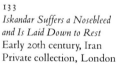

133
Iskandar Suffers a Nosebleed and Is Laid Down to Rest
Early 20th century, Iran
Private collection, London

CHAPTER TWO: POETRY AND PAINTING

Dimensions
23.8×16.7 cm

Condition
The blue sky is not original; the tree has been repainted; areas of the gray horse have been retouched.

Incorporated Verses

Three omitted verses at top of illustration:

> *["This is the place that the learned scholar*
> *Warned you of your death."*
>
> *When he became aware of his own death (and)*
> *That the road of hope was shortened for him,*
>
> *He called for a scribe of luminous mind,*
> *So that he might pour dark ink on the white tablet.]*

Attributions
Stchoukine: Group 2, Artist 2; Titley: Shaykh-Muhammad; S. C. Welch: Shaykh-Muhammad.

References
Dickson & Welch, 1:175A, fig. 232; Stchoukine, *MS*, 128; Titley, *PMP*, 106;
S. C. Welch, *PP*, 126–27, with repro. color.

1. Iskandar's robe has the same densely patterned design as those worn by several of the female figures in FGA 46.12, folio 253a.
2. The three shields at the center of this composition seem more Ottoman than Safavid. See Atil, *Süleyman*, cat. nos. 100–101, with repro. color; *Oruzheinaya*, Atlas: pls. 1, 345.
3. For discussion of arms and armor in Persian paintings, see Gorelik.
4. This coiffure is similar to that of the acrobat in FGA 46.12, folio 30a, and the boy climbing the tree in FGA 46.12, folio 52a.
5. The repainting of the sky and possibly other parts of this composition was necessitated by water damage, which also affected FGA 46.12, folios 296–303. The restorer also may have made a partial copy of the scene, now in a private collection, London, over an unrelated manuscript page (fig. 133). Robinson has attributed this work to the Pahlavi period, likely made after Sultan Ibrahim Mirza's manuscript was bought by Hagop Kevorkian at the Chiesa sale in 1926 and before it was acquired by the Freer in 1946. The painting depicts the core group of figures surrounding Iskandar, including the horses behind the lower rocks. The upper landscape includes some of the soaring rocks in folio 298a, but the flaming tree has been reduced to a smaller and much more ordinary example with a twisted trunk. The beige ground and gray-blue sky have a blotchy surface, not dissimilar to the repainted area in folio 298a. The surrounding margins are illuminated with gold designs, also perhaps in emulation of the Freer Jami.
6. For examples, see Norgren & Davis, listing for 6:52–55; and Dodkhudoeva, no. 230, fig. 9. For additional reproductions, see Robinson, *BL*, pl. XXIII; Robinson, *IOL*, 219; Stchoukine, *Nizami*, pls. IIIb, xxxvb.
7. At least as documented by the last surviving colophon dated Shawwal 972/May 1565.

CHAPTER THREE: PATRON AND ARTISTS

The sixteenth century marks a high point in the arts of the book in the Islamic world, most notably in Ottoman Turkey, Safavid Iran, Uzbek Shaybanid Transoxiana, and Mughal India. These arts engaged innumerable artists and artisans of all kinds, from papermakers to gilders to bookbinders, who were encouraged and supported by royal and noble sponsors.[1] Of the many patrons active during the sixteenth century, few are as compelling as the Safavid prince Sultan Ibrahim Mirza. While hardly in the same realm as Tahmasp, Suleyman, or Akbar, who commanded the power of dynasties and the resources of empires, Ibrahim Mirza occupies an elevated niche in the pantheon of princely patrons whose contributions to the literary and visual arts had a significant impact on the culture of their day and resonated well into the future. His *Haft awrang* manuscript alone attests to the time, energy, and expense that as a patron he was willing and able to lavish on a work of art.

Much already has been written about Sultan Ibrahim Mirza's life, achievements, and patronage. The first part of this chapter seeks to look again at the historical and art-historical record and to consider the prince's biography and career, his artistic interests and accomplishments, and his activities as a collector and patron. From this review emerges both a personal history and an account of the particular circumstances in which a great work of art was created.

The story of Sultan Ibrahim Mirza as patron naturally involves those whom he patronized. Altogether we know of some twenty individuals—poets, musicians, and artists—in the prince's circle or service. The roster of visual artists includes six calligraphers: Shah-Mahmud al-Nishapuri, Rustam-Ali, Muhibb-Ali, Malik al-Daylami, Ayshi ibn Ishrati, and Sultan-Muhammad Khandan.[2] Three others, noted primarily as painters and illuminators, also figure in this group: Abdullah al-Shirazi, Ali Asghar, and Shaykh-Muhammad. Seven of these artists are documented through their own signatures as having contributed to commissions for Sultan Ibrahim Mirza. All are known to have worked for the prince's *kitabkhana*, a Persian term that literally means "book house" and that regularly appears in the primary sources with reference both to libraries and to artistic ateliers. The nine individuals connected with the kitabkhana of Sultan Ibrahim Mirza are the subject of the second part of this chapter.

1. For an overview of patronage during the sixteenth-century, see Denny, "Late Islam," and Brend, chapters 6–8, which include more specific discussion of patrons of the book arts in Iran, Turkey, and India.
2. There is yet another calligrapher, Mir Vajihuddin Khalilullah Husayni, known for his close association with Sultan Ibrahim Mirza. He does not seem, however, to have contributed to either of the works of art commissioned by the prince, nor is he recorded as having worked for the prince's kitabkhana.

134
Text folio of *Yusuf u Zulaykha*
Copied by Muhibb-Ali
in the *Haft awrang* of Jami
964/1557, Iran, Mashhad
34.5×23.5 cm (folio)
FGA 46.12, folio 131b

CHAPTER THREE: PATRON AND ARTISTS

If family lineage and circumstances have any bearing on personal destiny, then Ibrahim Mirza would have been predisposed for a lifetime of involvement with the arts. Scion of the Safavid dynasty that ruled Iran for more than two centuries (906–7–1148/1501–1736) and fostered many important artistic developments, Ibrahim Mirza was the second son of Bahram Mirza, brother of the second Safavid monarch Shah Tahmasp.[1] In many respects Ibrahim Mirza's life closely followed that of his father, who held royal appointments and engaged in a variety of artistic activities, apparently with greater success and enthusiasm for the latter than the former.[2] Another probable, and perhaps even closer, role model for the prince was his uncle Sam Mirza, who distinguished himself as an author, artist, and patron, disgraced himself as a rebel, and died as a probable victim of political assassination.[3]

The greatest influence on Ibrahim Mirza's career in both politics and culture doubtless came from his uncle Tahmasp, head of the Safavid state for more than fifty years.[4] Ultimately it was Tahmasp who supervised the young prince's education, determined his role in dynastic affairs, arranged his marriage, and, it seems, encouraged or at least endorsed his interests in art and literature. Indeed Ibrahim Mirza seems to have shared with his uncle the same spirit of patronage that inspired the shah's great *Shahnama* and *Khamsa* manuscripts and emerges as the primary heir within his generation of the Safavid tradition of intense involvement in the literary and visual arts (fig. 134).

Today Ibrahim Mirza's achievements appear all the more notable for having started in adolescence and ended tragically in early middle age. The documented milestones of the prince's relatively short life (946–984/1540–1577) are few, and at close hand the historical record contains many gaps and inconsistencies. It is possible, however, to construct a basic chronology and biography for Sultan Ibrahim Mirza with the help of a half-dozen or so primary sources, among them well-known texts such as the *Gulistan-i hunar* (Garden of the arts) of Qazi Ahmad and the *Sharafnama* (Book of the nobility) of Sharafuddin Khan Bidlisi and less familiar works, such as the *Naqavat al-athar* (Selections of history) by Afushta'i Natanzi.[5] Extant works of art associated with the prince are also essential in the reconstruction and evaluation of his life history, including, in addition to the *Haft awrang*, a volume of the *Naqsh-i badi'* (Design of the marvelous) copied in the spring of 982/1574 and a posthumous copy of his own *Divan* (Poems) dated 990/1582–83. Both these works shed light on the prince's tastes and ambitions in art and literature and corroborate much of what is already known, or can be deduced, about his activities as prince, poet, and patron.

Sultan Ibrahim Mirza as Prince

Sultan Ibrahim Mirza was born at the end of Dhu'l-qa'da 946/April 1540 to prince Bahram Mirza and Zaynab Sultan of Shirvan.[6] He spent part of his childhood in Shushtar, the capital of Khuzistan province, where Bahram Mirza served as governor.[7] Following his father's death in Ramadan 956/October 1549, Sultan Ibrahim Mirza was brought to the royal harem, then presumably in Qazvin, by Shahzada (princess) Sultanum, his paternal aunt, who seems to have been particularly fond of him.[8] His paternal uncle, Shah Tahmasp, also appears to have liked the boy and been pleased by his "understanding and intelligence."[9] The monarch took a direct interest in the education of Sultan Ibrahim Mirza and, "despite [the prince's] youth, would include him in all his [the shah's] council meetings and listen and act upon his suggestions."[10] Tahmasp's evident esteem for his nephew also was such that he appointed Ma'sum Beg Safavi, a close companion then serving as *vakil* of the *divan-i al'a* (that is, vice–grand vizier), to be the boy's *lala*, or guardian.[11]

According to Qazi Ahmad, the only known source to mention Ibrahim Mirza's upbringing, the prince spent seven years at court with his uncle the shah, that is, until the early 960s/early to mid-1550s.[12] Toward the end of this period, and in another mark of Tahmasp's favor, Ibrahim Mirza presided for three days over the festivities held in Tabriz to celebrate the marriage of his first cousin (and the shah's second son) Isma'il.[13]

Sultan Ibrahim Mirza's career in affairs of state began in 962/1554–55 when he was sixteen and "the shah considered him wise and mature."[14] At that time Tahmasp appointed his nephew governor of the city of Mashhad in the northeastern province of Khurasan. The actual *farman* (decree) of this royal appointment, written in the first person, as if in Tahmasp's own words, and closely followed by Qazi Ahmad, gives a general idea of what the shah expected of his "dear beloved son."[15] Ibrahim Mirza was to spend his time in devotional duties and religious ceremonies and in supervising the details of all the city's governmental (*umur-i malikati*) and financial (*mali*) affairs. In addition, he was to secure the rights of Muslims and the protection of the region, to assist the guardian (*mutavalli*) of the shrine of the Imam Reza in the administration of religious rules and regulations, and to dispense justice. Finally, he was to stay abreast of and record events in the region and especially to oversee the affairs of nobles, landowners, and officials, ranging from amirs and governors (*hakam*) to town superintendents (*darugharan*) and sheriffs (*kadkhudayan*), in the area extending from the border of Simnan to Herat and Sijistan, to report on their conduct to the shah, and to reward or punish them as necessary.[16] It is here that Ibrahim Mirza's real mission in Mashhad becomes clear: he was to serve as the eyes and ears of the shah and to attend to a situation that Tahmasp apparently could no longer tolerate.[17] Qazi Ahmad certainly implies that Ibrahim Mirza had the shah's trust when he says, toward the end of his description of the appointment, that the prince "was at all times and during all events privy to the decisions and actions of [his] majesty in all matters, such as honesty, charity, and the [administration] of laws of justice and judgment on disobedience," and further that "the shah honored Ibrahim Mirza with this position among the people of knowledge."[18] As a final mark of his high regard and expectations, Tahmasp gave the prince a retinue of about five hundred courtiers, bodyguards (*qurchi*s), and noblemen "whom he had selected one by one according to their esteem and dignity."[19]

Sultan Ibrahim Mirza and his entourage set off from Qazvin at the beginning of Rabi' II 962/late February 1555 and arrived in Mashhad on 7 Jumada I 963/19 March 1556.[20] According to Qazi Ahmad, the city was decorated from the gate of Idgah to the shrine of Imam Reza in honor of the new governor,[21] while Afushta'i Natanzi mentions that Ibrahim Mirza was welcomed to Mashhad "by scholars and dignitaries of that region."[22]

Ibrahim Mirza's appointment to Mashhad more or less coincided with arrangements for his marriage to Gawhar-Sultan Khanim, eldest daughter of Shah Tahmasp. As with the governorship, this marriage was arranged, or at least agreed upon, by the shah himself. In Afushta'i Natanzi's account, Tahmasp selected Gawhar-Sultan as his nephew's bride because her "intelligence, beauty, and wisdom were superior to that of his other daughter."[23] It is even more likely that the union of Sultan Ibrahim Mirza and Gawhar-Sultan Khanim had been projected for quite some time and resulted from a variety of practical and dynastic, rather than personal or sentimental, considerations.

The precise date of the marriage is difficult to determine, with primary sources giving varying accounts.[24] Qazi Ahmad in particular details an extensive period of betrothal and prenuptial negotiations, beginning in Dhu'l-qa'da 964/August–September 1557, when Tahmasp agreed to the

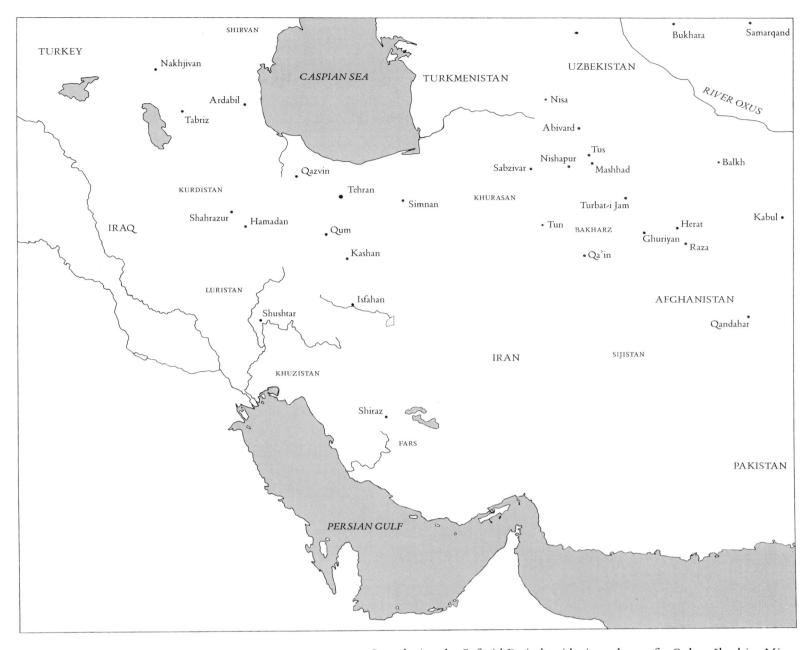

Iran during the Safavid Period, with sites relevant for Sultan Ibrahim Mirza

marriage, and continuing until sometime in 967/1559–60, when Gawhar-Sultan Khanim, accompanied by female relatives, elderly advisers, and eunuchs, set off from Tabriz for Mashhad.[25] The wedding party was welcomed first at Sabzivar, a town some 170 kilometers to the west of Mashhad, by a group of distinguished representatives sent by Sultan Ibrahim Mirza and later by the prince himself and a large entourage at the area of Alaqa-band and the plain of Arifi. By then it was the spring of 967, roughly corresponding to the period March to June 1560, and Mashhad and its environs were covered with flowers and "armies of odoriferous herbs."[26] The wedding party then proceeded into the town, which had been elaborately decorated for the wedding festivities. There seem to have been several phases to the celebration, lasting altogether three to four months until the marriage was consummated.[27]

By this time Sultan Ibrahim Mirza's most important artistic commission, the *Haft awrang* manuscript, was already under way (fig. 135). While the primary sources offer no hint of a connection between the commission and his appointment to Mashhad and marriage to Gawhar-Sultan Khanim, his *Haft awrang* contains several compositions illustrating marital and amorous themes. Of these, the paintings of the aziz of Egypt bringing jewels to Zulaykha's litter (FGA 46.12, folio 100b; see fig. 76) and of Yusuf giving a royal banquet in honor of his marriage (FGA 46.12, folio 132a; see fig. 92) suggest the most obvious parallels to the events recorded at the time of Ibrahim Mirza's marriage to Gawhar-Sultan Khanim. Many of the details in the large and lively scene in which the vizier greets his bride outside the Egyptian capital seem to correspond to Qazi Ahmad's description of Gawhar-Sultan Khanim's bridal party and its arrival in the Mashhad area. And while there is no way of verifying whether the festivities in Mashhad included a "stag party" similar to the one illustrated in the Freer Jami, the inscription with Ibrahim Mirza's name right over the head of the groom Yusuf suggests a direct and deliberate link. Thus it may be that Sultan Ibrahim Mirza had the possibility or even the eventuality of marriage to Gawhar-Sultan Khanim in mind when planning the pictorial program of this magnificent *Haft awrang*.[28]

135
Masnavi heading and text folios
of *Tuhfat al-ahrar*
Copied by Rustam-Ali
in the *Haft awrang* of Jami
963/1556, Iran
46.8×34.5 cm (two folios)
FGA 46.12, folios 200b–201a

CHAPTER THREE: PATRON AND ARTISTS

Certainly the wedding looms large in the annals on Ibrahim Mirza, at least in comparison with the information available about his official activities as governor of Mashhad. The *Khulasat al-tawarikh* (Abstract of history) of Qazi Ahmad reports that after the prince took up residence in the Chahar-bagh,

> he gave audiences for the first few days, and then arranged his weekly schedule as follows: after daily visits to the shrine, he would spend three days inquiring about the council [divan], about the condition of the weak and subordinates, and dealing with governmental and financial matters [umuri-i mulki-u mali]. The other two days were spent on [acquiring] virtues and perfection and the practice of poetry and calligraphy and painting and the other arts and skills and in conversation with learned and wise men, scientists, poets, and calligraphers, and painters. The rest of the week he would spend on excursions, riding, and playing qabaq [an archery game] and polo.[29]

The same author's *Gulistan-i hunar* gives an even more generalized, and undoubtedly formulaic, account of Ibrahim Mirza's activities: "From dawn until late evening he would spend his time on government affairs [masalih mamlikat] and from sunrise to sunset he was engaged in seeking virtues [in search of knowledge]."[30]

It may be that Ibrahim Mirza's presence in Mashhad was intended to be largely symbolic and his duties largely ceremonial.[31] As implied in the farman of appointment, and notwithstanding the responsibilties it outlines, the prince basically served as a representative of the shah. A certain amount of his time seems to have been taken up with visitors, including various family members. Among these, perhaps the most welcome would have been his uncle Sam Mirza, who came to Mashhad on pilgrimage in 964/1556–57 and spent about a month there. "Ibrahim Mirza treated his uncle with the greatest respect, visited him every day, and organized for him the most lavish feasts, and the two were always engaged in learned discussion on science and poetry and passed the time fruitfully."[32] That same year Sultan Sulayman Mirza, the four-year-old son of Shah Tahmasp, came to Mashhad to be raised and educated by Ibrahim Mirza for future duties as guardian (*khadim*) of the Imam Reza shrine. According to Qazi Ahmad, the child "was to avoid and abstain from everything unlawful, was not allowed to wear silk clothing," and most ironically (and perhaps also most significantly) considering Ibrahim Mirza's literary interests and activities, "was absolutely prohibited from reading books of poetry."[33]

Whatever his other duties in Mashhad, Sultan Ibrahim Mirza was assisted by Mir-Munshi Husayni, a Safavid court secretary appointed by Shah Tahmasp to serve as vizier, and more specifically as senior counselor and chief financial and administrative officer, to the young prince.[34] Mir-Munshi was accompanied to Mashhad in 964/1556–57 by his son, Qazi Ahmad, then age eleven.[35] Qazi Ahmad's later accounts of the life and times of Sultan Ibrahim Mirza were obviously based in part on the recollections of events witnessed or heard about during his father's tenure in Mashhad, including the prince's marriage to Gawhar-Sultan Khanim.[36]

In 969/1561–62 Mir-Munshi was removed as vizier at the instigation of Ma'sum Beg Safavi, the former vice–grand vizier who had been Ibrahim Mirza's guardian during the time the prince spent at the Safavid court. The Munshi's successor was Khwaja Mirza Beg Sabaqi (or Sabiq), vizier of the qurchis for Ma'sum Beg.[37] No explanation seems to be available for this replacement, but it immediately preceded a major change in Ibrahim Mirza's status and may signal some perception on the part of the Safavid court, perhaps even the shah, that the prince now required more rigorous guidance or supervision. Indeed, what up to this point appears to have been a pleasant and uneventful life, punctuated by marriage festivities, family visits, polo matches, and artistic gatherings, suddenly encountered professional and personal difficulties.

Toward the end of 970/beginning of 1563 a high-ranking courtier named Amir Qayb Sultan Ustajlu came to Mashhad.[38] Sultan Ibrahim Mirza subsequently wrote his uncle the shah, saying he would like to come and see him. Tahmasp gave permission for this visit and made Amir Qayb governor of Mashhad. At the same time, he gave Ibrahim Mirza the governorship (*tawliyat*) of Ardabil in northwestern Iran. While en route from Mashhad, the prince stopped in Simnan (approximately 300 kilometers east of Qazvin), where a member of the Safavid court named Qazi Muhammad Razi jokingly remarked one night: "What is the good of being in charge of the abode of right guidance [Ardabil], when there is the fortress of Qahqaha?"[39] News of this comment apparently reached Tahmasp, who retracted his nephew's appointment to Ardabil. Instead the shah appointed Ibrahim Mirza to the governorship of Qa'in (*hakumat-i valiyat Qa'in*), a small provincial town approximately 300 kilometers due south of Mashhad, and ordered him to return to Khurasan.[40]

This period of what certainly sounds like a royal reprimand does not seem to have lasted very long,[41] and by 973/1565–66 Ibrahim Mirza was reinstated to his official position in Mashhad.[42] His rehabilitation must have been due, at least in part, to his participation beginning the previous year (972/1564–65) in two military campaigns led by Maʿsum Beg Safavi, one of which— the well-documented expedition against Qazaq Khan Takkalu in Herat—was particularly successful.[43]

Sultan Ibrahim Mirza's redemption turned out to be relatively short-lived. Within a year or two, Tahmasp had removed the prince from Mashhad for the second, and final, time and sent him to serve as governor of Sabzivar. Afushtaʿi Natanzi gives a detailed account of the circumstances surrounding this new reversal in the prince's fortunes.[44] In 974/1566–67 prince Sultan Muhammad Mirza (the future Muhammad Khudabanda) encountered difficulties with the Uzbeks and was besieged in the fort at Turbat, halfway between Mashhad and Herat. Apparently all the amirs in Khurasan sent forces to help lift the siege except Sultan Ibrahim Mirza, who instead seems to have reveled in his cousin's misfortune. "In fact, wherever he heard how the situation of those in the fort had worsened and that it would soon fall, he would express astonishment and joy and would make arrangements for a feast that day and spend it celebrating and merrymaking. In addition he would make jocular comments on the subject and allude to it in witty ways."[45]

Afushtaʿi Natanzi goes on to relate that when the news of this behavior reached Tahmasp, the shah became very upset and sent Shahvali Sultan Tati-quli Zulqadar to Mashhad to punish Sultan Ibrahim Mirza by removing him from office. The shah's emissary "arrived in the vicinity of the city in the afternoon and set up camp outside. Looking very angry, he entered the city with only a footman and rode to the gate of the prince's garden. He remained on horseback in front of Sultan Ibrahim Mirza's house, while pondering the decree regarding the prince's expulsion."[46] Following a brief standoff during which the prince's amirs attempted to persuade Tati-quli to delay the implementation of the royal order, Sultan Ibrahim Mirza was finally obliged to leave Mashhad. He then proceeded to Sabzivar, as per Shah Tahmasp's orders. These also included instructions to Khwaja Shaykh Uways, the vizier of Sabzivar and some nearby regions, to pay the disgraced prince one tuman cash daily.[47]

According to Afushtaʿi Natanzi, Ibrahim Mirza spent twelve years in Sabzivar, although his governorship there actually may not have lasted quite that long.[48] During this period the prince "did not get involved in any important matters of that region and acted most respectfully toward the people and, except for obedience and prayer, engaged in little else. He frequented the pious men of the [Sufi] tariqa, whom he honored with his benevolence."[49]

That is not to say that Sultan Ibrahim Mirza renounced all previous interests. Nor did he accept his reduced circumstances without a murmur. Qazi Ahmad characterizes Ibrahim Mirza's years in Sabzivar as "weary and vexing"[50] and quotes several verses that the prince composed under his pen-name Jahi that certainly seem to attest to dissatisfaction, if not downright despair:

Out of negligence the moon took our sigh as far as the firmament,
But out of propriety she will not talk about our sin to anyone.

Do not complain about tyranny, Jahi, it is neither good nor patient;
May God make the shah's heart forgive us.

Jahi, if the martyr of Tus [Imam Reza] endeavors,
Then I may drag my feet out of the mud of Sabzivar.[51]

In due course, Ibrahim Mirza's prayers were answered, and he was recalled to the Safavid court at Qazvin by Shah Tahmasp. Qazi Ahmad reports that he arrived in the capital on 8 Ramadan 982/22 December 1574 and was greeted by most of the royal princes and honored with royal receptions (fig. 136).[52] The Qazi says further that Ibrahim Mirza was "treated with justice and dignity. . . . When the shah talked with [him], he realized that he had been unfair and wrong all this time for having deprived himself of the company of someone so wise and dignified."[53] Presumably as a consequence of this change of heart, Tahmasp appointed his nephew ishak aqasi bashi, or grand master of ceremonies, and "spent his nights and days talking to him and discussing important matters until the time of his death."[54]

Shah Tahmasp died on 15 Safar 984/14 May 1576 after a long illness. His demise was imme-
diately followed by a bitter struggle for succession between two of his sons, Haydar Mirza and
Isma'il, in which Sultan Ibrahim Mirza was actively embroiled.[55] Initially the prince championed
the cause of his younger cousin and friend Sultan Haydar Mirza, but upon the ascendance of the
pro-Isma'il forces, he allied himself with the new shah.[56] Qazi Ahmad's account of Ibrahim
Mirza's activities in the days immediately following Tahmasp's death suggests that the prince main-
tained dual loyalties: on 17 Safar 984/16 May 1576 he buried Sultan Haydar Mirza, and on 18 Safar
984/17 May 1576 he ordered the khutba to be read in the name of Isma'il II at the Masjid-i Jami of
Qazvin.[57]

On 22–30 Safar 984/21–28 May 1576 Isma'il II and his army left the fort at Qahqaha, where
the new Safavid ruler had been imprisioned by Tahmasp some twenty years earlier, and proceeded
to Qazvin. En route to the capital, Isma'il was greeted on the plain of Zanjan by Sultan Ibrahim
Mirza in his capacity as master of ceremonies.[58] According to Iskandar Beg Munshi, Isma'il
embraced his cousin and addressed him as "brother."[59] These cordial relations continued
after Isma'il reached the Safavid court.[60] The new shah promoted Ibrahim Mirza to the posi-

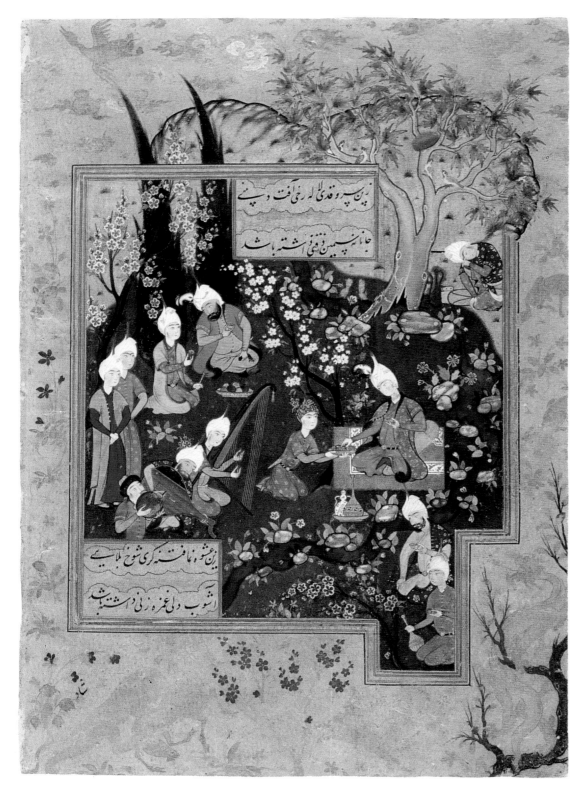

136
Princely Entertainment
in the *Divan* of Sultan Ibrahim Mirza
990/1582–83, Iran, Qazvin
23.8×16.8 cm (folio)
SAK MS 33, folio 29b
Collection Prince Sadruddin Aga Khan,
Geneva

tion of keeper of the royal seal (*mohrdar*) and, in addition, gave him the town of Kashan and other wealthy villages as fiefs.[61] By Isma'il's orders Sultan Ibrahim Mirza also took a seat on the court of justice and, along with with three other officials, passed judgment on various kinds of cases.[62]

The two cousins remained on good terms for about eight months. During that time, however, various individuals close to the shah began to conspire against Ibrahim Mirza, presumably because of his initial allegiance to Haydar Mirza, and apparently also because of his increasingly indiscreet and impolitic remarks at court.[63] Ibrahim Mirza's position deteriorated still further soon after the death of his older brother, Sultan Husayn Mirza, in Qandahar.[64] At that point it became apparent that Isma'il had befriended and favored Ibrahim Mirza in order to keep an eye on Sultan Husayn Mirza, whom the shah feared might start a revolt in Khurasan.[65] Sensing the shift in Isma'il's attitude, Ibrahim Mirza withdrew from court, ostensibly to mourn in private.[66] According to Qazi Ahmad, the prince remained at home in prayer and meditation. He also composed some verses and sent them to the shah. These begin with the plea:

Oh brother, do not bloody your hands
For there is already much on your hands

and end even more pointedly:

Happy the one who has reaped nothing but the seed of goodness
But you with these base acts will not benefit either from your rule or from your life.[67]

This self-imposed seclusion may have delayed the inevitable, but could not prevent it.[68] Eventually, as Iskandar Beg Munshi recounts in dramatic terms, the shah sent a squad of "blue-eyed Circassians of hideous aspect" to mount guard over the prince's house.[69] Soon thereafter Isma'il issued the death sentence and the Circassians entered the harem, dragged Ibrahim Mirza away from his wife Gawhar-Sultan Khanim, and strangled him. Qazi Ahmad specifies that this "tragic event" occurred at the end of Sunday, 5 Dhu'l-hijja 984/Saturday, 23 February 1577.[70]

Qazi Ahmad also recounts that Ibrahim Mirza was initially buried in the cemetery of the Imamzada Husayn in Qazvin. Later his daughter, Gawhar-Shad Begum, had the bodies of both her mother (who died on 17 Rabi' 1 984/4 June 1577)[71] and father taken to Mashhad and buried in a spot near or within the shrine of the Imam Reza that Sultan Ibrahim Mirza himself had selected and prepared for this purpose during his governorship.[72]

In his *Gulistan-i hunar* Qazi Ahmad quotes a chronogram composed by the poet Abdi Junabadi (d. 988/1580–81) following Ibrahim Mirza's murder. It begins with an evocation of the prince in religious terms as

The rose of the flower garden of Haydar Kharrar
The scion of the house of Ahmad

and proceeds to extoll his

Departure from this palace of vanity
With a true heart and a sound nature.

These verses are followed by a prayer in Arabic entreating God to "unite him [on the day of judgment] with the one who is called Abu'l-Hasan, the Imam to whom submission is due and whose protection is necessary, may God bless him and turn away from [any of] his shortcomings and trespasses."[73]

From what Qazi Ahmad says elsewhere in this treatise and in his earlier *Khulasat al-tawarikh*, it might be supposed that Sultan Ibrahim Mirza had no shortcomings and trespasses. Indeed, for this obviously less than impartial observer, the prince was a paragon of all virtues, endowed with a noble nature, natural intelligence, eloquent speech, and engaging personality and embued with piety, compassion, patience, generosity, and courage.[74] Throughout his life he manifest a great enthusiasm and capacity for learning and "embraced all branches of traditional and estoric knowledge" from religious studies to the arts and sciences (fig. 137). He was also gifted as a writer, artist, and musician as well as being an avid sportsman and hunter, accomplished cook, ardent lover, and veritable jack-of-all-trades. These many fine qualities, Qazi Ahmad would have us believe, made Sultan Ibrahim Mirza universally beloved and admired by his family (at least during his youth),

137
Text folio of *Tuhfat al-ahrar*
Copied by Rustam-Ali
in the *Haft awrang* of Jami
963/1556, Iran, Mashhad
21.8×13 cm (written surface)
FGA 46.12, folio 221a

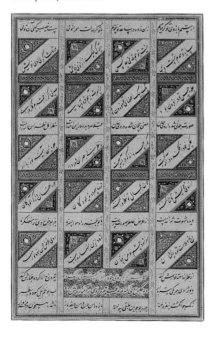

by other rulers at home and abroad, and by everyone else, from erudite scholars to humble dervishes, who had the pleasure of his company.

In reality, of course, the prince had his shortcomings, most noticeably an unfortunate tendency to offend his superiors, including the second and third Safavid monarchs, with inappropriate jokes and indiscreet remarks. This apparent inability to control his tongue, as Sadiqi Beg succinctly puts it, coupled with an evident lack of political astuteness, led to Ibrahim Mirza's "demotions" in the 1560s and to his ultimate downfall in 984/1577.[75]

Sultan Ibrahim Mirza as Poet and Artist
That Sultan Ibrahim Mirza was broadly accomplished, or at least interested, in diverse endeavors was hardly unusual, since it had long been the custom for Iranian princes to receive training in intellectual and cultural as well as military and governmental affairs.[76] Although little is known about the prince's general education, it may be assumed to have been undertaken, at least from the time of his father's death, at the Safavid court and under the aegis of Shah Tahmasp. Certainly the shah would have been able to foster and further his young nephew's interests in the arts, which had been among his own principal passions since childhood.[77]

According to Qazi Amad, and seemingly confirmed (or at least repeated) by Sharafuddin Khan Bidlisi, Iskandar Beg Munshi, and Sadiqi Beg, Ibrahim Mirza was an eager and adept student in a wide range of spiritual and secular subjects: the reading and recitation of the Koran,[78] Muslim biographies and *hadith* (traditions relating to the Prophet Muhammad), history and genealogy, philosophy (natural, theological, and medical), logic and rhetoric, and geometry, mathematics, and astronomy.[79] He also studied music and musical composition, mastered musical modes and techniques, composed melodies and songs, played the tanbur, and even made musical instruments.[80] Both Qazi Ahmad and Iskandar Beg Munshi record that the prince was a pupil of an ill-fated dulcimer player named Qasim Qanuni, from whom he learned "the art of composing ballads."[81]

Sultan Ibrahim Mirza also had a deep, and it seems lifelong, passion for poetry, and, again according to Qazi Ahmad, he excelled in "poetical criticism, the solution of fine points of versification, and nuances and Sufism and love."[82] While he was governor of Mashhad, Ibrahim Mirza was frequently engaged in discussions about poetry, sometimes with his uncle Sam Mirza, author of an important treatise on contemporary poets and literati.[83] Based on the two extant manuscripts he commissioned, we may assume that the prince enjoyed the classical poetry of Abdul-Rahman Jami, author of the *Haft awrang*, and of Muhammad Ghazali Mashhadi, a contemporary poet from Mashhad (d. 980/1572–73) and author of the *Naqsh-i badi'*. He is also said by Qazi Ahmad to have greatly favored the poems of another sixteenth-century poet, Mawlana Lisani Shirazi (d. 942/1535–36), whose complete *Divan* he kept close at hand.[84]

Using the pen-name Jahi, Sultan Ibrahim Mirza himself composed poetry in both Persian and Turkish.[85] In this he continued the practices of other members of the Safavid family, among them his grandfather, Shah Isma'il, his father Bahram Mirza, and uncles Tahmasp and Sam Mirza.[86] Qazi Ahmad is especially effusive about Sultan Ibrahim Mirza as poet, extolling him as "sweet-tongued in poetry and poetics and clear in his presentation . . . and gifted in the art of metrics, rhyming, and puzzles [*mu'amma*]."[87] The Qazi also quotes, at various points in both the *Gulistan-i hunar* and his earlier *Khulasat al-tawarikh*, a number of the prince's verses in various poetic forms and meters.[88] Among these are lines praising an unnamed poet; here Sultan Ibrahim Mirza undoubtedly refers to himself.

When his pen lays musk-colored grains,
many a bird of meaning is snared.

He is as sweet of speech as Khusraw;
Hasan's style has received good news of him.

Bravo! He is as rare a poet as Nizami,
and poetry itself has been ordered by him.

From the world of the unseen Surush comes to his banquet.
He is as worthy as Jami to drink from Surush's goblet.[89]

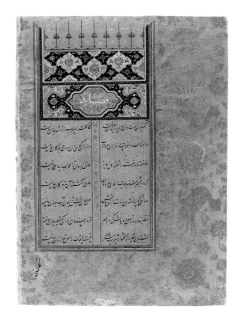

138
Qasida heading folio
in the *Divan* of Sultan Ibrahim Mirza
990/1582–83, Iran, Qazvin
23.8×16.8 cm (folio)
SAK MS 33, folio 3b
Collection Prince Sadruddin Aga Khan,
Geneva

139
Text folio
in the *Divan* of Sultan Ibrahim Mirza
990/1582–83, Iran, Qazvin
23.8×16.8 cm (folio)
SAK MS 33, folio 57b
Collection of Prince Sadruddin Aga Khan,
Geneva

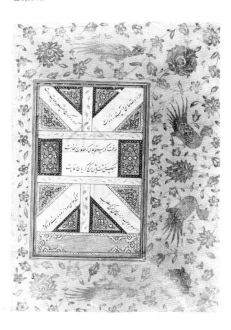

Not long after Sultan Ibrahim's death, his daughter Gawhar-Shad Begum ordered several thousand of his verses to be compiled as a *Divan*. She wrote a *dibacha* (preface) to this collection and "sent copies to all the lands of Iran, Turan, the east, India and Rum."[90] Two of these copies survive today: one dated 989/1581–82 in the Gulistan Library, Tehran (GL 2183), and the other dated 990/1582–83 in the collection of Prince Sadruddin Aga Khan, Geneva (SAK MS 33; figs. 138 and 139). Both volumes involved the participation of Abdullah al-Shirazi, an artist who also worked on Sultan Ibrahim Mirza's *Haft awrang* and whose service evidently shifted to Gawhar-Shad Begum after the prince's death.[91]

The *Divan* of Ibrahim Mirza begins with a prose preface in which the prince's daughter, referring to herself as "this weak female of few possessions," explains that after her father's death many copies of his poems were lost. She therefore "strove her utmost to gather each and every line and each and every poem in the hopes that perhaps some sympathetic person may open his lips to ask for forgiveness and mercy for them, and thus they many obtain mercy."[92] The prince's verses are arranged in three parts: first the qasidas in Persian, then the ghazals in Persian, and finally the *turkiyat*s in Turcoman Turkish.[93] All evoke the theme of love and longing common to classical Persian and Turkish poetry and draw on conventional imagery of the genre. In addition, some of the Turkish poems are of a devotional character and indicate an attachment to the Imams of Shi'ite Iran.

Qazi Ahmad's compliments notwithstanding, there is little to distinguish the verses of Sultan Ibrahim Mirza from those of, say, his grandfather, Shah Isma'il, who wrote under the pen-name Khata'i and whose equally formulaic verses have at least an added interest as expressions of strong sectarian concerns. Nor is there any indication that Sultan Ibrahim Mirza was trying to imitate either Shah Isma'il or any of the poets whose works he is known to have admired. Furthermore, even though the prince compares himself to the poet Abdul-Rahman Jami in the self-referential verse quoted by Qazi Ahmad, there is nothing in his *Divan* that suggests direct emulation of Jami's *Haft awrang* or other writings.

In addition to his literary and musical interests, Sultan Ibrahim Mirza was said to be gifted in the arts of the book. Qazi Ahmad exclaims that the prince had "golden hands in painting and decorating"[94] and also that he displayed mastery in "bookbinding [*sihafi*], and gilding [*mudhahhabi*], and gold sprinkling [*afshangari*], and the making of stencils [*aks-sazi*], and the mixing of colors [*rang-amizi*], and as a goldsmith [*zargari ustad*]."[95] "And in his designs [*tarrahi*] and paintings [*naqqashi*] his work recalled that of Mani and served as a reminder of master Bihzad Haravi."[96]

The prince's real forte seems to have been in calligraphy, and Qadi Ahmad speaks of him as "among the most accomplished calligraphers," presumably meaning of that time.[97] Ibrahim Mirza took instruction from Malik al-Daylami, who copied the first masnavi in his *Haft awrang*.[98] This instruction probably took place in Mashhad, where Malik was working some time prior to Dhu'l-hijja 963/October 1556, the date of his first colophon in the Freer Jami. In any event, the arrangement was apparently short-lived (Qazi Ahmad describes it as lasting only "for a few days"),[99] and it may be that Ibrahim Mirza had already attained "advanced amateur standing" in calligraphy by the early 960s/1550s. He also appreciated the work of other calligraphers and took as his model Mawlana Mir-Ali, imitating that master's writings and pages (*qatiat*).[100] According to Qazi Ahmad, Ibrahim Mirza "made progress in a short time" and was equally competent in large (*jali*) and fine (*khafi*) scripts.[101]

As with his poetry, Ibrahim Mirza would have come by these calligraphic and other artistic predilections naturally, since his grandfather, father, aunt, and uncles were similarly inclined, as attested by extant examples of their work.[102] Unfortunately, and despite Qazi Ahmad's assertion that "the paintings of the late prince are numerous and are in every town and in every clime,"[103] nothing of that medium from the hand of Ibrahim Mirza seems to have survived. The prince's *Haft awrang*, however, attests to his high standards in the arts of the book (fig. 140). The multiplicity of its scribes and length of its transcription notwithstanding, this manuscript exhibits absolute consistency and uniformity in calligraphic style. The nasta'liq used for both the masnavi verses and rubrics on each of the volume's 302 original folios displays the sureness and clarity of line, delicate and fluid curve of letters, and rhythmic and even progression of pen across paper characteristic of this cursive script at its finest. Surely these features are what Ibrahim Mirza must have strived for in his own calligraphy.

The quality and quantity of the materials in the *Haft awrang*, including its brilliant pigments, also surely would have been de rigueur for someone reported to have been skilled in the mixing of colors. Likewise the copious use of gold throughout the manuscript would have been both expected and admired by a patron who was apparently proficient in gilding and gold sprinkling. Of particular note are the illuminated headings with central gold cartouches, gold-dusted text paper, column dividers filled with gold floral scrolls, and margins decorated with gold-painted and stenciled designs. Finally, the manuscript's illustrations, especially those in which figures occupy the gilded borders, were probably what Ibrahim Mirza would have sought in his own designs (tarrahi) and paintings (naqqashi). In all, it is safe to assume both that the *Haft awrang* met the exacting standards of its patron and that the prince applied those same standards to his own artistry.

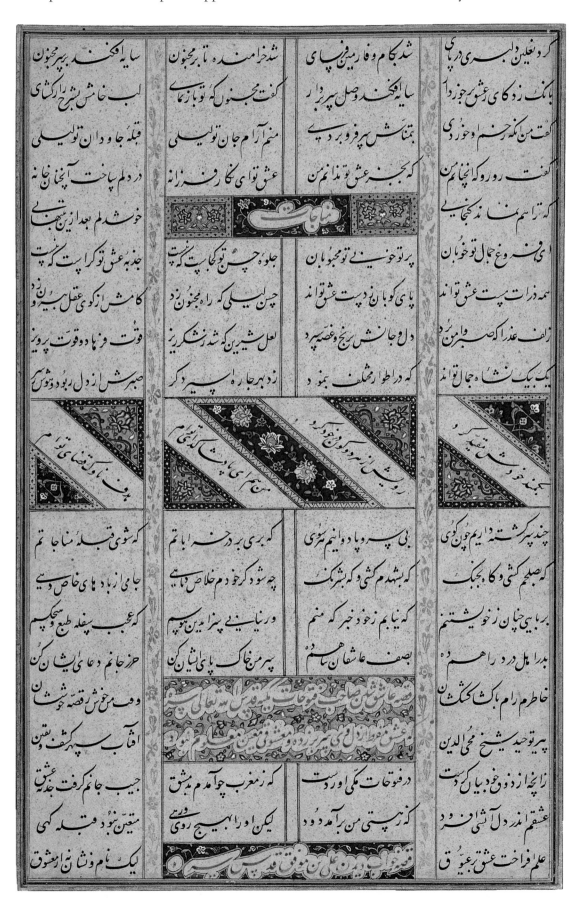

140
Text folio of *Silsilat al-dhahab*, second daftar in the *Haft awrang* of Jami
Copied by Malik al-Daylami
964/1557, Iran, Mashhad
21.8×13 cm (written surface)
FGA 46.12, folio 58a

Sultan Ibrahim Mirza as Collector and Patron

Qazi Ahmad relates a poignant anecdote, regularly repeated by modern scholars, about how, immediately after Sultan Ibrahim Mirza's death, his bereaved widow washed out a treasured album (*muraqqaʿ*) of calligraphy and paintings so that it might not come to the attention of his murderer, Ismaʿil II.[104] Whether accurate or, as is more likely, apocryphal, this story confirms Sultan Ibrahim Mirza's reputation as a connoisseur and collector and places him in a well-established Safavid family tradition.[105]

Another version of the same tale, recounted by Iskandar Beg Munshi, implies that Sultan Ibrahim Mirza had a collection of china, probably meaning Chinese porcelain.[106] Although this statement cannot be verified, the prince did seem to have an appreciation for three-dimensional objects and perhaps also antiquities. In 967/1559–60 there was a major flood caused by the rising of the Cheshma-i sabz (Green Spring) about twelve farsangs or 120 kilometers from Mashhad. When the waters finally receded, the local inhabitants found a number of gold and silver objects that had come to the surface during the flooding. In due course Sultan Ibrahim Mirza was informed and went to the area with his retinue to investigate. The account of this fascinating incident comes from Qazi Ahmad, who continues as follows:

> At the spring, whenever they dug they found gold and silver objects, some in the form of animals. The prince spent two days at the site and found about sixty to seventy silver and a number of solid gold objects that he took back to Mashhad. He sent them as a gift to the shah, who put someone in charge of the area. It was later found out that before the Islamic era, idolaters worshiped at this spring and would throw precious objects into the source in the hope of having their wishes fulfilled.[107]

Qazi Ahmad does not elaborate further, but we may suppose that Ibrahim Mirza took charge of these silver and gold objects because he recognized their historical importance and monetary value and because he saw an opportunity to impress Tahmasp with his acumen as connoisseur and with the proper discharge of his responsibilities as governor.

Certainly Ibrahim Mirza and his uncle (and by now father-in-law) shared a common pleasure in collecting examples of two-dimensional works of art, particularly calligraphy and painting. Ibrahim Mirza not only emulated the calligraphic style of Mir-Ali but also gathered a number of albums, along with other works, written by this artist; his total collection consisted, according to Qazi Ahmad, of "half of the examples that the Mawlana had written during his lifetime."[108] Another prized possession—the album later washed out by Gawhar-Sultan Khanim and effusively praised by Qazi Ahmad—contained "the writing of masters and paintings of Mawlana Bihzad and others."[109] This muraqqaʿ was assembled for Ibrahim Mirza in Mashhad by contemporary artists, who also may have contributed to its contents, and is likely to have been similar in genre to, for instance, the marvelous album completed for his father, Bahram Mirza, in 951/1544–45.[110] According to Qazi Ahmad, these albums formed part of Sultan Ibrahim Mirza's "well-ordered kitabkhana," a library numbering altogether "some three to four thousand volumes of all types."[111]

Virtually no other particulars are available about works of art that Ibrahim Mirza that may have collected and kept in his kitabkhana. Much is recorded or can be reconstructed, however, about his patronage of a kitabkhana as an atelier, his commission of works of art, and particularly his support of writers, musicians, and artists.

Various sources mention that the prince spent much of his time as governor of Mashhad in the company of learned men, men of letters in general and poets in particular, as well as musicians and composers, calligraphers and painters.[112] Both Qazi Ahmad and Iskandar Beg Munshi, for instance, cite Khwaja Husayn Sana'i Mashhadi, a Khurasani poet noted for his abstruse odes, as being in service to the prince.[113] The Qazi also records the names of other poets who served Sultan Ibrahim Mirza in Mashhad.[114]

These poets are mentioned in the context of a long anecdote, actually more like a biography, concerning yet another member of the prince's circle, the dulcimer player Qasim Qanuni of Herat.[115] Ibrahim Mirza had heard about this musician from some Herati connoisseurs, apparently at an early date during his governorship of Mashhad, and sent an emissary to ask Qazaq Khan Takkalu (then the governor of Herat who later rebelled against the shah, leading to the military campaign of 972/1564–65 in which Ibrahim Mirza took part) to allow Qasim Qanuni to come to Mashhad. Qazaq obliged, and the musician arrived in Mashhad in 967/1559–60, settling into

quarters that Ibrahim Mirza had built in the Chahar-bagh.[116] According to Qazi Ahmad, Qasim Qanuni spent ten or twelve years in the service of prince Ibrahim Mirza and accompanied him on his journey to Herat (this presumably means the campaign against Qazaq) and during his governorships in Qa'in and Sabzivar.[117] During this time the musician performed daily for Ibrahim Mirza and taught him to compose ballads. Sometime later, as the result of an apparently scandalous incident involving another musician and the Safavid prince Haydar Mirza, all the players and singers in Tahmasp's realm were ordered to be put to death. The shah's execution edict singled out Qasim Qanuni in particular. Ibrahim Mirza kept the musician hidden for a time in a underground chamber dug in his own house, but the poor fellow died the day he emerged from hiding.[118]

Ibrahim Mirza's entourage also included a tanbur player named Sultan-Mahmud Tanbura'i. Unlike the dulcimer player Qasim, who reportedly followed the prince on various expeditions and postings, Sultan-Mahmud was with Ibrahim Mirza in Mashhad only.[119]

Mir Vajihuddin Khalilullah Husayni was another member of the coterie of literati supported by Ibrahim Mirza in Mashhad.[120] He was also the uncle of Qazi Ahmad, a connection that explains the extensive recitation of his biography in the *Gulistan-i hunar*. The ties between Khalilullah and his princely patron appear to have been close, and in 967/1559–60 Ibrahim Mirza entrusted him with the secret negotiations in Herat for the services of Qasim Qanuni. Khalilullah also shared Ibrahim Mirza's interest in versification and is said by his nephew to have written good poetry, including a plaintive verse concerning an "exile" that seems to echo Ibrahim Mirza's poetic sentiments, as quoted above. First and foremost, however, Khalilullah seems to have been a calligrapher and wrote in *ta'liq* for thirty years. While in Mashhad, he switched to nasta'liq, which he practiced under the direction of the master Mir Sayyid-Ahmad Mashhadi, who also taught Qazi Ahmad. After Ibrahim Mirza's death in 984/1577, Khalilullah moved to Qum, where he died in 1004/1593–94.[121]

With Khalilullah, we step into the circle of those around Ibrahim Mirza whose professional expertise lay in the visual, rather than the literary or performing, arts. Like this calligrapher, most served Ibrahim Mirza in Mashhad and either remained there after his departure or moved on to other places and patrons. Certainly the thinning of the artistic ranks that seems to have occurred when the prince irrevocably lost the prestigious position at Mashhad in 974/1566–67 must have been directly linked to his reduced circumstances and resources while governor of Sabzivar. Once again, this is not to say that Ibrahim Mirza was obliged to abandon his artistic interests and patronage altogether. Besides the dulcimer player Qasim Qanuni, Ibrahim Mirza was served in Sabzivar by two artists: Shaykh-Muhammad and Sultan-Muhammad Khandan.

Although at least one source places Shaykh-Muhammad with Ibrahim Mirza in Sabzivar, no known work by this artist can be securely demonstrated as having been executed there. The calligrapher Sultan-Muhammad Khandan, on the other hand, speaks directly about working for the prince in Sabzivar. In Muharram 982/April–May 1574, he completed the transcription of a volume of the *Naqsh-i badi'* "by order of the kitabkhana of his highness, governor of the world, Sultan Ibrahim Mirza, in the city of Sabzivar" (TKS R. 1038, folio 38a; fig. 141; see also fig. 200).[122] In addition to documenting his own whereabouts, Sultan-Muhammad Khandan's colophon confirms that Sultan Ibrahim Mirza continued to patronize the arts, to add to his collection of manuscripts, and to maintain a kitabkhana as artistic atelier even after the reversal in his political fortunes and move from Mashhad. At the same time, the manuscript copied by Sultan-Muhammad Khandan reveals either a change in the prince's taste or, as is more likely, the direct impact of the situation in Sabzivar on his ability to attract and support artists creating first-rate works of art.

The *Naqsh-i badi'* comprises a masnavi on mystical love by Muhammad Ghazali Mashhadi, a writer of both prose and poetry who was born in Mashhad circa 936/1529–30 and was at the court of Shah Tahmasp in 958/1550–51.[123] Sometime later he left Iran for India, where he was attached to Ali Quli Khan (also known as Khan Zaman), a general in the imperial Mughal army and at that time governor of Jaunpur in the province of Uttar Pradesh. It was while serving this patron that Muhammad Ghazali wrote his *Naqsh-i badi'*, which contains a panegyric to Shah Tahmasp followed by a eulogy to Khan Zaman.[124]

It is tempting to think that Ibrahim Mirza might have known Muhammad Ghazali, either as a youth at the Safavid court or later in Mashhad. If so, he may have wanted a copy of the poet's work out of personal, as much as literary, considerations. It is equally intriguing to imagine (and equally impossible to prove) that Ibrahim Mirza had a volume of the *Naqsh-i badi'*, as opposed to one of

141
Colophon folio
Signed by Sultan-Muhammad Khandan
in the *Naqsh-i badi'* of Muhammad Ghazali
Mashhadi
982/1574, Iran, Sabzivar
25.6×15.8 cm (folio)
TKS R. 1038, folio 38a
Topkapi Sarayi Müzesi, Istanbul

Muhammad Ghazali's other works, made for his kitabkhana precisely because it contains a pane-gyric to Tahmasp. Perhaps such a commission, were Tahmasp to hear of it, would be one way for the prince, still "languishing" in Sabzivar, to ingratiate himself once again to his uncle and father-in-law. Indeed the commission may have been intended as a modest offering to Tahmasp upon Ibrahim Mirza's return to Qazvin.

Whatever his motivations, Sultan Ibrahim Mirza could undoubtedly anticipate the manu-script's final form even before Sultan-Muhammad Khandan began the transcription of the text. For while the *Naqsh-i badiʿ* is a deluxe manuscript in the technical sense of the term, made of fine mate-rials and embellished with paintings and various kinds of illumination, it hardly can compare to the *Haft awrang*. Simply put, it is a far more modest work of art.

The *Naqsh-i badiʿ* consists of thirty-eight folios, of which two are illustrated. In addition, it con-tains an illuminated heading at the beginning of the text and illuminated panels on the last three folios, decorated column dividers and margins, multicolored rulings, and rubric panels (fig. 142; see also figs. 201 and 202). While seemingly intact and in good condition, the manuscript in fact has been subjected to considerable refurbishment, making the overall contrast with the Freer Jami even more striking.

This contrast is exemplified by the *Naqsh-i badiʿ*'s two paintings, which definitely appear to have been done by the same hand. Both compositions are small, occupying little more than an average written surface and basically confined within their rulings. Both illustrate mystical themes. The first, on folio 23b, accompanies two verses about the tortures of love. Its composition and iconography—featuring four young men in a garden setting—are a quintessential example of formulaic Safavid painting (fig. 143). The second illustration, on folio 26a, is more animated but no less standardized (fig. 144). Here the poetry reminds the reader of the fate of Zulaykha, who loved Yusuf with thoughtless passion. The painting picks up the theme with a representation of Zulaykha trying to hold back the fleeing Yusuf. The scene's familiar treatment derives directly from the classic iconog-raphy for Yusuf's flight as recounted, for instance, in Jami's masnavi and as illustrated in various copies of the *Haft awrang* and other manuscripts.[125]

Both illustrations are carefully executed, and both conform, especially in figural style, to the mode of painting traditionally associated with Mashhad and Qazvin in the latter part of the six-teenth century. In terms of artistic conception and imagination, however, neither can compare with any of the paintings in the Freer Jami, not even the relatively simple ones on folios 10a and 207b. Most likely whoever was responsible for the illustration of Ibrahim Mirza's *Naqsh-i badiʿ* neither had seen his *Haft awrang* nor possessed the talent to emulate it.

142
Text folios
Copied by Sultan-Muhammad Khandan
in the *Naqsh-i badiʿ* of Muhammad Ghazali
Mashhadi
982/1574, Iran, Sabzivar
25.6×15.8 cm (one folio)
TKS R. 1038, folios 3b—4a
Topkapi Sarayi Müzesi, Istanbul

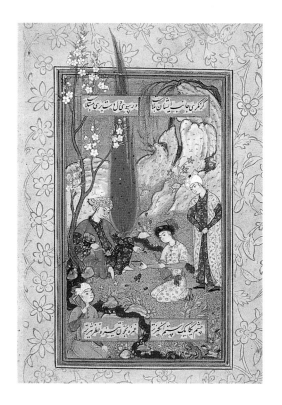

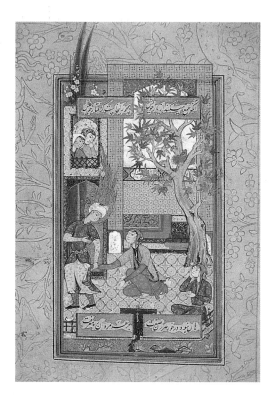

143
Gathering in a Landscape
in the *Naqsh-i badiʿ* of Muhammad Ghazali
Mashhadi
982/1574, Iran, Sabzivar
14×8 cm (painting)
TKS R. 1038, folio 23b
Topkapi Sarayi Müzesi, Istanbul

144
Zulaykha Tries to Hold Back the Fleeing Yusuf
in the *Naqsh-i badiʿ* of Muhammad Ghazali
Mashhadi
982/1574, Iran, Sabzivar
14×8 cm (painting)
TKS R. 1038, folio 26a
Topkapi Sarayi Müzesi, Istanbul

The *Haft awrang* and the *Naqsh-i badiʿ* represent the two poles of Sultan Ibrahim Mirza's patron-age as measured in conceptual and qualitative terms. It is likely, however, that Ibrahim Mirza com-missioned other works, and indeed, there are some that have been associated with the prince and may represent, or at least reflect, his patronage.

Of these, perhaps the most tantalizing is a volume of the *Gulistan* of Saʿdi with one illustra-tion.[126] The colophon is signed (but not dated) by the calligrapher Abdul-Vahhab al-Husayni al-Mashhadi. It is also said to contain the name of Abu'l-Fath Sultan Ibrahim Mirza. According to the published description, the volume opens with an illuminated heading, and the text is copied in fine nastaʿliq on colored text paper (yellow, blue, pink, and green) dusted in gold and inset into gold-flocked colored margins.[127] Its single painting illustrates the second chapter of the *Gulistan* and depicts a king entertaining a dervish (fig. 145).[128] The manuscript seems to have retained its origi-nal, or at least a contemporary, lacquered binding with flowers and birds.

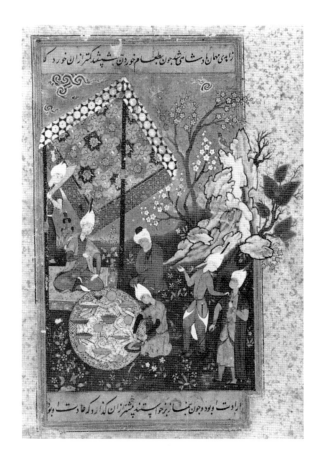

145
A King Entertains a Dervish
in the *Gulistan* of Saʿdi
ca. 1520–30, Iran
31.5×20.5 cm (folio); 19.5×10.5 cm
(written surface)
Negarestan Museum, Tehran
(after SOTH 1.XII.69, lot 192)

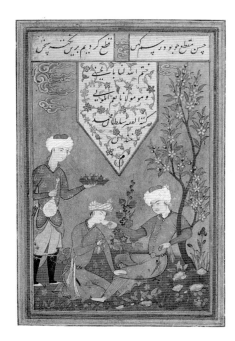

146
Colophon
Signed by Sultan-Muhammad Khandan
in the *Subhat al-abrar* of Jami
ca. 1575–80, Iran, attributed to Mashhad
11.1×7.1 cm (written surface)
GULB LA 159, folio 137a
Calouste Gulbenkian Foundation, Lisbon

147
Princely Hunting Party
(right half of a double-page frontispiece)
in the *Subhat al-abrar* of Jami
ca. 1575–80, Iran, attributed to Mashhad
21.7×14.5 cm (folio)
GULB LA 159, folio 1b
Calouste Gulbenkian Foundation, Lisbon

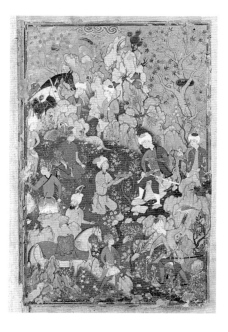

Although not as elaborate as the Freer Jami and less extensively illustrated than even the *Naqsh-i badi*, this work certainly would have been worthy of a princely patron such as Ibrahim Mirza. It is likely that manuscript's scribe, Abdul-Vahhab, transcribed the text in his hometown of Mashhad, where Qazi Ahmad met him.[129] This connection, in turn, would date the manuscript to Ibrahim Mirza's two-part tenure in Mashhad, that is, the spring of 963/March 1556 until the end of 970/beginning of 1563 and 973/1565–66 until 974/1566–67. Certainly it is possible to imagine both that the prince would have wanted a copy of a great literary classic such as the *Gulistan* and that he would have commissioned other manuscripts while his *Haft awrang* masterpiece was in preparation.

The only complication with such a scenario is that the delicate style of the painting, in which the king and the dervish are seated outside under a canopy while an attendant prepares a dish on a circular rug in front and others look on, is closer to that characteristic of Tabriz during the decades prior to the Ibrahim Mirza's appointment in Mashhad and the concurrent initiation of the Freer Jami project. Indeed, various details of its setting, including the canopy and knotted clouds, and its slim participants recall the famous picnic scene in *Divan* of Hafiz long thought to have been made for Ibrahim Mirza's uncle Sam Mirza and attributed to circa 1527.[130] The round "tablecloth" with its symmetrical array of dishes brings to mind fountains in the Nizami manuscript made for Shah Tahmasp and dated 946–49/1539–43.[131] This echo suggests that the manuscript was commissioned before Ibrahim Mirza left the Safavid court and thus constitutes a unique example of the prince's early taste and patronage. An alternative is that the *Gulistan* illustration was painted in Mashhad by an artist steeped in traditional (and by the 1560s rather outmoded) forms and that Ibrahim Mirza retained an appreciation for the discretion and control of this older painting style while simultaneously supporting the animated and complex modes that pervade his *Haft awrang* illustrations.[132]

The other works associated with Sultan Ibrahim Mirza fall into two distinct, albeit overlapping, categories: manuscripts copied and/or illustrated by artists known to have been in the prince's service, and those with paintings and often other features, such as illuminations, that are stylistically related to those in the Freer Jami. With both groups the evidence for Ibrahim Mirza's patronage is more circumstantial than for the *Gulistan*, and the issue of provenance is sometimes even more convoluted.

The first group includes a small, undated volume of the *Subhat al-abrar* copied, but not dated, by Sultan-Muhammad Khandan (GULB LA 159; figs. 146 and 147).[133] The manuscript contains four compositions: a double-page frontispiece, an apparent text illustration, a colophon finispiece, and a second double-page finispiece. All have affinities with the Freer Jami illustrations, and the single text illustration appears to clinch the relationship to Sultan Ibrahim Mirza since it is signed by Abdullah al-Shirazi, author of the inscribed title piece in the *Yusuf u Zulaykha* (FGA 46.12, folio 84b; see figs. 20, 32, 203, and 207), and dated 972/1564–65. As it happens, however, the composition by Abdullah has been inserted into the manuscript, and thus there is no guarantee that its date has anything to do with the *Subhat* itself. Furthermore, both the double-page frontispiece and finispiece also have been pasted into the manuscript. Their status as insertions does not diminish their significance in terms of the painting style, but it does mean that their relationship to the Freer Jami must be considered independently from the issue of the *Subhat*'s patronage.

Besides the manuscript's codicology, the identity of its calligrapher also poses a problem in terms of establishing a concrete link with Sultan Ibrahim Mirza. The Sultan-Muhammad Khandan who signed the *Subhat* colophon is unlikely to be the Sultan-Muhammad Khandan who signed the *Naqsh-i badi* colophon but an older, and more celebrated, calligrapher by the same name.[134] This possibility is suggested on the basis of calligraphic style and also in consideration of the absence of any mention of Sultan Ibrahim Mirza, of which Sultan-Muhammad Khandan made such a point in his *Naqsh-i badi* colophon. The *Subhat al-abrar* is, at best, a tentative addition to the shelves of Sultan Ibrahim Mirza's kitabkhana.[135]

Another manuscript with a possible connection to Sultan Ibrahim Mirza through its scribe is a lavish volume of six of Jami's masnavis copied by Muhibb-Ali over a two-year period from the beginning of 978/July 1570 to the end of 979/April–May 1572 (TKS H. 1483; figs. 148, 149, and 150).[136] By this time Ibrahim Mirza was serving as governor in Sabzivar, while Muhibb-Ali, who identifies himself in the Freer Jami as the prince's kitabdar, was in the Safavid capital at Qazvin. It is entirely possible, of course, that the artist continued working at a remove for his former patron. Furthermore, the overall quality of this manuscript corresponds to the prince's *Haft awrang*, and its

CHAPTER THREE: PATRON AND ARTISTS

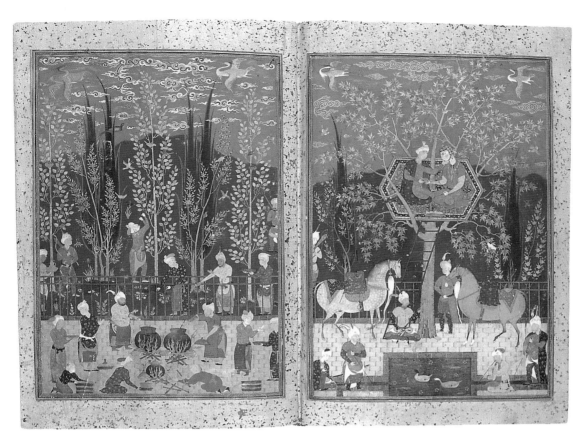

148 (*left*)
Double-page frontispiece
Copied by Muhibb-Ali
in the *Six Masnavis* of Jami
978-79/1570-72, Iran,
attributed to Qazvin and Mashhad
34.9×23.3 cm (one folio)
TKS H. 1483, folios 1b-2a
Topkapi Sarayi Müzesi, Istanbul

149 (*below left*)
Masnavi heading of *Silsilat al-dhahab*, first daftar
Copied by Muhibb-Ali
in the *Six Masnavis* of Jami
979/1572, Iran, attributed to Qazvin and
Mashhad
34.9×23.3 cm (folio)
TKS H. 1483, folio 105b
Topkapi Sarayi Müzesi, Istanbul

150 (*below right*)
Colophon folio of *Khiradnama-i Iskandari*
Signed by Muhibb-Ali
in the *Six Masnavis* of Jami
978/1570-71, Iran, attributed to Qazvin and
Mashhad
34.9×23.3 cm (folio)
TKS H. 1483, folio 229a
Topkapi Sarayi Müzesi, Istanbul

paintings definitely relate stylistically to those in the Freer Jami. These compositions, comprising a double-page frontispiece, twenty-five text illustrations, and four colophon finispieces, were almost certainly executed by the same hand and have been attributed to Shaykh-Muhammad, an artist who hailed from Sabzivar and is known to have worked for Sultan Ibrahim Mirza.[137] This attribution presents the possibility that the Jami manuscript of 978-79/1570-72 was illustrated in Sabzivar after having been transcribed in Qazvin, making it another peripatetic project like the Freer Jami.

Such an appealing scenario notwithstanding, it is necessary to consider why in 978-79/ 1570-72 Ibrahim Mirza would want another copy of Jami's poems, especially one with a pictorial program that is comparable in many respects to the *Haft awrang* he had already commissioned.[138] This question seems particularly relevant in light of Ibrahim Mirza's reduced circumstances and evident restrictions on his artistic patronage, as reflected in the *Naqsh-i badi*ʿ codex, during his tenure in Sabzivar. The most we can say is that this is the type of manuscript that Ibrahim Mirza surely would have admired but probably neither needed nor could have afforded at the time.[139]

As indicated, the Sultan-Muhammad Khandan *Subhat al-abrar* and the Muhibb-Ali *Haft awrang* contain paintings that are stylistically related to those in Ibrahim Mirza's *Haft awrang*. A number of other works share the same connection: a complete *Haft awrang* dated 1 Dhu'l-qa'da 971/11 June 1564 (PWM MS 55.102; fig. 151; see also figs. 74 and 113),[140] a *Bustan* of Saʿdi dated 933/1527 and with four paintings attributed to Mashhad or Sabzivar circa 1565 (AHT no. 66),[141] a manuscript of three poems by Hilali dated 976/1568-69 (GULB LA 192),[142] a *Garshaspnama* (Book of Garshasp) of 981/1573-74 (BL Or. 12985),[143] a poetic anthology dated Dhu'l-hijja 982/ March-April 1575 (SOTH 6.XII.67, lot 206),[144] a double *Khamsa* by Nizami and Amir Khusraw Dihlavi dated Dhu'l-qa'da 984/January-February 1577 and Rabiʿ I 985/May-June 1577 (KEIR PP 28-32),[145] a *Divan* of Hafiz (with at least one painting now detached) dated Ramadan 989-Rabiʿ I 994/September 1581-February 1586 (TKS H. 986 and KEIR III.232),[146] and two illustrations detached from a volume of Jami's *Silsilat al-dhahab* (MINN 43.31.2 and AHT no. 93).[147] Although some of these works postdate Ibrahim Mirza's lifetime, all reveal the impact of the *Haft awrang* paintings and thus could be considered, by extension, reflections of the prince's taste and patronage.

151
Caravan Encampment
in the *Haft awrang* of Jami
971/1564, Iran, Raza (Bakharz district, Khurasan)
24.6×14.3 cm (painting)
PWM MS 55.102, folio 76a
Courtesy, Trustees, Prince of Wales Museum of Western India

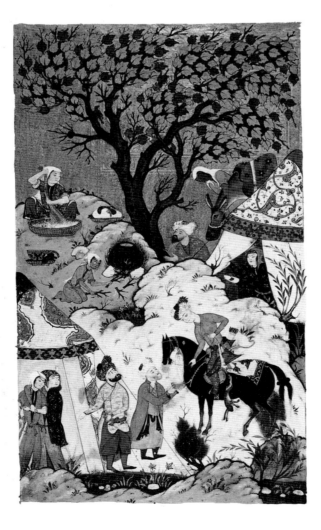

CHAPTER THREE: PATRON AND ARTISTS

1. Primary sources: Afushta'i Natanzi [Ishraqi], 44–51; Mustafa Ali Efendi [Ibn ül-Emin], 67; Bidlisi [Charmoy], 2:584, 592, 609–11, 637–38, 643; Bidlisi [Velaminof-Zernof], 2:202, 209, 223–25, 247–48, 253; Hasan Rumlu [Nava'i], 433, 484, 541, 544, 546, 607, 621, 630, 632–33; Hasan Rumlu [Seddon], 151, 155, 184–85, 203, 205, 207–8; Iskandar Beg Munshi [Afshar], 1:105, 119, 136, 193–94, 196–98, 200, 206–9; Iskandar Beg Munshi [Savory], 1:175, 189–90, 198, 220, 285, 290, 293, 295–96, 306, 308–11; Khuzani, folios 216a–18b; Qazi Ahmad [Ishraqi], 1:367, 376–77, 380–92, 396–97, 401, 407, 410, 413, 415–16, 434, 436, 439–40, 447–53, 460, 567, 570, 588–89, 605, 607, 2:633–37, 640–43, 645; Qazi Ahmad [Minorsky], 3–11 (introduction), 155–64, 183–84; Qazi Ahmad [Suhayli-Khunsari], 106–19, 143–44; and Sadiqi Beg [Khayyampur], 25–26 (translated in A. Welch, *Artists*, 158).

Selected secondary sources: Mehdi Bayani, 1–2:9–13; Dickson & Welch, 1:36A, 45A–48B, 115B, 143B, 153A, 159B, 250B n. 8, 252A n. 8; Farhad & Simpson; Gray, *PP* 2, 142; Huart, 233–34, 336; Stchoukine, *MS*, 18–20 and cat. nos. 170, 170^bis; Titley, *PMP*, 103–6; A. Welch, *Artists*, 150–58; S. C. Welch, *KBK*, 72–73; S. C. Welch, *PP*, 23–24; S. C. Welch, *WA*, 30–31; and Welch & Welch, 87–88, 94–98.

For further information and selected evaluation of both primary and secondary sources, see the Historiography in Appendix B. Direct quotations from and paraphrases of Qazi Ahmad's *Khulasat* (Qazi Ahmad [Ishraqi]) and Afushta'i Natanzi's *Naqavat al-athar* (Afushta'i Natanzi [Ishraqi]) are the work of Massumeh Farhad.

2. Primary sources: Bidlisi [Charmoy], 2:558, 563, 566, 569–71, 582, 584; Bidlisi [Velaminof-Zernof], 2:178–79, 183, 186, 189–90, 200, 202; Dust-Muhammad [Mehdi Bayani], 1–2:192–93, 203; Dust-Muhammad [Thackston], 338, 349–50; Hasan Rumlu [Nava'i], 315, 318, 326–27, 332, 336–39, 361, 362, 375; Hasan Rumlu [Seddon], 111, 133, 155; Iskandar Beg Munshi [Afshar], 1:44, 58, 59–60, 67–75, 98, 110; Iskandar Beg Munshi [Savory], 1:74, 96–98, 100, 111–12, 114–15, 120–22, 163, 182–83; Membré [Morton], 19, 20–22, 24–25, 28–29, 31, 35, 39, 41, 46, 68 (translator's biographical notes); Qazi Ahmad [Ishraqi], 1:155, 200, 212, 216–17, 222, 228, 231, 243–44, 247, 262, 289, 299, 307–8, 321, 327–28, 332, 334, 338, 340–41; Qazi Ahmad [Minorsky], 3, 5, 7 (introduction), 60, 75, 91 n. 278, 147, 183; Qazi Ahmad [Suhayli-Khunsari], 20, 33, 138–39; Sadiqi Beg [Khayyampur], 21–22; Sam Mirza [Dastgirdi], 9–10; Sam Mirza [Humayun-Farrukh], 11–12; and Tahmasp [Nava'i], 122, 177, 182.

Principal secondary sources: Adle, "Autopsia" (with a thorough review of primary and secondary sources); Mehdi Bayani, 1–2:103–4, 188–91, 207–8; *CHI*, 6:235, 237, 886; Dickson & Welch, 1:15A, 35B–36A, 40A, 46A, 51B, 95A, 206A, 244A n. 1, 246B n. 3, 247A n. 9; *EIr*, Priscilla P. Soucek, "Bahram Mirza"; Röhrborn, 41, 43, 44, 46, 100–101; Roxburgh, 1:254–60; Simpson, "Bahram Mirza"; Stchoukine, *MS*, 18 and cat. nos. 34, 40, 194; and A. Welch, *Artists*, 167.

3. Primary sources: Iskandar Beg Munshi [Afshar], 1:44, 50, 62, 65, 68, 98; Iskandar Beg Munshi [Savory], 1:73–74, 84, 102–3, 108, 113, 163; Membré [Morton], 20, 25, 41, 52, 76 (translator's biographical note); Qazi Ahmad [Ishraqi], 1:389–90, 550–57, 2:992; Qazi Ahmad [Minorsky], 2, 19 (introduction), 133 (the notes in this translation include many citations to Sam Mirza's anthology, the *Tuhfa-yi sami* [Gift of Sam; or, Some princely curios]); and Qazi Ahmad [Suhayli-Khunsari], 85.

Secondary sources: Adle, "Autopsia," 246 n. 141; Mehdi Bayani, 1–2:229; *CHI*, 6:236, 238–39, 242, 246, 962, 980; Dickson & Welch, 1:36A–38B, 44A, 54B, 63A, 69B, 80B, 95B, 240B n. 12, 245B n. 2, 258A–B n. 3; Kazi; Stchoukine, *MS*, 18, 50, 161,

170–71, 189 and cat. no. 12; Storey, 1:797–800; S. C. Welch, *KBK*, 55–60; S. C. Welch, *PP*, 20–21, 62–69; and S. C. Welch, *WA*, 119–29.

According to Qazi Ahmad ([Ishraqi], 1:389), Sultan Ibrahim Mirza was Sam Mirza's favorite nephew.

4. There is a considerable body of literature about Tahmasp and his reign. All pertinent primary sources and principal secondary sources up to 1978 are employed and reviewed in Dickson & Welch. See also *CHI*, 6:233–50, 351–62, 768–73, 878–94; Membré [Morton]; and the titles listed under Anthony Welch and Stuart Cary Welch in the Historiography in Appendix B.

5. See note 1 for the full list of primary sources, as well as the Historiography in Appendix B.

6. The prince's date of birth is given in Qazi Ahmad [Ishraqi], 2:635. It should be noted, however, that the same passage, as well as subsequent discussions by Qazi Ahmad, mentions that Ibrahim Mirza was thirty-four years old when he died in 984/1577 (Qazi Ahmad [Ishraqi], 2:635, 640; Qazi Ahmad [Minorsky], 161; Qazi Ahmad [Suhayli-Khunsari], 116). Qazi Ahmad may have erred in the year of birth or in his calculations of the prince's age at death. In any case, this is but the first instance of persistent inconsistencies in Sultan Ibrahim Mirza's biography as presented by Qazi Ahmad and as discussed in Farhad & Simpson (especially p. 287 regarding the prince's life dates). As it happens, Qazi Ahmad's remark in the *Gulistan-i hunar* about Sultan Ibrahim Mirza's age at death has led modern scholars to calculate that the prince was born in 950/1543–44 (e.g., Qazi Ahmad [Minorsky], 3 [translator's introduction]; Titley, *PMP*, 105; A. Welch, *Artists*, 150; Welch & Welch, 94). Dickson & Welch do not seem to give a precise year, but mention (1:47B) that Ibrahim Mirza was seventeen in about 1557 and thirty-five in 1575, both of which would yield 1540 as his year of birth. Similarly, S. C. Welch (*PP*, 23) says that the prince was sixteen in 1556. Mehdi Bayani (1–2:12) gives the date of Dhu'l-hijja 946/April 1540 for Ibrahim Mirza's birth.

Little is known about Ibrahim Mirza's mother, Zaynab Sultan, except that she was the sister of Imaduddin Shirvani and that she died in Jumada I 978/October 1570 at Qazvin, where she had lived at court following her husband's death. Shah Tahmasp then instructed Sultan Quli-beg, nephew of Imaduddin Shirvani, to take Zaynab Sultan's body to Mashhad (Qazi Ahmad [Ishraqi], 1:570). Iskandar Beg Munshi describes Sultan Ibrahim Mirza's mother simply as being from a noble family of Shirvan without any mention of her name (Iskandar Beg Munshi [Afshar], 1:136; Iskandar Beg Munshi [Savory], 1:220).

Ibrahim Mirza had two brothers: the older was Sultan Husayn Mirza, the younger Badi' al-Zaman Mirza. All three were the sons of Bahram Mirza (Bidlisi [Charmoy], 2:584; Bidlisi [Velaminof-Zernof], 2:202; Hasan Rumlu [Nava'i], 636; Hasan Rumlu [Seddon], 155), but it is uncertain if they had the same mother. The three brothers died in the same year, 984/1576–77.

The primary sources variously refer to the prince as Ibrahim Mirza and Sultan Ibrahim Mirza. In addition, Qazi Ahmad frequently uses the honorific Abu'l-Fath Sultan Ibrahim Mirza. It is likely, although not entirely certain, that "Sultan" was part of the name given to him at birth. As mentioned at the outset, Sultan Ibrahim Mirza and Ibrahim Mirza are used interchangeably in this study.

7. Qazi Ahmad [Ishraqi], 2:640. Bahram Mirza served as governor of Hamadan and Khuzistan from either 951/1544 or the end of autumn–beginning of winter 952/1545–46 until his death in 956/1549 (Adle, "Autopsia," 230, 241). In 955/1548–49 various members of his family were captured by Alqas Mirza after that rebellious Safavid prince (and a brother of Bahram Mirza) had joined forces with the Ottomans. For this

episode, which may have involved Ibrahim Mirza, see Hasan Rumlu [Nava'i], 433; Hasan Rumlu [Seddon], 151; Iskandar Beg Munshi [Afshar], 1:69–75; and Iskandar Beg Munshi [Savory], 1:115–24. See also *CHI*, 6:242–453; *EIr*, Cornell Fleischer, "Alqas Mirza"; and Priscilla P. Soucek, "Bahram Mirza."

8. Qazi Ahmad [Ishraqi], 2:640. This passage states—undoubtedly with hyperbole—that the princess "particularly favored him [Sultan Ibrahim Mirza] because of his cunning and intelligence and dignity and strength and eloquence and full compliance and understanding, and without question preferred him to the other princes and her nephews." Shahzada Sultanum was a uterine sister of Tahmasp and Bahram Mirza; her given name was Mahin Banu. She never married and lived in the royal haram. See Szuppe, 216 (especially nn. 22 and 23 for primary sources), 219, 233, 238 table 7, 241, 243–44, 245–46, 247–48, 251; Membré [Morton], 80–81; and A. Welch, *Artists*, 170–71.

As has been frequently discussed, Tahmasp relocated the Safavid capital from Tabriz to Qazvin sometime in the early to mid-950s/mid- to late-1540s. The transfer seems to have taken place over an extended period of time, beginning with initial plans to establish Qazvin as the capital in the spring of 950/1544 through the completion of the new palace gardens in 966–67/1559–60 or 968–69/1561–62. A succinct précis of the entire process, with references to various primary sources, is given in Dickson & Welch, 1:250B n. 10. See also Membré [Morton], xxiv. In these discussions the critical moment is cited as the fall of 962/1555, whereas elsewhere the move to Qazvin is reported as having been effected by 955/1548–49 (*CHI*, 6:243, 249). A manuscript completed in 953/1546 by Shah-Mahmud al-Nishapuri *bi-dar al-sultana* (in the abode of the government) (FGA 35.18) suggests that Tabriz was still regarded as the royal capital at that time. Whatever the precise chronology, the Safavid court remained peripatetic, and its shifts had obvious implications for both the history and art history of this period. See, for instance, Adle, "Autopsia," 240–42; *CHI*, 6:243 n. 1; Echraqi; and Mazzaoui.

9. Qazi Ahmad/Ishraqi, 1:381, 2:640 (direct quotation). Much has been made in the secondary literature about the relations between Tahmasp and Ibrahim Mirza. See, for instance, Dickson & Welch, 1:46A–47B; Gray, *PP* 2, 142; A. Welch, *Artists*, 151; S. C. Welch, *PP*, 24; and Welch & Welch, 87, 96. It is obvious from Qazi Ahmad and other sources that this relationship had its ups and downs, the latter as evidenced by the two occasions when Tahmasp removed the prince from Mashhad. Whether either the historical or visual evidence justifies the psychological interpretations given by modern writers is another matter.

10. Qazi Ahmad [Ishraqi], 2:640. See also Qazi Ahmad [Ishraqi], 1:381: "Ibrahim Mirza enjoyed the shah's supervision and was among his close companions. Despite his youth he spent most of his time following the royal [the shah's] example in acquiring fine qualities and attributes, particularly justice and benevolence toward people."

11. Qazi Ahmad [Ishraqi], 2:640. For Mas'um Beg, see also below, note 43, and Iskandar Beg Munshi [Afshar], 1:161; Iskandar Beg Munshi [Savory], 1:253.

12. Qazi Ahmad [Ishraqi], 2:640.

13. Qazi Ahmad [Ishraqi], 1:376–77 (with considerable detail about the wedding celebration). Isma'il's marriage to Safiya-Sultan Khanim occurred in 962/1554–55. Qazi Ahmad ([Ishraqi], 1:367) reports that in the previous year, 961/1553–54, Ibrahim Mirza participated in a military campaign at Shahrazur in Kurdistan against the Ottoman Rostam Pasha. Here the chronicler may be referring to an incident that actually took place in the fall of 956/1549, when Bahram Mirza led Qizilbash forces into the area of Shahrazur in pursuit of Alqas Mirza, his renegade

brother and a central figure in the Ottoman-Safavid conflicts of the period. See *EIr*, Cornell Fleischer, "Alqas Mirza."

14. Qazi Ahmad [Ishraqi], 2:640. The year comes from an earlier part of the text, specifically the heading on Qazi Ahmad [Ishraqi], 1:375; what happened to Ibrahim Mirza that year is detailed a few pages later (Qazi Ahmad [Ishraqi], 1:380–83).

15. The document is entitled

نقل فرمان حکومت مشهد مقدس معلی
و نظارت آستانه حضرت امام رضا علیه
التحیه و الثنا بنام سلطان ابراهیم میرزا

The account of the farman assigning Sultan Ibrahim Mirza to the governorship of the sacred, sublime Mashhad and the administration [supervision] of the tomb of the lord Imam Reza, benediction and salutation [be upon him].

Khuzani, folios 216a–18b; Qazi Ahmad [Ishraqi], 1:380–83 (with a summary version in 2:640). The phrase "dear beloved son" (*farzand-i a'azz arjumand*) appears in Khuzani, folio 217a, and in a slightly different variant in Qazi Ahmad [Ishraqi], 1:382.

16. A similar statement about the extent of Ibrahim Mirza's authority appears in Qazi Ahmad [Ishraqi], 2:641. Kathryn Babayan analyzes the political significance of Tahmasp's appointment of Ibrahim Mirza to Mashhad in her dissertation. I am grateful to Professor Babayan for sharing her paper on "The Turko-Mongol Ingredients of the Safavi Synthesis," presented at the 1995 annual meeting of Middle East Studies Association, which includes a succinct discussion of the prince's lineage and appointment.

17. It is evident that the conduct of the officials in Khurasan was a matter of grave concern to Tahmasp, and the farman stresses that past governors of Mashhad had failed to obey the shah's orders to put a stop to disgraceful "goings-on" there (Khuzani, folio 216b). Qazi Ahmad [Ishraqi], 1:380) makes a similar point about Tahmasp's displeasure at the "negligence and carelessness of the governors of Mashhad" in carrying out rules and regulations and specifies that "he removed Hasan Sultan Rumlu, the governor [hakim] and began thinking of another candidate." As we have now seen, Ibrahim Mirza was the shah's choice. In his subsequent summary of the prince's life (Qazi Ahmad [Ishraqi], 2:640), the author says that the shah granted his nephew the finances (*dara'i*) and government (*hakumat*) of the holy city of Mashhad. Although the title of the farman refers to the administration or supervision (*nazarat*) of the tomb of Imam Reza, there is nothing either in the text of the farman or in Qazi Ahmad to suggest that Ibrahim Mirza had any direct responsibility for the shrine, as has been stated in various secondary sources (e.g., *EIr*, Priscilla P. Soucek, "Abdallah Sirazi"; A. Welch, *Artists*, 151).

18. Qazi Ahmad [Ishraqi], 1:382 (first quotation), 2:641 (second quotation).

19. Qazi Ahmad [Ishraqi], 1:383; 2:640 (where the retinue is described as "made up of about five hundred princes, high-ranking officials, members of various tribes and qurchis of Tehran"). For the role of the qurchis during the reign of Shah Tahmasp, see *CHI*, 6:246. At this point Qazi Ahmad mentions, almost parenthetically, that Tahmasp appointed his father, Mir-Munshi, to serve as vizier to Ibrahim Mirza (Qazi Ahmad [Ishraqi], 1:383), while Afushta'i Natanzi (p. 47) says that Ahmad Sultan Afshar was made Sultan Ibrahim Mirza's lala at the time of the prince's appointment to Mashhad.

20. Qazi Ahmad [Ishraqi], 1:383–84. Qazi Ahmad begins his statement about Ibrahim Mirza's departure with the curious remark that "the shah

did not grant the prince permission to leave." Elsewhere in his writings Qazi Ahmad contradicts himself on the date of the departure for Mashhad (Farhad & Simpson, 287). In the second volume of the *Khulasat*, for instance, he states that Tahmasp sent Sultan Ibrahim Mirza to Khurasan "in the months of 964" (Qazi Ahmad [Ishraqi], 2:641). He gives the same year of 964/1556–57 in his discussion in the *Gulistan-i hunar* of the scribe Malik al-Daylami who accompanied the prince to Mashhad (Qazi Ahmad [Suhayli-Khunsari], 93–94; Qazi Ahmad [Minorsky], 142).

Yet another date for Sultan Ibrahim Mirza's appointment and departure appears in the *Sharafnama* of Sharafuddin Khan Bidlisi. This chronicle records for the year 963/1555–56 that Tahmasp gave the governorship of Mashhad to Sultan Ibrahim Mirza and made him leave for Khurasan (Bidlisi [Charmoy], 2:592; Bidlisi [Velaminof-Zernof], 2:209). That Sultan Ibrahim Mirza is said to have received one of his cousins in Mashhad during 963 (see note 33) does suggest that he had taken up residence there by that year. Furthermore, two of the colophons of the prince's *Haft awrang* are dated 963, and the scribes specify that they completed their work in Mashhad (folio 46a, written by Malik al-Daylami, and folio 181a, written by Shah-Mahmud al-Nishapuri). In a previous consideration of the date of Sultan Ibrahim Mirza's appointment and departure for Mashhad, I suggested, based on the indication of the year 964 in the *Gulistan-i hunar*, that perhaps the *Haft awrang* was being prepared in Mashhad while Ibrahim Mirza was still in Qazvin (Simpson, "Jami," 99). This scenario now seems less likely, given the evidence available from the *Khulasat* for Ibrahim Mirza's presence in Mashhad in 963.

Modern scholarship has tended to accept the date of 964 (or the equivalent of 1556 or 1556–57) as the year of Sultan Ibrahim Mirza's appointment, on the strength of Qazi Ahmad's reference to Malik al-Daylami's accompanying the prince to Mashhad at that time. See, e.g., Gray, *PP* 2, 142; Stchoukine, *MS*, 18; Titley, *PMP*, 105; A. Welch, *Artists*, 151; and S. C. Welch, *WA*, 196 n. 1; but see Welch & Welch, 96, with the date of 963/1555–56.

21. Qazi Ahmad [Ishraqi], 1:384. The same passage goes on to recount that, upon his arrival, Ibrahim Mirza first went to the royal hammam and changed into fresh clothes. He then proceeded to the shrine and paid his respects. From there he rode to the governor's residence, referred to as the Chahar-bagh, and settled in.

22. Afushta'i Natanzi [Ishraqi], 47. This passage also says that Sultan Ibrahim Mirza left for Mashhad after his new lala, Ahmad Sultan Afshar, had been appointed and that both the prince and his guardian were received by scholars and dignitaries at Mashhad. In addition, it reiterates what Qazi Ahmad says (see previous note) about Ibrahim Mirza's paying his respects to the shrine after his arrival.

23. Afushta'i Natanzi [Ishraqi], 47. Qazi Ahmad ([Ishraqi], 1:415) also emotes that she was "superior to the other princesses in her quest for knowledge and in her piety." Somewhat confusingly, Afushta'i Natanzi calls the bride Gawhar-Shad Begum, which was actually the name of the daughter of Ibrahim Mirza and Gawhar-Sultan Khanim. See also Szuppe, 217–18 (with a long discussion in n. 31 of Gawhar-Sultan's life dates), 236 n. 112, 239 table 8, 241, 244.

24. The *Sharafnama*, for instance, says the marriage occurred in 963/1555–56 at the same time Ibrahim Mirza received the governorship of Mashhad and left for Khurasan, with the two events reported as if they occurred simultaneously or in immediate sequence (Bidlisi [Charmoy], 2:592; Bidlisi [Velaminof-Zernof], 2:209). Afushta'i Natanzi ([Ishraqi], 47) also describes Ibrahim Mirza's marriage and appointment to Mashhad as if they coincided, but without specifying any dates.

25. Qazi Ahmad gives both a summary account ([Ishraqi], 1:390) and a long description of the wedding ([Ishraqi], 1:415–17). His chronology and narrative, however, are not always easy to follow. His initial reference to the marriage occurs under the year 964/1556–57 where he mentions that Tahmasp had already agreed to the marriage and that Sultan Ibrahim Mirza had sent his vizier, Mir-Munshi, to bring the princess from Tabriz to Mashhad. The second, and much more detailed, version of these events appears under the year 967/1559–60. This account starts with a seemingly contradictory reference back to 965/1557–58 when, Qazi Ahmad now says, Mir-Munshi was sent on his mission. It is also somewhat difficult to sort out the exact venues where the marriage negotiations occurred. It is clear, however, that the negotiations involved an exchange of gifts and payment of a bridal price in which Sultan Ibrahim Mirza's aunt, Shahzada Sultanum, participated (Qazi Ahmad [Ishraqi], 1:390, 415). The process culminated in a royal audience at which Gawhar-Sultan Khanim was asked for her hand in marriage (Qazi Ahmad [Ishraqi], 1:390, 416). The exact date of the bride's departure for Mashhad, as well as the various events that followed, is also not entirely certain. Qazi Ahmad specifies a lapse of four years, which is a bit longer than the dates he records would suggest (Qazi Ahmad [Ishraqi], 1:416). In the absence of any other accounts, we can only assume that the arrival of the princess and her party at Mashhad, the decoration of the city, and the wedding festivities—all of which Qazi Ahmad describes under the year 967/1559–60—actually took place at that time.

26. Qazi Ahmad [Ishraqi], 1:416.

27. Qazi Ahmad [Ishraqi], 1:417. One child is recorded from this marriage, a daughter named Gawhar-Shad Begum. Iskandar Beg Munshi reports that, during the reign of Shah Abbas (996–1038/1588–1629), Gawhar-Shad Begum went on the pilgrimage to Mecca, where she married Amir Nasiruddin Husayn Shirazi, a sayyid of the Dashtaki family, and settled in that city (Iskandar Beg Munshi [Afshar], 1:136; Iskandar Beg Munshi [Savory], 1:220). See below for more on Gawhar-Shad Begum following the death of her parents in 984/1577. A synopsis of the Dashtakis of Shiraz appears in Hoffman, 25–26.

28. This possibility already has been suggested in Simpson, "Jami," 100. See also Dickson & Welch, 1:47B; and S. C. Welch, *PP*, 113 (followed by Titley, *PMP*, 106), for the suggestion that the beautiful figure of Yusuf might be a flattering representation of Ibrahim Mirza.

29. Qazi Ahmad [Ishraqi], 1:385. A similar account is given by Afushta'i Natanzi [Ishraqi], 48.

30. Qazi Ahmad [Suhayli-Khunsari], 108. This sentence is not in Qazi Ahmad [Minorsky].

31. Mention is made of the prince's negotiating the release of a number of captured Uzbeks and accepting two hundred mans in return for their freedom. This act of what would seem to be expedient altruism occurred in 965/1557–58. Two years later, in 967/1559–60, Ibrahim Mirza received from Tahmasp one hundred captured soldiers, formerly in the army of the Ottoman prince Bayazid, who had sought refuge in Iran (Qazi Ahmad [Ishraqi], 1:396, 407).

32. Qazi Ahmad [Ishraqi], 1:389–90.

33. Qazi Ahmad [Ishraqi], 1:391–92. Other members of the Safavid family who visited Ibrahim Mirza in Mashhad include his cousin Sultan Muhammad Mirza, the eldest son of Shah Tahmasp and future Safavid ruler, who came from Herat with his guardian, Ali Sultan Takkalu, on 4 Sha'ban 963/13 June 1556 for a stay of about twenty days (Qazi Ahmad [Ishraqi], 1:385), and Ibrahim Mirza's cousin Isma'il, who came sometime in Safar or Rabi' I 964/December 1556 or January 1557 while en route to Herat. Qazi Ahmad ([Ishraqi], 1:387–88) reports here that

Isma'il left Qazvin for Mashhad on 9 Safar 964/12 December 1556, left Mashhad for Herat after praying at the shrine of the Imam Reza, and arrived in Herat on 9 Rabi' 11 964/9 February 1557. Ibrahim Mirza's younger brother, Badi' al-Zaman, stopped at Mashhad for about ten or fifteen days in 965/1557–58 while en route to Sistan, where he had been appointed governor (Qazi Ahmad [Ishraqi], 1:397), and his older brother, Sultan-Husayn Mirza, came for a visit of twenty days in 969/1561–62. Apparently he had planned to stay longer, until news arrived that their aunt, Shahzada Sultanum, had died (Qazi Ahmad [Ishraqi], 1:434).

Other visitors received by Ibrahim Mirza include an officer of the Takkalu tribe named Muhammad Khan Takkalu, then elderly and ailing, whom Ibrahim Mirza entertained with a polo match in 964/1556–57 (Qazi Ahmad [Ishraqi], 1:390); also in 964/1556–57, a group of exiled Kharazmi grandees, among them Yunus Khan and his brothers Phalavan Quli Sultan and Hajim Khan, for whom Ibrahim Mirza arranged a reception in the Chahar-bagh at which various Mashhad guilds (isnafs) displayed their best wares (Qazi Ahmad [Ishraqi], 1:392), and Isa Khan, the son of Lavand Khan Ghurji and an apparent favorite of Shah Tahmasp. The boy came with a letter from the shah, dated 3 Jumada 1 967/31 January 1560, placing him in Ibrahim Mirza's charge (Qazi Ahmad [Ishraqi], 1:410).

34. Mir-Munshi's real name was Sharafuddin Husayn al-Husayni; the title Mir-Munshi was given him by Shah Tahmasp (Qazi Ahmad [Minorsky], 76; Qazi Ahmad [Suhayli-Khunsari], 34). Qazi Ahmad is the principal source for his father's life and career: Qazi Ahmad [Ishraqi], 1:383, 415, 436, 477–78, 2:641; Qazi Ahmad [Minorsky], 60, 76–78; Qazi Ahmad [Suhayli-Khunsari], 20, 33–37. See also the discussions in Qazi Ahmad [Ishraqi], 1:xi–xii, and Qazi Ahmad [Minorsky], 2–4, 7–8, 55 n. 133.

Mir-Munshi already had strong ties with Ibrahim Mirza's family and had been associated both with Sam Mirza, whom he served as munshi, or secretary, in Herat, and with Bahram Mirza, with whom he shared an enthusiasm for calligraphy. Qazi Ahmad ([Minorsky], 3, 60; Qazi Ahmad [Suhayli-Khunsari], 20) recounts that Bahram Mirza lent Mir-Munshi a piece of cloth inscribed by the great thirteenth-century calligrapher Yaqut for use as a calligraphic model.

Qazi Ahmad is inconsistent in both the date of his father's appointment and the length of his tenure in Mashhad (Farhad & Simpson, 288–89). The appointment itself is mentioned twice in the Khulasat: first under the year 962/1554–55 and at the end of the description of the prince's own appointment to Mashhad (Qazi Ahmad [Ishraqi], 1:383: "And he [the shah] appointed the father of the author, Mir-Munshi al-Qumi, as vizier [umur-i vazirat], and senior counselor [rish-sifid; literally, 'white beard'] in the household of the prince of the world and in charge of governmental and financial matters"); and later in the summary narrative about Ibrahim Mirza, where mention of Mir-Munshi follows upon a sentence containing "the months of 964" (Qazi Ahmad [Ishraqi], 2:641: The shah "realized that the prince would need a vizier known for his integrity [?], modesty, diligence, caution, sincerity, intelligence, and expertise. After careful consideration and thought, the choice for that position fell on the father of this one, Mir-Munshi"). In that same passage Qazi Ahmad states that his father stayed in Mashhad for eight years. He records otherwise in the Gulistan-i hunar. The English version of this text first specifies that Mir-Munshi's vizierate lasted for ten years and subsequently that it lasted for seven (Qazi Ahmad [Minorsky], 76, 78), while the Persian says that Mir-Munshi spent seven years with Ibrahim Mirza in Mashhad and three more as vizier there on behalf of Aqa Kamaluddin, the vizier of Khurasan

(Qazi Ahmad [Suhayli-Khunsari], 35). In the Khulasat (Qazi Ahmad [Ishraqi], 1:477–78), Qazi Ahmad reports that by 975/1567–68 he and his father were back in Qazvin, where they formed part of a group of writers and artists appointed by Tahmasp to prepare a letter for the Ottoman ruler, Sultan Selim. Mir-Munshi died in Dhu'l-qa'da 990/December 1582.

35. The year is specified in the Gulistan, at the very end of the section on the calligrapher, Shah-Mahmud al-Nishapuri (Qazi Ahmad [Minorsky], 138; Qazi Ahmad [Suhayli-Khunsari], 89).

36. Thus the effect of Mir-Munshi's tenure in Mashhad was longer lasting and more significant in historiographic terms than any actual accomplishments during his vizierate.

37. Qazi Ahmad [Ishraqi], 1:436. Here again we encounter inconsistencies in Qazi Ahmad's dating. If Mir-Munshi did come to Mashhad in 964, as reported by Qazi Ahmad, and was replaced as vizier in 969, as also specified by Qazi Ahmad, then his vizierate was even shorter than the seven (or eight or ten) years recorded by his son.

38. The events that follow are reported only in Qazi Ahmad [Ishraqi], 1:439–40. The passage begins with the news that in that same year (i.e., 970/1562–63) Mir Abdul-Vahhab Shushtari was appointed guardian of the shrine at Mashhad. There is no way to know if this appointment had anything directly to do with Ibrahim Mirza, although there is the distinct possibility that the two events were not mere coincidence. According to Iskandar Beg Munshi, the brother of Mir Abdul-Vahhab, named Mir Sayyid-Ali, was guardian (mutavalli) of the shrine for a time (Iskandar Beg Munshi [Afshar], 1:149; Iskandar Beg Munshi [Savory], 1:238). For Amir Qayb Sultan (or Beg) Ustajlu, see Dickson & Welch, 1:238B n. 5.

39. Qazi Ahmad [Ishraqi], 1:440. The joke seems to hinge around the fact the fortress of Qahqaha was also a prison where various members of the Safavid family, including the future Shah Isma'il 11, were kept. Isma'il had, in fact, been imprisoned there by his father soon after visiting Ibrahim Mirza in Mashhad in 964/1556–57. For comments on the location of Qahqaha, see Johnson, 126 n. 13; Barthold, Geography, 93; and Storey, 1:798 n. 6.

40. There are two additional mentions of this appointment made by Qazi Ahmad. One appears in the summary account of Ibrahim Mirza's life and career (Qazi Ahmad [Ishraqi], 2:641): "He was in charge of the government [hakumat] of Qa'in and its vicinities for a little over a year." The other appears within an account in one version of the Gulistan-i hunar (Qazi Ahmad [Minorsky], 163; Qazi Ahmad [Suhayli-Khunsari], 113) concerning Ibrahim Mirza's friendship with the musician Mawlana Qasim Qanuni.

41. Qazi Ahmad ([Ishraqi], 2:641) says Ibrahim Mirza spent a little over a year in Qa'in. This period of the prince's life has been variously treated by modern scholars, and sometimes in conjunction with a much longer term in Sabzivar. See, for instance, Dickson & Welch, 1:250B n. 8, 252A n. 8, where Sultan Ibrahim Mirza's time in Qa'in is calculated as December 1564–February 1566 and interpreted as a period of demotion and exile. See also A. Welch, Artists, 151. S. C. Welch, WA, 196 n. 1, says that the prince was in exile in Qa'in from 1564 until 1556—an obvious typographical error. Dickson & Welch (1:250B n. 8) also mention that he spent most of this time in Herat—evidently a reference to the campaign against Qazaq Khan Takkalu, governor of Herat, during 972/1564–65, in which Ibrahim Mirza participated. Welch & Welch (p. 87) say that Tahmasp turned against his nephew in 1565 and exiled him to Qa'in, "a small oasis in Kuhistan." Titley (PMP, 106) gives 1563 for the year of Ibrahim Mirza's removal to Mashhad.

Sultan Ibrahim Mirza evidently was still out of Mashhad in 971/1563–64 when the Uzbek prince Pir Muhammad Khan laid siege to the holy city.

The attack was successfully repelled by the inhabitants of Mashhad, and there is no evidence that Sultan Ibrahim Mirza participated in the city's defense (Bidlisi [Charmoy], 2:605–6; Bidlisi [Velaminof-Zernof], 2:221; Hasan Rumlu [Nava'i], 540–41; Hasan Rumlu [Seddon], 183).

42. Qazi Ahmad [Ishraqi], 1:452 (the position is described here as dara'i), 2:641 (and here as dara'i u hakumat).

43. Although these campaigns are discussed at length in the primary sources, they have been overlooked in the secondary literature. The first expedition was directed against the Uzbek prince Ali Sultan and involved a blockade of the fort of Abivard in northern Khurasan, then held by Abu'l-Muhammad Khan, a nephew of Ali Sultan. The Safavids, including Sultan Ibrahim Mirza, besieged the fort for some time, until Ali Sultan came to his nephew's rescue. Ma'sum Beg then lifted the siege and withdrew to Mashhad. For more complete details, see Bidlisi [Charmoy], 2:607; Bidlisi [Velaminof-Zernof], 2:222 (in addition to Abivard, this account mentions Nisa, west of Merv, as a city that the Safavid forces set out to conquer); Iskandar Beg Munshi [Afshar], 1:105; Iskandar Beg Munshi [Savory], 1:175 (this account of the expedition specifically mentions Ibrahim Mirza's involvement). Qazi Ahmad ([Ishraqi], 1:442) seems to refer to the Abivard expedition under the year 971/1563–64, when he records that Ali Sultan and his nephew Abu'l-Muhammad Khan entered Khurasan and came to the vicinity of Mashhad. Subsequently they were attacked by the Safavids and returned to their own territory. Qazi Ahmad ([Ishraqi], 1:447) also mentions that the Uzbeks marched toward Khurasan in 972/1564–65, whereupon Tahmasp ordered Ma'sum Beg together with a number of other amirs to follow them. They set off on 20 Rabi' 1 972/26 October 1564. Qazi Ahmad ([Ishraqi], 1:453) also records, under the year 973/1565–66, that Shah Tahmasp ordered a number of amirs to accompany Sultan Ibrahim Mirza to Nisa and Bavard. The group left on 26 Rabi' 1 973/21 October 1565, surrounded the fortress of Abivard, and defeated the Uzbeks whose leader, Abu'l-Muhammad Khan, promised never to attack Khurasan during his lifetime. A final and more fleeting reference to Sultan Ibrahim Mirza's participation in the Abivard siege is made in volume 2 of the Khulasat (Qazi Ahmad [Ishraqi], 2:641). Some of what Qazi Ahmad says about this expedition may be conflated or confused with the second military operation in which Sultan Ibrahim Mirza took part.

This next campaign, which was far more extensive and decisive for the Safavid forces, is recorded in much greater detail in the primary sources. See Bidlisi [Charmoy], 2:608–11; Bidlisi [Velaminof-Zernof], 2:222–25; Hasan Rumlu [Nava'i], 543–45; Hasan Rumlu [Seddon], 184–85; Iskandar Beg Munshi [Afshar], 1:119–20; Iskandar Beg Munshi [Savory], 1:189–90; and Qazi Ahmad [Ishraqi], 1:447–49 (with specific dates not mentioned in other sources). It seems that, at the time of the previous expedition, Qazaq Khan Takkalu, the governor of Herat and guardian of Tahmasp's son Muhammad Sultan Mirza, had refused to join the Safavid ranks. This rebellious act angered the shah, who sent a large army, including many amirs, under the command of Ma'sum Beg to Herat to bring Qazaq into line. Judging from the various references, Ibrahim Mirza seems to have played a more active role in this engagement than in the previous one. Hasan Rumlu ([Nava'i], 456; Hasan Rumlu [Seddon], 184), for instance, mentions Ibrahim Mirza at the head, even preceding Ma'sum Beg Safavi, of a long list of those commanded by the shah to go the Herat. Qazi Ahmad ([Ishraqi], 1:448) specifies that Tahmasp appointed Ibrahim Mirza head (sardar) of a Safavid force on 15 Jumada 1 972/19 December 1564 and ordered him to wait in Khawf, some 200 kilometers

west of Herat, to launch an attack on the Uzbeks. (The term *sardar* is used elsewhere with reference to Mas'um Beg, who clearly was directing the overall operation as supreme commander.) It may be, as Qazi Ahmad suggests, that Ibrahim Mirza was put in charge of some part of the forces, but this position is not corroborated by any other primary source. Qazi Ahmad ([Ishraqi], 1:449) also gives the impression that Qazaq Khan was captured by Sultan Ibrahim Mirza and his forces, whereas the other sources make it clear that Ma'sum Beg was responsible.

The Safavid army proceeded first to Ghuriyan, due west of Herat, where Qazaq's forces had besieged the fort of Kouchouiyah. Qazi Ahmad says that Ma'sum Beg, Badi' al-Zaman, and others joined Sultan Ibrahim Mirza and went to Ghuriyan. Both Hasan Rumlu and Sharafuddin Khan Bidlisi mention that the Safavid army was joined by Safi Wali Khalifa Rumlu, governor of Ghuriyan and commander of the fortress at Kouchouiyah, who, according to the *Sharafnama*, had previously sent word about the siege to Mas'um Beg and to the princes Sultan Ibrahim Mirza and Badi' al-Zaman (Bidlisi [Charmoy], 2:609; Bidlisi [Velaminof-Zernof], 2:223). At Ghuriyan the forward forces attacked and routed the Takkalu rebels, who offered no resistance. Qazi Ahmad ([Ishraqi], 1:449) records that the battle broke out on 10 Jumada II 972/13 January 1565, whereas Hasan Rumlu says that Ma'sum Beg marched against Qazaq's men on Monday and that the Safavid scouts attacked the enemy on 10 Rabi' II 972/15 November 1564. Various stages of the battle then ensued, including the arrival of the Persian center, "strengthened by officers such as Ibrahim Mirza and Ma'sum Beg Safavi" (Hasan Rumlu [Nava'i], 544; Hasan Rumlu [Seddon], 185).

According to the *Sharafnama*, Qazaq Takkalu was then suffering from a serious illness and took refuge in the fort of Ikhtiaruddin with prince Sultan Muhammad Mirza. Hasan Rumlu ([Nava'i], 547; Hasan Rumlu [Seddon], 185) specifies that Sultan-Husayn Mirza, the older brother of Sultan Ibrahim Mirza, was also in the fortress. Ma'sum Beg and his entourage of royal princes and amirs were able to enter Herat without encountering any resistance. From there the Safavid commander rode to the fort where Qazaq had holed up, brought out Sultan Muhammad Mirza, and captured the ailing and rebellious Qazaq. Again Hasan Rumlu and Qazi Ahmad differ in the dating of this event. The former records that the capture of Qazaq Khan occurred on 16 Rabi' II 972/21 November 1564 (Hasan Rumlu [Nava'i], 426; Hasan Rumlu [Seddon], 185), whereas Qazi Ahmad ([Ishraqi], 1:449) has 16 Jumada II 972/19 January 1565. The *Sharafnama* reports further that Ma'sum Beg and the amirs spent the winter in Herat (Bidlisi [Charmoy], 2:611; Bidlisi [Velaminov-Zernof], 2:225). Sultan Ibrahim Mirza seems to have been accompanied at this particular point, and perhaps throughout the mission, by his kitabdar Muhibb-Ali, who completed the *Layli u Majnun* section of the prince's *Haft awrang* "in the abode of the government Herat, at the beginning of the month of Shawwal . . . the year 972" (folio 272a). This date, corresponding to early May 1565, means that at least Muhibb-Ali, and perhaps also his royal master, stayed on in Herat into the springtime. See also Dickson & Welch (1:250B n. 8) for this same point.

Following this successful campaign, Tahmasp sent Mirgansh Qumi to Herat to reward the participants (Qazi Ahmad [Ishraqi], 1:451–52) and gave Amir Qayb Sultan Ustajlu the governorship of Herat province (Bidlisi [Charmoy], 2:611; Bidlisi [Velaminof-Zernof], 2:225). Qazi Ahmad says these honors were given in 973/1565–66 and specifies that the shah reappointed Sultan Ibrahim Mirza to Mashhad at the same time (Qazi Ahmad [Ishraqi], 1:451–52, 2:641).

44. Afushta'i Natanzi [Ishraqi], 49–51, but without giving a date. See also Dickson & Welch, 1:47B, 252A n. 8, for another extremely useful synopsis of the following series of events, also based on the *Naqavat al-athar*. The date comes from Qazi Ahmad ([Ishraqi], 1:460), who introduces his reference to Sultan Ibrahim Mirza's removal from Mashhad and the "favor" of Sabzivar within the entry for the year 974/1566–67 by remarking that "Tahmasp was upset with Ibrahim Mirza for having written harsh letters to his companions." Qazi Ahmad ([Ishraqi], 2:642) also refers to the appointment to Sabzivar in his summary account of Ibrahim Mirza's life: "After that, the shah became upset with the prince and removed him from the governorship of Mashhad and appointed him to the governorship of Sabzivar, the abode of the faithful." Dickson & Welch (1:252B n. 8) link Ibrahim Mirza's difficulties at this point to his patronage of Qasim Qanuni.
45. Afushta'i Natanzi [Ishraqi], 49.
46. Afushta'i Natanzi [Ishraqi], 49.
47. Afushta'i Natanzi [Ishraqi], 50. According to this source, the shah's orders also specified that the keeper of Ibrahim Mirza's magazine was to receive 12,000 *man* (approximately 136 kilograms) from the local harvest for bread and cattle fodder.
48. Afushta'i Natanzi [Ishraqi], 50. Qazi Ahmad ([Ishraqi], 2:642) says that the prince spent six years in Sabzivar. There is considerable divergence in the secondary literature about the chronology of events here. S. C. Welch variously gives 1564 (*WA*, 30) and 1565 (*PP*, 24) as the year that Sultan Ibrahim Mirza was removed from Mashhad and dismissed to Sabzivar. Dickson & Welch (1:47B, 130A, 249A n. 5, 252B n. 8) say this demotion occurred in 1567 and that the prince spent eight years in Sabzivar, January 1567–December 1574. Welch & Welch (p. 87) cite the same years (but without the months). S. C. Welch (*WA*, 196 n. 1) gives the years 1566–74. A. Welch (*Artists*, 151) conflates Ibrahim Mirza's time in Sabzivar with his previous appointment to Qa'in and gives 970–73/1563–66 as the period in Qa'in and Sabzivar, where work on the *Haft awrang* manuscript continued.
49. Afushta'i Natanzi [Ishraqi], 50. The author goes on to say that Sultan Ibrahim Mirza bought a house for his father, who was a Sufi, in a district outside Sabzivar called Abdulrahimi or Abdulhumi, for which the prince paid eight Tabrizi tumans.
50. Qazi Ahmad [Ishraqi], 2:642.
51. Qazi Ahmad [Ishraqi], 2:642; Qazi Ahmad [Minorsky], 157 (these verses are not in Qazi Ahmad [Suhayli-Khunsari]). See also Dickson & Welch, 1:252B n. 8; and A. Welch, *Artists*, 151. These translations of Ibrahim Mirza's poems were prepared by Massumeh Farhad. The second and third bayts differ slightly from the translations in Dickson & Welch, Qazi Ahmad [Minorsky], and A. Welch, *Artists*.
52. Qazi Ahmad [Ishraqi], 1:588 (here it is said rather poignantly that Sultan Ibrahim Mirza was allowed to leave Sabzivar "after years of asking to see Tahmasp"). According to Qazi Ahmad's earlier account, Ibrahim Mirza previously had been summoned to Qazvin in 978/1570–71 after his cousin Sultan Muhammad Mirza had been appointed governor of Khurasan (Qazi Ahmad [Ishraqi], 1:567). Again there is a certain ambiguity in the chronology of events. In the second volume of the *Khulasat*, Qazi Ahmad says that, at the time he returned to Qazvin, Sultan Ibrahim Mirza had spent sixteen years away from the shah (Qazi Ahmad [Ishraqi], 2:642). Afushta'i Natanzi ([Ishraqi], 50) remarks only that "Tahmasp forgave Ibrahim Mirza toward the end of his reign and recalled him to the capital." There is also divergence in the secondary sources as to when Sultan Ibrahim Mirza was reinstated at court. Dickson & Welch (1:47B) say that Sultan Ibrahim Mirza was then thirty-five, without citing a specific year; S. C. Welch (*WA*, 30, 196 n. 1) and Welch

& Welch (pp. 87, 96) give 1574 as the year that Shah Tahmasp relented and brought Sultan Ibrahim Mirza back to Qazvin. Rogers (*TKS*, 158), Titley (*PMP*, 106), and A. Welch (*Artists*, 158) place the prince back at court in 1568.
53. Qazi Ahmad [Ishraqi], 2:642.
54. Qazi Ahmad [Ishraqi], 1:589. Here Qazi Ahmad gives the date of the appointment as 26 Dhu'l-qa'da 982/9 March 1575 and says (2:642) that Ibrahim Mirza succeeded the deceased Farukhzad Beg as ishak aqasi bashi. Iskandar Beg confirms the appointment of Ibrahim Mirza to the post of ishak aqasi bashi, and also mentions that the prince was "a most capable and talented young man whose advice the shah frequently sought" (Iskandar Beg Munshi [Afshar], 1:136, Iskandar Beg Munshi [Savory], 1:220). He also says that Ibrahim Mirza was "extremely influential at court" (Iskandar Beg Munshi [Afshar], 1:119; Iskandar Beg Munshi [Savory], 1:198). See also Dickson & Welch (1:47B), where Sultan Ibrahim Mirza is described as at last "a fully trusted administrator in charge of the inner palace in the innermost cirle of the court. Now an exceedingly active and ambitious man of thirty-five, this sympathetic nephew must have spent many happy hours with his uncle." Curiously, A. Welch (*Artists*, 157) says, regarding Ibrahim Mirza following his recall to Qazvin, that "what post he held under Tahmasp is not known."
55. For the events surrounding the death of Shah Tahmasp and the accession of Shah Isma'il II to Qazvin, see, in general, *CHI*, 6:247–48, 250–51. Sultan Ibrahim Mirza's role in the struggle for succession and its aftermath is variously recounted by Bidlisi [Charmoy], 2:637–38; Bidlisi [Velaminof-Zernof], 2:247–48; Hasan Rumlu [Nava'i], 598–615; Hasan Rumlu [Seddon], 202–4; Iskandar Beg Munshi [Afshar], 1:118–19, 192–208; and Iskandar Beg Munshi [Savory], 1:197–98, 283–309. Qazi Ahmad has very little to say about this momentous period in Safavid court life.
56. The bonds between the two cousins may have been strengthened because Sultan Haydar Mirza also had had Ma'sum Beg Safavi for a guardian (Hasan Rumlu [Nava'i], 637; Hasan Rumlu [Seddon], 209). On the evening that Tahmasp died, the supporters of Haydar Mirza, including Safavid, Georgian, and Ustajlu leaders, gathered at the home of Husayn Beg Yusbashi (the centurion) to put into effect their plan to take the royal palace. When the pro-Isma'il forces heard about this move, they marshaled troops around the palace harem. Sultan Ibrahim Mirza was definitely involved at this point, although precisely how has been variously recorded. Hasan Rumlu has it that Ibrahim Mirza tried to dissuade Husayn Beg from fighting (Hasan Rumlu [Nava'i], 609; Hasan Rumlu [Seddon], 203), while Sharafuddin Khan Bidlisi says that he participated in an attack on the anti-Haydar supporters at the Ala-qapu gate (Bidlisi [Charmoy], 2:638; Bidlisi [Velaminof-Zernof], 2:248). Iskandar Beg Munshi says that Ibrahim Mirza was with Husayn Beg and the other Haydar supporters as they prepared to set off for the palace but that, in the midst of the confusion, he slipped away to his own residence nearby (Iskandar Beg Munshi [Afshar], 1:193–94; Iskandar Beg Munshi [Savory], 1:285–87). That move certainly would have been prudent since by the next morning the palace had been taken by Isma'il's Circassian and Turcoman supporters and Haydar Mirza had been killed. At a gathering at the palace later that day to proclaim Isma'il II, Sultan Ibrahim Mirza is said to have declared that he had only joined the Haydar Mirza camp in order to try to prevent Husayn Beg and the others from taking up arms and that he had not participated on their march to the palace (Iskandar Beg Munshi [Afshar], 1:196; Iskandar Beg Munshi [Savory], 1:290). A line in Hasan Rumlu suggests that Ibrahim Mirza actually may have habored secret aspirations for the throne (Hasan Rumlu [Nava'i], 607; Hasan Rumlu [Seddon], 203).

57. Qazi Ahmad [Ishraqi], 1:605, 607. The burial was temporary and in a wine shop (*sharabkhana*).

58. Hasan Rumlu [Nava'i], 621; Hasan Rumlu [Seddon], 205; Iskandar Beg Munshi [Afshar], 1:198, 200, Iskandar Beg Munshi [Savory], 1:293, 295–96. According to Iskandar Beg Munshi, Isma'il II also was greeted by Mirza Salman, the keeper of the royal regalia and supervisor of the royal workshops.

59. Iskandar Beg Munshi [Afshar], 1:200; Iskandar Beg Munshi [Savory], 1:296.

60. The relationship of Sultan Ibrahim Mirza and Isma'il II, the shah, is recounted by Iskandar Beg Munshi, who has it that the prince attended all the shah's private audiences and that the shah regarded his cousin as a brother. Iskandar Beg Munshi [Afshar], 1:200, 206–7; Iskandar Beg Munshi [Savory], 1:296, 306, 308.

61. The appointment as mohrdar is mentioned in Afushta'i Natanzi [Ishraqi], 50 (who also notes that Sultan Ibrahim Mirza retained his post of ishak aqasi bashi); Hasan Rumlu [Nava'i], 630; Hasan Rumlu [Seddon], 207 (although the sequence of events is confusing); Iskandar Beg Munshi [Afshar], 1:206; Iskandar Beg Munshi [Savory], 1:306 (who says that Isma'il II did not consider the office of ishak aqasi bashi suitable for Ibrahim and elevated him instead to mohrdar); and Qazi Ahmad [Ishraqi], 2:642 (also with information about the fiefs). See Minorsky, *Tadhkirat*, 62–63, for the functions of mohrdar.

62. Iskandar Beg Munshi [Afshar], 1:207, Iskandar Beg Munshi [Savory], 1:308.

63. Qazi Ahmad recounts that Mir Makhdum Sharifi, a pro-Sunni cleric favored by Isma'il II, warned the shah that as long as "Ibrahim Mirza was alive, none of the shah's wishes would be realized, and that moreover, the prince had become extremely jocular and jesting. Although his language and conversation were highly sophisticated and eloquent, it was offensively direct, [and] he would openly discuss everything that happened without any consideration. Shah Isma'il was offended by his language, like the contents of this bayt:

کوز عمر کهنه به ریش عمر نو
[آنم] عمر کهنه و اینم عمر نو

Qazi Ahmad [Ishraqi], 2:633–34. Wheeler Thackston has commented that the verse defies translation.

64. According to Hasan Rumlu, the news of Sultan-Husayn Mirza's death came from Qandahar to Qazvin on or soon after 7 Sha'ban 984/20 October 1576 (Hasan Rumlu [Nava'i], 629–30; Hasan Rumlu [Seddon], 206–7). This chronicler also says, somewhat confusingly, that it was at this time that Quch Khalifa was dismissed as keeper of the seal and the office given to Sultan Ibrahim Mirza.

65. Afushta'i Natanzi [Ishraqi], 44–45, 50; Iskandar Beg Munshi [Afshar], 1:207–8; Iskandar Beg Munshi [Savory], 1:309; Qazi Ahmad [Ishraqi], 2:633. Iskandar Beg Munshi says that at first Isma'il was extremely solicitous of his bereaved cousin and offered his condolences and robes of honor. Within a few days, however, the shah began to show his true feelings, and sympathy quickly turned to criticism.

66. Iskandar Beg Munshi [Afshar], 1:208; Iskandar Beg Munshi [Savory], 1:309 (who says that Ibrahim Mirza "momentarily expected his death warrant"); Qazi Ahmad [Ishraqi], 2:634.

67. Qazi Ahmad [Ishraqi], 2:634.

68. The primary sources recount Sultan Ibrahim Mirza's fate in varying detail: Afushta'i Natanzi [Ishraqi], 50; Bidlisi [Charmoy], 2:643; Bidlisi [Velaminof-Zernof], 2:253; Hasan Rumlu [Nava'i], 632–33; Hasan Rumlu [Seddon], 2:208; Iskandar Beg Munshi [Afshar], 1:208–9; Iskandar Beg Munshi [Savory], 1:309–11 (the most extensive account); Qazi Ahmad [Ishraqi], 2:634; Qazi

Ahmad [Minorsky], 162–63; Qazi Ahmad [Suhayli-Khunsari], 117–19.

69. Iskandar Beg Munshi [Savory], 1:309. These forces sealed off all the outer portals, locked the inner doors, and stationed themselves outside the harem where Ibrahim Mirza had taken refuge. Iskandar Beg Munshi [Afshar], 1:208–9; Iskandar Beg Munshi [Savory], 1:309–10. Qazi Ahmad ([Ishraqi], 2:634) says that after Sultan Ibrahim Mirza withdrew to his house, Shah Isma'il sent Aslamas Aqa Shamlu and a number of others to guard him, and further that it was the Shamlus who killed him a few days later.

70. Qazi Ahmad [Ishraqi], 2:634. Ibrahim Mirza's murder has also been recorded as occurring on 6 Dhu'l-hijja 984/24 February 1577, which might be even more correct if it took place after midnight, as suggested by Qazi Ahmad's emphasis on the end of the day. Hasan Rumlu [Nava'i], 632–33; Hasan Rumlu [Seddon], 2:207–8; Iskandar Beg Munshi [Afshar], 1:209; Iskandar Beg Munshi [Savory], 1:310.

As mentioned, there are also conflicting reports in both primary and secondary sources as to Sultan Ibrahim Mirza's age at death. The confusion has been pointed out by Minorsky (Qazi Ahmad [Minorsky], 11 n. 35). Qazi Ahmad says he was thirty-four (Qazi Ahmad [Ishraqi], 2:635, 640; Qazi Ahmad [Suhayli-Khunsari], 116; Qazi Ahmad [Minorsky], 161). S. C. Welch (*PP*, 24) says the prince was thirty-eight, which would be correct if the prince was born in Dhu'l-qa'da 946/April 1540.

Five other royal princes were murdered on the same day by order of Isma'il II, including Ibrahim Mirza's younger brother Badi' al-Zaman (Bidlisi [Charmoy], 2:643; Bidlisi [Velaminof-Zernof], 2:253; Hasan Rumlu [Nava'i], 632–33; Hasan Rumlu [Seddon], 2:208; Iskandar Beg Munshi [Afshar], 1:209; Iskandar Beg Munshi [Savory], 1:311).

71. Iskandar Beg Munshi [Afshar], 1:209; Iskandar Beg Munshi [Savory], 1:311 (who says—mistakenly—that Gawhar-Sultan Khanim died in the same month as Ibrahim Mirza from exhaustion brought on by the effort of destroying her husband's belongings); Qazi Ahmad [Ishraqi], 2:645.

72. Qazi Ahmad [Ishraqi], 2:643 (this passage says Sultan Ibrahim Mirza was buried within the sacred precinct, *darun haram muhtaram*); Qazi Ahmad [Minorsky], 162 (this translation is more ambivalent: "the prince was buried in [under?] the gate of the sanctuary"); Qazi Ahmad [Suhayli-Khunsari], 118 (here it is said that he was buried in the precinct of the sacred shrine, *dar haram rausat muhtaram*).

73. Qazi Ahmad [Minorsky], 162–63; Qazi Ahmad [Suhayli-Khunsari], 118–19.

74. The summary characterization of Ibrahim Mirza that follows is drawn primary from Qazi Ahmad's *Gulistan-i hunar*, whose adulatory passages are well known, primarily through the Minorsky translation, and frequently quoted in the scholarly literature (Qazi Ahmad [Minorsky], 155–63; Qazi Ahmad [Suhayli-Khunsari], 106–16). The same author's *Khulasat* is also relevant (Qazi Ahmad [Ishraqi], 1:384–85, 389–90; 2:633, 635–37, 640, 642), as are the *Naqavat al-athar* (Afushta'i Natanzi [Ishraqi], 48, 50), the *Sharafnama* (Bidlisi [Charmoy], 2:643; Bidlisi [Velaminof-Zernof], 2:253), the *Majma' al-khavass* (Concourse of the elite) (Sadiqi Beg [Khayyampur], 25–26 [translated in A. Welch, *Artists*, 158]), and the *Ta'rikh-i alam-ara-yi Abbasi* (History of Shah Abbas) (Iskandar Beg Munshi [Afshar], 1:136, 209; Iskandar Beg Munshi [Savory], 1:220, 311). Most of what these texts have to say about Ibrahim Mirza's character and talents is cast in the tadhkira mode and thus typically tends to overstatement.

75. Sadiqi Beg [Khayyampur], 25–26 (translated in A. Welch, *Artists*, 158).

76. See, for instance, the discussion of the varied talents of the Timurid prince Baysunghur in Lentz, "Baysunghur," 3–27. In general for the Timurids, see Lentz & Lowry, 80–81, 109, 112–14, 122.

77. The Ottoman historian Mustafa Ali Efendi refers to both Sultan Ibrahim Mirza and his uncle Shah Tahmasp as having "the rare recognition previously reserved for such princely percursors in the arts as Sultan Uvays Bahadur, epigon of the glorious Jalayrid dynasty, and Mirza Baysunghur, worthy scion of the line of Timur. The refinement of technique and the peerless accomplishments displayed by these Safavi princes in the realm of art have become universally recognized as truly unique" (Dickson & Welch, 1:45A). The mutual interest and abilities in the arts shared by Tahmasp and Ibrahim Miza are mentioned in virtually all the secondary sources and elaborated upon particularly by S. C. Welch. See, for instance, Dickson & Welch, 1:46A–B; and S. C. Welch, *KBK*, 72.

78. Ibrahim Mirza's teachers in this area were Shaykh Fakhruddin Tayyi and the shaykh's father, Shaykh Hasan Ali (Qazi Ahmad [Minorsky], 156; Qazi Ahmad [Suhayli-Khunsari], 108).

79. Qazi Ahmad [Ishraqi], 2:636; Qazi Ahmad [Minorsky], 156; Qazi Ahmad [Suhayli-Khunsari], 108. The paraphrases and direct quotations from the *Gulistan-i hunar* in this section come from a new translation by Massumeh Farhad, based on the Suhayli-Khunsari edition and differing slightly from the published Minorsky translation. Attention is drawn to significant divergences between these versions, as appropriate.

80. For Ibrahim Mirza's musical abilities, see Afushta'i Natanzi [Ishraqi], 48; Iskandar Beg Munshi [Afshar], 1:209; Iskandar Beg Munshi [Savory], 1:311; Qazi Ahmad [Ishraqi], 2:636; Qazi Ahmad [Minorsky], 156–57, 160; Qazi Ahmad [Suhayli-Khunsari], 109, 115; Sadiqi Beg [Khayyampur], 25 (translated in A. Welch, *Artists*, 158). The *Gulistan-i hunar* passages contain some textual variations. Qazi Ahmad ([Minorsky], 157) relates that the prince "improvised sweet popular songs [*varsaq*]." For this same phrase, Qazi Ahmad ([Suhayli-Khunsari], 110) has that he "composed two *Saqinamas*," which may make better sense since the reference appears within a passage discussing Ibrahim Mirza's abilities as a poet. In addition Qazi Ahmad ([Minorsky], 157) states that "melodies and songs [*naqsh-ha va saut-ha*] of that sun-visaged prince are on the tongues of all contemporaries and known throughout the inhabited quarter of the world." Qazi Ahmad ([Suhayli-Khunsari], 109) gives the same phrase as *naqshha va suratha*, or "designs and portraits." The Minorsky version seems a better continuation of the discussion of Ibrahim Mirza's musical talents.

81. Iskandar Beg Munshi [Afshar], 1:209; Iskandar Beg Munshi [Savory], 1:311 (quotation); Qazi Ahmad [Suhayli-Khunsari], 112. Qazi Ahmad [Minorsky] does not refer to Qasim Qanuni as the prince's teacher. Afushta'i Natanzi ([Ishraqi], 40) reports in general that the prince had musicians and composers at his gatherings while governor.

82. Qazi Ahmad [Minorsky], 159; Qazi Ahmad [Suhayli-Khunsari], 114. Qazi Ahmad here compares Sultan Ibrahim Mirza to Khaqani, Rumi, and Khusraw Dihlavi.

83. See above for Sam Mirza's visit to Mashhad in 964/1556–57, and the Historiography section in Appendix B for more on his *Tuhfa-yi Sami*. See also the article on this text by Kazi.

84. Qazi Ahmad [Minorsky], 159; Qazi Ahmad [Suhayli-Khunsari], 114.

85. Qazi Ahmad [Ishraqi], 2:636; Qazi Ahmad [Minorsky], 157; Qazi Ahmad [Suhayli-Khunsari], 110. In the Minorsky translation *Jahi* is explicated as "glorious," and Qazi Ahmad is made to say that Sultan Ibrahim Mirza adopted this particular name "in view of his kingly position [*shahi*]." Both the *Khulasat* text and the Suhayli-Khunsari text of the *Gulistan* suggest that Sultan Ibrahim Mirza took such a pen-name because it

accorded or rhymed with *shahi*. Ibrahim Mirza also seems to have written prose, and the *Khulasat* says that "his commentary and creative writing were also developed to a very high degree" (Qazi Ahmad [Ishraqi], 2:636). The *Gulistan* says that "he had no equal or superior [*adil va nazir nadasht*], and was unrivaled in his skill [*fan*] and taste [*saliqa*] in composition" (Qazi Ahmad [Suhayli-Khunsari], 111). The Minorsky translation has the prince as without peer "in the composition of riddles and in tasteful epistolary style" (Qazi Ahmad [Minorsky], 158).

86. Qazi Ahmad [Minorsky], 75 (for Bahram Mirza); Qazi Ahmad [Suhayli-Khunsari], 33–34 (for Bahram Mirza); Sadiqi-Beg [Khayyanpur], 21–22 (for Bahram Mirza [translated in A. Welch, *Artists*, 165]); Sam Mirza [Dastgirdy], 6 (for Ismaʿil I), 9–10 (for Bahram Mirza); Sam Mirza [Humayun-Farrukh], 8 (for Ismaʿil I), 9 (for Tahmasp), 11–12 (for Bahram Mirza).

See also Adle, "Autopsia," 233 (for Bahram Mirza); Mehdi Bayani, 1–2:103–4, 188–91, 207–8 (for Bahram Mirza); Kazi (for Sam Mirza, also pp. 26–27 for some of Bahram Mirza's verses); Thackston, "*Diwan*" (for the *Divan* of Shah Ismaʿil, as well as important remarks about Turco-Persian poetry in the Timurid and Safavid periods).

87. Qazi Ahmad [Minorsky], 157; Qazi Ahmad [Suhayli-Khunsari], 110.

88. Qazi Ahmad [Ishraqi], 2:634, 638–40, 642; Qazi Ahmad [Minorsky], 157–58, 160; Qazi Ahmad [Suhayli-Khunsari], 110, 116. The Suhayli-Khunsari edition and Minorsky translation of the *Gulistan* do not contain the exact same selection of verses by Ibrahim Mirza.

89. Qazi Ahmad [Suhayli-Khunsari], 110. These lines are not in Qazi Ahmad [Minorsky]. The references in the second bayt are to the Delhi poets Amir Khusraw (d. 725/1325) and Hasan Sagzi (also known as Ala-i Sanjari, d. 729/1328). In the last line Sultan Ibrahim Mirza compares himself to Abdul-Rahman Jami, with an obvious double entendre on the word *jam* (goblet). The translations and identifications are by Wheeler Thackston. The angel Surush was a legendary adviser to various Iranian kings and makes frequent appearances in the *Shahnama*.

90. Qazi Ahmad [Ishraqi], 2:637. This is the only reference in a primary source to Gawhar-Shad Begum as responsible for the compilation of the *Divan*, an attribution that is confirmed by the wording in the preface. Szuppe (p. 244) erroneously reads the same reference as crediting Gawhar-Sultan Khanim with the compilation.

Qazi Ahmad cites a varying number of verses as actually composed by Ibrahim Mirza and/or extant in his *Divan*. The *Khulasat* states that "his poetry and prose are such that up to two to three thousand of his Turkish and Persian bayts are recited by people" (Qazi Ahmad [Ishraqi], 2:636). The Persian edition of the *Gulistan-i hunar* says that the prince's *Divan* contains "about three thousand separate bayts with an introduction" (Qazi Ahmad [Suhayli-Khunsari], 110), while the English translation mentions "five thousand verses of every kind" (Qazi Ahmad [Minorsky], 157). This version also contains a note (p. 157 n. 550) with a gloss from version H of the *Gulistan*: Qazi Ahmad collected some three thousand of the prince's bayts and wrote a preface.

91. The Tehran manuscript has been published in Atabay, *Muraqqaʿat*, 337–40; that in Geneva in Welch & Welch, cat. no. 30. The discussion of the poetic contents of Sultan Ibrahim Mirza's *Divan* is based exclusively on SAK MS 33.

92. SAK MS 33, folios 1b–3a, translation by Wheeler Thackston. Gawhar-Shad Begum does not actually refer to herself by name, but the wording of the preface seems to confirm Qazi Ahmad's report (see note 90, above) that the prince's daughter was responsible for compiling his *Divan*.

93. SAK MS 33, folios 3b–16b (qasidas), 16b–68a (ghazals), 68a–85a (turkiyats). The *Divan* thus confirms what Qazi Ahmad says (see note 85, above) about Sultan Ibrahim Mirza writing in both Persian and Turkish. For the use of Turcoman Turkish and Persian as poetic languages in the Safavid period, see Thackston, "*Diwan*," 37, 39–41.

94. Qazi Ahmad [Minorsky], 183; Qazi Ahmad [Suhayli-Khunsari], 143.

95. Qazi Ahmad [Minorsky], 160; Qazi Ahmad [Suhayli-Khunsari], 115.

96. Qazi Ahmad [Minorsky], 159 (with a slightly different reading: "By his sketches [in black] and his paintings he called to mind the image of Mani and the master Bihzad Haravi"); Qazi Ahmad [Suhayli-Khunsari], 115.

97. Qazi Ahmad [Minorsky], 155 (again the Minorsky translation differs slightly, characterizing Ibrahim Mirza as "one of the recognized calligraphers of Iran"); Qazi Ahmad [Suhayli-Khunsari], 106.

98. Qadi Ahmad [Minorsky], 155; Qazi Ahmad [Suhayli-Khunsari], 106.

99. Qazi Ahmad [Minorsky], 155; Qazi Ahmad [Suhayli-Khunsari], 106.

100. Qazi Ahmad [Minorsky], 155; Qazi Ahmad [Suhayli-Khunsari], 106. Presumably Qazi Ahmad is referring here to Mir-Ali Haravi (as opposed to Mir-Ali Tabrizi), whom he calls Mawlana Mir-Ali in his extended discussion in the *Gulistan* (Qazi Ahmad [Minorsky], 126–31; Qazi Ahmad [Suhayli-Khunsari], 78–84; see also Simpson, "Bahram Mirza," 382–83).

Bayani apparently had two samples of Ibrahim Mirza's calligraphy written in the style of Mir-Ali Haravi, one in white nastaʿliq, and the other in saffron (yellow?). The signatures read

فقير ابراهيم بن بهرام غفر ذنوبه

the poor Ibrahim ibn Bahram may his sins be forgiven

فقير ابراهيم

the poor Ibrahim

respectively (Mehdi Bayani, 1–2:13).

101. Qazi Ahmad [Minorsky], 155; Qazi Ahmad [Suhayli-Khunsari], 106–7.

102. Works by Ismaʿil I: IUL F. 1422, folios 46a–47b (see Dickson & Welch, 1:206A).

Works by Tahmasp: TKS H. 2154, folio 1b (see Adle, "Autopsia," 227–30, and pl. 7; Roxburgh, 2:805; Simpson, "Bahram Mirza," 378 n. 13; and S. C. Welch, *KBK*, 61–62 and fig. 14); IUL F. 1422, folio 64b (see Dickson & Welch, 1:206A); SOTH 10.IV.89, lot 128 and pl. 33: a double-page calligraphic exercise (described as an illuminated frontispiece), signed and dated by Shah Tahmasp: *katabahu banda shah vilayat Tahmasp fi sanat-i 970* (written by the slave to the king of sainthood [Ali Tahmasp] in the year 1562–63). In general, see Qazi Ahmad [Minorsky], 181–83; and Qazi Ahmad [Suhayli-Khunsari], 138–39. See also Dickson & Welch, 1:45A–B, 206A.

Works by Bahram Mirza: TKS H. 2154, folios 17^bis A, 85a, 134b (see Roxburgh, 2:818, 907–8, 976–77; Simpson, "Bahram Mirza," 376–78 nn. 10–11 with additional references); IUL F. 1422, folio 64b (see Dickson & Welch, 1:206A). In general, see Qazi Ahmad [Minorsky], 183; Qazi Ahmad [Suhayli-Khunsari], 138–39; and Sam Mirza [Dastgirdi], 9. See also Adle, "Autopsia," 234; and Simpson, "Bahram Mirza," 376–78.

Works by Shahzada Sultanum: TKS H. 2154, folios 7b–8a (see Adle, "Dust-Mohammad," 228; Dickson & Welch, 1:247B n.15; Qazi Ahmad [Minorsky], 147 n. 508; Roxburgh, 2: 816; Simpson, "Bahram Mirza," 378 n. 13; Soudavar, 172–73).

Works by Sam Mirza: IUL F. 1422, folio 64b (see Dickson & Welch, 1:206A).

103. Qazi Ahmad [Minorsky], 184; Qazi Ahmad [Suhayli-Khunsari], 144.

104. Qazi Ahmad [Minorsky], 184; Qazi Ahmad [Suhayli-Khunsari], 144. Iskandar Beg Munshi also recounts how Gawhar-Sultan Khanim destroyed many of her husband's belongings after his death "so that they should not fall into the hands of the shah" (Iskandar Beg Munshi [Afshar], 1:209; Iskandar Beg Munshi [Savory], 1:311 [overstating the specific kinds of works that were destroyed]).

105. The collecting of art by Sultan Ibrahim Mirza and other Safavids is distinguished here from their patronage and direct commissioning of works of art. The royal and princely "collections" of the Safavid era generally took the form of albums containing works by noted calligraphers and painters; many of these Safavid albums survive today in whole or in part, primarily in the libraries of Istanbul. See, for instance, Adle, "Autopsia"; Rogers, *TKS*, 13–14; Roxburgh; and Simpson, "Bahram Mirza," 376–78.

Bahram Mirza also is known to have owned two important fourteenth-century manuscripts: a Koran dated 739/1338–39, previously belonging to the Mamluk Sultan Qaytbay (1468–96), which Bahram Mirza bequeathed to the Ardabil shrine in 946/1539 (Tehran, Iran Bastan Museum 2061; James, *Mamluks*, 138, 227 [cat. no. 20] and fig. 98); and the *Divan* of Khwaja Kirman made in Baghdad for Sultan Ahmad Jalayir (1382–1410) and dated Jumada I 798/February–March 1396 (BL Add. 18,113; Fitzherbert, 150 n. 40; Rieu, 2:622). See also Roxburgh, 1:258–60.

106. Iskandar Beg Munshi [Afshar], 1:209; Iskandar Beg Munshi [Savory], 1:311. The Persian text actually involves a flowery and formulaic allusion to the prince's china room (*chinikhana*) being the envy of China and Cathay's picture room and thus may not really refer to a collection per se. There were several important groups of Chinese ceramics amassed in Iran and Turkey during the sixteenth century; see Krahl; Misugi; Pope, *Ardabil*; Pope, *Topkapu*.

107. Qazi Ahmad [Ishraqi], 1:413. The objects sound as if they might have been of Sasanian origin, particularly the reference to some in animal form (suggesting rhytons). The silver and gold objects, including small sculptures of humans and animals, that constitute the celebrated Oxus Treasure also are said to have been brought to light by flood and river wash. See Dalton, xiii, 1–41 (catalogue of objects).

108. Qazi Ahmad [Minorsky], 155; Qazi Ahmad [Suhayli-Khunsari], 107. The Minorsky translation says that, in addition to several of Mir-Ali's albums, the prince owned "some samples, manuscripts and books" by the master. The Suhayli-Khunsari edition enumerates these holdings as "[manuscript] copies and specimens [*nuskhiha va qaʿtaha*]."

109. Qazi Ahmad [Minorsky], 183; Qazi Ahmad [Suhayli-Khunsari], 143.

110. Adle, "Autopsia"; Simpson, "Bahram Mirza," 376–78.

111. Qazi Ahmad [Minorsky], 155, 158 (this passage describes the library as containing "some three thousand volumes and treatises"); Qazi Ahmad [Suhayli-Khunsari], 107 (this passage omits the adjective "well-ordered"), 111. The kitabkhana probably also housed the "other treasures" that Qazi Ahmad reports Gawhar-Sultan Khanim as having destroyed along with the album after her husband's death (Qazi Ahmad [Minorsky], 184; Qazi Ahmad [Suhayli-Khunsari], 144).

That Sultan Ibrahim Mirza placed a high value on manuscripts is confirmed by remarks he supposedly made when his cousin, Shah Ismaʿil II, was preparing to send fifty illustrated manuscripts to the Ottoman court (Soudavar, 250).

112. Afushtaʿi Natanzi [Ishraqi], 48; Iskandar Beg Munshi [Afshar], 1:209, Iskandar Beg Munshi [Savory], 1:311; Qazi Ahmad [Ishraqi], 1:385; Qazi Ahmad [Minorsky], 158–59 (the translation

lacks one passage in Qazi Ahmad [Suhayli-Khunsari], 109); Qazi Ahmad [Suhayli-Khunsari], 109–12. Adle ("Autopsia," 228) refers to such an artistic coterie as amala-yi tarab va khalvat. Qazi Ahmad says that Sultan Ibrahim Mirza himself trained artists—probably an overstatement—and gave them the title "Ibrahimi" (Qazi Ahmad [Minorsky], 160; Qazi Ahmad [Suhayli-Khunsari], 109 [this passage is not in Qazi Ahmad {Minorsky}], 115). This patron-artist relationship is borne out by a qit'a (poetic specimen) signed "the lowly Muhibb-Ali Ibrahimi" (TKS B. 407, folio 40a).

113. Iskandar Beg Munshi [Afshar], 1:181–82; Iskandar Beg Munshi [Savory], 1:276; Qazi Ahmad [Minorsky], 158; Qazi Ahmad [Suhayli-Khunsari], 110. Characterized by Qazi Ahmad as "a second Khaqani," this poet composed odes that, according to Iskandar Beg, were in such abstruse language that virtually no one could understand them.

114. Qazi Ahmad [Minorsky], 158 (this does not give the phrase bi-khadmat-i navab [in service to the prince] found in the Persian text); Qazi Ahmad [Suhayli-Khunsari], 111. Those listed are Mawlana Lufti Jarfardghani (the Minorsky translation gives Isfahani or Turbadhangani), Mawlana Milli (Minorsky has Mayli Haravi), Mawlana Sharaf Hakak, Mawlana Harfi, Mawlana Kamal Shushtari, Mawlana Shu'uri Nishapuri, and Khwaja Ahmad Mirak Sufi Mashhadi. One of these poets may be responsible for a qit'a dedicated to Sultan Ibrahim Mirza (SPL Dorn 148, folio 36b).

115. Qazi Ahmad [Minorsky], 158–59, 163–64; Qazi Ahmad [Suhayli-Khunsari], 112–14. The poets wrote Ibrahim Mirza to ask if Qasim Qanuni could accompany them so that they could listen to his music. The prince replied with a pun on the names of Qanuni and each of the seven poets. Qazi Ahmad cites this response as an example of the prince's creativity as a writer (Qazi Ahmad [Minorsky], 159; Qazi Ahmad [Suhayli-Khunsari], 112).

116. Qazi Ahmad [Minorsky], 163; Qazi Ahmad [Suhayli-Khunsari], 113. All these arrangements apparently had to be carried out in secret for fear of incurring the wrath of Shah Tahmasp, who by that point had turned against the visual and performing arts.

117. Qazi Ahmad [Minorsky], 163; Qazi Ahmad [Suhayli-Khunsari], 113. As noted above, this simultaneous reference to the prince's governorships in Qa'in and Sabzivar has caused problems in previous reconstructions of the prince's biography.

118. Qazi Ahmad [Minorsky], 163–64; Qazi Ahmad [Suhayli-Khunsari], 114. These two versions of the Gulistan offer different readings of the individuals involved in this scandal. Dickson & Welch (1:252a n. 8) date the scandal that incurred Tahmasp's wrath and caused him to order death for all musicians to circa 1570 and locate the underground refuge where Qasim hid in Ibrahim Mirza's palace in Sabzivar. In addition, they connect Ibrahim Mirza's patronage of Qasim Qanuni with the prince's removal from Mashhad and "banishment" to Sabzivar.

119. Iskandar Beg Munshi [Afshar], 1:191; Iskandar Beg Munshi [Savory], 1:281.

120. Qazi Ahmad [Minorsky], 163, 166–67; Qazi Ahmad [Suhayli-Khunsari], 112, 120–21.

121. Qazi Ahmad [Minorsky], 167 n. 590; Qazi Ahmad [Suhayli-Khunsari], 121. It is not clear if Khalilullah stayed on in Mashhad after Ibrahim Mirza left for Sabzivar and ultimately Qazvin.

122. See the oeuvre of Sultan-Muhammad Khandan in Appendix E for the complete text and translation of the Naqsh-i badi' colophon. See Appendix A.III for a summary description of the manuscript, including bibliography. The manuscript does not figure in any of the principal publications on Safavid painting or patronage (e.g., Stchoukine, MS; Dickson & Welch; A. Welch, Artists; S. C. Welch, PP; S. C. Welch, WA).

123. Qazi Ahmad [Ishraqi], 1:349; Qazi Ahmad [Minorsky], 185 n. 656. Here Qazi Ahmad recounts how Tahmasp ordered Muhammad Ghazali to compose a poem for a high-ranking official named Khwaja Amir Beg Kajji who had been arrested in Sabzivar for unspecified reasons. See also Dickson & Welch, 1:178a, 253b n. 3 (citing various primary sources, including the Khulasat but seemingly misinterpreting Qazi Ahmad's remarks), 254b n. 15; Ethé, 429; Rieu, 2:661b–63a; Rypka, 723; and Storey, 803–5.

124. After the general's death in 974/1566–67, Muhammad Ghazali entered the service of the emperor Akbar, who gave him the title malik al-shu'ara, or "king of poets." He died some six years later, in 980/1572–73, and was buried in Ahmadabad.

125. See Appendix D, Mudarris-Gilani, 683–84, for examples of this illustration in the Haft awrang. The most celebrated—and imaginative—representation of Yusuf's flight from Zulaykha is by Bihzad in the Bustan of Sa'di dated Rajab 893/June 1488 (GEBO Adab Farsi 908, folio 52b; color repro.: Lentz & Lowry, 294).

126. NM (SOTH 1.XII.69, lot 192 and repro.: Soudavar, 229 and color fig. 35). The description that follows is adapted from the entry in SOTH 1.XII.69, lot 192, which also gives the number of folios (seventy-six) and dimensions (31.5×20.5 cm, presumably for the full sheet; 19.5×10.5 cm, presumably for the written surface). Robinson, "Kevorkian" cat. no. LXX (74) attributes the manuscript to circa 1540.

127. SOTH 1.XII.69, lot 192, also states that the manuscript has rubrics written in colors (presumably meaning colored ink), colored and gold rulings, and "a few pages with backgrounds of flowers in gold." The sequence of the catalogue description suggests that these background floral designs adorn the written surface.

128. Sa'di [Farughi], 73. The passage reads: "A dervish was the guest of a king. When they sat down to eat he [the dervish] ate less than he desired, and when they got up to pray [he] prayed more than he was accustomed to." Identification and translation by Marjan Adib.

129. Qazi Ahmad gives a vivid portrait of this artist, who came from a family of Husayni sayyids in Mashhad and was the nephew of the great calligrapher Sultan-Ali Mashhadi. In addition to calligraphy, Abdul-Vahhab was skilled in gold sprinkling and the decoration of margins and rulings. Qazi Ahmad [Minorsky], 138; Qazi Ahmad [Suhayli-Khunsari], 90. See also Mehdi Bayani, 1–2:421–22.

130. S. C. Welch, PP, color pl. 15. See also S. C. Welch, WA, cat. no. 41. Welch attributes the painting to Sultan-Muhammad.

131. S. C. Welch, PP, color pls. 24, 26. See also S. C. Welch, WA, cat. nos. 54, 56.

132. This is not to say that the Gulistan illustration has nothing to do with Ibrahim Mirza's Haft awrang, and features such as its rocky craigs and bushy tree, two males standing on the diagonal, and even the canopy and knotted clouds appear in the Freer Jami. It seems unlikely, however, that the Gulistan artist participated in the Haft awrang project. Furthermore, the Gulistan composition has little in common with those in Ibrahim Mirza's Naqsh-i badi'.

Abdullah al-Shirazi has been suggested as a possible candidate for the authorship of the Gulistan scene (Soudavar, 229), although this painting does not accord very well with his recognized oeuvre.

133. The manuscript's colophon is signed by Sultan-Muhammad Khandan, who may not, however, be the scribe of Sultan Ibrahim Mirza's Naqsh-i badi' but an older, and more celebrated, calligrapher by the same name. The volume contains 138 folios; the average sheet dimensions are 21.7×14.5 cm; the average written surface dimensions are 10.1×6 cm. Adey; Gray, OIA, cat. no. 126; Stchoukine, MS, 126–27, no. 169.

The Gulbenkian catalogue entry for this manuscript (Gray, OIA, cat. no. 126) contains various errors, including a misreading of the scribe's name, a mistaken folio number for Abdullah's illustration, and inaccurate dimensions. There is also an apparent attribution, given without explanation, of the manuscript to the library of Sam Mirza and a confusing reference to a comparative illustration, which relates to folio 1b and not to the Abdullah illustration on folio 101a.

The patronage of the Subhat is discussed by A. Welch (Artists, 155), who posits that this manuscript and an undated Divan of Shahi were "presumably produced for Ibrahim Mirza in Mashhad while the Freer manuscript was still in progress." A. Welch also gives two different dates for the manuscript: 1564 (Artists, 155) and 1565 (Artists, 156 n. 157).

134. The confusion between these the two scribes named Sultan-Muhammad Khandan is discussed in a subsequent section of this chapter.

135. The single text illustration is discussed further in the section devoted to Abdullah. The left side of the double-frontispiece, depicting a prince, or perhaps princes, visiting a hermit is closely related to FGA 46.12, folio 153b, as already pointed out in Chapter Two.

136. References for the manuscript are given in Appendix C.

137. The attribution appears in Stchoukine, "Shaykh," 5–11. The primary sources differ in where Shaykh-Muhammad worked for Ibrahim Mirza: Iskandar Beg Munshi says that the artist entered the prince's service in Sabzivar, while Qazi Ahmad specifies Mashhad. See Simpson, "Shaykh Muhammad," 100. The artist's biography is discussed in full in a subsequent section of this chapter, along with all the pertinent references.

In a paper presented at the Institute of Fine Arts, New York University, in February 1993, Zeren Tanindi attributed the illuminations in TKS H. 1483 to Abdullah al-Shirazi on the basis of their similarities to the illuminations in the Freer Jami.

138. TKS H. 1483 shares three specific scenes with the Freer Jami; these are as discussed in Chapter Two in the entries for Freer Jami folios 162a, 231a, and 298a.

139. The connection of this Jami manuscript to Sultan Ibrahim Mirza and his kitabkhana in Mashhad is asserted without qualification by Stchoukine, "Shaykh," 7 (in addition, Stchoukine identifies the double frontispiece as "Ibrahim Mirza avec sa femme Gawhar Sultan Begum [sic] assis dans un arbre, tandis que leur suite est disposée autour"); and Rogers, TKS, 181 (nos. 113–18). There is nothing in Muhibb-Ali's colophons, or anywhere else in the volume, to support these claims. The wording of the calligrapher's final colophon (folio 229a) does suggest, however, that the manuscript was made for a courtly patron.

140. For references, see Appendix C.

141. Soudavar, cat. no. 66a–c.

142. Gray, OIA, cat. no. 127.

143. Titley, "Garshaspnameh," 27–32; Titley, PMP, 106–7. Here the author also refers to a dispersed Shahnama, generally attributed to the patronage of Isma'il II, which Titley (PMP, 107–8) says must have been begun for Ibrahim Mirza and continued for Isma'il II or produced in its entirety after Isma'il II: "No illustrated copy of the Shahnama commissioned by Ibrahim Mirza is known, and, as it is likely that he would want one, the project would probably have begun after the completion of the Garshaspnama, in circa 1574–75." For a reconstruction of the Shahnama, see Robinson, "Isma'il."

144. SOTH 6.XII.67, lot 206 and repro.

145. Robinson et al., 19–20.

146. Çağman & Tanindi, cat. no. 106; Robinson, Keir, 184.

147. Grube, CS, cat. no. 80; Grube, MMP, cat. no. 95; Sims, "Minneapolis," 65–66; Soudavar, cat. no. 93.

THE PRINCE'S ARTISTS

The nine indviduals documented as having been involved in the production of illustrated manuscripts for Sultan Ibrahim Mirza represent two successive and overlapping generations of Safavid artists. Shah-Mahmud al-Nishapuri and Rustam-Ali belong to the first generation; these two artists began their careers in the early decades of the sixteenth century, received patronage from Shah Tahmasp and other members of the Safavid family, and remained active until their deaths, two years apart, in the early 970s/mid-1560s. The second generation includes a larger cohort: Muhibb-Ali, Malik al-Daylami, Ayshi ibn Ishrati, Sultan-Muhammad Khandan, Abdullah al-Shirazi, Ali Asghar, and Shaykh-Muhammad. Although not all are known to have trained or worked at the Safavid court, most seem to have reached artistic maturity while in service to Sultan Ibrahim Mirza and continued their careers after the prince's death.

In addition to the ties of common patronage and projects, attested to directly by seven of the nine artists and in the primary sources for the two others, certain members of these two generations were closely related either as father-son or master-pupil.[1] The calligraphers were further bonded through their perfection of nasta'liq script, which placed them in the tradition of the artistic silsila, or chain of transmission, and linked them to the great practitioners of this cursive style, in particular Sultan-Ali Mashhadi.[2]

A considerable amount of information is available today about Sultan Ibrahim Mirza's artists, in the form of historical accounts (of which Qazi Ahmad's *Gulistan-i hunar* occupies pride of place) and original works of art, and is presented here in nine ministudies. In certain cases these discussions are tentative; it has not been possible, for instance, to reconstruct full biographies for all nine artists or even to pinpoint specific milestones, such as the year an individual began to work for the prince. The lists of each artist's known oeuvre in Appendix E are also far from definitive and range from the undoubtedly overinflated, as in the case of Shah-Mahmud, to the woefully underrepresented, as with Muhibb-Ali. However preliminary, these lists are useful in confirming, correcting, and, in many instances, supplementing the primary sources in the establishment of personal chronologies (i.e., when and where the artists were working). Equally important, the recorded oeuvres reveal much about the types of projects the artists undertook.

In addition to the copying of manuscripts, all of Sultan Ibrahim Mirza's calligraphers were actively engaged in the writing of qit'as, or poetic specimens. The vast majority of their qit'as share the same standard format: a vertical piece of paper (often colored) with two or three verses (with the hemistichs superimposed) written in nasta'liq script on the diagonal, lower right to upper left, and with triangular panels in the upper-right and lower-left corners. The calligraphers usually signed their names in the lower triangle using a script somewhat smaller than that used for the verses. Their signatures commonly begin with the phrase *katabahu* (written by) or *mashaqahu* (copied by), indicating that the qit'a verses were composed by others. Occasionally, however, the calligraphers penned qit'as of their own composition as signifed by signature formulations such as *li-katibiha* and *li-muharririhi* (composed and copied by), *qa'iluhu* (composed by), and *katibiha va qa'iliha* (written and composed by). The signatures also record, sometimes when the eye cannot easily observe, instances where a qit'a has been outlined (*harrarahu*) or cut out (*qati'uha*). Finally, and most rarely, the signatures reveal that from time to time qit'as were created in collaboration, with one artist, for instance, responsible for the writing and another for the cutting (fig. 152). Thus qit'as could be joint, as well as the more common individual, calligraphic exercises.[3]

The normal artistic practice of the sixteenth-century seems to have been to mount qit'as on larger sheets for compilation into albums (singular, *muraqqa*'). Often the qit'as were illuminated around the calligraphy and/or on the surrounding margins either before or after insertion into an album. Although many album leaves contain just a single qit'a, they frequently include multiple specimens, mounted side-by-side or in groups, along with detached manuscript folios, paintings, and drawings. Many sixteenth-century albums are veritable art galleries, with works of varied provenance and dates; others seem more like a single artist's personal portfolio.[4]

Most of the qit'as listed in the appended oeuvres remain in their original albums, made for various members of the Safavid family and court and generally known by the names of their owners. Of particular importance are those albums housed today in the library of the Topkapi Sarayi Müzesi, Istanbul: the Bahram Mirza album, compiled by the calligrapher and connoisseur Dust-Muhammad ibn Sulayman Haravi in 951/1544–45 (TKS H. 2154); the Tahmasp album pre-

152
Calligraphy
Signed by Shah-Mahmud al-Nishapuri and cut by Dust-Muhammad Musavvir
in the Bahram Mirza album
undated, Iran
49×35.2 cm (folio)
TKS H. 2154, folio 125a, bottom right
Topkapi Sarayi Müzesi, Istanbul

pared by the shah's keeper of seals Shah-Quli Kalifa probably sometime during the 1530s (IUL F. 1422); the album of Amir Husayn Beg, treasurer at the Safavid court, assembled by Malik al-Daylami in 968/1560–61 (TKS H. 2151); and the album of Amir Qayb Beg, the Ustajlu courtier who replaced Sultan Ibrahim Mirza in Mashhad in 970/1562–63, prepared by Mir Sayyid-Ahmad Mashhadi in 972/1564–65 (TKS H. 2161).[5]

In addition to a fascinating collection of calligraphies and paintings, the Bahram Mirza album includes Dust-Muhammad's history of calligraphy and painting and the equally invaluable roster of the painters and calligraphers at the kitabkhana of Shah Tahmasp. The shah's own splendid muraqqa‘ is notable for its fragments from a fourteenth-century *Kalila wa Dimna* and a magnificent painted and lacquered binding. The album made for Amir Husayn Beg begins with an introduction by Malik al-Daylami discussing various notable calligraphers of the day.

The nine biographies presented here are arranged in a kind of loose genealogy through the two artistic generations—a scheme that yields, in turn, a fairly secure, if not necessarily complete, roster for Sultan Ibrahim Mirza's kitabkhana. It is quite likely that the prince patronized additional artists, among them doubtless some or even all of the painters to whom modern scholarship has attributed the unsigned illustrations of the Freer Jami.

1. A. Welch (*Artists*, 152–53) has a very interesting discussion of, as well as useful documentation for, what he calls the "dynastic arrangements" among leading Safavid artists, including those who worked on the Freer Jami. See also Dickson & Welch, 1:8A; A. Welch, *Calligraphy*, 41; A. Welch, "Patrons," 13–14; S. C. Welch, *KBK*, 22.

2. Schimmel, *Calligraphy*, 36.

3. Little seems to have been written about qit‘as, and the term is used for both the form of a calligraphic specimen and its poetic content. See, for instance, the glossaries in Porter, 213 (where it is also translated as *le papier découpé*); Thackston, *Century*, 384; and S. C. Welch et al., 307. See also Adle, "Dust-Mohammad," 52. Little attempt has been made in the present study to translate or to identify the texts of the hundreds of qit‘as listed in the oeuvres of Ibrahim Mirza's artists. The only exception are some of the qit‘as composed by the artists themselves.

The terminology of signature formulations is also a fascinating, and little-studied, subject. Some signature phrases seem relatively straightforward, while others are open to considerable interpretation. A case in point is *harrarahu*. Schimmel ("Album," 33) translates this term as "has written" and points out that in Turkish calligraphy it was "sometimes used for clean copying." See also Schimmel, *Calligraphy*, 171 n. 61, where the same term is explained, again in a Turkish context, as "writing a vocalized text." Dickson & Welch (1:244B–45A n. 7) give the following definition: "*Harrarahu*, literally, 'penned this' or 'inked this,' or, more loosely, 'wrote this' (cf. the related forms *muharrir*, penman, and *tahrir*, penning) occurs widely as a general formula for authorship." Discussing an illustration in the Tahmasp Nizami inscribed by the artist Mir-Musavvir, they go on to say that here *harrarahu* is "applied as a technical term and refers to the illuminator's art of 'penning in,' or surrounding whole lines of calligraphy with cursive ornament and arabesque in colored inks or gold." That "penning in" also can occur in the context of the calligrapher's art is confirmed by an unfinished and unsigned qit‘a where the last word of a single-line inscription remains in outline form only while all the others have received their black "in-fill" (TKS H.

2151, folio 20a). The original contour lines of any qit‘a written in this fashion are obliterated when they are the same color ink (generally black) as the "in-fill." Wheeler Thackston has suggested (private communication) that *harrarahu* should be translated as "outlined by" only in cases of qit‘as in which an actual outline can be seen; otherwise he prefers the translation "written by." He also has suggested that *harrarahu* can mean the cloud or bubblelike contours that often surround lines of calligraphy. Like *harrarahu*, the meaning of *tahrir* also varies according to context. When used in a signature to a manuscript it may be understood as "written"; in a signature to a qit‘a it may mean either "written" or "outlined."

A tangential translation issue may be noted here. Calligraphers occasionally date their works using the word *gharra* (literally, the first day of a lunar month) and *salk* (literally, the last date of a lunar month). In the list of calligraphers' oeuvres in Appendix E, these words are translated as the beginning of the month and the end of the month, respectively.

4. See S. C. Welch et al., 23–26, for general remarks on muraqqa‘, with emphasis on Mughal Indian examples.

5. These albums have never been thoroughly or systematically studied, nor have their contents been completely published. In general, for the Istanbul albums, see Adle, "Dust-Mohammad"; Atasoy; Çağman & Tanindi; *IA*, vol. 1 (with extensive bibliography); and Rogers, *TKS*. The doctoral dissertation on Timurid and Safavid albums and album making by David Roxburgh was completed just as this volume went to press, and it was unfortunately not possible to take full advantage of the substance of its detailed contents and stimulating analysis. For TKS H. 2154, see also Adle, "Autopsia"; Roxburgh, 1:235–350, 2:771–998; and Simpson, "Bahram Mirza," 376–78; for IUL F. 1422, see Cowen; and Roxburgh, 1:351–77; and for IUL F. 1422 and TKS H. 2161, see Diba, "Lacquerwork" 2, cat. nos. 12, 22; and Dickson & Welch, 1:238A n. 5. The introductions to TKS H. 2151, 2154, and 2161 are translated in Thackston, *Century*, 335–56, and also discussed in Roxburgh, 1:262–73, 377–80.

SHAH-MAHMUD AL-NISHAPURI

Of the various calligraphers in service to Sultan Ibrahim Mirza, Shah-Mahmud al-Nishapuri is perhaps the best known today and doubtless the most famous of those who copied the prince's *Haft awrang*.[1] Certainly he was highly regarded by his colleagues and contemporary chroniclers: Dust-Muhammad places Shah-Mahmud at the head of his list of "scribes of the royal library who are renowned for their calligraphy," while Qazi Ahmad consistently uses the sobriquet *zarin-qalam* (golden pen) in reference to the master and places him in the pantheon with Sultan-Ali Mashhadi and Mir-Ali Tabrizi.[2]

Shah-Mahmud was already at least four decades into a long and extremely prolific career by the time he completed copying the *Subhat al-abrar* poem in the Freer Jami.[3] A native of Nishapur in the province of Khurasan,[4] Shah-Mahmud learned the calligraphic arts from his maternal uncle, Abdi Nishapuri, who in turn had been a pupil of Sultan-Ali Mashhadi (d. 10 Rabiʿ I 926/29 February 1520).[5] Shah-Mahmud seems to have first worked professionally in Khurasan, as suggested by a copy of the *Bustan* of Saʿdi, among the earliest manuscripts in his known oeuvre, which he completed in the summer of 925/1519 in Mashhad (TKS R. 930; fig. 153). Within nine years, if not sooner, he had moved on to Tabriz; his first known mention of the Safavid capital appears in the colophon to a now-fragmentary copy of the *Guy u chawgan* (Ball and mallet) of Arifi signed and dated Safar 934/November 1527 (BN suppl. pers. 1954).[6] It was presumably at about this time that he began his association with the court of Shah Tahmasp, making his reputation there with important commissions such as the *Khamsa* of Nizami of 946–49/1539–43 (BL Or. 2265).[7] Shah-Mahmud signed his first and last colophons in this celebrated volume as *al-shahi*, a *laqab* or title of honor that clearly reflects the extent of Tahmasp's esteem.[8]

The shah's younger brother, Bahram Mirza, also appears to have been a great admirer of Shah-Mahmud; his famous album complied in 951/1544–45 contains close to fifty calligraphic samples signed by the master (TKS H. 2154). In addition the prince commissioned, presumably directly, a poetic anthology with a painting of a reading youth surmounted by two verses and signed below by Shah-Mahmud (TKS R. 957, folio 2a). This slim, deluxe manuscript is undated, but it obviously was created, or at least ordered, prior to Bahram Mirza's death in Ramadan 956/October 1549 (and possibly much earlier) and confirms that Shah-Mahmud was patronized more or less simultaneously by two members of the royal family.[9]

153
Opening folios
Copied by Shah-Mahmud al-Nishapuri
in the *Bustan* of Saʿdi
925/1519, Iran, Mashhad
22.4×13.1 cm (one folio)
TKS R. 930, folios 1b–2a
Topkapi Sarayi Müzesi, Istanbul

Shah-Mahmud continued working in Tabriz through at least 953/1546, the date of the last known manuscript with a colophon specifying that city (FGA 35.18; fig. 154). The calligrapher precedes the place name Tabriz with the phrase *bi-dar al-sultana* (in the abode of the ruler), an interesting formulation considering that by the early-to-mid 950s/mid-to-late 1540s the Safavid capital had begun to shift to Qazvin. It may be that Shah-Mahmud stayed on in Tabriz after this transfer and never took up residence in the new capital.[10] In any event, by late summer 956/1549 Shah-Mahmud was in Ardabil, where he completed the transcription of a *Silsilat al-dhahab* of Jami (SPL Dorn 434). Within two years, he had moved on to Mashhad, as evidenced by his colophon in a *Bustan* volume dated Rajab 958/July 1551 (CB MS 221).[11] This manuscript, the first of a series of known works executed by Shah-Mahmud in Mashhad, among them one section of the Freer Jami, reveals that the calligrapher was occupied there well before the arrival of Sultan Ibrahim Mirza in the spring of 963/1556.

According to Qazi Ahmad, Shah-Mahmud lived in Mashhad for some twenty years, continuing his work and composing specimens of calligraphy. He also avers that during this time the master received no pensions, land grants, or patronage, though the absence of patronage is belied by Shah-Mahmud's contribution to the *Haft awrang*.[12] It may be, however, that this was the only project the calligrapher worked on for Ibrahim Mirza. In any event, Shah-Mahmud remained active well past his completion of the *Subhat al-abrar* masnavi in Dhu'l-hijja 963/October 1556, as demonstrated by his surviving oeuvre. He died in Mashhad in 972/1564–65 at age eighty and was buried there beside the tomb of the famous calligrapher, Sultan-Ali Mashhadi.[13]

In addition to calligraphy, Shah-Mahmud received considerable recognition for his poetry. Sam Mirza, for instance, includes Shah-Mahmud in his chapter of "august personages who, though themselves not poets, did upon occasion address themselves to verse," and Dust-Muhammad exclaims that Shah-Mahmud's "gift for verse is accepted worldwide."[14] Qazi Ahmad specifies that the master excelled in qasida, ghazal, qit'a, and ruba'i and that he composed five hundred bayts.[15] At least a few of these survive today in Shah-Mahmud's own hand (e.g., TKS H. 2161, folios 58b, 104a, 132a, 134a, 149a; and TKS H. 2165, folios 14b, 17b; fig. 155).[16] Qazi Ahmad also gives a selection, including part of a self-deprecatory qasida in praise of the Imam Reza that Shah-Mahmud reportedly placed in the passage of the imam's mausoleum.[17] In general, Shah-Mahmud's verses are formulaic and concern mystical themes.

The sentiments and placement of the poem to the Imam Reza also underscore Shah-Mahmud's general reputation for piety and virtue, as mentioned in several primary sources.[18] Qazi Ahmad is at particular pains to stress the artist's religious devotion, reporting that Shah-Mahmud spent his time in Mashhad praying and visiting the shrine. The chronicler also makes a good deal of Shah-Mahmud's taking up residence in madrasas at both Tabriz and Mashhad.[19] His purpose in locating Shah-Mahmud's dwelling place so precisely may have less to do with documenting biographical particulars than with casting the calligrapher as a model of righteous behavior. The same may be true of Qazi Ahmad's report that Shah-Mahmud chose not to marry or have a family life and of the accompanying Koranic quotation that effectively equates Shah-Mahmud with the chastity of Jesus.[20] Indeed, as portrayed by Qazi Ahmad and others, Shah-Mahmud seems to have epitomized the ascetic-scholar who leads a poor but admirable existence, devoting his days to expounding the glory of God through his writings and prayers and abstaining from worldly pleasures.[21]

Although Shah-Mahmud may have lived alone, he obviously was not a complete recluse. Qazi Ahmad mentions that the calligrapher received visitors and testifies that, on one or two occasions, he himself went to see Shah-Mahmud, who "instructed me in writing and talked briefly about his exercises and religious devotions."[22] And while Shah-Mahmud may not have been as actively engaged in teaching as his contemporary Rustam-Ali, he does seem to have had a few students besides Qazi Ahmad.[23] One of these was named Muhammad Husayn, for whom Shah-Mahmud wrote a qit'a (TKS H. 2161, folio 58b). Another student, Salim Katib, copied part of a poetic anthology that also contains a section signed and dated by Shah-Mahmud himself in 930/1523–24 (FGA 37.35).

Shah-Mahmud also was involved with other professional colleagues, perhaps at the impetus of Bahram Mirza, to whom the various collaborative projects are connected. The second folio in the prince's *Kulliyat* (TKS R. 957), for instance, is inscribed with the names of Shah-Mahmud, who wrote the two poetic verses at the top (as well as the signature inscription and probably the entire manuscript), and Ali al-Husayni, who painted the beautiful picture of the reading youth. This artist

154
Colophon folio
Signed by Shah-Mahmud al-shahi al-Nishapuri
in the *Halnama* of Arifi
953/1546, Iran, Tabriz
25×17.5 cm (folio)
FGA 35.18, folio 21a

155
Calligraphy
Signed by Shah-Mahmud al-Nishapuri
in an album
undated, Iran
36×24.1 cm (folio)
TKS H. 2165, folio 14b
Topkapi Sarayi Müzesi, Istanbul

can probably be identified as the well-known Mir-Ali Haravi, whose career began in Herat and Mashhad in the early part of the sixteenth century. In 935/1528–29 Mir-Ali was captured in Herat by the Uzbek Shaybanids and taken off to their capital of Bukhara, where he worked, evidently not very happily, until his death sometime after midcentury. The date of Mir-Ali's enforced move to Bukhara provides a possible terminus ante quem for his contribution to Bahram Mirza's manuscript and for his association with Shah-Mahmud, since after that time he was unlikely to have been free to undertake projects for a Safavid patron.[24] There is no certainty, however, that Shah-Mahmud would have been working side-by-side with Ali al-Husayni/Mir-Ali; the painter could have created his single-figure study, including all its marvelous accessories (gold pen box, silver scissors and seal, and three pieces of fruit), and then Shah-Mahmud could have come along at any time and written the verses and inscription. In other words, there could have been a gap in the execution of the two distinct elements of the composition, and the two artists did not actually have to be in direct contact.[25]

Definite evidence of collaboration between Shah-Mahmud and other artists does appear, however, in Bahram Mirza's album of 951/1544–45 (TKS H. 2154). Of particular interest is a calligraphic specimen that Shah-Mahmud did with Dust-Muhammad, a celebrated Safavid court artist.[26] Their joint creation is a qit'a of three verses, with each distich written in a different colored ink (cream, white, and pink) on blue paper and mounted with pink margins decorated with silver flowers (folio 125a). It bears the inscription "written [katibiha] by Shah-Mahmud and cut [qati'uha] by Dust-Muhammad Musavvir,"[27] indicating that the former copied out the verses and the latter cut around the lines so that they could be pasted onto the blue paper. Equally noteworthy is the collaboration evidenced in a qit'a dated 930/1523–24 (folio 123b). Here the verses were first outlined (harrarahu) in black by Mir-Musavvir, yet another highly regarded Safavid artist who created illustrations for Tahmasp's *Shahnama*, and then copied (mashaqahu) in pink ink by Shah-Mahmud. The artists apparently followed the same process for their signatures, which appear in the lower cornerpiece of the qit'a, except that the black outlines are filled with light blue, rather than pink, ink.[28] A similar "division of labor" between these two artists is seen elsewhere in the Bahram Mirza album (folio 6a).

According to Qazi Ahmad, Shah-Mahmud "enjoyed writing so much that during summer nights, he would sit in the light of the full moon from evening until dawn and write in large script."[29] The impression of constant creativity is certainly reinforced by Shah-Mahmud's known oeuvre, which numbers more than sixty volumes, including both religious and literary texts, and more than three hundred pieces of calligraphy.[30] A significant number of these works are dated, and quite a few give a place-name, indicating a concern for self-documentation on the part of Shah-Mahmud that other artists of the period, including his colleagues on the Freer Jami project, did not always share.[31]

From the outset of his career, Shah-Mahmud worked regularly with fine materials and on projects of deluxe form and quality. His earliest known manuscript, for instance, a small volume of the *Vassiyatnama* (advice given by the Prophet Muhammad to Ali), dated 923/1517–18, is copied on firm, cream-colored paper, highly polished and dusted with gold, and inlaid into pink margin paper (CB MS 232). The lines of text, written in medium-sized nastal'iq, are generously spaced and enframed in multicolored rulings alternating with gold. The text itself begins on folio 1b with a beautiful two-part heading. The area underneath the colophon on folio 10a is filled with large gold peony blossoms on gold scrolls.[32] The *Bustan* of Sa'di that Shah-Mahmud completed in Mashhad in Rajab 925/June–July 1519 features similar materials and decoration, including folios with fine white text paper set into pink, gold-flocked margin paper (TKS R. 930).

At approximately this same time, Shah-Mahmud began his first known multipart illustrated manuscript, a *Khamsa* of Amir Khusraw Dihlavi (TKS H. 797). As evidenced by his colophon dates, the calligrapher copied the poetic text over an eight-year period, ending in Muharram 936/September 1529. Even then the project was left incomplete, with the spaces reserved for illustration not painted until later in the sixteenth century. Clearly, however, Shah-Mahmud had to conceive the layout of the folios, or at least transcribe their verses, with illustrations in mind. The format of the folios preceding three of the manuscript's five colophons was undoubtedly also his idea. On two of these he alternated horizonal and diagonal lines of text, forming a zigzag pattern with the first hemistich of each diagonal verse going down and the next going up (folios 41b and 123b); on the third he wrote all but the very top and bottom lines on the diagonal to form a diaper or diamond pattern (folio 166b).[33]

Another illustrated manuscript that remains today in close to pristine condition gives an even better idea of Shah-Mahmud's achievements toward the end of the first decade of his professional career. This is a volume of *Yusuf u Zulaykha*—the first of a number of Jami's poems that Shah-Mahmud would copy over the years—dated Shawwal 931/August 1525 and with five illustrations generally attributed to Tabriz (TKS R. 910). And although Shah-Mahmud makes no mention of the Safavid capital in his colophon, the quality of the artistry and materials certainly reflects the standards then prevailing at the court of Shah Tahmasp. As in previous Shah-Mahmud manuscripts, the folios here are composed of two different kinds of paper. The narrow writing surface is of an extremely fine and highly polished white paper, while the generous margins are of thicker paper in a veritable rainbow of colors (blue, beige, pink, yellow, olive green, blue-green, and a marbleized blue) and densely flocked in gold. Shah-Mahmud wrote the poetic text in two columns with only fourteen lines per page. This spacing makes his beautiful black nasta'liq appear to be floating on the crisp white paper and enhances the striking contrast between the written surface and the surrounding colorful margins. The calligrapher has also varied the text layout on folios preceding or following illustrations. On folio 57b, for instance, the middle four of six lines of poetry are written on the diagonal, with each verse slanting upward toward the upper left, almost as if to push the reader's eye toward the facing scene, *Yusuf Is Rescued from the Well* (fig. 156). On folio 93b, immediately after the illustration of Zulaykha trying to seduce Yusuf, the four masnavi verses are written on alternating diagonals going downward (upper left to lower right, and vice versa) to form two parallel, vertical zigzags that are stopped, as it were, at the lower edge by a fifth verse centered with one hemistich above the other. Shah-Mahmud also took great care with the rubrication of this manuscript, writing the rubric text in blue, red, burgundy, and gold ink. This calligraphy was then surrounded in gold contour panels, embellished with very small green stems and multicolored buds.[34]

156
Text folio and *Yusuf Is Rescued from the Well*
Copied by Shah-Mahmud al-Nishapuri
in the *Yusuf u Zulaykha* of Jami
931/1525, Iran
23.4×14.5 cm (one folio)
TKS R. 910, folios 57b–58a
Topkapi Sarayi Müzesi, Istanbul

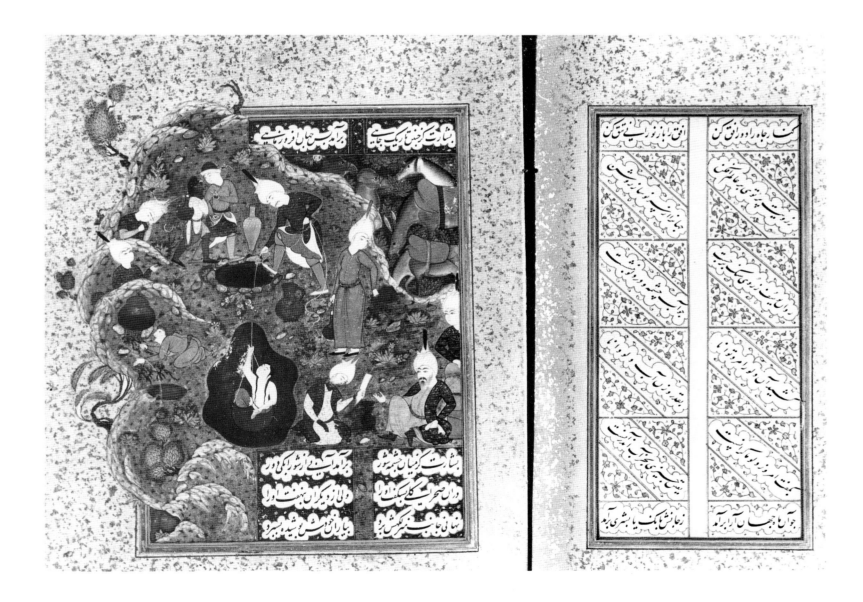

As we have already seen, by at least the late fall–early winter of 934/1527 Shah-Mahmud was in Tabriz, where he remained for some twenty years and completed a number of fine manuscripts. Among the most impressive, albeit today in rather poor condition, is a little-known copy of the *Divan* of Hafiz dated Shawwal 938/May 1532 (SPL Dorn 408; fig. 157). The volume was clearly intended to be illustrated although the compositions were never painted, and, in the process of transcribing the text, Shah-Mahmud ruled off the spaces to be painted and wrote the verses to be incorporated into the picture planes (e.g., folio 34a), thereby fixing the layout of the folios to be illustrated as well as the iconography of the scenes. Shah-Mahmud wrote the Hafiz text in two columns of beautifully proportioned black nasta'liq on firm, cream-colored paper dusted in gold.[35] Whereas on most folios the distichs extend the width of the entire written surface, on some they are compressed into narrow columns that are ruled off on the side with thin gold lines, creating empty "frames" parallel, and virtually identical in size, to the main column divider. As in TKS R. 910, Shah-Mahmud's objective with these, in this case discrete, modifications of the folio layout may have been to draw attention to other elements in the manuscript, such as the expected illustrations.[36]

In the summer of 945/1538 Shah-Mahmud completed a magnificent volume of the Koran that he transcribed in nasta'liq, a most unusual choice of script for Islam's holy text (TKS H.S. 25; fig. 158).[37] By this time the calligrapher would have been firmly established within Safavid artistic court circles, and certainly the quality of the paper, calligraphy, and illumination of this Koran suggests that it was made for an elite patron.[38] Shah-Mahmud's spacing of the script here is particularly generous, with nine lines per page written on cream-colored paper densely dusted in gold.[39] The opening folios contain only five lines, separated by wide bands of tight arabesque scrolls (folios 1b–2a). In overall format these two folios recall the beginning of Shah-Mahmud's *Divan* of 938/1532 (SPL Dorn 408), but the decoration here is much more complex, including side "sunburst" projections and an edging of intricate finials. For the sura headings, Shah-Mahmud switched scripts, from hanging nasta'liq in black ink to a more rounded and compact riqa' in white

157
Text folios
Copied by Shah-Mahmud al-Nishapuri
in the *Divan* of Hafiz
938/1532, Iran, Tabriz
16.8×17.3 cm (one folio)
SPL Dorn 408, folios 33b–34a
National Library of Russia, Saint Petersburg

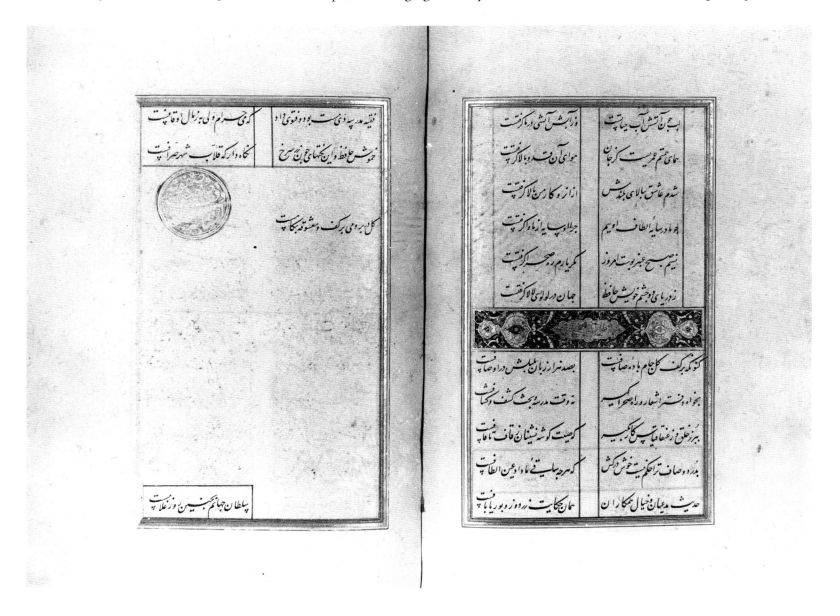

ink. The decoration of these headings, which resembles the richly colored rubrics commonly found in contemporary literary manuscripts, consists of rectangular panels with the sura titles written in central gold cartouches flanked by half-medallions with dense floral designs and surrounded by a zigzag border of black and gold. The first seventy or so folios of the manuscript also feature small marginal medallions, marking the fifth and tenth verses of the Koranic text, in a great variety of shapes. The margins of the last several folios are illuminated with gold floral and leaf designs, including bushy blossoms on folio 352a–b that recall those found throughout the Freer Jami. Finally, Shah-Mahmud's colophon is set off with illuminated contour lines and vertical and horizontal panels of varied geometric and floral designs that also relate closely to colophons in secular manuscripts.

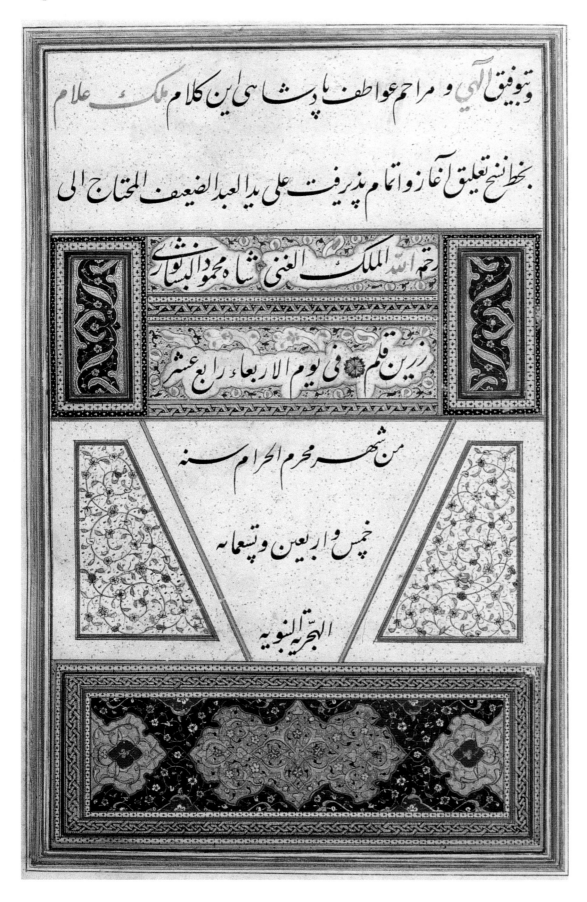

158
Colophon folio
Signed by Shah-Mahmud al-Nishapuri
in the Koran
945/1538, Iran
37.4×25.8 cm (folio)
TKS H.S. 25, folio 361b
Topkapi Sarayi Müzesi, Istanbul

Indeed, the richness of Shah-Mahmud's Koran of 945/1538 anticipates the *Khamsa* of Nizami that the calligrapher copied for Shah Tahmasp beginning in the fall of 946/1539 (BL Or. 2265; figs. 159 and 160).[40] This celebrated manuscript, widely discussed in the scholarly literature for its splendid illustrations and illuminations, was doubtless the most challenging manuscript project of Shah-Mahmud's years in Tabriz. As is well known, the *Khamsa* was refurbished with great care in the late seventeenth century, with the addition of several paintings and the replacement of many borders. Although this refurbishment certainly attests to the manuscript's continued appreciation in subsequent eras, it also complicates an assessment of its original physical form and contents.[41] There can be no doubt, however, that Shah-Mahmud was the manuscript's sole calligrapher, since he signed his name in all five colophons, adding the laqab *al-shahi* in gold in the first and last (folios 35a and 396a; see fig. 159). As in the Koran and other manuscripts that Shah-Mahmud transcribed in Tabriz, the *Khamsa* folios consist of single sheets of cream-colored paper, with the written surface dusted in gold.[42] Notwithstanding the time it took him to copy the Nizami text (Jumada II 946 to Dhu'l-hijja 949/October 1539 to March 1543), his handwriting remained consistent throughout: an elegant, delicate nasta'liq, with the last word or letter of a hemistich often hovering above the

159
Colophon folio of *Makhzan al-asrar*
Signed by Shah-Mahmud al-Nishapuri
in the *Khamsa* of Nizami
946/1539, Iran, Tabriz
36×25 cm (folio)
BL Or. 2265, folio 35a
By permission of the British Library

CHAPTER THREE: PATRON AND ARTISTS

line. It is this fine (ghubar) script that Qazi Ahmad signaled out for special praise, commenting in the *Gulistan-i hunar* that, in the view of Shah-Mahmud's colleagues, no other calligrapher had ever written so clearly.[43] The page layout also stayed constant: each full text page contains forty-two verses written in twenty-one lines and divided into four columns.[44] A number of folios, particularly but not exclusively those preceding illustrations, have alternate lines of text written on the diagonal from lower right to upper left, in a scheme that Shah-Mahmud had used for previous manuscripts. The format and placement of his colophon panels also continue earlier practices: four of the five are triangular, although each differs in exact dimensions, and are placed the equivalent of one line below the end of the masnavi, and one is rectangular and comes immediately below the text (folio 128a). The elements of the *Khamsa* manuscript that Shah-Mahmud must have determined directly— its materials, page proportions, and, of course, calligraphy—contribute in important and subtle ways to the sense of majesty that exudes from its every folio. Shah-Mahmud also must have been involved in the concept of the illumination, on which much of the sumptuous manuscript's reputation rests.[45]

Compared with the 945/1538 Koran and the 946–49/1539–43 *Khamsa*, the other known works that Shah-Mahmud executed in the second half of the 940s and early 950s/late 1530s–early 1540s appear to have been much less ambitious undertakings, although all are finely written. Several also contain some noteworthy decoration, such as the diverse animal margins on pink paper in a medical treatise dated 949/1542–43 (BN suppl. pers. 1967); the illuminated title piece, rubrics, and triangular cornerpieces (all now quite damaged) in a *Yusuf u Zulaykha* of 950/1543–44 (BN suppl. pers. 1919); and the two illuminated headings in a volume of Jami's poems dated Muharram 951/March–April 1544 (IOL P&A 49).[46] Shah-Mahmud's last-known Tabriz manuscript—an illustrated *Halnama* (Book of ecstasy) of Arifi dated Safar 953/April–May 1546 (FGA 35.18; see fig. 154)—maintains the same respectable standard.[47] It is interesting that Shah-Mahmud signed this volume with the laqab *al-shahi* in gold, although its relative simplicity and that of all the known manuscripts Shah-Mahmud copied between 946/1539–40 and 953/1546–47 do not suggest direct court patronage.

Shah-Mahmud's departure from Tabriz and move first, it seems briefly, to Ardabil and then on more permanently to Mashhad, resulted in his working once again on projects of the caliber of the Tahmasp *Khamsa*. Among these is a splendid volume of Jami's *Silsilat al-dhahab* that Shah-Mahmud copied in Ardabil during the summer of 956/1549 (SPL Dorn 434). Although the overall dimensions are somewhat larger than the *Khamsa* (possibly as a result of the latter's refurbishment), the dimensions and layout of the written surface are virtually identical. Shah-Mahmud's text calligraphy here is equally refined (perhaps even a bit stronger, if that could be possible), and

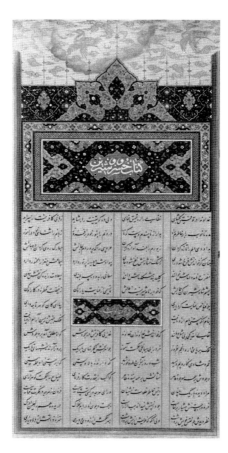

160
Masnavi heading folio of *Khusraw u Shirin*
Copied by Shah-Mahmud al-Nishapuri
in the *Khamsa* of Nizami
947/1540, Iran, Tabriz
36×25 cm (folio)
BL Or. 2265, folio 36b
By permission of the British Library

161
Text folios
Copied by Shah-Mahmud al-Nishapuri
in the *Silsilat al-dhahab* of Jami, first daftar
956/1549, Iran, Ardabil
42×27.5 cm (one folio)
SPL Dorn 434, folios 2b–3a
National Library of Russia, Saint Petersburg

the rubrics in gold nasta‘liq are assuredly in his hand. Like the *Khamsa*, the *Silsilat* contains a great deal of brilliant illumination: a shamsa with radiating pendant medallions inscribed with the name of the text and its author (folio 1a), an **I** form text surround with eleven lines of Shah-Mahmud calligraphy encased in gold contour panels embellished with small blossoms (folios 2b–3a; fig. 161), a complex heading at the beginning of the second *Silsilat* daftar (folio 47b), numerous rubrics, and colophon decorations. Although lacking in text illustrations, the manuscript contains a superb double-page frontispiece in pure Safavid style depicting a princely hunting scene (folios 1b–2a) and an inserted finispiece, also of the hunt, in Turcoman style of the late fifteenth century (folio 81b).[48] While the *Silsilat* maintains much of the *Khamsa*'s style, its general effect is even more dazzling than its measured predecessor, perhaps partly because of the contrast between its highly polished cream text paper and the brightly colored (in salmon, green, cream, pink, yellow, and three shades of blue) and gold-flocked margin color, and partly because of the sharper palette of the illumination as well as the more lavish use of gold. Certain features of the *Silsilat* even seem to anticipate manuscripts Shah-Mahmud would work on in Mashhad.[49]

A *Bustan* dated Rajab 958/July 1551 (CB MS 221) confirms that Shah-Mahmud continued to work on deluxe projects after leaving Ardabil for Mashhad sometime after the completion of the 956/1549 *Silsilat*.[50] As in the Jami volume, the folios in this Sa‘di manuscript are composed of cream text paper, here dusted with gold, inlaid into gold-flocked margins of many bright colors (salmon, cream, yellow, green, and three shades of blue). The scheme is enriched still further by the use of different colors on the recto and verso of the same folio and by the occasional appearance of marbleized margins. Sadly, the first folios of the manuscript have been damaged: the introductory shamsa is a replacement (folio 1a), and the illuminated surround of the opening verses is in very poor condition (folios 1b–2a), although enough survives to reveal similarities in design and decorative detail to the Ardabil *Silsilat*. In transcribing the *Bustan* text, Shah-Mahmud left spaces for

162
Colophon folio of *Subhat al-abrar*
Signed by Shah-Mahmud al-Nishapuri
in the *Haft awrang* of Jami
963/1556, Iran, Mashhad
34.5×23.4 cm (folio)
FGA 46.12, folio 181a

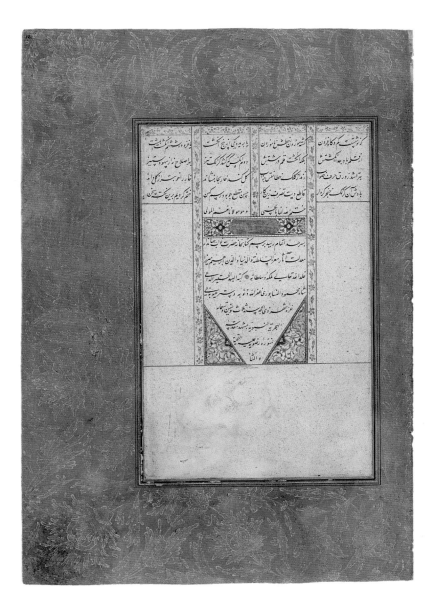

twelve illustrations: six of these contain detailed line drawings, evidently for paintings that were never executed, and six remain blank. All these picture planes incorporate text panels, which Shah-Mahmud filled in with *Bustan* verses. The calligrapher also preceded many of the folios intended for illustration with text written on the diagonal. Throughout the manuscript he copied the poetic text in black nasta'liq and the rubrics in gold, red, and blue nasta'liq.

The *Subhat al-ahrar* that Shah-Mahmud completed in Dhu'l-hijja 963/October 1556 for the *Haft awrang* of Sultan Ibrahim Mirza certainly maintains the same aesthetic quality as his other known work created during from the mid-950s/late 1540s onward (FGA 46.12, folios 140b–81a; fig. 162, see also fig. 33). The nasta'liq calligraphy of both the text (in black ink) and rubrics (in orange and blue ink) is exquisite, with particularly elegant letter extensions. The sureness of Shah-Mahmud's hand is also revealed in the catchwords, including those written in small script in the lower-left corner of virtually all the text folios and the larger ones in the lower margins of two illustrated folios (153b and 169b). Shah-Mahmud preceded three of the masnavi's five illustrations, as well as his colophon, with folios of verses written on the diagonal, all lower right to upper left (fig. 163). The triangular cornerpieces that set off his diagonal verses exhibit an incredible variety of colors and patterns; in one instance these illuminations are set within a grid of dense scrollwork (folio 161b), and in another they are capped with horizontal panels of zigzag designs (folio 179a).

The Freer Jami is one of the last manuscripts in Shah-Mahmud's recorded oeuvre and was certainly a fitting project for such an impressive career. Yet the *Subhat al-ahrar* masnavi is not the longest or the most imaginatively laid out and decorated masnavi in the Freer Jami. Admittedly, Shah-Mahmud had entered his eighth decade at the time he was working on *Subhat*, and it may be that thirty folios or so of text were all that he was willing to undertake. It may even be that Sultan Ibrahim Mirza (or perhaps his librarian, Muhibb-Ali) had to be make a special effort to persuade Shah-Mahmud to contribute a section to the *Haft awrang*.

163
Text folio of *Subhat al-ahrar* and *The Fickle Old Lover Is Knocked off the Rooftop*
Copied by Shah-Mahmud al-Nishapuri in the *Haft awrang* of Jami
963–72/1556–65, Iran 34.4×46.8 cm (two folios)
FGA 46.12, folios 161b–62a

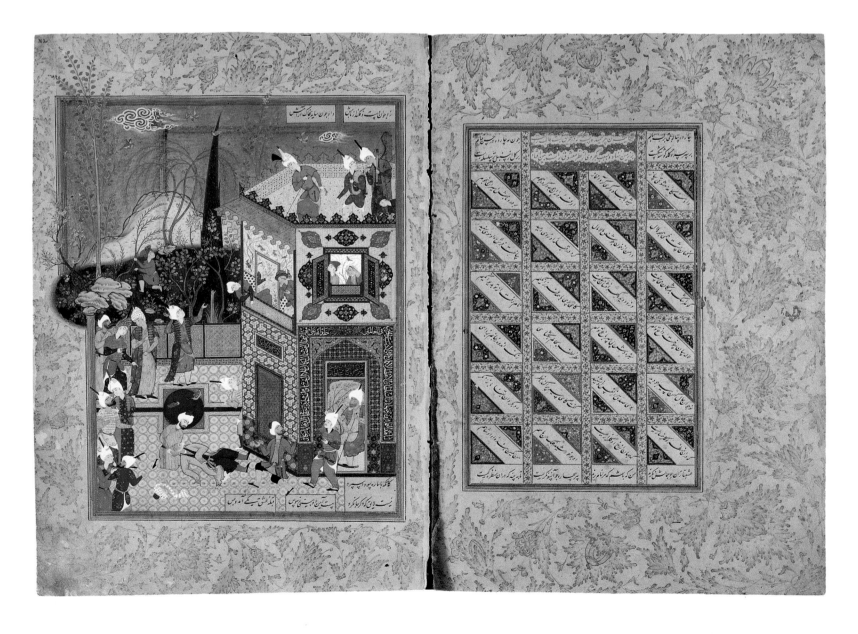

164
Text folios
Copied by Shah-Mahmud al-Nishapuri
in the *Arba'in hadith*
942/1535, Iran, Tabriz
19.5×12 cm (one folio)
TKS E.H. 681, folios 5b–6a
Topkapi Sarayi Müzesi, Istanbul

165
Text folios
Copied by Shah-Mahmud al-Nishapuri
in the *Arba'in hadith*
966/1558–59, Iran, Mashhad
23.8×15 cm (one folio)
CB MS 346, folios 2b–3a
Reproduced by kind permission of the Trustees
of the Chester Beatty Library, Dublin

Although each of Shah-Mahmud's manuscripts has its own individual character, it is interesting to note that copies of the same text could be quite similar, even when executed decades apart. Five copies of the *Arba'in hadith* (Forty traditions of the Prophet Muhammad) with metrical paraphrases by Abdul-Rahman Jami, transcribed by Shah-Mahmud in Muharram 942/July 1535 (TKS E.H. 681), 950/1543–44 in Tabriz (CB MS 342), Rabi' 1 962/January–February 1555 (TKS H. 2248, folios 3b–11a), 964/1556–57 in Mashhad (CB MS 227), and 966/1558–59, also in Mashhad (CB MS 346), respectively, provide a case in point. Shah-Mahmud used very fine white or cream-colored text paper for all four volumes. After he had transcribed the text, his calligraphy was heavily dusted with gold, making the paper look even lighter and finer by comparison. The surrounding margin paper is gold flocked.[51] The text layout of the four volumes consists of seven panels per page with three lines of hadith in Arabic, copied in large dark nasta'liq that cuts across the written surface, alternating with four lines of Persian verses in smaller and more delicate nasta'liq.[52] The opening text in the 962/1555 volume is set within an elaborate illuminated frame (TKS H. 2248, folios 3b–4a), while the four other manuscripts begin with two-part illuminated headings.[53] Three of the manuscripts boast illumination in the triangular corners of the panels with diagonal verses (TKS E.H. 681, TKS H. 2248, and CB MS 346; figs. 164 and 165). It could be, of course, that the striking similarities in the materials and layout of these manuscripts resulted from Shah-Mahmud's having followed, or been obliged to follow, a standard or predetermined format for this particular text. It is equally possible that Shah-Mahmud himself came up early on with this scheme and simply stuck with it throughout the better part of his career, either for convenience' sake or out of an inherently conservative artistic nature.

Qazi Ahmad clearly was not exaggerating (for once) when he stated that Shah-Mahmud's calligraphic samples "both in a large [jali] and small [khafi] hand, are numerous,"[54] judging from the several hundred qit'as surviving today. Most of these are still mounted in albums prepared at or for the Safavid and Ottoman courts, and it is possible that some such volumes, such as IUL F. 1426, TKS B. 407, TKS H. 2138, and TKS H. 2145, were compiled specifically to show off Shah-Mahmud's work. Certainly cognoscenti such as prince Bahram Mirza, Amir Husayn Beg, and Amir Qayb Beg (or their representatives) seem to have made an effort to collect Shah-Mahmud's calligraphy in their albums (TKS H. 2154, TKS H. 2151, and TKS H. 2161, respectively), while Ottoman artists and their patrons expressed their admiration by embellishing the master's work with additional decoration (e.g., IUL F. 1426, folios 22b and 27a).

In general, Shah-Mahmud's poetic qit'as follow the standard format, with poetic verses written diagonally on a vertical piece of paper and the upper-right and lower-left corners ruled off into triangular panels. His earliest dated piece of 922/1516–17 is a typical, and rather undistinguished, example of the genre (TKS H. 2156, folio 63b). Shah-Mahmud wrote this piece in what might be considered his medium-sized hand on dull, rather muddy colored paper, signing his name in the lower triangle and the date in the upper one. Other examples reveal greater concern for coloristic effects and are written on highly polished white, cream, bright blue, light blue, yellow, pink, brown, and marbleized paper. Very often the paper is gold-dusted or gold-flecked, or both, adding further sheen to the written surface. By at least the 950s, if not considerably earlier, Shah-Mahmud regularly wrote qit'as in a large, firm hand in very glossy black ink, which also enhances the visual impact of his calligraphy. It is interesting to note, with respect to his large hand, that Shah-Mahmud signed a few such pieces with harrarahu, suggesting that he may first have outlined the contours of the letters and then filled them in with black ink (e.g., BMFA 14.595 [recto]; CB MS 227; TKS H. 2138, folio 40b; TKS H. 2139, folio 5b; TKS H. 2156, folios 16b, 41b, 64a; and TKS H. 2161, folios 47a, 64a). The verses written in Shah-Mahmud's larger hand also seem to be more generously spaced than those in smaller and more delicate nasta'liq and naturally result in larger overall dimensions of the qit'as.[55] Occasionally Shah-Mahmud used colored inks, as he also did, for instance, for the rubrics in the *Silsilat* manuscript he completed in Ardabil in 956/1549 (SPL Dorn 434); a striking example combines verses in yellow and white ink and signature in pink—all written on black paper (TKS H. 2156, folio 55a; fig. 166).

166
Calligraphy
Signed by Shah-Mahmud al-Nishapuri
in an album
undated, Iran
45.2×30 cm (folio)
TKS H. 2156, folio 55a
Topkapi Sarayi Müzesi, Istanbul

Shah-Mahmud's calligraphic oeuvre also includes a number of samples written on the hori-
zontal. Some of these are folios removed from manuscripts and remounted in albums as isolated
specimens (e.g., TKS H. 2156, folio 64a; and IUL F. 1426, folios 2b–3a).[56] In other cases, they seem
to be more deliberate creations in varied format, intended perhaps to demonstrate the calligrapher's
versatility. These include single Persian verses (SPL Dorn 488, folio 14b) and Arabic prayers and
excerpts from the Koran (TKS H. 2137, folio 32b; CB MS 179, folios 2b–3a, 6b–7a; and BSM I. 4596).
Another notable example appears on the very last folio of Bahram Mirza's famous album. Here a
painting of a youth playing a sitar is surmounted by two pairs of verses, evidently written by Shah-
Mahmud, who signed and dated the sheet (950/1543–44) beneath the musician's feet (TKS H. 2154,
folio 148a).[57]

Like the qitᶜas of many other calligraphers, Shah-Mahmud's album specimens are often elab-
orately illuminated. It is frequently easy to tell that the decoration was added at the time the album
was compiled, especially where similar borders and contour panels, for instance, embellish con-
tiguous works by different artists (e.g., TKS H. 2151, folio 42a) or appear both on the qitᶜa itself and
the surrounding borders (e.g., TKS H. 2156, folio 64a, where the same stenciled designs appear in
the triangular cornerpieces flanking three of Shah-Mahmud's verse panels and on the surrounding
margin paper). In many cases, however, the illumination seems to be sufficiently individualized
(that is, not repeated on nearby samples) to imagine that it was intended by Shah-Mahmud himself.
This scheme seems particularly likely where distinctive illumination surrounds either the qitᶜa itself
or the calligrapher's signature in the lower triangular cornerpieces and single floral medallions (e.g.,
TKS H. 2137, folio 32b; TKS H. 2140, folio 4a; and TKS H. 2156, folios 16b, 54b; fig. 167).

Of the artists who worked on Sultan Ibrahim Mirza's *Haft awrang*, Shah-Mahmud seems to
have been the most productive, with by far the most extensive oeuvre. His dedication to his art may
explain why the historical record shows no direct contact between the calligrapher and his patron
or fellow artists connected with Ibrahim Mirza's kitabkhana. On the Freer Jami project, Shah-
Mahmud was apparently a detached participant, but in the history of Safavid art, Shah-Mahmud
was definitely a principal contributor.

167
Calligraphy
Signed by Shah-Mahmud al-Nishapuri
in an album
971/1563–64, Iran
17.5×7.4 cm (written surface)
TKS H. 2156, folio 16b, bottom left
Topkapi Sarayi Müzesi, Istanbul

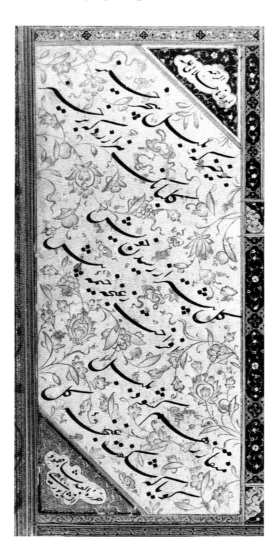

CHAPTER THREE: PATRON AND ARTISTS

1. Primary sources: Abu'l-Fazl [Blochmann], 1:109 (with one reference to Shah-Mahmud of Nishapur and another to Mawlana Shah-Mahmud zarin-qalam); Dust-Muhammad [Mehdi Bayani], 1–2:200; Dust-Muhammad [Thackston], 347; Iskandar Beg Munshi [Afshar], 1:170; Iskandar Beg Munshi [Savory], 1:266; Malik al-Daylami [Mehdi Bayani], 3–4:606; Malik al-Daylami [Thackston], 352 (with one reference to Shah-Mahmud Nishapuri and another to Shaykh Mahmud zarin-qalam); Mustafa Ali Efendi [Ibn ül-Emin], 52–53; Mustafa Ali Efendi [Fisher], 51; Qazi Ahmad [Ishraqi], 1:450; Qazi Ahmad [Minorsky], 134–38, 152; Qazi Ahmad [Suhayli-Khunsari], 87–89; Sam Mirza [Dastgirdi], 81; and Sam Mirza [Humayun-Farrukh], 133–34.

Selected secondary sources: Mehdi Bayani, 1–2:295–307; Dickson & Welch, 1:27B, 34A, 42A, 45B, 118B, 129B–30A, 240A–B n. 11, 244A–45B n. 7, 246A n. 4, 249A nn. 4–5; Schimmel, *Calligraphy*, 30, 61, 64, 67, 112, 183 n. 228; Simpson, "Bahram Mirza," 382; Simpson, "Kitab-Khana," 113; A. Welch, *Artists*, 153–54; A. Welch, *Calligraphy*, 40–41; and A. Welch, "Patrons," 12.

The English translation of the *Gulistan-i hunar* also contains an entry for Shah-Mahmud Katib, whose teacher, Salim Katib, is recorded as a pupil of Shah-Mahmud zarin-qalam (Qazi Ahmad [Minorsky], 153). The Persian edition of this text calls this homonym Shah-Muhammad (Qazi Ahmad [Suhayli-Khunsari], 104). Shah-Mahmud and Shah-Muhammad have been confused in the secondary literature, as evidenced by the discussion (Gray, *PP 2*, 142) of a Jami manuscript said to have been copied by Shah-Mahmud but actually by the hand of Shah-Muhammad (BL Or. 4122).

2. Dust-Muhammad [Mehdi Bayani], 1–2:200; Dust-Muhammad [Thackston], 347; Qazi Ahmad [Ishraqi], 1:450; Qazi Ahmad [Minorsky], 134–35; Qazi Ahmad [Suhayli-Khunsari], 87 (Shah-Mahmud is also referred to as *zarin-qalam* in Abu'l-Fazl [Blochmann], 108). Malik al-Daylami attaches *zarin-qalam* to Shaykh-Mahmud "who wrote a *Khamsa* in the ghubar script, was a contemporary of Azhar and a student of Jaʿfar Tabrizi" (Malik al-Daylami [Mehdi Bayani], 3–4:606; Malik al-Daylami [Thackston], 352).

3. Shah-Mahmud's birth date is not recorded. According to Qazi Ahmad, the master lived to be about eighty and died in 972/1564–65 (Qazi Ahmad [Suhayli-Khunsari], 89; Shah-Mahmud's age is not mentioned in Qazi Ahmad [Minorsky]). This would put his year of birth around 892/1486–87. Mehdi Bayani (1–2:297) seems to misinterpret the Qazi Ahmad text, adding eight more years onto Shah-Mahmud's age.

4. It should be noted that when writing his *nisba* (part of a name, referring in this case to the calligrapher's place of origin), Shah-Mahmud sometimes omitted the diacritical marks for the letters *shin* (sh) and *baʾi farsi* (p), resulting in Nisaburi instead of Nishapuri. Account of these variants is taken in the transcription of Shah-Mahmud's signatures in his oeuvre listed in Appendix E, although in the accompanying translation the calligrapher's nisba appears as Nishapuri. The same transliteration is used throughout the text of this study.

5. Dust-Muhammad [Mehdi Bayani,] 1–2:200; Dust-Muhammad [Thackston], 347; Malik al-Daylami [Mehdi Bayani], 3–4:606; Malik al-Daylami [Thackston], 352; Qazi Ahmad [Minorsky], 134–35; Qazi Ahmad [Suhayli-Khunsari], 88. For more on Abdi Nishapuri, see Sam Mirza [Dastgirdy], 176; and Sam Mirza [Humayun-Farrukh], 134. See also Mehdi Bayani, 1–2:424–36; and Thackston, *Century*, 347 n. 64.

Shah-Mahmud pays homage, in a sense, to his teacher's teacher in two sets of verses he copied after the writing of Sultan-Ali Mashhadi (BN pers. 129, folios 12b–13a, 17b–18a).

That Shah-Mahmud's uncle studied with Sultan-Ali Mashhadi introduces an interesting wrinkle into the genealogy of Safavid artists, since Rustam-Ali, a contemporary of Shah-Mahmud, is also said to have studied with this master.

6. Within two years Shah-Mahmud seems to have returned to Khurasan, although perhaps only for a brief time, as evidenced by one section of a *Khamsa* of Amir Khusraw Dihlavi that the calligrapher completed in the region of Bakharz, to the south of Mashhad in Khurasan province, in Muharram 936/September 1529 (TKS H. 797, folio 167a). Shah-Mahmud apparently began the manuscript much earlier, as documented by another colophon dated Shawwal 927/September 1521 (folio 219a). It is likely that at this time he was still in Khurasan. He then seems to have set the project aside and turned back to it during the summer of 935 and early fall of 936/May–September 1529, evidently during a return visit to his native region. In any event he transcribed the text over an extended period, and his five colophons are not in sequential order. Thus this *Khamsa* reflects the same kind of chronological disjunction as the Freer Jami. See Simpson, "Codicology," for more on this issue (and on Bakharz).

7. The possibility exists that Shah-Mahmud was trained in Tabriz while his mentor and uncle Abdi Nishapuri served Tahmasp. Certainly Qazi Ahmad gives the impression that Shah-Mahmud was quite young when he began working for Tahmasp (Qazi Ahmad [Minorsky], 135; Qazi Ahmad [Suhayli-Khunsari], 87–88). His description, however, sounds very formulaic.

The report of Ali Efendi that Shah-Mahmud was in service to Tahmasp's father, Shah Ismaʿil, by at least 920/1514 when he was sequestered, along with the painter Bihzad, in a cave during the battle of Chaldiran, now must be discounted as a result of the convincing analysis in Dickson & Welch, 1:240A n. 11. See also *EIr*, Priscilla P. Soucek, "Behzad"; and Lentz & Lowry, 311. Dickson & Welch (1:42A) suggest that Shah-Mahmud may have been one of the calligraphers of the famous *Shahnama* made for Shah Tahmasp.

8. BL Or. 2265, folios 35a (signed Shah-Mahmud al-shahi, with the laqab written in gold), 396a (signed Shah-Mahmud al-Nishapuri al-shahi, again with the laqab in gold). Shah-Mahmud also signed himself *al-shahi* in a *Halnama* dated 953/1546 (FGA 35.18, folio 21a, also with the laqab in gold).

Shah-Mahmud's teacher, Abdi Nishapuri, also used the same laqab, evidenced by his surviving work. See Mehdi Bayani, 1–2:425–26.

Shah-Mahmud also gives evidence of his feelings about Shah Tahmasp in a laudatory poem directed toward the shah (IUL F. 1422, folio 10a). The final line, invoking God's protection on "his [presumably Tahmasp's] kingdom and reign," is written in gold.

9. Shah-Mahmud may also have worked for Sam Mirza, who has been proposed as the patron of the *Silsilat al-dhahab* that Shah-Mahmud copied in Ardabil in Shaʾban 956/August 1549 (SPL Dorn 434). See Dickson & Welch, 1:27A–B, 129B–30A, 249A nn. 4–5; and S. C. Welch, *PP*, 20, for the manuscript's possible patronage.

10. The shift of the capital from Tabriz to Qazvin corresponds with the period when Shah Tahmasp began to lose interest in the arts, and it has been generally assumed that Shah-Mahmud, as well as other calligraphers and artists connected with the king's kitabkhana, left the Safavid capital at about midcentury for work elsewhere. Tahmasp's gradual change in attitude toward the arts has been considered at length by Dickson and Welch, who pinpoint the beginning of the shah's disaffection to around 1544–45. But see Membré [Morton], xvi, and Adle, "Dust-Mohammad," 239–40, where this development is dated ten years earlier. Interestingly enough, Dickson & Welch base their discussion on comments made by Qazi Ahmad in the midst of his entry on Shah-Mahmud (Qazi Ahmad

[Minorsky], 135; Qazi Ahmad [Suhayli-Khunsari], 88) and arrive at the date of 1544–45 by working backward twenty years, the length of time Qazi Ahmad says Shah-Mahmud spent in Mashhad, from the calligrapher's death in 972/1564–65. See Dickson & Welch, 1:45B; S. C. Welch, *KBK*, 68, 72–73; S. C. Welch, *WA*, 27. See also A. Welch, *Artists*, 153–54. Thus Shah-Mahmud becomes a key figure in the reconstruction of a critical moment in Safavid art history.

11. Qazi Ahmad states that Shah-Mahmud had permission, presumably meaning that of Shah Tahmasp, to go to Mashhad (Qazi Ahmad [Minorsky], 135; Qazi Ahmad [Suhayli-Khunsari], 88). See also A. Welch, *Artists*, 153–54, for further remarks on Shah-Mahmud's "dismissal" from Tahmasp's employ and "retirement" to Mashhad.

12. Qazi Ahmad [Minorsky], 135–36; Qazi Ahmad [Suhayli-Khunsari], 88.

13. Qazi Ahmad [Ishraqi], 1:450 (where it is further specified that Shah-Mahmud was buried "near the window in the dome [*gunbad*, also conceivably meaning "vault"] of Mir Ali-Sher [Navaʿi]"); Qazi Ahmad [Minorsky], 136; Qazi Ahmad [Suhayli-Khunsari], 89.

Shah-Mahmud's last known work in Mashhad is a *Arabʿin hadith* dated 966/1558–59 (CB MS 346). There also exists a volume of poetry (the *Ghazals* of Amir Humayun Isfarayni) signed by Shah-Mahmud, apparently in 970/1562 (SOTH 11.IV.88, lot 134; the final digit of the year seems to be lacking). The last line of the colophon indicates that the volume was copied in the town of Raza in Bakharz, the same region where Shah-Mahmud worked almost four decades earlier (see note 6 above and TKS H. 797, folio 167a). However, the calligraphy of this line is much more cramped than Shah-Mahmud's normal colophon hand, and it is possible that the indication of place is a subsequent addition. The manuscript is listed in the oeuvre in Appendix E among the problematic works.

14. Sam Mirza [Dastgirdi], 81; Sam Mirza [Humayun-Farrukh], 133; Dust-Muhammad [Mehdi Bayani], 1–2:200; Dust-Muhammad [Thackston], 347.

15. Qazi Ahmad [Minorsky], 136; Qazi Ahmad [Suhayli-Khunsari], 88.

16. Shah-Mahmud himself makes the distinction between "written" (katibiha) and "composed" (qaʾiliha) quite clear in his signature of TKS H. 2165, folio 14b.

17. Qazi Ahmad [Ishraqi], 1:450 (two lines of the Imam Reza qasida); Qazi Ahmad [Minorsky], 136–37 (with five other verses not in Qazi Ahmad [Suhayli-Khunsari]); Qazi Ahmad [Suhayli-Khunsari], 88–89. See also Sam Mirza [Dastgirdi], 81; Sam Mirza [Humayun-Farrukh], 134.

18. Dust-Muhammad [Mehdi Bayani], 1–2:200; Dust-Muhammad [Thackston], 347 (with reference to Shah-Mahmud's "good and pleasing characteristics"); Sam Mirza [Dastgirdi], 81; Sam Mirza [Humayun-Farrukh], 133 (with reference to Shah-Mahmud as a faqir and dervish).

19. Qazi Ahmad [Minorsky], 135; Qazi Ahmad [Suhayli-Khunsari], 88–89.

20. Qazi Ahmad [Minorsky], 135–36; Qazi Ahmad [Suhayli-Khunsari], 88.

21. Qazi Ahmad furthers this image, so typical of the tadhkira genre, with his selection of verses composed by Shah-Mahmud, of which one ghazal reads:

He who like Mahmud has withdrawn himself from the world,
Has found much happiness in the corner of poverty and contentment.

(only in Qazi Ahmad [Minorsky], 137).

22. Translation by Massumeh Farhad after Qazi Ahmad [Suhayli-Khunsari], 89. This passage of the *Gulistan* differs somewhat from the Minorsky translation (Qazi Ahmad [Minorsky], 136, 138).

23. These students are identified by Mehdi Bayani (1–2:298, with reference to Mustafa Ali Efendi) as Salim Nishapuri, Hajj Muhammad Tabrizi, Muhammad Husayn Bakharzi, Sultan-Mahmud Tarbati [sic?], and Qutbuddin Yazdi. Some of these figure in the *Gulistan-i hunar*, although only Salim Katib is cited as a student of Shah-Mahmud, and then only in the English translation. See Qazi Ahmad [Minorsky], 90 (Sultan-Mahmud Najati) 150–51 (Mir-Muhammad Husayn Bakharzi), 152 (Salim Katib), 166 n. 585 (translator's reference to Qutbuddin Muhammad Yazdi); and Qazi Ahmad [Suhayli-Khunsari], 48 (Sultan-Mahmud Najati), 104 (Salim Katib), 123 (Muhammad Husayn Bakharzi). Qazi Ahmad does mention more generally, apropos Shah-Mahmud in Mashhad, that "friends and potential students [*shagirdan khali az-jahl*; literally 'students empty of ignorance'] would come and benefit from his company." Qazi Ahmad ([Minorsky], 135) has a slightly different translation and omits the word "students" [*shagirdan*]. See also Qazi Ahmad [Suhayli-Khunsari], 88.
24. See Simpson, "Bahram Mirza," 382–83, for further discussion of the painting signed by Ali al-Husayni and the complications in identifying this artist and dating Bahram Mirza's manuscript. If the painter was Mir-Ali (hitherto known only as a poet and calligrapher), then he and Shah-Mahmud may perhaps have worked on the *Kulliyat* in Khurasan, where Shah-Mahmud remained until at least the fall of 934 and where Mir-Ali was captured the following year. As it happens, Bahram Mirza was governor of Khurasan at the time.
25. Another instance of Shah-Mahmud's collaboration with a painter, although in this case an anonymous one, occurs in the Bahram Mirza album, where a painting of a youth playing the sitar is surmounted by two pairs of verses signed and dated by Shah-Mahmud in 950/1543–44 (TKS H. 2154, folio 148a).
26. A thorough discussion of Dust-Muhammad appears in Dickson & Welch, 1: chapter 1 (p. 118B refers specifically to the artist's collaboration with Shah-Mahmud al-Nishapuri). See also Adle, "Autopsia," 243–48, 250–51; Adle, "Dust-Mohammad" (where the identities of various artists named Dust-Muhammad are discussed and a clear distinction is made between Dust-Muhammad ibn Sulayman [Guvashani?] Haravi, the calligrapher and connoisseur responsible for assembling Bahram Mirza's album, and Dust-Muhammad Musavvir, the painter); and Soudavar, 258 n. 74.
27. The piece is discussed by Dickson & Welch, 1:118B (where Dust-Muhammad's "tag" as *musavvir*, or painter, is pointed out but not analyzed), Adle, "Autopsia," 245; and Adle, "Dust-Mohammad," 286. The first two sources also credit Shah-Mahmud and Dust-Muhammad with another qit'a in the Bahram Mirza album, which must be the one on folio 5a, top.
28. Mir-Musavvir is the subject of Dickson & Welch, 1: chapter 2. This particular qit'a seems to be the one listed in Mehdi Bayani, 1–2:305, and discussed in Dickson & Welch, 1:244B–45A n. 7, although neither reference mentions the presence of a date.

It is a curious coincidence that the two colleagues with whom Shah-Mahmud collaborated are the only two with signed paintings in the Tahmasp *Shahnama* (Mir-Musavvir on folio 60b, Dust-Muhammad on folio 521b). Shah-Mahmud's qit'a with Mir-Musavvir would have been done early on in the lengthy *Shahnama* project, which is believed to have been started circa 1522, if not earlier.
29. Qazi Ahmad [Minorsky], 138 n. 473; Qazi Ahmad [Suhayli-Khunsari], 89.
30. Shah-Mahmud's known oeuvre includes manuscripts and calligraphies bearing, or recorded as bearing, authentic signatures. Works with his "signature," but dated after his accepted date of death, that is 972/1564–65, are considered problematic and listed separately.

Mention already has been made of Shah-Mahmud's orthography of al-Nishapuri, as well as his use of the laqab *al-shahi* (see above, notes 4 and 8). Occasionally he added *al-katib* after his name (e.g., BL Or. 2265, folios 192a, 259b, 396a; GL 2209; GL 2163), which can lead to confusion with a later scribe called Shah-Mahmud Katib in the English translation of the *Gulistan-i hunar* (Qazi Ahmad [Minorsky], 153). As mentioned in note 1, however, the Persian edition of the Qazi Ahmad text gives this scribe's name as Shah-Muhammad (Qazi Ahmad [Suhayli-Khunsari], 104). In one manuscript colophon, Shah-Mahmud styles himself *nurbakhshi*, meaning "light-bestowing" (IOL P&A 49). Much more typically, and formulaically, he refers to himself as *al-abd al-mudhnib* (the sinful servant) or *al-abd al-faqir al-mudhnib* (the lowly, sinful servant).
31. Forty-two manuscripts are accepted here as being by Shah-Mahmud contain dated colophons. There is an almost equal number of dated calligraphies (forty-four), but this is, of course, a much smaller percentage of the total known calligraphic oeuvre. It is interesting that, whereas Shah-Mahmud often includes the day, month, and year in his manuscript colophons, he gives the year only in the calligraphies—a difference that may have as much to do with the size and format of the qit'a as with a conscious distinction in record-keeping.
32. There is a likelihood that this manuscript has been refurbished. Folio 5b, for instance, contains a painting (which in and of itself is unexpected for such a text) in late-fifteenth-century style, which was clearly cut from a larger composition and inset into CB MS 232. The pink paper around the painting is, however, the same as on the other nine folios of the manuscript, suggesting that the margins also may have been replaced. The marginal illuminations include four different designs, found on facing folios: large floral arabesques within a lattice pattern, gazelles being chased by felines against a floral scroll, peafowl in foliage scroll, and mythical animals in a landscape. It may be that all the illumination in this manuscript, including the heading and colophon decoration, postdates Shah-Mahmud's original transcription of the text.
33. The interstices in these patterned folios are illuminated with gold floral designs. These, however, may not be original with Shah-Mahmud's transcription of the manuscript. Also clearly later are the large-scale bird and animal designs on the two initial folios (folios 1b–2a), in the margins at the beginning of each masnavi (folios 2b–3a, 42b–43a, 92b–93a, 124b–25a, and 167b–68a), in the margins of the illustrated folios (folios 73a, 84a, 104b, 112b, 133b, 137b, 141b, 145a, 150a, 156a, 160b, and 178b), and beneath the colophons (folios 42a, 92a, 124a, 167a, and 219a). The gold contours surrounding Shah-Mahmud's colophon texts are also probably not original. On the other hand, the elaborate opening shamsa (folio 2a) and the illuminated title pieces, each featuring a gold cartouche in the lower field and a sunburst projection above, at the start of each masnavi (folios 2b, 42b, 92b, 124b, and 167b) are original.
34. Other areas of the volume's illumination, which Shah-Mahmud may not have executed but which he may have either planned or approved, are even more lavish, with its opening folios receiving particular attention. In addition to being heralded on folio 1a by an exquisite two-part heading with the masnavi title written (presumably by Shah-Mahmud) in a minute hand and punctuated on folio 2a by a large and empty gold rubric panel, each of the verses on folios 1b–2a is surrounded in a blue contour panel, edged in gold and decorated with small gold stems and multicolored buds. The column dividers on these facing folios are illuminated with a vertical row of gold lozenges, each decorated in the center with a floral motif; the interstices between the lozenges are marked with a white cross or diamond on a black ground; and the

dividers are framed with blue and gold lines punctuated with white crosses. This strong, even unusual, decorative scheme also carries over into four of the manuscript's five illustrations, where the incorporated verses are set in blue or gold contour panels and the column dividers filled in with colorful lozenges (folios 45b, 58a, 61b, and 102b). More delicate decoration appears on folio 58a, where the triangular cornerpieces created by the diagonal position of the verses are illuminated in gold with dense floral designs.

The manuscript's binding is also of note and definitely appears to be original. The doublures are of rich, dark brown leather enhanced with intricate and brightly colored filigree medallions and borders. The outer, painted and lacquered binding represents two scenes of princely entertainment executed in exquisite early Safavid style. Although there is little question here of any direct involvement on the part of Shah-Mahmud (who is not known to have been talented in binding), these beautiful and rich covers offer final proof of the value of the codex that he had so beautifully copied.
35. It is possible to see the impression of the mistar, or grid, that Shah-Mahmud followed on folio 143b.
36. The deluxe character of this Hafiz manuscript is also signaled by its rubrics. These cut across the entire width of the written surface and are richly illuminated in a great variety of designs. The basic rubric form consists of a central gold cartouche, with the text in white or blue (perhaps not by the hand of Shah-Mahmud), flanked by a pair of pendants or half-pendants and surrounded by a bright blue ground with colored floral scrolls. Also noteworthy is the sumptuous illuminated surround of the preface on its initial folios (folios 1b–2a). The double-page layout here recalls manuscripts of the late Timurid period and features a vertical block with six lines of text, obviously written by Shah-Mahmud.
37. Schimmel (*Calligraphy*, 30) points to this work as "one of the very few specimens of a whole Koran in the hanging style which is not aesthetically well suited to Arabic."
38. Safadi (p. 28) states that Shah-Mahmud made this Koran for Shah Tahmasp. The calligrapher's colophon (which is preceded by a lengthy encomium to the fourth imam) makes no specific reference to any patron; the phrase *mulk alam* (Almighty), written in gold, clearly refers to God. Complicating the matter, the manuscript opens with a shamsa on folio 1a, containing a dedication (beginning *birasm-i kitabkhana* . . .) to Sultan Muhammad Bahadur Khan. This rosette is pasted in and therefore not original to the manuscript, although the style of its illumination is consistent with the sixteenth century. It is possible that the dedicatee was Muhammad Khudabanda, fourth ruler of the Safavid dynasty (r. 985–96/1578–88). On the other hand, the manuscript's binding is clearly Ottoman, comparable to that of the *Süleymanname* (Book of Suleyman) of mid-Ramadan 965/late June–early July 1558 (TKS H. 1517; repro.: Atil, *Süleymanname*, 81–82). The shamsa dedication may refer to a late Ottoman owner of Shah-Mahmud's Koran, and both it and the binding may have been added to the manuscript in Turkey.

The lack of any specific mention of Shah Tahmasp in Shah-Mahmud's Koran does not, of course, rule out the Safavid monarch as the manuscript's patron. Indeed, it is tempting to speculate that TKS H.S. 25 is the Koran sent by Tahmasp, along with his splendid *Shahnama*, to Turkey in 1567 as part of the Safavid gifts to Selim II upon his accession to the Ottoman throne. For an account of the Safavid embassy to the Ottoman court, see Dickson & Welch, 1:270.

Shah Mahmud has been credited with the transcription of another Koran, also said to have been made for Shah Tahmasp. See *Treasures*, cat. no. 66. The format and calligraphy of this Koran are quite different, however, from those of TKS H.S. 25.

39. While hardly the biggest Koran in existence, the volume is definitely larger than an average Safavid manuscript (sheet: 37.5×26 cm; written surface with rulings: 21.3×12.9 cm). It is unusual that the gold dusting, which was applied to the sheet before Shah-Mahmud began to write the text, is limited to the written surface and rulings and does not continue out into the margins.

40. The shah's name appears in the palace frieze in the illustration of *Khusraw Enthroned* (folio 60b, repro.: S. C. Welch, *WA*, cat. no. 57). It is interesting that the manuscript contains no actual "dedication" or documentation of its commission such as the kitabkhana inscription in Tahmasp's *Shahnama* (folio 16a, repro.: S. C. Welch, *WA*, cat. no. 5).

41. Although all the scholarly sources mention the refurbishment, with particular reference to three paintings by Muhammad Zaman dated 1086/1675–76, there seems to have been no systematic attempt to identify the other folios that sustained major modification in the same, late-seventeenth-century, campaign. It is easy enough to see (and indeed, this also has been noted) where certain original illustrations have been cut out and remounted with new borders (e.g., folios 18a and 77b, repro.: S. C. Welch, *WA*, cat. nos. 51 and 56). It is much more difficult to pick out the replacement borders on other folios, especially since there was obviously a great effort, as can be seen on the illustrated folios just cited, on the part of the "refurbishers" to replicate the original border designs. Text folios (i.e., not illustrated) that seem to have replacement borders include folios 82, 152, 175, 220, 227–28, 248, 272, 286, and 325.

42. The tone of the paper varies from very white cream to dark cream, as can be observed even on the colophon folios (where the written surface, at least, is presumed to be original). This coloration may have resulted from uneven "aging" over the centuries. It is also possible that Shah-Mahmud used different batches of paper during the three years he spent copying the text. There are also very slight variations in the dimensions of the written surface, as measured on the colophon pages: 21.7×13.2 cm (folio 35a), 21.8×13.1 cm (folio 128a), 21.8×12.9 cm (folio 192a), 21.2×12.9 cm (folio 259b), and 21.8×13 cm (folio 396a).

It is interesting to note that neither of Shah Tahmasp's major manuscript projects, that is, his *Shahnama* and *Khamsa*, has margins of different colors, as are found in so many other Safavid manuscripts, including the Freer Jami. It may be that the shah's taste did not extend to such coloristic contrasts.

43. Qazi Ahmad [Minorsky], 135; Qazi Ahmad [Suhayli-Khunsari], 87. Malik al-Daylami also seems to be referring to Shah-Mahmud when he cites "Shaykh-Mahmud zarin-qalam, who wrote a *Khamsa* in the ghubar script" (Malik al-Daylami [Mehdi Bayani], 3–4:606; Malik al-Daylami [Thackston], 352).

44. The mistar of horizontal and vertical lines that Shah-Mahmud used to create this layout is clearly visible on the blank versos of three of the colophon pages (folios 35a, 128a, and 192a). The dimensions of the written surface (21.7×12.9 cm) are virtually identical to those of the 945/1538 Koran (21.7×12.9 cm, including rulings).

45. The volume opens on folios 1b–2a with two illuminated shamsas with empty gold roundels, perhaps intended for either a dedication to Tahmasp or the title of Nizami's texts (or both; folio 1b, repro.: S. C. Welch, *WA*, 135). These are followed on folios 2b–3a by a splendid text surround (usually referred to as a frontispiece; folio 2b, repro.: S. C. Welch, *WA*, 137) that is very similar to the opening pages of the 945/1538 Koran (TKS H.S. 25). The arabesques in the *Khamsa* frontispiece illumination have been signaled out for particular praise (S. C. Welch, *WA*, cat. no. 49).

The decoration immediately around Shah-Mahmud's calligraphy on folios 2b–3a is also

noteworthy; each line is enframed in pricked gold contour lines, and the gold background is filled with minute blue sprigs and leaves, some in their own contour lines. Certain elements are even more intricate, such as the multiple medallions, linked by a skein of white lines, that flank the central cartouches in the four rectangular panels above and below the opening lines of the text. As in the Koran, Shah-Mahmud inscribed the central cartouches, containing Nizami's names and the titles of his five poems, in white riqa' outlined in black.

The *Khamsa* manuscript includes many illuminated rubrics that occupy the middle two text columns of the page and feature central gold cartouches of various forms. The script in the rubric text also varies: sometimes it is written in colored *naskh* (an early cursive script), sometimes in white nasta'liq with black outlines, and other times, especially in the *Khusraw u Shirin* section of the text, in rather spindly looking nasta'liq in white, blue, or red.

This lack of uniformity (and in some cases rather sloppy execution) suggests that Shah-Mahmud may not have been the *Khamsa*'s rubricator. Someone other than Shah-Mahmud also may have inscribed the large white titles in the masnavi headings (folios 36b, 129b, 193b, 260b, and 349b), which may date from the manuscript's reburbishment.

As in many deluxe Safavid manuscripts, the Tahmasp *Khamsa* contains folios with text written on the diagonal and illuminated triangular cornerpieces. It appears, however, that not all these folios are original. For instance, folio 83a is laid out for diagonal verses on lines 3, 6, 9, and 12, but there is text only in the first and final pair of diagonal panels. Yet all the triangular cornerpieces on folio 83 have been illuminated. This decoration may indicate that the folio is a complete replacement and that someone was willing to replicate the original illumination but not Shah-Mahmud's calligraphy.

46. These manuscripts also have illustrations, although those in BN suppl. pers. 1919 (folios 17a and 32b) have been repainted and those in BN suppl. pers. 1967 (double-frontispiece) are not original. The two small illustrations in IOL P&A 49 (folios 61b and 133b) are small and simple compositions that combine Turcoman and Timurid elements and thus hark back to a painting style no longer generally employed at the time Shah-Mahmud copied this manuscript.

47. This manuscript contains two illustrations (now removed and numbered FGA 35.19 and 35.20) that are finely painted but stylistically quite different from compositions usually associated with Tabriz.

48. Dickson & Welch (1:27B) state apropos the finispiece that "by 1549, it was in the hands of Sam Mirza for whom it was bound as a tailpiece into a superb manuscript of Jami's *Chain of Gold*, copied at Ardabil by Shah-Mahmud of Nishapur." I have found no internal evidence to link either the manuscript or its inserted finispiece to Sam Mirza.

49. The specific rubric types of the *Silsilat* (*a* and *b*), for instance, are similar to the Freer Jami. Also like the *Haft awrang*, this manuscript was part of the Abbas waqf to the Ardabil shrine, as evidenced by the donation inscription and waqf seal on folio 1a.

50. See Dickson & Welch, 252B n. 12, for a discussion of the patronage of this manuscript, as well as the attribution of its six line drawings.

51. The folios in both CB MS 342 and CB MS 346 consist of single sheets of cream-colored paper with gold-flocked margins; those in TKS E.H. 681 are composed of thin white text paper inset into yellow (folios 1–7) or blue (folio 8) gold-flocked margins; in CB MS 227 the margins are of marbleized paper in pink and blue with gold flocking. The margins in TKS H. 2248 are also elaborate: the written surfaces are enframed in brightly illuminated borders, with a different design on each pair of facing folios and the margins decorated with painted and stenciled designs in gold on multicolored paper.

52. The text actually begins with a prose preface; in the first two volumes this is transcribed on the first page (TKS E.H. 681, folio 1b, ten lines; CB MS 342, folio 1b, nine lines), whereas in the latter three it spreads out over a double page (TKS H. 2248, folios 3b–4a; CB MS 227, folios 1b–2a [only one line remains at the bottom of folio 2a; the rest of the text has been erased to accommodate a single-figure study drawn in mid-seventeenth-century style]; CB MS 346, folios 1b–2a).

The first and fourth panels of Jami's poetry, each with a single verse at the top and bottom of the written surface, are written on the horizontal and inset from the sides of the written surface; the second and third contain two verses written on the diagonal.

53. Each of these illuminations has its peculiarities: the heading in TKS E.H. 681, folio 1b, is in delicate early Safavid style but seems a bit small in proportion to the written surface it precedes; the colors of the heading in CB MS 342, folio 2b, are garish, and the entire lower field clearly has been pasted in, as can be seen on the recto of the folio; five faces with leafy headdresses and collars are incorporated into the illumination of the heading in CB MS 227, folio 1b; and the colors of the heading in CB MS 346, folio 1b, are of a pale tonality unusual for sixteenth-century illumination.

TKS E.H. 681, the earliest of these manuscripts, also has illuminated column dividers between the top and bottom lines of Persian verse, consisting of floral motifs in blue and gold. CB MS 227 has a large, shamsalike medallion on folios 1a and 9b, apparently added by a subsequent owner of the manuscript. The last volume, CB MS 346, contains the most elaborate illumination, including a round shamsa in Timurid style (folio 1a; this device has definitely been pasted on and embellished with two pairs of pendant medallions) and bands of multicolored floral and bird scrolls on gold stems flanking the preface text (folios 1b–2a). In addition, the two lines of Shah-Mahmud's colophon, written on the horizontal and enframed as a rectangular panel, are illuminated with contour panels of pairs of white buds, orange and green leaves, and green stems against a gold ground. Beneath the illuminated colophon are three panels (corresponding to the last panel with diagonal text and the two with horizontal text) filled with large floral scrolls with multicolored blossoms and gold stems and leaves and punctuated with clusters of blue dots. The cornerpieces in this manuscript recall those in the Freer Jami.

54. Qazi Ahmad [Minorsky], 135; Qazi Ahmad [Suhayli-Khunsari], 87 (here the key adjective is *biza*, meaning "unique").

55. The difference may be seen, for example, in two pieces mounted side-by-side in TKS H. 2151, folio 85b.

56. Sometimes a sequence of folios has been so mounted in album form, and it is still possible to identify the original text (if not the original manuscript). These are included in the manuscript section within Shah Mahmud's oeuvre in Appendix E (e.g., BN suppl. pers. 1954, dated 934/1527; TKS H. 2248, dated Rabi' I 962/January–February 1555).

57. In 964/1556–57 Shah-Mahmud penned verses around another painting, this one depicting a horse and a kneeling youth playing the sitar (TKS H. 2169, folio 57b).

168
Colophon folio
Signed by Rustam-Ali
in the *Divan* of Hafiz
947/1540–41, Iran, Tabriz
35.5×23.5 cm (folio)
GULB LA 165, folio 166a
Calouste Gulbenkian Foundation, Lisbon

169
Calligraphy (detail of signature)
Signed by Rustam-Ali
in the Shah Tahmasp album
945/1538–39, Iran
IUL F. 1422, folio 69b
Istanbul University Library

270 CHAPTER THREE: PATRON AND ARTISTS

The name of Kamaluddin Rustam-Ali immediately follows that of Shah-Mahmud in Dust-Muhammad's roster of notable calligraphers at the royal library during the reign of Shah Tahmasp.[1] After introducing him as a writer of large (jali) and small (khafi) script, Dust-Muhammad praises Rustam-Ali as "foremost among modern calligraphers in colored ink [rang-niwisi] and in proficiency."[2] This high opinion was echoed by Malik al-Daylami in his introduction to the Amir Husayn Beg album of 968/1560–61, where Rustam-Ali's name is modified by the adjective "superb," and later by Qazi Ahmad, who notes that the calligrapher "wrote excellently."[3]

Like Shah-Mahmud, Rustam-Ali had a long career, which he, too, seems to have begun in his native Khurasan, judging from a manuscript copied in Herat in 919/1513–14 (SJML A/N 241 M. no. 19). Qazi Ahmad first places the artist in the kitabkhana of Bahram Mirza; this post could have been held in the 930s/1530s while the prince was governor of Khurasan.[4] By at least 947/1540–41, Rustam-Ali was in Tabriz, where he copied a *Divan* of Hafiz (GULB LA 165; fig. 168). In the colophon of this manuscript Rustam-Ali signed himself *al-shahi*, indicating that he had already found favor, and presumably also employment, with Shah Tahmasp. In fact, this association may have begun two years earlier, as suggested by a qit'a that Rustam-Ali dated 945/1538–39 and signed with the laqab *shahi* (IUL F. 1422, folio 69b; fig. 169). That he was still working for Tahmasp in 951/1544–45 is confirmed by Dust-Muhammad in the introduction to the Bahram Mirza album; that he enjoyed the shah's continued esteem is revealed in the regular appearance of the royal laqab in his signatures.

Although Rustam-Ali's surviving oeuvre does not include any manuscripts that can be definitely linked with the shah, Tahmasp's album does contain a pair of telling qit'as (IUL F. 1422, folios 69a, top right, and 70b, bottom right; fig. 170). Both poems address the shah, praising his justice and leadership; the second also invokes blessings on his life and rule. It may be that Rustam-Ali wrote these formulaic pieces for or on a special occasion, such as Nowruz (the Persian new year), for direct presentation to Tahmasp.[5] The Bahram Mirza album preserves a more unusual work from the hand of Rustam-Ali. This qit'a was written "by order of his highness the shah" for a certain Ibrahim "the keeper of the ink" [or secretary of state] (TKS H. 2154, folio 140a, right). Here Tahmasp himself apparently directed the calligrapher and designated the recipient of his work, presumably a member of the Safavid court whom the shah wished to favor.

170
Calligraphy
Signed by Rustam-Ali
in the Shah Tahmasp album
undated, Iran
IUL F. 1422, folio 70b, bottom right
Istanbul University Library

171
Calligraphy
Signed by Rustam-Ali and cut by Muzaffar-Ali
in the Bahram Mirza album
undated, Iran
49×35.2 cm (folio)
TKS H. 2154, folio 142b, top right
Topkapi Sarayi Müzesi, Istanbul

172
Illuminated frontispiece
Copied by Rustam-Ali
in the *Divan* of Hafiz
947/1540–41, Iran, Tabriz
35.5×23.5 cm (one folio)
GULB LA 165, folios 1b–2a
Calouste Gulbenkian Foundation, Lisbon

Eventually Rustam-Ali left the service of the shah and moved to Mashhad, where he was employed in the kitabkhana of Sultan Ibrahim Mirza for seven years. Qazi Ahmad does not give any dates, saying only that the calligrapher was then "in his old age."[6] Presumably Rustam-Ali's service with Ibrahim Mirza began before Shawwal 963/August 1556, when the calligrapher completed his portion of the *Haft awrang*, although the colophon to the *Tuhfat al-ahrar* does not specify his whereabouts at that particular moment.[7] In any event, Qazi Ahmad reports that Rustam-Ali died in Mashhad in 970/1562–63 and was buried beside the tomb of Sultan-Ali Mashhadi, where Shah-Mahmud was also to be interred two years later.[8]

Unlike that of his prodigious contemporary, Rustam-Ali's recorded oeuvre is modest, consisting today of some twenty qit'as, all still mounted in their original albums, and three dated manuscripts. Most of his calligraphic specimens follow the standard qit'a format; many are written on white or cream paper in bold, black nasta'liq, while others are on colored paper and/or in colored ink. Rustam-Ali invariably copied the text of a qit'a in one color and signed it in another and always wrote the laqab *shahi* or *al-shahi* in gold. He seems to have particularly liked pink paper for his writing surface, bright blue ink for the text, and white ink for the signature (e.g., TKS H. 2154, folio 141a). He also wrote qit'as in yellow ink on blue paper and pink ink on brown paper (TKS H. 2156, folio 21a; and TKS H. 2154, folio 142b, top right; fig. 171). These colorful works confirm the calligrapher's reputation, as promoted by Dust-Muhammad, for rangniwisi.

Rustam-Ali's oeuvre also demonstrates that he had the opportunity to work on full-scale, deluxe manuscript projects. The *Divan* he copied in Tabriz in 947/1540–41 and signed with the laqab *al-shahi* was originally quite a large manuscript, judging from the scale of its opening pages (GULB LA 165). These contain an elaborate double-page illumination with four cartouches inscribed with the title of Hafiz's work and twelve lines of text enclosed in contour panels (folios 1b–2a; fig. 172). The final folio is also illuminated with dense gold scrollwork around Rustam-Ali's triangular colophon (folio 166a). The manuscript originally was intended for illustration, another marker of its deluxe status.[9]

There is a gap of more than fifteen years between the creation of this *Divan* and the next—and, equally significant, the last—manuscript project known from the hand of Rustam-Ali. Like that of his contemporary Shah-Mahmud, Rustam-Ali's contribution to the *Haft awrang* was modest, comprising only twenty-four folios of the *Tuhfat al-ahrar*, one of Jami's shortest masnavis (FGA 46.12, folios 200b–224b; fig. 173). The initial impression of the calligrapher's nasta'liq (black for

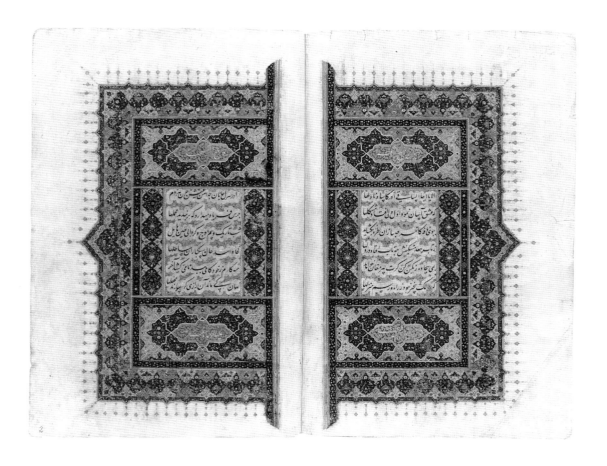

the text, blue and orange for the rubrics) is one of boldness and vigor; closer examination reveals a certain shakiness in the outer contours of many letters. Yet the overall layout and visual effect of the folios are often distinctive, as on several sets with diagonal lines where Rustam-Ali oriented verses from upper right to lower left, as well as the more familiar lower right to upper left (folios 206b–7a, 214a–15a, and 220b–21a; fig. 174). The illumination of these folios adds to their appeal and exhibits great consistency in the design elements, including the regular appearance of human faces and the color scheme of predominantly mauve and blue tones. Some of the rubric illuminations in the *Tuhfat* are also eye-catching (as in the blue and white palette of the bottom rubrics on folios 204a and 212a) and certainly more varied than in the *Subhat al-abrar* copied by Shah-Mahmud. At the same time, the masnavi heading for the *Tuhfat* is the smallest one in the Freer Jami and lacks the upper rectangular field characteristic of the seven others. Such a noticeable difference in the treatment of the beginning of the poem may be significant in terms of Sultan Ibrahim Mirza's interest in this section of the *Haft awrang* text—and perhaps equally telling in terms of Rustam-Ali's place within the Freer Jami project.

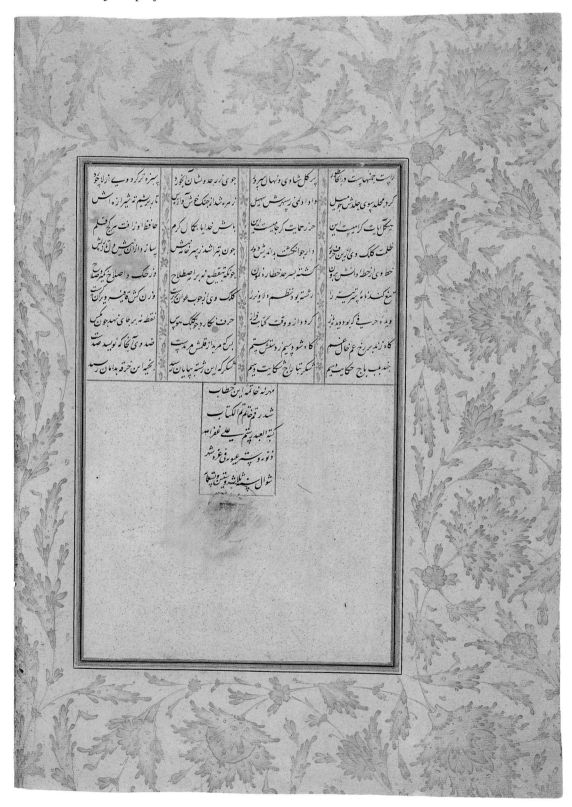

173
Colophon folio of *Tuhfat al-ahrar*
Signed by Rustam-Ali
in the *Haft awrang* of Jami
963/1556, Iran
34.5×23.4 cm (folio)
FGA 46.12, folio 224b

174 *(overleaf)*
Text folios of *Tuhfat al-ahrar*
Copied by Rustam-Ali
in the *Haft awrang* of Jami
963/1556, Iran
34.5×46.8 cm (two folios)
FGA 46.12, folios 214b–15a

کوشش نجوده دارد روز خود تو کند کم
آب حیات است مرا خاک نشان
جامی ازین مرده دلان کشته کم
زنده شدم از نظر پاکنشان

وی بسخن بادره در کار آمده
بر خط حکم تو نهند بر فلک
گر کشتی از آن نقطه زبانت زیل
نقط نطقت ترا بر زبان
ای زبان شکست گذار آمده

چونکه تهی شد از صد اپرست
خم پر از باده تهی از صدق است
ولوله طبل زیبه از معنی است
کفن بیارهها ازبغویی است

کیسه تهی ماند از لعل و زر ست
بسوزن رعناکه زبان و پرست
لعل وزرش بین که ردبین
پنجه که بنو دبه هاش ز بان

پیچ طبع است در کن کنده کج
حوصله تنک حدیث فراخ
پیچ بدین کر وش ام حویش
جرخه حلاج مزاران حروش
پرسنده ذنانت صافی پرخویش
پیش صفت آدب تو پردکش
کرده زبان متبع پای سخن
خنده شوی پرده در و صفت شکن
کرسخن خالصیت رکیت
موجب صدکوه پردکنده کیت
زندگی افروی دل زنده را
ورد مکن قول پراکنده را
چشم برآمد سداانفاس پس دار
وین دوسه نوآمده در باس دار
هرنفس ازوکه بهبو لی وشیت
قایل نقش خوش نشت خوشت

The paucity of Rustam-Ali's oeuvre (perhaps an accident of history) and his limited involvement with the ambitious *Haft awrang* project (perhaps a function of advancing age) should not diminish the fact that he attained considerable recognition as a calligrapher among his contemporaries and consistent favor among members of the Safavid family. His real significance within the history of Safavid art, however, may be more as a link in the chain of cultural heritage and transmitter of artistic traditions than as a creator or an innovator. This role began virtually at birth: as is well known, Rustam-Ali was the nephew of the celebrated painter Bihzad, who rose to fame at the court of the last Timurid ruler and ended his career at that of the early Safavids.[10] Rustam-Ali's distinguished family lineage, which surely would have enhanced, and perhaps even determined, his career, is matched by his professional training. According to Malik al-Daylami, Rustam-Ali was a student of Sultan-Ali Mashhadi (d. 10 Rabi' 1 926/29 February 1520), the most revered calligrapher of the late Timurid–early Safavid period, next to whom he was buried.[11] Malik goes on to describe Rustam-Ali as "the intermediary through whom Hafiz Baba Jan Udi, the present writer [Malik], and master Muzaffar-Ali derive their discipline from Sultan-Ali."[12] In other words, Rustam-Ali had pupils to whom he taught the calligraphic arts that he had learned from one of its foremost practitioners. Muzaffar-Ali was actually the son of Rustam-Ali's sister and collaborated with his master-uncle on a découpage in the Bahram Mirza album.[13] Rustam-Ali wrote the qit'a in light pink and white ink, and Muzaffar-Ali cut the verses out and presumably also affixed them to their brown paper (TKS H. 2154, folio 142b, top right; see fig. 171).[14] Rustam-Ali also collaborated, in a manner of speaking, with his pupil Malik al-Daylami during the preparation of the Freer Jami, completing the transcription of his masnavi just slightly before Malik finished the first daftar of the *Silsilat al-dhahab*. In addition, Rustam-Ali was doubtless responsible, in whole or in part, for training his own son, Muhibb-Ali, who rose to prominence as a calligrapher in the service of Sultan Ibrahim Mirza, even occupying the important position of kitabdar at the prince's kitabkhana and copying two sections of the Jami manuscript.

In short, Rustam-Ali both belonged to the first generation of Safavid artists associated with the Freer Jami and spawned the second. He was thus the lynchpin in a succession of calligraphers and painters who constituted the artistic heritage to which Sultan Ibrahim Mirza was heir and his *Haft awrang* the grand finale.

CHAPTER THREE: PATRON AND ARTISTS

1. Primary sources: Dust-Muhammad [Mehdi Bayani], 1–2:200; Dust-Muhammad [Thackston], 347; Iskandar Beg Munshi [Afshar], 1:170; Iskandar Beg Munshi [Savory], 1:266; Malik al-Daylami [Mehdi Bayani], 3–4:606; Malik al-Daylami [Thackston], 352; Qazi Ahmad [Ishraqi], 1:247A n. 11; Qazi Ahmad [Minorsky], 3, 7, 24, 147, 186; and Qazi Ahmad [Suhayli-Khunsari], 100, 141.

Secondary sources: Mehdi Bayani, 1–2:207–9 (two successive entries here seem to deal with the same person: no. 326, Rustam-Ali Khurasani; and no. 327, Rustam-Ali Shahi; some of the information provided by Mehdi Bayani cannot be verified); Binyon et al., 186; Dickson & Welch, 1:155A, 246B n. 4, 247A–B n. 11, 250A–B nn. 6–8, Huart, 223; A. Welch, *Artists*, 152; and A. Welch, "Patrons," 11.

2. Dust-Muhammad [Mehdi Bayani], 1–2:200; Dust-Muhammad [Thackston], 347. According to an unidentified sixteenth-century source, Dust-Muhammad and Rustam-Ali were close contemporaries or associates and possessed equal skills in calligraphy (Dickson & Welch, 1:247A–B n. 11 [where the source is incorrectly identified as Qazi Ahmad's *Khulasat al-tawarikh*]; Shafi, 29). This relationship may explain the prominence Dust-Muhammad gives Rustam-Ali.

3. Malik al-Daylami [Mehdi Bayani], 3–4:606; Malik al-Daylami [Thackston], 352; Qazi Ahmad [Minorsky], 147; Qazi Ahmad [Suhayli-Khunsari], 100.

4. I know of no extant works of art that Rustam-Ali executed for Bahram Mirza. That the prince admired Rustam-Ali is evidenced, however, by the selection of the calligrapher's qit‘a in the Bahram Mirza album (TKS H. 2154). Dickson & Welch (1:250A n. 6) assert that Rustam-Ali had been especially close to Bahram Mirza until the prince's death in 1549. Their source is Qazi Ahmad who, in fact, says only that the calligrapher worked in the prince's kitabkhana (Qazi Ahmad [Minorsky], 147; Qazi Ahmad [Suhayli-Khunsari], 100). A. Welch (*Artists*, 152) extrapolates further and states that Rustam-Ali "had been with Bahram Mirza during that prince's governorship in Hamadan from 1545 to 1549, and on Bahram's death in that year he almost certainly transferred his service to the young prince [Ibrahim Mirza]." Bahram Mirza was indeed governor of Hamadan from around 952/1545–46 until his death in Ramadan 956/October 1549. By that time, however, Rustam-Ali was in Tabriz, as will be discussed momentarily.

5. Neither work actually mentions Tahmasp by name. In the first piece the word *shah* is written in the first bayt in gold and in the second bayt in pink (IUL F. 1422, folio 69a, top right). Similar qit‘as were written by Shah-Mahmud and Shaykh-Muhammad, and likewise mounted into Tahmasp's album (e.g., IUL F. 1422, folios 10a and 65a).

6. Qazi Ahmad [Minorsky], 147 (this text lacks the reference to seven years); Qazi Ahmad [Suhayli-Khunsari], 100. It is interesting that Qazi Ahmad makes no mention of Rustam-Ali's service to Shah Tahmasp in either the *Gulistan* or the *Khulasat*; this absence may be what misled A. Welch to propose that Ibrahim Mirza "inherited" Rustam-Ali upon his father's death in 1549 (see above, note 4).

7. The year 963 fits with what Qazi Ahmad reports about the length of time of Rustam-Ali's service to Ibrahim Mirza and with the calligrapher's year of death (also as per Qazi Ahmad, see below). It is interesting to note that Rustam-Ali's signature in the *Haft awrang* does not contain the *al-shahi* laqab, suggesting that this honorific was a sign of particular employment rather than a general, lifetime title.

8. Qazi Ahmad [Minorsky], 147; Qazi Ahmad [Suhayli-Khunsari], 100.

9. The codicology of the manuscript is complicated, and it is difficult today to reconstruct its original appearance completely. The folios have been remargined with colored borders (light blue, salmon, pink, and yellow) and stenciled designs of angels, animals, and birds as well as geometric patterns. This refurbishment may have taken place during the first quarter of the seventeenth century, the period to which the manuscript's four paintings may be dated on stylistic grounds (folios 91a, 121b, 135a, and 145a; Gray, *OIA*, cat. no. 142, identifies only three). The manuscript's leather binding was restored following a flood at the Gulbenkian in 1967.

The manuscript's full folios currently measure 36×23.4 cm, which may approximate the original dimensions. The written surfaces do not seem to have been refurbished; they measure an average 22×13 cm (without the rulings), essentially the same size as the Freer Jami.

10. Qazi Ahmad specifies that Rustam-Ali was the son of Bihzad's sister (Qazi Ahmad [Minorsky], 147; Qazi Ahmad [Suhayli-Khunsari], 100).

In a brief discussion of Bihzad's family, Dickson & Welch (1:155A, 250A–B n. 7) speculate that the famous artist had two sisters, one the mother of Rustam-Ali and the other of the painter Haydar-Ali. They also propose that Rustam-Ali in turn had a sister who married their cousin Haydar-Ali. The fruit of this union was Muzaffar-Ali, who became a pupil of his maternal uncle Rustam-Ali.

11. Malik al-Daylami [Mehdi Bayani], 3–4:606; Malik al-Daylami [Thackston], 352. Malik places Rustam-Ali at the end of a long listing of Sultan-Ali's students, which includes Abdi Nishapuri. As discussed in the preceding section of this chapter, Abdi was the uncle and teacher of Shah-Mahmud al-Nishapuri, who here is regarded as a contemporary of Rustam-Ali, as may be confirmed by their parallel careers and close death dates. It may be that Rustam-Ali was a late student of Sultan-Ali Mashhadi (hence his position at the end of Malik's list), or that Malik was mistaken. Qazi Ahmad does not include Rustam-Ali in his list of Sultan-Ali's students (Qazi Ahmad [Minorsky], 106; Qazi Ahmad [Suhayli-Khunsar i], 64), nor does he mention Rustam-Ali's training. *EIr*, Priscilla P. Soucek, "Behzad" (p. 115), states that Rustam-Ali "is known to have been trained at Tabriz," without specifying a source. Rustam-Ali's proficiency in jali and khafi scripts, commented upon by Dust-Muhammad (see note 2, above) may reflect diligent adherence during his student days to Sultan-Ali's reported dictum: "At daytimes one should practice the small hand, khafi, in the evening the large one, jali" (Schimmel, *Calligraphy*, 38).

12. Malik al-Daylami [Mehdi Bayani], 3–4:606; Malik al-Daylami [Thackston], 352.

13. For Muzaffar-Ali, see Dickson & Welch, chapter 6; and Simpson, "Bahram Mirza," 379–81 (with a listing of primary and secondary sources, 380 n. 21). A. Welch (*Artists*, 152) says that Muzaffar-Ali "is known to have been a member of Ibrahim's atelier and must surely have been one of the leading painters for the manuscript." This assertion seems to be based on the attributions in the secondary literature (notably Dickson & Welch) and is not corroborated by any primary sources.

14. Dickson & Welch (1:155A) state that the Bahram Mirza album contains several joint works by Rustam-Ali and Muzaffar-Ali; the one on folio 142b is the sole example known to me.

MUHIBB-ALI

The second generation of Safavid artists who worked on the *Haft awrang* begins with Muhibb-Ali, reputedly the favorite son of Rustam-Ali.[1] Like his father, Muhibb-Ali had ties to the Safavid family before becoming involved with Sultan Ibrahim Mirza. Sam Mirza comments that Muhibb-Ali "was with me for a while," clearly meaning prior to 957/1550 when the prince composed his *Tuhfa-yi Sami*.[2] This vague remark is preceded by more specific—and rather tantalizing—information on the artist's biography and character: "He is from Herat and plays the nay well and his nasta'liq script is not bad, but he is without inhibitions, independent, has very good taste and is witty." Sam Mirza goes on to report that Shah Tahmasp subsequently "gave" Muhibb-Ali to a sayyid known as Sayyid Mansur Kamana, whom Muhibb-Ali first offended and then amused with a joke concerning a farting camel and Arabic poetry.[3] This anecdote is presumably intended to illustrate Muhibb-Ali's cleverness, just as the verses with which Sam Mirza concludes his entry demonstrate the calligrapher's reputation as a poet.

Qazi Ahmad says nothing of Muhibb-Ali's early career and starts his account at the point when the calligrapher was *kitabdar* (literally meaning "librarian," but more accurately "head of the kitabkhana") to Sultan Ibrahim Mirza. It is likely that Muhibb-Ali took up this position at about the time the prince came to Mashhad, that is, the spring of 963/1556, although, like Shah-Mahmud al-Nishapuri, he could have already been in Khurasan. In any event, he certainly was in both place and post the following spring, specifically Rajab 964/May 1557, when he signed the *Yusuf u Zulaykha* masnavi of the *Haft awrang* (FGA 46.12, folio 139a; fig. 175, see also fig. 12): "Muhibb-Ali, the librarian, in the holy, the illustrious, the purified Mashhad."

According to Qazi Ahmad, Muhibb-Ali served the prince for eight years.[4] That his service continued for at least that period, which included Ibrahim Mirza's first removal from Mashhad, is confirmed by the last colophon in the Freer Jami, which Muhibb-Ali completed in Herat in Shawwal 972/May 1565. From this information we also may infer that Muhibb-Ali joined Ibrahim Mirza during (or at least after) the Safavid expedition to quell Qazaq Khan Takkalu, the rebellious governor of Herat. The *Sharafnama* records that the participants in the expedition (which other sources record as drawing to a successful close in either Rabi' II or Jumada II 972/November 1564 or January 1565) spent the winter in Herat. Evidently Ibrahim Mirza and his kitabdar stayed on through springtime.[5]

It is worth noting that Qazi Ahmad introduces the calligrapher as Muhibb-Ali Ibrahimi and mentions that Sultan Ibrahim Mirza's kitabdar signed his name as *Ibrahimi*. In fact, Muhibb-Ali did not include this laqab in either of his *Haft awrang* colophons, although he did use it as part of his signature to a presumably contemporary qit'a (TKS B. 407, folio 40a; fig. 176). We are disabused of any sense of implied modesty here, however, by what Qazi Ahmad goes on to report. "When Muhibb-Ali became kitabdar, he was no longer satisfied and had total access to the prince's temperaments and interfered in governmental affairs."[6] This observation certainly fits with what Sam Mirza previously had to say about the artist's forceful personality; and whereas Muhibb-Ali had once offended and joked with a patron, it now sounds as if he tried to manipulate or dominate one. Perhaps it was concern about such influence that caused Shah Tahmasp to remove Muhibb-Ali from his post, although the calligrapher's dismissal may have been a direct consequence of Ibrahim Mirza's own final ouster from Mashhad in 974/1566–67.[7]

Whatever the explanation for Muhibb-Ali's removal from Mashhad, it was coupled with a royal summons to Qazvin.[8] After spending some time in the Safavid capital, Muhibb-Ali obtained permission to go on pilgrimage. He then returned to Qazvin, where he died; his body was taken to Mashhad and buried next to that of his father, Rustam-Ali. An epithet quoted by Qazi Ahmad ends with a chronogram giving the year of Muhibb-Ali's death as 973/1656–66.[9] In fact, Muhibb-Ali was still alive and professionally active in 978–79/1570–72, when he copied a deluxe volume containing six of the seven masnavis of Jami's *Haft awrang* (TKS H. 1483).

Muhibb-Ali's improbably sparse oeuvre provides no other clues to his biography. The surviving works do confirm, however, Qazi Ahmad's comment that the calligrapher wrote in large and small script. The three known qit'as also exhibit a certain calligraphic and coloristic flair; they are all written in very dark and bold nasta'liq, which in two cases stands out quite dramatically against a bright blue ground decorated with an irregular dusting of small gold sprinkles and larger gold flecks (TKS H. 2151, folio 52b; TKS H. 2156, folio 37a; fig. 177). Muhibb-Ali's signature is also distinctive: he seemed to like to superimpose the two parts of his name and extend the final letter of each into two essentially mirror-reversed parallel curves (TKS H. 2151, folio 52b; TKS H. 2156, folio 37a; FGA 46.12, folios 139a and 272a).

Muhibb-Ali's two extant manuscripts also demonstrate his talents in large and complicated projects. The *Haft awrang* made for Sultan Ibrahim Mirza may have been Muhibb-Ali's responsibility from start to finish inasmuch as he was its patron's kitabdar. Traditionally, a kitabdar was the head of a kitabkhana and directed its activities, including the making and collecting of books.

While Muhibb-Ali may have been in charge of everything related to Ibrahim Mirza's patronage of the arts of the book, it is just as feasible that his duties involved the *Haft awrang* only. And within that complex project he could have been the designer of the manuscript's layout and visual program and/or the principal coordinator for all the subsequent steps of its transcription, illumination, illustration, and collation. Or perhaps he was primarily responsible for "quality control" and scheduling among the calligraphers—that is, for ensuring that the seven masnavis were copied to the prescribed standard and submitted to the kitabkhana in a timely fashion. Certainly he copied a larger proportion of the manuscripts (two poems, totaling just over one hundred folios) than any of his four colleagues and thus did double-duty as *katib* (calligrapher) and kitabdar.

Besides being beautifully written (and thus up to the standard he himself may have set), Muhibb-Ali's two sections of the Freer Jami contain some of the most imaginative and lavish decoration of the entire codex as well as some of its most memorable compositions. The *Yusuf u Zulaykha* poem, for instance, begins with the manuscript's only inscribed heading (folio 84b; see figs. 20 and 203), and the subsequent folios include several stunning sequences of triangular cornerpieces (e.g., folios 90a–90b and 98b–100a; fig. 178), a very high proportion of type *b* rubrics (including some with human faces), one of the two margins painted with an animal scene (around illustrated folio 110b), and two paintings that may refer directly to the life of Sultan Ibrahim Mirza (folios 100b and 132a, the latter inscribed with the prince's name). The *Layli u Majnun* features without a doubt the most complex composition of the entire pictorial program (folios 253a) and a unique colophon illumination featuring a pair of white vases (folio 272a). It may be that, as kitabdar, Muhibb-Ali was able to ensure that special care was taken in the illumination and illustration of the two parts of the text he had copied (folios 230b–31a; fig. 179).[10]

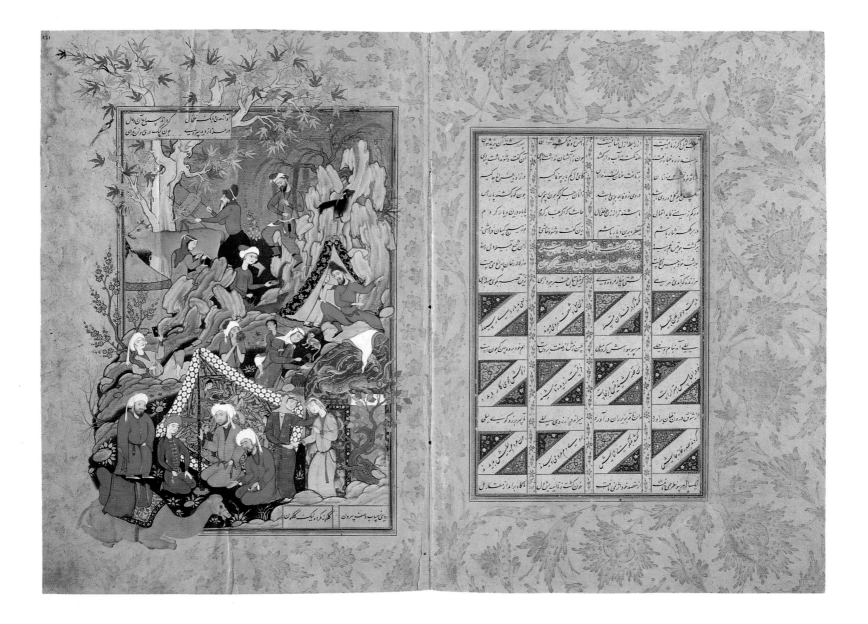

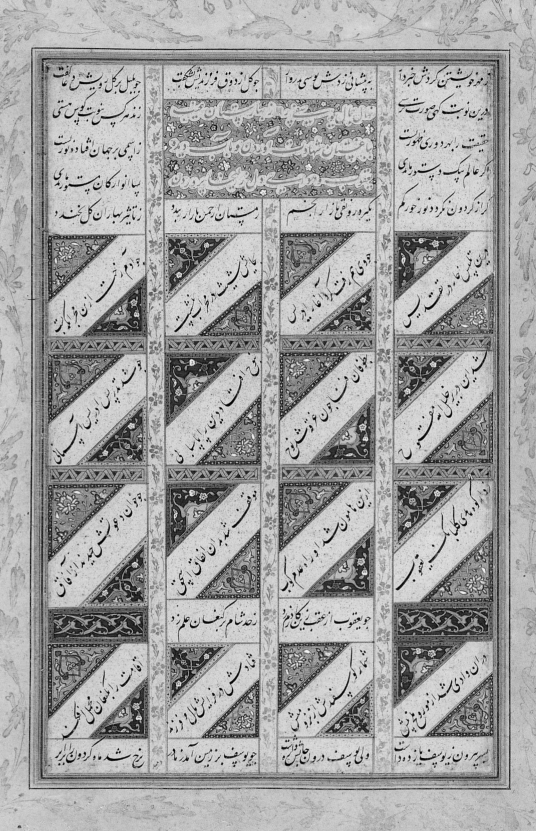

Muhibb-Ali's only other surviving manuscript is yet another illustrated copy of Jami's masnavis, minus the *Yusuf u Zulaykha* (TKS H. 1483; see figs. 120, 132, and 148–50). Like the Freer Jami, this work contains multiple, dated colophons arranged in nonsequential order that document its transcription over a two-year period, from Muharram 978/July 1570 to Dhu'l-hijja 979/April 1572, and that point to a complex codicology and process of collation.[11] Muhibb-Ali copied the poetic verses in black nasta'liq on cream-colored paper densely dusted with gold. In writing the rubrics, he switched to colored inks, employing a different color for each masnavi.[12] In addition to fine materials and elegant calligraphy, the manuscript boasts its original brown leather cover and an extensive decorative and pictorial program. The illumination, for instance, features eight masnavi headings and multiple pages of triangular cornerpieces that are every bit as diversified, intricate, and arresting as their counterparts in the Freer Jami (fig. 180). The decoration of rubrics is also distinctive and features large gold scrolls that often incorporate animals and animal heads amid colored flowers and golden leaves. The colophon illumination is even more original: three are flanked and enframed with large vertical and horizontal panels of brightly colored geometric and floral designs (folios 105a, 151a, and 229a) and four are followed by pictorial finispieces featuring figures in landscapes (folios 37b, 59b, 170b, and 200a; fig. 181). The volume's double frontispiece and twenty-five text illustrations are also of the finest quality and have many formal affinities with the paintings in the Freer Jami. Their style is, however, homogeneous, undoubtedly the result of having been painted by a single hand.

Both inside and out, Muhibb-Ali's last-recorded project (presumably a commission despite the lack of a patron's name) certainly befits someone who had worked on the Freer Jami and served as kitabdar to Sultan Ibrahim Mirza. It is thus all the more frustrating that the career and oeuvre of such an obviously gifted artist are so ill preserved today. Of those who frequented Ibrahim Mirza's artistic circle, Muhibb-Ali remains the most elusive.

180
Masnavi heading folio of *Silsilat al-dhahab*, second daftar
Copied by Muhibb-Ali
in the *Six Masnavis* of Jami
978/1570–71, Iran
34.9×23.3 cm (folio)
TKS H. 1483, folio 151b
Topkapi Sarayi Müzesi, Istanbul

181
Illustrated colophon folio of *Salaman u Absal*
Copied by Muhibb-Ali
in the *Six Masnavis* of Jami
978/1570, Iran
34.9×23.3 cm (folio)
TKS H. 1483, folio 200a
Topkapi Sarayi Müzesi, Istanbul

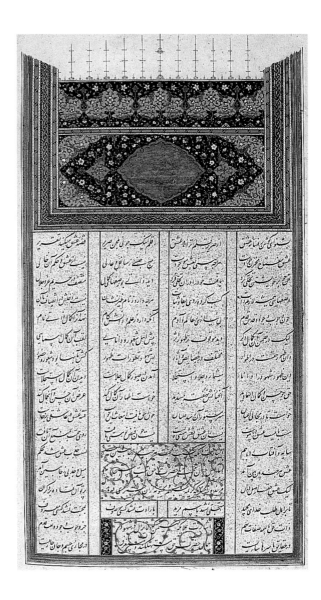

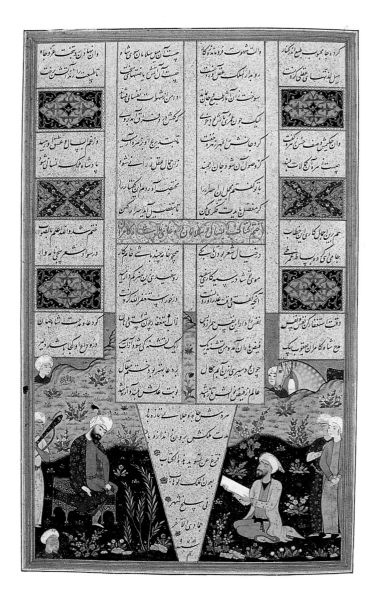

1. Primary sources: Qazi Ahmad [Minorsky], 7, 24, 147–48; Qazi Ahmad [Suhayli-Khunsari], 100; Sam Mirza [Dastgirdi], 84; and Sam Mirza [Humayun-Farrukh], 140.

Secondary sources: Mehdi Bayani, 3–4:16–17 (under the entry Muhibb-Ali Na'i); Dickson & Welch, 1:250B n. 8; *EIr*, Priscilla P. Soucek, "Behzad"; A. Welch, *Artists*, 152–53; and A. Welch, "Patrons," 13–14.

This characterization of Muhibb-Ali as the favorite son of Rustam-Ali appears only in Qazi Ahmad [Minorsky], 147. Mehdi Bayani (3–4:616) states that Muhibb-Ali was the pupil or apprentice (*shagird*) of Rustam-Ali. Although this relationship may or should be assumed, the primary sources actually do not mention Muhibb-Ali's training, an absence that may, in fact, confirm that he learned calligraphy from his father. *EIr*, Priscilla P. Soucek, "Behzad" (p. 115) states that, because Rustam-Ali was "known to have been trained in Tabriz, the same [may be] implied" of Muhibb-Ali and his cousin Muzaffar-Ali. Both artists are characterized here as painters, a characterization accurate only for Muzaffar-Ali.

2. Sam Mirza [Dastgirdi], 84; Sam Mirza [Humayun-Farrukh], 140. These citations also pertain for the Sam Mirza quotations and paraphrases that follow.

3. Sam Mirza ([Dastgirdi], 84) gives the name only as Sayyid Mansur. Dickson & Welch (1:250B n. 8) report the same anecdote, translating Sam Mirza's remarks about Muhibb-Ali's character in stronger terms: "dissolute and lewd and a great wit."

4. Qazi Ahmad [Suhayli-Khunsari], 100. Qazi Ahmad ([Minorsky], 147) says twenty years (although with an editorial insertion to the eight years in manuscript H), which seems unlikely. Twenty years is also the same amount of time that Qazi Ahmad says Shah-Mahmud al-Nishapuri spent in Mashhad. It may be that two decades was more a convenient temporal formula than chronological reckoning. Muhibb-Ali's actual tenure in Mashhad may have coincided with that of Sultan Ibrahim Mirza.

5. Sultan Ibrahim Mirza's role in this expedition has already been discussed. See also Dickson & Welch, 1:250B n. 8, for Muhibb-Ali in Herat.

6. Qazi Ahmad [Suhayli-Khunsari], 100. This passage is not in the text of the English translation, although it is mentioned in a footnote (Qazi Ahmad [Minorsky], 147 n. 509). Dickson & Welch (1:250B n. 8) also quote it in a slightly different translation.

7. Qazi Ahmad [Suhayli-Khunsari], 100; Qazi Ahmad [Minorsky], 147; Dickson & Welch, 1:250B n. 8. There can be little doubt that Muhibb-Ali was expelled by, or on orders from, the shah, whom Qazi Ahmad refers to as *shah jamjah*, that is, imperial majesty. This is the only place in the primary sources where Muhibb-Ali is linked directly to Tahmasp (although the shah presumably approved of, and perhaps arranged for, his service to Ibrahim Mirza), and there is no evidence to support a description of the calligrapher as the shah's librarian (Roger, *TKS*, captions and notes for pl. nos. 113–18).

8. Qazi Ahmad gives no information about Muhibb-Ali's activities in Qazvin. Mehdi Bayani (3–4:617) says that the calligrapher now worked for Sam Mirza and Sayyid Mansur, although this statement does not accord with what Sam Mirza says.

Muhibb-Ali's summons from Mashhad to Qazvin parallels the experience of his colleague Malik al-Daylami, although the circumstances were quite different. It is particularly interesting that both artists were removed from service to the prince by explicit order of Tahmasp at a time when the shah presumably had little involvement in the arts, or at least in the patronage of manuscripts.

9. Qazi Ahmad [Minorsky], 147–48; Qazi Ahmad [Suhayli-Khunsari], 100.

10. In addition to proposing that Muhibb-Ali was in charge of the *Haft awrang* project and that he "set its tone," Dickson & Welch (1:250B n. 8) have suggested that he exercised special influence on certain paintings, specifically those on folios 30a and 105a (the latter in the *Yusuf u Zulaykha* masnavi), which they attribute to Muhibb-Ali's cousin Muzaffar-Ali. Their characterization of the Muhibb-Ali as the "evil genius" behind these two illustrations apparently derives from Qazi Ahmad's comment that Muhibb-Ali was "one lost to all decency" and from Sam Mirza's description of the scribe as "dissolute and lewd and a great wit." For the specific citations (and alternative translations), see notes 1 and 3, above.

11. Muhibb-Ali's name actually appears in only two of the eight colophons (folios 184a and 229a), but it is assumed here that he was responsible for the entire manuscript. For the manuscript's structure, see Simpson, "Codicology," 135–36. The colophons postdate Muhibb-Ali's move from Mashhad to Qazvin, and it may be presumed that the volume was executed there, as also suggested by the style of its illustrations.

12. The rubrics are orange in the *Subhat al-abrar* masnavi, rosy red in *Layli u Majnun*, blue in *Silsilat al-dhahab*, gold in *Salaman u Absal*, and burgundy in *Khiradnama-i Iskandari*. Muhibb-Ali evidently did not have time to complete the manuscript's rubrication, as the rubric panels in the *Tuhfat al-ahrar* are empty. The margins of this masnavi also contain a series of unusual illuminated bands that seem to mask tears in the paper, also visible in the written surfaces (e.g., folios 41–42).

In transcribing the masnavi text, Muhibb-Ali sometimes missed a verse, which he then wrote on the vertical in the nearest margin (e.g., folio 5b). When the colored rulings were drawn around the written surfaces in such cases, they were extended to incorporate Muhibb-Ali's marginal verses.

In 968/1560–61 Malik al-Daylami completed the introduction to an album of calligraphy and paintings that he had compiled for the Safavid royal treasurer, Amir Husayn Beg (TKS H. 2151).[1] The text begins with long prefatory remarks, including praises to the amir, followed by a laudatory passage concerning three artists—Muzaffar-Ali, Mulla Masihullah the illuminator (*mudhahhib*), and Jalal Beg the gold flecker (*afshangar*)—who evidently collaborated in the album's organization and decoration.[2] The body of the introduction constitutes a catalogue of the artists whose work was to be found in the album, grouped by calligraphic style and artistic relationship. The hierarchy starts with Sultan-Ali Mashhadi, the celebrated master of nasta'liq, and continues with his artistic mentors and students, his students' students, and other calligraphers of nasta'liq script. The final section of the introduction contains the names of "masters of other styles."

In addition to serving as a guide to the artistic contents of the Amir Husayn Beg album, Malik's introduction provides important historical and biographical information. The long section about Sultan-Ali's pupils, for instance, ends with Rustam-Ali, who, as we have already seen, is described as the intermediary or link between Sultan-Ali and Hafiz Baba Jan Udi, Muzaffar-Ali, and Malik al-Daylami. Thus does Malik establish, in all likelihood quite consciously, his own place in the nasta'liq silsila and at the same time record the name of his teacher and the names of two fellow pupils.[3] This same passage also includes the name of Shah-Mahmud al-Nishapuri; a bit further on Malik makes mention of Ayshi Haravi, another colleague on the Freer Jami project.[4]

The compilation and introduction of this album for Shah Tahmasp's treasurer seem to have been the capstone of a long and productive career. Known as Daylami, the name of a large noble family in Qazvin, Malik was the son of Shahra-Mir Qazvini, a calligrapher noted for the excellence of his naskh script.[5] According to Qazi Ahmad, Malik first trained under his father, learning thuluth and naskh, and eventually developed such proficiency in the latter that "no one could distinguish his naskh from that of Yaqut."[6] Malik then turned his hand to nasta'liq, which by his own account he learned from Rustam-Ali.

According to the *Gulistan-i hunar*, Malik also studied the sciences, including astronomy, grammar, logic, and rhetoric and was especially proficient in mathematics, astronomy, geometry, music, and riddles or puzzles (mu'amma).[7] In addition he is reported to have been virtuous and of lofty character (*mawlawiyat*) and to have spent his time studying and in learned conversation. His mentor in these scholarly endeavors, which included the recitation of and commentary upon the Koran, was the distinguished scholar Khwaja Jamaluddin Mahmud Shirazi.[8]

These studies apparently took place while both Khwaja Jamaluddin and Malik were on the staff of the Safavid vizier Qazi Jahan Vakil.[9] This connection suggests that Malik was then in service at court, although the start of his employment there is not recorded.[10] He definitely was in Tabriz in 955/1548–49, when he completed the transcription of a copy of Ali ibn Abi Talib's *Munajat* (Prayers; IUL F. 500). As the manuscript's date falls within the period during which the Safavid capital was being transferred from Tabriz to Qazvin, the *Munajat* may have been Malik's last work in Tabriz.[11] It also may have been during his years in Tabriz that Malik composed and copied a qit'a praising the shah (TKS H. 2149, folio 24b).

Malik evidently was among those court artists for whom provisions were made after Shah Tahmasp lost interest in the arts, judging from his subsequent appointment by "orders of the monarch" to the kitabkhana of Sultan Ibrahim Mirza.[12] Qazi Ahmad specifies that Malik accompanied the prince to Mashhad in 964/1556–57, but this statement must be an error since Ibrahim Mirza actually received the governorship of Mashhad in 962/1554–55 and took up residence there in Jumada I 963/March 1556. Furthermore, Malik himself records in his first colophon to the *Silsilat al-dhahab* in the prince's *Haft awrang* that he was in Mashhad in Dhu'l-hijja 963/October 1556 (FGA 46.12, folio 46a; see figs. 9 and 44). Almost three years later, in Ramadan 966/June–July 1559, Malik was back in Qazvin, where he completed the third daftar of the *Silsilat al-dhahab* (FGA 46.12, folio 83b; see fig. 11). It is clear from his wording in this third colophon, however, that most of his work on the Freer Jami had been accomplished in Mashhad; from this it may be inferred that he had only recently arrived in Qazvin.[13] Certainly the circumstances of Malik's departure from Mashhad and return to Qazvin were different from those of Muhibb-Ali, who, as we have seen, was summoned to the Safavid capital in disgrace. Malik, by contrast, was ordered back by Shah Tahmasp to provide inscriptions on some newly constructed

government buildings.[14] Thus he seems to have been still very much in the shah's favor.

Malik's work for Tahmasp in Qazvin is recorded by Qazi Ahmad, who reports that the calligrapher wrote inscriptions in the Saʿadat-abad garden and on the Chihil-situn. The garden inscriptions, which no longer survive, included a chronogram, corresponding to 969/1561–62, by Qazi Ataʾullah Varamini; those on the Chihil-situn comprised a ghazal by Hafiz and a ghazal of Mawlana Husamuddin Maddah on the iwan and entranceway, respectively.[15] The two epigraphs on the Chihil-situn were dated 966/1558–59, so evidently Malik was working on Tahmasp's buildings at the same time he was finishing up his contributions to Ibrahim Mirza's manuscript. Part of Malik's time in Qazvin also must have taken up with other book projects, including the compilation of the album for Amir Husayn Beg.

According to Qazi Ahmad, Ibrahim Mirza made various appeals to the Safavid throne in an attempt to regain the calligrapher's services after the completion of the Saʿadat-abad and Chihil-situn inscriptions, presumably in or about 969/1561–62. Despite these efforts on the part of his former patron, Malik was not allowed to return to Mashhad. Instead, he remained in Qazvin, where he continued studying and writing until his death in the same year of 969/1561–62.[16]

In addition to his reputation as a calligrapher and a scholar, Malik was highly regarded as a poet of qasidas and ghazals. Qazi Ahmad presents a selection of these verses in the *Gulistan-i hunar*; the evocations of the beloved and lamentations about the torments of love indicate that Malik conceived his verses in the traditional mode of Persian romantic and mystical poetry. Another familiar theme—that of the polo ball and mallet—inspired a poem entitled *Guy u chawgan*, which Malik wrote for Sultan Ibrahim Mirza.[17] Like the better-known poem of the same title by Arifi of Herat (d. ca. 853/1449), Malik's composition was probably also intended as a metaphor for the relationship between lover and beloved.

Qazi Ahmad was particularly well placed to chronicle Malik's career and accomplishments since he had studied calligraphy with Malik during the master's time in Mashhad in the 960s. As we have seen, Sultan Ibrahim Mirza also took some brief instruction in calligraphy from Malik. Others recorded as Malik's pupils include Muhammad Husayn Tabrizi, Shah-Muhammad Mashhadi, Ayshi, Qutbuddin Yazdi, and Mir-Imad.[18]

Malik's artistic legacy is far more substantial than that of his teacher Rustam-Ali and his contemporary Muhibb-Ali. It includes fifteen manuscripts or parts of manuscripts and more than one

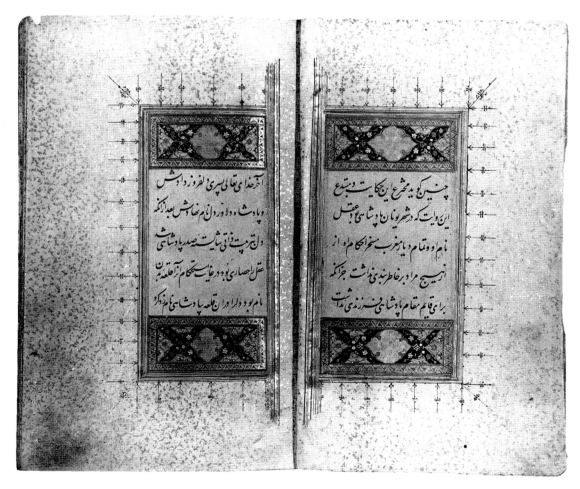

182
Opening folios
Copied by Malik al-Daylami
in the *Husn u dil* of Yahya Fattahi al-Nishapuri
954/1547–48, Iran
22.1×13.5 cm (one folio)
SPL Dorn 477, folios 1b–2a
National Library of Russia, Saint Petersburg

hundred calligraphic samples. Among his earliest surviving works is a slim but impressive codex of thirty-three folios dated 954/1547–48 (SPL Dorn 477).[19] Its text is the little-known *Husn u dil* (Beauty and heart), an allegorical tale of a king who wanted a son, written in Persian prose by the fifteenth-century author Yahya Fattahi al-Nishapuri. Malik al-Daylami copied the story in firm, black nasta'liq onto thick yellow paper dusted in gold. The surrounding margins are thinner, cream-colored, and densely flecked in gold. The opening lines are set between two pairs of rectangular panels, each containing an empty gold cartouche bracketed by dark blue Xs decorated with multicolored blossoms (folios 1b–2a; fig. 182). In addition to these illuminations, the manuscript contains three small and quite beautiful illustrations painted in very delicate style that seems archaistic for the date of the manuscript (folios 13a, 21b, and 32a).

Another manuscript that Malik may have transcribed about the same time as the *Husn u dil* is a circa 1550 volume of the *Marsiya*, an anonymous poetic elegy to Amir Ali-Mir (d. Jumada II 906/January 1501; SPL Dorn 450).[20] Although some twenty folios shorter than the *Husn u dil* codex, this volume has virtually the same sheet and written surface dimensions, as well as number of lines per page. Of even greater note is the similarity of the black nasta'liq, which, again, is bold and striking. The calligrapher actually characterizes this distinctive handwriting in the *Marsiya* colophon (folio 12b; fig. 183), where he says that he copied the work "in the writing [style] of the master Sultan-Ali al-Mashhadi."[21] It may be that Malik was also imitating Sultan-Ali in the staggered rows of the *Marsiya* text, which bring to mind a typical form for calligraphic samples as preserved in such albums as the one Malik compiled for Amir Husayn Beg. Certainly the quality of materials in this manuscript, particularly its multicolored and variously decorated margins surrounding the firm text paper, is worthy of Malik's homage to the great Sultan-Ali.[22]

Malik's work during what probably could be considered his artistic maturity is represented by the three daftars of the *Silsilat al-dhahab* in the Freer Jami.[23] As the first masnavi in the manuscript, the *Silsilat* sets the tone for those that follow, and Malik's sure and even nasta'liq certainly achieves the calligraphic standards expected in a project of this kind. His assignment turned out to be more complicated than that of the other Freer Jami calligraphers since he had to move from Mashhad to Qazvin sometime before the completion of the third daftar. The interruption is not readily apparent in the *Silsilat* folios, although the text script seems a bit less firm and a bit more spindly in the last section of the masnavi. On the other hand, the rubrics, including quite a number with lengthy text, are consistent throughout all three daftars, and Malik regularly wrote the individual lines in a different colored ink, alternating red, blue, orange, and green, and outlined many lines in gold.

In addition to punctuating the *Silsilat* with different colored rubrics, Malik also had a passion for varying the folio layout with lines of text written on the diagonal (fig. 184). Like Muhibb-Ali, he seems to have been particularly interested in the creation of zigzag patterns by switching the direction of diagonally written lines. Folios 37b–39b offer a fine example of how Malik devised a sequence of such folios, each with two diagonal lines oriented in opposite directions, while folio 58b shows how a series of lines on the same folio create the effect of vertical zigzags. Although most of Malik's diagonal folios either precede or follow an illustration or colophon, his first such zigzag pattern appears on folio 20a in the middle of an extended sequence of text folios. The purpose here may have been to relieve a visually repetitive section of the masnavi, but Malik may also have been experimenting with the formats to be used before and after subsequent illustrated folios.

Although he did not copy the greatest number of text folios in the *Haft awrang* (that distinction goes to Muhibb-Ali), Malik was the only calligrapher on the project with successive colophons. All are richly illuminated, and the last, on folio 83b, features the most unusual colophon format in the entire manuscript, with two large side sections of text written on opposing diagonals. Thus Malik ended his contribution to the Freer Jami—all the more impressive for having been begun in Mashhad and completed in Qazvin—with a flourish.

It was probably also in Qazvin that Malik copied another deluxe manuscript, comprising selected verses by Amir Khusraw Dihlavi and Abdul-Rahman Jami, dated 967/1559–60 (BN pers. 245). Although much smaller than the Freer Jami and without illustrations, this manuscript shares some of the same features, including cream-colored and finely gold-dusted text paper set into separate margins, tinted various colors, and illuminated in gold. The layout of the written surface resembles that of the circa 1550 *Marsiya*, with eight lines of text per page arranged in staggered rows. The manuscript's lavish illumination opens with an elaborate text surround and colored margins painted in gold with real and fantastic animals and birds in landscape settings (folios 1b–2a; fig.

183
Colophon folio
Signed by Malik al-Daylami
in the *Marsiya*
ca. 1550, Iran
22.8×14.6 cm (folio)
SPL Dorn 450, folio 12b
National Library of Russia, Saint Petersburg

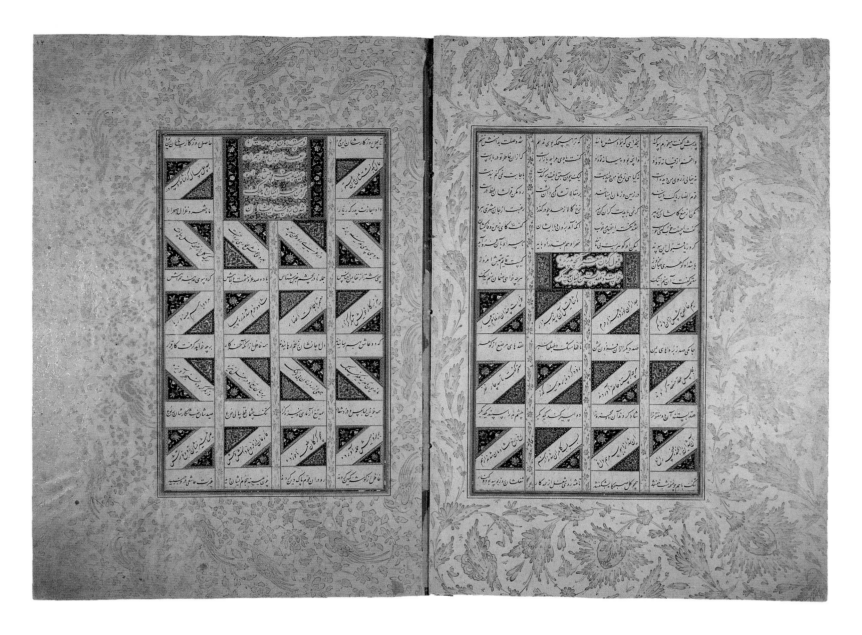

184
Text folios of *Silsilat al-dhahab*, second daftar
Copied by Malik al-Daylami
in the *Haft awrang* of Jami
964/1557, Iran, Mashhad
34.4×46.8 cm (two folios)
FGA 46.12, folios 63b–64a

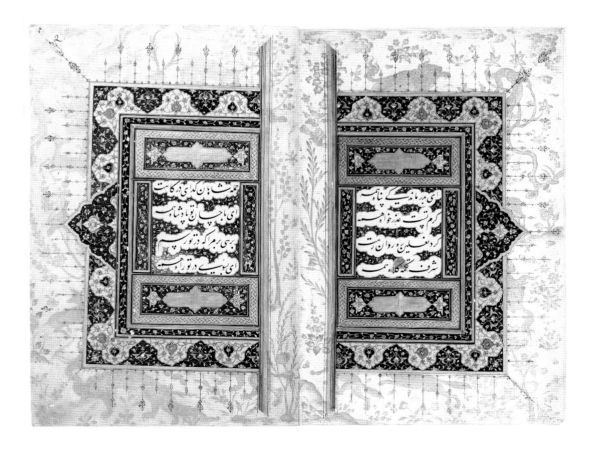

185
Illuminated frontispiece
Copied by Malik al-Daylami
in the *Divan* of Amir Khusraw Dihlavi
and the *Divan* of Jami
967/1559–60, Iran
26.2×17.5 cm (one folio)
BN pers. 245, folios 1b–2a
Cliché Bibliothèque Nationale de France, Paris

185).[24] This decorative scheme continues throughout the manuscript with a different marginal scene on virtually every folio; it is occasionally interspersed with margins illuminated either with large, leafy scrolls similar to those in the Freer Jami, or lattice designs, again comparable to the single instance of this type of illumination in the Freer Jami (FGA 46.12, folio 47b), or with knotted gar/lands wrapping around leafy, floral scrolls. The diversity of the decoration extends to the manu/script's headings on the verso of every folio, as well as to the multicolored rulings. Curiously, there is no special illumination to enhance Malik's colophon, although the surrounding margins of bright blue paper are embellished with animal motifs (BN pers. 245, folio 43a). Malik's signature in this manuscript is extremely succinct and far less informative than his colophons in the Freer Jami. It is hard to imagine, however, that such a beautiful and in many respects original codex was intended for anyone other than a bibliophile of considerable taste and means. Perhaps this work was commissioned by Amir Husayn Beg, for whom Malik must have been busy with the compi/lation of his album.

186
Title/piece folio
Copied by Malik al/Daylami
in the *Firaqnama* of Salman Savaji
ca. 1560, Iran
31×19.7 cm (folio)
BN pers. 243, folio 2b
Cliché Bibliothèque Nationale de France, Paris

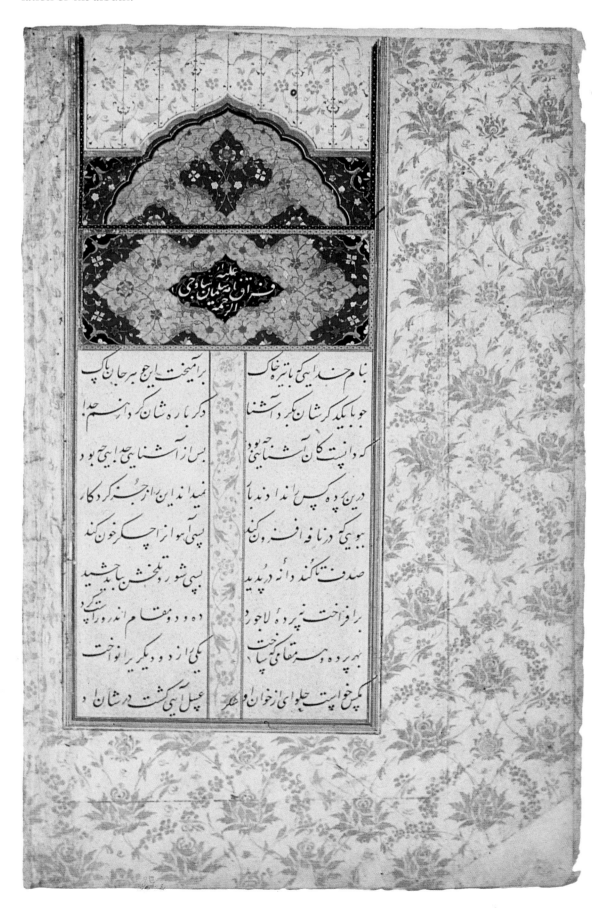

Also surviving from Malik al-Daylami's hand is an undated copy of the *Firaqnama* (Book of separation) by the fourteenth-century poet Salman Savaji (BN pers. 243). Comparable in size, material, and decoration to the manuscript of 967/1559–60, this volume also contains a double-page frontispiece depicting Solomon in the midst of a large entourage, painted by Bahram Quli Afshar (folios 1b–2a). This composition is followed by a large title piece composed of two super-imposed fields (folio 2b; fig. 186), similar to the illuminations at the head of the Freer Jami masnavis. The manuscript's rubrics are much simpler than those in the *Haft awrang* or the Khusraw Dihlavi and Jami anthology, with the rubric text written directly on the plain paper and separated with thin black and gold lines from side panels enclosing floral sprays or scrolls in gold. On the other hand, Malik has written many of the *Firaqnama* verses on the diagonal, creating intermediary diagonal bands filled with gold and red floral scrolls and triangular cornerpieces with golden blossoms. His colophon here is illuminated with a design of large peony blossoms and leaves in two shades of gold. The overall effect of the *Firaqnama* is thus every bit as impressive as either of the other two works transcribed by Malik between 963/1556 and 967/1559–60, and the manuscript very well may have been produced in the same period.

The Amir Husayn Beg album offers perhaps the most comprehensive perspective on Malik al-Daylami's artistic sensibilities and abilities (TKS H. 2151). This work opens with Malik's introduction, of which the first twelve lines are set within a beautiful illuminated frame (folios 1b–2a; fig. 187), quite similar in layout and individual motifs to that of his 967/1559–60 manuscript. As in his previous works, Malik's handwriting throughout the album introduction is extremely clear and firm; typically he wrote twelve lines per page, which are occasionally enhanced with illumination, including gold contour panels and multicolored column dividers between various poetic insertions into the prose text (e.g., folios 25b and 98a).[25] The surrounding margins are of different colored paper, variously illuminated in gold with scroll, cloud, and lattice designs.

187
Opening folios of the introduction to the Amir Husayn Beg album
Signed by Malik al-Daylami
in the Amir Husayn Beg album
968/1560–61, Iran
49.3×34.2 cm (one folio)
TKS H. 2151, folios 1b–2a
Topkapi Sarayi Müzesi, Istanbul

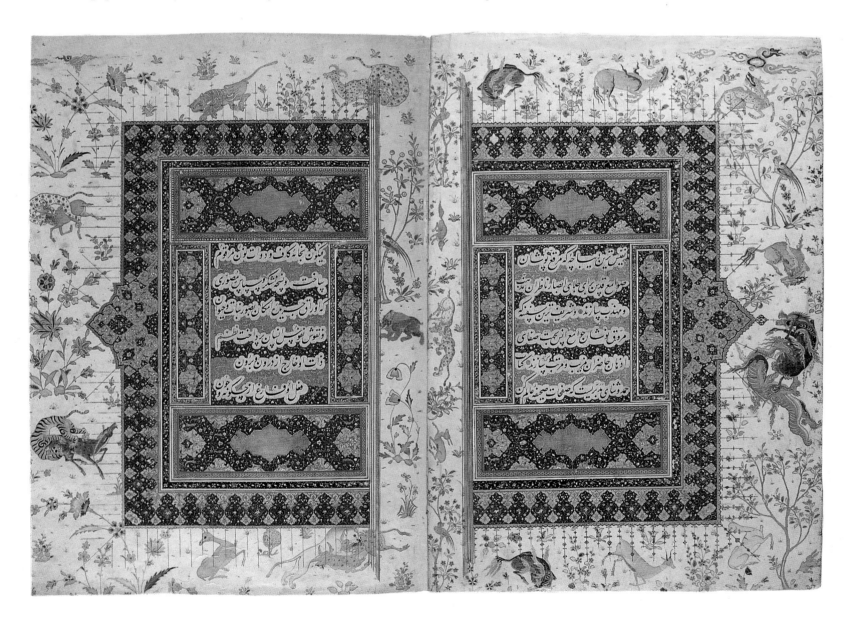

In addition to the introduction, the Amir Husayn Beg album contains other examples of Malik's work, including parts of two separate manuscripts, of which one is a *Munajat* (folio 35b). The other is a didactic prose text, its folios mounted in sets of four, which Malik also wrote for Amir Husayn Beg (TKS H. 2151, folios 5a–5b, 9a–9b, 82a–82b, 102a–b; and TKS H. 2161, folios 121b–22a). The calligrapher's colophon to this text, fortunately preserved, has been embellished with panels of particularly fine and delicate illumination (TKS H. 2151, folio 102b).

Yet another work in the album that Malik prepared for the royal treasurer is a didactic poem in Arabic with Persian interlinear translation (TKS H. 2151, folio 76a; fig. 188).[26] That the piece may have been prepared specifically for Amir Husayn Beg album is suggested by its date of 968/1560–61 and by its elegant animal margins. Malik wrote the verses in a distinctive layout, alternating the size and direction of the script, and signed it in an unusual hand resembling thuluth. The same features

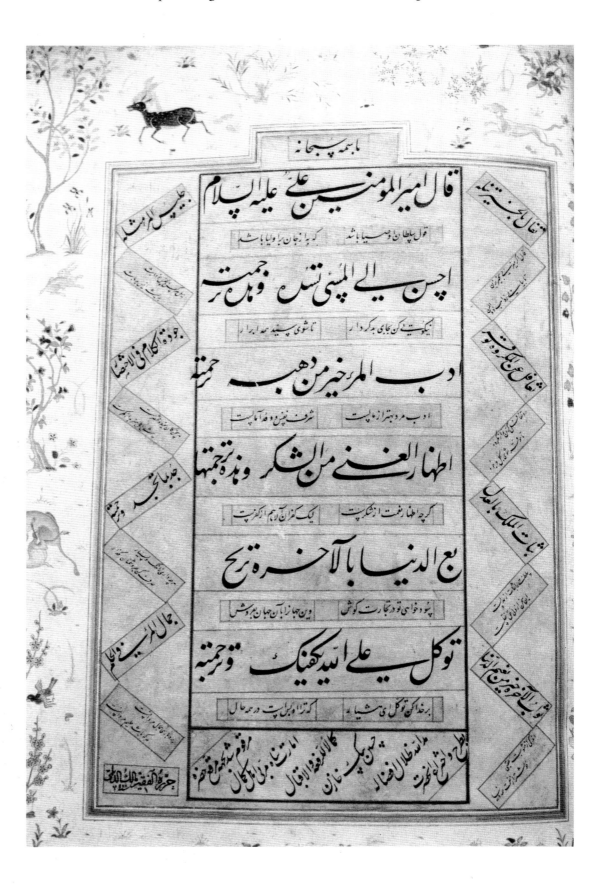

188
Calligraphy
Signed by Malik al-Daylami
in the Amir Husayn Beg album
968/1560–61, Iran
36×23 cm (written surface)
TKS H. 2151, folio 76a
Topkapi Sarayi Müzesi, Istanbul

CHAPTER THREE: PATRON AND ARTISTS

appear in another album folio dated Shawwal 969/June–July 1562 (SPL Dorn 148, folio 29b), suggesting that Malik may have favored such a page layout and signature formulation toward the end of his life.

As noted, Malik recognizes the contributions of three colleagues in the preparation of the Amir Husayn Beg album. Of these, he signals out Muzaffar-Ali for particular appreciation, praising his "painted pages and drawings of combat" and prowess in découpage and outlining and crediting him with the decoration and illumination of the album's margins.[27] Thus it may be assumed that some, if not all, of the varied designs of animals, landscapes, and floral scrolls to be found throughout the marginal decor was the work of this artist.[28] Confirmation of Malik's comment about Muzaffar-Ali as an outliner, as well as of further collaboration between these two artists, is found in the albums made for Amir Husayn Beg (TKS H. 2151, folio 21a; fig. 189) and Amir Qayb Beg

189
Calligraphy
Signed by Malik al-Daylami and Muzaffar-Ali
in the Amir Husayn Beg album
undated, Iran
49.1×33.7 cm (folio)
TKS H. 2151, folio 21a
Topkapi Sarayi Müzesi, Istanbul

190
Calligraphy
Signed by Malik al-Daylami
in an album
961/1553–54, Iran, Nakhjivan
39.2×26.8 cm (folio)
CB MS 225, folio 1b
Reproduced by kind permission of the Trustees
of the Chester Beatty Library, Dublin

(TKS H. 2161, folio 105a). The former contains an especially striking qit‘a written on blue-green paper in very large black nasta‘liq and outlined in gold. The signature, in smaller orange ink, leaves no doubt that the outline was done by Muzaffar-Ali and the black ink filled in by Malik. The importance given this collaboration may be reflected in the qit‘a's decoration, which includes four illuminated medallions between and alongside the verses and contour panels with multicolored frames around both the initial invocation and signature in the upper and lower cornerpieces.[29]

Other works by Malik in these and other albums reveal a fondness for writing on blue, marbleized, and gold-flecked paper (e.g., TKS H. 2151, folios 43a, 56a, 58a, 68b, and 79a), as well as on cream paper painted with gold and colored designs (CB MS 225, folio 1b; TKS H. 2151, folio 42b; and TKS H. 2156, folio 64b; fig. 190). Often lines of qit‘a text and of Malik's signature are encased in contour panels illuminated with floral arabesques (SOTH 2.v.77, lot 24; SPL Dorn 488, folio 10b; and TKS H. 2151, folios 20b, 64b, and 79a; fig. 191).

A large number of calligraphies by Malik also exist in the Amir Qayb Beg album (TKS H. 2161), some of which may have migrated from the Amir Husayn Beg album (TKS H. 2151) along with the final folio of Malik's introduction (TKS H. 2161, folio 2a; fig. 192). These works also exhibit the firm, bold writing that may be considered the hallmark of Malik's calligraphic style.

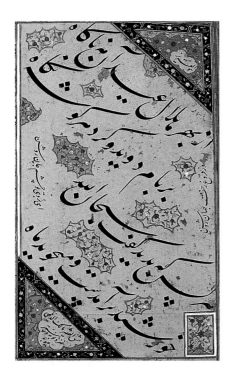

191
Calligraphy
Signed by Malik al-Daylami
in the Amir Husayn Beg album
undated, Iran
19.8×11 cm (written surface)
TKS H. 2151, folio 64b
Topkapi Sarayi Müzesi, Istanbul

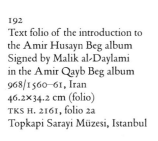

192
Text folio of the introduction to
the Amir Husayn Beg album
Signed by Malik al-Daylami
in the Amir Qayb Beg album
968/1560–61, Iran
46.2×34.2 cm (folio)
TKS H. 2161, folio 2a
Topkapi Sarayi Müzesi, Istanbul

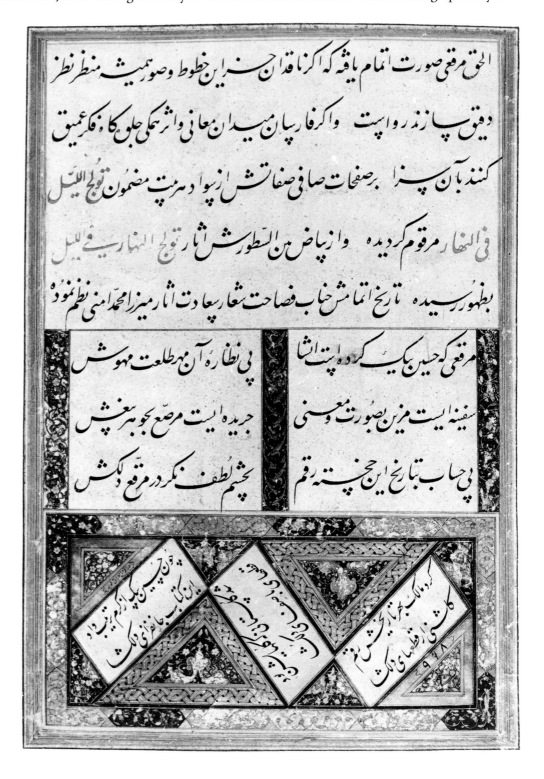

1. Primary sources: Abu'l-Fazl [Blochmann], 109; Iskandar Beg Munshi [Afshar], 1:170, 171; Iskandar Beg Munshi [Savory], 1:266, 268; Malik Daylami [Thackston], 351–52; Mustafa Ali Efendi [Fisher], 51; Qazi Ahmad [Ishraqi], 1:435–36; Qazi Ahmad [Minorsky], 6, 75, 141–45, 155, 167; Qazi Ahmad [Suhayli-Khunsari], 93–97, 121; Qisseh-Khwan [Khadiv-Jam], 670; and Sadiqi Beg [Khayyampur], 208.

Secondary sources: Mehdi Bayani, 3–4:598–609; Dickson & Welch, 1:154A–55B, 247A n. 10, 248A n. 3, 250A n. 5; Gray, *PP* 2, 142; Gray, "Safavid," 890; Huart, 237–38; A. Welch, *Artists*, 13, 154–55; and A. Welch, "Patrons," 12.

See Malik al-Daylami [Mehdi Bayani]; and Malik al-Daylami [Thackston] for the text of Malik's introduction to the Amir Husayn Beg album. Thackston (*Century*, 351 n. 1) reconstructs the correct sequence of the introduction, including its final folio now bound into TKS H. 2161. (The correct order is also given in Malik's oeuvre in Appendix E.) The current disorder of the album, including the "migration" of its final folio, may explain why a number of the artists whom Malik identifies as having samples in the album are, in fact, not represented and why the album includes works by approximately twenty other artists whom Malik does not mention.

In addition to the introduction and numerous poetic qit'as, the album contains other works copied by Malik al-Daylami, including folios from the Koran and other religious texts and parts of two didactic texts.

2. For Muzaffar-Ali, see Dickson & Welch, 1: chapter 6; and Simpson, "Bahram Mirza," 379–81. Dickson & Welch (1:154B) describe Muzaffar-Ali as a kind of associate editor of the album. Malik credits him with the marginal decoration and illumination.

3. Malik further demonstrates his attachment to Sultan-Ali in two undated works, one a manuscript (SPL Dorn 450; discussed below) and the other a calligraphy (TKS H. 2161, folio 114a), which he copied in the style of Sultan-Ali. Shah-Mahmud al-Nishapuri also copied works in the style of the same master (BN pers. 129, folios 12b–13a and 17b–18a).

4. Malik's mention here of three of his colleagues on the Freer Jami project makes the absence of the fourth, Muhibb-Ali, all the more glaring, especially since the latter was Ibrahim Mirza's kitabdar and like Malik a pupil (and, of course, son) of Rustam-Ali. Furthermore, Muhibb-Ali is represented in the Husayn Beg album. It may be that there was some rivalry between Malik and Muhibb-Ali dating back from their days as student calligraphers or from the period when both were working on the Freer Jami. On the other hand, there are several lacunae in the introduction (Thackston, *Century*, 351 n. 1); perhaps Malik discussed Muhibb-Ali in one of the now-missing passages.

Malik's high regard for Shah-Mahmud al-Nishapuri is further reflected in an undated qit'a "copied in the writing [style] of the master Mawlana Shah-Mahmud" (TKS H. 2154, folio 132a).

5. Qazi Ahmad [Minorsky], 141; Qazi Ahmad [Suhayli-Khunsari], 1:93. Both the Persian and English texts specify that Malik was from Filvakush (today Filvagush), the district where Qazvin is located. The Persian text gives Malik's father's name as Amir Shahra. Qazi Ahmad has a short passage on this calligrapher (Qazi Ahmad [Minorsky], 75; Qazi Ahmad [Suhayli-Khunsari], 33). The characterization of the Daylami family comes from Sadiqi Beg [Khayyampur], 208. Mehdi Bayani (3–4:598) says that Malik was born in 924/1518–19, without specifying any source.

6. Qazi Ahmad [Suhayli-Khunsari], 93. This particular comment, referring to the great thirteenth-century calligrapher Yaqut al-Musta'simi, is not in the Minorsky translation. Both versions mention that Malik wrote the six traditional styles of cursive script and that his calligraphies were comparable to those by the masters of the six.

7. Qazi Ahmad [Minorsky], 142 n. 488; Qazi Ahmad [Suhayli-Khunsari], 93.

8. The khwaja died in 953/1546–47, according to Qazi Ahmad [Suhayli-Khunsari], 93 n. 1.

9. For this court official, see Iskandar Beg Munshi [Afshar], 98, 160–61; Iskandar Beg Munshi [Savory], 1:163, 252–53.

10. Qazi Ahmad ([Suhayli-Khunsari], 93) does place Malik with Qazi Jahan Vakil, but with only a vague indication of chronology.

11. The *Munajat* volume is also mentioned by Dickson & Welch, 1:250A n. 5 (following Mehdi Bayani, 3–4:608) at the start of their reconstructed chronology for Malik. Certain details of this chronology are amended in the present discussion.

An additional bit of biographical data to be gleaned from the surviving corpus of Malik's oeuvre is that the calligrapher was in Nakhjivan in 961/1553–54 and again in the early fall of 966/1559 (CB MS 225, folio 1a; TKS H. 2161, folio 128b). Located on the Araxes River at the southern edge of Armenia and some 150 kilometers northwest of Tabriz, this town was an important Christian center in the fourteenth and fifteenth centuries and survived as an episcopal see and archbishopric until the mid-eighteenth century (Barthold, *Geography*, 226; *CHI*, 6:374).

12. Gray (*PP* 2, 142) states that Malik was taken to Mashhad by Ibrahim Mirza to be the first head of his kitabkhana as well as his personal calligraphy instructor. There is no evidence that Malik ever served in the capacity of kitabdar, and the former remark may reflect some confusion between Malik al-Daylami and Muhibb-Ali. Malik also seems to have been confused with a painter named Murad Daylami, cited in at least one secondary source as "in the employ of Ibrahim Mirza" (*EIr*, Priscilla P. Soucek, "'Abdallah Sīrāzī," 207).

13. It is also worth noting that in his colophon to the third daftar of the *Silsilat al-dhahab*, finished in Qazvin in Ramadan 966/June–July 1559, Malik describes himself as "the sinful servant, exiled from the regions of power and joy." Although this description could be a continuation of the formulaic self-deprecations with which the colophon begins, it may also reflect Malik's unhappiness at being obliged to leave Mashhad and his patron Ibrahim Mirza (whom he then goes on to praise at great length). At the same time the calligrapher seems to be hedging his bets here with a politic allusion to Shah Tahmasp.

14. Qazi Ahmad [Minorsky], 142; Qazi Ahmad [Suhayli-Khunsari], 94.

15. Qazi Ahmad [Minorsky], 142–44; Qazi Ahmad [Suhayli-Khunsari], 96–97. The Persian edition and English translation differ somewhat here. See also Echraqi, 110.

16. Qazi Ahmad [Minorsky], 144; Qazi Ahmad [Suhayli-Khunsari], 97. Dickson & Welch (1:250A n. 5) give Malik's death as August 1562. Apparently toward the end of his life Malik began to copy the Koran in nasta'liq, but the task was never completed. This bit of information appears only in Qazi Ahmad [Minorsky], 145, and is also reported by Dickson & Welch, 1:250A n. 5. That Malik continued to write calligraphic samples until his death is evidenced by an example dated Shawwal 969/June–July 1562 (SPL Dorn 148, folio 29b).

17. Qazi Ahmad [Minorsky], 144–45. This passage is not in Qazi Ahmad [Suhayli-Khunsari].

18. Mehdi Bayani, 3–4:600–601. Huart (p. 238) states that Malik's pupils included Khwaja Mahmud, son of Ishaq. See also Qazi Ahmad [Minorsky], 167 n. 592. It is likely that Malik also taught his son, Ibrahim [pen-name Saghiri] (Qazi Ahmad [Minorsky], 145; this is not in Qazi Ahmad [Suhayli-Khunsari]). In addition, A. Welch (*Artists*, 152–53 n. 4) mentions that Malik had a brother-in-law named Abdul-Hadi who was also his student.

19. The manuscript is in excellent condition. Its opening folio contains the seal of Shah Abbas and a waqf inscription dated 1022/1613–14 deeding the manuscript to the Ardabil shrine. Dorn (cat. no. 477) associates this manuscript with Abbas II, who did not, however, ascend the throne until 1052/1642.

20. The *Marsiya* also was given to the Ardabil shrine by Shah Abbas and contains his waqf inscription dated 1022/1613–14.

21. One of Malik's qit'as bears a similar signature (TKS H. 2161, folio 114a).

22. Several of the *Marsiya* margins are marbleized and flecked with gold; others are splattered with pink dots and painted with gold floral designs; and a few feature plants and animals painted in gold. In addition to these illuminations, the *Marsiya* volume opens with a small but very fine heading with a central gold cartouche surrounded by multicolored floral scrolls on a deep blue and red ground.

23. All three daftars are assumed to have been copied by Malik, although the colophon of the second daftar is unsigned.

24. The right side of the 967/1559–60 illumination (BN pers. 245, folio 1b) contains what at first inspection looks like a minute inscription, possibly a signature. Examination under high-power magnification, however, failed to yield a reading of the epigraphic squiggle.

The illumination of folios 1b–2a is comparable in many details to the frontispiece in the dispersed *Divan* of Hafiz of circa 1526–27 (HUAM loan; S. C. Welch, *WA*, cat. no. 40).

25. The two illuminated verses (actually a rubai'at) on TKS H. 2151, folio 25b, concern the death of Amir Husayn Beg; the gold ground beneath the second verse contains the date, in digits, of 968/1560–61.

26. The poem begins with twelve lines written on the horizontal (with the principal text in large bold nasta'liq and the alternating translation in a smaller, finer hand), and continues in two bands along the sides, with the large Arabic and smaller Persian alternating in a zigzag pattern. The reference to Amir Husayn appears in a panel beneath the horizontal text lines. Malik signed and dated this distinctive piece at the bottom of the zigzag text line at left.

27. Malik al-Daylami [Mehdi Bayani], 3–4:605; Malik al-Daylami [Thackston], 351.

28. Many of the album's margins are marbleized and generously flecked in gold. These may be the work of Mulla Masihullah the illuminator and Jalal Beg the gold flecker.

29. Malik also wrote a qit'a cut by Muhammad Amin (TKS H. 2161, folio 109a, right).

Toward the end of his introduction to the Amir Husayn Beg album, Malik al-Daylami mentions Ayshi Haravi, "the poet and calligrapher [and] a student of Sultan-Muhammad Khandan."[1] The identification of this artist with Ayshi ibn Ishrati, the copyist of the *Salaman u Absal* masnavi in Sultan Ibrahim Mirza's *Haft awrang*, is confirmed by Qazi Ahmad. His *Gulistan-i hunar* contains a brief discussion of Mawlana Ayshi, "an acknowledged scribe of Herat [who] wrote in the style of Maulana Sultan-Muhammad Nur."[2] The Qazi goes on to say that Ayshi came from Herat to Mashhad and was employed in the kitabkhana of Sultan Ibrahim Mirza.

Ayshi's service to Sultan Ibrahim Mirza would have begun sometime before the completion of his section of the *Haft awrang* in 968/1560–61. That the calligrapher was a favorite of the prince may be inferred from the statement in the *Gulistan-i hunar* that he received a regular salary and rich presents. Thus, at least as far as Qazi Ahmad was concerned, Ayshi's status in Mashhad contrasted markedly with that of Shah-Mahmud al-Nishapuri, who supposedly lived there without financial support or benefits.

Ayshi's recorded oeuvre yields some additional details about his life and career. His one known manuscript besides the *Haft awrang* is dated 944/1537–38, indicating that he already had many years of experience as a calligrapher before joining Sultan Ibrahim Mirza's kitabkhana in Mashhad (FWM MS 24-1948; fig. 193). The intervening years may have been spent in his hometown of Herat, where he executed, but did not date, a long qit'a of his own composition (SPL Dorn 147, folio 43a). While working on the *Haft awrang*, Ayshi came under the influence of at least one of the project's other contributors, as evidenced by a poem dated 968/1560–61 and copied "in the noble style of Malik al-Daylami" (TKS H. 2161, folio 115b, right; fig. 194).[3]

According to Qazi Ahmad, Ayshi was addicted to opium.[4] Perhaps this addiction was a factor in the artist's death, which Qazi Ahmad places in Mashhad without noting the date. A terminus post quem for Ayshi's death is given by two surviving qit'as dated 984/1576–77. These works were executed not in Mashhad, however, but in Qazvin. While Qazi Ahmad may have erred in reporting that Ayshi died in Mashhad, it is also possible that the calligrapher, like his patron, spent some time in Qazvin during the mid-970s to mid-980s/late 1560s to late 1570s and then returned to Mashhad toward the end of his life.

193
Colophon
Signed by Ayshi ibn Ishrati
in the *Yusuf u Zulaykha* of Jami
944/1537–38, Iran
24.5×15 cm (folio)
FWM MS 24-1948, folio 175a
Fitzwilliam Museum, Cambridge

194
Calligraphy
Composed by Ayshi ibn Ishrati
in the Amir Qayb Beg album
956/1549–50 (left), 968/1560–61 (right), Iran
46.2×34.2 cm (folio)
TKS H. 2161, folio 115b, left and right
Topkapi Sarayi Müzesi, Istanbul

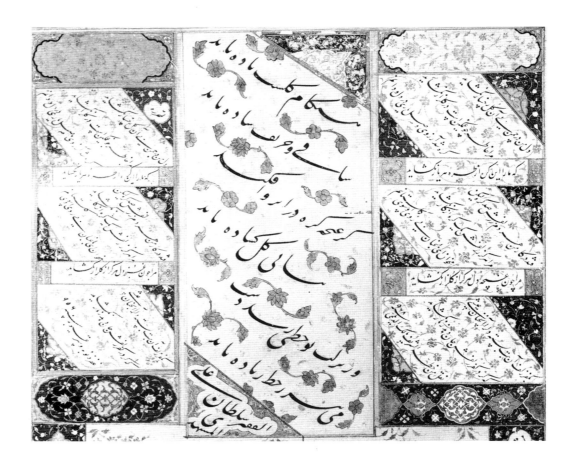

Malik al-Daylami's description of Ayshi as a poet is corroborated by Qazi Ahmad, who states that Ayshi wrote good verse. Qazi Ahmad quotes one of Ayshi's ghazals that speaks of a lover's yearning for his beloved and concludes with a self-referential evocation of the poet Ayshi as the lover.[5] Ayshi also incorporated his name—again presumably to signify authorship—into two other long poems that employ both love and garden imagery (TKS H. 2161, folio 115b, left; and SPL Dorn 147, folio 43a; fig. 195, see also fig. 194). In one of these, composed in Herat, Ayshi praises Shah-Quli Beg, a high Safavid official (d. Ramadan 963/July 1556).[6] The terms Ayshi uses here suggest that Shah-Quli was both the beloved sought by the lover in the ghazal and a friend or patron whom the poet wished to honor.

This poem is one of three qit'as that Ayshi executed with or for a fellow artist from Herat named Kamaluddin Husayn Vahid al-Ayn (SPL Dorn 147, folios 43a, 43b, and 44a; fig. 196, see also fig. 195). According to Qazi Ahmad, Kamaluddin wrote good nasta'liq, combined the six scripts, and was an expert in diluting lapis lazuli, a pigment used in ink.[7] He was also gifted in outlining, as evidenced in one of the SPL pieces (folio 44a) in which he is specifically identified as *muharrar* (outliner), and in the other two as *mudhahhib* (illuminator) and credited with the outlining.[8]

All three of these album samples are extremely elaborate, featuring striking color combinations and unusual formats. Ayshi wrote the qit'as on blue-green paper, first embellished with gold floral and leaf sprays on folios 43b and 44a, and used orange, pale blue, white, yellow, and black inks for the nasta'liq script. On folio 43a pairs of verses are written on a pronounced diagonal, lower left to upper right, and alternate with single, horizontal verses. The qit'a's final verse and colophon are written vertically at the left side. The verses on folios 43b and 44a also change direction, with the first and second distichs written on opposite diagonals (lower left to upper right and upper right to lower left), forming a series of sharp triangles down the page. The colophon of folio 43b is written vertically; that on folio 44a is horizontal. Colored rulings separate the various verse blocks in all three qit'as. The resulting spaces on folios 43a and 43b, including triangular panels and inter-columnar dividers, are filled in with brightly colored illuminations.[9] This decoration probably was the work of Kamaluddin.

195
Calligraphy: ghazal
Composed by Ayshi ibn Ishrati
in an album
undated, Iran, Herat
22×14 cm
SPL Dorn 147, folio 43a
National Library of Russia, Saint Petersburg

196
Calligraphy
Signed by Ayshi ibn Ishrati
in an album
undated, Iran
21.5×13.5 cm
SPL Dorn 147, folio 43b
National Library of Russia, Saint Petersburg

Colorful contrasts also characterize many of Ayshi's other calligraphies. These include one written in pink ink on dark green paper (TKS H. 2151, folio 62b) and one in black ink on light brown paper first decorated in gold with dense floral scrolls (TKS H. 2156, folios 27b). Two others are penned in white ink on pink paper (TKS H. 2156, folios 32b and 52b), while another is in white and gold ink on dark blue paper (TKS H. 2151, folio 45a; fig. 197). Ayshi tended to write these qitʿas in a large hand. The same calligraphic style appears in a piece where the verses are written in white and yellow ink on dark blue paper decorated with gold leaf sprays (SPL Dorn 148, folio 36b). Although the signature has been effaced, this qitʿa is also likely to be by Ayshi.

In addition to qitʿas mounted in albums, two other Ayshi calligraphies follow the end of the *Yusuf u Zulaykha* poem he transcribed in 944/1537–38 (FWM MS 24-1948). The first consists of verses written in very firm black nastaʿliq on top of gold with floral motifs (folio 175b). The second is unsigned but displays similar features (folio 176a). The Jami manuscript containing these two works has been refurbished, possibly more than once, complicating the evaluation of its original appearance.[10] Ayshi's calligraphy, consisting of black nataʿliq on brown and dark salmon paper dusted with gold, is, however, quite fine.

Ayshi's hand was still sure and elegant more than twenty years later when he undertook the transcription of the *Salaman u Absal* masnavi in the Freer Jami (fig. 198). That Ayshi was assigned the shortest poem in the manuscript and concluded it with the simplest of colophons suggests he may not have enjoyed quite as favored a position within Sultan Ibrahim Mirza's kitabkhana as implied in the *Gulistan-i hunar*. Yet his section of the *Haft awrang* is no less impressive than the others and includes folios with verses written on opposite diagonals and embellished with colorful illumination (e.g., folios 190a–95b; fig. 199). Other folios display a succession of distinctive rubrics and triangular cornerpieces (e.g., folios 197b–98b). Thus Ayshi's contribution to the Freer Jami reflects the same love for calligraphic manipulation and bright decoration found in his qitʿas.

197
Calligraphy
Signed by Ayshi ibn Ishrati
in the Amir Husayn Beg album
984/1576–77, Iran, Qazvin
49.1×33.7 cm (folio)
TKS H. 2151, folio 45a
Topkapi Sarayi Müzesi, Istanbul

198
Colophon of *Salaman u Absal*
Signed by Ayshi ibn Ishrati
in the *Haft awrang* of Jami
968/1560–61, Iran
21.8×13 cm (written surface)
FGA 46.12, folio 199a

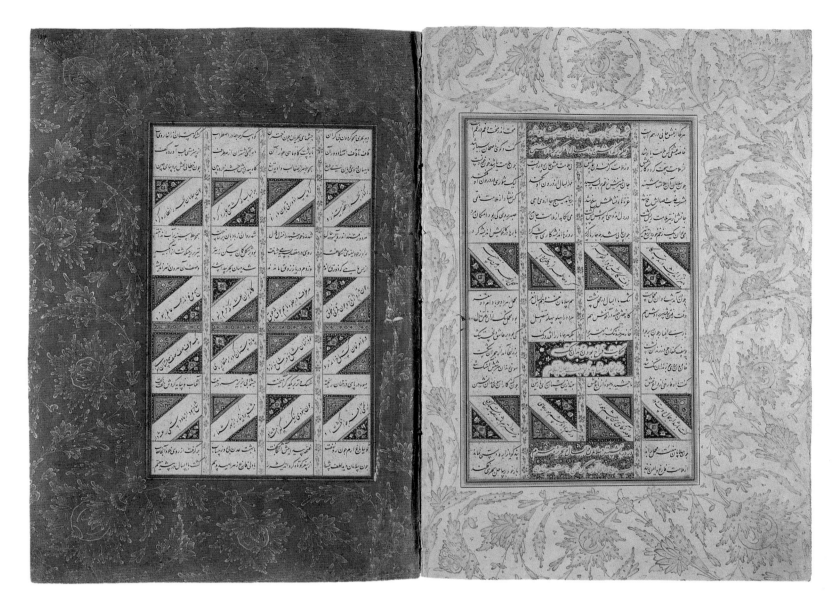

199
Text folios of *Salaman u Absal*
Copied by Ayshi ibn Ishrati
in the *Haft awrang* of Jami
968/1560–61, Iran
34.4×46.8 cm (two folios)
FGA 46.12, folios 193b–94a

1. Malik al-Daylami [Thackston], 352. Other primary sources: Abu'l-Fazl [Blochmann], 1:102; Qazi Ahmad [Minorsky], 7, 153–54; and Qazi Ahmad [Suhayli-Khunsari], 105.

Secondary sources: Mehdi Bayani, 1–2:545–46; Huart, 220; A. Welch, *Artists*, 155.

2. Qazi Ahmad [Minorsky], 153; Qazi Ahmad [Suhayli-Khunsari], 105. For Sultan-Muhammad Nur, see Mehdi Bayani, 1–2:272–80; Dust-Muhammad [Thackston], 342; Qazi Ahmad [Minorsky], 106, 134; and Qazi Ahmad [Suhayli-Khunsari], 62, 86. Mehdi Bayani places Sultan-Muhammad Nur at the court of Sultan-Husayn Mirza, the last Timurid ruler, and his death date at about 940/1533–34. The calligrapher's extant works, however, range from 912/1506–7 to 957/1550–51 (Thackston, *Century*, 342 n. 42).

3. Perhaps it was this emulation that caused Malik al-Daylami to include Ayshi in his introduction to the Amir Husayn Beg album.

4. Massumeh Farhad has noted that Ayshi's name means "pleasure loving"—a possible reference to his opium addiction.

5. Qazi Ahmad [Minorsky], 153–54; Qazi Ahmad [Suhayli-Khunsari], 105 (gives only the first verse).

6. Membré [Morton], 78–79.

7. Qazi Ahmad [Minorsky], 152; Qazi Ahmad [Suhayli-Khunsari], 104. Qazi Ahmad goes on to describe Kamaluddin as a humble dervish who traveled on foot and turned down presents from Shah Tahmasp. Thus he seems to have been quite a different character from Ayshi ibn Ishrati.

8. Black outlines are clearly visible around the variously colored inks used in all three qit'as. The colophon on folio 44a indicates that Ayshi wrote the qit'as for Kamaluddin.

9. Ayshi executed another complex qit'a on cream-colored paper mounted on folio 55b of the same album. Here two verses are written lower right to upper left and set off with a pair of illuminated cornerpieces. A third verse is on the horizontal at the bottom. The calligrapher signed this work in vertical panels at the left side and surrounded the ensemble with more text in gold script on blue paper.

10. The volume now opens with a pair of paintings in Bukharan style and a double illuminated frontispiece in Shiraz style (folios 1b, 2a, and 2b–3a). Its margins of cream-colored paper illuminated with sketchy gold blossoms and leaves are replacements.

SULTAN·MUHAMMAD KHANDAN

Of the calligraphers associated with Sultan Ibrahim Mirza, only Sultan·Muhammad Khandan is known to have worked for the prince during his years in Sabzivar. The artist's service is clearly documented by the colophon in the *Naqsh·i badi*, which Sultan·Muhammad Khandan finished in Muharram 982/April–May 1574 "by order of the kitabkhana of his highness, governor of the world, Sultan Ibrahim Mirza, in the city of Sabzivar" (TKS R. 1038, folio 38a; fig. 200, see also fig. 141). Ironically, this explicit statement is the sole secure record for Sultan·Muhammad Khandan, whose life and career are easily conflated with that of his famous homonym active during the late fifteenth century into the third decade of the sixteenth century.[1] The confusion even involves the Freer Jami, where the ghazals ending with the signature of Sultan·Muhammad Khandan on the inserted final leaf (folio 304a) are identifiable on the basis of calligraphic style as the work of the senior Sultan·Muhammad Khandan.[2]

Judging from the colophon to a fragmentary text dated Jumada I 957/May–June 1550 (TKS H. 2157, folio 42a), the younger Sultan·Muhammad Khandan may have practiced calligraphy for several decades prior to his transcription of the *Naqsh·i badi* for Sultan Ibrahim Mirza's kitabkhana. He also may have copied a volume of Jami's *Subhat al·abrar*, although the evidence is circumstantial (GULB LA 159).[3]

A slim volume of thirty·eight folios and two text illustrations, the *Naqsh·i badi* is the key work for any assessment of Sultan Ibrahim Mirza's patronage during his tenure in Sabzivar (see figs. 142, 143, and 144). It is also the only manuscript known from the hand of Sultan·Muhammad Khandan and reveals the calligrapher as an adept practitioner of nasta'liq. Sultan·Muhammad Khandan copied the *Naqsh·i badi* text on white, gold·dusted paper in black ink. His handwriting is medium·sized, with well·formed letters and smooth ligatures. As was frequently the tendency of sixteenth·century scribes in writing nasta'liq, Sultan·Muhammad Khandan has omitted many diacritical marks and regularly placed the final letters or words above the line. Throughout the manuscript, the lines are even and well spaced, an impression that is belied on the final folio where the gold ground, rather sloppily applied and probably at a later date, makes Sultan·Muhammad Khandan's colophon look ragged by comparison with the *Naqsh·i badi* verses. Various other areas of illumination in the manuscript, including the opening title piece and the stenciled borders, also appear to be later additions or replacements (figs. 201 and 202). The floral scrolls that fill the column dividers and the thin frame around each written surface do seem original, however, and reinforce the homogeneity of Sultan·Muhammad Khandan's calligraphy.

Compared to Sultan Ibrahim Mirza's *Haft awrang*, the *Naqsh·i badi* is a very modest work of art. It is likely to be typical of the type of projects undertaken by Sultan·Muhammad Khandan—an apparently minor artist who was overlooked by Safavid chroniclers but who had the opportunity to work for a Safavid prince by virtue of being in the right place at the right time.

200
Colophon
Signed by Sultan·Muhammad Khandan
in the *Naqsh·i badi* of Muhammad Ghazali
Mashhadi
982/1574, Iran, Sabzivar
25.6×15.8 cm (folio)
TKS R. 1038, folio 38a
Topkapi Sarayi Müzesi, Istanbul

CHAPTER THREE: PATRON AND ARTISTS

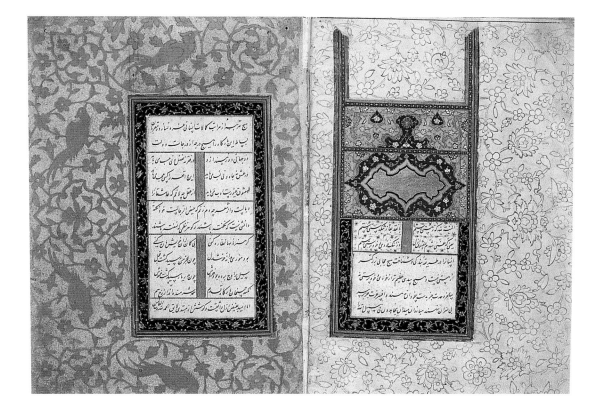

201
Title-piece and text folios
Copied by Sultan-Muhammad Khandan
in the *Naqsh-i badi ʿ* of Muhammad Ghazali
Mashhadi
982/1574, Iran, Sabzivar
25.6×15.8 cm (one folio)
TKS R. 1038, folios 1b–2a
Topkapi Sarayi Müzesi, Istanbul

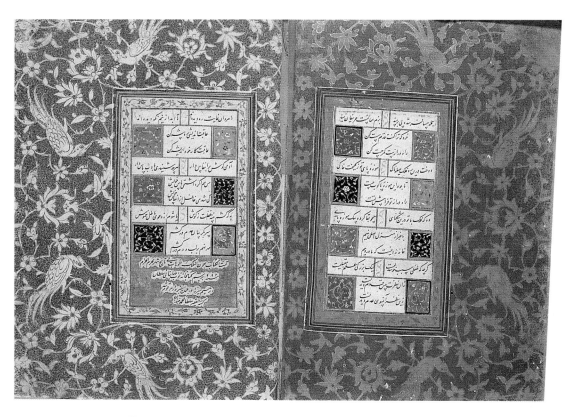

202
Text and colophon folios
Signed by Sultan-Muhammad Khandan
in the *Naqsh-i badi ʿ* of Muhammad Ghazali
Mashhadi
982/1574, Iran, Sabzivar
25.6×15.8 cm (one folio)
TKS R. 1038, folios 37b–38a
Topkapi Sarayi Müzesi, Istanbul

Notes

1. The senior Sultan-Muhammad Khandan studied with Sultan-Ali Mashhadi. He spent his entire life in Herat and worked at the court of the last Timurid ruler, Sultan-Husayn Mirza (r. 875–912/1470–1506). Primary sources: Dust-Muhammad [Thackston], 342–43; Malik al-Daylami [Thackston], 352; Qazi Ahmad [Minorsky], 106; and Qazi Ahmad [Suhayli-Khunsari], 62. Secondary sources: Mehdi Bayani, 1–2:268–71; Huart, 224; Subtelny, "Poetic Circle," 5 with reference to the *Taʾrikh-i Rashidi* (History of Rashid) by Mirza Muhammad Haydar of 954/1547.

Mehdi Bayani gives a partial listing of this artist's oeuvre, to which can be added the following dated works: *Divan* of al-Shahi dated 888/1483–84 (BL Or. 8760), *Ghazals* of Shahi dated 910/1504–5 (SPL Dorn 418), *Bustan* of Saʿdi dated 916/1510–11 (CB MS 183), *Divan* of Hafiz dated 920/1514–15 in Herat (CB MS 184), *Qiran al-saʿdayn* (Conjunction of the two lucky stars) of Amir Khusraw Dihlavi dated 925/1519–20 (IM O.S. 5033.1.79), and a qitʿa dated 933/1526–27 (SAK Calligraphy 7). There is also a signed but undated *Divan* of Shahi that has been attributed, on the basis of the style of its one painting, to the mid-sixteenth century (BN suppl. pers. 1962; Stchoukine, *MS*, 87, no. 54; A. Welch, *Artists*, 155). The calligraphic style of this manuscript suggests, however, that it belongs to the oeuvre of the senior Sultan-Muhammad Khandan. The Istanbul albums contain many of this artist's qitʿas: IUL F. 1422, folio 12a; TKS E.H. 2841, folios 12a, 13a; TKS H. 2145, folio 37b; TKS H. 2147, folio 16a; TKS H. 2154, folios 41a, 68a–b, 69b, 70a; TKS H. 2156, folios 27a, 85a; TKS H. 2161, folios 92a, 113b, 153a, 159a, 160a; TKS H. 2163, folio 3b; TKS H. 2169, folios 29b, 36a–b, 46a; TKS R. 2056, folio 42b. Sultan-Muhammad Khandan also signed a set of ghazals on the last folio in the Freer Jami (FGA 46.12, folio 304a).

2. The presence of this signature on inserted folio 304 has lead to the assumption that the senior Sultan-Muhammad Khandan worked on Sultan Ibrahim Mirza's *Haft awrang*. See Dickson & Welch, 1:246A n. 4 (with some reservation expressed about the identity of this Sultan-Muhammad Khandan); A. Welch, *Artists*, 155; A. Welch, *CIA*, 3:182.

3. The volume is undated but contains one inserted painting signed by Abdullah, another member of Sultan Ibrahim Mirza's artistic coterie, dated 972/1564–65. There remains the strong possibility that the colophon signature is that of the senior Sultan-Muhammad Khandan.

ABDULLAH AL-SHIRAZI

The chroniclers Qazi Ahmad and Iskandar Beg Munshi both cite three artists, meaning painters or illuminators, as having worked for Sultan Ibrahim Mirza: Shaykh-Muhammad, Ali Asghar, and Abdullah of Shiraz.[1] Of this trio only Abdullah has left personal corroboration of his service to the prince in the form of the signature within the inscribed and illuminated title piece at the beginning of the *Yusuf u Zulaykha* masnavi in the Freer Jami (FGA 46.12, folio 84b; fig. 203). Since Abdullah signed his name over a rubbed-out portion of an otherwise continuously decorated band, it is likely that he executed only the poetic inscription and flanking floral scrolls in the central cartouche, possibly well after the title piece illumination was completed.[2] Despite uncertainty about the extent and sequence of his work, Abdullah can surely be counted among the artists involved in the *Haft awrang* project, as long assumed in the scholarly literature.

Neither chronicler gives much additional or more specific information about Abdullah's life and career. Qazi Ahmad states only that the artist was a native of Shiraz and that he was employed in Sultan Ibrahim Mirza's kitabkhana for twenty years, a period generally interpreted as spanning the prince's governorship in Mashhad through his murder in Qazvin in 984/1577.[3] Iskandar Beg Munshi says nothing about the length or location of Abdullah's employment, mentioning instead that the artist joined the kitabkhana of Isma'il II after Ibrahim Mirza's death. Iskandar Beg reports that Abdullah was "closer to Ibrahim Mirza than any of his peers" and also characterizes the artist as a jovial and witty man.[4] Qazi Ahmad describes Abdullah simply as "among the intimates and confidants of the highest prince." On the other hand, he evidently also wanted to emphasize the artist's dedication to Sultan Ibrahim Mirza, for he concludes his *Gulistan-i hunar* entry by saying that, after the prince's death, Abdullah left court service and settled down in Mashhad. There he served as carpet spreader (*farrash*) at the shrine of the Imam Reza and attendant at the tomb of his former patron.[5]

Abdullah's continued attachment is confirmed by his contributions to two posthumous volumes of Sultan Ibrahim Mirza's *Divan*. The first, dated 989/1581–82, ends with a colophon specifying that it was completed by Abdullah, "the old companion of the deceased prince," in Mashhad in 989/1581–82 (GL 2183). Although the formulation "it was completed" normally precedes the name of a manuscript's scribe, the end of this colophon identifies a certain Jamal al-Mashhadi as having transcribed the text. Thus Abdullah may have supervised the manuscript's overall production or executed its double-page frontispiece and five text illustrations.[6] There can be no doubt about Abdullah's responsibility for the second copy of the *Divan*, since he signed and dated the opening illumination and one of the paintings in 990/1582–83 (SAK MS 33, folios 1b–2a and 23a; figs. 204 and 205). Abdullah possibly took on the illumination and illustration of these volumes in Mashhad as a memorial to Sultan Ibrahim Mirza at the behest of the prince's daughter Gawhar-Shad Begum.[7]

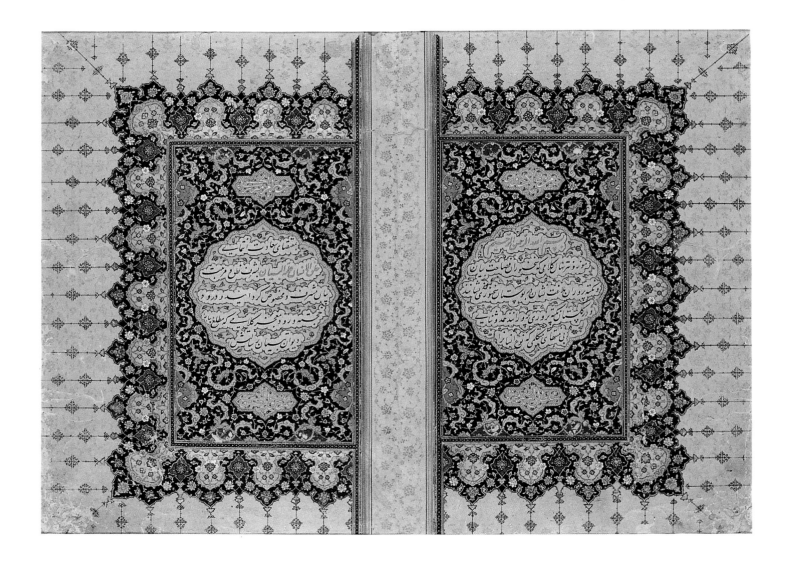

204
Double-page frontispiece
Signed by Abdullah al-Shirazi
in the *Divan* of Sultan Ibrahim Mirza
990/1582–83, Iran
24.7×17.1 cm (one folio)
SAK MS 33, folios 1b–2a
Collection Prince Sadruddin Aga Khan,
Geneva

205
A Prince Visits a Hermit
(detail of signature)
Signed by Abdullah al-Shirazi
in the *Divan* of Sultan Ibrahim Mirza
990/1582–83, Iran, Qazvin
23.8×16.8 cm (folio)
SAK MS 33, folio 23a
Collection Prince Sadruddin Aga Khan,
Geneva

Along with a painting of a youthful musician in a landscape also dated 99[0]/158[2–83], the two *Divan* manuscripts belie Qazi Ahmad's implication that Abdullah retired to Mashhad to tend Ibrahim Mirza's grave. That he also worked for other patrons during the early 990s/early 1580s is confirmed by his signed frontispiece illumination in a *Divan* of Hafiz dated 989–94/1581–86 (TKS H. 986, folios 5b–6a; fig. 206). According to an introductory note as well as the colophon, this manuscript was copied by the scribe Sultan-Husayn ibn Qasim al-Tuni in Tun, a town to the west of Herat in Khurasan province. The colophon also gives the name of the volume's patron as Sultan Sulayman, a Turcoman who governed Tun during the 1580s and early 1590s.[8] Whether Abdullah ever worked for Isma'il II in Qazvin, as reported by Iskandar Beg Munshi, cannot be so easily verified.[9]

The young musician is one of several known paintings signed by Abdullah al-Shirazi and ranging in date from 972/1564–65 to 99[0]/158[2–83]. Painting is an aspect of the artist's career that goes virtually unremarked in the two principal sources. Iskandar Beg Munshi describes Abdullah exclusively as an illuminator, characterizing his work as *khub* (good, beautiful, or excellent) but at the same time comparing it unfavorably to that of another Safavid mudhahhib named Hasan Baghdadi.[10] Qazi Ahmad is both less critical and more specific, praising Abdullah for his skill in ornamental gilding and in drawing sarlawhs and shamsas.[11] He adds further that "none worked better than he in preparing oil colors [*rang u raughan*]," an indication that Abdullah was a painter of lacquerwork.[12]

Abdullah seemed to regard, or at least wished to present, himself first and foremost as an illuminator, for he regularly used the signature Abdullah al-mudhahhib and never, for instance, Abdullah al-musavvir.[13] The artist was also consistent, as well as original, about where he signed his work. In three recorded illuminations, including the *Yusuf u Zulaykha* title piece, his signature is all but invisible, written in minute cursive script within a thin colored band enframing the primary illuminated field (FGA 46.12, folio 84b; SAK MS 33, folios 1b–2a; and TKS H. 986, folio 6a; see figs. 203 and 204).[14] These minuscule signatures (equivalent in size to two eyelashes laid side by side) seem to constitute a personal conceit through which Abdullah could assert his authorship while maintaining the traditional anonymity and modesty of the illuminator in Persian art. The artist signed and dated his paintings in an equally idiosyncratic, although far more conspicuous, fashion. The signature always appears on a rock or boulder shaped in the form of a jagged oval and prominently located in the left side of the composition. In three paintings Abdullah wrote his name in three short and tightly superimposed horizontal lines of black nasta'liq, with the word *amal*

206
Double-page frontispiece
Signed by Abdullah al-Shirazi
in the *Divan* of Hafiz
989–94/1581–86, Iran
31.5×20 cm (one folio)
TKS H. 986, folios 5b–6a
Topkapi Sarayi Müzesi, Istanbul

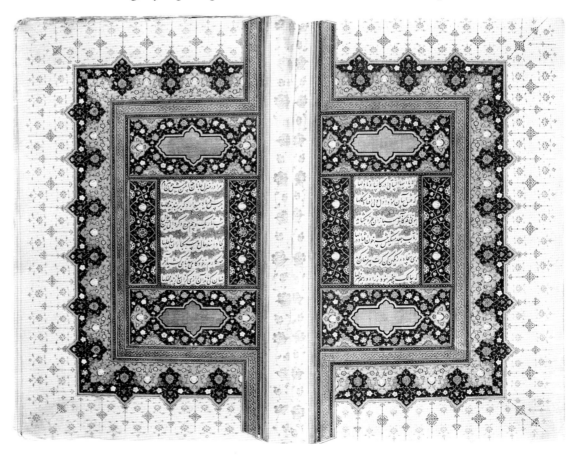

(work of) larger and extended in the middle and the date in digits sideways at the left (AHT no. 90a, folio 2a; GULB LA 159, folio 101a; and LKM).[15] The same scheme of superimposed lines appears on another painting, with the addition of a brief adage referring to the stone's writing surface and the placement of the date beneath the third line of text instead of to the side (SAK MS 33, folio 23a; see fig. 205). While Abdullah's "signature stones" may be unusual within the context of sixteenth-century Persian painting, the form of their inscriptions bears a distinct resemblance to seals of the kind stamped on documents and sometimes inside manuscripts.[16] The shape of the stone also resembles the cartouches commonly found in the center of illuminated title pieces, rubrics, and dedicatory rosettes. This shape suggests that Abdullah may have deliberately fashioned his signature stones as a device for proclaiming his double skills as painter and illuminator. Whatever the explanation, Abdullah emerges through his signatures—discrete in the illuminations and bold in the paintings—as an artist who might today be characterized having a mixed self-image or identity.

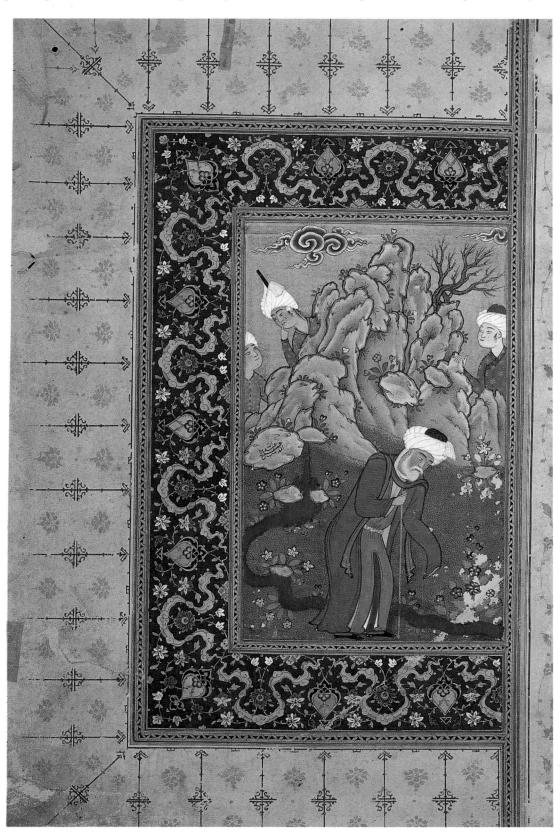

207
Old Man in Landscape
Signed by Abdullah al-Shirazi
in the *Subhat al-abrar* of Jami
972/1564–65, Iran
21.7×14.5 cm (folio)
GULB LA 159, folio 101a
Calouste Gulbenkian Foundation, Lisbon

Abdullah's dual talents are already apparent in his earliest known painting dated 972/1564–65 (GULB LA 159, folio 101a; fig. 207).[17] A stooped old man in a brown cloak stands beside a stream in the center foreground, while three youths peer out from behind a rocky promontory in the background. The scene is surrounded on its three outer sides by a broad band of illumination, featuring undulating garlands, ovoid pendants and blossoms, with blue finials projecting into the margin. Both the old man's position, turned toward his left, and the surrounding illumination strongly suggest that this painting was once the left side of a double composition, probably a frontispiece like the one Abdullah executed in 989/1581–82 for a *Sifat al-ashiqin* manuscript and also enframed in an elaborate illuminated border with blue finials (AHT no. 90a, folios 1b–2a; fig. 208).

The figural and landscape style of the 972/1564–65 painting confirms Abdullah as a competent, if not exactly brilliant, practitioner of Safavid painting as it developed at the Tabriz court of Shah Tahmasp during the first decades of the sixteenth century and subsequently continued in Mashhad and Qazvin. Abdullah appears most adept in his treatment of the background outcropping of purple, orange, and brownish green rocks with a few hidden faces—a favorite motif in Safavid painting.[18] Otherwise this painting seems static, an impression perhaps due to its present condition as only half a composition. Abdullah may also have created this work while still a relatively inexperienced painter. Its date falls within the period he would have been working for Sultan Ibrahim Mirza, according to Qazi Ahmad's account. Given the paucity of verifiable information for Abdullah's biography, however, it is impossible to confirm what professional stage the artist had reached when he painted his landscape with the old man.

The two manuscript paintings dated 989–90/1581–83 allow for a fuller assessment of what, seventeen to eighteen years later in Abdullah's career, we can presume to be the work of a more fully developed artist. Both are carefully designed and finely painted, revealing Abdullah's control of his art. The double-page frontispiece to the *Sifat al-ashiqin* is a conventional composition for late Safavid

208
Double-page frontispiece
Signed by Abdullah al-Shirazi
in the *Sifat al-ashiqin* of Hilali
989/1581–82, Iran
24×16 cm (one folio)
AHT no. 90a, folios 1b–2a
Art and History Trust, Courtesy of
Arthur M. Sackler Gallery, Smithsonian
Institution, Washington, D.C.

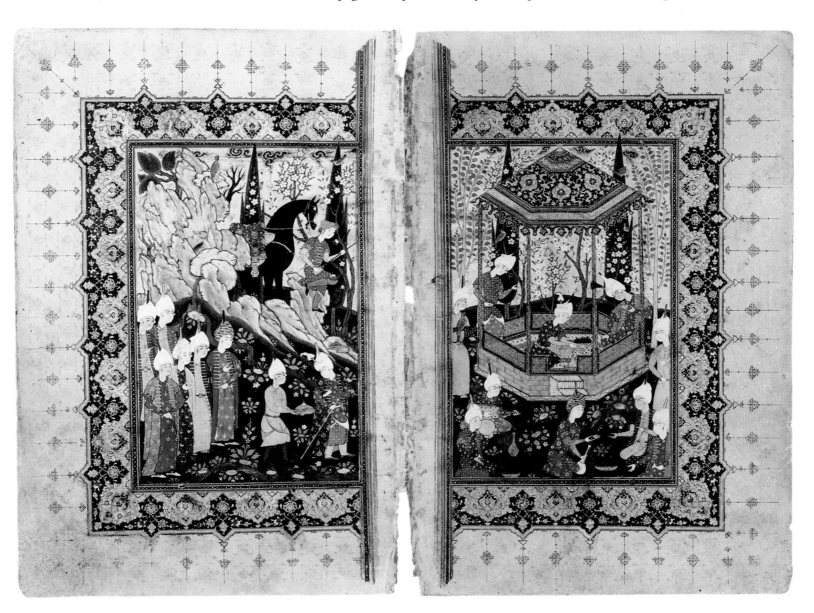

painting, presenting the familiar theme of princely entertainment as an outdoor scene in two distinct, yet clearly related, halves (AHT no. 90a, folios 1b–2a). The primary landscape features— knotted clouds, leafy flowers growing around rocks, and a rocky promontory with hidden faces and dead trees—are virtually identical to those in Abdullah's 972/1564–65 painting, revealing a notunexpected consistency in style. The many personages in both halves of the frontispiece correspond typologically to the slim and elegantly attired youths who populate so much of Safavid painting. Abdullah does vary their postures and gestures but otherwise treats them indiscriminately as stock figure types: the rows of standing courtiers, the musician perched on a rock, the falconer, the cupbearer, and so forth. Even the neighing horse belongs to what by the last quarter of the sixteenth century had become an extremely standardized repertoire of animals. In short, Abdullah has created an amalgam of forms that attests to proficiency, if not to originality, as an artist. Certainly he could work with the vocabulary of sixteenth-century court painting, but he seems to have been unwilling or unable extend the idiom. If anything, this painting tends to highlight Abdullah's skill as an illuminator, reflected in the dense filling of the picture plane (there is little "breathing space" in this composition); bright, pure palette; small, repeated textile patterns; and symmetrical arrangement of trees, blossoms, and leaves (particularly in the right half). The pavilion roof is especially revealing in this regard, since its blue and gold design of large medallions closely resembles, without exactly repeating, the illuminated border surrounding the frontispiece.

Abdullah's *Divan* illustration of 990/1582–83 shows that his approach to narrative also followed the prescribed conventions of contemporary Safavid painting (SAK MS 33, folio 23a). The scene, depicting a prince's visit to a hermit, employs a standard iconography and compositional scheme, with the specific placement and relationship of the figures seemingly "cued" by the text blocks incorporated into the picture plane. The figures retain the solidity of Abdullah's old man of 972/1564–65, although their faces and torsos appear a bit more elongated than even the youths in the *Sifat* painting. The landscape style, on the other hand, is completely consistent with Abdullah's other works. The piled-up formation of pastel-toned rocks (including some with faces) that defines the hermit's cave is identical to the promontories in both the 972/1564–56 halfcomposition and the 989/1581–82 double frontispiece; the quail and tripartite tree at the left edge of the rocky outcropping also resemble the *Sifat* painting, while the knotted cloud is a larger version of what appears in both earlier paintings.

These two signed and dated compositions by Abdullah invite obvious comparison with illustrations in the Freer Jami, specifically the *Divan* illustration with folio 153b and the *Sifat al-ashiqin* frontispiece with folio 179b. The first pair shares the same subject, landscape setting, and treatment of the scene's principal figures, including the pir and his attendant and the prince and his attendant. The right side of the *Sifat* frontispiece contains an identical garden pavilion and similar group of youths as in Freer Jami folio 179b. Specific points of comparison in this second pair of paintings include the decoration of the pavilion roof and the position and gestures of the two side figures with their arms wrapped around the pavilion supports, albeit in mirror relief. The similarities between the signed paintings by Abdullah and the unsigned *Haft awrang* compositions have led to the suggestion that these two paintings might also have been Abdullah's work.[19] Both the Freer Jami illustrations, however, are expansive narratives with a wealth of detail missing from Abdullah's signed work. Furthermore, the figures in both Jami scenes have an elegance and expressiveness that the stolid citizens in the *Divan* illustration certainly do not possess and that the *Sifat al-ashiqin* youths barely approach. Given the way Abdullah seems to have been painting at the time he presumably worked for Sultan Ibrahim Mirza, as evidenced by his old man in the landscape of 972/1564–65, it is unlikely that he could have simultaneously created the Freer Jami compositions.[20] Nor could he have lost the knack so completely twenty years later. It is much more probable that Abdullah saw the paintings in the Freer Jami, or at least those in the *Subhat al-abrar* masnavi to which folios 153b and 179b belong, when he worked on the *Yusuf u Zulaykha* title piece and that he drew upon certain of their iconographic and compositional features when he painted his *Divan* and *Sifat al-ashiqin* compositions twenty or so years later.[21]

Clearly Abdullah's greatest skill lay in illumination, as his frontispieces in the *Divan* of Sultan Ibrahim Mirza and the *Divan* of Hafiz reveal (SAK MS 33, folios 1b–2a; TKS H. 986, folios 5b–6a). While distinctive in the layout of their central fields, these double compositions share many features, including the same bright palette of deep blue, gold, and orange and controlled floral scrolls. The treatment of the buds and leaves—monochromatic with white highlights—that fill the background of the central text panels is also similar.[22] Other hallmarks of Abdullah's illumination style seen in these two works, as well as his *Sifat al-ashiqin* frontispiece (AHT no. 90a, folios 1b–2a), include the border around the central field, composed of two alternating bands of scalloped medallions (the inner one gold and the outer one blue), and the blue finials and gold blossoms in the outer margins.[23] These illuminated zones combine to form a rhythmic pattern of syncopated design and color. Finally, the two frontispieces confirm that Abdullah commanded a wide repertoire of decorative motifs, including knotted garlands as in the central field of the Ibrahim Mirza illumination and female faces found throughout the Hafiz illumination.

1. Primary sources: Iskandar Beg Munshi [Afshar], 1:177; Iskandar Beg Munshi [Savory], 1:274; Qazi Ahmad [Minorsky], 152, 189–90 (rubric: Mawlana Abdullah mudhabbib); Qazi Ahmad [Suhayli-Khunsari], 148 (rubric: Mawlana Abdullah Shirazi). Iskandar Beg Munshi calls the artist Mawlana Abdullah Shirazi; Qazi Ahmad calls him Mawlana Abdullah mudhahhib. Dust-Muhammad ([Thackston], 348) also mentions a Shirazi scribe named Nuruddin Abdullah (identified in note 67 as Abdullah ibn Shaykh-Murshid al-katib al-Shirazi), but without indicating a connection to Sultan Ibrahim Mirza.
Secondary sources: Mehdi Bayani, 1–2:356; Çağman & Tanindi, "Remarks," 135, 142; Diba, "Lacquerwork" 2, 125, 179–84, 188; Dickson & Welch, 1:168A, 246B n. 4, 252A n. 8, 252B n. 11; *EIr*, Priscilla P. Soucek, "'Abdallah Šīrāzī"; Gray, *PP* 2, 142; Huart, 339; *IA*, Ali Alparslan, "Abdullah-i Sirzai"; Schmitz, "Harat," 120–21; Simpson, "Jami," 98, 109; Soudavar, 228–29; Stchoukine, *MS*, 27 (Abdullah Khorasani, probably a different artist, although some of the works Stchoukine cites seem to be by Abdullah al-Shirazi); A. Welch, *Artists*, 20, 162, 214; and Welch & Welch, 97. Lowry et al. (cat. no. 351) briefly discuss the confusion in the scholarly literature between Abdullah Shirazi and at least one other artist named Abdullah who painted in the style of mid-sixteenth-century Bukhara (e.g., Sakisian, fig. 132, cited in Stchoukine, *MS*, 27).
2. Considering that this is the only masnavi heading in the Freer Jami with an inscription, it is also possible that Abdullah might have composed and transcribed the verses in the heading as well as embellishing them. Regarding Abdullah as the only one of this trio who left "personal corroboration," see the note on page 8.
3. *EIr*, Priscilla P. Soucek, "'Abdallah Šīrāzī." It may be that twenty years is a kind of historical or literary topos, since Qazi Ahmad also gives twenty years as the length of Shah-Mahmud al-Nishapuri's service to the prince.
4. Iskandar Beg Munshi [Afshar], 1:177; Iskandar Beg Munshi [Savory], 1:274 (the artist's relationship to Sultan Ibrahim Mirza is not mentioned in this translation).
5. Qazi Ahmad [Minorsky], 190; Qazi Ahmad [Suhayli-Khunsari], 148. The Suhayli-Khunsari text is quoted here. The English translation differs.
6. The first line of the colophon is now missing one or two words. These may have been further adjectives modifying either Mashhad or Abdullah as the old companion.
7. Although Gawhar-Shad Begum compiled her father's poetry, it is not certain that she was the patron of either of the surviving volumes of the *Divan*.

8. The governor's full name was Sulayman Khalifa Turcoman. He was involved in a military engagement in 988/1580–81 in Mashhad and another in 1002/1593–94 in Ozgand, where he was killed (Iskandar Beg Munshi [Afshar], 1:140, 256, 488; Iskandar Beg Munshi [Savory], 1:224, 379, 2:664–65).

9. Robinson ("Isma'il," 7) has credited Abdullah with an illustration in a *Shahnama* possibly made for Isma'il II. See also A. Welch, *Artists*, 214. This attribution now appears problematic (*EIr*, Priscilla P. Soucek, "'Abdallah Šīrāzī"). Soudavar (pp. 227–28) has proposed that Abdullah also worked for Mirza Salman, vizier during the reigns of Isma'il II (1576–77) and Muhammad Khudabanda (1578–88).

10. The chronicler's discussion of Abdullah follows a much longer passage devoted to Hasan Baghdadi at the end of his section on "Outstanding Artists of the Period." Iskandar Beg Munshi [Afshar], 1:177; Iskandar Beg Munshi [Savory], 1:274.

11. Qazi Ahmad [Minorsky], 190; Qazi Ahmad [Suhayli-Khunsari], 148. It is partly on the basis of Qazi Ahmad's account that some have wondered if Abdullah might not have been responsible for the marginal decoration and other details in the Freer Jami and even for the supervising the manuscript's entire program of illumination. See Gray, *PP 2*, 142; *EIr*, Priscilla P. Soucek, "'Abdallah Šīrāzī"; and Simpson, "Jami," 98.

12. Qazi Ahmad [Minorsky], 190 (n. 682 gives the Persian term as *rang-i raughan* and suggests that such colors were used on pen-case lids); Qazi Ahmad [Suhayli-Khunsari], 148 (gives term as *rang u raughan*). Diba ("Lacquerwork" 2, 125) describes Abdullah as a "master of lacquerwork" on the basis of Qazi Ahmad's statement, drawn from the 3d edition of Qazi Ahmad [Suhayli-Khunsari], where the Persian is given as *rang u raughankari*. Elsewhere ("Lacquerwork" 2, 184) she refers to Qazi Ahmad's praise of Abdullah for "his expertise in preparing *rang-i raughan*, again, the contemporary term for lacquer painting or, specifically, 'oil colors.'" Diba ("Laquerwork" 2, 124) also cites Sadiqi Beg's use of the term *rang-i raughan*, translating it as "color varnishing technique" and noting that it also appears "in relation to the mixing of colors and the application of gold leaf." See also Dickson & Welch, 1:261A, 263A n. 14, 265A–B.

13. The only variations on this signature formulation appear in two works signed in verbal form: FGA 46.12, folio 84b (illuminated by Abdullah rather than the illuminator) and TKS R. 918, folio 57a (painted and decorated by Abdullah rather than Abdullah the painter and illuminator; this may be an ascription, however, and not a genuine signature, as discussed in the list of Abdullah's oeuvre in Appendix E). Zeren Tanindi discussed R. 918 and other TKS manuscripts connected with Abdullah in a paper entitled "The Topkapi Palace Museum *Haft Avrang* of Jami: Muzehhib Abdullah Sirazi and Some New Aspects of His Work," at the Institute of Fine Arts, New York University, February 1994. See also Çağman & Tanindi, "Remarks," 136, 142, and figs. 8–9.

Like other Safavid artists, such as Shah-Mahmud al-Nishapuri, whose names included a nisba, Abdullah varied in his use of *al-Shirazi*.

14. The signature on folio 84b of the Freer Jami was first noticed and published in *EIr*, Priscilla P. Soucek, "'Abdallah Šīrāzī." Soucek's discovery has been erroneously credited to me and the illumination signed by Abdullah incorrectly described as a two-page *unvan* (here used to mean "frontispiece") (Gray, "Safavid," 890 n. 3).

The signature in a *Divan* of Sultan Ibrahim Mirza dated 990/1582–83 is written in two equal parts across the facing pages of the opening illuminated frontispiece (SAK MS 33, folios 1b–2a). It is recorded here for the first time, apparently

having not been noticed at the time the manuscript was exhibited in the United States in 1982–83 (Welch & Welch, cat. no. 30) and in Geneva in 1985 (*Treasures*, cat. no. 77). The entries in the respective exhibition catalogues speculate, however, that Abdullah executed the manuscript's illumination, including frontispiece, rubrics, and margins.

The third signature is hidden in the opening illumination in a volume of the *Divan* of Hafiz dated Ramadan 898–Rabi' I 994/September 1581–February 1586 (TKS H. 986, folio 6a). A small unit on the facing page (folio 5b) looks as if it could have accommodated a few words, which either were not written or have been covered up. Dr. Zeren Tanindi attributes illustrated folios 129a and 156a and the lacquered binding to Abdullah (see citation in note 13, above; also Çağman & Tanindi, "Remarks," 136; and personal communication, 5 March 1995).

Abdullah also seems to have concealed a dated signature within the illuminated frontispiece to a *Gulistan* of Sa'di (SAY Akhlaq 7, folio 1b or 2a; Nizamuddin, 137, 149–50). I have not been able to verify the published information.

15. The date is nestled along the last letter (*lam*) of *amal* and is quite small. On the painting of the youthful musician, Abdullah omitted the final digit, which can presumed to have been the 0 of 990/1582–83 (LKM). Priscilla P. Soucek (*EIr*, "'Abdallah Šīrāzī") has commented that the date is illegible on reproductions of this painting, although it is visible in Kühnel, *Miniaturmalerie*, fig. 70a; and Schulz, 2: color pl. 139. Abdullah also left off the final digit 0 of 990 in another painting (SAK MS 33, folio 23a).

16. The tight superimposition of the lines of different-sized script also invites comparison with calligraphic monograms (*tughras*). See Soudavar, cat. no. 55, for an early-sixteenth-century example of both a personal seal and tughra of the kind Abdullah may have been emulating or evoking.

The same *Divan* of Hafiz in which Abdullah signed the opening illumination contains two other signature stones. They are both inscribed *amal Bihzad Ibrahimi* (work of Bihzad Ibrahimi) (TKS H. 986, folios 21b and 111b; see Çağman & Tanindi, 50; Çağman & Tanindi, "Remarks," 136). The first inscription is quite small, spindly, and uneven, however, suggesting that it may have been a later addition, possibly in imitation of Abdullah's signature style. The father-and-son artists Aqa Reza and Abu'l-Hasan, who worked for the Mughal court in the first decades of the seventeenth century, also signed their names on rocks (Soucek, "Artists," figs. 7, 8, 9, 11).

17. This painting has been inserted into a volume of Jami's *Subhat al-abrar* copied by Sultan-Muhammad Khandan. Gray (*OIA*, cat. 126) does not accept the Abdullah signature as authentic and regards the painting as a copy of a composition in Saint Petersburg. Actually the (then Leningrad) painting he cites (Martin, 2: pl. 114) is comparable to the right half of the double composition pasted into the front of the *Subhat*. Stchoukine (*MS*, 126) considers the work genuine.

18. O'Kane, "Rock Faces," 225–26.

19. Stchoukine (*MS*, 126) first attributed folio 153b of the Freer Jami to Abdullah on the basis of its similarities between the *Divan* illustration and another unsigned painting (GULB LA 159, folio 3a). Although iconographically identical to the Freer Jami illustration, the latter work seems stylistically distinctive. Stchoukine's attribution of folio 153b suggests that he considered Abdullah to be the first unnamed painter in Group 2 of his categorization of Freer Jami paintings; there folio 153b is grouped with folios 105a, 194b, and 231a and described as belonging to the same artist. Stchoukine notes in particular the dynamic character of these compositions as expressed in the chaotic heaps of rocks, the dispersion and drawing of the leaves, the fleeing clouds, and, finally, the pronounced

diagonal orientation of the composition "qui entraine le regard du spectateur dans un fouillis de formes" (Stchoukine, *MS*, 128).

Soucek (*EIr*, "'Abdallah Šīrāzī") has attributed folio 179b to Abdullah. She remarks that the stylistic affinities between the *Sifat* and *Haft awrang* compositions extend to nearly all details, "except that the earlier painting [i.e., the one in the Freer Jami] appears to have a pronounced sense of internal rhythm." A scene of outdoor entertainment in the *Divan* of Hafiz of 989–994/1581–86 contains several features found in the *Sifat* frontispiece, including the central pavilion and its two seated figures, the *saqi* (cupbearer) kneeling on the grassy foreground, and the row of standing figures at the side (TKS H. 986, folio 156a). Zeren Tanindi (see notes 13 and 14, above) attributes this illustration, as well as a polo scene in the same manuscript (folio 129a), to Abdullah. See also Çağman & Tanindi, "Remarks," 136, and figs. 6–7.

20. It is telling in terms of attributing Freer Jami paintings to Abdullah that S. C. Welch does not identify this artist as one of the six painters who worked on the Freer Jami in any of his extensive discussions about the *Haft awrang*, although he certainly places the artist in the immediate circle of Sultan Ibrahim Mirza and has him accompanying the prince to Mashhad, Sabzivar, and Qazvin. Much of Welch's consideration of Abdullah (see note 1, above) is within the context of the painter Shaykh-Muhammad, to whom Welch attributes seven Freer Jami illustrations.

21. Abdullah's oeuvre contains several other attributed paintings, including folios 105a, 194b, and 231a in the Freer Jami, which really do not bear close scrutiny. The garden pavilion in the right side of the *Sifat* frontispiece (and the upper part of FGA 46.12, folio 179b), as well as the servant offering a bowl of fruit to a princely youth, reappear in one of the text illustrations to the *Divan* of Hafiz in which Abdullah signed the opening illumination (Çağman & Tanindi, "Remarks," fig. 7). This reappearance may be another example of artists drawing on the same prototype.

22. This same highlighting technique appears in the Freer Jami rubrics and may provide a clue to Abdullah's further involvement in that project.

23. Abdullah's painting of an old man in a landscape is also surrounded by a broad band of brightly painted alternating motifs (pendants, blossoms, and garlands) and by a zone of blue finials and gold blossoms in the margins (GULB LA 159, folio 101a).

ALI ASGHAR

Although the evidence is circumstantial, Ali Asghar, a native of Kashan, seems to have begun his artistic career at the court of Shah Tahmasp.[1] From there he went to Mashhad and the kitabkhana of Sultan Ibrahim Mirza, where he received a salary and rewards.[2] Iskandar Beg Munshi also states that Ali Asghar was in Ibrahim Mirza's employ and that the artist subsequently joined the staff of the royal library during the reign of Ismaʿil II (984–85/1576–78). This report places Ali Asghar in Qazvin during in the second half of the 1570s.

Somewhat atypically, Qazi Ahmad says nothing about Ali Asghar's artistic talents or reputation. Iskandar Beg Munshi, on the other hand, describes the artist as "very good on color, and unrivaled in painting mountain scenes and trees."[3]

No work of art signed by Ali Asghar is known today, precluding any firsthand assessment of the artist's painting skills and the type of projects he undertook. Quite a few manuscripts and detached paintings have been attributed to him, however, on the basis of an illustration inscribed with his name (AHT no. 100; fig. 209).[4] The composition, depicting Iskandar building the iron wall against Gog and Magog, comes from a copy of the *Shahnama* believed to have been commissioned by Shah Ismaʿil and datable to circa 1576–77. The ranks of Iskandar's masons here include various divs, who presumably represent the savage folk of Gog and Magog and add an original element to the iconography of this familiar scene. In general the painting reveals a command of the court style of the second half of the sixteenth century, particularly in its sure handling of figures and animals. On the other hand, it is very thinly painted, and certain landscape motifs, notably the rocky crags and clouds, receive summary treatment, as if the artist had dashed them off.[5]

Among the other works attributed to Ali Asghar by modern scholarship is the double-page hunting scene originally placed as the frontispiece (private collection) to the Ismaʿil *Shahnama*. The attribution is based largely on the assumption that Ali Asghar would have been assigned the opening composition in this important manuscript by virtue of his status as "a senior painter of high standing in Ismaʿil II's royal library."[6] In fact, the primary sources do not indicate Ali Asghar's position at the time of Shah Ismaʿil. Furthermore, the frontispiece composition is a great

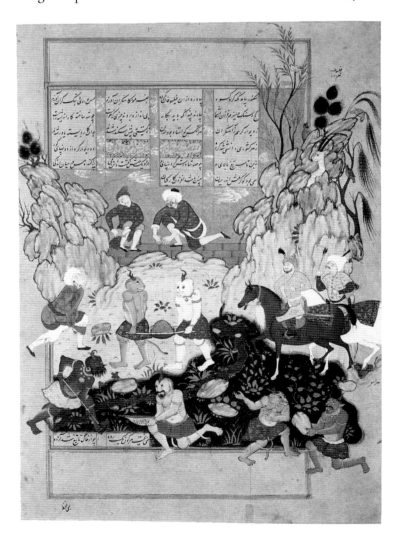

209
Iskandar Builds a Wall against Gog and Magog
Inscribed Ali Asghar
from the *Shahnama* of Firdawsi
ca. 1576–77, Iran, attributed to Qazvin
45.5×31.7 cm (folio); 40×31 cm (painting)
AHT no. 100
Art and History Trust, Courtesy of
Arthur M. Sackler Gallery, Smithsonian
Institution, Washington, D.C.

210 (*opposite*)
Three Men in a Landscape
Attributed to Ali Asghar
Painting mounted as an album page
ca. 1600, Iran
36×24.1 cm (folio); 26.7×19.2 cm (painting)
TKS H. 2165, folio 63b
Topkapi Sarayi Müzesi, Istanbul

deal more crowded than that of the inscribed Iskandar composition, and the figures and animals are rendered in much more awkward proportions and poses. There are some points of similarity in the two works, especially the configuration and coloration of the rock formations, but otherwise they have little in common.

One particular feature of the *Shahnama* frontispiece that does not appear in the text illustration is a male figure executed in profile with a long, flattened, and hooked nose. The same figure appears in other works attributed to Ali Asghar, such as a double-page frontispiece to a *Shah u gada* (King and beggar) manuscript of circa 1570–75.[7] While it is possible to track this distinctive figure and other specific stylistic details through a number of works, the association with Ali Asghar remains highly problematic. Certainly there is no way to determine on the basis of the available evidence what Ali Asghar might have executed for Sultan Ibrahim Mirza.

In the absence of a securely documented oeuvre, Ali Asghar's importance within the history of Safavid art ranks less as a painter of any recognizable style or distinction than as the father of Reza, the most celebrated artist at the court of Shah Abbas. Father and son may have collaborated on various works, such as an album painting now in Istanbul (TKS H. 2165, folio 63b; fig. 210). This composition includes two bearded men and a landscape setting typical of Reza's signed work of the late sixteenth–early seventeenth century and a third beardless figure with a flattened profile who resembles the figure in the *Shah u gada* frontispiece attributed to Ali Asghar.

Ali Asghar also remains memorable today as a participant in a scandal that took place around 1530, at what must have been an early point in his career. The fullest account of this episode is given by the late-sixteenth-century painter and writer Sadiqi Beg and has been frequently told.[8] Ali Asghar and Abdul-Aziz, another court artist and the apparent instigator of the affair, absconded with a young court page, the son of the royal surgeon at the court of Shah Tahmasp, and forged the royal seal while en route to India. Eventually the malefactors were captured and returned to court, where the page's father ordered Ali Asghar and Abdul-Aziz to be punished by having their noses and ears cut off. This mutilation, which led to Ali Asghar's being given the nickname *kalakush* (stump ear),[9] did not constitute a permanent disgrace or disability, however, and he was allowed to proceed with his career in the service of Sultan Ibrahim Mirza and Shah Isma'il II.

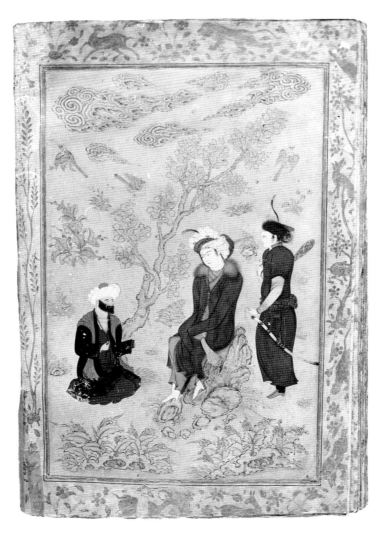

Notes

1. Primary sources: Ali Efendi, (as per Stchoukine, *MS*, 29); Iskandar Beg Munshi [Afshar], 1:176; Iskandar Beg Munshi [Savory], 1:273; Qazi Ahmad [Minorsky], 7, 10, 30, 188, 192; Qazi Ahmad [Suhayli-Khunsari], 140 n. 2, 144, 149, 150–51 n. 1; and Sadiqi Beg [Khayyampur], 254–55.
 Secondary sources: Canby, *Reformer*, 38–39, 42; Gray, *PP* 2, 142; Robinson, "Ali Asghar"; Robinson, "Isma'il," 7; Stchoukine, *MS*, 28–29; A. Welch, "Abbas," 465–66; A. Welch, *Artists*, 11, 20, 57, 79, 104–5, 152 n. 4, 162, 200 n. 5, 213–14; and Dickson & Welch, 1:52B, 168A, 224B, 227A, 228A.
 That Ali Asghar was at the court of Shah Tahmasp may be inferred from a story, to be discussed below, of how he and the artist Abdul-Aziz ran away with one of the shah's favorite young pages.
2. Qazi Ahmad [Suhayli-Khunsari], 144; Qazi Ahmad [Minorsky], 188. Neither the Suhayli-Khunsari edition nor the Minorsky translation mention Ibrahim Mirza by name, referring to him only as *navvab-i mirza'i* (his princely highness). The two versions differ, however, on other points. The Suhayli-Khunsari edition places Ali Asghar in Mashhad (omitted in the Minorsky translation), while the Minorsky translation calls the artist a courtier (not mentioned in Suhayli-Khunsari).
3. Iskandar Beg Munshi [Afshar], 1:176; Iskandar Beg Munshi [Savory], 1:273. The English translation of the *Gulistan-i hunar* includes a passage, at the end of the entry on Ali Asghar's son Aqa Reza, that has been read as meaning that Ali Asghar lived with Qazi Ahmad's family in Mashhad for ten years and helped Qazi Ahmad learn to draw (Dickson & Welch, 1:52B; Qazi Ahmad [Minorsky], 192; Robinson, "Ali Asghar," 125). This passage is not in Qazi Ahmad [Suhayli-Khunsari], and the English is actually somewhat ambiguous.
4. The artist's name is written in a very scratchy hand in the right margin. Soudavar (p. 252) has noted that Asghar is misspelled with a *sin* substituting for *sad*; the *lam* and *ye* of Ali also are very badly formed. Notwithstanding these orthographic irregularities, the inscription has been accepted as a secure attribution written by a contemporary connoisseur and accorded the same reliability as the inscriptions written on the majority of the other fifty-one illustrations belonging to Shah Isma'il's *Shahnama*.
5. Soudavar (p. 250) has pointed out that the painting is unfinished, and indeed, the rocky crags at both the left and right of the scene include several birds and additional trees rendered only in black outlines. The folio's incomplete status also extends to the blank rectangular panels above and below the painted surface. In other folios from the 1576–77 *Shahnama* such panels contain text written on the diagonal (A. Welch, *Artists*, pls. 1, 5, 14–16, 64).
6. Robinson, *PMA*, 33; Robinson, "Isma'il," 125; *Treasures*, 107.
7. Soudavar (p. 252) has commented on the painter's fluid and quick handling of the brushstroke and floating figures and identified these as further characteristics of Ali Asghar's style.
8. Dickson & Welch, 1:224A–B.
9. Qazi Ahmad [Suhayli-Khunsari], 144. This passage is not in Qazi Ahmad [Minorsky].

SHAYKH-MUHAMMAD

Like Ali Asghar, Shaykh-Muhammad left no clear trace of his association with Sultan Ibrahim Mirza, and nothing in his recorded oeuvre can be linked directly or automatically with the prince or his kitabkhana.[1] Evidence for the connection between artist and patron comes only from contemporary sources confirming that Shaykh-Muhammad served Ibrahim Mirza but differing as to where the service occurred. Qazi Ahmad reports that Shaykh-Muhammad worked for the prince in Mashhad, where author and artist undoubtedly knew each other.[2] Certainly Shaykh-Muhammad was in Mashhad for at least some, if not all, of Ibrahim Mirza's governorship, as evidenced by a calligraphy he signed and dated "at the holy shrine of the Imam," meaning the shrine of the Imam Reza in Mashhad, in 970/1562–63 (TKS H. 2137, folio 18b). Iskandar Beg Munshi, on the other hand, states that the artist entered Ibrahim Mirza's employ in Sabzivar.[3] A native of Sabzivar, Shaykh-Muhammad might very well have gone from Mashhad to his hometown when the prince was appointed governor there sometime in 974–75/1566–67. Munshi Budaq-i Qazvini mentions only that the artist was with Sultan Ibrahim Mirza in Khurasan, which could mean either Mashhad or Sabzivar.[4]

Iskandar Beg is the principal source for Shaykh-Muhammad's subsequent career. From Sabzivar the artist continued to serve Ibrahim Mirza in Iraq, probably signifying that he accompanied the prince on his return to Qazvin in Ramadan 982/December 1574. Shaykh-Muhammad remained in the Safavid capital after the accession of Shah Isma'il II (r. 984–85/1576–78) and served as a member of the royal kitabkhana. He later returned to Khurasan province. During the reign of Abbas I (r. 996–1030/1588–1629) Shaykh-Muhammad was once again employed at court and worked on the new palace (daulatkhana). At the time of his death, he was still in service to Shah Abbas.[5]

Like so many painters and calligraphers in the Safavid period, Shaykh-Muhammad came from an artistic family. His father was Shaykh-Kamal, noted as a master of the six calligraphic styles, especially thuluth and naskh, and as a copyist of the Koran. It can be presumed that Shaykh-Muhammad studied with his father, and he may have been guided by Shaykh-Kamal in the copying of a *Sad kalama* (One hundred sayings) in 943/1536–37 (TQV).[6] Both Budaq-i Qazvini and Qazi Ahmad specify, however, that he was a student of Dust-i Divana.[7] This brilliant but eccentric painter, whose full name was Dust-Muhammad musavvir, worked for Shah Tahmasp in Tabriz along with his teacher, master Bihzad, for about ten years beginning in the mid-1520s. After Bihzad's death in 942/1535–36, Dust-Muhammad left Iran for Kabul and entered the service of the Mughal court, working first for Prince Kamran and within ten years for the Emperor Humayun.[8] Budaq-i Qazvini states that Shaykh-Kamal and his children, presumably including Shaykh-Muhammad, also served Humayun.[9] Thus Dust-Muhammad musavvir may have taught Shaykh-Muhammad during their association with the Mughal court.[10]

Shaykh-Muhammad's career flourished from the mid-1550s through the early 1590s as he practiced the variety of arts evidenced in the surviving works and confirmed by the primary sources. Both Budaq-i Qazvini and Qazi Ahmad describe Shaykh-Muhammad as a painter, illuminator, and outliner and emphasize his proficiency in calligraphy, particularly nasta'liq.[11] According to Budaq-i Qazvini, the artist followed the writing of Mir-Ali [Haravi], a famous sixteenth-century calligrapher who was captured in his hometown of Herat by the Uzbek Shaybanids and impressed into service in Bukhara.[12] Shaykh-Muhammad himself acknowledges his admiration of this master through two copies, dated 970/1562–63 and 976/1568–69, of a plaintive poem composed by Mir-Ali after being taken off to Bukhara (TKS H. 2137, folio 18b; and TKS H. 2151, folio 39a; fig. 211).[13] In Qazi Ahmad's estimation, Shaykh-Muhammad's copies of works by masters could not be distinguished from the originals. As a painter he followed the Chinese qalam, or "pen," apparently meaning that he painted in a linear, calligraphic mode. He also was noted for his portraits in Chinese style.[14] Iskandar Beg Munshi similarly praises Shaykh-Muhammad's portraiture and his representation of faces (gunah-sazi). The later chronicler also comments that the artist imitated and popularized European painting (surat-i farangi), suggesting that Shaykh-Muhammad's work may have been perceived as more "realistic" than the typical Safavid painting.[15]

The recorded oeuvre of Shaykh-Muhammad, consisting of more than a dozen signed calligraphies, tinted drawings, and paintings, supplemented by a large number of attributed works, confirms the artist's virtuosity and versatility even within the same media. His qit'as, for instance,

211
Calligraphy of Mir-Ali Haravi
Signed by Shaykh-Muhammad
in the Amir Husayn Beg album
976/1568–69, Iran
23.9×14.3 cm (written surface)
TKS H. 2151, folio 39a
Topkapi Sarayi Müzesi, Istanbul

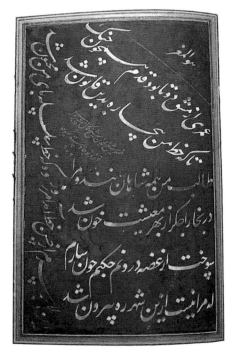

exhibit considerable variety in overall design and calligraphic form. The earliest known sample, the qit'a after Mir-Ali Haravi dated 970/1562–63, is written on cream-colored paper decorated with delicate gold plants and floral sprays (TKS H. 2137, folio 18b). Shaykh-Muhammad's nasta'liq is bold and very black, with two verses written on the diagonal and a third on the horizontal. He used both the flanking triangular cornerpieces for his signature, beginning with his acknowledgment to Mir-Ali above and his name and date below, then continuing, in a much smaller script, onto the central field of the qit'a for the evocation of the Imam Reza. Shaykh-Muhammad's next dated calligraphy, of 976/1568–69, is even more striking, with the qit'a verses by Mir-Ali written in colored inks, alternating lines of white and yellow nasta'liq, on a dark green ground (TKS H. 2151, folio 39a). The direction of the verses also varies, with one on the diagonal, two on the horizontal, and the final one on the vertical. Shaykh-Muhammad signed and dated this piece in small orange script beneath the first angled verse, creating still another area of visual interest. Yet a third, undated, qit'a consists of a sheet of bright blue paper with three verses written on the diagonal in black outlines filled in with gold (TKS H. 2140, folio 10b). Here, too, Shaykh-Muhammad made a point of highlighting his signature by writing it on the vertical in black ink at the left side of the blue paper.

The artist's originality as a calligrapher notwithstanding, he actually may have preferred to be regarded as a painter since he signed his earliest known qit'a of 970/1562–63 as Shaykh-Muhammad musavvir (TKS H. 2137, folio 18b). Certainly he had been practicing painting for some time, as confirmed by the well-known scene of a camel and cameleer dated 964/1556–67 (FGA 37.21; fig. 212). This small work, mounted and evidently conceived as an album painting, reveals Shaykh-Muhammad as a superb designer, draftsman, and colorist. Ostensibly simple, the composition is actually a study in contrasts, with the pale and delicately rendered landscape a perfect foil for the strong colors of the animal and human figures, including the pair of angel musicians on the saddle, as well as the rich and intricate patterns of the saddle blanket. Shaykh-Muhammad's rendering of man and beast, with the apparently anxious herdsman overwhelmed in size and bearing by the chained but imposing dromedary, provides another striking contrast and creates at once a tension and an ambiguity not often seen—or at least so clearly evident—in Safavid album paintings. That this effect was carefully calculated and intended as the visual component of a larger message becomes apparent when the painting is considered together with its surrounding verses.

212
Camel and Its Keeper
Signed by Shaykh-Muhammad
Painting mounted as an album page
964/1556–57, Iran
13.1×21.1 cm (folio)
FGA 37.21

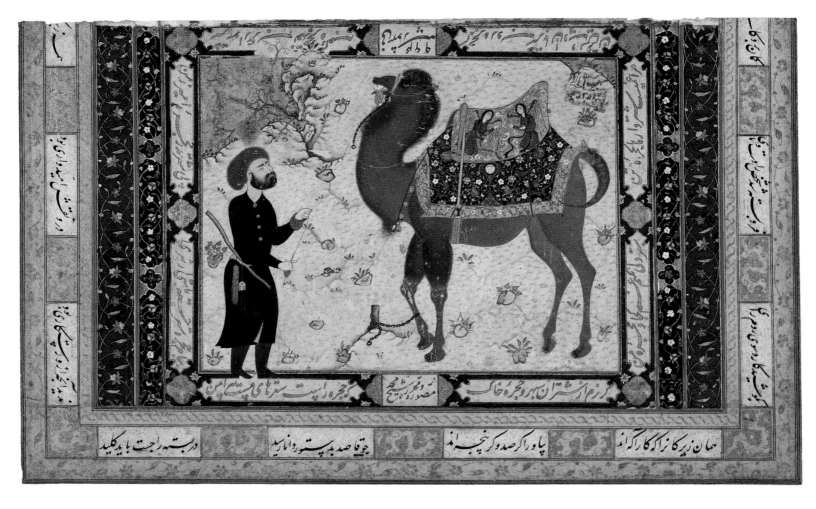

It has long been recognized that the text cartouches immediately around the painting were copied by Shaykh-Muhammad, as the artist's signature in the square central panels and the verses' placement on the same sheet of paper as the painting attest. As Chahryar Adle has now shown, the verses are part of an extremely complex qasida by Katibi Turshizi (d. 838 or 839/1434–35 or 1435–36) in which the words "camel" (*shutur*) and "cell" or "chamber" (*hujra*) appear in every hemistich.[16] Beyond its elaborate poetic construction, the poem concerns the misery of the world and the human condition. Its message is that release is possible if one follows the righteous path of Ali, the first Shi'ite leader. Among those who did walk in the way of Ali was a poor Arab cameleer named Vays-i Qaran, described as "the sweeper of his camel-keeper's cell" in the top verse framing the picture. Adle's explication de texte sheds new light on the iconography of Shaykh-Muhammad's album painting and extends its meaning beyond that of a psychologically charged confrontation between a camel and its keeper. Instead the painting represents Vays-i Qaran spinning wool (a typical activity for Iranian herdsmen) and contemplating the beast of burden and its saddleback images of two musical angels who symbolize the celestial beings that the faithful cameleer will encounter in paradise on judgment day. In short, this is an esoteric image that responds to the verses of Katibi and that reveals Shaykh-Muhammad to have been perfectly attuned to the sophisticated interaction of art and literature prevailing in the court culture of his day.

Yet, as Adle has also pointed out, Shayhk-Muhammad's masterful painting was by no means an original composition. It is likely to have been based on or influenced by a similar work by Bihzad, which also depicts the popular figure of Vays-i Qaran the cameleer.[17] Shaykh-Muhammad may have been directly familiar with the earlier version since his teacher Dust-i Divana had studied with Bihzad. Shaykh-Muhammad gave the popular figure of Vays-i Qaran the cameleer new emphasis, however, by coupling the painting with a poem based on the repetition of the word "camel." In so doing he seemed to be not merely emulating but deliberately rivaling his teacher's teacher.

The combination of a pictorial masterwork and a poetic tour de force surely would have appealed to a discriminating connoisseur like Sultan Ibrahim Mirza, and it seems safe to assume, given the painting's date of 964/1556–57, that Shaykh-Muhammad created it while in the prince's employ. Modern scholarship also has long assumed that Shaykh-Muhammad participated in the creation of Sultan-Ibrahim Mirza's *Haft awrang* and has attributed altogether ten illustrations to the artist (FGA 46.12, folios 64b, 100b, 114b, 120a, 132a, 162a, 179b, 253a, 264a, and 298a). Of these attributions, only one—that of *Bandits Attack the Caravan of Aynie and Ria* (folio 64b)—seems to be unanimous. There are indeed certain affinities between Shaykh-Muhammad's painting of Vays-i Qaran and the camel and the unsigned *Haft awrang* illustration, notably the high landscape scattered with tufts of grass and small rocks and marked with several lightly colored "fissures," as well as the tree with short, bare, spiky branches growing at a pronounced angle from the rocky horizon. Other common elements include, of course, the camels (although none of the beasts in the Freer Jami scene is as imperious in bearing or as resentful of his circumstances as the album camel) and certain details such as the camels' twisted blue and white reins and the long straight-sided container hanging from the waist of the young groom at the right side of the illustration.[18] But neither this active scene of combat, with its multiple focuses and disjointed composition, nor the album painting, with its controlled precision, seems to have much to do, except perhaps in select details, with the other Freer Jami paintings also believed to be by Shaykh-Muhammad. Indeed, some of the illustrations seem to have little to do with one another, and it is small wonder that the artist supposedly responsible for them has been characterized as "something of an oddity with a highly unusual style."[19]

Of all the *Haft awrang* compositions attributed to Shaykh-Muhammad, none is more idiosyncratic or at a greater stylistic remove from his signed album painting than *Majnun Approaches the Camp of Layli's Caravan* (folio 253a). This is also perhaps the most notorious painting in the Freer Jami and the one most frequently used as evidence for the style of its artist, the character of its manuscript, the predilections of its patron, and the tenor of its times. The painting is full of curious, even bizarre, features that combine with the complicated composition to mask, or at least detract attention from, its actual subject. Certainly this work could make one suppose that its artist was more interested in creating a pictorial sensation than a narrative illustration. Whether the painter can be dubbed "hallucinatory" and the painting "guilt-ridden, willfully heading for oblivion" is far more debatable.[20]

213
Youth with a Book and a Flower
Signed by Shaykh-Muhammad
Tinted drawing
ca. 1575, Iran
15.5×8.3 cm (drawing)
LVR K3427
Musée du Louvre, Section Islamique, no. K3427

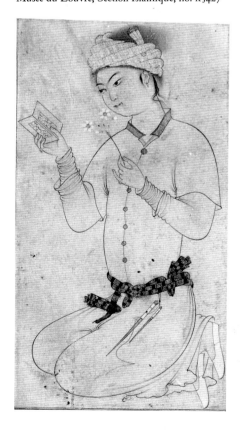

The question of Shaykh-Muhammad's possible contributions to the Freer Jami may be considered not only in terms of style but also of format. It is perhaps not just a fluke of survival that Shakyh-Muhammad's documented oeuvre contains only figure studies and lacks manuscript illustrations and frontispieces, such as Abdullah al-Shirazi created. The artist was, after all, known for his portraits and representation of faces. In addition to the more unusual (although by no means unprecedented) scene of Vays-i Qaran and the camel, Shaykh-Muhammad painted and drew primarily familiar figure types: standing and seated dignitaries, contemplative and leisurely youths, prisoners, dervishes, and princesses. Two are fully painted: a yoked and bearded prisoner (TKS H. 2156, folio 45a) and a seated woman, generally described as a princess, holding a flower (TKS H. 2166, folio 24b). Both works are executed in a carefully polished style with firm contours and bright blues and yellows for the garments. The prisoner's facial features are particularly fine, and his furrowed brow and aquiline nose recall the physiognomy of Vays-i Qaran.[21] Shaykh-Muhammad's princess, on the other hand, is a far less attractive version of a well-established figure type.[22] Everything about and around her appears flat, as if the artist were deliberately trying to suppress any sign of vitality and character.

The majority of Shaykh-Muhammad's signed oeuvre consists of tinted drawings that reveal the full extent of his consummate abilities as a draftsman. Surely it is the artist's fluid lines that the primary sources are referring to when they speak of him as following the Chinese qalam. The drawings include a bearded man leaning on a staff (TKS H. 2161, folio 172a) and a seated dervish with his hands tucked into his sleeves (CB MS 242.4). The dervish's body is very compact, with an almost continuous silhouette; his fine facial features are comparable to those of the yoked prisoner, and his wrinkled sleeves are a marvel of calligraphic rendering.

Shaykh-Muhammad also created three drawings of elegant kneeling youths, all facing in the same direction and dressed in similar attire and accessories. Two are virtual twins in pose and attributes, and each looks downward at an open book (inscribed with the same poetic verse) in the left hand while sniffing at a blossoming stem held in the right (LVR K3427; and TKS H. 2166, folio 9b; figs. 213 and 214). The third member of this group has been identified as a prince, apparently because of his additional jewelery, including a turban plume and pin (FGA 37.23; fig. 215). His gaze is level and focuses on a green parrot that he holds instead of a book and flower. Shaykh-Muhammad treated the eyes of these three figures in virtually identical style, with arched eyebrows that "wing" off the right side of the forehead and heavy eyelids that do not fully meet and also project to the side. The artist signed his name as "Shaykh" in the Louvre and Freer drawings, tucking the minute signature just where the ripple of the sitter's hem meets the smooth contour of the outer thigh. In the Istanbul drawing his full name appears, also in very small script, at the top of the penknife.

Other "signature" details favored by Shaykh-Muhammad in these three drawings as well as in other works include the turban cloth wrapped low around a fuzzy fur cap, the elaborately knotted and draped sash, the dangling pen and penknife, and sleeves that wrinkle in V-shaped folds. These features have resulted in the attribution to Shaykh-Muhammad of quite a number of drawings and paintings, some of which either lack the precision of the artist's outlines or take the hard edge of the seated "princess" to a calcified extreme.

The knotted sash and hanging pen and penknife make yet another appearance in Shaykh-Muhammad's last-known work, dated 1000/1591–92, which he created in collaboration with Reza Abbasi, by then the rising star in the artistic circle at the court of Shah Abbas I (TKS H. 2166, folio 18a). The wording of the artists' joint signature specifies their individual responsibilities: Shaykh-Muhammad created the design of the mustachioed man with a pillow and landscape, while Reza executed the drawing. Certainly the spontaneous quality of Reza's line—featuring varied widths, interrupted contours, and quick, staccatolike strokes of the pen—represents a significant departure from the much more calculated approach practiced by Shaykh-Muhammad.[23]

The chronology of Shaykh-Muhammad's painted and drawn oeuvre, like that of much of his career, remains problematic. The album painting of 964/1556–57 is the work of a mature artist, able to absorb complex poetic concepts and express them in subtle visual forms. The collaborative drawing of 1000/1591–92 reveals that artistic originality now lay with the next generation, which was moving away from the pictorial concerns of the second half of the sixteenth century and toward a entirely new approach for figural representation. Most of Shaykh-Muhammad's undated work is

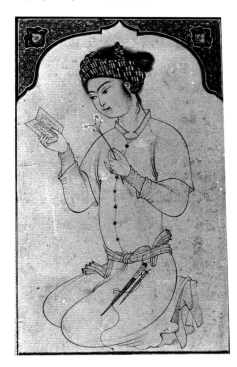

214
Youth with a Book and a Flower
Signed by Shaykh-Muhammad
Tinted drawing
in an album
ca. 1575, Iran
36.1×22.9 cm (folio)
TKS H. 2166, folio 9b
Topkapi Sarayi Müzesi, Istanbul

closer in spirit to the self-assured album painting and thus probably was executed, as scholars have generally proposed, in the 1550s through 1570s.

According to Iskandar Beg Munshi, Shaykh-Muhammad claimed to be unique in the painting of individual portraits. "And indeed, he was right in his self-claim for all the masters of painting agreed with him in this respect."[24] Certainly the recorded oeuvre confirms his specialization in single figure studies and points to the possibility that all the surviving works were created, like the painting of Vays-i Qaran the cameleer, for inclusion in albums compiled at the behest of patrons such as Sultan Ibrahim Mirza.

215
Prince with a Parakeet
Signed by Shaykh-Muhammad
Tinted drawing
ca. 1575, Iran
15.7×9.2 cm (folio)
FGA 37.23

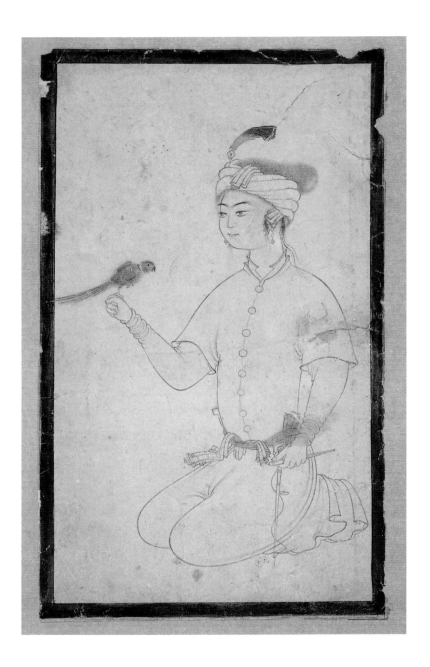

1. Primary sources: Iskandar Beg Munshi [Afshar], 1:172; Iskandar Beg Munshi [Savory], 1:273; Qazi Ahmad [Minorsky], 187–88; and Qazi Ahmad [Suhayli-Khunsari], 142.

Secondary sources: Adle, "Dust-Mohammad," 242–44, 271, 287–91 (drawing on Munshi Budaq-i Qazvini, *Javahir al-akhbar* [Jewel of the chronicles; SPL Dorn 288] as a source for the passage on Shaykh-Muhammad in Qazi Ahmad's *Gulistan-i hunar* and giving various versions of that passage); Mehdi Bayani, 3–4:741–42, 825–26, 837–38; Canby, *Reformer*, 39, 43, 129; Dickson & Welch, 1: chapter 7; Robinson, "Comments," 510; Simpson, "Shaykh-Muhammad"; Soudavar, 236 (with a partial translation of Munshi Budaq-i Qazvini), 305; Stchoukine, *MS*, 46–47; Stchoukine, "Shaykh," 3–11; A. Welch, "Abbas," 459–66; A. Welch, *Artists*, 20, 50, 86, 112–13, 152 n. 4, 156–57, 162; S. C. Welch, *KBK*, 71–72; S. C. Welch, "Pictures," 71; S. C. Welch, *PP*, 123–24; and S. C. Welch, *WA*, 29, cat. nos. 73, 76, 77, 80, 84.

During the final production stage of this book, I found a minute signature by Shaykh-Muhammad within the architectural decor of folio 120a. This discovery obviously clinches the artist's involvement with the Freer Jami and affects various conclusions that follow here. The implications will be taken up in a subsequent study.

2. Qazi Ahmad [Minorsky], 188; Qazi Ahmad [Suhayli-Khunsari], 142. These versions of the *Gulistan-i hunar* differ in their representation of Shaykh-Muhammad's status at the prince's court: Suhayli-Khunsari has it that the artist "was attached to the prince and received rewards," while Minorsky says that "he was a courtier and had a salary." See also Adle, "Dust-Mohammad," 288–91 (texts 5, 6a, 6b, 6j, 6d, 6h). Qazi Ahmad also states that he met Shaykh-Muhammad's father, the calligrapher Shaykh-Kamal, in Mashhad in 965/1557–58.

3. Iskandar Beg Munshi [Afshar], 1:172; Iskandar Beg Munshi [Savory], 1:273.

4. Adle, "Dust-Mohammad," 288 (text 5); Soudavar, 236. Munshi Budaq-i Qazvini also says that Ibrahim Mirza "educated" Shaykh-Muhammad after he came to Khurasan. The prince's mentorship presumably involved subjects other than art.

5. Iskandar Beg Munshi [Afshar], 1:172; Iskandar Beg Munshi [Savory], 1:273. Abbas shifted his capital from Qazvin to Isfahan in 1006/1597–98, so the new palace on which Shaykh-Muhammad worked doubtless was in Qazvin.

6. The peculiarities in Shaykh-Muhammad's signature in this manuscript, and particularly the use of the nisba *Nishapuri* (as opposed to *Sabzivari*) are discussed by Dickson & Welch (1:251B n. 7), who imply that this work could be by another Shaykh-Muhammad [son of] Kamal. The early date of this manuscript in the context of Shaykh-Muhammad's oeuvre as a whole also raises a question about its authorship. Unfortunately, it has not been possible to study the work at firsthand.

7. Adle, "Dust-Mohammad," 288 (text 5); Qazi Ahmad [Minorsky], 75; Qazi Ahmad [Suhayli-Khunsari], 37; Soudavar, 236.

8. Adle, "Dust-Mohammad," 238–63, 294–96. See also Qazi Ahmad [Minorsky], 180; and Qazi Ahmad [Suhayli-Khunsari], 135–36.

9. Adle, "Dust-Mohammad," 288 (text 5); Soudavar, 236. Munshi Budaq-i Qazvini gives no date for the appearance of Shaykh-Kamal and his children at the Mughal court, but they probably arrived sometime around 956/1549–50, when the Safavid painters Mir Sayyid-Ali and Abdul-Samad are known to have joined Humayun at Kabul.

Such a chronology, placing Shaykh-Muhammad as a pupil of Dust-Muhammad musavvir in Kabul in the mid-to-late 950s/early 1550s, makes it unlikely that Shaykh-Muhammad ever worked for Shah Tahmasp in Tabriz, or at least not as a mature artist. Thus the Mawlana Nizamuddin Shaykh-

Muhammad listed as "among the scribes of the royal library who are renowned for their calligraphy" in the introduction to the Bahram Mirza album may be another Shaykh-Muhammad altogether (Dust-Muhammad [Thackston], 348). Such a possibility would represent a significant revision in previous accounts of Shaykh-Muhammad's biography (Dickson & Welch, 1:167A, 168B, 175B; Simpson, "Shaykh-Muhammad," 99). On the other hand, the primary sources do praise Shaykh-Muhammad as a calligrapher. But could he have been in the same artistic generation as Shah-Mahmud al-Nishapuri and Rustam-Ali, as implied in the Bahram Mirza introduction?

10. Master and pupil may have collaborated on the illustration of a small *Khamsa* (BL Add. 25900; Adle, "Dust-Mohammad," 285; Dickson & Welch, 1:126A, 175B, and figs. 176–78).

11. Adle, "Dust-Mohammad," 288 (text 5); Qazi Ahmad [Minorsky], 187; Qazi Ahmad [Suhayli-Khunsari], 142; Soudavar, 236.

12. Simpson, "Bahram Mirza," 382–83.

13. Adle, "Dust-Mohammad," 288 (text 5). The reference to Mir-Ali does not appear in the Soudavar translation of Munshi Budaq-i Qazvini. See Qazi Ahmad [Minorsky], 130–31, and Qazi Ahmad [Suhayli-Khunsari], 82, for the poem by Mir-Ali Haravi that Shaykh-Muhammad copied.

14. Adle, "Dust-Mohammad," 288 (text 5), 50 (text 6h) (with corrections to Qazi Ahmad [Minorsky], 187, and important commentary on the meaning of "Cathayan" [i.e., Chinese] painting); Qazi Ahmad [Suhayli-Khunsari], 142; Soudavar, 236.

15. Iskandar Beg Munshi [Afshar], 1:172; Iskandar Beg Munshi [Savory], 1:273 (also praising Shaykh-Muhammad for his copies of master calligraphers). The term *gunah-sazi* has been translated previously as "genre-painting" (Dickson & Welch, 1:166A). Soudavar (p. 236) translates *surat-i farangi* literally as "European-style face" and points to the possibility that Shaykh-Muhammad's portraiture "deviates from the idealized and stylized manner of traditional Persian painting."

16. Adle introduced his new and provocative interpretation of the painting in a short presentation at the February 1991 meeting of the North American Historians of Islamic Art in Washington, D.C. His findings are also mentioned in "Dust-Mohammad," 243–44, and pl. XV, fig. 19, caption, and are preliminary to a more extensive publication in the future.

Adle's research also considers the verses in the album painting's outer frame and identifies them as describing Iskandar's dying days in Babylonia. The emperor sent for Aristotle and then died soon after the philosopher arrived. Adle finds a common thread with the Katibi poem in the notion of the inevitability of fate. While the poems may share a similar theme, it must be noted that those in the outer frame have been pasted, along with the intermediary bands of illumination, onto the larger cardboard mount to which Shaykh-Muhammad's painting and calligraphy are also affixed. There is no certainty, therefore, that the verses about Iskandar were part of Shaykh-Muhammad's original scheme for his composition. The handwriting of these verses is also inferior to Shaykh-Muhammad's calligraphy.

For the poet Katibi Turshizi (named in full by Adle as Shamsuddin Muhammad ibn Abdullah Katibi-yi Turshizi-yi Nishapuri), see Rypka, 283–84; and Yarshater, 270.

17. Binyon et al., pl. 87-A.

18. Notwithstanding S. C. Welch's comment that "one need only compare the two pictures to be convinced of their common authorship" (Dickson & Welch, 2:168B), firsthand comparison of both works in the Freer Gallery of Art does not necessarily confirm the similarity of all the elements cited by Welch in support of his attribution. The saddle blankets of the camel in the signed album painting and of the central camel in the Freer Jami

picture, for instance, are more distinctive than identical in their decoration. Likewise the cameleer, now identified as a popular subject in late Timurid and Safavid painting, does not pop up all over the place in the crowded battle scene. In fact, I have not been able to find his counterpart in any of the Freer Jami illustrations attributed to Shaykh-Muhammad, where the faces tend to be more angular and elongated, especially around the chin, and the brows unfurrowed.

19. A. Welch, *Artists*, 156.

20. Dickson & Welch, 1:45B.

21. Dickson & Welch (1:252B n. 14) propose that Shaykh-Muhammad originated the yoked prisoner topos and attribute other works of the same type to him.

22. For example, Simpson, *Fogg*, 62–63. Dickson & Welch (1:177A) characterize Shaykh-Muhammad's princess as almost caricatural.

23. Canby (*Reformer*, 39, 43–45) gives quite a different interpretation of Shaykh-Muhammad's influence on Reza.

24. Iskandar Beg Munshi [Afshar], 1:172; Iskandar Beg Munshi [Savory], 1:273.

CHAPTER FOUR: MAKING AND MEANING

As recounted in the preceding chapters, the story of the Freer Jami revolves around the volume's form and contents, including its twenty-eight illustrations, and circles outward to encompass the people involved in its creation. The human dimension of the manuscript is ultimately the most intriguing because it leads us to concentrate, essentially for the first time, on a series of lives and careers that had separate identities and that intersected for varying intervals in the making of a magnificent work of art.

The intersection of Sultan Ibrahim Mirza, Shah-Mahmud al-Nishapuri, Rustam-Ali, Muhibb-Ali, Malik al-Daylami, Ayshi ibn Ishrati, and Abdullah al-Shirazi with the *Haft awrang* of Abdul-Rahman Jami clearly could not have occurred without a concept, a program, and a context. The concept doubtless evolved out of the desire of Sultan Ibrahim Mirza to possess a deluxe manuscript that would be suitable for a scion of the Safavid dynasty while simultaneously setting off his literary and artistic inclinations from those of previous Safavid patrons. The program for the manuscript doubtless developed not as a flash of princely inspiration but as a result of examination of existing works of art, particularly illuminated and illustrated copies of Jami's masnavis, and consultation with selected artistic advisers.

The context or circumstances in which the idea for a deluxe *Haft awrang* evolved into a program or plan for the production of such a manuscript and eventually into the stunning work of art we admire today is explored in the first section of this chapter. The circumstances of the Freer Jami are perhaps best summarized in the explicit phrase "by order of the kitabkhana of Sultan Ibrahim Mirza" that appears in two paintings and several colophons (fig. 216).[1] In addition to documenting the *Haft awrang*'s patron, the phrase and its variants confirm two important points: the manuscript was a commission, and the commission was executed at or for Sultan Ibrahim Mirza's kitabkhana.[2] We already know from the primary sources, and especially from Qazi Ahmad, that the Safavid prince supported a kitabkhana and that his kitabkhana was at once a locus for the collection of manuscripts (that is, a library) and the focus for artistic activity (that is, a studio and workshop). What remains at issue is the structure and operation of the kitabkhana as studio and specifically how the tastes of a princely patron and the talents of his artists joined there in the creation of a major work of art.

Finally, in the second section of this chapter, the story of the Freer Jami circles back inward and takes up the issue of why Sultan Ibrahim Mirza devoted so many years and resources to a single commission and to the patronage of the kitabkhana and kitabkhana artists necessary for such an ambitious project. We must assume some purpose and meaning behind this tremendous enterprise. And, just as the paintings of the Freer Jami attracted and sustained scholarly attention since the manuscript's first mention in *A Survey of Persian Art*, so the themes and progression of its illustrations signal the manuscript's significance for its patron.

1. FGA 46.12, folios 38b, 139a, 162a, and 181a read *birasm-i kitabkhana Sultan Ibrahim Mirza*. (Sultan Ibrahim Mirza's name is preceded by honorifics in the colophon inscriptions on folios 139a and 181a.) Variants appear in the colophons on folios 46a (*biamr ali-ya navab* [by the high order of his highness]), 83b (*birasm-i bayt al-kutub* [by order of the library]), and 272a (*biamr navab* [by order of his highness]). All contain the name of Sultan Ibrahim Mirza.

The discussion of the kitabkhana in the following section depends on Simpson, "Kitab-Khana," which includes an introduction to the orthography and etymology of the word *kitabkhana* (pp. 116–17 n. 3). In general, see also Porter, chapter 9.

2. See Adle, "Autopsia," 237, for another view of the meaning of *birasm-i kitabkhana*; also Simpson, "Kitab-Khana," 118 n. 13.

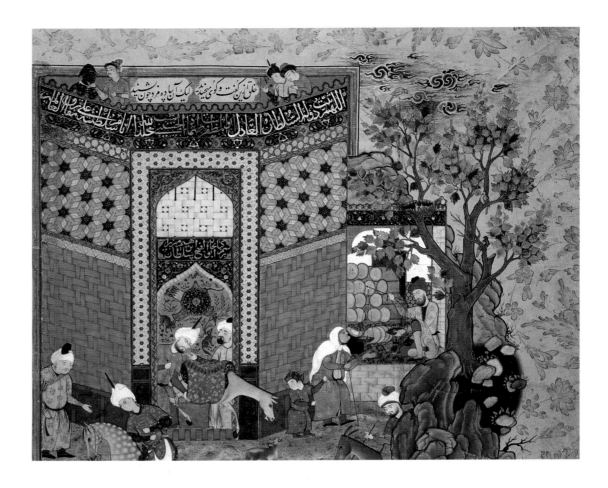

THE PRINCE'S KITABKHANA AND THE MANUSCRIPT'S PRODUCTION

While the multiple identity of the kitabkhana as collection, library, and workshop has long been accepted, its history as a manifestation of Persian court culture remains only partly understood. The earliest known and most carefully studied kitabkhana is that established by endowment of the famous vizier and author Rashiduddin (645–718/1247–1318) within the Rabʿ⁄i Rashidi complex outside the Il⁄Khanid capital of Tabriz.[1] As set forth in the waqfiyya, or endowment deed, the prin⁄cipal function of this kitabkhana was to produce annually a thirty⁄volume manuscript of the Koran, a collection of the hadith, and two copies (one in Arabic and one in Persian) of six of Rashiduddin's own texts. The waqfiyya specifies the material and format of the manuscripts to be copied as well as the intention to distribute them throughout the Il⁄Khanid realm. It also describes the kitabkhana personnel, including professional staff such as the overseer (mutavalli) charged with maintaining the annual production schedule, scribes capable of finishing the work within a year, and students who took down the texts from dictation. The staff also comprised many slaves, some of whom were skilled in calligraphy, painting, and gilding. Although the exact location of the bookmaking tasks is not stipulated, another of the mutavalli's duties was to assign workspace within the complex.[2]

It is clear from the waqfiyya that the Rabʿ⁄i Rashidi kitabkhana was conceived as a highly orga⁄nized and carefully controlled operation in which the vizier himself, as well as his sons, were directly involved.[3] Surviving copies of the Koran made under Rashiduddin's patronage and con⁄temporary manuscripts of his theological works attest to the high quality and uniformity attained at his kitabkhana and other pious foundations he endowed. The signatures of individual scribes and illuminators recorded in these volumes confirm that artists worked together to carry out the vizier's commissions. Although these artists belonged to a tightly knit network dependent on the interests and resources of the vizier, it is less certain that they formed part of a permanent kitabkhana staff.

Little of comparable substance is known about the mechanics of manuscript patronage and production during the rest of the Il⁄Khanid period and after the dynasty's fall in the middle of the fourteenth century. Documentation for the history of the kitabkhana resumes around 1420, when the Timurid artist Jaʿfar Tabrizi prepared a status report, or *arzadasht* (literally, "petition"), on work then in progress under his direction at the kitabkhana of his patron, prince Baysunghur Mirza

$(799-837/1397-1433).$[4] Essentially an itemized listing, Ja'far's report gives invaluable information about individual artists and their current projects, including the transcription, illustration, decoration, and binding of manuscripts and the painting of other works such as chests and timbers. The report is particularly revealing in terms of the number of artists working at Baysunghur's kitabkhana and the diversity of manuscript projects under way at the same time: altogether some twenty artists are named as at work on tasks ranging from the design of waves for two sea scenes in a copy of the *Gulistan* to the completion of twenty-five thousand verses of the *Shahnama*. Most of the artists are noted as working on their own; occasionally two or more are credited with successive steps in the same manuscript, such as the *Ta'rikh* (identifiable as the *Ta'rikh-i jahangusha*, History of the world conqueror) copied by Mawlana Sa'uddib with rulings and a sarlawh (probably meaning an illuminated title piece) added by Khwaja Ata. The report also contains instances of collaborative projects such as the saddle designed by Mir-Dawlatyar, copied by Khwaja Mir-Hasan, and executed in mother-of-pearl by Mir-Shamsuddin and master Dawlat-Khwaja. Similarly an artist named Khwaja Abdul-Rahmin is reported as "busy making designs for the binders, illuminators, tentmakers and tilemakers."[5]

Although the location of all these activities is not mentioned, they evidently took place within the same precincts, and specifically within Baysunghur's palace complex, judging from a second section in the arzadasht concerning architectural projects. This section begins with a description of work under way on the court (*dargah*), including the placement of a doorway for the picture gallery (*suratkhana*), and at the old palace (*qasr qadim*). A single-line passage states, "The kitabkhana begun for the painters has been finished, and the painters and scribes have taken up occupancy."[6] From this statement it would appear that the kitabkhana occupied specifically designated quarters. Equally significant, in terms of understanding the kitabkhana's structure and hierarchy, is that the painters and scribes were working in the same space.[7] The overall impression is of an extremely busy operation, with artists skilled in various aspects of the manuscript arts—copying, illuminating, painting, and binding—at work on many projects simultaneously.

While the waqfiyya of Rashiduddin sets forth the vizier's expectations and directives and tells what was supposed to happen at the Rab'-i Rashidi kitabkhana, the arzadasht reveals what actually was happening during one, albeit unspecified, period at a princely Timurid kitabkhana. Their distinctive purposes notwithstanding, both documents confirm that the making of manuscripts and other works of art involved numerous individual artists working at the same time and place for a single patron. Thus the sponsorship of a kitabkhana, no matter what its actual scale or products, in Iran during early Il-Khanid and early Timurid times was essentially an act of private, as opposed to state or dynastic, patronage and funding. Various members of the same family, such as the Timurids, could—and did—sponsor their own manuscript operations in far-flung regions and cities: Baysunghur in Herat, his brother Ibrahim Sultan in Shiraz, and a second brother Ulugh Beg in Samarqand. This princely patronage may very well have been directed toward the formulation and dissemination of a dynastic aesthetic through the involvement of artists who differed in individual styles while sharing the same formal approach and vision.[8] Yet, in fact, there was no central policy dictating the operation or coordinating the results of separate kitabkhanas.

An important manual of Safavid administration, the *Tadhkirat al-muluk* (Memorial for kings), confirms that a kitabkhana was part of its patron's own household or personal property, or *khassa*, as opposed to the official bureaucracy or divan of a dynasty or court.[9] Thus, as in Timurid times, kitabkhanas remained private undertakings, and throughout the Safavid period there was no such thing as a dynastic kitabkhana that functioned as an autonomous or continuous enterprise. Furthermore, there is no evidence that a kitabkhana as library and collection passed automatically and intact from father to son or from ruler to heir.[10] And while there clearly could be overlap in the personnel of kitabkhanas as workshops, kitabkhana patrons apparently did not inherit their staff or receive artists as a privilege of office. In general, the sponsorship of a kitabkhana seems to have resulted from personal initiative, usually connected to the patron's commission for a deluxe manuscript. It was the desire or need for deluxe manuscripts that prompted royal bibliophiles such as Isma'il I and his progeny to set up their own kitabkhanas, in the process enhancing their individual status and prestige.[11] Completely dependent on an individual patron for its very existence, a kitabkhana likewise could be disbanded at its patron's will, as occurred around the middle of the sixteenth century when Shah Tahmasp turned his attention to other affairs and allowed the artists working for his kitabkhana to leave the court and practice their art elsewhere.[12]

There exists no description of a sixteenth-century kitabkhana as a manuscript workshop from which to deduce the type of operation that produced Sultan Ibrahim Mirza's *Haft awrang*. A composite picture of the workings of a Safavid kitabkhana may be constructed, however, from various sources.[13] These include the same chroniclers who inform us about Sultan Ibrahim Mirza's artists as well as royal decrees concerning specific kitabkhana appointments, accounts of European visitors to Safavid Iran, and the *Tadhkirat al-muluk*.

At the central court, the kitabkhana was part of a series of over thirty *karkhana*s, or workshops, belonging to the royal household (*buyutat al-saltanati*). A number of these karkhanas served domestic functions, such as the kitchen and the barbershop. Others, such as the goldsmiths' workshop (*zargarkhana*), produced luxury items. The works of the kitabkhana may have fallen into this category. Another such karkhana was the *naqqashkhana*, or painting studio, which suggests that painting (presumably including manuscript illustration) was both equal to and separate from other aspects of manuscript production. This may not have been the case in earlier Safavid times, however, judging from the rare occurrence of the word *naqqashkhana* versus the common use of *kitabkhana* in sources referring, for instance, to artists at the court of Shah Tahmasp.[14]

As described in the *Tadhkirat al-muluk* and other sources, each of the royal karkhanas in the late Safavid period was run by a *sahib jam'* (meaning roughly, "workshop master") and a *mushrif* (overseer) who were responsible for estimating and obtaining supplies and for other internal arrangements. These two officials reported to the *nazir-i buyutat*, the overall superintendent of the workshops. In addition, the workshop staff included a *bashi* (chief) and *ustadan* (master craftsmen) who directed the workshop's technical affairs and received their raw materials from the mushrif. While the recorded duties of each member of the workshop seem vague, an image emerges of a well-defined administration and staff hierarchy, with various levels of management (the sahib jam' and mushrif) and labor (the bashi and ustadan).

It is probable that only the ruler's court could afford and support such an elaborate system of karkhanas. Certain aspects of the workshop structure and function could have been replicated elsewhere, however. Certainly the court of an ambitious princely patron such as Sultan Ibrahim Mirza would have provided a likely venue for this kind of operation, albeit on a reduced scale.

However and whenever Sultan Ibrahim Mirza decided to commission an illustrated copy of Jami's *Haft awrang* and the consequent formation of a kitabkhana, he would have definitely needed someone to supervise the project and direct the artistic establishment necessary to produce it. From the arzadasht it is evident that in Timurid times a single individual—in that case the scribe Ja'far Tabrizi—could be engaged in specific manuscript projects while also coordinating, or at least overseeing and reporting on, the activities of many different artists. The same arrangement seems to have prevailed at Sultan Ibrahim Mirza's kitabkhana, where Muhibb-Ali served both as calligrapher of two sections of the *Haft awrang* and as kitabdar, or head, of the kitabkhana as a whole (fig. 217). His general managerial and supervisory responsibilities may be inferred from a pair of Safavid decrees. The first, a well-known document dating from the early 1520s, announces the appointment of master Bihzad as head of the royal kitabkhana in Tabriz.[15] Specifically, the decree appoints Bihzad "to the post of superintendent [*mansab-i istifa*] and chief [*kalantari*] of the men of the royal kitabkhana—the scribes, painters, illuminators, rulers, fleckers, gold-leaf makers and lapis-lazuli washers, and the others who are attached to the aforesaid activities."[16] The decree then enjoins all the court officers, including agents of administrative and fiscal affairs and the kitabkhana personnel in particular to recognize Bihzad as superintendent, to perform all the tasks of the kitabkhana at his direction, to consider as official anything that he signs or seals, and to follow everything he says concerning the kitabkhana activities and organization. The second decree, dating some fifty years later (983/1575–76) at the very end of Shah Tahmasp's reign, concerns a similar appointment of the artist Hasan Mudhahhib as director (*niyasat-i kalantari*) of the assembly (*jama'at*) of illuminators, scribes, bookbinders, painters, gold-leaf makers, and paper sellers, also in the Safavid capital of Tabriz.[17] Hasan's supervisory duties were comparable to those set forth for Bihzad and included educating and training the staff and dismissing anyone who behaved inappropriately.

Inasmuch as Bihzad and Hasan were appointed directly by the reigning Safavid monarch to work at the court kitabkhana, the process of their appointment and the delineation of their authority and duties were apt to have been far more formal and official than whatever Muhibb-Ali experienced when he took up the role of kitabdar for Sultan Ibrahim Mirza in Mashhad.[18] Furthermore, Bihzad and Hasan Mudhahhib were charged with the supervision of an already functioning

kitabkhana, with existing staff and staff hierarchies.[19] By contrast, Muhibb-Ali presumably was dealing with a start-up operation and was obliged to launch both the *Haft awrang* project and the kitabkhana organization simultaneously—probably based on the precedence of other Safavid kitabkhanas. Thus his first, concurrent tasks would have been to devise the general concept and specifications for the *Haft awrang* manuscript and to put together the personnel necessary to carry out the plan.

Neither the Timurid arzadasht nor the Safavid decrees reveal anything about the relationship between a kitabdar and a kitabkhana sponsor or about the process of planning a major manuscript project. It has always been assumed, however, that patrons such as prince Baysunghur and Shah Isma'il were actively involved with at least the general scheme of their manuscript commissions.[20] The many references to Sultan Ibrahim Mirza in the Freer Jami certainly indicate that he wanted his patronage of the manuscript to be recognized and point to the possibility that he may have taken a direct role in its planning. The prince may even have had very specific ideas and opinions about

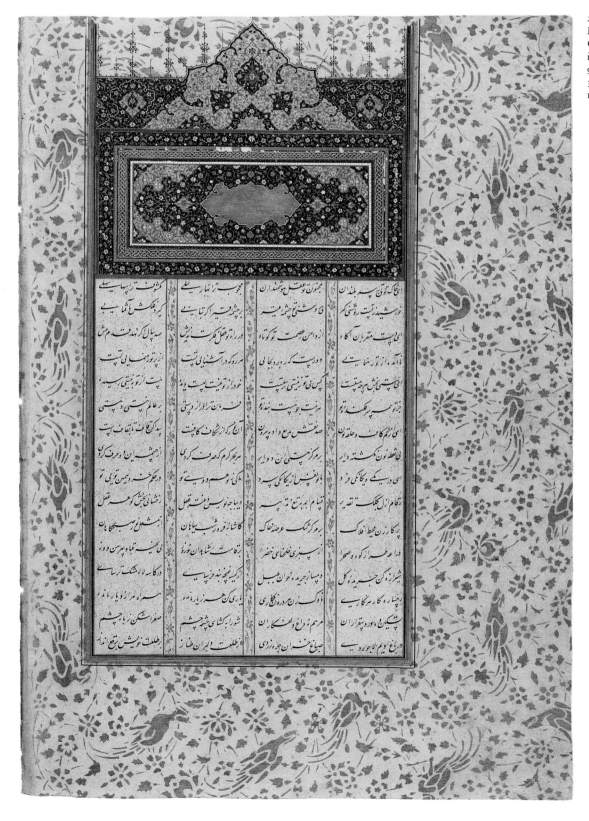

217
Masnavi heading folio of *Layli u Majnun*
Copied by Muhibb-Ali
in the *Haft awrang* of Jami
972/1565, Iran, Herat
34.5×23.4 cm (folio)
FGA 46.12, folio 225b

the final appearance of his manuscript and may have dictated many of its features to Muhibb-Ali. It is equally likely that Muhibb-Ali's role was to develop the material and artistic program for the volume and to consult with Sultan Ibrahim Mirza as necessary. Thus as kitabdar he would have determined features such as the manuscript's dimensions, number of folios, type of paper, folio layout, physical structure, areas of illumination, and probably even the *Haft awrang* scenes to be illustrated, and he may have presented a prospectus to the prince for consideration.

In other manuscript traditions, such as Byzantium and medieval western Europe, it was common practice for new volumes of a text to follow older volumes of the same text.[21] Likewise Muhibb-Ali may have sought models, or at least guidance, for Sultan Ibrahim Mirza's *Haft awrang* in other illustrated copies of Jami's masnavis.[22] Similarly, for general inspiration he may have looked to deluxe manuscripts created during the first half of the sixteenth century, or even earlier, such as the *Shahnama* and *Khamsa* made for Shah Tahmasp.

218
Colophon folio of *Silsilat al-dhahab*, first daftar
Signed by Malik al-Daylami
in the *Haft awrang* of Jami
963/1556, Iran, Mashhad
21.8×13 cm (written surface)
FGA 46.12, folio 46a

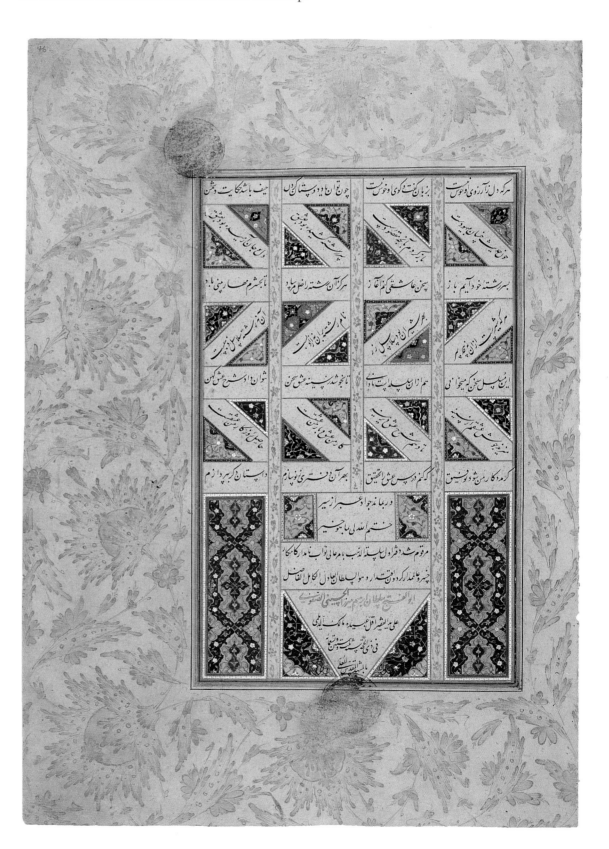

CHAPTER FOUR: MAKING AND MEANING

Once the manuscript's format and program had been planned, it probably would have been necessary to make a mock-up or dummy manuscript—a task that Muhibb-Ali most likely would have undertaken or at least supervised. Such a "model book" for the final codex would have been essential in a project that, from the very outset, had the potential to assume significant proportions. The dummy would have indicated, for instance, the placement of regular components of the manuscript such as the rubrics and particularly of special features like diagonal verses and illustrations.[23] Another crucial task at this stage would have involved the preparation of the two sets of paper for the *Haft awrang*: the fine, white paper for the text, and the colored paper for the margins. Both papers were doubtless made to order according to Muhibb-Ali's specifications, possibly within the kitabkhana or in another, separate workshop set up exclusively for that purpose.[24]

At the same time that the manuscript was being planned and its essential materials prepared, Muhibb-Ali would also have been occupied in lining up a kitabkhana staff, composed of the same range of artists enumerated in the Bihzad and Hasan Mudhahhib decrees, and in assigning individual tasks. Sultan Ibrahim Mirza probably would have participated in this step, too, judging from general workshop procedures of the later Safavid period. According to the French jeweler Jean Chardin, who spent the years 1665–69 and 1671–77 in Iran, potential candidates for employment in a workshop were vetted in a multistage process starting with the workshop master, then passing to the general superintendent, and requiring final approval by the workshop patron or sponsor. The review process that Chardin observed took place at court, where Shah Sulayman I (r. 1077–1105/1666–94) made the ultimate decision and fixed the wages and other benefits of the successful applicants.[25] Sultan Ibrahim Mirza probably performed the same function for his kitabkhana. His uncle Tahmasp may also have been involved; it was on the shah's orders that Malik al-Daylami, for instance, was appointed to Sultan Ibrahim Mirza's kitabkhana.

Since the first step in the creation of the manuscript as a volume of Abdul-Rahman Jami's poetry would be the copying of the seven masnavis, Muhhib-Ali's immediate need was for a calligrapher. According to Qazi Ahmad, Malik al-Daylami had accompanied Sultan Ibrahim Mirza to Mashhad, and thus he, too, conceivably could have played a role in planning the *Haft awrang*. The original idea may have been for Malik to copy the entire Jami text, as suggested by his transcription of the *Silsilat al-dhahab*, which is normally the first poem in a *Haft awrang* (fig. 218). Sultan Ibrahim Mirza and/or Muhibb-Ali may have decided early on to further apportion work on the masnavis and expand the calligraphic team, however, to take advantage of the opportunity to engage Shah-Mahmud al-Nishapuri, who had been living in Mashhad since at least the summer of 958/1551. Securing the services of such an illustrious calligrapher, the copyist of Tahmasp's beautiful *Khamsa* of Nizami (BL Or. 2265), surely would have had tremendous appeal for the young prince. More important, perhaps, the participation of Shah-Mahmud firmly grounded the *Haft awrang* project within the silsila tradition that shaped the Persian arts of the book. The same commitment to continuity—further reinforced by family ties—may have caused Muhibb-Ali to take on Rustam-Ali, another member of the older generation who also happened to be his father. Like Shah-Mahmud, Rustam-Ali had worked for both Bahram Mirza and Tahmasp, so he might have been eager to serve another member of the Safavid family. The prospect of working on a project with his son Muhibb-Ali, his former pupil Malik al-Daylami, and his former Tabriz colleague Shah-Mahmud may have been equally compelling.

Thus from the beginning the roster of Sultan Ibrahim Mirza's kitabkhana included Muhibb-Ali as kitabdar and Shah-Mahmud al-Nishapuri, Rustam-Ali, and Malik al-Daylami as *kitaban*s, or scribes. The three calligraphers presumably began to work on their assignments at more or less the same time.[26] Shah-Mahmud al-Nishapuri and Rustam-Ali would have been well on in years when the *Haft awrang* project was getting started, and Muhibb-Ali may have engaged them with the understanding that each would transcribe only one relatively short masnavi. Rustam-Ali completed the *Tuhfat al-ahrar* first in Shawwal 963/August 1556. Two months later, in Dhu'l-hijja 963/October 1556, Shah-Mahmud submitted the *Subhat al-abrar*. At that point both he and Rustam-Ali may have fulfilled their obligation to the project and possibly even been taken off the kitabkhana rolls.

Meanwhile Malik al-Daylami had finished the first daftar of the *Silsilat al-dhahab*, also in Dhu'l-hijja 963/October 1556. By then, however, complications had evidently arisen, for he did not turn in the second and relatively short daftar until Ramadan 964/June–July 1557 (fig. 219). As kitab-dar, Muhibb-Ali obviously would have been aware of the consequences of delay, especially if he had signed up illuminators and painters who were ready to work on the transcribed folios. This sit-uation may explain why he undertook to copy the *Yusuf u Zulaykha* masnavi himself, completing it in Rajab 964/May 1557, even before Malik al-Daylami finished the second daftar of the *Silsilat*.

Muhibb-Ali's "hands-on" participation as a calligrapher notwithstanding, a break of exactly two years then occurred in the progress of the *Haft awrang*'s transcription. Various factors may have contributed to this interruption, including a possible decline in Sultan Ibrahim Mirza's interest in or (more likely) financial support for his kitabkhana or unexpected changes in its staff. At some point, for instance, Malik al-Daylami had received a royal summons to Qazvin. There he wrote inscriptions on some new court buildings, and—perhaps in his free time—completed the third daftar of the *Silsilat al-dhahab* in Ramadan 966/June–July 1559 (fig. 220). The completion of this work probably also concluded his association with Sultan Ibrahim Mirza's kitabkhana. Meanwhile Muhibb-Ali evidently remained in Mashhad as kitabdar and must have been casting about for other calligraphers to finish the rest of his patron's *Haft awrang*. Eventually the experienced, but perhaps not very reliable, scribe Ayshi ibn Ishrati was engaged to copy the *Salaman u Absal* poem, which he finished in 968/1560–61 (fig. 221). After that there was an even longer hiatus in the manuscript's transcription. This time the problem may have been connected to upheavals and reversals in Sultan Ibrahim Mirza's fortunes, including the removal of his vizier Mir-Munshi in 969/1561–62, his short-lived appointments to Ardabil and Qa'in starting at the end of 970/beginning of 1563, and

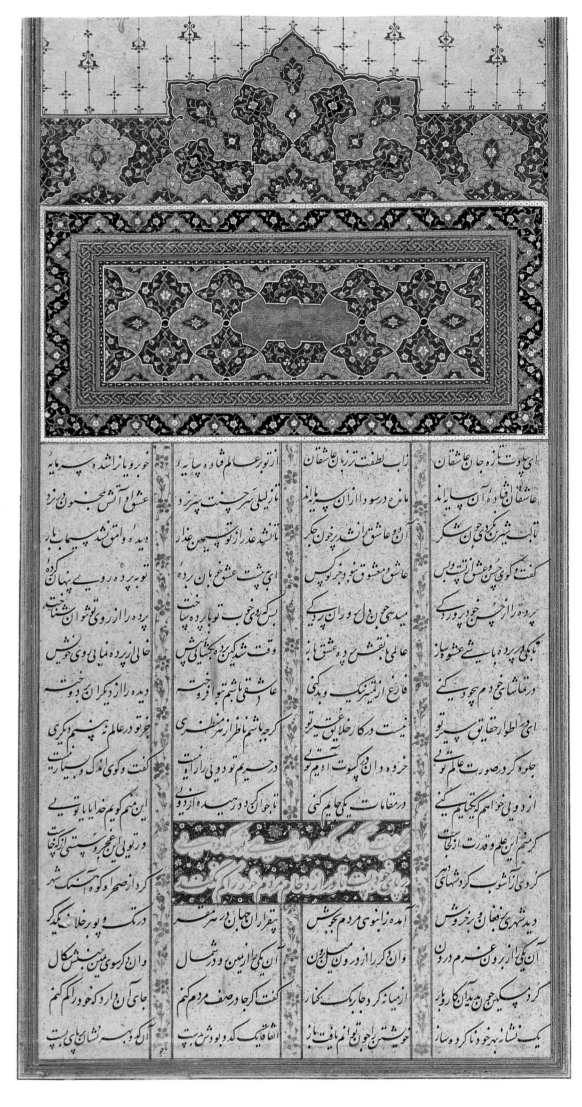

221
Masnavi heading folio of *Salaman u Absal*
Copied by Ayshi ibn Ishrati
in the *Haft awrang* of Jami
968/1560–61, Iran
34.5×23.4 cm (folio)
FGA 46.12, folio 182b

his participation in a military campaign in Herat from late 972/1564 through the early months of 973/1565. Small wonder that work on the *Haft awrang*—or at least the copying of the poems—was suspended during this period. It may even be that the kitabkhana as a center of artistic activity ceased to function altogether.[27] Muhhib-Ali, at least, remained loyal to both prince and project and even seems to have been with Sultan Ibrahim Mirza in Herat, where he completed the *Layli u Majnun* masnavi in Shawwal 972/May 1565.

Both the colophons of the Freer Jami and the careers of its calligraphers confirm emerging notions about the kitabkhana as artistic workshop and the locus of manuscript production, and particularly about its structure and operation during the Safavid period. First of all, there were obviously different kinds of kitabkhanas, depending on their patrons' circumstances. Whereas imperial kitabkhanas, such as that at the court of Shah Tahmasp in the first half of the sixteenth century and that described in the *Tadhkirat al-muluk* for the seventeenth century, maintained permanent or at least long-term staff, kitabkhanas at subimperial courts, such as that of Sultan Ibrahim Mirza, employed artists on a contract or project basis. In other words, a kitabkhana staff could be variable and possibly even skeletal at times. Furthermore, it was not necessary for an artist working on a kitabkhana project to be in residence, as is clear from Malik al-Daylami's last colophon in the *Silsilat al-dhahab*, which he began in Mashhad and completed in Qazvin, at a time when, as far as we know, Sultan Ibrahim Mirza remained in Mashhad. Malik al-Daylami's situation also suggests that artists could work simultaneously for two different patrons, while the careers of Shah-Mahmud al-Nishapuri and Rustam-Ali demonstrate that artists also could be affiliated with different kitabkhanas in succession. Thus there was a certain amount—and perhaps even a great deal—of professional movement in the ranks of those artists with kitabkhana affiliations during the Safavid period.[28]

It is also clear that kitabkhana artists could receive salaries, bonuses, and other financial and material benefits from their patrons. Furthermore, at the court of Shah Tahmasp they could receive the honor of signing themselves with the laqab *al-shahi*. They also could have a close relationship with a patron. Such status and intimacy notwithstanding, it remains less certain that artists ever attained the official rank of courtier (*mulazim*) except insofar as they were among various kinds of court attendants.[29]

Equally significant is the relationship among kitabkhana artists. We know from various works, particularly qit'as with joint signatures, that calligraphers could and did collaborate directly. Thus, for instance, Shah-Mahmud created pieces in tandem with Dust-Muhammad (TKS H. 2154, folios 5a and 125a) and Mir-Musavvir (TKS H. 2154, folios 6a and 123b), Rustam-Ali worked with Muzaffar-Ali (TKS H. 2154, folio 142b, top right), Malik al-Daylami with Muhammad Amin (TKS H. 2161, folio 109a, right) and Ayshi with Kamaluddin (SPL Dorn 147, folio 43a–b). In all these cases the collaborators were working on sequential tasks, such as first copying and then outlining, or copying and then cutting. Thus a jointly signed qit'a was actually executed in successive steps, and its two artists could have been collaborating and cooperating at a distance and over time rather than in immediate proximity to one another.

Compared with the creation of individual qit'as, the need for cooperation, and especially coordination as provided by the kitabdar, would have been far greater on a complex project such as the Freer Jami in which the collaborating artists worked not just on separate tasks but on entirely independent sections of the manuscript. During the copying of the *Haft awrang* text, Muhibb-Ali would have been primarily concerned with the accuracy, completeness, and timeliness of the scribes' work; that is, he exercised what might be called editorial oversight.[30] His role would have expanded to that of production manager when the making of the Freer Jami shifted from its transcription to its illumination. Although some parts of the illumination—such as the column dividers, verse illuminations, colophons, and even the rubrics—could have been executed on the text sheets whenever these were completed, other significant areas of the manuscript's decoration, including the colored rulings, painted and stenciled margins, and masnavi title pieces and finials, required the written surfaces to be joined to the margin paper. The illumination was, therefore, a two-part operation that could have been undertaken in successive stages as each masnavi was copied. The illumination of the *Tuhfat al-ahrar*, for instance, may have begun soon after Rustam-Ali submitted the transcribed text in Shawwal 963/August 1556, and that of the *Subhat al-abrar* after Shah-Mahmud turned in his assignment two months later. By that time the first phase of the *Tuhfat* illumination may have been accomplished and the full folios of this poem formed, allowing the second phase of its illumi-

nation to begin. In theory (although probably not in practice given the gaps in the submission of the transcribed text sheets), the illumination of all seven masnavis could have been under way simultaneously, with each masnavi at a different phase. In reality, and assuming that the illumination of the *Tuhfat* did commence upon the completion and review of its transcription, Muhibb-Ali now had to continue supervising and checking the other text assignments and to assign and coordinate the work of the *Tuhfat* illuminators. As the other masnavis were ready to be illuminated and the process of decorating the *Haft awrang* progressed, he probably would have had to devote even more efforts to coordination. In the midst of these many responsibilities he also had to copy the *Yusuf u Zulaykha* and the *Layli u Majnun* masnavis. Assuming that the Shawwal 972/May 1565 date for completion of the *Layli u Majnun* transcription also marked the initiation of the masnavi's illumination, Muhibb-Ali would have spent at least nine years—and possibly more—overseeing and coordinating the calligraphers and illuminators who worked for Ibrahim Mirza's kitabkhana.

Whatever the actual time span for the manuscript's illumination, the active kitabkhana roster obviously would have swelled considerably during the process. Clearly there were a number of artists responsible for specific parts of the manuscript's decoration, such as the rubrics and the margins. The sometimes subtle variation in the forms and motifs of these and other decorative elements suggests that teams of artists, each perhaps composed of a master and one or more assistants, worked on the decoration, probably simultaneously. Indeed, during the illumination the kitabkhana could have functioned on an assembly-line basis, with Muhibb-Ali putting the written surfaces first in the hands of one set or team of illuminators, who executed the columns dividers, verse illuminations, and so forth, then passing those same texts sheets to another group of artisans (perhaps not as specialized) to be joined to the margin papers, and then sending the by-then full folios back to the original illuminators, or another team, for the rulings, margins, and title pieces. Muhibb-Ali undoubtedly had to engage various such teams for the kitabkhana whenever two or more masnavis were being illuminated at the same time—as was probably the case. Regrettably, neither the Freer Jami itself nor the primary sources provide adequate information to identify the members of the illuminator teams. Only the heading of the *Yusuf u Zulaykha* is signed—by Abdullah al-Shirazi, who may have written the poetic inscription and painted the flanking floral scrolls as a special favor to Muhibb-Ali, the scribe of this section of the *Haft awrang* text, or at the personal request of Sultan Ibrahim Mirza. In any event, within the Freer Jami decoration, Abdullah made the sole documented contribution as a "name artist."[31]

Whereas the transcription of the Freer Jami was accomplished by calligraphers working in various parts of Iran under assignment to Muhibb-Ali, the equally protracted and even more complex process of its illumination probably had to take place at Sultan Ibrahim Mirza's kitabkhana under the kitabdar's direct supervision. The locus and procedures for the third major part of the manuscript's production—its illustration—are less certain. Muhibb-Ali probably began to secure the services of the best painters available, perhaps numbering a half-dozen or more, early on in the *Haft awrang* project, when the dummy manuscript was being prepared and the choice and placement of the scenes to be illustrated were being determined. Two of the compositions— *The Wise Old Man Chides a Foolish Youth* in the first daftar of the *Silsilat al-dhahab* (folio 10a) and *The Murid Kisses the Pir's Feet* in the *Tuhfat al-ahrar* (folio 207b)—could have been painted as soon as their text sheets were inset into the margins during the illumination process. Indeed, given the similarity of their subject matter and the resemblance between the pirs, it is possible that the paintings are the work of the same hand. Furthermore, the masnavis that these two paintings illustrate were among the earliest of the Jami poems to be completed: in Dhu'l-hijja 963/October 1556 and Shawwal 963/August 1556 respectively. Assuming that the illumination of these masnavis began soon after they were submitted and that the written surfaces were joined to the margins within six months or so of the start of the illumination, then the paintings on folios 10a and 207b probably were executed in mid-964/1557. The tight sequence for the transcription, illumination, and illustration of these folios leads to the conclusion that the "master of the pirs" worked at or in close proximity to Sultan Ibrahim Mirza's kitabkhana in Mashhad.

The artists responsible for the twenty-six other Freer Jami illustrations were probably more independent—or at least less dependent on the kitabkhana—since they were working on separate, full-sized sheets of paper.[32] Like Malik al-Daylami, who completed the third daftar of the *Silsilat* after being summoned from Mashhad to Qazvin, the majority of the Freer Jami painters did not really need to be in the same place as their patron or his kitabdar. Nor did they need to collaborate directly

with each other, as did the presumed teams of Freer Jami illuminators. What they would have required is the same kind of general oversight that Muhibb-Ali exercised over the calligraphers, including the assignment of scenes to be illustrated and the establishment of a schedule for the paintings to be completed. Thus Muhibb-Ali's greatest challenge with the painters may have been to ensure that they created compositions in accordance with the manuscript's proscribed pictorial program and executed them in a timely fashion.

His presumed efforts as a scheduler notwithstanding, Muhibb-Ali doubtless faced the same situation with the illustrations as the transcribed masnavis: they did not all come in at the same time. Thus the painted sheets were probably passed on to the illuminators one at a time, a system that would explain the variety of their decorative features compared with the Freer Jami's text folios.

One of Muhibb-Ali's most critical functions as kitabdar must have been quality control. At every stage of the manuscript's creation he would have had to check not only for technically accuracy and completeness but also for artistic or aesthetic standards. This would have been an increasingly difficult task as work on the project progressed, precisely because any necessary corrections or revisions inevitably would cause delays in bringing Sultan Ibrahim Mirza's *Haft awrang* to completion. An ink smudge or an uneven verse on a written surface would have required the text to be rewritten, but an infelicitous rubric would have meant that the text would have to be rewritten and any other illumination on that written surface also be redone. A sloppily executed margin would have caused the text to be recopied and the column dividers, verse illuminations, and rubrics to be repainted, the text and margin papers to be rejoined, and the colored rulings to the redrawn—all before the margin could be undertaken, more carefully, a second time. Presumably Muhibb-Ali attempted to protect the project against such time-consuming and labor-intensive situations by hiring the best artists at the outset and keeping a close eye on the work at every step. Technically speaking, it would have been easier to arrange for corrections to be made to the illustrations, assuming that they were painted on full-size pieces of blank paper. On the other hand, the illustrations were likely to have taken the longest time to create, and Muhibb-Ali probably could not afford to jeopardize the project as a whole by sending an entire composition back to the drawing board, as it were. Actually, the varied originality, style, and "success" of the twenty-eight extant compositions suggest that the paintings were conceived from the outset according to a more flexible standard than, say, the manuscript's illuminations. Thus the need for Muhibb-Ali to pass aesthetic judgment (if that is one way quality control may be characterized) may have been less of an issue with the paintings than with other components of the manuscript.

Ultimately—after at least nine years, and probably more, of supervising, coordinating, and checking calligraphers, illuminators, and painters—Muhibb-Ali would have had in hand 306 to 308 full-sized folios. At this point he would have gone through the entire stack of text and illustrated folios to arrange or verify their order. Here the kitabdar also would have recognized, if he had not been aware previously, that certain folios were not totally finished. We can only imagine Muhibb-Ali's sense of disappointment, frustration, and perhaps resignation that, notwithstanding the incredible amount of time and artistic resources lavished on the project, he had not entirely managed to produce a perfectly finished set of Jami's masnavis. His patron's reaction could have been even more extreme, given what it must have cost to support the project for such a long time.

Whatever his concern at the state of particular folios, Muhibb-Ali now would have assumed the role of collator and advanced the manuscript to its fourth and final phase. This phase involved several steps undertaken by yet another coterie of kitabkhana staff. First the folios were joined into bifolios, then the bifolios compiled into gatherings, and finally the gatherings stitched together as a codex. A binding, possibly with painted and lacquered exterior boards and flap and filigree leather doublures, then would have been added.[33] For all intents and purposes, Sultan Ibrahim Mirza's *Haft awrang* was now an integrated work of art, and the work of his kitabdar and kitabkhana on this particular project was completed.

Did Ibrahim Mirza then host a book party, just as Yusuf celebrated his marriage on folio 132a? Or did the Safavid prince, like Saʿdi in folio 147a, pore over the volume in private? Undoubtedly the conclusion of such an ambitious undertaking was a momentous occasion for its patron. The manuscript itself reveals how it came into being. Would that Sultan Ibrahim Mirza had left an epilogue or coda recording his reaction to the outcome.

1. Blair, *Compendium*, 13–14, 30–31, 61–62, 114–15; Blair, "Patterns"; Simpson, "Kitab-Khana," 117 n. 5.

2. The waqfiyya does refer to a manuscript repository (*dar al-masahif wa kutub al-hadith*) next to the winter mosque, as well as to a library (kitabkhana, *dar al-kutub, bayt al-kutub*) that also seems to have been a place where books were kept after being made elsewhere. Blair, "Rab'-i Rashidi," 76, 81–82.

3. That Rashiduddin was the author of many of the texts copied at the Rashidiyya and his other pious foundations as well as the kitabkhana sponsor and manuscript distributor makes his role particularly complex. That he was a high-level Il-Khanid official who apparently used his own, as opposed to government, funds to support manuscript operations may seem equally contradictory and yet anticipates the later history of the kitabkhana in Iran.

4. Neither Ja'far nor Baysunghur is directly mentioned in the report, and their identities have been inferred from the report's contents (Lentz & Lowry, 159–60, 165, 364–65, and fig. 51; Thackston, *Century*, 323–27).

5. Lentz & Lowry, 364; Thackston, *Century*, 325.

6. The word *kitabkhana* in this sentence is translated as "scriptorium" in Lentz & Lowry, 364, and as "atelier" in Thackston, *Century*, 325.

7. It is tempting to interpret the sequence of information here as meaning that the kitabkhana was initially intended for painters (*naqqashan*) only and upon its completion assigned to both painters and scribes (kitaban). Yet such an interpretation would probably be attaching far too much importance to the one-sentence account. In any event, painters and scribes were clearly at work under the same roof, confirming the proximity already suggested by the listing of kitabkhana projects in the first part of the arzadasht. The significance of picture gallery, mentioned at the start of the last part of the report, remains ambiguous.

8. Lentz & Lowry, chapter 3.

9. Minorsky, *Tadhkirat*, 14, 29. From detailed data in this text, as well as the accounts of various European visitors in Iran, we also know that, at least in the later Safavid period, the kitabkhana was part of a system of karkhanas, or workshops, that furnished both domestic and luxury services for the royal household. See Simpson, "Kitab-Khana," 111.

10. The Safavid experience thus differed from that in Mughal India, where many manuscripts are documented in flyleaf inscriptions as having been passed from Akbar to Jahangir to Shah Jahan and similar chains of Mughal dynastic succession (see Soudavar, cat. nos. 36, 66, 136).

11. See Simpson, "Kitab-Khana," 118 n. 19, for a listing of sixteenth-century manuscripts made for specific kitabkhanas.

12. Tahmasp's changed attitude toward the arts seems to have been a gradual development, beginning in the early-to-mid 1530s and culminating in 963/1555–56 with the so-called edict of sincere repentance. This critical juncture in Safavid cultural history remains to be systematically studied. Mention of Shah Tahmasp's disaffection for the arts and promulgation of an edict banning them appears regularly in Dickson & Welch, 1:45B, 52A, 95B, 115B, 130A, 168A, 189A–B, 246A n. 3; also S. C. Welch, *KBK*, 68, 72–73; S. C. Welch, *PP*, 23; and S. C. Welch, *WA*, 27. Membré ([Morton], xvi–xvii) focuses on Tahmasp's repentance and rejection of such sins as drinking, fornication, and sodomy as part of "an important stage in the imposition of the Shi'ite form of Islam on Iran." Adle ("Dust-Mohammad," 239–41 [with full citation of primary sources]) points out that there were actually two renunciations (*tawba*), which he dates to the beginning of 940/end of July 1533 and 963/1555–56. He also cautions against taking the date of 963/1555–56 as marking a complete cessation of Tahmasp's interests in the arts. See also Johnson, 125.

13. Simpson, "Kitab-Khana," 111–12. Some of the sources are later but appear at least partly relevant for the sixteenth century.

14. Qazi Ahmad [Minorsky], 191; Qazi Ahmad [Suhayli-Khunsari], 148.

15. Simpson, "Kitab-Khana," 112 (with citation to pertinent sources).

16. Lentz & Lowry, 312. The Persian terms are given in Qazwini & Bouvat, 160.

17. Simpson, "Kitab-Khana," 112.

18. How Muhibb-Ali received his appointment is not certain, although following the model of direct royal appointment for Bihzad and Hasan Mudhahhib, it is likely that he was selected or invited or hired as kitabdar directly by Sultan Ibrahim Mirza. It is equally possible, however, that, like Malik al-Daylami, he was assigned by Tahmasp at the same time the shah gave Sultan Ibrahim Mirza the governorship of Mashhad.

19. Staff hierarchy in the later Safavid period is summarized in Minorsky, *Tadhkirat*, 29–30.

20. For Baysunghur, see Lentz, "Baysunghur," 237–39; for Isma'il, see Dickson & Welch, 1:4A; and S. C. Welch, *KBK*, 18.

21. Alexander, 53; Weitzmann. The tradition of making manuscripts by copying other manuscripts is graphically conveyed in fifteenth-century French illustrations (de Hamel, cover and fig. 8).

22. The systematic use of other illustrated volumes of the *Haft awrang* is problematic, however, since (as will be discussed below) there was no such thing as a standardized illustrated text of Jami's masnavis in the sixteenth century.

23. See Alexander, 54–56, for the use of maquettes or dummies in medieval Europe.

24. The *Tadhkirat al-muluk* lists the head of the kitabkhana as receiving fees from the papermaker (Minorsky, *Tadhkirat*, 100). From this it has been inferred that papermaking was a subsidiary function of the kitabkhana, although it may have been independent (Keyvani, 169; Porter, 153). Sixteenth-century Persian paintings depict papermakers working in proximity to copyists (AMSG S1986.221, repro. color: Lowry, 182–83).

25. Simpson, "Kitab-Khana," 112.

26. It may be further assumed that they were provided with copies of the Jami masnavis they were to transcribe, along with stacks of the gold-dusted and gridded paper, specially prepared for the *Haft awrang* project, on which to write.

27. On the other hand, the illumination of the transcribed masnavis may have been under way by this time, in which case the kitabkhana presumably would have remained operative at least in terms of having artists on the payroll.

28. See Farquhar, especially 53, for pertinent remarks on the availability of artists working on the production of a fifteenth-century book of hours in Flanders.

29. At issue here is interpretation of the term *mulazim*. See Adle, "Dust-Mohammad," 290–91; also Simpson, "Kitab-Khana," 113 (where *mulazim* is translated erroneously as "courtier," following Qazi Ahmad [Minorsky], 188).

30. This responsibility would probably have included checking the transcribed masnavis, possibly against the same copies of Jami's poems from which the calligraphers had been copying.

31. But see the note on page 8.

32. As discussed in Chapter One, it remains uncertain whether the artists were painting on single sheets of paper that were blank on both sides or laminated folios with the unillustrated obverses composed of written surfaces joined to their margins. If the painters had blank sheets, then they could have begun their work at the same time as, for instance, the calligraphers began theirs. If the painters worked on laminated folios, then they would have had to wait until at least midway through the illumination process, when the written surfaces and margins were joined.

33. Blair & Bloom (p. 172) give a condensed—and somewhat misleading—account of the various steps undertaken to assemble the Freer Jami.

PICTORIAL PROGRAM AND MEANING

Although certain steps and sequence of steps in the kitabkhana operations that produced the Freer Jami must be inferred, on the whole the making of Sultan Ibrahim Mirza's *Haft awrang* can be confidently reconstructed through documentation, material form, and structure. The meaning of the manuscript or what might be called its private history is, on the other hand, more elusive, and any consideration inevitably ends in speculation rather than reconstruction.

We may assume that Sultan Ibrahim Mirza and his artists intended at the outset to create a work of art with a special artistic character. Part of that character lies in the manuscript's decorative treatment and pictorial interpretation of the *Haft awrang* masnavis—a set of poems that had a history of illumination and illustration even before the Safavid era. This history began during the lifetime of Abdul-Rahman Jami (817–898/1414–1492), as attested by a copy of the *Yusuf u Zulaykha* masnavi transcribed by the poet's son Pir-Ali ibn Abdul-Rahman al-Jami at the end of Rajab 893/beginning July 1488 (ÖNB Mixt. 1480).[1] The manuscript, which opens with a splendid double-page illumination enclosing the first seven verses of the masnavi text (folios 1b–2a), contains two spaces reserved for text illustrations (folios 80a and 94a). Although neither illustration was executed, traces of an architectural setting and two figures are visible in the first scene, which may be identified by its placement within the text as representing Yusuf and Zulaykha in Zulaykha's newly built palace.

Curiously—although perhaps not coincidently—the date of this earliest-known *Yusuf u Zulaykha* planned for illustration is the very month and year that a celebrated copy of the *Bustan* of Sa'di was made in Herat for Jami's patron, the last Timurid ruler Sultan-Husayn Mirza (GEBO Adab Farsi 908). This manuscript includes an evocative composition of Zulaykha attempting to seduce Yusuf in her palace, signed by the great Timurid painter Bihzad (folio 52b).[2] The artist has set the scene in a multistoried, mazelike structure with the couple isolated in the uppermost room: the love-struck Zulaykha kneels at her beloved's feet, while Yusuf pulls away in the direction of flight and salvation. Although Bihzad was ostensibly illustrating a text by the thirteenth-century poet Sa'di, he may have been more immediately inspired in his conception and rendition of the climax to Zulaykha's passion for Yusuf by the mystical version of this time-honored tale written by his colleague Jami.[3] This artistic influence may have been reciprocal. While the comparable illustration in the contemporary *Yusuf u Zulaykha* manuscript, had it been painted, is unlikely to have achieved the originality of the *Bustan* composition, it is probable that the presence of Bihzad and other gifted artists in Herat during the time Jami was composing his masnavis led the poet to appreciate the value of pictures in conveying the messages of his *Haft awrang*.[4] At the very least, the court of Sultan-Husayn Mirza provided the right setting for poetry and painting to combine in the initial illustration of a new literary "classic" such as Jami's *Haft awrang*.

Certainly the practice of illustrating Jami's seven poems was well established by the second decade of the sixteenth century, as evidenced by manuscripts dated 911/1505–6, 912/1506–7, and 914/1508–9 (SOTH 11.IV.88, lot 131; TKS R. 888; and SOTH 18.X.95, lot 57).[5] These volumes, comprising a complete *Haft awrang*, a *Khamsa*, and a *Tuhfat al-ahrar* respectively, also confirm that, during the early Safavid period, Jami's masnavis were transcribed and illustrated in various forms: as a complete compilation of the seven poems, as a selection of multiple poems, and as individual poems. While this variety holds throughout the entire recorded corpus of close to two hundred copies of Jami's masnavis, there are, in fact, less than a dozen volumes of the complete *Haft awrang* and about the same number with four, five, or six masnavis. A typical copy of one of these volumes of multiple masnavis dating from the first three or four decades of the sixteenth century contains between six and twelve paintings. The rate of illustration rose considerably at midcentury, with some manuscripts of the 960s/1550s through 990s/1580s containing twenty or more pictures.

Most of the Jami manuscripts illustrated during the sixteenth century consist of a single masnavi. *Yusuf u Zulaykha* was illustrated with the greatest frequency, and more than seventy copies, some with extensive series of illustrations, survive today. Certain scenes from this masnavi, such as *Yusuf Is Rescued from the Well*, *Yusuf Is Sold at Market in Misr (Egypt)*, and *Egyptian Women Overwhelmed by Yusuf's Beauty*, are among the most familiar illustrations in sixteenth-century Persian art.[6] A dozen illustrated volumes of each of three other Jami poems—the *Silsilat al-dhahab*, *Tuhfat al-ahrar*, and *Subhat al-abrar*—are known. These manuscripts have an average of three or four illustrations; some contain six to eight. The illustrations to the *Silsilat* include quite a few unique scenes, whereas those

in the *Tuhfat* and *Subhat*, such as *Yusuf Is Presented a Mirror by the Traveler from Canaan*, *The Flight of the Tortoise*, and *The Wanton Youth Meets the Old Thorn Carrier*, are often repeated. Only a handful of illustrated copies of *Salaman u Absal* exist, and none of either the *Layli u Majnun* or *Khiradnama-i Iskandari*. The lack of appeal of these poems as vehicles for illustration seems strange considering that they are composed of more or less continuous narratives and populated with easily recognizable protagonists. In the case of the *Layli u Majnun* and the *Khiradnama-i Iskandari*, it may be that the Nizami versions of these poems, on which Jami based his texts, had essentially "cornered the market" and there was no interest in another separate series of Majnun or Iskandar compositions.

The practice of illustrating Jami's masnavis was by no means confined to the Safavid realm during the sixteenth century. Many copies of the *Haft awrang* poems were produced in Bukhara, the principal city of Transoxiana and an important center for the arts of the book during the reign of the Uzbek Shaybanids (905–1007/1500–98). The taste for the *Haft awrang* masnavis in Transoxiana is understandable given Jami's prominent role within Naqshbandi order of Sufi Islam named after the Bukharan shaykh Muhammad Baha'uddin Naqshband.[7] Although Jami's primary sphere of influence and activity was Timurid Herat, his works were widely diffused both during and after his lifetime. Their popularity among the Shaybanids was probably also due to the presence in Bukhara of artists from Herat whom the Shaybanids had impressed into service following various conquests of the former Timurid capital during the first decades of the sixteenth century. These Herati artists, including calligraphers and painters, worked for the kitabkhanas of several Shaybanid rulers and often incorporated their patrons' names into *Haft awrang* illustrations.[8]

Whether working in a Safavid or Shaybanid milieu, sixteenth-century artists took a consistent approach toward the illustration of the *Haft awrang*, one that subscribed to several long-standing principles and practices within the history of Persian painting. First, artists in Iran never seem to have been concerned with the formation of fixed pictorial recensions. Thus, while certain scenes recur regularly in illustrated copies of Jami's masnavis, there is no standard cycle—or even series of cycles—of *Haft awrang* illustrations any more than there seems to have been for the *Shahnama* of Firdawsi or the *Khamsa* of Nizami. Illustrated manuscripts did not depend upon or follow on each other as models. Each volume comprises its own individual set of illustrations, often including scenes that do not appear elsewhere. In short, within the recorded corpus of illustrated *Haft awrang* manuscripts, illustrative variety and iconographic variation are the norm.

Second, the relationship of works of Persian art to works of Persian literature always tends to be very literal, and text illustrations were evidently conceived as faithful visual manifestations of literary expression, with artistic emphasis generally on tangible forms rather than on abstract ideas. Both in their choice and in their treatment of scenes, *Haft awrang* illustrators focused on the human actions and reactions through which Jami conveyed the mystical and moralizing themes that permeate his poetry. For masnavis without continuous narratives, such as the *Silsilat al-dhahab, Tuhfat al-ahrar,* and *Subhat al-abrar,* artists selected scenes from among the many anecdotes and parables that Jami used both to link and to frame the poems' primary discourses. Whether creating large compositions that occupy a full page and incorporate a couple of masnavi verses (see figs. 82, 84, 91, and 115) or smaller ones enframed by many lines of poetry (see figs. 67, 74, 104, and 120), they always related the subjects of their scenes, including the principal action and actors, clearly and directly to the nearest verses. There can be no ambiguity as to the identification of a composition featuring a bearded figure holding up a severed hand when the surrounding text recounts the tale of a king who ordered his vizier's hand cut off as punishment for extortion.[9] Here, as in virtually all Jami illustrations, the imagery is deliberately overt.

Within these traditions of Persian painting, the Freer Jami is an "average" illustrated manuscript, and more specifically a "typical" copy of the *Haft awrang*: its illustrative program includes both familiar and unique scenes that all represent concrete episodes in the poetic text and are all easily identifiable with reference to their nearest verses. In other respects, however, the volume is far more ambitious. With its original series of twenty-nine compositions (including the one now missing from the *Layli u Majnun* masnavi), the Freer Jami is the most heavily illustrated copy of the *Haft awrang* known today.[10] More significantly, while all its illustrations relate to the precise moment narrated in the incorporated verses, very few are restricted to the literal representation of Jami's text alone. The majority include additional, covert features not derived from the *Haft awrang* text that simultaneously expand and reinforce the overt imagery in a variety of ways and respond to and parallel the metaphorical language and mystical messages of Jami's poems. In some cases, these

extrapictorial elements can be inferred from the text, as in folio 153b where a royal disciple or murid brings a brace of ducks as a gift to a holy man (*The Pir Rejects the Ducks Brought as Presents by the Murid*; see fig. 98). The principal characters in this anecdote to the *Subhat al-abrar* discourse on abstinence form the core for a number of other individuals—identifiable as members of the murid's retinue—whose presence is not required by Jami's poem but who do make iconographic sense in terms of the disciple's status. Furthermore the grooms, falconers, and other retainers disposed within the composition's rocky landscape emphasize the point that a man who is so attached to attributes of worldly power and material possessions has much to learn before he can achieve abstinence, much less ever hope to attain salvation.

Even more intriguing are those illustrations containing elements that could not be anticipated or even imagined from the text—what might be called "deep cover" as opposed to "merely" covert. This tendency is signaled at practically the very start of the Freer Jami in the *Silsilat al-dhahab* illustration to folio 30a (*A Depraved Man Commits Bestiality and Is Berated by Satan*; see figs. 63 and 64). Here the overt imagery is confined to a small quadrant of the composition, while the rest of the scene is given over to what is probably a gypsy encampment. Some of the activities and denizens of this camp—such as the woman washing clothes, the mother and child at the tent entrance, the herder guarding his flocks, and the man spinning wool—were probably intended to contrast, by their very normality and domesticity, with the unnatural behavior taking place in the lower left. Other covert elements—including the boys playing hobbyhorse, the acrobats, and musicians, and the figures in various stages of undress—echo the sodomite's sexual deviancy. And if by chance

222
Majnun Approaches the Camp of Layli's Caravan
(detail)
in the *Haft awrang* of Jami
963–72/1556–65, Iran
23.5×19.5 cm (painting)
FGA 46.12, folio 253a

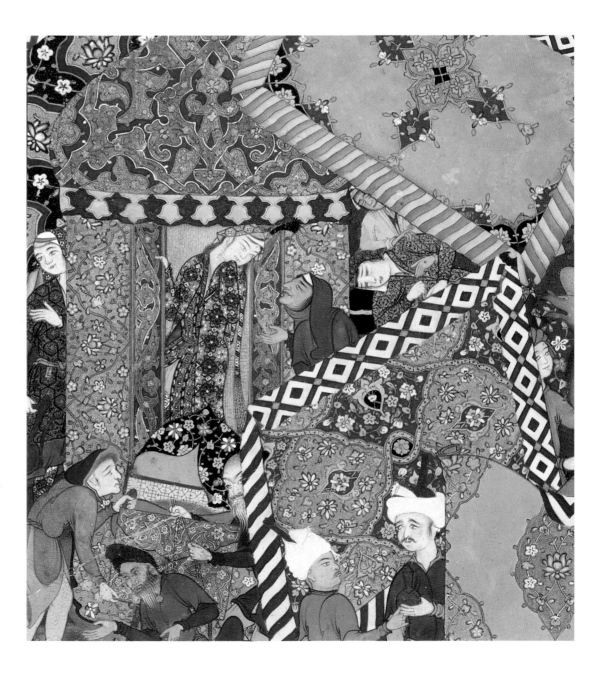

CHAPTER FOUR: MAKING AND MEANING

anyone were to miss the subject of the *Silsilat* narrative—and Jami's message that those who do not uphold the pillars of gnostic devotion are even more reprehensible than the devil—the artist of folio 30a has included another covert motif in the form of a gesturing man who directs the attention of both the spinner and the viewer toward the core (or perhaps in this case it might be "hard-core") activity at the left. The illustration on folio 253a (*Majnun Approaches the Camp of Layli's Caravan*; fig. 222, see also figs. 122 and 123) is completely dominated by covert features to the extent that the viewer is apt to spend far more time trying to decode the significance of such figures as the fainting or sleeping girl in the upper center than to contemplating Majnun's emotion upon coming upon the caravan encampment of his beloved.

Sometimes the covert imagery reinforces the *Haft awrang* text by the visual contrast and complement of singular details. Again, these motifs do not figure in the masnavi text, nor can they necessarily be inferred from it. The sleeping servant in folio 105a (*Yusuf Is Rescued from the Well*; fig. 223, see also figs. 78 and 79), for instance, is oblivious—as are all the other many figures in this caravan scene—to what is going on in the lower right where Yusuf is freed by the angel Gabriel in the first of a series of enslavements, entrapments, and imprisonments that the future prophet was to suffer, all the while remaining pure and free in his love of God. Similarly the act of greed and desecration that constitutes the overt imagery in folio 179b (*The Townsman Robs the Villager's Orchard*; see figs. 105 and 106) illustrating the final aqd in the *Subhat al-abrar* is bracketed and contrasted by a pair of covert groups: the peaceful gathering of four youths in the garden above and the charitable gift at the doorway below.

223
Yusuf Is Rescued from the Well (detail)
in the *Haft awrang* of Jami
963–72/1556–65, Iran
24×20.8 cm (painting)
FGA 46.12, folio 105a

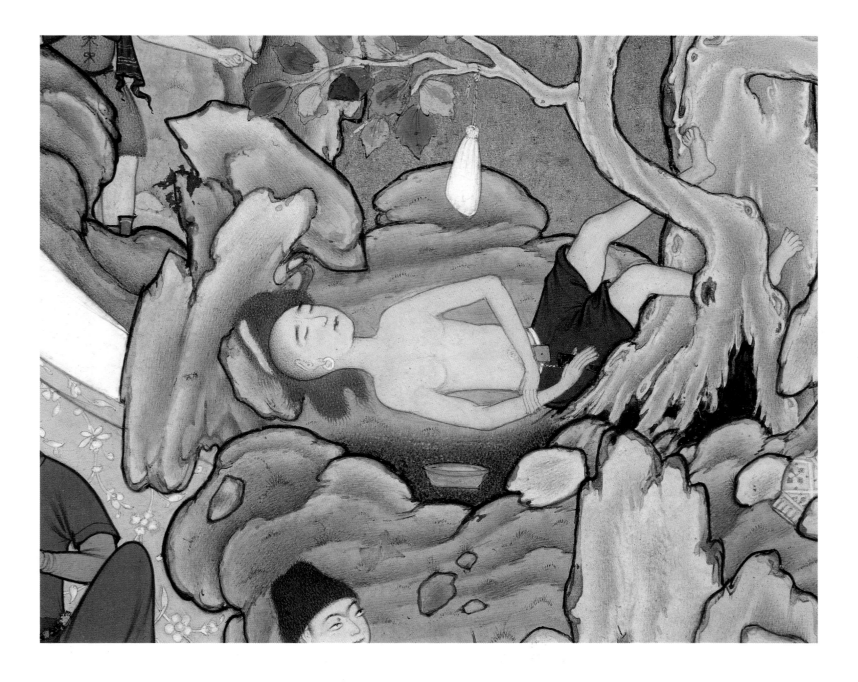

The poetic inscriptions that are worked into the architectural setting of a half-dozen Freer Jami illustrations constitute another, equally significant type of covert imagery. In some cases these inscriptions respond to physical conditions or attributes explicit in the *Haft awrang* text, such as in folio 100b (*The Aziz and Zulaykha Enter the Capital of Egypt and the Egyptians Come Out to Greet Them*; see figs. 1, 76, and 77), where the verse over the entrance to the city refers to the features of a beautiful young woman, as if deliberately repeating Jami's characterization of Zulaykha. Similarly in folio 114b (*Yusuf Preaches to Zulaykha's Maidens in Her Garden*; see figs. 86 and 87) the inscription combines references to the setting—which is both terrestrial and celestial—and to the message about God's mysterious purpose that Yusuf has been teaching the maidens.

The love poem being written on the back wall of folio 52a (*A Father Advises His Son about Love*; fig. 224, see also figs. 68 and 69) constitutes a more complex example of a text-image-text continuum. Indeed, in this illustration where the overt figures—the father and son—are not so immediately apparent, the covert features concentrated toward the back of the scene—including the chessboard and its players and the tortured poet and the painted "portrait" of his beloved—play a critical role in conveying Jami's message about the vagaries of human love and the complexities of divine love.

Some of the at once densest and subtlest blending of overt and covert imagery occurs in the *Silsilat al-dhahab* masnavi, which, as the first poem in the Freer Jami, sets the pictorial tone for the entire manuscript. It is also in the *Silsilat* that Sultan Ibrahim Mirza is first identified as the volume's patron and where at least one motivation for his great commission is first indicated. It is doubtless not just a coincidence that the initial documentation of the manuscript's history appears in the masnavi whose very title—*Silsilat al-dhahab*, or Chain of Gold—evokes the dual concept of continuity and transmission that is so central to Iranian culture. In undertaking to support a kitabkhana, to employ court artists, and to order a deluxe volume of a classic work of Persian literature, Sultan Ibrahim Mirza was consciously continuing the artist patronage of the Safavid dynasty as practiced by his grandfather, father, and uncles. Of this distinguished lineage of Safavid patrons, the prince paid most conspicuous homage to Tahmasp—his uncle and father-in-law, mentor and monarch—by having a laudatory inscription to the shah written above his own kitabkhana "tag" in the third *Silsilat* illustration (folio 38b; see fig. 216) and reinterated a little more than halfway through the manuscript (folio 162a; see figs. 19 and 100). At the same time Sultan Ibrahim Mirza deviated from previous family patronage as exemplified by Tahmasp in choosing

224
A Father Advises His Son about Love (detail) in the *Haft awrang* of Jami
963–72/1556–65, Iran
26.3×16.8 cm (painting)
FGA 46.12, folio 52a

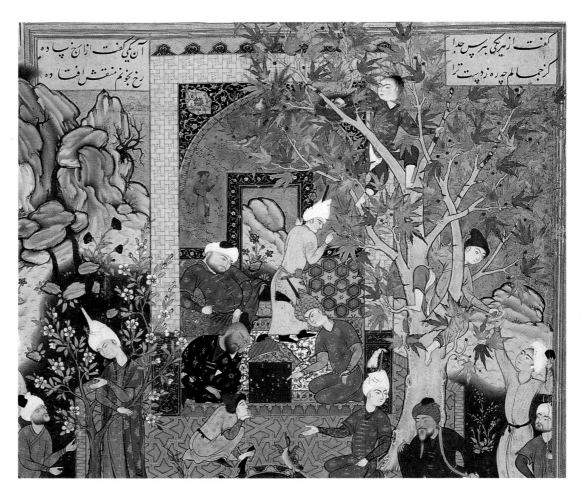

the *Haft awrang* by Abdul-Rahman Jami as the literary vehicle for a major artistic commission. Whereas Tahmasp's kitabkhana (directly carrying on from that of Isma'il I) produced volumes of works by long-venerated poets like Firdawsi and Nizami, the prince had his kitabkhana create the first illustrated Safavid copy of a relatively new literary classic by a mystical author whose ideas and beliefs were suspect within certain quarters of the Safavid dynasty. Thus, while Sultan Ibrahim Mirza clearly wanted to emulate and honor the older members of his family, he also sought to challenge, rival, and perhaps even surpass the patronage of Isma'il, Tahmasp, Bahram Mirza, and Sam Mirza by daring to commission a very different (and more contemporary) type of literary masterpiece.

The timing of the prince's commission is equally significant. In 963/1555–56 Shah Tahmasp promulgated his so-called edict of sincere repentance, culminating a long period of disengagement from the arts and other pleasures. One consequence of the shah's gradual withdrawal from active patronage is that many of the artists previously employed at the royal kitabkhana were free to work for other patrons. Circumstances were certainly propitious for Sultan Ibrahim Mirza to pick up, as it were, where Tahmasp had left off, and the prince may have been enabled or emboldened to set up the kind of kitabkhana workshop necessary for the production of a deluxe manuscript precisely because of the availability of leading artists whose services were no longer required at his uncle's court.[11] It certainly can be no accident that during the latter part of 963/1556 three court artists— Malik al-Daylami (who had been assigned by Tahmasp to his nephew's kitabkhana), Rustam-Ali, and Shah-Mahmud al-Nishapuri—completed key sections of the prince's *Haft awrang*. By this time Sultan Ibrahim Mirza had taken up residence in Mashhad as governor—an important position to which he had been appointed by the shah—and doubtless had begun to contemplate the eventuality of marriage to his cousin, the shah's daughter, Gawhar-Sultan Khanim. What better way for the prince to celebrate his "coming of age" than with the commission of a deluxe manuscript, one whose quality would complement previous Safavid patronage and whose originality, both as a work of literature and a work of art, would proclaim his independence within that family tradition.

The notion of coming of age forms part of a broader construct of the human life cycle or the ages of man. The pictorial program of the Freer Jami expresses key stages in that life cycle, including both its temporal and spiritual dimensions. The manuscript's illustration is informed by and interwoven with pervasive *Haft awrang* themes—the mystery and power of love; the conflict between good and evil, reality and illusion; and death as the ultimate form of release—themes that are integral to Jami's poetic and mystical leitmotif of the search for enlightenment and fulfillment through knowledge of the divine. The progression toward this goal begins in the first illustration, where a callow youth learns a key lesson about the direction he should pursue from a spiritual guide (folio 10a), and ends in the final composition with the impending death of Iskandar, a valiant explorer of the mysteries of life and ardent seeker of truth (folio 298a). Between initiation into the path of true belief and release to union with God come many other defining moments of human existence. These include the formation and affirmation of essential relationships critical to one's course through life (folios 153b and 207b), the trauma of self-doubt (folios 147a and 221b), and the recognition or assertion of self-worth (folio 169b and 291a). Maturation through these stages brings the ability to accept responsibility and to distinguish between right and wrong (folios 52a and 188a). The unwillingness to mature, to take decisive action, or to accept a fundamental verity has adverse and sometimes even fatal consequences (folios 38b, 162a, 179b, 194b, and 215b). Thus moments of weakness and failure (folio 30a) are balanced by those of triumph and apotheosis (105a and 275a). Throughout life there is the bliss and torment of passion that begins with physical attraction (folios 59a, 100b, and 231a), passes through various trials and tribulations (folios 110b, 114b, 120a, and 253a), and ends either in tragedy or sanctity—or both (folios 64b, 132a, and 264a; fig. 225).

It would be pushing the case too far to equate the life cycle as illustrated in the Freer Jami with the life history of Sultan Ibrahim Mirza. Yet given the young prince's poetic and artistic interests, it is entirely plausible that he deliberately sought to intensify the message of Jami's poetry—and perhaps even to personalize it—through the medium of painting. Certainly various biographical details—such as the prince's authorship of mystical poetry and involvement with Sufi devotees, his gubernatorial appointments and military service, the events leading up to and surrounding his marriage, and the contrast between his charmed youth and the fallen fortunes of later years—seem to be reflected in the choice and interpretation of a number of *Haft awrang* scenes.

In the absence of a direct equation, a general scenario has to suffice. An erudite and ambitious patron desires a copy of a particular poetic work. He signifies his admiration for the complete oeuvre through the commission of a deluxe manuscript and his appreciation of specific stories and themes through the inclusion of beautiful illustrations. Through a conjunction of manifest and latent imagery, the significant themes and anecdotes are adapted to personal circumstances and concerns. Through the expressive pictorial program, the patron—now reader—is compelled to reflect more deeply on the contents and meaning of the poetic text that attracted his attention in the first place.

Sultan Ibrahim Mirza may have selected the *Haft awrang* for illustration because of its message about life, and he may have inspired or compelled his kitabkhana artists to create compositions that would embody his reading of that message. The history of Persian manuscript illustration contains other notable examples of the integration—and even manipulation—of text and image for both illustrative and interpretive ends.[12] The *Haft awrang* made for Sultan Ibrahim Mirza both sets a new standard in this strategy and stands as a magnificent marker of a cultural tradition in which patronage of the literary and visual arts was a virtual imperative of princely life.

225
*Yusuf Gives a Royal Banquet
in Honor of His Marriage* (detai
in the *Haft awrang* of Jami
963–72/1556–65, Iran
27×19.4 cm (painting)
FGA 46.12, folio 132a

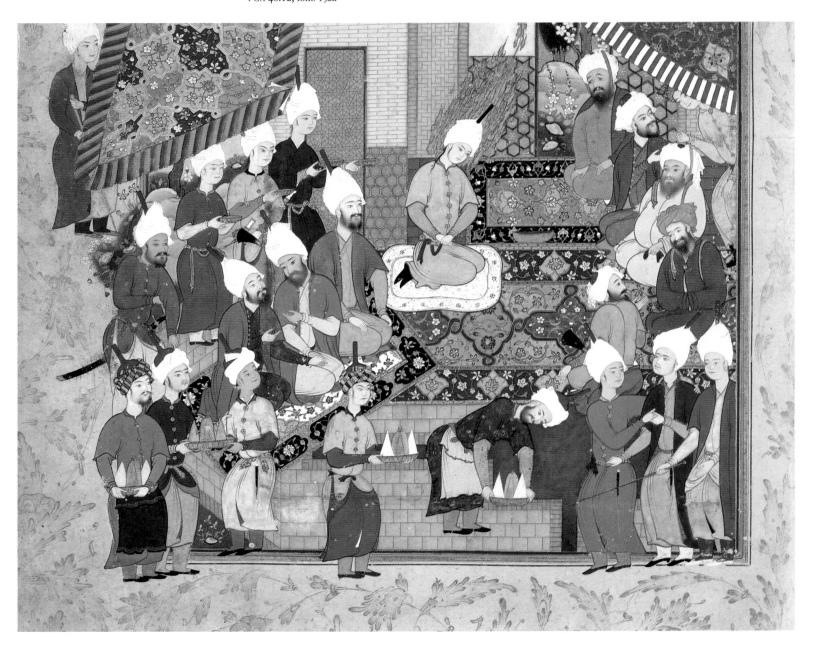

CHAPTER FOUR: MAKING AND MEANING

1. For references, see Appendix C.

2. See Lentz & Lowry, 294, for a color repro.

3. This speculation is based in part on the compelling analysis of the Bihzad painting as a mystical image directly related to Jami's poem in Golombek, "Classification," 28–29. See also Brosh, 35; and Lentz & Lowry, 292–93.

4. Bürgel (pp. 131–32) makes a more general comment to this same effect.

5. For references, see Appendix C.

6. In addition to manuscript illustrations, the scene of *Egyptian Women Overwhelmed by Yusuf's Beauty* also appears on Safavid textiles. See Bier, cat. no. 23; and Jenkins, p. 154.

7. A quarter of the Jami manuscripts known to have been illustrated in Buhkara are of the *Tuhfat al-ahrar*, a poem with a particularly Naqshbandi, and thus Transoxianan, connection since Jami named it after Khwaja Nasiruddin Ubaydullah Ahrar, the influential superior of the Naqshbandiyya who greatly expanded the order's ideas and powers during the fifteenth century. It is also in the *Tuhfat* that Jami proclaims his adherence to the Naqshbandiyya. The *Subhat al-abrar* and *Silsilat al-dhahab*, two poems largely concerned with the nature of Sufism, were also illustrated in Bukhara with some frequency. See also Soudavar, 212.

8. The following Jami manuscripts, listed chronologically here and in Appendix C, were made for a succession of Shaybanid rulers, as documented by internal inscriptions: 925/1519–20, *Silsilat al-dhahab* (TKS R. 895); 9[4?]2/1535–36[?], *Subhat al-abrar* (KNM LSN 16 MS); 954–75/1547–68, Four masnavis (CB MS 213); 955/1548–49, *Tuhfat al-ahrar* (CB MS 215), 971/1563–64, *Tuhfat al-ahrar* (SAK MS 17); 972/1564–65, *Yusuf u Zulaykha* (SOTH 18.X.95, lot 58); and 973/1565–66, *Yusuf u Zulaykha* (AHT no. 80).

9. Appendix D: Mudarris-Gilani, 426–27.

10. There is one *Haft awrang* manuscript that predates the Freer Jami with twenty-three illustrations (SOTH 6.XII.67, lot 197, dated Ramadan 956/September–October 1549), a contemporary *Yusuf u Zulaykha* with twenty-five illustrations (BL Or. 4535, attributed to ca. 1550–70), and a contemporary *Haft awrang* with twenty-seven illustrations (PWM MS 55.102, dated Dhu'l-qa'da 971/June 1564). The only other manuscripts with twenty or more illustrations postdate the Freer Jami (TKS H. 1483, dated 978–79/1570–72; BOD Elliot 149, attributed to ca. 1575; KEV 889, dated Dhu'l-qa'da 988/January 1581).

11. Such a scenario would fit with the circumstances for the establishment of a kitabkhana that prevailed in the Il-Khanid and Timurid periods and continued during Safavid times, as discussed above.

12. Golombek, "Classification"; Hillenbrand, "*Shah-nama-yi Shahi.*"

APPENDICES

APPENDIX A

Manuscript Descriptions and Collations

Summary Description of Sultan Ibrahim Mirza's *Haft awrang*

This copy of the *Haft awrang* by Jami was made for Sultan Ibrahim Mirza. Text transcribed in Mashhad, Qazvin, and Herat by Malik al-Daylami, Muhibb-Ali, Shah-Mahmud al-Nishapuri, Ayshi ibn Ishrati, and Rustam-Ali. Dated 963–72/1556–65. Illustrated with 28 paintings (originally 29), unsigned (but see note on page 8) and undated. Collection of the Freer Gallery of Art, 46.12.

1. SIZE

a. *Present*

304 folios: 1 and 304 are replacements; 2 folios (one illustrated) are missing between folios 261b and 262a. 4 modern flyleaves, 2 before folio 1a and 2 after folio 304a.

b. *Original*

306 folios and possibly 2 additional folios at beginning.

2. TEXT

a. *Contents*

Folios	Masnavis	Page references in Mudarris-Gilani edition
1b–83b	*Silsilat al-dhahab*, 3 daftars	2–309
1b–46a	daftar 1	2–183
46b–47a	blank	
47b–69b	daftar 2	185–258
70a	blank	
70b–83b	daftar 3	260–309
84a	blank	
84b–139a	*Yusuf u Zulaykha*	578–748
139b–40a	blank	
140b–81a	*Subhat al-abrar*	445–575
181b–82a	blank	
182b–99a	*Salaman u Absal*	311–64, 575–76
199b–200a	blank	
200b–224b	*Tuhfat al-ahrar*	366–443
225a	blank	
225b–72a	*Layli u Majnun*	750–910
272b–73a	blank	
273b–303a	*Khiradnama-i Iskandari*	912–1013

b. *Significant Replacements, Omissions, Changes, and Additions*

Folios	Masnavis	Page references in Mudarris-Gilani edition
Silsilat al-dhahab		
1b	replacement folio with opening text on verso	2–3
14a	4 sections omitted	49–52
41a	3 sections and 13 verses of a fourth section omitted	146–48
43b–44a	2 sections omitted	158–63
46a	32 sections and 3 verses of thirty-third section omitted	170–82
Subhat al-abrar		
181a	epilogue omitted	575–76
Salaman u Absal		
199a	epilogue of *Subhat al-abrar* added to end	575–76
Layli u Majnun		
261b–62a	95 verses missing, equal to 2 folios with 1 illustration and illuminations	871–75
Khiradnama-i Iskandari		
303a–b	folio moved; text follows folio 299b	1000–1003
304	final 4 verses omitted, possibly also colophon missing; replacement folio contains ghazals by Qasim Anvar, Hafiz, and Amir Khusraw Dihlavi signed by Sultan-Muhammad Khandan (304a); seals and inspection notes dated to Mughal period (304b)	

3. MATERIAL

a. *Text Folios (text on both recto and verso)*

Thin, polished ivory paper in center for text. Thicker, two-ply colored paper for margins: pink (invariably discolored), cream, yellow, light blue, bright blue, deep blue, green (often discolored to blue-green), and brown. Margins same color on recto (a) and verso (b).

Exceptions on folios 47, 70, 84, 182, 225, and 273: laminated folios with single sheets of cream-colored or light blue paper on rectos (a); versos (b) same as other text folios except that color of margin differs from recto margin.

b. *Illustrated Folios (text on one side of folio, illustration on the other)*

Single sheets of cream-colored paper on illustrated sides. Thin, polished ivory paper in center for text. Thicker, cream-colored paper for margins on unillustrated sides. Sometimes a third piece of paper between recto and verso (e.g., folios 52 and 188).

Exceptions on folios 10 and 207: both recto (a) and verso (b) are like text folios with painting and text on thin, polished ivory paper in center and two-ply cream-colored paper for margins.

Exceptions on folios 59, 194, 221, 253, 264, and 275: cream-colored paper on illustrated sides and colored paper margins on unillustrated sides.

c. *Flyleaves*

Modern brown paper without watermarks.

d. *Interleaf Folios*

Polished paper, probably inserted at later date as guard sheets in front of illustrated and some illuminated folios. Most consist of full sheets of fine, white paper; others are smaller, thick paper with visible laid marks. Several full sheets are pasted down on top of blank folios between masnavis; others have been removed.

4. DIMENSIONS *(average)*

a. *Full Folio*

34.5×23.4 cm (trimmed from approximately 37.5×25.4 cm)

b. *Written Surface*

21.8×13 cm

c. *Margin Widths*

gutter: 2.8 cm
bottom: 6.1 cm
fore edge or side: 7.1 cm
top: 6.0 cm

5. CONSTRUCTION

a. *Gatherings (see also Appendix A.II)*

39 gatherings, all but perhaps 2 comprised of quaternions (4 bifolios); bifolios formed by overlap.

G[1]: probably originally a binion (2 bifolios)
G34: now a ternion (3 bifolios) but originally a quaternion; middle bifolio with illustration now missing.
G39: probably originally a ternion (3 bifolios); folio 303 originally between folios 299 and 300.

b. *Stitching*

5 stitching stations; various other stitching stations possibly errors.
Orange silk thread (not original), frequently broken.

6. PREPARATION OF FOLIOS

a. *Text Sections*

Thin ivory paper dusted or sprayed with gold and impressed with grid of 21 horizontal lines and 6 vertical lines forming 4 text columns and 3 column dividers per page; black drafting lines sometimes drawn over right-hand vertical line of each pair of column dividers.
Exceptions on folios 140a and 181b: not gold dusted.

GRID SYSTEM, WITH AVERAGE DIMENSIONS:

Text written with lines centered on top of horizontal grids, 21 lines per page and 2 verses per line.
Exceptions on 46 pages where verses written diagonally (see below).
Catchwords written at diagonal on verso, in lower left corner of text paper. In most cases, catchwords trimmed off or covered up when text paper inlaid into margin paper, and then rewritten in left-hand column divider. Some original catchwords still visible in whole or part (e.g., folios 43b, 45b, 70b, 104b [enframed in a roundel], 110b, 131b [enframed in a roundel], 153b [enframed in a cartouche], 169b [enframed in a cartouche], and 220b [enframed in a roundel]). Rewritten catchwords sometimes incorporated into rubric illumination (e.g., folios 192a, 295b, and 303b).
Rubrics written most frequently between horizontal grid lines.
Colophons written without following grid lines; each differs in size and placement.

b. *Margins*

"Windows" cut at slightly off-center position into colored paper.

c. *Joining of Text Paper and Margin Paper*

Text paper inlaid into "windows" of margin paper after text transcribed, to form full folios. Inlay visible on folios 46b, 139b–40a, 181b, 199b–200a, and 272b.

7. CALLIGRAPHY

Nasta'liq throughout manuscript.
Text verses and catchwords written in black ink; rubrics in pink, green, red, and various shades of blue; colophons in black, occasional words in pink (folio 46a) and/or gold (folios 46a and 139a).

8. ILLUMINATION

a. *Masnavi Headings*

Eight original illuminated headings (or title pieces) on opening text folios: 47b, 70b, 84b, 140b, 182b, 200b, 225b, and 273b. (Heading on folio 1b not original.)
Headings composed of two superimposed rectangles: lower rectangular section with empty gold cartouche in center against ground of geometric units and floral motifs and surrounded by an inner geometric border and an outer floral border; narrow upper rectangle with geometric motifs, often with large scalloped triangular projection in center (folios 47b, 140b, 182b, 225b, and 273b) and adorned with blue finials of varying heights. No two headings identical.
Exception on folio 200b: lacks narrow upper rectangle.
Exception on folio 84b: gold cartouche inscribed with 4 verses and signed in green band below:

این نامه که یوسف و زلیخاست بنام
خطش چو خم زلف بتان غالیه فام

نقشش چو لب سبز خطان رنگ آمیز
نظمیست که میرساند از وحی پیام

ذهبه عبدالله الشیرازی

This book that is Yusuf u Zulaykha *in name,*
Its writing is a fragrant black like the curls and the locks of the beloved,

Its images [are] colorful like the lips adorned with youthful down,
It is a poem that conveys a message from the divine.

Illuminated by Abdullah al-Shirazi

Dimensions

folio 47b: 10.2×13 cm
folio 70b: 8.5×13.3 cm
folio 84b: 7.3×13 cm
folio 140b: 9.2×13 cm
folio 182b: 11.2×13 cm
folio 200b: 6.7×13.2 cm
folio 225b: 11.3×13 cm
folio 273b: 10.5×13 cm

b. *Rubrics*

Virtually every folio has one or more rectangular panels containing rubrics of 1–4 lines. Panels always extend across 2 central text columns and usually end at innermost line of column dividers, although some cut across column divider (e.g., folio 276a).
Average dimensions are 1.2–2.3×6.2–7.4 cm.
Altogether, there are 771 rubric panels, with the following distribution:

Silsilat al-dhahab	295
daftar 1 (168)	
daftar 2 (77)	
daftar 3 (50)	
Yusuf u Zulaykha	76
Subhat al-abrar	132
Salaman u Absal	76
Tuhfat al-ahrar	63
Layli u Majnun	57
Khiradnama-i Iskandari	72

Two types of rubrics:

Type *a*: simple rectangle. Rubric text fills entire width of panel, with lines of writing outlined in contour lines (either black or colored lines edged in black); gold (often pricked for texture) or dark blue background, painted with small blossoms and buds growing out from contour lines; background illumination on folios 193b and 295b includes human and animal heads. Panels framed top and bottom with gold band between 2 black lines; various panels on folios 163b–78a include a blue line between 2 sets of gold and black lines.

Variation on folios 5a and 82a: one line of rubric text (either final or middle) centered and flanked by two small illuminated boxes; labeled *a+b* in Appendix A.II.

Variation on folios 23a, 26b, 27b, 29a, 30b, and 39b: vertical band of illumination on one side; labeled *a–b* in Appendix A.II.

Variation on folio 188b: rubric extends across entire written surface; labeled *a+* in Appendix A.II.

Exception on folio 211a: rectangle panel with vine scroll of blue grapes and leaves and red and white blossoms; no rubric text.

Type *b*: tripartite rectangle. Rubric text concentrated in center of panel with lines of writing outlined in contour lines against a gold or dark blue background and decorated with flowers as in rubric type *a*. Central text section generally straight-sided rectangle. Two vertical side sections filled with great variety of multicolored geometric, floral, and figural motifs, alone or in combination, against gold or dark blue background. Panels framed on all sides with black line, plus border of black crosses and dots in alternation on colored ground around vertical side sections.

Variations within the first daftar of the *Silsilat al-dhahab* (folios 5b, 7a–b, 8b, 12a, 13a–b, 16a, 17b, 22a–b, 23b, 25a, 26a, 27a, 28b, 32a, 35b, 36a, 37a, 43b, and 44a): central section similar to a cartouche with scalloped ends; 2 flanking sections "indented" rather than straight-sided; labeled *b¹* in Appendix A.II.

Variation on folio 10a: band of illumination between 2 lines of rubric text link 2 side sections to form H design; labeled *b²* in Appendix A.II.

Variation on folio 180a: rubric totally enframed with illuminated band (i.e., standard illuminated side sections linked at top and bottom by bands of same width to form continuous frame); labeled *b³* in Appendix A.II.

c. *Verse Illuminations*

Found on 46 folios where text written in diagonal lines, generally preceding or following an illustration or preceding a colophon: 20a, 29b (before illustration), 37b–38a (before illustration), 39a–b (after illustration), 45b–46a (before and on colophon folio), 58a–b (before illustration), 63b–64a (before illustration), 90a–b, 98b–100a (before illustration), 104b (before illustration), 110a (before illustration), 114a (before illustration), 131b (before illustration), 161b (before illustration), 168b–69a (before illustration), 179a (before illustration), 180a–b (after illustration), 187b (before illustration), 193b–94a (before illustration), 198b (before colophon), 206b–7a (before illustration), 214a–15a (before illustration), 220b–21a (before illustration), 230b (before illustration), 252b (before illustration), 261b (before now-missing illustration), 290b (before illustration), 297b (before illustration), 302a–b (before now-missing final folio and hypothetical colophon; upper line of 302a repainted, upper 2 lines on 302b repainted).

Each diagonal line equals three horizontal text lines. Four pairs of triangular cornerpieces illuminate each diagonal line of text.

Illumination includes cartouches, floral scrolls, blossoms, and occasionally a human form or animal face. Similar motifs are often arranged in several different patterns on same page. Illuminated parallelograms (e.g., folios 58b and 114a) or lines of horizontal panels (e.g., folios 58b, 90b, 99b, and 104b) sometimes accompany triangular cornerpieces.

d. *Colophons*

5 colophon folios variously illuminated: 46a, 69b, 83b, 181a, and 272a.

Text outlined in contour lines against gold ground decorated with flowers (folios 69b and 83b); sections of colophon flanked by triangular and/or square and/or rectangular panels filled with multicolored floral motifs and/or medallions and/or flower vases (folios 46a, 69b, 83b, 181a, and 272a); narrow rectangular panels filled with multicolored floral and/or geometric motifs and lozenge patterns and placed above or below colophon (folios 83b, 181a, and 272a).

e. *Column Dividers*

On all text folios, each pair of gridded column dividers ornamented with band of gold flowers (resembling daisies and jonquils), stems and leaves arranged in complementary or alternating S curves between 2 gold lines, each flanked by a thin black line. Style of flowers and leaves varies somewhat throughout manuscript.

Average width of illuminated column dividers: .5 cm

f. *Rulings*

A series of black and colored lines or rulings frame all written and painted surfaces. On all masnavi heading folios, rulings continue above top rectangle and terminate at a sharp angle. The lists that follow show the sequence from inner to outer edge.

Sequence for all text and all colophon folios, for masnavi heading folios 140b and 200b, and for illustrated folios 10a and 207b:

thin black line
gold line
thin black line
dark or light blue line
thin black line
brownish red/reddish brown line
thin black line
green line
thin black line
gold line
2 thin black lines with space in between
space
dark blue line

Sequence for masnavi heading folios 47b, 70b, 84b, 182b, 225b, and 273b is more elaborate:

thin black line
gold line
thin black line
bright or light blue line
thin black line
gold line
thin black line
orange line
thin black line
gold line
thin black line
green line
thin black line
gold line
2 thin black lines with space in between
space
dark blue line

Sequence for illustrated folios 30a, 38b, 59a, 64b, 110b, 114b, 153b, 169b, 188a, 215b, 264a, 275a, and 291a is more diversified:

thin black line	
gold line	
thin black line	
orange line	(38b, 264a, and 291a substitute blue; 169a substitutes green)
thin black line	
gold line	(188a and 215b omit altogether)
thin black line	
green line	(38a substitutes pink; 114a substitutes light blue; 169b substitutes orange; 188a and 215b omit altogether)
thin back line	
gold line	
2 thin black lines with space in between	
space	
dark blue line	

Sequence for illustrated folios 52a, 100a, 105a, 120a, 132a, 147a, 162a, 179b, and 221b, and 298a is even more complex:

thin black line	
gold line	
thin black line	
dark or light blue line	(179b substitutes orange)
thin black line	
gold line	
thin black line	
orange line	(52a substitutes space; 179b substitutes blue)
thin black line	
gold line	
thin black line	
green line	(120a, 132a, and 298a omit altogether)
thin black line	
gold line	
2 thin black lines with space in between	
space	
dark blue line	

Exceptions on folios 10a and 207b: ruling system as on text folios.

Exception on folio 194b: series of black and gold lines with no color.

Exception on folio 231a: rulings irregular and lack various black lines:

thin black line
gold line
thin black line
light blue line
orange line
green line
thin black line
gold line
2 thin black lines
space
dark blue line

Exception on folio 253a; rulings only around text panel:

thin black line
gold line
thin black line
orange line
thin black line
gold line
thin black line
dark blue line

g. Margins

Margins decorated with either painted or stenciled designs.

Painted margin designs on all text folios and around illustrations on folios 30a, 38b, 52a, 64b, 100b, 105a, 110b, 114b, 120a, 132a, 147a, 153b, 162a, 169b, 179b, 188a, 194b, 215b, 221b, 231a, 264a, 275a, 291a, and 298a. All but 2 margins decorated with gold floral designs: 6 large, bushy, heart-shaped blossoms spaced at regular intervals around top, side or fore edge, and bottom margins and united by curving and intersecting stems from which grow additional branches, leaves, and rosettes; series of long, leafy branches in wavy line up gutter, delineated by thin gold line. Size of blossoms and overall arrangement modified somewhat around illustrations to skirt parts of composition projecting into margins.

Variations around illustrations on folios 110b and 291a: margins decorated in various shades of gold with compositions of real and fantastic animals and birds in landscape settings.

Stenciled margin designs on masnavi heading folios 47b, 84b, and 225b; on both recto and verso of illustrated folios 10 and 207; on folios 30b, 38a, 52b, 64a, 100a, 105b, 110a, 114a, 120b, 147b, 153a, 162b, 169a, 179a, 215a, and 291b (all text obverses of illustrated folios). All but 5 margins decorated with long-tailed birds, stenciled in pink and outlined in gold, in various poses amid peonies, rosettes, stems, and leaves also stenciled in pink and outlined in gold.

Exceptions on folios 10a, 84b, 207b, and 225b: same design stenciled in gold and not outlined.

Variation on masnavi heading folio 47b: geometric lattice design stenciled in gold.

Exceptions on folios 47a, 70a, 84a, 182a, 225a, and 273a: single colored sheets (cream or light blue; see 3.a, above) flecked overall in gold; folio 47a covered by a white guard sheet.

Exceptions on folios 46b, 139b–40a, 181b, 199b–200a, and 272b: unilluminated folios between masnavis.

Exception on folio 253: no marginal decoration on recto or verso (folio unfinished).

9. ILLUSTRATIONS

a. Subjects and Dimensions (dimensions follow inner rulings around painted surfaces unless noted)

Silsilat al-dhahab

folio 10a *The Wise Old Man Chides a Foolish Youth*
14.6×13 cm

folio 30a *A Depraved Man Commits Bestiality and Is Berated by Satan*
25×19 cm

folio 38b *The Simple Peasant Entreats the Salesman Not to Sell His Wonderful Donkey*
26.3×14.5 cm

folio 52a *A Father Advises His Son about Love*
26.3×16.8 cm

folio 59a *The Dervish Picks Up His Beloved's Hair from the Hammam Floor*
30.1×19 cm (including architectural extensions)

folio 64b *Bandits Attack the Caravan of Aynie and Ria*
27.9×18.2 cm

Yusuf u Zulaykha

folio 100b *The Aziz and Zulaykha Enter the Capital of Egypt and the Egyptians Come Out to Greet Them*
29.1×19.5 cm (including extensions)

folio 105a *Yusuf Is Rescued from the Well*
24×20.8 cm (including projections on left side)

folio 110b *Yusuf Tends His Flocks*
20.5×16.4 cm (including extensions)

folio 114b *Yusuf Preaches to Zulaykha's Maidens in Her Garden*
23.7×15.9 cm

folio 120a *The Infant Witness Testifies to Yusuf's Innocence*
21.6×14 cm (including extensions)

folio 132a *Yusuf Gives a Royal Banquet in Honor of His Marriage*
27×19.4 cm (including top and side extensions)

Subhat al-abrar

folio 147a *The Gnostic Has a Vision of Angels Carrying Trays of Light to the Poet Sa'di*
23.1×16.7 cm

folio 153b *The Pir Rejects the Ducks Brought as Presents by the Murid*
23.9×17.4 cm

folio 162a *The Fickle Old Lover Is Knocked off the Rooftop*
24.8×19.4 cm

folio 169b *The Arab Berates His Guests for Attempting to Pay Him for His Hospitality*
26.2×19 cm

folio 179b *The Townsman Robs the Villager's Orchard*
24.5×15.6 cm

Salaman u Absal

folio 188a *Solomon and Bilqis Sit Together and Converse Frankly*
23×18.7 cm (including architectural extensions)

folio 194b *Salaman and Absal Repose on the Happy Isle*
22.7×19 cm (including landscape extensions on right)

Tuhfat al-ahrar

folio 207b *The Murid Kisses the Pir's Feet*
21.6×13.2 cm

folio 215b *The Flight of the Tortoise*
21.7×19.5 cm (including extensions on right)

folio 221b *The East African Looks at Himself in the Mirror*
24×13.7 cm

Layli u Majnun

folio 231a *Qays First Glimpses Layli*
25.2×15.6 cm

folio 253a *Majnun Approaches the Camp of Layli's Caravan*
23.5×19.5 cm

(One illustrated folio now missing between folios 261b and 262a.)

folio 264a *Majnun Comes before Layli Disguised as a Sheep*
23.3×14.5 cm

Khiradnama-i Iskandari

folio 275a *The Mi'raj of the Prophet*
23.3×17.6 cm

folio 291a *Khusraw Parviz and Shirin Deal with the Fishmonger*
25×17.2 cm

folio 298a *Iskandar Suffers a Nosebleed and Is Laid Down to Rest*
23.8×16.7 cm

b. Technique

Illustrations on folios 10a and 207b painted after thin paper in center set into 2-ply margin paper. Other illustrations painted on single sheets of cream-colored paper.

All illustrations are vertical rectangles, but dimensions vary (see 9.a, above). All but folios 10a and 207b incorporate panels reserved for 1–8 text verses; some panels impressed with grid for column dividers. Vertical rectangles and text panels possibly defined with black drafting lines, as are visible on folio 264a.

Illustrations first drawn in and then painted, with gold possibly added before colors.

Text transcribed in panels after painting, with catchwords sometimes added in lower margins (e.g., folios 110b, 153b, and 169b); text panels empty on folios 194b, 253a, 264a, 275a, and 298a. Text panels illuminated in various forms: thin gold lines flanked by black lines define column dividers and enframe panels on folios 30a, 52a, 59a, 64b, 100b, 105a, 110b, 114b, 120a, 132a, 147a, 153b, 162a, 169b, 179b, 188a, 207b, 215b, 231a, 264a, 275a, and 291a (this illumination incomplete on folios 52a, 110b, 153b, 231a, 264a, and 291a); double set of gold and black lines enframe text panels on folios 100b, 194b, and 298a; system of colored rulings

enframe text panel on folio 253a (see 8.f, above); band of gold flowers, stems, and leaves ornament column dividers on folios 10a, 147a, and 221b; multicolored floral designs ornament column dividers on folio 253a and enframe lower verse on folio 38b; upper verse on folio 38b surrounded with gold.

Rulings in various systems surround illustrations (see 8.f, above) except on folio 253a; usually do not extend around all 4 sides of painted surface; sometimes added before text. Margin decorations painted around all illustrations (see 8.g, above) except on folio 253a; sometimes gold roundels surround catchwords in margins.

10. UNFINISHED AREAS

folio 45a: middle column divider missing at lower edge
folio 105b: blank space left for 1 verse
folio 114a: blank space left for 1 verse
folio 139a: no black lines flanking gold lines in column dividers
folio 147b: contour lines around rubrics not edged in black
folio 153b: contour lines around rubrics not edged in black
folio 162b: 2 rubrics lack illumination
folio 253b: rubrics and margins lack illumination

Gold cartouches on all masnavi headings except on folio 84b lack calligraphy. Various paintings lack text and illumination (see 9.b, above).

11. CONDITION

Water stains on folios 2–52; serious water damage on upper parts of folios 296b–303a; sections of text paper replaced on folios 299–303; folio 303 bound out of order (belongs after folio 299a); text rewritten and rubrics replicated on folio 302a; pigment from illustration on folio 298a offset and smeared on folio 297b.

All paintings touched up to some extent, especially in landscapes; upper section of illustration on folio 298a repainted, probably as a result of water damage.

12. REPLACEMENT FOLIOS

folio 1a: blank with traces of an inscription and seal
folio 1b: illuminated masnavi heading (Qajar style, late 18th–19th century) and 32 verses of *Silsilat al-dhahab*
folio 304a: 22 ghazals by Qasim Anvar, Hafiz, Amir Khusraw Dihlavi; signed:

كتبه العبد المذنب \ سلطان محمد خندان
غفر ذنوبه

Written by the lowly servant Sultan-Muhammad Khandan, may his sins be forgiven.

Folio 304b: 11 seal impressions and 19 inspection notes of Mughal period, most signed and/or dated (see 15.c,d, below; also Ettinghausen, fs, 28–29).

13. BINDING

Manuscript no longer has original binding.

a. Front and back covers

Lacquered boards with painted floral compositions on red ground, Qajar style (late 18th–19th century); pasted onto heavy boards.

b. Doublures

Painted red board, edged with painted gold and black border.

c. Spine

Red leather tooled with 5 identical compartments with flower in center, European-style (late 19th–20th century?).

a. Colophons

folio 46a, Silsilat al-dhahab, first daftar:

مرقوم شدددفتر اول سلسلة الذهب بامرعالى نواب
نامدار كامكار \ خسرو عالمدار گردون اقتدار
وهوالسلطان العادل الكامل الفاضل \
ابوالفتح سلطان ابرهيم ميرزا الحسينى
الصفوى \ على يد الفقير اقل عبيده مالك
الديلمى \ فى ذى الحجة سنه ثلث و ستين
و تسعمائه \ بالمشهد المقدس المُعلَى

The first book of the Silsilat al-dhahab *was written by the high order of his highness, the celebrated, the successful, the world-mastering Khusraw as mighty as the heavens, the just, the perfect, the virtuous Abu'l-Fath Sultan Ibrahim Mirza [in pink and gold] al-Husayni al-Safavi [in pink and gold], by the hand of the lowly [and] lowliest of his servants Malik al-Daylami in Dhu'l-hijja, the year 963/October 1556 in the holy, the sublime Mashhad.*

folio 69b, Silsilat al-dhahab, second daftar:

تم كتابة الدفتر الثانى من سلسلة الذهب فى
رمضان سنه ٩٦٤

The writing of the second book of the Silsilat al-dhahab *was finished in Ramadan the year 964/June–July 1557.*

folio 83b, Silsilat al-dhahab, third daftar:

right:

خدم باتمامها العبد الفقير المذنب المهجور الغايب \
من مواطن العز و السرَور مالك الديلمى ببلده
قزوين \ بعد مااتفق ابتدأهاوكتابه اكثرها بالمشهد
المنوَر \ المقدَس المعلَى المطهَر المزكى على روضة \
مشرفه اشرف الصلوَة و \ الثناء

The humble, sinful servant, exiled from the regions of power and joy, Malik al-Daylami, served by completing it in the city of Qazvin, after its beginning and the greatest part of it [was done] in the illustrious, holy, sublime, sanctified, purified Mashhad. May the noblest prayers and praises be upon the gardens [tomb] of he who ennobled it [Imam Reza].

center:

فى رمضان سنه ٩٤٤

In Ramadan the year 966/June–July 1559.

left:

برسم بيت الكتب السلطان العادل الكامل
المختصَ بمزيد \ الكرامة الالهيه الممتاز بين السلاطين
بالطاف \ الحضره الشاهيَة اعنى السلطان ابرهيم
ميرزا الحسينى الصفوى \ لا زال ظلال سلطنته
فى ظلَ ظل اظلية الله \ و اثار مكارمه فى البرايا \
جليله

By order of the library of the sultan, the just, the perfect, chosen for increased divine blessings, distinguished among sultans for the benevolence of the royal presence [Shah Tahmasp], that is, Sultan Ibrahim Mirza al-Husayni al-Safavi. May the shadows of his reign not diminish under the shadow of the shadow of God and the effects of his noble works remain magnificent among the people.

folio 139a, Yusuf u Zulaykha:

تمام شد بعون الله تعالى برسم كتابخانه نواب نامدار
كامكار \ گردون وقار خورشيد اشهار ابوالفتح
سلطان ابرهيم ميرزا خلدالله \ تعالى ايام سلطنته
و عدالته ثانى عشر رجب المجرب سنه اربع \
و ستين و تسعمائه على يد العبد الفقير محب
على كتابدار فى المشهد المقدس المنور المزكى \ تم

[It was] finished with the help of God the highest, by order of the kitabkhana of his highness, the illustrious, who is as majestic as the heavens, as renowned as the sun, Abu'l-Fath Sultan Ibrahim Mirza [in gold]. May God the most high perpetuate the days of his rule and justice. The twelfth of the venerable [month of] Rajab in the year 964/11 May 1557, by the hand of the lowly servant Muhibb-Ali the librarian, in the holy, the illustrious, the purified Mashhad. The end.

folio 181a, Subhat al-abrar:

بسرحد اتمام رسيد برسم كتابخانه حضرت نواب
جهاندار \ معدلت آثار معزّ السلطنة و الدنيا
و الدين ابرهيم ميرزا \ خلدالله تعالى ملكَه و سلطانه ·
كتبه العبد الحقير الداعى \ شاه محمود النشابورى
غفرالله ذنوبه و ستر عيوبه فى \ غرَة شهر ذى
الحجه سنه ثلث و ستين و تسعمائه \ الهجرية النبوْيه
بمشهد مقدسة \ منوَرَة رضويه عليه التحية \ والثنا

It has reached the frontiers of completeness by order of the library of his highness, the lord, the world keeper, just in his works, the glorifier of rule, the world, and religion, Ibrahim Mirza, may God protect his kingdom and rule. Written by his humble, supplicant servant, Shah-Mahmud al-Nishapuri, may God forgive his sins and conceal his faults, at the beginning of the month of Dhu'l-hijja, the year 963/early October 1556 of the Prophet's hegira, in the holy, illustrious, blessed Mashhad, salutations and praise be upon it.

folio 199a, Salaman u Absal:

كتبه العبد الفقير عيشى بن عيشرتى \
غفر ذنوبه و ستر عيوبه \بتاريخ سنه ٩٦٨

Written by the lowly servant Ayshi ibn Ishrati, may his sins be forgiven and his faults concealed. Dated the year 968/1560–61.

folio 224b, Tuhfat al-ahrar:

كتبه العبد رستم على غفر الله \ ذنوبه و ستر عيوبه
فى غره شهر \ شوال سنه ثلث و ستين و تسعمائه

Written by the servant Rustam-Ali, may God forgive his sins and conceal his faults, at the beginning of the month of Shawwal, the year 963/early August 1556.

folio 272a, Layli u Majnun:

تمام شد كتابت ليلى و مجنون كه بامر نواب كامكار
جم اقتدار \ كامرانى كشور ستانى جهانبانى ولى
النعمى ابوالفتح سلطان ابرهيم ميرزا \ خلد الله
ظلال حشمته اقل عباد الله الغنى محب على بكتابت
آن اقدام داشت \ در دارالسلطنه هراة فى غره شهر\
شوال ختمه بالخير و اقبال سنه ٩٧٢

The writing of Layli u Majnun *was finished by order of his highness, as mighty as Jamshid in his success at conquering kingdoms, governing the world, and dispensing beneficence, Abu'l-Fath Sultan Ibrahim Mirza, may God perpetuate the shadow of his magnificence. Muhibb-Ali, the least of the servants of God, the self-sufficient, was engaged in its writing. In the abode of the government Herat, at the beginning of the month of Shawwal, it came to a good and auspicious end, the year 972/early May 1565.*

b. Other Documentary Inscriptions

folio 38b, Silsilat al-dhahab:

inscribed over the doorway:

برسم كتابخانه ابوالفتح سلطان ابرهيم ميرزا

By order of the kitabkhana of Abu'l-Fath Sultan Ibrahim Mirza

inscribed at the top of the building:

الهمَ ثبَتُ دولة السُلطان العادل ابوالمظفر شاه طهماسب
الحسينى خلدالله ايام سلطنته على مفارق العالمين

Oh God, strengthen the rule of the just Sultan Abu'l-Muzaffar Shah Tahmasp al-Husayni. May God perpetuate his reign beyond the separation of the two worlds [death].

folio 132a, Yusuf u Zulaykha:

inscribed on arch:

ابوالفتح سلطان ابرهيم ميرزا

Abu'l-Fath Sultan Ibrahim Mirza

folio 162a, Subhat al-abrar:

inscribed over the door:

برسم كتابخانه ابوالفتح سلطان ابرهيم ميرزا

By order of the kitabkhana of Abu'l-Fath Sultan Ibrahim Mirza

inscribed around the door:

بناة هذا العمارة و زينتهابامر السُلطان الاعضم الاكـل
زنده اولاد سَيداالمرسلين \ فى العالمين ابو المظفر شاه
طهماسب الحسينى خلدالله على\ مفارق اهل افضل
والكمال ظلال احسانه و امر و حمة و ايَد فى صفحات
الدَهر اثار مكان

The building of this structure and its decoration [was done] by order of the mightiest and most perfect sultan, Abu'l-Muzaffar Shah Tahmasp al-Husayni [in gold], may the offsprings of the lord of apostles [Muhammad] support him in this world and the next. May God perpetuate the shadow of his beneficence and mercy over the crowns of heads of people of knowledge and excellence and [may God] support the traces of his generous works through the pages of time.

a. *Sultan Ibrahim Mirza*

Name of Sultan Ibrahim Mirza appears in colophons on folios 46a, 83b, 139a, 181a, and 272a and in inscriptions on illustrated folios 38b, 132a, and 162a.

b. *Waqf of Shah Abbas*

Seal impressions dated 1017/1608–9 of an endowment given by waqf of Shah Abbas to the Safavid shrine at Ardabil on folios 2a, 3a, 4a, 5a, 6a, 7a, 9a, 10a, 12a, 14a, 15a, 16a, 17a, 18a, 19a, 20a, 22a, 23a, 34a, 46a (2 impressions), 47b, 60a, 69b, 71a, 83b, 85a, 100a, 100b, 114b, 116a, 132a, 140b, 147a, 153b, 169b, 179b, 183a, 188a, 199a, 200b, 207b, 215b, 221b, 224b, 225b, 226a, 231a, 253a, 264a, 272a, 274a, 275a (2 impressions), 291a, and 298a. Placement of seals varies; almost all effaced, but still possible to read full inscription on folios 4a, 12a, 15a, 16a, and 17a:

وقف استانه متبرکه صفیه صفویه ۱۰۱۷

Waqf of the blessed and pure Safavid threshold, 1017/1608–9.

c. *Mughal Seals*

The numbers correspond to those on the key to folio 304b in figure 226 (below).

226
Folio with seals and inspection notes in the *Haft awrang* of Jami
17th–18th century, India
34.3×22.7 cm (folio)
FGA 46.12, folio 304b

Seals:

S1:

لا اله الا الله محمد رسول الله

There is no God but Allah, Muhammad is the Prophet of Allah.

S2:

مراد[خا]ن [بنده؟] شاه جهان پادشاه غازی

Murad [Kha]n [slave of ?] Shah Jahan, Emperor, Ghazi.

S3:

میمنت خان ۱۱۲۲

Maymanat Khan 1122/1710–11.

S4:

عبدالحق مرید شاه جهان باد

Abd al-Haqq . . . disciple of Emperor Shah Jahan.

S5:

محمد علی شاه جهانی ۲۴ [۱۰]

Muhammad-Ali Shah Jahani [10]24.
(Compare Jackson & Yohannan, 110, seal 4.)

S6:

عبدالرشید ... بنده شاه جهان

Abdul-Rashid slave of Shah Jahan.

S7:

رشیدخان خانه زاد شاه عالم پادشاه غازی ۱۱۲۱

Rashid Khan the slave of the ghazi emperor Shah Alam 1121/1709–10.

S8:

عبدالله خانه زاد شاه عالمگیر باد

Abdullah the slave of emperor Alamgir [Awrangzib].

S9:

کفایت الله خان

Kifayatullah Khan.

S10:

شاه جهان مرشد صالح بود ۱۰۵۶

Shah Jahan was Salih's spiritual guide, 1056/1646–47.

(See Jackson & Yohannan, 110, seal 1, for an identical seal, although the date is not recorded, and for information on Salih.)

S11:

سید علی حسینی مرید شاه عالم [گیر؟]

Sayyid Ali al-Husayni, the disciple of Emperor Alam[gir?].

Key to folio 304b

d. Mughal Inspection Notes

Translations by Wheeler Thackston, with emended readings courtesy of John Seyller (see also Seyller, "Inspection"). Ellipses indicate undecipherable words.

IN1:

بتاریخ شهر شعبان سنه ۳۱ عرض دیده [شد] قیمت پنجهزار روپیه

Inspected on the date of 31st of the month of Shawwal. Value five thousand rupees.

IN2:

نطقه وزیری کلان کاغذ متن سمرغندی و حاشیه کاغذ الوان دولتابادی حکاری بیست یك مسطر چهار مصرعی نوشته سر سخن تذهیب و متن اکثر جایها داغدارو آب رسیده و حرف ... شده جلد ... سرلوح و شمسه در پشت ... رنگ ... ۱۶۰ ورق قیمت ... پنج ۵ ماه اردیبهشت الی سنه احد تحویل خواجه دولت شد

Large vaziri size; paper of the text, white Samarqandi; and of the margins, colored Dawlatabadi; gilded margins. Text twenty-one lines to the page, four-columned; at the beginning of the text is an illumination; the text is spotted and water damaged in many places; the word . . . a sarlawh and a shamsa, on the back of . . . , . . . color, . . . one hundred and sixty folios [the number is rewritten]. Value: . . . five. On the 5th of Urdibihisht Ilhahi year 1 it was entrusted to Khwaja Dawlat.

IN3:

دهم شعبان سنه ۳۱ از وجوه [اختیار؟] تحویل خواجه هلالی شد قیمت ۴۰۰۰ ۳۱۶ورق

[On] 10 Shawwal year 31 it was transferred from [Ikhtiyar ?] to Khwaja Hallali. Value 4000. 316 folios.

IN4:

۲ صفر سنه ۱۲ تحویل خواجه سهیل شد

[On] 2 Safar year 12 it was entrusted to Khwaja Suhayl.

IN5:

بتاریخ ۲۹ محرم الحرام سنه ۱۱ مطابق ۱۰۴۸ حجری عرض دیده تحویل خواجه سهیل نموده شد قیمت پنج هزار روپیه

On the date of the 29th of the venerable month of Muharram year 11 corresponding to 1048 Hegira/12 June 1638, it was inspected [and] entrusted to Khwaja Suhayl. Value [numerical symbol rubbed] five thousand rupees.

IN6:

بیست و پنجم ذی قعده سنه ۷ عرض دیده شد

Inspected on 25 Dhu'l-qa'da year 7.

IN7:

بتاریخ ۱۲ شهر شوال سنه ۱۲ جلوس همیونی عرض دیده شد

Inspected on the date of the 12th of the month of Shawwal of the august reign.

IN8:

الله اکبر پنجم اردیبهشت سنه احد عرض دیده شد

God is great. Inspected on the fifth of Urdibihisht year one.

IN9:

۲۷ شوال سنه ۱۴ جلوس همیونی عرض دیده شد

Inspected on 27 Shawwal year 14 of the august reign.

IN10:

۱۹ محرم سنه ۲۴ عرض دیده شد

Inspected on 19 Muharram year 24.

IN11:

۲۹ شعبان سنه ۱۲ جلوس مبارکه همایون ... تحویل بنده درگاه سهیل شد

[On] 29 Sha'ban year 12 of the auspicious reign, it was entrusted to the servant of the court, Suhayl.

IN12:

۲۸ شوال سنه ۱۶ از وجوه محافضخان تحویلدار مستوفی تحویل محمدحافظ شد قیمت سابق ...

[On] 28 Shawwal year 16 [it was] transferred from Mahafiz Khan, the chief tahvildar [treasurer] to Muhammad Hafiz The previous value . . .

IN13:

بیست ونهم جمادی الاول سنه احد عرض دیده شد

Inspected on 29 Jumada 1 year one.

IN14:

هشتم شوال سنه احد جلوس میمنت مانوس از نظر مقدس همیونی اعلی گذشت

[On] 8 Shawwal year one of the august reign it passed before the august gaze of his majesty.

IN15:

۲۴ شوال سنه ۲۲ جلوس مبارک موافق سنه ۱۰۵۸ تحویل خواجه نعمت شد العبد محمد صالح مشرف قیمت چهار پنجهزار روپیه

Entrusted to Khwaja Ni'mat on 24 Shawwal year 22 of the auspicious reign corresponding to 1058/1648–49. [Certified by] the servant Muhammad Salih, the inspector. Value 4 . . . five thousand (5000) rupees.

IN16:

۲۴ صفر سنه ۲۳ از قفوه خواجه نعمت تحویل خواجه میرخان [میرجان؟] شد العبد محمد صالح مشرف

[On] 24 Safar year 23 [it was] transferred from the custody of Khwaja Ni'mat to Khwaja Mir-Khan [Mirjan?]. Certified by the servant Muhammad Salih, the inspector.

IN17:

واقعه بیست و چهارم محرم سنه ... تحویل محمد باقر شد العبد نور محمد قیمت چهارهزار پنجهزار روپیه

[On] the occasion of the twenty-fourth of the month of Muharram the year [it was] entrusted to Muhammad Baqir. [Certified by] the slave Nur Muhammad. Value 4 Four [thousand? word effaced], five thousand (5000) rupees.

IN18:

۲۲ شوال سنه ۲۶ عرض دیده عبدالله چلبی [۵؟]

[On] 22 Shawwal the year 26, inspected by the servant Abdullah Chilibi [5?].

IN19:

۲۴ محرم الحرام سنه ۴۱ از وجوه سهیل تحویل محمد باقر شد کمترین خانه زادان محمد رشید مشرف قیمت چهار پنجهزار روپیه

[On] the 24th of the venerable month of Muharram year 41, [it was] transferred from the custody of Suhayl to that of Muhammad-Baqir. [Certified by] the least of the servants Muhammad Rashid, the inspector. Value 4000, five [thousand (5000) rupees].

e. Achille and Achillito Chiesa, Milan

As documented in the 1926 sale catalogue (see 16, below).

f. Hagop Kevorkian, New York

Acquired by Kevorkian in April 1926 (see 16, below). Sold by Kevorkian to Freer Gallery of Art in 1946. Flyleaf (a) inscribed in pencil, upper left: Kevorkian #6.

16. SALES AND EXHIBITIONS

1926 New York, American Art Galleries (American Art Association Inc.)
Sale of Achillito Chiesa collection, 16–17 April
catalogue: *Chiesa 3*, lot no. 447.

1930 Detroit, Detroit Institute of Arts
"The Fourteenth Loan Exhibition: Mohammedan Decorative Arts"
catalogue: Detroit, cat. no. 12.

1940 New York, The Iranian Institute
"Exhibition of Persian Art"
catalogue: Ackerman, 260 (gallery IX, case 16, item B)

1971 Washington, D.C., Freer Gallery of Art
"Exhibition of 2500 Years of Persian Art"
catalogue: Atil, *Persian*, cat. no. 39.

1979–80 Washington, D.C., Freer Gallery of Art
"Art of the Court of Shah Tahmasp"
checklist: "Tahmasp," inner leaves 2–3 no. 30.

1986 Washington, D.C., Freer Gallery of Art
"From Concept to Context: Approaches to Asian and Islamic Calligraphy"
catalogue: Fu et al., cat. no. 51.

See Appendix B for annotated bibliography.

Collation of Sultan Ibrahim Mirza's
Haft awrang

The *Haft awrang* today consists of 304 folios joined together in bifolio pairs and gathered into 39 quires or gatherings. This collation presents the order of the manuscript's gatherings and folios in a series of columns arranged from left to right. Both the recto (a) and verso (b) sides of each folio are listed, and the middle bifolio of each gathering is joined by a line. The text sequence follows the Mudarris-Gilani edition of Jami's seven masnavis. The collation also locates and identifies the following features: illumination (e.g., number and type of rubrics, cornerpieces, masnavi headings), titles of illustrations, colophons, color of margin paper and type of marginal design (painted or stenciled), and waqf seals. The purpose of the collation is to set forth the original construction of the *Haft awrang* as a key element of its codicology.

KEY TO SYMBOLS AND ABBREVIATIONS

G	gathering or quire
*	replacement leaf
[]	reconstructed gathering, folio, or illumination
vv	verses

QUIRE	MASNAVI	FOLIO	MUDARRIS-GILANI REFERENCE	ILLUMINATION, ILLUSTRATION, COLOPHON	MARGIN PAPER, DECORATION	SEALS
G[1]	*Silsilat al-dhabab*, first daftar					
		[Aa		shamsa]		
		[Ab		illuminated frontispiece]		
		[Ba		illuminated frontispiece]		
		[Bb		illustrated frontispiece]		
		1a*		[illustrated frontispiece]		
		1b*	2–3	masnavi heading	dark blue, gold floral	square seal and inscriptions (effaced)
		2a	3–5	2 rubrics *a*, *b*	yellow, gold floral	waqf seal, upper margin
		2b	5–7	2 rubrics *a*, *b*	yellow, gold floral	
G[2]	*Silsilat al-dhabab*, first daftar					
		3a	7–9	1 rubric *a*	pink, gold floral	waqf seal, upper margin
		3b	9–10	1 rubric *a*	pink, gold floral	
		4a	10–12	1 rubric *a*	brown, gold floral	waqf seal, upper margin
		4b	12–14		brown, gold floral	
		5a	14–16	3 rubrics *a*, *a+b*, *a*	pink, gold floral	waqf seal, upper margin
		5b	16–18	4 rubrics *b*, *a*, *b¹*, *b*	pink, gold floral	
		6a	18–20	1 rubric *a*	green, gold floral	waqf seal, upper margin
		6b	20–22	4 rubrics *a*, *a*, *a*, *a*	green, gold floral	
		7a	22–24	3 rubrics *a*, *a*, *b¹*	yellow, gold floral	waqf seal, upper margin
		7b	24–25	2 rubrics *a*, *b¹*	yellow, gold floral	
		8a	25–27	1 rubric *a*	bright blue, gold floral	
		8b	27–29	2 rubrics *a*, *b¹*	bright blue, gold floral	
		9a	29–31	2 rubrics *a*, *a*	pink, gold floral	waqf seal, upper margin
		9b	31–33	3 rubrics *a*, *a*, *a*	pink, gold floral	
		10a	33	1 rubric *b²* *The Wise Old Man Chides a Foolish Youth*	cream, stenciled with gold birds, a few black outlines	waqf seal, left margin
		10b	34–36	2 rubrics *a*, *a*	cream, stenciled with pink birds, gold outlines	
G3	*Silsilat al-dhabab*, first daftar					
		11a	36–37	2 rubrics *a*, *b*	green, gold floral	
		11b	37–39	2 rubrics *a*, *a*	green, gold floral	
		12a	39–41	2 rubrics *b¹*, *b*	pink, gold floral	waqf seal, upper margin
		12b	41–43	2 rubrics *a*, *a*	pink, gold floral	
		13a	43–45	5 rubrics *a*, *a*, *a*, *b*, *b¹*	light blue, gold floral	
		13b	45–47	3 rubrics *b¹*, *b¹*, *b*	light blue, gold floral	
		14a	47–49, 52	4 rubrics *a*, *a*, *a*, *b*	yellow, gold floral	waqf seal, upper margin
		14b	50–54	3 rubrics *a*, *a*, *a*	yellow, gold floral	
		15a	54–56	2 rubrics *a*, *a*	pink, gold floral	waqf seal, upper margin
		15b	56–58	2 rubrics *a*, *a*	pink, gold floral	
		16a	58–60	4 rubrics *b¹*, *b¹*, *b¹*, *b*	green, gold floral	waqf seal, upper margin
		16b	60–62		green, gold floral	
		17a	62–64	2 rubrics *a*, *a*	yellow, gold floral	waqf seal, upper margin
		17b	64–66	1 rubric *b¹*	yellow, gold floral	
		18a	66–67	2 rubrics *a*, *b*	light blue, gold floral	waqf seal, upper margin
		18b	67–69	2 rubrics *a*, *a*	light blue, gold floral	
G4	*Silsilat al-dhabab*, first daftar					
		19a	69–71	2 rubrics *a*, *a*	pink, gold floral	waqf seal, upper margin
		19b	71–73	2 rubrics *a*, *a*	pink, gold floral	
		20a	73–74	1 rubric *a* 6 lines cornerpieces, 2 squares flanking rubric	brown, gold floral	waqf seal, upper margin
		20b	74–75	2 rubrics *a*, *a*	brown, gold floral	
		21a	75–77		deep blue, gold floral	
		21b	77–79	2 rubrics *a*, *a*	deep blue, gold floral	
		22a	79–81	3 rubrics *b¹*, *b*, *b¹*	yellow, gold floral	waqf seal, upper margin
		22b	81–83	3 rubrics *b¹*, *b¹*, *b¹*	yellow, gold floral	
		23a	83–84	2 rubrics *a-b*, *a*	pink, gold floral	waqf seal, upper margin
		23b	84–87	2 rubrics *b¹*, *a*	pink, gold floral	
		24a	87–89	2 rubrics *a*, *a*	yellow, gold floral	
		24b	89–90		yellow, gold floral	
		25a	90–92	2 rubrics *b¹*, *a*	pink, gold floral	
		25b	92–94	2 rubrics *a*, *a*	pink, gold floral	
		26a	94–96	2 rubrics *a*, *b¹*	brown, gold floral	
		26b	96–98	3 rubrics *a*, *a-b*, *a*	brown, gold floral	

G5	*Silsilat al-dhahab*, first daftar						
			27a	98–100	3 rubrics b^1, a, b^1	deep blue, gold floral	
			27b	100–102	1 rubric a-b	deep blue, gold floral	
			28a	102–3	1 rubric a	pink, gold floral	
			28b	103–5	4 rubrics b^1, a, a, a	pink, gold floral	
			29a	106–7		green, gold floral	
			29b	107–9	2 rubrics b, a-b	green, gold floral	
					1 line cornerpieces		
			30a	109	*A Depraved Man Commits Bestiality and Is Berated by Satan*	cream, gold floral	
			30b	109–11	3 rubrics a, a-b, b	cream, stenciled with pink birds, gold outlines	
			31a	111–13	2 rubrics b, a	yellow, gold floral	
			31b	113–14	2 rubrics a, b	yellow, gold floral	
			32a	115–16	1 rubric b^1	deep blue, gold floral	
			32b	116–18	3 rubrics a, a, a	deep blue, gold floral	
			33a	118–20	2 rubrics a, a	deep blue, gold floral	
			33b	120–22	2 rubrics a, a	deep blue, gold floral	
			34a	122–24	2 rubrics b, a	pink, gold floral	waqf seal, upper margin
			34b	124–26	2 rubrics b, a	pink, gold floral	
G6	*Silsilat al-dhahab*, first daftar						
			35a	126–27	1 rubric b	light blue, gold floral	
			35b	127–29	4 rubrics b^1, b^1, b^1, b^1	light blue, gold floral	
			36a	129–31	3 rubrics b^1, a, b	pink, gold floral	
			36b	131–33	2 rubrics a, a	pink, gold floral	
			37a	133–34	1 rubric b^1	green, gold floral	
			37b	135–36	1 rubric b	green, gold floral	
					2 lines cornerpieces		
			38a	136–37	1 rubric b	cream, stenciled with pink birds, gold outlines	
					2 lines cornerpieces		
			38b	137–38	*The Simple Peasant Entreats the Salesman Not to Sell His Wonderful Donkey*	cream, gold floral	
			39a	138–39	2 lines cornerpieces	yellow, gold floral	
			39b	139–41	2 rubrics a-b, a	yellow, gold floral	
					2 lines cornerpieces		
			40a	141–42	1 rubric a	bright blue, gold floral	
			40b	143–44	2 rubrics a, a	bright blue, gold floral	
			41a	144–49	2 rubrics a, b	pink, gold floral	
			41b	149–50	1 rubric a	pink, gold floral	
			42a	150–52	1 rubric a	deep blue, gold floral	
			42b	153–54	2 rubrics a, a	deep blue, gold floral	
G7	*Silsilat al-dhahab*, first daftar						
			43a	154–56	2 rubrics b, a	pink, gold floral	
			43b	156–58	4 rubrics a, a, b^1, b^1	pink, gold floral	
			44a	163–65	2 rubrics a, b^1	yellow, gold floral	
			44b	165–67	1 rubric a	yellow, gold floral	
			45a	167–69	1 rubric a	deep blue, gold floral	
			45b	169–70	1 rubric a	deep blue, gold floral	
					3 lines cornerpieces		
			46a	170 (3vv) 182–83	colophon, 2 small rectangular panels, 2 large rectangular panels, 2 triangular panels, 3 lines cornerpieces	pink, gold floral	2 waqf seals: 1 upper-left margin, 1 lower-middle margin
			46b			pink, no decoration	
			47a			light blue, gold flecked (now covered with white guard sheet)	
	Silsilat al-dhahab, second daftar		47b	185–86	masnavi heading 1 rubric b	yellow, stenciled with lattice pattern	waqf seal, upper-right margin
			48a	186–88	3 rubrics a, a, a	bright blue, gold floral	
			48b	188–90	1 rubric a	bright blue, gold floral	
			49a	190–92	2 rubrics a, b	pink, gold floral	
			49b	192–93		pink, gold floral	
			50a	193–95	1 rubric a	green, gold floral	
			50b	195–97	2 rubrics a, b	green, gold floral	

G8	*Silsilat al-dhahab*, second daftar						
			51a	197–99	1 rubric *b*	deep blue, gold floral	
			51b	199–201	1 rubric *a*	deep blue, gold floral	
			52a	201 (3vv)	*A Father Advises His Son about Love*	cream, gold floral	
			52b	201–2	1 rubric *b*	cream, stenciled with pink birds, gold outlines	
			53a	202–4	3 rubrics *a, a, a*	bright blue, gold floral	
			53b	204–6	5 rubrics *a, a, a, b, b*	bright blue, gold floral	
		[54a	206–8	3 rubrics *b, b, a*	pink, gold floral	
			54b	208–10	3 rubrics *b, b, a*	pink, gold floral	
			55a	210–12	3 rubrics *b, a, a*	yellow, gold floral	
		[55b	212–13	2 rubrics *a, b*	yellow, gold floral	
			56a	213–15	2 rubrics *a, a*	deep blue, gold floral	
			56b	215–17	2 rubrics *a, b*	deep blue, gold floral	
			57a	217–19	3 rubrics *a, a, a*	pink, gold floral	
			57b	219–21	3 rubrics *a, a, b*	pink, gold floral	
			58a	221–22	3 rubrics *b, a, a* 1 line cornerpieces, 1 central parallelogram	deep blue, gold floral	
			58b	222–23	1 rubric *a* 4 lines cornerpieces, 2 lines horizontal panels, 2 parallelograms flanked by cornerpieces	deep blue, gold floral	
G9	*Silsilat al-dhahab*, second daftar						
			59a	223 (3vv)	*The Dervish Picks Up His Beloved's Hair from the Hammam Floor*	cream, gold floral	
			59b	223–25	1 rubric *a*	light blue, gold floral	
			60a	225–27		yellow, gold floral	waqf seal, upper margin
			60b	227–29	2 rubrics *a, a*	yellow, gold floral	
			61a	229–30	1 rubric *b*	deep blue, gold floral	
			61b	230–32	2 rubrics *a, b*	deep blue, gold floral	
		[62a	232–34	2 rubrics *a, a*	pink, gold floral	
			62b	234–36	2 rubrics *a, a*	pink, gold floral	
			63a	236–37	2 rubrics *a, b*	yellow, gold floral	
		[63b	237–39	1 rubric *b* 3 lines cornerpieces	yellow, gold floral	
			64a	239–40	1 rubric *b* 2 pairs cornerpieces flanking rubric, 4 lines cornerpieces	cream, stenciled with pink birds, gold outlines	
			64b	240 (3vv)	*Bandits Attack the Caravan of Aynie and Ria*	cream, gold floral	
			65a	240–42	2 rubrics *a, b*	bright blue, gold floral	
			65b	242–43	1 rubric *b*	bright blue, gold floral	
			66a	243–45	1 rubric *a*	pink, gold floral	
			66b	245–47	1 rubric *a*	pink, gold floral	
G10	*Silsilat al-dhahab*, second daftar						
			67a	247–48		deep blue, gold floral	
			67b	248–50	1 rubric *a*	deep blue, gold floral	
			68a	250–52	2 rubrics *b, b*	yellow, gold floral	
			68b	252–54	3 rubrics *a, a, a*	yellow, gold floral	
			69a	254–56	3 rubrics *b, a, a*	pink, gold floral	
			69b	256–58	3 rubrics *a, a, a* colophon, 2 square panels flanking colophon	pink, gold floral	waqf seal, lower margin
	Silsilat al-dhahab, third daftar	[70a			light blue, gold flecked	
			70b	260–61	masnavi heading 2 rubrics *a, b*	pink, gold floral	
			71a	261–63	1 rubric *a*	yellow, gold floral	waqf seal, upper margin
		[71b	263–65		yellow, gold floral	
			72a	265–67	2 rubrics *a, a*	deep blue, gold floral	
			72b	267–68	4 rubrics *a, a, a, a*	deep blue, gold floral	
			73a	268–70	3 rubrics *a, a, a*	pink, gold floral	
			73b	270–72	1 rubric *a*	pink, gold floral	
			74a	272–73	1 rubric *a*	bright blue, gold floral	
			74b	273–75	3 rubrics *a, a, a*	bright blue, gold floral	

QUIRE	MASNAVI	FOLIO	MUDARRIS-GILANI REFERENCE	ILLUMINATION, ILLUSTRATION, COLOPHON	MARGIN PAPER, DECORATION	SEALS
G11	*Silsilat al-dhahab*, third daftar					
		75a	275–77	2 rubrics *a, a*	yellow, gold floral	
		75b	277–79	2 rubrics *b, a*	yellow, gold floral	
		76a	279–81	2 rubrics *a, b*	pink, gold floral	
		76b	281–83	2 rubrics *a, a*	pink, gold floral	
		77a	283–85	3 rubrics *a, b, b*	deep blue, gold floral	
		77b	285–87	3 rubrics *a, a, a*	deep blue, gold floral	
		78a	287–88	3 rubrics *a, a, a*	pink, gold floral	
		78b	288–90	1 rubric *a*	pink, gold floral	
		79a	290–92	2 rubrics *a, a*	bright blue, gold floral	
		79b	292–93	2 rubrics *a, a*	bright blue, gold floral	
		80a	293–96	2 rubrics *a, b*	yellow, gold floral	
		80b	296–99	2 rubrics *a, a*	yellow, gold floral	
		81a	299–300	2 rubrics *a, b*	green, gold floral	
		81b	301–2	1 rubric *a*	green, gold floral	
		82a	302–4	1 rubric *a+b*	green, gold floral	
		82b	304–6	1 rubric *b*	green, gold floral	
G12	*Silsilat al-dhahab*, third daftar					
		83a	306–8	2 rubrics *a, b*	pink, gold floral	
		83b	308–9	colophon, 2 short bands, 2 cornerpieces, 1 long band at bottom	pink, gold floral	waqf seal, lower margin
		84a			light blue, gold flecked	
	Yusuf u Zulaykha	84b	578–79	masnavi heading 1 rubric *b*	pink, stenciled with gold birds, no outlines	
		85a	579–81	1 rubric *b*	yellow, gold floral	waqf seal, upper margin
		85b	581–82	2 rubrics *b, b*	yellow, gold floral	
		86a	582–84	2 rubrics *b, a*	bright blue, gold floral	
		86b	584–86		bright blue, gold floral	
		87a	586–87	1 rubric *b*	pink, gold floral	
		87b	588–89	1 rubric *b*	pink, gold floral	
		88a	589–91	1 rubric *b*	deep blue, gold floral	
		88b	591–93	1 rubric *b*	deep blue, gold floral	
		89a	593–95	2 rubrics *b, b*	yellow, gold floral	
		89b	595–97	1 rubric *a*	yellow, gold floral	
		90a	597–98	4 lines cornerpieces	pink, gold floral	
		90b	598	1 rubric *a* 4 lines cornerpieces, 2 lines horizontal panels, 2 horizontal panels	pink, gold floral	
G13	*Yusuf u Zulaykha*					
		91a	599–600		green, gold floral	
		91b	600–602	1 rubric *b*	green, gold floral	
		92a	602–4		deep blue, gold floral	
		92b	604–5	1 rubric *b*	deep blue, gold floral	
		93a	605–7	1 rubric *b*	pink, gold floral	
		93b	607–9	1 rubric *b*	pink, gold floral	
		94a	609–11		bright blue, gold floral	
		94b	611–12	1 rubric *b*	bright blue, gold floral	
		95a	612–14		yellow, gold floral	
		95b	614–16	1 rubric *a*	yellow, gold floral	
		96a	616–17	1 rubric *b*	pink, gold floral	
		96b	617–19	1 rubric *a*	pink, gold floral	
		97a	619–21		yellow, gold floral	
		97b	621–23	1 rubric *b*	yellow, gold floral	
		98a	623–24	1 rubric *b*	deep blue, gold floral	
		98b	624–25	1 rubric *b* 3 lines cornerpieces	deep blue, gold floral	

			99a	625–26	4 lines cornerpieces	light blue, gold floral	
G14	Yusuf u Zulaykha		99b	626–27	6 lines cornerpieces, 5 lines horizontal panels	light blue, gold floral	
			100a	627–29	1 rubric b / 1 line cornerpieces	cream, stenciled with pink birds, gold outlines	waqf seal, upper margin
			100b	629 (4vv)	The Aziz and Zulaykha Enter the Capital of Egypt and the Egyptians Come Out to Greet Them	cream, gold floral	waqf seal, lower margin
			101a	629–30	1 rubric b	pink, gold floral	
			101b	630–32		pink, gold floral	
			102a	632–34	1 rubric b	yellow, gold floral	
			102b	634–36	1 rubric b	yellow, gold floral	
			103a	636–37	2 rubrics b, b	deep blue, gold floral	
			103b	637–39	1 rubric b	deep blue, gold floral	
			104a	639–41		yellow, gold floral	
			104b	641–42	1 rubric b / 2 lines cornerpieces, 1 line horizontal panels	yellow, gold floral	
			105a	642 (4vv)	Yusuf Is Rescued from the Well	cream, gold floral	
			105b	642–44	1 rubric a	cream, stenciled with pink birds, gold outlines	
			106a	644–46	1 rubric a	bright blue, gold floral	
			106b	646–47	1 rubric b	bright blue, gold floral	
G15	Yusuf u Zulaykha		107a	647–49	1 rubric b	yellow, gold floral	
			107b	649–51	1 rubric b	yellow, gold floral	
			108a	651–52		pink, gold floral	
			108b	652–54	1 rubric b	pink, gold floral	
			109a	654–56		light blue, gold floral	
			109b	656–57	2 rubrics b, b	light blue, gold floral	
			110a	657–58	1 rubric b / 2 lines cornerpieces, 5 lines horizontal bands	cream, stenciled with pink birds, no outlines	
			110b	658 (3vv)	Yusuf Tends His Flocks	cream, gold painted with animals and landscape	
			111a	658–60	1 rubric b	pink, gold floral	
			111b	660–62	1 rubric b	pink, gold floral	
			112a	662–64	1 rubric b	deep blue, gold floral	
			112b	664–65	1 rubric b	deep blue, gold floral	
			113a	665–67	1 rubric b	yellow, gold floral	
			113b	667–69	1 rubric a	yellow, gold floral	
			114a	669–70	1 line cornerpieces, separated by 3 parallelograms	cream, stenciled with birds, gold outlines	
			114b	670 (3vv)	Yusuf Preaches to Zulaykha's Maidens in Her Garden	cream, gold floral	waqf seal, lower margin
G16	Yusuf u Zulaykha		115a	670–72	1 rubric b	pink, gold floral	
			115b	672–74	1 rubric b	pink, gold floral	
			116a	674–75	1 rubric b	light blue, gold floral	waqf seal, upper margin
			116b	675–77		light blue, gold floral	
			117a	677–79	1 rubric b	pink, gold floral	
			117b	679–80		pink, gold floral	
			118a	680–82		yellow, gold floral	
			118b	682–84		yellow, gold floral	
			119a	684–86	1 rubric b	deep blue, gold floral	
			119b	686–87	1 rubric b	deep blue, gold floral	
			120a	687 (2vv)	The Infant Witness Testifies to Yusuf's Innocence	cream, gold floral	
			120b	687–89	1 rubric b	cream, stenciled with pink birds, gold outlines	
			121a	689–91		yellow, gold floral	
			121b	691–92		yellow, gold floral	
			122a	692–94	1 rubric b	deep blue, gold floral	
			122b	694–96		deep blue, gold floral	

QUIRE	MASNAVI	FOLIO	MUDARRIS/GILANI REFERENCE	ILLUMINATION, ILLUSTRATION, COLOPHON	MARGIN PAPER, DECORATION	SEALS
G17	*Yusuf u Zulaykha*					
		123a	696–97	1 rubric *b*	pink, gold floral	
		123b	697–99	1 rubric *b*	pink, gold floral	
		124a	699–701		bright blue, gold floral	
		124b	701–2	1 rubric *b*	bright blue, gold floral	
		125a	703–4		pink, gold floral	
		125b	704–6	1 rubric *b*	pink, gold floral	
		126a	706–8		yellow, gold floral	
		126b	708–9	2 rubrics *b*, *b*	yellow, gold floral	
		127a	709–11	1 rubric *b*	deep blue, gold floral	
		127b	711–13	1 rubric *b*	deep blue, gold floral	
		128a	713–14		yellow, gold floral	
		128b	714–16	1 rubric *b*	yellow, gold floral	
		129a	716–18		pink, gold floral	
		129b	718–19	1 rubric *b*	pink, gold floral	
		130a	719–21	1 rubric *a*	light blue, gold floral	
		130b	721–23	1 rubric *b*	light blue, gold floral	
G18	*Yusuf u Zulaykha*					
		131a	723–25		yellow, gold floral	
		131b	725–26	1 rubric *b* 3 lines cornerpieces, 2 pairs cornerpieces flanking rubric, 1 line horizontal panels, 1 pair horizontal panels	yellow, gold floral	
		132a	726 (IV)	*Yusuf Gives a Royal Banquet in Honor of His Marriage*	cream, gold floral	waqf seal, left margin
		132b	726–28		cream, gold floral	
		133a	728–29	1 rubric *b*	pink, gold floral	
		133b	729–31	1 rubric *a*	pink, gold floral	
		134a	731–32	1 rubric *b*	bright blue, gold floral	
		134b	732–34		bright blue, gold floral	
		135a	734–36		yellow, gold floral	
		135b	736–38	1 rubric *b*	yellow, gold floral	
		136a	738–39		pink, gold floral	
		136b	739–41	1 rubric *a*	pink, gold floral	
		137a	741–43		deep blue, gold floral	
		137b	743–44	1 rubric *a*	deep blue, gold floral	
		138a	744–46		pink, gold floral	
		138b	746–48	1 rubric *a*	pink, gold floral	
G19	*Yusuf u Zulaykha*					
		139a	748	colophon	deep blue, gold floral	
		139b			deep blue, undecorated	
		140a			pink, undecorated	
	Subhat al-abrar	140b	445–46	masnavi heading 1 rubric *b*	pink, gold floral	waqf seal, middle of heading
		141a	446–48	1 rubric *b*	yellow, gold floral	
		141b	448–49	1 rubric *a*	yellow, gold floral	
		142a	449–51		light blue, gold floral	
		142b	451–53	1 rubric *a*	light blue, gold floral	
		143a	453–55	1 rubric *a*	pink, gold floral	
		143b	455–57	1 rubric *a*	pink, gold floral	
		144a	457–58	1 rubric *a*	green, gold floral	
		144b	458–60	1 rubric *a*	green, gold floral	
		145a	460–62	2 rubrics *a*, *a*	deep blue, gold floral	
		145b	462–64	1 rubric *a*	deep blue, gold floral	
		146a	464–66	3 rubrics *a*, *a*, *a*	yellow, gold floral	
		146b	466–67	1 rubric *a*	yellow, gold floral	

G20	Subhat al-abrar					
		147a	467–68	*The Gnostic Has a Vision of Angels Carrying Trays of Light to the Poet Sa'di*	cream, gold floral	waqf seal, left margin
		147b	468–69	2 rubrics *a, a*	cream, stenciled with pink birds, gold outlines	
		148a	469–71	2 rubrics *a, b*	light blue, gold floral	
		148b	471–73	1 rubric *a*	light blue, gold floral	
		149a	473–75	3 rubrics *a, a, a*	pink, gold floral	
		149b	475–76	1 rubric *a*	pink, gold floral	
		150a	477–78	2 rubrics *a, a*	green, gold floral	
		150b	478–80	1 rubric *a*	green, gold floral	
		151a	480–82	2 rubrics *a, a*	green, gold floral	
		151b	482–84	2 rubrics *a, a*	green, gold floral	
		152a	484–85	1 rubric *b*	yellow, gold floral	
		152b	485–87	3 rubrics *a, a, b*	yellow, gold floral	
		153a	487–89	1 rubric *a*	cream, stenciled with pink birds, gold outlines	
		153b	489 (5vv)	*The Pir Rejects the Ducks Brought as Presents by the Murid*	cream, gold floral	waqf seal, upper margin
		154a	489–91	2 rubrics *b, a*	pink, gold floral	
		154b	491–93	2 rubrics *a, b*	pink, gold floral	
G21	Subhat al-abrar					
		155a	493–94	1 rubric *a*	light blue, gold floral	
		155b	494–96	3 rubrics *a, b, a*	light blue, gold floral	
		156a	496–98		pink, gold floral	
		156b	498–500	3 rubrics *a, b, a*	pink, gold floral	
		157a	500–1	1 rubric *b*	green, gold floral	
		157b	501–2	2 rubrics *b, b*	green, gold floral	
		158a	502–5	3 rubrics *a, a, b*	green, gold floral	
		158b	505–6	2 rubrics *b, a*	green, gold floral	
		159a	507–8	3 rubrics *a, b, a*	pink, gold floral	
		159b	508–10	1 rubric *a*	pink, gold floral	
		160a	510–12	2 rubrics *a, b*	light blue, gold floral	
		160b	512–14	2 rubrics *a, b*	light blue, gold floral	
		161a	514–15	1 rubric *a*	yellow, gold floral	
		161b	515–16	1 rubric *a* 6 lines cornerpieces, 3 column dividers, 6 lines of horizontal panels with gold floral scrolls	yellow, gold floral	
		162a	516 (3vv)	*The Fickle Old Lover Is Knocked off the Rooftop*	cream, gold floral	
		162b	516–17	2 rubrics *b, a* (undecorated)	cream, stenciled with pink birds, gold outlines	
G22	Subhat al-abrar					
		163a	517–20	2 rubrics *a, a*	yellow, gold floral	
		163b	520–22	2 rubrics *a, a*	yellow, gold floral	
		164a	522–23	2 rubrics *a, a*	green, gold floral	
		164b	523–25	3 rubrics *a, a, a*	green, gold floral	
		165a	525–27	2 rubrics *b, a*	pink, gold floral	
		165b	527–29	2 rubrics *a, a*	pink, gold floral	
		166a	529–30	2 rubrics *a, a*	light blue, gold floral	
		166b	530–32	2 rubrics *a, a*	light blue, gold floral	
		167a	532–34	2 rubrics *a, a*	yellow, gold floral	
		167b	534–36	2 rubrics *a, a*	yellow, gold floral	
		168a	536–37	3 rubrics *a, b, a*	green, gold floral	
		168b	537–38	5 lines cornerpieces	green, gold floral	
		169a	538–39	1 rubric *b* 3 lines cornerpieces, 1 pair cornerpieces flanking rubric	cream, stenciled with pink birds, gold outlines	
		169b	539–40	*The Arab Berates His Guests for Attempting to Pay Him for His Hospitality*	cream, gold floral	waqf seal, upper right of painting
		170a	540–41	3 rubrics *a, a, a*	pink, gold floral	
		170b	541–43	3 rubrics *a, b, b*	pink, gold floral	

G23	*Subhat al-abrar*						
			171a	543–45	2 rubrics *b, b*	bright blue, gold floral	
			171b	545–46	1 rubric *a*	bright blue, gold floral	
			172a	547–48	3 rubrics *b, a, a*	yellow, gold floral	
			172b	548–50	3 rubrics *b, a, a*	yellow, gold floral	
			173a	550–52	3 rubrics *a, a, b*	pink, gold floral	
			173b	552–53	2 rubrics *a, b*	pink, gold floral	
		⌈	174a	553–55	2 rubrics *b, a*	green, gold floral	
		│	174b	555–57		green, gold floral	
		│	175a	557–59	3 rubrics *a, b, a*	green, gold floral	
		⌊	175b	559–60	1 rubric *b*	green, gold floral	
			176a	561–62	2 rubrics *a, a*	yellow, gold floral	
			176b	562–64	1 rubric *b*	yellow, gold floral	
			177a	564–66	2 rubrics *a, a*	light blue, gold floral	
			177b	566–67	2 rubrics *b, a*	light blue, gold floral	
			178a	567–69	1 rubric *b*	yellow, gold floral	
			178b	569–70	3 rubrics *a, a, b*	yellow, gold floral	
G24	*Subhat al-abrar*						
			179a	571–72	1 rubric *b* 2 lines cornerpieces, 2 horizontal bands	cream, stenciled with pink birds, gold outlines	
			179b	572 (4vv)	*The Townsman Robs the Villager's Orchard*	cream, gold floral	waqf seal, upper right of painting
			180a	572–74	2 rubrics *b*³, *b* 2 lines cornerpieces, 1 pair flanking rubric, 2 lines horizontal bands, 1 pair cornerpiece flanking rubric	pink, gold floral	
			180b	574–75	3 lines cornerpieces, 3 lines horizontal bands	pink, gold floral	
			181a	575	colophon 1 horizontal panel, 2 large triangles, 1 line horizontal bands	green, gold floral	
			181b			green, undecorated	
	Salaman u Absal	⌈	182a			cream, gold flecked	
		│	182b	311–12	masnavi heading 1 rubric *a*	pink, gold floral	
		│	183a	312–14	2 rubrics *a, a*	yellow, gold floral	waqf seal, upper margin
		⌊	183b	314–16	2 rubrics *a, b*	yellow, gold floral	
			184a	316–18	3 rubrics *a, a, a*	green, gold floral	
			184b	318–20	2 rubrics *a, a*	green, gold floral	
			185a	320–21	2 rubrics *a, a*	green, gold floral	
			185b	321–23	4 rubrics *a, a, a, a*	green, gold floral	
			186a	323–25	3 rubrics *a, a, a*	pink, gold floral	
			186b	325–27	3 rubrics *a, a, a*	pink, gold floral	
G25	*Salaman u Absal*						
			187a	327–29	3 rubrics *a, a, a*	bright blue, gold floral	
			187b	329–30	2 rubrics *a, a* 2 lines cornerpieces	bright blue, gold floral	
			188a	330 (1v)	1 rubric *a* *Solomon and Bilqis Sit Together and Converse Frankly*	cream, gold floral	waqf seal, upper margin
			188b	330–32	1 rubric *a*+	cream, gold floral	
			189a	332–34	2 rubrics *a, b*	yellow, gold floral	
			189b	334–36	2 rubrics *a, b*	yellow, gold floral	
		⌈	190a	336–37	3 rubrics *b, a, a*	green, gold floral	
		│	190b	337–39	4 rubrics *b, a, a, a*	green, gold floral	
		│	191a	339–41	2 rubrics *a, a*	green, gold floral	
		⌊	191b	341–42	3 rubrics *b, a, b*	green, gold floral	
			192a	342–44	3 rubrics *a, a, a*	pink, gold floral	
			192b	344–46	5 rubrics *b, b, b, a, a*	pink, gold floral	
			193a	346–47	3 rubrics *b, b, b*	yellow, gold floral	
			193b	347–49	3 rubrics *a, b, a* 2 lines cornerpieces	yellow, gold floral	
			194a	349–50	4 lines cornerpieces, 1 line horizontal bands	deep blue, gold floral	
			194b		*Salaman and Absal Repose on the Happy Isle*	cream, gold floral	

QUIRE	MASNAVI	FOLIO	MUDARRIS-GILANI REFERENCE	ILLUMINATION, ILLUSTRATION, COLOPHON	MARGIN PAPER, DECORATION	SEALS
G26	*Salaman u Absal*					
		195a	350–52	2 rubrics *a, a*	light blue, gold floral	
		195b	352–54	4 rubrics *a, b, a, a*	light blue, gold floral	
		196a	354–56	3 rubrics *a, a, a*	yellow, gold floral	
		196b	356–57	2 rubrics *b, a*	yellow, gold floral	
		197a	357–59	2 rubrics *a, a*	pink, gold floral	
		197b	359–61	2 rubrics *b, a*	pink, gold floral	
		198a	361–62	1 rubric *a*	light blue, gold floral	
		198b	362–64	1 rubric *a* 1 line cornerpieces	light blue, gold floral	
		199a	364, 575–76	1 rubric *b* colophon	pink, gold floral	waqf seal, bottom of colophon
		199b			pink, undecorated	
		200a			pink, undecorated	
	Tuhfat al-ahrar	200b	367–69	masnavi heading	pink, gold floral	waqf seal, right margin
		201a	369–70	1 rubric *a*	green, gold floral	
		201b	370–72	1 rubric *a*	green, gold floral	
		202a	372–74	2 rubrics *a, a*	pink, gold floral	
		202b	374–76	2 rubrics *a, a*	pink, gold floral	
G27	*Tuhfat al-ahrar*					
		203a	376–77	2 rubrics a, a	light blue, gold floral	
		203b	377–79		light blue, gold floral	
		204a	379–81	2 rubrics a, *b*	yellow, gold floral	
		204b	381–82	2 rubrics b, *a*	yellow, gold floral	
		205a	383–84	1 rubric *a*	green, gold floral	
		205b	384–86	1 rubric *a*	green, gold floral	
		206a	386–88	1 rubric *a*	yellow, gold floral	
		206b	388–89	1 rubric *a* 1 line cornerpieces	yellow, gold floral	
		207a	389–90	1 rubric *a* 4 lines cornerpieces	cream, stenciled with pink birds, gold outlines	
		207b	390 (2vv)	*The Murid Kisses the Pir's Feet*	cream, stenciled with gold birds, no outlines	waqf seal, upper margin
		208a	390–92	1 rubric *b*	pink, gold floral	
		208b	392–94	1 rubric *b*	pink, gold floral	
		209a	394–96	1 rubric *a*	yellow, gold floral	
		209b	396–97	2 rubrics *a, a*	yellow, gold floral	
		210a	397–99	2 rubrics *a, a*	pink, gold floral	
		210b	399–401	2 rubrics *a, a*	pink, gold floral	
G28	*Tuhfat al-ahrar*					
		211a	401–3	1 rubric *a* 1 horizontal band (in place of rubric)	green, gold floral	
		211b	403–4	2 rubrics *a, a*	green, gold floral	
		212a	404–6	2 rubrics *a, a*	green, gold floral	
		212b	406–8	2 rubrics *a, a*	green, gold floral	
		213a	408–10	1 rubric *a*	pink, gold floral	
		213b	410–12	2 rubrics *b, a*	pink, gold floral	
		214a	412–13	1 rubric *a* 1 line cornerpieces	light blue, gold floral	
		214b	413–14	1 rubric *b* 3 lines cornerpieces, 1 pair cornerpieces flanking rubric	light blue, gold floral	
		215a	414–15	1 rubric *a* 4 lines cornerpieces, 1 line horizontal bands	cream, stenciled with pink birds, gold outlines	
		215b	415 (2vv)	*The Flight of the Tortoise*	cream, gold floral	waqf seal, upper margin
		216a	415–17	2 rubrics *b, a*	green, gold floral	
		216b	417–19	1 rubric *a*	green, gold floral	
		217a	419–21	2 rubrics *a, a*	yellow, gold floral	
		217b	421–22	2 rubrics *a, a*	yellow, gold floral	
		218a	422–24	1 rubric *a*	light blue, gold floral	
		218b	424–26	1 rubric *a*	light blue, gold floral	

QUIRE	MASNAVI	FOLIO	MUDARRIS-GILANI REFERENCE	ILLUMINATION, ILLUSTRATION, COLOPHON	MARGIN PAPER, DECORATION	SEALS
G29	*Tuhfat al-ahrar*					
		219a	426–28	2 rubrics *b*, *a*	pink, gold floral	
		219b	428–29	2 rubrics *a*, *a*	pink, gold floral	
		220a	429–31	1 rubric *a*	green, gold floral	
		220b	431–33	1 rubric *a* 3 lines cornerpieces, 2 lines horizontal bands	green, gold floral	
		221a	433–34	1 rubric *a* 5 lines cornerpieces, 2 lines horizontal bands	pink, gold floral	
		221b	434 (2vv)	*The East African Looks at Himself in the Mirror*	cream, gold floral	waqf seal, upper margin
		222a	434–35	2 rubrics *a*, *b*	yellow, gold floral	
		222b	436–37	2 rubrics *a*, *a*	yellow, gold floral	
		223a	437–39	1 rubric *a*	light blue, gold floral	
		223b	439–41	1 rubric *a*	light blue, gold floral	
		224a	441–42	2 rubrics *a*, *a*	yellow, gold floral	
		224b	442–43	colophon	yellow, gold floral	waqf seal, underneath colophon (apparently superimposed with a square seal)
		225a			cream, gold flecked	
		225b	750–51	masnavi heading	pink, stenciled with gold birds, no outlines	waqf seal, middle of title-piece cartouche
		226a	751–53	1 rubric *a*	green, gold floral	waqf seal, upper margin
		226b	753–54	1 rubric *b*	green, gold floral	
G30	*Layli u Majnun*					
		227a	754–56	1 rubric *b*	green, gold floral	
		227b	756–58	1 rubric *b*	green, gold floral	
		228a	758–60	1 rubric *b*	yellow, gold floral	
		228b	760–62	1 rubric *a*	yellow, gold floral	
		229a	762–64	1 rubric *b*	bright blue, gold floral	
		229b	764–65		bright blue, gold floral	
		230a	765–67	1 rubric *a*	pink, gold floral	
		230b	767–68	1 rubric *a* 3 lines cornerpieces	pink, gold floral	
		231a	769 (3vv)	*Qays First Glimpses Layli*	cream, gold floral	waqf seal, left margin
		231b	769–70	1 rubric *a*	cream, gold floral	
		232a	770–72	1 rubric *a*	pink, gold floral	
		232b	772–74		pink, gold floral	
		233a	774–76	1 rubric *b*	yellow, gold floral	
		233b	776–78		yellow, gold floral	
		234a	778–79	1 rubric *b*	bright blue, gold floral	
		234b	779–81	1 rubric *b*	bright blue, gold floral	
G31	*Layli u Majnun*					
		235a	781–83	1 rubric *a*	yellow, gold floral	
		235b	783–84		yellow, gold floral	
		236a	784–86	1 rubric *b*	deep blue, gold floral	
		236b	786–88	1 rubric *a*	deep blue, gold floral	
		237a	788–89		deep blue, gold floral	
		237b	789–91	1 rubric *a*	deep blue, gold floral	
		238a	791–93	1 rubric *a*	pink, gold floral	
		238b	793–94		pink, gold floral	
		239a	794–96	1 rubric *b*	bright blue, gold floral	
		239b	796–98	1 rubric *b*	bright blue, gold floral	
		240a	798–99		yellow, gold floral	
		240b	799–801	1 rubric *b*	yellow, gold floral	
		241a	801–3	1 rubric *a*	green, gold floral	
		241b	803–5		green, gold floral	
		242a	805–7	1 rubric *a*	pink, gold floral	
		242b	807–8	1 rubric *b*	pink, gold floral	

QUIRE	MASNAVI	FOLIO	MUDARRIS-GILANI REFERENCE	ILLUMINATION, ILLUSTRATION, COLOPHON	MARGIN PAPER, DECORATION	SEALS
G32	*Layli u Majnun*					
		243a	809–10		bright blue, gold floral	
		243b	810–12	1 rubric *a*	bright blue, gold floral	
		244a	812–14		yellow, gold floral	
		244b	814–15	1 rubric *a*	yellow, gold floral	
		245a	815–17		pink, gold floral	
		245b	817–19		pink, gold floral	
		246a	819–20		yellow, gold floral	
		246b	820–22		yellow, gold floral	
		247a	822–24	1 rubric *b*	pink, gold floral	
		247b	824–25	1 rubric *b*	pink, gold floral	
		248a	825–27		bright blue, gold floral	
		248b	828–29	1 rubric *b*	bright blue, gold floral	
		249a	829–30		yellow, gold floral	
		249b	830–32	1 rubric *b*	yellow, gold floral	
		250a	832–34		pink, gold floral	
		250b	834–36	1 rubric *b*	pink, gold floral	
G33	*Layli u Majnun*					
		251a	836–37	1 rubric *b*	deep blue, gold floral	
		251b	837–39		deep blue, gold floral	
		252a	839–41		pink, gold floral	
		252b	841–42	1 rubric *b* 2 lines cornerpieces, 1 line horizontal bands	pink, gold floral	
		253a		*Majnun Approaches the Camp of Layli's Caravan*	cream, undecorated	waqf seal, left margin
		253b	842–44	1 rubric undecorated	yellow, undecorated	
		254a	844–46	1 rubric *a*	bright blue, gold floral	
		254b	846–47	1 rubric *a*	bright blue, gold floral	
		255a	847–49		pink, gold floral	
		255b	849–51	1 rubric *b*	pink, gold floral	
		256a	851–52		green, gold floral	
		256b	852–54	1 rubric *a*	green, gold floral	
		257a	854–56	1 rubric *a*	deep blue, gold floral	
		257b	856–58	1 rubric *b*	deep blue, gold floral	
		258a	858–59		yellow, gold floral	
		258b	859–61		yellow, gold floral	
G34	*Layli u Majnun*					
		259a	861–63	1 rubric *a*	pink, gold floral	
		259b	863–64	1 rubric *b*	pink, gold floral	
		260a	864–66	1 rubric *b*	bright blue, gold floral	
		260b	866–68		bright blue, gold floral	
		261a	868–70	1 rubric *a*	yellow, gold floral	
		261b	870–71	5 lines cornerpieces, 2 lines horizontal bands	yellow, gold floral	
		[Aa	871–72	at least 1 rubric several lines cornerpieces, several lines horizontal bands	unable to reconstruct]	
		[Ab	872–73	illustration to passage "the illness and death of Layli's husband"	unable to reconstruct]	
		[Ba	873–74	several lines cornerpieces	unable to reconstruct]	
		[Bb	874–75	at least 1 rubric	unable to reconstruct]	
		262a	875–77		deep blue, gold floral	
		262b	877–79		deep blue, gold floral	
		263a	879–80	1 rubric *b*	yellow, gold floral	
		263b	880–82		yellow, gold floral	
		264a		*Majnun Comes before Layli Disguised as a Sheep*	cream, gold floral	waqf seal, upper left of painting
		264b	882–84	1 rubric *b*	light blue, gold floral	

G35	*Layli u Majnun*						
			265a	884–86	1 rubric *b*	pink, gold floral	
			265b	886–88		pink, gold floral	
			266a	886–90		deep blue, gold floral	
			266b	890–91	1 rubric *a*	deep blue, gold floral	
			267a	892–93	1 rubric *a*	yellow, gold floral	
			267b	893–95		yellow, gold floral	
		[268a	895–98	1 rubric *a*	deep blue, gold floral	
			268b	898–99	1 rubric *a*	deep blue, gold floral	
			269a	899–900	1 rubric *a*	pink, gold floral	
		L	269b	900–2	1 rubric *a*	pink, gold floral	
			270a	902–4		light blue, gold floral	
			270b	904–5	1 rubric *a*	light blue, gold floral	
			271a	905–7	1 rubric *b*	pink, gold floral	
			271b	907–9	1 rubric *b*	pink, gold floral	
			272a	909–10	colophon 2 horizontal panels	yellow, gold floral	waqf seal, bottom margin
			272b			yellow, undecorated	
G36	*Khiradnama-i Iskandari*						
			273a			bright blue, gold flecked	
			273b	912–13	masnavi heading	green, gold floral	
			274a	913–15	1 rubric *a*	yellow, gold floral	waqf seal, upper margin
			274b	915–17	2 rubrics *a, a*	yellow, gold floral	
			275a		*The Mir'aj of the Prophet*	cream, gold floral	2 waqf seals: 1 lower left of painting and margin, 1 upper center of painting and margin
			275b	917–19	1 rubric *a*	pink, gold floral	
		[276a	919–21	2 rubrics *a, a*	bright blue, gold floral	
			276b	921–23	1 rubric *a*	bright blue, gold floral	
			277a	923–24	1 rubric *a*	pink, gold floral	
		L	277b	925–26	2 rubrics *a, a*	pink, gold floral	
			278a	926–28		green, gold floral	
			278b	928–30	1 rubric *a*	green, gold floral	
			279a	930–32	1 rubric *a*	deep blue, gold floral	
			279b	932–33	2 rubrics *a, a*	deep blue, gold floral	
			280a	933–35		yellow, gold floral	
			280b	935–37	2 rubrics *b, a*	yellow, gold floral	
G37	*Khiradnama-i Iskandari*						
			281a	937–38	1 rubric *a*	bright blue, gold floral	
			281b	938–40	1 rubric *a*	bright blue, gold floral	
			282a	940–42	1 rubric *a*	pink, gold floral	
			282b	942–44	1 rubric *b*	pink, gold floral	
			283a	944–45		green, gold floral	
			283b	945–47	2 rubrics *a, b*	green, gold floral	
		[284a	947–49		pink, gold floral	
			284b	949–51	1 rubric *a*	pink, gold floral	
			285a	951–52	1 rubric *b*	deep blue, gold floral	
		L	285b	952–54		deep blue, gold floral	
			286a	954–56	1 rubric *a*	yellow, gold floral	
			286b	956–58	1 rubric *b*	yellow, gold floral	
			287a	958–59	2 rubrics *a, b*	pink, gold floral	
			287b	959–61	2 rubrics *a, b*	pink, gold floral	
			288a	961–63	1 rubric *a*	bright blue, gold floral	
			288b	963–64	2 rubrics *a, b*	bright blue, gold floral	

QUIRE	MASNAVI	FOLIO	MUDARRIS-GILANI REFERENCE	ILLUMINATION, ILLUSTRATION, COLOPHON	MARGIN PAPER, DECORATION	SEALS
G38	Khiradnama-i Iskandari					
		289a	964–66	1 rubric *a*	pink, gold floral	
		289b	966–68	1 rubric *a*	pink, gold floral	
		290a	968–70	2 rubrics *a, a*	yellow, gold floral	
		290b	970–71	1 rubric *a* 1 line cornerpieces	yellow, gold floral	
		291a	971–72 (3vv)	*Khusraw Parviz and Shirin Deal with the Fishmonger*	cream, gold animals	waqf seal, upper margin
		291b	972–73	1 rubric *a*	cream, stenciled with pink birds, gold outlines	
		292a	973–75	2 rubrics *a, a*	deep blue, gold floral	
		292b	975–77	2 rubrics *a, a*	deep blue, gold floral	
		293a	977–79	1 rubric *a*	yellow, gold floral	
		293b	979–81	1 rubric *a*	yellow, gold floral	
		294a	981–82		deep blue, gold floral	
		294b	982–84	2 rubrics *a, b*	deep blue, gold floral	
		295a	984–86		pink, gold floral	
		295b	986–87	2 rubrics *a, a*	pink, gold floral	
		296a	987–89		bright blue, gold floral	
		296b	989–91	1 rubric *a*	bright blue, gold floral	
G[39]	Khiradnama-i Iskandari					
		297a	991–93	1 rubric *a*	pink, gold floral	
		297b	993–94	1 rubric *a* 1 line cornerpieces	pink, gold floral	
		298a		*Iskandar Suffers a Nosebleed and Is Laid Down to Rest*	cream, gold floral	waqf seal, left margin
		298b	994–96		cream, gold floral	
		299a	996–98	1 rubric *a*	deep blue, gold floral	
		299b	998–99	3 rubrics *a, a, b*	deep blue, gold floral	
		303a	1000–1001	6 rubrics *b, b, b, b, b*	yellow, gold floral	
		303b	1001–3	5 rubrics *b, b, b, b*	yellow, gold floral	
		300a	1003–5	2 rubrics *b, b*	pink, gold floral	
		300b	1005–7	1 rubric *b*	pink, gold floral	
		301a	1007–9	(1 space for rubric on replacement paper)	deep blue, gold floral	
		301b	1009–10	(1 space for rubric on replacement paper)	deep blue, gold floral	
		302a	1011–12	1 rubric (not original) 1 line cornerpieces (not original), 1 rubric *a* (original), 1 line cornerpieces (original)	cream, gold floral	
		302b	1012–13	2 lines cornerpieces (not original), 2 lines cornerpieces (original)	cream, gold floral	
	Khiradnama-i Iskandari	[304a	1013	colophon	unable to reconstruct]	
		[304b			unable to reconstruct]	
		304a*		ghazals by Qasim Anvar, Hafiz, and Amir Khusraw Dihlavi	blue, gold landscape	
		304b*		Mughal seals and inspection notes		

Summary Description of Sultan Ibrahim
Mirza's *Naqsh-i badi*

This copy of the *Naqsh-i badi* by Muhammad Ghazali
Mashhadi was made for Sultan Ibrahim Mirza. Text
transcribed in Sabzivar by Sultan-Muhammad Khandan.
Dated Ramadan 982/April–May 1574. Illustrated with 2
paintings, unsigned and undated. Collection of Topkapi
Sarayi Müzesi, R. 1038.

1. SIZE AND COLLATION

38 folios in 11 gatherings, with 8 composed of 2 bifolios and
3 composed of a single bifolio each.

2. MATERIAL

Same for both full text folios and illustrated folios: thin,
polished white paper in center for text and for text and
illustration on folios 23b and 26a.

Thicker, two-ply paper for margins. Most folios have
cream-colored margins on both recto and verso. 9 folios have
cream-colored margins on one side and colored margins on
the other: blue (folios 2a, 30b, and 37b), pink (folio 6b),
gray-green (or possibly faded blue; folios 7a, 10a, and 24a),
and green (folios 8a and 9a). Margins may not be original.

Exception on folio 1: cream-colored paper in center for
text, an intermediary band of paper around all four sides of
text paper, and three-ply paper for margins.

Exception on folio 6: three-ply paper for margins.

Exception on folio 34: single-ply paper for margins.

3. DIMENSIONS (*average*)

a. *Full Folio*

23.6×25.9 cm

b. *Written Surface*

11.5×5.7 cm

c. *Margin Widths*

gutter: 3.0 cm
bottom: 6.1 cm
fore edge or side: 7.0 cm
top: 6.0 cm

4. PREPARATION OF FOLIOS AND CONSTRUCTION

Thin, cream-colored paper dusted or sprayed with gold and
impressed with grid of 12 horizontal lines (height: 1.0 cm
between each line) and 2 vertical lines forming 2 text
columns and 1 column divider per page (width: .6 cm)

Exception on folios 1b–2a: layout includes both columns
for verse text and lines that run the full width of written
surface for prose text.

Text paper inlaid into "windows" of margin paper after
text transcribed, to form full folios. Structure of illustrated
folios 23 and 26 definitely original since parts of landscape go
over joint between text paper and margins. Other current
margins may be replacements.

5. CALLIGRAPHY

Nasta'liq in black ink throughout manuscript.

6. ILLUMINATION

a. *Title-Piece Heading (folio 1b)*

2 superimposed rectangles, separated and enframed by a band
of white crosses on a bright blue ground that continues at the
sides into the upper margin. The larger bottom field contains
a central scalloped cartouche in gold with a thick, black
inner contour. This contour is surrounded by a somewhat

lighter gold band and a dark blue border decorated with colored blossoms on gold stems. The narrow upper rectangle contains a central medallion in dark blue, crowned at its apex by a large orange lotus blossom and flanked by 2 pear-shaped pendants. The backgound of both fields is decorated with large pink and blue blossoms and gold garlands on a gold ground.

Title piece cut out, repainted at sides and pasted onto new margins.

b. *Rubrics*

15 rectangular panels for rubrication, equal in width to written surface and in height to 1 or 2 lines of text. None contains text. Most are totally filled with gold paint.

Exceptions on folios 3b and 7a: central gold cartouche, scalloped and outlined in blue.

Exception on folio 8b: central gold cartouche, scalloped and flanked by gold floral sprays.

Exceptions on folios 20a and 26b: panels blank, usually end at innermost line of column dividers, although some cut across column divider (e.g., folio 276).

c. *Verse Illuminations*

Final 3 folios (36b–38a) have distinctive page layout, with alternate verses written in middle of line and hemistichs superimposed, forming 11 rectangular text panels. Each of these panels flanked by 2 small squares, enframed by a gold or colored band and painted in various bright colors (red, green, orange, sky blue, and black) and sketchy multicolored floral designs.

d. *Colophon (folio 38a)*

4 lines of colophon text outlined in black contour line against gold ground. Possibly later addition. Another line written at an angle on top of gold ground at left has been rubbed out.

تمَت الكتاب بعون الوَهاب فى تاريخ شهر محَرم الحرام ۱
سنه ۹۸۲ برسم كتابخانه نواب جهانبانى سلطان ۱
ابراهيم ميرزا در بلده سبزوار مرقوم شد ۱
كتبه الفقير سلطان محمد خندان

The book was completed with the help of the almighty Lord, in the venerable month of Muharram, the year 982/April–May 1574. It was written by order of the kitabkhana of his highness, govenor of the world, Sultan Ibrahim Mirza, in the city of Sabzivar. Written by the lowly Sultan-Muhammad Khandan.

e. *Column Dividers*

On all text folios, each pair of gridded column dividers ornamented with band of thin gold tendrils (blossoms, leaves, and stems) arranged in complementary or alternating S curves between two gold lines, each flanked by a thin black line. Style of tendrils varies somewhat throughout manuscript.

Exception on folios 1b, 2a, and 7a: tendrils grow downward on bright orange ground. Average width of illuminated column dividers: .4 cm

f. *Text Frame and Rulings*

text frame:

Written surface on text folios enframed with a band of gold floral scrolls, similar to decoration of column dividers, painted on margin paper (so color of background same as color of margin paper). Band ruled on inner edge with 2 thin black lines filled with gold.

Exception on folios 1b and 2a: gold floral scrolls on black ground.

Exception on folio 7a: thick gold wave design on black ground.

rulings:

All written and painted surfaces framed in a series of black and colored lines or rulings (from inner to outer edge):

thin black line
gold line
thin black line
thin bright blue line
purplish or reddish or gold line
light or bright green line
gold line (quite thick on 2 illustrated folios)
2 thin black lines with space in between
space
blue or white or orange line

g. *Margins*

All margins decorated with a combination of painted and stenciled designs featuring birds, animals, ribbons, and medallions. Designs executed directly on margin paper and generally outlined (and often highlighted) in gold. Backgounds rendered in a different color (pink, green, or light blue), often in a kind of sponge or stippled technique. Some of the animal compositions upside-down (e.g., folios 4a, 8a, and 30b), indicating that the margins have been refurbished and perhaps totally replaced.

h. *Other*

folio 1b: first two verses illuminated with small gold tendrils touched with blue.

7. ILLUSTRATIONS (*subjects, dimensions, and incorporated verses*)

Translations by Wheeler Thackston.

folio 23b, *Gathering in a Garden*, 14×8 cm

If you look at them, it is a calamity,
If you stretch out your hand toward the heart, it is afflicted.

Eyes each more seditious than the other;
Winks sharpened for blood, glances even sharper.

folio 26a, *Zulaykha Tries to Hold Back the Fleeing Yusuf*, 14×8 cm

He who has designs on his beloved
Will fall prey to himself, like Zulaykha.

Beware, for the draught of men who tread the way
To gnosis is not meant for every effeminate.

8. UNFINISHED AREAS

Lack of text in title-piece heading and rubrics may indicate that manuscript was never totally completed.

9. CONDITION

Generally good, although manuscript obviously has been refurbished: folio 1 with illuminated title-piece heading on verso; possibly all margins except illustrated folios 23b and 26a; gold ground added around colophon on folio 38a.

10. BINDING

Present binding not original: brown leather boards covered on exterior front, back, and flap with marbelized paper; purple paper doublures.

11. PROVENANCE

Sultan Ibrahim Mirza

Name of Sultan Ibrahim Mirza appears in colophon on folio 38a.

12. BIBLIOGRAPHY

Çağman & Tanindi, cat. no. 105; Karatay, *Farsça*, cat. no. 787 (with no reference to Ibrahim Mirza); Simpson, "Jami," postscript insert sheet; Togan, 37.

I. PRIMARY SOURCES

Rarely are individual works of art, especially manuscripts, mentioned in Safavid sources, and the *Haft awrang* of Jami is no exception. Its patron and artists, however, received varying degrees of attention in two genres of contemporary texts: the historical chronicle and the tadhkira. The former range from summary dynastic histories, such as the *Takmilat al-akhbar* (Perfection of history) of Abdi Beg Shirazi, to extended year-by-year accounts with detailed records of specific events, such as the *Sharafnama* (Book of the nobility) of Sharafuddin Khan Bidlisi and the *Ta'rikh-i alam-ara-yi Abbasi* (History of Shah Abbas) written by Iskandar Beg Munshi. These works tend to be concerned more with affairs of state than of art and culture, and the selective notice they pay to Ibrahim Mirza confirms his relatively minor position in the political history of the period. It is possible, however, to construct a basic biography for the prince through these sources (particularly his appointment to Mashhad in 962/1554–55, participation in an expedition to Herat in 972/1564–65, and assassination in 984/1577) and to learn something of the artists in his employ.

The tadhkira texts are far more numerous and informative, although their typically effusive rhetoric provides a definite challenge to any latter-day assessment of real accomplishments and abilities. Akin to the "who's who" of modern times, such sources provide biographical data, usually in the form of entries arranged either alphabetically, chronologically, or according to other systems, on contemporary and earlier literati and artists.[1] Princely patrons also are featured prominently in these texts, partly on account of their patronage and partly on account of their own literary and artistic achievements. One of the most important Safavid tadhkiras, comprising a collection of biographies of poets, was written by Sam Mirza, younger brother of Shah Tahmasp. Other such anthologies and memoirs were written by Safavid artists, including Dust-Muhammad, Malik al-Daylami, and Sadiqi Beg. The most extensive tadhkira is the *Gulistan-i hunar* (Garden of the arts) of Qazi Ahmad, whose father served Ibrahim Mirza in Mashhad. These texts vary in the extent of their biographical notices on Sultan Ibrahim Mirza and his artists. The exclusions may be as telling as the inclusions, however, and they all provide interesting insights on the merits and status of their authors' colleagues.

Abdi Beg Shirazi. *Takmilat al-akhbar* (Perfection of history), written 978/1570–71, Persian text edited by Abdul-Husayn Nava'i (Tehran: Nashr-i Nay, 1369/1990).

Sultan Ibrahim Mirza is mentioned in passing in this short history of the Safavid dynasty from its beginnings in the thirteenth century to the year 978/1570–71.

Abu'l-Fazl. *A'in-i Akbari* (Code of Akbar), written 987/1579–80, English translation of volume 1 by H. Blochmann (Calcutta: Bibliotheca Indica, 1927–39; reprint, New Delhi, 1977–78).

The *A'in-i Akbari* contains a section on the arts of calligraphy and painting and lists calligraphers noted for their skill in nasta'liq, including Shah-Mahmud al-Nishapuri, Ayshi [ibn Ishrati], Malik [al-Daylami], and Shaykh-Muhammad.

Afushta'i Natanzi, Muhammad ibn Hidayat Allah. *Naqavat al-athar* (Selections of history), written 998–1007/1590–98, Persian text edited by Ihsan Ishraqi (Tehran: Bunga-yi tarjuma-yi nashr-i kitab, 1328/1950).

The *Naqavat al-athar* begins with the reign of Shah Tahmasp and ends with Shah Abbas's eleventh regnal year in 1007/1598–99. It includes a unique and detailed account of Sultan Ibrahim Mirza's removal from Mashhad and his assignment to Sabzivar.

Bidlisi, Sharafuddin Khan. *Sharafnama* (Book of the nobility), written 1004–5/1596, Persian text edited by V. V. Velaminov-Zernof, 2 vols. (Saint Petersburg: L'academie imperiale des sciences, 1861); French translation by François Bernard Charmoy, *Cheref-nameh ou Fastes de la nation kourde*, 2 vols. (Saint Petersburg: L'academie imperiale des sciences, 1868–75).

This chronicle provides brief but useful references to Ibrahim Mirza's various political and military engagements, including the siege of Abivard and the expedition against Qazaq Khan Takkalu in Herat, both in 972/1564–65. It also describes the aftermath of Tahmasp's death, including Ibrahim Mirza's support of Haydar Mirza, and lists the prince among those put to death at Qazvin by order of Ismaʿil II.

Dust-Muhammad. Introduction to the Bahram Mirza album, written 951/1544–45, TKS H. 2154, folios 8b–17b. Persian text edited by M. Abdullah Chaghatai, *Halat-i hunarvaran/Treatise on calligraphists and miniaturists* (Lahore: Chabuk Sawaran, 1936); Persian text edited by Mehdi Bayani in *Ahval va athar-i khushnivisan* (Lives and works of calligraphers) (Tehran: Intisharat-i ilmi, 1363/1985), 1–2:192–203; English paraphrase of extract as "Dust Muhammad's Account of Past and Present Painters," in Laurence Binyon, J. V. S. Wilkinson, and Basil Gray, *Persian Miniature Painting* (1933; reprint, New York: Dover, 1971), 183–88; English translation by Wheeler Thackston in *A Century of Princes: Sources on Timurid History and Art* (Cambridge, Mass.: Aga Khan Program for Islamic Architecture, 1989), 335–50.

Dust-Muhammad was one of the leading artists at the Safavid court from the 1530s through mid-1560s. His introduction "traces the history of calligraphy, master-pupil relationships in the calligraphic art, [and] the history of painting and painters, and inventories the scribes and artists who were employed in Shah Tahmasp's studio."[2] Included among the latter are Shah-Mahmud al-Nishapuri, Rustam-Ali, and Shaykh-Muhammad. The document is of additional interest as it was prepared for Bahram Mirza, father of Sultan Ibrahim Mirza, and the album it introduces contains calligraphic specimens by Shah-Mahmud, Malik al-Daylami, Rustam-Ali, and Shaykh-Muhammad.

Hasan Rumlu. *Ahsan al-tawarikh* (Beauty of history), completed 986/1578; Persian text edited by Abdul-Husayn Navaʾi (Tehran: Intisharat-i Babak, 1349–57/1970–79); abridged English translation by C. N. Seddon, *Ahsanuʾt-Tawarikh: A Chronicle of the Early Safawis*, 2 vols. (Baroda: Gaekwad's Oriental Series, 1931–34).

This Safavid chronicle lists Ibrahim Mirza as one of the sons of Bahram Mirza and refers to his participation in the expedition to Herat in 972/1564–65, in the struggle for succession after the death of Shah Tahmasp, and in the events following the accession of Ismaʿil II. It also records his murder, along with that of other royal princes, in 984/1577, and hints at the cause.

Iskandar Beg Munshi. *Taʾrikh-i alam-ara-yi Abbasi* (History of Shah Abbas), written 1025–38/1616–29; Persian text edited by Iraj Afshar, 2 vols. (Tehran: Amir-i Kabir, 1334–35/1956–57); English translation of section on artists in Thomas Arnold, *Painting in Islam* (1928; reprint, New York: Dover, 1965), 141–44; English translation by Roger Savory, *The History of Shah Abbas the Great*, 2 vols. (Boulder, Colo.: Westview Press, 1978).

This well-known history of the Safavid period through the reign of Shah Abbas contains a brief biography of Sultan Ibrahim Mirza in the section devoted to the sons, daughters, and nephews of Shah Tahmasp. Further details of the prince's political career also appear in the account of Tahmasp's reign and the aftermath of his death as well as in the section on the accession and reign of Ismaʿil II. The latter includes a long description (the most extensive of any source) of the events leading up to and through Ibrahim Mirza's murder. Iskandar Beg Munshi also describes (and in the Savory translation waxes eloquent on) Ibrahim Mirza's artistic and literary

accomplishments. In addition, the *Taʾrikh-i alam-ara* includes brief biographies of the notable calligraphers, artists, and poets in the time of Shah Tahmasp and mentions Shah-Mahmud and Rustam-Ali as among the (by then deceased) outstanding calligraphers of nastaʿliq script. It also gives brief biographies of three still active artists who worked for Ibrahim Mirza: Shaykh-Muhammad, Ali Asghar, and Abdullah al-Shirazi.

Khuzani. *Afzal al-tawarikh* (The noblest history), written early seventeenth century, Persian text in manuscript, BL Or. 4678.

This unpublished chronicle traces Safavid dynastic history from the time of Ismaʿil I through the early years of Shah Abbas. Its first volume includes many royal decrees, including Tahmasp's farman appointing Ibrahim Mirza to Mashhad.

Malik al-Daylami. Introduction to the Amir Husayn Beg album, written 968/1560–61, (TKS H. 2151, folios 1b–2a, 74a–b, 25a–b, 23a–b, 98a–b, 33a–b (reconstructed order of text), one folio bound in TKS H. 2161, folio 2a; abbreviated Persian text edited by Mehdi Bayani in *Ahval va athar-i khusnivisan* (Lives and works of calligraphers) (Tehran: Intisharat-i ilmi, 1363/1985), 3–4:601–7; English translation by Wheeler Thackston in *A Century of Princes: Sources on Timurid History and Art* (Cambridge, Mass.: Aga Khan Program for Islamic Architecture, 1989), 351–53.

Malik al-Daylami was one of the scribes who transcribed Ibrahim Mirza's *Haft awrang*. His introduction to the album of Amir Husayn Beg consists of a roster of notable masters of calligraphy, among them Shah-Mahmud al-Nishapuri and Ayshi Haravi, as well as their relationships. The album itself contains works by the author and the four other scribes on the Freer Jami project (Shah-Mahmud al-Nishapuri, Ayshi ibn Ishrati, Muhibb-Ali, and Rustam-Ali) as well as one by Shaykh-Muhammad.

Qazi Ahmad [Qazi Ahmad bin Sharafuddin al-Husayn al-Husayni al-Qumi). *Gulistan-i hunar* (Garden of the arts), written ca. 1005/1596–97, second redaction completed ca. 1015/1606; Persian text based on redaction of ca. 1015/1606 and edited by Ahmad Suhayli-Khunsari (Tehran: Bunyad-i Farhang-i Iran, 1352/1973; 2d ed., Tehran: Kitabkhana Manuchihri, n.d.) (this edition has more detailed and useful notes than the earlier Minorsky translation); Russian translation by B. N. Zakhoder, *Traktat o kalligrafah i khusodozhnikah, 1596–97/1005* (Treatise on calligraphy and artists) (Moscow and Leningrad: Gosudarstvennoe izdatelstvo "Iskusstvo," 1947); English translation based on redaction of ca. 1015/1606 by V. Minorsky, *Calligraphers and Painters: A Treatise by Qadi Ahmad, Son of Mir-Munshi (circa A.H. 1015/A.D. 1606)* (Washington, D.C.: Freer Gallery of Art, 1959).

This is the best-known, and most frequently cited, primary source for Safavid artists and patrons. Qazi Ahmad (born 17 Rabiʿ I 953/18 May 1546) and his family had close ties with the family of Ibrahim Mirza: his father, Sharafuddin Husayn al-Husayni (called Mir-Munshi), was secretary to Sam Mirza in Herat, a friend of Bahram Mirza, and senior counselor to Ibrahim Mirza in Mashhad; and his uncle, Khalilullah, was reported to have been a companion of Ibrahim Mirza himself, also in Mashhad.[3] Connected from childhood with the artistic circles in Mashhad,[4] Qazi Ahmad was in a unique position when he came to write his *Gulistan* (as well as the earlier *Khulasat*, see below), which, as a consequence, has been accorded the credibility of an eyewitness account. The third ("On the masters of the nastaʿliq style") and fourth ("On painters, gilders, masters of gold sprinkling") sections of the treatise contain much information on the artistic interests and accomplishments of Ibrahim Mirza, including his patronage of a kitabkhana. They also present the lives and careers of the artists in the prince's employ, with individual entries on Shah-Mahmud al-Nishapuri, Rustam-Ali, Malik al-Daylami, Muhibb-Ali, Ayshi [ibn Ishrati], Abdullah Shirazi, Shaykh-Muhammad, and Ali Asghar.

Qazi Ahmad [Qazi Ahmad bin Sharafuddin al-Husayn al-Husayni al-Qumi). *Khulasat al-tawarikh* (Abstract of history), written 984–1001/1577–93; Persian text edited by Ihsan Ishraqi, 2 vols. (Tehran: Intisharat-i danishgah-i Tehran, 1359/1980); Persian text edited by Muhammad Shafiʿ, "Extracts on Calligraphers from an Anonymous History," *Oriental College Magazine* (Lahore) 10, no. 4 (August 1934): 23–30. Ihsan Ishraqi, "Le *Kholasat al-tawarikh* de Qazi Ahmad connu sous le nom de Mir Monshi," *Studia Iranica* 4 (1975): 73–89.

Conceived as a multivolume work, the *Khulasat al-tawarikh* traces the history of the Safavids from their origins as a religious order in the thirteenth century to 1001/1592–93. Much less well known than the *Gulistan*, it contains the earliest and most detailed biography of Ibrahim Mirza and provides an invaluable (albeit not always the most consistent) framework for reconstructing the chronology of events in the prince's life and career.[5] The *Khulasat* also deals quite extensively with Ibrahim Mirza's artistic interests and patronage, and the discussion here must have served as a basis for the entry in the *Gulistan*. In addition, it includes a selection of the prince's poetry. Qazi Ahmad also mentions certain painters and calligraphers such as Shah-Mahmud al-Nishapuri, Malik al-Daylami, and Rustam-Ali. The biographical information is similar to that which appears in the *Gulistan*.

Qutbuddin Muhammad Yazdi (known as Qisseh-Khwan). *Risala-yi dar taʾrikh-i khatt u naqqashan* (Treatise on the history of calligraphy and painting), written 964/1556–57 as an introduction to an unknown album mounted for Shah Tahmasp; Persian text edited by Husayn Khadiv-Jam in *Sukhan* (Tehran) 17, no. 67 (1346/1967): 666–76.

The treatise lists Malik al-Daylami as among the outstanding calligraphers of Shah Tahmasp's time.

Sadiqi Beg. *Majmaʿ al-khavass* (Concourse of the elite), written late 16th–early 17th century; Chaghatay-Turkish text edited with Persian translation by Abdul-Rasul Khayyampur (Tabriz: Akhtar-i Shimal, 1327/1948).

Sadiqi Beg's *Majmaʿ* provides important biographical entries on Safavid literati. The text includes royal princes such as Bahram Mirza and Sultan Ibrahim Mirza and the calligrapher Malik al-Daylami among the noteworthy poets of the Safavid period.

Sam Mirza. *Tuhfa-yi Sami* (Gift of Sam; or, Some princely curios), written ca. 957/1550; Persian text edited by Iqbal Husayn (Aligarh: Aligarh Muslim University, 1934; 2d ed., 1973); Persian text edited by Vahid Dastgirdi (Tehran: Armaghan, 1314/1936); Persian text edited by Ruknuddin Humayun-Farrukh (Tehran: Chapkhana Ilmi, 1346/1968); English translation of extracts by Mahfuz ul Haq, "Persian Painters, Illuminators, and Calligraphers, etc.," *Journal of the Asiatic Society of Bengal*, n.s. 38 (1932): 239–49.

Sam Mirza was the second son of Shah Ismaʿil and the younger brother of Tahmasp. His "who's who" of Safavid and (some Timurid) literati is typical of the tadhkira genre. It includes important biographical information on the poet Jami as well as many Safavid calligrapher-poets subsequently associated with the *Haft awrang* commissioned by his nephew Ibrahim Mirza. There are entries, for instance, on Shah-Mahmud al-Nishapuri and Muhibb-Ali as well as samples of their poetry.[6]

Ibrahim Mirza's *Haft awrang* made its modern public debut on 16–17 April 1926 in a sale of the Chiesa collection at the American Art Galleries, New York.[7] This extensive collection, formed in the late nineteenth century by Achille Chiesa, a Milanese businessman, and inherited by his son Achillito (in whose name the New York sale occurred), consisted almost exclusively of Italian and other European works of art, including paintings, sculpture, majolicas, ivories, woodwork, enamels, textiles, and furniture.[8]

The *Haft awrang* was evidently the only manuscript and sole work of Islamic art offered at the New York sale. Although the sales catalogue gives no hint as to how Chiesa senior came into possession of the *Haft awrang*, it does provide a detailed, three-page entry (lot 447) accompanied by two reproductions (folios 105a and 132a). The entry begins with a description of the manuscript's size, format, paper, illumination, and paintings. The next two pages are devoted to an enumeration of the seven masnavis and to their colophons, with translated excerpts of the sections giving names, dates, and places and a few additional references to the patron and scribes. This discussion is followed by a few succinct paragraphs on the seal stamped in the *Haft awrang* and Shah Abbas's waqf to the Safavid shrine at Ardabil.

Although there are some errors and omissions, the description of the manuscript is extremely thorough, mentioning the inlaid paper, guard sheets, and final leaf containing text unrelated to the *Haft awrang*. While no credit is given for the catalogue entry, it must have been prepared by someone with considerable knowledge of Persian language, literature, and manuscripts. The catalogue also reveals an appreciation of the art-historical importance of Ibrahim Mirza's *Haft awrang*. Its foreword concludes: "One of the most important objects in the collection is the extremely rare XVI century Persian manuscript, magnificently illuminated; it is indeed a work of great beauty and artistic value." The beginning of the descriptive entry is similarly effusive, proclaiming in capital letters that lot 447 is "the finest Persian illumination manuscript which has ever been sold in America."

The *Haft awrang* was acquired at the Chiesa sale by the New York dealer Hagop Kevorkian, who kept the manuscript for twenty years before selling it to the Freer Gallery of Art.[9] During that time the *Haft awrang* appeared in two U.S. exhibitions. The catalogue for the first show, at the Detroit Institute of Arts in 1930, states that the manuscript was written for the library of Sultan Ibrahim Mirza by "four calligraphers over a period of ten years in several cities of Persia." It also mentions the twenty-eight miniatures and margins of different colors illuminated in gold on floral design.[10] In 1940 the volume was shown at an exhibition of Persian art organized by the Iranian Institute. The guide to the exhibition, written by Phyllis Ackerman, gives the basic roster of names, dates, and places for the *Haft awrang*, mentions its twenty-eight paintings, and proclaims it to be "one of the most sumptuous manuscripts in existence."[11]

As with so many important works of Iranian art, Sultan Ibrahim Mirza's *Haft awrang* entered the scholarly domain through *A Survey of Persian Art* of 1939, in Ernst Kühnel's long chapter on miniature painting. Other scholars who discussed the manuscript in the 1940s through 1960s are Richard Ettinghausen, Ivan Stchoukine, Basil Gray, and Basil Robinson. Without exception, they directed their attention to the work's patron, painters, paintings, and painting style.

Scholarship on the Freer Jami (as it was by now commonly called) intensified in the 1970s and 1980s, with the most thoughtful and extensive consideration coming from Stuart Cary Welch as part of his seminal study of the Tahmasp (Houghton) *Shahnama* and other royal manuscripts of the Safavid period. Others who either continued to advance traditional lines of research on the Freer Jami or have attempted to extend the investigation into other areas of art-historical inquiry include Anthony Welch, Milo C. Beach, Olympiada Galerkina, Norah Titley, Marianna Shreve Simpson, Abolala Soudavar, and Sheila R. Canby. The ideas and approaches of these scholars are discussed in order of their contributions.

Kühnel, Ernst. "History of Miniature Painting and Drawing," in *A Survey of Persian Art from Prehistoric Times to the Present*, edited by Arthur Upham Pope and Phyllis Ackerman, vol. 3, *The Art of the Book* (London: Oxford University Press, 1939), 1878–79, and vol. 5, *Plates*, pl. 904 (folio 162a).

A Survey of Persian Art contains the first discussion of the *Haft awrang* by a recognized expert in Islamic art. It is evident, however, that the information published about the manuscript in 1926 and 1930 was not yet in wide scholarly circulation, or at least not available to Kühnel. This eminent scholar clearly did not have any firsthand knowledge of the manuscript and seems to have based his remarks ("a fine miniature in an unidentified collection") on a photograph of a single painting whose whereabouts he did not know.[12] In any event, he mentions the painting (folio 162a) in a brief discussion of Muzaffar-Ali and attributes the painting to him. The connection between this well-known Safavid artist and the court of Shah Tahmasp, along with the painting's own references to the Safavid monarch and his nephew in its architectural inscriptions, led Kühnel to assign the manuscript to Tabriz.

Ettinghausen, Richard. "Six Thousand Years of Persian Art: The Exhibition of Iranian Art, New York, 1940," *Ars Islamica* 7 (1940): 111–12; folder sheet 46.12, Freer Gallery of Art; "The Emperor's Choice," in *De Artibus Opuscula XL: Essays in Honor of Erwin Panofsky*, ed. Millard Meiss (New York: New York University Press, 1961), 118, and fig. 13 (folio 153b).

Ettinghausen's first published notice of Sultan Ibrahim Mirza's *Haft awrang* appears in a long review of the famous exhibition of Persian art held under the auspices of the Iranian Institute in New York in 1940. At that time the manuscript was still in the possession of Hagop Kevorkian. Ettinghausen succinctly lauds the work as "the most important single manuscript which came to light for this exhibition" and characterizes it as "unit[ing] the polished polychromy of the Timurid-Safavid tradition with the newly acquired taste for the pastoral and urban everyday life in the Muhammadi fashion." He also points out the influence of the manuscript on Mughal painting, with reference to a copy of one of its paintings in an album of Indian miniatures in Berlin (formerly in the collection of the duke of Hamilton) and its general resonance in the Jahangir album also in Berlin.[13] In passing, Ettinghausen gives some specific data about the manuscript but errs in the number of scribes and dates and makes no mention of the cities where it was transcribed.

When the Freer Gallery of Art acquired the manuscript from Kevorkian in 1946, it also received a long memorandum on the dealer's letterhead describing the work's principal literary, artistic, and historical features (text, patron, illuminations, miniatures, colophons, provenance), and art-historical significance.[14] By then Ettinghausen was serving as the Freer's curator of Near Eastern art and seems to have been largely responsible for the acquisition of the manuscript and certainly for the preparation of the extensive dossier of documentation, known at the Freer as a folder sheet. This document constitutes the first systematic description of the manuscript and continues to be maintained by the Freer as an ongoing record of art-historical and technical opinions, conservation treatments, exhibition labels, bibliographic citations, and so forth.

Ettinghausen begins the folder sheet with a discussion of the seven masnavis in the *Haft awrang* and their sequence in the Freer Jami compared to other copies of the text. He then presents the historical data found in each Freer Jami colophon including, as relevant, its scribe, date, place of production, and any mention of the patron. He does not, however, transcribe or translate the colophon texts and transliterates Ayshi ibn Ishrati as "Ashirini (?)." He does note that the last folio of the *Khiradnama-i Iskandari* is missing and that replacement folio 304 is an unidentified poetical text signed by Sultan-Muhammad Khandan. This information is followed by a long discussion of Sultan Ibrahim Mirza, starting with the architectural inscriptions on folios 38b, 132a, and 162a (transcribed and translated in full) and the colophon citations on folios 46a, 139a, 181a, and 272a. Ettinghausen also provides considerable genealogical and biographical information about the prince, drawn from various sources. He then discusses the five scribes of the *Haft awrang* plus Sultan-Muhammad Khandan, often

pointing out discrepancies in the historical record as it was available in 1946 and listing the scribes' other known works.

Next comes a list of the miniatures, with provisional titles, in order of folio number and masnavi, with the omission of the final painting on folio 298a. This list is followed by a lengthy discussion of the possible authorship of the miniatures, drawing on Qazi Ahmad for the names of potential candidates.[15] Among those whom Ettinghausen suggests may have been involved in the illustration of the manuscript is Abdullah, without apparently realizing that this artist signed the heading of folio 84b. He also proposes Aqa Reza, Mir Sayyid-Ali, and Abdul-Samad as other likely participants in the Freer Jami project, on the basis of formal similarities between various Freer Jami paintings and those in published manuscripts and albums. This discussion leads to a consideration of the general style of the manuscript and its position within the historical development of Safavid painting. Ettinghausen then introduces the manuscript's extensive illuminations and lists what he calls the "triangular space fillers." Finally, he discusses seal impressions and librarian annotations, including a chart of all the seals on folio 304b.

During his tenure as curator (1944–67), Ettinghausen added other comments to the folder sheet on the Freer Jami, specifically about the order of the transcription and illumination of the text, the dissemination of the Mashhad style after the death of Sultan Ibrahim Mirza, and its influence in Mughal India (continuing a theme introduced in his review of the 1940 exhibition). Ettinghausen may have been planning to publish the *Haft awrang*; in his discussion of the artists who may have painted the illustrations he mentions that "the problems of identification can only be cleared up in a special monograph which the Jami certainly deserves." Ettinghausen's intention to prepare a more complete study of the manuscript may have been signaled abroad by the late 1950s, for in *Les peintures des manuscrits Safavis*, Stchoukine says that unfortunately he is not able to present a detailed analysis of the Freer Jami paintings, "leur publication étant réservée au musée qui les détient."[16]

Ettinghausen's last published comments on the Freer Jami in the Panofsky festschrift pick up a point introduced in his review of the 1940 exhibition: the influence of Safavid painting on Mughal painting. Here the context is the image of the Mughal emperor, and the connection between the *Haft awrang* paintings and Mughal painting is made via the iconography of the prince visiting a hermit.

Stchoukine, Ivan. *Les peintures des manuscrits Safavis de 1502 à 1587* (Paris: Librarie orientaliste Paul Geuthner, 1959), 18–20 (Sultan Ibrahim Mirza and his artists), 27 (Abdullah), 28–29 (Ali Asghar), 43 (Muzaffar-Ali), 46–47 (Shaykh-Muhammad), 127–29 (cat. no. 170), 150 (style of animal painting), 154–55 (architectural decor of school of Mashhad), 165 (representation of man in school of Mashhad), 184–85 (composition) and pls. XL (folio 253a), XLII (folio 100b), and XLIII (folio 231a).

Stchoukine presents the Freer Jami within the context of his important historical survey of Safavid manuscripts and paintings, schools and styles, patrons and artists. His discussion of Sultan Ibrahim Mirza is drawn almost exclusively from Qazi Ahmad, and his brief introductions to various artists cited in Qazi's treatise as having worked for the Safavid prince are fleshed out with references to documented and attributed paintings.

The entry on Ibrahim Mirza's *Haft awrang* appears as catalogue number 170 in the section of works from Mashhad.[17] It begins with a listing of the Freer Jami colophons, which excludes certain data (such as references to Qazvin in folio 83b and Herat in folio 272a) and includes the colophon on inserted folio 304a as though it were part of the original manuscript. Stchoukine's primary concern is with the attribution of the twenty-eight paintings, which he believes were done by several artists over ten or more years. He proposes two major groupings, each with several subgroupings:

Group 1: folios 10a, 30a, 38b, 52a, 59a, 64b, 100b, 110b, 114b, 147a, 162a, 169b, 179b, 188a, 207b, and 215b. Stchoukine sees these paintings as stylistically close to the *Khamsa* of 1539–43. He attributes the rural scenes and scenes of daily life on folios 30a, 38b, and 52a to an artist close to Mir-Sayyid Ali; and folios 64b, 100b, 162a, and 179b, with their richness of detail, to a master of courtly scenes, perhaps a rival

of Shaykh-Muhammad. In his opinion, the nine other paintings in this group were the work of other artists of the same atelier.

Group 2: folios 105a, 120a, 132a, 153b, 194b, 221b, 231a, 253a, 264a, 275a, 291a, and 298a. Stchoukine regards these dozen paintings as representing a stylistic stage later than the 1539–43 *Khamsa.* Folios 105a, 153b, 194b, and 231a belong to a single artist. They are distinguished by a dynamism expressed in the accentuated diagonals of their compositions, chaotic rock piles, scattered foliage, and fleeing clouds. Certain figures in folio 231a anticipate the work of Muhammadi. Folios 120a, 132a, 253a, and 298a belong to a second artist of this group who had his own repertoire of figures for lord, shaykh, dervish, and peasant and a more accentuated manner of rendering facial features. This artist achieved some audacious compositional effects, as for instance, on folio 253a. Folios 275a and 291a are characterized by a vigorous drawing style and must have been the work of a third artist of this group.

Stchoukine's conclusion to catalogue number 170 exemplifies the encomia awarded this manuscript in the scholarly literature: "The Jami's twenty-eight paintings constitute a magnificent ensemble and place this volume among the most beautiful illustrated manuscripts of the period. They attest to the high level of pictorial art at the court of Sultan Ibrahim Mirza and confirm the testimony of literary sources about the prince as a lover and connoisseur of beautiful things. The compositions are directly related to the best tradition of royal ateliers; if they were done in Mashhad, it was by artists trained in Tabriz and Qazvin."[18]

The connection between the Freer Jami paintings, presented by Stchoukine as the products of Mashhad, and artists coming from Tabriz and Qazvin is continued elsewhere in *Les peintures des manuscrits Safavis,* specifically with reference to the representation of the "splendid horses and caparisoned camels," human figures, and architectural decor. Without citing either artistic center, Stchoukine sees the compositions in the Freer Jami as alternating between the two grand currents coming out of the royal studios: the "classic" and the "baroque."[19]

Gray, Basil. *Persian Painting* (Geneva: Skira, 1961), 142–45, with color plate of folio 194b (misidentified in caption as folio 147a); "The Arts in the Safavid Period," in *The Cambridge History of Iran,* vol. 6, *The Timurid and Safavid Periods,* edited by Peter Jackson and Laurence Lockhart (Cambridge: Cambridge University Press, 1986), 889–92, and fig. 62 (folio 221b).

Like Stchoukine, Gray sees the Freer Jami as "one of the most famous surviving achievements of the [Safavid] period" and "one of the crucial artistic documents for the understanding of Safavid book-painting in the mid-sixteenth century."[20] He first discusses basic data about the manuscript's patron and scribes, beginning with Mawlana Malik (Malik al-Daylami), but cites only Mashhad as its place of origin. Gray relies exclusively on Qazi Ahmad for information about artists who worked for Ibrahim Mirza and credits all twenty-eight paintings to Shaykh-Muhammad, Ali-Asghar, and Abdullah, without giving specific attributions. He also wonders if Abdullah might not have been responsible for the marginal paintings in the manuscript, without knowing, of course, that Abdullah did participate in the decoration of the manuscript (folio 84b). Gray notes that while marginal decoration is an established feature of Safavid book production, the foliage in the margins of the Freer Jami is less stylized than in other works, perhaps inspired by Chinese blue-and-white porcelain decoration. Gray compares the Freer Jami's marginal decoration with that in the *Khamsa* of 1539–43, citing in particular a common use of a broken spray falling across other foliage in counterpoint. Although obviously keen to establish other connections between the Freer Jami and Chinese painting, Gray finds in folio 194b only certain cloud forms with cometlike tails and compares these with the curled convolutions in the background of dragon robes worn by officials of Ming dynasty. He also sees the influence of Flemish or French manuscript illumination in the tapestry effect of certain compositions, specifically those on folios 194b and 253a. The latter is further commended by Gray for its "delightfully sympathetic animal drawing," which recalls a manuscript of Qazvini's *Aja'ib al-makhluqat* (Wonders of creation) dated 25 Jumada I 952/4 August 1545 (CB MS 212). Conversely, folio 253a is dismissed for its "unpleasantly realistic" features.[21]

Gray concludes his 1961 discussion by supposing that other manuscripts must have been produced for Sultan Ibrahim Mirza after the completion of the Freer Jami in 972/1565. One such possible work is a *Yusuf u Zulaykha* of Jami (BN Or. 4122) copied by Shah-Mahmud (whom Gray notes as having died in Mashhad in 972/1564–65) and with twelve paintings, which may have been finished ca. 1565–70 by Ibrahim Mirza's staff.

By the time the sixth volume of the *Cambridge History of Iran* was published, considerably more information and ideas about the Freer Jami had been introduced into the scholarly literature. Gray uses this new material to fill in some of the factual lacunae, confirm some hypotheses (for instance, about the involvement of Abdullah in the illumination), and, in general, expand on his earlier presentation of the manuscript. In this discussion he particularly stresses the contemporaneity of the *Haft awrang* text, marginal illuminations, and miniatures. Once again he reviews the artists known to have worked for Ibrahim Mirza, with citations this time from both Qazi Ahmad and Iskandar Beg Munshi, and affirms the validity of looking at the *Haft awrang* paintings "as certain evidence for the work of this group of artists in Mirza Ibrahim's library" as well as for evidence of style.[22] To this end he summarizes Stchoukine's division of the paintings into two artistic groups, adding his own comments on style, and compares Stchoukine's Group 2 pictures with those in a *Garshaspnama* of 964/1573 and a dispersed *Shahnama* made for Shah Isma'il. This discussion leads to a comparison of the stylistic differences between the artists of Mashhad and those of Qazvin.

Robinson, Basil W. *Persian Drawings from the Fourteenth through the Nineteenth Century* (Boston: Little, Brown, 1965), 23, and pls. 45 (folio 110b), 48 (folio 275a), and discussions on pp. 135–36; "Rothschild and Binney Arts of the Book," in *Persian and Mughal Art,* catalogue of an exhibition at Colnaghi's, April–May 1976 (London, 1976), 15, 50 (cat. no. 24); "A Survey of Persian Painting (1350–1896)," in *Art et société dans le monde iranien,* edited by Chahryar Adle (Paris: Editions recherche sur les civilisations, 1982), 50–51, and figs. 24 (folio 253a, misidentified as 235), 25 (folio 194b).

With his 1965 publication, Robinson adds two more paintings to the Freer Jami's published repertory and characterizes all twenty-eight as illustrative of "the transition from the court style of Tabriz to that of Qazvin with its increasing emphasis on naturalism and bold draughtsmanship." His discussion of folio 110b also provides basic information about the Freer Jami, including its patron and scribes, but cites only Mashhad as the place of production. He further comments that the manuscript was "the masterpiece of the library staff of one of the most aesthetically cultivated Persian princes of any periods."[23] He also notes that it was formerly in the library of the Ardabil shrine.

In his essay to Colnaghi's exhibition catalogue of 1976, Robinson expands further on the Freer Jami as a "volume which ranks as one of the finest manuscripts in the world" and the product of a "team of the foremost calligraphers and painters of the time." He characterizes the manuscript as representing the transition from the style favored by Tahmasp at Tabriz to that at Qazvin, characterizing the former as "slightly academic and formal" and the latter as a "freer, more relaxed and sometimes decadent manner later moulded in the hands of Riza into what we call the Isfahan style, or the style of Shah Abbas." Robinson comments on an encampment scene in a manuscript of Hilali's *Sifat al-ashiqin* (now AHT no. 90b) dated 990/1582–83 as "typical of the style patronized at Mashhad by prince Ibrahim Mirza," explaining the differences in date between the 963–72/1556–65 Jami and the 990/1582–83 Hilali by implying that the mountain encampment must have been painted earlier and added to the later manuscript.[24]

Robinson's most substantive consideration of the Freer Jami to date was published in 1982 as one section (xv. "Ibrahim Mirza: Khurasan, c. 1550–1590") in a historical survey of Persian painting. Its rubric notwithstanding, section XV looks only briefly at Sultan Ibrahim Mirza and concentrates instead on the attributions and style of the Freer Jami, with reference to the scholarship of Stuart Cary Welch. Without citing specific examples, Robinson accepts Welch's association of the Freer Jami paintings with those of the *Shahnama* and *Khamsa* made for Shah Tahmasp. He also points to a new and differ-

ent trend manifest in certain Jami paintings, particularly those attributed by Welch to Shaykh-Muhammad and Muzaffar-Ali. New features cited by Robinson include attenuated figures, emphasis on outlines and curves, rounder faces and longer necks on youthful faces and caricatural treatment of older figures, increasing disregard for marginal rulings around illustrations, and finally, the "first signs of the languorous decadence, which is the underlying element of seventeenth-century Isfahan painting, make their appearance; youths are seen in unhealthy proximity to one another and to older men."[25]

Bayani, Mehdi. *Ahval va athar-i khushnivisan* (Lives and works of calligraphers), 4 parts in 2 vols. (Tehran: Danishgah-i Tehran, 1345–48/1966–69; 2d ed., Tehran: Intisharat-i ilmi, 1363/1985), 1–2:9–13 (Sultan Ibrahim Mirza), 356–37 (Abdullah al-Shirazi), 545–46 (Ayshi ibn Ishrati), 207–8 (Rustam-Ali), 295–307 (Shah-Mahmud al-Nishapuri), 268–71 (Sultan-Muhammad Khandan); 3–4:616–17 (Muhibb-Ali), 601–7 (Malik al-Daylami).

This invaluable source consists of alphabetically arranged entries on calligraphers and other Perisan artists of the fifteenth through nineteenth centuries. Each entry includes biographical documentation, drawn from various primary sources such as Qazi Ahmad's *Gulistan-i hunar,* and lists of manuscripts and calligraphic samples with colophons. Many works are from private collections in Iran and are otherwise unrecorded. Both the patron and artists of the Freer Jami are discussed.

Welch, Stuart Cary. *A King's Book of Kings: The Shah-Nameh of Shah Tahmasp* (New York: Metropolitan Museum of Art, 1972), 71–73, 76; *Persian Painting: Five Royal Safavid Manuscripts of the Sixteenth Century* (New York: Braziller, 1976), 23–27, 31, 98–127; *Wonders of the Age: Masterpieces of Early Safavid Painting, 1501–1576,* exhibition catalogue (Cambridge, Mass.: Fogg Art Museum, Harvard University, 1979), 27–30; with Martin Bernard Dickson, *The Houghton Shahnameh,* 2 vols. (Cambridge, Mass.: Harvard University Press, 1981), 45B–48B and passim; with Anthony Welch, *Arts of the Islamic Book: The Collection of Prince Sadruddin Aga Khan,* exhibition catalogue (Ithaca, N.Y.: Cornell University Press for the Asia Society, 1982), 87–88 (S.C.W.), and 94–98 (A.W.).

The valuable work of an earlier generation notwithstanding, it is Stuart Cary Welch who has made the most sustained contribution to scholarship on the Freer Jami, particularly to the role of Sultan Ibrahim Mirza within Safavid royal patronage and the place of his *Haft awrang* within the history of sixteenth-century painting. The most extensive exposition of Welch's findings and ideas is contained within the two-volume *Houghton Shahnameh,* coauthored with the historian Martin Dickson. This monumental publication focuses on the magnificent copy of the Persian national epic executed for Shah Tahmasp (and now tragically dispersed), with a vital, concomitant interest in other works, such as Sultan Ibrahim Mirza's *Haft awrang,* produced by the royal Safavid ateliers and artists. Welch is also responsible, through his various exhibition catalogues and what he himself calls "popular" publications, for the greater public recognition and admiration accorded the Freer Jami. It is in one such book, the lavishly illustrated *Persian Painting* of 1976, that the first published listing of the Freer Jami illustrations appears, along with the first complete set of reproductions.

As with other scholars, Welch's primary concern has been with identifying the painters who worked on the Freer Jami, attributing the twenty-eight paintings to specific hands, and characterizing the manuscript's style and mood as well as its patron's taste. His approach combines precise attention to individual motifs (turbans, earlobes, tufts of grass) and their treatment by individual artists and a firm belief in the notion of the linear progression of style, both that of an individual painter and that of a period. What distinguishes Welch from his predecessors is the consistent, almost rigorous, application of method and premise and his interest in presenting the patron and artists of the Freer Jami as real people with distinctive personalities. The result is a very elaborate and imaginative portrait, often sketched in fanciful terms and seemingly grounded in psychoanalytic concepts and language: a young and enthusiastic patron with a penchant for the bizarre, vulgar, and

"baroque"; six artists, identified with enviable confidence as Mirza-Ali, Muzaffar-Ali, Shaykh-Muhammad, Aqa-Mirak, and the more elusive Painters A (possibly Qadimi) and D (possibly Abdul-Aziz), who had previously worked on the great *Shahnama* and other projects for Shah Tahmasp and who responded variously to their new patron's taste, sometimes eagerly and sometimes with considerable reluctance; a series of miniatures divided between those that reflect artistic preferences for earlier and "happier" days (the decades before Tahmasp issued his edict of sincere repentance) and those that reflect the tensions and struggles of the present (1556–65); and finally, a period ethos tainted with evil and morality, sex, and salaciousness, completely at odds with "classical" notions of compositional harmony, subtlety, and naturalism.

A review of Welch's writings on the Freer Jami reveals that many of his eloquent assertions and confident conclusions, especially those about the overall character of the manuscript, are based on a relatively small number of its twenty-eight paintings. His repeated references to the jaded ambience at the court of Ibrahim Mirza, for instance, seem to be based on the illustrations on folios 30a (attributed by Welch to Muzaffar-Ali, who is presented as the most attune of all the Jami artists to the "hellfire" persona of Ibrahim Mirza) and 253a (attributed to Shaykh-Muhammad, whom Welch credits with seven paintings and describes as at the peak of his artistic powers during the years he worked on the Jami). Although there is no denying the potentially eyebrow-raising subject of the former or the convoluted style of the latter, these two paintings may be even more idiosyncratic within the overall program of Freer Jami illustrations than Welch seems to have considered.

Perhaps the greatest strength of Welch's analyses of the Freer Jami is that connoisseurship is matched by documentation. Although previous scholars had canvassed primary sources for information about Sultan Ibrahim Mirza and the artists of his kitabkhana, the historical record has never been culled so systematically. This aspect of research on the Freer Jami is the province of Welch's collaborator, Professor Dickson, whose readings of such sources as Qazi Ahmad, Dust-Muhammad, Iskandar Beg Munshi, and Ali Efendi are clearly behind the biographies and chronologies that provide the historical framework for Welch's artistic commentaries and stylistic interpretations. While the fruit of this collaboration is evident in all publications authored or coauthored by Welch, it is displayed to most complete advantage in the *Houghton Shahnameh*, where the footnotes are a positive gold mine of historical data.[26]

As is inevitable in a study of such magnitude, there are errors of fact and discrepancies of opinion. The summary entry on the Freer Jami in *Persian Painting* neglects to cite the scribe Ayshi ibn Ishrati or the cities of Qazvin, where Malik al-Daylami completed the third book of the *Silsilat al-dhahab*, and Herat, where Muhibb-Ali finished the transcription of *Layli u Majnun*. More curious, considering that the reading of the colophons was apparently checked specifically for the *Houghton Shahnameh* volumes, is the citation of the signature by Sultan-Muhammad Khandan on folio 304a as if it were the actual colophon of the *Khiradnama-i Iskandari*.[27] Perhaps more confusing is, on the one hand, the characterization of the Freer Jami as the last great surviving manuscript of Tahmasp's reign and indicative in many respects of the shah's spirit in 1556–65, and, on the other, the impression that the manuscript's paintings are more inventive and even wilder and cruder than anything Tahmasp could have tolerated. The *Houghton Shahnameh* also contains some contradictory information on the life and career of Sultan Ibrahim Mirza.

Welch, Anthony. "Painting and Patronage under Shah Abbas I," Studies on Isfahan: Proceedings of the Isfahan Colloquium, part 2, edited by Renata Holod, *Iranian Studies* 7 (summer/autumn 1974): 460 and passim; *Artists for the Shah: Late Sixteenth-Century Painting at the Imperial Court of Iran* (New Haven, Conn.: Yale University Press, 1976), 150–58 and passim; with Stuart Cary Welch, *Arts of the Islamic Book: The Collection of Prince Sadruddin Aga Khan*, exhibition catalogue (Ithaca, N.Y.: Cornell University Press for the Asia Society, 1982), 87–88 (S.C.W.) and 94–98 (A.W.); "Art in Iran, IX: Safavid to Qajar," *Encyclopedia Iranica*, 2:624.

Although published several years before Dickson and Welch's *Houghton Shahnameh*, Anthony Welch's early studies of Iranian painting at the end of the Safavid period owe a great deal to their monumental successor, as the author acknowledges in the first note of his 1974 article and in the preface and subsequent notes of his 1976 book. Particularly apparent are the similar art-historical methodologies and interest in artistic personalities and matters of connoisseurship. The purpose of the Shah Abbas article is to present the artists patronized by that great Safavid monarch; the first member of this coterie is Shaykh-Muhammad, who grew to artistic maturity under the patronage of Ibrahim Mirza. The discussion of the prince's *Haft awrang* is thus within the context of a specific artist and the seven paintings in the manuscript attributed to him. It is evidently consideration of these seven paintings (of which only folio 253a, is, however, cited directly) that led Welch to conclude that "concentration upon the specific content of the *Haft awrang* is singularly weak."[28]

In *Artists for the Shah* the Freer Jami looms large within the fifth chapter, devoted to "personalities and patronage," which begins with a long discussion of Ibrahim Mirza. This chapter includes biographical information, drawn primarily from Qazi Ahmad's *Gulistan*, and an account of the history of the prince's *Haft awrang*, specifically its origins in Mashhad and its continuation in Sabzivar and Qa'in where, according to Welch, the prince served a period of political exile during 970–973/1563–66. Welch then turns to the calligraphers who transcribed and the painters who illustrated the Freer Jami, with particular attention to what he calls the "dynastic arrangements," the familial and professional relationships among some artists, and to the hereditary nature of Safavid patronage. Each artist is presented in order of these relationships, including Sultan-Muhammad Khandan, who, in fact, is not known to have worked on the manuscript, as well as Aqa-Mirak, Mirza-Ali, Muzaffar-Ali, Shaykh-Muhammad, and two anonymous masters, all of whom have been connected to the project through the attributions of S. C. Welch. Anthony Welch concludes that the Freer Jami was a "watershed manuscript," a kind of last hurrah for its painters, none of whom were to be involved ever again in the illustration of a major manuscript. Similarly, Welch continues, Ibrahim Mirza drops out of sight as a patron after being recalled to Qazvin, and it is not known what became of his library and atelier, although his books, painters, and scribes may have been absorbed into the royal library. Be that as it may, "during the nine years of Ibrahim Mirza's residence in Qazvin from 1568 to 1577 there is no single work approaching in quality the 1556–65 *Haft awrang*." It is curious, then, since Welch believes the prince's patronage to have ceased and his kitabkhana to have dissolved in 1565, that he also considers his murder in 1577 to be a "great blow to the future of Iranian painting."[29]

Welch presents much of the same information and many of the same ideas in his entries in *Arts of the Islamic Book* and the *Encyclopedia Iranica*.

Galerkina, Olympiada. "Some Characteristics of Persian Miniature Painting in the Latter Part of the Sixteenth Century," *Oriental Art*, n.s., 21 (autumn 1975): 232–33.

The author is concerned with the manifestation of Sufi elements in Safavid paintings and with the stylistic features in later sixteenth-century paintings that reflect, or may be inspired by, Sufi doctrine and beliefs, particularly as expounded in the works of Abdul-Rahman Jami. Another central theme is the relationship between Sufism and the ruling elite of Iran. After noting the growing diffusion of illustrated manuscripts of Jami's poems and the frequent representation of Sufis in these works, Galerkina links the poet's "preoccupations . . . to the philosophical and aesthetic views of the courts of Qazvin and Mashhad in the later 16th century." She finds expression of these views or ideals in the "transitional" style of the Mashhad-Qazvin school as well as in the relatively peaceful political climate of the second part of the century, "when intellectual pursuits flourished and the ideal of the just ruler again became paramount." This situation is epitomized at Mashhad by Ibrahim Mirza, whom Galerkina sees represented in the guise of a literary hero in a number of Mashhad school miniatures, including folio 153a in the *Haft awrang*. Her interpretation of these scenes "where the Prince may be surrounded by peasants and artisans" is that they signify the "equality of all men before God." She comments, in addition, on the warm color scheme of such compositions, stating that they "leave us with a feeling of rest: nature with all its various scenes, in whose bosom man

lives as a creature striving towards God, while the monarch humbly visits his Sufi master"[30] (this in an apparent reference to FGA 46.12, folio 153b). She then quotes Qazi Ahmad's praise of Ibrahim Mirza's devotion to Sufism and pious behavior at the same time referring to the prince's more worldly interests. Galerkina's perspective is quite different from that taken by most other scholars who have written on the Freer Jami and its patron, although it does fit with an increasing scholarly interest in poetic and artistic metaphor.

Beach, Milo Cleveland. *The Imperial Image: Paintings for the Mughal Court*, exhibition catalogue (Washington, D.C.: Freer Gallery of Art, 1981), 55–57, cat. no. 4.

Beach presents Ibrahim Mirza's *Haft awrang* as contemporary with a multivolume *Hamzanama* (Tale of Hamza) made for the Mughal emperor Akbar circa 1562–77 and exemplifying the style in which Safavid artists who moved from Iran to India would have been trained. Beach posits that two such artists, Mir Sayyid-Ali and Abdul-Samad, would have worked on the manuscript but that they stayed in Iran. Its "highly, even overly, refined aesthetic sensibility and technical expertise" would not, however, have suited Akbar's taste. Thus, in the Mughal context, the Freer Jami becomes a foil for "understanding Mughal innovations within Islamic traditions."[31]

Titley, Norah M. *Persian Miniature Painting and Its Influence on the Art of Turkey and India: The British Library Collections* (London: British Library Board, 1983), 103–7.

Chapter 9 of this survey concerns painting and illustrated manuscripts produced in Qazvin, Mashhad, and Herat during the late sixteenth to early seventeenth century. Titley credits the patronage of illustrated manuscripts made in Qazvin during the 1570s to Sultan Ibrahim Mirza, whose life and career she summarizes in an account based largely on the *Gulistan-i hunar* of Qazi Ahmad.

The ensuing discussion of the prince's *Haft awrang* begins with information about its transcription, mentioning only Malik al-Daylami and Shah-Mahmud al-Nishapuri as the calligraphers working in Mashhad and stating that Shah-Mahmud had to complete the copying of the manuscript after Shah Tahmasp recalled Malik to Qazvin. Titley then turns to the manuscript's illustrations (referring to them as "magnificent full-page paintings"), which she regards as "marking an intermediate stage" of stylistic development and "often awkward in composition" in comparision with the paintings in the *Khamsa* made for Shah Tahmasp.[32] In addition she points to crowded compositions, simplified rock formations built up in vertical blocks, elongated figures with inordinately long necks, cloud masses characteristic of both Qazvin and late sixteenth-century Herat painting, and portraitlike representation of figures with distinct personalities akin to Mughal style (including the depiction of Ibrahim Mirza as Yusuf on folio 132a). This latter feature she associates with Shaykh-Muhammad, on the basis of Iskandar Beg Munshi's report about the artist's introducing European-style painting to Iran and his reputation as unequaled in drawing faces and figures, to whom she attributes folios 132a, 231a, 253a, and 298a.

Titley then goes on to compare the *Haft awrang* to the *Garshaspnama* of 981/1573 (BL Or. 12985) and a now-dispersed *Shahnama* made for Shah Isma'il II in 1576–77, citing common features such as "long narrow rocks built up vertically, the landscape extending well into the borders, and the large tree (usually a chinar or oriental place) in the background."[33] She posits that the *Shahnama* may have been begun for Ibrahim Mirza, a hypothesis that seems to rest both on stylistic evidence and on the absence of any known copy of the epic having been made for the prince. Titley concludes the discussion of Ibrahim Mirza with the mention that, after his death, Shah Isma'il II employed many of the same artists and scribes who had worked for the prince in Mashhad and later in Qazvin.

Simpson, Marianna Shreve. "The Production and Patronage of the *Haft Aurang* by Jami in the Freer Gallery of Art," *Ars Orientalis* 13 (1982): 93–119; "Codicology in the Service of Chronology: The Case of Some Safavid Manuscripts," in *Les manuscrits du Moyen-Orient: Essais de codicologie et de paléographie. Actes du Colloque d'Istanbul (Istanbul, 26–29 mai 1986)*, edited by François Déroche (Istanbul: Institut Français d'Études Anatoliennes d'Istanbul; Paris: Bibliothèque Nationale, 1989), 133–39; "The Making of Manuscripts and the Workings of the *Kitab-khana* in Safavid Iran," in *The Artist's Workshop*, edited by Peter M. Lukehart, Studies in the History of Art 38 (Washington, D.C.: National Gallery of Art, 1993), 105–21.

This series of articles marks a shift in research on the Freer Jami away from the connoisseurship of the paintings and issues of attribution and style and toward an appreciation of the manuscript as an integral work of art, with particular emphasis on its codicology (material contents and structure) and method of manufacture. The physical examination was prompted by the recognition of the manuscript's complex internal chronology, as documented in the nonsequential colophons, and in an effort to better understand how five scribes worked in three cities over a nine-year period. This investigation has resulted, first, in a detailed description of the Freer Jami and reconstruction of the sequence of steps required for its production, from the copying of the text to the collation of the folios, and then in a discussion of the particular historical circumstances in which this process occurred. Here the role of Sultan Ibrahim Mirza comes into play, particularly his sponsorship of an active kitabkhana and patronage of individual artists. This discussion leads, in turn, to a consideration of the organization and operation of the kitabkhana as an artistic institution and focus of manuscript manufacture in sixteenth-century Iran.

Soudavar, Abolala. *Art of the Persian Courts: Selections from the Art and History Trust Collection* (New York: Rizzoli, 1992), 183, 221, 228, and 229 (Abdullah).

This catalogue of a private collection and circulating exhibition concerns the history of Persian painting as it developed through period styles and courtly patronage and with the attributions of individual works of art. In chapter 5 ("The Safavid Synthesis") the author credits three Safavid court painters—Aqa-Mirak, Mirza-Ali, and Muzaffar-Ali—with collaborating on the *Haft awrang* made for Sultan Ibrahim Mirza as well as on the *Shahnama* and *Khamsa* made for Shah Tahmasp. Soudavar discusses the *Haft awrang* and its patron at somewhat greater length in a subsequent chapter on the sixteenth century, with particular reference to artistic developments in the province of Khurasan following the promulgation of Shah Tahmasp's edict of sincere repentance. Once again he places Mirza-Ali among the artists who worked for Sultan Ibrahim Mirza and also identifies Shaykh-Muhammad and Muhammadi as responsible for developing the Mashhad style of painting. He makes specific stylistic comparisons between the Freer Jami and a *Sifat al-ashiqin* dated 990/1582–83, which opens with a double-page frontispiece signed by Abdullah. Soudavar also attributes to Abdullah an illustration in a *Gulistan* of Sa'di, a manuscript he says was copied for Ibrahim Mirza.

Canby, Sheila R. *Persian Painting* (London: British Museum Press, 1993), 85–86.

As in the Soudavar catalogue, this succinct survey of the history of Persian painting considers the Freer Jami within the context of the dispersal of artists from the Safavid court following Shah Tahmasp's repudiation of the arts at midcentury. Canby does not identify those artists who went to work for Sultan Ibrahim Mirza in Mashhad but characterizes their style as "mannerist." Specific features that typify the Mashhad style in the 1560s include heads that appear large in proportion to their bodies, pouchlike cheeks, low turbans and fur caps (instead of the high turban fashionable earlier in the sixteenth century), and slippery and insubstantial rocks.

NOTES TO APPENDIX B

1. For tadhkira in general, see Rypka, 109 (where such texts are characterized as biographies and anthologies), 119, 453–4 (where they are characterized as memoirs). A useful historical introduction, with particular emphasis on Timurid literary history and the *Majalis* (Assembly) of Ali-Sher Nawa'i, appears in Subtelny, "Poetic Circle," 19–38. An extremely thoughtful analysis from an art-historical perspective of tadhkira texts (considered as "unofficial" sources), including several employed for the present study, is given by Lentz, "Baysunghur," 3–27.
2. Thackston, *Century*, 335. For a detailed discussion of various aspects of Dust-Muhammad's introduction, including its date, see Adle, "Autopsia."
3. Qazi Ahmad [Ishraqi], 1:xii–xiii; Qazi Ahmad [Minorsky], 2–3, 7–9. See also Farhad & Simpson, and Chapter Three for more on Qazi Ahmad, his family, and the *Gulistan*.
4. Qazi Ahmad [Minorsky], 20.
5. For more on this point, see Farhad & Simpson.
6. Sam Mirza [Humayun-Farrukh], 133, 149.
7. *Chiesa* 3, lot 447.
8. Two-thirds (primarily paintings) of the collection was sold in New York in 1926.
9. Despite the extensive promotion of the manuscript in the American Art Association catalogue, there seems to have been little competition at the actual moment of sale, perhaps because lot 447 apparently came up earlier in the sale session than originally scheduled. Kevorkian evidently knew that the lot had been advanced, whereas other potential buyers did not. I owe this anecdote to B. W. Robinson, who believes he heard it at the Freer in the early 1950s. Although hearsay, the story fits with Kevorkian's general reputation for acumen as a dealer. The Freer's files on the *Haft awrang* contain a lengthy description of the manuscript on Kevorkian letterhead (incorporated into Ettinghausen, fs, 37–38). Much of the wording of this document is similar to the entry in the Chiesa sales catalogue. It is possible that Kevorkian was the specialist who wrote the entry for lot 447 and equally possible that he used the information in the catalogue for his own purposes. One curious discrepancy in Kevorkian's description is a reference to twenty-nine full-page paintings; in the 1926 catalogue twenty-eight are cited (*Chiesa* 3, lot 447, reads: "27 full-page and one three-quarter page beautiful paintings of excellent design and brilliant coloring"). The Kevorkian document continues at greater length (and rapture) than the sales catalogue about the paintings but obviously without much attention to their subject matter and perhaps without much knowledge of the *Haft awrang* text. The scenes are indicated in general terms (e.g., a battle, polo game, a funeral, and street scenes; the second is pure invention, and the third may refer to the final illustration, where Iskandar appears to be dying). The only specific reference is to one with a "shepherd with his flock shown making modest offering to a lady of rank"; this is clearly folio 264a illustrating *Majnun Comes before Layli Disguised as a Sheep.*
10. Detroit, cat. no. 12.
11. Ackerman, 260 (gallery IX, case 16b).
12. Kühnel, "History," 1878. All this is somewhat curious since Phyllis Ackerman, coeditor of *A Survey of Persian Art*, was responsible for the catalogue of the 1940 Iranian Institute show in which the *Haft awrang* was exhibited. It may be, however, that Kühnel submitted his section on miniature painting well before Ackerman or Pope were aware of the masterpiece then in Kevorkian's possession. According to Pope's preface to the *Survey*, dated June 1938, the publication was first "projected" in April 1926 (the very month and year of the Chiesa sale!) and much of its text typeset by 1935. (*Survey*, 1:x, xii; the year of 1935 is not actually specified but can be inferred from Pope's reference to a governmental decree promulgated in that year changing the official designation of Persia to Iran.) The preface (*Survey*, 1:xii) goes on to say: "The bulk of the text incorporated material that was formulated several years before the publication date, which means that the authors, owing to the time required for the production of the *Survey*, could not present their discoveries at once." This time lag must have been exacerbated by wartime conditions, another possible explanation for Kühnel's evident lack of familiarity with the *Haft awrang*. The folio of the *Haft awrang* discussed by Kühnel is reproduced with the notation "Present owner unknown" (*Survey*, 5: pl. 904). Again this is strange since

Kevorkian made no secret of his ownership of the *Haft awrang*, and Ackerman and Pope obviously knew of Kevorkian and his collection since his name appears in other credit lines throughout the *Survey* and among the acknowledgments for color plates (*Survey*, 1:xv; unfortunately, there is no comparable listing of credits for black-and-white reproductions such as pl. 904).
13. Ettinghausen, "Exhibition," 111–12. See also Ettinghausen, "Indische," 167–68. The album Ettinghausen calls the duke of Hamilton album is now generally known as the Polier album after its original owner (BSM I 4596). See the discussion of FGA 46.12, folio 132a, in Chapter Two for more on the Mughal copy.
14. In the middle of the first page of this single-spaced two-page document is an effusive paragraph, phrased in idiosyncratic English and typed in upper-case letters, which reflects not only Kevorkian's enthusiasm for the manuscript but that of virtually all its subsequent admirers: "The manuscript is a monument of pictorial and caligraphic [sic] art and represents, in perfect state of preservation, the aesthetic culture which reached its meridian at the court of Shah Tahmasp middle of 16th century. It has no peer in any library or collection public or private."
15. Actually translated extracts from Qazi Ahmad's *Gulistan-i hunar* published by Edwards.
16. Stchoukine, *MS*, 185. Skelton ("Farrokh Beg," 396 n. 20) remarks similarly that the Freer is planning a complete publication of the miniatures.
17. Stchoukine, *MS*, 125–29. The other works in this section (cited here with some information not provided by Stchoukine; see also Chapter Three) are no. 166, *Ta'rikh-i A'imma al-massumin* (History of the pure imams) of Muhammad ibn Arabshah (SPL Dorn 312), with several paintings attributed by Stchoukine to Mashhad, ca. 1530, no. 167; *Bustan* of Sa'di (CB MS 221), copied by Shah-Mahmud al-Nishapuri at Mashhad and dated Rajab 958/July 1551, with six preliminary drawings for paintings; no. 168, painting of a groom and camel (now FGA 37.21), signed by Shaykh-Muhammad and dated 965/1556–57, with reference to four paintings in the Freer Jami (folios 64b, 100b, 162a, and 179b) in a similar style; no. 169, *Subhat al-abrar* of Jami (now GULB LA 159), copied by Sultan-Muhammad Khandan, and with two paintings that resemble certain compositions in the Freer Jami and probably were done by same group of artists trained in royal ateliers in Tabriz. One painting is signed by Abdullah Mudhahhib and dated 972/1564; Stchoukine attributes FGA 46.12, folio 153b, to the same artist and suggests that the affinities between the *Haft awrang* and the *Subhat al-abrar* indicate that the latter was also executed in Mashhad for Ibrahim Mirza; no. 170bis, *Divan* for Sultan Ibrahim Mirza (now SAK MS 33), incorrectly cited by Stchoukine as having been copied by the prince's daughter, and with a discussion of two paintings, of which Stchoukine describes one (folio 32a) as painted in the style of school of Qazvin in the second half of the sixteenth century, and another (folio 23a) inscribed and dated by Abdullah Mudhahhib 99 (for 990/1582, as noted by Stchoukine). Stchoukine sees similarities between these paintings and certain ones in the Freer Jami as well as in *Subhat al-abrar* (no. 169, where the *Divan* painting by Abdullah is already mentioned) and, as a consequence, proposes the *Divan* was also executed in Mashhad.
18. Stchoukine, *MS*, 128–29.
19. Ibid., 150, 184.
20. Gray, *PP* 2, 142; Gray, "Safavid," 889.
21. Gray, *PP* 2, 145.
22. Gray, "Safavid," 891.
23. Robinson, *PD*, 135 (caption for pl. 41).
24. Robinson, *PMA*, 15, cat. no. 24ii.
25. Robinson, "Survey," 50.
26. For further comments on Dickson & Welch, see the extensive and extremely thoughtful discussion in Soucek, "Review."
27. Dickson & Welch, 1:246A n. 4.
28. A. Welch, "Abbas," 460.
29. A. Welch, *Artists*, 157, 158.
30. Galerkina, 232, 233.
31. Beach, *Imperial Image*, 57.
32. Titley, *PMP*, 106.
33. Ibid., 107.

Illustrated Manuscripts of the *Haft awrang*

This list contains manuscripts of the *Haft awrang* and its seven masnavis with text illustrations. Omitted here are those with only frontispieces and/or finispieces. Also omitted are manuscripts with double-page illustrations between individual masnavis; occasionally these paintings represent a familiar *Haft awrang* narrative (e.g., the Egyptian women overwhelmed by Yusuf's beauty) but do not constitute text illustrations. Also omitted are manuscripts with illustrations added after the sixteenth century, unless they seem to have been originally intended for illustration.

In Appendix C.2, an asterisk (*) denotes manuscripts not examined at firsthand or in reproduction, or those for which no complete published description is available. The use of "attributed to" indicates that a manuscript's place of origin is not given in its colophon. When a difference of opinion exists for an attribution, the specific source of the attribution is given in parentheses.

1. MANUSCRIPTS BY COLLECTION

AHT ART AND HISTORY TRUST, LICHTENSTEIN

| AHT no. 80 | 973/1565–66 |
| AHT no. 81 | 973/1566 |

AMSG ARTHUR M. SACKLER GALLERY, WASHINGTON, D.C.

AMSG S1986.40	966/1558
AMSG S1986.44	956/1549–50
AMSG S1986.46	ca. 1540
AMSG S1986.52	921/1515–16
AMSG S1986.55	ca. 1565–70

BL BRITISH LIBRARY, LONDON

BL Or. 2935	934/1527–28
BL Or. 4122	ca. 1565–70
BL Or. 4535	ca. 1550–70
BL Or. 4389	975/1568

BN BIBLIOTHÈQUE NATIONALE, PARIS

BN suppl. pers. 547	973–74/1565–67
BN suppl. pers. 561	978/1570
BN suppl. pers. 1015	ca. 1550–60
BN suppl. pers. 1344	second half 16th century
BN suppl. pers. 1768	996/1588
BN suppl. pers. 1919	950/1543–44

BOD BODLEIAN LIBRARY, OXFORD

BOD Elliot 149	ca. 1575
BOD Elliot 186	970–72/1563–65
BOD Elliot 337	1005/1596–97
BOD Elliot 415	ca. 1550–60
BOD Elliot 418	1004/1595–96
BOD Greaves 1	977/1569
BOD Hyde 10	940/1533
BOD Marsh 431	ca. 1575
BOD Ouseley 28	ca. 1550–60
BOD Ouseley 77	961/1554
BOD Ouseley Add. 23	ca. 1570–80
BOD Whinfield 12	ca. 1575

CB CHESTER BEATTY LIBRARY, DUBLIN

CB MS 211	948/1541–42
CB MS 213	954–75/1547–68
CB MS 215	955/1548–49
CB MS 216	957/1550–51
CB MS 238	ca. 1560–70
CB MS 239	980/1572–73
CB MS 247	993/1584–85
CB MS 251	947/1540

CHR CHRISTIE'S, LONDON
CHR 30.V.62, lot 216 ca. 1575–80
CHR 29.IV.70, lot 42 965/1558
CHR 18.X.94, lot 72 978/1570

CUL CAMBRIDGE UNIVERSITY LIBRARY
CUL MS MM 6.3 954/1547–48

ELG ELGHANAYAN COLLECTION, NEW YORK
ELG 10 ca. 1570–80
ELG 53 ca. 1560s
ELG 62 ca. 1525–30

FGA FREER GALLERY OF ART, WASHINGTON, D.C.
FGA 46.12 963–72/1556–65

FRE FREE LIBRARY, PHILADELPHIA
FRE MS 79 9[8?]8/1580–81

FSB FORSCHUNGSBIBLIOTHEK, GOTHA
FSB MS Orient. P77 945/1538

GEBO GENERAL EGYPTIAN BOOK ORGANIZATION, CAIRO
GEBO Litt. pers. M 45 940/1533–34

GL GULISTAN LIBRARY, TEHRAN
GL 709 928/1522
GL 671 977/1570

GULB CALOUSTE GULBENKIAN FOUNDATION, LISBON
GULB LA 184 962/1554–55

HRM HERMITAGE MUSEUM, SAINT PETERSBURG
HRM VP-992 995/1586–87

IM ISRAEL MUSEUM, JERUSALEM
IM 5028.1.79 ca. 1550–60
IM 5032.1.79 980/1572–73

IOL INDIA OFFICE LIBRARY, LONDON
IOL MS 366 ca. 1560
IOL MS 737 1007/1599
IOL MS 3426 ca. 1560
IOL P&A 49 951/1544–45

IOS INSTITUTE OF ORIENTAL STUDIES, ACADEMY OF TASHKENT
IOS MS 9597 ca. 1550–60

JS JEAN SOUSTIEL COLLECTION, PARIS
JS no. 11 962/1554–55

KEIR KEIR COLLECTION, RICHMOND, SURREY
KEIR III.196–198 late 15th century
KEIR III.224–226 ca. 1550–60
KEIR III.314–320 ca. 1570–80
KEIR III.418–419 901/1495–96

KEV FORMERLY HAGOP KEVORKIAN COLLECTION, NEW YORK
KEV 73 926/1519–20
KEV 1039 ca. 1525–50
KEV 57 944/1537
KEV 1046 ca. 1540–50
KEV 889 988/1581

KNM DAR AL-ATHAR AL-ISLAMIYYAH (ALSABAH COLLECTION), KUWAIT (formerly Kuwait National Museum)
KNM LNS 10 MS 926/1519–20
KNM LNS 16 MS 9[4?]2/1535–36[?]

LMV MUSEUM FÜR VÖLKERKUNDE, LEIPZIG
LMV WAS 2292 late 16th century

MET METROPOLITAN MUSEUM OF ART, NEW YORK
MET 13.228.5 930/1523–24
MET 13.228.8 ca. 1550–60

MOA MUSEUM OF ORIENTAL ART, MOSCOW
MOA MS 1961/II ca. 1560–70

NYPL NEW YORK PUBLIC LIBRARY
NYPL Spencer, Pers. MS 64 mid-16th century

ÖNB ÖSTERREICHISCHE NATIONALBIBLIOTHEK, VIENNA
ÖNB A.F. 18 late 16th century
ÖNB A.F. 66 951/1544
ÖNB A.F. 108 982/1574
ÖNB N.F. 127 992/1584
ÖNB Mixt. 1480 893/1488
ÖNB Mixt. 1614 944/1537

PWM PRINCE OF WALES MUSEUM, BOMBAY
PWM MS 55.102 971/1564

RYL JOHN RYLANDS LIBRARY, MANCHESTER
RYL Pers 20 924/1518–19
RYL Pers 23 957/1550–51

SAK COLLECTION OF PRINCE SADRUDDIN AGA KHAN, GENEVA
SAK MS 8 936/1529
SAK MS 17 971/1563–64

SJML SALAR JUNG MUSEUM AND LIBRARY, HYDERABAD
SJML A./Nm. 549 late 16th century
SJML A./Nm. 551 late 16th century
SJML A./Nm. 584 962/1554–55
SJML A./Nm. 1040 995/1586–87
SJML A./Nm. 1043 late 16th century
SJML A./Nm. 1050 early 16th century
 (M. no. 118)
SJML A./Nm. 1053 late 16th century
 (M. no. 206)

SOTH SOTHEBY'S, LONDON
SOTH 6.XII.67, lot 197 956/1549
SOTH 1.XII.69, lot 190 late 15th–first half 16th century
SOTH 1.XII.69, lot 195 989/1581–82
SOTH 17.XII.69, lot 281 mid-16th century
SOTH 17.XII.69, lot 283 ca. 1580–90
SOTH 7.XII.70, lot 189 ca. 1550
SOTH 7.XII.70, lot 199 ca. 1580s
SOTH 14.VII.71, lot 298 ca. 1570
SOTH 23.XI.76, lot 402 late 16th century
SOTH 2.V.77, lot 170 935/1528–29
SOTH 3.V.77, lot 149 981/1573–74
SOTH 3.IV.78, lot 158 early 16th century
SOTH 3.IV.78, lot 165 ca. 1575
SOTH 23.IV.79, lot 159 ca. 1560
SOTH 23.IV.79, lot 162 ca. 1575–1600
SOTH 21.IV.80, lot 196 975/1567–68
SOTH 22.IV.80, lot 306 989/1581–82
SOTH 13.X.81, lot 235 994/1585–86
SOTH 6.VII.81, lot 47 mid-16th century
SOTH 26.IV.82, lot 91 984/1576–77
SOTH 21–22.XI.85, lot 416 mid-16th century
SOTH 11.IV.88, lot 131 911/1505–6

SOTH 10.IV.89, lot 243 ca. 1570
SOTH 10.IV.89, lot 245 late 16th century
SOTH 22.X.93, lot 162 ca. 1580
SOTH 18.X.95, lot 57 914/1508–9
SOTH 18.X.95, lot 58 972/1564–65

SPL NATIONAL LIBRARY OF RUSSIA (FORMERLY STATE PUBLIC LIBRARY), SAINT PETERSBURG
SPL Dorn 425 ca. 1560s
SPL Dorn 426 ca. 1580s
SPL Dorn 429 ca. 1550–60
SPL Dorn 430 946/1539–40
SPL IIHC-86 1006/1597–98
SPL IIHC-389 mid-16th century

TKS TOPKAPI SARAYI MÜZESI, ISTANBUL
TKS H. 724 973/1565
TKS H. 725 948/1541–42
TKS H. 726 959/1552–53
TKS H. 727 second half 16th century
TKS H. 728 ca. 1550–60
TKS H. 804 929/1522–23
TKS H. 810 mid-16th century
TKS H. 812 975/1568
TKS H. 1084 late 16th century
TKS H. 1087 second half 16th century
TKS H. 1114 927/1520–21
TKS H. 1483 978–79/1570–72
TKS R. 888 912/1506–7
TKS R. 892 early 16th century
TKS R. 895 925/1519–20
TKS R. 897 976/1568–69
TKS R. 898 second half 16th century
TKS R. 899 ca. 1550–60
TKS R. 900 first half 16th century
TKS R. 907 982/1574–75
TKS R. 910 931/1525
TKS R. 912 930/1523–24
TKS R. 915 989/1581
TKS Y. 47 second half 16th century

TRN TRINITY COLLEGE LIBRARY, CAMBRIDGE
TRN R.13.8 937/1530

WAG WALTERS ART GALLERY, BALTIMORE
WAG W.644 second half 16th century

893/1488 *Yusuf u Zulaykha* ÖNB Mixt. 1480
 date: end of Rajab 893/beginning of July 1488
 scribe: Pir-Ali ibn Abdul-Rahman al-Jami
 place: attributed to Herat
 illustration: 2 spaces for illustration
 reference: Duda, 1:210–11, and 2: pls. 30–31

901/1495–96 *Silsilat al-dhahab* KEIR III.418–419
 date: 901/1495–96
 scribe: Muhammad Qasim Ustad
 place: Bakharz
 illustrations: 2 (added in the 19th century in spaces
 originally reserved for illustration)
 references: Robinson, *Keir*, cat. no. III.418–419
 (with previous reference)

late 15th *Tuhfat al-ahrar* (fragment) KEIR III.196–198
century
 date: late 15th century, Turcoman period
 place: attributed to a provincial center
 illustrations: 3
 reference: Robinson, *Keir*, cat. no. III.196–198,
 and pl. 44

early 16th century *Khamsa* TKS R. 892
 date: early 16th century
 scribe: Mir-Muhammad
 place: attributed to Herat
 illustrations: 15 plus 1 double-page frontispiece
 (*Tuhfat al-ahrar*: 2; *Subhat al-abrar*: 3; *Yusuf u Zulaykha*: 4;
 Layli u Majnun: 3, *Khiradnama-i Iskandari*: 3)
 reference: Karatay, *Farsça*, no. 715

early 16th century **Yusuf u Zulaykha* SJML A./Nm.1050
 (M. no. 118)
 date: early 16th century
 scribe: Yari al-Haravi
 place: attributed to Shiraz
 illustrations: 4 plus 4 later additions
 reference: Ashraf, 5:281–82

early 16th century *Yusuf u Zulaykha* SOTH 3.IV.78, lot 158
 date: early 16th century
 place: attributed to Bukhara
 illustrations: 2
 reference: SOTH 3.IV.78, lot 158, and repro.

first half *Subhat al-abrar* TKS R. 900
16th century
 date: first half 16th century
 place: attributed to Shiraz
 illustrations: 10
 reference: Karatay, *Farsça*, no. 728

late 15th–first **Four masnavis* SOTH 1.XII.69, lot 190
half 16th century
 date: late 15th–first half 16th century
 place: attributed to Transoxiana (Robinson)
 illustrations: 13 (*Yusuf u Zulaykha, Layli u Majnun,
 Khiradnama-i Iskandari, Silsilat al-dhahab*)
 references: SOTH. 1.XII.69, lot 190; Robinson, *FC*, 55
 (referred to as a *Yusuf u Zulaykha*)

911/1505–6 **Haft awrang* SOTH 11.iv.88, lot 131
 date: 911/1505–6
 scribe: Abu Tahir al-Haravi
 place: attributed to Herat ("school of Bihzad")
 illustrations: 12 (*Silsilat al-dhahab*: 2; *Salaman u Absal*: 2;
 Tuhfat al-abrar: 1; *Subhat al-abrar*: 1; *Yusuf u Zulaykha*: 3;
 Layli u Majnun: 3)
 references: SOTH 15.IV.85, lot 328; SOTH 11.IV.88, lot 131

912/1506–7 *Khamsa* TKS R. 888
 date: 912/1506–7 [colophon possibly altered]
 scribe: Sultan-Ali al-Mashhadi
 place: attributed to Bukhara
 illustrations: 7 plus 1 double-page frontispiece (*Tuhfat al-
 ahrar*: 1; *Subhat al-abrar*: 1; *Yusuf u Zulaykha*: 3; *Layli u
 Majnun*: 2)
 reference: Karatay, *Farsça*, no. 711

914/1508–9 **Tuhfat al-ahrar* SOTH 21.X.95, lot 57
 date: 914/1508–9
 place: attributed to Khurasan
 illustrations: 4 plus 1 frontispiece and 1 finispiece
 (attributed to ca. 1570–80)
 references: SOTH 21.IV.89, lot 198; SOTH 21.X. 95, lot 57

921/1515–16 *Tuhfat al-ahrar* AMSG S1986.52
 date: 921/1515–16
 scribe: Sultan Muhammad Nur al-katib
 place: Bukhara
 illustrations: 3
 references: Lowry et al., cat. no. 179

924/1518–19 *Yusuf u Zulyakha* RYL Pers 20
 date: 924/1518–19
 place: Shiraz, at the tomb (*astana*) of Hazrat Mawlana
 Husamuddin Ibrahim
 illustrations: 5 plus possibly 1 removed
 reference: Robinson, *RL*, cat. nos. 562–66, and repros.

925/1519–20 *Silsilat al-dhahab* TKS R. 895
 date: 925/1519–20
 patron: Abu'l-Ghazi Abdullah Bahadur Khan (on
 shamsa, folio 3a)
 scribe: Sultan Muhammad Nur al-katib
 place: attributed to Bukhara
 illustrations: 3 plus 1 double-page frontispiece
 reference: Karatay, *Farsça*, no. 718

ca. 1525–50 **Yusuf u Zulaykha* KEV 1039
 date: ca. 1525–50
 place: attributed to Tabriz
 illustrations: 7
 reference: Robinson, "Kevorkian," cat. no. LXVIII

926/1519–20 *Yusuf u Zulaykha* KNM LNS 10 MS
 date: 926/1519–20
 place: attributed to Shiraz
 illustrations: 4
 references: Robinson, "Kevorkian," cat. no. LXXXVIII;
 SOTH 23.IV.79, lot 153, and repro.

926/1519–20 **Yusuf u Zulaykha* KEV 73
 date: 926/1519–20
 place: attributed to late Herat style
 illustrations: 2
 reference: Robinson, "Kevorkian," cat. no. CXXVIII

927/1520–21 *Yusuf u Zulaykha* TKS H. 1114
 date: 927/1520–21
 scribe: Maqsud-Ali
 place: attributed to Shiraz
 illustrations: 2
 reference: Karatay, *Farsça*, no. 738

928/1522 **Khamsa* GL 709
 date: Rabi 1 928/January–February 1522
 scribe: Ali al-Husayni al-Haravi
 place: attributed to Herat
 illustrations: 2 plus 3½[?] double compositions
 (originally 2 double-page frontispieces and 2 double
 finispieces [?])
 references: Atabay, *Divan*, cat. no. 73 with repros.; Binyon
 et al., cat. no. 129, and pls. LXXXV–LXXXVI; Dickson &
 Welch, 1:249B–250A n. 2; Gray & Godard, 20, and pls.
 XXV–XXVI; Lentz & Lowry, 301 n. 76; Minorsky,
 "Persian Manuscripts," 72–73, and figs. IV–V;
 Stchoukine, *MS*, 32, 34, 37, 40, 43
 Note that Gray & Godard and Lentz & Lowry give the
 date of 886/1481, which is actually the year Jami
 completed the *Tuhfat al-ahrar*, as specified in Mudarris-
 Gilani, 442.

929/1522–23 *Haft awrang* TKS H. 804
 date: 929/1522–23 (possibly altered)
 scribe: Abdi al-Nishapuri
 illustrations: 6 (*Tuhfat al-ahrar*, 2; *Subhat al-abrar*: 1; *Yusuf
 u Zulaykha*: 1; *Layli u Majnun*: 1; *Khiradnama-i Iskandari*: 1)
 references: Diba, "Lacquerwork" 2, 97, 145, and cat.
 no. 9; Karatay, *Farsça*, no. 712

930/1523–24 *Yusuf u Zulaykha* MET 13.228.5
 date: 930/1523–24
 scribe: Mir-Ali al-Husayni
 place: attributed to Bukhara
 illustrations: 3
 references: Jackson & Yohannan, cat. no. 18; Pijoán,
 fig. 506

930/1523–24 *Haft awrang* TKS R. 912
 date: Jumada II 930/November 1523–October 1524
 scribe: Muhammad ibn Abdul-Razzaq al-Tabib
 place: attributed to Herat
 illustrations: 14 (*Tuhfat al-ahrar*: 2; *Subhat al-abrar*: 2; *Yusuf
 u Zulaykha*: 2; *Layli u Majnun*: 2; *Khiradnama-i Iskandari*: 2;
 Silsilat al-dhahab: 3; *Salaman u Absal*: 1)
 reference: Karatay, *Farsça*, no. 703

ca. 1525–30 *Yusuf u Zulaykha* ELG 62
 date: ca. 1525–30
 place: attributed to Tabriz (Simpson) and Mashhad
 (Brosh)
 illustrations: 12
 reference: Brosh, cat. no. 18

931/1525 *Yusuf u Zulaykha* TKS R. 910
 date: Shawwal 931/July 1525
 scribe: Shah-Mahmud al-Nishapuri
 place: attributed to Tabriz
 illustrations: 5
 references: Çagman & Tanindi, cat. no. 95; Diba,
 "Lacquerwork" 2, 144–46, and cat. no. 17; Karatay,
 Farsça, no. 739; Stchoukine, "Poème"

934/1527–28 *Haft awrang* BL Or. 2935
 date: 934/1527–28
 scribe: Ali Hajurani
 place: Herat
 illustrations: 2 (*Subhat al-abrar*: 1; *Yusuf u Zulaykha*: 1)
 reference: Titley, *MPM*, cat. no. 205

935/1528–29 **Subhat al-abrar* SOTH 2.V.77, lot 170
 date: 935/1528–29
 scribe: Mir-Ali al-katib al-sultani
 place: attributed to Bukhara
 illustrations: 2
 references: Robinson, "Kevorkian," cat. no. CXXIX; SOTH
 2.V.77, lot 170

936/1529 *Yusuf u Zulaykha* SAK MS 8
date: 23 Rabi' II 936/25 December 1529
scribe: Abu'l-Karim ibn Abu'l-Fath ibn Muhammad
place: attributed to Tabriz
illustrations: 8
reference: A. Welch, *CIA*, 2: MS 8

937/1530 *Khamsa* TRN R. 13.8
date: Rabi' II 937/11 December 1530
scribe: Abdullah Haravi
place: attributed to Tabriz (Simpson) and Shiraz
(Stchoukine)
illustrations: 4 plus 6 double-page compositions and 2
finispieces (*Tuhfat al-abrar*: 1; *Layli u Majnun*: 1; *Yusuf u
Zulaykha*: 1; *Khiradnama-i Iskandari*: 1)
references: Binyon et al., cat. no. 13a, and pl. XC-A; Diba,
"Lacquerwork" 2, 139, and cat. no. 14 (with full
references); Stchoukine, *MS*, no. 102

940/1533 *Yusuf u Zulaykha* BOD Hyde 10
date: Rabi' I 940/September–October 1533
place: attributed to Shiraz
illustrations: 3
references: Robinson, *BL*, cat. nos. 696–98, and pl. XI
left; Stchoukine, *MS*, no. 104

940/1533–34 *Yusuf u Zulaykha* GEBO Litt. pers. M 45
date: 940/1533–34
place: attributed to Tabriz (Dickson & Welch,
Stchoukine) and Qazvin (Stchoukine)
illustrations: 7
references: Dickson & Welch, 1:40B–41A; Stchoukine,
MS, no. 13 (with previous references) and pls. XVI–XVII

9[4?]2/1535–36 [?] *Subhat al-abrar* KNM LSN 16 MS
date: 9[4?]2/1535–36 [?] (altered to 902/1496–97)
patron: Abu'l-Ghazi Abdullah Bahadur Khan (on
illustrations folios 1a and 76a)
scribe: Mahmud ibn Ishaq al-Shihabi al-Haravi
place: attributed to Bukhara
illustrations: 2 (not in sequence)
references: Atil, *Kuwait*, cat. no. 75; Jenkins, 101;
Robinson, "Kevorkian," cat. no. CXLIX (dated
972/1564–65); SOTH 21.IV.80, lot 186

944/1537 *Yusuf u Zulaykha* KEV 57
date: late Muharram 944/early July 1537
scribe: Mir-Ali al-katib al-sultani
place: Bukhara
illustrations: 4
reference: Robinson, "Kevorkian," cat. no. CXXX

944/1537 *Subhat al-abrar* ÖNB Mixt. 1614
date: 1 Rabi' I 944/8 August 1537
place: attributed to Tabriz
illustrations: 4
reference: Duda, 1:225–26, and 2: pls. 161–64

945/1538 *Yusuf u Zulaykha* FSB MS Orient. P77
date: 945/1538
place: attributed to Shiraz
illustrations: 5
reference: *OIH*, 68–69

946/1539–40 *Yusuf u Zulaykha* SPL Dorn 430
date: 946/1539–40
scribe: Farid
place: attributed to Shiraz
illustrations: 5
references: Dorn, cat. no. 430; *USSR Colls.*, 43–48

ca. 1540 *Tuhfat al-ahrar* AMSG S1986.46
date: ca. 1540
place: attributed to Bukhara
illustrations: 3 plus 1 double-page frontispiece
reference: Lowry et al., cat. no. 180

ca. 1540–50 *Yusuf u Zulaykha* KEV 1046
date: ca. 1540–50
place: attributed to Shiraz
illustrations: 5
reference: Robinson, "Kevorkian," cat. no. XCIX

947/1540 *Yusuf u Zulaykha* CB MS 251
date: 3 Jumada II 947/5 October 1540
place: attributed to Tabriz
illustrations: 5
reference: Arberry et al., 3: cat. no. 251

948/1541–42 *Yusuf u Zulaykha* CB MS 211
date: 948/1541–42
scribe: Abdul-Latif
place: attributed to Tabriz
illustrations: 4
reference: Arberry et al., 2: cat. no. 211

948/1541–42 *Yusuf u Zulaykha* TKS H. 725
date: 948/1541–42
scribe: Muhammad Qasim al-Jami
place: attributed to Tabriz
illustrations: 5
reference: Karatay, *Farsça*, no. 741

950/1543–44 *Yusuf u Zulaykha* BN suppl. pers. 1919
date: 950/1543–44
scribe: Shah-Mahmud al-Nishapuri
place: attributed to Tabriz
illustrations: 2
reference: Blochet, *Persans*, 3: no. 1701

951/1544–45 *Silsilat al-dhahab* and *Itiqadnama* IOL P&A 49
date: 951/1544–45
scribe: Shah-Mahmud al-Nishapuri
place: attributed to Tabriz
illustrations: 2
reference: Robinson, *IOL*, cat. nos. 134–35

951/1544 *Khamsa* ÖNB A.F. 66
date: 5 Muharram 951/29 March 1544
scribe: Mahmud ibn Mirak al-Darjizini
place: attributed to Bukhara
illustrations: 13 (*Tuhfat al-ahrar*: 2; *Subhat al-abrar*: 3; *Yusuf
u Zulaykha*: 3; *Layli u Majnun*: 3; *Khiradnama-i Iskandari*: 2)
reference: Duda, 1:22–25, and 2: pls. 34–49

954/1547–48 *Yusuf u Zulaykha* CUL MS MM 6.3
date: 954/1547–48
scribe: Muhammad Qivam
place: attributed to Shiraz
illustrations: 4 plus possibly 1 additional
references: Guest, app. no. 22, and pl. 35; Robinson, *BC*,
cat. no. 76; Stchoukine, *MS*, no. 109

954–75/1547–68 Four masnavis CB MS 213
dates: 954/1547; 974/1567; 975/1568 (dates not in
sequence)
patron: attributed to Abdul-Aziz Bahadur Khan
scribes: Mir-Husayn al-katib al-Khaqani al-Husayni;
Muhammad Ali ibn al-Mahmud al-munajjim al-
Khaqani; Khwaja Jan al-katib
place: attributed to Bukhara
illustrations: 9 (*Silsilat al-dhahab*: 2; *Subhat al-abrar*: 1; *Layli
u Majnun*: 4; *Khiradnama-i Iskandari*: 2)
reference: Arberry & et al., 2: cat. no. 213

955/1548–49 *Tuhfat al-ahrar* CB MS 215
date: 955/1548–49 (manuscript misdated 915/1509–10);
painting dated 955/1548–49 (folio 37b)
patron: Abdul-Aziz Bahadur Khan (on painting folio
37b)
scribe: Mir-Ali al-Husayni al-katib
librarian: Sultan-Mirak kitabdar
place: attributed to Bukhara
illustrations: 3
references: Arberry et al., 2: cat. no. 215; Binyon et al.,
cat. no. 110; Robinson, *BI*, cat. no. 160

956/1549 *Haft awrang* SOTH 6.XII.67, lot 197
date: Ramadan 956/September–October 1549
scribe: Abdul-Fattah ibn Wali al-Husayni
place: attributed to Tabriz
illustrations: 23
references: Robinson, "Kevorkian," cat. no. LXXI; SOTH
6.XII.67, lot 197, and repros.

956/1549–50 *Silsilat al-dhahab* AMSG S1986.44
date: 956/1549–50
scribe: Isma'il ibn Ibrahim al-Astarabadi
place: attributed to Tabriz
illustrations: 4
reference: Lowry et al., no. 177

ca. 1550 *Yusuf u Zulaykha* SOTH 7.XII.70, lot 189
date: manuscript dated 898/1492–93
scribe: Sultan-Ali Mashhadi
illuminator: Sultan-Mirak kitabdar
place: attributed to Bukhara
illustrations: 2 (attributed to ca. 1550)
references: SOTH 7.XII.70, lot 189; Robinson,
"Kevorkian," cat. no. CXXXV

mid-16th century *Yusuf u Zulaykha* SPL IIHC-389
date: mid-16th century
scribe: Jamaluddin Husayn Shirazi
place: attributed to Shiraz
illustrations: 5 plus 1 double-page frontispiece
reference: *USSR Colls.*, 66–74

mid-16th century *Haft awrang* TKS H. 810
date: mid-16th century
scribe: Shah-Muhammad
place: attributed to Shiraz
illustrations: 17 (*Silsilat al-dhahab*: 5; *Tuhfat al-abrar*: 2;
Subhat al-abrar: 3; *Yusuf u Zulaykha*: 5; *Layli u Majnun*: 2)
reference: Karatay, *Farsça*, no. 706

mid-16th *Yusuf u Zulaykha* SOTH 17.XII.69, lot 281
century
date: mid-16th century
place: attributed to Shiraz
illustrations: 2
reference: SOTH 17.XII.69, lot 281

mid-16th *Yusuf u Zulaykha* NYPL Spencer, Pers. MS 64
century
date: mid-16th century
patron: Kamran, son of Babur
scribe: attributed to Abdullah Shirazi
place: attributed to Bukhara
illustrations: 6
references: Robinson, "Kevorkian," cat. no. CXXXVI;
Schmitz, *NYPL*, no. II.15; SOTH 23.IV.79, lot 156

mid-16th century *Subhat al-abrar* SOTH 6.VII.81, lot 47
date: mid-16th century
scribe: Muhammad Qivam al-Shirazi
place: attributed to Shiraz
illustrations: 4; 2 added later over text
references: SOTH 21.IV.80, lot 188; SOTH 6.VII.81, lot 47

mid-16th *Yusuf u Zulaykha SOTH 21.IV.80, lot 190
century
 date: mid-16th century
 place: attributed to Astarabad
 illustrations: 10 (repainted)
 reference: SOTH 21.IV.80, lot 190

mid-16th *Yusuf u Zulaykha SOTH 21–22.XI.85, lot 416
century
 date: mid-16th century
 place: attributed to Bukhara
 illustrations: 8 (5 not relevant to text)
 reference: SOTH 21–22.XI.85, lot 416, and repros.

second half 16th *Salaman u Absal* BN suppl. pers. 1344
century
 date: second half 16th century
 place: attributed to Shiraz or Isfahan
 illustrations: 3
 reference: Blochet, *Persans*, 4: no. 1682

second half 16th century *Yusuf u Zulaykha* ELG 10
 date: second half 16th century
 place: attributed to Shiraz
 illustrations: 36 (many not listed in Appendix D due to
 uncertain subjects)
 reference: Brosh, cat. no. 23

second half 16th century *Yusuf u Zulaykha* TKS H. 727
 date: second half 16th century
 scribe: Hasan al-Shirazi
 place: attributed to Shiraz
 illustrations: 8
 reference: Karatay, *Farsça*, no. 750

second half 16th century *Silsilat al-dhahab* TKS H. 1087
 date: second half 16th century
 place: attributed to Shiraz
 illustrations: 4
 reference: Karatay, *Farsça*, no. 720

second half *Tuhfat al-ahrar* and *Subhat al-abrar* TKS R. 898
16th century
 date: second half 16th century
 place: attributed to Shiraz
 illustrations: 6 plus 1 double-page frontispiece
 reference: Karatay, *Farsça*, no. 727

second half 16th century Six masnavis TKS Y. 47
 date: second half 16th century
 place: attributed to Shiraz
 illustrations: 11 (*Silsilat al-dhahab*: 3; *Tuhfat al-ahrar*: 2;
 Yusuf u Zulaykha: 2; *Layli u Majnun*: 4)
 reference: Karatay, *Farsça*, no. 701

second half 16th century *Yusuf u Zulaykha* WAG W.644
 date: second half 16th century
 place: attributed to Shiraz
 illustrations: 3
 reference: *Bookbinding*, 40

ca. 1550–60 *Yusuf u Zulaykha* BOD Ouseley 28
 date: ca. 1550–60
 place: attributed to Shiraz
 illustration: 1
 reference: Robinson, *BL*, cat. no. 832

ca. 1550–60 *Yusuf u Zulaykha* BN suppl. pers. 1015
 date: ca. 1550–60
 place: attributed to a provincial center
 illustrations: 8
 references: Blochet, *Persans*, 3: no. 1704; Stchoukine,
 MS, no. 188

ca. 1550–60 *Subhat al-abrar* SPL Dorn 429
 date: ca. 1550–60
 place: attributed to style of Tabriz (Ashrafi) or Qazvin
 (*USSR Colls.*)
 illustrations: 3 plus 1 double-page frontispiece
 references: Ashrafi, 64; Dorn, cat. no. CDXXIX; *USSR
 Colls.*, 9, 11, 13, 28

ca. 1550–60 *Subhat al-abrar* TKS R. 899
 date: ca. 1550–60
 scribe: Mahmud ibn Mirak al-Darjarsi
 illustrations: 2
 reference: Karatay, *Farsça*, no. 732

ca. 1550–60 *Yusuf u Zulaykha* IOS MS 9597
 date: ca. 1550–60
 place: attributed to Shiraz
 illustrations: 11
 reference: *USSR Colls.*, 49–65

ca. 1550–60 *Subhat al-abrar* IM 5028.1.79
 date: ca. 1550–60
 scribe: [?] al-Haravi
 place: attributed to Bukhara
 illustrations: 3
 reference: Milstein, cat. no. 28

ca. 1550–60 *Salaman u Absal* KEIR III.224–226
 date: ca. 1550–60
 place: attributed to provincial center [Tabriz?]
 illustrations: 2 plus 1 double-page frontispiece
 reference: Robinson, *Keir*, cat. no. III.224–226, and pl. 53

ca. 1550–60 *Yusuf u Zulaykha* MET 13.228.8
 date: ca. 1550–60
 scribe: Muhammad Qivam al-Shirazi
 place: attributed to Shiraz
 illustrations: 4
 references: Guest, app. no. 24, and pl. 44a; Jackson &
 Yohannan, cat. no. 19; Pijoán, fig. 507

ca. 1550–60 *Yusuf u Zulaykha* BOD Elliot 415
 date: ca. 1550–60
 place: attributed to a provincial center
 illustrations: 3
 reference: Robinson, *BL*, cat. nos. 1108–10

ca. 1550–60 *Yusuf u Zulaykha* TKS H. 728
 date: ca. 1550–60
 place: attributed to Qazvin
 illustrations: 3
 references: Diba, "Lacquerwork" 2, cat. no. 37;
 Karatay, *Farsça*, no. 746

ca. 1550–70 *Yusuf u Zulaykha* BN Or. 4535
 date: ca. 1550–70
 artist: Abd Sayyid Shamsuddin (signed on folio 136b)
 place: attributed to Qazvin
 illustrations: 25
 references: Robinson, *BI*, cat. no. 181; Stchoukine, *MS*,
 no. 192; Titley, *MPM*, cat. no. 216 (with all previous
 references)

957/1550–51 *Yusuf u Zulaykha* RYL Pers 23
 date: 957/1550–51
 scribe: Muhammad Amin ibn Abdullah
 place: attributed to Mashhad
 illustrations: 6
 reference: Robinson, *RL*, cat. nos. 681–85, and repros.

957/1550–51 *Yusuf u Zulaykha* CB MS 216
 date: 957/1550–51
 scribe: Ahmad al-Husayni
 place: attributed to Herat
 illustrations: 3
 reference: Arberry et al., 2: cat. no. 216

959/1552–53 *Yusuf u Zulaykha* TKS H.726
 date: Ramadan 959/December 1552–53
 scribe: Hasan al-Sharif al-Shirazi
 place: attributed to Shiraz
 illustrations: 5
 reference: Karatay, *Farsça*, no. 742

961/1554 *Yusuf u Zulaykha* BOD Ouseley 77
 date: end of Jumada II 961/end of May 1554
 scribe: Maqsud katib
 place: attributed to Shiraz
 illustrations: 4
 reference: Robinson, *BL*, cat. nos. 828–31

962/1554–55 *Tuhfat al-ahrar* GULB LA 184
 date: 962/1554–55
 scribe: Mir-Husayn al-Husayni
 place: attributed to Bukhara
 illustrations: 3
 reference: Gray, *OIA*, cat. no. 124

962/1554–55 *Yusuf u Zulaykha* JS no.11
 date: 962/1554–55
 scribe: Mir-Husayn al-Husayni
 place: attributed to Bukhara
 illustrations: 4
 reference: *OAI*, no. 11, 20–21

962/1554–55 *Subhat al-abrar* SJML A./Nm. 584
 date: 962/1554–55
 scribe: Sultan-Husayn Haravi
 place: attributed to Herat
 illustrations: 3
 reference: Ashraf, 5:277–78

963–72/1556–65 *Haft awrang* FGA 46.12
 dates: *Silsilat al-dhahab*: Dhu'l-hijja 963/October 1556;
 Ramadan 964/June–July 1557; Ramadan 966/June–July
 1559; *Yusuf u Zulaykha*: 12 Rajab 964/11 May 1557;
 Subhat al-abrar: 1 Dhu'l-hijja 963/6 October 1556;
 Salaman u Absal: 968/1560–61; *Tuhfat al-ahrar*: Shawwal
 963/August 1556; *Layli u Majnun*: Shawwal 972/May
 1565
 patron: Sultan Ibrahim Mirza
 scribes: Malik al-Daylami, Muhibb-Ali, Shah-Mahmud
 al-Nishapuri, Ayshi ibn Ishrati, Rustam-Ali
 places: Mashhad, Herat, Qazvin
 illustrations: 28 (originally 29) (*Silsilat al-dhahab*: 6; *Yusuf
 u Zulaykha*: 6; *Subhat al-abrar*: 5; *Salaman u Absal*: 2; *Tuhfat
 al-ahrar*: 3; *Layli u Majnun*: 3 (originally 4); *Khiradnama-i
 Iskandari*: 3)
 references: see Appendix B

965/1558 *Haft awrang* CHR 29.IV.70, lot 42
 date: 1 Jumada II 965/30 April 1558
 place: attributed to Shiraz
 illustrations: 4 (*Silsilat al-dhahab*: 1; others
 unknown)
 reference: CHR 29.IV.70, lot 42

966/1558 *Tuhfat al-Ahrar* AMSG S1986.40
 date: end of Muharram 966/November 1558
 scribe: Baba Mirak al-katib al-Tashkandi
 place: attributed to Bukhara
 illustrations: 1 plus 1 double-page frontispiece
 reference: Lowry et al., cat. no. 181

ca. 1560 *Yusuf u Zulaykha* IOL MS 3426
date: ca. 1560
scribe: Muhammad al-Qivam [al-]Shirazi
place: attributed to Shiraz
illustrations: 5
references: Guest, app. no. 23 and pl. 31b; Robinson, *BI*,
cat. no. 49; Robinson, *IOL*, cat. nos. 297–301 (with
other previous references), and repros.; Stchoukine, *MS*,
no. 126

ca. 1560 *Silsilat al-dhahab* IOL MS 366
date: ca. 1560
place: attributed to Shiraz
illustrations: 5
reference: Robinson, *IOL*, cat. nos. 292–93

ca. 1560s *Tuhfat al-ahrar* SPL Dorn 425
date: ca. 1560s
scribe: Mir-Husayn al-Husayni (also known as Mir-
Kulangi-Khodja)
place: attributed to Bukhara
illustrations: 3
references: Ashrafi, 86–89; Dorn, cat. no. 425; *USSR
Colls.*, 87, 89, 90

ca. 1560s *Yusuf u Zulaykha* ELG 53
date: ca. 1560s
place: attributed to Shiraz
illustrations: 5
references: Brosh, cat. no. 22; Robinson, "Kevorkian,"
cat. no. XCIX

ca. 1560 *Yusuf u Zulaykha* SOTH 23.IV.79, lot 159
date: ca. 1560
place: attributed to a provincial center
illustrations: 6
reference: SOTH 23.IV.79, lot 159, and repro.

ca. 1560–70 *Subhat al-abrar* CB MS 238
date: ca. 1560–70
place: attributed to Bukhara
illustrations: 3 plus 1 double-page frontispiece
reference: Arberry et al., 3: cat. no. 238

ca. 1560–70 *Silsilat al-dhahab* MOA MS 1961/II
date: manuscript dated 1519 (Maslenitsyna)
scribe: Mir-Ali
place: attributed to Mashhad
illustrations: 2 (attributed to ca. 1560–70)
references: Ashrafi, 68–72, and color pls. 46–47;
Maslenitsyna, 118–19, and color pls. 110–11; *USSR
Colls.*, 21, 23

970–72/1563–65 *Khamsa* BOD Elliot 186
dates: *Tuhfat al-ahrar*: Dhu'l-hijja 972/June–July
1565; *Subhat al-abrar*: Dhu'l-hijja 972/June–July 1565;
Khiradnama-i Iskandari: Dhu'l-hijja 971/July–August
1654; *Layli u Majnun*: Rabiʿ I 971/October–November
1563; *Yusuf u Zulaykha*: Dhu'l-hijja 970/July–August
1563
scribe: Kamaluddin Husayn ibn Jalaluddin Mahmud
place: attributed to a provincial center
illustrations: 8 (*Tuhfat al-ahrar*: 2; *Subhat al-abrar*: 1;
Khiradnama-i Iskandari: 1; *Layli u Majnun*: 1; *Yusuf u
Zulaykha*: 3)
references: Robinson, *BL*, cat. nos. 1116–23;
Stchoukine, *MS*, no. 189

971/1563–64 *Tuhfat al-ahrar* SAK MS 17
date: 971/1563–64
patron: Abu'l-Ghazi Abdullah ibn Iskandar (on folio
29b)
scribe: Mahmud ibn Ishaq al-Shahabi
place: attributed to Bukhara
illustrations: 2
references: Robinson, "Kevorkian," cat. no. CXLIX-A;
A. Welch, *CIA*, 4: MS 17

971/1564 *Haft awrang* PWM MS 55.102
date: 1 Dhu'l-qaʾda 971/11 June 1564
scribe: Muhammad ibn Alaʾuddin of Raza
place: Raza village, Bakharz district (Khurasan)
illustrations: 27 plus 8 double-page compositions between
masnavis; many repainted in India (*Silsilat al-dhahab*: 6;
Salaman u Absal: 3; *Tuhfat al-ahrar*: 3; *Subhat al-abrar*: 2;
Yusuf u Zulaykha: 6; *Layli u Majnun*: 5; *Khiradnama-i
Iskandari*: 2)
references: Schmitz, "Harat," 18; Skelton, "Bakharz,"
198–204

972/1564–65 *Yusuf u Zulaykha* SOTH 18.X.95, lot 58
date: 972/1564–65
patron: Abu'l-Ghazi Abdullah Bahadur Khan (on
painting folio 92a and one other unspecified folio)
scribe: Abdul-Rahman al-Bukhari
place: attributed to Bukhara
illustrations: 8 (illustration on folio 92a dated
971/1563–64)
references: Robinson, "Kevorkian," cat. no. CXLVII;
SOTH 21.IV.80, lot 194, and repros.; SOTH 18.X.95, lot 58,
and repros.

973/1565 *Yusuf u Zulaykha* TKS H. 724
date: Safar 973/August–September 1565
scribe: Shaykh-Muhammad ibn Jalaluddin Jahrami
place: attributed to Shiraz
illustrations: 4
reference: Karatay, *Farsça*, no. 745

973/1566 *Yusuf u Zulaykha* AHT no. 81
date: Dhu'l-qaʾda 973/May–June 1566
scribe: Sultan-Bayazid ibn Mir Nizam
illustrations: 2 (1 pasted in)
references: Robinson, "Kevorkian," cat. no. CL (identified
as *Bustan* of Saʿdi); SOTH 1.XII.69, lot 193, and repro.
(folio 193a); Soudavar, cat. nos. 81a–b, and repros.

973/1565–66 *Yusuf u Zulaykha* AHT no. 80
date: 973/1565–66
patron: Abu'l-Ghazi Abdullah Bahadur Khan (on
paintings folios 65a and 123b)
scribe: Muhammad ibn Ishaq al-Shihabi al-Haravi
artist: attributed to Mahmud mudhahhib
place: attributed to Bukhara
illustrations: 5
references: Robinson, "Kevorkian," cat. no. CXLV; SOTH
23.IV.79, lot 160, and repros.; Soudavar, cat. nos. 80a–f,
and repros.

973–74/1565–67 *Khamsa* BN suppl. pers. 547
dates: *Tuhfat al-ahrar*: 974/1566–67; *Subhat al-abrar*:
Muharram 973/July–August 1565; *Yusuf u Zulaykha*:
mid-Rabiʿ II 973/early November 1565; *Layli u Majnun*:
mid-Jumada II 973/early January 1566 (dates not in
sequence)
scribe: Muhammad ibn Alaʾuddin Raza
place: Raza village, Bakharz district (Khurasan)
illustrations: 13 (*Tuhfat al-ahrar*: 2; *Subhat al-abrar*: 2; *Yusuf
u Zulaykha*: 5; *Layli u Majnun*: 3)
references: Blochet, *Persans*, 3: no. 1679; Robinson, *BL*,
151; Simpson, "Codicology," 135–39; Titley, *PMP*, 109

ca. 1565–70 *Yusuf u Zulaykha* BN Or. 4122
date: ca. 1565–70
scribe: Shah-Muhammad al-katib
place: attributed to Shiraz (Stchoukine) and Mashhad
(Gray)
illustrations: 11 plus 1 double-page frontispiece
references: Gray, *PP* 2, 144–45 (scribe incorrectly given as
Shah-Mahmud al-Nishapuri); Robinson, *BI*, cat. no.
153; Stchoukine, *MS*, no. 125; Titley, *MPM*, cat. no.
214

ca. 1565–70 *Yusuf u Zulayka* AMSG S1986.55
date: ca. 1565–70
place: attributed to Qazvin
illustrations: 4
reference: Lowry et al., cat. no. 187

975/1568 *Yusuf u Zulaykha* BN Or. 4389
date: Shaʾban 975/February 1568
place: attributed to Bukhara
illustrations: 3
reference: Titley, *MPM*, cat. no. 215

975/1567–68 *Subhat al-abrar* SOTH 21.IV.80, lot 196
date: 975/1567–68
scribe: Ishaq Muhammad ibn Ishaq Junabadi
place: attributed to Bukhara
illustrations: 9 (later additions)
references: Robinson, "Kevorkian," cat. no. CCCXXVI;
SOTH 7.II.49, lot 3; SOTH 21.IV.80, lot 196

975/1568 *Yusuf u Zulaykha* TKS H. 812
date: 12 Shawwal 975/10 April 1568
scribe: Shah-Mahmud al-katib Mashhadi
place: Shiraz
illustrations: 4 plus 1 double-page frontispiece and 1
double-page finispiece
reference: Karatay, *Farsça*, no. 744

976/1568–69 *Tuhfat al-ahrar* TKS R. 897
date: Rajab 976/20 December 1568–18 January 1569
scribe: Ali Reza al-katib
place: attributed to Bukhara
illustrations: 2 plus 1 double-page frontispiece
reference: Karatay, *Farsça*, no. 722

977/1569 *Yusuf u Zulaykha* BOD Greaves 1
date: Rabiʿ II 977/September–October 1569
place: attributed to Qazvin
illustrations: 5 plus 1 double-page frontispiece
references: Diba, "Lacquerwork" 2, cat. no. 46;
Robinson, *BL*, cat. nos. 1021–26 and pl. XXVII–XXVIII,
left; Stchoukine, *MS*, no. 68

977/1569–70 *Silsilat al-dhahab* GL 671
date: Ramadan 977/February–March 1570
scribe: Baba Shah Isfahani
place: attributed to Isfahan
illustrations: 14
references: Atabay, *Divan*, cat. no. 94; Diba,
"Lacquerwork" 2, 190, and cat. no. 38; Robinson, *PD*,
135–36, pl. 47; A. Welch, *Artists*, 157 n. 14

978/1570 *Yusuf u Zulaykha* CHR 18–20.X.94, lot 72
date: Rabiʿ I 978/August 1570
scribe: Mir-Husayn al-Husayni (known as Mir-Kulangi)
place: attributed to Bukhara
illustrations: 4 plus 1 double-page frontispiece
reference: CHR 18–20.X.94, lot 72, and repros.

978/1570 *Yusuf u Zulaykha* BN suppl. pers. 561
date: mid-Rajab 978/9–18 December 1570
scribe: Muhammad Husayn al-Husayni
place: Malan village, Bakharz district (Khurasan)
illustrations: 6
references: Blochet, *Persans*, 3: no. 1707; Schmitz,
"Harat," 112; Titley, *PMP*, 109–10

978–79/1570–72 Six masnavis TKS H. 1483
dates: *Subhat al-abrar*: 28 Shawwal 978/25 March 1571;
Tuhfat al-ahrar: 978/1570–71; *Layli u Majnun*: beginning of
Rabiʿ 1 979/late July 1571; *Silsilat al-dhahab*: beginning of
Dhuʾl-hijja 979/latter part of April 1572; last day of
Muharram 979/4 July 1570; 978/1570–71; *Salaman u
Absal*: last day of Jumada II 978/28 November 1570;
Khiradnama-i Iskandari: 978/1570–71 (dates not in
sequence)
scribe: Muhibb-Ali (on folios 184a and 229a)
place: attributed to Qazvin (Rogers) or Mashhad
(Stchoukine)
illustrations: 25 plus 1 double-page frontispiece and 4
finispieces (*Subhat al-abrar*: 5; *Tuhfat al-ahrar*: 2; *Layli u
Majnun*: 7; *Silsilat al-dhahab*: 5; *Salaman u Absal*: 4;
Khiradnama-i Iskandari: 2)
references: Çagman & Tanindi, no. 102; Karatay, *Farsça*,
no. 360; Rogers, *TKS*, pls. 113–18; Simpson,
"Codicology," 135–39; Stchoukine, "Shaykh," 3–11

ca. 1570 *Yusuf u Zulaykha* SOTH 14.VII.71, lot 298
date: ca. 1570
place: attributed to Bukhara
illustrations: 3
references: SOTH 24.VI.41, lot 83; SOTH 14.VII.71, lot 298

ca. 1570 *Yusuf u Zulaykha* SOTH 10.IV.89, lot 243
date: ca. 1570
place: attributed to Shiraz
illustrations: 3
reference: SOTH 10.IV.89, lot 243

ca. 1570–80 *Subhat al-abrar* BOD Ouseley Add. 23
date: ca. 1570–80
scribe: Jamaluddin Husayn Shirazi
place: attributed to Shiraz
illustrations: 8 plus 1 other damaged text illustration and
1 double-page frontispiece
reference: Robinson, *BL*, cat. nos. 868–77

ca. 1570–80 *Silsilat al-dhahab* (fragment) KEIR III.314–320
date: ca. 1570–80
place: attributed to Shiraz
illustrations: 1 (KEIR III.315)
reference: Robinson, *Keir*, cat. no. III.314–320 (with
previous references), and pl. 71

980/1572–73 *Yusuf u Zulaykha* IM 5032.I.79
date: 980/1572–73
scribe: Ali Reza al-katib
place: attributed to Bukhara
illustrations: 6 plus 1 double-page finispiece
references: Brosh, cat. no. 21; Milstein, cat. no. 29

980/1572–73 *Tufhat al-ahrar* CB MS 239
date: 980/1572–73
scribe: Mir-Husayn (known as Mir-Kulangi)
place: attributed to Bukhara
illustrations: 3
reference: Arberry et al., 3: cat. no. 239

981/1573–74 *Yusuf u Zulaykha* SOTH 3.V.77, lot 149
date: 981/1573–74
place: attributed to Bukhara
illustrations: 5
reference: SOTH 3.V.77, lot 149, and repro.

982/1574 *Yusuf u Zulaykha* ÖNB A.F. 108
date: 7 Rabiʿ 1 982/27 June 1574
scribe: Sharafuddin al-Sharif al-Kharazmi
place: Yazd
illustrations: 3 plus 1 double-page frontispiece and 1
double-page finispiece
reference: Duda, 1:40–42, and 2: pls. 195–99

982/1574–75 *Yusuf u Zulaykha* TKS R. 907
date: 982/1574–75
scribe: Muizuddin Muhammad al-Husayni
illustrations: 7
reference: Karatay, *Farsça*, no. 747

ca. 1575 *Haft awrang* BOD Elliot 149
date: ca. 1575
scribe: Muhammad Qivam katib Shirazi
place: attributed to Shiraz
illustrations: 20 (*Silsilat al-dhahab*: 5; *Salaman u Absal*: 1;
Tufhat al-ahrar: 2; *Subhat al-abrar*: 3; *Yusuf u Zulaykha*: 5;
Layli u Majnun: 3; *Khiradnama-i Iskandari*: 1)
references: Robinson, *BL*, cat. nos. 878–97; Stchoukine,
MS, no. 157

ca. 1575 *Yusuf u Zulaykha* BOD Whinfield 12
date: ca. 1575
place: attributed to Bukhara
illustrations: 5
reference: Robinson, *BL*, cat. nos. 988–92

ca. 1575 *Yusuf u Zulaykha* BOD Marsh 431
date: ca. 1575
scribe: Qivam al-katib al-Shirazi
place: attributed to Shiraz
illustrations: 3
references: Robinson, *BL*, cat. nos. 865–967; Stchoukine,
MS, no. 142

ca. 1575 *Yusuf u Zulaykha* SOTH 3.IV.78, lot 165
date: ca. 1575
place: attributed to Khurasan
illustrations: 3 (overpainted in Qajar period)
references: Robinson, "Kevorkian," cat. no. CLXXVI;
SOTH 3.IV.78, lot 165

984/1576–77 *Yusuf u Zulaykha* SOTH 26.IV.82, lot 91
date: 984/1576–77
place: attributed to Shiraz
illustrations: 4
reference: SOTH 26.IV.82, lot 91

ca. 1575–80 *Yusuf u Zulaykha* CHR 30.V.62, lot 216
date: ca. 1575–80
place: attributed to Shiraz
illustrations: 8
references: CHR 30.V.62, lot 216, and repro. facing p. 39;
Robinson, *BC*, cat. no. 53; Robinson, *PP*, pl. 25;
Stchoukine, *MS*, no. 150, and pl. LXXXIV

ca. 1580s *Tufhat al-ahra* SPL Dorn 426
date: manuscript dated 886/1487
place: attributed to Qazvin
illustrations: 3 (attributed to 1580s)
references: Ashrafi, 62–63, 75–78; Dorn, cat. no. 426;
USSR Colls., 31, 33, 35

ca. 1580s *Salaman u Absal* SOTH 7.XII.70, lot 199
date: ca. 1580s
place: attributed to Khurasan
illustrations: 4
references: Robinson, "Kevorkian," cat. no. CLXXV;
SOTH 7.XII.70, lot 199, and repro.

ca. 1580s *Subhat al-abrar* SOTH 22.X.93, lot 162
date: ca. 1580s
place: attributed to Shiraz
illustrations: 4
references: Robinson, "Kevorkian," cat. no. CLXXXIV;
SOTH 2.V.77, lot 169; SOTH 22.X.93, lot 162

ca. 1580–90 *Yusuf u Zulaykha* SOTH 17.XII.69, lot 283
date: ca. 1580–90
place: attributed to Qazvin
illustrations: 4
reference: SOTH 17.XII.69, lot 283

988/1581 *Haft awrang* KEV 889
date: 25 Dhuʾl-qaʾda 988/1 January 1581
place: attributed to Khurasan
illustrations: 27
references: Robinson, "Kevorkian," cat. no. CLXXXV;
Schmitz, "Harat," 113

9[8?]8/1580–81 *Yusuf u Zulaykha* FRE MS 79
date: 9[8?]8/1580–81
place: attributed to Shiraz
illustrations: 3 plus right half of finispiece
reference: Simsar, cat. no. 79

989/1581 *Salaman u Absal* TKS R. 915
date: Rabiʿ 1 989/April–May 1581
scribe: Baba Shah ibn Sultan-Ali
place: attributed to Isfahan
illustrations: 2
reference: Karatay, *Farsça*, no. 736

989/1581–82 *Yusuf u Zulaykha* SOTH 22.IV.80, lot 306
date: 989/1581–82
scribe: Ali Reza al-katib
place: attributed to Bukhara
illustrations: 2 (one incomplete)
references: Robinson, "Kevorkian," cat. no. CLII; SOTH
23.IV.79, lot 166, and repro.; SOTH 22.IV.80, lot 306, and
repro.

989/1581–82 *Yusuf u Zulaykha* SOTH 1.XII.69, lot 195
date: 989/1581–82
place: attributed to Qazvin
illustrations: 5
references: Robinson, "Kevorkian," cat. no. CXC; SOTH
1.XII.69, lot 195, and repro.

992/1584 *Silsilat al-dhahab* ÖNB N.F. 127
date: 20 Jumada I 992/30 May 1584
place: attributed to Shiraz
illustrations: 1 plus 4 double-page compositions
unrelated to text
reference: Duda, 1:67–69, and 2: pls. 318–21

993/1584–85 *Tufhat al-ahrar* CB MS 247
date: 993/1584–85
scribe: Shah-Husayn Shihabi
place: attributed to Isfahan
illustrations: 2
reference: Arberry et al., 3: cat. no. 247

994/1585–86 *Yusuf u Zulaykha SOTH 13.X.81, lot 235
date: 994/1585–86 (inscribed on painting folio 91b)
place: attributed to Bukhara
illustrations: 8
references: SOTH 3.IV.78, lot 160; SOTH 22.IV.80, lot 308;
SOTH 13.X.81, lot 235

995/1586–87 Silsilat al-dhahab HRM VP-992
date: 995/1586–87
place: attributed to Shiraz
illustrations: 4
references: Diakonova, 28, and pls. 32–33; Galerinka, 236
and fig. 14; USSR Colls., 38–39

995/1586–87 *Yusuf u Zulaykha SJML A./Nm. 1040
date: 995/1586–87
illustrations: 6
reference: Ashraf, 5:283–84

996/1588 Yusuf u Zulaykha BN suppl. pers. 1768
date: 10 Rabiʿ II 996/9 March 1588
place: attributed to southwest Iran
illustrations: 6 plus 1 blank space for a seventh
reference: Blochet, Persans, 2: no. 1709

1004/1595–96 Yusuf u Zulaykha BOD Elliot 418
date: 1004/1595–96
scribe: Badr-i Munir ibn Mahmud of Bukhara
place: attributed to Bukhara
illustrations: 13
reference: Robinson, BL, 994–1006, and pl. XXV

1005/1596–97 Silsilat al-dhahab BOD Elliot 337
date: 1005/1596–97
scribe: Badr-i Munir ibn Mahmud of Bukhara
place: attributed to Bukhara
illustrations: 4
reference: Robinson, BL, cat. nos. 1007–10

1006/1597–98 Haft awrang SPL IIHC-86
date: 1006/1597–98
scribe: Pir Muhammad al-katib
place: attributed to Shiraz
illustrations: 8 (Silsilat al-dhahab: 3; Subhat al-abrar: 1;
Yusuf u Zulaykha: 2; Layli u Majnun: 1; Khiradnama-i
Iskandari: 1)
reference: USSR Colls., 75–85

1007/1599 Yusuf u Zulaykha IOL MS 737
date: 24 Rajab 1007/20 February 1599
scribe: Mir-Salih al-katib
place: attributed to Bukhara
illustrations: 7
references: Ethé, 760, no. 1342; Robinson, IOL, cat.
no. 737

ca. 1575–1600 Yusuf u Zulaykha SOTH 23.IV.79, lot 162
date: ca. 1575–1600
place: attributed to Shiraz
illustrations: 5
reference: SOTH 23.IV.79, lot 162

late 16th century *Yusuf u Zulaykha LMV WAS 2292
date: late 16th century
place: attributed to Shiraz
illustrations: 5
reference: OIH, cat. no. 18, and repro.

late 16th century Silsilat al-dhahab ÖNB A.F. 18
date: late 16th century
place: attributed to Shiraz
illustrations: 2 plus 1 double-page frontispiece
reference: Duda, 1:15–19, and 2: pls. 190–94

late 16th century *Subhat al-abrar SJML A./Nm. 549
date: late 16th century
scribe: Muhammad al-Qivam al-katib al-Shirazi
place: attributed to Shiraz
illustrations: 3
reference: Ashraf, 5:278–79

late 16th century *Subhat al-abrar SJML A./Nm. 551
date: late 16th century
place: attributed to Shiraz
illustrations: 7
reference: Ashraf, 5:279–80

late 16th century *Yusuf u Zulaykha SJML A./Nm. 1043
date: late 16th century
place: attributed to Shiraz
illustrations: 2
reference: Ashraf, 5:284–85

late 16th century *Yusuf u Zulaykha SJML A./Nm. 1053
(M. no. 206)
date: late 16th century
place: attributed to Shiraz
illustrations: 2
reference: Ashraf, 5:284

late 16th century *Yusuf u Zulaykha SOTH 23.XI.76,
lot 402
date: late 16th century
place: attributed to Qazvin
illustrations: 8
reference: SOTH 23.XI.76, lot 402

late 16th century *Haft awrang SOTH 10.IV.89,
lot 245
date: late 16th century
illustrations: 3
reference: SOTH 10.IV.89, lot 245

late 16th century Yusuf u Zulaykha TKS H. 1084
date: late 16th century
place: attributed to Shiraz
illustrations: 13
reference: Karatay, Farsça, no. 749

This appendix includes illustrations to intact manuscripts only. Page numbers in Mudarris-Gilani and other text references generally include the entire section of text (equivalent to a chapter) to which an illustration relates. Page numbers are more precise in cases where an illustration relates to a specific section of the text or where individual illustrations relate to different episodes within the same section (*Tuhfat al-ahrar*, Mudarris-Gilani, 377–78 and 378–79). The titles within the individual masnavis generally correspond to the text rubrics; those in the Freer Jami have been standardized to conform to titles used elsewhere in this volume. Illustrations under the same title may have diverse iconographies.

An asterisk (*) denotes illustrations not examined firsthand or in reproduction (including unpublished slides and photographs) or whose iconography has not otherwise been confirmed.

1. *Silsilat al-dhahab*

Moses as a herdsman
Mudarris-Gilani, 15–16
TKS H. 1483, folio 109a (repro.: Stchoukine, "Shaykh," pl. 5)

Hypocritical Sufis dance
Mudarris-Gilani, 23–24
SPL IIHC-86, folio 8a

The difference between the dance of frauds and that of gnostics
Mudarris-Gilani, 24–25
TKS H. 1087, folio 34a

The story of the frog who hid in the minaret
Mudarris-Gilani, 28
BOD Elliot 149, folio 11a

The wise old man chides a foolish youth
Mudarris-Gilani, 33
FGA 46.12, folio 10a

The king tests his two slaves
Mudarris-Gilani, 41
CB MS 213, folio 13b
PWM MS 55.102, folio 14a

A simple-hearted man who has been robbed ties his drawers around his head
Mudarris-Gilani, 58–59
TKS H. 810, folio 18b

A learned discussion on the subject that the desired meaning of man is the perfection of humanity
Mudarris-Gilani, 72–73
IOL MS 366, folio 23b

The truth-seeking shaykh and the muttering disciple
Mudarris-Gilani, 60
ÖNB A.F. 18, folio 90a (repro.: Duda, 2: pl. 192)

The grammarian, the common man, and the Sufi converse in the same language, but their words have different meanings
Mudarris-Gilani, 73–74
TKS H. 1483, folio 123b

On encouraging the reading of the Koran
Mudarris-Gilani, 77–78
TKS H. 1087, folio 30a

The heron who had the urge to catch a dove
Mudarris-Gilani, 91–92
CB MS 213, folio 42a
HRM VP-992, folio 73a (repro.: *USSR Colls.*, 39 [caption switched]; Diakonova, fig. 32)
PWM MS 55.102, folio 28a (repro.: Skelton, "Bakharz," 199)

The champion who saw a sodomite prostrating on the ground at the Ka'ba
Mudarris-Gilani, 95–96
BOD Elliot 149, folio 29b

The questioning of a pious hermit
Mudarris-Gilani, 100–101
TKS H. 1483, folio 130b

A depraved man commits bestiality and is berated by Satan
Mudarris-Gilani, 109
IOL P&A 49, folio 61b (repro.: Robinson, *IOL*, 46)
FGA 46.12, folio 30a
TKS Y. 47, folio 29a

Iskandar arrives at a terrain covered with pebbles and tells his army they are gems
Mudarris-Gilani, 113–14
ÖNB A.F. 18, folio 133b (repro.: Duda, 2: pl. 193 [iconography of painting does not relate to surrounding text])
ÖNB N.F. 127, folio 90a (repro.: Duda, 2: pl. 224)

A master relates the parable about the hypocrisy of those who make a show of being Sufis
Mudarris-Gilani, 126
IOL MS 366, folio 40b

A desert Arab buys food in Rayy
Mudarris-Gilani, 129–30
HRM VP-922, folio 104a
TKS H. 810, folio 40b

The widow who was misled on her way to town to sell cooking fat
Mudarris-Gilani, 133–35
HRM VP-922, folio 107b

The simple peasant entreats the salesman not to sell his wonderful donkey
Mudarris-Gilani, 137–38
FGA 46.12, folio 38b
SPL IIHC-86, folio 35b

Hisham ibn Abdul-Malik watches Imam Zayn al-Abidin circumambulating the Ka'ba
Mudarris-Gilani, 141
AMSG S1986.44, folio 66a (repro.: Lowry et al., 148)
BOD Elliot 149, folio 42b
TKS R. 912, folio 230a

Majnun frees the gazelle because of its resemblance to Layli
Mudarris-Gilani, 155
TKS H. 810, folio 48a
ÖNB A.F. 18, folio 167b (repro.: Duda, 2: pl. 193)

The bear who slipped into the water and was mistaken for a fur skin
Mudarris-Gilani, 168
PWM MS 55.102, folio 49b (repro.: Skelton, "Bakharz," 200)

The princess sees the Aleppan youth
Mudarris-Gilani, 192–93
TKS Y. 47, folio 49a

The princess confesses her love for the Aleppan youth
Mudarris-Gilani, 193–94
BOD Elliot 337, folio 67b

A father advises his son about love
Mudarris-Gilani, 200–01
FGA 46.12, folio 52a
MOA MS 1961/II, folio 52a (repro.: Ashrafi, fig. 46; Maslenitsyna, fig. 110; *USSR Colls.*, 21)

The sage who witnessed the wondrous works of the gnostics
Mudarris-Gilani, 210
KEIR III.418, folio 7b

The Egyptian woman who was rooted to one spot for thirty years in a state of amazement
Mudarris-Gilani, 215
TKS R. 912, folio 250b
*SOTH 11.IV.88, lot 131, folio 43a (identifies the subject as a young man rather than a woman)

The bath-furnace stoker on fire while contemplating the prince's beauty
Mudarris-Gilani, 219–20
TKS R. 895, folio 166a

Layli and Majnun together in the wilderness
Mudarris-Gilani, 220–21
AMSG S1986.44, folio 102b
IOL P&A 49, folio 133a
KEIR III.315 (repro.: Robinson, *Keir*, pl. 71)
TKS R. 895, folio 167b

The dervish picks up his beloved's hair from the hammam floor
Mudarris-Gilani, 223–24
BOD Elliot 149, folio 64b
FGA 46.12, folio 59a

The Christian girl who fell in love with the Muslim youth
Mudarris-Gilani, 225
BOD Elliot 337, folio 78a
IOL MS 366, folio 70b

The handmaiden and slave of the caliph of Baghdad throw themselves into the Euphrates
Mudarris-Gilani, 227–28
TKS H. 810, folio 64a

The youth in love with his cousin relates his story to the king
Mudarris-Gilani, 229
BOD Elliot 337, folio 79a

Ria tells her situation to Mu'tamar
Mudarris-Gilani, 233–34
*SOTH, 11.IV.88, lot 131, folio 47a

The betrothal of Aynie and Ria
Mudarris-Gilani, 238–39
MOA MS 1961/II, folio 63b (repro.: Ashrafi, fig. 47; Malenitsyna, fig. 111; *USSR Colls.*, 23)

Bandits attack the caravan of Aynie and Ria
Mudarris-Gilani, 239–40
FGA 46.12, folio 64b
IOL MS 366, folio 75b
PWM MS 55.102, folio 70a

The shaykh informs the merchant of his wish to buy the singer Tuhfa
Mudarris-Gilani, 246–49
GL 671 (folio not specified)
TKS H. 1483, folio 167b

The old farmer finds a pot full of wheat grains
Mudarris-Gilani, 268–69
PWM MS 55.102, folio 79a
SPL IIHC-86, folio 69a (repro.: *USSR Colls.*, 77)

The old widow comes before Sultan Mahmud
Mudarris-Gilani, 270
HRM VP-992, folio 211b (repro.: *USSR Colls.*, 38 [caption switched]; Diakonova, fig. 33)

The old woman complains to Sanjar about the soldiers who robbed her
Mudarris-Gilani, 272–74
GL 671 (folio not specified)
TKS H. 1483, folio 174b
TKS R. 912, folio 267b

Sultan Ghazan kills an oppressor for a feed bag of hay
Mudarris-Gilani, 274–75
KEIR III.419, folio 15b
TKS Y. 47, folio 267b

Nushirvan pardons the cupbearer
Mudarris-Gilani, 283–84
IOL MS 366, folio 89a
PWM MS 55.102, folio 83b
TKS H. 1087, folio 267b

Ya'qub Sultan shoots the oppressive tyrant
Mudarris-Gilani, 294–95
AMSG S1986.44, folio 139a

Abu Ali Sina cures the Buyid suffering from melancholy
Mudarris-Gilani, 299–300
GL 671 (folio not specified)
TKS H. 810, folio 86b

The poet Unsari with Mahmud of Ghazna
Mudarris-Gilani, 303–5
BOD Elliot 149, folio 88a
TKS R. 895, folio 231b

2. Salaman u Absal

The philosopher tells the king the beginning of the story of Salaman and Absal
Mudarris-Gilani, 325; Arberry, 154–55
TKS H. 1483, folio 189a

Solomon and Bilqis sit together and converse frankly
Mudarris-Gilani, 330–31; Arberry, 161
FGA 46.12, folio 188a

Absal becomes Salaman's nurse
Mudarris-Gilani, 333
PWM MS 55.102, folio 98b
*SOTH 11.IV.88, lot 131, folio 67a

Salaman plays polo
Mudarris-Gilani, 336; Arberry, 168
BOD Elliot 149, folio 97b
BN suppl. pers. 1344, folio 26a
KEIR III.225
PWM MS 55.102, folio 99b
*SOTH 7.XII.70, lot 199, folio 3a
TKS H. 1483, folio 192a

Salaman comes to Absal at night
Mudarris-Gilani, 342; Arberry, 175–76
PWM MS 55.102, folio 101b
TKS H. 1483, folio 342a
TKS R. 915, folio 29a

The bedouin and the caliph
Mudarris-Gilani, 343–44; Arberry, 177–78
BN suppl. pers. 1344, folio 33b

The sage counsels Salaman
Mudarris-Gilani, 346–47; Arberry, 181
TKS H. 1483, folio 346a

Salaman and Absal embark upon the sea
Mudarris-Gilani, 349–50; Arberry, 185
TKS R. 912, folio 288a

Salaman and Absal repose on the happy isle
Mudarris-Gilani, 350–51; Arberry, 186
FGA 46.12, folio 194b
*SOTH 11.IV.88, lot 131, folio 71b (repro.: SOTH 15.IV.85, lot 328 [page number not specified])

Salaman kindles a fire, which he enters with Absal
Mudarris-Gilani, 355; Arberry, 192–93
TKS R. 915, folio 41a

Salaman is proclaimed king and crowned by his father
Mudarris-Gilani, 360
KEIR III.226

3. Tuhfat al-ahrar

The modest author discusses his work
Mudarris-Gilani, 376
TRN R. 13.8, folio 5a

The mi'raj of the Prophet
Mudarris-Gilani, 377–78 (second na't)
BOD Ouseley Add. 23, folio 27a
PWM MS 55.102, folio 113a
SOTH 18.X.95, lot 57 (folio not specified)
TKS H. 804, folio 6b
TKS R. 892, folio 7a
TKS R. 912, folio 5a

The Prophet in the veil of divine light
Mudarris-Gilani, 378–79 (second na't)
TKS H. 1483, folio 42a

The murid kisses the pir's feet
Mudarris-Gilani, 389–90 (first conversation)
BN suppl. pers. 547, folio 9b
BOD Elliot 186, folio 11a
FGA 46.12, folio 207b
PWM MS 55.102, folio 117a

The murid sees the light of certainty
Mudarris-Gilani, 391–93 (second conversation)
AMSG S1986.40, folio 25a

The truth-seeing pir and the murid
Mudarris-Gilani, 393–94 (third conversation)
*SOTH 18.X.95, lot 57 (folio not specified)

Yusuf is presented a mirror by the traveler from Canaan
Mudarris-Gilani, 399 (anecdote to second discourse: on the creation of mankind)
AMSG S1986.46, folio 34a (repro.: Lowry et al., 154 left)
AMSG S1986.52, folio 58b (illustration misplaced in relation to text; repro.: Lowry et al., 151)
CB MS 215, folio 37b (illustration misplaced in relation to text)
CB MS 239, folio 33b
CB MS 247, folio 34a
GULB LA 184, folio 29a (repro.: Gray, *OIA*, no. 124)
KEIR III.196
SAK MS 17, folio 29b (repro.: A. Welch, *CIA*, 4: MS 17)
SOTH 18.X.95, lot 57 (folio not specified)
SPL Dorn 425, folio 31a (repro.: *USSR Colls.*, 87)
TKS H. 810, folio 117b

Ali only notices his wound from the battle of Uhud at prayer time
Mudarris-Gilani, 403 (anecdote to fourth discourse: on lasting power of the five prayers)
TKS Y. 47, folio 106a

Ali ibn Muwafaq praying to God
Mudarris-Gilani, 410–11 (anecdote to seventh discourse: on pilgrimage to the House of God)
BOD Ouseley Add. 23, folio 93a (rubric text specifies Ghadr instead of Ali)

The flight of the tortoise
Mudarris-Gilani, 415 (anecdote to ninth discourse: on silence)
AMSG S1986.46, folio 49b (repro.: Lowry et al., 154 left)
AMSG S1986.52, folio 41a (repro.: Lowry et al., 150)
BN suppl. pers. 547, folio 17a
BOD Elliot 186, folio 19b
CB MS 215, folio 18a
CB MS 239, folio 50a
FGA 46.12, folio 215b
GULB LA 184, folio 42b
PWM MS 55.102, folio 124a
SAK MS 17, folio 48b (repro.: A. Welch, *CIA*, 4:66)
SPL Dorn 425, folio 46a (repro.: *USSR Colls.*, 89)
SPL Dorn 426, folio 50a (repro.: *USSR Colls.*, 31)
TKS R. 897, folio 50a (repro.: Inal, fig. 16)
TKS R. 912, folio 16a

The eleventh discourse: on the description of Sufis who have no distinguishing mark and live in extreme hardship
Mudarris-Gilani, 418
ÖNB A.F. 66, 20b (repro.: Duda, 2: pl. 38)

The Sufi dancing
Mudarris-Gilani, 419–20 (anecdote to eleventh discourse: description of Sufis)
TKS R. 892, folio 21a

The extortionist vizier with his severed hand
Mudarris-Gilani, 426–27 (anecdote to fourteenth discourse: description of viziers and court secretaries)
BOD Elliot 149, folio 123a
BOD Ouseley Add. 23, folio 125a (repainted; rubric different)
CHR 29.IV.70, lot 42 (folio not specified; repro.: CHR 29.IV.70, facing p. 24)
TKS H. 810, folio 126b
TKS H. 1483, folio 55a
TKS R. 888, folio 18b
TKS Y. 47, folio 112a

The old man courts a young beauty and is rejected
Mudarris-Gilani, 428–29 (anecdote to fifteenth discourse: on the awareness of old age)
GULB LA 184, folio 54a
SPL Dorn 425, folio 73a (repro.: *USSR Colls.*, 90)
SPL Dorn 426, folio 64a (repro.: *USSR Colls.*, 33)
*SOTH 11.IV.88, lot 131, folio 90a

The East African looks at himself in the mirror
Mudarris-Gilani, 433–34 (anecdote to seventeenth discourse: on the beauty of beloveds)
FGA 46.12, folio 221b

The lover looks at someone else in the presence of his beloved
Mudarris-Gilani, 436 (anecdote to eighteenth discourse: on love and its characteristics)
AMSG S1986.46, folio 70a (repro.: Lowry et al., 154 right)
AMSG S1986.52, folio 59a (repro.: Lowry et al., 151 left)
BOD Ouseley Add. 23, folio 136a (cropped)
CB MS 215, folio 63b
CB MS 247, folio 69a
ÖNB A.F. 66, folio 27a (repro.: Duda, 2: pl. 39)
TKS R. 897, folio 70a
TKS H. 804, folio 22a

The lean poet Lagari and the stout nobleman
Mudarris-Gilani, 439 (anecdote to nineteenth discourse: on poetry and the poet)
SPL Dorn 426, folio 74a (repro.: *USSR Colls.*, 35)

The author completes the book
Mudarris-Gilani, 442
TKS H. 1483, folio 59b

4. Subhat al-abrar

A gnostic has a vision of angels carrying trays of light to the poet Saʿdi
Mudarris-Gilani, 467–68 (anecdote to third aqd: on versed speech)
FGA 46.12, folio 147a
IM 5028.1.79, folio 16b (repro.: Milstein, 59)
KNM LNS 16 MS, folio 76a (repro. color: Atil, *Kuwait*, cat. no. 75)
*SJML A/Nm. 584, folio 19b
TKS R. 898, folio 26b

The sick king is cured by one physician
Mudarris-Gilani, 473–74 (anecdote to fifth aqd: on the unparalled uniqueness of God)
TKS H. 810, folio 141a
TKS H. 1483, folio 10a

The fish in search of the ocean
Mudarris-Gilani, 476–77 (anecdote to sixth aqd: on essence of divine truth)
TKS R. 899, folio 26a

Moses asks the Sufi-type why he does not prostrate himself before Adam
Mudarris-Gilani, 480 (anecdote to seventh aqd: describing Sufism, which means escaping the bond of formal ceremony)
BOD Ouseley Add. 23, folio 37a
SPL Dorn 429, folio 37a (repro.: Ashrafi, 59)
TKS R. 900, folio 27a

The pir's disciple seated in fire
Mudarris-Gilani, 483 (anecdote to eighth aqd: on the will of intention toward the desired truth)
CB MS 213, folio 64a
ÖNB A.F. 66, folio 45a (repro.: Duda, 2: pl. 40)

The vizier who fell into the pit of eminence
Mudarris-Gilani, 486 (anecdote to ninth aqd: on the stages of renunciation)
ÖNB Mixt. 1614, folio 36b
TKS R. 892, folio 44a

The pir rejects the ducks brought as presents by the murid
Mudarris-Gilani, 489 (anecdote to tenth aqd: on abstinence)
FGA 46.12, folio 153b
PWM MS 55.102, folio 146a
TKS R. 898, folio 48a

Jesus encounters the sleeping but wakeful-hearted man
Mudarris-Gilani, 492 (anecdote to eleventh aqd: on ascetic piety)
TKS R. 900, folio 37b

Abraham converts the old man to Islam after receiving remonstrances from heaven
Mudarris-Gilani, 507 (anecdote to sixteenth aqd: on hope)
*SOTH 11.IV.88, lot 131, folio 106b
SPL IIHC 86, folio 129b (repro.: *USSR Colls.*, 78)
TKS H. 1483, folio 19a
TKS R. 898, folio 66b
TKS R. 900, folio 50b

Shaykh Abu Turab Nasafi sleeps in the midst of battle
Mudarris-Gilani, 510 (anecdote to seventeenth aqd: on trust in God)
BN suppl. pers. 547, folio 45a
BOD Elliot 149, folio 147a (repro.: Robinson, *BL*, pl. 16)
TKS R. 888, folio 40a
TKS R. 912, folio 43a

The fickle old lover is knocked off the rooftop
Mudarris-Gilani, 515–16 (anecdote to nineteenth aqd: on loving)
BOD Elliot 186, folio 54b
BOD Ouseley Add. 23, folio 72a
CB MS 238, folio 14b
FGA 46.12, folio 162a
ÖNB A.F. 66, folio 57a (repro.: Duda, 2: pl. 41)
ÖNB Mixt. 1614, folio 62b (repro.: Duda, 2: pl. 162)
*SJML A./Nm. 549, folio 62b
SPL Dorn 429, folio 73b (repro.: *USSR Colls.*, 11)
TKS H. 804, folio 49b
TKS H. 810, folio 155a
TKS H. 1483, folio 21b
TKS R. 898, folio 75b
TKS R. 899, folio 57a
TKS R. 900, folio 57a

The caliph's slave girl and slave boy throw themselves into the Tigris
Mudarris-Gilani, 518–19 (anecdote to twentieth aqd: on delight and its advantages)
TKS R. 892, folio 55a

Zualnun converses with the love-mad youth
Mudarris-Gilani, 524 (anecdote to twenty-second aqd: on intimate closeness)
TKS R. 900, folio 64a

Zulaykha tries to prevent Yusuf from fleeing after he has seen her idols
Mudarris-Gilani, 526 (anecdote to twenty-third aqd: on modesty)
BOD Ouseley Add. 23, folio 82a
CB MS 238, folio 20b

The wanton youth meets the old thorn carrier
Mudarris-Gilani, 528–29 (anecdote to twenty-fourth aqd: on freedom)
BN suppl. pers. 547, folio 51a
BOD Elliot 149, folio 153b (rubric missing)
IM 5028.1.79, folio 67a (repro.: Milstein, 58)
ÖNB Mixt. 1614, folio 73b (repro.: Duda, 2: pl. 163)
PWM MS 55.102, folio 157b
*SJML A./Nm. 551, folio 79b
*SJML A./Nm. 584, folio 72a
SOTH 2.V.77, lot 170, folio 70b (repro.: SOTH 2.V.77, facing p. 72)
TKS R. 898, folio 88b

The man on his way to the Kaʿba is rewarded for his truthfulness
Mudarris-Gilani, 534 (anecdote to twenty-sixth aqd: on truthfulness)
TKS R. 900, folio 73a

The Persian hears Arabs talking and prays
Mudarris-Gilani, 536–37 (anecdote to twenty-seventh aqd: on sincerity)
TKS H. 1483, folio 27a
TKS R. 912, folio 51a

The Arab berates his guests for attempting to pay him for his hospitality
Mudarris-Gilani, 539-40 (anecdote to twenty-eighth aqd: on liberal giving and munificence)
FGA 46.12, folio 169b
TKS R. 898, folio 100a
TKS R. 900, folio 78a

The wise man who contended himself with one sprig out of the world's herb garden
Mudarris-Gilani, 541–42 (anecdote to twenty-ninth aqd: on contentment)
KNM LNS 16 MS, folio 32b

The noble-spirited old man berates the noble-born youth
Mudarris-Gilani, 544 (anecdote to thirtieth aqd: on humility)
SPL Dorn 429, folio 102a (repro.: *USSR Colls.*, 13)
TKS R. 900, folio 82b

The hermit who did not believe the devil when he pretended to be Jesus
Mudarris-Gilani, 546–47 (anecdote to thirty-first aqd: on meekness, humility, benevolence, and forgiveness)
ÖNB A.F. 66, folio 68b (repro.: Duda, 2: pl. 42)

An old woman inquires of the Prophet if she will go to heaven
Mudarris-Gilani, 549 (anecdote to thirty-second aqd: on openness of countenance)
BOD Ouseley Add. 23, folio 105b
*SJML A./Nm. 551, folio 100a

The story of the crow and the dove
Mudarris-Gilani, 551 (anecdote to thirty-third aqd: on showing love and union)
*SOTH 6.XII.67, lot 197 (folio not specified)

The Sufi with the Arab and his bound slave
Mudarris-Gilani, 553–54 (anecdote to thirty-fourth aqd: on the samaʿ dance)
BL Or. 2935, folio 157b
BOD Elliot 149, folio 162a
CB MS 238, folio 46b
TKS H. 1483, folio 32a
TKS R. 888, folio 167b
TKS R. 892, folio 67a

Umar ibn Abdul-Aziz accepts the advice of his slave
Mudarris-Gilani, 560–61 (anecdote to thirty-sixth aqd: on the goodwill of rulers)
IM 5028.1.79, folio 73a

Moses watches as a youth decapitates a man
Mudarris-Gilani, 563 (anecdote to thirty-seventh aqd: on people's indiscriminate acknowledgment of rulers)
BOD Ouseley Add. 23, folio 120a
ÖNB Mixt. 1614, folio 104a (repro.: Duda, 2: pl. 164)
*SJML A./Nm. 551, folio 115a
TKS R. 900, folio 98b

The townsman robs the villager's orchard
Mudarris-Gilani, 572–73 (anecdote to fortieth aqd: Jami's pleas to his readers)
FGA 46.12, folio 179b
*SJML A./Nm. 551, folio 124a

The author completes the book
Mudarris-Gilani, 573–75
TKS H. 1483, folio 37b

5. Yusuf u Zulaykha

The miʿraj of the Prophet
Mudarris-Gilani, 584–86; Bricteux, *YZ*, 10–13
BL Or. 4535, folio 8b
ELG 62, folio 9a
GEBO Litt. pers. M 45, folio 8b (repro.: Binyon et al., pl. XCII–A)
SPL IIHC-389, folio 9a (repro.: *USSR Colls.*, 69)
TKS H. 727, folio 14a
TKS H. 812, folio 10b
TKS H. 1084, folio 11a (repro.: Inal, fig. 18)
TKS R. 907, folio 10a
TKS Y. 47, folio 119b

The wisdom of love
Mudarris-Gilani, 593–94; Bricteux, *YZ*, 22–24; Pendlebury, 6
ÖNB A.F. 66, folio 85b (repro.: Duda, 2: pl. 43)

Adam seated with his descendants, including Yusuf
Mudarris-Gilani, 596–98; Bricteux, *YZ*, 27–29; Pendlebury, 9–10
BL Or. 4535, folio 18b
BN suppl. pers. 547, folio 71a
BN suppl. pers. 561, folio 21a
PWM MS 55.102, folio 178a

Zulaykha's background
Mudarris-Gilani, 601–4; Bricteux, *YZ*, 33–37
*JS no. 11 (folio not specified)
TKS R. 907, folio 29a

Zulaykha dreams of Yusuf for the first time
Mudarris-Gilani, 604–6; Bricteux, *YZ*, 37–40; Pendlebury, 14–15
BL Or. 4535, folio 25b
ELG 10, folio 25b
TKS H. 812, folio 38b

Zulaykha's nurse asks about the reason for her melancholy
Mudarris-Gilani, 609; Bricteux, *YZ*, 42–46; Pendlebury, 18–19
BOD Elliot 418, folio 12a
TKS R. 907, folio 36a

Zulaykha dreams of Yusuf for second time
Mudarris-Gilani, 611–13; Bricteux, *YZ*, 46–48; Pendlebury, 20–21
BOD Elliot 418, folio 13b (repro.: Gray, *PP* 1, pl. 13)

Zulaykha is bound in chains after a second vision
Mudarris-Gilani, 613–14; Bricteux, *YZ*, 48–49; Pendlebury, 21–22
BL Or. 4122, folio 38b (repro.: Stchoukine, *MS*, pl. L)
BL Or. 4535, folio 33b
BN suppl. pers. 561, folio 37b
BOD Elliot 149, folio 179a
BOD Greaves 1, folio 34b
BOD Marsh 431, folio 35b
BOD Ouseley 28, folio 105a
CB MS 211, folio 52b
CB MS 251, folio 37a
CUL MS MM 6.3, folio 37b (repro.: Guest, pl. 35a)
*ELG 10, folio 35a
ELG 62, folio 108a (folio out of original order)
ELG 53, folio 34b (repro.: Brosh, fig. 22)
IOL MS 3426, folio 37b
KNM LNS 10 MS, folio 37b
MET 13.228.8, folio 38a
*SOTH 1.XII.69, lot 195 (folio not specified; repro.: SOTH 1.XII.69, facing p. 97)
SPL IIHC-389, folio 33a (repro.: *USSR Colls.*, 71)
TKS H. 724, folio 35a
TKS H. 727, folio 29a
TKS H. 810, folio 187a
TKS R. 907, folio 40a

Zulaykha dreams of Yusuf for the third time
Mudarris-Gilani, 614–16; Bricteux, *YZ*, 49–52; Pendlebury, 22–24
BN suppl. pers. 1015, folio 34a
BOD Hyde 10, folio 39b
BOD Ouseley 77, folio 42b
GEBO Litt. pers. M 45, folio 35b (repro.: Stchoukine, *MS*, pl. XVII left)
TKS H. 726, folio 40a

Ambassadors from everywhere except Egypt arrive to ask for Zulaykha's hand in marriage
Mudarris-Gilani, 617–19; Bricteux, *YZ*, 52–55; Pendlebury, 25–26
BL Or. 4535, folio 37b
ELG 10, folio 39a
TKS R. 892, folio 88a

Zulaykha travels to Egypt
Mudarris-Gilani 621–24; Bricteux, *YZ*, 58–61; Pendlebury, 29–30
BOD Elliot 415, folio 43b
BOD Elliot 418, folio 17b (repro.: Robinson, *BL*, pl. XXV)

The aziz and his entourage meet Zulaykha
Mudarris-Gilani, 624–25; Bricteux, *YZ*, 62–63; Pendlebury, 31–32
BN suppl. pers. 547, folio 79b
BN suppl. pers. 1919, folio 17a (repainted in India)
BOD Elliot 149, folio 182b
GEBO Litt. pers. M 45, folio 43a (repro.: Stchoukine, *MS*, pl. XVI)
PWM MS 55.102, folio 186b (repro.: Skelton, "Bakharz," 200)
RYL Pers 20, folio 48b
SOTH 11.IV.88, lot 131, folio 136a (repro.: SOTH 11.IV.88, pl. X)

Zulaykha sees the aziz of Egypt through a slit in the tent and realizes that he is not the vision of her dreams
Mudarris-Gilani, 625–26; Bricteux, *YZ*, 63–66; Pendlebury, 32–34
BL Or. 4122, folio 51a
BL Or. 4535, folio 45a
ELG 10, folio 71b (folio out of original order)
ELG 62, folio 40a
RYL Pers 23, folio 42b (repro.: Robinson, *RL*, pl. XI)
SAK MS 8, folio 33b
TKS H. 728, folio 41b

The aziz and Zulaykha enter the capital of Egypt and the Egyptians come out to greet them
Mudarris-Gilani, 627–29; Bricteux, *YZ*, 66–69; Pendlebury, 34–36
AMSG S1986.55, folio 52a (replacement folio with blank space left for illustration)
BN suppl. pers. 561, folio 52a
BOD Elliot 418, folio 20b
FGA 46.12, folio 100b
IOL MS 737, folio 46a
SPL Dorn 430, folio 53a (repro.: *USSR Colls.*, 43)
SPL IIHC-389, folio 47a
TKS H. 727, folio 41a (repro.: Inal, fig. 8)
TKS R. 910, folio 45b (repro.: Stchoukine, "Poème," pl. XXI)
WAG W.644, folio 50b

Yusuf asks Jacob for a jeweled staff from heaven
Mudarris-Gilani, 633–34, Bricteux, *YZ*, 73–74
TKS R. 888, folio 71b

A celestial messenger brings Jacob a jeweled staff for Yusuf
Mudarris-Gilani, 634; Bricteux, *YZ*, 74
BN suppl. pers. 1015, folio 50a
TKS H. 726, folio 59a

Jacob kneels beside Yusuf, who is dreaming of sun, moon, and eleven stars
Mudarris-Gilani, 634–36; Bricteux, *YZ*, 74–75; Pendlebury, 40–41
BL Or. 4535, folio 53a
ELG 62, folio 49b

Yusuf's brothers ask Jacob for permission to take Yusuf to the country
Mudarris-Gilani, 639–41; Bricteux, *YZ*, 78–80; Pendlebury, 42–43
BL Or. 4535, folio 56a
ELG 10, folio 58b
ELG 62, folio 51b (repro.: Brosh, 72)
IOL MS 3426, folio 62a
TKS H. 804, folio 86a

Yusuf being ill treated by his brothers
Mudarris-Gilani, 640–41; Bricteux, *YZ*, 80–82; Pendlebury, 44–45
BL Or. 4535, folio 57b
LMV WAS 2292, folio 127a
*SOTH 3.IV.78, lot 158, folio 51a (repro.: SOTH 3.IV.78, facing p. 168)
TKS H. 1084, folio 67b

Yusuf is rescued from the well
Mudarris-Gilani, 642–43; Bricteux, *YZ*, 84–86; Pendlebury, 46–47
AHT no. 80a (repro. color: Soudavar, 213)
AHT no. 81a (repro. color: Soudavar, 216)
BL Or. 4122, folio 69a
BL Or. 4389, folio 58a
BL Or. 4535, folio 60b (repro.: Titley, *MPM*, fig. 24)
BN suppl. pers. 547, folio 85a
BOD Whinfield 12, folio 57b
CB MS 216, folio 65a
ELG 62, folio 55b (repro.: Brosh, 73)
FGA 46.12, folio 105a
IM 5032.1.79, folio 55a
IOL MS 737, folio 57b
IOS MS 9597, folio 64a (repro.: *USSR Colls.*, 49)
NYPL Spencer, Pers. MS 64, folio 53b (repro.: Schmitz, *NYPL*, fig. 110)
ÖNB A.F. 66, folio 102b (repro.: Duda, 2: pl. 44)
PWM MS 55.102, folio 192a
SAK MS 8, folio 45a
*SOTH 7.XII.70, lot 189 (folio not specified)
*SOTH 3.V.77, lot 149, folio 58a
*SOTH 22.IV.80, lot 306, folio 57b
*SOTH 18.X.95, lot 58, folio 49a
TKS H. 725, folio 52a
TKS H. 726, folio 74a
TKS H. 810, folio 197a
TKS H. 1084, folio 73a
TKS R. 907, folio 70b
TKS R. 910, folio 58a (repro.: Stchoukine, "Poème," pl. XXIV)

Yusuf bathes in the Nile
Mudarris-Gilani, 645–46; Bricteux, *YZ*, 88–91; Pendlebury, 49
AHT no. 80b (repro. color: Soudavar, 213)
BL Or. 4122, folio 73a (repro.: Stchoukine, *MS*, pl. XLIX)
BL Or. 4389, folio 59a
BL Or. 4535, folio 63a
BN suppl. pers. 561, folio 70b (repro.: Stchoukine *MS*, pl. LXXI)
BN suppl. pers. 1015, folio 61a
BOD Elliot 418, folio 24b
BOD Whinfield 12, folio 61a
ELG 10, folio 44a
IM 5032.1.79, folio 58a (repro.: Brosh, 79)
IOL MS 737, folio 61a
MET 13.228.5, folio 58b
*SJML A./Nm. 1040, folio 54b
*SOTH 3.V.77, lot 149, folio 61a
*SOTH 21.IV.80, lot 194, folio 52a
*SOTH 22.IV.80, lot 306, folio 60a (repro.: SOTH 23.IV.79, facing p. 120)

Yusuf arrives before the king of Egypt
Mudarris-Gilani, 646; Bricteux, *YZ*, 90–91; Pendlebury, 49–50
TKS R. 910, folio 61b

Zulaykha recognizes Yusuf at the Egyptian court
Mudarris/Gilani, 646–48; Bricteux, *YZ*, 91–93; Pendlebury, 50–51
ELG 10, folio 73b
*GEBO Litt. pers. M 45, folio 63a
SPL Dorn 430, folio 72a (repro.: *USSR Colls.*, 46)

Yusuf is sold at market in Misr (Egypt)
Mudarris/Gilani, 648–50; Bricteux, *YZ*, 93–95; Pendlebury, 52–54
AHT no. 80c (repro. color: Soudavar, 214)
AMSG S1986.55, folio 73a
BL Or. 4122, folio 76b (repro.: Gray, *PP* 2, 144)
BL Or. 4535, folio 67a
BN suppl. pers. 561, folio 73a
BN suppl. pers. 1015, folio 64b
BOD Elliot 149, folio 190a
BOD Elliot 415, folio 63a
BOD Hyde 10, folio 72b
BOD Marsh 431, folio 71a (repro.: Robinson, *BL*, pl. XV)
BOD Ouseley 77, folio 78b
BOD Whinfield 12, folio 63b
CB MS 216, folio 72a (repro.: Arberry et al., 2: pl. 43a)
CB MS 251, folio 72a
CUL MS MM 6.3, folio 73b
ELG 10, folio 75b
ELG 53, folio 67b
ELG 62, folio 62a (repro.: Brosh, 73)
IM 5032.1.79, folio 61a (repro.: Milstein, 61)
IOL MS 3426, folio 73b (repro.: Guest, pl. 31b)
IOS MS 9597, folio 71a (repro.: *USSR Colls.*, 51)
*JS no. 11 (folio not specified; repro.: *OAI*, p. 21)
KNM LNS 10 MS, folio 73b
MET 13.228.8, folio 73b
ÖNB A.F. 108, folio 59b (repro.: Duda, 2: pl. 196)
RYL Pers 23, folio 63b (repro.: Robinson, *RL*, 245)
*SOTH 23.XI.76, lot 402 (folio not specified; repro.: SOTH 23.XI.76, facing p. 44)
*SOTH, 21.IV.80, lot 194, folio 55b
SPL IIHC/389, folio 64a (repro.: *USSR Colls.*, 73)
TKS H. 725, folio 58b
TKS H. 726, folio 74a
TKS H. 727, folio 56a
TKS H. 810, folio 199b
TKS H. 812, folio 76a
TKS H. 1114, folio 86b
TKS R. 892, folio 98b
TKS R. 912, folio 73a

The beautiful Bazigha falls in love with Yusuf
Mudarris/Gilani, 650–54; Bricteux, *YZ*, 96–100; Pendlebury, 55–58
BOD Elliot 418, folio 27b
ELG 10, folio 79a

Yusuf tends his flocks
Mudarris/Gilani, 657–59; Bricteux, *YZ*, 105–7; Pendlebury, 61–62
BL Or. 4122, folio 87b
BN suppl. pers. 561, folio 84b
BN pers. 1768, folio 100b
ELG 10, folio 87a
ELG 62, folio 73b (repro.: Brosh, 74)
FGA 46.12, folio 110b
IOS MS 9597, folio 81a (repro.: *USSR Colls.*, 52)
MET 13.228.5, folio 69a
*SOTH 18.X.95, lot 58, folio 65a
TKS H. 810, folio 203b
TKS H. 1084, folio 93a

Zulaykha implores Yusuf for his attention but is refused
Mudarris/Gilani, 664–66; Bricteux, *YZ*, 114–17; Pendlebury, 63–64
BL Or. 4535, folio 79a
ELG 10, folio 96a
*JS no. 11 (folio not specified)

Zulaykha's maidens wait on Yusuf in her beautiful garden
Mudarris/Gilani, 666–69; Bricteux, *YZ*, 117–20; Pendlebury, 71–72
BL Or. 4122, folio 98b
BN suppl. pers. 561, folio 96a
BOD Elliot 418, folio 33a
ELG 10, folio 100b
IM 5032.1.79, folio 77a
IOS MS 9597, folio 90a (repro.: *USSR Colls.*, 53)
PWM MS 55.102, folio 200b
*SOTH 23.IV.79, lot 159 (folio not specified; repro.: SOTH 23.IV.79, facing p. 108)
TKS H. 724, folio 92a
TKS H. 725, folio 75a
TKS H. 1084, folio 104a
TKS R. 892, folio 105a

Yusuf preaches to Zulaykha's maidens in her garden
Mudarris/Gilani, 669–71; Bricteux, *YZ*, 120–23; Pendlebury, 72–74
AMSG S1986.55, folio 94b
BL Or. 4122, folio 101a (repro.: Stchoukine, *MS*, pl. LI)
BL Or. 4535, folio 83b
BL suppl. pers. 1015, folio 84b
BOD Elliot 186, folio 200b
CB MS 211, folio 101b
CB MS 251, folio 94a
ELG 10, folio 101b
ELG 62, folio 86b
FGA 46.12, folio 114b
FRE MS 79, folio 86a
NYPL Spencer, Pers. MS 64, folio 76b (repro.: Elgood, fig. 5)
*SOTH 3.V.77, lot 149, folio 81b
*SOTH 3.IV.78, lot 165 (folio not specified; repainted in nineteenth century; repro.: SOTH 3.IV.78, facing p. 192)
*SOTH 21.IV.80, lot 194, folio 71b
TKS H. 727, folio 72a
TKS R. 888, folio 81b
TKS R. 907, folio 97a

Zulaykha's newly built palace
Mudarris/Gilani, 673–74; Bricteux, *YZ*, 126–28; Pendlebury, 77–78
ELG 10, folio 102b
ÖNB Mixt. 1480, folio 80a (underdrawing only)
SAK MS 8, folio 66b
TKS H. 1084, folio 112a

Zulaykha takes Yusuf to her palace
Mudarris/Gilani, 675–78; Bricteux, *YZ*, 128–32; Pendlebury, 78–81
BL Or. 4535, folio 89b
BN suppl. pers. 1919, folio 32b
BOD Elliot 418, folio 36b
ELG 10, folio 109a
RYL Pers 23, folio 89a (repro.: Robinson, *RL*, 246)

Zulaykha takes Yusuf into the seventh chamber
Mudarris/Gilani, 678–79; Bricteux, *YZ*, 133–40; Pendlebury, 81–83
BOD Elliot 149, folio 199a
BOD Elliot 418, folio 37b
ELG 10, folio 109a
GEBO Litt. pers. M 45, folio 91b (repro.: Binyon et al., pl. XCII/B)
IOL MS 737, folio 90a
*SOTH 3.V.77, lot 149, folio 84b
*SOTH 11.IV.88, lot 131, folio 150b
TKS H. 728, folio 90a
TKS H. 1084, folio 119a
TKS R. 907, folio 110a
TKS R. 910, folio 93b

Zulaykha threatens suicide if Yusuf does not yield to her advances
Mudarris/Gilani, 682–83; Bricteux, *YZ*, 137–38; Pendlebury, 84–85
BL Or. 4535, folio 94b
BOD Greaves I, folio 95b (repro.: Robinson, *BL*, pl. XXVII)
*CHR 30.V.62, lot 216 (folio not specified; repro.: Stchoukine, *MS*, pl. LXXXIV)
KNM LNS 10 MS, folio 109b
RYL Pers 20, folio 107b (repro.: Robinson, *RL*, 156)
SPL IIHC/86, folio 175a (repro.: *USSR Colls.*, 79)
TKS H. 1084, folio 124a
TKS Y. 47, folio 147b

Zulaykha tries to hold back the fleeing Yusuf
Mudarris/Gilani, 683–84; Bricteux, *YZ*, 139; Pendlebury, 85–86
BL Or. 4535, folio 96a (repro.: Arnold, *ONT*, pl. x)
ELG 62, folio 99b (repro.: Brosh, 74)
IOS MS 9597, folio 106b (repro.: *USSR Colls.*, 55)
MET 13.228.5, folio 91a
SPL Dorn 430, folio 110b (repro.: *USSR Colls.*, 46)
TKS H. 810, folio 212a
TRN R. 13.8, folio 146a

Yusuf encounters the aziz outside Zulaykha's palace and Zulaykha accuses Yusuf
Mudarris/Gilani, 684–87; Bricteux, *YZ*, 140–43, Pendlebury, 87–88
BN suppl. pers. 561, folio 111a
BOD Elliot 186, folio 206b
BOD Whinfield 12, folio 97b
ELG 10, folio 120a
*SOTH 10.IV.89, lot 243, folio 34a

The infant witness testifies to Yusuf's innocence
Mudarris/Gilani, 687–88; Bricteux, *YZ*, 144–46; Pendlebury, 89–90
BL Or. 4535, folio 99a
BOD Marsh 431, folio 111b (repro.: Stchoukine, *MS*, pl. LXIV)
ELG 10, folio 123b
FGA 46.12, folio 120a
TKS H. 1084, folio 129b

Egyptian women overwhelmed by Yusuf's beauty
Mudarris/Gilani, 689–90; Bricteux, *YZ*, 150–52; Pendlebury, 92–95
AMSG S1986.55, folio 118a (repro.: Lowry et al., 159)
BL Or. 2935, folio 198a
BL Or. 4535, folio 104a (repro.: Stchoukine, *MS*, pl. LXXII)
BN suppl. pers. 547, folio 99a
BN suppl. pers. 561, folio 148b
BN suppl. pers. 1015, folio 104a
BOD Elliot 186, folio 209b (repro.: Stchoukine, *MS*, pl. LXIII)
BOD Elliot 415, folio 108a
BOD Elliot 418, folio 42b
BOD Greaves I, folio 104a
BOD Hyde 10, folio 117a
BOD Ouseley 77, folio 127a
BOD Whinfield 12, folio 103a
CB MS 211, folio 125a
CB MS 216, folio 109a (repro.: Arberry et al., 2: pl. 43b)
CB MS 251, folio 117a
CUL MS MM 6.3, folio 118a (repro.: Guest, pl. 35b)
ELG 10, folio 128b
ELG 53, folio 109a
FSB MS Orient. P77
GEBO Litt. pers. M 45, folio 103b
IM 5032.1.79, folio 98a (repro.: Milstein, 62)
IOL MS 737, folio 102b
IOL MS 3426, folio 117b
IOS MS 9597, folio 115b (repro.: *USSR Colls.*, 57)
*JS no. 11 (folio not specified)
KNM LNS 10 MS, folio 120a
MET 13.228.8, folio 102b
NYPL Spencer, Pers. MS 64, folio 95b (repro.: Elgood, fig. 3)
*ÖNB A.F. 66, folio 121a
ÖNB A.F. 108, folio 95b (repro.: Duda, 2: pl. 197)
PWM MS 55.102, folio 207b
RYL Pers 20, folio 118a (repro.: Robinson, *RL*, 157)
SAK MS 8, folio 79a

*SJML A./Nm. 1050 (M. no. 118), folio 103a
*SJML A./Nm. 1040, folio 91b
*SOTH 3.V.77, lot 149, folio 104a
SOTH 23.IV.79, lot 162 (folio not specified; repro.: SOTH 23.IV.79, p. 109)
SOTH 18.X.95, lot 58, folio 92a (repro.: SOTH 21.IV.80, facing p. 152)
SPL Dorn 430, folio 120a (repro.: *USSR Colls.*, 47)
SPL IIHC-389, folio 103a (repro.: *USSR Colls.*, 74)
TKS H. 724, folio 116b
TKS H. 725, folio 95a
TKS H. 726, folio 119a
TKS H. 727, folio 88a
TKS H. 810, folio 215b
TKS H. 812, folio 120b
TKS H. 1084, folio 137a
TKS H. 1114, folio 141a
TKS R. 910, folio 102b
TKS R. 911, folio 35a
TKS R. 912, folio 96a
WAG W.644, folio 116a

Egyptian women implore Yusuf to cease his cruel treatment of Zulaykha
Mudarris-Gilani, 693–96; Bricteux, *YZ*, 153–55; Pendlebury, 96–98
ELG 10, folio 131a

Yusuf being led to prison
Mudarris-Gilani, 699–700; Bricteux, *YZ*, 158–59; Pendlebury, 104–5
BL Or. 4535, folio 109b
ELG 10, folio 136a

Zulaykha goes to prison at night to see Yusuf
Mudarris-Gilani, 702–5; Bricteux, *YZ*, 164–67; Pendlebury, 104–5
BOD Elliot 418, folio 47a
ELG 10, folio 144b
IOS MS 9597, folio 128a (repro.: *USSR Colls.*, 59)
SAK MS 8, folio 87b
TKS H. 1084, folio 149a (repro.: Inal, fig. 14)

The king of Egypt chastizes the Egyptian women for spreading tales about Yusuf
Mudarris-Gilani, 711–12; Bricteux, *YZ*, 175–77; Pendlebury, 112–13
BL Or. 4535, folio 121b
ELG 10, folio 152b

Yusuf rides from prison to court of Egyptian king
Mudarris-Gilani, 712–13; Bricteux, *YZ*, 178–79; Pendlebury, 113–14
BN suppl. pers. 547, folio 106b
BN suppl. pers. 561, folio 140b
PWM MS 55.102, folio 214a
SAK MS 8, folio 94a
*SJML A./Nm. 1053 (M. no. 206), folio 87b
SPL IIHC-86, folio 182a (repro.: *USSR Colls.*, 81)
TKS R. 892, folio 120b

Yusuf seated with king of Egypt and interprets his dreams
Mudarris-Gilani, 713–14; Bricteux, *YZ*, 179–81; Pendlebury, 114–15
AHT no. 80d (repro. color: Soudavar, 214)
BL Or. 4122, folio 140b
BL Or. 4389, folio 110a
BN suppl. pers. 547, folio 106a
BN suppl. pers. 1015, folio 123a
BOD Greaves I, folio 123a (repro.: Robinson *BL*, pl. XXVII)
CHR 18.X.94, lot 72 (folio not specified; repro.: CHR 18.X.94, p. 47)
ELG 10, folio 154a
GEBO Litt. pers. M 45, folio 122b (repro.: Stchoukine, *MS*, pl. XVII right)
IOS MS 9597, folio 138a (repro.: *USSR Colls.*, 61)
*SOTH 11.IV.88, lot 131, folio 157b
SOTH 18.X.95, lot 58, folio 111a (repro.: SOTH 18.X.95, p. 50)
TKS H. 724, folio 138a
TKS H. 725, folio 113a
TKS H. 1084, folio 160a

The aged Zulaykha builds herself a cabin along Yusuf's path
Mudarris-Gilani, 718–20; Bricteux, *YZ*, 186–88; Pendlebury, 118–20
BL Or. 4535, folio 129a
*SOTH 18.X.95, lot 58, folio 116a

The aged Zulaykha watches Yusuf ride by and is unable to attract his attention
Mudarris-Gilani, 720–21; Bricteux, *YZ*, 189–90; Pendlebury, 120–21
BOD Elliot 149, folio 212a
ELG 10, folio 160b
IOL MS 3426, folio 147b
*SOTH 1.XII.69, lot 195 (folio not specified)
*SOTH 23.IV.79, lot 160, folio 130b

Zulaykha smashes her idols and prays
Mudarris-Gilani, 721–22; Bricteux, *YZ*, 190–91; Pendlebury, 121
BL Or. 4535, folio 131a

Yusuf, riding with attendants, finally recognizes the aged Zulaykha
Mudarris-Gilani, 722–23; Bricteux, *YZ*, 191–92; Pendlebury, 121–122
AHT no. 80e (repro. color: Soudavar, 215)
CB MS 211, folio 146a
CUL MS MM 6.3, folio 147a
ELG 10, folio 163b
ELG 53, folio 136b
ELG 62, folio 132b
FRE MS 79, folio 139a
IM 5032.1.79, folio 122a (repro.: Milstein, 63)
IOS MS 9597, folio 146a (repro.: *USSR Colls.*, 62)
NYPL Spencer, Pers. MS 64, folio 120b (repro.: Elgood, fig. 8)
RYL Pers 20, folio 148a
SAK MS 8, folio 100a
SOTH 21–22.XI.85, lot 416, folio 132a
TKS H. 728, folio 126a
TKS H. 1084, folio 171a

The aged Zulaykha comes before Yusuf enthroned
Mudarris-Gilani, 723–24, Bricteux, *YZ*, 192–94, Pendlebury, 123–24
BL Or. 4535, folio 133a
ELG 10, folio 165a

Yusuf gives a royal banquet in honor of his marriage
Mudarris-Gilani, 725; Bricteux, *YZ*, 195; Pendlebury, 126
BOD Ouseley 77, folio 163b
ELG 53, folio 142a
FGA 46.12, folio 132a
WAG W.644, folio 150b

Yusuf and Zulaykha on their wedding night
Mudarris-Gilani, 726–28; Bricteux, *YZ*, 196–97; Pendlebury, 126–28
BL Or. 4122, folio 155b
BL Or. 4535, folio 135b (Yusuf and Zulaykha seated)
BL Or. 4535, folio 136b (Yusuf and Zulaykha in bed)
BN suppl. pers. 1015, folio 135a
BOD Elliot 418, folio 56a (repro.: Robinson, *BL*, pl. XXV)
CHR 30.V.62, lot 216 (folio not specified; repro.: Robinson, *PP*, pl. 25; CHR 30.V.62, facing p. 39)
ELG 10, folio 167a
ELG 62, folio 138b
FRE MS 79, folio 145a
IOS MS 9597, folio 152a (repro.: *USSR Colls.*, 63)
MET 13.228.8, folio 139b
ÖNB A.F. 108, folio 124a (repro.: Duda, 2: pl. 198)
RYL Pers 23, folio 133b (repro.: Robinson, *RL*, 248)
*SOTH 10.IV.89, lot 243, folio 74b
SPL Dorn 430, folio 156b (repro.: *USSR Colls.*, 48)
TKS H. 727, folio 115a

Yusuf and Zulaykha in the oratory
Mudarris-Gilani, 728–30; Bricteux, *YZ*, 198–201; Pendlebury, 130
ELG 10, folio 171b
TKS H. 726, folio 158a
TKS R. 888, folio 97a

Gabriel tells Yusuf his death is near
Mudarris-Gilani, 732–33; Bricteux, *YZ*, 204; Pendlebury, 133
BOD Greaves I, folio 140b (repro.: Robinson, *BL*, pl. XXVIII)
ELG 10, folio 174b

The death of Yusuf
Mudarris-Gilani, 733; Bricteux, *YZ*, 204; Pendlebury, 133
BOD Elliot 418, folio 59
IOS MS 9597, folio 159 (repro.: *USSR Colls.*, 65)
*SJML A./Nm. 1040, folio 124
TKS H. 727, folio 122

Zulaykha mourns over Yusuf's tomb
Mudarris-Gilani, 734–36; Bricteux, *YZ*, 205–8; Pendlebury, 133–35
RYL Pers 20, folio 162b

6. Layli u Majnun

Qays first glimpses Layli
Mudarris-Gilani, 768–70
BOD Elliot 149, folio 226a (repro.: Robinson, *BL*, pl. XVII)
FGA 46.12, folio 231a
PWM MS 55.102, folio 231b
TKS H. 1483, folio 65b

Majnun and Layli meet and she confesses her love and suffering
Mudarris-Gilani, 772–75
CB MS 213, folio 98a
SOTH I.XII.69, lot 190 (folio not specified; repro.:
SOTH I.XII.69, facing p. 93)
TKS H. 810, folio 242b

Majnun goes to Layli again
Mudarris-Gilani, 793–95
SOTH 11.IV.88, lot 131, folio 178b (repro.: SOTH 11.IV.88, pl.
IX)
TKS R. 912, folio 126b

Majnun goes on pilgrimage
Mudarris-Gilani, 795–97
TKS Y. 47, folio 178a

The caliph hears of Majnun's love for Layli
Mudarris-Gilani, 837–38
BOD Elliot 149, folio 246b

Layli's father entertains Majnun's father, who has come to ask
for Layli's hand in marriage
Mudarris-Gilani, 808–12
TKS H. 1483, folio 77a
TKS Y. 47, folio 182b

Naufal visits Majnun in the desert
Mudarris-Gilani, 815–22
CB MS 132, folio 111a
ÖNB A.F. 66, folio 166b (repro.: Duda, 2: pl. 45)
PWM MS 55.102, folio 246b (repro.: Skelton, "Bakharz," 203)
TKS R. 888, folio 121a
TKS R. 912, folio 155a

Majnun buys a gazelle's freedom
Mudarris-Gilani, 825–28
*SOTH 11.IV.88, lot 131, folio 187b
TKS H. 1483, folio 81b

Majnun meets a shepherd in the desert and hears news of Layli
Mudarris-Gilani, 828–32
BN suppl. pers. 547, folio 140b
PWM MS 55.102, folio 250b

Majnun approaches the camp of Layli's caravan
Mudarris-Gilani, 841–44
FGA 46.12, folio 253a

Majnun and Layli at the Ka'ba
Mudarris-Gilani, 844–46
SPL IIHC-86, folio 204a (repro.: *USSR Colls.*, 83)
TKS H. 1483, folio 86b (repro.: Stchoukine, "Shaykh," pl.
III)

The youth from Saqif asks for Layli's hand in marriage
Mudarris-Gilani, 846–51
TKS R. 912, folio 166a

Majnun in wilderness with animals after hearing of Layli's marriage
Mudarris-Gilani, 851–54
BN suppl. pers. 547, folio 148b
CB MS 213, folio 122a
KEIR III.198

Majnun becomes increasingly melancholic about the news of Layli's
marriage
Mudarris-Gilani, 854–57
BOD Elliot 149, folio 252a
TKS H. 810, folio 268a

A messenger delivers Layli's letter to Majnun in the wilderness
Mudarris-Gilani, 864–68
ÖNB A.F. 66, folio 185a (repro.: Duda, 2: pl. 46)

Majnun meets a dog from Layli's camp
Mudarris-Gilani, 875–79
BN suppl. pers. 547, folio 148b
TKS H. 1483, folio 95b

Majnun comes before Layli disguised as a sheep
Mudarris-Gilani, 879–82
FGA 46.12, folio 264a

Layli revives the fainted Majnun
Mudarris-Gilani, 882
CB MS 213, folio 130a
PWM MS 55.102, folio 266b

Majnun prays to Layli
Mudarris-Gilanii, 883
ÖNB A.F. 66, folio 191a (repro.: Duda, 2: pl. 47)

Majnun goes to Layli's tent in beggar's garb
Mudarris-Gilani, 884–86
BOD Elliot 186, folio 159a
TKS H. 1483, folio 98a (repro.: Stchoukine, "Shaykh," pl. IV)
TKS R. 892, folio 178a
TKS R. 912, folio 154a

Majnun has a final vision of Layli
Mudarris-Gilani, 886–90
BN suppl. pers. 547, folio 158b
*SOTH 11.IV.88, lot 131, folio 202a
TKS H. 804, folio 157b

The Arabs hear about Majnun and pay him a visit
Mudarris-Gilani, 890–92
*SOTH 11.IV.88, lot 131, folio 204b

The Arabs find Majnun dead
Mudarris-Gilani, 892–97
PWM MS 55.102, folio 270a
TKS H. 1483, folio 100b
TKS R. 888, folio 139a
TRN R. 13.8, folio 108b

7. Khiradnama-i Iskandari

The mi'raj of the Prophet
Mudarris-Gilani, 916–17
FGA 46.12, folio 275a

On the verge of death, Philip asks Aristotle to write a book of wisdom
for Iskandar
Mudarris-Gilani, 933–35
TKS H. 1483, folio 207a
TKS R. 892, folio 195b

Iskandar is elevated to kingship
Mudarris-Gilani, 937–38
TKS H. 804, folio 172b
TKS R. 912, folio 169b

The groom and his father witness the king's generosity
Mudarris-Gilani, 938–39
KEIR III.197

The camel who on the advice of the fox jumped into the water
Mudarris-Gilani, 941
PWM MS 55.102, folio 285a (repro.: Skelton, "Bakharz," 204)

Hippocrates takes the pulse of the enamored prince
Mudarris-Gilani, 952–56
SPL IIHC-86, folio 245a (repro.: *USSR Colls.*, 85)
TKS R. 892, folio 202a

The ugly man who made his house beautiful
Mudarris-Gilani, 963–64
ÖNB A.F. 66, folio 221a (repro.: Duda, 2: pl. 48)

Iskandar's arrival in India
Mudarris-Gilani, 970
PWM MS 55.102, folio 296b

Khusraw Parviz and Shirin deal with the fishmonger
Mudarris-Gilani, 971–72
BN suppl. pers. 547, folio 181b
CB MS 213, folio 156b
FGA 46.12, folio 291a
TKS Y. 47, folio 227b

Iskandar hears of the wisdom of Aristotle's students and offers them
gold
Mudarris-Gilani, 979–80
BOD Elliot 149, folio 287b

The king begs the wise man to come reside with him
Mudarris-Gilani, 986–87
BOD Elliot 186, folio 101b
CB MS 213, folio 161b

Iskandar arrives at Qaf mountain from the sea and asks its angel for
guidance
Mudarris-Gilani, 989–91
TKS R. 892, folio 214a

Iskandar suffers a nosebleed and is laid down to rest
Mudarris-Gilani, 993–97
FGA 46.12, folio 298a
TKS H. 1483, folio 223b (repro.: Stchoukine, "Shaykh," pl.
VI)

Iskandar specifies in his will that his hand should be brought
outside his coffin
Mudarris-Gilani, 997–98
TKS R. 912, folio 187b

Iskandar's death
Mudarris-Gilani, 998–99
ÖNB A.F. 66, folio 234a (repro.: Duda, 2: pl. 49)

The conclusion of the masnavi
Mudarris-Gilani, 1012–13
TRN R. 13.8, folio 195b

APPENDIX E

Artists' Oeuvres

Transcriptions and translations by Massumeh Farhad, in consultation with Wheeler Thackston, unless otherwise noted.

This listing contains works, documented through colophons and signatures, by the artists employed by Sultan Ibrahim Mirza. Most of the works have been examined at firsthand or in reproduction, and the Persian transcriptions and English translations have been prepared for this study. Previously published transcriptions are annotated with the author's name in parentheses (e.g., Atabay, Mehdi Bayani). Transcriptions that cannot be verified are marked with an asterisk (*). The commentary that occasionally appears at the end of the entries is by Simpson.

1. SHAH-MAHMUD AL-NISHAPURI

Dated Manuscripts and Calligraphies

922/1516–17 Calligraphy TKS H. 2156
 signed and dated (folio 63b, top):

كتبه العبد الفقير المذنب \ شاه محمود
النيشابوري \ غفر ذنوبه \ فى شهور سنه اثنى و
عشرين و تسعمايه

Written by the lowly, sinful servant Shah-Mahmud al-Nishapuri, may his sins be forgiven, in the months of the year 922/1516–17.

923/1517–18 Ali ibn Abi Talib, CB MS 232
 Vassiyatnama
 signed and dated (folio 10a):

كتبه العبد المذنب شاه محمود النيشابورى \
غفر الله ذنوبه فى شهور \ سنه ٩٢٣

Written by the sinful servant Shah-Mahmud al-Nishapuri, may God forgive his sins, in the months of the year 923/1517–18.

reference: Arberry et al., 3: no. 232.

923/1517–18 *Sa'di, *Bustan* BAY
 signed and dated:

تمَت الكتاب بعون الملك الوهاب، كتبه العبد الفقير
المذنب اقل عباد الله شاه محمود نيشابورى غفر
الله ذنوبه و ستر عيوبه، فى تاريخ ثلث و عشرين
و تسعمائة الهجرية
(Mehdi Bayani)

The book was finished with the help of the all-giving Almighty, written by the lowly, sinful, the lowliest of God's servants, Shah-Mahmud Nishapuri, may his sins be forgiven and his faults concealed, in the year 923/1517–18 of the Prophet's hegira.

reference: Mehdi Bayani, 1–2:301.

925/1519 Sa'di, *Bustan* TKS R. 930
Mashhad
signed, dated, and located (folio 152b):

تمَت الكتاب بعون الملك الوهاب كتبه العبد المذنب \
شاه محمود النيشابوري \ بمشهد مقدسيه \
رضويه عليه التحيه و الثناى فى شهر رجب سنه \
خمس و عشرين و تسعمانه اللهم اغفر لقايله \
و لناظره و لصاحبه و لكاتبه \ بحق محمد و آله

*The book was completed with the help of the all-giving Almighty,
written by the sinful servant Shah-Mahmud al-Nishapuri, in the
holy, blessed Mashhad, salutations and praise be upon it, in the
month of Rajab, the year 925/June–July 1519. Oh God, forgive
the poet, the viewer, the owner, and the scribe through Muhammad
and his family.*

reference: Karatay, *Farsça*, no. 564.

927/1521 Hilali, *Shah u gada* BL Add. 7781
signed and dated (folio 55a):

كتبه العبد الفقير المذنب شاه محمود النيشابورى \
غفر ذنوبه و ستر عيوبه تحريراً فى شهر \
الشعبان سنه سبع و عشرين \ و تسعمانه الهجريه \
النبويه \ م

*Written by the lowly, sinful servant Shah-Mahmud al-Nishapuri,
may his sins be forgiven and his faults concealed. Written in the
month of Sha'ban, the year 927/July–August 1521 of the
Prophet's hegira. The end.*

reference: Rieu, 2:656.

927–36/1521–29 Amir Khusraw Dihlavi, TKS H. 797
Bakharz *Khamsa*
signed (folios 167a and 219a), dated (folios 42a, 92a,
124a, 167a, and 219a), and located (folio 167a)
folio 42a:

تمَت الكتاب بعون الملك الوهاب تحريراً \ فى تاريخ
شهر رمضان المبارك \ سنه ٩٢٥ غفر ذنوبه و ستر \
عيوبه \ تم

*The book was completed with the help of the all-giving Almighty,
written in the blessed month of Ramadan, the year 935/May–June
1529, may God forgive his [the scribe's] sins and conceal his faults.
The end.*

folio 92a:

تمَت الكتاب بعون الملك الوهاب \ تحريراً فى تاريخ
بيست و پنجم شهر شوال المعظم سنه ٩٢٥ \ غفر
ذنوبه و ستر \ عيوبه \ تم

*The book was completed with the help of the all-giving Almighty,
written on the twenty-fifth of the honored month of Shawwal, the
year 935/2 July 1529, may his sins be forgiven and his faults
concealed. The end.*

folio 124a:

تمَت الكتاب تحريراً فى تاريخ شهر \ ذى قعده
سنه ٩٢٥ ختم بالخير \ تم

*The book was completed. Written in the month of Dhu'l-qa'da,
the year 935/July–August 1529. It ended well. The end.*

folio 167a:

تمَت الكتاب بعون الملك الوهاب تحريراً فى تاريخ \
غره شهر محرم الحرام سنه ٩٣٦ در بلده \ باخرز
صورت تحرير يافت \ كتبه العبد المذنب شاه
محمود النيشابورى \ غفر ذنوبه و ستر عيوبه \ تم

*The book was completed with the help of the all-giving Almighty,
written at the beginning of the venerable month of Muharram, the
year 936/early September 1529 in the region of Bakharz. Written
by the sinful servant Shah-Mahmud al-Nishapuri, may his sins be
forgiven and his faults concealed. The end.*

folio 219a:

تمَت الكتاب بعون الله وحسن توفيقه على يد \
الضعيف \ المحتاج شاه محمود النيشابورى غفر
الله \ ذنوبه و ستر عيوبه فى تاسع \ شهر شوال
سنه سبع \ عشرن و تسعمايه \ تم

*The book was completed with the help of God and his felicitous
divine guidance by the hand of the weak and needy servant, Shah-
Mahmud al-Nishapuri, may God forgive his sins and conceal his
faults, on the ninth of the month of Shawwal, the year 927/12
September 1521. The end.*

reference: Karatay, *Farsça*, no. 598.

928/1522 Sana'i, *Hadiqat al-haqiqat* SPL Dorn 351
signed and dated (folio 22a):

تمَت الكتاب العبد المذنب شاه محمود \ غفر ذنوبه
فى التاريخ سلخ شهر رجب \ سنه ثمان و عشرين
\ و تسعمايه

*The book was completed by the sinful servant Shah-Mahmud, may
his sins be forgiven, at the end of the month of Rajab, the year
928/late June 1522.*

reference: Dorn, cat. no. 351.

929/1522–23 Calligraphy TKS H. 2161
signed and dated (folio 91b, center, left, and right):

مشقه شاه محمود \ نيشابورى \ فى شهور سنه
تسع عشرين و تسعمايه

*Copied by Shah-Mahmud Nishapuri, in the months of the year
929/1522–23.*

930/1523–24 Calligraphy TKS H. 2154
signed and dated (folio 123b, bottom):

مشقه شاه محمود نيشابورى \ حرَره العبد \ مير
مصور \ فى شهور سنه ثلاثين و تسعمايه

*Copied by Shah-Mahmud Nishapuri. Outlined by the servant
Mir-Musavvir, in the months of the year 930/1523–24.*

references: Mehdi Bayani, 1–2:305 (without date);
Dickson & Welch, 1:244B–45A n. 7 (also no reference to
date); Roxburgh, 2:958.

930/1523–24 *Kulliyat* FGA 37.35
signed and dated (folio 8b):

كتبه على يد عبد الفقير المذنب شاه محمود
نيشابورى \ غفر ذنوبه و ستر عيوبه فى شهور سنه
ثلاثين و تسعمايه

*Written by the hand of the lowly, sinful servant Shah-Mahmud
Nishapuri, may his sins be forgiven and his faults concealed, in the
months of the year 930/1523–24.*

Another section of this manuscript was signed by Salim
Katib, a pupil of Shah-Mahmud; see Fu et al., no. 46.

931/1524–25 Calligraphy TKS H. 2161
signed and dated (folio 134a, left):

مشقه شاه محمود \ نيشابورى تحريرا فى شهور
سنه احدى و ثلاثين و تسعمايه

*Copied by Shah-Mahmud Nishapuri. Written in the months of
the year 931/1524–25.*

931/1525 Jami, *Yusuf u Zulaykha* TKS R. 910
signed and dated (folio 150a):

كتبه العبد المذنب شاه محمود نيشابورى غفر
ذنوبه \ تحريراً فى سلخ شهر شوال سنه احدى و
ثلاثين و تسعمايه \ الهجريه النبويه تم

*Written by the sinful servant Shah-Mahmud Nishapuri, may his
sins be forgiven. Written at the end of the month of Shawwal, the
year 931/late August 1525 of the Prophet's hegira. The end.*

place: attributed to Tabriz
references: Çağman & Tanindi, no. 95; Diba,
"Lacquerwork" 2, 144–46, and cat. no. 17; Dickson &
Welch, 1:245A nn. 7 and 12; Karatay, *Farsça*, no. 739;
Stchoukine, "Poème," 291–97.

934/1527 Arifi, *Guy u chawgan* BN suppl. pers. 1954
Tabriz (fragment)
signed, dated, and located (folio 4a):

تمَت الرسالة الشريفة \ على يد الحقر العباد\ شاه
محمود نيشابورى بدارالسلطنه تبريز \ فى سلخ
شهرصفر سنة \ اربع و ثلاثين \ و تسعمائة \ تم

*This noble treatise was completed by the hand of the humblest
servant Shah-Mahmud al-Nishapuri in the abode of the
government Tabriz at the end of the month of Safar, the year
934/late November 1527. The end.*

references: Mehdi Bayani, 1–2:304; Blochet, *Persans*,
4:364, no. 2444.

935/1528–29 *Ali ibn Abi Talib, SJML A./Nm. 1118
Tabriz *Munajat*
signed, dated, and located:

Shah-Mahmud Nishapuri, 935/1528–29, Tabriz.

reference: Ashraf, 5: cat. no. 1739.

938/1532 Hafiz, *Divan* SPL Dorn 408
Tabriz
signed, dated, and located (folio 217a):

كتبه العبد الفقير المذنب شاه محمود النيشابورى \
غفر ذنوبه و ستر عيوبه فى عشرين شهر شوال \
سنه ثمان و ثلاثين و تسعمايه الهجرية \
النبوية بدارالسلطنه \ تبريز

Written by the lowly, sinful servant Shah-Mahmud al-Nishapuri, may his sins be forgiven and his faults concealed, on the twentieth of the month of Shawwal, the year 938/26 May 1532 of the Prophet's hegira in the abode of the government Tabriz.

reference: Dorn, cat. no. 408.

939/1532-33 Prayers of Ali and invocations CB MS 179
Tabriz and traditions of Ali
signed, (folios 7a and 8a), dated, and located (folio 7a)

folio 7a:

مشقه العبد المذنب شاه محمود \ غفر ذنوبه
بدارالسلطنه تبريز \ ٩٣٩

Copied by the sinful servant Shah-Mahmud, may his sins be forgiven, in the abode of the government Tabriz, 939/1532-33.

folio 8a:

غفر الله له الذنوب التى اكتبها بالنظر العبد
المذنب \ شاه محمود

May God forgive his sins that he [God] has written down against him, the sinful servant Shah-Mahmud.

references: Arberry et al., 2: no. 179; Diba, "Lacquerwork" 2, cat. no. 41.

939/1532-33 Calligraphy TKS H. 2154
signed and dated (folio 5a, bottom):

عبده شاه محمود نيشابورى \ على سبيل \
[السَرعه؟] \ سنه ٩٣٩

His [God's] servant, Shah-Mahmud Nishapuri, done in a [hasty?] manner, the year 939/1532-33.

reference: Roxburgh, 2:811.

939/1532-33 Calligraphy TKS H. 2154
Tabriz
signed, dated, and located (folio 6a, bottom center):

مشقه العبد شاه محمود النيشابورى \ بدارالسلطنه
تبريز \ فى سنه ٩٣٩

Copied by the servant Shah-Mahmud al-Nishapuri, in the abode of the government Tabriz, in the year 939/1532-33.

reference: Roxburgh, 2:813.

942/1535-36 Calligraphy TKS H. 2154
signed and dated (folio 125b, bottom left):

مشقه العبد الفقير \ شاه محمود \ فى شهور \
سنه \ اثنى و اربعين و تسعمايه

Copied by the lowly servant Shah-Mahmud, in the months of the year 942/1535-36.

reference: Roxburgh, 2:962.

942/1535-36 Calligraphy TKS H. 2161
signed and dated (folio 74a):

مشقه شاه محمود \ فى سنه ٩٤٢

Copied by Shah-Mahmud, in the year 942/1535-36.

942/1535-36 *Calligraphy TEH
signed and dated:

Shah-Mahmud al-Nishapuri, 942/1535-36.

reference: Mehdi Bayani, 1-2:304.

942/1535 *Arba'in hadith* (with metrical TKS E.H. 681
Tabriz paraphrases by Jami)
signed, dated, and located (folio 8b):

كتبه العبد الفقير المذنب شاه محمود النيشابورى
غفر الله ذنوبه \ و ستر عيوبه فى سلخ شهر محرم
الحرام \ سنه اثنى و اربعين و تسعمايه \ الهجريه
بدارالسلطنه تبريز

Written by the lowly, sinful servant Shah-Mahmud al-Nishapuri, may God forgive his sins and conceal his faults, at the end of the venerable month of Muharram, the year 942/late July 1535 of the hegira in the abode of the government Tabriz.

reference: Karatay, *Farsça*, no. 17.

944/1537-38 *Jami, *Subhat al-abrar* GL 469
signed and dated:

اتمام اين جواهر آبدار و اختتام اين لآلى شاهوار فى
سنه ٩٤٤ على يد اضعف العباد العبد المذنب شاه
محمود نيشابورى غفر ذنوبه

(Atabay)

The completion of this resplendent jewel and the finishing of this royal pearl [took place] in the year 944/1537-38 by the hand of the weakest servant, the sinful Shah-Mahmud Nishapuri, may his sins be forgiven.

references: Atabay, *Divan*, 211-12; Mehdi Bayani, 1-2:300.

945/1538 Koran TKS H.S. 25
signed and dated (folio 361b):

اين كلام ملك عالام بخط نسخ تعليق آغاز و اتمام
پذيرفت على يد العبد الضعيف المحتاج الى رحمة
الله الملك الغنى شاه محمود النيشابورى \ زرين قلم
فى يوم الاربعاء رابع عشر \ من شهر محرم الحرام
سنه \ خمس و اربعين و تسعمايه \ الهجريه النبويه

This word of God [Koran] was begun and ended in the nasta'liq script by the hand of the humble, weak servant, needy of the blessing of the all-giving, bountiful God, Shah-Mahmud al-Nishapuri zarin-qalam [golden pen], on the fourteenth day of the venerable month of Muharram, [the year] 945/12 June 1538 of the Prophet's hegira.

references: Karatay, *Arapça*, 1: no. 423 (catalogued under old number H.S. 183); Lings, pl. 91; Safadi, 28, and repro. (detail of folio 1b); Schimmel, *Calligraphy*, 30.

946-49/1539-43 Nizami, *Khamsa* BL Or. 2265
Tabriz
patron: Shah Tahmasp (inscription on folio 60b)
signed, dated (folios 35a, 128a, 192a, and 259b), and located (folio 396a)

folio 35a:

كتبه العبد الفقير المذنب شاه محمود الشاهى
غفر الله ذنوبه و ستر عيوبه فى غرة شهر
جمادى الثانى سنه ٩٤٦

Written by the lowly, sinful servant Shah-Mahmud al-shahi [in gold], may God forgive his sins and conceal his defects, at the beginning of the month of Jumada II, the year 946/mid-October 1539.

folio 128a:

تمت الكتاب بعون الملك الوهاب على يد احقر العباد \
شاه محمود النيشابورى غفر الله ذنوبه و ستر عيوبه
فى سلخ \ شهر ربيع الاول سنه سبع و اربعين و
تسعمايه الهجريه النبويه

The book was completed with the help of the all-giving Almighty by the hand of the humblest servant Shah-Mahmud al-Nishapuri, may God forgive his sins and conceal his faults, at the end of the Rabi' I, the year 947/early August 1540 of the Prophet's hegira.

folio 192a:

كتبه العبد الفقير المذنب شاه محمود النيشابورى
الكاتب \ فى سلخ الشهر الرمضان المبارك سنه سبع
اربعين و تسعمايه \ الهجريه النبويه عليه التحيه و
الاكرام

Written by the lowly, sinful servant Shah-Mahmud al-Nishapuri the scribe, at the end of the blessed month of Ramadan, the year 947/late January 1541 of the Prophet's hegira, salutations and blessings be upon him.

folio 259b:

كتبه العبد المذنب شاه محمود النيشابورى الكاتب \
غفر الله ذنوبه و ستر عيوبه فى اواسط شهر جمادى
الاول \ سنه ثمان و اربعين و تسعمايه

Written by the sinful servant Shah-Mahmud al-Nishapuri the scribe, may God forgive his sins and conceal his faults, in the middle of the month of Jumada I, the year 948/early September 1541.

folio 396a:

فرغ من تحرير هَذه الكتاب بعون الملك الوهاب على
يد \ العبد الفقير المذنب شاه محمود النيشابوري
الشاهى الكاتب \ غفر ذنوبه و ستر عيوبه فى
عشرين شهر \ ذى الحجه سنه تسع و اربعين و
تسعمائه \ بدارالسلطنه تبريز

The writing of this book was completed with the help of the all-giving Almighty by the hand of the lowly, sinful servant Shah-Mahmud al-Nishapuri al-shahi [in gold] the scribe, may his sins be forgiven and his faults concealed, on the tenth of the month of Dhuʾl-hijja, the year 949/17 March 1543 in the abode of the government Tabriz.

references: Mehdi Bayani, 1–2:302 (cites one colophon dated 947, without al-shahi); Binyon; Dickson & Welch, 1:290A (s.v., Nizami: Khamsa [1539–43, British Library]); Titley, MPM, cat. no. 315 (with previous references); S. C. Welch, PP, 70–97; S. C. Welch, WA, 134–81.

947/1540 Saʿdi, Bustan BN suppl. pers. 1431
signed and dated (folio 140a):

تحريراً فى غره شهر\ رجب المرجب سنه \ سبع
اربعين و تسعمايه \ كتبه شاه محمود

Written at the beginning of the honored month of Rajab, the year 947/early November 1540. Written by Shah-Mahmud.

reference: Blochet, Persans, 3:164, no. 1474.

949/1542–43 Medical aphorisms BN suppl. pers. 1967
signed and dated (folio 6a):

حرَره العبد المذنب شاه محمود \ غفر الله ذنوبه فى
شهور سنه ٩٤٩ \ الهجريه النبويه

Written [or outlined] by the sinful servant, Shah-Mahmud, may God forgive his sins, in the months of the year 949/1542–43 of the Prophet's hegira.

references: Blochet, Persans, 2:268, no. 1672; Robinson, BL, 159.

950/1543–44 Calligraphy TKS H. 2154
(above painting of a standing youth playing the sitar)
signed and dated (folio 148a):

مشقه العبد المذنب \ شاه محمود النيشابورى \ غفر
ذنوبه و ستر عيوبه \ فى سنه خمسين و تسعمايه

Copied by the sinful servant Shah-Mahmud al-Nishapuri, may his sins be forgiven and his faults concealed, in the year 950/1543–44.

references: Roxburgh, 2:997; Simpson, "Bahram Mirza," 383–84, and fig. 51b.

950/1543–44 *Ahli Shirazi, Muntakhab-i ashʿar GL 2203
signed and dated:

كتبه العبد الفقير شاه محمود سنه خمسين و
تسعمائه

(Atabay)

Written by the lowly servant Shah-Mahmud, the year 950/1543–44.

references: Atabay, Divan, no. 59; Mehdi Bayani, 1–2:300.

950/1543–44 *Ali ibn Abi Talib, Chihil kalama GL 2209
Tabriz
signed, dated, and located:

تمت على يد العبد المذنب شاه محمود الكاتب غفر
الله ذنوبه و ستر عيوبه فى شهور سنه خمسين و
تسعمائه بدارالسلطنه تبريز

Completed by the hand of the sinful servant, Shah-Mahmud the scribe, may his sins be forgiven and his faults concealed, in the months of the year 950/1543–44 in the abode of the government Tabriz.

references: Atabay, Dini, no. 131 (gives the date as 910, which does not correspond with the published colophon); Mehdi Bayani, 1–2:299–300 (refers to the same manuscript as a copy of the Sad kalama).

950/1543–44 Jami, Yusuf u Zulaykha BN suppl. pers. 1919
signed and dated (folio 54b):

كتبه العبد المذنب شاه محمود النيشابورى \ غفر
ذنوبه وستر عيوبه \ فى شهور سنه خمسين و
تسعمايه من الهجريه النبويه

Written by the sinful servant, Shah-Mahmud al-Nishapuri, may his sins be forgiven and his faults concealed, in the months of the year 950/1543–44 of the Prophet's hegira.

reference: Blochet, Persans, 3:286–87, no. 1701.

950/1543–44 Arbaʿin hadith CB MS 342
Tabriz (with metrical paraphrases by Jami)
signed, dated, and located (folio 8b):

كتبه العبد المذنب شاه محمود النيشابورى \ غفر
الله ذنوبه فى شهور سنه خمسين و تسعمايه \
بدار السلطنه تبريز

Written by the sinful servant, Shah-Mahmud al-Nishapuri, may God forgive his sins, in the months of the year 950/1543–44 in abode of the government Tabriz.

reference: Arberry et al., 3: no. 342.

951/1544 Jami, Silsilat al-dhahab IOL P&A 49
and Itiqadnama
signed and dated (folio 137b):

باتمام رسيد فى شهر محرم الحرام ٩٥١ \ كتبه
العبد الفقير المذنب شاه محمود نيشابورى
نوربخشى \ غفر ذنوبه و ستر عيوبه

Completed in the venerable month of Muharram 951/March–April 1544, written by the lowly, sinful servant Shah-Mahmud Nishapuri Nurbakhshi, may his sins be forgiven and his faults concealed.

place: attributed to Tabriz
reference: Robinson, IOL, 134–35.

951/1544–45 *Amir Shahi Sabzavari, Divan GL 2163
Tabriz (selection)
signed and dated:

كتبه العبد المذنب شاه محمود الكاتب غفر ذنوبه و
ستر عيوبه فى شهور سنه احدى و خمسين و
تسعمائه بدار السلطنه تبريز

(Atabay)

Written by the sinful servant, Shah-Mahmud the scribe, may his sins be forgiven and his faults concealed, in the months of the year 951/1544–45 in the abode of the government Tabriz.

references: Atabay, Divan, no. 31; Mehdi Bayani 1–2:299.

951/1544–45 *Arbaʿin hadith TEH
(with metrical paraphrases by Jami)
signed and dated:

كتبه العبد المذنب شاه محمود الكاتب فى سنه ٩٥١

(Mehdi Bayani)

Written by the sinful servant, Shah-Mahmud the scribe, in the year 951/1544–45.

reference: Mehdi Bayani, 1–2:300–301.

953/1546 Arifi, Halnama FGA 35.18
Tabriz (also known as Guy u chawgan)
signed, dated, and located (folio 21a):

كتبه العبد الفقير شاه محمود الشاهى النيشابورى \
غفر ذنوبه و ستر عيوبه فى شهر الصفر سنه ثلاث \
و خمسين و تسعمائه الهجريه النبويه عليه الصلوة
واللهم بدار السلطنه تبريز

Written by the lowly servant Shah-Mahmud al-shahi [in gold] al-Nishapuri, may his sins be forgiven and his faults concealed, in the month of Safar, the year 953/April 1546 of the Prophet's hegira, blessings be upon him and his family, in the abode of the government Tabriz.

954/1547–48 Calligraphy TKS H. 2161
signed and dated (folio 99b, bottom):

كتبه العبد شاه محمود \ النيشابورى فى شهور
سنه \ ٩٥٤

Written by the servant Shah-Mahmud al-Nishapuri, in the months of the year 954/1547–48.

955/1548 *Jami, Divan MVD
signed and dated:

تحريراً فى بيستم شهر جمادى الاخر سنة خمس و
خمسين و تسعمائه كتبه العبد الفقير المذنب شاه
محمود الكاتب غفر ذنوبه

(Mehdi Bayani)

Written on the twentieth of the month of Jumada II, the year 955/27 July 1548, the lowly, sinful servant Shah-Mahmud the scribe, may his sins be forgiven.

reference: Mehdi Bayani, 1–2:300.

955/1548–49 *Nassayih* BAY
signed and dated:

كتبه العبد المذنب شاه محمود النيشابوري غفر الله
ذنوبه و ستر عيوبه فى سنة خمسمائة تسعمائة
الهجرية

(Mehdi Bayani)

Written by the sinful servant, Shah-Mahmud al-Nishapuri, may God forgive his sins and conceal his faults, in the year 955/1548–49 of the hegira.

reference: Mehdi Bayani, 1–2:301.

956/1549 Jami, *Silsilat al-dhahab* SPL Dorn 434
Ardabil
signed, dated (folio 50b), and located (folio 81a)
folio 50b:

كتبه العبد الفقير المذنب شاه محمود النيشابوري
الكاتب غفرالله ذنوبه و ستر عيوبه فى عشر الآخر
جمادى الاول سنه ٩٥٦

Written by the lowly, sinful servant, Shah-Mahmud al-Nishapuri the scribe, may God forgive his sins and conceal his faults, on 20 Jumada 1 956/16 June 1549.

folio 81a:

كتبه افقر العباد شاه محمود النيشابوري غفر الله
ذنوبه و ستر عيوبه فى غرة شهر شعبان المعظم سنة
ست و خمسين و تسعمائة الهجرية النبوية بدار
السلطنه اردبيل حميت عن الآفات

Written by the lowliest servant, Shah-Mahmud al-Nishapuri, may God forgive his sins and conceal his faults, at the beginning of the month of Sha'ban in the year 956/late August 1549 of the Prophet's hegira, in the abode of the government Ardabil, may it be protected from misfortunes.

references: Akimushkin & Ivanov, *PM*, pls. 42–43; Mehdi Bayani, 1–2:302; Diba, "Lacquerwork" 2, 177–78, 205–6, and cat. no. 7; Dickson & Welch, 1:27A–B, 129B, 130A, 249A nn. 4 and 5; Dorn, cat. no. 434; Martin, 2: pls. 116–17; *USSR Colls.*, 6–7, 28.

956/1549 *Jami, Divan* CHR 28.IV.92, lot 105
signed and dated (folio 250a [?]):

كتبه العبد الفقير شاه محمود نيشابوري \ فى شهر
رجب سنه ست و خمسين و تسعمائه سنه ٩٥٦ تم

Written by the lowly servant Shah-Mahmud Nishapuri, in the month of Rajab, the year 956 [repeated]/July–August 1549. The end.

reference: CHR 28.IV.92, lot 105, and repro.

958/1551 Sa'di, *Bustan* CB MS 221
Mashhad
signed, dated, and located (folio 193a):

كتبه العبد الفقير المذنب شاه محمود النيشابوري \
غفر الله ذنوبه و ستر عيوبه بمشهد مقدس امام
رضا عليه التحيته و الثنا فى عشر الاول من شهر
رجب \ سنه ثمان و خمسين و تسعمايه

Written by the lowly, sinful servant, Shah-Mahmud al-Nishapuri, may God forgive his sins and conceal his faults, in holy Mashhad of Imam Reza, salutations and praise be upon it, on the tenth of the month of Rajab, the year 958/14 July 1551.

references: Arberry et al., 2:221; Mehdi Bayani, 1–2:303; Dickson & Welch, 1:249A n. 5; Stchoukine, *MS*, cat. no. 167.

958/1551 Variorum SPL Dorn 324
signed and dated (folio 8a):

لكاتبه \ االعبد شاه محمود النيشابوري \ فى شهور
سنه ٩٥٨

Composed by the servant Shah-Mahmud al-Nishapuri, in the months of the year 958/1551.

references: Mehdi Bayani, 1–2:302; Dorn, cat. no. 324.

961/1553–54 Calligraphy TKS H. 2161
signed and dated (folio 167a, top right):

مشقه العبد شاه محمود \ النيشابوري \ سنه ٩٦١

Copied by the servant Shah-Mahmud al-Nishapuri, the year 961/1553–54.

962/1554–55 Calligraphy TKS H. 2156
signed and dated (folio 54a, bottom):

مشقه العبد الفقير الحقير شاه محمود فى شهور \
سنه ٩٦٢

Copied by the lowly, humble servant Shah-Mahmud, in the months of the year 962/1554–55.

962/1554–55 Calligraphy TKS H. 2156
signed and dated (folio 54b, right):

مشقه العبد الفقير شاه محمود النيشابوري فى
شهور \ سنه ٩٦٢

Copied by the lowly servant Shah-Mahmud al-Nishapuri, in the months of the year 962/1554–55.

962/1554–55 Calligraphy TKS H. 2161
signed and dated (folio 60b):

كتبه احقر العباد شاه محمود \ النيشابوري فى
سنه ٩٦٢

Written by the humblest servant Shah-Mahmud al-Nishapuri, in the year 962/1554–55.

962/1554–55 Calligraphy TKS H. 2161
signed and dated (folio 91b, center):

كتبه العبد الحقير شاه محمود \ النيشابوري ٩٦٢

Written by the humble servant Shah-Mahmud al-Nishapuri, 962/1554–55.

962/1554–55 *Nassayih-i hukama* TIEM 2039
signed and dated (folio 10a):

كتبه الحقر العباد شاه محمود \ النيشابوري فى
شهور سنه ٩٦٢

Written by the humblest servant, Shah-Mahmud al-Nishapuri, in the months of the year 962/1554–55.

962/1555 *Arba'in hadith* TKS H. 2248
signed and dated (folio 11a):

كتبه العبد المذنب شاه محمود النيشابوري غفرالله
ذنوبه \ فى شهر ربيع الاول سنة اثنى ستين
و تسعمايه

Written by the sinful servant Shah-Mahmud al-Nishapuri, may God forgive his sins, in the month of Rabi' 1, the year 962/January–February 1555.

TKS H. 2248 seems to have been prepared as a small album and contains calligraphic samples on folios 1–3. The *Arba'in hadith* occupies folios 3b–11a.

963/1555–56 Calligraphy TKS H. 2138
signed and dated (folio 37b):

مشقه العبد شاه محمود \ فى سنه ٩٦٣

Copied by the servant Shah-Mahmud, in the year 963/1555–56.

reference: Mehdi Bayani, 1–2:305.

963/1555–56 Calligraphy TKS H. 2151
signed and dated (folio 51a):

مشقه العبد الحقير شاه محمود \ النيشابوري فى
سنه ثلاث \ و ستين و تسعمايه

Copied by the humble, sinful servant Shah-Mahmud al-Nishapuri, in the year 963/1555–56.

963/1555–56 Calligraphy TKS H. 2156
signed and dated (folio 6a):

مشقه العبد المذنب \ شاه محمود غفر الله \ ذنوبه \
فى سنه ثلث \ و ستين و تسعمايه

Copied by the sinful servant Shah-Mahmud, may God forgive his sins, in the year 963/1555–56.

963/1555–56 Calligraphy TKS H. 2156
signed and dated (folio 6b, top left):

مشقه العبد شاه محمود النيشابوري \ فى شهور
سنه \ ثلث و ستين و تسعمايه

Copied by the servant Shah-Mahmud al-Nishapuri, in the months of the year 963/1555–56.

963/1555–56 Calligraphy TKS H. 2161
signed and dated (folio 163b):

مشقه العبد شاه محمود \ النيشابوري \ فى سنه
ثلاث \ و ستين و تسعمايه

Copied by the servant Shah-Mahmud al-Nishapuri, in the year 963/1555–56.

963/1555–56 Calligraphy TKS H. 2161
signed and dated (folio 167a, top left):

مشقه العبد الحقير المذنب شاه محمود غفر الله \
ذنوبه \ فى سنه ثلث \ و ستين و تسعمايه

Copied by the humble, sinful servant Shah-Mahmud, may God forgive his sins, in the year 963/1555–56.

963/1556 Hatifi, *Timurnama* SPL Dorn 444
signed and dated (folio 191a):

فرغ من هذا الكتاب الموسوم به تيمورنامه \ فى
بيستم شهر جيمدى الاول سنه ثلث و ستين و
تسعماية \ الهجريه النبويه عليه افضل الصلواة و
اكمل التحيه \ كتبه الفقير الحقير شاه محمود
النيشابورى

The writing of this book known as Timurnama was completed on the twentieth of Jumada I, the year 963 [repeated]/1 April 1556 of the Prophet's hegira, the highest blessings and the most complete praise be upon him. Written by the lowly, humble Shah-Mahmud al-Nishapuri.

reference: Dorn, cat. no. 444.

963/1556 Jami, *Subhat al-abrar* FGA 46.12
Mashhad (part of a complete *Haft awrang*)
patron: Sultan Ibrahim Mirza
signed, dated, and located (folio 181a):

بسرحد اتمام رسيد برسم كتابخانه حضرت نواب
جهاندار \ معدلت آثار معزّ السلطنة و الدنيا و
الدين ابراهيم ميرزا \ خلد الله تعالى ملكة و سلطانه
كتبه العبد الحقير الداعى \ شاه محمود النيشابورى
غفر الله ذنوبه و ستر عيوبه فى \ غرّه شهر
ذى الحجه سنه ثلث و ستين و تسعمايه \
الهجرية النبويه بمشهد مقدسة \ منوّره رضويه عليه
التحية \ والثنا

It has reached the frontiers of completeness by order of the library of his highness, the lord, the world keeper, just in his works, the glorifier of rule, the world, and religion, Ibrahim Mirza, may God protect his kingdom and rule. Written by his humble, suppliant servant, Shah-Mahmud al-Nishapuri, may God forgive his sins and conceal his faults, at the beginning of the month of Dhu'l-hijja, the year 963/early October 1556 of the Prophet's hegira, in the holy, illustrious, blessed Mashhad, salutations and praise be upon it.

references: Mehdi Bayani, 1–2:303 (with incorrect date); Simpson, "Jami," 106, fig. 5; Simpson, "Kitab-Khana," fig. 5.

964/1556–57 Calligraphy TKS H. 2169
(surrounding a painting of a horse and a kneeling youth holding the reins and playing a sitar)
signed and dated (folio 57b):

مشقه العبد الفقير شاه محمود \ فى شهور سنه ٩٦٤

Copied by the lowly servant Shah-Mahmud, in the months of the year 964/1556–57.

964/1556–57 *Husayn ibn Sayfuddin Haravi,* BAY
Mashhad trans., *Arba'in kalama*
signed, dated, and located:

كتبه العبد المذنب شاه محمود النيشابورى غفر الله
ذنوبه و ستر عيوبه بمشهد المقدسة الرضوية عليه
الصلواة و السلام فى شهور سنة ٩٦٤
(Mehdi Bayani)

Written by the sinful servant Shah-Mahmud al-Nishapuri, may God forgive his sins and conceal his faults, in the holy, illustrious, blessed Mashhad, salutations and peace be upon it, in the months of the year 964/1556–57.

reference: Mehdi Bayani, 1–2:301.

964/1556–57 *Arba'in hadith* CB MS 227
Mashhad (with metrical paraphrases by Jami)
signed, dated, and located (folio 9a):

حرّره العبد المذنب شاه محمود النيشابورى \ غفر
الله ذنوبه بمشهد مقدسه منوره فى سنه ٩٦٤

Written [or outlined] by the sinful servant Shah-Mahmud al-Nishapuri, may God forgive his sins, in the holy, illustrious Mashhad, in the year 964/1556–57.

references: Arberry et al., 3: no. 227; Binyon et al., no. 342.

964/1556–57 Abdullah Ansari, *Maqalat* SPL Dorn 260
signed and dated (folio 6a):

كتبه العبد شاه محمود النيشابورى \ فى سنه اربع
و ستين و تسعمايه

Written by the servant Shah-Mahmud al-Nishapuri, in the year 964/1556–57.

reference: Dorn, cat. no. 260.

965/1557–58 *Calligraphy GL 1631
signed and dated:

Shah-Mahmud al-Nishapuri, 965/1557–58.

reference: Atabay, *Muraqqa'at*, cat. no. 142.

965/1557–58 Calligraphy IM 587.69
signed and dated:

مشقه العبد شاه محمود النيشابورى \ فى سنه
خمسين و ستين و تسعمايه

Copied by the servant Shah-Mahmud al-Nishapuri, in the year 965/1557–58.

reference: Milstein, cat. no. 18, and repro.: p. 192.

965/1557–58 Calligraphy ÖNB Mixt. 313
dated (folio 33a):

965/1557–58.

reference: Duda, 1:138, and 2: fig. 372.

Attributed to Shah-Mahmud on the basis of similarity to folio 21b (see under Undated Calligraphies, below).

965/1557–58 Calligraphy SPL Dorn 147
signed and dated (folio 14b):

العبد شاه محمود \ نيشابورى \ فى شهور خمسين
و ستين و تسعمايه

The servant Shah-Mahmud Nishapuri, in the months of the year 965/1557–58.

reference: Dorn, cat. no. 147.

965/1557–58 Calligraphy TKS H. 2145
signed and dated (folio 41a):

مشقه العبد الحقير شاه محمود النيشابورى \ فى
سنه خمسين \ و ستين و تسعمايه

Copied by the humble servant Shah-Mahmud al-Nishapuri, in the year 965/1557–58.

965/1557–58 Calligraphy TKS H. 2145
signed and dated (folio 52a):

مشقه العبد الفقير شاه محمود \ النيشابورى شهور
سنه ٩٦٥

Copied by the lowly servant Shah-Mahmud al-Nishapuri, the months of the year 965/1557–58.

965/1557–58 Calligraphy TKS H. 2151
signed and dated (folio 15a):

مشقه احقر العباد شاه محمود \ النيشابورى فى
سنه خمسين \ و ستين و تسعمايه

Copied by the humblest servant Shah-Mahmud al-Nishapuri, in the months of the year 965/1557–68.

965/1557–58 Calligraphy TKS H. 2151
signed and dated (folio 42b):

مشقه العبد شاه محمود \ النيشابورى فى سنه
خمسين \ و ستين و تسعمايه

Copied by the servant Shah-Mahmud al-Nishapuri, in the year 965/1557–58.

965/1557–58 Calligraphy TKS H. 2161
signed and dated (folio 172a):

مشقه العبد شاه محمود \ النيشابورى \ فى سنه
خمسين \ و ستين و تسعمايه

Copied by the servant Shah-Mahmud al-Nishapuri, in the year 965/1557–58.

966/1558–59 Calligraphy TKS H. 2149
signed and dated (folio 25a):

مشقه العبد الفقير شاه محمود \ النيشابورى \
عليه رحمة \ و المغفرة فى شهور \ سنه ٩٦٦

Copied by the lowly servant Shah-Mahmud al-Nishapuri, may he be blessed and forgiven, in the months of the year 966/1558–59.

966/1558–59 Calligraphy TKS H. 2158
signed and dated (folio 28b):

مشقه احقر العباد شاه محمود النيشابورى عليه
الرحمة \ و المغفرة \ فى شهور سنه ٩٦٦

Copied by the humblest servant Shah-Mahmud al-Nishapuri, may he be blest and forgiven, in the months of the year 966/1558–59.

966/1558–59 *Arba'in hadith* CB MS 346
Mashhad (with metrical paraphrases by Jami)
signed, dated, and located (folio 9a):

كتبه العبد المذنب شاه محمود النيشابوري غفر الله
ذنوبه في شهور سنه \ ست و ستين و تسعمايه
بمشهد مقدسه منوره رضوريه عليه التحته و الثنا

Written by the sinful servant Shah-Mahmud al-Nishapuri, may God forgive his sins, in the months of the year 966/1558–59 in the holy, illustrious, blessed Mashhad of Imam Reza, salutations and praise be upon him.

reference: Arberry et al., 3: no. 346.

966/1559 *Ali ibn Abi Talib, Location unknown
Arba'in hadith
signed and dated:

تمَت بترجمه هذا اربعين [...] كتبه العبد الفقير
المذنب شاه محمود النيشابوري غفرالله ذنوبه و ستر
عيوبه في عشر الآخر شهر جميدى الاول
سنة ٩٦٦ تم

(Mehdi Bayani)

The translation of this Arba'in [two Persian verses] was completed. Written by the lowly, sinful servant Shah-Mahmud al-Nishapuri, may God forgive his sins and conceal his faults, on the twentieth of the month Jumada I, the year 966/28 February 1559. The end.

reference: Mehdi Bayani, 1–2:306–7.

970/1562–63 Calligraphy TKS H. 2159
signed and dated (folio 61b):

كتبه العبد الحقير شاه محمود \ النيشابورى٩٧٠

Written by the humble servant Shah-Mahmud al-Nishapuri, 970/1562–63.

970/1562–63 Calligraphy TKS H. 2161
signed and dated (folio 74b, top):

كتبه العبد الحقير شاه محمود \ النيشابورى٩٧٠

Written by the humble servant Shah-Mahmud al-Nishapuri, 970/1562–63.

970/1562–63 *Attar, Asrarnama GL 373/2711
signed and dated:

كتبه العبد الفقير شاه محمود النيشابورى غفر ذنوبه
و ستر عيوبه فى٩٧٠

(Mehdi Bayani)

Written by the lowly servant, Shah-Mahmud al-Nishapuri, may his sins be forgiven and his faults concealed, in 970/1562–63.

reference: Mehdi Bayani, 1–2:300.

971/1563–64 Koran, sura 1:1–3 BSM I. 4596
signed and dated (folio 25a):

كتبه العبد المذنب شاه محمود غفر الله له فى
سنه ٩٧١

Written by the sinful servant Shah-Mahmud, may God forgive him, in the year 971/1563–64.

reference: Enderlein, pl. 8.

971/1563–64 Calligraphy TKS H. 2156
signed and dated (folio 16b, bottom left):

حرَّره العبد شاه محمود \ النيشابورى ٩٧١

Written [or outlined] by the servant Shah-Mahmud al-Nishapuri, 971/1563–64.

971/1563–64 Calligraphy TKS H. 2161
signed and dated (folio 74a, right):

كتبه العبد الحقير شاه محمود \ النيشابورى ٩٧١

Written by the humble servant Shah-Mahmud al-Nishapuri, 971/1563–64.

971/1563–64 Calligraphy TKS H. 2161
signed and dated (folio 74b, left):

كتبه العبد الحقير شاه محمود \ النيشابورى ٩٧١

Written by the humble servant Shah-Mahmud al-Nishapuri, 971/1563–64.

971/1563–64 Calligraphy TKS H. 2161
signed and dated (folio 74b, right):

كتبه العبد شاه محمود \ النيشابورى ٩٧١

Written by the servant, Shah-Mahmud al-Nishapuri, 971/1563–64.

971/1563–64 Calligraphy SOTH 10.X.77, lot 155
signed and dated:

مشقه العبد شاه محمود النيشابورى سنه ٩٧١

Copied by the servant Shah-Mahmud al-Nishapuri, 971/1563–64.

reference: SOTH 10.X.77, lot 155.

972/1564–64 Calligraphy SPL Dorn 148
signed and dated (folio 25a):

مشقه العبد شاه محمود النيشابورى ٩٧٢

Copied by the servant Shah-Mahmud al-Nishapuri, 972/1564–65.

references: Dickson & Welch, 1:249A n. 5; Dorn, cat. no. 148.

Problematic Dated Manuscripts

These manuscripts may have altered dates or false signatures with dates postdating Shah-Mahmud's death.

936/1530 *Sa'di, Kulliyat SOTH 20.VII.77, lot 240
signed and dated:

Shah-Mahmud al-Nishapuri, Jumada [?] II 936/ January–February [?] 1530.

reference: SOTH 20.VII.77, lot 240, and repro.

The handwriting on the single page from this manuscript reproduced in the sales catalogue does not seem consistent with Shah-Mahmud's style.

952/1545–6 Nizami, *Haft paykar* BL Or. 1578
signed and dated (folio 71a):

كتبه العبد المذنب شاه محمود النيشابورى غفر
ذنوبه و ستر عيوبه سنه ٩٥٢

Written by the sinful servant, Shah-Mahmud al-Nishapuri, may his sins be forgiven and his faults concealed, the year 952/1545–46.

references: Diba, "Lacquerwork" 2, 192–93; Rieu, 2:547.

This manuscript was refurbished in 1264/1847–48 by order of Farhad Mirza, and many parts of the text, including the colophon, were recopied. While Shah-Mahmud's calligraphic style appears to have been carefully followed, technically speaking the manuscript is no longer in his hand.

956/1549–50 Arifi, *Guy u chawgan* TKS R.1046
signed and dated (folio 17a):

كتبه العبد الفقير المذنب شاه محمود الكاتب \ غفر
ذنوبه و ستر عيوبه فى شهور سنه ست \ و
خمسين و تسعمايه

Written by the lowly, sinful servant Shah-Mahmud the scribe, may his sins be forgiven and his faults concealed, in the months of the year 956/1549–50.

reference: Karatay, *Farsça*, no. 664.

This manuscript may be by the hand of Shah-Mahmud Katib, whose teacher, Salim Katib, was a student of Shah-Mahmud al-Nishapuri. The style of the paintings, however, seems much earlier than the date of the colophon. The volume also contains a *Halnama* copied by Hajj Hasan Ali and later paintings.

9[5]9/15[5]2 or Amir Khusraw BN suppl. pers. 1149
9[7]9/15[7]2 Dihlavi, *Khamsa*
Raza (Bakharz)
patron: Bahram Mirza (probably false dedication)
signed (folio 221a) and dated (folio 125a)

folio 125a:

فى تاريخ شهر ذى حجَه ٩[٥]٩ \ م

In the month of Dhu'l-hijja 9[5]9 or 9[7]9//November– December 15[5]2 or April–May 15[7]2. The end.

As pointed out by Stchoukine (*MS*, no. 194), the middle digit here appears to have been altered, making a 7 look like a 5.

folio 221a:

باتمام رسيد و بحسن اختتام انجاميد كتاب پنج
كنج از كفتار امير خسرو دهلوى اطاب الله \ سراه
و جعل الخير مثواه در شهر صفر ختم بالخير و
الظفر على يد العبد الضعيف المحتاج \ شاه محمود
النيشابورى غفر ذنوبه و ستر عيوبه بولايت باخرز
در قريه رزه تحرير يافت

The book of the Five Treasures, among the works of Amir Khusraw Dihlavi, may God perfume his dust and reward him with blessings, was completed and terminated favorably in the month of Safar by the hand of the weak, needy servant Shah-Mahmud al-Nishapuri, may his sins be forgiven and his faults concealed. It was written in the district of Bakharz in the town of Raza.

references: Mehdi Bayani, 1–2:303; Blochet, *Persans*, 3: no. 1521; Lowry et al., 171; Robinson, *BL*, 151; Stchoukine, *MS*, no. 194.

It is most uncharacteristic for Shah-Mahmud to give the month, but not the year, of the completion of his work. Furthermore, the calligraphy in this manuscript is much more spindly and uneven than other Shah-Mahmud manuscripts (such as SPL Dorn 434 or BL Or. 2265), and the signature or/and dedication may be a total fabrication.

The manuscript opens with a double-page illumination consisting of two gold roundels and surrounded by a latticelike pattern of large peony and lotus blossoms and floral sprays. This central field, more or less equivalent in format and size to the written surface of the manuscript's text pages, is ruled off with colored and gold lines from an outer margin decorated in gold and blue with birds and animals. The two central rosettes are inscribed in bold black thuluth; the inscription on folio 1b says that the manuscript was made for the treasury (khazana) of Bahram Mirza Safavi al-Husayni.

Nothing about the decoration or epigraphy of these opening pages corresponds to recognized shamsas of the period (such as the one in the Tahmasp Shahnama), and they are probably the creation of much later and possibly Ottoman artists. In any event, Bahram Mirza was long dead before the preparation of the manuscript—even if the date of 959 in the first colophon were to be correct.

97[0]/156[2] Amir Humayun SOTH 11.IV.88. lot 134
Raza (Bakharz) Isfarayni, *Ghazal*
signed, dated, and located:

كتبه العبد المذنب شاه محمد \ نيشابورى فى
اواسط شهر رجب المرجب [٠]٩٧ \ غفر ذنوبه و
ستر عيوبه بقريه \ رزه باخرز تحريريافت

Written by the sinful servant Shah-Mahmud Nishapuri, in the middle of the month of Rajab 97[0]/mid-March 156[2], may his sins be forgiven and his faults concealed. It was written in the town of Raza [in] Bakharz.

reference: SOTH 11.IV.88, lot 134, and pl. 31.

The colophon seems to have been written in two different hands and may not be completely original.

976/1569 *Mulla Husayn Kashifi, *Risala hatimiya* ML 683
signed and dated:

تمَت الرسالة الحاتمية فى تاريخ شهر شعبان المعظم
سنه ٩٧٦ كتبه العبد المذنب شاه محمود الكاتب
غفرله [كذا]

The Risala al-hatimiya *was completed in the month of Sha'ban, the year 976/January–February 1569. Written by the sinful servant Shah-Mahmud the scribe, [thus] may he be forgiven.*

reference: Mehdi Bayani, 1–2:300.

978/1570–71 *Shahi, *Divan* NL 3832
signed and dated:

Shah-Mahmud al-Nishapuri, 978/1570–71.

982/1574 *Chihil kalama* Location unknown
signed and dated:

كتبه العبد الفقير المحتاج الى رحمة ربَه الودود شاه
محمود غفرذنوبه و ستر عيوبه فى اواسط شهر
جميدى الثانى سنة ٩٨٢ اثنى و ثمانين و تسعمائة
(Mehdi Bayani)

Written by the lowly servant, needy of the loving God's mercy, Shah-Mahmud, may his sins be forgiven and his faults concealed, in the middle of the month of Jumada II, the year 982 [repeated]/early October 1574.

reference: Mehdi Bayani, 1–2:301 (erroneously says manuscript is in TIEM).

Undated Manuscripts

These manuscripts are listed by collection.

undated *Saʿdi, *Bustan* GL 400/395
signed:

تمت الكتاب بعون الله الملك الوهاب تحريرا فى تاريخ
شهر ربيع الاول سنه٠٠٠٠كتبه العبد المذنب شاه
محمود نيشابورى

(Atabay)

The book was completed with the help of the all-giving Almighty, in the month of Rabiʿ I, the year [. . .]. Written by the sinful servant, Shah-Mahmud Nishapuri.

references: Atabay, *Divan*, no. 211; Mehdi Bayani, 1–2:300.

undated *Saʿdi, *Bustan* GL 2167
(selections)
signed:

كتبه العبد شاه محمود النيشابورى غفرالله ذنوبه تم
(Atabay)

Written by the servant Shah-Mahmud al-Nishapuri, may God forgive his sins. The end.

references: Atabay, *Divan*, no. 203; Mehdi Bayani, 1–2:300.

2d quarter Arifi, *Halnama* IM 4987.12.78
16th century (also known as *Guy u chawgan*)
signed (folio 21a):

العبد الفقير شاه محمود

The lowly servant Shah-Mahmud.

place: attributed to Tabriz
reference: Milstein, cat. no. 19.

undated Jami, *Silsilat al-dhahab* ÖNB Mixt. 1466
(second daftar)
signed:

تمت بترجمه هذه الاربعين بتوفيق من هو خير ناصر
ومعين \ متع الله و بها كل فريق و فيه و الحمدلله
على الا تمام \و الصلواة و السلام على محمدوآله
البرة \ و الكرام كتبه العبد المذنب شاه محمود
النيشابورى \ غفر ذنوبه

The translation of this [collection] of forty [hadith] was completed with the help of him who is the best helper [God]. May God make every group and community enjoy it. Praise be to God for the completion, and prayers and salutations upon Muhammad and his immaculate and noble family. Written by the sinful servant Shah-Mahmud al-Nishapuri, may his sins be forgiven.

reference: Duda, 1:208–10, and 2: figs. 403–9.

The colophon appears to belong an *Arbaʿin hadith* rather than Jami's *Silsilat al-dhahab*.

ca. 1550 *Hatifi, *Timurnama* SOTH 18.X.95, lot 66
signed:

شاه محمود النيشابورى [perhaps not complete]

Shah-Mahmud al-Nishapuri.

references: Mehdi Bayani, 1–2:303.; Robinson, *BL*, 171; Robinson, "Kevorkian," cat. no. 323; SOTH 18.X.95, lot 66, and repros.

ca. 1550–60 *Anthology* SOTH 30.IV.92, lot 345
signed (folio 44a?):

Shah-Mahmud al-Nishapuri.

reference: SOTH 30.IV.92, lot 345.

undated *Koran (*juz*) TEH
Tabriz
signed and located:

كتبه العبد المذنب شاه محمود النيشابورى غفر
ذنوبه و ستر عيوبه بدارالسلطنه تبريز

(Mehdi Bayani)

Written by the sinful servant, Shah-Mahmud al-Nishapuri, may his sins be forgiven and his faults concealed, in the abode of the government Tabriz.

reference: Mehdi Bayani, 1–2:302.

undated Ali ibn Abi Talib, TIEM 1909
Arbaʿin hadith
signed:

كتبه العبد الفقير شاه محمود غفر ذنوبه و ستر
عيوبه

Written by the lowly servant Shah-Mahmud, may his sins be forgiven and his faults concealed.

reference: Mehdi Bayani, 1–2:301.

ca. 1540 *Kulliyat* TKS R. 957
patron: Bahram Mirza
signed (folio 2a):

صوره العبد على الحسينى كتبه شاه محمود
النيشابورى

Painted by the servant Ali al-Husayni. Written by Shah-Mahmud al-Nishapuri.

references: Karatay, *Farsça*, no. 898; Simpson, "Bahram Mirza."

undated Jami, *Divan* WAG W. 640
signed (folio 306a):

كتبه العبد شاه محمود النيشابورى \ غفر ذنوبه و
ستر عيوبه

Written by the servant Shah-Mahmud al-Nishapuri, may his sins be forgiven and his faults concealed.

reference: *Bookbinding*, cat. no. 93.

undated *Saʿdi, *Bustan* Location unknown
signed:

تمَت الكتاب بعون الملك الوهاب كتبه العبد المذنب
شاه محمود نيشابورى غفر ذنوبه و ستر عيوبه

(Mehdi Bayani)

The book was completed with the help of the all-giving Almighty. Written by the sinful servant, Shah-Mahmud Nishapuri, may his sins be forgiven and his faults concealed.

reference: Mehdi Bayani, 1–2:301–2 (erroneously says manuscript is in TIEM).

undated *Buzurgmihr and Ansari, Location unknown
Nassaya and *Munajat*
signed:

تمَت المناجات بعون الله تعالى العبدشاه محمود
النيشابورى

(Mehdi Bayani)

The munajat was completed with the help of God Almighty, the servant Shah-Mahmud al-Nishapuri.

reference: Mehdi Bayani, 1–2:302 (erroneously says manuscript is in TIEM).

Problematic Undated Manuscript

undated Hilali, *Shah u gada* SNL N.M. 233–42/1918
(fragment of ten folios,
including seven with illustrations, ca. 1590–1600)

references: Adahl; Mehdi Bayani, 1–2:303 (says undated); Binyon et al., no. 271; Munthe, 55–75; Stockholm 1957, cat. nos. 36–45 (with earlier references); Stockholm 1985, cat. nos. 50–51.

The *Shah u gada* manuscript to which these illustrated folios originally belonged is said to have been copied by Shah-Mahmud Nishapuri in 945/1539 (Martin, 1:65) or 946/1539 (Stockholm 1957, cat. nos. 36–45). In fact, the surviving leaves do not include a colophon, and the SNL records do not contain any document in support of the Shah-Mahmud attribution or date.

Undated Calligraphies

These calligraphies are listed by collection.

undated Calligraphy AMSG S1986.348
(three verses from the *Bustan*
of Saʿdi)
signed:

فقير شاه محمود

The lowly Shah-Mahmud.

reference: Lowry et al., cat. no. 435, and repro.

undated Calligraphy AMSG S1986.347
signed:

مشقه العبد الفقير \ شاه محمود

Copied by the lowly servant Shah-Mahmud.

reference: Lowry et al., cat. no. 434, and repro.

undated Calligraphy BMFA 14.583–591
signed:

شاه محمود النيشابورى غفر ذنوبه

Shah-Mahmud al-Nishapuri, may his sins be forgiven.

reference: Coomaraswamy, cat. no. 43, and pl. 23.

undated Calligraphy BMFA 14.595
signed (recto):

حرّره العبدشاه محمود النيشابورى

Written [or outlined] by the servant Shah-Mahmud al-Nishapuri.

references: Coomaraswamy, cat. no. 46a, and pl. 25a;
S. C. Welch, *WA*, cat. no. 83 (corrects BMFA number as
given in Coomaraswamy).

undated Calligraphy BMFA 14.595
signed (verso of previous folio):

كتبه العبد شاه محمود النيشابورى

Written by the servant Shah-Mahmud al-Nishapuri.

reference: Coomaraswamy, cat. no. 46b, and pl. 25b.

undated Calligraphy BN arabe 6074
signed (folio 12b):

مشقه العبدشاه محمود نيشابورى

Copied by the servant Shah-Mahmud Nishapuri.

reference: Blochet, *Arabes*, cat. no. 6074.

undated Calligraphy BN pers. 129
(fourteen verses of the ghazals of Hafiz)
signed (folios 12b–13a):

هذا خط قبله الكتاب مولانا سلطان على المشهدى \ حرّره
شاه محمود النيشابورى \ غفر له

*This writing of the qibla of books, Sultan-Ali al-Mashhadi, [was]
outlined by Shah-Mahmud al-Nishapuri, may he be forgiven.*

references: Blochet, *Persans*, 1: no. 129; Richard, 148
(deduces from the signature that Shah-Mahmud executed
the calligraphy in the style of Sultan-Ali).

undated Calligraphy BN pers. 129
(six verses of a Turkish ghazal)
signed (folios 17a–18b):

ذا خط قبله الكتاب مولانا سلطان على المشهدى \
رّره شاه محمود النيشابورى

*This writing of the qibla of books, Sultan-Ali al-Mashhadi,
[was] outlined by Shah-Mahmud al-Nishapuri, may he be
forgiven.*

references: Blochet, *Persans*, 1: no. 129; Richard, 149
(deduces from the signature that Shah-Mahmud executed
the calligraphic page in the style of Sultan-Ali).

undated Calligraphy BN suppl. pers. 392
signed (folio 51a):

العبد شاه محمود \ غفر الله له

The servant Shah-Mahmud, may God forgive him.

reference: Blochet, *Persans*, 2: no. 1115.

undated Calligraphy BN Smith-Lesoeüef 247
signed (folio 26a):

مشقه العبدشاه محمود النيشابورى

Copied by the servant Shah-Mahmud al-Nishapuri.

undated Calligraphy BSM I. 4598
signed (folio 2a):

مشقه العبد الفقير شاه محمود \ النيشابورى

Copied by the lowly servant, Shah-Mahmud al-Nishapuri.

reference: Enderlein, pl. 6.

undated *Calligraphy DAM
signed:

مشقه شاه محمود النيشابورى

Copied by Shah-Mahmud al-Nishapuri.

reference: Mehdi Bayani, 1–2:304.

undated Calligraphy FGA 46.15
signed:

مشقه العبد شاه محمود

Copied by the servant Shah-Mahmud.

reference: Atil, *Brush*, cat. no. 15.

undated *Calligraphy GL 1504
signed:

كتبه العبد شاه محمود النيشابورى

Written by the servant Shah-Mahmud al-Nishapuri.

reference: Atabay, *Muraqqaʿ*, no. 26.

undated *Calligraphy GL 1707
signed:

شاه محمود النيشابورى

Shah-Mahmud al-Nishapuri.

reference: Atabay, *Muraqqaʿ*, no. 1.

undated Calligraphy IUL F. 1422
signed (folio 5a):

مشقه العبد المذنب \ شاه محمود

Copied by the sinful servant Shah-Mahmud.

undated Calligraphy IUL F. 1422
signed (folio 10a):

مشقه العبد الداعى شاه محمود \ نيشابورى غفر \
ذنوبه

*Copied by the supplicant servant Shah-Mahmud Nishapuri, may
his sins be forgiven.*

undated Calligraphy IUL F. 1422
signed (folio 69a):

مشقه العبد الداعى شاه محمود

Copied by the supplicant servant Shah-Mahmud.

undated Calligraphy IUL F. 1422
signed (folio 75b):

مشقه العبد الفقير \ شاه محمود

Copied by the lowly servant Shah-Mahmud.

undated Calligraphy IUL F. 1425
signed (folio 3b):

العبد الفقير الحقير \ شاه محمود غفرالله ذنوبه

*The lowly, humble servant Shah-Mahmud, may God forgive his
sins.*

undated Koran, sura 1:1–7 IUL F. 1426
signed (folio 2b):

عبده الفقير شاه محمود النيشابورى

His [God's] lowly servant Shah-Mahmud al-Nishapuri.

reference: Atil, *Süleyman*, 104–5, and repro.: cat. no. 49b.

undated Koran, sura 1:1–7 IUL F. 1426
signed (folio 3a):

كتبه العبد شاه محمود

Written by the servant Shah-Mahmud.

reference: Atil, *Süleyman*, 104–5, and repro.: cat. no. 49b.

undated Calligraphy IUL F. 1426
signed (folio 7a):

مشقه العبد الفقير \ شاه محمود

Copied by the lowly servant Shah-Mahmud.

undated Calligraphy IUL F. 1426
signed (folio 10a):

العبد شاه محمود

The servant Shah-Mahmud.

undated Calligraphy IUL F. 1426
signed (folio 14a, left):

مشقه شاه محمود

Copied by Shah-Mahmud.

undated Calligraphy IUL F. 1426
signed (folio 14a, right):

مشقه العبد شاه محمود \ النیشابوری

Copied by the servant Shah-Mahmud al-Nishapuri.

undated Calligraphy IUL F. 1426
signed (folio 14b):

العبد الفقیر \ شاه محمود

The lowly servant Shah-Mahmud.

undated Calligraphy IUL F. 1426
signed (folio 15a, left):

مشقه العبد الفقیر \ شاه محمود

Copied by the lowly servant Shah-Mahmud.

undated Calligraphy IUL F. 1426
signed (folio 15a, right):

كتبه العبد الحقیر \ شاه محمود

Written by the humble servant Shah-Mahmud.

undated Calligraphy IUL F. 1426
signed (folio 18b):

مشقه العبد شاه محمود

Copied by the servant Shah-Mahmud.

undated Calligraphy IUL F. 1426
signed (folio 19a):

مشقه احقر العباد \ شاه محمود

Copied by the humblest servant Shah-Mahmud.

undated Calligraphy IUL F. 1426
signed (folio 21b):

مشقه العبد المذنب \ شاه محمود نیشابوری

Copied by the sinful servant Shah-Mahmud Nishapuri.

undated Calligraphy IUL F. 1426
signed (folio 22a):

مشقه العبد المذنب \ شاه محمود غفر \ ذنوبه

Copied by the sinful servant Shah-Mahmud, may his sins be forgiven.

undated Calligraphy IUL F. 1426
signed (folio 22b):

مشقه العبد الفقیر \ شاه محمود

Copied by the lowly servant Shah-Mahmud.

reference: Atil, *Süleyman*, 104–5, and repro.: cat. no. 49d.

undated Calligraphy IUL F. 1426
signed (folio 27a):

مشقه العبد المذنب شاه محمود النیشابوری

Copied by the sinful servant Shah-Mahmud al-Nishapuri.

reference: Atil, *Süleyman*, 104–5, and repro.: cat. no. 49d.

undated Calligraphy IUL F. 1426
signed (folio 31b):

مشقه العبد الفقیر \ شاه محمود

Copied by the lowly servant Shah-Mahmud.

undated Calligraphy IUL F. 1426
signed (folio 38a):

مشقه شاه محمود \ غفر ذنوبه

Copied by the servant Shah-Mahmud, may his sins be forgiven.

undated Calligraphy IUL F. 1426
signed (folio 39a):

مشقه العبد الحقیر \ شاه محمود

Copied by the humble servant Shah-Mahmud.

undated Calligraphy MAH 1971–107/289
signed:

الفقیر شاه محمود النیشابوری

The lowly Shah-Mahmud al-Nishapuri.

references: Robinson, "Pozzi" 1, cat. no. 289, and repro.; Robinson, *Pozzi* 2, cat. no. 565, and repro.

undated Calligraphy MAH 1971–107/293
signed:

مشقه العبد شاه محمود النیشابوری

Copied by the servant Shah-Mahmud al-Nishapuri.

references: Robinson, "Pozzi" 1, cat. no. 293, and repro.; Robinson, *Pozzi* 2, cat. no. 569.

undated Calligraphy MAH 1971–107/307
signed:

مشقه شاه محمود

Copied by Shah-Mahmud.

references: Robinson, "Pozzi" 1, cat. no. 307, and repro.; Robinson, *Pozzi* 2, cat. no. 583, and repro.

undated Calligraphy MAH 1971–107/309
signed:

كتبه الفقیر العباد \ شاه محمود

Written by the lowliest servant Shah-Mahmud.

references: Robinson, "Pozzi" 1, cat. no. 309, and repro.; Robinson, *Pozzi* 2, cat. no. 585, and repro.

undated Calligraphy MAH 1971–107/312
signed:

بجز تعلق خاطر بماه رخساری
كه خاطر از همه غمها بیاد شادست

خوشست قطع تعلق تعالم از همه چیز
مرا دلیل برین نكته قول استادست

غلام همّت آنم كه زیر چرخ كبود
ز هرچه رنگ تعلق پذیر آزادست

لكاتبه \ العبد شاه محمود

*Aside from being in love with a beauty
With the memory of whom the mind is happy despite all sadness;*

*To sever all relations with everything in the world is a good thing,
The reason for saying this is the words of the master;*

*I am the servant of the mind that under the azure sky,
Is free of all that is associated with bondage.*

Composed [and written] by the servant Shah-Mahmud.

references: Robinson, "Pozzi" 1, cat. no. 312, and repro.; Robinson, *Pozzi* 2, cat. no. 588, and repro.

undated Calligraphy MAH 1971–107/346
signed:

كتبه الفقیر شاه محمود \ غفر الله ذنوبه

Written by the lowly Shah Mahmud, may God forgive his sins.

reference: Robinson, *Pozzi* 2, cat. no. 130, and repro.

undated *Calligraphy MSL
Tabriz
signed and located:

العبد شاه محمود النیشابوری بدارالسلطنه تبریز

(Mehdi Bayani)

The servant Shah-Mahmud al-Nishapuri, in the abode of the government Tabriz.

reference: Mehdi Bayani, 1–2:304.

undated Calligraphy ÖNB Mixt. 313
signed (folio 13b):

شاه محمود

Shah-Mahmud.

reference: Duda, 1:120–21.

undated Calligraphy ÖNB Mixt. 313
(cartouches in the borders of a
calligraphy by Ali al-katib)
signed (folio 14a):

شاه محمود

Shah-Mahmud.

reference: Duda, 1:121–22.

undated Calligraphy ÖNB Mixt. 313
signed (folio 14b):

كتبه العبد الحقير شاه محمود

Written by the humble servant Shah-Mahmud.

reference: Duda, 1:122–23, and fig. 362.

undated Calligraphy ÖNB Mixt. 313
(masnavi verse)
signed (folio 19a):

مشقه العبد الفقير شاه محمود النيشابورى غفر الله
ذنوبه

*Copied by the lowly servant Shah-Mahmud al-Nishapuri, may
God forgive his sins.*

reference: Duda, 1:127–28, and fig. 366.

undated Calligraphy ÖNB Mixt. 313
(ghazals of Shahi)
signed (folio 21b):

مشقه العبد شاه محمود النيشابورى

Copied by the servant Shah-Mahmud al-Nishapuri.

reference: Duda, 1:129.

undated Calligraphy ÖNB Mixt. 313
signed (folio 22b):

مشقه العبد الفقير شاه محمود النيشابورى

Copied by the lowly servant Shah-Mahmud al-Nishapuri.

reference: Duda, 1:130.

undated Calligraphy ÖNB Mixt. 313
(verses from Khwaju Kermani,
Rawdat al-anvar)
signed (folio 24a):

مشقه العبد شاه محمود النيشابورى

Copied by the servant Shah-Mahmud al-Nishapuri.

reference: Duda, 1:131.

undated Calligraphy ÖNB Mixt. 313
signed (folio 25a):

مشقه العبد المذنب شاه محمود النيشابورى

Copied by the sinful servant Shah-Mahmud al-Nishapuri.

reference: Duda, 1:131.

undated Calligraphy ÖNB Mixt. 313
signed (folio 25b):

مشقه العبد الفقير شاه محمود

Copied by the lowly servant Shah-Mahmud.

reference: Duda, 1:132.

undated Calligraphy ÖNB Mixt. 313
signed (folio 29b):

عبده شاه محمود نيشابورى

His [God's] servant Shah-Mahmud Nishapuri.

reference: Duda, 1:136, and 2: fig. 377.

undated Calligraphy ÖNB Mixt. 313
(verses from Jami, *Subhat al-ahrar*)
signed (folio 40a):

كتبه شاه محمود

Written by Shah-Mahmud.

reference: Duda, 1:144.

undated Calligraphy SOTH 2.V.77, lot 22
signed:

مشقه العبد شاه محمود النيشابورى

Copied by the servant Shah-Mahmud al-Nishapuri.

reference: SOTH 2.V.77, lot 22, and repro.

undated Calligraphy SPB 15.XII.78, lot 203
signed:

مشقه العبد الحقير شاه محمود النيشابورى

Copied by the humble servant Shah-Mahmud al-Nishapuri.

reference: SPB, 15.XII.78, lot 203, and repro.

undated Calligraphy SPL Dorn 147
signed (folio 3b):

العبد المذنب شاه محمود

The sinful servant Shah-Mahmud.

undated Calligraphy SPL Dorn 147
signed (folio 7a):

العبد المذنب شاه محمود

The sinful servant Shah-Mahmud.

undated Calligraphy SPL Dorn 147
signed (folio 7b):

مشقه العبد شاه محمود

Copied by the sinful servant Shah-Mahmud.

undated Calligraphy SPL Dorn 147
signed (folio 16a):

كتبه شاه محمود غفر ذنوبه

Written by Shah-Mahmud, may his sins be forgiven.

undated Calligraphy SPL Dorn 147
signed (folio 31a):

مشقه العبد شاه محمود النيشابورى

Copied by the servant Shah-Mahmud al-Nishapuri.

undated Calligraphy SPL Dorn 147
signed (folio 49b):

كتبه شاه محمود \ غفر ذنوبه و ستر \ عيوبه

*Written by Shah-Mahmud, may his sins be forgiven and his faults
concealed.*

undated Calligraphy SPL Dorn 147
signed (folio 52b):

مشقه العبد المذنب \ شاه محمود غفر \ ذنوبه

*Copied by the sinful servant Shah-Mahmud, may his sins be
forgiven.*

undated Calligraphy SPL Dorn 147
signed (folio 54a):

مشقه العبد المذنب شاه محمود \ الكاتب غفر ذنوبه

*Copied by the sinful servant Shah-Mahmud the scribe, may his
sins be forgiven.*

undated Calligraphy SPL Dorn 148
signed (folio 16b):

مشقه العبد الفقير الحقير شاه محمود

Copied by the lowly, humble servant Shah-Mahmud.

undated Calligraphy SPL Dorn 148
signed (folio 26b):

مشقه العبد شاه محمود النيشابورى

Copied by the servant Shah-Mahmud al-Nishapuri.

undated Calligraphy SPL Dorn 148
signed (folio 31a):

مشقه العبد شاه محمود

Copied by the servant Shah-Mahmud.

undated Calligraphy SPL Dorn 148
signed (folio 34b):

العبد شاه محمود

The servant Shah-Mahmud.

signed (folio 36a):

كتبه العبد المذنب شاه محمود \ النيشابوري غفر الله \ ذنوبه

Written by the sinful servant Shah-Mahmud al-Nishapuri, may God forgive his sins.

undated Calligraphy SPL Dorn 148
signed (folio 41b):

مشقه العبد شاه محمود النيشابوري

Copied by the servant Shah-Mahmud al-Nishapuri.

undated Calligraphy SPL Dorn 488
signed (folio 14b):

مشقه العبد شاه محمود

Copied by the servant Shah-Mahmud.

undated Calligraphy TKS B. 407
signed (folio 25a):

العبد الفقير الحقير \ شاه محمود

The lowly, humble servant Shah-Mahmud.

undated Calligraphy TKS B. 407
signed (folio 25b):

كتبه العبد المذنب \ شاه محمود غفرالله [...]

Written by the sinful servant Shah-Mahmud, may God forgive [him].

undated Calligraphy TKS B. 407
Mashhad
signed and located (folio 26a):

در مشهد مقدس \ انور نوشته شد \ العبد المذنب شاه محمود غفر الله [...]

Written in the holy, illustrious Mashhad; the sinful servant Shah-Mahmud, may God forgive [him].

undated Calligraphy TKS B. 407
signed (folio 31a):

مشقه العبد شاه محمود النيشابوري

Copied by the servant Shah-Mahmud al-Nishapuri.

undated Calligraphy TKS B. 407
signed (folio 32a):

مشقه شاه محمود

Copied by Shah-Mahmud.

undated Calligraphy TKS B. 407
signed (folio 40b):

مشقه العبد شاه محمود الكاتب

Copied by the servant Shah-Mahmud the scribe.

undated Calligraphy TKS B. 407
(passage from the Koran)
signed (folio 43a):

العبد الحقير شاه محمود غفر ذنوبه

The humble servant Shah-Mahmud, may his sins be forgiven.

undated Calligraphy TKS B. 407
signed (folio 43a):

مشقه العبد الحقير شاه محمود

Copied by the humble servant Shah-Mahmud.

undated Calligraphy TKS B. 407
signed (folio 44a):

مشقه افقر العباد شاه محمود

Copied by the lowliest servant Shah-Mahmud.

undated Calligraphy TKS B. 407
signed (folio 45a):

مشقه افقر العباد شاه محمود

Copied by the lowliest servant Shah-Mahmud.

undated Calligraphy TKS B. 407
signed (folio 55a):

مشقه العبد الفقير شاه محمود النيشابوري

Copied by the lowly servant Shah-Mahmud al-Nishapuri.

undated Calligraphy TKS B. 407
signed (folio 59b):

مشقه العبد الفقير الحقير شاه محمود غفر الله ذنوبه

Copied by the lowly, humble servant Shah-Mahmud, may God forgive his sins.

undated Calligraphy TKS E.H. 2841
signed (folio 21a):

مشقه العبد شاه محمود النيشابوري

Copied by the servant Shah-Mahmud al-Nishapuri.

undated Calligraphy TKS H. 2137
signed (folio 32b):

العبد الفقير شاه محمود

The lowly servant Shah-Mahmud.

undated Calligraphy TKS H. 2138
signed (folio 18a):

كتبه شاه محمود غفر الله \ ذنوبه

Written by Shah-Mahmud, may God forgive his sins.

undated Calligraphy TKS H. 2138
signed (folio 18b):

مشقه شاه محمود \ غفر ذنوبه

Copied by Shah-Mahmud, may his sins be forgiven.

undated Calligraphy TKS H. 2138
signed (folio 19a):

مشقه العبد شاه محمود\ نيشابوري

Copied by the servant Shah-Mahmud Nishapuri.

undated Calligraphy TKS H. 2138
signed (folio 19b):

مشقه الفقير شاه محمود

Copied by the lowly Shah-Mahmud.

undated Calligraphy TKS H. 2138
signed (folio 20b):

العبد المذنب \ شاه محمود

The sinful servant Shah-Mahmud.

undated Calligraphy TKS H. 2138
signed (folio 36a):

العبد المذنب شاه محمود\ نيشابوري \ غفر ذنوبه

The sinful servant Shah-Mahmud Nishapuri, may his sins be forgiven.

undated Calligraphy TKS H. 2138
signed (folio 40a):

العبد المذنب شاه محمود غفر الله ذنوبه

The sinful servant Shah-Mahmud, may God forgive his sins.

undated Calligraphy TKS H. 2138
signed (folio 40b):

حرره العبد المذنب \ شاه محمود

Written [or outlined] by the sinful servant Shah-Mahmud.

undated Calligraphy TKS H. 2138
signed (folio 43a):

مشقه شاه محمود

Copied by Shah-Mahmud.

undated Calligraphy TKS H. 2138
signed (folio 44a):

فقير الحقير شاه محمود غفراﷲ \ ذنوبه

The lowly, humble Shah-Mahmud, may God forgive his sins.

undated Calligraphy TKS H. 2138
signed (folio 44b):

مشقه العبد الداعى \ شاه محمود

Copied by the supplicant servant Shah-Mahmud.

undated Calligraphy TKS H. 2138
signed (folio 47a):

مشقه العبد الفقير \ شاه محمود

Written by the lowly servant Shah-Mahmud.

undated Calligraphy TKS H. 2139
signed (folio 5b):

حرّره العبد المذنب شاه محمود النيشابورى غفر اﷲ له

Written [or outlined] by the sinful servant Shah-Mahmud al-Nishapuri, may God forgive him.

undated Calligraphy TKS H. 2140
signed (folio 4a):

مشقه العبد شاه محمود النيشابورى

Copied by the servant Shah-Mahmud al-Nishapuri.

undated Calligraphy TKS H. 2145
signed (folio 7b):

عبده شاه محمود

His [God's] servant Shah-Mahmud.

undated Calligraphy TKS H. 2145
signed (folio 10b):

فقير المذنب شاه محمود

The lowly, sinful servant Shah-Mahmud.

undated Calligraphy TKS H. 2145
signed (folio 11b):

شاه محمود نيشابورى

Shah-Mahmud Nishapuri.

undated Calligraphy TKS H. 2145
signed (folio 19b):

شاه محمود النيشابورى

Shah-Mahmud al-Nishapuri.

undated Calligraphy TKS H. 2145
signed (folio 21a):

العبد شاه محمود

The servant Shah-Mahmud.

undated Calligraphy TKS H. 2145
signed (folio 23a):

مشقه احقر العباد شاه محمود \ النيشابورى

Copied by the humblest servant Shah-Mahmud al-Nishapuri.

undated Calligraphy TKS H. 2145
signed (folio 25a, top):

مشقه العبد شاه \ محمود

Copied by the servant Shah-Mahmud.

undated Calligraphy TKS H. 2145
signed (folio 25a, bottom):

كتبه الفقير الحقير شاه محمود

Written by the lowly, humble servant Shah-Mahmud.

undated Calligraphy TKS H. 2145
signed (folio 29a):

مشقه العبد شاه محمود النيشابورى

Copied by the servant Shah-Mahmud al-Nishapuri.

undated Calligraphy TKS H. 2145
signed (folio 37b):

كتبه العبد المذنب شاه محمود \ النيشابورى

Written by the sinful servant Shah-Mahmud al-Nishapuri.

undated Calligraphy TKS H. 2145
signed (folio 43b):

مشقه العبد شاه محمود \ النيشابورى

Copied by the servant Shah-Mahmud al-Nishapuri.

undated Calligraphy TKS H. 2147
signed (folio 30a):

كتبه شاه محمود

Written by Shah-Mahmud.

undated Calligraphy TKS H. 2149
signed (folio 12a):

لكاتبه شاه محمود \ النيشابورى \ غفر له

Composed [and copied] by Shah-Mahmud al-Nishapuri, may he be forgiven.

undated Calligraphy TKS H. 2149
signed (folio 13a):

لكاتبه شاه محمود \ النيشابورى \ غفر له

Composed [and copied] by Shah-Mahmud al-Nishapuri, may he be forgiven.

undated Calligraphy TKS H. 2149
signed (folio 17b):

مشقه العبد شاه محمود \ نيشابورى

Copied by the servant Shah-Mahmud Nishapuri.

undated Calligraphy TKS H. 2149
signed (folio 25a):

مشقه العبد الفقير شاه محمود \ النيشابورى

Copied by the lowly servant Shah-Mahmud al-Nishapuri.

undated Calligraphy TKS H. 2149
signed (folio 29a):

كتبه احقر العباد \ شاه محمود

Written by the humblest servant Shah-Mahmud.

undated Calligraphy TKS H. 2149
signed (folio 33b):

كتبه العبد المذنب شاه محمود \ الكاتب نيشابورى

Written by the sinful servant Shah-Mahmud the Nishapuri scribe.

undated Calligraphy TKS H. 2151
signed (folio 3a):

مشقه احقر العباد شاه محمود \ نيشابورى

Copied by the humblest servant Shah-Mahmud Nishapuri.

undated Calligraphy TKS H. 2151
signed (folio 7a, right):

كتبه العبد الفقير الحقير \ شاه محمود

Written by the lowly, humble servant Shah-Mahmud.

undated Calligraphy TKS H. 2151
signed (folio 12b, center):

مشقه العبد الداعى \ شاه محمود

Copied by the supplicant servant Shah-Mahmud.

undated Calligraphy TKS H. 2151
signed (folio 12b):

مشقه العبد الفقير \ شاه محمود

Copied by the lowly servant Shah-Mahmud.

undated Calligraphy TKS H. 2151
signed (folio 15b, right):

العبد الفقير \ شاه محمود

The lowly servant Shah-Mahmud.

undated Calligraphy TKS H. 2151
signed (folio 17a):

مشقه العبد الفقير \ شاه محمود

Copied by the lowly servant Shah-Mahmud.

undated Calligraphy TKS H. 2151
signed (folio 17b, left):

مشقه احقر العباد \ شاه محمود

Copied by the humblest servant Shah-Mahmud.

undated Calligraphy TKS H. 2151
signed (folio 20a):

شاه محمود نيشابورى

Shah-Mahmud Nishapuri.

undated Calligraphy TKS H. 2151
signed (folio 20b, bottom):

كتبه العبد شاه محمود

Written by the servant Shah-Mahmud.

undated Calligraphy TKS H. 2151
signed (folio 42a, left):

شاه محمود نيشابورى

Shah-Mahmud Nishapuri.

undated Calligraphy TKS H. 2151
signed (folio 43a, top right):

مشقه العبد شاه محمود

Copied by the servant Shah-Mahmud.

undated Calligraphy TKS H. 2151
signed (folio 51a, center):

مشقه افقر العباد \ شاه محمود

Copied by the lowliest servant Shah-Mahmud.

undated Calligraphy TKS H. 2151
signed (folio 64a, bottom left):

مشقه افقر العباد \ شاه محمود

Copied by the lowliest servant Shah-Mahmud.

There is another calligraphy on this folio signed Mahmud.

undated Calligraphy TKS H. 2151
signed (folio 64b, bottom):

كتبه العبد الحقير شاه محمود \ النيشابورى

Written by the humble servant Shah-Mahmud al-Nishapuri.

undated Calligraphy TKS H. 2151
signed (folio 68a, top right):

مشقه احقر العباد شاه محمود \ نيشابورى

Copied by the humblest servant Shah-Mahmud Nishapuri.

undated Calligraphy TKS H. 2151
signed (folio 68b, top right):

العبد الحقير شاه محمود غفر الله ذنوبه

The humble servant Shah-Mahmud, may God forgive his sins.

undated Calligraphy TKS H. 2151
signed (folio 70a, top center):

شاه محمود

Shah-Mahmud.

undated Calligraphy TKS H. 2151
signed (folio 70a, top right):

شاه محمود

Shah-Mahmud.

undated Calligraphy TKS H. 2151
signed (folio 83a, top left):

مشقه العبد الحقير \ شاه محمود النيشابورى

Copied by the humble servant Shah-Mahmud al-Nishapuri.

undated Calligraphy TKS H. 2151
signed (folio 85b, top left):

كتبه افقر العباد \ شاه محمود

Written by the lowliest servant Shah-Mahmud.

undated Calligraphy TKS H. 2151
signed (folio 85b, top right):

مشقه العبد الفقير الحقير \ شاه محمود

Copied by the lowly, humble servant Shah-Mahmud.

undated Calligraphy TKS H. 2151
signed (folio 85b, bottom right):

مشقه شاه محمود

Copied by Shah-Mahmud.

undated Calligraphy TKS H. 2151
signed (folio 91a, top right):

كتبه العبد الفقير المذنب \ شاه محمود غفر \ ذنوبه

Written by the lowly, sinful servant Shah-Mahmud, may his sins be forgiven.

undated Calligraphy TKS H. 2154
signed (folio 5a, top):

حرّره دوست محمد \ مصور \ مشقه العبد \ شاه محمود

Outlined by Dust-Muhammad musavvir. Copied by the servant Shah-Mahmud.

reference: Roxburgh, 2:810–11.

undated Calligraphy TKS H. 2154
signed (folio 5a, bottom):

مشقه شاه محمود

Copied by Shah-Mahmud.

reference: Roxburgh, 2:811.

undated Calligraphy TKS H. 2154
signed (folio 5b, top left):

مشقه العبد المذنب \ شاه محمود الكاتب \ غفر \ ذنوبه

Copied by the sinful servant Shah-Mahmud the scribe, may his sins be forgiven.

reference: Roxburgh, 2:812.

undated Calligraphy TKS H. 2154
signed (folio 5b, bottom left):

مشقه العبد الاحقر \ شاه محمود

Copied by the humblest servant Shah-Mahmud.

reference: Roxburgh, 2:812.

undated Calligraphy TKS H. 2154
signed (folio 5b, bottom right):

مشقه العبد الفقير \ شاه محمود

Copied by the lowly servant Shah-Mahmud.

reference: Roxburgh, 2:811–12.

undated Calligraphy TKS H. 2154
signed (folio 6a, top right):

مشقه العبد شاه محمود نيشابورى

Copied by the servant Shah-Mahmud Nishapuri.

reference: Roxburgh, 2:813.

undated Calligraphy TKS H. 2154
signed (folio 6a, top left):

[شاه محمود] النيشابورى حررهٔ مير مصور

[Shah-Mahmud] al-Nishapuri. Outlined by Mir-Musavvir.

reference: Roxburgh, 2:812.

undated Calligraphy TKS H. 2154
signed (folio 6a, center left):

مشقه العبد شاه محمود \ النيشابورى غفر \ ذنوبه

Copied by the servant Shah-Mahmud al-Nishapuri, may his sins be forgiven.

reference: Roxburgh, 2:813.

undated Calligraphy TKS H. 2154
signed (folio 6a, center center):

العبد الفقير الحقير \ شاه محمود النيشابورى

The lowly, humble servant Shah-Mahmud al-Nishapuri.

reference: Roxburgh, 2:813.

undated Calligraphy TKS H. 2154
signed (folio 6a, center right):

مشقه العبد شاه محمود \ نيشابورى

Copied by the servant Shah-Mahmud Nishapuri.

reference: Roxburgh, 2:813.

undated Calligraphy TKS H. 2154
signed (folio 6a, bottom right):

مشقه العبد المذنب شاه محمود \ نيشابورى

Copied by the sinful servant Shah-Mahmud Nishapuri.

reference: Roxburgh, 2:813–14.

undated Calligraphy TKS H. 2154
signed (folio 6a, bottom left):

مشقه العبد المذنب \ شاه محمود

Copied by the sinful servant Shah-Mahmud.

reference: Roxburgh, 2:813.

undated Calligraphy TKS H. 2154
signed (folio 6b, top left):

مشقه العبد الداعى \ شاه محمود

Copied by the supplicant servant Shah-Mahmud.

reference: Roxburgh, 2:814.

undated Calligraphy TKS H. 2154
signed (folio 6b, right):

مشقه العبد الداعى \ شاه محمود غفر \ ذنوبه

Copied by the supplicant servant Shah-Mahmud, may his sins be forgiven.

reference: Roxburgh, 2:814.

undated Calligraphy TKS H. 2154
signed (folio 57b, center right):

العبد شاه محمود \ غفر ذنوبه

The servant Shah-Mahmud, may his sins be forgiven.

reference: Roxburgh, 2:872.

undated Calligraphy TKS H. 2154
signed (folio 95b, bottom left):

مشقه العبد شاه محمود \ نيشابورى

Copied by the servant Shah-Mahmud Nishapuri.

reference: Roxburgh, 2:923.

undated Calligraphy TKS H. 2154
signed (folio 122a)

مشقه العبد الفقير الداعى شاه محمود

Copied by the lowly supplicant servant Shah-Mahmud.

reference: Roxburgh, 2:956.

undated Calligraphy TKS H. 2154
signed (folio 122a)

مشقه العبد الداعى شاه محمود غفر ذنوبه

Copied by the supplicant servant Shah-Mahmud, may his sins be forgiven.

reference: Roxburgh, 2:956–57.

undated Calligraphy TKS H. 2154
signed (folio 122b):

العبد شاه محمود

The servant Shah-Mahmud.

reference: Roxburgh, 2:957.

undated Calligraphy TKS H. 2154
signed (folio 123a, top left):

مشقه شاه محمود

Copied by Shah-Mahmud.

undated Calligraphy TKS H. 2154
signed (folio 123b, center left):

مشقه العبد المذنب \ شاه محمود غفر ذنوبه

Copied by the sinful servant Shah-Mahmud, may his sins be forgiven.

reference: Roxburgh, 2:958.

undated Calligraphy TKS H. 2154
signed (folio 123b, center right):

مشقه العبد الفقير \ شاه محمود

Copied by the lowly servant Shah-Mahmud.

reference: Roxburgh, 2:958.

undated Calligraphy TKS H. 2154
signed (folio 124a, top right):

مشقه العبد الفقير الداعى شاه محمود \ نيشابورى
غفر \ ذنوبه

Copied by the lowly, supplicant servant Shah-Mahmud Nishapuri, may his sins be forgiven.

reference: Roxburgh, 2:959.

undated Calligraphy TKS H. 2154
signed (folio 124a, bottom left):

مشقه العبد المذنب \ شاه محمود غفر \ ذنوبه

Copied by the sinful servant Shah-Mahmud, may his sins be forgiven.

reference: Roxburgh, 2:959.

undated Calligraphy TKS H. 2154
Tabriz (surrounding a painting of a youth
drinking from a cup while another
offers a bowl of fruit)
signed and located (folio 124b):

مشقه العبد الفقير الداعى شاه محمود \ نيشابورى
غفر ذنوبه \ بدارالسلطنه تبريز

Copied by the lowly, supplicant servant Shah-Mahmud Nishapuri, may his sins be forgiven, in the abode of the government Tabriz.

reference: Roxburgh, 2:960.

undated Calligraphy TKS H. 2154
signed (folio 124b, lower left):

العبد شاه محمود

The servant Shah-Mahmud.

. reference: Roxburgh, 2:960.

undated Calligraphy TKS H. 2154
signed (folio 125a, bottom right):

كاتبها شاه محمود و قاطعها \ دوست محمد مصور

Written by Shah-Mahmud and cut by Dust-Muhammad musavvir.

references: Adle, "Dust-Mohammad," 286; Mehdi Bayani, 1–2:305; Dickson & Welch 1:118A; Roxburgh, 2:961.

undated Calligraphy TKS H. 2154
signed (folio 125b, top left):

مشقه العبد\ شاه محمود

Copied by the servant Shah-Mahmud.

reference: Roxburgh, 2:961.

undated Calligraphy TKS H. 2154
signed (folio 125b, lower left):

العبد شاه محمود

The servant Shah-Mahmud.

reference: Roxburgh, 2:962.

undated Calligraphy TKS H. 2154
signed (folio 126a, top left):

مشقه العبد \ شاه محمود

Copied by the servant Shah-Mahmud.

reference: Roxburgh, 2:962.

undated Calligraphy TKS H. 2154
signed (folio 126a, center left):

مشقه العبد الفقير \ شاه محمود

Copied by the lowly servant Shah-Mahmud.

reference: Roxburgh, 2:962.

undated Calligraphy TKS H. 2154
signed (folio 126a, center right):

كتبه العبد شاه محمود \ النيشابورى

Written by the servant Shah-Mahmud al-Nishapuri.

reference: Roxburgh, 2:962.

undated Calligraphy TKS H. 2154
signed (folio 126a, bottom):

مشقه العبد شاه محمود \ غفر ذنوبه

Copied by the servant Shah-Mahmud, may his sins be forgiven.

reference: Roxburgh, 2:962–63.

undated Calligraphy TKS H. 2154
signed (folio 126b, left):

مشقه العبد شاه محمود \ غفر ذنوبه

Copied by the servant Shah-Mahmud, may his sins be forgiven.

reference: Roxburgh, 2:963.

undated Calligraphy TKS H. 2154
signed (folio 126b, right):

مشقه العبد الداعى \ شاه محمود

Copied by the supplicant servant Shah-Mahmud.

reference: Roxburgh, 2:963.

undated Calligraphy TKS H. 2154
signed (folio 126b, bottom right):

مشقه العبد الفقير \ شاه محمود

Copied by the lowly servant Shah-Mahmud.

reference: Roxburgh, 2:964.

undated Calligraphy TKS H. 2154
signed (folio 127a, top left):

مشقه العبد الفقير المذنب \ شاه محمود
النيشابورى \ غفر ذنوبه

Copied by the lowly, sinful servant Shah-Mahmud al-Nishapuri, may his sins be forgiven.

reference: Roxburgh, 2:964.

undated Calligraphy TKS H. 2154
signed (folio 127a, center left):

مشقه العبد شاه محمود النيشابورى \ غفر ذنوبه و
ستر \ عيوبه

Copied by the servant Shah-Mahmud al-Nishapuri, may his sins be forgiven and his faults concealed.

reference: Roxburgh, 2:964.

undated Calligraphy TKS H. 2154
signed (folio 127a, bottom left):

مشقه العبد المذنب شاه محمود \ الكاتب غفر
ذنوبه \ و ستر عيوبه

Copied by the sinful servant Shah-Mahmud the scribe, may his sins be forgiven and his faults concealed.

reference: Roxburgh, 2:964.

undated Calligraphy TKS H. 2154
signed (folio 127a, bottom):

كتبه العبد المذنب \ شاه محمود غفر \ ذنوبه

Written by the sinful servant Shah-Mahmud, may his sins be forgiven.

reference: Roxburgh, 2:965.

undated Calligraphy TKS H. 2154
signed (folio 127a, right):

العبد شاه محمود نيشابورى

The servant Shah-Mahmud Nishapuri.

reference: Roxburgh, 2:964–65.

undated Calligraphy TKS H. 2154
signed (folio 127b, top left):

مشقه العبد الداعى \ شاه محمود

Copied by the supplicant servant Shah-Mahmud.

reference: Roxburgh, 2:965.

undated Calligraphy TKS H. 2154
signed (folio 128a, upper left):

مشقه شاه محمود \ نيشابورى

Copied by Shah-Mahmud Nishapuri.

reference: Roxburgh, 2:965–66.

undated Calligraphy TKS H. 2154
signed (folio 128a, center):

مشقه العبد شاه محمود \ غفر الله ذنوبه و ستر
عيوبه

Copied by the servant Shah-Mahmud, may God forgive his sins and conceal his faults.

reference: Roxburgh, 2:966.

undated Calligraphy TKS H. 2154
signed (folio 128a, bottom):

مشقه العبد شاه محمود نيشابورى غفر \ ذنوبه

Copied by the servant Shah-Mahmud Nishapuri, may his sins be forgiven.

reference: Roxburgh, 2:966.

undated Calligraphy TKS H. 2156
signed (folio 5a, top left):

مشقه العبد شاه محمود

Copied by the servant Shah-Mahmud.

undated Calligraphy TKS H. 2156
signed (folio 5a, bottom left):

شاه محمود

Shah-Mahmud.

undated Calligraphy TKS H. 2156
signed (folio 5a, bottom):

شاه محمود

Shah-Mahmud.

undated Calligraphy TKS H. 2156
signed (folio 5b, bottom):

مشقه العبد المذنب \ شاه محمود غفر الله \ ذنوبه

Copied by the sinful servant Shah-Mahmud, may God forgive his sins.

undated Calligraphy TKS H. 2156
signed (folio 6a, center):

كتبه العبد المذنب \ شاه محمود غفر الله \ ذنوبه

Written by the sinful servant Shah-Mahmud, may God forgive his sins.

There is another calligraphy on this folio signed Mahmud.

undated Calligraphy TKS H. 2156
signed (folio 10a, top right):

مشقه العبد الفقير \ شاه محمود

Copied by the lowly servant Shah-Mahmud.

undated Calligraphy TKS H. 2156
signed (folio 18b, top left):

عبده شاه محمود النيشابورى

His [God's] servant Shah-Mahmud al-Nishapuri.

undated Calligraphy TKS H. 2156
signed (folio 18b, bottom left):

العبد شاه محمود غفر \ ذنوبه

The servant Shah-Mahmud, may his sins be forgiven.

undated Calligraphy TKS H. 2156
signed (folio 22b, top right):

مشقه العبد شاه محمود نيشابورى \ غفر ذنوبه و ستر عيوبه

Copied by the servant Shah-Mahmud Nishapuri, may his sins be forgiven and his faults concealed.

undated Calligraphy TKS H. 2156
signed (folio 22b, bottom left):

كتبه العبد الحقير شاه محمود \ النيشابورى غفر \ ذنوبه

Written by the humble servant Shah-Mahmud al-Nishapuri, may his sins be forgiven.

undated Calligraphy TKS H. 2156
signed (folio 27b, left):

مشقه العبد الفقير \ شاه محمود

Copied by the lowly servant Shah-Mahmud.

undated Calligraphy TKS H. 2156
signed (folio 32a, top left):

مشقه العبد الفقير \ شاه محمود

Copied by the lowly servant Shah-Mahmud.

undated Calligraphy TKS H. 2156
signed (folio 41a, top right):

مشقه العبد الفقير \ شاه محمود

Copied by the lowly servant Shah-Mahmud.

undated Calligraphy TKS H. 2156
signed (folio 41b, top right):

حرَره \ شاه محمود النيشابورى

Written [or outlined] by Shah-Mahmud al-Nishapuri.

undated Calligraphy TKS H. 2156
signed (folio 54a):

الكاتبه شاه محمود \ غفر الله ذنوبه

Its scribe Shah-Mahmud, may God forgive his sins.

undated Calligraphy TKS H. 2156
signed (folio 54b, left):

مشقه العبد الفقير \ شاه محمود

Copied by the lowly servant Shah-Mahmud.

undated Calligraphy TKS H. 2156
signed (folio 55a):

الفقير الحقير المذنب شاه محمود الكاتب \ غفر ذنوبه

The lowly, humble, sinful Shah-Mahmud the scribe, may his sins be forgiven.

undated Calligraphy TKS H. 2156
signed (folio 63b):

مشقه العبد شاه محمود

Copied by the servant Shah-Mahmud.

undated Calligraphy TKS H. 2156
signed (folio 64a):

حرَره العبد المذنب شاه محمود غفر الله ذنوبه

Written [or outlined] by the sinful servant Shah-Mahmud, may God forgive his sins.

undated Calligraphy TKS H. 2156
signed (folio 85a, bottom left):

مشقه العبد الداعى \ شاه محمود

Copied by the supplicant servant Shah-Mahmud.

undated Calligraphy TKS H. 2156
signed (folio 85a, center):

العبد شاه محمود

The servant Shah-Mahmud.

undated Calligraphy TKS H. 2156
signed (folio 93a, right):

مشقه العبد شاه محمود \ النيشابورى

Copied by the servant Shah-Mahmud al-Nishapuri.

undated Calligraphy TKS H. 2157
signed (folio 40b):

مشقه العبد الفقير \ شاه محمود

Copied by the lowly servant Shah-Mahmud.

undated Calligraphy TKS H. 2157
signed (folio 52a):

مشقه العبد الحقير \ شاه محمود

Copied by the humble servant Shah-Mahmud.

undated Calligraphy TKS H. 2157
signed (folio 57b):

مشقه العبد الفقير شاه محمود \ النيشابورى

Copied by the lowly servant Shah-Mahmud al-Nishapuri.

undated Calligraphy TKS H. 2159
signed (folio 4b):

مشقه العبد الحقير شاه محمود النيشابورى

Copied by the humble servant Shah-Mahmud al-Nishapuri.

undated Calligraphy TKS H. 2159
signed (folio 23b):

مشقه الفقير \ شاه محمود

Copied by the lowly Shah-Mahmud.

undated Calligraphy TKS H. 2159
signed (folio 25b):

كتبه العبد الفقير \ شاه محمود

Written by the lowly servant Shah-Mahmud.

undated Calligraphy TKS H. 2159
signed (folio 26b, top):

العبد الفقير \ شاه محمود

The lowly servant Shah-Mahmud.

undated Calligraphy TKS H. 2159
signed (folio 26b, bottom):

العبد الفقير الحقير \ شاه محمود

The lowly, humble servant Shah-Mahmud.

undated Calligraphy TKS H. 2159
signed (folio 48b):

مشقه العبد المذنب \ شاه محمود غفر \ ذنوبه

Copied by the sinful servant Shah-Mahmud, may his sins be forgiven.

undated Calligraphy TKS H. 2159
signed (folio 57a):

مشقه العبد المذنب \ شاه محمود غفر [...]

Copied by the sinful servant Shah-Mahmud, [. . .] forgiven.

undated Calligraphy TKS H. 2161
signed (folio 5a):

العبد شاه محمود النيشابوري \ غفر ذنوبه و ستر \ عيوبه

The servant Shah-Mahmud al-Nishapuri, may his sins be forgiven and his faults concealed.

undated Calligraphy TKS H. 2161
signed (folio 39a):

كتبه العبد المذنب شاه محمود \ غفر الله \ ذنوبه

Written by the sinful servant Shah-Mahmud, may God forgive his sins.

undated Calligraphy TKS H. 2161
signed (folio 47a):

حرّره شاه محمود النيشابوري

Written [or outlined] by Shah-Mahmud al-Nishapuri.

undated Calligraphy TKS H. 2161
signed (folio 52a):

مشقه العبد شاه محمود \ النيشابوري

Copied by the servant Shah-Mahmud al-Nishapuri.

undated Calligraphy TKS H. 2161
signed (folio 58b):

جهت فرزند ارجمند محمد حسين \ تحرير شد \ العبد \ شاه محمود

Written for [my] noble son, Muhammad Husayn, the servant Shah-Mahmud.

reference: Mehdi Bayani, 1–2:305.

undated Calligraphy TKS H. 2161
signed (folio 59b):

كتبه العبد شاه محمود \ النيشابوري

Written by the servant Shah-Mahmud al-Nishapuri.

The signature may be pasted in.

undated Calligraphy TKS H. 2161
signed (folio 60a):

مشقه العبد المذنب شاه محمود \ النيشابوري غفر \ الله \ ذنوبه

Copied by the sinful servant Shah-Mahmud al-Nishapuri, may God forgive his sins.

undated Calligraphy TKS H. 2161
signed (folio 61a):

مشقه العبد الحقير \ شاه محمود

Copied by the humble servant Shah-Mahmud.

undated Calligraphy TKS H. 2161
signed (folio 61b):

مشقه العبد الحقير شاه محمود \ النيشابوري

Copied by the humble servant Shah-Mahmud al-Nishapuri.

undated Calligraphy TKS H. 2161
signed (folio 64a):

حرّره العبد شاه محمود النيشابوري

Written [or outlined] by the servant Shah-Mahmud al-Nishapuri.

undated Calligraphy TKS H. 2161
signed (folio 71b):

كتبه العبد الفقير \ شاه محمود

Written by the lowly servant Shah-Mahmud.

undated Calligraphy TKS H. 2161
signed (folio 72b):

مشقه العبد الفقير \ شاه محمود

Copied by the lowly servant Shah-Mahmud.

undated Calligraphy TKS H. 2161
signed (folio 74a):

مشقه العبد الحقير شاه محمود \ النيشابوري غفر \ الله \ ذنوبه

Copied by the humble servant Shah-Mahmud al-Nishapuri, may God forgive his sins.

undated Calligraphy TKS H. 2161
signed (folio 91a, top):

مشقه العبد شاه محمود النيشابوري

Copied by the servant Shah-Mahmud al-Nishapuri.

undated Calligraphy TKS H. 2161
signed (folio 91a, left):

مشقه العبد شاه محمود \ النيشابوري

Copied by the servant Shah-Mahmud al-Nishapuri.

undated Calligraphy TKS H. 2161
signed (folio 91a, right):

كتبه العبد المذنب شاه محمود \ النيشابوري

Written by the sinful servant Shah-Mahmud al-Nishapuri.

undated Calligraphy TKS H. 2161
signed (folio 91b, top):

مشقه العبد شاه محمود نيشابوري

Copied by the servant Shah-Mahmud Nishapuri.

undated Calligraphy TKS H. 2161
signed (folio 91b, bottom):

مشقه العبد شاه محمود نيشابوري \ غفر ذنوبه \ وستر \ عيوبه

Copied by the servant Shah-Mahmud Nishapuri, may his sins be forgiven and his faults concealed.

undated Calligraphy TKS H. 2161
signed (folio 94b):

كتبه العبد شاه محمود \ غفر ذنوبه

Written by the servant Shah-Mahmud, may his sins be forgiven.

undated Calligraphy TKS H. 2161
signed (folio 98b, bottom):

مشقه شاه محمود \ غفر ذنوبه

Copied by Shah-Mahmud, may his sins be forgiven.

undated Calligraphy TKS H. 2161
signed (folio 99a):

مشقه العبد الفقير الحقير \ شاه محمود

Copied by the lowly, humble servant Shah-Mahmud.

undated Calligraphy TKS H. 2161
signed (folio 101b, bottom right):

مشقه \ شاه محمود

Copied by Shah-Mahmud.

undated Calligraphy TKS H. 2161
signed (folio 104a, bottom left):

لكاتبه شاه محمود \ النيشابوري

Composed [and copied] by Shah-Mahmud al-Nishapuri.

undated Calligraphy TKS H. 2161
signed (folio 107a):

مشقه العبد الفقير الحقير \ شاه محمود

Copied by the lowly, humble servant Shah-Mahmud.

undated Calligraphy TKS H. 2161
signed (folio 108a, left):

مشقه احقر العباد \ شاه محمود

Copied by the humblest servant, Shah-Mahmud.

undated Calligraphy TKS H. 2161
signed (folio 111a, top):

كتبه العبد المذنب شاه محمود \ النيشابورى غفر
الله \ ذنوبه

Written by the sinful servant Shah-Mahmud al-Nishapuri, may God forgive his sins.

undated Calligraphy TKS H. 2161
signed (folio 116a, top):

مشقه الفقير شاه محمود

Copied by the lowly Shah-Mahmud.

undated Calligraphy TKS H. 2161
signed (folio 117a):

مشقه العبد الفقير شاه محمود \ النيشابورى

Copied by the lowly servant Shah-Mahmud al-Nishapuri.

undated Calligraphy TKS H. 2161
signed (folio 118a):

مشقه العبد الداعى \ شاه محمود

Copied by the supplicant servant Shah-Mahmud.

undated Calligraphy TKS H. 2161
signed (folio 122b):

كتبه العبد المذنب شاه محمود

Written by the sinful servant Shah-Mahmud.

undated Calligraphy TKS H. 2161
signed (folio 124b, bottom):

مشقه العبد شاه محمود \ النيشابورى

Copied by the servant Shah-Mahmud al-Nishapuri.

undated Calligraphy TKS H. 2161
signed (folio 125b, right):

مشقه العبد الفقير \ شاه محمود

Copied by the lowly servant Shah-Mahmud.

undated Calligraphy TKS H. 2161
signed (folio 130a):

كتبه احقر العباد \ شاه محمود

Written by the humblest servant Shah-Mahmud.

undated Calligraphy TKS H. 2161
signed (folio 132a, left):

لمحرره احقر العباد شاه محمود \ النيشابورى

Composed and copied by the humblest servant Shah-Mahmud al-Nishapuri.

undated Calligraphy TKS H. 2161
signed (folio 132a, bottom):

مشقه العبد شاه محمود \ النيشابورى

Copied by the servant Shah-Mahmud al-Nishapuri.

undated Calligraphy TKS H. 2161
signed (folio 134a, left):

مشقه شاه محمود

Copied by Shah-Mahmud.

undated Calligraphy TKS H. 2161
signed (folio 134a, center):

لكاتبه شاه محمود النيشابورى

Composed [and copied] by Shah-Mahmud al-Nishapuri.

undated Calligraphy TKS H. 2161
signed (folio 134a, bottom):

شاه محمود

Shah-Mahmud.

undated Calligraphy TKS H. 2161
signed (folio 134b, left):

مشقه العبد الفقير \ شاه محمود

Copied by the lowly servant Shah-Mahmud.

undated Calligraphy TKS H. 2161
signed (folio 134b, right):

مشقه العبد الفقير الحقير \ شاه محمود
النيشابورى \ غفر ذنوبه

Copied by the lowly, humble servant Shah-Mahmud al-Nishapuri, may his sins be forgiven.

undated Calligraphy TKS H. 2161
signed (folio 135a, left):

كتبه العبد الحقير \ شاه محمود

Written by the humble servant Shah-Mahmud.

undated Calligraphy TKS H. 2161
signed (folio 135a, right):

كتبه العبد شاه محمود النيشابورى

Written by the servant Shah-Mahmud al-Nishapuri.

undated Calligraphy TKS H. 2161
signed (folio 135a, bottom left):

شاه محمود

Shah-Mahmud.

undated Calligraphy TKS H. 2161
signed (folio 135b, right):

مشقه العبد الفقير \ شاه محمود

Copied by the lowly servant Shah-Mahmud.

undated Calligraphy TKS H. 2161
signed (folio 139a, top right):

كتبه العبد المذنب \ شاه محمود غفر الله له

Written by the sinful servant Shah-Mahmud, may God forgive him.

undated Calligraphy TKS H. 2161
signed (folio 140b, top right):

مشقه العبد الفقير \ شاه محمود

Copied by the lowly servant Shah-Mahmud.

undated Calligraphy TKS H. 2161
signed (folio 141a, bottom left):

شاه محمود

Shah-Mahmud.

undated Calligraphy TKS H. 2161
signed (folio 142b, bottom):

شاه محمود

Shah-Mahmud.

undated Calligraphy TKS H. 2161
signed (folio 143a, top right):

كتبه العبد الفقير \ شاه محمود

Written by the lowly servant Shah-Mahmud.

undated Calligraphy TKS H. 2161
signed (folio 144a, bottom):

كتبه العبد شاه محمود \ النيشابورى

Written by the servant Shah-Mahmud al-Nishapuri.

signed (folio 144b, top):

كتبه العبد المذنب شاه محمود غفر الله \ ذنوبه

Written by the sinful servant Shah-Mahmud, may God forgive his sins.

undated Calligraphy TKS H. 2161
signed (folio 146a, top left):

شاه محمود نيشابورى

Shah-Mahmud Nishapuri.

undated Calligraphy TKS H. 2161
signed (folio 146a, bottom left):

شاه محمود نيشابورى

Shah-Mahmud Nishapuri.

undated Calligraphy TKS H. 2161
signed (folio 148b, top left):

مشقه العبد الفقير \ شاه محمود

Copied by the lowly servant Shah-Mahmud.

undated Calligraphy TKS H. 2161
signed (folio 148b, bottom):

شاه محمود

Shah-Mahmud.

undated Calligraphy TKS H. 2161
signed (folio 149a, top left):

لحَرره العبد محمود \ النيشابورى

Composed and copied by the servant Shah-Mahmud al-Nishapuri.

undated Calligraphy TKS H. 2161
signed (folio 149b, center right):

مشقه العبد شاه محمود \ النيشابورى

Copied by the servant Shah-Mahmud al-Nishapuri.

undated Calligraphy TKS H. 2161
signed (folio 150b, top left):

شاه محمود

Shah-Mahmud.

undated Calligraphy TKS H. 2161
signed (folio 151a, top):

مشقه العبد \ شاه محمود

Copied by the servant Shah-Mahmud.

undated Calligraphy TKS H. 2161
signed (folio 153b):

مشقه العبد شاه محمود

Copied by the servant Shah-Mahmud.

undated Calligraphy TKS H. 2161
signed (folio 155a, top left):

مشقه العبد الفقير \ شاه محمود

Copied by the lowly servant Shah-Mahmud.

undated Calligraphy TKS H. 2161
signed (folio 162a, bottom):

مشقه العبد \ شاه محمود

Copied by the servant Shah-Mahmud.

undated Calligraphy TKS H. 2161
signed (folio 162a):

مشقه العبد \ شاه محمود

Copied by the servant Shah-Mahmud.

This folio has other calligraphies signed Mahmud.

undated Calligraphy TKS H. 2161
signed (folio 165a):

كتبه العبد الحقير \ شاه محمود غفر \ ذنوبه

Written by the humble servant Shah-Mahmud, may his sins be forgiven.

undated Calligraphy TKS H. 2161
signed (folio 165b, bottom right):

كتبه العبد الحقير \ شاه محمود غفر \ ذنوبه

Written by the humble servant Shah-Mahmud, may his sins be forgiven.

undated Calligraphy TKS H. 2161
signed (folio 168a, top left):

مشقه العبد الحقير \ شاه محمود

Copied by the humble servant Shah-Mahmud.

undated Calligraphy TKS H. 2161
signed (folio 168a, bottom):

مشقه العبد الحقير \ شاه محمود النيشابورى

Copied by the humble servant Shah-Mahmud al-Nishapuri.

undated Calligraphy TKS H. 2161
signed (folio 168b, top left):

كتبه العبد المذنب \ شاه محمود

Written by the sinful servant Shah-Mahmud.

undated Calligraphy TKS H. 2161
signed (folio 169a, left):

كتبه العبد الحقير \ شاه محمود

Written by the humble servant Shah-Mahmud.

undated Calligraphy TKS H. 2161
signed (folio 170b, top left):

الفقير شاه محمود النيشابورى \ غفر ذنوبه و ستر \ عيوبه

The lowly Shah-Mahmud al-Nishapuri, may his sins be forgiven and his faults concealed.

undated Calligraphy TKS H. 2161
signed (folio 172b, top left):

مشقه العبد المذنب \ شاه محمود

Copied by the sinful servant Shah-Mahmud.

undated Calligraphy TKS H. 2161
signed (folio 172b, bottom):

كتبه العبد الفقير \ شاه محمود غفر\ ذنوبه

Written by the lowly servant Shah-Mahmud, may his sins be forgiven.

undated Calligraphy TKS H. 2161
signed (folio 173a, bottom center):

كتبه العبد المذنب \ شاه محمود غفر الله \ ذنوبه

Written by the sinful servant Shah-Mahmud, may God forgive his sins.

undated Calligraphy TKS H. 2161
signed (folio 173b, left):

مشقه احقر العباد \ شاه محمود

Copied by the humblest servant Shah-Mahmud.

undated Calligraphy TKS H. 2161
signed (folio 175a):

كتبه العبد المذنب \ شاه محمود غفر \ ذنوبه

Written by the sinful servant Shah-Mahmud, may his sins be forgiven.

undated Calligraphy TKS H. 2161
signed (folio 176b, bottom):

العبد الفقير \ شاه محمود

The lowly servant Shah-Mahmud.

undated Calligraphy TKS H. 2161
signed (folio 177b, left):

مشقه العبد المذنب شاه محمود \ النيشابورى غفر
الله \ ذنوبه

*Copied by the sinful servant Shah-Mahmud al-Nishapuri, may
God forgive his sins.*

undated Calligraphy TKS H. 2161
signed (folio 180b, bottom):

كتبه العبد الفقير \ شاه محمود

Written by the lowly servant Shah-Mahmud.

undated Calligraphy TKS H. 2165
signed (folio 14b):

كاتبها و قايلها شاه محمود \ النيشابورى

Written and composed by Shah-Mahmud al-Nishapuri.

undated Calligraphy TKS H. 2165
signed (folio 17b):

لكاتبه \ و انا العبد المذنب شاه محمود\
النيشابورى غفر الله \ ذنوبه

*Composed [and copied], and this is the sinful servant, Shah-
Mahmud al-Nishapuri, may God forgive his sins.*

undated Calligraphy TKS H. 2165
signed (folio 20b):

كتبه العبد شاه محمود النيشابورى

Written by the servant Shah-Mahmud al-Nishapuri.

undated Calligraphy TKS H. 2165
signed (folio 29a):

مشقه العبد المذنب \ شاه محمود غفر الله \ ذنوبه

*Copied by the sinful servant Shah-Mahmud, may God forgive his
sins.*

undated Calligraphy TKS H. 2165
signed (folio 33b):

مشقه العبد الفقير \ شاه محمود

Copied by the lowly servant Shah-Mahmud.

undated Calligraphy TKS H. 2165
signed (folio 61b):

لكاتبه \ الفقير الحقير شاه محمود \ النيشابورى

*Composed [and copied] by the lowly humble Shah-Mahmud al-
Nishapuri.*

undated Calligraphy TKS H. 2165
signed (folio 65a):

مشقه العبد \ شاه محمود

Copied by the servant Shah-Mahmud.

undated Calligraphy TKS H. 2166
signed (folio 20b):

مشقه احقر العباد \ شاه محمود

Written by the humblest servant Shah-Mahmud.

undated Calligraphy TKS H. 2169
signed (folio 16b):

مشقه العبد شاه محمود

Copied by the servant Shah-Mahmud.

undated Calligraphy TKS H. 2169
signed (folio 23a):

كتبه الفقير المذنب شاه محمود \ النيشابورى غفر
ذنوبه

*Written by the lowly sinful Shah-Mahmud al-Nishapuri, may his
sins be forgiven.*

undated Calligraphy TKS H. 2169
signed (folio 33a):

مشقه العبد \ شاه محمود

Copied by the servant Shah-Mahmud.

undated Calligraphy TKS H. 2169
signed (folio 40a):

مشقه العبد شاه محمود \ النيشابورى

Copied by the servant Shah-Mahmud al-Nishapuri.

undated Calligraphy TKS H. 2169
signed (folio 45b):

كتبه شاه محمود النيشابورى غفر له

Written by Shah-Mahmud al-Nishapuri, may he be forgiven.

undated Calligraphy TKS H. 2169
signed (folio 57a):

العبد الفقير محمود النيشابورى

The lowly servant Mahmud al-Nishapuri.

undated Calligraphy TKS R. 2056
signed (folio 26a):

مشقه العبد الاقل شاه محمود غفر ذنوبه

*Written by the lowliest servant Shah-Mahmud, may his sins be
forgiven.*

undated Calligraphy TKS R. 2056
signed (folio 56a):

مشقه العبد شاه محمود النيشابورى غفر الله ذنوبه

*Copied by the servant Shah-Mahmud al-Nishapuri, may God
forgive his sins.*

Dated Manuscripts and Calligraphies

These calligraphies are listed by collection.

919/1513–14 *Sa'di, *Gulistan* SJML A/N 241 M. 19
Herat

signed, dated, and located:

Rustam-Ali, 919/1513–14, Herat.

reference: Ashraf, 4: cat. no. 1323.

945/1538–39 Calligraphy IUL F. 1422
signed and dated (folio 69b, left):

مشقه رستم علی شاهی \
فی شهور سنه خمس و اربعین

Copied by Rustam-Ali shahi [in gold], in the months of the year 945/1538–39.

reference: Thackston, *Century*, 347 n. 65.

947/1540–41 Hafiz, *Divan* GULB LA 165
Tabriz

signed, dated, and located (folio 166a):

قد تشرف بكتابة هذا الكتاب بعون الملك الوهاب \
العبد المحتاج الی رحمة الاهی رستم علی الشاهی \
بدار السلطنه تبریز فی سنه سبع \
و اربعین تسعمائه من الهجره \ النبویه

The writing of this book was completed with the help of the all-giving Almighty by the servant, needy of divine blessing, Rustam-Ali al-shahi [in gold], in the abode of the government Tabriz, in the year 947/1540–41 of the Prophet's hegira.

reference: Gray, *OIA*, cat. no. 142.

963/1556 Jami, *Tuhfat al-ahrar* FGA 46.12
(part of a complete *Haft awrang*)
patron: Sultan Ibrahim Mirza
signed and dated (folio 224b):

كتبه العبد رستم علی غفر الله \ ذنوبه و ستر
عیوبه فی غره شهر \ شوال سنه ثلاث و ستین
و تسعمائه

Written by the servant Rustam-Ali, may God forgive his sins and conceal his faults, at the beginning of the month of Shawwal, the year 963/early August 1556.

reference: Simpson, "Jami," 106, fig. 7.

undated Calligraphy IUL F. 1422
signed (folio 5a, bottom left):

مشقه رستم علی شاهی \ غفر له

Copied by Rustam-Ali shahi [in gold], may he be forgiven.

undated Calligraphy IUL F. 1422
signed (folio 69a, top right):

از آمدن شاه جهان چون خبردار شد
در باغ سعادت گل شادی ببر آمد

آسود جهان از تف خورشید حوادث
تا در کیف عدل شه دادگر آمد

مشقه رستم علی شاهی \ غفر ذنوبه

*When the world heard of the arrival of the shah, [in gold],
In the garden of felicity, flowers bloomed;*

*The world rested from the heat of the sun of calamities,
When it experienced the pleasure of the just king's rule.*

Copied by Rustam-Ali shahi [in gold], may his sins be forgiven.

undated Calligraphy IUL F. 1422
signed (folio 69a, bottom):

مشقه رستم علی شاهی

Copied by Rustam-Ali shahi [in gold].

undated Calligraphy IUL F. 1422
signed (folio 69b, bottom right):

مشقه رستم علی الشاهی \ غفر ذنوبه

Copied by Rustam-Ali al-shahi [in gold], may his sins be forgiven.

undated Calligraphy IUL F. 1422
signed (folio 70b, bottom left):

مشقه رستم علی شاهی \ غفر ذنوبه

Copied by Rustam-Ali shahi [in gold], may his sins be forgiven.

Column 1

undated Calligraphy IUL F. 1422
signed (folio 70b, bottom right):

شاها ز شهان برده سبق خواهی بود

در دفتر عقل سرور خواهی بود

گر حوادثه گیر و همه اطراف جهان

شد نیست که در پناه حق خواهی بود

عمر تو و دولت تو بر مرید

عید تو چو بخت تو بادا سعید

مشقه رستم علی الشاهی

Oh shah, you will precede other kings,
In the book of wisdom, you will be the opening page;

Should all the world be overrun by misfortune,
You will not be defeated for righteousness protects you;

May your life and your rule increase,
May your feast like your fortune be auspicious.

Copied by Rustam-Ali al-shahi [all in gold].

undated Calligraphy IUL F. 1422
signed (folio 77a, bottom):

مشقه رستم علی شاهی \ غفر ذنوبه

Copied by Rustam-Ali shahi [in gold], *may his sins be forgiven.*

undated Calligraphy TKS H. 2154
signed (folio 140a, top left):

مشقه رستم علی الشاهی غفر ذنوبه و ستر \ عیوبه

Copied by Rustam-Ali al-shahi [in gold], *may his sins be forgiven and his faults concealed.*

reference: Roxburgh, 2:984.

undated Calligraphy TKS H. 2154
signed (folio 140a, bottom center):

مشقه اقل العباد \ رستم علی بهزاد

Copied by the lowliest servant, Rustam-Ali Bihzad.

reference: Roxburgh, 2:984–85.

undated Calligraphy TKS H. 2154
signed (folio 140a, right):

بفرموده حضرت شاه جهت ابراهیم \ دواتدار

نوشته شد \ مشقه رستم علی الشاهی \ غفر

ذنوبه و ستر \ عیوبه

By the order of his highness the shah [in gold], *it was written for Ibrahim, the keeper of the ink* [secretary of state]. *Copied by Rustam-Ali al-shahi* [in gold], *may his sins be forgiven and his faults concealed.*

references: Mehdi Bayani, 1–2:209; Roxburgh, 2:985

Column 2

undated Calligraphy TKS H. 2154
signed (folio 141a, top left):

مشقه رستم علی شاهی \ غفر ذنوبه

Copied by Rustam-Ali shahi [in gold], *may his sins be forgiven.*

reference: Roxburgh, 2:986.

undated Calligraphy TKS H. 2154
signed (folio 141a, lower left):

مشقه رستم علی شاهی \ غفر ذنوبه

Copied by Rustam-Ali shahi [in gold], *may his sins be forgiven.*

reference: Roxburgh, 2:986.

undated Calligraphy TKS H. 2154
signed (folio 141a, lower center):

مشقه رستم علی \ غفر ذنوبه

Copied by Rustam-Ali, may his sins be forgiven.

reference: Roxburgh, 2:987.

undated Calligraphy TKS H. 2154
signed (folio 141a, lower right):

مشقه رستم علی الشاهی \ غفر ذنوبه

Copied by Rustam-Ali al-shahi [in gold], *may his sins be forgiven.*

reference: Roxburgh, 2:987.

undated Calligraphy TKS H. 2154
signed (folio 141b, top):

مشقه رستم علی الشاهی \ غفر ذنوبه و ستر \ عیوبه

Copied by Rustam-Ali al-shahi [in gold], *may his sins be forgiven and his faults concealed.*

reference: Roxburgh, 2:987.

undated Calligraphy TKS H. 2154
signed (folio 141b, bottom left):

مشقه رستم علی \ غفر ذنوبه

Copied by Rustam-Ali, may his sins be forgiven.

reference: Roxburgh, 2:987.

undated Calligraphy TKS H. 2154
signed (folio 141b, bottom right):

مشقه رستم علی \ غفر ذنوبه

Copied by Rustam-Ali, may his sins be forgiven.

reference: Roxburgh, 2:987.

Column 3

undated Calligraphy TKS H. 2154
signed (folio 142b, top left):

مشقه رستم علی الشاهی \ غفر ذنوبه

Copied by Rustam-Ali al-shahi [in gold], *may his sins be forgiven.*

reference: Roxburgh, 2:988.

undated Calligraphy TKS H. 2154
signed (folio 142b, top right):

کاتبها رستم علی قاطعها مظفرعلی

Written by Rustam-Ali [in gold]. *Cut by Muzaffar-Ali.*

reference: Roxburgh, 2:989.

undated Calligraphy TKS H. 2154
signed (folio 142b, bottom):

مشقه رستم علی الشاهی \ غفر ذنوبه و ستر \ عیوبه

Copied by Rustam-Ali al-shahi [in gold], *may his sins be forgiven and his faults concealed.*

reference: Roxburgh, 2:989.

undated Calligraphy TKS H. 2156
signed (folio 21a):

مشقه رستم علی \ غفر ذنوبه

Copied by Rustam-Ali, may his sins be forgiven.

undated Calligraphy TKS H. 2161
signed (folio 141b, top left):

مشقه رستم علی

Copied by Rustam-Ali.

Dated Manuscripts

964/1557 Jami, *Yusuf u Zulaykha* FGA 46.12
Mashhad (part of a complete *Haft awrang*)
 patron: Sultan Ibrahim Mirza
 signed, dated, and located (folio 139a):

تمام شد بعون الله تعالی برسم کتابخانه نواب نامدار
کامکار \ گردون وقار خورشید اشهار ابوالفتح
سلطان ابرهیم میرزا خلدالله \ تعالی ایام سلطنته
و عدالته ثانی عشر رجب المرجب سنه اربع \
و ستین و تسعمائه علی ید العبد الفقیر محب علی
کتابدار فی المشهد المقدس المنور المزکی \ تم

[It was] finished with the help of God the highest, by order of the kitabkhana of his highness, the illustrious, who is as majestic as the heavens, as renowned as the sun, Abu'l-Fath Sultan Ibrahim Mirza [in gold]. May God the most high perpetuate the days of his rule and justice. The twelfth of the venerable [month of] Rajab in the year 964/11 May 1557, by the hand of the lowly servant Muhhib-Ali the librarian, in the holy, the illustrious, the purified Mashhad. The end.

 references: Simpson, "Jami," 106, fig. 4; Simpson, "Kitab-Khana," fig. 4.

972/1565 Jami, *Layli u Majnun* FGA 46.12
Herat (part of a complete *Haft awrang*)
 patron: Sultan Ibrahim Mirza
 signed, dated, and located (folio 272a):

تمام شد کتابت لیلی و مجنون که بامر نواب کامکار
جم اقتدار \ کامرانی کشور ستانی جهانبانی ولی
النعمی ابوالفتح سلطان ابرهیم میرزا \ خلدالله ضلال
حشمته اقل عباد الله الغنی محب علی بکتابت آن
اقدام داشت \ در دارالسلطنه هراة فی غره شهر \
شوال ختمه بالخیر و اقبال سنه ۹۷۲

The writing of Layli u Majnun *was finished by order of his highness, as mighty as Jamshid in his success at conquering kingdoms, governing the world, and dispensing beneficence, Abu'l-Fath Sultan Ibrahim Mirza, may God perpetuate the shadow of his magnificence. Muhibb-Ali, the least of the servants of God, the self-sufficient, was engaged in its writing. In the abode of the government Herat, at the beginning of the month of Shawwal, it came to a good and auspicious end, the year 972/early May 1565.*

 references: Simpson, "Jami," 106, fig. 8; Simpson, "Kitab-Khana," fig. 7.

978–79/1570–72 Jami, Six masnavis TKS H. 1483
 (minus *Yusuf u Zulaykha*)
 dated (folio 37b):

کتبت تا تسییر علی حسب \ ضیق المجال و
تشتت البال \ فی یوم الخمسین \ الثامن عشرین \
من شهر شوال \ سنه ۹۷۸ \ تم تم تم

I wrote what I could given the strictures of circumstances and distractions of attentions on Thursday, twenty-eighth of the month of Shawwal of the year 978/25 March 1571. The end [repeated twice].

dated (folio 59b):

فرغت عن تسوید هذا الکتاب \ تحفه الاحرار
توفیق الملک \ العزیز الجبار \ فی سنه ۹۷۸
من الهجریه النبویه \ تم تم \ تم

The writing of this book, the Tuhfat al-ahrar, was completed through the divine guidance of the magnificent almighty God in the year 978/1570–71 of the Prophet's hegira. The end [repeated twice].

dated (folio 105a):

تمت الکتاب بعون الملک الوهاب \ فی اوایل ربیع
الاول سنه \ تسع و سبعین و تسعمائه \ تم تم تم

This book was completed with the help of the all-giving Almighty at the beginning of Rabi' I, the year 979/late July 1571. The end [repeated twice].

dated (folio 151a):

اللهم غفر لکاتبه \ و لقاریه و لمن نظریه \ بتاریخ
اوایل ذی حجَه \ سنه سبع و تسعین و تسعمائه \
مرقوم قلم شکسته \ رقم شد

Oh, God, forgive the book's scribe, its reader, and whoever views it. Dated the beginning of Dhu'l-hijja, the year 979/latter part of April 1572. It was written by the broken pen [of this scribe].

dated (folio 170b):

فرَغ من سوید هذه الکتاب \ بعون الملک الوهاب \
فی سلخ محَرم الحرام \ سنه ۹۷۸

The writing of this book was completed with the help of the all-giving Almighty on the last day of the venerable month of Muharram, the year 978/4 July 1570.

signed and dated (folio 184a):

تمت الکتابت بعون الملک \ الوهاب فی سنه ۹۷۸ \
کتبه المذنب الفقیر الحقیر \ محب علی غفرا ذنوبه

The book was completed with the help of the all-giving Almighty in the year 978/1570–71. Written by the lowly, humble servant Muhibb-Ali, may his sins be forgiven.

dated (folio 200a):

فرَغ من تسوید هذه الکتاب \ بعون الملک الوهاب \
فی سلخ شهر \ جمادی الاخر \ سنه ۹۷۸ \ تم

This book was completed with the help of the all-giving Almighty on the last day of the month of Jumada II, the year 978/28 November 1570. The end.

signed and dated (folio 229a):

فرغ من تسويد هذه الكتاب بعون الملك الجليل
الوهاب \ حسب الامر نواب كامياب كردون قباب
ملك جناب \ آفتاب سپهر سلطنت و كامرانى دُرَ
بحار معدلت \ و جهانبانى مظهر اوامرالهى مصدر
فيض نامتناهى باسط بساط الامن و الامان رافع
اعلام عدل و احسان

The copying of this book was completed with the help of the all-giving Almighty, upon the order of the successful lord, the one who inhabits the domes [of the heavens], the august ruler, the sun of the celestial spheres of rule and government, the pearl of the sea of justice and world protection, the manifestation of divine commands, the source of infinite grace, the one who provides law and order, the one who raises the banner of justice and beneficence;

رخ بخاك درش نهاده ز مهر

The face has lowered itself at his door out of love;

خلد الله ملكه و سلطانه و اوضح على العالمين عدله و
احسانه \ مرقوم قلم شكسته رقم شد\ كتبه العبد
المذنب محب على كاتب غفر ذنوبه و \ ستر عيوبه \
فى شهور سنه ثمان و ستين و \ تسعمايه \ تم تم

May God extend his kingdom and his rule and may God cause his justice and benevolence to shine upon the universe. Written by the broken pen, written by the sinful servant Muhibb-Ali the scribe, may his sins be forgiven and his faults concealed, in the months of the year 978/1570–71. The end [repeated].

references: Çağman & Tanindi, no. 102; Karatay, *Farsça*, no. 360; Rogers, *TKS*, pl. and caption nos. 113–18; Simpson, "Codicology," 135–39; Stchoukine, "Shaykh," 3–11.

Undated Calligraphies

These calligraphies are listed by collection.

undated Calligraphy TKS B. 407
 signed (folio 40a):

فقير محب على ابراهمى

The lowly Muhibb-Ali Ibrahimi.

undated Calligraphy TKS H. 2151
 signed (folio 52b):

الفقير محب على

The lowly Muhibb-Ali.

undated Calligraphy TKS H. 2156
 signed (folio 37a):

الفقير محب على

The lowly Muhibb-Ali.

Dated Manuscripts, Calligraphies, and Architectural Inscriptions

950/1544 *Jami, *Subhat al-abrar* BAY
(selections)
signed and dated:

حسب الاشارة جناب وحيد الافاق جامع مكارم
الاخلاق المولى عبد المحسن سلمه الله و ابقاه ووفقه
لمايحب و يرضاه صورت انتخاب كرفت و سمت
استكتاب پذيرفت فى ذى قعدة خمسين و
تسعمائة هجرية كاتبها داعى صاحبه الفقير
مالك غفرالله ذنوبه و ستر عيوبه

(Mehdi Bayani)

It was selected and written by order of his excellency, Abdul-Muhsin, the one who is unique on the horizons, the embodiment of virtues and good conduct, may God keep him safe and grant him long life and success in whatever he pleases and satisfies him, in Dhu'l-qaʾda [of the year] 950/January 1544 after the hegira. Written by the one who is supplicant of his Lord, the lowly Malik, may his sins be forgiven and his faults concealed.

reference: Mehdi Bayani, 3–4:609.

951/1544 Calligraphy TKS H. 2161
signed and dated (folio 176a):

مشقه العبد الفقير المذنب \ مالك الديلى غفر \
ذنوبه و ستر عيوبه \ تحريرا فى شهر محرم
الحرام \ سنه احدى و خمسين و تسعمايه

Copied by the lowly, sinful servant Malik al-Daylami, may his sins be forgiven and his faults concealed. Written in the venerable month of Muharram, the year 951/March–April 1544.

954/1547–48 Yahya Fattahi al-Nishapuri, SPL Dorn 477
Husn u dil
signed and dated (folio 33a):

مخترع منظوب و منثور اقل العباد فتاحى \
نيشابورى و الحمدلله وحده \ سوده مالك فى
سنه ٩٥٤

The composer of the verse and prose [was] the lowliest servant Fattahi Nishapuri, praise be to the one God. Copied by Malik in the year 954/1547–48.

references: Mehdi Bayani, 3–4:608; Dorn, cat. no. 477; Kostygova, cat. no. 33, and fig. 33.

955/1548–49 *Ali ibn Abi Talib, IUL F. 500
Tabriz *Munajat* and *Mufradat*
signed, dated, and located:

مشقه العبد المذنب الراجى الى رحمة ربه الغنى \
مالك الديلى غفر ذنوبه و ستر عيوبه
بدارالسلطنه تبريز \ فى سنه ٩٥٥

(Mehdi Bayani)

Copied by the sinful servant, needy of the bountiful God's mercy, Malik al-Daylami, may his sins be forgiven and his sins concealed, in the abode of the government Tabriz in the year 955/1548–49.

reference: Mehdi Bayani, 3–4:608.

956/1549–50 *Risala-yi Bab-i Hadi Ashar TQV
signed and dated:

تشرّف بتحرير هذه النسخة الشريفة و استسعد
بمطالعتها العبد الفقير الى عفوه سبحانه مالك الديلى
ختم الله بالحسنى فى شهور سنه ٩٥٦ من الهجرة

(Mehdi Bayani)

The honor of copying this noble manuscript and the good fortune of studying it [belong to] to the lowly servant, may God forgive him, Malik al-Daylami. May God end it well, in the months of the year 956/1549–50 after the hegira.

reference: Mehdi Bayani, 3–4:608.

957/1551–52 *Final folio of SOTH 11.VII.72, lot 205
an unidentified text
signed and dated:

Malik al-Daylami, 957/1550–51.

reference: SOTH 11.VII.72, lot 205.

961/1553–54 Calligraphy CB MS 225
Nakhjivan
signed, dated, and located (folio 1b):

النبى ايضا فى نعت \ و سلوات الرحمن عليه و
آله \ و سلام الله على تابعى افعاله \ و كتب ببلده
نخجوان \ فى شهر احدى ستين و تسعمائه \
مالك الديلى \ غفر ذنوبه

Again in praise of the Prophet, prayers and mercy be upon him and his family and God's peace upon those who follow his deeds; and written in the city of Nakhjivan in the months of 961/1553–54, Malik al-Daylami, may his sins be forgiven.

references: Arberry et al., 3: no. 255; James, "Album," 243.

963/1556 Jami, *Silsilat al-dhahab*, FGA 46.12
Mashhad (first daftar, part of a complete
Haft awrang)
patron: Sultan Ibrahim Mirza
signed, dated, and located (folio 46a):

مرقوم شد دفتر اول سلسلة الذهب بامر عالى نواب
نامدار كامكار \ خسرو عالمدار گردون اقتدار وهو
السلطان العادل الكامل الفاضل \ ابوالفتح ابرهيم
ميرزا الحسينى الصفوى \ على يد الفقير اقل
عبيده مالك الديلى \ فى ذى الحجة سنه ثلث و
ستين و تسعمائه \ بالمشهد المقدس المُعلّى

The first book of the Silsilat al-dhahab was written by the high order of his highness, the celebrated, the successful, the world-mastering Khusraw as mighty as the heavens, the just, the perfect, the virtuous Abu'l-Fath Sultan Ibrahim Mirza [in pink and gold] al-Husayni al-Safavi [in pink and gold], by the hand of the lowly [and] lowliest of his servants Malik al-Daylami in Dhu'l-hijja, the year 963/October 1556 in the holy, the sublime Mashhad.

references: Simpson, "Jami," 106, and fig. 1; Simpson, "Kitab-Khana," fig. 6.

964/1557 Jami, *Silsilat al-dhahab* FGA 46.12
(second daftar, part of a complete
Haft awrang)
patron: Sultan Ibrahim Mirza
dated (folio 69b):

تم كتابة الدفتر الثانى من سلسلة الذهب فى
رمضان سنه ٩٦٤

*The writing of the second book of the Silsilat al-dhahab was
finished in Ramadan the year 964|June–July 1557.*

reference: Simpson, "Jami," 106, fig. 2.

966/1559 Jami, *Silsilat al-dhahab* FGA 46.12
Qazvin (third daftar, part of a complete
Haft awrang)
patron: Sultan Ibrahim Mirza
signed, dated, and located (folio 83b):

right:

خدم باتمامها العبد الفقير المذنب المهجورالغايب \
من مواطن العز و السرور مالك الديلمى ببلده
قزوين \ بعد ماتفى ابتدأهاوكتابه اكثرها بالمشهد
المنور \ المقدس المعلى المطهّر المزكى على روضة \
مشرفه اشرف الصلوة و \ الثناء

*The humble, sinful servant, exiled from the regions of power and
joy, Malik al-Daylami, served by completing it in the city of
Qazvin, after its beginning and the greatest part of it [was done]
in the illustrious, holy, sublime, sanctified, purified Mashhad. May
the noblest prayers and praises be upon the gardens [tomb] of he
who ennobled it [Imam Reza].*

center:

فى رمضان سنه ٩٤٤

In Ramadan the year 966|June–July 1559.

left:

برسم بيت الكتب السلطان العادل الكامل
المختصّ بزيد \ الكرامة الالهيه المتاز بين السلاطين
بالطاف \ الحضره الشاهيّة اعنى السلطان ابرهيم
ميرزا الحسينى الصفوى \ لا زال ظلال سلطنته
ظلّ ظل اظليّة الله \ و اثار مكارمه فى
البرايا \ جليله

*By order of the library of the sultan, the just, the perfect, chosen
for increased divine blessings, distinguished among sultans for the
benevolence of the royal presence [Shah Tahmasp], that is, Sultan
Ibrahim Mirza al-Husayni al-Safavi. May the shadows of his
reign not diminish under the shadow of the shadow of God and the
effects of his noble works remain magnificent among the people.*

references: Simpson, "Jami," 106, and fig. 3; Simpson,
"Kitab-Khana," fig. 3.

966/1558–59 Hafiz, *Ghazal*
Qazvin
location: Qazvin, Chihil Sutun Palace [no longer extant]
signed:

Malik al-Daylami.

references: Mehdi Bayani, 1–2:599; Qazi Ahmad
[Minorsky], 143; Qazi Ahmad [Suhayli-Khunsari],
95–96.

966/1558–59 Hisamuddin Maddah, *Ghazal*
Qazvin
location: Qazvin, Chihil Sutun Palace
[no longer extant]
signed and dated:

Malik al-Daylami, 966|1558–59.

references: Mehdi Bayani, 1–2:599; Qazi Ahmad
[Minorsky], 143–44; Qazi Ahmad [Suhayli-Khunsari],
95–96.

966/1559 Nakhjivan Calligraphy TKS H. 2161
Nakhjivan
signed and dated (folio 128b):

مشقه العبد الفقير المذنب مالك الديلمى غفر ذنوبه \
و ستر عيوبه \ ببلده نخجوان \ فى آخر شهر
ذى حجه سنه ٩٦٦

*Copied by the lowly, sinful servant Malik al-Daylami, may his
sins be forgiven and his faults concealed in the town of Nakhjivan
at the end of the month Dhu'l-hijja 966|September–October
1559.*

967/1559–60 Verses from Amir Khusraw BN pers. 245
Dihlavi, *Divan*, and Jami, *Divan*
signed and dated (folio 43a):

نمقه العبد الفقير المذنب \ مالك الديلمى غفر
ذنوبه \ فى شهور سنه ٩٦٧

*Copied by the lowly, sinful servant Malik al-Daylami, may his
sins be forgiven, in the months of the year 967|1559–60.*

references: Blochet, *Persans*, 3: no. 1543; Richard, 257–59.

The final folio of this manuscript, folio 43b, has pasted on
it two bayts from the *Divan* of Saʿdi copied by Mir-Ali al-
katib.

967/1559–60 Didactic prose text TKS H. 2151
(fragments)
signed and dated (folio 102b):

خدم بكتابها باشارة الامير الكبير مقرب الحضرة \
العليه العليّة صاحب الكمال و العزة الجود و الاقباله
نظامالله و لهُ الحشمة و الرفّعه والاجلال حسين
بيك \ مد الله ظلال حكومته و افضاله فى \ شهور
سنه ٩٦٧ و انا العبد \ مالك الديلمى \ غفر له

*The writing was undertaken by order of the exalted amir, the
monarch's companion, the sublime, the possessor of perfection, and
glory and generosity and good fortune. May God protect him,
Husayn Beg, and his magnificence and dignity and splendor. May
God extend the shadow of his government and his glory. In the
months of the year 967|1559–60, and this is the servant Malik al-
Daylami, may he be forgiven.*

Seven folios of this text are mounted on folios 102a–b.
Other folios appear on folios 5a–b, 9a–b, 82a–b, as well
as in TKS H. 2161, folio 121b–22a.

968/1560–61 Introduction to TKS H. 2151 and
Amir Husayn Beg album TKS H. 2126
signed and dated (TKS H.2161, folio 2a):

كرد مالك بهر تاريخش رقم
گلشنى از قطعهاى دلگشا \ ٩٦٨

*For its date, Malik put to writing a flower garden of pleasing
[calligraphic] specimens, 968|1560–61.*

references: Mehdi Bayani, 1–2:601, 607–9 (gives date as
967/1559–60); Thackston, *Century*, 351–52 (on p. 351,
the date is given as 958/1560–61).

The folios of the preface to this album are now dispersed
between TKS H. 2151 and H. 2161. The correct sequence
of surviving folios is as follows: TKS H. 2151, folios
1b–2b, 74a–b, 25a–b, 23a–b, 98a–b, 33a–b; TKS H. 2161,
folio 2a. The distich at the end of TKS H. 2151, folio 2a,
forms a chronogram that gives the same date as the digits
(trans. Thackston, *Century*, 351 but citing H. 2161, folio
2a, instead of H. 2151, folio 2a). A part of the text in TKS
H. 2151, folio 25b, is also dated 968/1560–61.

968/1560–61 Calligraphy TKS H. 2151
signed and dated (folio 76a):

مرقوم شد بجهته مرقع حضرة \ امارت پناه مربى
اهل كمال \ كمالاً الرفعة والاقبال \ حسين بيك
خازن \ مدالله ظلال افضاله \ بطرح و اختراع
الحضرت \حرّرَه الفقيرمالك الديلمى سنه ٩٦٨

*It was written for the album of his lordship, the refuge of power,
the teacher of the most perfect, perfect dignity and good fortune,
Husayn Beg the treasurer, may God's shadow protect his
accomplishments. According to the design and invention of his
lordship. Written [or outlined] by the lowly Malik al-Daylami,
the year 968|1560–61.*

969/1561–62 Qazi Ataʾullah Varamini,
Qazvin Chronogram
location: Qazvin, Saʿadat-abad garden [no longer extant]
dated:

969|1561–62.

references: Mehdi Bayani, 3–4:599; Qazi Ahmad
[Minorsky], 142–43; Qazi Ahmad [Suhayli-Khunsari],
96.

969/1562 Calligraphy SPL Dorn 148
signed and dated (folio 29b):

نمقه العبد الفقير \ مالك الديلمى \ غفرله \
فى شوال سنه \ تسع و ستين و \ تسعمائة

*Copied by the lowly servant al-Malik Daylami, may he be
forgiven, in Shawwal of the year 969|June–July 1562.*

references: Mehdi Bayani, 3–4:608; Dorn, cat. no. 148;
Kostygova, cat. no. 34, and fig. 34.

Undated Manuscripts

ca. 1550 Proverbs and aphorisms SOTH 19.X.94, lot 117
signed (folio 11a):

كتبه مالك الديلمي غفرالله \ ذنوبه

Written by Malik al-Daylami, may God forgive his sins.

reference: SOTH 19.X.94, lot 117, and repro.

ca. 1550 *Marsiya* SPL Dorn 450
signed (folio 12b):

نقلت من خط المولى سلطان على \ المشهدى و
انا الفقير مالك الديلمى غفر \ ذنوبه

Copied in the writing [style] of the master Sultan-Ali al-Mashhadi and this is, the lowly Malik al-Daylami, may his sins be forgiven.

reference: Dorn, cat. no. 384.

ca. 1560 Salman Savaji, *Firaqnama* BN pers. 243
signed (folio 32a):

كتبه العبد المذنب مالك الديلمى \ غفر له

Written by the sinful servant Malik al-Daylami, may he be forgiven.

references: Blochet, *Persans*, 3: no. 1567; Richard, 255–56.

ca. 1560 *Munajat* TKS H. 2151
(fragment)
signed (folio 35b):

العبد الفقير الحقير المذنب \ مالك الديلمى غفر له

The lowly, humble, sinful servant, Malik al-Daylami, may he be forgiven.

Undated Calligraphies

These calligraphies are listed by collection.

undated Calligraphy BN pers. 129
signed (folio 35a):

مالك

Malik.

reference: Richard, 152.

undated Calligraphy BOD Laud. Or. 149
signed (folio 5b):

فقير مالك الديلمى

The poor Malik al-Daylami.

undated Calligraphy IUL F. 1435
signed (folio 5a):

مشقه العبد المذنب مالك الديلمى

Copied by the sinful servant Malik al-Daylami.

undated Calligraphy MAH Inv. 1971–107/307
signed:

مشقه العبد مالك غفر ذنوُبه

Copied by the servant Malik, may his sins be forgiven.

references: Robinson, "Pozzi" 1, cat. no. 307; Robinson, *Pozzi* 2, cat. no. 583.

undated Calligraphy MAH Inv. 1971–107/310
signed:

مشق الفقير مالك \ غفر له

Exercise of the lowly Malik, may he be forgiven.

references: Robinson, "Pozzi" 1, no. 310; Robinson, *Pozzi* 2, cat. no. 586 and pl. XXXVIII.

undated *Calligraphy ÖNB Mixt. 313
signed (folio 44a):

مشق الفقير الحقير \ مالك

Exercise of the lowly, humble Malik.

reference: Duda, 1:149.

undated Calligraphy SOTH 2.V.77, lot 24
signed:

فقير مالك الديلمى \ غفر له

The lowly Malik al-Daylami, may he be forgiven.

references: SOTH, 2.V.77, lot 24 and repro.; *Treasures*, cat. no. 70, and repro.

undated Calligraphy SPL Dorn 148
signed (folio 11a):

مشق الفقير مالك

Exercise of the lowly Malik.

reference: Dorn, cat. no. 148.

undated Calligraphy SPL Dorn 148
signed (folio 15b):

مشقه العبد المذنب \ مالك الديلمى غفر \ ذنوبه

Copied by the sinful servant Malik al-Daylami, may his sins be forgiven.

reference: Dorn, cat. no. 148.

undated Calligraphy SPL Dorn 148
signed (folio 20a):

مشق الفقير مالك

Exercise of the lowly Malik.

reference: Dorn, cat. no. 148.

undated Calligraphy SPL Dorn 148
signed (folio 30a):

بنده خاكسار بيمقدار \ مالك الديلمى غفر \ ذنوبه

The abject, unworthy servant Malik al-Daylami, may his sins be forgiven.

reference: Dorn, cat. no. 148.

undated Calligraphy SPL Dorn 488
signed (folio 10b):

الفقير مالك

The lowly Malik.

reference: Dorn, cat. no. 488.

undated Calligraphy TKS B. 407
signed (folio 32b):

عبده مالك الديلمى غفر \ ذنوبه و ستر \ عيوبه

His [God's] servant Malik al-Daylami, may his sins be forgiven and his faults concealed.

undated Calligraphy TKS B. 407
signed (folio 33a):

مشقه العبد المذنب مالك الديلمى \ غفرله

Copied by the sinful servant Malik al-Daylami, may he be forgiven.

undated Calligraphy TKS B. 407
signed (folio 50a):

العبد المذنب \ مالك الديلمى ستر الله عيوبه

The sinful servant Malik al-Daylami, may God conceal his faults.

undated Calligraphy TKS H. 2137
signed (folio 29a):

فقير مالك

The lowly Malik.

Column 1

undated Calligraphy TKS H. 2138
signed (folio 12b):

مشقه العبد الحقير المذنب \ مالك الديلمى غفر \ ذنوبه

Copied by the humble, sinful servant Malik al-Daylami, may his sins be forgiven.

undated Calligraphy TKS H. 2140
signed (folio 10a):

مشقه العبد المذنب مالك الديلمى

Copied by the sinful servant, Malik al-Daylami.

undated Calligraphy TKS H. 2145
signed (folio 27b):

مالك الديلمى

Malik al-Daylami.

undated Calligraphy TKS H. 2149
signed (folio 24b):

پادشاها لشكر توفيق همراه تواند
خيز اگر بر عزم تسخير جهان ره ميكنى

با چنين اوج كمال از پيشگاه سلطنت
اگهى و خدمت مردان كه ميكنى

كتبه العبد \ المذنب مالك الديلمى

Majesty, the army of success is with you.
Arise if you intend to conquer the world.

With such a degree of perfection at the helm of government,
You inform and serve men.

Written by the sinful servant Malik al-Daylami.

undated Calligraphy TKS H. 2151
signed (folio 11b):

مشق الفقير مالك

Exercise of the lowly Malik.

undated Calligraphy TKS H. 2151
signed (folio 20b):

مشقه العبد الفقير المذنب \ مالك الديلمى \ غفرله

Copied by the lowly, sinful servant Malik al-Daylami, may he be forgiven.

undated Calligraphy TKS H. 2151
signed (folio 21a):

كاتبها مالك الديلى و محررها \ الاستاد مظفرعلى \ غفر ذنوبها

Written by Malik al-Daylami and outlined by master Muzaffar-Ali, may their sins be forgiven.

Column 2

undated Calligraphy TKS H. 2151
signed (folio 42b):

مشقه العبد المذنب \ مالك الديلمى \ غفرله

Copied by the sinful servant Malik al-Daylami, may he be forgiven.

undated Calligraphy TKS H. 2151
signed (folio 43a):

مشقه العبد الحقير المذنب \ مالك الديلمى \ غفر ذنوبه

Copied by the humble, sinful servant Malik al-Daylami, may his sins be forgiven.

undated Calligraphy TKS H. 2151
signed (folio 56a):

عبده مالك

His [God's] servant Malik.

undated Calligraphy TKS H. 2151
signed (folio 56b):

نمقه العبد المذنب \ مالك

Copied by the sinful servant Malik.

undated Calligraphy TKS H. 2151
signed (folio 58a):

مشقه العبد الفقير المذنب \ مالك الديلمى \ غفرله

Copied by the lowly, sinful servant Malik al-Daylami, may he be forgiven.

undated Calligraphy TKS H. 2151
signed (folio 64b):

مشق الفقير مالك الديلى \ غفر ذنوبه و ستر عيوبه

Exercise of the lowly Malik al-Daylami, may his sins be forgiven and his faults concealed.

undated Calligraphy TKS H. 2151
signed (folio 68b, upper left):

العبدمالك

The servant Malik.

undated Calligraphy TKS H. 2151
signed (folio 68b, lower left):

مشق مالك

Exercise of Malik.

Column 3

undated Calligraphy TKS H. 2151
signed (folio 79a):

مشقه العبد الفقير المذنب \ مالك الديلمى غفر ذنوبه و \ ستر عيوبه

Copied by the lowly, sinful servant Malik al-Daylami, may his sins be forgiven and his faults concealed.

undated Calligraphy TKS H. 2154
signed (folio 132a):

مشقه العبد الفقير المذنب \ مالك الديلمى ستر الله عيوبه

Copied by the lowly, sinful servant Malik al-Daylami, may God forgive his sins.

reference: Roxburgh, 2:972.

undated Calligraphy TKS H. 2154
signed (folio 132a):

نقل من خط الاستاد \ مولانا شاه \ محمود \ مشقه الفقير المذنب \ مالك غفر ذنوبه

Copied in the writing [style] of the master Mawlana Shah-Mahmud. Copied by the lowly, sinful Malik, may his sins be forgiven.

reference: Roxburgh, 2:972–73.

undated Calligraphy TKS H. 2156
signed (folio 6b):

مشق الفقير مالك

Exercise of the lowly Malik.

undated Calligraphy TKS H. 2156
signed (folio 26a):

مشقه الفقير \ مالك

Copied by the lowly Malik.

undated Calligraphy TKS H. 2156
signed (folio 64b):

مالك

Malik.

undated Calligraphy TKS H. 2156
signed (folio 84b):

فقير مالك الديلى \ غفر ذنوبه

The lowly Malik al-Daylami, may his sins be forgiven.

undated Calligraphy TKS H. 2156
signed (folio 85a):

مشقه العبد الفقير \ مالك الديلمى \ غفر له

Copied by the lowly servant Malik al-Daylami, may he be forgiven.

undated Calligraphy TKS H. 2159
signed (folio 1b):

كتبه الفقير مالك الديلمى

Written by the lowly Malik al-Daylami.

undated Calligraphy TKS H. 2159
signed (folio 2a):

مشقه مالك الديلمى

Copied by Malik al-Daylami.

undated Calligraphy TKS H. 2161
signed (folio 71a):

مشق الفقير مالك

Exercise of the lowly Malik.

undated Calligraphy TKS H. 2161
signed (folio 92a):

مشقه العبد المذنب \ مالك

Copied by the sinful servant Malik.

undated Calligraphy TKS H. 2161
signed (folio 98a, right):

مشق الفقير مالك الديلمى غفر ذنوبه و \
ستر \ عيوبه

Exercise of the lowly Malik al-Daylami, may his sins be forgiven and his faults concealed.

undated Calligraphy TKS H. 2161
signed (folio 98a, lower):

مشقه العبد الحقير المذنب \ مالك الديلمى \
غفر ذنوبه

Copied by the humble, sinful servant Malik al-Daylami, may his sins be forgiven.

undated Calligraphy TKS H. 2161
signed (folio 99a):

مشق فقير مالك

Exercise of the lowly Malik.

undated Calligraphy TKS H. 2161
signed (folio 102b, top):

مشق مالك

Exercise of Malik.

undated Calligraphy TKS H. 2161
signed (folio 102b, left):

مشقه العبد المذنب \ مالك الديلمى غفر ذنوبه

Copied by the sinful servant Malik al-Daylami, may his sins be forgiven.

undated Calligraphy TKS H. 2161
signed (folio 102b, right):

مالك

Malik.

undated Calligraphy TKS H. 2161
signed (folio 103a):

نقله العبد الحقير المذنب \ مالك

Copied by the humble, sinful servant Malik.

undated Calligraphy TKS H. 2161
signed (folio 103b):

مالك

Malik.

undated Calligraphy TKS H. 2161
signed (folio 104a):

از تركيبات خاص فقير \ مالك ديلميست \
غفر ذنوبه

This is [one of] the lowly Malik al-Daylami's special compositions, may his sins be forgiven.

undated Calligraphy TKS H. 2161
signed (folio 104b):

مشق مالك

Exercise of Malik.

undated Calligraphy TKS H. 2161
signed (folio 105a, left):

قاطعها مظفر على و \ راقمها ملك غفر \ ذنوبه

Cut by Muzaffar-Ali and written by Malik, may he be forgiven.

undated Calligraphy TKS H. 2161
signed (folio 105a, right):

مشقه العبد الحقير المذنب \ مالك الديلمى غفرله

Copied by the humble, sinful servant Malik al-Daylami, may he be forgiven.

undated Calligraphy TKS H. 2161
signed (folio 105b):

مشقه العبد الفقير المذنب \ مالك الديلمى غفر \
ذنوبه

Copied by the lowly, sinful servant Malik al-Daylami, may his sins be forgiven.

undated Calligraphy TKS H. 2161
signed (folio 106b):

عبده مالك

His [God's] servant Malik.

undated Calligraphy TKS H. 2161
signed (folio 107a):

فقير مالك

The lowly Malik.

undated Calligraphy TKS H. 2161
signed (folio 107b):

مشق الفقير مالك

Exercise of the lowly Malik.

undated Calligraphy TKS H.2161
signed (folio 108a):

مشق الفقير مالك

Exercise of the lowly Malik.

undated Calligraphy TKS H. 2161
signed (folio 109a, lower left):

فقير حقير مالك الديلمى

The lowly, humble Malik al-Daylami.

undated Calligraphy TKS H. 2161
signed (folio 109a, right):

كاتبها مالك و قاطعها \ محمد امين غفر لهما

Written by Malik and cut by Muhammad Amin, may they be forgiven.

undated Calligraphy TKS H. 2161
signed (folio 109b):

مشق الفقير مالك

Exercise of the lowly Malik.

undated Calligraphy
signed (folio 112a):

TKS H. 2161

مشق مالك

Exercise of Malik.

undated Calligraphy
signed (folio 112b):

TKS H. 2161

مشقه العبد \ مالك

Copied by the servant Malik.

undated Calligraphy
signed (folio 114a):

TKS H. 2161

نقل من خط مولانا سلطان \ على المشهدى \
الفقير مالك

Copied in the writing [style] of Mawlana Sultan-Ali al-Mashhadi, the lowly Malik.

undated Calligraphy
signed (folio 114b, left):

TKS H. 2161

كتبه العبد الفقير \ مالك

Written by the lowly servant Malik.

undated Calligraphy
signed (folio 114b, right):

TKS H. 2161

مشقه العبد \ مالك

Copied by the servant Malik.

undated Calligraphy
signed (folio 115a):

TKS H. 2161

مشقه العبد المذنب \ مالك الديلى \ غفر ذنوبه

Copied by the sinful servant Malik al-Daylami, may his sins be forgiven.

undated Calligraphy
signed (folio 115b)

TKS H. 2161

مشقه فقير مالك

Copied by [the] lowly Malik.

undated Calligraphy
signed (folio 116a):

TKS H. 2161

كتبه \ العبد مالك غفرله

Written by the servant Malik, may he be forgiven.

undated Calligraphy
signed (folio 117b, top):

TKS H. 2161

مشقه العبد الفقير \ مالك الديلى

Copied by the lowly servant, Malik al-Daylami.

undated Calligraphy
signed (folio 117b, center left):

TKS H. 2161

كتبه \ العبد مالك الديلى

Written by the servant Malik al-Daylami.

undated Calligraphy
signed (folio 124a):

TKS H. 2161

نمقه العبد الفقير المذنب \ مالك الديلى غفر\ ذنوبه

Copied by the lowly, sinful servant Malik al-Daylami, may his sins be forgiven.

undated Calligraphy
signed (folio 124b):

TKS H. 2161

فقير مالك

The lowly Malik.

undated Calligraphy
signed (folio 125b):

TKS H. 2161

فقير مالك

The lowly Malik.

undated Calligraphy
signed (folio 135b):

TKS H. 2161

نمقه العبد الحقير \ مالك

Copied by the humble servant Malik.

undated Calligraphy
signed (folio 136a):

TKS H. 2161

مشقه العبد الفقير المذنب \ مالك الديلى \
غفر ذنوبه

Copied by the lowly, sinful servant Malik al-Daylami, may his sins be forgiven.

undated Calligraphy
signed (folio 138a):

TKS H. 2161

مشق الفقير مالك

Exercise of the lowly Malik.

undated Calligraphy
signed (folio 140b):

TKS H. 2161

الفقير مالك

The lowly Malik.

undated Calligraphy
signed (folio 141a):

TKS H. 2161

الفقير مالك

The lowly Malik.

undated Calligraphy
signed (folio 142a):

TKS H. 2161

مشقه العبد الفقير المذنب \ مالك الديلى \
غفر ذنوبه

Copied by the lowly, sinful servant Malik al-Daylami, may his sins be forgiven.

undated Calligraphy
signed (folio 147a):

TKS H. 2161

مالك الديلى \ غفر ذنوبه

Malik al-Daylami, may his sins be forgiven.

undated Calligraphy
signed (folio 148a):

TKS H. 2161

مشق الفقير مالك

Exercise of the lowly Malik.

undated Calligraphy
signed (folio 148b):

TKS H. 2161

الفقير مالك الديلى ستر عيوبه

The lowly Malik al-Daylami, may his faults be concealed.

undated Calligraphy
signed (folio 163b):

TKS H. 2161

مشق الفقير مالك

Exercise of the lowly Malik.

undated Calligraphy
signed (folio 164a):

TKS H. 2161

الفقير مالك غفرله

The lowly Malik, may he be forgiven.

undated Calligraphy
signed (folio 167a):

TKS H. 2161

مالك

Malik.

undated Calligraphy
signed (folio 167b):

TKS H. 2161

مالك

Malik.

undated Calligraphy
signed (folio 177b):

TKS H. 2161

مشق الفقير مالك \ غفر ذنوبه و ستر \ عيوبه

Exercise of the lowly Malik, may his sins be forgiven and his faults concealed.

undated Calligraphy TKS H. 2161
signed (folio 178a):

نمقه العبد المذنب \ مالك الديلمى غفر \ ذنوبه

Copied by the sinful servant Malik al-Daylami, may his sins be forgiven.

undated Calligraphy TKS H. 2161
signed (folio 178a):

مشق الفقير مالك

Exercise of the lowly Malik.

undated Calligraphy TKS H. 2161
signed (folio 179b):

مشقه العبد \ مالك \ غفر ذنوبه

Copied by the servant Malik, may his sins be forgiven.

undated Calligraphy TKS R. 2056
signed (folio 40a):

قاطعها مالك الديلمى

Cut by Malik al-Daylami.

Attribution

undated Calligraphy SPL Dorn 148
inscribed (folio 25a):

خط مولانا مالك

Writing of master Malik.

reference: Kostygova, cat. no. 1, and fig. 1.

5. AYSHI IBN ISHRATI

Dated Manuscripts and Calligraphies

944/1537–38 Jami, *Yusuf u Zulaykha* FWM MS 24-1948
signed and dated (folio 175a):

كتبه العبد المذنب عيشى \ الكاتب غفر ذنوبه و \
ستر عيوبه فى شهور \ سنه ٩٤٤

Written by the sinful servant, Ayshi the scribe, may his sins be forgiven and his faults concealed, in the months of the year 944/1537–38.

references: Mehdi Bayani, 1–2:546; Binyon et al., cat. no. 161; Wormald & Giles, 508.

This manuscript also contains two undated calligraphies by Ayshi, listed below, following folio 175a.

956/1549–50 Calligraphy TKS H. 2161
composed and dated (folio 115b, left):

دل من در چمن بى آن گل رخسار گشايد
مرا خاطر چو غمگين است در گلزار نگشايد

گره شدآرزوى وصل يارى در دل و دانم
كه مارا اين گره از طره هر يار نگشايد

فتد در راه من هر دم زززلفش صد گره ليكن
مرا هرگز زززلفش يك گره از كار نگشايد

مخوان اى باغبان بى روى او سوى گلستانم
مرا چون غنجه دل هرگز از گلزار نگشايد

بكفر زلف آن بت بسته دلرا آنچنان عيشى
كه در كفر زلفش جان دهد نار بگشايد

ليمحَرره \غفر ذنوبه و ستره عيوبه سنه ٩٥٦

My heart does not blossom in the meadow without that rosy-cheeked one.
Since I am melancholic, my mind will not find rest in the garden.

My hope of union with the beloved is tied in a knot, and I know
That this knot will not be untied by the locks of any beloved.

A hundred knots fall across my path from the locks of his/her hair, but
Never for me will one knot of his/her hair become untangled.

Oh gardener, do not call me to the garden in the absence of his/her face.
My heart will never blossom like a rosebud in the garden.

The pleasure of the heart [or Ayshi's heart] is so attached to the curse of that idol's locks,
That if he expires from the curse of his/her locks, pomegranates will [burst] forth.

Composed and written [by Ayshi]. May his sins be forgiven and his faults concealed, the year 956/1549–50.

reference: Mehdi Bayani, 1–2:546 (with date of 965).

Column 1

968/1560–61 Calligraphy TKS H. 2161
composed and dated (folio 115b, right):

دل من در چن بی آن گل رخسار گشاید

مرا خاطر چو غمگین است در گلزار نگشاید

گره شد آرزوی وصل یاری در دل و دانم

که مارا این گره از طره هر یار نگشاید

فتد در راه من هر دم ز زلفش صد گره لیکن

مرا هرگز ز زلفش یك گره از كار نگشاید

بكفر زلف آن بت بسته دلرا آنچنان عیشی

كه در كفر زلفش جان دهد نار بگشاید

نقل من خط الشریف مالك الدیلمی سنه ٩٦٨

My heart does not blossom in the meadow without that rosy-
cheeked one.
Since I am melancholic, my mind will not find rest in the garden.

My hope of union with a [certain] beloved was tied in a knot, and I
know
That this knot will not be untied by the locks of any beloved.

A hundred knots fall across my path from the locks of his/her hair.
Never for me will one knot of his/her hair become untangled.

The pleasure of the heart [or Ayshi's heart] is so attached to the
curse of that idol's locks,
That if he expires from the curse of his/her locks, pomegranates
will [burst] forth.

Copied in the noble style of Malik al-Daylami, in the year
968/1560–61.

968/1560–61 *Salaman u Absal* FGA 46.12
(part of a complete *Haft awrang*)
patron: Sultan Ibrahim Mirza
signed and dated (folio 199a):

كتبه العبد الفقیر عیشی بن عشرتی \

غفره ذنوبه و ستره عیوبه \ بتاریخ ٩٦٨

Written by the lowly servant Ayshi ibn Ishrati, may his sins be
forgiven and his faults concealed. Dated the year 968/1560–61.

reference: Simpson, "Jami," 106, fig. 4.

984/1576–77 Calligraphy TKS H. 2151
Qazvin
signed, dated, and located (folio 45a):

فقیر عیشی \ فی سنه ٩٨٤ \ بدارالسلطنه قزوین

The lowly Ayshi, in the year 984/1576–77, in the abode of the
government Qazvin.

984/1576–77 Calligraphy TKS H. 2156
Qazvin
signed, dated, and located (folio 52b):

فقیر حقیر عیشی غفر ذنوبه \ و ستر عیوبه \

بدارالسلطنه قزوین \ فی شهور ٩٨٤

The lowly, humble Ayshi, may his sins be forgiven and his faults
concealed, in the abode of the government Qazvin, in the year
984/1576–77.

Column 2

Undated Calligraphies

These calligraphies are listed by collection.

undated Calligraphy FWM MS 24-1948
signed (folio 175b):

مشقه عیشی

Copied by Ayshi.

undated *Calligraphy MDV
signed:

عیشی

Ayshi.

reference: Mehdi Bayani, 1–2:546.

undated Calligraphy (ghazal) SPL Dorn 147
Herat
composed and located (folio 43a):

نخلی كه در این باغ سلامت زخزان است

در گلشن جان قامت آن سرو روانست

عارض چو برافروخته روشن شده عالم

قامت چو برافروخته آشوب جهان است

با یار كنم شرح غم خویش نهانی

چون یار مرا محرم اسرار نهانست

از كج روی چرخ زبد مهری ایام

در هم شده كارم چو سر زلف بتان است

دل گفت كه در سایه كرمی رو

كو بر همه خلق جهان نفع رسان است

بحر كرم كان سخا شاهقلی بگ

كه آن مردمك دیده صاحب نظران است

در فهم و خرد جا نكند وصف كمالش

وزهر چه كند عقل تصویر به از آن است

ناگاه فلك گفت بوصفش زسر مهر

این قطعه كه هر بیت مرا مونس جان است

ای آنكه ترا دولت و اقبال قرینست

پیوسته دعای تو مرا ورد زبان است

سوی من سر كشته غمدیده نظر كن

كز گردش ایام مرا حال چه بیان است

خواهم كه دهم شرح غم خود بتو لیكن

جابی كه عیان است چه حاجت بیان است

در دور لب لعل توچون عیشی بیدل

پیوسته مرا كوی خرابات مكان است

بدار السلطنه هراة \ حرّره كمال الدین مذهب

The palm tree in this garden of well-being is in its autumnal phase;
In the garden of the soul, it is exact like an elegant cyprus.

When the cheek becomes flushed, the world lights up;
When [the beloved] stands tall, he creates havoc in the world.

I explain to the beloved my sorrow in secret,
Because my beloved is privy to my secrets.

Column 3

From the crooked path of the sphere and the ill-will of fate,
My lot has become as tangled as the tresses of the beauties.

The heart said to walk in the shadow of the noble one,
For he benefits all the people of the world.

The sea of generosity, the mine of liberality, Shah-Quli Beg,
For he is the pupil of the eyes of the connoisseurs.

In knowledge and wisdom, there is no room to describe his
perfection,
And he surpasses whatever the mind is able to imagine.

Suddenly the sphere said, describing him affectionately,
Every line of this [poetic] piece delights my soul.

Oh you, to whom fortune and prosperity are joined,
I continually invoke prayers on you.

Look at me, who is perplexed and grief-stricken.
What can I say now about the passage of time.

I would like to explain to you my grief, but why belabor what is
obvious.
Around the ruby lips, like Ayshi, who has lost his heart, I
continually dwell in the tavern's lane.

In the abode of the government Herat. Outlined by
Kamaluddin the illuminator.

undated Calligraphy SPL Dorn 147
signed (folio 43b):

العبد المذنب \ عیشی الكاتب \ ابن عشرتی

حرره كمال الدین مذهب

The sinful servant Ayshi the scribe ibn Ishrati. Outlined by
Kamaluddin the illuminator.

undated Calligraphy SPL Dorn 147
signed (folio 44a):

جهت كمال الدین محرَّر نوشته شد \

الفقیر عیشی بن عشرتی

Written for Kamaluddin the outliner; the lowly Ayshi ibn Ishrati.

undated Calligraphy SPL Dorn 147
signed (folio 51a):

العبد عیشی

The servant Ayshi.

undated Calligraphy SPL Dorn 147
Herat
signed and located (folio 55b):

مشقه العبد المذنب عیشی غفر ذنوبه ستر عیوبه \

بدارالسلطنه هراة

Copied by the sinful servant Ayshi, may his sins be forgiven and
his faults concealed, in the abode of the government Herat.

undated Calligraphy SPL Dorn 148
Mashhad
signed and located (folio 36a):

كتبه عیشی \ در شهر مشهد مقدس انور

نوشته شد

Written by Ayshi. It was written in the holy, blessed Mashhad.

undated Calligraphy TKS H. 2151
signed (folio 62b):

<div dir="rtl">

كتبه عيشى
</div>

Written by Ayshi.

reference: Mehdi Bayani, 1–2:546.

undated Calligraphy TKS H. 2156
signed (folio 27b):

<div dir="rtl">

العبد عيشى
</div>

The servant Ayshi.

undated Calligraphy TKS H. 2156
signed (folio 32b):

<div dir="rtl">

عيشى
</div>

Ayshi.

undated Calligraphy TKS H. 2156
signed (folio 78b):

<div dir="rtl">

العبد عيشى
</div>

The servant Ayshi.

undated Calligraphy TKS H. 2157
signed (folio 52b):

<div dir="rtl">

مشقه عيشى
</div>

Copied by Ayshi.

undated Calligraphy TKS H. 2159
signed (folio 45a):

<div dir="rtl">

عيشى
</div>

Ayshi.

undated Calligraphy TKS H. 2161
signed (folio 98b):

<div dir="rtl">

قايلة عيشى
</div>

Composed by Ayshi.

reference: Mehdi Bayani, 1–2:546.

undated Calligraphy TKS H. 2161
signed (folio 106a):

<div dir="rtl">

العبد عيشى
</div>

The servant Ayshi.

reference: Mehdi Bayani, 1–2:546.

undated Calligraphy TKS H. 2161
signed (folio 107b):

<div dir="rtl">

مشقه عيشى
</div>

Copied by Ayshi.

reference: Mehdi Bayani, 1–2:564.

undated Calligraphy TKS H. 2161
signed (folio 108b):

<div dir="rtl">

العبد عيشى
</div>

The servant Ayshi.

undated Calligraphy TKS H. 2161
signed (folio 115a):

<div dir="rtl">

كتبه عيشى
</div>

Written by Ayshi.

reference: Mehdi Bayani, 1–2:564.

undated Calligraphy Location unknown
signed:

<div dir="rtl">

كتبه عيشى
</div>

Written by Ayshi.

reference: Qazi Ahmad [Suhayli-Khunsari], repro.
(n.p.).

Attributed Calligraphies

undated Calligraphy SPL Dorn 148
signature effaced (folio 36b, right)

undated Calligraphy FWM MS 24-1948
unsigned (folio 176a)

6. SULTAN-MUHAMMAD KHANDAN

Dated Manuscripts

957/1550 Unidentified text (fragment) TKS H. 2157
signed and dated (folio 42a):

كتبه سلطان محمد خندان \ جمیدی الاول سنه ۱۹۵۷
سبع و خمسین و تسعمایه

*Written by Sultan-Muhammad Khandan, Jumada I the year 957
nine hundred and fifty seven/May–June 1550.*

reference: Mehdi Bayani, 1–2:271.

Other folios of the same text are mounted on folios 1b–2a,
13b, 22a–b, 26b, 27a–b, 30a–b, 37a–b of this album.

982/1574 Muhammad Ghazali Mashhadi, TKS R. 1038
Sabzivar *Naqsh-i badiʿ*
patron: Sultan Ibrahim Mirza
signed, dated, and located (folio 38a):

تمّت الكتاب بعون الوهاب فى تاریخ شهر محرّم
الحرام \ سنه ۹۸۲ برسم كتابخانه نواب جهانبانى
سلطان \ ابراهیم میرزا در بلده سبزوار مرقوم
شد \ كتبه الفقیر سلطان محمد خندان

*The book was completed with the help of the almighty Lord, in the
venerable month of Muharram, the year 982/April–May 1574. It
was written by order of the kitabkhana of his highness, governor of
the world, Sultan Ibrahim Mirza, in the city of Sabzivar.
Written by the lowly Sultan-Muhammad Khandan.*

references: Çağman & Tanindi, no. 105; Karatay, *Farsça*,
no. 787; Simpson, "Kitab-Khana," 115–16, and figs.
9–10; Togan, 37.

Problematic Undated Manuscript

ca. 1575–80 Jami, *Subhat al-abrar* GULB LA 159
signed (folio 128a):

كتبه الفقیر سلطان محمد \ خندان \ م

Written by the poor Sultan-Muhammad Khandan. The end.

place: attributed to Mashhad
references: Adey; Gray, *OIA*, cat. no. 126; Stchoukine,
MS, no. 169.

7. ABDULLAH AL-SHIRAZI

Dated Manuscripts, Illuminations, and Paintings

after 964/1557 Masnavi heading in Jami, FGA 46.12
 Yusuf u Zulaykha
 (part of a complete *Haft awrang*)
patron: Sultan Ibrahim Mirza
signed (folio 84b):

این نامه كه یوسف و زلیخاست بنام
خطش چو خم زلف بتان غالیه فام
نقشش چو لب سبز خطان رنگ آمیز
نظمیست كه میرساند از وحى پیام
مذهبه عبدالله الشیرازی

*This book that is Yusuf u Zulaykha in name,
Its writing is a fragrant black like the curls and the locks of the
beloved,*

*Its images [are] colorful like the lips adorned with youthful down,
It is a poem that conveys a message from the divine.*

Illuminated by Abdullah al-Shirazi.

masnavi signed and dated by Muhibb-Ali, 12 Rajab
964/11 May 1557.

references: Diba, "Lacquerwork" 2, 181; *EIr*, Priscilla P.
Soucek, "ʿAbdallah Šīrāzī," pl. 10; Simpson, "Jami,"
98, and fig. 13.

972/1564–65 Painting inserted into GULB LA 159
 Jami, *Subhat al-abrar*
signed and dated (folio 101a):

عمل عبدالله المذهب ۹۷۲

Work of Abdullah the illuminator, 972/1564–65.

manuscript signed by Sultan-Muhammad Khandan.

references: Adey, 190–95 (gives date of Abdullah's
signature as 972/1554); Diba, "Lacquerwork" 2, 181;
Gray, *OIA*, cat. no. 126; Schmitz, "Harat," 120–21;
Stchoukine, *MS*, no. 169.

The manuscript also contains other inserted paintings:
double-page frontispiece (folios 1b–2a), colophon
illustration (folio 137a), and double-page finispiece (folios
137b–38a).

978/1570–71 *Double-page frontispiece SAY Akhlaq 7
 in Saʿdi, *Gulistan*
patron: Navab Musatab Khan
signed and dated (folio 1b or 2a):

عمل عبدالله شیرازی ۹۷۸

(Nizamuddin)

Work of Abdullah Shirazi, 978/1570–71.

manuscript signed and dated (folio 106b) by [Hasan?]
Ibn al-Husayn al-Sharif al-Husayni al-Mashhadi,
986/1578–79.

references: Nizamuddin, 137, 140–41 (refers to pl. 4 but
this is not reproduced), 149–50; Schmitz, "Harat," 120,
122.

989/1581–82 Jahi [Sultan Ibrahim Mirza], *Divan* GL 2183
Mashhad
signed, dated, and located:

در مشهد مقدس انور... \ و ملازم قديمى نواب
مغفرت پ[ناه] \ سلطان ابراهيم ميرزا مولانا\
عبدالله المذنب الشيرازى \ صورت اتمام يافت فى
شهور سنه ٩٨٩ كتبه جمال المشهدى \ غفر ذنوبه

It was completed in the holy, illustrious Mashhad [rest of line damaged] and the old companion of the deceased prince Sultan Ibrahim Mirza, Mawlana Abdullah the illuminator from Shiraz, in the months of the year 989/1581–82. Written by Jamal al-Mashhadi, may his sins be forgiven.

references: Atabay, *Divan*, 339–41 (mentions a double-page frontispiece and 5 text illustrations); Diba, "Lacquerwork" 2, 182–83; Soudavar, 229 (identifies manuscript as GL 218 and interprets colophon to say that Abdullah illustrated the manuscript).

989/1581–82 Double-page frontispiece AHT no. 90a
painting (folio 1b–2a) in Hilali,
Sifat al-ashiqin
patron: attributed to Mirza Salman
signed and dated (folio 2a, on rock):

عمل عبدالله المذهب ٩٨٩

Work of Abdullah the illuminator, 989/1581–82.

manuscript signed and dated by Muzaffar Husayn al-Husayni, 990/1582–83.

place: attributed to Mashhad
references: Binney, no. 47, and frontispiece; Diba, "Lacquerwork" 2, 181–82; *EIr*, Priscilla P. Soucek, "'Abdallah Šīrāzī"; Grube, *CS*, no. 79.1; Kevorkian & Sicré, 225; Robinson, *PMA*, cat. no. 24, and repro. 126–27; Schmitz, "Harat," 120, 123; Soudavar, cat. no. 90a, and color repro.; *Treasures*, cat. no. 76.

989–94/1581–86 Double-page frontispiece TKS H. 986
illumination in Hafiz, *Divan*
patron: Sultan Sulayman (Khalifa Turcoman)
signed (folio 6a):

عمل عبدالله المذهب

Work of Abdullah the illuminator.

manuscript signed, dated, and located by Sultan-Husayn ibn Qasim al-Tuni, 20 Ramadan 989/18 October 1581 and mid-Rabi' I 994/early March 1586 in Tun.

references: Çağman & Tanindi, cat. no. 106, and fig. 36; Çağman & Tanindi, "Remarks," 134–36 (discussion includes the attribution of two illustrations to Abdullah), and figs. 4–7, 10; Diba, "Lacquerwork" 2, cat. no. 30; Karatay, *Farsça*, no. 634; Robinson et al., 184, and color pl. 24.

The manuscript contains 8 illustrations. A ninth was removed and is now KEIR III. 232.

990/1582–83 Double-page frontispiece SAK MS 33
illumination and text
illustrations in Sultan
Ibrahim Mirza, *Divan*
signed and dated (folios 1b–2a):

عمل عبدالله المذهب شيرازى سنه ٩٩٠

Work of Abdullah the illuminator from Shiraz, the year 990/1582–83.

signed and dated (folio 23a on rock):

هو \ در سنگ چنين نوشت نقاش
دنيا نكند وفا تو خوش باش
عمل عبدالله المذهب سنه ٩٩[٠]

On this stone the painter has written that the world lacks constancy; therefore be happy. Work of Abdullah the illuminator, the year 99[0]/158[2]–8[3].

references: Diba, "Lacquerwork" 2, 182; Marteau & Vever, 2: pl. 50, no. 122 (folio 32a), and pl. 51, no. 124 (folio 23a); Schmitz, "Harat," 120, 123; Stchoukine, *MS*, 126; *Treasures*, cat. no. 77, and color repro. (folio 23a); Welch & Welch, cat. no. 30, and color repro. (folio 86b; also reproduced in black and white, p. 95, and misidentified as folio 23b).

99[0]/158[2]–8[3] *A Youthful Musician* LKM
(fragment)
signed (on rock):

عمل عبدالله المذهب ٩٩[٠]

Work of Abdullah the illuminator, 99[0]/158[2]–8[3].

references: Diba, "Laquerwork" 2, 180 and ill. 41; *EIr*, Priscilla P. Soucek, "'Abdallah Šīrāzī" (comments that date is illegible in published repro.); Kühnel, *Miniaturmalerie*, fig. 70a; Martin, 2: pl. 101, lower left; Schulz, 2: color pl. 139; Stchoukine, *MS*, 27 (refers to artist as Abdullah Khurasani), 90, and no. 63.

Attributions

949/1543 Sa'di, *Gulistan* MAR
reference: Martin, 1:117.

959/1552 Koran Private collection
date: Sha'ban 959/July–August 1552
reference: *Treasures*, cat. no. 66, and color repros.

ca. 1556–65 Illustrations in Jami, *Haft awrang* FGA 46.12
folio 59a: Soudavar, 229 n. 64.
folio 153b: Stchouckine, *MS*, 126–28.
folio 179b: *EIr*, Priscilla P. Soucek, "'Abdallah Šīrāzī."
folio 188a: Soudavar, 229.
folio 275a: Soudavar, 229 n. 64.

ca. 1560 Illustration in Sa'di, *Gulistan* NM
patron: attributed to Sultan Ibrahim Mirza
manuscript signed and dated by Abdul-Wahhab al-Husayni al-Mashhadi, 966/1558–59.

references: Diba, "Lacquerwork" 2, 183; Soudavar, 229, and color fig. 35 (detail); SOTH 1.XII.69, lot 192, and repro.

976/1568–69 Marginal illuminations in GULB LA 192
Hilali, *Three Poems*
manuscript signed and dated (folio 63a) by Muizzuddin Muhammad al-Husayni, 976/1568–69.

references: Diba, "Lacquerwork" 2, 183; *EIr*, Priscilla P. Soucek, "'Abdallah Šīrāzī"; Gray, *OIA*, cat. no. 127, and repro.; Schmitz, "Harat," 122.

ca. 1576–77 *Second Battle between* CB MS 256.4
Kai Khusraw and Afrasiyab
from Firdawsi, *Shahnama*
patron: attributed to Shah Isma'il II
place: attributed to Qazvin
references: *EIr*, Priscilla P. Soucek, "'Abdallah Šīrāzī"; Robinson, "Isma'il," 4, and nos. 40, 7; A. Welch, *Artists*, 214, and fig. 66.

undated *Boy Sitting on a Branch* Location unknown
references: Martin, 2: pl. 101, upper; Stchoukine, *MS*, 27.

Zeren Tanindi also has attributed illuminations in the following TKS manuscripts to Abdullah: H. 403, H. 406, H. 407, H. 780, H. 1483, R. 884, and R. 924. See p. 307 n. 13.

Problematic Works

mid-16th century Jami, *Yusuf* NYPL Spencer, Pers. MS 64
u Zulaykha
signed (folio 143b):

كتبه عبدالله شيرازى جهت شاهزاده كامران بن
شاه بابر تحرير نمود

Written by Abdullah Shirazi; copied for Prince Kamran, the son of Babur.

references: Adle, "Dust-Mohammad," 19–28; Elgood, 34–40; Schmitz, *NYPL*, no. II.15; SOTH 23.IV.79, lot 156.

The volume contains a double-page frontispiece and 4 text illustrations, which appear to be later additions in Bukharan style. Adle has proposed that Abdullah copied the manuscript while Kamran was still prince, that is, before 1543. Schmitz has suggested that the colophon is fraudulent. Certainly there is nothing in Abdullah's biography to connect him to the Mughal court. As Prince Kamran died in 963/1555–56, Abdullah would have had to copy this manuscript before he inscribed the heading in FGA 46.12, folio 84b.

987/1579–80 Hilali, *Sifat al-ashiqin* TKS R. 918
inscribed and dated (folio 57a):

عبدالله الشيرازى \صوره \ و ذهبته ٩٨٧

Depicted [painted] and illuminated by al-Abdullah Shirazi, 987/1579–80.

manuscript signed and dated (folio 57a) by Muhammad al-katib al-Razi, Sha'ban 989/August–September 1581.

references: Çağman & Tanindi, "Remarks," 136, and figs. 8–9 (attributes painting and illuminations to Abdullah); Diba, "Lacquerwork" 2, 179–80, 183, and cat. no. 29 (attributes paintings, illuminations, and binding to Abdullah); *IA*, Ali Alparslan, "Abdullah Šīrāzī," with color repros.; Karatay, *Farsça*, no. 776; Kevorkian & Sicré, 51 color repro.

The manuscript contains 2 pairs of figure studies for both frontispiece and finispiece (1b–2a, and 57b–58a) and 3 text illustrations (folios 20b, 29b, and 50b). The inscription with Abdullah's name is written in white ink within a gold eight-pointed star underneath the manuscript's colophon. Neither the form and content of this inscription nor the style of the text illustrations corresponds to known works by Abdullah. The four figure studies do resemble figures in compositions signed by Abdullah such as AHT no. 90a. Zeren Tanindi (paper presented at Institute of Fine Arts, New York University, February 1994) sees similarities between the illustration on folio 29b and FGA 46.12, folio 59a.

8. ALI ASGHAR

Attributions

Undated manuscripts are listed in chronological order of attribution.

991/1583–84 Illustrations in Location unknown
Firdawsi, *Shahnama*
manuscript dated: 991/1583–84
place: attributed to Qazvin
references: Robinson, "Ali Asghar," 126 and pl. IIIa; Robinson, "Isma'il," 7; Robinson, *PMA*, 110–13, and cat. no. 18.

ca. 1570–75 *Iskandar Shoots* BM 1937–7–10–0323
Birds from a Ship
(possibly from Mir-Ali Sher,
Sadd-i Iskandar)
references: Robinson, "Ali Asghar," 126, and pl. IIIb; Titley, *MPM*, cat. no. 300.

ca. 1570–75 Double-page frontispiece SPL PNS 106
and one illustration in Arifi,
Guy u Chawgan
references: Akimushkin & Ivanov, *PM*, pls. 53, 54, 56; Robinson, "Ali Asghar," 126, and pl. IV.

ca. 1570–75 Double-page frontispiece CB MS 237
in Hilali, *Sifat al-ashiqin*
reference: Arberry et al., 3: no. 237, and pl. 12; Robinson, "Ali Asghar," 126, and pl. V.

ca. 1570–75 Double-page frontispiece and TEH
double-page finispiece in Hilali,
Shah u gada
references: Robinson, "Ali Asghar," 126, and pl. VIa; Soudavar, 252, and color repro. (detail).

ca. 1575 Double-page frontispiece TKS R. 1520
in Hatifi, *Timurnama*
manuscript signed by Diya'uddin Muhammad ibn Muhammad Amin.

place: attributed to Qazvin
references: Canby, *Reformer*, 38; Rogers, *TKS* , no. 119, and color repro.; Soudavar, 252.

ca. 1576–77 Double-page frontispiece Private collection
in Firdawsi, *Shahnama*
patron: attributed to Shah Isma'il II
place: attributed to Qazvin
references: Canby, *Reformer*, 220, and fig. 10; Robinson, "Ali Asghar," 125, and pl. II; Robinson, "Isma'il," 2 and no. 2, 7 and pl. I; Robinson, *PMA*, 116–17, and cat. no. 19II; *Treasures*, cat. no. 73, and color repro.; A. Welch, *Artists*, 214.

ca. 1576–77 *Iskandar Builds a Wall against Gog* AHT no. 100
and Magog, in Firdawsi, *Shahnama*
patron: attributed to Shah Isma'il II
inscribed:

Ali Asghar.

place: attributed to Qazvin
references: Canby, *Reformer*, 38; Robinson, "Ali Asghar," 125–26, and pl. I; Robinson, "Isma'il," 5, no. 50, 7; Soudavar, cat. no. 100, and color repro.

ca. 1580 Illustrations in Firdawsi, *Shahnama* TKS H. 1512
reference: Robinson, "Ali Asghar," 127, and pl. VIb.

ca. 1590 Illustrations in BN suppl. pers. 1313
al-Nishapuri, *Qisas al-anbiya*
manuscript signed and dated by Mir ibn Muhhib-Ali Rashidi, 989/1581–82.

references: Lowry et al., cat. no. 413 n. 3; Soudavar, 252; Stchoukine, *MS*, no. 198.

ca. 1590–1600 *Solomon and Bilqis* AMSG S1986.186
Enthroned
place: attributed to Isfahan
references: Lowry et al., cat. no. 413; Robinson, "Ali Asghar," 127.

ca. 1600 *Three Men in a Landscape* TKS H. 2165
(painting, folio 63b)
references: Ipşiroğlu, pl. 96; Robinson, "Ali Asghar," 127.

ca. 1600 Double page frontispiece DC 29/1962 and
from an unidentified manuscript 18/1970
place: attributed to Isfahan
references: Folsach, 53, and color fig. 33; "AWI," cat. no. 240, and color repro.; Robinson, "Ali Asghar," 128 n. 13.

9. SHAYKH-MUHAMMAD

Dated Manuscripts, Calligraphies, and Paintings

943/1536–37 *Sad kalama TQV
signed and dated:

مشقه العبد المذنب شیخ محمدکمال کاتب
نیشابوری غفر ذنوبه و ستر عیوبه سنه ۹۴۳

(Mehdi Bayani)

Copied by the sinful servant Shaykh-Muhammad [son of] Kamal the Nishapuri scribe, may his sins be forgiven and his faults concealed, the year 943/1536–37.

references: Mehdi Bayani, 3–4:825–26; Dickson & Welch, 1:251B nn. 3, 7.

964/1556–57 *Camel and Its Keeper* FGA 37.21
(painting mounted as an album
page, possibly depicting Vays-i
Qaran the cameleer)
signed and dated in two central panels within
calligraphic frame:

مرا غمیست شتروارها حجره تن
شتر دلی نکنم غم کجا و حجرهٔ من

I have camel-loads of grief in this cell of my body.
[But] I am not camel-hearted [vindictive or cowardly], for this grief and my cell are worlds apart.

کرنرم از شتران سپهر و حجرهٔ خاك
که حجره راست شترهای مست پیراهن

I will escape from the Constellation of the Camel and this earthly cell,
Since the cell is surrounded by rutting camels.

بیام حجره شتر جسته باشی از نبری
پی شتر بدرحجرهٔ امیر زمن

It would be [as foolish as] seeking [or driving] your camel on the roof of a cell,
Not to follow its tracks to the door of the Master of the World's [Ali's] cell.

شترسوار عرب نقدحجرهٔ کعبه
که حجره روب شتربان اوست ویس قران

May that Arab camel-rider offer up his life to the Kaʿba's cell,
He who has Vays-i Qaran as the sweeper of his camel-keeper's cell.

مصور و محرر شیخ محمد \ فی شهور
سنة ۹۶۴

Depiction and fair copy by Shaykh-Muhammad in the months of the year 964/1556–57.

Translation of poem courtesy of C. Adle.
references: Adle, "Dust-Mohammad," 243–44, and pl. xv, fig. 19; Atil, *Brush*, cat. no. 16, and fig. 16a; Binyon et al., no. 156; Dickson & Welch, 1:166B–67A (with variant reading of signature), and fig. 226; Sakisian, fig. 85; Simpson, "Shaykh Muhammad," 105, pl. 1; Stchoukine, *MS*, 47.

970/1562–63 Calligraphy TKS H. 2137
Mashhad (qitʿa by Mir-Ali Haravi)
signed, dated, and located (folio 18b):

نقل از خط شریف حضرت استادی \ مخدومی
امیر علی علیه رحمة \ فقیر شیخ محمد مصور
غفر \ ذنوبه و ستر عیوبه \ فی مشهد مقدس
حضرت امام علیه السلام ۹۷۰۱

Copy of the noble writing of the exalted, omnipotent master, Amir-Ali, peace be upon him. The lowly Shaykh-Muhammad musavvir, may his sins be forgiven and his faults concealed, at the holy shrine of the exalted Imam [in Mashhad], peace be upon him. 970/1562–63.

references: Mehdi Bayani, 3–4:837–38; Dickson & Welch, 1:251B n. 3; Simpson, "Shaykh-Muhammad," 100.

976/1568–69 Calligraphy TKS H. 2151
(qitʿa by Mir-Ali Haravi)
signed and dated (folio 39a):

فقیر شیخ محمد بن شیخ کمال سبزواری غفر
ذنوبها و ستر عیوبها ۹۷۶

The lowly Shaykh-Muhammad, the son of Shaykh-Kamal of Sabzivar, may their sins be forgiven and their faults concealed, 976/1568–69.

references: Mehdi Bayani, 3–4:742; Dickson & Welch, 1:251B n. 3.

1000/1591–92 *Seated Man with Pillow* TKS H. 2166
(tinted drawing)
signed and dated (folio 18a, left):

طرح مولانا شیخ محمد و قلم آقا رضا ۱۰۰۰

Design of Mawlana Shaykh-Muhammad and pen of Aqa Riza, 1000/1591–92.

references: Canby, *Reformer*, 39, 43–45 (with color repro.), and cat. no. 14; Canby, "Work of Riza," 75, and fig. 5; *ALBK*, Richard Ettinghausen, "Riza," 402, and no. 7; Sakisian, 129; Schroeder, 124, no. 2; Stchoukine, *MSA*, 115 (with different title); A. Welch, "Abbas," 464, and fig. 3.

Undated Calligraphies

These calligraphies are listed by collection.

undated Calligraphy IUL F. 1422
signed (folio 14a):

الفقیر الحقیر \ شیخ محمد \ م

The lowly, humble servant Shayhk-Muhammad. The end.

undated Calligraphy IUL F. 1422
signed (folio 65a):

مشقه العبد الفقیر المذنب شیخ محمد الکاتب \
غفر الله ذنوبه و ستر \ عیوبه

Copied by the lowly, sinful servant Shaykh-Muhammad the scribe; may God forgive his sins and conceal his faults.

undated Calligraphy IUL F. 1422
signed (folio 70b):

عبده الداعی شیخ محمد \ غفر الله ذنوبه

His [God's] supplicant servant Shaykh-Muhammad, may God forgive his sins.

undated Calligraphy TKS H. 2140
signed (folio 10b):

عبده الداعی شیخ محمد

His [God's] supplicant servant, Shaykh-Muhammad.

undated Calligraphy TKS H. 2154
signed (folio 115b, top left):

العبد شیخ محمد \ عفی عنه

The servant Shayhk-Muhammad, may he be forgiven.

reference: Roxburgh, 2:946–47.

undated Calligraphy TKS H. 2154
signed (folio 115b, top center):

الداعی شیخ محمد \ عفی عنه

The supplicant Shayhk-Muhammad, may he be forgiven.

reference: Roxburgh, 2:947.

undated Calligraphy TKS H. 2154
signed (folio 115b, top right):

عبده شیخ محمد \ عفی عنه

His [God's] servant Shaykh-Muhammad, may he be forgiven.

reference: Roxburgh, 2:947.

undated Calligraphy TKS H. 2154
signed (folio 115b, center):

عبده الداعی شیخ محمد \ غفر الله ذنوبه

His [God's] supplicant servant Shayhk-Muhammad, may God forgive his sins.

reference: Roxburgh, 2:947.

undated Calligraphy TKS H. 2154
signed (folio 115b, bottom left):

کاتب شیخ محمد

The scribe Shayhk-Muhammad.

reference: Roxburgh, 2:947.

undated Calligraphy TKS H. 2154
signed (folio 115, bottom right):

عبده الداعی \ شیخ محمد

His [God's] supplicant servant Shayhk-Muhammad.

reference: Roxburgh, 2:947.

undated Calligraphy TKS H. 2154
signed (folio 131a, top left):

عبده الداعی \ شیخ محمد

His [God's] supplicant servant Shayhk-Muhammad.

reference: Roxburgh, 2:970–71.

undated Calligraphy TKS H. 2154
signed (folio 131a, bottom left):

عبده الداعی شیخ محمد \ عفی عنه

His [God's] supplicant servant Shayhk-Muhammad, may he be forgiven.

reference: Roxburgh, 2:971.

undated Calligraphy TKS H. 2161
signed (folio 141a):

الفقیر شیخ محمد

The lowly Shaykh-Muhammad.

Undated Paintings and Tinted Drawings

ca. 1556–65 *The Infant Witness Testifies to Yusuf's* FGA 46.12
Innocence, in Jami, *Haft awrang*
(painting, folio 120a)
patron: Sultan Ibrahim Mirza
signed (to left of inscription over central arch):

کتبه شیخ محمدمصور

Written by Shaykh-Muhammad [the] painter.

ca. 1565 *Seated Princess* TKS H. 2166
(painting)
signed (folio 24b, at left above rocky ridge):

قلم شیخ محمد

The pen of Shaykh-Muhammad.

references: Blunt, fig. 65; Dickson & Welch, 1:177A, 253B n. 15; A. Welch, "Abbas," 460.

ca. 1575 *Man Leaning on a Staff* TKS H. 2161
(tinted drawing)

signed (folio 172a):

صوَره شیخ محمد

Depicted by Shaykh-Muhammad.

reference: Adle, "Dust-Mohammad," pl. xv, fig. 18.

ca. 1575 *Prince with a Parakeet* FGA 37.23
[also known as *Kneeling Youth with Bird*]
(tinted drawing)
signed (beneath penknife):

راقمه شیخ

Penned [drawn] by Shaykh.

references: Atil, *Brush*, cat. no. 16, and color repro.; Binyon et al., no. 147; Dickson & Welch, 1:165A, and fig. 224; Simpson, "Shaykh-Muhammad," 109, pl. 12; Stchoukine, *MS*, 47.

ca. 1575 *Youth with a Book and a Flower* LVR K3427
(tinted drawing)
signed (beneath knee):

راقمه شیخ

Penned [drawn] by Shaykh.

references: Canby, *Reformer*, 39, and fig. 20; Dickson & Welch, 1:165A, and fig. 223; *Islam* 2, cat. no. 659 (with previous references) and repro.; Stchoukine, *MS*, 47; S. C. Welch, *WA*, cat. no. 76; A. Welch, "Abbas," 461.

ca. 1575 *Youth with a Book and a Flower* TKS H. 2166
(tinted drawing)
signed (folio 9b, on penknife):

راقمه شیخ محمد

Penned [drawn] by Shaykh-Muhammad.

references: Blunt, fig. 59; Dickson & Welch, 1:251B n. 1.

ca. 1575 *A Turcoman Prisoner* TKS H. 2156
(painting)
signed (folio 45a, on tip of bow sticking out of case):

عمل شیخ محمد

The work of Shaykh-Muhammad.

references: Dickson & Welch, 1:252B n. 14; A. Welch, "Abbas," 462–63, and fig. 1.

ca. 1580 *Seated Dervish* CB MS 242.4
(tinted drawing)
signed:

راقمه شیخ محمد

Penned [drawn] by Shaykh-Muhammad.

references: Arberry et al., 3: no. 242 (IV); Canby, *Reformer*, fig. 19; A. Welch, "Abbas," 463, and fig. 2.

Attributions

early 1540s *The First Joust of the Rooks:* Private collection
Fariburz versus Kalbad, from
Firdawsi, *Shahnama*
(painting, folio 341b)
patron: Shah Tahmasp
references: Adle, "Dust-Mohammad," 270–71; Dickson & Welch, 1:168B, 175B, and 2: pl. 174; *Treasures*, cat. no. 55, and color repro.; S. C. Welch, *KBK*, 164–67; S. C. Welch, *WA*, cat. no. 27.

ca. 1545 *Camel with Its Keeper* CMA 44.489
(ink drawing)
references: Dickson & Welch, 1:167A, 252B–53A n. 14, and fig. 225; Martin, 2: pl. 118; S. C. Welch, *WA*, cat. no. 73.

ca. 1545 *A Literary Man* Private collection
(ink drawing)
reference: Dickson & Welch, 1:177B, 252B–53A n. 14, and fig. 235.

ca. 1550 *Yoked Prisoner* Location unknown
(painting on silk)
references: Dickson & Welch, 1:176B, 252B n. 14; Martin, 2: pl. 82.

ca. 1550–1600 *Yoked Prisoner* LVR K3426
(painting)
references: Dickson & Welch, 1:252B n. 14; *Islam* 2, cat. no. 431 (with all previous references).

958/1551 Six illustrations in Sa'di, *Bustan* CB MS 221
Mashhad (underdrawings, folios 11b, 19b, 42a, 71b, 84b, and 173b)
manuscript signed, dated, and located by Shah-Mahmud al-Nishapuri, 10 Rajab 958/14 July 1551, Mashhad.

references: Arberry et al., 3: no. 221; Binyon et al., cat. no. 180, and pl. 58a; Dickson & Welch 1:253B n. 12; Stchoukine, *MS*, no. 167.

ca. 1556–65 Ten illustrations in FGA 46.12
 Jami, *Haft awrang*
patron: Sultan Ibrahim Mirza
folios 64b, 114b, 120a (see above), 132a, 253a, 264a, and
298a (attributed by S. C. Welch)
folios 64b, 100b, 162a, and 179b (attributed by
Stchoukine)
folios 132a, 231a, 253a, and 298a (attributed by Titley)
folio 132a (tentatively attributed by A. Welch, *Artists*,
112–13)
references: Dickson & Welch, 1: chapter 7, especially
168A–75B; Simpson, "Shaykh-Muhammad," 107–8, pls.
2–11; Stchoukine, *MS*, 47, 126–28; Titley, *PMP*, 106;
A. Welch, "Abbas," 460; A. Welch, *Artists*, 112–13.

ca. 1557 *An Uzbek Prince* BMFA 14.592
 (painting)
references: Dickson & Welch, 1:176B; Martin, 2: pl. 113;
S. C. Welch, *WA*, no. 77.

ca. 1557 *Uzbek Warlord* AHT no. 91
 (tinted drawing)
reference: Soudavar, cat. no. 91.

ca. 1560 *A Beckoning Page* BN pers. 129
 (ink drawing, folio 16a)
references: Dickson & Welch, 1:252B n. 12; Richard, 148;
Stchoukine, *MS*, pl. 31, left.

ca. 1560 *Kneeling Man with a Book* TKS H. 2140
 and Spray of Flowers
 (painting, folio 14a)
reference: Dickson & Welch, 1:252B n. 12

ca. 1560 *Young Prince with a Falcon* TKS H. 2140
 (painting, folio 24b)
reference: Robinson, "Comments," 510.

ca. 1560 *Large Man in Yellow Robe and* TKS H. 2140
 Green Coat
 (painting, folio 28a)
reference: Dickson & Welch, 1:252B n. 12.

ca. 1560 *An Uzbek Prince* Private collection
 (painting) (HUAM loan, 727.1983)
references: Canby, *Reformer*, 39, and fig. 21; Dickson &
Welch, 1:176A–B, and fig. 233.

ca. 1560 *Seated Man* LVR
 (drawing)
reference: Dickson & Welch, 1:176B.

ca. 1575 Three illustrations in SPL Dorn 426
 Jami, *Tuhfat al-ahrar*
folios 50a, 64a, 74a (attributed by Ashrafi and accepted by
S. C. Welch)
references: Ashrafi, 62–65; Dickson & Welch, 1:253A n.
15; Dorn, cat. no. 426; *USSR Colls.*, 31–35.

978–79/1570–72 Double-page frontispiece, TKS H. 1483
 text illustrations, and
 finispieces in Jami,
 Haft awrang (minus *Yusuf*
 u Zulaykha)
manuscript signed and dated (folios 37b, 59b, 105a, 151a,
170b, 18a, 200a, and 229a) by Muhibb-Ali,
978–79/1570–72.

reference: Stchoukine, "Shaykh," 4–11.

early 1570s *Two Embracing Youths* LVR 7121
 (drawing)
references: Canby, *Reformer*, 39, and fig. 18; Dickson &
Welch, 1:177B, 252B–53A nn. 14, 15, and fig. 234;
Marteau & Vever, 1: no. 13; Sakisian, fig. 170; A. Welch,
"Abbas," 462; S. C. Welch, *WA*, cat. no. 84.

early 1570s *Young Hawker Mounting Stallion* TKS H. 2165
 (tinted drawing, folio 36b)
reference: Dickson & Welch, 1:252B n. 12.

ca. 1575 *Yoked Prisoner* BOD Ouseley Add. 171
 (tinted drawing, formerly
 BOD Ouseley Add. 173, folio 1a)
references: Dickson & Welch 1:252B n. 14; Robinson,
BL, no. 1036, and pl. 21.

GLOSSARY

This listing includes terms (but not names or literary titles) that appear more than once in the text. It draws upon Blair & Bloom, 340; Lentz & Lowry, 380–81; Rypka, 94–98; Thackston, *Century*, 379–87; Thackston, "*Diwan*," 41; and S. C. Welch et al., 307.

amir; mir: prince or military commander, often part of a given name (e.g., Mir-Ali)

aqd: discourse on a specific theme, as found in the *Subhat al-abrar*

arzadasht: petition or report

aziz: vizier, minister

bayt: distich

bayt al-kutub: library

begim; begum: literally, "my lady"

chinar: plane tree

daftar: book or text volume

dar al-kutub: library

dervish: mendicant, generally associated with the Sufi order of Islam

dhikr: Sufi meditation and invocation of God, often including music and dancing

dibacha: preface; illuminated medallion at beginning of a manuscript or double-page frontispiece

dihqan: landlord, landowner

dinar: silver coin

divan: collection of a poet's works, usually including ghazals, qasidas, ruba'iyat, and other rhyme forms; state council or ministry, including administrative, fiscal, and (sometimes) military offices

divan-i a'la: supreme military council

farman: decree

ghaza; ghazi: holy war; warrior for the faith of Islam

ghazal: a monorhyme Persian verse form of five to twelve lines, lyrical and amatory

hadith: sayings traditionally associated with the Prophet Muhammad

hegira; hijra: often designated as A.H.; the Muslim era, based on a lunar calendrical system, beginning with the emigration of the Prophet Muhammad to Medina in 1 A.H./622 A.D.

iwan: arched entryway or barrel-vaulted architectural space open at one end

jali: the large form of calligraphic styles

juz: one of thirty sections of the Koran (plural: *azja'*)

kalantar: workshop head or director

karkhana: workshop

katib: secretary, clerk, scribe, calligrapher

khafi: the small form of calligraphic styles

khamsa: quintet or group of five, usually referring to five poems such as those by Nizami and Amir Khusraw Dihlavi

khanim; khanum: female equivalent to khan or leader, ruler

khwaja: doctor

kitabdar: librarian, head of manuscript workshop

kitabkhana: collection of books or library; workshop or atelier where books were produced (plural: *kutubkhana*)

laqab: honorific title, such as *al-shahi*, or nickname

maqalat: discourse, adage, or proverb, as found in the *Tuhfat al-ahrar*

masnavi: Persian verse form, consisting of rhyming couplets with two hemistichs (half-lines) that rhyme independently of other lines, used for epic and didactic poems

mi'raj: the Prophet Muhammad's night journey to heaven

mudhahhib: illuminator

munajat: prayer to God, as found in the *Subhat al-abrar*

muraqqa': album in codex form (plural: *muraqqa'at*)

murid: disciple or scholar

mutavalli: overseer

naksh: a common writing cursive style for copying manuscripts

naqqashkhana: painting workshop or studio

nasta'liq: "hanging" cursive calligraphic style developed in Iran around 1400

nisba: part of a person's name denoting family relationship or lineage, professional affiliation, or geographical origin

qabaq: an archery game on horseback involving shooting at a gourd, ring, or other target mounted on a pole

qasida: a monorhyme Persian verse form of twelve or more lines, used for panegyrics, satires, descriptions, and praises to God

qit'a: an occasional poem on philosophical, ethical, or meditative themes; a calligraphic specimen or sample of calligraphy

peri: celestial creature or angel

pir: spiritual master or guide

ruba'i: quatrain with rhyme scheme aaba (plural: *ruba'iyat*)

sama': Sufi dance ritual

sarlawh: an illuminated heading, usually at the beginning of a manuscript or of a text section; often used interchangably with *unvan*

shah: king

shamsa: illuminated roundel or medallion in the shape of a sunburst, usually preceding the text in a manuscript

Sufi; Sufism: mystic; mystical branch of Islam

tadhhib: illumination or gilding

tadhkira: literally "notices"; memoir, biography, or biographical dictionary

taj-i Haydari: red cap or turban with twelve pleats or gores denoting the twelve Shi'ite Imams, devised by Haydar, the founder of the Safavid order, as the distinguishing attribute of his followers, the Qizilbah

tariqa: mystical path

thuluth: majuscule form of *naskh* often used in headings and inscriptions

turkiyat: Turkish quatrain

unvan: an illuminated heading, usually at the beginning of a manuscript or of a text section; often used interchangably with *sarlawh*

ustad: teacher

vizier: minister in charge of fiscal affairs of state

waqf; waqfiyya: land or property perpetually endowed to a pious institution; deed of endowment

This listing begins with the reproductions to the Freer Jami. Other works of art follow, listed by their collections.

COLLECTION/MS	FOLIO	FIGURE(S)
FGA 46.12		
	1b	24
	10a	50, 61, 62
	15a	21, 39
	22a	40
	30a	57, 63, 64
	35b–36a	28
	37b–38a	42
	38b	18, 52, 66, 216
	45b	29
	45b–46a	41
	46a	9, 44, 218
	47b	31
	52a	58, 68, 69, 224
	53b–54a	6
	58a	140
	59a	56, 70, 71
	63b–64a	184
	64b	73, 75
	69b	10, 219
	70b	7
	83b	11, 220
	84b	20, 32, 203
	90b	178
	98b–99a	43
	100b	1, 76, 77
	105a	78, 79, 223
	110b	54, 83
	114b	86, 87
	120a	89, 90
	131b	134
	132a	17, 92, 93, 225
	139a	12, 175
	140b	33
	147a	8, 96, 97
	153b	98
	157b–58a	26
	161b–62a	163
	162a	19, 100
	168b–69a	48
	169b	53, 102, 103
	179a	5
	179b	105, 106
	181a	13, 162
	182b	2, 36, 221
	187b–88a	46
	188a	107, 108
	192b–93a	47
	193b–94a	199
	194b	109, 110
	199a	14, 198
	199b–200a	30
	200b	34
	200b–201a	135
	207b	111, 112
	214b–15a	174
	215b	60, 114
	221a	137
	221b	116, 117
	224a	25
	224b	15, 173
	225b	35, 217
	228b–29a	3
	230b–31a	179
	231a	118, 119
	252b–53a	27
	253a	55, 122, 123, 222
	264a	51, 124, 125
	272a	16, 45
	273b	37
	275a	126, 127
	280b–81a	38
	291a	4, 128
	298a	49, 59, 130, 131
	299b–300a	22
	304a	23
	304b	226

COLLECTION/MS	FOLIO	FIGURE(S)
AHT no. 90	1b–2a	208
AHT no. 100		209
BL Or. 2265	35a	159
	36b	160
BL Or. 4122	69a	82
	87b	85
BL Or. 4389	58a	81
BN pers. 243	2b	186
BN pers. 245	1b–2a	185
BOD Elliot 149	64b	72
BSM I 4596	19	95
CB MS 215	18a	115
CB MS 225	1b	190
CB MS 251	94a	88
CB MS 346	2b–3a	165
FGA 35.18	21a	154
FGA 35.21		212
FGA 37.23		215
FWM MS 24/1948	175a	193
GULB LA 159	1b	147
	2a	99
	101a	207
	137a	146
GULB LA 165	1b–2a	172
	166a	168
IUL F. 1422		
	69b	169
	70b	170
LVR K3427		213
MET 13.228.5	69a	84
Negarestan Museum, Tehran		145
Private collection, London		133
PWM MS 55.102	70a	74
	76a	151
	117a	113
SAK MS 33	1b–2a	204
	3b	138
	23a	205
	29b	136
	57b	139
SPL Dorn 147	43a	195
	43b	196
SPL Dorn 408	33b–34a	157
SPL Dorn 434	2b–3a	161
SPL Dorn 450	12b	183
SPL Dorn 477	1b–2a	182
SPL IIHC	35b	67
SPUHLER		80
TKS B. 407	40a	176
TKS E.H. 681	5b–6a	164
TKS H. 810	155a	101
TKS H. 986	5b–6a	206
TKS H. 1084	129b	91
TKS H. 1483	1b–2a	148
	65b	120
	105b	149
	151b	180
	200a	181
	223b	132
	229a	150
TKS H. 2151	1b–2a	187
	21a	189
	39a	211
	45a	197
	64b	191
	76a	188
TKS H. 2154	125a	152
	142b	171
TKS H. 2156	4a	121
	16b	167
	37a	177
	55a	166
TKS H. 2161	2a	192
	115b	194

COLLECTION/MS	FOLIO	FIGURE(S)
TKS H. 2165	14b	155
	63b	210
TKS H. 2166	9b	214
TKS H.S. 25	361b	158
TKS R. 900	78a	104
TKS R. 910	57b–58a	156
TKS R. 930	1b–2a	153
TKS R. 1038	1b–2a	201
	3b–4a	142
	23b	143
	26a	144
	37b–38a	202
	38a	141, 200
TKS Y. 47	29a	65
	227b	129
WAG W.644	150b	94

Abdi Beg Shirazi [Nava'i]
Abdi Beg Shirazi. *Takmilat al-akhbar* (Perfection of history). Edited by Abdul-Husayn Nava'i. Tehran: Nashr-i Nay, 1990.

Abel
Abel, Armand. "La figure d'Alexandre en Iran." In *Atti del convegno sul tema: La Persia e il mondo greco-Romano*, 119–34. Rome: Accademia Nazionale dei Lincei, 1966.

Abu'l-Fazl [Blochmann]
Abu'l-Fazl. *A'in-i-Akbari* (Code of Akbar). Translated by H. Blochmann. 3 vols. Reprint, New Delhi: Oriental Books, 1977–78.

Ackerman
Ackerman, Phyllis. *Guide to the Exhibition of Persian Art*. New York: Iranian Institute, 1940.

Adahl
Adahl, Karin. *Shah u Gada: Prinsen och dervischen*. Stockholm: Medelhavsmuseet, 1995.

Adey
Adey, More. "Miniatures Ascribed to Sultan Muhammad." *Burlington Magazine* 25 (1914): 190–95.

Adle, "Autopsia"
Adle, Chahryar. "Autopsia, in absentia, sur la date de l'introduction et de la constitution de l'album de Bahram Mirza par Dust-Mohammad en 951/1544." *Studia Iranica* 19 (1990): 219–56.

Adle, "Dust-Mohammad"
Adle, Chahryar. "Les artistes nommés Dust-Mohammad au XIVᵉ siècle." *Studia Iranica* 22 (1993): 219–96.

Adle, "Module" 1
Adle, Chahryar. "Recherche sur le module et le tracé correcteur dans la miniature orientale 1. La mise en évidence à partir d'un example." *Le monde iranien et l' Islam* 3 (1975): 81–105.

Adle, "Module" 2
Adle, Chahryar. "Un diptyque de fondation en ceramique lustrée, Kâsân 711/1312 (Recherche sur le module et le tracé correcteur/regulateur dans la miniature orientale, 11)." In *Art et société dans le monde iranien*, edited by Chahryar Adle, 199–218. Paris: Éditions recherche sur les civilisations, 1982.

Afushta'i Natanzi [Ishraqi]
Afushta'i Natanzi, Muhammad ibn Hidayat Allah. *Naqavat al-athar* (Selections of history). Edited by Ihsan Ishraqi. Tehran: Bunga-yi tarjuma-yi nashri kitab, 1328/1950.

Akimushkin
Akimushkin, Oleg F. "Baisungur-mirza i ego rol' v kul'turnoi i politicheskoi zhizni Khorasanskogo sultanata Timuridov pervoi treti xv veka." *Petersburgskoe vostokovedenie* 5 (1994): 143–68.

Akimushkin & Ivanov, "Illumination"
Akimushkin, Oleg F., and Anatol A. Ivanov. "The Art of Illumination." In *The Arts of the Book in Central Asia*, edited by Basil Gray, 46–50. Boulder, Colo.: Shambhala, 1979.

Akimushkin & Ivanov, *PM*
Akimushkin, Oleg F., and Anatol A. Ivanov. *Persidskie miniatyiury XIV–SVII, VV*. Moscow: Izdatel'stvo "Nauk," 1968.

ALBK
Allgemeines Lexikon der Bildenden Künstler von der antike bis zur gegenwart. Edited by Hans Vollmer. Reprint, Leipzig: E. A. Seemann, 1970–71.

Alexander
Alexander, Jonathan J. G. *Medieval Illuminators and Their Methods of Work*. New Haven, Conn., and London: Yale University Press, 1992.

Algar
Algar, Hamid. "The Naqshbandi Order: A Preliminary Survey of Its History and Significance." *Studia Islamica* 44 (1976): 123–52.

Andrews
Andrews, Peter Alford. "The Generous Heart of the Mass of Clouds: The Court Tents of Shah Jahan." *Muqarnas* 4 (1987): 149–65.

Arberry
Arberry, A. J. *Fitzgerald's "Salaman and Absal."* Cambridge: Cambridge University Press, 1956.

Arberry et al.
Arberry, A. J., É. Blochet, B. W. Robinson, and J. V. S. Wilkinson. *The Chester Beatty Library: A Catalogue of the Persian Manuscripts and Miniatures*. 3 vols. Dublin: Hodges & Figgis, 1959–62.

Arnold, *ONT*
Arnold, Sir Thomas W. *The Old and New Testaments in Muslim Religious Art*. Oxford, 1932.

Arnold, *PI*
Arnold, Sir Thomas W. *Painting in Islam*. 1928. Reprint, New York: Dover, 1965.

Arts
The Arts of Islam. London: Arts Council of Great Britain, 1976.

Ashraf
Ashraf, Muhammad. *A Concise Descriptive Catalogue of the Persian Manuscripts in the Salar Jung Museum and Library*. 5 vols. Hyderabad: Shri Masood Ahmed Razvi, 1969.

Ashrafi
Ashrafi, M. M. *Persian-Tajik Poetry in Fourteenth–Seventeenth Century Miniatures*. Dushanbe: Dushanbe Printing House "Irfon," 1974.

Atabay, *Dini*
Atabay, Badri. *Fihrist-i kitab dini va mazhabi kitabkhana-i saltanati Tehran* (Catalogue of the religious books in the Imperial Library, Tehran). Tehran: Chapkhana-yi Ziba, 1352/1977–78.

Atabay, *Divan*
Atabay, Badri. *Fihrist-i divanha-yi khati kitabkhana-i saltanati* (Catalogue of the manuscripts in the Imperial Library). Tehran: Kitabkhana-yi Ziba, 2535/1976.

Atabay, *Korans*
Atabay, Badri. *Fihrist-i Qu'ran-yi khatti kitabkhana-i saltanati Tehran* (Catalogue of the Koran manuscripts in the Imperial Library, Tehran). Tehran: Chapkhana-yi Ziba, 135l/1976–77.

Atabay, *Muraqqa'at*
Atabay, Badri. *Fihrist-i muraqqa'at kitabkhana-i saltanati Tehran* (Catalogue of the albums of the Imperial Library, Tehran). Tehran: Chapkhana-yi Ziba, 1353/1978–79.

Atasoy
Atasoy, Nurhan. "Four Istanbul Albums and Some Fragments from Fourteenth-Century Shah-namehs." *Ars Orientalis* 8 (1970): 19–48.

Atil, *Brush*
Atil, Esin. *The Brush of the Masters: Drawings from Iran and India*. Washington, D.C.: Freer Gallery of Art, 1978.

Atil, "Humor"
Atil, Esin. "Humor and Wit in Islamic Art." *Asian Art and Culture* 7 (Fall 1994): 12–29.

Atil, *KD*
Atil, Esin. *Kalila wa Dimna: Fables from a Fourteenth-Century Arabic Manuscript*. Washington, D.C.: Smithsonian Institution Press, 1981.

Atil, *Kuwait*
Atil, Esin, ed. *Islamic Art and Patronage: Treasures from Kuwait*. New York: Rizzoli, 1990.

Atil, *Persian*
Atil, Esin. *Exhibition of Twenty-five Hundred Years of Persian Art*. Washington, D.C.: Freer Gallery of Art, 1971.

Atil, *Süleyman*
Atil, Esin. *The Age of Sultan Süleyman the Magnificent*. Washington, D.C.: National Gallery of Art; New York: Abrams, 1987.

Atil, *Süleymanname*
Atil, Esin. *Süleymanname: The Illustrated History of Süleyman the Magnificent*. Washington, D.C.: National Gallery of Art; New York: Abrams, 1986.

Aumer
Aumer, Joseph. *Die persischen Handschriften der K. Hof- und Staatsbibliothek in München*. 1866. Reprint, Wiesbaden: Otto Harrassowitz, 1970.

"AWI"
"Art from the World of Islam, Eighth–Eighteenth Century." *Louisiana Revy* 27 (March 1987): 3–115.

Awn
Awn, Peter J. *Satan's Tragedy and Redemption: Iblis in Sufi Psychology*. Leiden: Brill, 1983.

Babayan
 Babayan, Kathryn. "The Waning of the Qizilbash: The Spiritual and Temporal in Seventeenth-Century Iran." Ph.D. diss., Princeton University, 1993.

Barthold, *Découverte*
 Barthold, V. V. *La Découverte de l'Asie: Histoire de l'Orientalisme en Europe et en Russie.* Translated by B. Nikitine. Paris: Payot, 1947.

Barthold, *Geography*
 Barthold, V. V. *An Historical Geography of Iran.* Translated by Svat Soucek. Princeton, N.J.: Princeton University Press, 1984.

Barthold, *Sochineniia*
 Barthold, V. V. *Sochineniia* (Complete works). Vol. 9. Moscow: Eastern Library Publisher, 1977.

Bayani, Manijeh [cited as Manijeh Bayani]
 Bayani, Manijeh. "*Kalilah wa Dimna* Themes in Persian Literature." In Grube, *MP*, 125–27.

Bayani, Medhi [cited as Mehdi Bayani]
 Bayani, Mehdi. *Ahval va athar-i khushnivisan* (Lives and works of calligraphers). 2d ed. 4 parts in 2 vols. Tehran: Intisharat-i ilmi, 1363/1985.

Beach, *Grand Mogul*
 Beach, Milo Cleveland. *The Grand Mogul: Imperial Painting in India, 1600–1660.* Williamstown, Mass.: Sterling and Francine Clark Art Institute, 1978.

Beach, *Imperial Image*
 Beach, Milo Cleveland. *The Imperial Image: Paintings for the Mughal Court.* Washington, D.C.: Freer Gallery of Art, 1981.

Becka
 Becka, Jiri. "Alexander the Great in Persian-Tajik and Czech Literatures." *Archiv Orientalni* 53 (1985): 314–88.

Beveridge
 Beveridge, Annette Susannah, trans. *The Baburnama in English.* 1922. Reprint, London: Luzac, 1969.

Bidlisi [Charmoy]
 Bidlisi, Sharafuddin Khan. *Cheref-nameh ou Fastes de la nation kourde.* Translated by François Bernard Charmoy. 2 vols. Saint Petersburg: L'Académie imperiale des sciences, 1868–75.

Bidlisi [Velaminof-Zernof]
 Bidlisi, Sharafuddin Khan. *Sharafnama* (Book of the nobility). Edited by V. V. Velaminof-Zernof. 2 vols. Saint Petersburg: L'Académie imperiale des sciences, 1860–62.

Bier
 Bier, Carol, ed. *Woven from the Soul, Spun from the Heart: Textile Arts of Safavid and Qajar Iran, Sixteenth– Nineteenth Centuries.* Washington, D.C.: Textile Museum, 1987.

Binney
 Islamic Art from the Collection of Edwin Binney 3rd. Washington, D.C.: Smithsonian Institution, 1966.

Binyon
 Binyon, Laurence. *The Poems of Nizami.* London: Studio, 1928.

Binyon et al.
 Binyon, Laurence, J. V. S. Wilkinson, and Basil Gray. *Persian Miniature Painting.* 1933. Reprint, New York: Dover, 1971.

Blair, *Compendium*
 Blair, Sheila S. *A Compendium of Chronicles: Rashid al-Din's Illustrated History of the World.* London: Azimuth Editions, 1995.

Blair, "Patterns"
 Blair, Sheila S. "Patterns of Patronage and Production in Ilkhanid Iran: The Case of Rashid al-din." *Oxford Studies in Islamic Art* (forthcoming).

Blair, "Rab'-i Rashidi"
 Blair, Sheila S. "Ilkhanid Architecture and Society: An Analysis of the Endowment Deed of the Rab'-i Rashidi." *Iran* 22 (1984): 67–90.

Blair & Bloom
 Blair, Sheila S., and Jonathan M. Bloom. *The Art and Architecture of Islam, 1250–1800.* New Haven, Conn., and London: Yale University Press, 1994.

Blochet, *Arabes*
 Blochet, Édgard. *Catalogue des manuscrits arabes des nouvelles acquisitions.* Paris: Editions de la Gazette des Beaux-arts, 1925.

Blochet, *Persans*
 Blochet, Édgard. *Catalogue des manuscrits persans de la Bibliothèque nationale.* 4 vols. Paris: Bibliothèque nationale, 1905–34.

Blunt
 Blunt, Wilfred. *Isfahan, Pearl of Persia.* New York: Stein & Day, 1966.

Bookbinding
 The History of Bookbinding, 1525–1950 A.D.: An Exhibition Held at the Baltimore Museum of Art. Baltimore: Walters Art Gallery, 1957.

Bosch
 Bosch, Gulnar K. "The Staff of the Scribes and the Implements of the Discerning: An Excerpt." *Ars Orientalis* 4 (1961): 1–13.

Bosch et al.
 Bosch, Gulnar, John Carswell, and Guy Petherbridge. *Islamic Bindings and Bookmaking: A Catalogue of an Exhibition at the Oriental Institute. the University of Chicago. May 18– August 18, 1981.* Chicago: University of Chicago, 1981.

Bothmer
 Bothmer, Hans Casper Graf v. *Kalila va Dimna.* Wiesbaden: Reichert, 1981.

Brend
 Brend, Barbara. *Islamic Art.* Cambridge, Mass.: Harvard University Press, 1991.

Bricteux, *SA*
 Bricteux, Auguste, trans. Djami, *"Salaman et Absal": Poème allegorique persan.* Paris: Carrington, 1911.

Bricteux, *YZ*
 Bricteux, Auguste, trans. Djami, *"Youssouf et Zouleikha."* Paris: Librarie orientaliste Paul Geuthner, 1927.

Brosh
 Brosh, Na'ama, with Rachel Milstein. *Biblical Stories in Islamic Painting.* Jerusalem: Israel Museum, 1991.

Browne, *LHP*
 Browne, Edward G. *A Literary History of Persia.* 4 vols. Cambridge: Cambridge University Press, 1928.

Browne, "Sufiism"
 Browne, Edward G. "Sufiism." In *Religious Systems of the World*, 314–32. London: Swan Sonnenschein, 1901.

Bürgel
 Bürgel, Johann C. *The Feather of Simurgh: "The Licit Magic" of the Arts in Medieval Islam.* New York: New York University Press, 1988.

Çağman & Tanindi
 Çağman, Filiz, and Zeren Tanindi. *Topkapi Saray Museum: Islamic Miniature Painting.* Istanbul: Turcümen, 1979.

Çağman & Tanindi, "Remarks"
 Çağman, Filiz, and Zeren Tanindi. "Remarks on Some manuscripts from the Topkapi Palace Treasury in the Context of Ottoman-Safavid Relations." *Muqarnas* 13 (1996): 132–48.

Calkins, "Distribution"
 Calkins, Robert G. "Distribution of Labor: The Illuminators of the Hours of Catherine of Cleves and Their Workshop." *Transactions of the American Philosophical Society* 69 (1979): 1–83.

Calkins, "Stages"
 Calkins, Robert G. "Stages of Execution: Procedures of Illumination as Revealed in an Unfinished Book of Hours." *GESTA* 17 (1978): 61–70.

Canby, *Masters*
 Canby, Sheila R., ed. *Persian Masters: Five Centuries of Painting.* Bombay: Marg, 1990.

Canby, *PP*
 Canby, Sheila R. *Persian Painting.* London: British Museum Press, 1993.

Canby, *Reformer*
 Canby, Sheila R. *The Rebellious Reformer: The Drawings and Paintings of Riza-yi Abbasi of Isfahan.* London: Azimuth Editions, 1996.

Canby, "Work of Riza"
 Canby, Sheila R. "Age and Time in the Work of Riza." In Canby, *Masters*, 71–84.

Carswell
 Carswell, John. *Blue and White: Chinese Porcelain and Its Impact on the Western World.* Chicago: Alfred Smart Gallery, 1985.

Chardin
 Chardin, Jean. *Journal du voyages du Chevalier Chardin en Perse et autres lieux de l'Orient.* 10 vols. Paris: Langlès, 1811.

Chelkowski et al.
 Chelkowski, Peter J., Priscilla P. Soucek, and Richard Ettinghausen. *Mirror of the Invisible World: Tales from the "Khamseh" of Nizami.* New York: Metropolitan Museum of Art, 1975.

CHI
 The Cambridge History of Iran. Volume 6, *The Timurid and Safavid Periods.* Edited by Peter Jackson and Laurence Lockhart. Cambridge: Cambridge University Press, 1986.

Chiesa 1
 The Collection of Achillito Chiesa, Esq. of Milan. Part I. [Auction catalogue, 27 November 1925.] New York: American Art Association, 1925.

Chiesa 2
 The Collection of Achillito Chiesa. Part II. [Auction catalogue, 16 April 1926.] New York: American Art Association, 1926.

Chiesa 3
 The Collection of Sr. Achillito Chiesa of Milan. Part III. [Auction catalogue, 16–17 April 1926.] New York: American Art Association, 1926.

Chittick
 Chittick, William C. "The Perfect Man as the Prototype of the Self in the Sufism of Jami." *Studia Islamica* 49 (1979): 135–57.

CHR 30.V.62
 Fine Oriental Miniatures and Manuscripts. [Auction catalogue, 30 May 1962.] London: Christie's, 1962.

CHR 29.IV.70
 Catalogue of Oriental Manuscripts and Miniatures. [Auction catalogue, 29 April 1970.] London: Christie's, 1970.

CHR 28.IV.92
 Islamic Works of Art. [Auction catalogue, 28 April 1992.] London: Christie's, 1992.

CHR 18–20.X.94
 Islamic Art, Indian Miniatures, Rugs and Carpets Including Property from the Dr. Arthur M. Sackler Collection. [Auction catalogue, 18 and 20 October 1994.] London: Christie's, 1994.

Cockerell
 Cockerell, Douglas. *Bookbinding and the Care of Books.* 1901. Reprint, London: Pitman Press; New York: Pentalic Corporation, 1978.

Coomaraswamy
 Coomaraswamy, Ananda K. *Les miniatures orientales de la Collection Goloubew au Museum of Fine Arts de Boston.* Paris and Brussels: van Oest, 1929.

Corbin
 Corbin, Henri. *Histoire de la philosophie islamique.* Paris: Gallimard, 1964.

Cowen
 Cowen, Jill Sanchia. *Kalila and Dimna: An Animal Allegory of the Mongol Court.* New York: Oxford University Press, 1989.

DA
 Dictionary of Art. London: Macmillan Publishers, 1996.

Dalton
 Dalton, O. M. *The Treasure of the Oxus with Other Examples of Early Oriental Metal-Work.* 3d ed. London: British Museum. 1964.

Davis
 Davis, F. Hadland. *The Persian Mystics: Jami.* London: Murray, 1918.

De Hamel
 De Hamel, Christopher. *Medieval Craftsmen: Scribes and Illuminators.* London: British Museum Press, 1992.

Dehqan
 Dehqan, Iraj. "Jami's *Salaman and Absal*." *Journal of Near Eastern Studies* 30 (1971): 118–26.

Delaissé, "History"
 Delaissé, L. M. J. "Towards a History of the Medieval Book." *Divinitas* 11 (1967): 423–35.

Delaissé, *Siècle*
 Delaissé, L. M. J. *Le siècle d'or de la miniature flamande: Le mécenat de Philippe le Bon.* Brussels: Palais des beaux arts, 1959.

Delaissé et al.
Delaissé, L. M. J., James Marrow, and John de Wit. *The James A. De Rothschild Collection at Waddesdon Manor: Illuminated Manuscripts*. Fribourg: Office du Livre for the National Trust, 1977.

Denny, "Late Islam"
Denny, Walter B. "Late Islam: The Age of Empires (1500–1800)." In Atil, *Kuwait*, 215–31.

Denny, "Saz"
Denny, Walter B. "Dating Ottoman Turkish Works in the Saz Style." *Muqarnas* 1 (1983): 103–21.

Déroche, *BN*
Déroche, François. *Catalogue des manuscrits Arabes*. Paris: Bibliothèque nationale, 1972.

Déroche, *Coran*
Déroche, François. *Les manuscrits du Coran, aux origines de la calligraphie coranique*. Paris: Bibliothèque nationale, 1983.

Déroche, *Manuscrits*
Déroche, François, ed. *Les manuscrits du Moyen-Orient: Essais de codicologie et de paléographie. Actes du Colloque d'Istanbul (Istanbul, 26–29 mai 1986)*. Istanbul: Institut français d'études anatoliennes d'Istanbul; Paris: Bibliothèque nationale, 1989.

Detroit
The Fourteenth Loan Exhibition: Mohammedan Decorative Arts. Detroit: Detroit Institute of Arts, 1930.

Diakonova
Diakonova, N. V. *Central Asian Miniatures, Sixteenth–Eighteenth Centuries*. Moscow, 1964.

Diba, "Lacquerwork" 1
Diba, Layla S. "Lacquerwork." In Ferrier, 243–53.

Diba, "Lacquerwork" 2
Diba, Layla S. "Lacquerwork of Safavid Iran and Its Relationship to Persian Painting." Ph.D. diss., New York University, 1994.

Dickson & Welch
Dickson, Martin Bernard, and Stuart Cary Welch. *The Houghton Shahnameh*. 2 vols. Cambridge, Mass.: Harvard University Press, 1981.

Dihkhuda, *Amsal*
Dihkhuda, Ali Akbar. *Amsal va hakam* (Proverbs and sayings). 4 vols. Tehran: Intisharat-i Amir Kabir, 1339/1960.

Dihkhuda, *Lughatnama*
Dihkhuda, Ali Akbar. *Lughatnama* (Dictionary). 50 vols. Tehran: Tehran University Press, 1324–58/1946–79.

DMA
Dictionary of the Middle Ages. New York: Charles Scribner's Sons, 1982–89.

Dodkhudoeva
Dodkhudoeva, L. N. *The Poetry of Nizami in Illustrated Manuscripts of the Middle Ages*. Moscow: Eastern Literature Publication, 1985.

Dols
Dols, Michael W. *Majnun: The Madman of Islamic Society*. Edited by Diana E. Immisch. Oxford: Clarendon Press and Oxford University Press, 1992.

Don Juan
Don Juan of Persia. Edited by Guy Le Strange. 1928. Reprint, New York: Arno, 1973.

Dorn
Dorn, B. *Catalogue des manuscrits et xylographes orientaux de la Bibliothèque imperiale publique de Saint Petersbourg*. Saint Petersburg: L'Académie imperiale des sciences, 1852.

Duda
Duda, Dorothea. *Die illuminierten Handschriften der österreichischen Nationalbibliothek: Islamische Handschriften, 1: Persische Handschriften*. 2 vols. Vienna: Verlag der österreichischen Akademie der Wissenschaften, 1983.

Dust-Muhammad [Mehdi Bayani]
Dust-Muhammad. "Introduction to the Bahram Mirza Album." In Mehdi Bayani, 1–2:192–203.

Dust-Muhammad [Thackston]
Dust-Muhammad, "Preface to the Bahram Mirza Album." In Thackston, *Century*, 335–50.

Echraqi
Echraqi, Ehsan. "Le *Dar al-Saltana* de Qazvin, deuxième capitale des Safavides." In *Safavid Persia: The History and Politics of an Islamic Society*, edited by Charles Melville, 105–15. Pembroke Papers 4. London and New York: I. B. Tauris & Co., 1996.

Edwards
Edwards, Clara C. "Calligraphers and Artists: A Persian Work of the Late Sixteenth Century." *Bulletin of the School of Oriental and African Studies* 10 (1939): 199–211.

EIr
Encyclopedia Iranica. Edited by Ehsan Yarshater. London: Routledge & Kegan Paul, 1985–.

EIs
Encyclopedia of Islam. Leiden: Brill; London: Luzac, 1908–36.

EIs 2
Encyclopedia of Islam. Leiden: Brill; Paris: Larousse, 1979–.

EIs 3
Encyclopedia of Islam. Edited by H. A. Gibbs and J. H. Kramers. Ithaca, N.Y.: Cornell University Press, 1974.

EJ
Encyclopedia Judaica. New York: Macmillan, 1971–72.

Elgood
Elgood, Heather. "The Earliest Extant Illustrated Manuscript for a Prince of the Mughal Family." *Arts and the Islamic World* 1 (spring 1985): 34–40.

Enderlein
Enderlein, Volkmar. *Indische Albumblätterminiaturen und Kalligraphien aus der Zeit der Mughul Kaiser*. Leipzig: Gustav Kiepenheuer, 1979.

Ethé
Ethé, Hermann. *Catalogue of Persian, Turkish, Hindustan, and Pushtu Manuscripts in the Bodleian Library*. Part 1: *The Persian Manuscripts*. Oxford: Oxford University, 1889.

Ettinghausen, *AP*
Ettinghausen, Richard. *Arab Painting*. Geneva: Skira, 1962.

Ettinghausen, "Ascension"
Ettinghausen, Richard. "Persian Ascension Miniatures of the Fourteenth Century." In *Accademia Nazionale dei Lincei, Atti del XII convegno 'Volta' . . . tema: Oriente e Occidente nel medioevo*, 360–83. Rome: Accademia Nazionale dei Lincei, 1957.

Ettinghausen, "Bobrinski"
Ettinghausen, Richard. "The Bobrinski 'Kettle': Patron and Style of an Islamic Bronze." *Gazette des beaux arts*, 6th ser., 24 (October 1943): 193–208.

Ettinghausen, "Choice"
Ettinghausen, Richard. "The Emperor's Choice." In *De Artibus Opuscula, XL: Essays in Honor of Erwin Panofsky*. edited by Millard Meiss, 98–129. New York: New York University Press, 1961.

Ettinghausen, "Exhibition"
Ettinghausen, Richard. "Six Thousand Years of Persian Art: The Exhibition of Iranian Art, New York, 1940." *Ars Islamica* 7 (1940): 106–17.

Ettinghausen, fs
Ettinghausen, Richard. Folder sheet for accession number 46.12, Freer Gallery of Art, Washington, D.C.

Ettinghausen, "Illumination"
Ettinghausen, Richard. "Manuscript Illumination." In *Survey*, 3:1968–74.

Ettinghausen, "Indische"
Ettinghausen, Richard. "Indische Miniaturen der Berliner Museen." *Pantheon* 15 (1935): 167–70.

Ettinghausen, "Zoomorphic"
Ettinghausen, Richard. "The Dance with Zoomorphic Masks and Other Forms of Entertainment Seen in Islamic Art." In *Arabic and Islamic Studies in Honor of Hamilton A. R. Gibb*, edited by George Makdasi, 211–24. Leiden: E. J. Brill, 1965.

Farhad & Simpson
Farhad, Massumeh, and Marianna S. Simpson. "Sources for Study of Safavid Painting and Patronage, or Mefiez-vous de Qazi Ahmad." *Muqarnas* (Essays in Honor of Oleg Grabar) 10 (1993): 286–91.

Farhadi
Farhadi, ʿAbd-al-Ghafour Ravan. "L'amour dans les recits de Djami." *Studia Iranica* 4 (1975): 207–18.

Farquhar
Farquhar, James Douglas. "Manuscript Production and the Discovery of Evidence for Localizing and Dating Fifteenth-century Books of Hours: Walters Ms. 239." *Journal of the Walters Art Gallery* 45 (1987): 44–57.

Fehérvári & Safadi
Fehérvári, Geza, and Yasin H. Safadi. *Fourteen Hundred Years of Islamic Art: A Descriptive Catalogue*. London: Khalili Gallery, 1981.

Ferrier
Ferrier, R. W., ed. *The Arts of Persia*. New Haven, Conn.: Yale University Press, 1989.

Fitzherbert
Fitzherbert, Teresa. "Khwaju Kirmani (689–753/ 1290–1352): An *Eminence Grise* of Fourteenth-Century Persian Painting." *Iran* 29 (1991): 137–51.

Folsach
Folsach, Kjeld von. *Islamic Art: The David Collection*. Cophenhagen: David Samling, 1990.

Fu et al.
Fu, Shen, Glenn D. Lowry, and Ann Yonemura. *From Concept to Context: Approaches to Asian and Islamic Calligraphy*. Washington, D.C.: Freer Gallery of Art, 1986.

Galerkina
Galerkina, Olympiada. "Some Characteristics of Persian Miniature Painting in the Latter Part of the Sixteenth Century." *Oriental Art*. n.s., 21 (autumn 1975): 231–41.

Gandjei
Gandjei, Tourkhan. "Uno scritto apologetico di Husain Mirza, soltano del Khorasan." *Annali del'Istituto orientale di Napoli*, n. s., 5 (1953): 157–83.

Ghazoul
Ghazoul, Ferial Jabouri. *The Arabian Nights: A Structural Analysis*. Cairo: Cairo Associated Institution for the Study and Presentation of Arab Cultural Values, 1980.

Gibb
Gibb, E. J. W. *A History of Ottoman Poetry*. 6 vols. Leiden: Brill, 1900–1909.

Gierlichs
Gierlichs, Joachim. *Drache, Phönix, Doppeladler: Fabelwesen in der islamischen Kunst*. Berlin: Museum für Islamische Kunst, 1993.

Golombek, "Classification"
Golombek, Lisa. "Toward a Classification of Islamic Painting." In *Islamic Art in the Metropolitan Museum of Art*. edited by Richard Ettinghausen, 23–34. New York: Metropolitan Museum of Art, 1972.

Golombek, "Draped"
Golombek, Lisa. "The Draped Universe of Islam." In *Content and Context of Visual Arts in the Islamic World*, edited by Priscilla P. Soucek, 25–49. University Park, Pa.: Pennsylvania State University Press for College Art Association of America, 1988.

Golombek & Wilber
Golombek, Lisa, and Donald N. Wilber. *The Timurid Architecture of Iran and Turan*. 2 vols. Princeton, N.J.: Princeton University Press, 1988.

Gorelik
Gorelik, Michael, "Oriental Armour of the Near and Middle East from the Eighth to the Fifteenth Centuries as Shown in Works of Art." In *Islamic Arms and Armour*, edited by Robert Elgood, 30–64. London: Scholar Press, 1979.

Grabar
Grabar, Oleg. *The Mediation of Ornament*. Princeton, N.J.: Princeton University Press, 1992.

Grabar & Blair
Grabar, Oleg, and Sheila Blair. *Epic Images and Contemporary History: The Illustrations of the Great Mongol Shahnama*. Chicago: University of Chicago Press, 1980.

Gramlich
Gramlich, Richard. *Die schiitischen Derwischorden Persiens. Dritter Teil: Brauchtum und Riten*. Wiesbaden: Deutsche Morgenlandische Gesellschaft, 1981.

Gray, *OIA*
Gray, Basil. *Oriental Islamic Art: Collection of the Calouste Gulbenkian Foundation*. Lisbon: Museu nacional de arte antiga, 1963.

Gray, *PP* 1
Gray, Basil. *Persian Painting*. London: Benn, 1931.

Gray, *PP* 2
Gray, Basil. *Persian Painting*. Geneva: Skira, 1961.

Gray, "Safavid"
Gray, Basil. "The Arts in the Safavid Period." In *CHI* 877–912.

Gray & Godard
 Gray, Basil, and André Godard. *Iran: Persian Miniatures—Imperial Library*. New York: New York Graphic Society; Paris: United Nations Educational and Scientific Organization, 1956.
Gross, "Roles"
 Gross, Jo-Ann. "Multiple Roles and Perceptions of a Sufi Shaikh: Symbolic Statements of Political and Religious Authority." In *Naqshbandis*, 109–21.
Gross, "Status"
 Gross, Jo-Ann. "The Economic Status of a Timurid Sufi Shaykh: A Matter of Conflict or Perception?" *Iranian Studies* 21 (1988): 84–105.
Grube, *CS*
 Grube, Ernst J. *Classical Style in Islamic Painting: The Early School of Herat and Its Impact on Islamic Painting of the Later Fifteenth, the Sixteenth, and Seventeenth Centuries: An Exhibition at the Pierpont Morgan Library, November 6, 1968–January 4, 1969*. New York: Oriens, 1968.
Grube, "Kalilah wa Dimnah"
 Grube, Ernst J. "The Early Illustrated *Kalilah wa Dimnah* Manuscripts." In Grube, *MP*, 33–51.
Grube, "Language"
 Grube, Ernst J. "The Language of the Birds: Seventeenth-Century Miniatures." *Bulletin of the Metropolitan Museum of Art*, n.s., 25, no. 9 (May 1967): 339–52.
Grube, *MMP*
 Grube, Ernst J. *Muslim Miniature Painting from the Thirteenth to the Nineteenth Century from Collections in the United States and Canada*. Venice: Neri Pozza, 1962.
Grube, *MP*
 Grube, Ernst J., ed. *A Mirror for Princes from India: Illustrated Versions of the Kalilah wa Dimnah, Anvar-i Suhayli, Iyar-i Danish, and Humayun Nameh*. Bombay: Marg, 1991.
Grube, "Prolegomena"
 Grube, Ernst J. "Prolegomena for a Corpus Publication of Illustrated *Kalilah wa Dimnah* Manuscripts." *Islamic Art* 4 (1991): 301–482.
Grube, *WI*
 Grube, Ernst J. *The World of Islam*. New York: McGraw-Hill, 1966.
Gruijs
 Gruijs, Albert. "Codicology or the Archaeology of the Book? A False Dilemma." *Quaerendo* 2 (1972): 87–108.
Guest
 Guest, Grace Dunham. *Shiraz Painting in the Sixteenth Century*. Washington, D.C.: Freer Gallery of Art, 1949.

Habib
 Habib, Madeleine. "Some Notes on the Naqshbandi Order." *Muslim World* 59 (1969): 40–49.
Hafiz-i Abru [Bayani]
 Hafiz-i Abru. *Zayl-i jami' al-tawarikh-i Rashidi* (Appendix to the Rashidi world history). Edited by Khanbaba Bayani. 2 vols. Tehran: Chapkhana-i ilmi, 1317–19/1936–38.
Hasan Rumlu [Nava'i]
 Hasan Rumlu. *Ahsan al-tawarikh* (Beauty of history). Edited by Abdul-Husayn Nava'i. 2 vols. Tehran: Intisharat-i Babak, 1349–57/1970–79.
Hasan Rumlu [Seddon]
 Hasan Rumlu. *Ahsanu't-Tawarikh: A Chronicle of the Early Safawis*. Translated by C. N. Seddon. 2 vols. Baroda: Gaekwad's Oriental Series, 1931–34.
Heer
 Heer, Nicolas, trans. *The Precious Pearl: Al-Jami's al-Durrah al-Fakhirah*. Albany, N.Y.: State University of New York Press, 1979.
Herbert
 Herbert, Sir Thomas. *Thomas Herbert Travels in Persia, 1627–1629*. New York: McBride, 1929.
Hikmat
 Hikmat, Ali Asghar. *Jami*. Tehran: Chapkhana-yi Bank-i Melli, 1320–21s/1941–42.
Hillenbrand
 Hillenbrand, Robert. *Imperial Images in Persian Painting*. Edinburgh: Scottish Arts Council, 1977.

Hillenbrand, *"Shah-nama-yi Shahi"*
 Hillenbrand, Robert. "The Iconography of the *Shah-nama-yi Shahi*." In *Safavid Persia: The History and Politics of an Islamic Society*, edited by Charles Melville, 53–78. Pembroke Papers 4. London and New York: I. B. Tauris & Co., 1996.
Hoffman
 Hoffman, Brigitt. "Turkmen Princes and Religious Dignitaries: A Sketch in Group Profiles." In *Timurid Art and Culture: Iran and Central Asia in the Fifteenth Century*, edited by Lisa Golombek and Maria Subtelny, 23–29. Leiden: Brill, 1992.
Huart
 Huart, Clément. *Les calligraphes et les miniaturistes de l'Orient musulman*. Paris: Leroux, 1908.
Hunarfar
 Hunarfar, Lutfullah. *Ganjina-yi athar-i ta'rikhi-yi Isfahan* (Treasury of the historical monuments of Isfahan). Isfahan: Chapkhana-yi Imami, 1344s/1964.

IA
 Islamic Art. 4 vols. Geneva: Bruschettini Foundation for Islamic and Asian Art; New York: Islamic Art Foundation, 1981–91.
Ibn al-Muqaffa' [Miguel]
 Ibn al-Muqaffa'. *Le livre de Kalila et Dimna*. Translated by André Miguel. Paris: Klincksieck, 1957.
Inal
 Inal, Güner. "Realistic Motifs and the Expression of Drama in Safavid Miniatures." *Sanat Tarihi Yilligi* 7 (1976–77): 59–88.
Ipşiroğlu
 Ipşiroğlu, M. . *Islamda Resim: Yasaği ve Sonuçlari*. Istanbul: Doğan Kardeş Matbaacilik Sanayii A.Ş., 1973.
Ishraqi
 Ishraqi, Ihsan. "Le *Kholasat al-tawarikh* de Qazi Ahmad connu sous le nom de Mir Monshi." *Studia Iranica* 4 (1975): 73–89.
Iskandar Beg Munshi [Afshar]
 Iskandar Beg Munshi. *Ta'rikh-i alam-ara-yi Abbasi* (History of Shah Abbas). Edited by Iraj Afshar. 2 vols. Tehran: Chapkhana Gulshan, 1350/1972.
Iskandar Beg Munshi [Savory]
 Iskandar Beg Munshi. *The History of Shah Abbas the Great*. Translated by Roger Savory. 2 vols. Boulder, Colo.: Westview Press, 1978.
Islam 1
 Arts de l'Islam des origines à 1700 dans les collections publiques françaises. Paris: Réunion des Musées nationaux: 1971.
Islam 2
 Islam dans les collections nationales. Paris: Éditions des musée nationaux, 1977.

Jackson & Yohannan
 Jackson, Williams, and Abraham Yohannan. *A Catalogue of the Collection of Persian Manuscripts . . . Presented to the Metropolitan Museum of Art*. New York: Columbia University Press, 1914.
James, "Album"
 James, David. "The Millennial Album of Muhammad Quli Qutb Shah." *Islamic Art* 2 (1987): 243–50.
James, *Mamluks*
 James, David. *Qur'ans of the Mamlūks*. New York: Thames & Hudson, 1988.
Jenkins
 Jenkins, Marilyn, ed. *Islamic Art in the Kuwait National Museum: The Al-Sabah Collection*. London: Philip Wilson for Sotheby's, 1983.
Jewett
 Jewett, Iran B. "Fitzgerald and Jami's *Salaman and Absal*." *Orientalia Suenaca* 19–20 (1970–71): 179–85.
Johnson
 Johnson, Rosemary Stanfield. "Sunni Survival in Safavid Iran: Anti-Sunni Activities during the Reign of Tahmasp I." *Iranian Studies* 27 (1994): 123–33.

Karatay, *Arapça*
 Karatay, Fehmi E. *Topkapi Sarayi Müzesi Kütüphanesi: Arapça Yazmalar Katalogu*. 4 vols. Istanbul: Topkapi Sarayi Müzesi, 1951.
Karatay, *Farsça*
 Karatay, Fehmi E. *Topkapi Sarayi Müzesi Kütüphanesi. Farsça Yazmalar Katalogu*. Istanbul: Topkapi Sarayi Müzesi, 1961.
Karimzadeh Tabrizi
 Karimzadeh Tabrizi, Muhammad Ali. *Ahval va asar-i naqqashan-i qadim-i Iran* (Lives and art of old painters of Iran and a selection of masters from the Ottoman and Indian regions). 3 vols. London: Mohammad Ali Karimzadeh Tabrizi, 1985.
Kashifi [Ouseley]
 Kashifi, Husayn Vayz. *Anvar-i Suhaili or Lights of Canopus, Being the Persian Version of the Fables of Bidpai*. Edited by J. W. J. Ouseley. Hertford, England: Stephen Austin for the Hon. East India Company, 1851.
Kashifi [Wollaston]
 Kashifi, Mulla Husayn bin Ali Vayz. *The Anvar-i-Suhaili or Lights of Canopus, Commonly Known as Kalilah and Dimnah*. Translated by Arthur N. Wollaston. London: Murray, 1904.
Kazi
 Kazi, M. I. "Sam Mirza and His 'Tuhfa-i Sami.'" *Indo-Iranica* 13/1 (1960): 18–39.
Kevorkian & Sicré
 Kevorkian, A. M., and J. P. Sicré. *Les jardins du desir: Sept siècles de peinture persane*. Paris: Phebus, 1983.
Keyvani
 Keyvani, Mehdi. *Artists and Guild Life in the Later Safavid Period: Contributions to the Social-Economic History of Persia*. Berlin: Klaus Schwarz Verlag, 1982.
Khayrallah
 Khayrallah, As'ad E. *Love, Madness, and Poetry: An Interpretation of the Majnun Legend*. Cairo: Cairo Associated Institution for the Study and Presentation of Arab Cultural Values, 1980.
Khunji [Minorsky]
 Khunji, Fadlullah bin Ruzbahan. *Ta'rikh-i alam-ara-yi Amini: Persia in A.D. 1478–1490*. Translation by V. Minorsky. London: Royal Asiatic Society, 1957.
Khuzani
 Khuzani. *Afzal al-tawarikh* (The noblest history). MS British Library, Or. 4678.
Knappert
 Knappert, Jan. *Islamic Legends: Histories of the Heroes, Saints, and Prophets of Islam*. 2 vols. Leiden: Brill, 1985.
Kostygova
 Kostygova, G. J., intro. *Calligraphic Samples from Iran and Central Asia, 15–19th Centuries*. Moscow: Oriental Literature Publishing House, 1963.
Krahl
 Krahl, Regina. *Chinese Ceramics in the Topkapi Saray Museum, Istanbul: A Complete Catalogue*. Edited by John Carswell. 3 vols. London: Sotheby's with Topkapi Sarayi Müzesi, 1986.
Kühnel, "History"
 Kühnel, Ernst. "History of Miniature Painting and Drawing." In *Survey*, 3:1829–97.
Kühnel, *Miniaturmalerei*
 Kühnel, Ernst. *Miniaturmalerei im islamischen Orient*. Berlin: Cassirer, 1923.

Lady Sheil
 Lady Sheil, Mary Leonora. *Glimpses of Life and Manners in Persia*. London: Murray, 1856.
Lentz, "Baysunghur"
 Lentz, Thomas Woodward, Jr. "Painting at Herat under Baysunghur ibn Shahrukh." Ph.D. diss., Harvard University, 1985.
Lentz, "Bihzad"
 Lentz, Thomas W. "Changing Worlds: Bihzad and the New Painting." In Canby, *Masters*, 39–54.
Lentz & Lowry
 Lentz, Thomas W., and Glenn D. Lowry. *Timur and the Princely Vision: Persian Art and Culture in the Fifteenth Century*. Los Angeles: Los Angeles County Museum of Art; Washington, D.C.: Arthur M. Sackler Gallery, 1989.

Levey

Levey, M. "Medieval Arabic Bookmaking and Its Relation to Early Chemistry and Pharmacology. " *Transactions of the American Philosophical Society* 52 (1962): 5–79.

Levy

Levy, Reuben. *An Introduction to Persian Literature*. New York: Columbia University Press, 1969.

Lewis

Lewis, Bernard. *Race and Color in Islam*. New York: Octagon Books, 1979.

Lings

Lings, Martin. *The Quranic Art of Calligraphy and Illumination*. London: World of Islam Festival Trust, 1976.

Losty

Losty, Jeremiah P. *The Art of the Book in India*. London: British Library Reference Division Publications, 1982.

Lowry

Lowry, Glenn D., with Susan Nemazee. *A Jeweler's Eye: Islamic Art of the Book from the Vever Collection*. Washington, D.C.: Arthur M. Sackler Gallery with University of Washington Press, 1988.

Lowry et al.

Lowry, Glenn D., and Milo Cleveland Beach with Roya Marefat and Wheeler M. Thackston. *An Annotated and Illustrated Checklist of the Vever Collection*. Washington, D.C.: Arthur M. Sackler Gallery with University of Washington Press, 1988.

Lukens, "Language"

Lukens, Marie G. "The Language of the Birds: Fifteenth-Century Miniatures." *Bulletin of the Metropolitan Museum of Art* n.s., 25, no. 9 (May 1967): 317–39.

McChesney

McChesney, Robert D. "Waqf and Public Policy: The Waqfs of Shah ʿAbbas, 1011–1023/1602–1614." *Asian and African Studies* 15 (1981): 165–90.

Malik al-Daylami [Thackston]

Malik al-Daylami. "Preface to the Amir Husayn Beg Album." In Thackston, *Century*, 351–53.

Malik al-Daylami [Mehdi Bayani]

Malik al-Daylami. "Introduction to Amir Husayn Beg Album." In Mehdi Bayani, 3:601–7.

Manijeh Bayani. *See* Bayani, Manijeh

Marteau & Vever

Marteau, Georges, and Henri Vever. *Miniatures persanes tirées des collections de MM Henry d'Allemagne, Claude Anet . . . et exposées au Musée des arts décoratifs, juin–octobre 1912*. 2 vols. Paris: Bibliotheque d'art et archéologie, 1913.

Martin

Martin, Frederik Robert. *The Miniature Painting and Painters of Persia, India, and Turkey from the Eighth to the Eighteenth Century*. 2 vols. London: Quaritch, 1912.

Mashkur

Mashkur, Muhammad Javad. *Nazar-i bi ta'rikh-i Azarbaijan va asar-i bastani va jami'at shinasi-yi an* (Look at the history, ancient monuments, and people of Azerbaijan). Tehran: Chapkhana Bahman, 1349/1971.

Maslenitsyna

Maslenitsyna, S. *Persian Art in the Collection of the Museum of Oriental Art (Moscow)*. Leningrad: Aurora Art Publishers, 1975.

Massé

Masse, Henri, ed. *Djami, le Beharistan*. Paris: Librarie orientaliste Paul Geuthner, 1925.

Matthee

Matthee, Rudi. "Unwalled Cities and Restless Nomads: Firearms and Artillery in Safavid Iran." In *Safavid Persia: The History and Politics of an Islamic Society*, edited by Charles Melville, 389–416. Pembroke Papers 4. London and New York: I. B. Tauris & Co., 1996.

Mazzaoui

Mazzaoui, Michael M. "From Tabriz to Qazvin to Isfahan: Three Phases of Safavid History." In *XIX deutscher Orientalistentag vom 28. September bis 4. Oktober 1975 in Freiburg im Breisgau, Vorträge*, edited by Wolfgang Voight, 514–22. Wiesbaden: Franz Steiner, 1977.

Mehdi Bayani. *See* Bayani, Mehdi

Melikian-Chirvani, "Mirak"

Melikian-Chirvani, Assadullah Souren. "Khwaje Mirak Naqqash." *Journal Asiatique* 276 (1988): 97–146.

Melikian-Chirvani, "Saloman"

Melikian-Chirvani, Assadullah Souren. "Le royaume de Saloman: Les inscriptions persanes de sites archéménides." *Le Monde Iranien et l'Islam* 1 (1971): 1–41.

Membré [Morton]

Membre, Michele. *Mission of the Lord Sophy of Persia (1539–1542)*. Translated by A. H. Morton. London: School of Oriental and African Studies, University of London, 1993.

Met. Bull.

Metropolitan Museum of Art Bulletin 36 (autumn 1978): 1–48 [issue on the Metropolitan's Islamic collections].

Milstein

Milstein, Rachel. *Islamic Painting in the Israel Museum*. Jerusalem: Israel Museum, 1984.

Minorsky, "Persian Manuscripts"

Minorsky, V. "Two Unknown Persian Manuscripts." *Apollo* 13 (1931): 71–75.

Minorsky, *Tadhkirat*

Minorsky, V., trans. *Tadhkirat al-Muluk: A Manual of Safavid Administration*. 1943. Reprint, Cambridge: University Press, 1980.

Minorsky, "Tsiganes"

Minorsky, V. "Les Tsiganes et les Lurs Persans." *Journal Asiatique* 218 (1931): 281–305.

Misugi

Misugi, T. *Chinese Porcelain Collections in the Near East*. Volume 2, *The Topkapi Palace Museum*; Volume 3, *The Ardabil Shrine Collection*. Hong Kong: Hong Kong University Press, 1981.

Morris, "Miraj" 1

Morris, James Winston. "The Spiritual Ascension: Ibn ʿArabi and the Miraj." Part 1. *Journal of the American Oriental Society* 107, no. 4 (1987): 629–52.

Morris, "Miraj" 2

Morris, James Winston. "The Spiritual Ascension: Ibn ʿArabi and the Miraj." Part 2. *Journal of the American Oriental Society* 108, no. 1 (1988): 63–77.

Morton, "Ardabil" 1

Morton, Alexander H. "The Ardabil Shrine in the Reign of Tahmasp 1." Part 1. *Iran* 12 (1974): 31–64.

Morton, "Ardabil" 2

Morton, Alexander H. "The Ardabil Shrine in the Reign of Tahmasp 1." Part 2. *Iran* 13 (1975): 39–58.

Mudarris-Gilani

Mudarris-Gilani, Murtiza, ed. *Masnavi-yi Haft awrang* (Masnavis of the *Haft awrang*). 2d ed. Tehran: Chapkhana Maharat, 1366s/1988.

Muʿin

Muʿin, Muhammad. *Farhang-i Farsi* (Farsi dictionary). 5 vols. Tehran: Amir-Kabir, 1346–47/1968.

Munthe

Munthe, Gustaf. "Persiska Miniatyrer." *Nationalmusei Arsbok* 5 (1923): 55–75.

Murray

Murray, H. J. R. *A History of Chess*. Oxford: Clarendon, 1913.

Mustafa Ali Efendi [Fisher]

Fisher, Alan. "Mustafa Ali's *Menakib-i Hunerveran* [Exploits of calligraphers]." In *Brocade of the Pen: The Art of Islamic Writing*, 47–54. Edited by Carol Garrett Fisher. East Lansing, Mich.: Kresge Art Museum, Michigan State University, 1991.

Mustafa Ali Efendi [Ibn ül-Emin]

Ali Efendi. *Menakib-i hunerveran* [Exploits of calligraphers]. Turkish text edited by Ibn ül-Emin [Mahmud Kemal Bey]. Istanbul: Türk Tarin Encümeni, 1926.

Najam

Najam, Aziz Ali. *Heritage Reviewed, Tradition Revived*. Karachi: Aga Khan University, n.d.

Naqshbandis

Naqshbandis: Chemisements et situation actuelle d'un ordre mystique musulman/Historical Developments and Present Situation of a Muslim Mystical Order. Actes de la Table Ronde de Sèvres 2–4 Mai/Proceedings of the Sèvres Round Table, 2–4 May 1985. Edited by Marc Gaborieau, Alexander Popovic, and Thierry Zarcone. Istanbul and Paris: Éditions Isis, 1990.

Nasr

Nasr, Seyyed Hossein. *Islamic Science: An Illustrated Study*. London: World of Islam Festival, 1976.

Nizamuddin

Nizamuddin, M. "More Light on the Description of a Rare Illustrated Sixteenth-Century Manuscript of the *Gulistan* of Saʾdi in Hyderabad, Deccan." In *The Memorial Volume of the Fifth International Congress of Iranian Art and Archaeology*, 2:137–51. 2 vols. Tehran: Ministry of Culture and Arts, 1972.

Norgren & Davis

Norgren, Jill, and Edward Davis. *Preliminary Index of Shah-Nahmeh Illustrations*. Ann Arbor: University of Michigan, Center for Near Eastern and North African Studies, 1969.

OAI

Objets d'art de l'Islam: Presentation d'un ensemble objets d'art musulman appartenant à Joseph Soustiel. Paris: Librairie Legueltel, 1973.

OIH

Orientalische illustrierte Handschriften aus Museen und Bibliotheken der Deutschen Demokratischen Republik. Berlin: Islamisches Museum der Staatlichen Museen, 1964.

Okada

Okada, Amina. *Indian Miniatures of the Mughal Court*. Translated by Deke Dusinberre. New York: Harry N. Abrams, Inc., 1992.

O'Kane, "Rock Faces"

O'Kane, Bernard. "Rock Faces and Rock Figures in Persian Painting." *Islamic Art* 4 (1990–91): 219–46.

O'Kane, Timurid

O'Kane, Bernard. *Timurid Architecture in Khurasan*. Costa Mesa, Calif.: Mazda, in association with Udena, 1987.

Oruzheinaya

Oruzheinaya Palata: Opis Moskovski Oruzhennoi Palata (The Armory Palace: Description of the Moscow Armory Palace). 7 vols. & Atlas. Moscow: Society for the Distrbution of Books, 1884–93.

Pal

Pal, Pratapaditya, ed. *Islamic Art: The Nasli M. Heeramaneck Collection*. Los Angeles: Los Angeles County Museum of Art, 1973.

Palmer

Palmer, E. H. *A Descriptive Catalogue of the Arabic, Persian, and Turkish Manuscripts in the Library of Trinity College*. Cambridge: Deighton, Bell, 1870.

Papadopoulo

Papadopoulo, Alexandre. *Islam and Muslim Art*. Translated by Robert Erich Wolf. New York: Abrams, 1979.

Pendlebury

Pendlebury, David, trans. and ed. *Yusuf and Zulaikha: An Allegorical Romance by Hakim Nuruddin Abdurrahman Jami*. London: Octagon, 1980.

Persian Art

Treasures of Persian Art. Louisville, Ky.: J. B. Speed Art Museum, 1966.

Philonenko

Philonenko, M. *Joseph et Aseneth*. Leiden: Brill, 1968.

Pijoán

Pijoán, José. *Summa artis: Historia general del arte*. Vol. 12. Madrid: Espasa-Calipe, 1949.

Pope, *Ardabil*

Pope, John A. *Chinese Porcelains from the Ardabil Shrine*. 2d ed. London: Sotheby's, 1981.

Pope, *Topkapu*

Pope, John Alexander. *Fourteenth-Century Blue-and-White: A Group of Chinese Porcelains in the Topkapu Sarayi Müzesi, Istanbul*. 2d ed. Washington, D.C.: Freer Gallery of Art, 1970.

Porter

Porter, Yves. *Peinture et arts du livre: Essai sur la litterature technique indo-persane*. Paris: Institut français de recherche en Iran, 1992.

Qazi Ahmad [Ishraqi]

Qazi Ahmad. *Khulasat al-tawarikh* (Abstract of history) Edited by Ihsan Ishraqi. 2 vols. Tehran: Intisharat-i danishgah-i Tehran, 1359/1980.

Qazi Ahmad [Minorsky]
Qazi Ahmad. *Calligraphers and Painters: A Treatise by Qadi Ahmad, Son of Mir Munshi (circa A.H. 1015/A.D. 1606)*. Translated by V. Minorsky. Washington, D.C.: Freer Gallery of Art, 1959.

Qazi Ahmad [Suhayli-Khunsari]
Qazi Ahmad. *Gulistan-i hunar* (Garden of the arts). Edited by Ahmad Suhayli-Khunsari. 2d ed. Tehran: Kitabkhana Manuchihri, n.d.

Qazwini & Bouvat
Qazwini, Mirza Muhammad, and L. Bouvat. "Deux documents inédits rélatifs à Behzad." *Revue du monde Musulman* 26 (1914): 146–61.

Qisseh-Khwan [Khadiv-Jam]
Qutbuddin Muhammad Yazd [Qisseh-Khwan]. "Risalah-i dar taʾrikh-i khatt u naqqashan" (Treatise on the history of calligraphy and painting). Edited by Husayn Khadiv-Jam. In *Sukhan* 17, no. 67 (1346/1967): 666–76.

Raby
Raby, Julian. "Mehmed the Conqueror's Greek Scriptorium." *Dumbarton Oaks Papers* 37 (1983): 15–34.

Razi
Razi, Hashim, ed. *Divan-i Kamil-i Jami* (The complete divan of Jami). Tehran: Chapkhana-i Piruz, 1341s/1962.

Richard
Richard, Francis. *Catalogue des manuscrits persans 1: Ancien fonds*. Paris: Bibliotheque nationale, 1989.

Rieu
Rieu, Charles. *Catalogue of the Persian Manuscripts in the British Museum*. 4 vols. London: British Museum, 1876, 1879– 95.

Robertson
Robertson, D. S. "The Date of Jami's *Silsilat al-dhahab*." *Journal of the Royal Asiatic Society* (1945): 165–68.

Robinson, "Ali Asghar"
Robinson, B. W. "Ali Asghar, Court Painter." *Iran* 26 (1988): 125–29.

Robinson, *BC*
Robinson, B. W. *Catalogue of a Loan Exhibition of Persian Miniatures from British Collections*. London: Victoria and Albert Museum, 1951

Robinson, *BI*
Robinson, B. W. *Persian Miniature Painting from Collections in the British Isles*. London: Victoria and Albert Museum, 1967.

Robinson, "Bidpai"
Robinson, B.W. "Prince Baysunghur and the Fables of Bidpai." *Oriental Art*, n.s., 16 (1970): 145–54.

Robinson, *BL*
Robinson, B. W. *A Descriptive Catalogue of the Persian Paintings in the Bodleian Library*. Oxford: Oxford University Press, 1958.

Robinson, "Comments"
Robinson, B. W. "Comments." *Studies on Isfahan* 7 (1974): 508–9.

Robinson, *FC*
Robinson, B. W. *Fifteenth-Century Persian Painting: Problems and Issues*. New York: New York University Press, 1991.

Robinson, *IOL*
Robinson, B. W. *Persian Painting in the India Office Library*. London: Philip Wilson, 1976.

Robinson, "Ismaʿil"
Robinson, B. W. "Ismaʿil II's Copy of the *Shahnama*." *Iran* 14 (1976): 1–8.

Robinson, *Keir*
Robinson, B. W., Ernst J. Grube, G. M. Meredith-Owens, and R. W. Skelton. *Islamic Painting and the Arts of the Book: The Keir Collection*. London: Faber & Faber, 1976.

Robinson, "Kevorkian"
Robinson, B. W. "The Kevorkian Collection: Islamic and Indian Manuscripts, Miniatures, Paintings, and Drawings." New York: Kevorkian Foundation, 1953. Mimeographed.

Robinson, "Muhammadi"
Robinson, B. W. "Muhammadi and the Khurasan Style." *Iran* 30 (1992): 17–29.

Robinson, *PD*
Robinson, B. W. *Persian Drawings from the Fourteenth through the Nineteenth Century*. Boston: Little, Brown, 1965.

Robinson, *PMA*
Robinson, B. W. "Rothschild and Binney Collections: Persian and Mughal Arts of the Book." In *Persian and Mughal Art*, 11–164. London: Colnaghi, 1976.

Robinson, "Pozzi" 1
Robinson, B. W. "Catalogue des peintures et des calligraphies islamiques léguées par Jean Pozzi au Musée d'art et d'histoire de Génève." *Genava*, n.s., 21 (1973): 109–329.

Robinson, *Pozzi* 2
Robinson, B. W., Afsaneh Ardalan Firouz, Marielle Martiniani-Reber, and Claude Ritschard. *Jean Pozzi: L'Orient d'un collectionneur*. Geneva: Musée d'art et d'histoire de Génève, 1992.

Robinson, *PP*
Robinson, B. W. *Persian Paintings*. London: Victoria and Albert Museum, 1952.

Robinson, *RL*
Robinson, B. W. *Persian Paintings in the John Rylands Library: A Descriptive Catalogue*. London: Sotheby's, 1976.

Robinson, "Survey"
Robinson, B. W. "A Survey of Persian Painting (1350–1896)." In *Art et société dans le monde iranien*, edited by Chahryar Adle, 13–89. Paris: Éditions recherche sur les civilisations, 1982.

Robinson et al.
Robinson, B. W., Ernst J. Grube, G. M. Meredith-Owens, and R. W. Skelton. *Islamic Art in the Keir Collection*. London: Faber & Faber, 1988.

Roemer
Roemer, H. R. "The Successors of Timur." In *CHI*, 147–88.

Rogers, *IAD*
Rogers, J. Michael. *Islamic Art and Design, 1500–1700*. London: British Museum, 1983.

Rogers, *TKS*
Topkapi Saray Museum: The Albums and Illustrated Manuscripts. Translated, expanded, and edited by J. M. Rogers, from the original Turkish by Filiz Çağman and Zeren Tanindi. London: Thames & Hudson, 1986.

Rogers & Ward
Rogers, J. M., and R. M. Ward. *Süleymann the Magnificent*. London: British Museum, 1988.

Röhrborn
Röhrborn, K. M. *Provinzen und Zentralgewalt Persiens im 16. und 17. Jahrhundert*. Berlin: de Gryter, 1966.

Roxburgh
Roxburgh, David J. "'Our Works Point to Us': Album Making, Collecting, and Art (1427–1567) under the Timurids and Safavids." 3 vols. Ph.D. diss., University of Pennsylvania, 1996.

Russell
Russell, James R. "Review of M. S. Southgate, *Iskandernameh*." *Journal of the American Oriental Society* 103, no. 3 (1983): 634–36.

Rypka
Rypka, Jan. *History of Iranian Literature*. Dordrecht: Reidel, 1968.

Sacy
Sacy, Silvestre de, trans. *Abd al-Rahman al-Jami: Vie des Soufis ou les haleines de la familiarité (Kitab Nafahat al-Uns min Hadarat al-Ouds)*. Reprint, Paris: Michel Allart Editions orientales, 1977.

Saʿdi [Farughi]
Kulliyat Saʿdi (The collected works of Saʿdi). Edited by Muhammad Ali Farughi. Tehran: Amir Kabir, 2536/1355/1976.

Sadiqi Beg [Khayyampur]
Sadiqi Beg. *Majmaʿ al-khavass* (Concourse of the elite). Edited and translated by Abdul-Rasul Khayyampur. Tabriz: Akhtar-i Shimal, 1327/1948.

Safadi
Safadi, Y. H. *Islamic Calligraphy*. Boulder, Colo.: Shambala, 1979.

Sakisian
Sakisian, Arménag. *La miniature persane du XII au XVII siècle*. Paris: van Oest, 1929.

Saljuqi
Saljuqi, Fikri. *Khiaban* (Street). Kabul: Nashriat Anjuman-i Jami, 1343s/1964.

Sam Mirza [Dastgirdi]
Sam Mirza. *Tuhfa-yi Sami* (Gift of Sam; or, Some princely curios). Edited by Vahid Dastgirdi. Tehran: Armaghan,1314/1936.

Sam Mirza [Humayun-Farrukh]
Sam Mirza. *Tadhkira-i tuhfa-yi Sam Mirza* (A biographical memoir of some princely curios). Edited by Ruknuddin Humayun-Farrukh. Tehran: Chapkhana ilmi, 1347/1968.

Sarna
Sarna, Nahum M. *Understanding Genesis*. New York: Jewish Theological Seminary of America, 1966.

Savory
Savory, Roger. "The Sherley Myth." *Iran* 5 (1967): 73–81.

Scarce
Scarce, Jennifer. "The Development of Women's Veils in Persia and Afghanistan." *Costume* 9 (1975): 4–14.

Schimmel, "Album"
Schimmel, Annemarie. "The Calligraphy and Poetry of the Kevorkian Album." In S. C. Welch et al., 31–44.

Schimmel, *Calligraphy*
Schimmel, Annemarie. *Calligraphy and Islamic Culture*. New York: New York University Press, 1984.

Schimmel, *MD*
Schimmel, Annemarie. *Mystical Dimensions of Islam*. Chapel Hill, N.C.: University of North Carolina Press, 1975.

Schimmel, *MM*
Schimmel, Annemarie. *And Muhammad Is His Messenger: The Veneration of the Prophet in Islamic Piety*. Chapel Hill, N.C.: University of North Carolina Press, 1985.

Schimmel, "Review"
Schimmel, Annemarie. "Review of *Persian Miniature Painting*, by Norah Titley." *Journal of American Oriental Society* 108 (January–March 1988): 175.

Schimmel, *Veil*
Schimmel, Annemarie. *As through a Veil: Mystical Poetry in Islam*. New York: Columbia University Press, 1982.

Schmitz, "Harat"
Schmitz, Barbara J. "Miniature Painting in Harat, 1570–1640. " Ph.D. diss., New York University, 1981.

Schmitz, *NYPL*
Schmitz, Barbara. *Islamic Manuscripts in the New York Public Library*. New York and Oxford: Oxford University Press and the New York Public Library, 1992.

Schroeder
Schroeder, Eric. *Persian Miniatures in the Fogg Museum of Art*. Cambridge, Mass.: Harvard University Press, 1942.

Schulz
Schulz, P. Walter. *Die persisch-islamische Miniaturmalerei*. 2 vols. Leipzig: Hiersemann, 1914.

Séguy
Séguy, Marie-Rose. *The Miraculous Journey of Mohamet: Miraj Nahmeh*. New York: Braziller, 1977.

Seyller
Seyller, John. "Codicological Aspects of the Victoria and Albert *Akbarnama* and Their Historical Implications." *Art Journal* 49 (winter 1990): 379–87.

Seyller, "Inspection"
Seyller, John. "The Inspection and Valuation of Manuscripts in the Imperial Mughal Library." *Artibus Asiae* (forthcoming).

Shafi
Shafi, Muhammad, ed. "Iqtibas az *Khulasat al-tawarikh* (?)" (Extracts from the *Abstract of history* [?]). *Oriental College Magazine* 10 (1934): 19–30.

Sidersky
Sidersky, D. *Les origines des legendes musulmans dans le Coran*. Paris: Librarie orientaliste Paul Geuthner, 1935.

Simpson, *AI*
Simpson, Marianna Shreve. *L'Art islamique, Asie: Iran, Afghanistan, Asie Centrale, et Inde*. Paris: Flammarion, 1983.

Simpson, "Bahram Mirza"
Simpson, Marianna Shreve. "A Manuscript Made for the Safavid Prince Bahram Mirza." *Burlington Magazine* 133 (June 1991): 376–84.

Simpson, "Codicology"
Simpson, Marianna Shreve. "Codicology in the Service of Chronology: The Case of Some Safavid Manuscripts." In Deroche, *Manuscrits*, 133–39.

Simpson, *Epic*
Simpson, Marianna Shreve. *The Illustration of an Epic: The Earliest Shahnama Manuscripts.* New York: Garland, 1979.
Simpson, *Fogg*
Simpson, Marianna Shreve. *Arab and Persian Painting in the Fogg Art Museum.* Cambridge, Mass.: Fogg Art Museum, Harvard University, 1980.
Simpson, "Jami"
Simpson, Marianna Shreve. "The Production and Patronage of the *Haft Aurang* by Jami in the Freer Gallery of Art." *Ars Orientalis* 13 (1982): 93–119.
Simpson, "Kitab-Khana"
Simpson, Marianna Shreve. "The Making of Manuscripts and the Workings of the *Kitab-Khana* in Safavid Iran." In *The Artist's Workshop*, edited by Peter M. Lukehart, pp. 105–21. Studies in the History of Art 38. Washington, D.C.: National Gallery of Art, 1993.
Simpson, "Shaykh-Muhammad"
Simpson, Marianna Shreve. "Shaykh-Muhammad." In Canby, *Masters*, 99–113.
Sims, "Minneapolis"
Sims, Eleanor. "Persian Miniature Painting in the Minneapolis Institute of Arts." *Minneapolis Institute of Arts Bulletin* 62 (1975): 50–73.
Sims, "Timurid"
Sims, Eleanor. "Painting in Timurid Iran." *Asian Art* 2 (spring 1989): 62–79.
Simsar
Simsar, Muhammad Ahmed. *Oriental Manuscripts of the John Frederick Lewis Collection in the Free Library of Philadelphia.* Philadelphia: Muhammad A. Simsar, 1937.
Skelton, "Bakharz"
Skelton, Robert. "An Illustrated Manuscript from Bakharz." In *The Memorial Volume of the Fifth International Congress of Iranian Art and Archaeology*, 2:198–204. 2 vols. Tehran: Ministry of Culture and Arts, 1972.
Skelton, "Farrokh Beg"
Skelton, Robert. "The Mughal Artist Farrokh Beg." *Ars Orientalis* 2 (1957): 393–411.
SOTH 24.VI.41 *Catalogue of Fine Oriental Miniatures and Manuscripts.* [Auction catalogue, 24 June 1941.] London: Sotheby's, 1941.
SOTH 7.II.49
Catalogue of Extremely Fine Persian and Moghul Miniatures. Oriental Manuscripts, etc. [Auction catalogue, 7 February 1949.] London: Sotheby's, 1949.
SOTH 6.XII.67
Highly Important Oriental Manuscripts and Miniatures: The Property of the Kevorkian Foundation. [Auction catalogue, 6 December 1967.] London: Sotheby's, 1967.
SOTH 1.XII.69
Catalogue of Highly Important Oriental Manuscripts and Miniatures: The Property of the Kevorkian Foundation. [Auction catalogue, 1 December 1969.] London: Sotheby's, 1969.
SOTH 17.XII.69
Catalogue of Oriental Manuscripts and Miniatures: The Property of Mrs. A. Bergier de Rouville and Other Properties. [Auction catalogue, 17 December 1969.] London: Sotheby's, 1969.
SOTH 7.XII 70
Catalogue of Highly Important Oriental Manuscripts and Miniatures: The Property of the Kevorkian Foundation. [Auction catalogue, 7 December 1970.] London: Sotheby's, 1970.
SOTH 14.VII.71
Oriental Manuscripts and Miniatures and Printed Books. [Auction catalogue, 14 July 1971.] London: Sotheby's, 1971.
SOTH 11.VII.72
Catalogue of Oriental Manuscripts and Miniatures. [Auction catalogue, 11 July 1972.] London: Sotheby's, 1972.
SOTH 13.IV.76
Fine Oriental Miniatures, Manuscripts, and Qajar Paintings. [Auction catalogue, 13 April 1976.] London: Sotheby's, 1976.
SOTH 23.XI.76
Catalogue of Fine Oriental Miniatures, Manuscripts, and Persian Lacquer. Part Two. [Auction catalogue, 23 November 1976.] London: Sotheby's, 1976.
SOTH 2.V.77
Catalogue of Important Oriental Manuscripts and Miniatures: The Property of the Hagop Kevorkian Fund. [Auction catalogue, 2 May 1977.] London: Sotheby's, 1977.

SOTH 3.V 77
Catalogue of Fine Oriental Miniatures, Manuscripts, Qajar Paintings, and Lacquer. Part One. [Auction catalogue, 3 May 1977.] London: Sotheby's, 1977.
SOTH 20.VII.77
Catalogue of Fine Oriental Miniatures, Manuscripts, and an Important Qur'an. [Auction catalogue, 20 July 1977.] London: Sotheby's, 1977.
SOTH 10.X.77
Catalogue of Fine Oriental Miniatures and Manuscripts. [Auction catalogue, 10 October 1977.] London: Sotheby's, 1977.
SOTH 3.IV.78
Catalogue of Important Oriental Manuscripts and Miniatures. The Property of the Hagop Kevorkian Fund. [Auction catalogue, 3 April 1978.] London: Sotheby's, 1978.
SOTH 23.IV.79
Catalogue of Important Oriental Manuscripts and Miniatures: The Property of the Hagop Kevorkian Foundation. [Auction catalogue, 23 April 1979.] London: Sotheby's, 1979.
SOTH 21.IV.80
Catalogue of Important Oriental Manuscripts and Miniatures: The Property of the Hagop Kevorkian Fund. [Auction catalogue, 21 April 1980.] London: Sotheby's, 1980.
SOTH 22.IV.80
Catalogue of Fine Oriental Manuscripts, Miniatures, and Qajar Lacquer. [Auction catalogue, 22 April 1980.] London: Sotheby's, 1980.
SOTH 6.VII.81
Oriental Manuscripts and Miniatures. [Auction catalogue, 6 July 1981.] London: Sotheby's, 1981.
SOTH 13.X.81
Fine Oriental Miniatures, Manuscripts, and Printed Books. [Auction catalogue, 13 October 1981.] London: Sotheby's, 1981.
SOTH 18.XII.81
Fine Oriental Miniatures, Manuscripts, and Printed Books. [Auction catalogue, 18 December 1981.] London: Sotheby's, 1981.
SOTH 26.IV.82
Catalogue of Fine Oriental Manuscripts: The Property of the Hagop Kevorkian Fund. [Auction catalogue, 26 April 1982.] London: Sotheby's, 1982.
SOTH 27.IV.82
Fine Oriental Miniatures, Manuscripts, and Printed Books: The Property of the Hagop Kevorkian Fund and Other Properties. [Auction catalogue, 27 April 1982.] London: Sotheby's, 1982.
SOTH 15.IV.85
Fine Oriental Manuscripts and Miniatures, Including Seven Illustrated Leaves from the Siyar-i Nabi. [Auction catalogue, 15 April 1985.] London: Sotheby's, 1985.
SOTH 21–22.XI.85
Fine Oriental Manuscripts and Miniatures. [Auction catalogue, 21–22 November 1985.] London: Sotheby's, 1985.
SOTH 11.IV.88
Oriental Manuscripts and Miniatures. [Auction catalogue, 11 April 1988.] London: Sotheby's, 1988.
SOTH 10.IV.89
Oriental Manuscripts and Miniatures. [Auction catalogue, 10 April 1989.] London: Sotheby's, 1989.
SOTH 21.IV.89
Oriental Manuscripts and Miniatures. [Auction catalogue, 21 April 1989.] London: Sotheby's, 1989.
SOTH 26.IV.90
Oriental Manuscripts and Miniatures. [Auction catalogue, 26 April 1990.] London: Sotheby's, 1990.
SOTH 29–30.IV.92
Oriental Manuscripts and Miniatures. [Auction catalogue, 30 April 1992.] London: Sotheby's, 1992.
SOTH 22.X.93
Oriental Manuscripts and Miniatures. [Auction catalogue, 22 October 1993.] London: Sotheby's, 1993.
SOTH 19.X.94
Oriental Manuscripts and Miniatures. [Auction catalogue, 19 October 1994.] London: Sotheby's, 1994.
SOTH 18.X.95
Oriental Manuscripts and Miniatures. [Auction catalogue, 18 October 1995.] London: Sotheby's, 1995.
Soucek, "Artists"
Soucek, Priscilla P. "Persian Artists in Mughal India: Influences and Transformations." *Muqarnas* 4 (1987): 166–81.

Soucek, "*Makhzan*"
Soucek, Priscilla P. "The New York Public Library *Makhzan al-Asrar* and Its Importance." *Ars Orientalis* 18 (1988): 1–37.
Soucek, "Review"
Soucek, Priscilla P. "Review of *The Houghton Shahnameh*, by Martin Bernard Dickson and Stuart Cary Welch." *Ars Orientalis* 14 (1984): 133–38.
Soudavar
Soudavar, Abolala, with a contribution by Milo Cleveland Beach. *Art of the Persian Courts: Selections from the Art and History Trust Collection.* New York: Rizzoli, 1992.
Soulis
Soulis, George C. "Gypsies in the Byzantine Empire and the Balkans in the Late Middle Ages." *Dumbarton Oaks Papers* 15 (1961): 141–65.
Southgate
Southgate, Minoo S., trans. *Iskandarnameh: A Persian Medieval Alexander Romance.* New York: Columbia University Press, 1978.
SPB 15.XII.78
Fine Oriental Miniatures, Manuscripts, Islamic Works of Art, and 19th Century Paintinas. [Auction catalogue 4197, 15 December 1978.] New York: Sotheby Parke Bernet, 1978.
Stchoukine, *MS*
Stchoukine, Ivan. *Les peintures des manuscrits Safavis de 1502 à 1587.* Paris: Librairie orientaliste Paul Geuthner, 1959.
Stchoukine, *MSA*
Stchoukine, Ivan. *Les peintures des manuscrits de Shah Abbas I^er à la fin des Safavis.* Paris: Librairie orientaliste Paul Geuthner, 1964.
Stchoukine, *Nizami*
Stchoukine, Ivan. *Les Peintures des manuscrits de la Khamseh de Nizami au Topkapi Sarayi Müzesi d'Istanbul.* Paris: Librairie orientaliste Paul Geuthner, 1977.
Stchoukine, *PI*
Stchoukine, Ivan. *La peinture iranienne sous les derniers Abbasides et les Il-Khans.* Bruges: Imprimerie Sainte Catherine, 1936.
Stchoukine, *PMT*
Stchoukine, Ivan. *Les peintures des manuscrits timurides.* Paris: Librairie orientaliste Paul Geuthner, 1954.
Stchoukine, "Poème"
Stchoukine, Ivan. "Un poème de Jami illustré à Tabriz en 931/1525." *Syria* 51 (1974): 291–97.
Stchoukine, "Shaykh"
Stchoukine, Ivan. "Maulana Shaykh Muhammad: Un maitre de 1'école de Meshhed du XVI^e siècle." *Ars Asiatique* 30 (1974): 3–11.
Stockholm 1957
Oriental Miniatures and Manuscripts in Scandinavian Collections. Stockholm: National Museum, 1957.
Stockholm 1985
Islam konst och kulture/Art and Culture. Stockholm: Stations Historiska Museum, 1985.
Storey
Storey, Charles Ambroise. *Persian Literature: A Bio-bibliographical Survey.* 2 vols. London: Ulzac, 1927–77; Leiden: Brill, 1977.
Subtelny, "'Ali Shir
Subtelny, Maria Eva. "'Ali Shir Nava'i: *Bakshi and Beg.*" *Harvard Ukrainian Studies, Eucharisterion* 3–4, pt. 2 (1979–80): 797–807.
Subtelny, "Herat"
Subtelny, Maria Eva. "Scenes from the Literary Life of Timurid Herat." In *Logos Islamikos: Studia Islamica in honorem Georgii Michaelis Wickens*, edited by Roger M. Savory and A. Dionisius Agius, 137–55. Toronto: University of Toronto, 1984.
Subtelny, "Ikhlasiyya"
Subtelny, Maria Eva. "A Timurid Educational and Charitable Foundation: The Ikhlasiyya Complex of 'Ali Sher Nava'i in Fifteenth-Century Herat and Its Endowment." *Journal of the American Oriental Society* 111 (January–March 1991): 38–61.
Subtelny, "Poetic Circle"
Subtelny, Maria Eva. "The Poetic Circle at the Court of the Timurid Sultan Husain Baiqara and Its Political Significance." Ph.D. diss., Harvard University, 1979.

Subtelny, "Reform"
Subtelny, Maria Eva. "Centralizing Reform and Its Opponents in the Late Timurid Period." *Iranian Studies* 21 (1988): 123–51.

Subtelny, "Socioeconomic"
Subtelny, Maria Eva. "Socioeconomic Bases of Cultural Patronage under the Later Timurids." *International Journal of Middle Eastern Studies* 20, no. 4 (1988): 479–505.

Survey
Pope, Arthur Upham, and Phyllis Ackerman, eds. *A Survey of Persian Art from Prehistoric Times to the Present*. 6 vols. London: Oxford University Press, 1939.

Swietochowski, "Borders"
Swietochowski, Marie Lukens. "Decorative Borders in Mughal Albums." In S. C. Welch et al., 45–78.

Swietochowski, "*Mantiq*"
Swietochowski, Marie Lukens. "The Historical Background and Illustrative Character of the Metropolitan Museum's *Mantiq al-tayr* of 1483." In *Islamic Art in the Metropolitan Museum of Art*, edited by Richard Ettinghausen, 39–72. New York: Metropolitan Museum of Art, 1972.

Szuppe
Szuppe, Maria. "La participation des femmes de la famille royale à l'exercice du pouvoir en Iran Safavides au XVIᵉ siècle (première partie)." *Studia Iranica* 23 (1994): 211–58.

Taherzade Behzad
Taherzade Behzad, H. "Book Painting: The Preparation of the Miniaturist's Materials." In *Survey*, 3:1921–27.

Tahmasp
Art of the Court of Shah Tahmasp. [Exhibition leaflet.] Washington, D.C.: Freer Gallery of Art, [1979].

Tahmasp [Nava'i]
Shah Tahmasp Safavi: Majmu-ye asnad va mukhatibate tarikhi hamrah ba yadashthaye tafzili (Shah Tahmasp Safavid: A collection of historical documents and correspondence together with commentary notes). Edited by Abdul-Husayn Nava'i. Tehran: Instisharat-i Bonyad-i Farharg Iran, 1350/1971.

Thackston, *Century*
Thackston, Wheeler M. *A Century of Princes: Sources in Timurid History and Art*. Cambridge, Mass.: Aga Khan Program for Islamic Architecture, 1989.

Thackston, "*Diwan*"
Thackston, Wheeler M. "The *Diwan* of Khata'i: Pictures for the Poetry of Shah Isma'il I." *Asian Art* 1, no. 4 (fall 1988): 37–63.

Thackston, *Simnani*
Thackston, Wheeler M., ed. *'Ala'uddawla Simnani: Opera Minora*. Cambridge, Mass.: Harvard University, 1988.

Titley, "*Garshaspnameh*"
Titley, Norah M. "A Manuscript of the *Garshaspnameh*." *British Museum Quarterly* 31 (1966): 27–32.

Titley, *MPM*
Titley, Norah M. *Miniatures from Persian Manuscripts: A Catalogue and Subject Index of Paintings from Persia, India, and Turkey in the British Library and the British Museum*. London: British Museum, 1977.

Titley, *PMP*
Titley, Norah M. *Persian Miniature Painting and Its Influence on the Art of Turkey and India: The British Library Collections*. London: British Library Board, 1983.

Togan
Togan, Zeki Velidi. *On the Miniatures in Istanbul Libraries*. Istanbul: Baha Matbaasi, 1963.

Treasures
Treasures of Islam. Edited by Toby Falk. London: Sotheby's, Philip Wilson for Musée d'art et d'histoire de Génève, 1985.

Triningham
Triningham, J. Spencer. *The Sufi Orders in Islam*. Oxford: Clarendon, 1971.

USSR Colls.
Sixteenth-Century Miniatures Illustrating Manuscript Copies of the Work of Jami from the USSR Collections. Moscow: Izdatelstvo Sovetskii, n.d.

Waley
Waley, Muhammad Isa. "Problems and Possibilities in Dating Persian Manuscripts." In Deroche, *Manuscrits*. 1–15.

Walzer
Walzer, Sofie. "The Topkapi Sarayi Manuscript of the Persian *Kalila wa-Dimna* Dated A.D. 1413." In *Paintings from the Islamic Lands*, edited by R. Pinder-Wilson, 48–84. Oxford: Cassirer, 1969.

Weitzmann
Weitzmann, Kurt. *Illustrations in Roll and Codex: A Study of the Origin and Method of Text Illustration*. 2d ed. Princeton, N.J.: Princeton University Press, 1970.

A. Welch, "Abbas"
Welch, Anthony. "Painting and Patronage under Shah Abbas I." Studies of Isfahan: Proceeding of the Isfahan Colloquium, part 2, ed. Renata Holod. *Iranian Studies* 7 (summer-autumn 1974): 458–507.

A. Welch, *Artists*
Welch, Anthony. *Artists for the Shah: Late Sixteenth-Century Painting at the Imperial Court of Iran*. New Haven, Conn.: Yale University Press, 1976.

A. Welch, *Calligraphy*
Welch, Anthony. *Calligraphy in the Arts of the Muslim World*. New York: Asia Society, 1979.

A. Welch, *CIA*
Welch, Anthony. *Collection of Islamic Art: Prince Sadruddin Aga Khan*. 4 vols. Geneva: Chateau de Bellerive, 1972–78.

A. Welch, *Isfahan*
Welch, Anthony. *Shah 'Abbas and the Arts of Isfahan*. New York: Asia Society, 1973.

A. Welch, "Patrons"
Welch, Anthony. "Patrons and Calligraphers in Safavi Iran." *Middle East Librarians Association Notes* 12 (October 1977): 10–15.

S. C. Welch, *India*
Welch, Stuart Cary. *India: Art and Culture. 1300–1900*. New York: Metropolitan Museum of Art and Holt, Rinehart & Winston, 1985.

S. C. Welch, *KBK*
Welch, Stuart Cary. *A King's Book of Kings: The Shah-Nameh of Shah Tahmasp*. New York: Metropolitan Museum of Art, 1972.

S. C. Welch, "Pictures"
Welch, Stuart Cary. "Pictures from the Hindu and Muslim Worlds." *Apollo* 107 (May 1978): 68–73.

S. C. Welch, *PP*
Welch, Stuart Cary. *Persian Painting: Five Royal Safavid Manuscripts of the Sixteenth Century*. New York: Braziller, 1976.

S. C. Welch, *WA*
Welch, Stuart Cary. *Wonders of the Age: Masterpieces of Early Safavid Painting, 1501–1576*. Cambridge, Mass.: Fogg Art Museum, Harvard University, 1979.

Welch & Welch
Welch, Anthony, and Stuart Cary Welch. *Arts of the Islamic Book: The Collection of Prince Sadruddin Aga Khan*. Ithaca, N.Y.: Cornell University Press for the Asia Society, 1982.

S. C. Welch et al.
Welch, Stuart Cary, Annemarie Schimmel, Marie L. Swietochowski, and Wheeler M. Thackston. *The Emperor's Album: Images of Mughal India*. New York: Metropolitan Museum of Art, 1987.

Wiet
Wiet, Gaston. *Miniatures persanes, turques, et indiennes: Collection de son excellence Cherif Sabry pacha. Mémoires de l'Institut d'Égypte*. Cairo: Institut d'Égypte, 1943.

Wilber
Wilber, Donald. "The Timurid Court: Life in Gardens and Tents." *Iran* 17 (1979): 127–33.

Witkam
Witkam, J. J. *Arabic Manuscripts in the Library of the University of Leiden and Other Collections in the Netherlands: A General Introduction to the Catalogue*. Leiden: Brill, 1982.

Woods
Woods, John. *The Aqquyunlu: Clan, Federation, Empire: A Study in Fifteenth/Ninth Century Turko-Iranian Politics*. Minneapolis and Chicago: Bibliotheca Islamica, 1976.

Wormald & Giles
Wormald, F., and P. M. Giles. *A Descriptive Catalogue of the Additional Illuminated Manuscripts in the Fitzwilliam Museum*. Cambridge: Cambridge University Press, 1982.

Yarshater
Yarshater, Ehsan. "The Indian Style: Progress or Decline?" In *Persian Literature*, edited by Ehsan Yarshater, 249–88. Albany: N.Y.: Bibliotheca Persica, 1988.

Yohannan
Yohannan, John D. *Joseph and Potiphar's Wife in World Literature: An Anthology of the Story of the Chaste Youth and the Lustful Stepmother*. New York: New Directions, 1968.